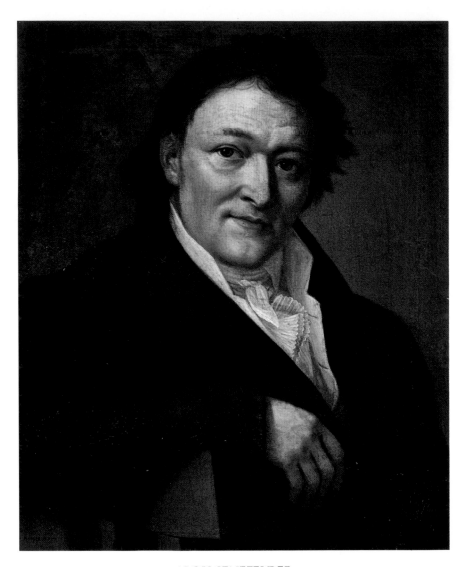

ALOIS SENEFELDER

Portrait painted in 1829 by Professor Joseph Hauber.
The original painting is in the *Deutsches Museum,* Munich.
This illustration was reproduced in four-color lithography
by the Litho-Krome® Company, Columbus, Georgia.
A subsidiary of Hallmark Cards, Inc.

THE LITHOGRAPHERS MANUAL

Seventh Edition

THE
LITHOGRAPHERS
MANUAL

Seventh Edition

Edited by

RAYMOND N. BLAIR

THE GRAPHIC ARTS TECHNICAL FOUNDATION, INC.
FORTY-SIX FIFTEEN FORBES AVENUE
PITTSBURGH, PENNSYLVANIA
15213

Printed in the United States of America

Foreword

In 1937, the late Walter Soderstrom published a 305-page treatise called *The Photo-Lithographer's Manual*. Soderstrom was the sole author of the text and he financed its printing by including advertisements in a section at the book's end. From the start, *The Photo-Lithographer's Manual* represented a giant stride forward in the literature of lithographic technology.

Continuing that tradition, this new Seventh Edition is the best single-volume summary of lithographic technology available. Since 1937, *The Lithographers Manual* has doubled in number of pages and tripled in number of illustrations. Over the years, the line leading in Soderstrom's original edition has been reduced to pack more information on a page. The advertisements have been replaced by reports issued by the GATF Research Department. Today's *Lithographers Manual* is the product of the collective knowledge of some of the greatest experts lithography and printing has known.

As *The Lithographers Manual* has mirrored the explosion in our knowledge of lithographic technology for close to half a century, so the development of GATF has mirrored the phenomenal growth of the lithographic industry during six decades. What began as a one-man research effort at the University of Cincinnati has become a multifaceted organization whose membership now spans the globe. The industry grew with help from GATF, and GATF grew with the industry.

These years of the Foundation and of *The Lithographers Manual* witnessed the transformation of lithography from a small, struggling stepchild of the printing industry into today's giant. It is a transformation that has left a profound mark both on the Foundation and on this *Manual*.

GILBERT W. BASSETT, *Executive Director*
Graphic Arts Technical Foundation, Inc.

Editor's Preface

This volume has evolved from the contributions of many persons over a period of many years. As a perusal of the Table of Contents will show, the bedrock work of those whose names have been bywords in the industry for decades is intermingled with the fresh material of rising young talent.

The first edition was written entirely by its publisher, Walter E. Soderstrom. By the time of the Twentieth Anniversary Edition, the field had developed so greatly that a complete revision of the *Manual* was planned. This edition was published in two volumes, and its editor, Victor Strauss, gave credit to the following persons, in addition to Soderstrom, for contributions and/or other major assistance:

Fred W. Baker	William C. Huebner	Frank M. Preucil
G. O. Baker	Anselm Inzinger	Robert F. Reed
Michael H. Bruno	Leo H. Joachim	Walter E. Reed
Kenneth Burchard	A. F. Johnson	Fred Roblin
Hamilton C. Carson	Edward E. Katz	Charles Shapiro
Maxwell R. Conclin	John L. Kronenberg	Vincent Stafford
Walter F. Cornell	Albert T. Kuehn	Earl Sundeen
Byron G. Culver	Charles W. Latham	Bernard Taymans
Clarence Dickinson	Douglas G. Manley	Richard B. Tullis
John S. Dively	Joseph Mazzaferri	Roy P. Tyler
Thomas E. Dunwoody	Dante V. Mazzocco	August A. Saul
Ellsworth Geist	John McMaster	Carl Siebke
John G. Gervase	Carl Mellick	John Vinton
Rod Greig	J. Tom Morgan	Reginald F. Wardley
Wade E. Griswold	R. J. Niederhauser	Martin J. Weber
Syl Hall	John F. Perrin	J. A. C. Yule
William F. Hall	Harry A. Porter	

In subsequent editions, during which a more compact format made possible a return to the single volume, a policy of partial revision of different portions of the book from edition to edition was established. This has permitted revising each time the material most in need of update, thus keeping the *Manual* as current as economically feasible.

It has become impractical to continue trying to acknowledge individually the legions of people who contribute usefully to a volume of this magnitude and complexity. Names of new writers are added in the Table of Contents, and photograph suppliers (other than GATF) are acknowledged in credit lines under the pictures; but for the larger number of others whose contributions have been invaluable—GATF staff specialists, information suppliers from various segments of the industry, and the paper manufacturers, trade houses, and printers (all preferring to remain anonymous) who contribute supplies and typesetting, printing, and binding services for the *Manual*—a general but very appreciative expression of thanks will have to suffice.

The purpose of this book has always been to supply concise, up-to-date information on all phases of lithography and related subjects. Suggestions, general and specific, for improved realization of this objective are always welcome.

RAYMOND N. BLAIR, *Editor-in-Chief*
March 1983

TABLE OF CONTENTS

CHAPTER ONE
THE HISTORY OF LITHOGRAPHY
W. E. Soderstrom

CHAPTER TWO
GATF: TRAILBLAZER IN THE GRAPHIC ARTS
Nina Forsythe

CHAPTER THREE
THE FLOW OF LITHOGRAPHIC PRODUCTION

CHAPTER FOUR
THE PREPARATION OF TYPE AND ART

Type Preparation
Frank Benevento, Ray Blair, Daniel Makuta, Raymond Stachowiak

Art Preparation
Donna C. Mulvihill

TABLE OF CONTENTS

CHAPTER FIVE
THE CAMERA DEPARTMENT

CHAPTER SIX
COLOR-SEPARATION PHOTOGRAPHY
J. A. C. Yule

CHAPTER SEVEN
PHOTOGRAPHIC MASKING AND COLOR CORRECTING

CHAPTER EIGHT
THE LITHO ART DEPARMTENT
Bernard R. Halpern

TABLE OF CONTENTS

CHAPTER NINE
THE STRIPPING AND PHOTOCOMPOSING DEPARTMENTS

CHAPTER TEN
THE PLATEMAKING DEPARTMENT
Michael H. Bruno

CHAPTER ELEVEN
THE PROOFING DEPARTMENT

CHAPTER TWELVE
LITHOGRAPHIC PRESSWORK
Charles Shapiro

TABLE OF CONTENTS

The History of Lithography_____

Section One: The Invention of Lithography

Lithography was invented in 1798 by Alois Senefelder. The story goes that Senefelder, who was interested in printing some of his own compositions, had at hand a freshly polished stone upon which he wrote down a laundry list for his mother using a greasy crayon. Being curious, he experimented with the stone and found that, when chemically treated and inked, impressions could be pulled from the stone; thus lithography was born.

FACTS, FICTION AND A LAUNDRY LIST

Actually, the Senefelder laundry list has been highly fictionized in the course of time. Almost every single item in the above told story is distorted. If we want to use contemporary expressions we can say that Senefelder had been working on a printing and engraving research project for quite some time before this famous incident.

In 1796, when this incident occurred, Senefelder was practicing for copperplate engraving on the cheaper Bavarian limestone rather than on the expensive copper. The stone was therefore not at hand by chance. Nor was the greasy crayon a crayon. Senefelder wrote on the stone with an ink specially developed by him. (Alois Senefelder, *The Invention of Lithography*, N. Y. 1911, p. 8.)

If the word compositions refers to *musical* composition, as one can often read, this is again misleading. Senefelder was no musician; he was bred for the law and had studied for three years at a Bavarian university. The so-called compositions were dramatic writings with which he tried to earn a living after his father died. *Finally, and most important, the result of the laundry list incident was not lithography but a relief etching process.* It is indeed surprising how many errors and halftruths can be packed in a few sentences!

This distortion of the origin of lithography is that much more unnecessary as Senefelder himself laid down the story for the record in his book "The Invention of Lithography" which was translated into English (the second time) by J. W. Muller and published by the Fuchs & Lang Manufacturing Company in 1911 in New York. There Sene-

felder states clearly that the 1796 process was "purely mechanical in its purpose" whereas lithography "may be called purely chemical" (op. cit., p. 7). In this book he also vigorously protests against the story that he invented lithography by chance: "I have told all these things fully in order to prove to the reader that I did not invent stoneprinting through lucky accident, but that I arrived at it by a way pointed out by industrious thought" (op cit., p. 6).

THE LITHOGRAPHIC PRINCIPLE

The principle on which lithography is based is the mutual repellence of water and greasy substances. The limestone used by Senefelder was porous and particularly well suited to lithography. But limestone is not essential for the process. Senefelder preferred the term *chemical printing* for his invention and used this term as a generic one; stone printing (in German *Steindruck*) or lithography was for him only one branch of many possible in chemical printing.

Terminology is neither generally accepted nor consistent throughout history. At certain times and in certain countries a distinction was made for example, between lithography and zincography (lithography from zinc plates). The term chemical printing was less used in the Anglo-American orbit than planography, and planography too has been used and is used by different people with differing connotations. In the course of this century the term lithography has lost its meaning as stone printing and is in our day more or less generally used in the same sense in which Senefelder used chemical printing.

LITHOGRAPHY AND COPPERPLATE ENGRAVING

The original method of stone printing was slow and cumbersome if compared with our contemporary lithographic techniques but it was very fast and simple in comparison to copperplate engraving, the art with which the new invention competed the most vigorously.

The superiority of lithography — at least costwise — is set forth in a cost comparison of lithography and copper-

plate engraving in the English translation (by C. Hullmandel) of Raucourt's treatise on lithography, published in London, 1821. There it is shown that "lithography is about seven times cheaper than copperplate engraving, if plate costs of both processes are compared. The printing costs show much less of a difference, but lithographic printing costs only a little more than half of the printing of copperplate engravings. (*A Manual of Lithography* translated from the French by C. Hullmandel, Second Edition, London, 1821, p. 128 ff)

LITHOGRAPHY AS A DUPLICATING PROCESS

The great popularity of lithography can be explained by these cost figures. Lithography is also ideal as a "duplicating process." Our illustration shows an "Autographic Press," if not the first, then certainly one of the first lithographic duplicators. Under the title "Every man his

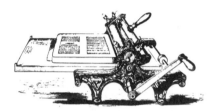

The Autographic Press, possibly the first lithographic duplicating machine.

own printer, or lithography made easy" a book was published anonymously in 1854 in London, Manchester and Edinburgh. This book is obviously sales literature for the Autographic Press which enables "any person of ordinary intelligence to perform all the operations of this form of lithography without being compelled to seek the aid of a professional printer."

This "wonderful" press was at first intended merely to facilitate the production of a few copies of manuscripts of a private nature, for which the merchant or banker would ordinarily employ the more valuable services of confidential clerks to copy by hand. In a short time, however, the press came into use, not only in the counting houses of the merchant, but in the offices of the principal railway and insurance companies; proving a valuable accessory (op. cit., p. iv). Times have not changed so much, after all!

EARLY LITHOGRAPHY WAS COMPLETELY DO-IT-YOURSELF

The technical details of stone lithography are much too involved to be discussed in the frame of this study. At the beginning, the lithographer had to provide all equipment by his own efforts. There were neither lithographic presses nor inks or chemicals available for purchase. The art was primitive but it was very difficult to learn; a successful lithographer did not easily divulge his trade secrets.

Every step, every item had to be slowly and painfully developed. The preparation of the stone, the creation of the image, inking and dampening, preparing the paper, and finally taking the impression were all manually performed.

According to the craftsman's ability and training the results differed greatly.

But the intrinsic strength of the lithographic process was powerful enough to overcome all these hurdles. Lithography spread from Munich, its birthplace, to Vienna and Offenbach as well as to other German cities; then to France, England, Russia and over all of Europe. In 1818 it reached the shores of the New World. But before we proceed, a short biographical sketch on Alois Senefelder, the inventor of lithography, is in order.

THE INVENTOR OF LITHOGRAPHY

Alois Senefelder (1771-1834) was born in Prague, then belonging to Austria, as the son of a German actor in 1771. He received an excellent education by the standards of his time in Munich, where his father found permanent employment at the Electoral Court Theatre.

When his father died in 1792, Senefelder could not continue his studies for the law at the University of Ingolstadt, Bavaria, but had to earn a living. We know already that he invented lithography in 1798. In 1799 the *Churfuerst* (Prince-Elector) Max Joseph of Bavaria gave him an exclusive privilege lasting 15 years for the exploitation of his invention. In 1809 Senefelder was appointed, by the King of Bavaria, Royal Inspector of Lithography at the Lithographic Institute operated by the Crown. His salary was 1500 gulden and permitted a very comfortable living.

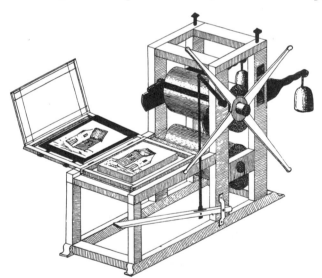

Senefelder's first lithographic press.

The life of Senefelder was devoted to lithography. In the interests of lithography he travelled to Vienna, Paris and London. He was engaged in various business enterprises, had legal and family trouble but kept on improving lithography as long as he lived. In 1817 he submitted a model of a lithographic press, with automatic inking and dampening, to the Royal (Bavarian) Academy which gave him a gold medal in recognition of this invention. At about the same time, he invented the first paper plates with which he wanted to replace the heavy lithographic stones (Senefelder, op. cit., p. 90).

Contrary to the widely spread story, Senefelder's merits were well recognized by his contemporaries. He received valuable presents and prizes as well as medals. Senefelder was two times married, seems to have been rather careless with money, was always thinking about new inventions and died after a very full and active life at the age of sixty three. It is deplorable that his biography by Carl Wagner is not translated into English. (Carl Wagner, *Alois Senefelder, His Life and Work,* Leipzig, 1914.)

LITHOGRAPHY AS A MEDIUM FOR ARTISTIC SELF-EXPRESSION

Alois Senefelder, though not an artist himself, gave to the world a new medium of artistic expression. From its very inception lithography has led a dual existence. It has been a commercial process for the reproduction of art, books, music and advertising material; at the same time it has been a medium for artists who work directly on stone with crayon, brush or pen, and produce fine limited editions. In this latter respect lithography is similar to the processes of etching or wood engraving; the final prints are multiplications of the artist's design without the intervention of a commercial engraver. It is the work of the artist-lithographer that is discussed in the following.

Of all the graphic arts none is so simple as the making of a lithograph by drawing on stone. The wood or steel engraver must learn to draw lines with a graver or burin, which is no easy task. The etcher must learn to bite in his lines with acid, a delicate and uncertain proceeding. Furthermore, the wood block or metal plate in no way resembles the finished print and the artist must wait until a proof is pulled to ascertain the result of his effort. In lithography the lines drawn by the artist are the lines that will print and he sees them before him all the time he works. With the possible exception of color, all the beauty of line and tone and texture that oils or pen and ink or any other media offer to the artist may be found in lithography; all effects from line to full tone, from black to lightest gray may be transposed to stone.

In nearly a century and a half, commercial lithography has made extraordinary technical advances. Photographic methods, halftone screens, metal plates, offset presses and other developments have revolutionized lithography without, however, altering the basic principles discovered by Senefelder. That the artist-lithographers of today use the same type of Bavarian limestone recommended by Senefelder and, with but few changes, employs the principles explained in Senefelder's book, *The Complete Course of Lithography,* is evidence of the basic soundness of the process. Modern commercial methods have increased production and lowered costs; photography has entirely changed the commercial methods of platemaking; but for the artist the original methods are still the best, and the archaic hand press still has its place in a world of high speed production.

Because lithography is an easy medium for the artist, its reputation has, throughout its existence, been hurt by the work of the unskillful. It has often been used by the lazy as a means of acquiring many pictures with the labor of doing one.

Following the discovery of lithography, came a wave of popularity which spread throughout Europe and resulted in the enduring work of Isabey, Raffet, and Daumier in France, Bonnington and Harding in England, Goya in Spain, and Menzel in Germany. Then less masterful artists brought the medium into disrepute, and for a long time it was considered principally as a commercial means of reproduction. Soon, however, the inherent value of the medium reasserted itself, and to the second great era belong such men as Manet, Fantin-Latour, Toulouse-Lautrec, and Whistler, followed by Sterner, Pennell, Davies and Bellows. Today lithography is in the hands of Kent and many other contemporaries in this country, who are sustaining the highest standards of the art.

Section Two: Stone Lithography in America

The first lithograph to be published in the United States is by Bass Otis and appeared in the Analectic Magazine of August, 1819. This magazine also published a comparatively detailed description of the process. It summarized the uses to which this art can be employed in the following eight points. (Analectic Magazine, August 1819, p. 72-3.)

1st. It is a perfect facsimile: there can be no mistake or miscopy.

2d. It supersedes all kinds of engraving: when the drawing is finished, it is now sent to the engravers, and no impression can be taken till the engraving is finished: in lithography, impressions can be taken the instant the drawing is dry, more perfect than any engraving can possibly produce.

3d. It can imitate not only drawings in crayon and Indian ink, but etching, mezzo-tinto, and aqua tinta.

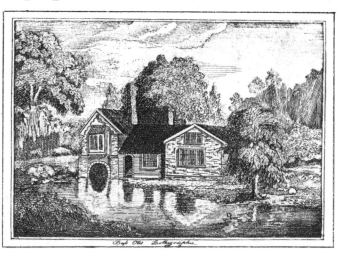

The first American lithograph.

4th. The plate is never worn out as in copper-plate engraving. In France, 70,000 impressions of a circular letter were taken, before the engraving was finished of a similar letter written on paper.

5th. Maps, large prints, calico printing, &c. can be executed in this way on rollers of stone, turned and the design drawn, etched or aqua tinted, on the stone roller itself. For roller work in calico-printing, it would be inestimable.

6th. All works of science may now be freed from the prodigious expense attending numerous engravings.

7th. Any man who can draw can take off any number of impressions of his own designs, without trusting to any other artist.

8th. The advantage of expedition in the process now recommended is beyond all calculation.

The publication of Bass Otis' lithograph did not lead to an immediate spreading of lithography in the United States. Only a handful of people were active in this field during the twenties and thirties of the nineteenth century. Barnett and Doolittle opened shop in New York in 1821 and therewith became the first lithographers of the U.S.

The most important early American lithographers were two brothers, William S. and John B. Pendleton. Harry T. Peters, to whose admirable work we owe much of our knowledge of American lithography, says that "these two brothers may almost be spoken of as the founders of American lithography." (Harry T. Peters, *America on Stone*, N.Y. 1931, p 312.) William S. Pendleton started the first lithographic business of Boston together with Abel Bowen in 1825. His brother John B. Pendleton became, together with Francis Kearny and Cephas G. Childs the first Philadelphian lithographer in 1829 or 1830.

In 1835 Duval, of whom you will later read more, produced the first American color lithograph "Grandpapa's Pet, drawn and lithotinted by John R. Richards, expressly for Miss Leslie's Magazine." (Peters, op. cit., p. 164.)

But the real spread and growth of lithography in the United States did not set in before the forties of the nineteenth century. In the following decade chromolithography, the making of lithographic prints in many colors, became established. In these chromos stone lithography reached its highest and in a sense final form. The next great changes, whereby modern lithography—lithography without stone—was created, did not take place before the beginning of the twentieth century.

THE PRODUCTS OF EARLY LITHOGRAPHY

Lithography became soon the most popular and the most economical picture and illustration reproduction process. The world was small a hundred years ago. In 1850 the population of the United States was a little over twenty-three millions. The majority of the American people lived outside of cities, and the cities themselves were far from big. In our age, when speed and mass production dominate everything, hand printing from stones looks hopelessly inadequate. But a hundred years ago, when everything was handmade, this was not the case. Lithography was a very efficient process if measured by the standards of its own time.

The products of lithography were highly diversified. Prints stood possibly in the first place. The American people could participate in politics, the exploration of their country, great and not so great political events, the achievements of science and technology, by looking at lithographic prints depicting the contemporary scene. Currier and Ives are the best known lithographic print-makers, but there was a host of others besides them. Other products of lithography were maps and sheet music. Illustrations of books and magazines, too, were often lithographed, and commercial lithography was of course not missing. Advertisements were often lithographed and so were business stationery and checks, not to forget the beautifully calligraphed stock and bond certificates or life insurance policies.

THE WORKINGS OF STONE LITHOGRAPHY

If you are interested in the technique of American stone lithography at the time of its flowering, in the seventies of the last century, you can find a full description in American Encyclopedia of Printing, edited by J. Luther Ringwalt (Philadelphia, 1871). Mr. Peter G. Duval, whose name is mentioned above, one of the outstanding American lithographers of the time, gives a very clear description of the subject.

A good lithographer was first and foremost a graphic artist; in some cases he was a creative artist himself, but in any case he had to be a good reproductive artist. No lithographic establishment could exist without good artists. In many cases a business man and an artist went into partnership. Currier & Ives are an example of this combination. Nathaniel Currier was the business man and J. Merrit Ives the artist.

The lithographer of the second half of the nineteenth century did not build his own press anymore. As the building of letterpress printing machines developed so did that of lithographic presses. Mr. Duval informs us that at about 1871 there were at least 450 hand- and about 30 steam-presses running in the United States (Ringwalt, op. cit., p. 278).

The same author tells us that: "the first steam-press was invented in Paris in 1850 by a Frenchman, named Eugues He sold the patent for England to Messrs. Hughes and Kimber, press builders of London, who made improvements on the first pattern and introduced it into the United States

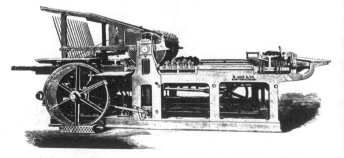

A lithographic steam press built by R. Hoe & Co.

in 1866. It is the pattern most in use at the present time, although there was one manufactured in Massachusetts some time previous which is still in use in some establishments in New York and Boston. There are now several patterns imported from Germany and Mr. Hoe, the celebrated American press builder, has also lately introduced a steam-lithographic press. (Ringwalt, op. cit., p. 278/9.) (The designation steam-press refers of course to the steam engine that supplied the power for this press.)

The lithographer of the time under discussion was already assisted by a supply industry. He could purchase his ink and many lithographic supplies on the market. But many a lithographer had his own special formula for this or that item which he kept highly secret and considered essential for his work. Lithography as chemical printing provided a fruitful field for the experimentalist with more or less of a chemical background.

It is of course not possible in the frame of this sketch to discuss or even indicate the many techniques of stone lithography. Most of them are of historical interest only in our time. But the transfer process must be mentioned, if ever so briefly, because the transfer process expresses one of the most essential lithographic features: the ease and simplicity of making duplicates of a printing image. When lithography was outclassed by other printing processes in the last two decades of the nineteenth and the first decade of the twentieth century — to indicate the approximate time — the transfer process was one of its greatest assets.

TRANSFER PROCESSES

Transferring goes back to Senefelder who was inclined to consider it the most important of his inventions. (Senefelder, op. cit., p. 190.) Senefelder had in mind the unique feature of lithography, whereby drawing or writing made with a special ink on a special paper can be transferred to the lithographic stone where it becomes the printing image.

The same principle can be used for making transfers from copperplate engravings, woodcuts and, last but not

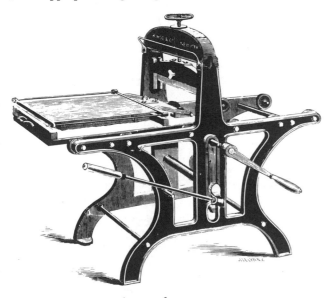

A transfer press.

least, engravings made on lithographic stones. The transfer process compensated for the slowness of stone lithography by making it possible to combine many units in a single printing image carrier. This feature became crucially important in label work where a great number of comparatively small units is needed.

The technique of transferring was rather involved. Inks and papers had to be just right; various kinds of inks and papers were used for particular purposes. The required number of transfers was pulled. These transfers were then placed on the stone and pressed onto its surface with great pressure. Thereafter the backs of the transfers were wetted, the paper was released and the inked image became the printing image of the stone after the proper treatments.

DIRECT ROTARY PRESSES

At the beginning of the twentieth century the position of lithography within the graphic arts was considerably weakened. The advance in photoengraving made quality picture reproduction by the letterpress method possible. The advances in printing press technology made it possible to print much more efficiently in letterpress than in lithography.

The flatbed stone press was well adapted to the necessities of stone lithography, but it was absolutely unsuitable for the use of photomechanically made printing image carriers. It did not require great ingenuity to aim at a replacement of the stone press by a press that would operate on the rotary principle, and where thin sheets of metal would replace the lithographic stone. The rotary principle had proved its soundness in newspaper press design, zinc was already suggested by Senefelder and had been successfully used for replacement of lithographic stones for quite some time, aluminum had also been introduced into lithography in the early nineties of the last century.

At this point it should be mentioned that the use of metals instead of stone was not only envisaged by Senefelder, but that he expressed also the thought that metals and other materials should be made capable of being used for chemical printing by treating them for this purpose and "thus change their natures," so to speak (Senefelder, op. cit., p. 97.) How far ahead the ingenious man was of the time is demonstrated by the fact that Cronak and Brunak, our effective plate-treatments for zinc and aluminum were developed more than 120 years later.

An additional and very important reason for the building of rotary lithographic presses was the scarcity and enormous cost of large size stones. Such stones were a necessity for the printing of large posters; their replacement by sheet metal which was available in the desired dimensions, was an economical necessity. In the nineties of the last century rotary lithographic presses began to be used. But they did not answer to the real needs of the lithographic industry.

Direct rotary presses fulfilled of course a function; they were valuable in the poster field and had other uses too, particularly in large sheet size applications. But direct

rotaries brought the problem of the lithographic plate to the fore. Be it now that lithographers did not know enough about platemaking, be it that the available paper was not suitable, direct rotary presses were, as a rule, not successful.

The solution to the problems of the lithographic industry came from a completely unexpected development: the offset press. But before we turn to the offset press we must discuss the effect of photography on lithography.

Section Three: Photography and Lithography in the Nineteenth Century

Photography and lithography are closely related to each other. Contemporary lithography is unthinkable without photography. Photography supplies not only a considerable part of the subject matter to be reproduced lithographically but it is also responsible for essential steps of the lithographic reproduction process itself.

The scientific basis of photography lies in physics and chemistry. The same sciences are of great importance to lithography. Even though these sciences are essential for all phases of the lithographic process they are nowhere more needed in a lithographic plant than in the departments in which photography plays a dominant role. These departments are the camera department, the tone and color correcting department and the platemaking department.

It is of course way beyond the scope of this historical sketch to give a history of photography. Here we are not concerned with photography as a picture making process but only with such aspects of photography as are used in the lithographic reproduction of pictures. These two functions of photography cannot be sharply divided but are closely related to each other.

Historically, photography was first used in lithography for the making of the printing image, the stone or the plate. The next important contribution of photography to lithography had to do with the reproduction of tonal images. At this point photography became a decisive step in the conversion of the subject matter to be lithographed into a press plate. Process color printing depends of course completely on photography. It is the latest but not the last contribution of photography to lithographic reproduction.

For the purpose of this study we will first trace the influence of photography on the making of the printing image, next we will discuss the role of photography in the making of tonal reproductions and last we will review process color printing.

HELIOGRAPHY AND DAGUERREOTYPY

The first practical photographic process was announced in 1839. It was the result of the combined efforts of two Frenchmen, Louis Jacques Nandé Daguerre (1765–1833), and Joseph Nicéphore Niepce (1765–1833). Daguerreotypy produced photographic images in a camera obscura on silvered copper plates. The silver was made light sensitive with iodine. Exposure took originally 15 to 30 minutes, but was later considerably reduced. The silver image was developed with fumes of mercury.

But daguerreotypy was not nearly as important for lithography as heliography, which is by some considered the true invention of photography. This process was developed by Joseph Nicéphore Niepce, in 1822. In this year Niepce made a contact print of an engraving representing Pope Pius VII which he oiled and thereby made more or less transparent on a glass plate coated with a solution of bitumen. Exposure time was two to three hours, development was done with a solvent consisting of a mixture of lavender oil and petroleum. The exposed areas became insoluble, the unexposed remained soluble and were washed out during development. (*The History of Photography*, by Helmut Gernsheim in collaboration with Alison Gernsheim, London, N.Y., Toronto, 1955, p. 38.)

Heliography plays an important role in the history of graphic reproduction. In 1826 Niepce made the first experimental photoengraving by using metal instead of glass and by etching the photoprinted and developed plate. (Gernsheim, op. cit., p. 39.) The first successful photolithographic process was based on the same material, bitumen. This process was developed in Paris by the optician Lerebours and the lithographer Lemercier in 1852. A grained lithographic stone was coated with a solution of bitumen of Judea in ether, contact printed and developed with ether. In 1853, prints made by this process and published "under the title *Lithophotographie* showed good half-tone, but the process was later abandoned in favor of Poitevin's, because only a limited number of proofs could be pulled" (Gernsheim, op. cit., p. 365). Lemercier and Lerebours were not the only ones to use the bitumen process. Gernsheim's *History of Photography* lists several other people in addition, none though in the United States.

BICHROMATED COLLOIDS

Bitumen or, as they are also called, asphalt processes were considerably refined in the course of the nineteenth century, but they were completely superseded by a group of processes which are all based on bichromates and colloids.

Mungo Ponton, the Secretary of the Bank of Scotland and an amateur photographer discovered in the spring of 1839 "that bichromate of potassium spread on paper was light sensitive." (Gernsheim, op. cit., p. 272.) He thought that the much cheaper bichromate could replace the expensive silver salts used in daguerreotypy.

Ponton's discovery was published in The Edinburgh New Philosophical Journal, July 1839. The French physicist

Edmond Becquerel "experimented with variations of Ponton's process on different kinds of papers." In 1840 "he established that it was not the bichromate of potash as such which was very light sensitive, but that the size in the paper (starch) greatly increased the light sensitivity." (Gernsheim, op. cit., p. 273.) Becquerel's observations were published in 1840.

The effect of bichromates on various colloids was studied by several people. In 1852 the English inventor William Henry Fox Talbot (1800–77) discovered the light sensitivity of a mixture of potassium bichromate and gelatin. "He took out an English patent on Oct. 29, 1852 for the production of photographic etchings on steel by the aid of this chromate mixture. . . ." (Josef Maria Eder, *History of Photography*, N.Y. 1954, p. 553).

Another investigator was the French chemist and civil engineer Alphonse Louis Poitevin (1819–1882), one of the greatest contributors to photomechanical reproduction processes. Poitevin was the inventor of collotype and several carbon processes. To him we also owe the invention of the first successful photolithographic process. Our surface plates are still based on his work.

Poitevin invented photolithography based on bichromated albumin in August, 1855. He designated his process *photolithography* but was not necessarily the first to use this term. Poitevin's procedure is described in Eder's *History of Photography* (p. 611) as follows: "Poitevin coated the stone (grained for halftone pictures) with a solution of potassium bichromate and albumin, equalized the coating with a tampon, dried, exposed under a negative, washed with water, rolled up with greasy ink (or rolled up first and then washed) which only adhered to the parts which had become insoluble by exposure to light but did not adhere to the moist parts. The stone was then etched and printed by the usual lithographic method."

In 1855 Poitevin started his own lithographic business in Paris. He was able to print 300 impressions from a stone; but two years later he sold his process to the well known Parisian lithographer Lemercier who got up to 700 impressions from a stone. (Gernsheim, op. cit., p. 365.) If we compare these figures with the number of impressions produced by contemporary lithography, we realize the enormous strides made.

PHOTOLITHOGRAPHIC TRANSFER PROCESSES

Sensitizing a lithographic stone and photoprinting directly on it was of course not a practical procedure. It was all but impossible to obtain uniform coatings and it was equally difficult to provide flawless contact during exposure. In the hands of very skilled craftsmen, and under the most favorable conditions, direct sensitization of stones could possibly work. But photolithography needed a different technique if it was to be commonly used. This technique consisted in making photolithographic transfers.

According to Eder (op. cit., p. 612), "the photolithographic transfer process from chromated papers was invented by Eduard Isaak Asser (1809–94), in 1857, at Amsterdam. . . . He was the first to make photographic prints with greasy ink on paper coated with starch paste and sensitized with bichromate for transfer on stone. . . ."

Photolithographic transfer processes were improved in 1859 by J. W. Osborn, head of the Government Survey Office in Melbourne, Australia, and independently in the same year by Colonel Sir Henry James (1803–77), head of the Ordnance Survey, Southampton, England. Osborn's method "allowed a much greater number of impressions to be taken — an edition of 2000 to 3000 against Lemercier's 700 by the Poitevin process," (Gernsheim, op. cit., p. 366).

Osborn and James also made transfers to zinc. They both were, in consequence of their position, most interested in cartographic or map printing. Stephen H. Horgan informs us that "the rights for the United States of Osborn's process were secured by the American Photolithographic Company of New York, and thus began in the seventies the use of photolithography for reproducing government maps, Patent Office drawings, and the reproduction of steel engravings which were so popular for home decoration at that time." (Horgan's *Halftone and Photomechanical Processes,* by Stephen H. Horgan, Chicago, 1913, p. 12.)

THE DEVELOPMENT OF THE HALFTONE PROCESS

Two problems dominate the history of picture reproduction. One is the rendering of tonal values, the other is the combination of reading matter and pictures for printing in one and the same press run. The halftone process is the first effective solution of both problems. It was developed for letterpress printing and made possible the reproduction of photographs and other tonal pictures together with reading matter.

It was not by chance that "this important invention was perfected at precisely the time that the technical revolution in photography was taking place. Dry plates, flexible film, anastigmat lenses and hand cameras made it possible to produce negatives more quickly, more easily, and of greater variety of subjects than ever before. The halftone enabled these photographs to be reproduced economically and in limitless quantity in books, magazines and newspapers." (*The History of Photography from 1839 to the Present Day,* by Beaumont Newhall, the Museum of Modern Art, N.Y., 1949, p. 221.)

The development of the halftone process took place outside of lithography. In the eighties of the nineteenth century, when the revolution in photography occurred, lithography was utterly unsuitable for mass production printing. Nothing illustrates this backwardness better than the story of the New York Daily Graphic. On March 4, 1873, the New York Daily Graphic published its first issue and therewith "the first illustrated daily newspaper in the world." (Horgan, op. cit., p. i.) "The Daily Graphic was an eight page paper, the pictorial four pages were printed first lithographically and the inside four pages were run off from type." (Horgan, op. cit., p. 13.)

The pictorial part of the Daily Graphic was produced by a photolithographic transfer process on stone presses. Production on these presses was between 700 and 800 sheets

per hour, much too small to satisfy the demand. Lithographic stone presses were completely outdistanced by letterpress machinery. The halftone process was developed for letterpress. In photoengraving, letterpress found an excellent picture reproduction process.

As the development of the halftone process does not belong in the history of lithography, the subject is here treated very briefly. In 1851 Frederick Scott Archer, an Englishman (1813–1857), published the wet collodion process which was the basis of most graphic arts photography until the middle of the twentieth century (Gernsheim, op. cit., p. 153) In 1855 Archer made his second great contribution to graphic arts photography by inventing the stripping of collodion film. (Eder, op. cit., p. 346.) Many people worked on the problem of making tonal pictures reproducible by breaking them up into very small units. Fredrick Eugene Ives (1856–1937), of Philadelphia, solved the problem of tonal reproduction in 1886 by introducing the glass cross-line screen. Max Levy of Philadelphia succeeded in 1890 in developing a precision manufacturing process for these screens. (Eder, op. cit., p. 632/3.) These contributions were by no means the only ones that made photoengraving into the leading reproduction process. Lithography stagnated technically until it received its next great impulse through the offset press.

The offset press revived the interest in photolithography. But now conditions had vastly changed if compared to the seventies of the nineteenth century when photolithography had been a contact printing transfer process for line work. At the time of the broad new interest in photolithography, which may be arbitrarily placed at the period shortly after the First World War, graphic arts photography had immensely advanced. Now photolithography acquired a different meaning. It stood for offset lithographic printing in which the camera and, where necessary, the halftone screen was used for converting line and tone originals by means of photography into printable form. This new photolithography could and did draw on the storehouse of knowledge developed, since the nineties of the past century, by photoengraving.

PROCESS COLOR PRINTING

The thought of producing a wide gamut of color by printing with only three inks was first conceived and executed by James Christopher Le Blon (1667–1741), a painter and etcher. Le Blon based his process on Newton's theory of color. He made his color separation by eye, and his plates in the mezzo-tinto process, then a very popular gravure reproduction method. In 1704 he was ready for commercial exploitation of his three-color process (*Color Printing and Color Printers,* by R. N. Burch, New York, 1911, p. 53). The few prints still in existence attest to the beauty of Le Blon's process. But the process failed to establish itself permanently.

Three color printing in the modern sense is a product of the nineteenth and twentieth century, it is closely related to color photography. The development of color photography is outside the frame of this study. Here, just as in the history of the halftone process, we will merely mention some of the most outstanding events. The first of these took place on May 17, 1861 at the Royal Institution of Great Britain. On this day James Clerk Maxwell lectured on the theory of primary colors and demonstrated a photograph in color. (*Principles of Color Photography,* by Ralph N. Evans, W. T. Hanson, Jr. and Lyle Brewer, New York, 1953, p. 271.) The next impulse to color photography and to color printing came from two Frenchmen, Louis Ducos du Hauron and Charles Cros who: "Independently of each other and without either one knowing anything of the other's work outlined, in 1868 and 1869, the idea of producing objects in their natural colors by the superimposition of three photographically produced pictures (blue, yellow and red)." (Eder, op. cit., p. 642.)

Du Hauron is not only important in the history of color photography because "he forecast, in fact, almost all the color processes which have since been invented" (Evans, Hanson, and Brewer, op. cit., p. 273), but also in the history of graphic arts reproduction. From a lithographic stone print made in three colors, we know that he experimented with three-color lithography. One such print was presented by him to Stephen H. Horgan and dated 1870 by Horgan. This early process-color stone lithograph is in the possession of the American Museum of Photography in Philadelphia. A reproduction of this picture is included in "A Half Century of Color" by Louis Walton Sipley, Director of American Museum of Photography, New York, 1951, opposite page 10.

A further contribution to graphic arts color process work made in 1869 by Du Hauron must not be omitted. In this year he described not only full-color printing but also pointed to the importance of color-balance. "It must be emphasized that Du Hauron was the first to describe the screen color-plate process. He also pointed out the necessity of adjusting the screen by such an arrangement of color elements that it would appear gray and show no excess of any color whatsoever" (Eder, op. cit., p. 645).

One other basic contribution to photography and process-color reproduction must be mentioned. It is the discovery of photographic color sensitizers made by Dr. Herman Wilhelm Vogel (1834–1898) and published by him in 1873. "Vogel's discovery was another milestone in the history of photography, for it not only paved the way for correct reproduction of colors in paintings, landscapes and portraiture, obviating a lot of retouching, but also proved an essential step in color photography" (Gernsheim, op. cit., p. 269).

Much more work was necessary than the few above mentioned contributions before process color printing became practical. But at the end of the nineteenth century this result had been achieved. The lead was with letterpress printing; gravure followed second. Collotype was the only branch of Senefelder's chemical printing that counted in process color reproduction. Lithography lay dormant; color process work was plainly beyond the scope of stone lithography.

Section Four: The Offset Press

There can be no doubt that the offset press and photo-mechanics are the foundation of contemporary lithography. Of these two, the offset press is the more important contribution because the application of photomechanics would not have been nearly as successful without the offset press than it was with it. This statement is of course debatable. But it should be remembered that direct rotary presses had the field for themselves before the offset press appeared on the scene; it should further be considered that direct rotary presses did not establish themselves for general use but died out once the offset press had found acceptance. Nor should it be disregarded that our contemporary surface plates which permit long run quality reproductions are no radical innovations; their basic elements existed, on the contrary, at the time of direct printing. But direct printing put a much too heavy burden on photomechanical plates. Only indirect printing made modern long run lithography from photomechanical plates possible.

THE ORIGIN OF THE OFFSET PRESS

The origin of the offset press is one of the least discussed subjects in the literature on printing. It is agreed that the basic principle of this press was known for a long time before the paper offset press was introduced. It is also agreed that offset presses were used for metal lithography long before they were adapted to paper use.

The first metal decorating presses were lithographic stone presses equipped with an intermediate cylinder. In 1875 an English patent was granted to R. Barclay, of Barclay & Fry, for such a press. The intermediate cylinder had a surface of specially treated cardboard for transferring the inked design to the sheet metal. (Frank Heywood in "Photo-Litho and Offset Printing" by F. T. Crocket FRPS, London 1923, p. 60 and 61.) The same author informs us that shortly thereafter a rubber blanket was substituted for the cardboard and that such presses were successfully made in England at about 1880.

It is interesting to note that there were also made offset presses that could be used for either paper or metal in case a lithographer wanted to use the same press for both materials. But strangely enough the offset method was never used for paper lithographing by the owners of these machines. One can only agree with Mr. Heywood's melancholy comment: "When one realized that for offset printing on paper it was only necessary to use this machine . . . it is really astonishing that offset was not discovered twenty five years earlier." (Frank Heywood in op. cit., p. 63.)

The history of lithography and of the offset press is not yet written. The best account of the beginnings of offset lithography known to the present writer was given by Mr. Harry A. Porter, retired Senior Vice-President of the Harris-Seybold Company. Mr. Porter not only participated in the early days of offset printing but also collected much valuable historical data. He discussed the early days of offset printing at a meeting of the Detroit Litho Club on December 14, 1950, and has graciously permitted the use of his notes for the following presentation.

IRA W. RUBEL DEVELOPS THE FIRST PAPER OFFSET PRESS

It is generally agreed that Ira W. Rubel was the first to develop an offset-lithographic press for the printing of paper. According to Mr. Porter, Ira Rubel operated a small paper mill in Nutley, N.J. There he made sulphite bond and converted this paper lithographically into bank deposit slips.

At the time when Mr. Rubel developed his offset press, assumedly 1904 and 1905, lithographic stone presses had a rubber blanket on the surface of their impression cylinder. Whenever the feeder, then not a machine but a person, missed feeding a sheet when the press was operating, the inked image was transferred to the rubber blanket from the stone. The following sheet would then be printed on both sides because the rubber blanket transferred the inked image to the back of the sheet. It was generally known that this unintentionally made transfer produced a print superior to that made directly from stone. Mr. Rubel noticed this fact and decided to utilize it as the basis of a printing press.

Like many other inventors Ira Rubel had not enough capital. He joined forces with a Chicago lithographer, A. B. Sherwood and formed together with him the Sherbel Syndicate. The policy of the syndicate was to admit only one lithographer in a territory and therewith to monopolize the new invention. Approximately twelve presses were placed in this manner. These presses were built by the Potter Printing Press Co., of Plainfield, N.J. The Potter Printing Press Company was merged in 1927 with the Harris and the company name was changed to Harris-Seybold-Potter Co. The engineer who redesigned the original Rubel Press at Potter was Mr. Irving F. Niles, later Chief Engineer of the Harris Automatic Press Company.

We are not informed about the internal trouble in the Sherbel Syndicates, but we may assume that there was plenty of it. In 1906, Mr. Rubel went to England and took an offset press along, the first ever installed in this country. "The manufacture of this machine was undertaken by a firm of Lancashire engineers, and although for various reasons — the principal being Rubel's somewhat untimely death in 1908 — it failed to make good, his efforts must be recognized as beneficial and a distinct contribution to lithographic offset printing." (Heywood, in op. cit., p. 73.)

The plan to monopolize the offset press proved unworkable. Competition was keen; those who had offset presses took advantage of them and made their competitors who were outside the syndicate look for an independent source of supply. They found it in the Harris Automatic Press Company.

HARRIS ENTERS THE PICTURE

According to Mr. Porter, who was then working for the Harris Automatic Press Company, things took place as follows. Some time prior to June 1906 a Harris salesman tried to sell a rotary stone press, developed by Harris, to the Goes Lithograph Company in Chicago. "Mr. Charles B. Goes was not at all interested in this type of machine but apparently had been needled by Sherwood and told our representative that, if we could make him a machine which he described, he would be interested.

"The salesman returned with Charles G. Harris who was the inventive genius of the Harris Company at that time. They then returned to Niles, the seat of the Harris Company, and I know from personal experience (although Goes did not get the first press) that, from the ideas developed, work was immediately started on an offset press designed and built around the sheetfed letterpress machine which

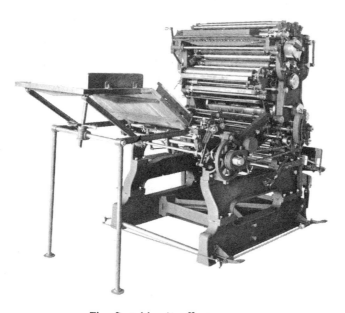

The first Harris offset press.

was known as the S4, the same size as the S4L 22 x 30. Different frames were designed and three cylinders instead of two were used." (Quoted from Mr. Porter's notes for his Detroit lecture.)

At this point it should be mentioned that Mr. A. F. Harris had witnessed the offset-effect in 1898 while installing a Harris Envelope Press in the plant of the Enterprise Printing Company in Cleveland, Ohio. This press was installed right along the side of a lithographic stone press. The feed girl missed a sheet and Mr. Harris, who was at that time not conversant with lithography, got a demonstration of offset printing then and there. He remembered this incident when his company was asked to build an offset press. It should also be kept in mind that the Harris brothers were builders of rotary letterpress equipment and therewith experienced in the design of rotary printing machinery. Starting with October 1906, four presses were shipped by Harris during the year of 1906; the remaining six presses in the first lot of ten were shipped in 1907.

THE IMPACT OF THE OFFSET PRESS

The offset press was the talk of lithography, as can be seen from the trade press. The National Lithographer discussed "The Rubber Blanket Puzzle" in its September, 1906 issue (p. 11). The confusion that was caused by various rumors on the offset press is well reflected in this item.

In November, 1906, The National Lithographer discusses the offset press again (p. 13). This time the tone is changed. The offset press is clearly considered a very important topic, as can be seen from the following quotation: "There is nothing in the lithographic trade which is attracting so much interest today as is the offset, rubber blanket, commercial lithographic press. That these presses will be a success nobody doubts, and just why some of the manufacturers do not get them on the market is a question. . . ."

Next month, in December, 1906, The National Lithographer reports again on the rubber blanket offset press. "Quite a number of letters have been received this month on the subject of the rubber blanket offset press. From Chicago comes the information that in that city the Sherwood Litho Co., and the Goes Company are successfully using them. The largest size in use being 22 x 32 inches. One correspondent writes that the work done on them is far better than on stone and that they are an unqualified success, and then he wonders why the manufacturers are keeping so quiet about them." (p. 10.)

In April, 1907, The National Lithographer headlines a story: "Off-set Press a Success." Part of this story follows:

"The rubber blanket off-set press is no longer a mystery. We have finally been able to get a practical demonstration of its workings. . . . The job being run was a fine clouded letter heading, on a good quality bond paper. It had been engraved for a stone press, and therefore had to be re-transferred to the zinc plate of the offset press."

"An attempt had previously been made to print this job from the stone on dry paper, but the attempt was unsuccessful. It was then put on the off-set press and run at the rate of more than 4000 sheets per hour. The finished product was as good as could possibly be done from stone with dampened paper. In fact it was as satisfactory a piece of work as the writer ever saw turned out of a lithographic establishment. . . .

"This settles the question of the practicability of the offset press for commercial work — at least as far as the Harris Automatic model is concerned."

"The writer closed his report with the following sentence: 'The Harris Automatic Rubber Blanket Off-Set Press has revolutionized commercial lithography.'"

The offset press was of course not welcomed with the same enthusiasm by everybody in the lithographic industry. The subject was quite controversial, and, as is so often the case, also emotional. In December 1907, it reached the editorial page of The National Lithographer. The magazine had been attacked for booming the offset press even though its "columns do not contain the advertisement of such a

press, but, on the other hand, do contain advertisements of other styles of presses." The editor emphasized that "the editorial pages of this paper are not controlled by the advertisers." The reason for booming the off-set press was stated in one sentence: "We believe it to be the salvation of the commercial lithographer." The energetic and well written articles in The National Lithographer contributed much to the acceptance of the offset press. The history of lithography cannot overlook the important service rendered to the industry by Mr. Warren C. Browne (1856-1935), the editor of this magazine.

COMMERCIAL AND COLOR LITHOGRAPHY

The offset press was originally intended for commercial lithography but not for color lithography. Mr. Porter informs us of the then accepted definitions: "Commercial lithography is when the original is engraved on stone or sheet," whereas color lithography was the appropriate designation "when the original is drawn on stone, zinc, or aluminum."

Commercial lithography produced business and bank stationery, mainly in black and white; color lithography, greeting cards, labels, posters and so on. But it took not very long until the offset press was very successfully used for color work. Its advantages over stone and direct rotary presses were thereby established in both branches of lithography; as time went on the offset press became the dominant lithographic printing machine.

THE GROWTH OF THE OFFSET PRESS

The success of the offset press was a strong stimulus for many manufacturers to enter this field. Mr. Harry Porter informs us that at the end of 1912, 560 offset presses were in operation. These presses had been built by eight different concerns and were of at least ten different sizes. Another source (The Lithographers Journal, Vol. II, June 1916, p. 9) states that 847 off-set presses were in operation in the United States and Canada at the middle of 1916.

The detailed progress of the offset press cannot be told in this sketch. Every element of the press has been further and further developed in the sixty years of its existence. The first offset presses were hand fed; mechanical feeders followed several years later; then came proof presses. In 1914 Walter Scott & Co. installed perfecting offset presses for the printing of newspaper supplements in New York (*The American Manual of Presswork,* second ed.; N. Y. 1916, p. 166) Web offset presses and multicolor presses followed. Now the offset lithographic press is a marvel of efficiency and perfection, second to no other printing machine.

Section Five: Lithography in the Twentieth Century

The lithographic offset press made modern lithography possible; photomechanics made it practical and accounts, together with the offset press, for much of its success. It took some time until modern offset lithography became generally accepted. Approximately 25 years after the introduction of the offset press it dominated the field almost completely. Stone lithography had ceased to exist as a commercial printing process and had become a medium for artistic self expression. Direct lithography from metal plates, never too successful as an all-round method, was more and more replaced by the offset press until it finally lost much of its importance. The offset press grew and developed at an increasing speed; press sizes became larger and running speed faster; two, three and more color presses as well as perfectors became available.

THE NATURE OF LITHOGRAPHIC PROGRESS

It must be understood that progress in lithography — like in other industries — depends on progress in each component element. The continued growth of lithography is not the result of one single advance; it is due to many improvements in every element and phase of the process. Many people and many companies played and continue to play important roles in this process. Constant improvements in plates and presses, but also in photographic materials and techniques, papers, inks, rollers and blankets have made lithography what it is now.

Most of these improvements are made outside the lithographic shop or plant and are therefore too easily overlooked. But it should be understood that it takes a long time and a sizeable investment before an improvement of lasting value is created. It is unfortunately not possible to go into the wide variety of improvements in all different fields that have contributed so much to lithographic technology. Our historical remarks are here restricted to problems of the lithographic plate, and the founding of the Lithographic Technical Foundation. But not even a sketch of lithographic history can omit William C. Huebner, the most prolific inventor of the graphic arts in the first half of this century.

WILLIAM C. HUEBNER AND THE PHOTOCOMPOSING MACHINE

William C. Huebner, an American lithographer, was the first who grasped the full potentialities of offset lithography combined with photomechanics. From 1906 to 1912 Mr. Huebner invented many machines and processes that have since become commonly used in lithography.

The invention of the photocomposing machine is one of Mr. Huebner's major contributions to lithography. This invention made it possible to produce press plates bearing multiple images in a precision until then never considered possible. The first photocomposing machine, together with the equipment and materials needed for its operation, was shipped in 1912 to the plant of Stone Ltd., at Toronto, On-

tario, Canada. The cost of this equipment was (as Mr. Huebner informed the present writer by letter of Dec. 3, 1956) over $50,000.

The photocomposing machine was only one of the very many inventions made by Mr. Huebner. Here, it is merely mentioned that Mr. Huebner was also one of the pioneers of lithographic process color reproduction. "In 1910 Huebner reproduced in four colors, by offset lithography, a full-color photograph of orchids, in which the separations were made direct from the object. A set of press sheet progressives of this historically interesting work was presented by Mr. Huebner to the American Museum of Photography as part of its historical collection. Six reproductions appeared on a sheet — all being identical. . . ." (Louis Walton Sipley, Director of American Museum of Photography, *A Half Century of Color*, N. Y., 1951, p. 55.)

THE LITHOGRAPHIC PLATE AND THE FOUNDING OF LTF

At a first glance it may look odd that the problem of the lithographic plate and the founding of LTF are to be discussed under the same heading. But they are not only the two points singled out for our brief historical discussion of the technical side of modern lithography, but these two subjects are also very related to each other.

The plate was the most important single problem in lithography during the first half of this century. The plate was also the problem closest to the individual lithographer. All other elements combined in lithography were either not at all or only to a very small degree subject to change by the individual average lithographer. Presses, paper, ink, photographic materials, rollers and blankets are all manufactured by specialized industries. But the plate was made in the lithographic shop; it was the only major item that was produced by the individual lithographer. (It was, of course, possible to purchase plates from firms specializing in their making. But these firms were not better equipped to cope with the problems of the lithographic plate than many a lithographic shop.)

The quality of the plate is important in many respects. For one, it is decisive for the quality of the final lithographic print. Another point is plate life which has a great influence on length of run and costs. Photomechanical platemaking is a complex process. The effort necessary to control this process could never be made by an individual lithographic shop of average size. The solution of the plate problem had to wait until the industry had learned to do co-operative research — until LTF was in existence.

Two kinds of photomechanically made plates were used in lithography up to the end of the Second World War: albumin plates and deep-etch plates. Albumin was first used by Poitevin as already mentioned; deep-etch plates have a long history in which many inventors participated. Mr. J. S. Mertle credits the Reverend Hannibal Goodwin for having made "one of the first attempts toward the reversal of photomechanical images on metal plates" which he patented in 1881. (J. S. Mertle, *Photolithography and Offset Printing*, Chicago, 1937, p. 193.) Many other inventors worked on lithographic deep-etch plates. Their contributions can be found in chapter XIII of the quoted work by Mr. Mertle.

But the real change in platemaking techniques had to wait for LTF, which was founded in the early twenties. This is not the place to discuss the work of LTF; this subject is treated in the following chapter. Nor is it intended to say that all plate problems are eliminated for lithography. But the plate has ceased to be the problem child of lithography, due to the efforts of LTF. In the middle of the twentieth century lithographic platemaking became a field of activity for the supply industry. Chronologically, bimetallic plates preceded pre-sensitized plates which appeared in the nineteen-hundred-fifties. In the sixties there came into commercial use the "wipe-on" plates.

THE NEW LITHOGRAPHER

As the lithographic process changed, so changed the lithographers. During the dominance of stone lithography artistic ability was an essential personality trait of a good lithographer. With the disappearance of stone lithography and the ascendance of photomechanics, artisic ability in the traditional lithographic sense became unnecessary.

The modern offset lithographer needs a thorough understanding of photography and photomechanics much more than the ability to draw or paint. He also should have a good scientific background because science, chemistry and physics play an ever-increasing role in lithography. Nor must managerial ability be forgotten. Lithography sheds more and more of its craft characteristics and becomes more and more an industry. Here too, as in every other industry, management becomes a decisive factor.

THE ECONOMIC IMPORTANCE OF THE LITHO-GRAPHIC INDUSTRY

The question is often asked, "How many lithographic plants are there in the United States?" Those who ask this question sometimes want to know the number of plants whose chief item of production is lithography. Others want to know the total volume of lithography produced, while still others want to know the approximate number of firms who have lithographic equipment, even though it may be but a small part of their productive equipment.

The number of lithographers operating in this country depends on the definition of "lithographer." Obviously firms specializing in operating lithographic presses are lithographic firms. Then there are those firms who operate a number of small duplicating presses, such as the Multilith or the Davidson. These small firms operate their equipment on the same principles and utilize, in a large part, the same supplies and materials as the owner of a larger lithographic plant; finally, they produce a lithographed product. Some of these small duplicating press owners do a volume running into six figures and therefore can be considered as lithographers. However, if such a firm has only one or two small duplicating presses, should it be considered a lithographic plant? If the answer to this question is in the affirmative, then the number of lithographers is much higher than otherwise.

TABLE I
Census of Lithography*

Year	Number of Establishments	Wage Earners	Value of Receipts
1899	263	12,994	$ 22,240,679
1904	248	12,614	25,245,266
1909	318	15,073	34,109,233
1914	336	15,171	39,135,973
1919	331	15,618	73,151,115
1921	296	13,971	79,472,260
1923	328	16,317	91,670,752
1925	331	16,957	98,721,268
1927	309	16,348	97,050,124
1929	376	18,979	121,014,321
1931	364	16,215	87,164,000
1933	346	14,579	68,447,000
1935	387	17,688	92,046,916
1937	516	22,533	129,244,000
1939	789	26,000	159,527,000
1947	1413	52,408	485,081,000
1954	2924	77,037	853,571,000
1958	3746	89,678	1,290,412,000
1963	6822	121,072	2,150,000,000
1972	8304	137,700	5,110,800,000

*Does not include *lithographic production* of greeting cards, books, lithographic plates made for others.

TABLE II
Value of Shipments ($1,000)

Products	1954	1963	1967
Newspapers, ready prints, etc.	2,481	9,165	59,300
Magazines and Periodicals	34,195	138,547	296,100
Maps, Atlas, and Globe Covers	4,082	11,996	10,000
Cards other than Greeting Cards	4,507	4,717	NA**
Labels and Wrappers	98,019	147,343	186,900
Business Forms	112,000	300,000	NA**
Tickets and Coupons	1,702	6,883	5,500
Calendars and Pads	32,222	24,457	32,500
Catalogs and Directories	50,452	165,269	267,700
Other General Commercial Printing	469,484	99,528	420,100
Decals	11,339	10,559	13,500
Book Printing	72,940	230,796	NA**
Litho Plates Made for Others	40,952	129,502	151,000
TOTALS	934,375	1,288,762	

Source: Census of Manufactures, Bureau of Census
**NA: Not Available

It is very difficult, therefore, to give an incontestable figure, because there is no one source of figures that covers all phases of lithography. The best source of information is the Census of Manufactures of the U.S. Department of Commerce. For companies primarily engaged in lithographing in 1972 the following figures were released by that agency.

Number of establishments: 8304; wage earners: 137,700; value of receipts: $5,110,800,000. The last figure, however, excludes lithographic printing done by letterpress establishments (although it includes any receipts for any other printing processes performed in the primarily lithographic plants). Table I, Census of Lithography, was especially prepared for this study and reflects the growth of lithography from 1899 to 1972.

Table II, Lithographic Commercial Printing By-Products, provides a more comprehensive picture of the lithographic industry for the years 1954, 1963, and 1967. A study of the percentage change shows which branches of lithography have grown fastest.

An examination of the figures also shows that the number of lithographic plants in 1972 was almost 43% more than the 3,746 reported in 1958 and the value of receipts in 1972 was about 40% more than the value of receipts in 1958.

The effort to determine the number of lithographic plants is further complicated by the fact that there are many "cap-tive" plants which produce both paper and metal lithography in business concerns doing printing solely for their own use; and further, that there are some who utilize lithographic equipment for research purposes. It is estimated that, including all firms who own presses 17" x 22" or two or more duplicating presses or larger equipment, there are no less than 7,000 lithographic firms.

Because of different methods of collecting and assembling information, in Table II 1954, 1963, and 1967 Census of Manufactures, this data is not strictly comparable in all cases. For complete information, reference should be made to the detailed census reports available through the Printing and Publishing Division of the Department of Commerce.

THE WIDE RANGE OF LITHOGRAPHED PRODUCTS

What types of products does the lithographic industry turn out each year to amass such impressive figures? In its earliest days litho stones were usually employed to produce drawings and paintings by well-known fine and commercial artists. Years later, with the advent of photolithography, many lithographers made their living turning out comparatively short runs of such inartistic items as office forms, cards, mailing pieces, etc. In more recent years, however, and particularly since World War II, color has come into great demand, and

offset has been ready to supply it. The process is used for such high quality jobs as direct mail advertising, business reports, point-of-purchase material, posters, display cards, packaging materials, bank stationery, books and book jackets, magazines, maps, menus, cards, calendars, decalcomanias, metal products, (such as beer and oil cans, trays, etc.) and (as history repeats itself) art prints.

The rapid expansion of lithography, the figures indicate, has not altogether been at the expense of other processes—all processes have made marked gains in recent years—but, it is interesting to note that lithography's gains have outdistanced all others. During the past thirty years the dollar volume of lithography has increased from about 10 percent to about 25 percent of the total printing dollar volume.

THE BEST IS YET TO COME

Prophesying is always risky, but even a conservative person will agree that the future of lithography seems assured. If the past permits conclusions for the future, the growth of lithography will continue for many years to come. The lithographic industry has many modern well-equipped shops and commands a large number of highly skilled craftsmen; the product of lithography is in demand wherever printing is bought; new developments are in process in every phase of lithography. Last but not least important, the amount of knowledge residing in the industry is most impressive as reflected in the fact that so large a volume as this edition of the Lithographers Manual is considered as only a survey of the industry. *The best is yet to come.*

GATF: Trailblazer in the Graphic Arts ——————

Section One: An Overview

The Graphic Arts Technical Foundation is a member-supported, nonprofit, scientific, technical, and educational organization serving the international graphic communications industries. Its fundamental purpose is to continue the scientific progress of those industries that are basic to one of the greatest human needs—the graphic communication of information, ideas, and knowledge.

From its small beginnings as the Lithographic Technical Foundation in 1924, this industry-inspired, member-supported organization has grown into one of the world's leading centers for graphic communications research and education. Today, the programs at GATF cover all major graphic processes and related areas, such as career counseling and recruitment, environmental control, training and education, occupational health and safety, and typography, to name a few.

The industry, as a whole, benefits from GATF in four basic areas: research; scientific, technical, and craft education; technical services; and technical information. The broad programs encompass a variety of activities in each area.

Among GATF's facilities are a wide range of scientific instruments, tools, and machinery for studies in phototypesetting, photography, image assembly, platemaking, color reproduction, surface chemistry, physics, paper, ink, and instrumentation. The Foundation's pressroom is one of the most complete of any research center in the world. The E. H. Wadewitz Memorial Library houses one of the most extensive collections of technical literature in the field of graphic communications. Many educational seminars and workshops are conducted every year both at the Center in Pittsburgh and at various locations all over the world. The Foundation also publishes books on just about every aspect of printing at various levels of difficulty, learning modules (step-by-step instructional booklets) and other educational materials, audiovisuals, and scientific, technical, and educational reports.

The Foundation is staffed by researchers, educators, and technical specialists, all of whom are professionally trained and bring to the Foundation a wide range of experience in their respective fields, along with a strong awareness of the needs of the graphic communications industries.

The Foundation's boards and committees comprise some 300 representatives of member companies. It is these industry representatives who develop and, in large measure, direct the programs of GATF. Thus, GATF *is* its member companies, of which there are more than 2,000 in close to 60 countries throughout the world.

These members represent every facet of graphic communications: printers and packagers of every size, product, and process; book, magazine, and newspaper publishers with or without printing facilities; suppliers of ink, paper, chemicals, plates, and

Exterior view of the Graphic Arts Technical Center in Pittsburgh, Pennsylvania.

press and prepress equipment. Also, there are typographers, binderies, advertising and design houses, trade shops and photoengravers, research and development centers, colleges and universities, and students and teachers of graphic arts at every level of education. Over the years, the Foundation has changed remarkably to meet the needs of these members, but it has never swerved from its original purpose of advancing the industry through research and education.

Section Two: History of the Foundation

In the early 1920s, lithography was a small struggling part of the printing industry. As of 1923, only 328 plants in the entire United States, ones largely engaged in specialty printing, could be classed as lithographic. Most of these shops were still printing from stone, and the offset press was still relatively new. Lithography was an unwieldy process that was difficult to master; it was an art craft, the chemistry and physics of which remained to be explored.

THE FOUNDING OF LTF

The idea of a cooperative research and educational effort by the lithographic industry to rectify this situation was first voiced in 1921 by William H. Merten at the annual convention of the National Association of Employing Lithographers (NAEL). At the 1923 NAEL convention, Alfred B. Rode followed up on the idea, proposing the formation of the Lithographic Technical Foundation, whose "principal purposes and objects" would be the "training and education of lithographic workmen, the promotion and maintenance of lithographic trade schools, the investigation of subjects of a scientific or technical character which relate to lithographic processes, and other similar purposes and objects." The proposal was received with such great enthusiasm that within one half hour, over $100,000 was pledged to support the Foundation.

On April 21, 1924, the Lithographic Technical Foundation (LTF) was incorporated. It was the job of Alfred Rode, the first president of LTF, and the twelve directors to raise funds for the fledgling organization. The industry continued to respond enthusiastically, contributing, by the close of the fund-raising campaign, approximately three-quarters of a million dollars. This money comprised the Foundation's endowment, the interest from which would be used for operating expenses.

Research Beginnings. Research work began in March 1925 at the University of Cincinnati under the direction of

Robert Reed examining blanket samples.

Robert F. Reed. It was the first organized research effort in the graphic arts; thus, there was no background of scientific knowledge on which to build. Reed began with the basics, identifying precisely the physical and chemical requirements that the lithographic process placed on paper. Before the end of the year, he completed the first Foundation bulletin, "The Characteristics of Paper," which was published in 1926. The relationship between paper, relative humidity, and temperature was established, leading to the development of the paper hygroscope, the first in what was to become a long line of devices and materials directly resulting from LTF research.

Another early concern was that of plates and platemaking. After studying the light sensitivity of bichromated coatings, Reed arrived at a single coating formula that would yield optimum results. He also began researching plate processing procedures and techniques, which remained a major research concern for the next thirty years. The deep-etch process, a method for increasing plate life, was also investigated, and a copper-aluminum deep-etch plate, called Lithengrave, was perfected. On another front, the research department developed Lithotine, a washup solvent that does not cause dermatitis or destroy litho blankets.

The major development in ink studies was simply a change in the understanding of lithographic inks. Robert Reed and others began explaining the performance of lithographic inks in terms of tack, or the way in which ink splits, which explained the causes and influences of many lithographic press problems. Ink research led to the development of the Bench Inkometer, which measured the tack of a given sample of ink and paper.

Research in the early years progressed rapidly even though there were never more than four full-time researchers for the first twenty years. Many problems yielded to solution simply because all they required was an analysis conducted in orderly fashion. Thus, LTF research was bringing order where there had been chaos, but it also had a subtler, longer-range effect. Research findings were made available to all of the industry, a policy continued to the present day. The free exchange of scientific information lessened chances that the growth of lithography would be stunted by trade secrets and hamstrung by proprietary information. The industry as a whole benefited, and part of the groundwork was laid for the expansion of lithography into the giant it is today.

First Education Office. On September 1, 1925, an education office was opened in New York City under the direction of Dr. Layton S. Hawkins. Initially, publication of the results of LTF research was the extent of LTF education activities partly because of limited resources and mostly because of inadequate knowledge of the technology. It must be remembered that before the formation of the LTF Research Department, no organization was subjecting lithographic technical problems to continuous investigation.

A major impediment to lithographic education was the lack of textbooks and training materials. Hawkins tackled this problem by hiring Dr. David J. McDonald (who later became Education Director) to write some texts. McDonald began by making an analysis of the single-color offset pressman's trade, which served

as the basis for a seven-unit textbook on *The Single-Color Offset Press*. He also wrote a text on hand transferring and one on color correcting. When the first textbook was published in 1928, the covers, design, paper, plates, printing, and binding were contributed by members, which set a precedent for subsequent Foundation publications.

In this period, the Education Department attempted to organize cooperative education programs in school systems located in major printing centers. Students taking part in these programs would attend classes for a given period and then work in a plant for a similar period of time. Unfortunately, this attempt was not successful.

In the late 1920s, the Education Department arranged with New York University to conduct a series of evening courses in lithography that covered a range of subjects, including management, sales, science, and technology. The courses consisted of both lectures and plant visits. Other "hands-on" courses, principally in platemaking and camera work, were added later. In the summer of 1936, the Foundation conducted a ten-week intensive course in lithography for college graduates and undergraduates preparing for careers in lithography. Some of the participants in the course subsequently became industry leaders. The course continued to be offered throughout the next decade.

REORGANIZATION

The stock market crash in 1929 and the subsequent depression hit the fledgling organization hard. Some companies that had pledged contributions payable in five equal annual installments were unable to complete their payments and some of the Foundation's investments stopped paying dividends or interest. It was necessary to dip into the endowment itself, and the directors and a few other good friends of LTF were frequently called upon for special contributions to make up deficits. The Foundation also entered into a contract in 1940 for the compounding, packaging, marketing, and distribution of several of its original formulae. Still, income was insufficient to cover even the modest budgets of those years (about $38,000 per annum).

During this period, Alfred Rode submitted his resignation, and Edward H. Wadewitz, who had been a director, was elected president in 1944. In his new position, Wadewitz led a major

Exterior view of Glessner House from the courtyard.

Gordon Wheeler, staff researcher, Kathleen Overholser, librarian, George Jorgensen, photosensitive materials supervisor, and Robert Scott, staff researcher, in the Glessner House library.

reorganization effort, doubling the Foundation's endowment, substantially increasing its operating budget, and laying the groundwork for the numerous research and educational programs developed in the postwar period. Many of these achievements were the result of the ten-point program that he developed on the basis of an extensive survey of the industry. This program was used as the principal selling tool in a highly successful fund-raising effort.

Another result of his program was increased geographic and industry representation, bringing new people, new ideas, and new interest. The position of Executive Director was also created and first filled by Wade Griswold, who served in that capacity for twelve years.

In the fund-raising campaign of 1944, LTF sought not only contributions to the endowment but also, for the first time, membership support in the form of annual dues, which would be used for current operating expenses. Also, the endowment funds were separated from the operating funds.

In 1945, through an agreement with Armour Research Foundation of Illinois Institute of Technology, the Foundation moved its Research Department to Glessner House in Chicago with new and improved equipment and an expanded staff. Postwar research shifted back into gear under the direction of Michael H. Bruno, the new Research Manager. (Robert Reed had become a research consultant.) New plate surface treatments were investigated, and the Cronak and Brunak treatments were developed. Further improvements were made in the processing of deep-etch plates, and standards for plate graining were established. A stopping-out solution that simplified the processing of positive-working plates was also developed. Two new instruments of fundamental importance came out of LTF during this period: a packing gauge to aid pressmen in controlling cylinder pressures, and a sensitivity guide that permits evaluation of exposure and development before mounting a plate on the press. A cellulose gum substitute for gum arabic was developed, and investigation of ink drying mechanisms began.

Between 1923 and 1953, the lithographic industry had grown

ten-fold. The entire industry had become more conscious of the importance of research. Suppliers began to create in-house research departments, and printers began to assemble sophisticated technical staffs in their plants. Out of postwar Germany came the concept of a revolutionary image carrier: the presensitized plate. These developments and others caused the lithographic dollar volume to increase two and one-half times between 1950 and 1957.

The fifties were a golden age for LTF research. They also saw a gradual shift in emphasis from the constituents of the process (paper, ink, plates, press) to the way in which these elements interact. An example is the development of the Press Inkometer, a refinement of the Bench Inkometer, which is a highly effective monitor of ink/water balance. Another device developed in the fifties was the pick tester, which evaluated a sheet of paper's potential for picking before it was run on the press. A study of doubling and slurring led to the design of the Star Target, the first of a series of test images.

Postwar consumer demand led to heavier competition in consumer markets, creating a sharp increase in demand for color printing, especially full-color process work. The Research Department responded to the growth in color printing by promoting a photographic masking system that eliminated much of the need for laborious manual methods of color correcting and by developing the LTF color chart.

It was after the move to Chicago that technical services started gradually and rather informally as the Research Department began to receive letters and calls from member plants for help with technical problems. Because of limited resources, answering technical inquiries had to take second place to research that was to benefit the whole industry. However, as lithography grew in the postwar period, the rapidly increasing number of technical inquiries could be neither ignored nor handled effectively without changing the structure. By 1960, the number of inquiries was doubling annually. Answering them often involved extensive testing and sometimes required traveling to the plant site, all of which was handled by research personnel who were involved in other projects. The decision was made to create a Technical Services Division, staffed by its own personnel, to relieve the other research divisions of the burden of these services.

Another division, the Reduction to Practice Division, was responsible for translating research findings into practical procedures to be used in plants. Headed by Edward J. Martin, it was in charge of platemaking, press testing, materials testing, and printing research publications.

Lithographic Technical Forums also evolved at Glessner House and became so popular that they began to be held all over the United States. These were one-and-a-half-day programs designed for large audiences that covered all major aspects of the lithographic process. The first Color Seminars were given in 1957 and, likewise, became so popular that they were immediately expanded both in the number offered and in the subjects covered. The Seminars were small, three-day, intensive educational programs designed for limited audiences (ten to twenty) that focused on a specific technical aspect of printing.

The Administration and Education Departments also moved, locating in a building purchased by the Foundation in New York City. At about this time, Charles Shapiro began his long association with the Foundation, first as Education Director.

Because of the rapid growth of the lithographic industry, training became a major focus of the Education staff. Craft tests, textbooks, manuals, complete courses, and teaching and training materials poured out of the department to fill the existing void.

In addition, alternatives to printed media were explored with the intent of improving the total effectiveness of training and education. Some of these were pioneering efforts in the industrial application of audiovisual media. In 1949, the Research Department, still somewhat involved in education, sponsored one of the earliest closed-circuit television technical education programs. The use of filmstrips in education was also developed at this time.

Michael Bruno, research manager, and Edward Martin, reduction-to-practice supervisor, instructing over closed-circuit TV.

BROADENING THE SCOPE

In 1959, when William Webber took the helm as Executive Director, the Foundation entered a period of sustained growth. This growth was marked by many changes, both in the industry and in the direction of the Foundation. By this time, lithography was no longer a minor printing process. In fact, its growth rate outstripped that of the two other major processes, becoming the dominant process, for which much of the credit belongs to LTF. Many of the problems specific to lithography had been solved, and research was inevitably leading into areas that were common to all printing processes. In addition, both the Research and the Education Departments were outgrowing their facilities.

In 1961, a long-range plans committee was set up to study the direction of the Foundation and determine what changes would make it more effective. After two years of careful analysis, the committee presented its conclusions and recommendations, which were unanimously approved by the Board of Directors. Thus, in 1963, the Lithographic Technical Foundation officially became the Graphic Arts Technical Foundation, a name that reflected its broadening scope. Another recommendation was the consolidation of the Research, Education, and Administration Departments under one roof to increase efficiency. Accordingly, a search for an appropriate location for the new headquarters building and a fund-raising drive to finance its construction

Lobby of Technical Center, Pittsburgh.

were begun. The site finally chosen, in Pittsburgh, Pennsylvania, had much to recommend it: 135 research and technical organizations in the vicinity, a large number of scientific and technical personnel, several major scientific libraries, and a variety of specialized laboratories and research devices. In addition, four major educational institutions submitted a proposal for joint collaboration with GATF.

The new Technical Center's pressroom was equipped with a wide variety of presses, which were donated by the manufacturers. It also had several laboratories that had special features and equipment for the study of paper and ink, photography, plate-making, and color measurement. There were also seminar rooms to accommodate the expanding seminar programs. In 1965, the building was completed at a cost of $1.25 million. The Foundation, after forty years, had at last found a single home.

The change in scope naturally extended to the Research Department. One effect was that the Department had to coordinate its activities more closely with those of other research organizations to avoid wasteful duplication. Accordingly, in 1964, it conducted a survey of letterpress color proofing in cooperation with the Photoengraver's Research Institute.

The nature of research was also changing in another way. Investigations took a lot more time and were much more costly. Some problems were much more obscure and others involved a much wider scope. For example, in 1968, an eight-year analysis of web offset was completed, the results of which were published in three volumes. A team of researchers had, for the first time, scientifically isolated and studied the entire operation of a web press, using special instrumentation to monitor the press and

record information. Involving forty-eight days of field tests in ten web plants, 1,300 separate experiments, 2,000,000 signatures (of which 14,000 were evaluated), and mathematical analysis, the project cost well over $150,000.

The web offset study was also indicative of the trend toward mathematical analysis. Another important example of these trends was a systems analysis of the single-color offset lithographic press. It was the most comprehensive study of the lithographic process ever undertaken and led to the publication of the Lithographic Pressman's Handbook, the first press trouble-shooting guide ever to give the consequences of any adjustment. The study also demonstrated the feasibility of small, specially programmed computer consoles in teaching pressmen through simulated press operation.

Four-color process reproduction continued to grow, and GATF contributed by developing and improving color diagrams, the Compact Color Test Strip, the Standard Offset Color Control Bar, and the Color Communicator. It also cooperated with the Kollmorgen Corporation in developing and marketing the Munsell-Foss Color Chart. Research was also conducted to simplify and improve photographic masking and color separating.

A very important development was the creation of the Environmental Control Division in 1970. Already in 1967, GATF had an Air Pollution Control Program that secured a federal grant for research on air pollution due to printing. The result of the research was one of the first rigorous methods for sampling air contaminants. Besides doing research, the division published a newsletter informing industry about air pollution control procedures, devices, codes, and regulations. When Congress enacted the Occupational Safety and Health Act in 1970, the division began to compile data in this area, conduct exploratory investigations, and publish a newsletter on health and safety. Research included studies on noise measurement and the development of an isopropanol substitute, TechFount. In 1972, an autonomous organization called the Environmental Conservation Board of the Graphic Communications Industries (ECB) was formed to develop policy and coordinate the problems of the environment and its control relevant to the printing industry. The Foundation, one of seventeen member associations and companies, assisted by providing legislative and regulatory awareness and technical information.

The Techno-Economic Forecasting Division of Research, formed in 1974, reflected the growing industry concern with cost effectiveness and long-range planning. Its purpose was to provide GATF members with in-depth technical and marketing information on which to base their business plans, taking into account the changes in technology, marketing, and economics. The division produced first two, then three, five-year forecasts annually, which dealt with very specific aspects of the graphic communications industries. Some of the first subjects were micrographics, ink jet printing, web offset and rotogravure, and the use of energy in printing plants.

In 1967, the Technical Services Division became a separate department. Directed by Charles Gramlich, the department offered three types of service: troubleshooting; technical plant audits, a thorough examination and evaluation of a plant's production system or some part of it; and product evaluation for printing suppliers. In 1973, the Technical Services Department, in an effort to better serve more GATF members, appointed

Gramlich (who had in the meantime left the Foundation and returned) as West Coast representative. Other regional offices were subsequently opened in the midwest, the south, the northeast, and Canada.

Another department, Special Programs, was also established in 1967, this one taking over the training functions of the Research Department. Headed by McKinley Luther, the department conducted technical forums; seminars; workshops, one- or two-day seminars adapted to larger audiences in various industry centers; and conferences, which were directed to more broadly oriented people such as supervisors, salesmen, and advertising personnel. It relied heavily on research and, beginning in the mid-seventies, education personnel to do the teaching. The seventies saw phenomenal growth both in the number of programs offered and in the number of participants.

When William Webber retired in 1974, Gilbert W. Bassett took over as Executive Director and instituted some long-range plans that had significant effects. One was the establishment of the Marketing Department, which had its roots in the public relations function that developed during the building fund campaign. Public relations became the Foundation Advancement Department in 1969, and its functions included communicating with the membership, advertising all GATF programs, services, and activities, and planning. Foundation Advancement began monthly mailings, including a new, publicity-oriented newsletter, in 1971. However, the marketing of products and services was shared with other departments, resulting in inefficiency. Therefore, the Marketing Department was established in 1975 and charged with the responsibility to market membership, products, and services for the whole Foundation. The addition of a full-time membership marketing manager, combined with the concentrated and professional promotional activity, resulted in a renewed growth in membership, increased participation in GATF programs, and increased sales of GATF products and publications.

Another result of Gilbert Bassett's leadership was the establishment of the Production Department. Prior to 1974, press and prepress were the responsibility of the Reduction to Practice Division of research and there was not even any composition or bindery equipment. If any of the other departments wanted to get something printed on one of the presses, it had to be fit into the Research Department's priority schedule. This created quite a few conflicts and production snarls. The creation of an independent Production Department to service all of the departments enabled the Production Director to schedule the most efficient production sequence. More equipment, including composition and bindery equipment, was added and the production staff was enlarged.

The change in the scope of the Foundation had a significant impact on the Education Department as well. The publishing function was revitalized. Books were gradually expanded to cover all the graphic arts processes and new ones were developed. Audiovisual programs continued to be developed, including overhead transparencies, soon superseded by 35-mm slides. The *AV Series 50* on the offset press was a milestone in the Foundation's audiovisual program. Introduced in 1970, the series was composed of six units, totalling over 230 full-color slides, each unit building upon the information presented in the previous unit and progressing from a general orientation, through the apprentice, up to the journeyman level.

The Education Department also worked more closely with other graphic communications associations. The most significant example of this was the affiliation of GATF and the Education Council of the Graphic Arts Industry in 1967. This organization had been founded by the industry firms and associations in 1950 with the objective of developing effective cooperative programs that would strengthen and improve

Charles Lucas, illustrator/graphic designer, and Charles Shapiro, education consultant, collaborating on an AV presentation.

graphic arts education. These programs—such as career recruitment and counseling, aptitude testing, graphic arts film lending, an awards program, a cooperative industry exhibit, and publication of career materials—were continued and expanded through GATF efforts. The affiliation also involved a third organization, the National Scholarship Trust Fund (NSTF), which had been set up under the aegis of the Education Council to be a clearinghouse for graphic communications scholarships and fellowships.

GATF's growing commitment to the education sector was also evident in its 1968 decision to create a special low-cost student/teacher membership category. In the first five years, nearly 1,000 teachers and students became GATF members.

The Education Department also began to work more directly with graphic arts teachers by offering several programs funded by various industry associations: teacher institutes, two-week intensive learning programs; teacher seminars, intensive one-day sessions on updated graphic communications technology; and professional intern programs, half-year or year-long sabbatical terms taken at the Technical Center, involving both working and learning.

GATF has continued and deepened its commitment to the training needs of the industry. Both an Education Training Manager and a Training Specialist were hired to oversee the various workshops and to develop training materials. An in-plant training assistance service was also begun to identify training needs of plants and help set up appropriate in-plant training programs. This service is often requested following a technical plant audit by the Technical Services Department.

PROJECT 80

In 1979, the GATF board of directors announced Project 80, a major expansion and renovation plan for the Technical Center. The objective was to update GATF's facilities, programs, and services to better respond to the new needs of the industry. The two main parts of the project were a Color Center and a Web Center. Other changes included a new lecture hall with tiered seating for twenty-eight, four new testing and training areas, enlarged composition and bindery areas, expansion of the library, a lot of new equipment, and conversion of the top floor of the Center, which had previously been rented out, into offices for the Education, Technical Services, Administrative, and Marketing Departments.

The Color Center was equipped with the latest commercially available equipment and instrumentation for electronic color scanning, conventional color separation, prepress proofing, and color measurement, enabling GATF to expand its capabilities and efforts in research and testing, education and training, and technical assistance. It comprised two scanner areas, a camera gallery with a darkroom, a combination contact-processor room, and a viewing and proofing area. The focus of the Web Center was an $850,000, fully equipped, four-unit web offset press. Most of the equipment was either loaned or donated, and included a laser scanner, a four-color sheetfed press, a two-color duplicator,

Frank Benevento, education and training manager, teaching in the lecture hall, built as part of Project 80.

three single-color presses, an overhead camera, three film processors, a real-time composition system, and viewing and proofing equipment, totaling in value over $3.5 million. Thus, GATF continued to fulfill its original purpose of advancing the industry through research and education.

Section Three: Organization

GATF is governed by a board of directors elected by the Foundation membership. This board determines the policy and elects the officers of the Foundation and selects a full-time executive director to guide and execute the policies of the board.

Bettie Richter, executive secretary, showing Gilbert Bassett, executive director, the day's financial results.

There are seven departments in the Foundation, each headed by a staff director, who reports to the executive director. These departments are Administration, Education, Marketing, Production, Research, Special Programs, and Technical Services. Each

department is guided in its policies and direction by an industry committee led by a chairman appointed by the president of the Foundation.

In spite of the tidy subdivision of departments and divisions, there is quite a bit of interaction among them. For example, almost all of the programs offered by the Special Programs Department are taught by Education, Production, Research, and Technical Services personnel; Education's Publications Division and Research personnel collaborate on books; the Technical Services Department relies on Research personnel to run tests. In addition, all of the departments represent GATF at various meetings, trade shows, and so on.

Marcella Pisarek, administrative assistant, Karen Sutterlin secretary, Kathy Loughery, membership clerk, and James Alm, administration director, checking membership records.

ADMINISTRATION

The Administration Department is concerned with the financial and physical operations of the Foundation. Its activities include personnel functions, data processing, ordering, billing, accounting, and providing general services and information to the other departments and to GATF members. The department also handles orders for GATF publications and products, and it is actively involved, with the executive director and department directors, in developing the annual budget.

Cynthia Parsons, receptionist, Rolfe Stange, data processing programmer, Patricia Farner, order clerk, and Nicholas Duranko, assistant to administration director, processing orders.

EDUCATION

The Education Department provides educational assistance to industry and the graphic arts education field. Its activities include publishing books and reports, presenting teacher update programs, developing learning modules and audiovisuals, administering scholarships and fellowships, and involvement in various training programs, Education Council activities, and special programs. The department staff also serves on various advisory boards, represents GATF at various educational meetings and conferences, promotes special educational activities with other graphic arts organizations, and maintains liaison with government educational agencies and other educational associations.

Publications. The Publications Division, assisted by Education's design group, produces text and reference books and reports. In addition, it provides the other departments with editorial services. The books range widely in complexity and scope, covering many aspects of graphic communications. They are developed by Publications writer/editors working with outside authors, often in collaboration with GATF technical personnel, or entirely with GATF staff, and always reviewed by appropriate GATF specialists. Subject matter can be classified generally as operational, troubleshooting, materials, sciences as they apply to the graphic arts, and special.

This division also produces two reports that are published periodically and issued to GATF members free of charge. One is

Nina Forsythe, technical writer/editor, Raymond Blair, editor-in-chief, and Thomas Destree, senior technical writer/editor, choosing illustrations for a textbook.

directed to those in the printing community who are involved in education and/or training, the other addresses the needs of graphic communications teachers at all levels of instruction.

Teacher Update Programs. Several industry associations fund various teacher update programs conducted by GATF. *Teacher institutes* are two-week intensive programs designed to keep teachers up to date on advances in printing and provide a forum for exchange of ideas and methods. They include hands-on training, demonstrations, and lectures. Advanced teacher institutes follow up on the teacher institutes by providing more advanced, in-depth information.

Teacher seminars are intensive one-day sessions on graphic communications technology held throughout the United States and Canada. They are designed to acquaint teachers with industry developments and to offer practical demonstrations for use in the classroom.

Teacher conferences are two-day programs held at graphic arts trade shows. The purpose is to bring teachers up to date on the technology displayed at the show, and speakers include GATF personnel, industry personnel, and educators.

In the *professional internship program,* a selected teacher, who is on sabbatical leave, spends a school term or year as a member of the GATF staff developing under supervision specific educational materials. The intern also has the opportunity to attend workshops held at the Technical Center and other scheduled educational programs and activities.

Sponsored Person. A company or an association may sponsor someone to work and study at the Technical Center. The person is assigned to a department appropriate to his/her training needs, is given a specific project, and may attend workshops related to the project.

Trainee. A trainee comes to the Technical Center at his/her own expense to obtain training in a specific area. The Education Department develops a program for the trainee through whatever departments are deemed appropriate.

College Intern Program. A college intern is a college student who is assigned to work part-time at the Technical Center to fulfill college requirements. These programs serve to increase students' knowledge and experience while they contribute to the industry through GATF.

Learning Modules. Learning modules are hands-on, step-by-step skill training guides for use in schools and printing plants. The module concept of training permits users to progress at their own pace and provides an opportunity for hands-on operations. A system of testing and evaluating performance is built in to test the learner's comprehension.

Audiovisuals. Audiovisuals demonstrate methods and procedures used in the graphic arts. They are designed for individual use or for group presentation and may be used for in-plant or school educational programs. Each package consists of 35-mm color slides, a narrative illustrated with a black-and-white halftone of each slide, an audio-cassette, and discussion notes.

Carmella Manges, graphic designer/photographer, and Donna Mulvihill, technical writer/editor, setting up an illustration being photographed by Frank Kanonik, prepress supervisor/head photographer.

Productivity Training. The Education Department offers three types of in-plant training assistance. One involves hands-on in-plant training tailored to the plant's needs, which have been identified by way of a technical plant audit or a survey form. Another involves teaching selected supervisors how to set up and instruct in-plant training programs, and a third type involves developing in-plant training curriculum.

Education Council. The Education Council, which affiliated with GATF in 1967, is dedicated to furthering graphic arts education through various activities such as career recruitment, aptitude testing, a cooperative industry exhibit, an awards program, and planning assistance.

Career recruitment involves development and distribution of graphic arts career literature. A battery of aptitude tests, as well as a color aptitude and a color blindness test, are available from the Education Council.

Several graphic communications companies financially support a cooperative industry exhibit that is maintained by the Education Council. The exhibit is taken to education conventions to promote interest in graphic arts education and establish contact with various education groups.

The Education Council recognizes outstanding achievement and service through its awards program. One type of award is presented to an individual association member who has made a significant contribution to graphic communications education. Another is presented to an association that has contributed significantly to the development or improvement of local graphic communications education programs.

Planning assistance is a service offered to schools that want to establish or update graphic communications programs. Services include curriculum development or review, laboratory planning, providing educational materials, providing general information about the industry, and providing names of potential teachers.

Dr. Jack Simich, education director, Bonnie Bokor, secretary, and Babette Magee, administrative assistant, appraising a career booklet.

National Scholarship Trust Fund. The purpose of NSTF is to develop and dispense scholarship and fellowship assistance to talented young men and women interested in a career in graphic communications. There are two categories of scholarship recipients: high school and recent high school graduates entering two- or four-year programs and students who have completed between one and three years of study.

Fellowships are awarded to graduate students having not less than one year's study remaining. They are granted for research and/or study in mathematics, chemistry, physics, industrial education, engineering, and business as they relate to graphic communications.

NSTF solicits scholarship monies, mainly from industry firms and associations, and disseminates scholarship information and applications. Applicants are carefully screened by way of their applications and interviews, and a special screening committee selects the finalists and alternates.

MARKETING

The Marketing Department is responsible for the development of interest in and support for the Foundation and its products and services. Its activities fall into four categories:

membership marketing, North American marketing, international marketing, and communications. The department is also concerned with the development of funds and other support for Foundation programs.

John Burgess, marketing director, speaking at the dedication of GATF Far East.

Membership Marketing. Membership marketing involves retaining existing members, attracting new ones, and related membership activities in the U.S. and Canada. The Membership Manager corresponds with existent and prospective members, develops and conducts membership increase programs, handles membership dues, and develops membership publications and advertising.

North American Marketing. The North American marketing manager is responsible for promoting GATF products, services, and programs in the U.S. and Canada. This includes developing brochures for seminars, publications, and products; developing products and services catalogs; and advertising products, services, and programs.

International Marketing. International marketing involves the promotion of GATF products, services, and programs plus membership marketing at an international level. The activities are similar to those of North American marketing and membership marketing.

Communications. Communications is basically public relations work. It involves writing and sending news releases concerning GATF developments and activities to graphic arts and other publications; publishing a monthly GATF newsletter; writing articles for the trade press; developing the Foundation's annual report; and other related communications activities.

Terrence Mahoney, North American marketing manager, and Melinda Coops, communications manager, checking a press sheet of a workshop brochure.

PRODUCTION

The Production Department comprises phototypesetting; paste-up, art, design, and layout; graphic arts camera; stripping and platemaking; pressroom; bindery; and mailroom shipping and receiving. This department serves all the other departments in a number of ways. Its activities include internal printing production, running tests for Research and Technical Services, conducting workshops and demonstrations for Education and

Diane Wentworth, secretary, checking a new brochure for Thomas Clifton, membership marketing manager, and John McCague, international marketing manager.

Frank Gualtieri, production coordinator, Brian May, pressman, and Daniel Moczydlowski, pressman, printing the GATF newsletter.

Henry Grzegorczyk, photocomposition specialist, receiving a work order from Merrilee Gravel, head graphic designer.

Special Programs, manufacturing GATF quality control films, maintaining an inventory on all GATF publications, and assisting in designing custom press tests and training programs. Often, two or more activities are conducted at once, such as testing a fountain solution for Research while printing a run of brochures for Marketing. The Production Manager also oversees the general repair and maintenance of the Technical Center.

Paul Gerson, cameraman, examining halftones while William Wills, stripper/platemaker, and Jerome Cozart, training specialist, discuss a flat.

RESEARCH

The objective of the Research Department is to define technical problems in the graphic arts processes, pursue solutions using modern scientific methods, communicate the results, and examine and review research work done by others. The department provides the industry with benefits in the form of services, information, enhanced efficiency and productivity, new instruments and devices, new techniques, and new systems. There are six research divisions: Chemistry, Color and Photography, Engineering, Environmental Control, Physics, and Techno-Economic Forecasting. The divisions work on a wide variety of

projects, which can be categorized generally as problem solving and materials laboratory testing, contract or proprietary research, cooperative research, and in-house projects. The department produces an annual research department report on the year's activities, as well as research project reports as projects achieve significant objectives. It also assists the other departments extensively in their programs, services, and publications.

John Lind, research chemist, and John Peters, chemistry supervisor, watching Barbara Albinini, research analyst, do an ink drawdown.

Chemistry. The Chemistry Division is responsible for research, testing, and analysis of ink, paper, fountain solutions, plates, chemicals, and other chemical aspects of printing. It conducts over fifty standard laboratory tests and develops new ones, develops and evaluates new materials, systems, and methods, measures and specifies material performance attributes required on the press, and assists the other divisions and departments.

Color and Photography. The Color Center, which was added as a part of Project 80, is a research, technical, and educational facility used to analyze problems in color reproduc-

Thomas Whiteman, scanner operator/trainer, and Richard Warner, assistant research director, evaluating a color proof.

tion, to offer practical technical information and assistance in production problems relating to color, and to provide technical education programs in color. The staff conducts tests of color-related materials and systems, usually for suppliers, analyzes color reproduction problems and measurements, develops proofing standards and specifications, and develops test image patterns. Often, the work is done in cooperation with other industry groups or suppliers. The division is extensively involved in Education and Special Programs workshops and does the color work for the Production Department.

Engineering. The main functions of the Engineering Division are web offset research and electrical and electronics research. It may also design and develop test instrumentation and evaluate equipment designs. As do the other divisions, Engineering assists the other departments in teaching, writing, testing, and other activities.

Michael Huff, duplicator operator, making a web splice as Lloyd DeJidas, production director, and David Crouse, engineering supervisor, look on.

Environmental Control. The Environmental Control Division maintains an awareness of government environmental codes, regulations, and related activities pertinent to the graphic arts industry, interprets them, and passes the information on to the industry. To do this, it reviews twenty to thirty periodicals per month (including the five-times-weekly *Federal Register*) and distributes newsletters on environmental, health, and safety issues. The division also studies environmental control as related to graphic arts production, provides technical assistance and consultation, and researches paper, ink, fountain solutions, and dryer systems to reduce pollution, health, and safety problems..It assists the other divisions and departments in research, writing, and presentations concerning environmental affairs.

The division also acts as secretariat of the Environmental Conservation Board of the Graphic Communications Industry (ECB), an organization of industry associations that assists the graphic arts industry in meeting government environmental regulations, acts as a liaison with regulatory bodies, and distributes information. ECB has several committees concerned with particular areas (air, health and safety, water, hazardous wastes).

Physics. The Physics Division does research in the area of

Mary Pat David, environmental chemist, and Dr. William Schaeffer, research director, reviewing current literature.

optics, color, imagery, properties of materials, and mechanics. This includes definition and measurement of the physical factors responsible for the quality of images produced by graphic arts processes and systems analysis of graphic arts processes. It also provides assistance to the other divisions and departments.

Techno-Economic Forecasting. The Techno-Economic Forecasting Division provides GATF members with technical, marketing, and economic information affecting the graphic arts industry to help them plan for the future. Every year, the division produces a number of techno-economic forecasts, which involve examination of, trends in, and a five-year forecast for a particular

Michael Coulson, market research analyst, and Dr. Nelson Eldred, techno-economic forecasting manager, researching for a Techno-Economic Forecast.

aspect of the industry. It also publishes several smaller reports on specific segments of the industry, on graphic arts market trends, and on major graphic arts markets, and assists the other divisions and departments in the techno-economic aspect of the graphic arts industry.

SPECIAL PROGRAMS

The objective of the Special Programs Department is to provide the finest technical update programs possible; thus, both subject matter and format change according to industry needs, and participants are asked to evaluate the programs. Four types of programs are offered: workshops, seminars, conferences, and programs by special arrangement. The department depends heavily on all the other departments, except Administration, and industry people to lead the sessions.

Mary Newberger, seminar and conference coordinator, and Dwight Horner, technical workshop manager, discussing scheduling.

Workshops (originally called seminars) are longer programs for limited audiences that are held at the Technical Center. Most deal with a specific aspect of graphic communications and involve demonstrations or labs. Seminars (originally called workshops) are one-half- or one-day programs for larger audiences in various industry centers. The purpose of conferences is to bring broadly oriented people, such as managers, supervisors, salesmen, and advertising personnel, up to date on trends and emerging technology. In addition, programs can be arranged to be held either at a plant or at the Technical Center.

William Smith (right), special programs director, in conference with association representatives.

TECHNICAL SERVICES

The Technical Services Department offers a large variety of technical problem-solving and planning services. It is able to do this largely because of the cooperation of GATF staff in the other departments and the technical service consultants in

Eleanor Nesta, secretary, taking notes while Fred Higgins, technical consultant, and John Geis, technical services director, discuss layout of a new plant.

several states and in Canada. In turn, the Technical Services Department assists the other departments in the area of the technical aspects of the graphic arts industry.

The most widely used service is the technical inquiry desk, which handles questions on technical aspects of all graphic arts processes as promptly as possible. Troubleshooting involves on-the-spot investigations of specific problem areas conducted by GATF specialists. Sometimes the problem warrants laboratory testing and analysis of samples or press tests, both of which are offered by the department.

The Technical Services Department also offers services that are not geared to solving a particular problem, but to analyzing systems. Technical plant audits are comprehensive evaluations of a company's entire printing operation or any segment thereof. Efficiency, quality, methods, equipment, and personnel are

Janice Lloyd, GATF librarian.

critiqued, and recommendations are made for improving pro-
ductivity, upgrading quality, and reducing waste and "down-
time." A production measurement systems analysis evaluates the
effectiveness of a plant's production measurement systems.
Systems may also be recommended to plants not using any.
Waste and remake procedures can also be analyzed, and
recommendations for improvement made. The department also
evaluates plant layout and work flow in terms of suitability for
productivity and quality, as well as proposed construction
plans.

Customized information services are planned consultations,
usually at the Technical Center, covering specific technical
subjects. The E. H. Wadewitz Memorial Library, which is
administered by the Technical Services Department, houses one
of the most extensive collections of technical literature in the
field of graphic communications. Every month, the library
produces a digest of current technical articles and books,
abstracted and published in various subject categories. It also
conducts literature searches upon request.

Another service the department offers is product and equip-
ment evaluations for suppliers and manufacturers. Product
evaluations involve laboratory and press tests. New designs of
equipment, either at the blueprint stage or already built, are
evaluated by an unbiased, professional staff.

Finally, the department produces technical services reports,
which contain information on technical problems, how to avoid
them, and how to correct them. The subjects are selected from
problems most frequently reported to the Foundation.

The Flow of Lithographic Production_____

Section One: General Exposition of Lithography

In this section we are not concerned with the detail of lithography but only with its essentials. For the purpose of our presentation the subject is divided into the following units: (1) Alphabetic printing and picture printing, (2) Lithography and photography, (3) Water and oil do not mix, (4) The offset method, (5) The principle of Rotary printing, and (6) Lithography as an integrated industry. Each of them is presented in the following.

ALPHABETIC PRINTING AND PICTURE PRINTING

Printing in its original form (and that means letterpress or typographic printing) was marvellously suited for the mechanical reproduction of the written word. But it was sorely lacking when it came to picture reproductions. The nature of relief printing explains this limitation. For this reason a variety of picture reproduction methods such as etching, engraving and last but not least, lithographing developed side by side with printing. They are the forebears of our contemporary gravure and lithographic processes.

Stone Lithography was Not Suited for Printing Reading Matter in Bulk. Letterpress and stone lithography were in almost exactly opposite positions. Letterpress was badly limited in picture reproduction, but excellent in

A lithographic stone.

the printing of the written word; stone lithography excelled in picture reproduction, but was badly limited in its ability to duplicate the written word. Many books were produced by combining two processes, the verbal message was printed in letterpress and the pictures in engraving or lithography. The term "plate" that you still find used in books for full-page color illustrations reminds us of this condition.

Stone lithography was originally and for many decades primarily a picture printing process. It enriched the graphic arts in its own way, but did not change the existing division between printing of verbal and of pictorial matter by reproduction processes.

The Challenge of Photography to All Reproduction Processes. Things went on about the same way until the advent of photography. Photography brought a revolution to the graphic arts: Photography was responsible for an entirely new kind of picture that was in universal demand; a picture tied to the fleeting hour and impossible to reproduce by manual skills. All processes of printing were stymied. When it came to reproducing photographs, all were equally impotent.

The Equalizing Effect of Photography on Printing. But photography was not only a challenege to printing, it was also its great benefactor. Photography achieved what had seemed impossible for centuries: the combining of pictures — including photographs — with reading matter into a single printing plate. Even more! Photography achieved this result not for one or another graphic arts method but for the whole lot. Photography has become the greatest equalizer in the printing industry. This revolution has been going on for about a hundred years; it is still going strongly even though the first signs of a change, electronic devices, have already appeared. It is a sad proof of human inertia that many printers have not yet grasped the immense consequences of this photographic revolution. But ideas move fast; people are slow.

LITHOGRAPHY AND PHOTOGRAPHY

The relationship between lithography and photography is a very old one. Lithography actually stood at the cradle

of photography. Joseph Nicéphore Niepce, to whom photography owes so much, began his experiments in 1813 with lithography. The two arts have been related to each other ever since. Nobody can hope to understand lithography without a good basis in photography.

Lithographic Printing Plates are Made Photomechanically. Lithography was the first printing process that learned to make its whole printing plate, pictures and reading matter as well, photographically and photomechanically. But platemaking is not the only field of application for photography. Photography makes possible the conversion of pictures into printing plates and provides the lithographer with a variety of fast and economical processes for this purpose.

The Role of Photography in Color Printing. Last, but not least, photography spearheads the drive for economical and true color reproduction. No other topic can compare in interest for lithographers to this one. No other market for lithography is as bullish, as wide open as the color market; no other field is wider, more rewarding. Here too photography, including the related science of color, holds the key to success. No word is strong enough, no sign sufficiently arresting to emphasize how much a knowledge of photography, photomechanics and the science of color means for a modern lithographer.

WATER AND OIL DO NOT MIX

Our discussion of photography and its paramount role in modern lithographic production might lead the reader to the question whether there is anything left of the original invention, whether we have any right but that of custom and tradition to speak of lithography at all. This question can be simply answered without any if's and but's. Yes, there is something left of the original invention; yes, we have a right to call our process by its original name.

Lithography Has Retained Its Basic Principle. In spite of all developments, in spite of all metamorphoses that lithography has experienced, in spite of the fact that we neither use stones, nor write on them as the word lithography suggests, our process has still retained its basic principle. It is the proverbial truism that water and oil do not mix. Like all such simple statements it has its limitations when we get to the finer points. But for a basic explanation it may be taken at face value.

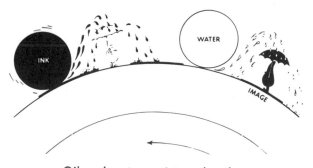

Oil and water resist each other.

The Printing Image Carrier Is the Most Characteristic Element of Every Printing Process. What bearing does the fact that water and oil do not mix have on lithography? To answer this question we must turn to the printing plate of lithography. The printing plate or, as their variety is called by a collective noun, the printing image carrier is the most characteristic element of every printing process. By comparing different printing image carriers we can learn a great deal about different printing processes.

The Essential Features of Lithographic, Letterpress, Gravure and Silk Screen Printing Image Carriers. If we look at a lithographic printing plate, we find that here the printing and non-printing areas have almost the same level. In letterpress, things are radically different; there, only the raised areas of the printing image carrier are inked and thereby also print. In gravure, on the other hand, things are exactly the reverse because there only the intaglio or sunken areas of the plate print. In silk screen, finally, the printing image carrier consists of a porous fabic through which the ink is pressed according to a pattern for printing.

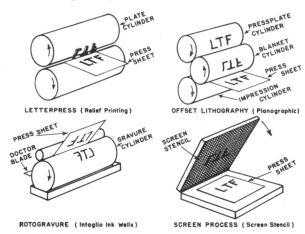

LETTERPRESS (Relief Printing) OFFSET LITHOGRAPHY (Planographic)

ROTOGRAVURE (Intaglio Ink Wells) SCREEN PROCESS (Screen Stencil)

The four principal printing processes.

Chemical Plate Treatment Is the Key to Lithographic Printing. In lithography, the printing and non-printing areas are at approximately the same level in the printing image carrier. In spite of this fact, ink adheres only to the printing areas of the plate and does not adhere to the rest. This unique result is based on the principle that oil and water don't mix, or — if we may re-phrase this statement — that ink is water-shy. (Ink consists to a large proportion of oils or other greasy substances.) *In lithography, the printing areas and the non-printing areas lie at the same level of the printing image carrier but they are differently treated chemically.* The non-printing areas are chemically treated for the contrary effect, namely, to be ink-repellent. A solution containing primarily water plays the key role in this process.

THE OFFSET METHOD

The overwhelming majority of contemporary lithographic presses use the offset method of indirect printing. This

method is not restricted to lithography, but it is nowhere in the graphic arts used to the same extent as in lithography. For this reason lithographic printing has become widely known as offset printing.

The Blanket Is Essential for the Offset Method. In offset or indirect lithography, the inked plate image is not directly impressed on the paper or other printing stock but transferred to an intermediate member, the blanket, which in turn makes the impression on the paper. Offset or indirect printing is a very essential feature of modern lithography. Old-style lithography was printed directly on the paper, either from stones or from metal plates; modern lithography prints indirectly and is therefore known as offset lithography, or abbreviated in colloquial speech, as offset printing.

The Consequences of Offset Printing. Indirect or offset printing has many consequences. One of them is the reversal of the plate image before it is transferred to the paper. Offset lithographic plates can therefore be made to *"read right"* as the printer says. The other result of the offset method is its ability to print finer detail on coarser or structured papers than is possible in direct printing. The blanket is comparatively soft and elastic, it snuggles itself onto the surface of the paper without squashing it. Still other consequences of the blanket will occupy our attention in other chapters when we discuss the process in its detail.

THE PRINCIPLE OF ROTARY PRINTING

The principle of rotary printing is used in many printing processes; it is not peculiar to lithography. But rotary printing is important for contemporary lithography, photography, photomechanics and indirect or offset printing.

The Principle of Rotary Printing Accounts for a Faster and More Economical Kind of Printing. All modern lithographic printing is done on rotary presses.

The consequences of rotary printing are difficult to exaggerate. Rotary printing is, other conditions equal, the fastest and most economic type of printing. The speed of offset printing as well as its comparatively simple makeready are intimately connected with rotary printing.

LITHOGRAPHY IS AN INTEGRATED INDUSTRY

The lithographic business is, as a rule, operated as an integrated business. The term integrated means in this context that a printing plant handles and controls a job in all its phases from the prepared copy to the completion of running.

Integrated Plants Have Their Own Platemaking Departments. Integrated lithographic plants have their own platemaking departments. But there are also plants that prefer to buy their plates from outside sources specializing in platemaking. This is particularly true for process-color printing. Many lithographic plants that make their own plates for all other jobs, buy plates for process-color work from specialized platemaking houses.

Integrated Operation Has Benefited the Lithographic Industry in General But May Not be Advisable in Specific Cases. The ways of American lithographers are not uniform; making plates inside of a plant is not necessarily preferable to buying them. But there is a school of thought that attributes the general growth of lithography to lithographic research directed towards all phases of lithography. The fact that so many lithographic businesses are operated as integrated plants is responsible for this all-embracing approach to lithographic research. Even though the author of this study is partial to this school of thought, he *wants to emphasize that the advantages and disadvantages of operating a platemaking department cannot be determined by generalizing, but only by detailed analyses of specific cases.*

Section Two: The Main Steps of Lithographic Production

In this section we present a brief survey of the main steps, and therewith the main production departments commonly found in a lithographic plant. The purpose of this presentation is two-fold: We want to survey the field for those who are not too well acquainted with it, and at the same time we want to provide a guide to and through The Lithographers Manual.

The subject is divided into three units: (1) The main steps of all graphic reproduction processes, (2) The flow of lithographic production, and (3) The lithographic industry. Each of these is presented in the following.

THE MAIN STEPS OF ALL GRAPHIC REPRODUCTION PROCESSES

All printing processes provide mechanical reproduction of graphically expressed statements or messages. These can be divided into two groups: reading matter and pictures. Reading matter does not need further explanation; under

pictures we subsume the great variety of drawings, paintings and photographs. As was pointed out in the preceding section, the efficient combination of both kinds of graphically expressed statements — *reading matter and pictures* — into one printing image carrier is a comparatively recent achievement that is due primarily to the progress of photography.

The Common Steps of All Graphic Reproduction Processes. All reproduction processes must take several steps in order to fulfill their tasks. If we want to bring these steps to some common denominators we can do that by distinguishing five phases of graphic arts production. These five phases are: (1) Art and copy preparation, (2) Conversion of art and copy into printable form, (3) Assembling the converted elements into a printing image carrier, (4) Printing itself or making the impression, and (5) Binding or finishing. Every graphic reproduction process takes these steps, but every one takes them in a different manner and also to a certain extent in a different order.

General Discussion of the Five Phases Common to All Reproduction Processes. Some of our five phases are self-evident, others need a few explanatory words. Art and copy preparation belongs to the first kind. It is the phase that provides the subject matter of printing. Two other more or less self-evident phases are printing itself, or making the impression and binding or other finishing.

Conversion of Art and Copy into Printable Form and Assembling the Material into a Printing Image Carrier. The two phases that need explanation are conversion of art and copy into printable form and assembling the converted material into a printing image carrier. These two phases are — if you permit a little sensationalism — the secret phases of printing, its real inside story. The first three mentioned phases are known to most people who have even a remote interest in printing: Everybody has seen art and copy, presses and the finished printed product. Not so the other two phases. They are highly technical and vary for every process and even for different applications and methods within a process. Both phases are necessary steps in the making of the printing image carrier, the most characteristic element of every process.

The Four Elements Necessary for All Printing Processes. All printing processes require a combination of four elements: (1) The printing press, (2) The printing image carrier, (3) The printing ink, and (4) The paper or other printing stock. The act of printing or making the impression takes place in the printing press. The printing image contained in the printing image carrier is transferred during this act by means of the printing ink to the paper. In this process the *printing* image becomes the *printed* image. All contemporary industrial printing requires a most careful combination of these four elements.

Printing Without Ink. It might be mentioned that there are also ways of printing without ink. People who have lost their eyesight use their fingers for reading. Braille, the printing process for the blind, does not employ ink. Other processes, at the time of this writing in the development stage, use colored powders instead of ink. In spite of these exceptions, we may nevertheless say that ink is one of the four essentials of all — or practically all — printing for people in possession of their eyesight, and that is fortunately the overwhelming majority of our population.

The Role of Planning. Planning is one of the most essential steps in all printing. Planning coordinates the five main phases of printing; it is an absolutely necessary prerequisite of successful operation. As printing is done on all economic levels, from the one-man shop to the industrial giant plant, planning varies accordingly. But even the very small shop needs planning, possibly more so than larger organizations. Printing is an intrinsically hazardous business where a small undertaking can cause a big damage. The role of careful planning, therefore, can hardly be exaggerated.

How Lithography Copes with the Problems and Executes the Tasks Common to All Graphic Reproduction Processes. The following unit explains how lithography works. This unit is also a guide to the chapters

of The Lithographers Manual. Planning for a lithographic plant is the subject matter of the third section of this chapter.

THE FLOW OF LITHOGRAPHIC PRODUCTION

In this unit we will present how lithography copes with the five phases of all graphic arts production and how these phases are treated in The Lithographers Manual. We will also discuss the specific characteristics of the four main elements of all printing for the lithographic process.

Our discussion follows the departmental structure of a lithographic plant which is also the basic plan of organization for The Lithographers Manual. We begin with the inception of a lithographic job, the creation of its subject matter, and end with the printed and finished product.

But before you begin your round trip through a lithographic plant you will be interested in background information on the lithographic industry. The following paragraphs give you a brief resume of each chapter of the Lithographers Manual.

Chapter One: The History of Lithography. In this chapter you find a discussion of the most important events in the fascinating history of lithography. You will read about the change wrought by the introduction of the offset principle and follow the course of all major developments as they took place in the growth of our industry.

Chapter Two: LTF now GATF—The Keystone of Modern Lithography. In this chapter you will be introduced to GATF and its method of operation. You will learn how research is planned, executed and how the results of these activities are disseminated in the industry.

Chapter Three: The Flow of Lithographic Production. You are in the middle of this chapter when you read these lines. Following our section you find a presentation of estimating and production control in a lithographic plant. The next chapter takes you to the inception of a lithographic job, the place where art and copy is prepared.

Chapter Four: The Creative Art Department. The extent to which a lithographic job requires art and copy preparation depends entirely on the job. Nor is art and copy preparation necessarily a part of the lithographer's services. Many jobs are prepared by advertising agencies or the advertising departments of business organizations. Art services and free-lance commercial artists, photographers and typographers, are very often commissioned by the buyers of lithographic printing to prepare art and copy.

In The Lithographers Manual art and copy preparation is treated very extensively. Art and copy preparation influences many phases of production as well as cost, quality, and delivery of a lithographic job. Further, many people prepare art and copy for lithography but know very little about lithographic production. There are, of course, highly qualified commercial artists and art directors in the field. But they will be the first to confirm the fact that the overwhelming majority of those who prepare art and copy for lithography are not overburdened with knowledge on the subject.

The Lithographers Manual provides the reader with very

Copy preparation.

detailed information on art and copy preparation. The progressive and sales-minded lithographer will find many hints on economical and effective art preparation. The lithographic salesman who bears the brunt of trouble in the struggle for the right kind of art preparation can learn from the Manual how art and copy must be prepared and why. He will be better equipped to explain these necessities to the customer or his art department and therewith increase his own prestige as well.

Finally a word on type and copy preparation. Lithographers are more and more learning that the printing of books and other jobs containing large amounts of reading matter is just as much within the province of lithography as the reproduction of pictorial subjects. For this reason and also because of the new developments in the field of photographic and other non-metallic type-setting, The Lithographers Manual contains a very detailed presentation of typography.

Chapter Five: The Camera Department. In the camera department begins the conversion process of art and copy into printable form for lithographic reproduction. The camera department is a key department of integrated lithographic plants. Its function and equipment vary with the size and specialization of a plant.

Generally speaking, the camera department produces transparent photographic film replicas of the copy in which the printing and the non-printing areas are sharply distinguished.

Our presentation of the camera department is especially broad. It covers basic scientific subjects, layout and equipment, line photography and three halftone processes, and also includes a discussion of the job habits and attitudes of the cameraman.

Chapter Six: Color Separation Photography. In this chapter you find a detailed discussion of color separation photography. The most advanced methods are here set forth, including exact instructions for their practical execution. The emphasis put on color separation photography is in keeping with the general policy of The Lithographers Manual that color printing is one of the most topical subjects of contemporary lithography. This policy finds its most striking expression in the next chapter "Photographic Masking and Color Correcting."

Chapter Seven: Photographic Masking and Color Correcting. No other chapter in The Lithographers Manual is as indicative of the great impact exerted by science on contemporary lithography. Masking for color correcting is beyond doubt the most intriguing topic for the progressive graphic arts color reproduction specialist, the photographer in particular.

The subject is new and old, depending on your way of looking at it. Old in the sense that some of the basic work dates back almost half a century, new in the sense that photographic masking and color correcting has achieved

Preparing to shoot the copy.

A litho artist at work.

industry-wide attention only recently. In this chapter The Lithographers Manual presents a unique collection of the most advanced work and the most important methods for process color reproduction.

Chapter Eight: The Litho-Art Department. The product of the camera department needs very often further treatment before it can be assembled for platemaking. The litho-art department is the place where highly skilled craftsmen improve the quality of negatives and positives, correct their flaws, and exercise special lithographic techniques for color reproduction. Once the material has passed the litho-art department it is ready for assembly.

Chapter Nine: The Stripping and Photocomposing Department. The stripping and photocomposing department is very characteristic for lithographic production. It provides the platemaking department with a complete and precise assembly suitable for making the final press plate.

Layout and stripping.

But stripping consists not only in assembling, it includes many highly technical operations besides. Very often stripping combines various elements into one, or converts negatives into positives before they can be finally assembled. In The Lithographers Manual photocomposing is discussed as part of the "Stripping and Photocomposing Department" chapter.

Chapter Ten: The Platemaking Department. In the platemaking department the conversion of art and copy into printable form is completed. The product of the platemaking department is the assembled printing image carrier, ready for the press.

Platemaking was for a long time the problem child of lithographic production. It was also the first part of lithography which was subjected to scientific study and improvement. The results of this process are known to the industry. The Lithographers Manual presents a comprehensive description of the whole subject, including the scientific basis of the work. This chapter of the Manual bears witness to

Platemaking.

the great achievements of the Lithographic Technical Foundation and is prepared by the man who directed this work during the last decade.

Chapter Eleven: The Proofing Department. The proofing department has a variety of functions. It is one department that is bound to increase in importance with the growth of process-color work.

Lithography has developed a great variety of proofing techniques. These were developed in the course of years according to the needs of different plants. In The Lithographers Manual you find a systematical discussion and comprehensive presentation of the whole subject.

Proofing.

Chapter Twelve: Lithographic Presswork. The pressroom is the department where the product of lithography is brought about. It is beyond doubt the most important department in a lithographic plant. Preparatory steps up to and including platemaking may be taken outside a lithographic plant, not so presswork. A pressroom is an absolute essential for every lithographic business.

In The Lithographers Manual this subject is treated with particular care and in a broad sweep. Here too you find discussions of the most modern equipment and techniques, from the single-color sheet-fed press to the complex multicolor web-press installation. Presswork is intimately related to ink and paper. They are the subject matter of the following chapter.

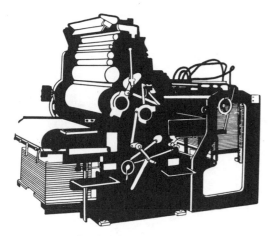

The lithographic press.

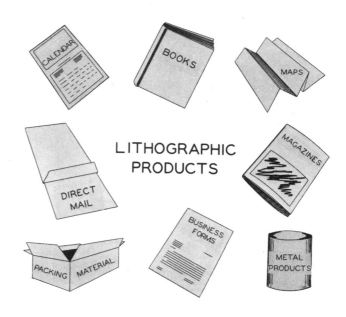

LITHOGRAPHIC PRODUCTS

Chapter Thirteen: Ink and Paper. These two are essential in all printing production. They are also very important cost factors. In The Lithographers Manual ink and paper are accorded a treatment commensurate with the importance of the subject and the vast amount of research devoted to it. All points of interest to the lithographer and to his supplier are extensively discussed, together with a great deal of background information.

Chapter Fourteen: Binding. The product of the pressroom is a lithographed sheet. This sheet must in most cases be further processed before it becomes the finished product ready for final use. Binding is one of these subsidiary processes. Binding, too, is not a static industry, but in constant flux. In The Lithographers Manual you find a presentation of the subject including modern techniques of bookbinding and binding for advertising specialties.

Chapter Fifteen: Various Supplementary Processes. In many cases the lithographed sheet is not bound, but subjected to some other supplementary processes. Labels, for example, are bronzed and varnished; posters and displays may be silk screened before they are finished; or, they may be mounted and diecut directly after lithographing. In this chapter, The Lithographers Manual presents information on bronzing, varnishing, silk screen printing, mounting, die-cutting, display finishing and folding box making.

THE LITHOGRAPHIC INDUSTRY

Lithographers are not only interested in the detail of production, but also in their industry in general. They know that the well-being of an individual plant is closely related to the life of the whole industry. The closing chapters of The Lithographer's Manual are devoted to this subject.

Chapter Sixteen: Trade customs. Trade customs are very important, particularly in case of disagreement between customer and lithographer. In the Manual you find a discussion of trade customs including the citation of court cases and court decisions on a variety of points.

Chapter Seventeen: Glossary of Terms. As lithography develops so does its language. In this chapter you find a short dictionary of lithographic and many other related technical terms.

Bibliography. The literature on lithography and related fields keeps growing. The Manual presents a selected list of books as well as a list of periodicals regularly abstracted by GATF. Both lists were prepared by the Research Department of GATF.

Section Three: Estimating and Production Control*

In this section you find a description of the estimating and production control system used at the Spaulding-Moss Company in Boston. Our presentation of the system includes all forms used in its practical execution. The subject is divided into the following five units: (1) The Production Control Supervisor, (2) Estimating, (3) Processing the

Order, (4) Production Control, and (5) Various Tie-in Functions. Each of them is presented in the following.

THE PRODUCTION CONTROL SUPERVISOR

The moment a lithographic sales department accepts an order it places the company under obligation to produce work:

1. When the customer expects it.
2. At the proper price.
3. Of satisfactory quality.

* Illustrations in this section are by courtesy of Marshall L. Russell.

BACK

PAPER STOCK

Name of Dealer
Name of Paper
Color
Finish
Sheet Size
Basis Weight
Shts Required
Waste
Total Sheets
Wt/M.Sheets
Total Weight
Cost per lb.
Total Cost
Profit
Paper Item

OUTSIDE WORK

TYPE	BY	FOR	
		cost	
		+profit	
		=total	
		cost	
		+profit	
		=total	
		cost	
		+profit	
		=total	
		cost	
		+profit	
		=total	
		cost	
		+profit	
		=total	

PLANNING DEPT. NOTE

FRONT

CUSTOMER
STREET
CITY
ATTENTION OF

IDENTIFICATION

Type　Mail　　DATE
Quote　Tri.　Source
CONFIRM.　Slmm.　EST. BY
ORD.REC　Cust.　Revis. #

No.Copies　No.Pages　Trimmed Size　Color Ink　of 2 sides　Stock

Item A　Item B　Item C　Item D　Item E

Backing
Plate
Negatives
Photo Comp.
Impressions
No. Plates
Order
Hand & Ship
Stock
Cutting
Punching
Folding
Binding
Covers
Typed
Typeset
Preparation
Halftones
Mkeup
Color Sep.

Return Originals
OLD W.O. NO.

PREPARATION	CAMERA	ASSEMBLY	PLATE	PRESS	FINISHING
Typing	Line Inserts	Color Sep.	Photo Comp.	Mashup	Punching
Typeset	H.T. (Silh.)	Retouch Negs.	Deep Etch	Ink	Round Cornering
Paste-up & Art	H.T. (Sqst.)	Stripping	Dble Exp.	Press Prfs.	Collating
Photo Retouching	Extra Photo.		Retouching	Spec. Mkdy.	Perf. or Scoring
Photog - Proofs			Rev. Plate		Folding & Binding
					Padding

Form SM 100

Front and back sides of the estimator's calculating sheet.

To carry out this obligation, the lithographer should have Production Control, Cost Control, and Quality Control.

In this study we will graphically show and explain a Production Control System in action.

A System is Never Better Than the People Who Operate It. The first thing we should recognize is the importance of the Production Control Supervisor and other workers who play a part in planning, scheduling, and loading. A system is necessary, but it is worthless without competent people to operate it.

The Necessary Qualifications for a Production Control Supervisor. When one selects an individual to head up Production Control it would be well to bear these qualifications in mind:

1. He should have a "sales" attitude — a real desire to serve the customer and meet deadlines.

2. He should be a clear thinker — one who can exercise good judgment and make proper decisions.

3. He should possess the ability to get along with other people — more especially the salesmen and production supervisors.

4. He should have a capacity for detail and a rigid adherence to complete follow-through.

ESTIMATING

Estimating normally is not considered as a part of Production Control. It does start the ball rolling in that direction, however, since delivery schedules and other factors affecting Production Control come into the picture and are determined and settled here.

Estimating Is Part of Selling. The job has not been sold at this point, so estimating is a part of the selling function in the sense of preparation and presentation of an estimate to the customer or prospect. The Estimating Department expense is charged to the plant. Organizationally this department comes under the Works Manager.

We try to develop a "selling" attitude in our Estimators, a real desire to "get the order" through intelligent thinking and planning as well as fair and proper pricing. The Estimators work from a complete list of standard prices for different types of work. These standards have been built from engineering studies of time against which the departmental hourly rates are applied. Although adjustments are many times necessary to care for a given estimating problem, our feeling is that this method affords greater uniformity of pricing.

Estimate Requests are Cleared Through the Sales Department. In our plant all estimate requests clear through the Sales Department first, mainly to check them for completeness of information, clarity, a chance to note selling ideas and immediate follow-up on new prospects. In addition, the Sales Department will also establish the date the estimate is needed by the customer. When the salesman enters a request for an estimate, he is required to write down the job specifications on the "Request for Estimate" sheet. Verbal requests are not accepted.

The Calculation Sheet. The Estimator does his figuring on the calculation sheet. At the top he writes name, address, and specifications. The body provides space for listing figures on one or more items and the pre-printed increments at the left save writing time and serve as a check list. Paper is computed in the right-hand section at the top. Below this area, figuring is done for clarification and future reference. Estimates from outside suppliers are also recorded within this same area. A form size 11" x 17" printed on one side is used here. The reverse side can be used if added space is required.

The Formal Estimate. Upon completion this form goes to the typist who prepares the formal Estimate for the customer. This is a 4-part form 8½" x 11". The original goes to the customer; one copy is attached to the calculation sheet and retained by the Estimating Department; a copy is given the salesman for follow-up and the final copy is kept by the sales office for analysis and diary follow-up with the salesman.

The Salesman Reports the Reasons Why Jobs are Received or Lost. When orders are received or lost, the salesman turns in his copy to the Sales Department. Space is provided wherein he can report reasons why job was received or lost as well as other available competitive information. This data is analyzed by an estimator and serves as a guide for future competitive pricing. When an order is received the estimating department's copy and the attached calculation sheet are pulled from the file and used to check specifications against the actual copy received. Variations, if any, are noted at this time, re-estimated, and discussed with the customer.

PROCESSING THE ORDER

In this unit we discuss first the work order and then the camera slip. The accompanying illustrations show the forms used in the work.

The Work Order. Orders are written, planned, and scheduled in one operation. Dates are set for each department, paper or ink is ordered, press time is set aside and any special need is acted upon. The Work Order is an 11" x 17" form printed on one side of a 13# translucent paper. When this is completed we have a master copy from which Ozalid whiteprint copies are made and used as follows:

The Traveling Work Order. This copy becomes the traveling Work Order. It is folded in half and pasted around a blank kraft envelope.

The Invoice Set. The invoice typist receives a copy and from this prepares the invoice set. This multiple part snap-out form contains customer invoice, file copy, accounting copy, salesman's copy, acknowledgment, packing and shipping slips. After typing, the acknowledgment goes to the customer, the packing and shipping copies are sent to the shipping office and the salesman's copy forwarded to the sales office for distribution. The file copy is detached and held in the order department for reference. Invoice and accounting copies are kept intact for billing. Price is typed on later after the job has been shipped and cost has been computed by the billing clerk.

Front and back sides of the work order.

Back

Front

The Invoice Set.

The Copy for the Stock Department. One copy is sent to the stock department — stock is placed at the press according to schedule.

The Copy for the Purchasing Department. One copy goes to Purchasing so that necessary outside materials or services can be ordered and coordinated to the schedule.

The Copy for the Press Supervisor. When ink matches or outside purchases of ink are called for, a copy of the Work Order goes to the press supervisor. He will compute the ink requirement and order by using the Material Requisition.

Additional Functions of the Work Order. In addition to providing space for basic job information such as quantity, size, stock, etc., the Work Order contains the complete production schedule and serves as a planning and layout sheet for stripping, press, and finishing.

Supplementary Records. We also record the following: (1) Outside purchases, (2) Location and description of customer's original copy, (3) Shipments made.

The Master of the Work Order is Preserved. The translucent master is kept in the order department for ready reference until the job is completed. When the work clears the plant, it is discarded.

The Camera Slip. If an order is complicated, or for some reason cannot be put into production quickly, the original copy is sent to camera so that work can get under way. The Order Writer fills out the camera slip and sends it to the camera department. The art department also uses the form to order negatives, contacts, etc. They are returned to the camera department to be accumulated in the Work Order Jacket. Later they are used by the billing clerk to price the job.

PRODUCTION CONTROL

We now arrive at the heart of the Control System. Here we use the Master Control Board and the Press Loading Board.

Control Board and Job Status Cards. The purpose of these cards is to show the location of each order in the plant as they move between departments. They provide a constant check on progress against the set delivery schedule. Cards are initiated when the order is written. Hung on the board in numerical order, they carry the Work Order number which eventually becomes the customer invoice number. White cards indicate black-and-white printing. Pink cards are used for color work.

The Board Card and Follow-Up Cards. A board card is the master of the set and contains customer name along with the complete production schedule. This is immediately hung on the control board and the remaining cards are handled in the following manner: Preparation and Camera cards are clipped to the Work Order; Stripping, Plate, Press and Finishing cards are sent directly to each department supervisor as advance notice of work to come. Each card shows in-and-out dates for a particular department.

Information on flats, plates, presswork and binding is also listed on the card for each supervisor so that he knows

The Production Control Board.

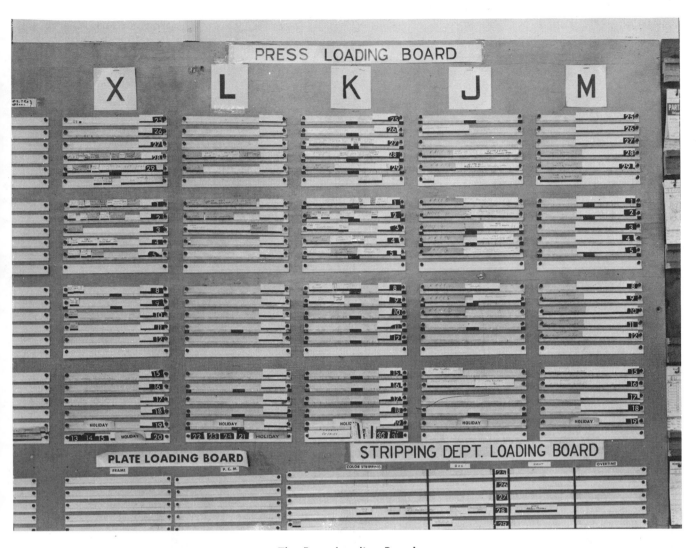

The Press Loading Board.

exactly what to expect. Every department has its own control board and cards are hung on them until the work clears.

Job Schedules and Their Changes on the Control Board. With few exceptions, a complete schedule is set for every job. Occasionally we find it is not possible to establish a complete schedule on a job. Schedules do change, however, and it then becomes necessary to revise dates. This is the responsibility of the man in charge of the scheduling board.

The Flow of Follow-Up Cards. As jobs flow from department to department the cards are stamped with the time cleared and are returned to Production Control to be hung on the control board with the board card. At a glance we then know the location of each job and can communicate with the department for specific information when needed.

Quick Reference Cards. Production Control has an assortment of quick reference cards which are hung to cover certain circumstances. Among these are "Proof Out," "No Stock," "Report of Delay," etc. Being printed with large type and colored ink they stand out on the board as reminders for necessary follow-up.

Handling of Delays. Whenever a job falls behind schedule and time cannot be made up, the new production schedule is sent to the Sales Department. Here it is decided how the customer should be informed in order to maintain good relations. As soon as the job is shipped, the cards are discarded.

The Press Loading Board. In setting up the Control System we found press loading critical to the Production Control problem. Actually we couldn't accurately schedule without proper knowledge of what work load was ahead for the presses. For this reason, press loading was incorporated into our Production Control function.

The Press Loading Board is Set Up for a Four-Week Period. The presses are indicated across the top. Each strip represents a work day. It is divided into two parts, day and night shift. Each shift is divided into seven one-hour periods.

The Operation of Press Loading Board. When the job ticket is written up, planned and scheduled, press time is estimated and a paper tab is cut to proper length in hours. This tab is then loaded under the press assigned

W. O. No. #4 PRESS PLATE Due Out Due in Press STRIP Due Out

W. O. No. #3 PRESS RUN BY: Due In PRESS Due Out

W. O. No. #2 PRESS

W. O. No. #1 PRESS Stock

NAME / No. / Press / F. B. T. / Run / Size / Color

BOARD CARD	SHIP	Due Out / Due In	FIN	Due Out	PLAN	Due Out	CAM.	Due Out	Proof	PREP.	Due Out	PREP. FILE	Due Out

Via

Date Rec'vd

- [] 9 A.M. [] 1 P.M.
- [] 10 A.M. [] 2 P.M.
- [] 11 A.M. [] 3 P.M.
- [] NOON [] 4 P.M.
- [] 5 P.M.

Customer

BINDERY
NAME
P.O. NO.

Run with
Press D X E N S P

- [] SADDLE [] NO.
- [] FOLD [] PAD
- [] PUNCH
- [] MISC.

A.U. I.U.

Customer
Description
EST.
ACT.
A.H. T.H.

Form S.M. 82

Schedule--Due Out

Prep	Strip
Proof	Plate
Cam.	Press.
Plan	Fin.

SHIP

Job status, Follow-up and Quick reference cards.

Form S-M MC #1

MATERIAL & SUPPLY REQUISITION
SPAULDING-MOSS COMPANY

DEPT.

DATE_____194___
REQ'N NO.

P. O. NO.

W. O. NO.

SUGGESTED SUPPLIER

PLEASE PLACE ORDER._____ DELIVER FROM STORES OR FROM ANOTHER DEPARTMENT._____

WANTED ON_____194___
ORDERED &
PRICED ON _____194___ AT _____ A/P M SCHEDULED
DELIVERY _____194___

ITEM	QUANTITY	DESCRIPTION	T L W C	TERMS - DISCOUNT	UNIT $	AGREED - TOTAL $

APPROVED BY | DR. DEPT. | DR. ACCT. | CR. DEPT. | CR. ACCT.

AUTHORIZED BY

PER _____

Materials and supply requisition form.

FORM SM 44

DAILY RECORD - LABOR UTILIZATION

NAME **FOLEY** TYPE OF WORK **ST** DATE **4/17/51**

8:00	W.O. NUMBER	ELAPSED TIME	CH'G.	1:00	W.O. NUMBER	ELAPSED TIME	CH'G.	6:00	W.O. NUMBER	ELAPSED TIME	CH'G
10				10	3522			10			
20				20				20			
30				30				30			
40	3501			40	3548			40			
50				50				50			
9:00				2:00				7:00			
10				10	3510			10			
20				20				20			
30				30				30			
40				40				40			
50				50				50			
10:00	3487			3:00				8:00			
10				10				10			
20				20				20			
30				30				30			
40				40				40			
50				50				50			
11:00				4:00				9:00			
10				10				10			
20	3522			20				20			
30				30				30			
40				40				40			
50				50				50			
12:00				5:00				10:00			
10				10				10			
20	LUNCH			20				20			
30				30				30			
40				40				40			
50	3522			50				50			
1:00				6:00				11:00			

(Overlaid job cost card)

W.O. # G 3548

CUST. Hosp. Service P.O. NO.

ART		COMP.		EXTRA STRIPPING					
DATE	HOURS	DATE	HOURS	DATE	OPERATION	HOURS		VENDOR	
4/16	.4								

EXTRA CAMERA WORK — P F PRICE

FOTOSETTER — DATE HOURS SIZE KIND

TOTAL HRS.

RATE

ACT. $

EST. $

QUOT. $

TOTAL HOURS

RATE

RATE $

TOTAL HRS.

RATE $

SM FORM # 34 (REV)

TOTAL $

IF WORK PERFORMED FALLS WITHIN A CLASSIFICATION OTHER THAN DESCRIBED AS "TYPE OF WORK" AT THE TOP OF THIS SHEET USE THE FOLLOWING SYMBOLS TO IDENTIFY IT:

DEPT. HEAD APPROVAL P—PREP. T—TYPING O—OPAQUING S—SPOTTING St—STRIPPING

Job cost card and daily record of labor utilization forms.

Purchase order set (materials other than type).

and on the day or days shown in the schedule. White tabs are used for black ink; colored tabs for color jobs. In loading ahead we try not to load shifts completely. An allowance is made to take care of down-time and special delivery needs which we recognize as bound to arise.

VARIOUS TIE-IN FUNCTIONS

Our presentation of the production control system would be incomplete without a discussion of several important tie-in functions. These as well as the forms used in their execution are now presented.

Material Requisition. The Material Requisition form is used to obtain material from the warehouse and request purchase through the purchasing department. Three copies are made out and sent along. The original is retained by the warehouse or purchasing. After pricing by the warehouse, or receipt of vendor's invoice, one is sent to accounting and the other is returned to the ordering department.

Purchase Orders. Our purchase orders are a four-part form. The original is sent to the vendor. One copy retained by purchasing for follow-up and file. One goes to the receiving department for check on incoming material and one goes to accounting with the vendor's invoice.

Special Purchase Order for Composition. The special purchase order form for composition is designed to speed up purchase of composition by the art department. This is a three-part form made out by the artist. The original goes to the vendor; one is retained in the art department for follow-up; one goes to Purchasing where it is checked against the vendor's invoice before being sent to accounting with the invoice for payment.

Job Cost Card. The job cost card form is used to record chargeable time in preparation and art departments, also for other operations not covered by predetermined standards. For example, color separation time in stripping department. It is originated by the cost control clerk and posted from the Daily Record of Labor Utilization. Prices of outside materials and services are also posted. Cards are kept on file until called for by the billing clerk. After billing they are filed in the Work Order.

Daily Record of Labor Utilization. The daily record of utilization form is used by the operator to record time spent on operations not covered by predetermined standards — operations which must be charged out on a time basis. Sheets are turned over to cost control clerk daily and chargeable time is recorded on the Job Cost Cards. They can also be used to check operating efficiency.

The Preparation of Type and Art _____

Section One: Type and Typography

A printed piece is made up of two essentially different elements: (1) type matter and (2) various kinds of illustration and decoration. The first four sections of this chapter deal with the nature and production of type matter.

Graphic symbols form the basis of written language. A written language that is based on an alphabet, permitting the in-line combination from a relatively small number of different letters into a vastly greater number of words, provides a system most convenient for printing reproduction.

For printing, the characters of written language—letters, figures, punctuation marks—must be rendered into standardized forms called *type*. While the rendering of each character must have a recognizable basic shape, each particular set of characters (called a font) may differ from another set in style, size, or both.

The particular style of a font is called its *face* or *typeface*, named from the flat printing surface on the three-dimensional type of letterpress. The design of a face affects the ease with which it can be read, the mood it establishes, and certain special functions that may be desired in special situations: attracting attention or providing emphasis. The design takes into account both the appearance of the individual characters and how they fit together into an overall effect.

A font has not only a particular style but a particular size. The principal identifying size is a vertical dimension that determines the distance from the baseline of one line of type to the baseline of an adjacent line of type when the two are at the designed distance apart—"set solid," with no additional line spacing between them. This dimension is called *"point size"* from the name of the unit (the point) used in type measure, as discussed subsequently.

The design and selection of the faces and sizes of types and their arrangement and spacing is called *typography*. The actual operation of assembling types into words and lines in accordance with the manuscript and typographic specifications is a part of typography called *typesetting*.

The Development of Typefaces. Type designed by the early printers copied the styles of the local scribes. In the northern part of Europe, the bold-faced Gothic letter forms, sometimes called black letter, were predominantly used. Thus, the letter form designed by Gutenberg in Germany for his 42-line Bible, which is said to be the first printing from movable type, is characterized by the heavy Gothic letter form. In Southern Europe, the influence of the early Venetian letter forms is responsible for what is known as the Roman letter. Nicholas Jenson, a Frenchman from Venice, designed a Roman letter form that still influences type designers. The Venetian Roman letter had minimal contrast between the thin upstrokes and the heavier downstrokes and is characterized by thick, rounded, uneven serifs (short cross-lines at the ends of main strokes) that were similar to those serifs formed by pen strokes or chiseled into stone. Shortly after Jenson, another Venetian, named Aldus Manutius, designed two more Roman faces and also the sloped letter known as italic. The influence of the Roman letter spread northward into France and England where designers such as Claude Garamond and William Caslon refined the Venetian Roman by increasing the contrast between the thin upstrokes and heavier downstrokes and forming serifs that angled out sharply from a rounded bracket where the serif joins the stem.

The first significant change from the Oldstyle Roman to what is termed a modern face was brought about by John Baskerville, who used wove paper for the first time in printing. The smoother paper surface made possible the use of finer typefaces. Baskerville's type, a transitional design, refined the thin strokes. Bracketed serifs trailed to a point, and the swells of the round letters, unlike those of Oldstyle Roman, were vertical except in the "e."

Transitional designs continued until the eighteenth century, when Giambattista Bodoni designed the first truly modern typeface. He made the first complete thrust away from the graceful, easy-flowing lines of oldstyle and transitional types. Instead, he designed with maximum contrast of thick and thin strokes, terminating the main strokes with straight, thin, and unbracketed serifs. Although he designed in the eighteenth century, the term "modern" still applies to type designs based on Bodoni's principles.

Elements of Type Design. The basic unit of type matter is the character, and everything discussed in the preceding segment concerns features of the character: weight of the strokes—thin, thick, or varying; kind of serif and how it is joined to the end of the stroke; slope of the character; shapes of the curved elements;

Folio Extra Bold

Bodoni Extra Bold

Futura Medium Condensed

Stymie Black

Whitin Black

Several popular display faces. Folio and Futura are sans serif designs; the Bodoni is modern; Stymie, square serif; Whitin, a "bracketed" face (it retains a style link with the oldstyle faces).

The distinguishing characteristics of a typeface. This composite shows characteristic elements of letter forms. First row shows serifs; second row, termination of top strokes; third row, weight of strokes; fourth row, shape of rounded character elements; fifth and sixth rows, terminals on j and f; seventh row, formation of ears in letter r. The faces represented: (1) Caslon Oldstyle; (2) Bodoni; (3) Garamond; (4) Futura; (5) Century Expanded.

character and the width of the type body on which the character is carried. Thus basic letterspacing is part of the type design.

One problem is that the visual space between characters is affected by the varying shapes of the adjacent sides of characters. Some combinations of side-by-side letters with normal spacing mesh better than others. Early designers improved many of these problem letter combinations by designing two or more characters together on one type body, a combination called a *ligature*. A few of these, such as "ff," "fi," "fl," "ffi," and "ffl," persist to the present in some fonts.

Sometimes portions of such characters as an italic "*f*" were made to project beyond the type body to permit overlapping an adjacent letter. A projecting part of this kind was called a *kern*. With the advent of phototypesetting, the term *kerning* was extended to the practice of achieving similar results electronically by reducing the normal letterspacing.

and special features, such as the kind of ear on the small "r." Such design elements affect the suitability of a typeface for specific purposes, as discussed in Section Three.

But type designers also have to be concerned with the overall appearance of the type as the characters are fitted together into words and lines. The first requirement for this, of course, is consistency of style, with respect to the features mentioned above, from character to character. Another consideration is how far one character is from the next. For metal or other three-dimensional types set side by side, this space between letters is the difference between the overall width of the

SIZE SIZE

WEIGHT WEIGHT

FORM FORM

COLOR COLOR

The basic considerations in type design.

Section Two: The Evolution of Typesetting

The operation of setting type by hand remained essentially unchanged from the days of Johannes Gutenberg (about 1450) to the invention of the Linotype in 1886, and is still in limited use today. Even the alloy used in casting the individual metal types had the same basic constituents as modern foundry type: lead, antimony, and tin. In the typesetting operation, individual types residing in a compartmented case are hand-assembled into

Type arrangement of the California Job Case.

words and lines in a hand-held device called a composing stick. From there the lines are transferred to a tray called a galley.

Although machine-setting has largely replaced hand-setting and two-dimensional type has largely replaced three-dimensional, the traditions, terminology, and principles of typography have their roots in the centuries-old system. For example, the terms "uppercase" and "lowercase" that are still applied to letters originated from the respective positions occupied by the capitals and small letters in the type case. The practice of increasing the spacing between type lines by inserting thin strips of lead is called "leading"; the same term is often applied to the control of interline spacing by paper advance in phototypesetting. And many other standard typographical terms originated in reference to the individual hand-set types.

THE NOMENCLATURE OF TYPE

Type is available for every letter, numeral, or other symbol that is used in graphic communications, and these letters and symbols appear in a great number of designs and sizes. To describe the characteristic appearance of types, a unique terminology for typography has been developed over several centuries, and since these terms are still used extensively, a student of typography must be thoroughly acquainted with them.

Type Font. A complete assortment of characters of one size of typeface that includes capitals, small capitals, lowercase letters, numerals, ligatures, and punctuation marks is called a font of type.

A font of type usually contains a sufficient assortment of characters for setting ordinary composition such as newspapers, magazines, and other nontechnical material. In some cases, a "pi" font must be used in conjunction with a main font to permit

abcdefghijklmnopqrstuv
wxyz .-,;:'?!& ""'' fffiflffiffl
ABCDEFGHIJKLMNOP
QRSTUVXYZ
$1234567890

The characters found in a typical font of type.

the setting of superior and inferior characters, mathematical symbols, and accented characters for certain languages.

Type Series. Most typefaces used in metal composition are made in a wide range of sizes known as a series. Generally, a type series in metal composition begins at a 6-point size and goes up to 36-point or in some cases as large as 96-point type.

The Point System. The term point is derived from the American Point System. This system of measurement is used in most English-speaking countries. The point system has two units of measurement: points and picas. There are 12 points in 1 pica and 6 picas in 1 in., or 72 points in 1 in. (Actually, 6 picas are not exactly equal to 1 in.; they measure 0.99576 in.) Type body size is specified in points, such as 10-point Bodoni. A pica type is 12 points, and agate type—used in newspaper ads—is 5½ points. There are 14 agate lines to a column inch. This is the measurement used to calculate the space occupied by advertisements in newspapers.

Large wood type used for posters is expressed in pica lines. For example, 10-line type would be 10 picas in height. Line length is also specified in picas such as an 18-pica line length.

Point Size or Body Size. The height of a font of characters is always referred to as the body size or point size and is expressed in typographic points. The measure of the height is

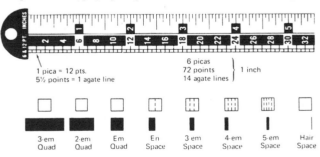

The point system. Note that 30 picas comes to slightly less than 5 in. The em is a square of the type's point size. Spaces are exact fractions of the em; quads are exact multiples.

Century Expanded

Century Expanded Italic

Century Bold

Century Bold Italic

Century Bold Condensed

Century Bold Condensed Italic

Century Oldstyle

Century Oldstyle Italic

Century Schoolbook

Century Schoolbook Italic

Century Schoolbook Bold

A typical type family set in 12 pt. Some large type designs are available in large families, some in small families. Decorative type designs seldom are available in a family.

slightly more than the distance from the highest ascender to the lowest descender of the characters in the font. It must be emphasized that, although different type designs may have the same body size, the size of the faces will appear different due to the difference in the lengths of the ascenders and descenders.

To determine the type size of a printed sample, measure the

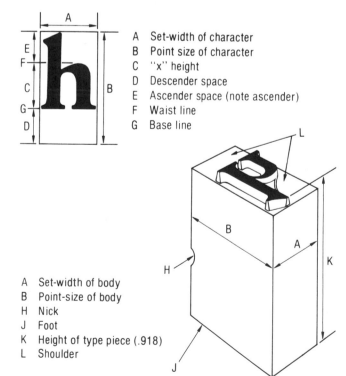

A Set-width of character
B Point size of character
C "x" height
D Descender space
E Ascender space (note ascender)
F Waist line
G Base line

A Set-width of body
B Point-size of body
H Nick
J Foot
K Height of type piece (.918)
L Shoulder

Type nomenclature. Left: terms related to the typeface; right: terms related to a piece of metal type.

depth in picas of twelve lines. If the material is set "solid," the measurement will be the point size of the type. If "leaded," the measurement (in picas) will be the point size plus the leading, such as "10 on 12" point, twelve lines of which will measure 10 picas.

Set Size or Set Width. All alphabets have characters of different widths; the letter "l," for example, is narrower than the letter "m." The type designer, or calligrapher, considers this when designing a new typeface so that any combination of letters in a word will appear to be consistently spaced. This characteristic is called the set-size or set-width of a typeface.

THE INVENTION OF LINECASTING

Many efforts were made in the nineteenth century to mechanize typesetting to meet the demands of the rapidly increasing volume of typesetting required daily by newspapers. These efforts had very little success as long as they attempted to accomplish mechanically the assembly of individual types.

Ottmar Mergenthaler set off the first revolution in typesetting by conceiving and bringing to fruition a completely new approach. His Linotype, which quickly evolved into a form basically similar to that still in limited use today, has a system in which *matrices* (individual character molds) rather than the type themselves are assembled a line at a time, after which the line of type is cast in lead and the matrices are recirculated.

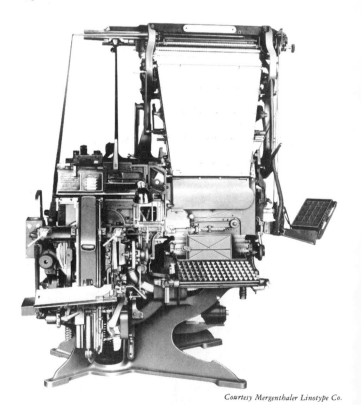

Courtesy Mergenthaler Linotype Co.

Keyboard-operated (manual) linecasting machine.

Fonts of matrices are stored separately in special containers called magazines. From one to eight magazines can be held on a machine at one time, depending on the machine model, and are

Courtesy Mergenthaler Linotype Co.

Matrices used for casting lines of metal type. Left: casting edge of a single-character mat; center: reference side; right: side view of a duplex (two-letter) mat showing point size and font number. The left edge shows the intaglio images.

easily removed when changing to a type font that is not on the machine. Extra magazines with additional fonts are stored in magazine racks and labeled according to face and size. A magazine is essentially a flat metal box with channels for each different character of the font. As many as twenty matrices of identical characters can be stored in each channel. The matrices are released from the bottom of the magazine by means of an escapement mechanism that releases only one matrix for each keystroke from the keyboard. Once the line has been cast, the matrices are redistributed into their proper channels.

The keyboard is unlike a typewriter keyboard in that it is composed of ninety keys arranged in three sections—lowercase on the left; figures, points, spaces in the center; and capital letters on the right. Through a series of cams and mechanical linkage, each key is connected to a magazine escapement. A touch by the operator's finger releases a matrix with instant response. A magazine has ninety channels, corresponding to the ninety keys

on the keyboard. A full magazine will hold twenty matrices in each channel; a three-quarter, sixteen; and a half, ten. Each mat has seven teeth on either side of the V-shaped top edge. The teeth correspond to matching grooves on a distributor bar. Mating of the teeth with the grooves releases each mat into its proper channel when the matrices are being distributed back into a magazine.

A reference also appears on each mat enabling the operator at a glance to distinguish each letter as it is being assembled. The mold side of a mat contains two characters, which are generally a roman and an italic or a light and a bold face. The two faces are in a vertical alignment on the side of the matrix, and the face to be cast is determined when the matrices are being assembled. In the assembly process, matrices are mechanically aligned on one of two horizontal levels, called rail positions. The lower rail would be roman, the upper rail would be italic or, with a different set of matrices, the lower rail could be light with the upper rail boldface.

When a key is depressed, a mat is released from the magazine and travels down a conveyor belt into an assembler, where mats

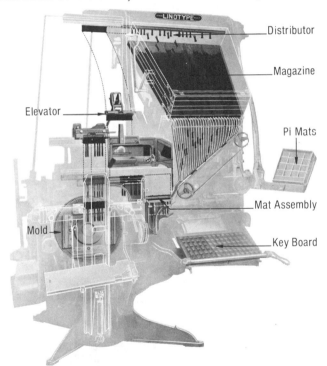

Courtesy Mergenthaler Linotype Co.

The recirculating matrix principle: an "X-ray" view showing the flow of mats in a linecasting machine.

and space bands are assembled into a complete line. The line is then transferred to the casting position, where a justification bar forces the wedge-shaped bands up, expanding and justifying the line between vise jaws that are set for the line measure and which hold the mats during casting.

Once a line is justified, molten metal is forced into a mold and against the mats, forming a slug of type. The bottom and sides are then automatically trimmed, and the slug is ejected into a galley.

While trimming and ejecting of the slug is taking place, the mats and space bands are mechanically separated by a series of

Courtesy Mergenthaler Linotype Co.

A complete line of Linotype mats (duplex mats in this case) and spacebands.

arms and elevators. A distributor elevator carries the used mats to a distributor box that transfers them, one at a time, to a series of distributor screws and distributor bar. The revolving distributor screws transport the mat across the distributor bar until a combination of the mat's teeth and the distributor bar teeth release the mat, dropping it into its respective channel for further use.

Most keyboard-driven linecasting machines are limited to a 30-pica line length. However, some machines have a 42-pica capability. Type sizes range from 4-point to 14-point for text composition. For special applications, these machines can set up to 60-point.

Linecasting machines can carry multiple magazines, as well as auxiliary magazines if equipped with auxiliary keyboards. However, such machines are made for specific applications. A machine with a single distributor and single magazine is generally used only for text composition. When equipped with multiple magazines and keyboards, it has the type-mixing capabilities required for advertising and complex typography.

Linecasting—Tape Operated. Tape-operated linecasting machines differ from manually operated machines in two ways: (1) mats of a tape-operated machine have predetermined unit value set-widths, matched to a tape perforator keyboard and (2) they are either keyboardless equipped with a tape reader or have a keyboard and a tape reader.

The prime feature of a tape-operated system is a paper tape perforating keyboard that counts characters and spaces, signalling when a justification range has been reached.

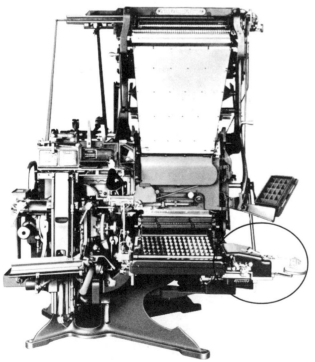

Courtesy Mergenthaler Linotype Co.

A tape-driven linecasting machine. The tape drive mechanism is circled; the machine can also be operated manually. Operating from the tape, machines of this type can set up to 15 newspaper lines per minute.

The six-level tape is read by the linecasting machine tape reader that mechanically activates the cams just as if an operator struck keys. The tape-driven machine is faster than a keyboard model. Manual speed of newspaper lines is eight lines per minute as compared to fifteen lines per minute on tape-operated machines.

Various input methods are available for tape-operated machines. The original TTS machine of Teletypesetter System was the first keyboard tape system developed for input to tape-operated machines for *local production* of news or commercial composition. The TTS system was also used for *wire transmission* of composed matter from one sending station to any number of distant cities to operate linecasting machines.

On a manually operated machine, the operator encodes the assembly of mats and space bands and determines line-ending hyphenation and justification range. Since there is no assembly of mats when keyboarding for tape-operated linecasters, a numerical width control must be used. The system uses eighteen units to the em.

Most keyboards are "blind"—do not produce a printed output. During operation, the operator, working on a typewriter keyboard configuration, watches a semicircular scale, having a series of pointers. The keyboard counts the unit value of each character, subtracts it from the total number of units in the line, and indicates to the operator when he is within justification range—that is, the range where there will be sufficient room for expansion of space bands. A prime function of the operator, while visually monitoring the justification scale, is to decide if a word, an additional syllable, or a better word division can fit on the line. This is a decision the operator must make. If the line is too loose and an additional word or syllable will not fit, he must erase the tape up to the last line, reperforate or rekeyboard the line and letterspace it to permit justification, or hyphenate the last word.

A multiface perforator has the ability to count non-unit width typefaces since such matrices can be divided into thirty-two units to the em. In this system, the narrowest character can be five units, or 5/32 of an em. Universal and multiface perforators utilize interchangeable counting magazines, which are simply hard-wired panels containing the unit-width information for various typefaces. Some perforators can carry four counting magazines for four duplexed typefaces.

The first typesetting system that used a numerical control for spacing and justification was not the tape-operated *linecasting* machine, but one that casts *single* characters, the Monotype.

TYPESETTING BY MONOTYPE

The Monotype System is the original tape-operated metal typesetting system. This system casts single characters one at a time and places them in a line, rather than a solid slug as produced on the previously described linecasting systems. Two machines are used in the Monotype system: a keyboard and a caster. The arrangement of keys on the keyboard is similar to that of a standard typewriter. The operator actuates it to produce a punched paper ribbon, thus encoding the copy. The encoded ribbon, which is about five inches wide, includes all necessary information to direct the caster in selecting and casting the proper character matrix and such spaces as are needed to produce justified lines of individual type characters.

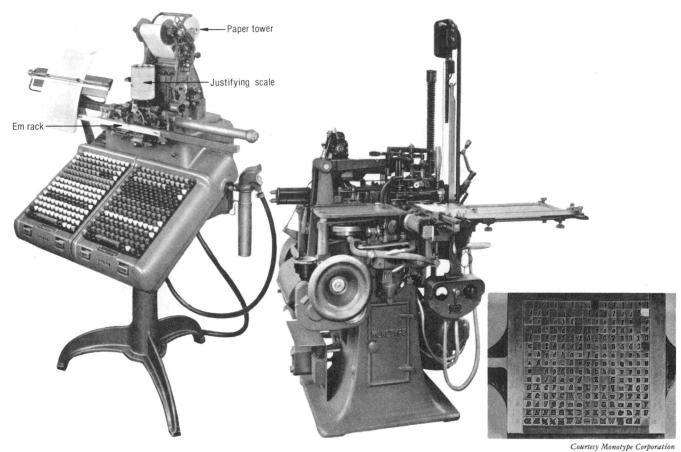

Courtesy Monotype Corporation

The Monotype keyboard. The Monotype caster. The Monotype mat case.

This system uses a single matrix for each character. These are stored in a matrix case and are not removed for casting as in a circulating-matrix system, but rather the matrix case is shifted and positioned above a mold for each character that is cast. The positioning of the matrix case is pneumatically controlled through the encoded holes on the perforated ribbon. This control of the caster is, in principle, similar to the much older Jacquard loom on which elaborately woven patterns were produced utilizing a punched paper master card.

CONVERSION FOR LITHOGRAPHY

With the rise of lithography and other printing methods having an image carrier produced by photomechanical means, metal type composition had to be converted into two-dimensional type images suitable for photomechanical use.

Several conversion procedures were developed. One was direct photography of the letterpress form. Another was a mechanical/chemical method employing a translucent conversion film with pressure-sensitive cellular coatings. The film was placed in contact with the relief image surface and pressure was applied by a large number of tiny metal balls vibrating against the back of the film. This action collapsed the coating cells in the areas of the typefaces. A dye applied to the film darkened it except in the collapsed-cell type areas, which were transparent. These conversion procedures are now obsolete.

Reproduction Proofing. A procedure that was common and that is still occasionally used—although conversion from metal composition by any method has become quite rare—is a carefully printed *reproduction proof* ("repro") of the type.

Quality in proofing requires standards of press settings, ink,

Type form locked on bed of repro proof press. Note horizontal tint bars and vertical bearer bars.

paper, bearers, use of a tint bar, etc. Only stiff inks that dry readily should be used for reproduction proofing. To accept ink properly, the printing face must be free of dirt and oil. Just before proofing, the form should be wiped with an oil-free solvent applied with a lintless cloth or clean type brush. The press rollers must be smooth and true and not too hard. The inking system, as well as the ink, must be free of lint, dust, dried ink particles, and other foreign matter.

The cylinder packing should be as hard as practical. The harder the packing, the less embossing, and the sharper the print. This requires great care in the leveling of the form, as well as good type and plates. It is desirable to use bearers on each side of the form, running in the direction of cylinder travel. This will minimize the wiping action of rollers over the face of the form. These type-high bars also help bear-off excessive roller pressure.

Reproduction proofs can be made on opaque, translucent, or transparent material. The opaque material is generally a stock made especially for letterpress proofing. A high-gloss cast-coated stock also may be used.

The importance of judging the proof under magnification cannot be overemphasized. Weak areas in the ink that appear black or solid to the unaided eye may be penetrated by the camera lights and ultimately result in ragged or broken letters.

DIRECT SETTING OF TYPE IMAGES

The makeshift nature of metal type conversion emphasized the desirability of typesetting systems that produced two-dimensional type images directly. Some of these already existed in forms that had been developed for other purposes. The typewriter, invented in 1868 for correspondence, was modified in special ways to make it more acceptable as a typesetter for printing. Such typewriter-like typesetting is called *strike-on*.

Strike-On. Strike-on typesetting systems generally require retyping to perform justification of lines. In the Varityper

system, the operator sets the carriage for a particular line length. He or she types the line until the internal counting mechanism signals that a line is within justification range. The operator tabs over and retypes the line at this time. The variable word space mechanism automatically adds space or subtracts space from between words to permit justification.

The IBM Selectric composer operates in a similar manner, that is, retyping each line. Both IBM and the Varityper have interchangeable fonts. The IBM has a golf ball–shaped carrier for various fonts while the Varityper has a disk-shaped font.

All strike-on typesetting devices utilize a nonreusable carbon ribbon to produce a sharp black image onto a reproduction grade paper. Paper output is generally mounted on mechanicals with art or other type elements. This system can also be used on paper plates, enabling direct platemaking.

Faster models of strike-on composition machines include the IBM magnetic tape units and the Friden Justowriter system. When the initial typing is done on the IBM unit, a magnetic tape is recorded, containing all line endings and hyphenation decisions. The magnetic tape is replayed through the reproducer unit, which automatically retypes and justifies each line at a high rate of speed.

The Justowriter system utilizes paper tape and two typing units. The recorder generates a perforated paper tape with line endings in justification range and a hard-copy printout. The paper tape is then inserted into a reproducing unit that contains two readers. The tape is read and strike-on type produced automatically in a justified form on a reproduction grade paper—again, using a onetime carbon ribbon for optimum reproduction.

In time, typewriters used for correspondence became more complex and began to be called *word processors*. Developments in this area produced equipment such that stored data from the keyboard can be input either to a typewriter or to a phototypesetter. (See the following segment, "Phototypesetting.")

Although of limited usefulness in the printing industry, various other methods for laying down letterforms for photome-

A strike-on typesetting system. In this particular configuration, the typewriter is driven from a magnetic-card reader. The reading unit is at the left.

Setting a line with dry-transfer type.

chanical reproduction are used, especially in the preparation of artwork: hand lettering, photolettering, and preprinted art type.

Hand Lettering. In hand lettering, the artist utilizes pens to produce type characters for reproduction. Commercially available stencils can also be used in hand lettering to produce either outlined letters or outlines filled in with pen or brush.

Photolettering. Photolettering is done by assembling individual characters of the alphabet in the form of film positives on a copyboard, carefully spacing them out, and photographing the assemblage. The film characters are redistributed into file boxes for future use. Skilled lettering artists, working on the photo print, then firm up the connectors on scripts, modify special characters, or rearrange them to fit the layout. Photolettering companies carry extensive libraries of unique and distinctive alphabets in many weights and configurations.

Preprinted Art Type. Preprinted art type is commercially available in several forms. Each sheet of preprinted art type contains a complete alphabet with capital and lowercase letters as well as figures and punctuation marks. This is an ideal method for setting a limited amount of display type and an inexpensive method for quick, rapid typesetting. However, small sizes of this

Assembling a line with cut-out acetate type.

material would prove extremely tedious and time-consuming. One form is the *dry transfer* sheet. Here, a character on a preprinted sheet is placed in position and burnished onto the mechanical. The succeeding letters are positioned in proper order until a completed word or line is set.

Cut-out acetate type consists of a preprinted sheet with an adhesive base under the characters. The characters are cut apart and positioned on a mechanical.

Another form of art type consists of characters printed on strips of paper. Each character is selected by hand and placed into a long wooden composing stick. After the type is set, a strip of tape is applied across the characters to hold them together, enabling them to be transferred onto the mechanical.

But even for the preparation of artwork, phototypesetting is now widely used, superseding other methods as it has in other areas.

PHOTOTYPESETTING

The hand-setting of individual types and the machine-casting of individual characters and of lines of type are all still performed to a small extent. But *phototypesetting*, the second thoroughgoing revolution in typesetting methods, has become so predominant as to have practically superseded all previous methods for most purposes.

A unit for photo-display typesetting.

Phototypesetting systems have undergone three major evolutionary changes from the development of the first phototypesetting device patterned after metal typesetting machines, to the present electronic cathode ray tube system. These are classified as first-, second-, or third-generation devices according to the extent of mechanical and electronic sophistication utilized in the system.

First-Generation Phototypesetters. The first phototypesetting machines, generally referred to as first-generation phototypesetting devices, evolved from two of the metal typesetting machines and one impact typesetting device. The Intertype Fotosetter, first marketed in 1950, incorporated the same mechanical features of the recirculating matrix system as the Intertype metal linecasting machine (a machine basically similar to the Linotype). One difference is that the Fotosetter matrix, called the Fotomat, contains a single photographic image in the center of the metal matrix rather than a duplex die image on its back edge. Once a line of Fotomats and word spaces are assembled, each Fotomat is positioned, one at a time between a lens and a light source to expose the type character onto film or

Courtesy Harris Corporation

A recirculating-matrix phototypesetting machine (the Fotosetter).

Courtesy Monotype Corporation

The Monophoto typesetter.

paper. The amount of space each character occupies in a line is determined by the width of the brass Fotomat which, by means of a rack and pinion, moves the film cassette the required distance. This is known as the letter escapement. Justification is automatic, but instead of spacebands there are fixed spaces used between words. Prior to exposure, the camera measures the entire line length including the fixed spaces, and the deficit needed for justification is automatically distributed between words and, in earlier models, between letters.

The Fotosetter magazines contain 117 channels; a double distributor permits mixing 228 characters. In addition, a manually operated revolving lens turret with fourteen different lenses makes possible reproduction sizes from 3 to 72 points, from matrices of 6, 8, 12, and 18 points.

The Monophoto Typesetter was developed to set type photographically rather than by "hot metal" as produced on the

Courtesy Harris Corporation

Matrix for the Fotosetter: the Fotomat.

Monotype caster. A similar Monotype keyboard for punching the paper ribbon is used. Justification is much the same as with metal, and manual adjustment of a single lens reproduces different image sizes. In place of the matrix case with metal matrices, the matrix case is a film assembly of the font.

The Justowriter impact typesetting machine, a typewriter-like device, was forerunner of a first-generation phototypesetting device, the *ATF Typesetter*. This phototypesetter is tape-operated and similar to the Justowriter except that instead of strike-on characters, it utilizes a revolving disk containing 168 letter images. The images on the disk are flashed on a photographic film or paper that is carried in a cassette. Escapement, or space required for each image, is determined by a gear mechanism that moves the carriage containing the cassette; the disk does not escape. Size changes can only be accomplished by changing the font disk. For each new font disk, a carriage gear ratio must be changed manually for the new "unit" of width.

Second-Generation Phototypesetters. Second generation is the classification for the earliest systems that were designed specifically for setting type photographically; they were not adaptations of earlier typesetting systems.

Second-generation phototypesetters can be operated directly from a keyboard in which both the keyboard and the photocomposition device are one unit, or from an encoded paper or magnetic tape prepared on a separate keyboard. Prior to keyboarding a manuscript, format data such as typeface, point size, set width, line length, and leading between lines must be

Courtesy Compugraphic Corporation

A direct-input phototypesetter (the Compuwriter).

Courtesy Mergenthaler Linotype Co.

A tape-driven phototypesetter.

entered into the keyboard mechanism. This is done by function switches or operator key commands. Once completed, the operator can then proceed to set the type. A line counter accumulates the width value of each character and space, and when a justification range is reached, the operator makes an end-of-line decision that may come at the end of a complete word or, if necessary to fill the line, at a discretionary hyphenation. Each line that is set is held in a buffer until an end-of-line decision is made, then it is released for automatic justification on tape or directly into the phototypesetting machine. On some phototypesetting machines, the character width value or escapement is carried on the tape, but others require prewired plug boards that are inserted into the phototypesetter for each font used.

Computerized Typesetting. Since perforated tape used for driving typesetting devices is encoded in digitized form,

computerized typesetting devices were practical to develop. These devices were made primarily to relieve the keyboard operator of end-of-line decisions, thus increasing machine output. Early models had a controller that contained a hard-wired logic to perform hyphenless justification or, in more sophisticated models, hyphenation and justification. Hyphenation in these systems was performed by pure logic only; dictionary and exceptions-to-the-rule hyphenation was not possible.

An input tape—sometimes referred to as "idiot tape"—was prepared with an encoding scheme that preceded the encoded manuscript. This tape, paper or magnetic, was placed into the controller that produced a second tape containing hyphenation and justification codes. This revised tape was then used to drive the phototypesetter.

In cases where hyphenation was not done logically by the controller, an operator would insert special hyphen codes between syllables in large words that might appear at the end of a line. If hyphenation was possible, the controller would select one of the hyphen codes for the end of the line. All other hyphen codes that were not used were automatically rejected.

The next development was the use of a stored-program computer. A format program (written specifications of typesetting requirements in a language acceptable to the computer) sets up the basic criteria from which the computer can arrange or compose the input data. The data is preceded by an encoded format code such as /F1. This code, when translated in the stored program codes, compiles and executes magnetic tape output that is hyphenated, justified, and paginated.

Hyphenation by computer is done by *logic* and by an *exception dictionary*. (An exception dictionary is a list available to the computer of all words not logically hyphenated.) A line is set until a word oversets the line. The overset word is passed through a hyphenation routine that first checks to see if the word is in the exception dictionary. Failing to find the word in the exception dictionary, the computer then subjects the word to a routine of hyphenation logic. The first breakdown is by prefix and suffix; then the root of the word is broken down according to logic criteria.

Once the hyphenation point is determined, the portion of the word that is to be retained is sent back to the line with a hyphen ending, and justification begins. The total number of spaces has been counted, and the additional space required to justify is equally divided among all the total word spaces. The original space between words is the minimum space allowable—approximately one-third of an "M." If the "M" is divided into 18 units, such as in Monotype composition, the minimum word space allowed would be six units.

The computer has since been replaced with a minicomputer that is combined with a phototypesetter. This permits hyphenation, justification, and other newer capabilities such as pagination on the single system. Or an off-line minicomputer—commonly called a host computer—can also be used for hyphenation and justification. A second minicomputer is still used on the phototypesetter as a control logic.

With this latter system, an unjustified and unhyphenated tape, or typed document that is scanned on an OCR (optical character recognition) device, can be put into the mini host computer that has several capabilities. It will character-translate, hyphenate, justify, and then send the information into the phototypesetter. The advantages of this system are the ease of operation and the

The more common font configurations used in second-generation phototypesetters. Left: a drum; upper center: a glass matrix; lower center: a film strip; right: a disk.

Courtesy Graphic Systems Inc.

Stored-program minicomputer for hyphenation and justification.

versatility of the computer. Computers have an I-O (input-output) buffer in the computer memory. All lines are read into the machine and stored in memory, from which there are many capabilities such as translation, hyphenation, justification, pagination, or deciphering by scanning the information for control codes and converting them into format statements that were previously stored.

Second-generation machines may use a grid, spinning disk, or drum to carry negative image matrices that are projected onto photographic film or paper. If a grid is used, the entire grid is illuminated and the desired character is selected by a series of optical wedges that allows only the character image to pass through a series of prisms, enlarging lenses, and mirrors until it is finally positioned and exposed on the photographic film or paper.

A stroboscopic light illuminates the negative images carried on spinning disks or drums. Photocomposing machines that use a spinning disk or spinning drum generate characters at a greater speed, since they do not depend upon the mechanical movement of optical wedges. Instead, as each encoded character is spun into position in front of an aperture or shield, a stroboscopic light illuminates and projects it on through the optic system to the film or paper.

Horizontal position of each character image is controlled by a traveling lens that escapes the required character width or by a moving carriage that holds the film or paper cassette. The film advance mechanism determines the vertical spacing between each line.

When phototypesetting is completed, the film cassette is removed and the film or paper is passed through a processor that develops and fixes the photographic images.

Third-Generation Phototypesetting. Computerized photocomposition systems that utilize a cathode ray tube as part of an image-forming system are termed third-generation photo-

The cathode ray tube photographic systems. Upper: standard lens system; lower: fiber optics system.

typesetting devices. These machines are pure electronic devices. The characters are created through the stroking of an electron beam on the face of a cathode ray tube.

Some machines have stored negative character images similar to second-generation machines. But, instead of strobe lights for illumination, light from an index or blank CRT passes through the matrix to photomultipliers or photoelectric cells, where they are converted to a digital format for stroking on a CRT tube. The strokes on the CRT tube are in vertical patterns, formed by a series of signals.

Each series of signals corresponds to a vertical scan of a narrow portion of the character. As the scan is made, on-off signals indicate the presence or absence of character portions within the vertical scan. For instance, a narrow vertical scan through the center of a capital "B" would have six on-off signals. These signals are then transmitted electronically to the face of a CRT. The speed of the scans and the generated signals that appear on the cathode ray tube is so rapid that the image appears

as a whole character rather than just vertical signals. The image is picked up from the tube by a traveling lens that projects it onto the film or paper.

Most CRT photocomposition machines use image patterns that are in a digital format and stored on either a magnetic tape or disk. When the first character of a font is called for, the entire font is brought over into the machine's electronic memory. Digitization of characters in a binary format is the recording of the starting and stopping points of each vertical stroke of an image. Other systems use a matrix of tiny dots for image formation. Many digitized fonts can be stored to be accessed on command at a very high rate of speed.

There are two systems for creating the image on photographic film or paper using a CRT. In the first system a line or character is generated on the face of the CRT and goes through a lens system—stationary lens or moving mirror—to the film. The second system uses fiber optics instead of a lens in which one end of the fiber optics is permanently fused against the face of the CRT and the other end is in intimate contact with the film. The systems that use a lens or moving mirror have a 5-in. CRT with a 2:1 ratio. This means that a 5-point image that is created on the face of the tube is blown up to 10-point on the film or paper. The systems using fiber optics have a 10-in. CRT and produce at a ratio of 1:1.

Speed of CRT machines varies from as much as 250 characters per second to 3,000 characters per second, depending upon point size, graphic arts quality of the images, and scan line density. Compared to a second-generation machine, which has a speed of from twenty to sixty lines per minute, CRT is much faster in terms of characters or lines produced. However, the CRT phototypesetting machine acts as a computer slave and must be driven by a computer-generated tape. Raw data is hyphenated, justified, and paginated on the host computer and encoded for proper operation on the CRT device.

Phototypesetting Systems. The cathode ray tube was also put to use in another device: the video display terminal. Such a device, with its keyboard and TV-like screen, permits typo-

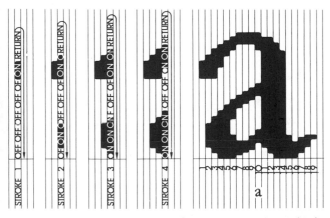

The generation of a character (Garamond) on the cathode ray tube. The character generates from left to right on a common baseline. The completely generated character appears exactly as shown at the right. The small "a" (14 pt.) is a direct photographic reduction of the image on the tube; the raggedness is not apparent, but can be seen readily under a magnifying glass.

Courtesy Harris Corporation

The Harris 1420 phototypesetting keyboard and video display terminal.

graphic material to be input (by keyboard or from a storage medium), displayed, and manipulated by deletion, insertion, and rearrangement; specifications of type size and style as well as line length and spacing to be applied; perhaps a hyphenation-and-justification routine to be performed; and the modified material to be output to a phototypesetter or other device. The VDT input/editor became an integral part of phototypesetting systems.

The equipment system that prepares input for the phototypesetter is sometimes called the "front end." The term "direct input" was originally applied to a system that combined the input keyboard and the phototypesetter in the same piece of equipment; the keyboarding and typesetting commonly operated simultaneously. Later the "direct input" term was extended to any small setup in which the same person keyboarded and operated the typesetter; but the keyboard would commonly record on a small, flexible disk ("floppy disk") for later rather than simultaneous typesetting; and there might be an additional input/editor keyboard without typesetter. This began to be called a "small integrated system" in contrast to the "large integrated system" consisting of several independent VDT keyboards all feeding the typesetting operation. It was to the VDT keyboards of the large integrated system that the term "front end" was most usually applied.

Section Three: Editing, Markup, and Typesetting Operations

The typesetter traditionally works from a manuscript, or "copy," usually typewritten. The manuscript as prepared by the author(s) normally undergoes two finishing operations before it reaches the typesetter: editing and design. Editing is concerned with the *content* of the written material; design is concerned with its *format* and *typographical style*. Both of these functions leave their mark on the manuscript in the form of handwritten codes.

Editing. In its largest sense, editing deals with the planning and development of written material in cooperation with its author(s), as well as correction; and much of this editorial function may be performed before a complete typescript is submitted. We are not concerned here with that stage of the editorial process—only the correction of typing and other errors and the marking of head and subhead levels for the information of the designer who does the markup.

A typescript is not a satisfactory manuscript for typesetting if it has many corrections—particularly if there are crowded-in or illegible insertions. The changes should be indicated with standard copyediting marks. The level of each head, if there are divisions and subdivisions of material, should be identified by writing a letter or number beside each head with a colored pencil, using a code agreed upon by the copy editor and markup designer.

Markup. The design function with respect to type matter is to determine the format, typefaces, type sizes, spacing, and other typographic specifications. Marking these specifications on the typesetter's copy is called *markup*.

With metal typesetting, a straightforward and fairly standard procedure of markup evolved. The markup person used standard symbols to convey formatting information and agreed-upon abbreviations to indicate typeface, size, line spacing, and other typographical specifications—for text, for each level of head, etc. The typesetter (for example, the linecaster operator) knew how to translate these marks into machine operations (for example, change to upper rail and later back to lower rail). And some of the formatting was done on the makeup table.

With the advent of phototypesetting, the same procedure at first continued. But as the systems evolved, provided new capabilities and flexibility, and as techniques such as command coding developed, new complexities were brought to the markup function.

Two general practices resulted, with a variety of gradations between them, depending on the nature of the equipment and the capabilities of personnel involved. One practice is to use traditional markup, relying on the operator to translate this information into appropriate machine instructions. The other extreme is to have markup specialists who completely code the copy before it goes to the typesetter.

Typesetting. The phototypesetting keyboard, like the typewriter keyboard, has two kinds of keys: those for the characters, often called the alphanumeric keys, and those for machine functions. The layout of the alphanumeric keys is nearly the same on the phototypesetting keyboard as on the standard typewriter keyboard, with a few important differences. On most typewriters, the lowercase "l" is used also to represent the figure "1"; in printing these two characters are different and therefore must have different keys. Typewriter beginning and ending quote marks are the same, the single being on one key and the double on another; in printing the beginning and ending quote marks are different and thus on different keys, while single or double is determined by the number of strokes. There are other differences, but the arrangement of letters is identical.

CRTronic phototypesetting systems apply digitized fonts.

DF-3 PRINT ELEMENT

The DF-3 print element is a

unique OCR font concept. This

element has a 'parity' bit

incorporated in the bar code

that appears below the regular

alpha-numeric characters.

The OCR bar code.

Courtesy CompuScan Incorporated

An alphanumeric OCR reader (CompuScan model Alpha).

Function keys are another matter. In addition to the space bar, shift, and return of the typewriter keyboard, the phototypesetter keyboard typically has a super shift to access "pi" characters, keys for en and em spaces, and such formatting keys as "quad left," "quad right," and "quad center." Instead of the typewriter's back space key, it has a whole series of editing keys, such as those controlling the movement of the video display cursor (which marks the spot where action occurs), those for character and word cancel, etc.

Although alphanumeric matter may be input without typographic specifications, the keyboard typically has provision for these: font selection, point size, line length, and line space. Advanced systems have additional capabilities, especially in formatting, up to pagination.

Thus function keys vary considerably on different equipment systems. At one time keys proliferated on keyboards because of the inclination to provide a separate key for each new command. But the use of precedence codes—special keys followed by certain combinations of character keys activating the computer to perform certain functions—and other techniques have

brought down the keyboards to a convenient size. These developments have also brought about the variety of special markup procedures previously mentioned.

An alternative method to inputting with a phototypesetting keyboard is to put typewritten material into an optical character recognition (OCR) device. This method is based on the concept of reading by a scanner and recording the typewritten material on a magnetic carrier device in a form recognizable by a typesetting machine. The basic input device is a standard typewriter equipped with a typeface recognizable by an OCR device, and the OCR device itself. Input can be created by the typographer or by the originator (publisher, author, agency). It provides greater flexibility since the typewriter is a low-cost device, and the work can be done by a typist.

There are two basic types of OCR units, the alphanumeric reader and the bar code reader. The alphanumeric reader reads and identifies common uppercase and lowercase alphabetic characters and numbers of a specific font. The bar code reader employs a special font element. This font prints both an alphanumeric character and a bar code associated with that character below it. The typist can read and identify the alphanumeric characters, and the machine reads the bar codes appearing beneath each character.

Section Four: Proofreading and Correction

A system of error detection must be used to make certain that galley proofs and page proofs are correct. This system is called proofreading. Usually, galley proofs are read by a proofreader or by two individuals, one called the copyholder, the other a reader. Original copy must be compared word for word to assure correctness. Each proof is marked with proofreader's marks, which indicate the nature of the error. Proofreader's marks are standard and used by experienced authors and typesetters.

Errors in metal composition are usually erroneous characters or transposition of characters during assembly of a line of mats, transpositions of lines when delivered to the galley, or wrong font characters running in the magazine.

In phototypesetting, additional errors can occur as a result of incorrect keyboarding. Incorrect formatting instructions and other miskeyed instructions are possibilities. A piece of dirt on a tape can cause an incorrect function sequence or character to be printed out on the film or paper. Error rates for electromechanical and computer-driven phototypesetting machines are practically nil, but, when they occur, they should be detected during the initial proofreading of line printer printouts or of the galley proofs.

A system of quality control of copy input in any typesetting system must be utilized to insure a rapid and accurate method of transferring material into type for further reproduction. This is of

prime importance in phototypesetting since corrections are even more costly than they were in metal typesetting systems. A style guide should be available to enable customers to submit copy to which all operators are accustomed. This will limit operator decisions and second guesses to a minimum, as well as reduce errors. The style guide should explain and list correct applications of the principles of typography, typesetting, and printing.

Control of photographic image quality, the essence of phototypesetting, is usually a function of the processor. His trained eye can determine sharpness or density of the photographic character, but in some cases, visual judgment cannot effectively tell a dark, sharp character from a slightly lighter character. A slight change in developer activity can alter the sharpness and density of characters. All this is effectively monitored if proper photographic processing control strips are used. A routine maintenance schedule must be maintained to keep readers, filmstrips, and lenses clean and free of dust and fingerprints. This will ensure a uniform exposure of each character and a uniform development that can be duplicated from job to job, especially when setting corrections.

Proofreading Procedures. Proofreading is normally carried out in four basic stages: (1) the first reading is to detect mechanical and human errors in the typesetting operation. The first galley proof is read to accomplish this. (2) A proofreading of the revised galley is performed to determine that the corrections have been properly made and their position is in correct sequence. (3) A second revised proof may take more than one reading to achieve complete accuracy. If the second phase results in completely correct galleys, the third proofreading phase is eliminated. (4) Composed or made-up pages are proofed for completeness of text including head placement, lines in proper

Courtesy AM International Inc.

Comp/Edit 6400 direct-input digital phototypesetter. This equipment may be used as a stand-alone phototypesetter or as the output CRT typesetter of a multiterminal system. It can use any combination of up to sixteen type styles on-line in 163 type sizes from 4 to 85 points. Type can be electronically expanded or condensed through a variety of set sizes independently of point sizes, and can be slanted to the right or left in 1° steps. The typesetter has a speed of 150 newspaper lines per minute.

sequence and correctly spaced, pages in proper sequence, and finally checked to see if all corrections have been made and all special instructions carried out.

Galley proofs are proofs of type before it is made into pages. The name derives from the proofs made from metal type that have just been set with no vertical spacing added. In photocomposition, the proof is a copy of the phototypesetter output.

Computer printouts are proofs of computerized typesetting that has not been processed through the phototypesetter. This information is output in nonjustified form, enabling proofing for keyboarding errors before the actual typesetting begins. Each line printed on the printout is numbered, permitting corrections or additions to be addressed or corrected internally in the central processing unit before typesetting or image generation begins. However, there is still the possibility, although slight, of a machine error by the phototypesetting machine.

Press sheets should not be checked for accuracy of typesetting, but should be checked for proper page locations, photo placement, and print quality. Making corrections at this stage is tantamount to redoing the job in its entirety.

Correction. The correction cycle can be more time-consuming and costly than the initial typesetting. In a non-computer-assisted phototypesetting system, corrections must be keyboarded into a machine-readable form, processed through the phototypesetting system, then developed. Corrections must be cut apart and either pasted over incorrect lines or, preferably, cut into the original output, causing difficulty in further proofing and handling. In addition to the awkwardness of inserting corrections, and high cost, the likelihood that the reset type may not perfectly match the original is quite high. Rigid control of processing procedures will minimize this.

In a computer-assisted system, each line is numbered and stored in the central processing unit's memory. Once the material is proofread, incorrect lines are noted and rekeyboarded, and the computer is instructed to find a certain line in its memory and manipulate the line from the keyboarded corrections. The computer generates a clean corrected version, which is reprocessed through the phototypesetting machine, ultimately outputting error-free copy. While this assures an even-appearing galley and is quite fast, whatever time is spent on corrections is very costly.

Video Display Terminals. Once the original source data has been converted into a machine-readable format it is entered into the phototypesetting device in either of two fashions: on a carrier device (magnetic tape or disk) or directly (on-line) to the phototypesetter. The data is then composed and set, producing film or paper output. Now the typeset data is proofread and there are errors. How do we correct the errors? There are a number of options. These are: (1) Reset the errored lines or paragraphs and manually strip these into the copy. (2) Using a computer, merge the corrections into the original tape, if it is on an intermediary carrier, by reference numbers (usually line numbers) and reset entire galley. (3) Proofread, from a computer printout, all information before it is typeset, and merge corrections using the computer. (4) Correct the data type using a video display terminal (VDT).

The typographic industry deals with data, which must be accessed, corrected, deleted, added to, or moved around. The terminal provides a visual window into this data. It is possible to see what you are doing. Deletions and additions are made more accurately because you are viewing the data on a VDT (TV tube) device.

The operator controls the data on the screen through keyboard controls. The keyboard consists of a standard typewriter keyboard, cursor movement and scroll controls, buttons for insertion, deletion, text area identification, and memory storage to control basic terminal action.

Input into the terminal for correction can be magnetic tape or disk. The data is read into the terminal and starts appearing on the screen. Once this happens, data will continue to be read until the memory buffer is filled. In general, the total amount of data in the device—including screen and buffer—is equal to approximately 75% of total buffer capacity. This allows room for additional data editing.

Working with the Data. All data on the screen is controlled by means of the cursor. The cursor can appear as a small line under a given character or a block of light over the character, or can cause the character selected to blink on and off on the screen. Whichever one is present on the tube, it is the cursor that controls the point at which work is to be done. The keyboard has controls for positioning the cursor in any horizontal or vertical position. A button is provided for scrolling the data. Remembering that only a portion (window) of the available data is shown on the tube, scrolling, or advancing the screen data one line at a time, will provide access to all data in the buffer area. Most terminals allow scrolling in both forward and backward directions.

Deletions are accomplished by various methods on different machines. Some devices have a delete character key used in this way: the cursor is positioned at the start of the deletion and the delete key is held down, deleting one character at a time until the deletion is completed. Some VDTs have additional keys for sentence and paragraph deletions. The cursor is placed anywhere within the element to be deleted (sentence or paragraph) and the corresponding key is pressed to complete the deleting action. Insertions are made by positioning the cursor at the point where the data is to be added, and pressing the insert button. The characters to be added are typed in, with the other correct characters being moved over. Once this is finished the insert key, or end insert key, is depressed to complete the operation. Replacements are made by either using a replace key, if the terminal has one, or successive deletion and addition routines.

Blocks of texts, not necessarily definable as a paragraph or sentence, may also be deleted or moved. This is accomplished by the block definition keys, where pressing the start block key initiates the beginning of the block, and the end block key ends it. Once the block has been defined, it can be moved or deleted through move or delete keys and cursor control. This allows a great deal of expanded capability during the editing and correction cycles.

Hyphenation and Justification. Many terminals provide hyphenation and justification routines. There are three ways of handling the h & j function, depending on the system. The first method is a two-pass system. All editing and correction is done first, and a new corrected carrier created. This is then run through the terminal again, using a different h & j program, and

a new h & j tape is created for input into the phototypesetter. The second method is to edit data as before, and when it is to be output from the buffer, it passes through the h & j program first, and the output data is in the h & j format, ready for the phototypesetter. The third method is to have the h & j programs in the terminal's internal computer. This system allows the operator to read a group of text into the buffer, edit and correct the text, and then call for h & j. The terminal will perform the hyphenation and justification of all text within the buffer area, and display the text on the tube for operator analysis. The operator can change hyphenation points in words, change line lengths, etc., then rehyphenate and justify by these new rules. This process can be repeated as many times as necessary to obtain the desired results. This type of interactive h & j on a video screen allows the typesetter exact control over the finished product.

The optimum use of both the terminals and manpower is in the text correction function, not proofreading or input. The purpose of input is to convert data into a coded form; seeing it on the tube will slow input down. The purpose of proofreading should be to read the data and mark errors. The terminal will provide the capability to make changes quickly and efficiently.

Art Preparation

Section Five: Art and Copy Preparation

Producing a printed piece involves a series of reproduction operations so interdependent and so often overlapping that the final operations of binding, finishing, and delivery to the customer can only be successful to the extent that the beginning operations of design and art and copy preparation are planned with those final processes in mind.

The production route a typical lithographic printing job must take to guarantee proper reproduction begins with the prepress functions of writing and editing (this implies that the idea has already been properly conceptualized and researched), designing, typesetting, adequate and proper proofreading, art and copy paste-up, graphic arts photography, film image assembly, prepress proofing, and platemaking. Of course planning, scheduling, and estimating job costs and the amount of time needed to complete each and all operation(s) must not be overlooked, and must occur before a job can begin its route through the stages of production. Following platemaking, the production flow continues into the actual presswork and then to the binding and finishing operations. Besides the conventional binding—folding, gathering, collating, inserting, tipping-in, etc.—varnishing, laminating, die-cutting, embossing, bronzing, scoring, and gluing may be performed. When all the required finishing operations are completed the "production" is completed. However, the job is not successful until it has been delivered to the correct customer, in the correct quantity, correctly packaged, and shipped *on time*. Although proper delivery to the customer is the last function to be performed, it is one of the first to be specified.

Including and not bypassing any of the operations in this production route does not "guarantee" that the printed piece will not encounter problems as it moves from one operation to another. However, if the people involved follow a prescribed operating procedure and communicate among all stages of reproduction on the job's status, there will be little chance for uncorrectable error.

In reality, smooth, well-established standard operating procedures and perfect communications are usually not the case. A communications gap between designers and artists and printing technologists can cause misunderstanding and misinterpretation of procedures. If designers or paste-up artists are unaware of the production problems and technical limitations faced in reproduction, and printing technologists—graphic arts photographers, film assemblers, platemakers, press operators, and binders and finishers—do not understand the means and techniques that artists must employ to achieve desired aesthetic effects, then high production costs and high tempers due to excessive and unnecessary steps in camera and stripping will result. The following twelve sections will help the graphic designer or artist to prepare art in a way that simplifies reproduction through communication and a knowledge of the "best" procedures for getting the results required without sacrificing the design.

Art and copy preparation means transforming the writer's and designer's concepts into a suitable form for reproduction. The artist may be called a *copy preparation artist, a mechanical artist,* or *paste-up artist.* The copy preparation may be done by the customer, the printer, an art studio, or an outside prepress trade shop. Often, all these may be involved in a facet of the art and copy preparation in which a special competency exists. The fact that this happens so often, coupled with the enormity and high volume of the graphic communications industry, makes good communications based on technical knowledge so essential.

The *graphic designer* or *creative artist* may originate the overall design of the printed piece or may design as well as paste up the camera-ready copy. As an art specialist—retoucher, calligrapher, illustrator, etc.—he or she may execute only certain elements of the design.

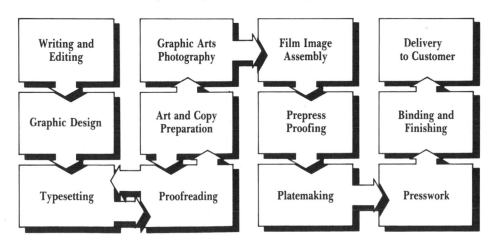

Producing a printed piece.

The *paste-up* or *mechanical artist* assembles all the elements of the piece—type, illustrations, etc.—by following an original design or layout, pasting the elements on the board or acetate that serves as the base sheet for the artwork. It is the paste-up artist's completed camera-ready copy that is photographed to make the negatives then printing plates.

It is the artist's responsibility to plan his or her work with the goal of minimizing extra production steps in the photomechanical and film assembly operations that follow copy preparation. The artist must even anticipate printing, finishing, and binding problems that may have been overlooked by the original designer.

The systems approach to production used in many plants divides the plant into cost centers with the lowest cost center performing operations in a manner that minimizes handling and production steps in the more expensive cost centers. In most printing plants, the copy preparation area represents a low cost center. It usually costs less to perform handwork on the drawing board than it does to require camera, film assembly, or platemaking departments to perform extra operations or correct and alter art that was inadvertently submitted as "camera-ready" copy. Camera, stripping, and platemaking operations usually represent a higher cost center. Presswork and finishing operations are usually the highest production cost centers because of their space, materials, machinery, and labor costs. An understanding of each production operation is necessary if copy is to be prepared for efficient production by the graphic designer or artist.

Section Six: Planning—Know Your Limitations

No other step in the graphics reproduction process is so neglected yet so essential as is planning. A successfully printed high-quality piece demands thorough job planning, and planning demands that the constraints of budget, time, and the reproduction process be evaluated before the job is begun. This cannot be stressed too heavily to the graphic designer, artist, or art director, for they are the ones often responsible for organizing the job, and it is during the conception and design stages that the specifications of the job are detailed for each step through the delivery of the printed piece.

Because too few people take the time to properly understand each stage of production as well as the attitudes, requirements, and customs of the segment of the industry they are working in, printed jobs are often poorly scheduled, incorrectly prepared, and subject to many last-minute corrections. That the same number of printed jobs are not unsuccessfully or poorly produced is a credit to the skill and ingenuity of the employees of the graphic communications industry.

A PLANNING CHECKLIST

Once the need for the printed piece has been recognized, it is important to discover and discuss the limiting aspects of the piece. Ideally this should be done in consultation with the key people who will work on the piece. They may include the client (a must), writer, typesetter, designer, production coordinator, account executive, art director, production manager, scheduler, and printer—in short, whoever must be aware of the details of the job early on, so that they may perform their tasks efficiently, without causing delays, needless work, or disappointment. Once the limiting factors of the job are defined, if they are intelligently followed, they will practically preplan the job.

In analyzing a printing job, answer the following:
☐ Does the client have a format and style in mind for the piece?
☐ What is the purpose of the piece?
☐ Who will receive it?
☐ How will it get there? What are the delivery requirements?
☐ How important is the piece to its overall purpose?
☐ How many colors will the job require?
☐ What is the budget for the piece?

☐ Is the designer limited in the type or color of paper or ink he/she can choose?
☐ Will the finished piece be handled excessively?
☐ What type of press will be used to print the piece?
☐ What binding and finishing operations may the piece require?
☐ What is the deadline for the finished work?
☐ Who will approve intermediate stages of design, manuscript, etc.?
☐ Are there any other special considerations or limitations that are important to the successful reproduction of this piece?

Does the client have a format and style in mind for the printed piece? Printed pieces can be produced in a variety of formats and styles involving different design characteristics, different production procedures, and varying costs. A format may be a simple, one-page, one-color mailing piece; the design may call for several parallel and perpendicular folds, or it may be a complex multicolor display with a series of folds and diecuts. Formats can take the shape of folders, booklets, direct-mail pieces, calendars, reply cards, packages, and posters, to name a few.* The more complex the format, the more difficult and more expensive it is to produce. The artist should know if the format chosen was determined as a result of a budgetary limitation by the client—he or she should be aware of what the client is trying to accomplish.

Style is the particular aesthetic approach the artist selects to present the client's message. The message may lend itself to typographic matter only, or it may require a photograph or line drawing with or without type. If illustrations are required, it may be beneficial to produce them in more than one color to achieve maximum impact. In some cases an unusual art treatment may be effective, such as special-effect screens, duotones, caricatures, or calligraphy. Of course, the artist should know the chosen or prospective printer's capabilities and the customer's cost limitations before settling on a particular design style.

What is the purpose of the piece? Answers to this question will help determine format, size, shape, and appearance. If it is to be a mailing piece, the postal regulations will have some influence; if an enclosure, the envelope or larger piece in which it

*See color photos p. 4:59.

is to be enclosed will help determine size, bulk, and weight; if it is intended to be filed, standard file sizes will have influence. If the piece is expected to sell, explain, instruct, or inform in detail, it must be large enough, in dimension or in number of pages, to accomplish its purpose effectively; if it is intended only to remind, announce, introduce, or repeat, brevity may be its virtue.

Who will receive it? How will it get there? What are the delivery requirements? Answers here will further determine quantity, format, and size. The habits of its intended consumers should be known. Shipping addresses, contacts, and the date(s) that the item should be received must be known. The type of packing, transportation, mailing, and handling should be detailed. The method of packing and distributing frequently influences the size of a lithographed piece, but its total bulk also needs to be considered.

Imagine, for example, the plight of a customer accustomed to thinking of 5,000 quantities as small quantities, who orders 5,000 12-sheet calenders and 5,000 2×12-in. mailing tubes shipped to a small office for inserting, addressing, and mailing. After the job is delivered, the customer is knee-deep in 60,000 calendar pages, and 140 cu. ft. of mailing tubes.

How important is the piece to its overall purpose? The importance of the individual job in relation to the purpose it serves will also affect the consideration of format, size, and quantity. Additionally, quality of design, printing, paper, and editorial content are involved. If the piece is but a small part of a large mailing packet, such as a reply card enclosed with information about a product line, then more attention and time may need to be given to the product literature than to a reply card, questionnaire, or envelope. Discussing the relative importance of each item will reveal where money can be saved and where it is better spent. Additionally, after considering the minimum numbers of colors necessary to accomplish the job, the piece may be reviewed again to determine how to derive maximum impact, results, and effectiveness.

How many colors will the job require? When the artist is limited in the use of colors, he or she should know how to gain maximum impact by using tints of colors, and by choosing proper color combinations if more than one color can be used. Also, the possibility of making the color of the paper a part of the design should not be overlooked.

If the artist is limited to the use of a single color, a multicolor effect can be achieved by using a solid of the single color, or tints of that same color, and the press requirement of one pass through a single-color press will not change. If the artist is limited to the use of two colors, the design can be produced by using solids and combinations of tints of the particular two colors. The minimum press requirement would then be a single pass through a two-color press or two passes through a single-color press.

The selection of a single color, or a combination of colors, should be determined primarily by the message being presented and the ease with which the message can be read. When combining white stock with text matter, optimum visual appearance and readability are achieved when dark colors such as black, dark gray, dark blue, or dark green are used rather than light colors such as pastels. However, light colors may be entirely appealing for large display type on white paper. A small, crisp spot of a brilliant color attracts as much attention as a larger area of a tint of the color.

What is the budget for the piece? This is probably the most important question discussed in beginning planning sessions because economic considerations affect almost every other aspect of a printed piece, and may well be the most limiting, and at times, unlimiting factor in the reproduction of the job. Not only must the budget be discussed but one must not hesitate to ask what consequences will result if the project runs over budget, should unforeseen problems or hidden costs (e.g., an increase in paper costs, a difficult on-location photograph that requires more than one trip to achieve acceptable results) occur.

Is the designer limited in the type or color of paper or ink he/she can choose? For aesthetic, practical, and cost considerations, attention must given to paper selection. Paper can represent as much as 50% of the total cost of a printing job. When the artist is able to select the paper, it should be coordinated with the design. When a particular paper is specified by the client, the artist must be certain that the design is compatible with the appearance as well as the print-quality characteristics of the paper. The artist should be aware of the wide variety of types, finishes, weights, grades, and colors of paper that are available. There is an easy way to get the "feel" of this abundance. All paper mills furnish swatch books of their products, and paper merchants are usually only too happy to distribute them. Sales representatives from the paper distributor are usually willing and able to help the designer choose a paper that is well suited to the printed piece. Do not hesitate to ask them for advice. Also, many paper merchants will construct the exact format (a dummy) of the piece, from the artist's specifications, in the papers that he or she chooses.

One technical point that a designer or artist must be aware of is that paper has a grain, and that the heavier weights of paper used for covers and portfolios fold more easily and more cleanly with the grain than across it. This is an important point to remember when designing pieces that must be folded. However, if a piece demands a fold across the grain, scoring the paper on press will permit a sharp fold in the bindery.

When choosing paper, keep in mind that stock with a textured surface may not be suitable for reproducing halftones or line work with fine detail. Rough-surfaced paper finishes and uncoated stock often require a coarser screen ruling for producing halftones than does a coated stock. A smooth, coated stock is best for producing halftone detail because a fine-line screen can be used.

Also, the thickness and bulk of a paper dictates certain limitations. The artist should avoid placing large, heavy, solid images on thin paper having low opacity and, consequently, high show-through. This applies only when the reverse side of a sheet is significant to the overall design of the finished printed product. Generally, it is best to avoid using paper with low opacity for a piece that is to be printed on both sides, no matter how heavy the ink coverage.

The color of paper can play a significant role in the overall appeal of a printed piece. Before beginning initial designs, the artist should know whether he or she is limited to designing for

white paper, or whether a colored stock may be selected. If the design must be limited to white paper, the use of color is limited to the number of inks that may be used. If a colored stock may be used and the piece is limited to the use of a single ink, the artist can create a two-color effect by coordinating the single-ink color with the color of the paper. Likewise, if the piece is printing in two ink colors, the artist can use a colored stock as a third color in the design.

It is difficult to coordinate colored ink and a colored stock when the ink must precisely match the color of a product in the design. This difficulty occurs because the appearance of color is affected by the surrounding environment of the color. For example, a solid circle of yellow opaque ink printed on a green background appears different from the same circle of yellow ink printed on a red background. The hue of transparent inks will change completely; for example, blue transparent ink printed on yellow paper will turn green.

To avoid the pitfall of misjudging how a particular ink will appear on a particular paper, the artist should request samples of the paper and inks to be used. Simple ink draw-down or ink roll-out tests that will show the effects of the inks on colored paper can then be made. Some larger art studios and art departments use a small offset duplicator for testing ink on paper. Another option is to send paper samples to ink suppliers for ink roll-out tests. Ink swatch books showing the various available colors printed on both coated and uncoated stock are available from most major ink suppliers. Also, paper mills that manufacture colored papers frequently supply brochures of their paper stocks printed with a variety of colored inks.* Transparent acetate sheets that are printed with various ink tints are also available. These can be placed over colored stock to help to visualize the combination of ink and paper.

If a paper sample can be obtained, it is possible to visualize what the ink will look like on the chosen paper sample using the GATF Color Communicator. The Color Communicator is a set of prescreened tints of the four process colors; magenta, yellow, cyan, and black. By inserting a sample of the paper into the viewing window and manipulating the sliding tabs that control the percentage of each color, the artist can visualize and match colors as necessary.*

Will the finished piece be handled excessively? Excessive handling of printed pieces coupled with heavy ink coverage usually requires that the piece be varnished on the press. Applying a coat of varnish during a final pass through the press will help preserve the piece during excessive use and will prevent fingerprints that might otherwise appear on solid inked areas.

Further discussion questions should be considered regarding the piece's end use: Will the item be read once and then discarded? Will it hang on a wall like a poster or calendar or will it sit on a shelf to be opened again and again, such as a book? Will it be frequently handled and reused, such as a catalog, cereal box, or bread wrapper? Finally, will it be subjected to extreme temperatures or to chemicals, such as a frozen food box or margarine wrapper; or to bleaching from sunlight, such as posters or calendars?

What type of press will be used to print the piece? The designer or artist should know whether the piece will be reproduced on a web or sheetfed press (the web may limit paper choices) as well as the size sheet the press accommodates. The press sheet layout required for the press must also be discussed. *Press sheet layout* or *imposition* refers to the position of the design on the press plate and the direction in which the paper will feed through the press. If no thought is given to press sheet layout when designing a multiple-page piece, *mechanical ghosting* or *ink starvation* may result. Mechanical ghosting or ink starvation is an uneven inking around the cylinder of the press; that is, ink fails to appear heavily enough in certain areas and the plate is starved of ink. This is often caused by the mere design of the

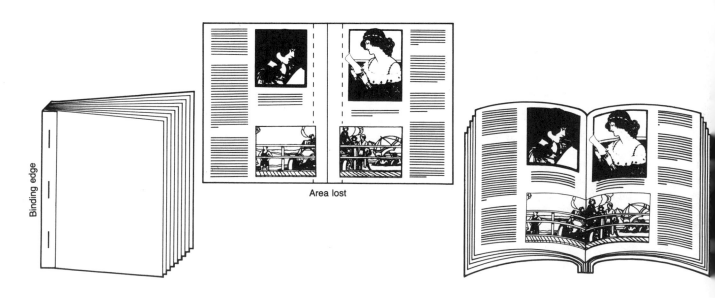

Gutter allowance showing loss of space in a side-stitched booklet.

*See color photos p. 4:59.

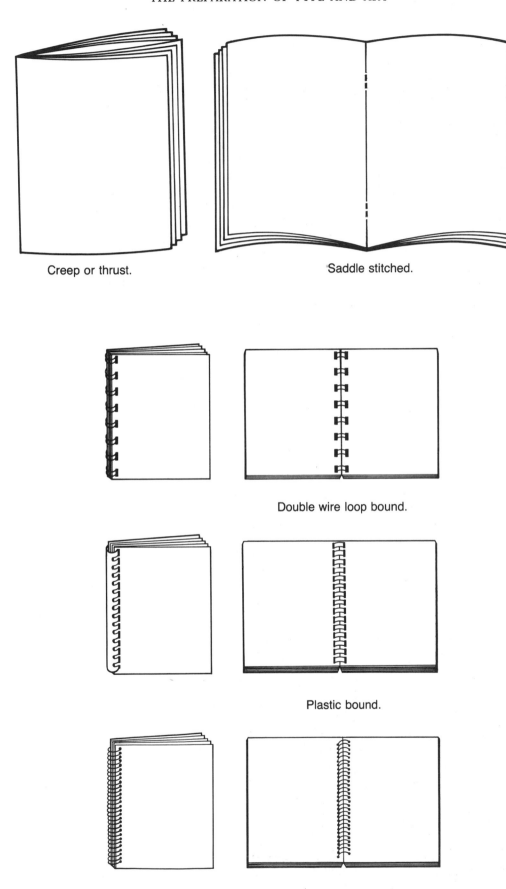

Creep or thrust.

Saddle stitched.

Double wire loop bound.

Plastic bound.

Spiral bound.

4:24 THE LITHOGRAPHERS MANUAL

piece. Certain designs tend to cause mechanical ghosting; one is the solid-ink T shape—heavy vertical and horizontal solid areas that join. The best safe-guard against such mishap is to consult with the printer as early in the design and planning stages as is possible. When mechanical ghosting is anticipated, and the design cannot be altered, the artist should consult with the printer to determine how best to lay out the sheet to at least minimize the printing problems that the design may cause.*

There are three principal types of sheet imposition for a sheetfed press, *sheetwise imposition*, *work-and-turn imposition*, and *work-and-tumble imposition*. Each type of imposition has its own advantages for planning where to use color in a multiple-page piece. If the artist has a basic knowledge of the types of imposition, then he or she can economically plan, along with the printer, the pages on which color will print. See Chapter Nine: The Stripping and Photocomposing Departments, and Chapter Fourteen: The Bindery for a more detailed discussion of imposition.

When designing photographs or elements across the fold of a multiple-page piece, keep in mind that bindery machines are not 100% accurate. Design so that slight misalignment will not occur by placing the elements on center spreads.*

What binding and finishing operations may the piece require? It is important that the artist know how a printed piece will be bound and finished. Finishing and binding procedures should be discussed with the bindery before the initial design is determined. Whether a piece will be saddle stitched, side wire stitched, spiral bound, or merely folded plays an important part in overall layout and design.

Binding that involves folded signatures, especially saddle-stitched binding, may require that the artist compensate in the page layout for *creep* or *thrust* of the inner pages unless allowances for this are to be made by the stripper. Creep or thrust results from a build-up of paper thickness at the backbone of the folded signatures. The thickness causes the inside pages of a signature to extend beyond the outside pages by the amount of buildup at the backbone. When the front edge of the book is trimmed, the horizontal dimension of the inside pages is shorter than that of the outer pages by the amount of the paper buildup at the backbone. The artist can determine the amount of creep or thrust that must be compensated for by having the bindery supply a folding dummy of the job, using the same paper on which the job will be printed. By placing a pin through all thickness of the paper, at both the gutter and outside margins,

the artist can see how much creep to allow for. To avoid trimming off the image areas that fall in the extended area of the inner pages, the artist must gradually reduce the gutter margins on the layouts and paste-ups as they approach the center of the signature. When bleed images or any art elements are required at the outside edge of the book, the artist must further adapt the design and page content to allow for creep. Keep in mind bleeds may add costs to the piece, in both paper and cutting time in the bindery.

Likewise, it is important for the artist to know when books are going to be spiral bound or side stitched so that the designs can be adapted accordingly. Spiral binding requires the pages be punched close to the spine; therefore, critical image segments along the punch line should be avoided. Side stitching necessitates that a portion of the page, sometimes as much as 3/8 in. along the binding edge, not have any part of the message printed there.

Another binding concern of the artist is the relation of paper grain direction to folding. This is important for almost any booklet or book job. When a cover is folded perpendicular to the grain, there is often a tendency for breaking or cracking at the fold. The problem does not occur when the grain direction is parallel to the fold. This breaking is particularly objectionable when a cover is printed with a solid crossing the spine. Generally avoid folding heavy, coated stocks that crack even when folded with the grain.

In all cases of design for a multiple-page format, the artist should acquire a folding dummy from the bindery.

What is the deadline for the finished work? Who will approve intermediate stages? Although seemingly straightforward, these questions should be answered both verbally and in writing. Many a job has failed because of missed deadlines or because deadlines were never concrete, but kept changing. The final deadline and any intermediate deadlines should be detailed with the person (usually the client) whose approval must be given at various stages (previously agreed upon) of production. This discussion should also include the consequences of missing deadlines.

Any other limitations or specifications of the job should be discussed at the beginning planning session. In fact, after the initial planning conference, update sessions should occur to keep all parties informed of any changes and of the progress of the job.

Section Seven: Layouts

After the various limitations in planning have been discussed and understood by key people who will work on the job, and a manuscript and visual have been approved, the artist is ready to begin planning the layouts that will lead to art preparation. There are three types of layouts: thumbnail sketches, rough layouts, and comprehensives. Each layout is progressively more precise.

THUMBNAIL SKETCHES

The thumbnail sketch, the simplest of all layouts, is drawn much smaller than the final piece will be, hence the name. The thumbnail, as it is called, is drawn quickly, perhaps within

minutes. No concern is given to specifications of size, color, type style, etc., but merely an attempt is made to get original conceptions on paper—to show a visual relationship between the design elements. The text need not be readable nor the illustrations recognizable. Many thumbnail sketches are produced before the artist achieves a satisfactory rendition worthy of expansion.

ROUGH LAYOUTS

When a particular thumbnail sketch is chosen for development and enlargement, the artist proceeds with preparation of a

*See color photos p. 4:59.

rough layout. The purpose of the layout is (1) to further develop the concept visualized in the thumbnail sketch and (2) to serve as a means of communicating both ideas and instructions among client, artist, and printer. In producing the rough layout, the artist shows more specific detail than was on the thumbnail sketch by carefully drawing illustrations and indications of type.

Markers are most often used to indicate color breaks directly on rough layouts, tissue overlays, or comprehensives. However, for an even more detailed and polished comp, artists can choose from a variety of colored papers and adhesive-backed films, which are placed directly on the comprehensive to show specific color area. These films and papers are color-matched to the litho printing inks that will be used on press. Using these color aids

Thumbnail sketches are drawn much smaller than the final piece will print.

Although text type is normally not sketched letter for letter, display and headline type are generally carefully indicated. Illustrations are roughly sketched and recognizable. Company logos are clearly indicated and design characteristics such as reverses, knockouts, and surprints are included. Rough layouts are normally produced to the finished trimmed size, clearly indicating spacing between elements and margins, but may or may not show color breaks.

When deadlines are tight and customer demands are not critical, the rough layout is sometimes used as the final layout for the submission to the client. As a final layout, the rough layout becomes the paste-up artist's guide for preparation of the camera-ready copy. Color is then shown on the layout or on a tissue overlay along with all references to type specifications.

COMPREHENSIVES

In preparing a comprehensive, the artist attempts to come as close as possible to showing what the final printed piece will look like. The artist may go to the expense of hiring specialists in lettering, or illustrators, or photographers. Actual type may be used, or ruled lines showing the precise length, x-height, and placement of the type may be drawn on the "comp." Photographs may also be included in place of sketched illustrations. All color breaks and special effects such as airbrushing, silhouettes, and vignettes are indicated on a finished comprehensive. Instructions and specifications should not be marked directly on a comprehensive layout since the comprehensive is usually an expensive and precise piece of work. All instructions and notations are shown on a tissue overlay that is taped across the top of the comprehensive. Once the comprehensive is approved by the client, it serves as the guide or "blueprint" for all art and copy preparation that follows.

Rough layout.

directly on the actual stock intended for printing when preparing the comprehensive helps the client, paste-up artist, and designer to further visualize what the printed piece will look like. In fact, all final comprehensives should be prepared on the stock on which the piece will print.

In addition to the colored papers and films, custom-image material (a type of film) can be purchased in various colors. This material, along with a negative or positive, is exposed to strong ultraviolet light and then developed. The image that remains can be burnished onto virtually any surface. Hence, the result is a custom-made, same-size rub-on.

When designing for books or multiple-page publications, the final layout or comprehensive is pasted to the folding dummy. This assists the artist in visualizing the appearance of the finished work. The folding dummy also enables the artist to establish bleeds and margins, as well as serves as an example or guide for binding and finishing operations. In book work, a few specimen pages are set and serve as the comprehensive. A comprehensive can take the exact form of a finished piece such as a display or folding carton, a direct-mail enclosure plus envelope and reply card, a candy wrapper, or even a reclosable food pouch for cookies.

WHAT THE PRINTER SHOULD KNOW ABOUT PAPER

GATF Graphic Arts Technical Foundation

The comprehensive serves as a guide for all art and copy preparation that follows.

Section Eight: Types of Copy

Once the final layout or comprehensive is approved by the client, the artist is ready to begin assembling the art elements required for preparing camera-ready copy. There are three types of copy elements: *line copy; continuous-tone copy;* and *full-color copy*. Each type of copy requires its own process-camera reproduction technique. Type is essentially line art, and is further treated in detail in Sections One through Four. Full-color copy is a kind of continuous-tone copy. However, because of its special nature and the techniques used in full-color reproduction, full-color copy is also discussed in Sections Fifteen and Sixteen.

Each type of copy may be submitted to the artist in a variety of forms and on a variety of materials. Line copy may come as an original illustration or diagram on various substrates; it may be a photostat; it may be a reproduction proof or galley of typeset copy ready to be cut apart and mounted onto the paste-up in accordance with the layout. Sometimes a positive film transparency is furnished. Continuous-tone copy may be a black-and-white or color photograph; it may be a painting; or a color transparency. Most often the artist must handle a wide variety of forms on a single paste-up.

As mentioned earlier, the artist must take the time to plan the overall job. It is also essential that he or she plan his or her tasks, particularly when faced with a job that requires handling a variety of different types of copy. However, the artist's plan must take into account not only his or her convenience and time, but

the convenience and time of others who will work on the job, as well as the production costs that the plan demands.

LINE COPY

Line copy is all copy that contains no shades of gray (continuous tones) and prints solid (black or color) on the finished piece without the use of a halftone screen. Pen-and-ink line drawings, shading film, and type are examples of line copy. Type reversals are also line copy since the background prints as a solid ink with the type appearing as white. Of the three categories of copy, line copy is the simplest to reproduce.

Quality Requirements of Line Copy. When submitted for reproduction, line copy must be solid black on a neutral white background. Off-white, cream, or blue backgrounds should be avoided since maximum contrast between image and nonimage areas is the key to good reproduction in the printed piece. The background on which the copy is drawn or mounted should be either smooth, hard-surfaced paper or illustration board. Textured, embossed, or pebble-grain surfaces may be required for creating special design effects, but a smooth, hard surface is important when clean, uniform, straight lines and edges are required. Soft or absorbent surfaces often create undesirable bleeding of ink or paint, and are not satisfactory for

producing the sharply defined lines of original line art.

When drawing line copy—illustrations, diagrams, etc.—it is important that all image segments have uniform density or blackness. If a large solid varies greatly in density, the low density areas may not reproduce as a solid. Type proofs also should be inspected by the artist (as well as the proofreader) for consistent density. Density variations are usually noticeable when inspecting galleys at normal viewing distance and frequently occur when corrected type is combined with original type—the corrected type appearing lighter or darker. Imperfections such as broken or fuzzy characters must be found and corrected. Normally, a quick scan over a phototypeset galley will reveal any broken or fuzzy type. This is best done with a hand-held magnifier. Density variations and broken characters are usually sufficient reasons for rejecting type proofs.

With all copy, the artist must keep in mind that imperfections will reproduce if not be magnified in the negatives made from the artwork. Therefore, corrections should be made in the artwork so that extra, costlier photographic and stripping charges will not be added to the job.

Type Surprints and Reverses. Type can be used effectively to surprint (overprint) over background tints of color, or as reverses, also called knockouts or dropouts. When designing a surprint, the artist should avoid placing black type on a dark background tint. Similarly, reverse type on a light background tint should be avoided. The artist will be able to combine solids, screens, and reverses in a manner that will add visual appeal and impact to the design.

The following guidelines will be helpful in deciding how best to use solid and reverse-type images on screen-tint backgrounds. Keep in mind that (1) the percent tint and (2) the color of ink have considerable influence on how surprints and reverse type will appear when reproduced.

1. On light-colored, background screen tints of up to 10%, small sizes of medium and bold type will work well. However, the monotony of long copy should be avoided.
2. Medium-weight typefaces work well on background screen tints of approximately 40%. However, typefaces with fine-line serifs should be avoided, as the serifs will be lost in the screen.
3. Typefaces of uniform thickness and strong, thick serifs will reproduce well on a 50% screen-tint background.
4. Small reversed type of 10 pt. or less may be difficult to read on a tint background of about 50%.
5. When printing reverse type on a solid background, provide for sufficient line spacing to prevent eye fatigue caused by the illusion of flickering or vibration of the type images.
6. When printing reverse type on a solid background, avoid types with fine lines and thin serifs as they are likely to fill in on the press.

Background screen tints or solids can be used effectively in color, in black, or tints of black, which produce grays. When using colors it is important to consider the overall effect of one ink color printed over another color. For example, if a solid background is printed with transparent yellow ink, and type is surprinted with transparent blue ink, the effect of the yellow and blue ink will produce green type. Opaque yellow, however, usually presents an excellent background since most other colors can be printed over opaque yellow without creating readability

10% tint of black.

50% tint of black.

70% tint of black.

100% black.

difficulties. Opaque inks are best used when surprinting, unless the apparent color change with transparent inks is desired. The point for the artist to keep in mind, when working with background tints or solids and reverses or surprints, is never to sacrifice readability for visual effect, unless this is deliberately called for in the design.

LINE ART TECHNIQUES

Line art (line drawings) is prepared by a number of techniques. Each technique involves the deposit of a uniform black image on a white background. Wherever possible, line art should be prepared larger than its final printed size. A convenient size is usually 25–50% larger than the image will be printed. Reducing original copy on camera minimizes imperfections, such as jagged or rough edges, although it does not eliminate them. Conversely, camera enlargements will tend to accentuate imperfections in the art.

Brush and Ink. Brush-and-ink illustrations are produced in the same way as pen-and-ink illustrations. The pen produces fine, crisp lines, whereas the brush produces broader strokes with feathered edges. Pen and ink and brush and ink can be combined in the same illustration for a special effect.

Charcoal or Pencil. Charcoal or pencil illustrations can create the illusion of continuous-tone copy. Highlight areas are created by applying light pressure to the charcoal or pencil. Shadow areas are produced with heavier pressure.

Shading Film. Shading film is pressure-sensitive, dry-transfer artwork on which a screen tint is printed. The film adheres to a paper backing that is peeled away before the film is placed on the artwork. Shading film is printed in black in various patterns, and in various percentages of tints. The more popular patterns include: the conventional round-dot screen in horizon-

Pen and ink.

Pencil sketch.

An exception to this rule is fine-line, detailed line copy. Detailed copy should be prepared in the same size as the printed size because it is difficult to predict how thin the fine lines will become during a camera reduction. Very thin lines may drop out entirely and very close lines may merge into a mass of solid black.

Some common techniques used to produce line art are pen and ink, charcoal or pencil, brush and ink, shading film, and line conversion or posterizations of continuous-tone subjects.

Pen and Ink. Pen-and-ink illustrations are usually the simplest form of line illustrations to reproduce. A simple line exposure on the process camera will usually produce a suitable negative for platemaking, needing little or no stripping handwork. Most pen-and-ink illustrations are drawn on hard high-quality, smooth, coated paper, or on illustration board, using a ruling pen, technical pen, or crow quill pen.

tal, vertical, or diagonal directions; straight-line screens in horizontal, vertical, or diagonal directions; circular screens; diamond or square-shaped screens; and mezzotint screens.

A piece of shading film that is cut larger than needed is placed over the areas of art that will appear as a shade or tone. The image is traced with a sharp knife and the excess film tint is peeled away. The film is then covered with tissue and burnished so that it stays in position.

Line Conversion or Posterization. Creating a line conversion or posterization means converting a continuous-tone photograph to line copy. This special effect is achieved by exposing a continuous-tone photograph to high-contrast line film. The resulting negative will drop out all highlight and light middletone areas, and reproduce all deep middletone and shadow areas as solids.

CONTINUOUS-TONE COPY

Continuous-tone copy is copy that contains tones of light and dark areas rather than a solid color only. There is a gradation of tones between the lightest highlight area and the deepest shadow area in continuous-tone copy. The most common example of continuous-tone copy is a black-and-white photograph. Notice that a photograph is made up of numerous tones ranging from the pure white of the paper to the deepest black shadow. Other examples of continuous-tone copy are color transparencies, paintings, and shaded drawings.

Since printing plates print only even layers of ink in the image areas, continuous-tone art must be converted to another form to be printed. A photograph or other continuous-tone illustration must be rephotographed with a process camera onto high-contrast film through a special film screen. The screen breaks up

Middletone dots are those dots that make up the mid range of tones in the reproduction. The middletone dot range is usually from a 35% dot to a 70% dot. When magnified, perfect 50% dots produce a checkerboard pattern showing an equal amount of white paper and ink, if a conventional halftone screen is used.

The shadow dots produce the darkest areas of the print, and normally range from a 70% to a 98% dot. In shadow areas, the dots become so large that they merge to produce a near solid image. Very little white paper can be seen in a shadow-dot area. The ratio of unprinted to printed area determines the depth of the shadow; a 70% dot (30% unprinted paper) will appear as a moderately dark gray while an area printed with a 98% dot will appear black.

Halftone Screens. The screens used to produce halftones are available in different screen rulings and patterns. Screen

Posterization.

Continuous-tone print.

the image into different-size dots. This screening process is called *halftoning,* and the resulting image is a *halftone negative.* When printed, the image will resemble the original photograph, with the smaller dots producing light shades of gray, or highlight areas, and the larger dots dark shades of gray, or shadow areas. While the dots vary in size, they are always spaced uniformly from center to center of each dot. These halftone dots are not visible at normal viewing distance, and create the illusion of continuous tone. In reproduction, each dot seen separately can be considered a piece of line art because it will reproduce as a single speck of ink.

Highlight, Middletone, and Shadow Dots. The effect of tonal differences in printed halftones is created by the amount of ink that is seen by the eye in proportion to the amount of white paper that surrounds it. The lightest highlight area will have tiny dots, and much white paper will be showing between the dots. Reproducible highlight dots may range as low as 2%; that is, 2% ink, 98% white paper.

Shading film tints.

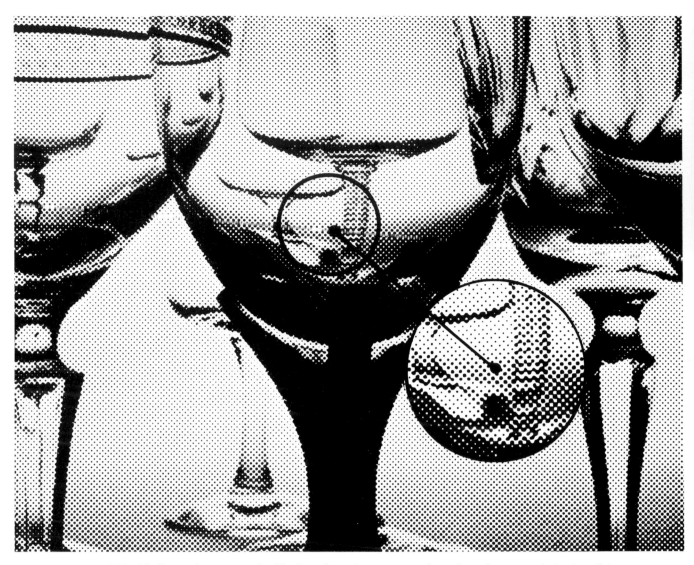

These individual halftone dots create the illusion of continuous tone when viewed at normal viewing distance.

ruling pertains to the fineness or coarseness of the screen and is designated in lines per inch. Although a screen may be made up of rows of dots, these dots are usually in a linear pattern and therefore measured in lines of dots per inch. The term "lines per inch" stems from halftones made from glass cross-line screens. The most commonly used halftone screen is made on film that contains a vignetted dot pattern, which will form the different-size dots on the final halftone negative.

Selection of screen ruling should be determined by the type of paper to be printed and the photographic detail required in the printed piece. As a rule, the finer the screen, the greater the detail of the printed halftone. Coarse, rough paper, such as newsprint, requires a coarser screen for best reproduction; therefore, newspaper halftones are produced with a screen ruling between 65 and 120 lines per inch. A coarse screen allows printing of each dot on the coarse surface of the paper, producing an adequate image. An uncoated stock, smoother than newsprint, usually produces halftones best with screens of 120 or 133 lines per inch. Highly coated, smooth stocks are frequently printed with screen rulings of 133 or 150 lines per inch. Halftone printing requiring the ultimate of detail is occasionally done with screens up to 300

lines per inch. However, the successful use of such screens requires the utmost control of film processing, platemaking, paper, ink, and press variables.

The most widely used halftone screens are those containing rows of square or elliptical dots. For special effects, the artist can specify screens having concentric-circular patterns, vertical-, horizontal-, or diagonal-line patterns, random-line patterns, pebble-grain patterns, wavy-line patterns, or mezzotint patterns. These special-effect screens are usually used when detail may be sacrificed for an aesthetic effect.

Black-and-White Photography. It takes artistry with a camera to illustrate a fact, create an impression, or tell a story photographically. But however skilled the photographer, the genius for staging and taking good pictures will suffer if allowances are not made for the changes that inevitably take place in each step—from the original film, to the photographic print, to the lithographer's negative, and finally to dots of ink printed on a sheet of paper. The most successfully printed photograph is one that has reproduced just what was specified for the final printed form. Therefore, vague specifications are

Mezzotint screen.

Concentric-circle screen.

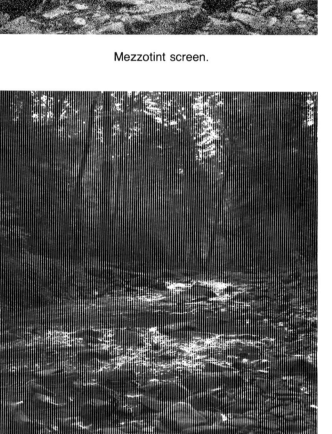

Vertical-line screen.

Etched steel-plate screen.

inappropriate when discussing what is desired in the final printed photograph.

Too often little time is devoted to considering the reproduction qualities of a potential photograph before it is taken. A little extra time and effort spent planning good photography can save later expenditures for costly and perhaps unsatisfactory retouching.

Additionally, photographs for reproduction should be taken by professional photographers. The photographer has a number of things to consider when planning a photograph—for instance, arrangement or composition, lighting, choice of film, exposure, filters, and developing process. The best insurance against photographic headaches is the service of a photographer who understands the requirements of photomechanical production, since the halftone process rarely improves the quality of an original photograph. Black ink cannot match the deep blacks of a photograph, and white printing paper cannot match the whiteness of white photographic paper; therefore, the tonal range from dark to light of an original photograph is compressed in the halftone process. The highlights appear duller and the shadows appear lighter. At the same time, a certain amount of detail is lost.

The term for the tonal difference between highlight and shadow areas of an original or reproduction is *contrast*. A photo with a great range between its deepest black and brightest white has high contrast. Conversely, photos in which the darkest and lightest tones are not greatly separated have low contrast.

Because of the apparent increase in contrast when a photo is printed, a moderately low-contrast print is usually preferred over a high-contrast print.

Overall contrast can be increased in the reproduction process, but nothing can be done to provide detail that was never recorded by the camera.

Some compensation for contrast can be made in black-and-white photography during the negative-to-positive printing; however, contrast should be controlled by proper lighting of the subject during the photographic session. The artist may benefit by understanding basic types of lighting so that he or she may further specify the desired result.

Flat, front lighting such as common flash-on-camera photography may produce high contrast but also may produce large masses of tones that are either very dark or very light. Details are lost. Notice in some newspaper portraits the subject's face is a white oval with no modeling of the features—flat, front lighting was most likely used.

Side lighting from a single source gives the illusion of depth, but here, too, there are very few middletones. Dark shadow edges of subjects merge with backgrounds and are lost, and the light side is often too bright to show any detail. Many improperly sunlit outdoor snapshots show this.

The alternative to these is a picture with the lighting balanced to show a full range of tones that distribute attention to all the desired details. The photo will have good contrast and detail, which are most often desired in a printed piece. (See Section

Print too flat. Highlight areas are veiled with a gray cast. Shadow areas do not carry full density.

Normal photo. Good film negative; well-exposed print. Full tonal scale — highlight areas adjacent to shadow areas with each properly separated to give excellent reproduction.

Print too contrasty. A client may prefer this higher contrast. Certainly it is preferable to the too-flat print. Yet, it does not hold true to the original scene.

Sixteen: Color Photography for more on this subject.)

Also, if a photograph is to be outlined, or must otherwise be retouched, the photographer can provide a clear distinction between subject and background by putting strong contrasts in tone between them; for example, placing a light background against dark machinery. Light objects, of course, require dark backgrounds. This practice eliminates guesswork by the artist or retoucher.

Even though it is not always possible to direct the picture taking, the photographic negative is often available to the artist who is responsible for preparing the copy. A little care in ordering the print will go a long way toward getting better reproduction at no extra cost.

Manufacturers of photographic films produce dozens of different types of photographic papers that vary in contrast, color, texture, and weight. With this selection, the same negative can produce a variety of different prints. Generally, the photographer will select the grade of paper that suits the contrast of the negative and produces a print of normal contrast, unless instructed otherwise. For satisfactory reproduction, the paper the photo is printed on must photograph well since the print will be rephotographed in the halftone process.

White fiber-base photographic papers are generally considered to produce the best halftone reproduction. Because of its superior processing speed, resin-coated waterproof paper is commonly used in making photographic prints, but because of its fluorescing properties, this type of print must be handled differently from conventional fiber-base paper in the process camera. Off-white, ivory, cream, and other colored papers, should be avoided because they tend to dull the highlights when photographed in the process camera. Similarly, various photographic papers produce images that differ in color. Those that produce a neutral or blue-black image tone are preferred.

The paper surface will influence the amount of detail reproduced from the original negative. A textured paper that is used for halftoning will result in less detail, specular highlights, and possibly moiré patterns in the final reproduction. A smooth, glossy surface is the best, especially when the halftones will be printed on coated stock. A glossy offers the best separation of tones and good detail. A matte surface is usually specified when photos are to be heavily retouched, or printed in a newspaper, where less contrast but larger tonal steps—from highlight to midtone and midtone to shadow—are present. Generally sepia and hand-colored prints make poor copy for lithographic reproduction.

Care and Protection of Continuous-Tone Copy. In order to get the best reproduction from black-and-white continuous-tone copy, it is imperative that the negatives, prints, and original art be stored and handled with care. Spots, stains, cracked emulsion, scratches, blurred images, and discoloration will result if the following precautions are not taken.

- Never write heavily on the backs of photographs. This will damage the surface of the print. In fact, writing on the backs of photographs should be avoided if possible.
- If photographs must be written on, use a felt-tip marker or grease pencil. Never use a pencil!
- Do not stack photos that have just been written on, particularly when using a felt-tip marker. Permanent marker ink takes a few minutes to dry, especially on resin-coated

photographic papers. Stacking photos directly after writing on them may cause the ink on the back of the top photo to offset on the image (front) of the bottom photo, ruining the photo. Also, a pressure-sensitive label or piece of masking tape can be placed on the back of artwork carrying pertinent information.

- Always protect continuous-tone art by covering each piece with a tissue overlay that is hinged to the back (top) with masking tape. No artwork should be mailed or sent into production without this protective tissue.
- Remember, when mailing artwork, to address the mailing envelope *before* inserting the artwork. Indentations and scratches may occur if pen pressure is applied to the package while the art is enclosed.
- Do not mail photos in mailing tubes. They should be mailed and stored flat.
- Refrain from eating, drinking, and smoking when preparing and handling artwork. Coffee, food, and cigarette ash stains ruin artwork, so avoid these possibilities altogether.

TREATING CONTINUOUS-TONE COPY

Photographs are often treated by the artist to achieve some special effect or to improve reproduction quality. Photographs of machinery frequently are retouched to sharply delineate the subject from the background, to emphasize highlights, or to make certain that small detail is clearly distinguishable. This type of alteration requires special skill and is costly.

Retouching. Much time and expense can be consumed when preparing continuous-tone copy, yet the result is not always what the art director or client had in mind. For example, contrast may be too high or too low, or certain items in the copy may not be detailed or emphasized enough. When such imperfections exist, the artist has two options to improve the copy. First, the photograph or artwork can be redone. In the case of a photograph, reshooting may be necessary. When budget and time do not allow reshooting, the artist must resort to the second option, retouching.

Continuous-tone copy can be retouched to improve tone or detail, or de-emphasize certain areas by using tone shading films or an airbrush. Airbrushing is the more effective but more expensive method. Also, the artist can apply special inks or spot dyes with a brush, especially when very small areas must be highlighted or made solid. However, a brush often does not apply a smooth continuous tone and the retouching may be obvious in the final printed piece. Whatever method is employed, be certain that the materials used are compatible with the artwork. In black-and-white photo retouching, some types of spotting dyes will match the print visually, but will record entirely differently by the process camera. (With color transparencies, extra care must be taken to ensure that the color dyes used are color-matched to the particular type of transparency being retouched.)

Continuous-Tone Shading Films. Continuous-tone shading films are similar to the shading film tints described in the section on line copy techniques. They are made of thin, pressure-sensitive material. Whereas the shading films applied to line copy have a definite printed pattern (black dots, lines, etc.),

the continuous-tone shading films have a uniform and continuous overall translucent gray tone. The films are available in a range of tones from light gray to dark gray.

If a key item or area in a photograph must be emphasized, de-emphasizing the photograph's background with an appropriate tone of shading film will accomplish this. First the shading film is placed over the entire photograph; then very carefully the item to be emphasized is traced with a sharp blade; and finally the shading film is peeled from the outlined image. To protect the photo, a piece of clear acetate can be attached and the shading film placed and burnished onto it.

Airbrushing. Airbrushing is the most effective means of altering emphasis, contrast, and detail of continuous-tone copy, especially photographs. However, airbrushing can be costly and time consuming and requires a skilled airbrush specialist.

Airbrushing resembles spraying paint through an aerosol container. However, the airbrush is a more controllable spray instrument. With the airbrush the artist can produce soft, subtle tonal gradations with many ranges from the lightest highlight tint to a solid opaque covering.

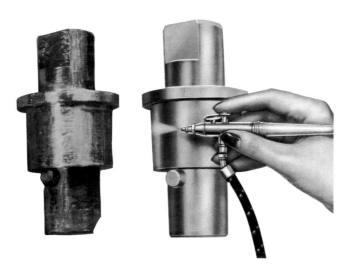

Before (left) and after (right) airbrushing.

Airbrushes are either "single action" or "double action." In the single-action airbrush, the flow of paint or ink is produced by pressing down on the finger trigger. The single-action airbrush has a control valve that regulates the flow for fine or coarse effects, and the width of the spray pattern can be varied during a single stroke, by varying the distance between he nozzle of the airbrush and the surface being sprayed.

The spray of a double-action airbrush is controlled by pressing the finger trigger while pulling back on the trigger. The fineness of the spray can be controlled by various special tips that are used on the airbrush.

An airbrush is run by an air compressor or a carbon dioxide cylinder. Usually, 25–30 lb. of pressure is sufficient for most airbrush work. The lower the pressure the coarser the spray.

The airbrush may be used free-hand for painting uniform backgrounds; however, masks or *friskets* are required for isolating specific areas to be sprayed and for precise spot-retouching.

Masking for Airbrushing. If a distinct shape must be airbrushed, a blotter or a sheet of acetate is cut to the desired shape and placed in position on the surface of the artwork. The spray is then directed along the edge of the mask. When the mask is removed, the airbrush pattern will be shown. If the mask is slightly off the surface when directing the spray, the sharp edge is softened.

A frisket can be laid over the art.

Friskets for Airbrushing. If the area to be airbrushed is too complicated or too large for a mask, a sheet of adhesive-backed frisket can be laid over the surface of the art. The frisket is then carefully cut away and removed from the area to be airbrushed. When the desired effect is obtained, the frisket is removed. If necessary, a frisket can be placed over an airbrushed area without doing harm.

Friskets will isolate the area to be airbrushed.

KINDS OF HALFTONES

Square-Finish Halftone. A square-finish halftone is any halftone whose outer edges form a rectangle. This is also called a conventional halftone.

Combination Halftone. The combination halftone combines a line negative, such as type, with a halftone negative to produce a single printing image. The continuous-tone original art is prepared in the same manner as for normal halftone reproduction. The line image may be superimposed on the halftone (surprinted); or a film positive of the line image can be used to form open images in the halftone (reverse printed). When preparing this type of halftone remember that the halftone dots distinguish the type. Place the type so that surprints are within a highlight and reverses are within a shadow area. Choose a sans serif type, as small, hairline serifs may not reproduce, since the edges of the type will be formed by dots.

Combination halftone.
Here the word, Pittsburgh, reverses out of the printed photograph.

Conventional (150-line screen) halftone.

Vignette Halftone. Vignetting is the gradual and subtle fade-out of a halftone screen pattern from the background of a halftone. This technique is popular in portrait photography. A properly prepared vignette will not show a sharp demarcation between the printed and nonprinted areas of a photograph, but will show a soft, gradual blending of the halftone edge into the paper.

Outline or Silhouette Halftone. An outline or silhouette halftone emphasizes a particular segment of a halftone image because the background is removed. Unlike the vignette halftone, the outline halftone has an immediate and abrupt transition

Vignette halftone.

between the printed and nonprinted areas of the photo. To make a silhouette halftone, the artist should outline the original continuous-tone copy in the desired shape on a tissue overlay and specify the removal of all halftone from the remaining background area. The film image assembler or camera operator does this by opaquing the halftone negative, or by photomechanically making a mask, covering the area that will not appear in the final printed piece.

The artist can do the silhouetting. He or she can prepare a mask by opaquing the unwanted area on clear acetate that is taped to the photo. Another method is to place a masking-film overlay over the entire photo and, with a sharp blade, trace the area that is to be masked. Then peel the masking material from the area that will not be seen in the final print. The overlay, by either method, is used as a mask to photomechanically outline or silhouette the halftone image. A third way is to use white paint to silhouette the subject directly on the continuous-tone copy. However, when halftoned, the white paint will reproduce with highlight dots in the final printed piece.

Positive-Halftone Prints. Positive-halftone prints (also called prescreened halftones) are photographic paper prints made from halftone negatives. Positive-halftone prints can be pasted directly on the paste-up and reproduced as line copy because the screened positive-halftone print is made up of dots, and the film will record them as line work.

The screened paper print is frequently used to minimize the cost of production. It is less expensive for the artist to silhouette

Outline or silhouette halftone.

Positive-halftone print.
Note the dots are easily seen. This halftone print is comparable to an 85-line screen halftone.

Rescreened halftone.
Large moiré pattern caused by rescreening a previously screened printed halftone without the use of a rescreening or interference filter.

and vignette on a screened print than it is for the graphic arts photographer or stripper to do the same retouching on halftone negatives.

The major disadvantage of a screened print is that halftone quality is reduced because of two extra steps in production. When making a conventional halftone, continuous-tone copy is exposed and processed into a halftone negative, and this negative is used for platemaking. When making a screened print, continuous-tone copy is made into a halftone negative then into a screened print, and then the already screened copy is shot as a line negative. With each step, some quality is lost.

Rescreened Halftone. There are occasions when an artist is forced to use a halftone illustration taken directly from a previously printed piece. For best reproduction, it is necessary for the printed halftone to be rehalftoned, particularly when the copy must be resized. When rescreening is required, the artist should specify that a rescreening or interference filter be used to avoid objectionable moiré patterns in the final print.

Moiré patterns in a rescreened halftone are caused by the misregister or conflict between the ruling of the halftone screen and the dots or lines of the previously screened printed halftone. Moiré can be alleviated by changing the screen angle or by using a different pattern or fineness of the halftone screen. Sometimes changing the size of the reproduction or diminishing the photograph's sharpness helps. For more on moiré and how it can be avoided, see Section Sixteen: Color Photography.

Section Nine: Scaling Art

All camera copy must be scaled before it can be reproduced. By properly scaling the artwork the artist tells the camera department the exact percentage of reduction or enlargement required, or that the copy is to be reproduced "same size." Camera copy is not only scaled to size but must often be cropped by the artist. This tells the film assembler what portion of the image must appear on the negative and plate.

The *diagonal-line method* is the most widely used method of cropping and scaling artwork. Along with this method a proportional scale or pocket calculator is used to determine the percent reproduction size of the artwork. Using the diagonal-line method, crop lines are drawn on tissue that has been placed over the artwork. Never rule these lines directly over paste-ups or camera copy without placing a sheet of acetate or mylar between the paste-up or original artwork and the tissue overlay. Use little pressure to avoid a depression on the mechanical or across the image area of the original art. Rule crop lines on the tissue with a thin felt-tip marker. Do not use ball-point pen or pencil.

Diagonal-Line Method of Cropping and Scaling Artwork. (See illustrated sequence of steps.)

1. Place an acetate sheet and then a tissue overlay on top of the paste-up and trace the reproduction size mask onto the tissue, extending the bottom right and upper left lines.

2. Draw a diagonal line from the lower left corner extending through the top right corner.

3. Remove the tissue overlay and acetate sheet and place them over the copy to be scaled so that the two extended lines define the bottom and left edges of the desired image area.

4. On the tissue overlay, draw perpendicular lines for the top and right margins of the desired image area, connecting the lines at a point on the diagonal line. These lines show where to place the crop marks.

5. Place thin crop marks on the borders (nonimage area) of the artwork using a grease pencil. This allows the marks to be removed and the artwork to be used again with a different set of crop marks. Only one set of crop marks should be used on each piece of camera copy. More than one set is confusing. Remember, never place crop marks in an area that will be printed. If you are using a full-frame illustration without borders, mount the artwork on a board larger than the artwork, and place crop marks accordingly.

6. Indicate the exact dimensions of both the reproduction size and the area that is cropped to fit the repro size on *the tissue overlay*. These figures will be needed when determining the percent reproduction size.

Tracing the reproduction size, extending the bottom right and top left lines.

Next, calculate the percentage of enlargement or reduction of the artwork using a pocket calculator or proportional scale.

Calculating the Percent Reproduction Size Using a Calculator. The simplest and most accurate way of determining percentage of enlargement or reduction is to use an electronic calculator.

1. Divide one dimension of the reproduction size desired by the corresponding dimension of the cropped original.

2. Multiply this figure by 100. The result is the percentage of

Drawing the diagonal line from bottom left through top right corner.

Drawing lines that connect at the diagonal to indicate cropped area.

Placing the sheet of acetate and tissue over the copy to be scaled. Let the left and bottom lines define the edges of the desired cropped area.

Placing crop marks on the borders (nonimage area) of the artwork using a grease pencil. Grease pencil is easily removed so the photo can be used again with a different set of crop marks.

The dimensions of the repro size and the cropped area will be used to calculate the percent reproduction size.

reduction or enlargement of the original needed to fit the area designated on the paste-up.

3. Check your answer by doing the same calculation using the measurements from the other two dimensions.

Calculating the percent reproduction size using a calculator.

Determining Percent Reproduction Size with a Proportional Scale. The most common proportional scale has two round disks, each with a scale marked in fractions of an inch. (There are also metric and pica scales.) The inside scale represents the original size, and the outside scale represents the final

or reproduction size.

1. Align one dimensional measurement of the original (inner scale) with the corresponding dimensional measurement of the reproduction size (outer scale).

2. Look at the scale's window to find the number the arrow points to. This is the percentage of reduction or enlargement needed of the original size.

Finding the percent reproduction size using a proportional scale.

3. While the scale is in place, look for the other dimension on the outer scale. The corresponding original dimension should align directly below the desired reproduction size for that dimension.

If the entire image area of the original is to be used, add one or two percentage points to the final percent. This is to ensure that the image completely fills the window allowed for it on the film assembler's negative. It is far better to have the negative a percentage point larger than originally figured than fall short of filling the window completely. This rounding eliminates costly remakes and the size increase is usually not noticeable.

Designating Reproduction Size. By custom, reproduction size should always be expressed as a percentage of original size. (The focusing scales on the process camera are calibrated in percentages.) For example, assume the original has a horizontal dimension of 18½ in. that is to be reduced to 14 in.; the reproduction size is 76%. Assume the original has a horizontal dimension of 14 in. that is to be enlarged to 18½ in.; the reproduction size is 132%. When marking the copy, this percentage of reduction or enlargement should be marked with grease pencil in the border, margin, or mounting of the artwork. To enhance communication between artist and camera operator or commercial lithographer, many artists will mark reproduction size as *76% of original,* or *132% of original.* Do not mark within the image area of the copy.

Some artists will include percent reproduction size *and* linear dimensions when marking in the margins of the copy. This is a dangerous and confusing practice. The camera operator won-

ders which to follow. Therefore only designate the percent required.

Finally, since each piece of copy has its specific placement on the paste-up, remember to write the number or letter given to the artwork (check the paste-up) in the border *on the front* of the artwork, or on the attached mounting that carries the percentage of enlargement or reduction.

Minimizing Variety of Reproduction Sizes. When the nature of the art permits, and on jobs containing many pieces of comparably sized artwork, the artist should make slight changes in cropping to reduce the number of different percentages. For example, if a group of similar subjects calls for reductions of 54%, 54½%, 55½%, and 56%, they should all be cropped and rescaled to 55%, if possible. This often permits four pieces of artwork to be shot in the time it takes to produce one large negative rather than four smaller ones. This will simplify the camera operator's job and reduce the cost of production without harming the design of a piece.

Section Ten: Graphic Arts Film

The designer or artist rarely becomes involved in the consideration of the film that is used for photomechanical reproduction. However, knowledge of the common types of film normally used, and their significant characteristics, helps the artist to understand why art should be prepared in certain ways for reproduction. In addition, such knowledge makes it easier to discuss special problems with the graphic arts photographer because the artist understands the basic principles of process photography.

Graphic arts films can be categorized by three criteria: (1) color sensitivity; (2) contrast; (3) base material and thickness.

Color Sensitivity. Daylight (white light) is an equal combination of the three primary colors: red, blue, and green. Artificial "white" light contains a mixture of all the spectrum colors, but the proportions of the colors vary, producing white light that may appear somewhat yellow, or blue, or red.

The color emitted by the lights on most process cameras is quite close to the theoretical "true" daylight. Film emulsions are formulated to be sensitive to all the colors in light or only to certain colors. There are good reasons for the availability of films with these special color sensitivities. Under the criterion of color sensitivity, films are classified in three groups:

Blue-sensitive film is sensitive to only the blue portion of the spectrum in white light. It does not "see" red or green so does not record red or green.

Blue-sensitive film, sometimes referred to as "color-blind" film, is best used for making film contacts for two principal reasons. (1) The nature of the emulsion and its processing chemistry offers considerable exposure and processing latitude; and (2) because the film is sensitive only to blue light, it can be handled under either a red or a yellow safelight. This characteristic is quite useful because the contacting procedure frequently involves producing a composite film for platemaking that may be a complex combination of film pieces each requiring a separate exposure.

Orthochromatic film is commonly referred to as ortho film, and is sensitive to light from the green as well as the blue regions of the spectrum. It does not "see" red light and therefore it can be handled under red safelight in the darkroom. Ortho film is the most widely used photomechanical film, for both line and halftone work. Because ortho is not sensitive to red light, the artist is able to use both red- and black-colored materials in preparing camera-ready copy. How this is done is explained in Section Eleven: Assembling the Paste-up. Since ortho film is sensitive to both blue and green light, exposure times are considerably shorter than would be possible if blue-sensitive film (such as that used in the contact frame) was used in the process camera.

Panchromatic film is commonly referred to as pan film, and is sensitive to all the colors of light that exist in the visible spectrum. It must be handled in total darkness. The most important use of pan film in process photography is in the reproduction of full-color copy, such as color transparencies, color prints, and art renditions. Panchromatic film is also used with colored filters that allow the film to see multicolor original copy as one color. This permits the graphic arts photographer to keep or eliminate portions of the copy.

A practical example of color elimination using pan film and filters is reproduction by the photographer of a black-and-white paste-up that has had some coffee spilled on it. By using pan film and a yellow filter, the photographer can reproduce the artwork without the coffee stain and without requiring a new paste-up.

Contrast. The tonal differences between highlight and shadow areas of an image represent its contrast. The way in which a film emulsion records the tones of a gray scale, graphically represented, is referred to as the characteristic curve of the emulsion. The gray scale, used to measure contrast, is a strip of photographic film or paper of graduated tones. A film gray scale will have tones ranging from a dense solid black to transparent. Film gray scales are used when reproducing transparent copy or making contacts. On a paper gray scale, from which light is reflected rather than transmitted (as it is with film), the tone gradation will range from a solid black to a pure white. Paper gray scales are used when reproducing reflection line work or halftoning reflection copy.

The gray scale is placed at the side of original copy and photographed along with the copy. In line work, the gray scale will check the negative or positive film for proper exposure and development. It will also measure the tonal range and fidelity obtained in halftone work. For color separation negatives, it will help determine color balance and proper tonal range of the separation negatives.

For film contacts the gray scale is placed on the film in the contact frame and is used to check the film contact for proper exposure and development.

High-contrast graphic arts film is referred to as lith-type film. Depending on exposure and development times, this film will record the graduated tones of a gray scale as either black or white. It will not record shades of gray. High-contrast film is the most commonly used graphic arts film. It is used extensively for

reproducing line work and halftones using a process camera, and for making contacts in a contact frame.

Continuous-tone graphic arts film will record all the graduated tones of the gray scale and the original copy. This kind of film is of lower contrast than the lith-type film and is used primarily in the color separation process.

Film Bases. Photographic emulsions are coated onto transparent film bases that are characterized by their thickness and the material from which they are made. The stability or degree of resistance to dimensional distortion caused by variations in temperature, humidity, and handling is dependent on both of these characteristics. The thickest and most stable base material is 0.007-in. polyester. A 0.004-in. polyester base is slightly less stable, and acetate-base film or polystyrene-base film even less. Film bases and thicknesses are selected according to the requirements of the job.

Work that calls for critical register requires a thick polyester base. Line work, or work that does not demand critical register, can be reproduced on a thin acetate-base film.

Section Eleven: Assembling the Paste-Up

To complete a paste-up (also called a mechanical) the artist begins by pasting all of the line-copy elements that can be photographed as a unit on a stiff base sheet of paper or acetate, by following the final layout or comprehensive. This is called the *base art* and includes type and line drawings—in short, anything that is not continuous-tone copy. Continuous-tone copy is not included on the base art because it must be photographed (halftoned) separately. See Section Eight: Types of Copy and Section Nine: Scaling Art for more on preparing continuous-tone art for reproduction. The paste-up often requires an overlay; for instance, when preparing art for surprints, reverses, or to indicate color breaks. Preparing overlays is detailed in the following section, Section Twelve: Overlays.

MATERIALS AND EQUIPMENT

Many kinds of materials, equipment, and tools are available for the artist to use to complete a paste-up. The choice of materials, the techniques used, and, therefore, the equipment and tools required, depends on the complexity of the job as well as the production procedures of the particular printer.

Some tools used for art preparation.

When preparing copy to be reproduced on an office duplicator, preprinted stock masters may be all that is needed. The manuscript may be typed directly on a master, and rules and line art can be added to the same master—in effect, the mechanical could be produced using only a typewriter, a ruler, and a pen. At the other extreme, a studio or art department may use a light table; a drafting table equipped with a highly sophisticated drafting machine; a large variety of triangles, templates, and adjustable curves; a compass; a swivel knife; numerous markers, paints, inks, and dyes; and a variety of art boards, paper stocks, and overlay materials, to name a few. To be sure, the materials and techniques used will vary from job to job.

Paper grids printed with nonrepro blue guidelines.

Grids. Base sheets preprinted with nonreproducing blue guidelines are often used when assembling a paste-up. Referred to as *grids*, the preprinted, lightweight paper sheets are most often used when assembling a large number of paste-ups that follow a similar design and format, such as pages of books, magazines, and newspapers. The same grid format is followed when the designer makes the comprehensive layout.

Grids are also printed in black on a clear acetate master sheet. This master grid is taped to a light table and either a blank sheet of lightweight translucent paper or clear stable-base plastic (acetate) is taped over the grid. The paste-up is then done on the paper or acetate following the guides of the grid.

GUIDELINES ON THE PASTE-UP

Before the artist can paste up the copy elements, certain marks

Clear acetate master grids.

that will be used as guidelines in the production of the printed piece must be ruled on the base sheet. All these marks are drawn in the nonimage area of the paste-up.

Crop or Trim Marks. Crop or trim marks indicate the final dimensions of the printed piece. They are drawn in the corners of the paste-up with black ink so that they will reproduce on the negative and can guide the film image assembler, as well as indicate to the bindery where to trim the printed sheets. Crop marks should be placed 1/8 in. back from the actual corner of the paste-up; that is, they should not meet to form a right angle, as they may appear on the final printed piece.

Fold Marks. Fold marks are drawn as thin dotted lines outside the trim area of the piece to show the printer and binder where the piece will fold.

Center-of-Image Marks. The center of all pages (vertical and horizontal) must be located and marked as a thin black line outside the trim area. Center-of-image marks help the film image assembler or platemaker prepare the plate properly.

Each of these marks and other inked lines are drawn with a technical pen. It is best to draw trim, fold, and center marks each as a thin line using a very narrow tip. Ruling pens can also be used, as the thickness of the lines drawn with a ruling pen can be varied by adjusting the vise of the pen. Other marks such as perforation indications and diecutting guidelines are usually drawn in nonreproducing blue pen.

Any ruled line that is part of the printed image should also be drawn at this stage in the paste-up. Ball point pens and fine-line markers are sometimes used to draw lines, but the ink flow is not consistent enough and line width is not uniform enough for high-quality work. Rules are often drawn slightly longer than necessary, and the excess is painted over with a brush and opaque white paint. This produces a neat, clean line ending. The white paint can also be used to cover any mistakes that may have been made when using the technical pen. Rules can also be drawn on a separate piece of coated stock, which is trimmed to the desired length and then positioned. Ruled lines are not always hand-drawn, but often made by the phototypesetting machine on the galley along with the typeset copy. The width, length, and leading of the lines are specified by the artist when the copy is ordered.

Other Production Requirements. It is the rare job where the artist need only be concerned with each page or unit of the piece as if it were the only page. Book or pamphlet work invariably requires pasting up at least two pages on a single base sheet. The artist must then consult with the printer to determine whether he or she should paste up facing pages as units, or folding pages as units. When multiple units are to be pasted up, the printer may require more than just trim, center, and fold marks. The greater the number of units on one board, the more marks required. It is important to consult with the binder and finisher, and to determine their needs for special guidelines.

BONDING THE ART TO THE PASTE-UP

After all guidelines have been included, the artist can bond each art element in its appropriate position on the mechanical. But first each element, beginning with the type, must be cut from the galley or trimmed before being placed on the paste-up. If possible, the elements to be mounted should be trimmed no closer than 1/8 in. from the image. If the edge of the cut-out copy creates a shadow on the negative when the mechanical is photographed, this margin will allow the shadow to be deleted easily without disturbing the art. It is good practice to use scissors when *first* cutting the copy from the galley. Since scissors give the paper a beveled edge, a shadow is less likely to occur on the negative than if a knife is used.

The three common bonding materials are (1) *wax*, (2) *rubber cement*, (3) *pressure-sensitive adhesive*.

Wax. Wax is the most popular adhesive used to bond art to a paste-up. Waxing machines range in sophistication from simple hand-held applicators that allow the artist to roll a thin, even coat of wax onto the back of copy to waxing machines that apply the melted wax to copy as it rolls through a series of distributor rollers. Most waxing machines allow the operator to control wax film thickness, melting temperature, and the speed of application. Waxing machines are more convenient and easier

Waxing machine.

to use than rubber cement. However, while wax bonds are repositionable, wax bonds are not as secure as rubber cement. If wax is used, it is usually applied before the copy is trimmed.

Rubber Cement. There are two types of rubber cement used today, *one-coat* rubber cement and *two-coat* rubber cement.

There are also three ways of using the cement; the dry-to-dry method, the wet-to-wet method, and the wet-to-dry method.

Using the dry-to-dry method, the rubber cement is brushed onto both the back of the trimmed copy and the surface of the paste-up. Both surfaces must dry completely before the copy is positioned on the paste-up. Drying may take several minutes, but the resulting bond between the copy and the paste-up is stronger than when using any other method. With the wet-to-wet method, the cement is brushed onto the copy and surface of the paste-up, but before the surfaces dry, the copy is positioned on the paste-up. Rubber cement is applied to only one surface using the wet-to-dry method. The cement is still wet when the copy is positioned.

Rubber cement.

A very strong bond is achieved with dry-to-dry bonding. However, while the other methods allow the copy to be repositioned, dry-to-dry does not. To remove or reposition copy, a small amount of rubber cement thinner applied to the edges of the copy will loosen it. The dry-to-dry method must then be repeated in order to adhere the copy to the paste-up again. In addition to the extra time required to mount art by this method, there are two other disadvantages. Dirt tends to accumulate around copy edges, and white copy, particularly phototypesetting paper, may fade to yellow over time. The degree of fading is dependent upon the quality of the rubber cement used and the age and type of phototypesetting paper.

Excess rubber cement on the paste-up and along the edges of the copy is as easily removed as wax is. A rubber cement "pick-up," a commercially available wedge of resilient rubber, can be rubbed along the paste-up, picking up dirt and excess cement. Excess wax is removed with a paper towel that has been wetted with rubber cement thinner.

Pressure-Sensitive Adhesive. The latest advance in bonding methods utilizes pressure-sensitive adhesive. A thin, uniform sheet of adhesive is placed on the back of the copy. The copy is then rubbed onto the paste-up or, together with the paste-up, rolled through a specialized machine that exerts pressure. The adhesive is neither a wax nor a rubber cement. The

Pressure-sensitive adhesive.

adhesive bonds quickly and, depending on whether hand- or machine-burnished, produces either a permanent or repositionable bond of the copy on the mechanical. If copy must be replaced or repositioned, the copy can be lifted and the adhesive backing will remain usable and intact. There will be little or no adhesive residue on the surface of the paste-up.

COMPLETING THE PASTE-UP

Once the copy is positioned on the paste-up according to the layout, the correct horizontal and vertical alignment of each element is checked with a T square and triangle. The copy is then burnished, or rubbed down, to secure the bond. A piece of tracing paper should be placed over the paste-up to protect the

copy while burnishing. Correct positioning is then rechecked, since burnishing may shift the copy.

All art elements that require enlargement or reduction different from the mechanical must be submitted as pieces separate from the mechanical (unattached). Continuous-tone and full-color copy must also be submitted individually, as these art elements require different handling. For ease in handling, most artwork can and should be mounted on a suitable board or paper

Positioning copy on the paste-up.

and covered with a tracing paper tissue overlay. The tissue overlay not only protects the art but carries instructions and explanations to the printer. However, writing on the tissue overlay should only be done after a piece of acetate has been slipped between the artwork and tissue. This prevents indentations into the surface of the artwork.

All line-art elements should be mounted on the paste-up to eliminate costly stripping time. When these elements are originally drawn, they are likely to be larger than reproduction size. The art can be shot to final size on high-contrast photomechanical transfer paper and mounted directly on the paste-up.

Costly errors are avoided in production when separate art elements are properly keyed and coded so that the graphic arts photographer and stripper know exactly where each copy element is positioned on the paste-up. A letter or number on each unattached art element should correspond to the paste-up. If a separate art element, such as a photo, is coded as "Copy A," the appropriate area on the paste-up, or tissue overlay, also should be marked "Copy A."

There are four ways of preparing a mechanical to indicate separate (unattached) art elements: (1) *keylining*, (2) *position-only print method*, (3) *halftone print method*, and (4) *window method*.

Keylining. Using black or red ink, the artist can outline the area on the paste-up where separate art elements are to appear. When photographed, the clear outline on the negative becomes a cutting guide for the film image assembler. After carefully cutting through the clear outlines to produce an open window in the film, the film image assembler will tape (strip) a halftone negative of the art into the window. Keylining is also used to indicate butting of solid colors.

Keylining to show where the halftone will be placed.

Position-Only Print Method. The artist can photostat separate art elements to reproduction size and then paste the photostats in proper position directly on the mechanical. Photostats present the advantage of allowing the artist to see the image in its reduced or enlarged state, and they help the film image assembler to properly position the halftone negative. They have the disadvantage of sometimes being dimensionally unstable and, therefore, imprecise in their reduced or enlarged form. Once placed on the mechanical, a photostat that is not for final reproduction must be clearly marked in black or red that it is "for position only." This precaution is taken so that the film

"For position only" is marked over the photostat so that the stripper will not be confused.

image assembler is not confused between the photostat negative and the negative of the original art. Sometimes it is the most accurate way of indicating placement to the stripper.

The film image assembler will remove the photostat and strip in the halftone negative or indicate to the platemaker to "double burn" the plate.

Halftone-Print Method. Halftone prints are positive photographic paper prints made from halftone negatives and are an easy way to reproduce continuous-tone copy. These positive-halftone prints are placed directly on the paste-up and repro-

A paper print of the halftone. . .

. . .can be pasted directly on the paste-up.

duced as line copy because the screened positive-halftone print is made up of dots and the film will record them as line work. However, a major disadvantage of using a positive-halftone print is that halftone quality is reduced. For more on using halftone prints see Section Eight: Types of Copy.

Window Method. This is the most commonly used method for indicating placement of halftones and screen tints on the paste-up. Following the window method, the paste-up artist applies an adhesive-backed, red masking material to the mechanical where separate artwork will print. This red mask appears as a clear window on the negative made from the base art. With this method, a halftone negative is made of the original photograph instead of a halftone print. The stripper positions the halftone negative behind the clear window made for it. The window method is often preferred since finer screens can be used than those used in the halftone-print method.

A block of adhesive-backed masking material indicates where separate artwork will print.

Quite often a positive-halftone print, shot to reproduction size, is mounted on a paste-up over the window, after it has been cut smaller than the red window. By referring to the mechanical, the stripper can make certain no errors are made when stripping the negative of the separate art element.

TIPS AND TECHNIQUES FOR PASTE-UP

- Because cut marks on the paste-up will show as clear on the negative, corrections within typeset copy must be made carefully. Mortise cutting is an effective way to eliminate outlines around single- or two-word corrections. Place the correction over the original type using a light table. Rub the new type into position. Cut out the correction both through the old and new layers of copy. Remove the old copy and replace with the new. This creates a "jigsaw puzzle" fit leaving no cut marks.
- When entire lines or blocks of copy must be replaced, use a T square to line up type for cutting. Cutting both old and new copy with the T square will allow the edges to butt evenly and therefore be invisible.
- Whenever possible do not position rules as single elements as they tend to bow when finally burnished. Instead, position two or more untrimmed rules, then burnish and trim.
- Do not use transparent or masking tapes to adhere art or copy elements to the paste-up. Not only are tapes unreliable

for adhesive, but they also can distort the copy when photographed.

- Know the minimum reduction and maximum enlargement capabilities of the process camera used.
- If a design dictates two or more nontouching flat colors, all line art may be pasted onto the base art. The negative will be duplicated and the appropriate areas marked for each color. But remember to indicate the color breaks correctly on the tissue overlay.
- Though the last stages are not the best time to remedy errors in the mechanical, it is better then than not at all. Before sending the paste-up to the next production stage, recheck the following:

■ Measure for correct dimensions of the paste-up on all boards.

■ Check that all color breaks and instructions are clearly indicated on the tissue overlay.

■ Be sure to include all photos and other separate art elements, color swatches, and the comprehensive and folding dummy.

Section Twelve: Overlays

When a layout or comprehensive calls for a surprint, a knockout, a silhouetted halftone, overlapping flat colors, or full-color artwork that butts a solid color, it is not practical to place each of the elements on the base art. Examples of such cases: black type printed over black halftones; reversing type out of a background; silhouetting the background of a photo; printing two or more overlapping flat colors, such as a rainbow effect; and a four-color photo that is tightly framed with a black rule. Under such circumstances, all elements can be made a part of the final camera-ready mechanical by using overlays.

Overlays are usually frosted or clear acetate or mylar. All overlays should be hinged at the top with masking tape so that they can be flipped entirely out of the way when the base art or separate art element they are attached to is to be photographed.

Overlays for Surprints. The base art will include all elements to be printed in the key color (usually black) shot as

This masked area (background) will print in a tint of cyan and the type will print in black. Note the register marks placed on the base art.

Peeling amber masking film from its acetate carrier sheet. This becomes an overlay to indicate a tint of ink. Note the overlay is hinged at the bottom since the copy to be tinted falls at the bottom of the paste-up.

line work. A surprint, such as type that overprints a halftone, should be prepared so that the type that will surprint is pasted on an overlay, which is properly positioned over the halftone area of the base art.

Overlays for Knockouts. To produce a knockout, such as type that will reverse out of a solid color, the type should be pasted on an acetate overlay, correctly positioned over the solid area on the base art. Even if the type will appear (print) white, black type can be used and the reverse will be photomechanically reproduced.

Overlays for Silhouetting Halftones. Exact silhouetting for photographs can be done with an overlay of red or amber peelable masking material that is adhered to a transparent acetate carrier sheet. A piece of masking film is cut larger than the size of the desired photograph. The film is hinged at the top over the photo. The outline of the image to be silhouetted is cut into the peelable masking film layer, but not into the acetate carrier sheet underneath. A second piece of acetate should be placed under the overlay to protect the photo while the masking material is being cut. The red or amber peelable mask is then peeled from the unwanted area, such as the background area of the photo. The clear carrier sheet becomes the overlay when the unwanted masking material is trimmed and peeled away. Register marks should be placed next to the photograph and it should be covered with a protective tissue overlay.

Overlays for Overlapping Flat Colors. Base art that is prepared from a design of flat colors that overlap, such as a

square of green and a square of red that touch, require a separate overlay for each color. In other words, two sheets of peelable masking film are hinged to the paste-up. Each film is cut in the square shape (overlapping a hair) and the background film is peeled away, leaving two amber or red squares, to indicate where the color will print.

An alternative to cutting overlays for overlapping flat colors is to draw keylines on the base art in the square shapes and let the masks be made photomechanically. The tissue overlay placed over the paste-up *must* contain an outline of these shapes with color and color identification filled in, and proper instructions to the printer. This type of keyline art is sometimes preferred to overlay art when hairline register is required.

Also, type or other art elements that print in different colors must be pasted on individual overlays if these elements overlap, touch, or come close to touching any base-art element. The overlay is positioned, in register, over the base art. This type of overlay is considered an overlay for color breaks. The base art and each (color-break) overlay are photographed separately. The resulting negatives are stripped separately and used to make individual plates for each color.

Overlays for Full-Color Art that Butts a Solid Color. When a full-color photograph is outlined by a solid rule, the photograph should be prepared as a red or orange mask placed in exact position within the rule. The rule should be placed on the base art.

To print these full-color photographs, overlays were used to indicate their placement on the paste-up. The black ruled lines were pasted directly on the base art.

Complex mechanicals requiring several photomechanical operations may require the preparation of more than a single overlay. Overlays do not always have to be the size of the paste-up but can be cut smaller, just a bit larger than the area to be covered. Register marks, either commercially available or ruled as very fine cross marks with black ink, should always be placed on the base art when using overlays.

Since, in reproduction, the base art and the overlays are photographed separately and the resulting negatives are combined by the stripper, the register marks will make precise positioning possible.

Finally, print the instructions for and identification of each overlay directly on the overlay with black grease pencil. This identification is useful if the overlay should become separated from the artwork.

THE FINAL OVERLAY

Once the paste-up is complete, it should be covered with a tissue and burnished. Another tissue overlay should be taped at

A tissue or tracing paper overlay is hinged to the top of the paste-up.

the top of the paste-up to protect it and carry information to the printer.

1. Instruction: instructions pertaining to color, tint percentages, reverses, knockouts, or any other information of use in the production operations following art and copy preparation should be clearly and neatly written on the tissue overlay.
2. Color breaks: as a precaution against any misunderstanding, using colored markers indicates the placement of each color on the tissue overlay.
3. Protection: Tracing paper or tissue overlays protect the camera-ready artwork from dust, fingerprints, and other damage that may jeopardize reproduction quality.

A tissue overlay protects the artwork, as well as carries instructions, tracings of the art elements, and shows the placement of color.

Section Thirteen: Types of Register

Registration is the accuracy with which images are combined or positioned. A printed, one-color job is in register when the images are correctly located with respect to all edges of the sheet. In other words, when the gripper-edge margins and the side-edge margins are correct throughout the run, the job is in register. A process color job is in register when the first color is correctly placed on the sheet and all other colors are properly placed in relation to the first.

To minimize register difficulties on press, all artwork should be prepared to simplify photography, film image assembly, platemaking, and press makeready. However, certain jobs do occur whose mechanical assembly of the elements is better left to the stripper, such as butting halftones and tints, making surprints or knockouts, and type reversals.

The kind of plan that the artist develops in consultation with the photographer, stripper, and platemaker for handling the preparation of a multicolor job depends on how critical the registration is.

Depending upon the complexity of the job, lithographers distinguish four types of register: **no register, loose register, lap register,** and **hairline register.** These terms are not standardized throughout the industry; in fact, many printers interchange these terms or use their own descriptions of register, such as close, butt, and tight.

No register means that several colors are completely independent of one another on the printed sheet. Textbooks often employ this use of color as spot color, printing text type in one color ink and headings and subheads in another color ink.

Loose register

Lap register.

be in writing. Keep carbons of all changes you make; they're convenient when you check the invoice for extra charges..

Approvals — type only
Depending on the size or complexity of the job, several kinds of proofs may be submitted to you for OK.
Galley proofs of the type before it is made up into pages give you an early chance to proofread, and to make *corrections* (printer's fault). Any *changes* (customer's fault) you make will be less expensive here than at later stages.

Approvals — lithographic proofs
Page-proofs of jobs without process color are often submitted by the printer as *silverprints* (also known as *brownprints* or *vandykes*). They

Color keys (also known a proofs, polychrome and Keys) impose each of th on sheets of transparent Each color can be separa the rest and checked ind this point more economi on the complete press pr
Scatterproofs are proofs c halftones placed in rand positions using either pr Cromalin or color key m Scatterproofs allow the p many halftones on a sin sheet.
Complete pressproofs are job, in effect, exactly as run on press. Proofs are hand or by power) from — in some cases, the act

No register.

Loose register means that minor variations in the relationship of one color to another are inconsequential. Rough shadings or blotches of spot color overprinted on a black line-drawing is an example of loose register. It is ideal to cut overlays for color breaks for these kinds of jobs so that each color is on a different "level" or overlay.

Lap register is achieved by overlapping a narrow strip of one color over the second color at the points that they join. This slight color overlap prevents the white of the paper from

Hairline register.

showing and is perceptible. Lap register eases the task of art preparation and minimizes register problems in stripping, platemaking, and presswork. Two black-and-white halftone photographs or screen tint panels separated by a thick red line is

considered lap register. Here overlay art is only useful if the desired lap allowance is in excess of 0.015 in. (0.38 mm). It is good practice *not* to butt colors of similar density, e.g., orange and green, as the lap will print as a dark line.

Hairline register is the joining or butting of two or more colors with no perceptible color overlap. Printing four-color photos side-by-side (touching) or printing solid colors (other than black)

that touch is printing hairline register. It is difficult to achieve precise hairline register, and, in fact, *some* overlap of color *must* occur to eliminate any white paper from showing; however, this overlap is considerably smaller than in lap register, and is not perceptible. Hairline register is best obtained from a single piece of base art that is prepared for reproduction with no overlays, but instead separated for precise register photomechanically.

Section Fourteen: Two-Color Process Copy

Producing a two-color process printed piece is not merely overprinting flat colors. The copy for two-color process printing is always a continuous-tone image such as a photograph or piece of artwork. The graphic arts photographer must create two different negatives from that single piece of copy. When these are printed one over the other the reproduction is called a duotone. Sometimes a halftone is printed over a flat solid or tint of another color. This results in an imitation or "fake" duotone, and is less costly than a conventional duotone.

"CONVENTIONAL" DUOTONES

A **duotone** is a two-color halftone image made from a single piece of continuous-tone copy with each printed ink emphasizing a different degree of the tonal range within the copy. The dominant ink, usually black, prints the full tonal range, while the less dominant, or second color, prints a smaller range of tones within the halftone.

The photograph or continuous-tone artwork is photographed twice through a halftone screen, with each image recorded at a different screen angle, at a different exposure, and on a different piece of film. The identical images are printed in register on the press. The dominant image is usually printed in a dark ink while the secondary image is printed in a lighter ink. The differing

tonal scales of the two images create an illusion of "more" in the reproduction than was in the original copy, because a properly made duotone extends the tonal range of the reproduction so that it closely approximates both the highlight and shadow areas of the original. This is usually not achievable in single-color halftone printing. For this reason duotones are used to render color, depth, and definition to a subject while hinting at the more expensive full-color process.

Artists will sometimes specify duotone reproduction of a halftone using a black for both colors (sometimes a black and a gray) to achieve the highlight to shadow tones of the original. The result is a black-and-white reproduction that is superior to a conventional black-and-white halftone. By convention, this two-impression black duotone is called a *true* duotone.

Keep in mind that duotones can be printed in almost any ink combination imaginable, including the same ink in varying tints, e.g., a dark blue and light blue; a dark red and light red. And, in specifying duotone reproductions, the artist is not limited to conventional halftone screens. Special effects can be created by using vertical-, horizontal-, or diagonal-line screens; circular screens; and mezzotint screens; and in varying line screen rulings.

The artist should provide the graphic arts photographer with suitable continuous-tone copy as would be submitted for

Conventional duotone—yellow and black.

Fake duotone—yellow and black.

conventional halftone printing. The copy should not be flat or contrasty but have a smooth and gradual tonal transition from highlight to shadow areas, yet be in sharp focus. Discussing the final duotone result wanted with the printer before the films are made is imperative, and providing the printer with ink swatches is the best method for ensuring that the proper result will be obtained.

As a service to the artist and lithographer, many ink and paper suppliers provide printed guides for duotone reproduction. These guides show the result created when printing various duotone color combinations with various paper colors, often called *tritones*. These are excellent designing aids, as they present a preview of what a particular ink and paper combination will

look like. Many duotone jobs have failed because clients were displeased with the result of duotone reproductions. On the other hand, carefully made duotones produced from properly processed negatives can simulate full-color reproduction.

"FAKE" DUOTONES

A duotone effect, sometimes known as a "fake" duotone, is created by combining a halftone and a solid or screen tint of a second color. The fake duotone does not produce the wide tonal range and sharp detail of a true duotone, but does add visual appeal. Since only one halftone negative is required in producing a fake duotone, the cost of reproduction is less than for producing a true duotone.

Section Fifteen: Four-Color Process Copy

Full-color copy is reproduced with three partially transparent inks, referred to as process inks, plus black. When combined and overprinted on white paper, these inks satisfactorily reproduce the color, tonal range, and detail of most types of original full-color copy. The three process colors are cyan, magenta, and yellow. Theoretically, cyan, magenta, and yellow should satisfactorily reproduce full-color copy when printed on a white substrate. However, because of imperfections in inks and papers, black is added to provide the depth and detail of original copy.

SUBTRACTIVE COLOR

Full-color reproduction is based on the subtractive color concept whereby color is selectively subtracted from white paper to produce color. For the purpose of color reproduction, white can be defined as equal amounts of red, green, and blue light waves. If it were practical to produce a white sheet of paper, the sheet would reflect equal amounts of red, green, and blue light that is seen by the eye as white. If either the red, green, or blue

Subtractive color mixing.

The effect of different colors of "white" paper when printed with cyan ink.

light is reflected, subtracted, or filtered from the eye, the visual sensation is that of another color. For instance, if the red light reflected from white paper were subtracted, the visual sensation to the eye would be that of the process color cyan. Cyan, therefore, transmits green and blue light and absorbs red light. If the green light were subtracted or filtered, the visual sensation to the eye would be magenta. Magenta transmits red and blue light and absorbs green light. If the blue light were subtracted, the eye would see yellow. Yellow then transmits red and green light waves and absorbs blue light waves.

With the subtractive concept of color in mind, one can understand that full-color process printing is really the selective subtraction of color inherent in white paper to produce a full-color printed piece. Because printing inks used for full-color process printing are partially transparent, they act as filters that subtract color reflected from the substrate. Each halftone dot of cyan, magenta, and yellow ink can be thought of as an individual filter. Theoretically, if cyan, magenta, and yellow were overprinted, the resulting color would be black, since the three colors in combination (one over the other) subtract all light reflected from the paper. However, like paper, printing inks are not perfect filters and therefore may not produce the deepest desirable black when overprinted. To compensate for the optical deficiencies of process inks and paper, the printer uses black ink as a fourth process color to provide the image tonal range and detail that is often required for faithful reproduction of original color copy. To overcome the combined deficiencies of papers and inks, full-color negatives often require correction by dot etching and color-correction masking, by the photomechanical department, or electronic color correction and manipulation on an electronic scanner.

KINDS OF FULL-COLOR COPY

Full-color copy is divided into two categories, reflection copy and transmission copy. All copy produced on an opaque material that reflects light, such as paper or board, is reflection copy. Examples include color photographs, paintings, drawings, etc. All copy that allows light to pass through it is called transmission (or "transparent") copy. A color transparency is the best example of transmission copy.

Viewing Color Reflection Copy and Transmission Copy. The way color is seen is affected by its environment, and surrounding illumination is the most important factor. Misunderstandings occur when a client or art director views a piece of color art under one type of illumination and surround, and the printing production manager, proofer, or press operator views the copy under a different illumination and surround. For example, fluorescent office lighting will give copy a "cool" effect, and tungsten light results in a "warm" effect. The reflected color of the surround will also affect color evaluation.

To overcome ambiguities caused by variations in illumination, the American National Standards Institute (ANSI) determined color viewing standards for the graphic arts industry. The standard calls for an illumination temperature of 5,000° Kelvin for viewing transparencies and reflection color copy, and for comparing such copy to proofs and production press sheets.

PREPARING FULL-COLOR COPY FOR REPRODUCTION

Compared to black-and-white copy, the problems in preparing full-color copy are multiplied. Here, the artist is not concerned with the control of one color, but with many colors. Color copy normally presents considerable expense; therefore, the artist must take all possible precautions to protect it.

The artist should try to specify color copy that will require little or no retouching. When producing photographs or transparencies, it is the commercial photographer's responsibility to "build in" good color balance, proper tonal range, and desirable detail. The less hand work required on color copy, the less chance there is for the art to become marred or even ruined, and the better the final print reproduction will be. However, when necessary, the skilled retoucher can perform miraculous retouching and image manipulation feats on color prints and, to a limited extent, on transparencies. Likewise, the electronic color scanner can color-correct and manipulate color electronically,

Reflection copy.

Transmission copy.

but this luxury does not preclude submitting or choosing quality copy.

Density of Color Copy. Tonal range density is as significant for faithful reproduction of color copy as it is for black-and-white copy. Extremely light highlight areas and extremely dark shadow areas will cause time-consuming and costly retouching and color correcting, or will result in reproduction difficulties on press.

The tonal reproduction of full-color copy can be predicted with a densitometer. Normally, detail will be reproducible within an optical density range of 0.2 in highlight areas to 3.6 in the shadow areas. Highlight areas of less than 0.2 in optical density and a shadow density of above 3.6 will tend to flatten detail. These measurements should be made in neutral highlight and shadow areas representing each color in the film.

The color reflection densitometer measures the amount of light that is reflected from the photograph and assigns numbers to that amount of light.

Retouching Full-Color Copy. Retouching and manipulating flexibilities are inherent in reflection color copy; very little can be done by hand to transparencies. Hand retouching can be performed on transparencies by using dyes and bleaches, but such work requires the skills of specialists who provide a unique transparency retouching service. Airbrushing directly on transparencies can be effective but only on the larger transparencies, such as the 8½ × 11-in. size. Normally, transparency retouching is expensive. If time permits, the artist may find that having new transparencies made is the more practical approach. A retouched transparency is subject to damage and loss. It is good policy to retouch a duplicate transparency to avoid ruining the original.

Retouching reflection color copy can be risky and time-consuming. However, reflection copy does provide the artist with flexibilities that are not available when working with transparencies. Airbrushing, for instance, is a realistic and often practical means of modifying or correcting reflection color copy. The artist can use paints, inks, or dyes. Care should be taken to minimize fluorescence caused by the use of some pigments and dyes. Fluorescence in retouched areas will "burn" or cause "hot spots" in the color separation films. There are new retouching dyes now on the market that are color-correct for use when color copy is to be color-separated.

COLOR SEPARATION OF FULL-COLOR COPY

The colors of both reflection and transmission copy must be electronically or photomechanically "separated" in order to produce the four negatives needed for making the printing plates required for printing the separate colors. The four separation negatives are the cyan, magenta, yellow, and black printers.

Nowadays the most prevalent method of color separation is electronic scanning. The negative for the cyan plate is produced by scanning the original color copy through a red filter. The negative for the magenta plate is produced by scanning the copy through a green filter. The negative for the yellow plate is produced by scanning the copy through a blue filter. The black negative is produced electronically by combining electronic signals from the red, green, and blue filters. The screen angle for each color separation must be different to avoid moiré patterns in the printed piece. The final corrected halftone negatives, or positives contacted from the scanned separations, are placed in register to one another and then used for platemaking.

DUPLICATING FULL-COLOR COPY

With the growth of color printing, the efficient color duplicating films, the color imagers, and photocomposing cameras now on the market, color duplication of original full-color copy has become a common procedure in advertising agencies and art departments. Each of the original transparencies or pieces of reflection copy that are to appear on one page are color-duplicated to a common scale or reproduction size. The color duplicates are then strip-composed or photomechanically positioned according to a layout. The complete layout is then color-separated as a unit, thus reducing costly scanner and stripping time and minimizing register and fit problems. In the case where six or more separate transparencies or color prints must be used per page, as is commonly the case in catalog production, twenty-four different negatives would have to be registered and stripped. In the case of strip-composed transparencies or assembled color prints that are color-separated as a unit, only four negatives must be handled.

Handling Full-Color Copy. When handling or submitting full-color copy to be color-separated, keep these guidelines in mind:

- Don't mount color prints on rigid boards that cannot be mounted around a color scanner cylinder.
- Consult with the color separator on the maximum artwork size the scanner or camera will accommodate. Likewise, know the maximum-size color-separation negative able to be made by the separator.
- Mark "TOP" on the front margin of color prints that may be confusing.
- Likewise scratch "TOP" in the emulsion of transparencies that may be confusing.
- It is a good idea to identify each transparency by scratching a job number in the nonimage area emulsion. Write a job number on the front margin (nonimage area) of color prints too. A pressure-sensitive label or a piece of masking tape containing this information can be attached to the back of color photos only if the prints will *not* be color-separated by an electronic scanner. Scanners often pick up writing on the back of prints and record it in the separation negatives.
- Submit all transparencies unmounted but protected in a plastic sleeve or plastic sheet with pockets. This also makes the transparencies easier to handle.

- Scratch the percentage or reduction or enlargement into the emulsion of each transparency. Additionally, write this percent with a grease pencil over the transparency on the plastic sleeve.
- Mounted transparencies present more trouble for the color separator than protection for the copy. Cardboard 35-mm mounts must be slit open, and plastic 35-mm mounts must be pried open before the transparency can be separated, usually with a knife or blade. Don't take the chance of accidentally scratching or cutting the emulsion of the transparency. Submit 35-mm transparencies unmounted.
- Glass mounts are no better protection than cardboard or plastic mounts. They can crack and splinter when opened or during shipping. Therefore, never mail fragile transparencies

in even more fragile glass mounts.
- Scratch the crop marks into the emulsion of transparencies. Crop marks on tissue overlays or on the protective plastic that covers the transparencies will not help the film image assembler because the marks will not show on the color-separation negatives.
- Include all pertinent information, e.g., reproduction size and instructions, with the color copy to be separated. Don't forget to include client comments. For example, if a client is generally happy with a transparency but comments that the overall green cast must be eliminated, and this comment is not written as an instruction to the color separator, the separator will most likely match the original in the separation negatives, and the separations will have to be remade.

Section Sixteen: Color Photography

Advancements in lithographic presses and inks, and the refinement of electronic scanners, densitometers, and prepress proofing systems have made it possible to accurately predict the color reproduction result of various ink, paper, press, and full-color copy combinations, and to precisely make the color-separation negatives and color-correction adjustments. This ability, coupled with the advances in color photography, makes it possible for the designer or artist to evaluate the reproduction suitability of full-color copy and to specify what is desired in the transparency, color print, or color duplicate, so that quality reproduction is achieved. To do this the artist must know the basics of color photography.

COLOR QUALITY OF ILLUMINATION

Though virtually unimportant in black-and-white photography, the color quality of the light source used is an extremely important aspect in color photography. Essentially, there are two types of color film with particular sensitivities (or "color balances") built into them. The first type is *daylight film*, or film that will accurately record color under daylight sources—a combination of sunlight and skylight. This film is said to be color balanced for daylight. The second type of film is *tungsten film*, which will accurately reproduce color under most types of incandescent light. Tungsten film is often used under the hot quartz lights of studios or when photographing work on a copystand.

Furthermore, color film does not "see" or record colors as human beings see them under varying light. For example, a book cover that appears green to a human in daylight will also appear green under incandescent light. In reality the type of light source illuminating the book *does* affect the color reaching the eye, but the brain automatically compensates for the change. Color film has no such automatic compensation; therefore, inaccurate recording of color will result if the film is not matched to the light source. If tungsten film is used to photograph a scene outside, the resulting color print or transparency will contain an overall blue cast. Similarly, if daylight film is used indoors, such as to photograph inside a home where conventional incandescent light bulbs are used, the resulting print or transparency will have an overall yellow cast.

When a photographer views a scene that is lit by two different

The effect of lighting on color perception. The subject on the left is under incandescent light. The one in the center is under 5,000° Kelvin. The right is under fluorescent light.

light sources—daylight and incandescent, his or her eye will adapt to see an intermediate color quality, reducing the color effects between the two sources. The film, however, does not adapt. If daylight film is used, the portion of the subject illuminated by incandescent light will record off-color. If tungsten film is used, the portion of the subject illuminated by the daylight will record off-color. In this case the photographer may choose to substitute electronic flash for the tungsten light since electronic flash units are made to be compatible and therefore "balanced" for daylight film.

Degrees Kelvin is the measurement scale used to measure overall color balance or illumination temperature (see Section Fifteen: Four-Color Process Copy) of a light source. The yellower the illumination, the lower the degrees Kelvin. The bluer the illumination, the higher the degrees Kelvin. For example, "typical" sunlight can be expressed as 5,500° Kelvin. Normal studio photoflood lights are rated at 3,200° Kelvin, and quartz studio lights, which are a bit bluer than photofloods, are rated at 3,400° Kelvin.

Kelvin degrees can be accurately measured with a color temperature meter, which numerically indicates the exact degree Kelvin. The photographer can, by placing special colored filters over the camera lens, compensate for or correct color imbalances between light source and film. Except when producing special-effect photography, a properly balanced photograph, especially in portraiture and critical color catalog work, can be the most critical aspect of quality color reproduction.

Changes in lighting direction alter highlights and color values—overhead lighting.

SUBJECT CONTRAST

At first glance, subject contrast might be considered only a property of the subject before the camera lens, but it is more. Suppose that a woman wearing a white shirt and a dark suit is being photographed. If the shirt reflects eight times as much light as the suit, and these are the lightest and darkest objects in which detail must be reproduced, one might assume that the subject contrast ratio is eight to one. Actually, eight to one is the *reflectance ratio.* From the point of view of the film, subject contrast involves an additional and very important factor, the *lighting contrast.*

Normal placement of lighting.

Main Lights and Fill-in Lights. Lighting contrast is the ratio between the highest and lowest amounts of illumination falling on the principal subject in a photograph. This is measured with a light meter. Continuing with the previous example, suppose the portrait of the woman will be shot using the simplest portrait lighting—only two lamps. One lamp would be placed at the same distance from the subject as the camera, but at a 45° angle from the camera axis. This light would be the *main light,* and would cast shadows that, seen through the camera, would define the contours of the subject's face. But the shadows cast by this single light would be dark enough to obscure some of the important detail of the face. Another light placed close to the camera would soften them. This is the *fill-in light,* because it would partially fill in with light the shadows caused by the main light.

With this particular lighting arrangement (two lamps of equal strength used at the same distance from the subject) the areas illuminated by both lamps would receive two units of illumination, while the areas illuminated by the fill-in light alone would

Lighting from the side.

Low-contrast lighting produces soft shadows and highlights.

The short exposure latitude of color film narrows the margin for error—overexposure.

Normal-contrast lighting.

Normal exposure.

High-contrast lighting produces hard shadows and sharp highlights.

Underexposure.

receive one unit. Thus the lighting ratio would be two to one. If the main light were replaced by another light twice as strong as the fill-in light, the areas illuminated by the fill-in light would still receive only one unit of illumination, but the areas illuminated by both lamps would now receive three units, and the lighting ratio would be three to one.

Soft Lighting. Even in black-and-white work, the skilled photographer knows that in lighting, special care must be exercised if detail in both the shadow and highlight areas are to be reproduced in the same picture. But since color transparencies are processed as positives by standardized techniques that do not allow the control possible in printing black-and-white negatives, softer basic lighting is mandatory. Light-colored and dark-colored objects cannot be reproduced successfully in the same transparency unless the lighting is adjusted to offset the more extreme differences in tone. If the lighting is not adjusted, dark areas will be much too dark and off-color, while light areas will be "burnt out" and lacking in color and detail. In general, the lighting ratio should not be greater than three to one. The use of higher lighting ratios for special effects should be undertaken only after considerable experience with relatively soft lighting.

Because of the short exposure latitude of color transparency film, it is imperative to determine lens settings properly, bracket exposures when possible, and process the film with the utmost attention to accuracy. Extra care must be exercised when working with color transparencies because the film that is exposed in the camera is the original used to make color-separation negatives. There is no separate printing stage as with negative-to-positive prints, in which compensation for over- or under-exposure in the camera can occur. However, original transparencies are sometimes used to make duplicate transparencies that may be retouched to improve the overall quality of the reproduction.

Color negative materials have somewhat more latitude than transparency films, because minor exposure or color-balance errors can be corrected when printing the photograph. For best results, however, they must be exposed with considerably more care than black-and-white films.

The Use of Exposure Meters. When determining camera settings, a photoelectric exposure meter is a must. Unusual lighting conditions and complex studio lighting arrangements particularly make accuracy impossible without one. However, the meter must be properly calibrated, and should be used in accordance with instructions. Furthermore, the photographer must be fully aware of the characteristics and limitations of the meter if he or she is to obtain consistently reliable exposure indications. For the most critical work, an actual photographic exposure test is recommended.

Daylight lighting conditions such as clear sun, hazy sun, etc., are constant enough so that it is practical to use fixed exposure recommendations found in tables, guides, and built-in camera computers. These recommendations give excellent results under the specified conditions. Similar exposure aids are supplied for use with simple arrangements of artificial lights.

CHOOSING FORMATS

The basic formats of cameras are the 35-mm, the $2\frac{1}{4} \times 2\frac{1}{4}$-in., the 4×5-in., and the 8×10-in. These sizes represent the size of the film used. It is a good rule of thumb to choose the camera/film size that will produce a print or transparency that will require the least amount of enlarging. For example, if the photographer is producing photos that will be printed in a brochure cropped to 3×4 in., then the sharpest detail and best resolution will be achieved using a $2\frac{1}{4} \times 2\frac{1}{4}$-in. camera. In general, the bigger the original format the better. Likewise, the least amount of enlarging necessary, the better the result. Usually the determining factor when deciding which format to use is the subject itself. For example, the size, weight, and flexibility of the 35-mm format is ideal when photographing moving subjects. When the subject is static, as in still-life photography, a large-format view camera, such as the 8×10-in., is the best choice. The large ground-glass viewing screen of an 8×10-in. camera allows the photographer to focus and compose the subject more accurately than a smaller camera does.

MOIRÉ IN FULL-COLOR WORK

Moiré is an undesirable pattern that occurs on the printed full-color halftone caused by a conflict between the screen angles and the lines or pattern of the original. Moiré is also caused by incorrect screen angles or misregister of the color impressions during printing. (Moiré can also occur in black-and-white photography.) Photographers can help reduce the chance of a disturbing moiré pattern in the final printed piece by knowing what subjects most often produce this effect. Closely spaced parallel lines and small checked patterns in photographic subjects have a high incidence of producing a moiré. For these reasons, avoid or watch for these possibilities in clothing and furniture fabrics, window screens, brick structures, slate roofs, patterned carpeting, wallpaper, drapery, and television screens.

Of course, it is difficult to predict what will definitely cause a moiré—some patterns that are thought to moiré may not—but an awareness of the potential problems will save time and money early in the reproduction stages before moiré is noticed on press.

Dos and Don'ts When Working with Photographs.
- Do mark "TOP" in the front margin of every photograph that may be confusing. This greatly helps the film image assembler when stripping the halftone negatives.
- Do flop a photograph when, for aesthetic reasons, the design calls for it. However, don't overlook items in the photo that, when flopped, will diminish the quality of the piece. Such things as buttoned clothing—a woman's coat buttons left over right, a man's buttons right over left—wrist watches worn on the left wrist, hair parts, anything that is printed and would be wrong-reading if flopped (clocks, signs, maps, labels, calendars, license plates, name plates on equipment), and machinery whose controls would be backwards if flopped should not be overlooked.
- When designing a photograph with a ruled frame around it, do remember to make the ruled line at least $\frac{1}{2}$ pt. thick to allow for image overlap when printing on a lithographic press.
- Do not cut photos to the crop lines.

Section Seventeen: Color Perception and Color Harmony

Color photographs occasionally show colors that appear faulty or false, but were actually present, though unnoticed, in the original scene. In judging results, photographers are frequently unable to compare the picture with the subject directly, but rely on a mental image of how the subject appeared when photographed. If photographers do not learn to observe color, that is, recognize subtle tints, mixtures, and reflections, they may find colors in the transparency or print that were not noticed in the original subject.

Unnoticed Colors. Unnoticed colors are largely due to the effects of lighting conditions and surroundings. An example is a snow scene photographed in bright sunlight under clear blue sky. Although it might be thought that shadows on white should be colorless, the picture shows bluish shadows. Actually, the shadows are blue, and appear so in the picture, because whatever light does reach the shadow areas comes largely from the blue of the sky.

Influence of Time of Day. A color photo taken outside early in the morning or late in the afternoon may come out too orange because the color of sunlight during these hours is quite orange. Although the warmth of color and shadow effects obtained early or late in the day may be desirable with architectural and scenic subjects, they seldom result in satisfactory rendering of skin tones.

Influence of Other Reflecting Surfaces. A third example is a portrait posed near a strongly colored reflecting surface, such as a red automobile, painted or wallpapered wall, or large building. The face and arms of the subject may look perfectly natural at the time the picture is taken, but the colored light reflected on them from the nearby object may produce an unnatural effect in the finished picture. It is interesting to note that if colored surroundings are actually included in the scene area, the resulting picture will seem more natural because the reason for the unexpected color in the subject is evident.

The Difficulty of Anticipating How Colors Will Appear in Photographs. There are two reasons why such color effects are more difficult to recognize in viewing the original scene than in viewing a reproduction of the scene in the form of a color photograph. First, the color of a real subject is commonly thought of as characteristic of it under all circumstances, and therefore no change is expected. Second, in viewing the original scene, the eye tends to reduce disturbing illumination color by adapting to it in a way quite beyond the powers of the film. The photographer can be trained to detect color effects in the original scene and take steps to prevent their appearance in the color picture. By doing this the photographer will attain a better appreciation of color and will improve his or her ability to remember colors and predict results in color photography. The experienced photographer avoids unnatural effects, and achieves realistic colors, by exposing film in the most favorable lighting and surroundings.

Color Differences between Objects and Color Photographs. The foregoing should not be interpreted as indicating that color films will provide a perfect reproduction of the colors of the light reflected from a subject into the camera lens. If critical measurements on the very best color photographs are made, considerable differences between their colors and those of the original subjects are found. Actually, there is no available process of color photography that can give entirely accurate and repeatable reproduction of color. Color films, properly used, however, do give "satisfactory" color rendering for their intended purposes, but present technical knowledge does not permit color materials to record precisely what the eye sees. Further, since the reproduction of a physical subject by means of a color transparency or print involves psychological factors in the response of the observer, it can never be "perfect" in any objective sense. It is often the designer's or artist's responsibility to educate the customer to the limitations of the reproduction process, and color photography is no exception.

Color Harmony. Color harmony is the systematic arrangement of colors to give a pleasing effect. The subject of color harmony is complex and very largely a matter of personal taste; nevertheless, a few general suggestions can be offered as a starting point.

THE HABITS OF THE MIND DECIDE WHAT IS PLEASING. Most outdoor scenes display good color harmony, probably because the mind has grown to accept the color combinations of nature as pleasing. Indoors, the colors of the background, clothing, and other properties are usually within the control of the photographer, and therein lies the danger that it is easy for the beginner in color work to become obsessed with the fact that a wide gamut of colors is at his or her disposal. However, the most pleasing photographs are generally those in which only a limited range of colors is used. The use of relatively unsaturated colors will frequently add to the naturalness of the color picture. In any case, care in selection of those colors that are subject to control will pay dividends in more pleasing results.

HARMONY IN COLOR PORTRAITURE. In portraiture, the face of the subject before the camera should be the center of interest in the picture. Since conspicuous patterns or contrasting brilliant colors in either clothing or background tend to distract attention from the face, they should be avoided. Clothing colors should harmonize with the complexion and hair color of the subject. Medium or light colors are usually more effective than dark colors or black, and do not require too much care in lighting to ensure satisfactory detail in the shadow areas. Large areas of solid, brilliant colors should be avoided because they are seldom pleasing, either in the original scene or in a color photograph.

BACKGROUND TREATMENT IN COLOR PHOTOGRAPHS. Unlike black-and-white photographs, color photographs do not require the use of a background lighter or darker than the subject,

because color differences help separate the planes of the scene. In general, the background color in a portrait should be *related to* the dominant color of the clothing, that is, one that lies near it on a color wheel. Touches of color complementary to the clothing color, that is, opposite it on the color wheel, are suitable for small areas or accessories. While these suggestions refer to hue, the photographer should never lose sight of the possibility, indeed desirability, of variations in brightness and saturation as well. All three characteristics of color play their parts in the success of the picture as a color composition.

THE USE OF COMPLEMENTARY COLORS. In commercial and illustrative work, where the principal subject will frequently dominate the picture simply because of its size or shape regardless of the color scheme, more dramatic effects can be obtained by surrounding the subject with complementary color.

Small touches of related colors will soften the severity of the bolder contrasts.

The Photographer's Originality and Personality. Color photography allows full scope to originality and individual taste. An observant eye can find endless ideas for effective color schemes in paintings, printed and woven fabrics, interior decoration, and in the purely accidental combinations that occur in everyday life. The effectiveness of a given color scheme depends not only upon the colors themselves, but also upon their comparative areas and their distribution in the scene area. The textures of the colored surfaces are also important, because they lead to different color rendering under different lighting arrangements. Ease in composing with color is to a great extent the result of experience and observation, but no color scheme can be entirely preconceived. There is always some adjustment, some shifting of the elements, until the scene "looks right" to the photographer.

Various design formats include folders, booklets, direct-mail pieces, magazines, greeting cards, and calendars.

The GATF Color Communicator can show the designer or artist the range of colors obtainable from the four process colors on various printing substrates.

After inserting the substrate to be printed in the viewing window, the white tabs are moved to the right until a visual match is seen through the window.

Effect of different colored papers on ink.

Mechanical ghosting or ink starvation is often caused by the design of the piece.

If this chart had been designed to print on a center spread, the misalignment of the art elements would not have occurred.

The Camera Department ————————————————

Section One: Light and Illumination

Light is a form of *radiant energy* that can illuminate objects. When light comes from or is reflected from an object, it enters the eye and permits the object to be seen. For practical purposes, light can be thought of as traveling in a straight line known as a *ray*. Subsequently, it is impossible to see through an opaque object. Since these rays do not, to any great degree, bend around the opaque object, a shadow is created behind the object.

Light Source. There are many sources of light—some natural and some artificial. Our most important source of *natural* light is the sun, while an electric light bulb is our most common *artificial* source. In the electric *light bulb, the wire filament* is heated electrically, causing it to radiate light. Light can also be created indirectly by means of certain chemical substances. For example, the inside of the glass tube of fluorescent lamps is coated with chemicals (phosphors) that fluoresce (glow) when struck by the invisible ultraviolet rays generated within the tube.

The Passage of Light. Light may pass through or be stopped by an object. If all the light hitting an object is kept from passing through it, the object is called *opaque.*

When some light passes through an object in such a way that we cannot clearly see other objects through it, the original object is *translucent.* An example of translucent material is ordinary waxed paper.

A *transparent* object, however, allows light to pass through it in such a way that we can clearly see objects through it. A window pane is such a transparent object.

The Speed of Light. Many people have tried, at one time or another, to measure the speed of light. As far back as 1675, a Danish astronomer noticed that, when the Earth was closest to Jupiter, an eclipse of one of Jupiter's moons occurred 1,000 seconds sooner than when the Earth was farthest away. He figured that the 1,000-second delay was due to the time it took the light to travel across the Earth's orbit. Since this distance was 186,000,000 miles, the light, therefore, traveled at 186,000 miles per second.

Later on, during the 1920s, Michaelson found a way to measure the speed of light over a distance on the Earth's surface. From this method, Michaelson figured the speed of light to be 186,285 miles per second.

One other factor about the speed of light should be mentioned: when a ray of light travels through a substance (known as a *medium*), the denser the substance, the more the ray is slowed down.

For example, since water is a denser medium than air, light travels slower in water. Diamonds, for example, slow down light rays to about 40% of what their speed would be in air.

Shadows. If we take a very small light source (known as a *point source* of light) and let its rays strike an opaque object, a sharply outlined shadow will be projected behind it.

Sharply outlined shadow.

Using a large (or *broad*) light source, the projected shadow has two areas: one of total darkness, the *umbra,* and one of partial darkness, the *penumbra.* Eclipses of the sun and moon are examples that show how areas of umbra and penumbra are formed by natural bodies.

Formation of umbra and penumbra.

Illumination. Light is used in the litho plant to provide general illumination for working areas or to examine materials or equipment.

Light is also used for photography. Here, light of a particular spectral energy distribution exposes film. Another use of light is to tan, or harden, the light-sensitive plate coatings in order to make them less soluble in water. In other instances, light is used to actuate meters and timing devices.

The amount of light that strikes a surface is called the *intensity*. The absolute brightness, or luminous intensity, of a light source is expressed in *candlepower*. Originally there was a special candle made of a certain type of oil that burned at a given rate, and this candle was used as a standard. Two such candles would produce a candlepower of two. The abbreviation of candlepower is "c.p."

Law of inverse squares.

Intensity of Illumination. The intensity on an illuminated surface is measured in *footcandles*. A footcandle is defined as the amount of light falling on a surface that is one foot away from the standard candle described previously.

The intensity of light that falls on an object depends upon two factors: the candlepower of the original source, and the distance from the source to the object. Over the distance (from light source to object), light obeys a rule known as the *Law of Inverse Squares*. This law states: "The intensity of light of a given source falling on an object varies inversely as the square of the distance from the source to the object."

This law can also be written as a ratio:

$$\text{Intensity} = \frac{\text{Candlepower of Source}}{\text{Square of Distance}} = \frac{\text{C.P.}}{(D_1)^2}$$

Intensity is in footcandles, and distance is in feet.

Applying the Law of Inverse Squares. A negative is placed in a printing frame that is 3 feet (D_1) away from a double-arc lamp. Each arc gives off 27,000 candlepower of light. Find the intensity of light falling on the printing frame. If the arcs were moved back to 5 feet (D_2), what would be the total intensity of light on the frame? If an exposure of 100 seconds made a good positive when the arcs were 3 feet (D_1) away, what would the equivalent exposure be now that the arcs are 5 feet (D_2) away?

For each arc (3-foot distance to frame):

$$\text{Intensity} = \frac{\text{C.P.}}{(D_1)^2}$$

$$= \frac{27,000}{(3)^2}$$

$$= \frac{27,000}{9}$$

$$= 3,000 \text{ footcandles}$$

Since there are two equal sources, the total intensity on the printing frame would be 2 x 3,000, or 6,000, footcandles when the lights are 3 feet away.

For each arc (5-foot distance to frame):

$$\text{Intensity} = \frac{\text{C.P.}}{(D_2)^2}$$

$$= \frac{27,000}{(5)^2}$$

$$= \frac{27,000}{25}$$

$$= 1,080 \text{ footcandles}$$

Total illumination when lights are 5 feet away would be 2 x 1,080, or 2,160, footcandles.

The new exposure can be determined in two ways.

In one method, the values obtained above can be substituted into the following formula:

$$\frac{\text{Original Intensity}}{\text{New Intensity}} = \frac{\text{New Exposure}}{\text{Original Exposure}}$$

Solving for x, the new exposure:

$$\frac{6,000}{2,160} = \frac{x}{100}$$

$$2,160x = 600,000$$

$$x = 277.8 \text{ sec. for new exposure}$$

In an alternate method, it is not necessary to determine the intensity of illumination for the two distances, rather the two distances are substituted into the following formula:

$$\frac{(D_1)^2}{(D_2)^2} = \frac{\text{Original Exposure}}{\text{New Exposure}}$$

D_1 is the original distance, and D_2 is the new distance. Solving for x, the new exposure:

$$\frac{(3)^2}{(5)^2} = \frac{100}{x}$$

$$9x = 2500$$

$$x = 277.8 \text{ seconds for new exposure}$$

The Photometer. When we must determine the strength of an unknown light source, we can use an instrument known as the photometer. It is a simple instrument consisting of a graduated bar having a known light source clamped to one end, a movable socket for the unknown source, and a movable card with a grease spot on it.

To use the photometer, you adjust the positions of the unknown light source and card until the grease spot apparently disappears. If you then substitute the distances from the lights to the card in the following formula, you can obtain the candlepower of the unknown source:

$$\frac{\text{Known C.P.}}{(D_1)^2} = \frac{x}{(D_2)^2}$$

D_1 is the distance between the grease spot and the bulb whose candlepower is known, D_2 is the distance between the grease spot and the bulb whose candlepower is unknown, and x is the candlepower of the unknown bulb.

Following is an example for finding candlepower of a bulb. A 10-c.p. bulb is used in a photometer. When the grease spot apparently disappears, the known, or 10-c.p., bulb is 2 feet away and the unknown bulb is 6 feet away from the card. What is the candlepower of the unknown bulb?

$$\frac{\text{Known C.P.}}{(D_1)^2} = \frac{x}{(D_2)^2}$$

$$\frac{10}{(2)^2} = \frac{x}{(6)^2}$$

$$\frac{10}{4} = \frac{x}{36}$$

$$4x = 360$$

$$x = 90 \text{ candlepower}$$

Footcandle Meter. The footcandle meter measures the intensity of illumination falling on it from any and all sources of light.

Usually, this type of meter uses a photoelectric cell connected to an indicator calibrated in footcandles. When light strikes the sensitive cell, it generates a current that registers directly on the indicator, giving a reading in footcandles.

Exposure Meters. The photoelectric exposure meter used to determine the correct exposure for negatives, positives, and color transparencies is essentially a footcandle meter as described

A photoelectric exposure meter.

above. It has, in addition, a number of scales on it. One is set for the speed of the emulsion used, and the second is set to the meter reading.

Then, from another scale, the correct exposure (in seconds or fractions of a second) can be read opposite the various apertures (lens openings) that can be used.

Light Integrators. Light integrators are a combination of light meter and timer. The light falling on a photoelectric cell generates the current that registers units on a timing device. When the preset time has been reached, the instrument turns off the device connected to it (usually the shutter and arc lights).

REFLECTION

The *Law of Reflection* states: "The angle of incidence is equal to the angle of reflection and that the incident ray, the reflected ray, and the normal all lie in the same plane." The word "plane" is used here to mean a flat area like a level surface. The angle of incidence (i) is the angle that the incident ray makes with the normal. The normal is the line perpendicular to the surface.

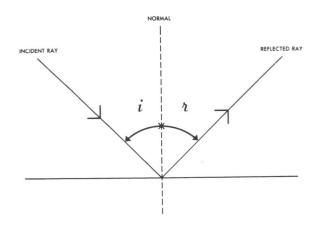

Angles of incidence and reflection.

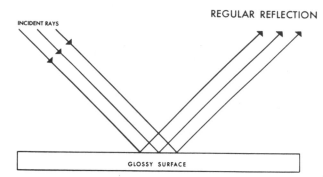

REGULAR REFLECTION

Regular reflection.

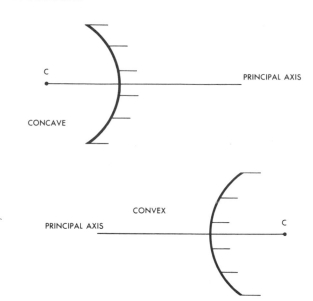

Concave and convex mirrors.

Regular Reflection. When a ray of light is reflected from a smooth surface, the reflection is known as *regular reflection*. The ordinary mirror that we look into when we comb our hair produces regular reflection. With this type of reflection, a parallel beam of incident light produces a parallel beam of reflected light, which explains why we get an undistorted image from our mirror.

Diffuse Reflection. When a beam of incident light strikes a rough surface, such as a grained lithographic plate, each light ray strikes a surface that has a slightly different angle. For this reason, a parallel beam of incident light becomes a group of rays that are reflected at many different angles and produce diffuse reflection. Reflection from uncoated papers is diffused, making the printed image appear to lack contrast. Some people term this "softness." Some jobs look better as a soft reproduction. Others require the "snappier" reproduction given by coated paper. This snappier appearance is due to the fact that the smooth surface produces much more regular reflection and less diffuse reflection than an uncoated paper.

Reflection and the Copyboard. The camera operator arranges the arc light to minimize glare from the copyboard glass. Since the glass surfaces of copyboards produce regular reflection, the glare level will be the lowest when lights are at a 45° angle to the board. As this angle decreases, there is more and more chance for unwanted reflections shining into the lens, especially if the area of the copyboard being covered by the lens is large. In other words, the direct reflection of the light must not be seen by the lens. When copying an oil painting, it is sometimes necessary to pick up the texture of the brush strokes. By reducing the angle between copyboard and lights, this added texture can be picked up.

Reflection and Curved Mirrors. There are two types of curved mirrors in general use: *concave* and *convex*. These mirrors are actually parts of a sphere whose center (the *center of curvature*) is shown as the point marked *"C"* in our illustration. The *principal axis* of the mirror is the line connecting the center of curvature to the midpoint of the mirror.

When a beam of incident light parallel to the principal axis strikes the surface of a concave mirror, the reflected rays cross the axis at a single point, the *focus*. In the case of the concave mirror, this point is a "real focus" since the rays of light actually meet at this point. This distance from the focus to the midpoint of the mirror is known as the *focal length*.

With a convex mirror, the results are slightly different. The parallel incident rays are spread out after being reflected from the mirror surface and do not cross the axis as in the case of the concave mirror. However, if we could extend these reflected rays

Reflection by a concave mirror.

Reflection by a convex mirror.

backwards through the mirror, they too would cross at a common point. This point is called a *virtual focus* because the reflected rays seem to come from this point although they do not really do so.

The Use of Curved Mirrors. If we wanted to send out a parallel beam of light to cover a copyboard evenly, we could obtain a sufficiently large concave mirror and place an arc light at its focus. This procedure would reverse the process described above and produce our parallel beam. Many types of arc lamps use this method to illuminate the copyboard.

Reflectors in automobile headlights, flashlights, and shaving mirrors are also of the concave type because they are able to magnify an image.

On the other hand, the convex mirror makes objects seem smaller. So we use it for the rear view mirror of an automobile in order to get a broad view of the highway behind our car in a mirror of small size.

REFRACTION AND LENSES

Refraction occurs when a ray of light is bent as it passes at an angle from one medium to another.

If you happen to drop a piece of soap in your bathtub, you sometimes find it difficult to pick up because it is not where it seems to be. This illusion is due to the refraction of light as it passes from the medium of water to the medium of air.

Refraction of light.

The Law of Refraction. All light rays obey the Law of Refraction. This law states: "A ray entering a less dense medium, at an angle other than perpendicular, will bend away from the normal. A ray entering a denser medium at an angle other than perpendicular will bend toward the normal. In addition, a ray passing from one medium to another parallel to the normal (perpendicular to the surface) will not be bent or refracted at all."

The Index of Refraction. Light travels at different speeds in different mediums. The *index of refraction* (n) is the ratio of the speed of light in the medium it is leaving to the speed of light in the medium it is entering.

The Effect of Refraction. Refraction makes an object appear to be in a different position than it really is. To show this illusion, let's take two examples: the parallel plate and the prism.

If we look at a can of developing ink obliquely (at an angle) through a piece of plate glass having sides parallel to each other, we will see the can in a slightly different position than it actually is.

Effect of refraction through plate glass.

What has happened is this: A ray of light leaving the can strikes the plate glass. Because glass is a heavier medium than air, the ray is bent toward the normal as it continues in the glass. However, within the glass, its rate of speed and angle of travel are different from when it traveled in air. When the ray finally exits from the glass, it is again bent — this time away from the normal because it is entering a lighter medium (air). After having been refracted twice, the ray leaves the glass at the same angle it entered because the glass sides are parallel. *In actual use this glass only slightly displaces our can of ink.*

A prism also refracts a light ray twice. But because the entering and exit sides of the prism are not parallel, the displacement is greater. The diagram shows the path of a ray of light through a prism.

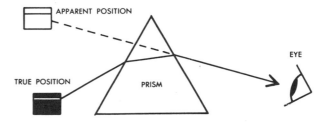

Effect of refraction through prism.

Critical Angle. Our illustration of the critical angle shows four rays of light striking the surface of water at different angles. Rays 1 and 2 are refracted into the water. At a certain angle, ray 3, after striking the surface, continues along the surface of the water. Ray 4 is totally reflected after striking the water surface.

The angle that ray 3 makes with the normal to the surface is called the *critical angle.* Light striking a surface at an angle larger than the critical angle will be reflected, while light striking at smaller angles will be refracted.

Suppose we have two different materials bonded together. When the angle of incidence of light in the first medium, at the

time it strikes the surface between the two mediums, is greater than the critical angle of the first medium, the ray becomes internally reflected within the first medium. This fact is used in the design of many optical instruments such as the prism binocular or the prism periscope, where the prism is used to change the direction of light.

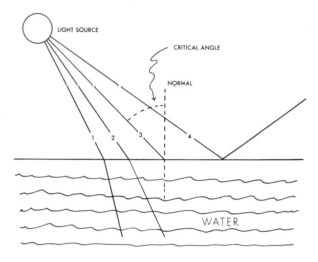

Critical angle.

The Lens. Because of the vital importance of lenses in photolithography, it's essential that we know more about them, so that we can more easily use them to suit our purposes.

Basically, a lens consists of one or more pieces of curved glass having polished surfaces and mounted in such a way that we can easily handle it. There are two basic types of lenses: *concave* and *convex*. In this, and in many other respects, lenses are very similar to the mirrors we have already described.

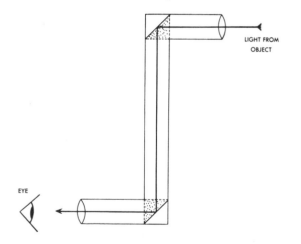

Prism periscope.

The convex lens is one whose center is thicker than its edges. If parallel light rays shine directly on this lens, the emerging rays will all come together at a point known as the focus. The focus is a definite distance from any given convex lens. This focus is real because the rays actually meet at this point.

The concave lens has edges thicker than its center, and parallel rays falling on its surface will be diverged. However,

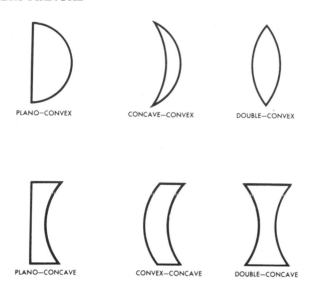

Various lens shapes.

extending these diverging rays backward, they will seem to come from one point—the focus of this lens. This focal point is virtual rather than real because the rays do not actually meet there.

The imaginary line drawn through the focus and the center of the lens is called the *axis*. The distance from the focus to the center of the lens is called the focal length of the lens.

Lenses do not always have both their sides curved in the same way. Subsequently, the name of the lens depends upon the curvature of the sides. Our diagram shows examples of various lenses.

Images and Ray Tracing. Perhaps we'd like to know what will happen to the image of an object as it passes through the lens system. To aid us in finding the answer, we use a method known as *ray tracing*. Using this method, we can take advantage of certain laws:

1. All light rays entering the lens parallel to the axis will emerge and pass through the focus of the lens.

2. All the light rays passing through the center of the lens (the point within the lens on the axis and halfway between both surfaces) and parallel to its axis will continue in a straight line.

These two laws can be used regardless of which side of the lens is toward the light source. Thus, each lens has two foci (focal points), one on each side of the lens.

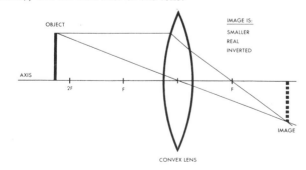

Object at a distance greater than twice the focal length of convex lens.

Image Formation by Convex Lenses. With the convex lens, we will assume the object to be in three different positions and will show what happens at each. The object distance can be: (1) at a distance greater than twice the focal length of the lens, (2) at the focus, or (3) at a distance less than the focal length of the lens.

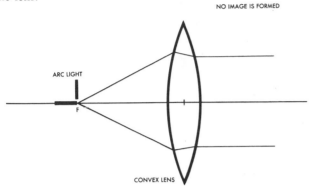

Object at the focal point of convex lens.

In each of these cases, it will be shown what the magnification is, whether the image is real or virtual, and its position.

When the object is at a distance greater than twice the focal length of the lens, the created image is smaller than the object, real, and inverted. As it nears the point that is twice the focal length, the image grows in size until at the point twice the focal length it becomes same size as the object. All this time the image remains real and inverted.

Between the distance of 1 and 2 focal lengths, the image size becomes larger than the object while still remaining real and inverted. Finally, at the focal point, no image is formed.

Now, as the object gets between the focus and the lens, the image gets larger and changes to virtual and erect.

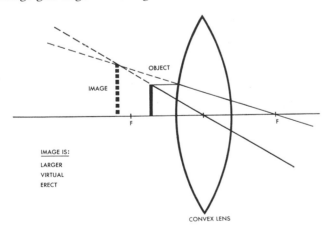

Object at a distance less than the focal length of convex lens.

Image Formation by Concave Lenses. Because the light rays diverge after striking a concave lens, we can only get virtual images. In all cases, these images are smaller than the object and erect. Our diagram shows an example of image formation by a concave lens.

Once more, we must take advantage of the "rules" of ray tracing mentioned previously. A ray through the lens center continues in a straight line, and an entering ray parallel to the

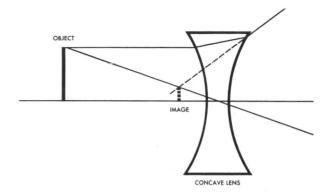

Image formation by concave lens.

axis will pass through the focus. With the concave lens, however, the emerging ray formed by the parallel ray will seem to come from the front focus of the lens rather than actually passing through the back focus, as in the case of convex lenses.

Lens Aberrations. Lenses can have a number of faults that will not permit them to create a perfect image. However, most of these faults are partially or completely corrected by the lens manufacturer. Common faults are *spherical aberration, astigmatism,* and *chromatic aberration.*

Spherical aberration is the aberration that occurs when the lens surfaces are spherical (curved). In this case, the rays entering the lens near its edges are brought to a focus closer to the lens than are the rays entering near the center of the lens. This variation produces a blurred image. Spherical aberration can be corrected in two ways. We can use a smaller diaphragm opening that would allow the light to pass through the central part of the lens, alone. However, this would require longer exposures to allow the same amount of light to fall on our film.

A second method of correction for this aberration is the use of other lenses combined with the faulty one. The compound lens (as the combination of two or more lenses is called) is especially designed to reduce spherical aberration to a minimum.

Astigmatism is another lens aberration. It is a defect that causes horizontal and vertical lines in an object to be brought to a focus on different planes. When the lens is sharply focused on the horizontal lines, the vertical lines are out of focus. When focused on the vertical lines, the horizontal lines are blurred. This fault is also corrected by a combination of lenses of different kinds of optical glass.

Chromatic aberration is a third form of lens aberration. In this case, the white light passing through the lens is split up into various colored beams. Each of these colors comes to a focus at different points. When this fault exists in a lens, the blue beam of light comes to a focus nearest to the lens and the red beam focuses farthest away. This again results in a blurred image and can be corrected by making the component parts of the lens of various types of glass to neutralize this effect.

When a lens is corrected for these three types of aberration—spherical, astigmatic, and chromatic—we call it an *anastigmat* lens.

LIGHTING COPY FOR REPRODUCTION

Light is the photographic process: it illuminates copy and

affects light-sensitive materials. To reproduce black-and-white or color originals, the light source used must provide consistent, even coverage of the copy, consistent light output (intensity), and consistent color temperature.

The common types of illumination used in the graphic arts include carbon arc, pulsed-xenon, tungsten filament, quartz-iodine, fluorescent, and mercury sources. The selection of the source is usually determined by the range of light or energy most effective in exposing a certain light-sensitive material with an adequate intensity to provide efficient operating conditions.

Each light source has a specific energy output, known as its color temperature. Color temperature refers to the spectral energy distribution emitted by a perfect radiator ("black body") heated to a specific temperature. Color temperature is most commonly measured in "degrees Kelvin ($^{\circ}$K)." The color temperature rating of a light source gives an indication of its spectral output: the higher the temperature, the bluer the light, with red predominating at lower temperatures. For black-and-white photography, a light source with a color temperature greater than 3,000°K is needed. However, for color work, the light source should have a color temperature greater than 5,000°K. (Sunlight has a color temperature of approximately 5,400°K.)

For many years, high-intensity *carbon arc lamps* were a standard light source for photographic exposure. Carbon arcs emit light because the carbons are cored with metallic salts. Carbon arcs have a color temperature of 5,400°K, which is excellent when using filters and panchromatic emulsions in reproducing color originals. The use of carbon arcs has been greatly reduced, however, because the fumes from carbon arcs are highly toxic and because other light sources offer safer, more reliable alternatives.

Pulsed-xenon lamps, probably the best alternative, are high-pressure discharge (arc) lamps widely used for film exposure. They are one of the best types of illumination for general black-and-white and color separation photography. Pulsed-xenon lamps are made of quartz tubing filled with xenon gas. The light is pulsing 120 times a second, but appears as a continuous emission of light.

Pulsed-xenon lamps have a broad spectral output that extends across the visible light region and closely approximates the color temperature of sunlight. The color temperature (5,400°K) and light output of pulsed-xenon lamps are very constant. Its spectral output is continuous but with many peaks that will slightly alter photographic response, such as to filters. Its ultraviolet radiation output is somewhat less than that of carbon arcs. Its shorter warm-up time than mercury vapor lamps and its cleaner and more uniform output compared with carbon arcs are favoring its general acceptance by the graphic arts industry.

As mentioned before, there are other light sources that can be used for color reproduction, but they are not as desirable as pulsed-xenon lamps. Most of the other types are more suitable for black-and-white reproduction.

Various problems will be encountered in the illumination of the copy, some of which are discussed in the following paragraphs. The accepted angle of lamp direction for illuminating reflection copy is 45° from the center of the copyboard. This angle may be varied, according to the size and nature of the copy. An example is the reproduction of a textured original, where it may be necessary to retain or accentuate the textured appearance in the reproduction. This can be done by placing one light or both lights (using two camera lamps) at unusual angles. Also, in black-and-white photography when reproducing large penciled drawings, a reflection from an area of pencil lines may reflect light at the 45° angle. To eliminate this problem it is necessary to change the angle of the lights to a more desirable position.

The evenness of the light coverage at the copyboard should and can be checked by reading the light falling upon each corner of the copyboard with an exposure meter. However, it is more important to measure the evenness of illumination on the ground glass of the camera back. Light positions and angles should be adjusted to provide maximum evenness of illumination at the film plane.

The use of a high-intensity light source that will emit a certain amount of ultraviolet light may cause a problem in making masks and color separations. Unusual density readings may be encountered in masks and/or separations from a particular piece of art. This can be accounted for by the fact that some art boards and pigments will absorb, reflect, or fluoresce the ultraviolet light. An ultraviolet-absorbing filter, used in front of the light source, may reduce this effect.

It is very important, in both color and black-and-white reproduction that maximum contrast for the process is obtained. Tonal contrast may be lost in camera negatives or positives (halftones and continuous tone) because of flare. Flare will have more effect on shadow contrast than on highlight contrast. It can be caused by a dirty optical system. One cause of flare is the "stray" illumination from a room light left on over the copyboard while making an exposure. An ideal setup to alleviate such a possibility is to have an electrical connection between the camera lamps and the room lights. When the camera lamps are switched on, the room lights are automatically switched off. Another factor that can contribute to flare, and result in poor image contrast, is the reflection from light-colored or glossy walls in the camera area.

Section Two: Densitometry

The densitometer is one of the most valuable control devices available to the photographer. With it you can measure numerically the density of a black-and-white or color tone area on transparent or opaque materials. These density measurements can be used as a guide in determining exposure conditions for simple black-and-white copying or for setting up masking procedures. However, an understanding of the term *density* is necessary before using a densitometer.

OPTICAL DENSITY

Density, in our context always meaning *optical* density, is a standard way of expressing the value of a tone area—its light-stopping ability. *The darker a tone, the higher its density.* The highlights on a photographic print will have a low density and the shadows a high density. On the negative, the same high-lights will appear dark and therefore will have a high density.

Transmission Density. The ability of a silver layer on film to absorb or pass light may be expressed in terms of transmission density. The term *transmission* refers to the light-passing ability of the silver layer. The term *density* refers to the light-absorbing ability of the layer.

The transmission of any tone area is the fraction of incident light transmitted through the area without being absorbed or scattered:

$$T = \frac{I_t}{I_i}$$

T is transmission, I_t is intensity of transmitted light, and I_i is intensity of incident light.

Density is equal to the logarithm of $\frac{1}{T}$:

$$D = \log \frac{1}{T} = \log \frac{I_i}{I_t}$$

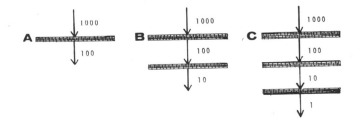

Transmission and density relationship.

The relationship between density and transmission is illustrated in the table. In the illustration, the light intensity on the first layer is the same for A, B, and C. However, the light intensity leaving the silver layer decreases as we increase the number of layers.

TRANSMISSION AND DENSITY RELATIONSHIP			
	A	B	C
Layers	1	2	3
Transmission	1/10	1/100	1/1000
Density	1	2	3

The transmission has decreased by a factor of 10 for each additional layer, while the density has increased by 1. When working with density units, we add to obtain combinations of different tones. When working with transmission units, we have to multiply. It is easier to handle density units in calculations. The use of the logarithmic scale for density units permits us to express large quantities with small numbers, which in turn permits us to plot a large range of numbers on a reasonably sized graph. Another reason for using a logarithmic scale is that the

response of the eye is logarithmic. For example, in our next illustration, we have a transparency with four different tones: W, X, Y, and Z. The intensity of the light transmitted through each tone is indicated by the lower arrows. The numerical values of the light intensity is shown beside the arrows. The length of the arrow is proportional to the light intensity it represents. The value of these tones as the eye sees them are indicated by the solid blocks, and the optical density of each tone is beneath the block.

Arrow X is only half as long as W, Y is half as long as X, and Z is half as long as Y. Since the light intensities are cut in half, the apparent tone values increase equally from W to Z, and the measured density increases by steps of 0.3. The eye sees equal changes of density units as equal tone steps.

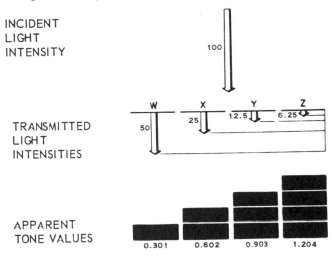

Incident light, transmitted light, and apparent tone values.

Reflection Density. Reflection density is very much like transmission density. When light falls on an image, for example a paper print, part of the light is absorbed, while the remainder is reflected in various directions. How much light is reflected in each direction depends on the tone density and the surface of the paper.

In measuring reflection densities, it is standard practice to

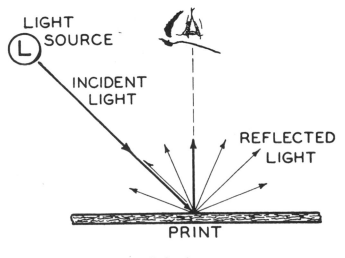

Reflection.

illuminate the area at an angle of 45° and measure the amount of light reflected at 90° to the surface.

Just as transmission density is based upon the transmittance of a tone area, so reflection density is based upon reflectance from a tone area. However reflectance does not involve the incident light at all. Reflectance is expressed as the ratio between the amount of light reflected from a given tone area and the amount reflected from a white area on the same paper, or a standard surface:

$$R = \frac{I_r}{I_{rw}}$$

R is reflectance, I_r is intensity of light reflected from tone, and I_{rw} is intensity of light reflected from white paper.

Reflection density has the same relationship to reflectance that transmission density has to transmittance:

$$D_T = \log 1/T, \text{ and } D_R = \log 1/R$$

D_T is transmission density, and D_R is reflection density.

Reflection density readings express the values of tones in an image, like a paper print, in exactly the same way that transmission density readings express the values of tones in a transparency. Reflection density values, like transmission density values, are proportional under most viewing conditions to visual tone values. Like transmission density readings, reflection density readings are relative. They are not affected by changes in intensity of illumination. They do not express the value of a tone in terms of light intensity. Instead, they tell how much darker a tone is than some other tone. The most extreme highlight on the print—a white area—is chosen as the zero point, and all of the other readings on the print are expressed in relation to this particular value.

CHOOSING A DENSITOMETER

There are various types of densitometers. They differ in what

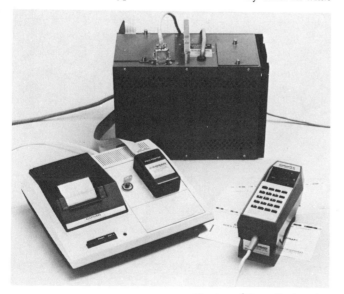

Courtesy of Cosar Corporation
Reflection densitometer.

they will do, how they do it, and what they cost. The choice of a particular densitometer depends on what it is to be used for and on how much is expected of it. The best instrument for a particular purpose will be the one that does everything required of it with the greatest accuracy, in the shortest time, and that changes least in accuracy with age and use.

Some densitometers are designed to measure only transmission densities, Others will measure only reflection densities. Combination instruments will measure both. If all the readings in the plant are to be made on one densitometer, the instrument should be equipped to measure both reflection and transmission densities. If a number of instruments are required, then it might be more economical to supply the pressroom with only the reflection type. The photographic and art departments should have combination instruments, since they handle transparent negatives and positives as well as opaque original copy.

Both reflection and transmission densitometers should cover a range from 0.0 to 3.0. The scale should be calibrated so that it can register a density difference of 0.02 over its entire scale. In practical plant operations, an accuracy of 0.02 units will be satisfactory. A calibrated reflection or transparent gray scale should be set aside as a standard against which the densitometer could be checked frequently. When an error of more than plus or minus 0.03 is detected, the instrument should be adjusted.

OPERATION OF A DENSITOMETER

Densitometers are of two general types: visual and photoelectric. In visual instruments, an arrangement of lenses and mirrors bring together the tone being measured and a control tone, for visual comparison. By making an adjustment, the operator increases or decreases the density of the control tone until, judging by eye, they match. The operator then reads the density on a calibrated scale.

Photoelectric Densitometers. There are several types of photoelectric densitometers. One variety uses a cell similar to that employed in photoelectric exposure meters, with a microammeter and a dial, reading directly in density values. This variety gives fast readings but the accuracy falls off for densities over 2. Other types have solid-state circuitry. The readout is usually digital. Such densitometers are usually equipped with color filters to measure process color densities.

Comparison of Visual and Photoelectric Units. Generally visual units are much less expensive than the photoelectric units. Because there are no electronic parts or sensitive meters involved, visual units are generally more rugged. The accuracy obtained with visual units is generally adequate for most lithographic work. Most people will feel eyestrain when making 20 or 30 readings with a visual unit. With visual units, it is sometimes difficult to make comparisons if there is a slight color difference between the tone being measured and the control tone. Electronic units can be used rapidly and easily. Measurements made with electronic units are generally more reproducible than those made with visual units. The physical condition of the operator does not affect the measurements made with electronic units. They can also be used as sensitive light meters, to measure the illumination level and evenness at the focal plane of the camera or in similar applications.

THE CHARACTERISTIC CURVE

Densitometry can be used to determine and graph the photographic response of a light-sensitive material. The characteristic curve, also known as the H & D curve, or D log E curve, is a graph that shows how the film or plate material can be expected to perform under certain conditions.

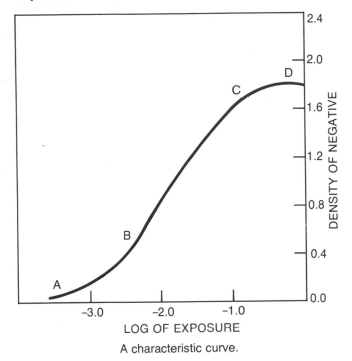

A characteristic curve.

The negative density is plotted against the logarithm of the exposure, as in our first graph. Film manufacturers use elaborate equipment to expose and develop the test strips used to make these curves. A more practical method of obtaining these curves can be used by the photographer. A gray scale can be photographed or contacted, and the density of the contact positive or camera negative can be plotted against the density of the original as in our second graph.

The curve obtained is for a given set of conditions; therefore, when you make these curves, indicate the materials and equipment used. Use fresh developer every time and try to develop the same way every time. After the negative or positive has been made, make a table of the scale step numbers, density of the original, and density of the negative or positive as in our table.

Step No.	Original Density	Density of Test
1	0.08	2.20
2	0.27	2.13
3	0.41	2.03
4	0.57	1.94
5	0.74	1.84
6	0.86	1.74

Using regular graph paper, set up a scale of density values along the vertical and horizontal axes as shown in our illustration. The horizontal axis will represent density values of the original, while the vertical axis will represent density values of the negative or positive. For point no. 1, which corresponds to step no. 1, we would locate 0.08 along the horizontal (D_o) axis and 2.2 along the vertical axis (D_n) axis. Where these two values intersect make a cross. Repeat for the other points. When all the points have been plotted, draw a smooth curve through the average of these points. (Seldom do all the points line up perfectly to produce a smooth curve.) This is the characteristic curve.

The curve has three general regions: the toe, the straight-line portion, and the shoulder. If we represent the curve as being cut by a series of lines at equally spaced horizontal distances, there is an unequal increase in vertical distance for equal horizontal distances in the toe and shoulder regions. This relationship indicates that there is an unequal density increase for equal amounts of exposure. However in the straight-line portion of the curve, the density rises an equal amount for equal increases in exposure. When working with photographic materials, we generally use the straight-line portion of the characteristic curve. If we use the toe or shoulder regions, we will get tone distortions.

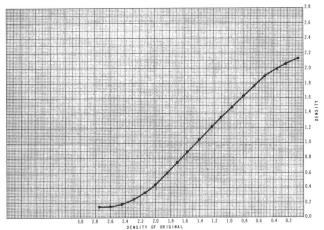

Making the final curve.

From a series of curves we can determine the contrast of an emulsion, filter ratios, and relative speed. While this information is generally given on the film data sheets, the results you obtain under your shop conditions may differ from those of the film manufacturers. You may also want to try combinations of emulsions and developers not specifically suggested by the

Plotting a characteristic curve.

manufacturer, and therefore there may not be any data available on these combinations.

Contrast. *Contrast* is a term that may have a different meaning for different people. Some people may use the term to describe the separation of tones in a picture. The words soft or hard may be used in describing the contrast of an image. When comparing a reproduction with the original, we might say that the reproduction has a higher or lower contrast. When examining a reproduction, we might speak of the contrast in different parts of the tone scale, such as the shadow contrast or the highlight contrast. When comparing a negative with the original, we again use the term contrast.

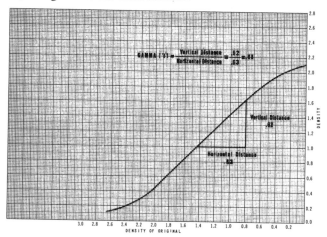

Analyzing a characteristic curve.

Gamma. In photography, the Greek letter *gamma* is defined as "a numerical designation for the contrast of a photographic material represented by the slope of the *straight-line portion* of the characteristic curve. Gamma is numerically equal to the tangent of the angle that the straight-line portion makes with the base line."

Generally, the longer you develop any film in any developer, the higher the gamma will be until it finally reaches a limit. We can say this another way: The higher the gamma, the greater the contrast of the negative, *due to development.* That italicized phrase is important. The total contrast is due to quite a few factors: for example, subject contrast, development contrast, or flare in the optical system of camera. So, when we talk about gamma, we are referring to development contrast only.

In our illustration we see how gamma is determined. Vertical and horizontal lines are drawn that intersect each other and the straight-line portion of the curve. The numerical value of gamma is equal to:

$$\gamma = \frac{\text{vertical distance}}{\text{horizontal distance}}$$

OTHER USES OF THE DENSITOMETER

At the Camera. The densitometer is an instrument of many practical uses in a photographic department. For example, the photoelectric cell of some instruments can be detached and placed on the ground glass of the camera. Here it can serve as a very sensitive light meter to measure the amount of light coming through the lens. Once a test negative has been made and the proper exposure determined, the ground glass reading will permit you to determine the correct exposure for other camera positions.

Densitometers with detachable heads also permit a simple and accurate method of positioning the arc lamps for proper illumination. "Proper illumination" means even illumination on the *ground glass of the camera.* Many process photographers make the mistake of thinking that if the copy is illuminated evenly, the exposure of the emulsion will also be even.

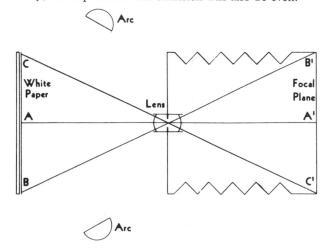

If the intensity of the light from A striking emulsion at A' is taken as 100%, the intensity of the light striking the emulsion at C' from C and at B' from B (25° off the axis) is only about 67%.

Our diagram shows why this wrong. Light rays from the outer edges of the copy have to travel farther than those that are on or closer to the optical axis of the lens. These same light rays also strike the emulsion at an angle, and since they cover a greater area than those close to or on the axis, their intensity is diminished further. In addition, lenses tend to vignette the light rays from the edges of the copy due to the barrel length, lens thickness, or both.

So, if the illumination at the focal plane (ground glass) is to be even, the edges of the copy must receive more light than the center of the copy. The procedure for checking illumination using a densitometer with a detachable head is as follows:

Adjust the camera and lens for same-size reproduction. Replace the ground glass in the camera with a pane of clear glass. Cover the copyboard with a sheet of white paper. Cover the window of the photometer search head with opalized glass and place the opalized glass against the clear glass in the camera. Open the shutter of the camera, turn on the lamps, and then slide the search head over the clear glass, noting the variations in light intensity on the readout. Move the arc lights to different positions until the meter readings show that the intensity of the light at the film plane is as uniform as possible. A record should be made of these final arc light positions and used whenever you are shooting at same-size.

This same procedure should be followed to determine the best positions of the arcs at other camera settings. Once the positions have been determined for each of the most commonly used camera settings, they should be recorded for reference on future jobs.

If only two arcs illuminate the copyboard, it probably will be possible to get fairly even illumination in a band across the focal plane, but not vertically. In such cases, oblong copy should always be placed on the copyboard with its longest dimension horizontal.

Color Control of Preseparated Artwork. In some areas of color printing, such as greeting cards and children's books, the artwork is prepared with copy for each color prepared as a separate piece of art. This art may be either a black medium (ink, paint, etc.) on opaque board or a colored film (Bourges, etc.). A reflection densitometer makes it possible to establish an exact relationship between the tone values of the art and the size of the halftone dots required on each color printer to produce the desired end result.

Color Control of Color Separations of Full-Color Copy. Most color separations of full-color art—opaque or transparent—are accomplished by the indirect method. The first step is to shoot a set of continuous-tone separation negatives. A transmission densitometer can be used to standardize

the operation of producing the desired halftone positives. This same type of densitometer is also useful to check the densities of the halftone positive to determine that the desired printed result will be produced. Here the densitometer can be used before and after any color correction is done. It will guide the dot etcher in planning his work and will indicate accurately when the desired end result has been accomplished.

Planning and Control of Black-and-White Photography. The use of a reflection densitometer to measure the densities of black-and-white continuous-tone copy makes it possible to plan the proper photographic technique for a desired result. Following this with density measurements of the halftone negative (or positive) will produce almost complete control. Such techniques make it possible to better group pieces of copy whose overall appearance will be reasonably uniform.

And Still Other Uses. Densitometry as a control technique is finding greater and greater use in the industry. Its uses will be discussed at appropriate places in this volume.

Section Three: The Chemistry of Photography

The chemistry of photography is a vast subject; in this Manual, we can merely present some of its fundamental aspects. Our presentation is divided into the following: (1) The photographic emulsion, (2) Developer solutions, (3) Fixation, and (4) Reducers.

THE PHOTOGRAPHIC EMULSION

The silver emulsion used on sensitized materials consists of a colloid such as gelatin, silver halides, and additives for producing certain effects.

Gelatin. About 1871, the first successful dry plate using gelatin was made. Since that time, the use of gelatin has been indispensable to the progress of emulsion technology. The unique properties of gelatin are responsible for this acceptance, and years of research have not to date yielded an equal or improved substitute.

Gelatin is a protein obtained from the tissues, hides, cartilage, and bones of animals. Since it is of animal origin, its composition is extremely varied and consequently complicated the process of standardization. The important specifications for photo use of gelatin are jelly strength, pH, moisture content, and metal contents of iron, lead, copper, and alumina, together with limits of ash and sulfur dioxide.

Silver Halides. The important salts of silver chloride, silver bromide, and silver iodide, which are formed by precipation in the emulsion, are extensively used in emulsion manufacture. Silver fluoride is not used to any extent because of its fog action in combination with other silver halides.

Silver bromide (AgBr) is the most widely used of the silver

salts for paper and film products. It is usually the major portion of the halide salts in film and is characterized by the effect of its high speed and low fog action on the emulsion.

Silver iodide (AgI) is used generally in combination with other halides. In speed, it is approximately one-third that of silver bromide.

Silver chloride (AgCl) is a pure white powder, which is used primarily on paper-type emulsions for amateur use. Its speed is approximately one-eighth that of silver bromide.

Although the halides of silver are widely used, the oxalates, nitrates, tartrates, and citrates of silver have been used to a lesser degree for sensitization.

Additives to Emulsions. The silver salts are color sensitive inherently to the blue portions of the spectrum only. To increase this sensitivity to red and green, color-sensitizing dyes are added to the photographic emulsion. These sensitizing dyes are absorbed by the silver halide, and the increase in color sensitivity by this process is referred to as optical sensitization.

To obtain special effects such as an increase in speed, prevention of fog, and control of gamma, all emulsions contain certain additives to achieve these desired effects. The specific chemical reactions and functions of these additives are complex and the subject of widespread patent literature.

Preparation of the Photographic Emulsion. The technique of manufacture for photographic emulsions has long been considered a "trade secret," but the basic procedure is well-known and consists essentially of the following:

1. Soaking and dissolving a portion of the gelatin.
2. Addition of bromides and iodides used in precipitation of the silver halide.

3. Addition of silver salts, causing the precipitation of the silver halide. (This process is called emulsification.)

4. Recrystallization of emulsion by heating. (This is commonly referred to as the "first ripening.")

5. Addition of the remaining gelatin, and chilling.

6. Formation of "noodles" by forcing the chilled gelatin through a wire screen.

7. Washing, to rid the emulsion of unwanted salts.

8. Reheating, which is referred to as after-ripening or second-ripening, to recrystallize the silver salts.

9. Addition of special chemicals, such as sensitizing dyes, preservatives, antifoggants, stabilizers, etc.

Although the preceding list of operations is considered a basic procedure, there are endless variations that will affect the finished product. Purity of gelatin, agitation, salt concentration, degree of heat, and procedure of addition of silver salts are just a very few of the factors that make emulsion manufacture a complex procedure.

DEVELOPER SOLUTIONS

Light affects the photographic emulsion by forming a latent image. This image has to be converted to a visible image, which is accomplished by reduction of the silver halide to black metallic silver with the use of a solution referred to as a developer.

The developing solution consists of:

1. A *solvent,* such as water.

2. A *developing* or *reducing agent,* such as metol or hydroquinone.

3. A *preservative,* such as sodium sulfite.

4. A *restrainer,* such as potassium bromide.

5. An *accelerator* or *alkali,* such as sodium hydroxide.

6. Miscellaneous additives.

Chemicals in a developer function according to the above grouping; the difference among developers is caused by the different types or proportions of these chemicals to achieve the desired developing action.

Constituents of a Developer. Almost all developers use water as their solvent, although some color-coupling developers use other solvents in combination with water. The water used for developers should be of fairly high purity and should not contain large amounts of calcium or chloride salts.

The Developing Agent. Organic chemicals are widely used as developing agents and are characterized as strong reducing agents containing the hydroxyl (–OH) and amino (–NH$_2$) groups in varying proportions. The most important of this group is paradihydroxybenzene (*hydroquinone*) and monomethyl paraminophenol (*Metol*). Hydroquinone is a slow but powerful developer, taking longer to show a visible image on the film but gaining density much more rapidly over a prolonged period of time. Metol is a much more energetic agent, showing an image rapidly but building density slowly. The combination of Metol and hydroquinone in developers is excellent, for each chemical helps correct the shortcomings of the other. Varying combinations of these two agents are used in the most popular types of paper and film developers.

The Preservative. Due to the high reducing action of the developing agent, a preservative (or antioxidant) is necessary to prevent or control developer oxidation. Sodium sulfite is the most common chemical in this group. The sulfite, in addition to acting as an antioxidant, also prevents the formation of staining developer products, acts as a silver solvent, and in some cases serves as a weak alkali, which increases the rate of development.

Accelerator. In order to increase the pH of the developing solutions, thereby increasing the ionization of the developing agent, the addition of an alkali, or accelerator as it is commonly referred to, is important in developing formulas. The alkali also has the dual function of absorbing the bromine ions formed by the action of the developing agent of the silver salts. The more important types of alkalis include the carbonates and hydroxides of sodium and potassium. Paraformaldehyde is the common type of alkali control used in "lith" type developers due to its ability to produce extreme contrast.

Restrainer. The action of potassium bromide in a developing solution is such that it reduces the ionization of the silver salt, thereby restraining development. This action, however, is greater on the fog image than on the denser image.

Miscellaneous Additives. There are a number of additives to developing solutions each designed to achieve some desired effect. The most common in use are the following:

1. *Wetting agent,* to permit the rapid penetration of developer into the gelatin.

2. *Desensitizer,* to reduce the color sensitivity of the emulsion without affecting its speed. Phenosafranine and the pinakryptols belong in this group of chemicals.

3. *Silver solvent,* for reduction of grain size, include sodium thiocyanate and ammonium chloride.

4. Other chemicals, used to increase gamma, control water impurities, and permit the use of developers in environments characterized by extremes of temperature.

Action of Development. The action of the developer on the photographic emulsion has been the subject of debate for sometime, and to date, there is not a complete understanding of this complex reaction. However, in the case of a hydroquinone developer, the reactions proceed as follows:

1. The alkali dissociates the hydroquinone, with the liberation of ions of the developing agent in solution.

2. The hydroquinone ion reacts with the silver bromide yielding quinone and ions of silver and bromine.

3. The quinone then reacts with sodium sulfite to form sodium hydroquinone monosulfonate and sodium hydroxide.

4. The sodium hydroquinone monosulfonate is oxidized to quinone monosulfonate, which in turn reacts with sulfite to form sodium hydroquinone disulfonate. The latter chemical is practically inert as a developer.

5. As the development proceeds, hydroquinone ionizes. At the same time, hydrogen ions are formed; and bromine ions are released into the solution, which is equivalent to adding potassium bromide to the developer.

Basically this reaction may be simplified by saying that the developing agent is gradually used up and during this process forms complex developing agent salts, which act on the image to a lesser degree. The solution then reaches a point when the

developing agent is completely exhausted and the bromine ions formed by the silver bromide restrain development and will not produce sufficient density in the negative or positive.

FIXATION

When development is completed, those areas not affected by exposure or development have to be removed to make the image on the film permanent. These unexposed and undeveloped areas are removed from the film by use of a fixing bath.

In addition to its reaction of dissolving the unexposed and undeveloped silver salts, the fixing bath also serves two other basic purposes: it neutralizes developer alkali, thereby stopping developer action and eliminating oxidation staining, and it sufficiently hardens the emulsion, preventing scratches and washing away of the gelatin image.

Composition and Reactions of the Fixing Bath. The fixing bath contains a number of chemicals each acting on the silver image in some manner. The formulation of a typical bath used for general purposes on lith films would consist of the following:

1. A *solvent,* such as water.
2. A *silver halide solvent,* such as sodium thiosulfate (hypo), which is used to dissolve the silver halides. Generally emulsions with large grain size will clear much faster if ammonium thiosulfate is used. This chemical is the common ingredient of the liquid-type fixers.
3. A *stabilizer,* such as sodium sulfite. In this reaction, the sodium sulfite combines with the ionized sulfur of the sodium thiosulfate to form a complex sulfite salt, thereby stabilizing the bath and preventing formation of a sulfur precipitate.
4. An *acid,* such as acetic acid, to bring the bath to the pH necessary to neutralize alkalinity caused during development.
5. A *buffer,* such as boric acid, to limit the change of pH of the fixing bath solution, thereby preventing formation of aluminum precipitates.

6. A *hardener,* such as potassium alum. In this reaction, the hardener toughens the emulsion so that the resulting physical hardness is such that it will not be affected by washing or normal handling when the film is dry. The hardening action of chrome alum is greater than that of the potassium salt, but since it has a tendency to form a sludge more rapidly, it is not used too widely.

REDUCERS

The action of a reducer is essentially that of an oxidizing agent: oxidizing the metallic silver to form a soluble silver salt. In some cases, the silver salt is insoluble in water, and the solution must contain another chemical that can convert the silver salt into soluble silver compound.

A common reducer is Farmer's reducer, which is a mixture of potassium ferricyanide and sodium thiosulfate. The silver reacts with the potassium salt to form silver ferrocyanide. At the same time, the iron in the ferricyanide ion is reduced to form ferrocyanide ions. Then the sodium thiosulfate reacts with the insoluble silver ferrocyanide, converting it into soluble complex ions.

Another reducer is a mixture of iodine and sodium or potassium cyanide. Potassium iodide reacts with the iodine to form potassium iodate. The latter substance oxidizes the silver. Silver iodide is very insoluble in water but is soluble in a potassium cyanide solution. The silver iodide is thus converted into a silver cyanide complex ion, which is soluble in water. This type of reducer is sometimes used for flat etching of halftone positives.

CONCLUSION

The chemistry of photography is an extremely broad and complex subject. However, an understanding of the basic points are helpful for a complete understanding of the photolithographic process.

Section Four: Photo-Materials and Their Properties

Our presentation of photographic materials and their properties is divided into the following thirteen subjects: (1) Dimensional stability of film bases, (2) Polyester film bases, (3) Acetate film bases, (4) Polystyrene film bases, (5) Film handling suggestions, (6) Photographic properties, (7) Color sensitivity and types of sensitizing, (8) Filters, (9) Safelight color and safety, (10) Emulsion contrast and the characteristic curve, (11) Effect of development on contrast, (12) Exposure, and (13) The use of the exposure index for graphic arts photography. Each is presented in the following.

DIMENSIONAL STABILITY OF FILM BASES

The dimensional stability of film is of critical importance in a number of applications, such as the reproduction of mechanical drawings, typographic maps, color separations, and various

other graphic arts and industrial products. This discussion is intended to explain why photographic films change size.

Photographic film is comprised of a plastic base coated with a light-sensitive emulsion usually made of gelatin. It is essentially a laminate of two chemically different materials, each of which is affected by environment and age. As a result, the dimensional behavior of film is extremely complex.

Classification of Dimensional Changes. To understand why films change size the way they do, it is helpful to classify the various types of dimensional changes into two groups: temporary or reversible dimensional changes, and permanent changes. Temporary or reversible dimensional changes may be due to humidity expansion or contraction, or to thermal expansion or contraction. Permanent shrinkage may be due to loss of residual solvent or plasticizer from the base, plastic flow of the

base caused by contraction of the emulsion, or release of mechanical strain (recovery of stretch introduced during the manufacturing process).

Factors Influencing Dimensional Changes. The magnitude of each of these types of dimensional change in a given film depends on the chemical composition and thickness of the base and emulsion, the treatment received in manufacture, and the conditions under which the film is stored. There are also other complex phenomena such as hysteresis and elastic memory. These account for small dimensional changes in photographic film.

Humidity Expansion. Humidity expansion or contraction of film is caused by the film gaining or losing moisture. The magnitude of this type of size change depends on the chemical nature of the film. Polystyrene, for example, changes much less with humidity than does acetate; polyester is only slightly affected by humidity. For any one film, it is the relative humidity of the air (not the absolute humidity) that determines the film's moisture content and corresponding size. After a change in the relative humidity of the air, the dimensions of a piece of polystyrene change gradually for about five minutes; those of acetate change gradually for about an hour. In both cases, the change continues until equilibrium between film and atmosphere is reestablished.

Thermal Expansion. Film, like other materials, also expands and contracts with changes in temperature. Thermal size changes occur rapidly, sometimes in a minute or two. Frequently, an increase in air temperature is accompanied by a decrease in relative humidity, or vice versa. Therefore, these two effects may partially cancel each other. Under other conditions, the effect of temperature and relative humidity may be additive.

Processing Shrinkage. Film swells during processing and contracts again during drying. If brought to equilibrium with the same relative humidity after processing as existed before, a small net change, called the "processing shrinkage," is usually experienced. If the film is not brought back to the same moisture content after processing, the apparent processing shrinkage may be increased by humidity contraction or reduced by humidity expansion, sometimes resulting in a small swell.

Aging Shrinkage. Permanent shrinkage during storage, prior to exposure, is generally very low and is unimportant for sheet film because there is no image on it at the time. After processing, film continues to shrink at a rate that gradually decreases with time in any given storage condition. Where negatives are used within a week or two after processing, shrinkage caused by aging is of little practical importance unless subjected to extremes of climatic conditions. Over longer periods of time, the amount of shrinkage depends on the composition of the particular film; for example, the residual solvent content of the base. Heat accelerates all three types of permanent shrinkage listed above, so that elevated storage temperature (over 90°F) should be avoided. Both extremes of relative humidity may result in permanent film shrinkage. Low relative humidity causes greater contraction of the emulsion, increasing plastic flow shrinkage. On the other hand, high relative

humidity facilitates escape of any residual solvent that may be present. For these reasons, film should be stored at approximately 70 to 80°F and 40 to 50% R.H. These storage conditions will minimize shrinkage due to aging.

POLYESTER FILM BASES

Most lithographic films employ a polyester base. Polyester film bases have excellent size-holding properties and are only slightly affected by changes in relative humidity and changes in temperature.

While not offered as an unqualified replacement for glass, polyester film bases are used for many applications where atmospheric conditions would rule out ordinary flexible bases.

Since the polyester film base contains neither solvents nor plasticizers, aging changes in the base itself will be negligible, and polyester film bases have excellent long-term storage characteristics. In normal shop operations, no particular handling precautions are necessary. But when extremely accurate film registration is required, the following suggestions may be found useful:

1. Maintain storage, exposing, stripping, and plate exposure areas at the same relative humidity and temperature insofar as possible.

2. Break the seal on fresh boxes of film 24 to 48 hours before use, and store in the working area to allow films to reach equilibrium with the room relative humidity and temperature.

3. Allow individual sheets to condition in the darkroom for at least twenty minutes before exposure in order to come to room equilibrium.

4. Handle all films of a set together.

5. Dry processed films quickly for most accurate register. Squeegee film surface, and dry in circulating warm air at 100 to 125°F for optimum results.

6. Allow processed films to condition at room temperature for at least two hours before further use. This permits all films in a set to become thoroughly dry and avoids usage of films before equilibrium is reached.

7. Store processed film sets together.

8. Note that season-to-season relative humidity changes are substantial in unconditioned shops. Return of stored processed films to original size can be obtained in such cases by conditioning them back to the relative humidity and temperature under which they were first used.

ACETATE FILM BASES

The term "acetate" base is commonly used to designate film base made of cellulose acetate butyrate or cellulose triacetate, which are cellulose esters. The film base is cast from solutions of the materials in a solvent. A small amount of this solvent remains in the base. The gradual escape of the solvent during aging is one possible cause of shrinkage.

Dimensional change properties values for the different acetate films vary somewhat depending on the thickness of the base, the particular emulsion used, and other factors. The reversible size changes of acetate film bases are more likely to be caused by humidity than by temperature.

A portrait or commercial film on a thick base exhibits only moderate shrinkage upon aging only as long as the storage

relative humidity does not exceed 60% for an extended period of time. Long storage at high relative humidities can result in shrinkage up to 1%.

Lith-type films on standard-thickness acetate base have quite low aging shrinkage properties under moderate storage conditions. If stored for a year or more at relative humidities above 60%, a shrinkage of 0.5 to 0.7% can result. These films have good uniaxialism, that is, their properties are nearly the same in both the length and width directions of the sheet. This is a desirable characteristic for map reproduction work. The dimensional stability of thin-base films is not quite as good as that of standard-thickness acetate base.

POLYSTYRENE FILM BASES

Polystyrene film bases have a humidity expansion coefficient that is only one-third that of similar films on acetate base. However, its thermal coefficient is approximately the same as that of acetate film, so that temperature control is relatively more important than humidity control when using polystyrene film.

Polystyrene film base contains no solvent or plasticizer. This eliminates one of the three types of permanent shrinkage in film, mentioned earlier. Polystyrene film base itself shows no change in size when put through photographic processing. However, polystyrene film bases do undergo small size changes in processing due to the complex effects of the photographic gelatin coating. If the room air is constant at some low relative humidity, the size change in processing is usually a swell of up to about 0.03%; if the room air is constant at some high relative humidity, the size change on processing is usually a shrinkage of up to about 0.03%. In a laboratory air conditioned at 70°F and 50% R.H., the processing shrinkage of polystyrene film base is almost zero. Polystyrene has a lower softening temperature than acetate film supports. As a result, its shrinkage may be excessive above about 120°F, although its actual softening temperature is around 200°F. Storage at 70 to 80°F and 40 to 50% R.H. is recommended.

FILM HANDLING SUGGESTIONS

Where the film user cannot prevent large variations in atmospheric conditions, size changes can be greatly minimized by giving attention to film handling procedures. Some change in moisture content of the unexposed film may occur depending on the storage conditions, manufacturer's packing specifications, etc. It is unlikely that the film will be in equilibrium with the workroom air. Where the utmost in dimensional stability is required, the film should be conditioned to the air of the workroom by hanging up individual sheets in the dark for approximately one hour before exposure. Gentle circulation of air is beneficial. If the film is reconditioned in the same atmosphere after processing, dimensional changes caused by changing humidity will be reduced.

Dimensional Stability Requirements in Color Work. In color work, a moderate amount of dimensional change is often permissible provided that all color separations change exactly the same amount. In such cases, it is important that each sheet of film be treated in exactly the same manner from the moment the original package is opened. It is desirable for the conditions in the workroom to be similar to those in the storage room. If the relative humidity of the workroom is either low or high, the films should each be conditioned to room air before exposure, as described above.

Air-Conditioning. Well-controlled air-conditioning for laboratories and workrooms is highly recommended. A temperature of 70 to 75°F and a relative humidity of 40 to 50% are most satisfactory. A too-low humidity should be avoided as it increases the possibility of static. If the film becomes electrified, dust will adhere and spots will appear after the film is exposed and developed. A too-high humidity (over 60%) is to be avoided because of the danger of mold and other moisture defects, as well as higher shrinkage of film.

PHOTOGRAPHIC PROPERTIES

The photographic properties of a film determine the type of image we get after exposure and processing. If we know what type of image is needed for a particular purpose, we can select the proper film to do the job. Specifying such properties as speed, contrast, and color sensitivity usually narrows the choice of material to a very few possibilities. The first consideration in the choice of a photographic film is usually the color sensitivity needed. In most cases, this is primarily a choice between the materials for use in black-and-white reproduction, on the one hand, and those for use in color reproduction, on the other. The former have sensitivity to a few colors of light, while many of the later are sensitive to all colors.

COLOR SENSITIVITY AND TYPES OF SENSITIZING

All photographic emulsions are sensitive to blue, violet, and the invisible ultraviolet light. For many applications, this sensitivity is not enough. The photographic emulsions used in photomechanical color reproduction must be capable of recording densities for the broader range of colors that the human eye can see—that is, the greens, yellows, oranges, and reds. During manufacture, dyes are added that make the emulsions sensitive to these other colors.

Wedge Spectrograms. The color sensitivity of each film is indicated by a "wedge spectrogram." These are positive prints made from the original spectrograms. In these diagrams, the height of the white patch indicates the relative sensitivity of the film or plate to the various colors. The diagrams would be more spectacular if we printed the actual colors in the background. Our spectrograms would then look like a slice from a rainbow, with the violet at the left, changing into blue, the blue into green, the green into yellow, orange and finally, red at the right end. We could then see at a glance the height of each color. This is rather difficult, so we have compromised by labeling the general areas of the spectrum so that we can interpret the diagrams more easily. The lens system used in making wedge spectrograms will not transmit ultraviolet light. For this reason, all of these spectrograms show a low sensitivity in this area. This causes little difficulty, because this light is not transmitted by process lenses either and can be ignored in all ordinary work. Shown are wedge spectrograms for three types of film and, for

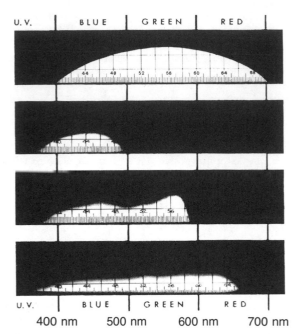

Wedge spectrograms showing (top) sensitivity of the human eye, (second) sensitivity range of colorblind materials, (third) sensitivity range of orthochromatic materials, and (bottom) sensitivity range of panchromatic materials.

comparison, the sensitivity of the human eye approximately as it would appear if we would make a similar wedge spectrogram of it.

Wedge spectrogram production depends on the composition of the light used in making the exposure. For example, if the light source gave off no blue light, the spectrogram could not indicate any sensitivity in the blue region, even though the film was sensitive to blue light. The spectrogram, then, shows the response of a particular photographic material to a particular light source—the one used in making a spectrogram with a light source that contain all or most of the visible colors of light. The white-flame arc is such a light source, and for this reason most spectrograms are made with such light. Spectrograms are made with tungsten light for those films with which tungsten light is commonly used. It should be noted that wedge spectrograms give no indication of film speed—only relative color sensitivity.

Blue-Sensitive Photographic Materials. Blue-sensitive, or "colorblind," photographic materials record high negative densities for blue areas of the original and, in the final reproduction render blues very light and reds, yellows, and greens very dark. Colorblind materials are very useful in such specialized work as copying black-and-white photographs.

Orthochromatic Films. Orthochromatic films are not sensitive to red light and are normally faster than blue-sensitive materials because they are sensitive to a wider range of colors.

Panchromatic Films. Panchromatic films are sensitive to all visible colors, as well as ultraviolet. They, therefore, give excellent monochromatic rendering of colored copy.

Infrared Materials. Infrared materials possess a particularly high sensitivity to infrared radiation. Their principal use in photomechanical reproduction is for making black printer negatives for color separation work.

FILTERS

A filter is a device that transmits light of certain colors while absorbing light of other colors. Common types are thin sheets or disks placed in front of the lens of the camera or in a slot in the lens mounting. By using the proper filters, we can "filter out" or reduce selected colors of light from a multicolored object. Our photograph will then record only the colors transmitted by the filter.

A filter never "changes" the color of light. It can only allow a part of some colors to pass through and stop other colors. A "red" filter appears to be red because it transmits red light to the eye and absorbs most other colors. This is shown in the accompanying illustration. All filters absorb some of the light that strikes them, making necessary longer exposures than when no filter is used under the same conditions of illumination.

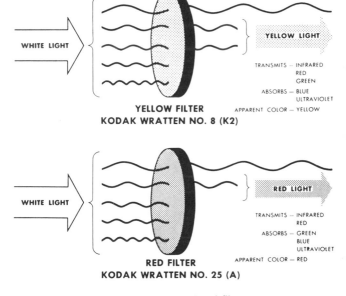

Action of yellow and red filters.

Filter Uses. There are two basic uses of filters in photomechanical work. In one, filters are used to emphasize or deemphasize tonal areas in making black-and-white reproductions from colored or soiled copy. In the other use, filters are used in making color reproductions from color copy.

In the latter case, the original is photographed successively through each of three *color-separation filters*. The three black-and-white negatives obtained are called *color-separation negatives* and are used in making the three printing plates that print the respective colors on the paper. (A fourth plate is usually added—the black printer—to add density to the dark areas of the picture.)

Filter Factors and Filter Ratios. Each of the above two uses of filters require a separate method of calculating the correct exposure when using a filter. The first is based on filter factors, and the second on filter ratios.

The filter factor, expressed as a number, such as 1.5 or 2, indicates the number of times the exposure must be increased when the filter is used, compared to the exposure under the same conditions with no filter.

The filter ratio is more useful for color-separation work. The correct exposure for the red filter is first determined by trial or by the use of the exposure index and a meter. The correct exposures for the other separation filters can then be calculated directly by multiplying this red filter exposure by the appropriate filter ratio for each of the other filters. For color-separation work, the filter ratios are determined for negatives developed to equal contrast and are corrected for reciprocity effects.

Specially selected gelatin filters are available for critical photomechanical work. They are particularly useful in cases where partial exposures are to be made through each of several filters, as in the split-filter method of making a black printer.

SAFELIGHT COLOR AND SAFETY

Any photographic material will fog if left long enough under safelight illumination. This is not necessarily because the safelight transmits any light that it should not, but because even blue-sensitive materials have some sensitivity to green, yellow, and red light. This sensitivity is not sufficient to be useful in picture taking, but it is enough to cause fog, or veiling, with prolonged exposure under a safelight.

Darkroom Illumination. Darkrooms used for photomechanical work should have as high a degree of illumination as is consistent with the type of materials being processed in them. It is the function of a safelight to transmit a maximum of the visible light to which the negative material is the least sensitive. If the safelight is chosen carefully and used wisely, this total illumination level can often be sufficiently high for very comfortable vision. For example, a negative material, such as ortho litho film, which is sensitive only to blue and green, can be handled briefly, for example, under a Kodak Wratten Series 1A (light red) safelight filter without danger of fogging. *Caution:* Ruby bulbs should not be used, because many of them transmit some green light to which orthochromatic films and plates are sensitive.

Handling Panchromatic Materials. With panchromatic materials, which are sensitive to all colors of light, the safelight, if any, must be of a color to which the eye is most sensitive. It is preferable to work in complete darkness where at all possible, but a dark-green safelight, such as the Kodak Wratten Series 3 safelight filter, can be used if the precautions furnished with each package of panchromatic material are observed.

Bulbs to Be Used for Direct and for Indirect Illumination. With direct illumination, where the light from the bulb shines directly through the safelight to the working space, a 15-watt bulb should be used in the safelight lamp at a distance of no less than 4 feet. With indirect illumination, where the light is reflected from a matte white surface inside or outside the safelight, a 25-watt bulb can be used at 4 feet. Note that, even with lights used as described, a safelight is "safe" for only a limited time. Under these conditions, materials can be handled for 30 seconds while dry, and for longer when in the developer. The absence of any fog in clear areas of the film does not prove that a safelight is safe, since overexposure to a safelight has an effect on halftone dots that is not readily noticeable. A safelight exposure that is insufficient to produce fog in clear areas of the film will frequently cause damage to halftone dots when added to the halftone image exposure. The size of a halftone dot is determined by the amount of exposure it receives, and the slight addition of an excessive safelight exposure can increase the size of the dots markedly and cause a fog in the areas between.

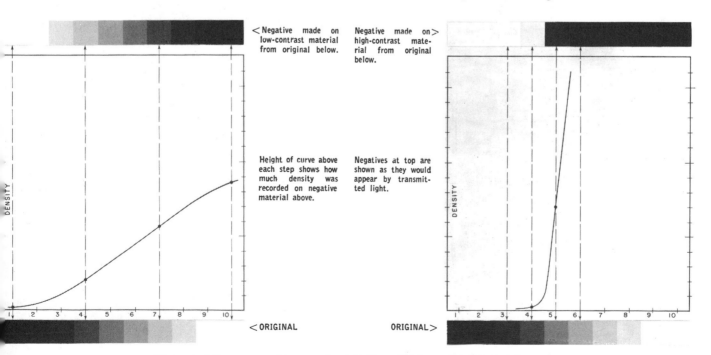

< Negative made on low-contrast material from original below.

Negative made on > high-contrast material from original below.

Height of curve above each step shows how much density was recorded on negative material above.

Negatives at top are shown as they would appear by transmitted light.

< ORIGINAL

ORIGINAL >

Characteristic curves of low-contrast (left) and high-contrast materials.

EMULSION CONTRAST AND THE CHARACTERISTIC CURVE

Contrast is a photographic term that refers to the separation of the tones in a picture or negative. We are discussing contrast when we say that a negative looks "flat" or "soft," or that it looks "contrasty" or "hard." In photomechanical work, where some loss in tones must be accepted because of the limitations of the printing process, we frequently refer to the contrast in particular portions of the scale of a picture as the "shadow contrast," "middletone contrast," and "highlight contrast." (Contrast should not be confused with *density range,* which is the difference between the maximum and minimum densities of a picture or negative.)

Indicating Contrast of Film. The contrast of films—that is, their tendency to produce pictures of high or low contrast—can best be indicated by their characteristic curves. The curve for each film commonly used in photomechanical work is furnished by the film manufacturer and available through film dealers.

The characteristic curve is a curve or line that shows how the film can be expected to react when it is used as recommended. Actually, it shows how much density will be recorded (how much blackening will take place) for the exposure correspond-

Gray scale and the corresponding tones in a picture.

ing to each tone in the original subject or picture being photographed. The shape of the characteristic curve is the key to the type of image obtainable from the film. The curve indicates whether or not a particular material will do the job at hand. Examining curves is easier than making trial exposures.

Comparing Film Characteristics by Comparing Pictures. One way to compare the characteristic of films would be to photograph the same pictures with each film and compare the effect, on the films, of each tone in the picture. We could select a typical picture like the one in our illustration and select a series of tones from the pictures to use in the comparison.

Gray Scale. Here, then, is a series of tones that can represent a picture and that has a uniform series of density steps of an easily seen and measured size.

Comparing Films by the Gray Scales. If we use this gray scale as our copy and photograph it with a negative working film, for example, we will get, after proper processing, a negative that looks much like the original in reverse—that is, each of the steps of the original will be recorded as a distinct density. By measuring with a densitometer the density of each step of the negative, recording it on a graph, and then drawing a line through the points, we get our curve as shown.

Numbering Gray Scale Steps. Since we started with a gray scale, of which each step represents a uniform density increase, we can merely number the steps and record their densities above the evenly spaced numbers on the horizontal scale (let's say, one every half-inch). Above these points on the horizontal scale, we place a point at a height that corresponds to the density on the negative for that particular step. A scale of densities is marked on the vertical edge to help us place these points.

Characteristic Curve of High-Contrast Film. We now get a characteristic curve of a typical high-contrast "line-and-halftone" material, so named because of the steep curve indicating a sharp jump from low to high density as a result of a slight increase in exposure. We need that sharp jump in density to give clean edges on lines and halftone dots. When this type of film is used behind a halftone screen, little or no density is recorded in the areas shielded by the opaque areas of the screen while a maximum density is recorded behind the almost clear areas, if at least the critical amount of light is passing through. More light passing through the screen causes the jump in density to take place farther from the almost clear center in all directions, and a larger dot results. The size of each dot therefore depends on the amount of light coming through the screen. A pattern of dots of varying size is formed—the halftone pattern.

The Gamma. In order to have a numerical value to represent contrast, the steepness of the curve—at least the straight-line portion of it—is measured and is known as "gamma." Thus a material developed to a high contrast can be represented by a steep curve and will be said to have a "high gamma."

EFFECT OF DEVELOPMENT ON CONTRAST

The contrast of continuous-tone materials increases with an

increase in development time and can be controlled satisfactorily to give great flexibility to photographic processes and techniques. The increase of the contrast with development time of continuous-tone films in the recommended developers is shown by the "time-gamma" curves in the data sheets available from dealers. Strictly speaking, gamma is the slope of the straight-line portion of the characteristic curve.

Effect of Temperature and Agitation on Contrast. Contrast for a given development time increases with increasing temperature up to the point where fogging begins to reduce contrast, particularly in the low-density areas of a negative. The contrast for a given development time is also increased by agitation during development. Agitation increases the rate of development.

Effect of Developers on Contrast. Highly concentrated and active developers develop an image more rapidly and produce an image of higher contrast than developers of the softer and slower-working types. A fresh developer solution works faster and, for a give development time, will produce images of somewhat higher contrast than a partly exhausted solution.

Development Characteristics of Different Materials. The development characteristics of litho materials are rather different from those of continuous-tone products. Litho materials are nearly always developed to their maximum contrast. With litho materials, an increase in effective emulsion speed with an increase in development time can often be used to advantage; for example, minor errors in exposure can be compensated for by varying the development time. This is referred to as "development latidude." Beyond a development time of about 2½ min., however, there is less change in effective speed. Film exposed to noncritical line copy so that it develops in about 2½ min. can be developed for a period of time after this and still produce a good negative. This characteristic is advantageous when several line negatives are processed together or whenever exact timing of development is difficult.

Time-Temperature Development Procedure. For consistent negative quality and shop efficiency, the use of the time-temperature development procedure is recommended. (Development by inspection is usually desirable for fine-line copy.) In "time-temperature" development adjust the temperature of the developer to the value recommended in the appropriate data sheet and develop for the recommended time. If it is necessary or desirable to work at some other temperature, the corresponding time is shown on the time-temperature development chart. (Automatic film processing is a time-temperature development procedure.)

EXPOSURE

An underexposed continuous-tone negative is lower in both contrast and density than a fully exposed negative, and lacks shadow detail. A negative that is greatly overexposed is also lower than normal in contrast, but is high in density and lacks highlight detail. A negative that is greatly overexposed is also lower than normal in contrast, but is high in density and lacks highlight detail. High-contrast line negatives lose sharpness

Proper exposure Underexposure Overexposure

Effects of exposures on continuous-tone positives. Notice the loss of shadow detail due to overexposure—effects that are opposite to those on continuous-tone negatives.

and detail when overexposed. When underexposed, the backgrounds of line negatives are not sufficiently opaque. When printed, fine detail has a tendency to spread; thus image sharpness is lost.

Film Speeds and Exposure Indexes. The many types of photographic films require different but quite definite amounts of exposure. Films that require very little exposure are loosely termed "fast" and, conversely, those that require more exposure are called "slow." Since these terms are relative and by themselves quite meaningless, films are assigned an "Exposure index"—a number related to their "speed"—to aid in exposure calculations. The higher the number, the "faster" the material, and the less exposure it requires. These exposure indexes can be used with standard photoelectric exposure meters calibrated for their use.

Exposure Meters. There are two common types of photoelectric exposure meters in use. The "incident-light" type, which is held in the position of the subject being photographed, measures the light falling on the subject. With this instrument, the exposure indexes can be used directly according to directions supplied by the manufacturers of the meter. The "reflected-light" type, on the other hand, measures the amount of light reflected by the subject toward the camera.

Using a Neutral Test Card. Since these readings otherwise vary from subject to subject and with the operator's method of using the meter, and since the variations are difficult to interpret, a *neutral test card* (18% gray side) should be placed at the copyboard position and the reflected-light measurement taken from this card. A matte white card can also be used, in which case the exposure should be five times the calculated exposure time. This procedure, in effect, converts the reflected-light meter to incident-light use. The slight variations from this exposure, which are needed for different subjects, are small and

can best be learned by experience. All the above calculations refer to continuous-tone and line work.

USE OF THE EXPOSURE INDEX FOR GRAPHIC ARTS PHOTOGRAPHY

Standard exposure indexes are calculated for lenses focused at infinity. However, in photomechanical work, where the lens is usually focused for same-size copying or for some reduction or enlargement in that vicinity, the quantity of light falling on the film varies greatly with change in image size and is considerably less than when the lens is focused at infinity. For this reason, the exposure calculated by use of the exposure meter and the exposure index must be adjusted for the percentage of enlargement or reduction. The following table indicates the amount by which the calculated exposure must be multiplied for a few typical situations.

Reproduction Percentage	25	50	100	150	200	300
Exposure Factor	.39	.56	1.0	1.6	2.25	4.0

For example, an exposure meter reading taken from an 18% gray card at the copy position indicates an exposrue of 5 seconds. If the reproduction is to be same size, the correct exposure is 5 x 4, or 20, seconds.

Screen Exposures. When a halftone screen is used in the camera, the light reaching the film is greatly reduced. For contact screens, the correct exposure time will be about 10 times the exposure calculated from the meter reading. For glass crossline screens, the factor is much higher, and variations in method of use make advisable a calculation of the factor by the user. This calculaton can be done by finding the ratio between a typically good screen-exposure time and a typically good line-exposure time.

Section Five: Selecting Photographic Materials

The fundamental requirement in a film for photomechanical line work and screened halftone work is high contrast. In negatives of line work, dark lines will then be rendered as clear areas, and background areas as extremely dense areas, even if the original copy has light or weak lines. In halftone work, the high contrast of the emulsion will produce sharp, crisp halftone dots. A fine-grain emulsion is also necessary so that the edges of lines and dots will not be ragged. Halftone dots must be of such quality that they can be altered in size by chemical means after development and still retain their opacity.

Our presentation is divided into the following four subjects: (1) Color-sensitized materials, (2) Stripping materials, (3) Direct-positive materials, and (4) Storage and care of films. Each of these is presented in the following.

COLOR-SENSITIZED MATERIALS.

For color copy, it is necessary to use a color-sensitized material that can record colors in their relative black-and-white tone values. Although emulsions with extreme contrast are lower in speed than continuous-tone materials, high film speed is important in reducing costs by saving time. Of equal importance, the films must be physically stable to withstand handling and rapid drying. They must dry flat for ease in handling under production conditions.

Each of the many photographic materials has characteristics that meet specific needs. In order to select the material best suited to a particular job, the information sheets provided by the manufacturers of photographic materials should be consulted.

STRIPPING MATERIALS

Stripping films are unlike other photographic materials. Their construction allows the image-bearing layer to be readily removed, or "stripped," from the support layer, or base, as indicated in our diagram. This "stripping" procedure permits a lateral reversal of the image on the metal printing surface in letterpress printing, necessary for obtaining a right-reading image in the final reproduction.

Construction of Stripping Films. As can be seen from the

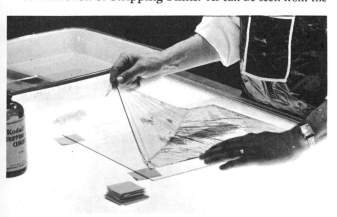

Thin membrane of stripping film.

diagram, stripping films contain more layers than do ordinary films. A thin adhesive layer, which softens in water, allows the image-bearing layer to be removed. The very thin support layer, or "skin," serves as a stable support for the emulsion layer while it is being stripped. After stripping (which usually includes lateral reversal), this tough thin layer serves as protection for the emulsion. It is so thin that it does not degrade the definition of the image when printing on metal. The procedures recommended for applying the stripping-film membrane to glass or acetate are given in the instructions supplied with the film.

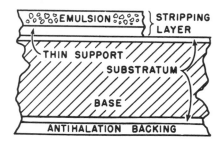

Cross section of stripping film.

Fixing Stripping Film. Proper handling of stripping film is quite important for the craftsman doing complicated insert work. Improperly hardened stripping film causes such difficulties as poor adhesion and curling of the edges. Fresh baths of rapid liquid fixer with hardener are quite satisfactory when used in accordance with instructions. The use of an acetic acid stop bath prolongs the useful life of a fixing bath. A 10-second rinse in 3 to 5% acetic acid just prior to wet stripping usually aids in producing better adhesion between the film and glass plate.

Causes of Stripping Troubles and Their Remedies. During periods of high relative humidity or when the temperature of tap water is increased, stripping troubles usually increase, especially if the fixing bath is not fresh. It is sometimes desirable to add extra hardener to the bath, particularly in the summer, when the relative humidity is high. In the winter, it may be desirable to reduce the quantity of hardener in the bath. The two-solution rapid liquid fixer with hardener is ideal because it is rapid in action and the amount of hardener can be easily controlled. The addition of one or two extra ounces of hardener solution to one gallon of fixing-bath solution will normally overcome any problems caused by insufficient hardening action. Too much hardening is to be avoided because this causes difficulties in laying the stripping skin down flat.

Stripping Film Cement. When stripping film is used in the normal manner for lateral reversal, the emulsion acts as an adhesive to hold the film negative in place. When the support side of the stripping film is to be in contact with the glass, however, stripping film cement should be applied to the glass, the film fitted into place, and a little cement spread in a thin coat around the edges of the cut film. As an extra precaution, place an extra "skin" of clear stripping layer over the negative when working in this manner. Stripping film cement assures position holding in all complex stripping and inserting jobs. A

thin coat of this material around the edges of all the pieces of film after they have been fitted into place will keep them flat.

Stripping Films in Photolithography. Stripping films were originally manufactured for the photoengraving trade, but have been found to be quite useful and adaptable in photolithography. Many photolithographers use stripping techniques similar to those employed by photoengravers. Production can often be facilitated by stripping negatives or positives of complicated combination work into glass, heavy sheet acetate, vinylite, or regular film base. The use of stripping film cement is recommended for these procedures. Easy lateral image reversal is obtained simply by "flopping" the negatives, and "normal" prints are made on metal printing plates without image reversal. Either method produces high-quality results, the film staying firmly in place with either emulsion or base side down on the glass or acetate.

DIRECT-POSITIVE MATERIALS

With direct-positive materials, a negative can be made directly from a negative, or a positive from a positive. This ability immediately makes practical a large number of operatons in multiple-negative work and step-and-repeat operations.

Duplicating Film. *Duplicating film* is a direct-positive photographic material that produces a duplicate image from a line or halftone original in one step. Camera and contact films produce the opposite result from an original—a positive from a negative or a negative from a positive. The duplicating film produces a duplicate negative from a negative and a duplicate positive from a positive.

Unlike other films that produce more density with more exposure, duplicating film produces less density with more exposure. Keep this in mind when calibrating for the duplicating film. The reason for this reaction is that the film has already been preexposed during its manufacture by a process called solarization. Simply stated, the duplicating film is preexposed to maximum density, so that additional exposure to the emulsion will cause less density.

The duplicating film is a blue-sensitive, relatively high-contrast continuous-tone film that has good exposure latitude and high resolving power. The film has a thin antihalation dye backing that permits exposure through the base for proper image orientation. The film is processed in a lith developer.

There are three general types of duplicating films available for photomechanical work: duplicating film, high-speed duplicating film, and super-speed duplicating film. The main difference between these films is their sensitivity to light.

The duplicating film is not very sensitive and requires exposure by a high-intensity exposure source, such as a plate exposure unit. This film material is used by the stripper making duplicates in the stripping or plate department. This film cannot be exposed satisfactorily with point light sources used in contact printing.

High-speed duplicating film is more sensitive to light and can be exposed by point light sources. The increased sensitivity makes it practical to perform duplicating operations by contact printing. Even with its increased film speed this film still requires longer exposure than any other product used in photo-

graphic contacting.

The super-speed duplicating film has the highest light sensitivity of this film class. In addition to providing shorter exposures in the contact duplicating process, it can be used to produce a line positive from line copy on a process camera in one step. This film also increases the practicality of doing duplicating in the contact darkroom with a point light source.

Autoreversal Film. *Autoreversal film* is similar to duplicating film in that they are both manufactured with a built-in density. However, autoreversal film has two unique characteristics: yellow light removes density, but white light adds or restores density. Because of these two characteristics, autoreversal film can produce many interesting results: (1) Outline effects of lettering and line work in a few simple steps; (2) Positive and negative combinations and effects on the same sheet of film without stripping; (3) Solid, clear, or tint lettering on halftone backgrounds; (4) Reflex copies, without the use of a camera or intermediate; and (5) Positive stripping keys instead of negative stripping keys.

Working with Autoreversal Materials. If autoreversal materials are developed without exposure, a high, even density will result. If however, the material is exposed to strong yellow light before development, this density will be removed. Furthermore, the density removed by the yellow light can be restored by reexposing to strong white light and again removed by strong yellow light. All these exposures must, of course, be made before the film is developed.

Remember, the basic principle in using autoreversal material is: Yellow light removes density; white light adds density.

Making Uniform Halftone Tints on Autoreversal Film. Since autoreversal film will develop to a uniform high density (about 6.0) before exposure, it can be used in making tints with high-density sharp dots that are free from pinholes. Use a gray contact screen or a magenta contact screen. (The exposure is more critical on the latter.) Place the screen in contact with the emulsion side of the film in a vacuum printing frame and expose through yellow sheeting. The percent dot size of the tint will, of course, vary with the exposure; as the exposure is increased, the dots will become smaller. For example, using a gray contact screen and a 35-ampere arc at 3 feet, the exposures might be as follows:

4-minute exposure— 80% dot
6-minute exposure— 50% dot
12-minute exposure— 20% dot

Normal Positive-Negative Work. Autoreversal films can be used when making a negative from a positive, or a positive from a negative, in normal room illuminaton. The following procedure can be used: first, flash the autoreversal film with an overall yellow-light exposure for 2 minutes with a 35-ampere arc at 3 feet, and then give a white-light image exposure for 5 seconds using contact printing methods.

Negative and Positive on the Same Film. By a simple masking operation, part of a negative can be printed as a negative and other parts as a positive, using autoreversal film. For example: (l) Place an opaque paper or film mask over those

parts of the image that are to be printed as a positive. (2) Print the remainder of the negative with yellow light. (3) Remove the negative, cover the areas just exposed, and uncover the area to be printed as a positive. (4) Give this "positive area" a 2-minute flash exposure to yellow light. (5) Replace the negative and expose this same area for 5 seconds to white light. (6) Process as usual.

This entire operation can be carried out easily if the autoreversal film is fastened to a base, such as a piece of pressboard or acetate sheet, by means of a few pieces of tape. Each mask is then placed in register and taped along one edge to serve as a hinge. By hinging these masks and the negative along different edges of the direct-positive film, any of them can be positioned immediately. A register frame can be used to maintain register between the various masks and negatives.

The masks may, of course, be lettering or line images on a litho film. By this means, clear or black lettering or other line work can be superimposed on a previously exposed area. Just remember that a yellow-light exposure will remove density and a white-light exposure will restore the density. *Note:* When a white-light exposure has been added to the original density, an increased amount or yellow exposure is necessary to remove the density.

Outline Effects. From a line negative containing lettering, for example, a negative can be made that has a fine clear line or a dark line at the edges of the letters. A line negative will produce lines on the outside of the edges, and a line positive will produce lines on the inside of the edges. Negatives with clear lines can be produced as follows: (1) Yellow-light exposure through the line negative (and spacer or diffusion sheeting to produce a spread negative); (2) White-light exposure through the line negative.

A dark outline on a clear background can be made as follows: (1) Uniform yellow-light flash exposure; (2) White-light exposure through the negative (and spacer or diffusion sheeting to produce a spread positive); (3) Yellow-light exposure through the negative.

The proportion of white and yellow light must be adjusted to retain the lines and maintain the proper background density. Wider lines can be produced if a spacer (a piece of clear, fixed-out film or a piece of sheet acetate) is placed between the negative and the film.

Intermediates for Making Positive Blue Keys. Usual practice in making blue-key plates for stripping guides in color work is to make a positive from the cyan-printer negative, and from this print, three blue-key negatives.

Stripping negatives to a blue-key positive is much easier and more accurate. By using autoreversal film, a laterally reversed duplicate negative can be made from the cyan-printer negative.

From this, the three blue-key positives are made.

Reflex Copying. Line work or typematter on paper can be copied by the reflex method. Place the autoreversal film facedown on the image side of the original and give a yellow-light exposure through the base of the film. A piece of clear glass can be used to maintain contact between the film and the original. Expose through yellow sheeting, for 90 seconds with one 35-ampere arc at 3 feet or for 45 seconds with four No. 2 reflector-type photo-floods at 2 feet.

STORAGE AND CARE OF FILM

To assure consistent processing results, all photographic materials should be stored under fairly constant conditions. Temperatures from 70° to 75°F and relative humidities between 40 and 50% are recommended. Moderate temperature with low relative humidity is preferred to low temperature with high relative humidity. Films should always be stored away from chemical mixing rooms, industrial gases, x-rays, and radioactive materials.

Heat. The packages in which sensitized photographic materials for the graphic arts are supplied provide adequate protection to withstand normal handling and the relative humidities commonly encountered in temperate climates. In general, they are not intended to withstand long periods of high relative humidities. The packages are not heatproof and should not be placed near sources of heat, or be left on top floors of uninsulated buildings or in other places where they might be subject to excessive heat.

Refrigerated Storage. During summer heat in temperate or tropical zones, refrigerated storage is recommended for unopened packages of films, particularly infrared and very fast films. To avoid condensation on the cold surfaces of these materials, packages that have been kept in cold storage should be removed to a warmer location several hours (preferably 24 hours) before they are to be opened for use. Packages of films that have been opened should not be placed in refrigerators, because the high humidity will damage photographic materials in open packages.

Storage of Processed Films. Processed films are best stored in dry, dust-free places away from harmful gases and chemicals. *They should not be stored, after processing, for long periods at high relative humidities (over 60%).* Film negatives should be filed in durable envelopes, plainly marked, in case further use of them is to be made. The envelope should be chemically inert, and the seam should be located along one side.

Section Six: The Darkroom

All darkrooms have somewhat the same layout and equipment. Processing of film requires the steps of development, stopping, fixing, and washing. Equipment such as ventilators, safelights, electrical fixtures, and entrances can be very nearly identical in darkrooms for professional, industrial, and photomechanical photography.

Darkroom layout is determined primarily by the size of the materials handled and the required flow of work. The general physical requirements of a satisfactory darkroom are as follows: (1) The room must be light proof. (2) Both "safe" and white-light illumination must be provided. (3) Trays, tanks, or a film-processing machine must be available for holding processing solutions. (4) Running hot-and-cold water is needed. (5) An accurate thermometer and timer or clock are necessary. (6) A bench-top or wall viewing light should be available. (7) Storage space of the proper type is necessary for photographic materials and supplementary equipment. (8) A drying rack or cabinet or automatic film dryer will be found useful.

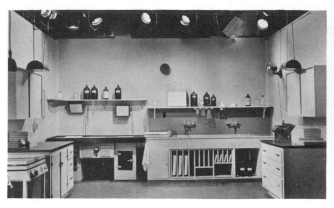

A well-planned and well-equipped darkroom.

LAYOUT OF A PHOTOMECHANICAL DARKROOM

The essential characteristic of any good darkroom layout is usability. It is true that the existing structural members of a plant or building may restrict the usability of a proposed design. But in unrestricted situations, darkrooms of simple and useful design should be considered.

Arrangements of Tanks and Trays. The necessary trays or tanks can be arranged along a wall, in a corner, or down the center of a room. However, the best arrangement is a straight line of trays or tanks along a wall. Sufficient working space should be allowed, with aisles at least three feet wide. When planning the area to be used, two factors should be considered: (1) the amount of work to be done each day, and (2) the possibility of a future increase in the production load.

Layout for a Combination Darkroom. Our halftone illustration shows a combination darkroom of a simple, workable design. This darkroom has been laid out for movement of work from left to right, ending with the densitometer (for photomechanical work) on the bench at the far right. This plan can be reversed easily for those who work from right to left.

SIZE OF DARKROOMS

The size of the darkroom is directly dependent on how the room will be used. It is often found best to have two specialized

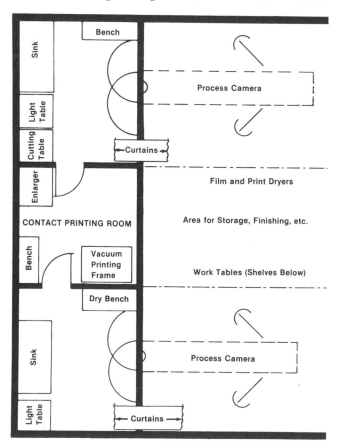

This layout was designed for two graphic arts cameras and darkrooms, with space for the possible addition of a third camera. The contact printing darkroom was placed between the graphic arts cameras' darkrooms so that it could be entered from either one.

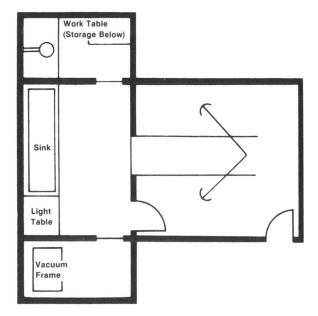

Layout for setting up a single 18-in. graphic arts camera. The number of darkrooms depends on the space available. Graphic arts camera manufacturers can supply data on the space required for other camera sizes.

darkrooms rather than one large universal room. For example, extra rooms may be feasible if a shop will do such work as contact printing and masking in its usual run of work.

Minimum Size. The minimum size for any photomechanical darkroom is usually considered to be 6 ft. by 8 ft. If equipment such as a darkroom-type camera is installed, this minimum should be increased to about 8 ft. by 10 ft. If you want to do contact printing and handle large film, your darkroom area should be approximately 10 ft. by 20 ft.

Planning the Proper Size. Rooms must be large enough to accommodate conveniently the maximum size film likely to be handled and to enable adequate ventilation to be maintained. On the other hand, large rooms with unusable space serve only to waste the time and efforts of the operator. The important thing is, again, preplanning.

DARKROOM ENTRANCES

It is desirable to be able to enter and leave the darkroom without admitting any light. This is possible by the construction of double doors or light locks. The walls of entrances and passageways should be painted with a dark, matte finish to prevent reflection of light around the baffle. Oftentimes two darkrooms can open into one light-locked passage.

The Open-Passage Entrance. The open-passage type of entrance is considered best because it provides both good ventilation and easy access. The latter is especially important when workers are carrying large films. Like darkrooms themselves, the exact size of these entrances must depend somewhat on the size of the photographic materials used.

Double-Door Light Lock. When floor space is at a premium, it may be necessary to use a double-door light lock. With this arrangement, one or both of the doors can be replaced by heavy single or double curtains. If two solid doors are used, it will be necessary to place a light-trapping vent in the wall of the passageway in order to relieve the changes in air pressure caused by opening and closing the doors. If several persons are to use a light lock, it is best to install a warning light or buzzer that will operate when either door is open, thus reducing the possibility of both doors being opened at once.

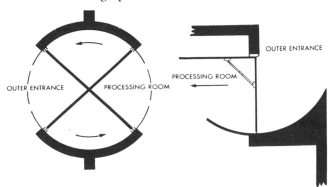

A revolving door can also be used as a light lock. The unit on the left is easier to use than the unit on the right, but it also takes up slightly more room.

DARKROOM EQUIPMENT

The selection of equipment is naturally a matter for each shop to consider in the light of other requirements. Well-built equipment will usually cost less in the long run, and all equipment should be selected with consideration of the maximum film size to be handled.

Processing Sinks. Careful consideration must be given to the materials and construction of processing sinks. Improper choice of materials may result in corrosion of the material itself, and faulty fabrication may cause leaks and shorten the useful life of a sink.

Many factors must be considered in selecting materials for the construction of processing sinks. These include resistance to the corrosive action of the solutions, mechanical durability, adaptability to fabrication, ease of cleaning, and appearance. Fiberglass and stainless steel are the most common materials from which processing sinks are made.

Care of Processing Sinks. The care of processing sinks consists largely of keeping them clean and repairing minor leaks. The type of material from which the sinks are constructed determines in many instances the best methods for cleaning and repairing.

Courtesy of nuArc Company
Processing sink.

Scouring powders can be used for cleaning stainless steel sinks. Citric acid can also be used for removing hard scale. A 10% solution is usually satisfactory and can be prepared by dissolving one pound of citric acid crystals in approximately five quarts of water. This method should be followed by a thorough rinsing with water.

Film Processing Machines. Film, in addition to being tray processed, can be processed automatically in film processors. Such machines typically develop, fix, wash, and dry film.

Film processors take up very little darkroom space, as only the feed portion of the processor is in the darkroom. However, space outside the darkroom is needed for the delivery end of the processor. The delivery end of the processor must be located in a relatively dust-free and clean area.

Space requirements for a film processor.

Machine processing may be used as the sole film processing method, or it may be used in combination with sink processing. Even if a machine will do the bulk of the work, a processing sink for specialized processing and as an emergency backup is recommended.

Sink-Top Light Table. Extra sink-top space can usually be used to build in a combination light table and dot-etching

Waterproof light table incorporating a foot treadle by which the operator controls the flow of washing water.

bench. It is most convenient to have this placed at the end of the sink so that the glass top, set in waterproof cement, can be sloped to drain into the sink. As shown in the illustration, frosted glass is installed below the clear glass to diffuse the light source. It is usually desirable to install a perforated waterpipe at the upper edge to supply washing and flushing water for negatives during reduction or etching and inspection. A foot-treadle type of valve for the wash water makes this arrangement even more convenient.

Tray Storage. General experience has shown that a vertical arrangement as illustrated is most convenient for tray storage. It permits easy access and at the same time allows wet trays to drain. Some workers prefer to have the lower portions of the

vertical separators cut off so as to provide easier access and cleaning of the storage areas.

Water Temperature Controls. Accurate and consistent control of the conditions under which photographic materials are processed, particularly control of the temperature of the processing solutions, is desirable in all cases and is a necessity in photomechanical work and in work with color materials.

When only small quantities of photographic materials are to be processed, it is possible to get along with manual adjustment of temperature. For example, the drain of the darkroom sink can be fitted with a standpipe, and water from an ordinary mixing

Suggested storage plan for small and medium-sized dark rooms.

faucet can be allowed to overflow from the washing tank and surround processing tanks to the level of the standpipe. With such an arrangement, a thermometer placed in the water flow must be watched constantly to make sure that varying loads on the water-supply lines are not allowed to change the temperature of the mixture.

When appreciable quantities of sensitized materials must be handled on a production basis, however, a more accurate and dependable temperature-control system is almost a necessity. With such a system, mistakes and delays can be avoided, and savings in time and materials will quickly repay a reasonable investment in equipment.

Mixing Valves. Automatic, thermostatically controlled mixing valves provide the most compact and least expensive of the systems available for the control of water temperatures.

These valves operate by mixing warm and cold water to obtain the desired temperature. Therefore, the temperature of the cold water supply must, of course, be at least as low as and preferably lower than the temperature required for the mixture. In areas where the cold water during the summer months is warmer than the desired temperature, an auxiliary cooling system is necessary. This, in turn, necessitates a few additional fittings to permit switching the unit from the normal use of existing hot-and-cold water supplies to the use of cold and artificially cooled water. In winter months, there will seldom be any necessity for a refrigerated water supply.

Temperature-Controlled Sinks. Several very satisfactory temperature-controlled processing sinks are available. There are

two basic types. One type has a built-in refrigeration unit with cooling coils under the sink. This type maintains a shallow level of water at a constant temperature. The other type has no coils directly under the sink, but continuously circulates water through a built-in mechanical cooler at the required developing temperature.

Suggested dimensions of a dry bench or a work bench.

Dry Bench. The dry bench is where sensitized goods are handled and stored. It should be located away from wet areas, such as sinks and chemical mixing benches. To provide storage space for supplies and accessories, a combination of drawers similar to the unit illustrated is recommended. It should include a lighttight drawer to store photographic materials.

An integral wiring system might be desirable for such a unit. Three separate circuits in the bench are recommended. A convenience outlet with a switch provides an outlet for the various electrical devices, such as timers, clocks, and printing lamps. A general convenience outlet should also be provided.

On the bench itself, a snap switch to control the safelights is especially useful if a photographic enlarger is used because it is easier to focus an enlarger without a safelight shining down on the easel.

Chemical Storage and Mixing. Chemicals and chemical solutions can be stored wherever it is relatively cool and dry. It is necessary to keep powders away from open film boxes. Space for bottled chemicals can be built into a sink unit.

Bench Tops. A linoleum covering is quite satisfactory for some sink and bench units. It is quite suitable for dry-bench work. If possible, it is desirable to carry the linoleum up on the back of the bench or sink to form a splash shield. A curved junction can be achieved by using 1½-in. cove molding under the linoleum where the bench joins the back of the bench or sink. This arrangement forms surfaces that are free of "dust catchers" and therefore easy to clean.

CAMERA DARKROOM FACILITIES

Space for the camera must also be provided in the darkroom. The primary function of process camera facilities is to provide a convenient means to safely load and unload film in the camera, and to provide a means to expose film. With a darkroom camera

(the type that has its back in a darkroom and the rest in the gallery, or light room), that section of a darkroom for the camera must be large enough to allow for the swing of the camera back (film holder). Additional room should be provided for the at-hand storage of light-sensitive materials and other materials, such as halftone contact screens, used in the photographic process. Depending on the camera and camera control systems used, some space may be needed for exposure control units. Usually a shelf can be used for the control units, thereby requiring minimal space. Sufficient safelighting should illuminate the area around the camera back to assist the camera operator in the placement of the materials on the film holder.

Many times, the camera is entirely enclosed within the darkroom. This method of camera location is very efficient in terms of the frequency of exposures, but since the camera lights are in the darkroom, excessive heat is produced, causing discomfort to the camera operator. Therefore, if such a camera location is necessary, ventilation and air conditioning must be provided. Just as if the camera were located partly in the darkroom and partly in the gallery area, sufficient space must be provided on all sides of the camera for traffic flow. In addition to having a work surface to lay copy, special lighttight storage cabinets must be in the darkroom to store the light-sensitive materials when the room lights or the camera lights are operating.

CONTACT PRINTING FACILITIES

Also to be considered in darkroom planning is contact printing. The first concern in organizing a contact printing facility is locating the contact printing frame and the light source. The ideal position is to have the printing frame in the center of the contact room if feasible. Although this location is the best design, it is not always possible because of space limitations. More commonly in many printing plants, the frame is located against a wall or in a corner of the room.

This arrangement is acceptable only if the necessary precautions have been taken; otherwise many problems will occur that will interfere with the accuracy and overall quality of the contacting intermediate. Don't place the frame directly against the wall—keep it as far away as practical. Keeping it away from walls, storage cabinets, and other reflective objects will lessen the interference of light reflection on reproduction quality. Light reflecting off the walls and across the printing frame is the cause of most problems in photographic contacting. Therefore, the walls around the frame must be painted black. Another potential problem results from placing the contact printing frame near air and exhaust ducts, air-conditioning vents, doorways, and other areas of air movement. Avoiding these areas will help keep the printing frame clean and dust-free during the contact process. A good printing frame location also provides convenient work flow in relation to the other components of the contact darkroom.

FLOOR COVERING

The choice of floor covering in a photographic darkroom presents several unusual problems. The ideal floor should have these qualities: resistance to corrosive substances, resistance to

staining, watertight installation, durability, freedom from slipperiness, resiliency for foot comfort, and a suitable color. It is impossible to obtain all of these qualities in one material, but a compromise can be achieved by selecting a flooring that combines the most essential properties for your use. Of the various floor coverings available, the following two types stand out as highly desirable:

Ceramic Tiles. Ceramic tiles are available in several colors and types. The degree of vitrification and body density are important factors in the choice of ceramic tiles. A fully vitreous tile will absorb practically no moisture and is therefore easily cleaned. Most porcelain and natural clay tiles are impervious to dirt and liquids, and are nonstaining, easily cleaned, and available in nonskid types. Semivitreous and nonvitreous tiles are not usually satisfactory because of their greater absorptivity for photographic solutions and chemicals.

Composition Tiles. Composition tiles are of many types and some are quite inexpensive. They are made of plastic, hard-rubber, asphalt, or synthetic resin and can be laid down over existing flooring, including wood. The asphalt tiles are usually the best for most installations because they are quite stain-resistant and have long-wearing properties. Hard-rubber and plastic tiles are usually satisfactory, but some types stain easily, so a certain amount of caution must be used in the selection of these materials.

Synthetic-resin tiles are undesirable because they tend to absorb chemicals and therefore stain easily.

SAFELIGHTS

Darkrooms for efficient work should have as high a degree of illumination as is consistent with the safety of the types of materials being processed in those darkrooms. It is the function of a safelight to transmit a maximum of the visible light to which the negative material is the least sensitive. Safelights must be chosen carefully and used wisely. In this way, the total illumination level of the darkroom can often be sufficiently high for very comfortable vision. For example, a negative material such as Kodalith Ortho Film, Type 2, which is sensitive only to blue and green, can be handled in a relatively high illumination of red light without danger of fogging. For this particular example, a Kodak Wratten Series 1A safelight filter is recommended. *Caution: Ruby red bulbs should never be used, because, even though they look red, they often transmit light to which orthochromatic films are sensitive.*

Panchromatic Materials. With panchromatic materials, which are sensitive to all colors of light, it is preferable to work in complete darkness where at all possible. If a safelight is used, it must be of the color to which the eye is most sensitive, namely, green. A dark-green safelight such as a Kodak Wratten Series 3 safelight filter is usable with panchromatic materials if the printed precautions furnished with each package of sensitized material are observed.

Safelight Colors. It is usually necessary to have several safelight and safelight filters for the different classes of photographic materials being used. The correct safelight filters are

recommended in the manufacturers' direction or date sheets packed in each film package or box.

Safelight filters have been specifically prepared and tested for exacting photographic use. Other materials may appear to have the same color as the tested safelight filter, but they may have a much greater photographic effect. The use of makeshift darkroom illumination is one of the surest ways of getting poor dot quality in halftones and poor tone rendition in continuous-tone images.

Safelight lamps are so constructed that it is a simple matter to change the safelight filters to suit the material being handled. When the safelight filters are not in use, they can be stored in slotted racks located in a convenient position.

In the case of indirect-light boxes that are mounted near the ceiling for general illumination, however, it usually will be difficult to reach them to change the filters. In this case it is desirable to have two safelights, each fitted with one of the two most commonly used safelight filters, and each controlled by a separate switch.

Safety of Safelights. Any photographic material will fog if left long under safelight illuminaton. This is not because the safelight transmits any light that it should not, but because even colorblind (blue-sensitive) materials have some sensitivity to green, yellow, and red light. This sensitivity is not sufficient to be useful in picture taking, but it is enough to cause fog or veiling with prolonged exposure under a safelight. All safelight filters, when used with the recommended bulb and at the recommended distance, are safe for at least 30 seconds with the dry materials for which they are recommended, and for a longer time when the material is in the developer.

Since safelight exposure can decrease quality even without producing fog, a more sensitive test of the safelights must be

KODAK SAFELIGHT FILTERS

Filter Designation	Color	For Use With:
OO	Light Yellow	Flashing halftones through Magenta contact screens for contrast control
OA	Greenish Yellow	Black-and-white contact and duplicating materials, projection films
OC	Light Amber	Contacting and enlarging papers
1	Red	Blue-sensitive materials
1A	Light Red	Slow Orthochromatic materials
2	Dark Red	Faster orthochromatic materials and green-sensitive x-ray films
3	Dark Green	Panchromatic materials*
6B	Brown	Blue-sensitive x-ray films and other materials (see specific instruction sheet)
7	Green	Black-and-Red infrared materials, except Kodak high-speed infrared films.
8	Dark Yellow	Color print and color intermediate films
10	Dark Amber	Color negative papers, color slide and print materials, panchromatic papers

*Fast panchromatic materials require that development be started in total darkness. After the material has been in the developer for at least half the total development time, it can be inspected for a few seconds by the light of a Kodak Safelight filter No. 3, provided the lamp is kept at a distance of at least 4 feet from the film.

used. When it is suspected that safelights are causing trouble, a simple but sensitive test can be made as follows:

1. Make a print from a typical halftone negative on a whole sheet of the film or paper in question, using the printing method commonly employed. Use a border mask to produce an unexposed area around the image. No safelight should be used during this part of the test.

2. Now expose parts of the same sheet of film or paper to the safelight by covering successive areas of the film or paper for different lengths of time and keeping one area covered at all times. The test should be made where the material will be handled and developed, and with the safelight located where it is commonly used.

3. Process the film or print and notice the amount of safelight exposure that can be given without noticeable change in quality of the image or highlight dots.

In general, it will be found that an amount of safelight exposure that does not produce any fog in the border will show appreciable veiling of highlight dots and highlight areas in the print.

DRYING FACILITIES

In planning drying facilities, there are two general types of graphic arts films that must be considered. Each dries at a different rate, and therefore the drying equipment depends on the type of materials used. Films with thin emulsions, such as ortho litho film, dry very quickly under almost any condition. Films with thicker emulsions dry more slowly under normal darkroom conditions.

Electric Fans. For small-volume plants that process films with thin emulsions, an electric fan is usually acceptable. In this case, when drying is to be accelerated, a flow of air from an ordinary electric fan can be directed toward the film or plate. Large-volume plants using all types of photographic materials can easily justify the expense of a film dryer.

Film Dryers. A dryer is a device in which photographic materials are dried. There are two basic physical designs for dryers.

Courtesy of Buckingham Graphics, Inc.
Film dryer.

In one design similar to a sauna "hot box," the dryer is a cabinet where air is circulated to quickly dry films. Cabinets are designed for a number of film lengths at one time or for a single length. A cabinet is basically a sheet-metal cupboard with rods at the top to suspend film. An electric fan draws air in through a dust filter. The air passes over an electric heating element, and then circulates through the cabinet drying the film. The air escapes through an opening in the cabinet top. The temperature inside the cabinet is indicated by a thermometer dial and is regulated by a thermostat. These cabinets can be equipped with rods to hold up to 100 lengths of roll film or with racks for sheet film.

For large batches of film, infrared lamps give more rapid drying. Infrared lamps penetrate the emulsion and can dry film in about two minutes. However, precautions are needed to prevent the emulsion from melting.

With the other common type of dryer, the photographic material is transported through the dryer on continuous tapes or rollers. The material enters at the front of the machine, is dried in the interior by either cool or warm air, and exits the machine in a dried condition. This type of dryer has the advantage of not melting or softening the emulsion if the dryer speed is compatible with the film emulsion being dried. Tape- or roller-transport dryers have two major drawbacks: low-volume drying because only one piece of material can pass through the machine at one time, and a high chance that the emulsion will be scratched by dirt particles on the transporting rollers. (A film dryer is usually an integral part of an automatic film-processing machine.)

VENTILATION

Satisfactory ventilation of any darkroom is more complex than the ventilation of a room for comfort only. Naturally, the health and efficiency of the cameraman must be considered, but certain other elements directly affect the air in these rooms. For example, uncovered solutions increase the humidity in the room, processing solutions create slight odors, and drying cabinets give off heat.

Effects of Temperature and Humidity. When improperly controlled, the temperature and humidity of the air have adverse physiological effects on the worker as well as physical effects on photographic materials during handling and storage. For example, excessive humidity causes the body to perspire, and damp fingers will readily leave marks on dry films or plates. If the air is too dry, film is susceptible to static electricity. In addition, lack of proper humidity causes the mucous membranes in the nasal passages of workers to become dry and the skin to become chapped.

Air Filtration. The incoming air should pass through suitable filters to remove dust particles. The air flow should be in sufficient volume to change the air in the darkroom six to ten times and hour.

It is advisable to have the air in the processing room maintained at a positive pressure, that is, the air should be pumped *in* rather than *out*. This will prevent dust entering through windows and doors.

Exhausting the Darkroom Air. The drying cabinet must never exhaust *into* the processing room. If an air-conditioning system is installed in the building, the use of the air from the processing room for the drying cabinet may be undesirable as it

might overload the ventilating systems and upset the balance of the pressure and circulation. In such instances, the dryer should have separate ducts not connected with the air-conditioning system. However, in other ventilating systems, the drying cabinet may be useful as a method of exhausting the air from the room.

ELECTRIC WIRING

Although high-voltage circuits do not extend into the darkroom, low-voltage electric outlets and fixtures may present a hazard under certain circumstances. Voltages of 110 volts or less can be fatal if electrical contact is made with moist skin. Care should be taken to avoid a situation in which the body becomes part of an electric circuit.

The electric wiring and equipment in the darkroom must conform to regulations in order to safeguard the worker and the plant. They are applicable not only to existing darkrooms but also to those in which new equipment is to be installed.

All exposed non-current-carrying metal parts of both fixed and portable equipment, such as the metal frame and exterior of each illuminator, safelight lamp, electric timer, and foot switch, must be grounded.

Insulation of Accessible Fixtures. As a safeguard, all outlets, switches, sockets, and the like should be composed of insulating materials. Chain pull-switches should have an insulating link in the chain or section of cord.

Foot-switches eliminate the need for the use of hands in operating electric fixtures. However, the precautions that apply to the grounding of other fixtures are even more imperative when foot-switches are installed, because the floor may be damp or, on occasion, even wet.

Planning. The placement and circuit wiring of the various outlets should be planned for the convenience of the worker. All processing-room circuits, white lights, safelight lamps, and outlets should be controlled by a master switch located above head height on or near the inside door frame. A red signal light should be located near the door outside the processing room. This should be controlled by the safelight lamp switch so that, when it is on, the red light will glow and thus indicate that the darkroom is in use. This will prevent accidental opening of the door while films are being processed.

Placement of Switches. Below the master switch, another switch should be placed above shoulder level to control the white ceiling light of the processing room. Both the master switch and the white-light switch are placed high in this manner so they will not be accidentally turned on. It is also well to have a switch lock in the form of a flat plate placed on the white-light switch so that the white light cannot be turned on unless the switch is unlocked. Below these two switches, another switch is placed at waist level to control the safelight lamps.

Painting the Darkroom. It is no longer necessary to paint darkrooms jet black. Light leaks should be plugged, and the walls painted light green, light gray, or white. These colors add pleasantness to the working surroundings, simplify keeping the darkroom clean, and at the same time increase the effectiveness of safe darkroom illumination.

Section Seven: The Graphic Arts Camera

In view of the many different kinds of copy submitted for reproduction, the camera in a lithographic plant must be extremely versatile, particularly if the plant has only one such unit. A camera may be small or compact with a maximum film size of 16 in. by 20 in. Or it may be extremely large, capable of producing film negatives up to 4 ft. by 6 ft. If intended for ordinary line and halftone work, the camera may be of simple design. But for color separation, multiple exposures, photo-composing, and other intricate camera operations, a fully equipped precision model is needed. Camera equipment should be chosen not only for the immediate needs but also with future requirements in mind. A graphic arts camera is a long-term investment; it must have enough flexibility to keep pace with plant expansion and changes in the type of work handled.

Our presentation of the graphic arts camera is divided into the following five points: (1) Camera elements and camera types; (2) Lens and its mounting; (3) Rear assembly of the graphic arts camera; (4) Various types of copy-holders; and (5) Operational accessories. Each of these points is discussed in detail in the following.

CAMERA ELEMENTS AND CAMERA TYPES

Knowledge of a few basic factors in selecting camera equipment may be repaid many times over in terms of immediate and future utility. It is the purpose of this article to discuss the design, function, and features of modern graphic arts cameras so that the data may help in making the initial decisions when selecting camera equipment. A camera of limited utility im-

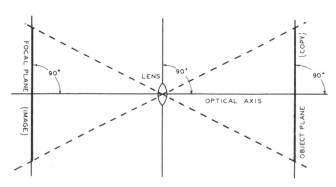

Basic requirements of a graphic arts camera.

Three possible structural forms of darkroom cameras—floor horizontal, overhead horizontal, and vertical.

stationary

movable

TYPE · A (standard)

no bellows

movable

WALL

movable

TYPE · B

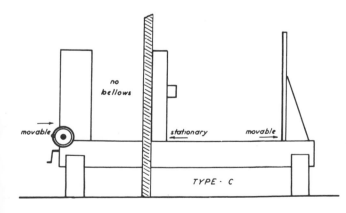

no bellows

movable

stationary

movable

TYPE · C

Three variations in the construction of the horizontal darkroom camera.

poses serious restrictions on the nature and quality of the output of the shop, for, with inadequate camera equipment, many jobs are handled improperly while others cannot be handled at all. In addition, the speed and economy with which the camera operations can be performed have considerable influence on the competitive position of the plant.

In this unit we concentrate on six fundamental items: (1) Basic parts of a process camera; (2) Gallery and darkroom cameras; (3) Overhead and floor-type cameras; (4) Vertical cameras; (5) Camera for color work, and (6) Size and capacity of cameras. Each of these six items is individually presented in the following.

Basic Parts of a Graphic Arts Camera. In order to clarify some of the camera terms to be used in the following discussion, it might be well to begin by analyzing the basic parts of a graphic arts camera. Negative-making for photomechanical purposes is essentially "copying" and generally calls for no more than the production of an image of a flat surface. This is accomplished by means of an image-forming lens that projects the image of the copy to the focal plane.

In its simplest form, the graphic arts camera is merely two parallel planes at right angles to the optical axis of the lens that lies between them. In practice, the focal plane is encased in a housing to which are attached all of the necessary devices—the focusing screen (ground glass) and the holder for the sensitive material. The copy is usually held in place by vacuum. An independent support maintains the alignment of the lens in relation to the copy and focal plane.

The three elements are mounted on a chassis, or main bed, which, in addition to providing the means for adjusting the relationship between lens, film, and copy for reducing or enlarging the image, also functions as the means for maintaining the parallelism between the three essential planes.

Gallery and Darkroom Cameras. There are two general types of graphic arts cameras: gallery and darkroom. The gallery camera is independent of the darkroom except for the bulky, lightproof holder for the sensitive material that must be transported between camera and darkroom for loading, exposing, and unloading.

The darkroom camera derives its name from the fact that the rear of the camera extends into, and is operated from, the darkroom. With a camera so designed and operated, it is possible to perform both darkroom and camera operations at one and the same time. For example, while exposing a negative, the

Floor-type horizontal camera.

film of a previous exposure can be processed.

Although a gallery camera can be installed within a darkroom, only one operation can be performed at a time—exposing or processing, not both. The efficiency and convenience of the darkroom camera over the gallery type is an established fact.

Overhead and Floor-Type Cameras. Structurally, three differing principles are employed in assembling the essential camera planes to form the complete darkroom camera. Our diagram illustrates the essential construction differences of the vertical, floor-type, and overhead varieties. The horizontal, floor-type camera main bed is raised anywhere from 6 in. to 3 ft. from the floor and can be serviced from the side only. The elevation of the main bed on the overhead camera permits easy and unobstructed accessibility to lens, copy, and lamps.

Vertical camera.

The amount of the camera protruding into the darkroom varies with its design. Three designs predominate. Designs B and C apportion the overall length of the camera between the darkroom and the area outside. In addition, both types require no bellows between camera back and darkroom wall. This is an advantage when it is desirable that the operator have access to the front side of the sensitive material for purposes of dodging and masking during exposure. Design A is, however, the most popular arrangement.

Vertical Cameras. The vertical darkroom camera has as its outstanding advantage, the conservation of space. The camera proper is horizontal and within the darkroom. The supporting structure for the copyboard is vertical, parallel to and closely hugging the outside of the darkroom wall. Since the focal plane and copy plane are at right angles to each other, the use of a reversing mirror or prism is mandatory. Laterally reversed images are therefore standard with this design.

A vertical camera that is entirely in the darkroom is also common in the graphic arts. The optical axis of the camera's lens is vertical, with the copyboard and film holder perpendicular to this vertical axis. The camera's supporting structure is vertical. In such a vertical camera, the copyboard is usually closest to the floor. Because of the camera's design, it cannot be used as a darkroom (through-the-wall) camera. Rather the entire camera must be in either a gallery area or a darkroom. One popular arrangement is to have the camera located in a small lighttight room directly adjacent to the darkroom.

The chief limitation of vertical cameras is in size (film and copy capacity) and in range of enlargement and reduction. The latter is due mainly to the fact that the camera back must be kept at a convenient working height, which, in turn, limits the extent of the copyboard movement. Nevertheless, within its capacity and range, the vertical camera is fully as functional as equivalent horizontal models.

Cameras for Color Work. So far we have made no distinction between operating features for black-and-white and color reproduction. Actually, no clear-cut distinction can be made since the requirements of many types of monotone (black-and-white) photography are as diversified and critical as those for color-separation work. Color work requires the utmost operating precision, hence color cameras are generally more rigid in construction. In addition, color work often requires features that are not essential for most black-and-white photography, as for example, the ability to rotate the transparency holder around the optical axis for "squaring-up" the image.

Since color copy includes such varied subjects as color transparencies, oil paintings, and other color drawings and photographs of both large and small dimensions, the copyholding facilities must be extremely versatile. A combination including a glass-covered copyboard and a transparency holder may be considered a satisfactory arrangement. The darkroom end of a color camera must also provide suitable and rigid support for the different sensitized materials likely to be employed.

The need for returning to a previous focus in the event that additional negatives or positives (makeovers) must be made to match the rest of a color set makes a scale focusing system mandatory on a color precision camera.

Although scale focusing systems are accurate enough for most

SCREEN CAPACITY

CAMERA	A	B	C	D	E	F	G	H	I
RATED SIZE	24"	24"	24"	24"	24"	24"	31"	31"	31"
MAXIMUM FILM OR PLATE	24 x 24	25 x 28	24 x 24	24 x 24	24 x 24	26 x 26	28 x 36	31 x 31	31 x 31
MAXIMUM LINE IMAGE	24 x 24	25 x 28	24 x 24	24 x 24	24 x 24	26 x 26	28 x 36	31 x 31	31 x 31
MAXIMUM RECTANGULAR SCREEN	20 x 24	20 x 24	20 x 24	20 x 24	20 x 24	21 x 25	28 x 36	26 x 30	26 x 30
MAXIMUM CIRCULAR SCREEN	23½	23½	31½	23½	31½	23½	37½	30	31½

Relationship between maximum film size and screen capacity of a representative group of graphic arts cameras.

camera operations, resetting a camera to a previous focus requires a high degree of accuracy. To eliminate any errors in resetting the focus, such as might occur from parallax in reading scale indicators or from backlash in the gear train of revolution counters, certain cameras are equipped wih an additional reset control. This usually takes the form of a dial micrometer gauge that is accurate to within 0.001 in., when measuring the physical location of lensboard and copyboard. In use, the dial micrometer is placed on the center-drive rack to correspond with a prerecorded number from the original focus. With the dial in position, the copyboard or lensboard is moved until the dial reading duplicates the original reading. By this means, the copyboard and lensboard are precisely relocated in their original position on the camera bed.

Size and Capacity. The size of the camera, i.e., capacity of filmholder, length of bed, and maximum and minimum bellows extension, must be determined by consideration of a number of independent but interrelated factors. For example, the design, size, and construction of the camera back influences not only the maximum area of film accommodated, but also the size of the halftone screen that may be employed. As a general rule, the construction of most modern cameras is such that both line and halftone negatives can be made practically equal in area to the maximum film size. This is true in the majority of cases only when applied to rectangular halftone screens.

When we consider circular halftone screens, however, we must anticipate considerable reduction in the size of the rectangular halftone image area. For example, although all of the 24-in. cameras listed in the chart are capable of producing 20-in. by 24-in. halftone images from rectangular screens, all but two of them are limited to the use of 23½-in. circular screens. The maximum image area (other than circular) obtainable from a 23½-in. screen is 15-in. by 18-in. If we should want a 20-in. by 24-in. halftone negative from a circular screen, we would require a circular screen of at least 31½-in. diameter. Since the capacity of the screen mechanism generally increases with increased film size, we would have to choose a 31-in. camera or larger.

For use with circular screens, then, the selection of camera size must be resolved by first ascertaining the diameter of the screen required to cover the largest rectangular image desired. The next step is to determine the total area occupied by the screen including the holder. Obviously, only a camera whose

halftone screen capacity and film capacity meet the requirements is suitable.

THE LENS AND ITS MOUNTING

In this section, we are discussing the following five points: (1) Mounting of the lens; (2) Covering power; (3) Range of reduction and enlargement; (4) Auxiliary lens; (5) Various lens requirements.

Mounting. A process lens consists of several glass elements that are most carefully made and joined together in the lens barrel. A lens barrel is usually filled with an iris diaphragm and may also have a slot for the inserting of other lens stops or color filters. Lenses for color work are often equipped with special metal holders for the speedy handling of color filters. The lens barrel is attached to the camera on the lensboard. The mounting permits simple and fast exchanging of various lenses or lens barrels.

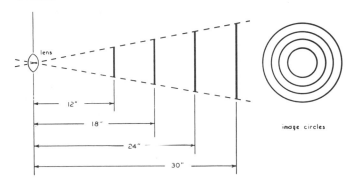

Covering power of lens—the size of image area covered without distortion or losses.

Covering Power. In order to determine the needed length of the camera bed, as well as the maximum and minimum positions of lensboard and copyboard, the focal length of the lens must be established. The covering power of a process lens is a fixed function of the lens. It is dependent upon the inherent image angle and the focal length. The diameter of the image area, with lenses of the same type and angle, becomes greater as the focal length increases.

When focused for same size, the image area and copy area are equal, as are the distances from lens to copy and lens to film. As the copy is brought nearer to the lens, the size of the image area

Diameter of image circle and image/copy relationship.

increases while the size of the copy area gets smaller. Just the opposite happens when the copy is moved further away from the lens. The size of the image area decreases while the copy area increases. Because of this, the focal length of the lens must be chosen on the basis of the image area desired and the scale of reproduction.

Range of Reduction and Enlargement. The next logical points for consideration are the length of the camera bed and the minimum and maximum bellows separation required to obtain the range of enlargements and reductions desired.

Focal Length of Lens	Reproduction Percentages								
	100%	50%	200%	33%	300%	20%	500%	10%	1,000%
10"	17	12	24	10½	31½	9½	47½	8½	85½
12"	21	15½	31	13½	40½	12	60	10½	105
18"	31½	23	46	20	60	17½	87½	16	160
24"	41	30	60	27	81	24	120	20	200
30"	49	37	74	31	93	28	140	25	250
36"	60	41	82	37	111	33	165	29	300

Approximate diameter in inches of the image circle sharply covered at f/22, at the various reproduction ratios shown, for lenses of different focal length.

The distances separating the lens, film, and copy are a function of the focal length of the lens and the scale of reproduction. The distance between lens and image, B, is directly related to the distance, A, separating the lens and copy. The distance between image and copy, C, is the total of A and B. Distances A and B are called conjugate foci and, except when the image and object are at same size, one is always greater than the other. The

Separation possible between lens and copy, B, and lens and film, A.

sum of conjugate foci, however, remains the same in all cases where the ratio between image and copy is the same. Assuming that the required separation between copy and image can be achieved, the minimum bellows distance will limit the range of reduction, while the maximum bellows extension will govern the range of enlargement.

Auxiliary Lenses. The standard lens is often supplemented by one of shorter focal length in order to increase the range of enlargement and reduction. This practice will prove satisfactory

only if the image-covering power is adequate and there are no mechanical limitations preventing the fulfillment of the required conjugate distances. For example, if the minimum distance between lens and image limits an 18-in. lens at 20% (5-1 reduction), then a lens of lesser focal length could not be brought close enough to the image plane to affect further reduction.

Various Lens Requirements. The optical considerations so far discussed are concerned with the lens characteristics that govern image size and camera range. The lens, more so than any other camera feature, is responsible for ultimate image quality and must be selected on the basis of all of its performance characteristics.

A good process lens must have excellent color correction, not only in the visible spectrum but, preferably, extending into the ultraviolet and infrared regions. The latter is necessary if color separation techniques are employed involving fluorescing and infrared-absorbing copy. Image resolution should be high (this will vary with focal length and with sensitive material), and the lens should be free from flare. The latter condition is eliminated or minimized in modern process lenses by a special antiflare coating.

Although the lithographer rightfully expects that the necessary lens qualities are built-in by the manufacturer, lens performance should be judged by practical tests made under the exact conditions of use.

REAR ASSEMBLY OF THE GRAPHIC ARTS CAMERA

Having established the overall dimensions of the camera on the basis of image size, image coverage, and range of enlargement and reduction, we now turn to the features of the camera's main operating station — the camera back or rear case. Located at this point are holding devices for the sensitive material, screen mechanisms, and other essential controls. These will be discussed in the following order: (1) The three types of film supports; (2) Vacuum filmholders; (3) Various kinds of vacuum filmholder attachments; (4) Horizontal and vertical vacuum backs; (5) Roll-film camera backs.

Three Types of Film Supports. Film and paper photographic material may be supported by any one of three methods—stayflat, vacuum, or sandwiched between two sheets of glass. This last method is rarely used except as an emergency measure. The stayflat method utilizes a sticky composition that is coated on a sheet of glass or metal. The back of the film or paper is pressed into contact with the stayflat surface by means of roller, squeegee, or the palm of the hand, after which the assembly is brought into the focal plane of the camera.

Vacuum Filmholders. The vacuum filmholder usually consists of a metal supporting surface having small holes or shallow grooves through which air is drawn by means of a vacuum pump. A film placed upon the supporting surface seals the vents and sets up a vacuum, and atmospheric pressure against the face of the film holds it in place. Vacuum backs are basically of two types—the masking variety and the valve-cutoff type. The main difference is how the area not covered by film is sealed.

SCALE OF FOCUS / FOCAL LENGTH OF LENS

SCALE OF FOCUS (Ratio of image to copy size)		10"	12"	18"	24"	30"	36"	48"
100% (1-1)	b —	20	24	36	48	60	72	96
	a —	20	24	36	48	60	72	96
	c —	40	48	72	96	120	144	192
50% (1-2)	b —	15	18	27	36	45	54	72
	a —	30	36	54	72	90	108	144
	c —	45	54	81	108	135	162	216
200% (2-1)	b —	30	36	54	72	90	108	144
	a —	15	18	27	36	45	54	72
	c —	45	54	81	108	135	162	216
33% (1-3)	b —	13.3	16	24	32	40	48	64
	a —	40	48	72	96	120	144	192
	c —	53.3	64	96	128	160	192	256
300% (3-1)	b —	40	48	72	96	120	144	192
	a —	13.3	16	24	32	40	48	64
	c —	53.3	64	96	128	160	192	256
25% (1-4)	b —	12.5	15	22.5	30	37.5	45	60
	a —	50	60	90	120	150	180	240
	c —	62.5	75	112.5	150	187.5	225	300
4% (4-1)	b —	50	60	90	120	150	180	240
	a —	12.5	15	22.5	30	37.5	45	60
	c —	62.5	75	112.5	150	187.5	225	300
20% (1-5)	b —	12	14.4	21.6	28.8	36	42.2	57.6
	a —	60	72	108	144	180	216	288
	c —	72	86.4	129.6	172.8	216	258.2	345.6
500% (5-1)	b —	60	72	108	144	180	216	288
	a —	12	14.4	21.6	28.8	36	42.2	57.6
	c —	72	86.4	129.6	172.8	216	258.2	345.6
16% (1-6)	b —	11.6	14	21	28	35	42	56
	a —	70	84	126	168	210	252	336
	c —	81.6	98	147	196	245	294	392
600% (6-1)	b —	70	84	126	168	210	252	336
	a —	11.6	14	21	28	35	42	56
	c —	81.6	98	147	196	245	294	392
14% (1-7)	b —	11.5	13.7	20.6	27.4	34.3	41.2	54.9
	a —	80	96	144	192	240	288	384
	c —	91.5	109.7	164.6	219.4	274.3	329.2	438.9
700% (7-1)	b —	80	96	144	192	240	288	384
	a —	11.5	13.7	20.6	27.4	34.3	41.2	54.9
	c —	91.5	109.7	164.6	219.4	274.3	329.2	438.9

Table of approximate lensboard and copyboard distances, B, for various focal lengths. The table indicates the physical requirements of bellows extension, A, and bed length, C, for a particular focus setting and focal length.

In the masking type, adjustable masks or individual metal shields corresponding to a particular film size are used. In the nonmasking type, a valve, or a series of valves, confines the vacuum to a specific area depending upon the size of film being used.

Vacuum filmholders are attached to the camera housings by means of hinges on either the side or base of the holder. In the case of side attachment, the holder is swung from the inoperative position (where the sensitive material is applied and removed) to the focal plane. This arrangement, in which the holder may be attached to either side, permitting a choice of left- or right-hand operation, makes possible the attachment, on the opposite side, of an additional unit such as a ground glass panel. When the base of the holder is hinged to the camera, the holder is lowered (tilted) to a horizontal position for applying or removing the sensitive material and is held in the horizontal plane by means of brackets or chains.

Horizontal and Vertical Vacuum Backs. Some cameras have both horizontal- and vertical-loading vacuum backs. In this case, the vacuum holder is hinged, at the base, within a frame hinged to the rear case on the side. At the operator's option, either loading arrangement can be used.

Roll-Film Camera Backs. A significant approach toward mechanizing the photographic operation is evident in cameras

equipped with backs that can accommodate roll film. This eliminates the steps involved in the conventional procedure for loading a camera for each shot. In addition to this, roll-film camera backs make it possible to have available in the camera, and ready for use, rolls of various widths. This allows the cameraman to select the width as well as the length that will be most economical for the shot being made. Another advantage is that of loading the camera with several types of film where the work requires this to a greater extent than it does size flexibilities.

A modern roll-film camera will also have holders for contact and/or glass halftone screens. One of the disadvantages of contact screens is their susceptibility to damage from handling. In the roll-film camera, the screens are moved into place mechanically and very seldom need to be handled. In addition to this, the camera can be so equipped as to make possible complete operation from the gallery, instead of requiring the cameraman to shuttle back and forth between gallery and darkroom several times for each shot.

Courtesy of Power Chemco

Roll-film camera.

On those occasions when it is necessary that sheet film be used, most roll-film backs are designed to make this feature also available. The roll-film camera does speed up the photographic operation considerably, as well as cut down on raw film costs as well as waste—all without any sacrifice of quality.

VARIOUS TYPES OF COPYHOLDERS

Since the greatest variation in working procedure is because of the vast differences in the size, thickness, and surface character of the copy submitted for reproduction, careful attention must be given to the devices for holding copy. Unless the work is highly specialized and limited to a particular kind of copy, it is advisable to select a camera with some form of multiple copyholder or one that, by design and construction, permits the installation of additional copyholding units as needed. Here we discuss three types of copyholders: (1) Open-face copyholders for reflection copy, (2) Glass-covered copyboards for reflection copy, and (3) Holders for transmission copy. Each of these is briefly described in the following.

Open-Face Copyholders for Reflection Copy. Originally, copyboards of the open-face type were generally made of wood panels on which the copy was fastened by means of tacks, nails or staples. Boards of metal or wood with special grooves and spring clips provided a means of attaching copy to open-face panels without the need for driving nails through the copy. The inability to achieve perfect flatness with wrinkled or very thin copy on the wooden panels led to the development of the open-face vacuum copyboard that, due to suction and atmospheric pressure, holds the copy firmly in place without pins and with a minimum of effort in placing the copy in position.

Despite the inefficiency of the wooden copyboard, it nevertheless has a place in camera operation when the copyboard must support extremely large copy and combine a number of copies of varying thickness. It is also desirable when it becomes necessary to position the arc lights at peculiar angles in order to minimize or retain surface characteristics of the copy, which, if under glass, might give rise to unwanted reflections (hot spots) or distortions from the glass surface.

Glass-Covered Copyboards for Reflection Copy. In the simplest design for a glass-covered copyboard, a metal frame holding the copyboard glass is hinged to a felt-covered board. Obviously, the "give" of the felt limits the thickness of the copy that can be used. The accommodation of thicker copy requires the use of other devices, such as a pressure back that consists of a cushioned panel supported by springs. By this arrangement, copy up to one inch in thickness can be used. Both of the above designs, however, are effective only if the copy is of reasonably uniform thickness.

If objects that vary in thickness must be placed under glass, a pneumatic cushion (air bag) device is desirable. The cushion is sandwiched between the glass and a stiff base. The copy is arranged on the surface of the cushion, and when the frame is closed, the air pressure within the cushion forces the copy surfaces against the glass. The difficulty often encountered with extremely thin or wrinkled copy may be overcome by using an enclosed vacuum copyboard similar in construction to vacuum printing frames.

All of the enclosed copyframes for horizontal cameras may be tilted to the horizontal position for inserting and removing copy. Glass-covered copyframes offer an additional advantage in that the surfaces of the copies, regardless of thickness, are always coincident with the object plane—a necessary condition on cameras with focusing scales.

Holders for Transmission Copy. Negatives and positives are supported between the pairs of clamps on adjustable bars or in metal or wooden frames called positive-negative kits. Either of the two methods may be incorporated in the copyboard carriage, in which case the removal of the standard or glass-covered copyboard exposes the unit for use.

These kits, generally a set of concentric interlocking frames of different size, make possible, in one unit, a range of openings corresponding to the standard transparency size.

In the other arrangement, a set of adjustable bars and clamps is attached to the back of a glass-covered copyframe with a removable pressure panel. An opal glass diffusing panel is generally provided when working with direct illumination, a curtain when operating by reflected light.

The bar-and-clamp-type holder usually includes a masking arrangement to exclude all light on all sides of the negative or positive. The kit type is self-masking since in each case the

opening in the frame corresponds to the size of negative or positive used.

OPERATIONAL CAMERA ACCESSORIES

In addition to the basic camera elements, there are numerous optional features and accessories that, although often overlooked, merit serious consideraton. In many cases, a certain accessory may be essential for one particular kind of work but a mere convenience for another. Regardless of the specific type of work done in a particular plant, the following items are desirable accessories to the graphic arts camera; (1) Scale focusing; (2) Aperture controls; (3) Single-and double-image reversers; (4) Single-reverser combined with special camera designs; (5) Lamp carriers; (6) Flashing lamps; (7) Screen compensators; and (8) Step-and-repeat backs.

Scale Focusing. In view of the fact that the distances separating the sensitive material, lens, and copy are not determined arbitrarily by the operator, but by definite optical laws, it is possible to predetermine the precise position of lensboard and copyboard for each degree of enlargement and reduction. Thus, by means of two factors—optical laws governing the minor and major conjugate foci, and the exact focal length of the lens—it is possible to compute the required settings mathematically and then correlate and mechanically apply them to the camera.

Types of Scale-Focusing Devices. Scale focusing can be done by means of: (1) Rigid linear scales attached to the camera chassis with sliding indicators on the lensboard and copyboard carriages; (2) Sliding tapes made of flexible metal attached to the lensboard and copyboard and extending to the rear of the camera where they pass under indicators in a panel; (3) Revolution counters and/or vernier dials attached to and synchronized with the movement of the lensboard and copyboard carriages. On some cameras, two focusing controls are provided, making it possible to focus the camera from both inside and outside the darkroom.

Calibration of Focusing Mechanisms. Calibrations may be expressed in a number of ways, all of which are correlated to the physical separation required. Thus, the linear scales and sliding tapes may be calibrated to read in inches, percentages, or some arbitrary but correlated set of numbers. The revolution counters usually read directly in inches or are correlated to distance by arbitrary readings. All of these systems operate in conjunction with some form of proportional slide rule or dial and master chart. It is only necessary to determine, by means of the control device, the relationship between image and copy sizes and then adjust the camera settings according to the indicated distance, percentage, or number.

Calibrations for Specific Lenses. It is advisable to remember that focusing calibrations are usually made for the lens supplied with the camera or the lens furnished by the customer. If additional lenses are to be used on the same camera, it will become necessary to have each lens calibrated. In the case of scales and tapes with graduations in inches and in the case of revolution counters, it is possible, after due allowance has been made for the difference in nodal position, to correlate all lenses to the focusing mechanism. Where the focusing device has been calibrated and so graduated that it functions exclusively with one lens, as in the case of perforated tapes and special linear scales, it is difficult if not impossible to correlate and apply such readings to other than the original lens, in which case all other lenses will have to be focused visually.

Aperture Controls. The aperture indicator, as supplied on some process lenses, gives only broad divisions, forcing the photographer to set the diaphragm to the intermediate points by interpolation. With such arbitrary settings, exposure can vary considerably due to lack of coordination between the diameter of the diaphragm and the distance between lens and film. For the same reasons, considerable deviation in the relationship between screen distance, diaphragm size, etc., will be encountered in halftone photography using a glass crossline screen.

With each change in distance between lens and film, a coordinated change must be made in the diameter of the lens diaphragm in order to maintain the required light transmission factor (f-stop). In halftone work using a glass halftone screen, where more than one stop is used, it is not only necessary to maintain the required relationship between the lens opening, screen distance, and bellows extension, but the relationship between the various stops must be accurately maintained. The minute changes cannot be judged accurately by means of the diaphragm ring and scale.

Fine Adjustment of Aperture. Various devices are available that greatly increase the accuracy of lens aperture settings. In general, they consist of a finely graduated dial attached to the lens or lensboard, a pointer fastened to the lens diaphragm ring and, in some cases, a vernier movement for precision settings. Although the graduations on the scale are sometimes coordinated to some particular halftone theory, most scales are simply a fine graduation of the f-stop. Whatever the scale may be, it will nevertheless permit lens settings exactly coordinated to the bellows extension. By means of such aperture control, the quality of halftone negatives will be improved, errors in exposure due to diaphragm variations will be eliminated, and a uniform line and halftone technique will be developed.

Several of these controls can be operated from the darkroom. This arrangement offers many advantages since the photographer need not leave the darkroom to change apertures during a halftone exposure or when making several negatives of different sizes from the same copy.

Single- and Double-Image Reversers. Many photographic operations require laterally reversed negatives or positives, i.e., transposition of image reading from left to right. The single-mirror, or prism, reverser usually employed for this purpose cannot be used on the conventional darkroom camera since the copy must be at right angles to the lens. Multiple-mirror reversers are designed to operate in a straight line and are thus applicable to darkroom type cameras.

The multiple-mirror reverser, however, because of distortion of the marginal rays, limits the usable picture area. When buying such equipment, it is advisable to check with the respective manufacturers as to the proper combination of lens

and reverser to adequately cover the maximum image area desired. As a general rule, a lens of longer-than-normal focal length will be required.

Lateral and "Lens Only" Image Reversal. Double multiple-mirror reversers are also available to provide both laterally reversed images and "lens only" type images. Two flat mirrors, or one mirror and one prism acting in unison, cancel out each other's reversal and thus produce the same type of image as when shooting through a lens alone. Three flat mirrors or one flat and one split mirror provide lateral straight-line reversal. On cameras equipped with the double-reversing systems, the change over from one to the other is usually accomplished electrically. The reversed and regular images are of the same size and in register at the focal plane. Some cameras with double-reversing mirror systems provide, in addition, the ability to shoot through a lens directly.

Since the mirror systems displace the optical axis, cameras so equipped generally have special lensboards and special copyboards (raised or laterally shifted centers). Because of this requirement, it is generally impossible, or impractical, to install this type of equipment on a standard camera.

Single Reverser Combined with Special Camera Design. The single-element reverser (mirror to prism) may be used in combination with a darkroom camera of special design. This camera has a separate bed for the copyboard set at right angles to the main camera bed. The two units are controlled from within the darkroom.

Lamp Carriers. In order to obtain uniformity of exposure, it is necessary that the desired distance and angle between the camera lamps and the copy remain constant. It is not always possible to judge, without actually measuring the distance and angle each time the camera is focused, whether or not the lamps are accurately positioned. Since the strength of light is inversely proportional to the distance between light source and illuminated surface, any variation in lamp position will result in a variation of light intensity reaching the copy. Such variation will induce underexposure, overexposure, or uneven illumination. A simple solution is to have a lamp carrier that connects a pair of lights to each other and to the copyboard at a fixed distance and angle. Not only is the copy illumination standardized by this means, but the movement of the lights is synchronized to that of the copyboard—thereby saving considerable time and effort, for both lights and copyboard are positioned at one and the same time.

The Three Basic Types of Lamp Carriers. Of the many lamp carriers available, there are only three basic types. The simplest arrangement is the bracket type that, by means of a set of adjustable rods, ties up the lights on their original stand to each other and the copyboard. An elaboration on this type consists of a separate carriage hooked up to the copyboard; the carriage supports the lamps. Both of these devices ride on the floor.

The second type consists of a pair of adjustable arms emanating from the copyboard carriage to which the lamps are attached. The third type utilizes a rail mounted under the camera bed and running the full length, to which are attached separate carriages with adjustable arms supporting the lamps.

The latter two types have advantages in that there is no connection between floor and lamps to impede the travel of the lamps or for transference of vibration to the camera bed. Overhead carriers, for use with both overhead and floor-type cameras, are also available.

Flashing Lamps. In most cases, halftone negatives require a nonimage, through-the-halftone-screen auxiliary exposure to build up the proper opacity in the shadow dots. This exposure is usually called the flash.

If a glass crossline screen is being used to make halftones, the flash exposure must be made either through the lens or from inside the bellows. The old procedure of exposing to a white sheet of paper or cardboard placed over the copy is not only a waste of time but eventually the flash sheet becomes dirty and wrinkled, which gives rise to an uneven or mottled flash exposure—particularly noticeable when making tints.

To obtain a more uniform flash exposure, it is advisable to use a flashing lamp. This flashing lamp consists of an incandescent light bulb in a housing with a suitable optical arrangement that produces a uniform and concentrated light source. A flashing lamp is operated at a very short distance from the front of the lens or just inside the bellows, and insures a short but uniform flash exposure.

Such flashing lamps are available in several styles. The least expensive is entirely hand-operated. The photographer brings it into position in front of the lens, holds it securely during the exposure and then sets it aside. Lamps that are permanently attached to the camera can easily be swung in or out of position. One such lamp is supported by a swinging bracket attached to the front or side of the lensboard panel. Another model is pivoted on a shaft protruding from the lensboard.

Another type is completely automatic in operation, being controlled entirely from the darkroom. By pushbutton control, the lamp is brought in or out of position and, by means of a synchronized electric timer, an accurate exposure interval is obtained. Obviously, this automatic flashing lamp, in conjunction with a darkroom diaphragm control, offers the most advantages since it eliminates the need for the photographer to leave the darkroom.

If a contact screen is used to make halftones, the flashing lamps can be arranged in one of three manners. In addition to being located on the copyboard side or filmholder side of the lens, the flashing lamp can be located on the ceiling or a wall of a darkroom. The darkroom flashing lamp must be a broad light source perpendicular to the open position of the camera back. Since the film and contact screen are held on the camera back by vacuum or other means, the camera back can be opened to the loading position in order to make the flash exposure.

Darkroom flashing lamps are simpler in design than those mounted on the camera. Roll-film cameras, no matter if they use glass crossline or contact halftone screens, must be equipped with a through-the-lens or inside-the-bellows flashing lamp.

Screen Compensators. When a camera has been focused with a glass crossline halftone screen in place and the screen is then removed, the size and sharpness of the image is no longer the same as when the screen was in place. The glass of the crossline screen causes the light rays passing through it to be

bent or refracted and thereby alters the distance between lens and film. If it is desired to obtain a line image of the same size and sharpness as a halftone image, two different camera settings would be required. This would prove an ambiguous situation on cameras with precision focusing systems for, unless adequate provision is made, the focusing system would be valid for either line or halftone use, but not both.

The difference between line and halftone focal points are easily eliminated by means of screen compensators, which are either disks or sheets of glass that possess the same refractive index as the halftone screen. By intentionally introducing an alteration or refraction of the light rays being projected to the film by means of the compensator device, we are able to produce line negatives that, at the same camera setting, will be equal in size and sharpness to halftone negatives. In use, the compensating device is brought into position when shooting line negatives and removed for halftone work.

Step-and-Repeat Backs. The step-and-repeat camera back is essentially a film back with a special mechanism that permits shifting the film material vertically and horizontally in relation to the image axis. By this means, a single image may be multiplied, or "stepped-up," on a plate in absolute register in black-and-white or color process. The movement of the plate may be actuated by vertical and horizontal micrometer screws or by quick acting micro-set stops and slide bars. As a general rule, cameras so equipped may also be used for all other camera operations.

Summary of Operational Camera Accessories. Individually, each of the devices under this discussion has a function that it can fulfill by itself. However, utmost utility or efficiency can sometimes be obtained only be means of a companion device. It might be well, therefore, to summarize some of the remarks made about these devices throughout this study.

Scale focusing is based on optical laws governing the function of lenses. Introduction of other optical equipment either in front or in back of the lens can and will alter the conditions on which a focusing scale is based. The glass halftone screen alters the focus sufficiently to require a different distance between lens and film, at a specific degree of enlargement or reduction, than for a line setting. Thus, to avoid the need and annoyance for differentiating (in focus) between line and halftone settings, scale focusing and screen *compensators* should be considered inseparable.

A through-the-lens flashing lamp operated electrically from within the darkroom serves no useful purpose unless the lens aperture can also be controlled inside the darkroom. An electronic exposure control, for greatest efficiency and advantage, should be complemented by *a diaphragm control* and *synchronized light carrier.*

Mention might also be made of *rotating filter holders* operated from the darkroom, which are desirable additions to cameras possessing darkroom-operated diaphragm controls and flashing lamps.

Most camera operations, with the exception of inserting or removing copy, can be performed or controlled within the darkroom. A fully electrified camera possesses many operating advantages if a definite need for such control exists. In the absence of a definite need, many automatic devices become mere gadgets.

Consideration must also be given to the fact that many camera features are available only when factory-installed or may be exclusive features of particular models. This may preclude installation, at a later date, of critically needed accessories.

Obviously, a camera with limited features will not keep pace with plant expansion and will soon prove inadequate. It is sound practice to fully determine the immediate camera requirements and also to anticipate future needs. The camera's features should meet both conditions.

Section Eight: Contact Printing

Photographic contacting, or contact printing, is a photomechanical process that is used to produce same-size line, halftone, and continuous-tone negatives, positives, and duplicates by a direct-contact procedure from camera-produced films or other forms of transparent or translucent (transmission) originals.

The basic method involves exposing through the original onto a sheet of sensitized material as the two sheets are in direct contact with each other.

The process of producing exact contacts is an important and critical step in the reproduction process and should be treated accordingly. Accuracy, standardization, and quality are the primary goals in photographic contacting.

CONTACT PRINTING FRAMES

A contact printing frame is the device that holds the imaged and the sensitized materials together. All printing frames cause close material contact through pressure. There are four basic styles of printing frames used for photographic contacting in the graphic arts: the pressure-type printing frame; the glass-covered vacuum frame; the acetate overlay vacuum frame; and the glassless, or open-faced, vacuum frame. The size and nature of contacting requirements determine the most appropriate frame size and style.

Pressure-Type Printing Frame. Contact printing frames use two methods to force the close contact of the imaged material and the unprocessed photographic material: mechanical pressure and vacuum. The pressure-type printing frame applies pressure by using a springlike mechanism and is relatively simple in construction. Usually it consists of a wooden frame, a glass top inserted in grooves in the wooden frame, and a firm backboard, which has a springlike mechanism.

This frame must be easily turned over to position materials prior to exposure. Therefore, the frame is small and portable. It is the least expensive type of printing frame because it relies only on mechanically produced pressure between the glass lid and

backboard to cause sufficient contact between the imaged and sensitized materials.

The frame is assembled for contact printing in this way: The frame is first placed upside down on a clean, flat surface. The imaged material is placed against the glass top, with the unprocessed film placed in contact with the imaged material. Next, the backboard is positioned, and the springlike mechanism is locked into place, exerting pressure and causing contact between the materials. The frame is then turned over, ready for exposure.

Pressure-type contact printing frame.

A pressure-type contact printing frame is suitable for continuous-tone and line contacting, but is not very efficient in the contacting of images with dot patterns, such as halftones. Fitted with register pins, a pressure-type frame can be used for small-size contacts and for special applications such as masking, making separations, producing special effects, or any contacting requiring the registering of small films.

Glass-Covered Vacuum Frame. The glass-covered vacuum printing frame is the most common style of printing frame used in lithography. The principles and methods of operation of a glass-covered printing frame vary considerably from those of a pressure-type frame.

A glass-covered vacuum frame is constructed differently. A glass-covered vacuum frame cannot be "flipped" because of the size and weight of its parts. The frame consists of a large heavy base, usually made of metal, connected to an electrically or a manually operated vacuum pump. The frame has a glass cover hinged to the back side of the base. In addition, a flexible

rubberlike blanket lies on the base of the printing frame. Materials to be contacted are placed on the blanket, the glass cover is closed, the vacuum turned on, and an exposure is made after sufficient time has been provided for the vacuum to bring materials into contact.

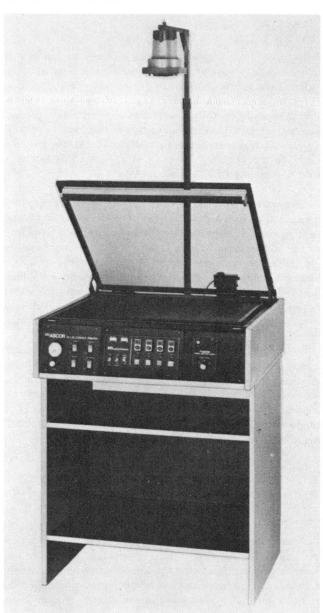

Courtesy of Berkey Technical Co.

Contact printing frame with integral exposure lamp.

For a glass-covered vacuum printing frame (and for all vacuum-based contact printing frames), vacuum is responsible for the contact pressure. Vacuum contact printing frames have a rubber or flexible blanket resting on the base. As air is vacated from the space between the blanket and the cover, the rubber blanket rises upward and forces the contacting materials together. The contacting pressure caused by air evacuation (vacuum) is greater than that exerted by the spring-locking device of a pressure-type frame. Increased pressure means the materials to

be contacted are closer together, leading to more accurate and higher quality reproductions.

If register pins are used with a glass-covered frame, caution is needed to prevent scratching and breaking the glass. To avoid imperfections such as pinholes in reproductions, the glass must be kept clean with lint-free tissues and nonstreaking glass cleaner.

Check the cover glass before each exposure to be sure that no opaque, tape residue, and dirt particles are present on the underside of the glass.

Vacuum Pump

Rubber Gasket

Blanket

Meter Safety Latch Bleed Valve

Glass-covered vacuum printing frame.

Drawdown time is the time required for the air to be vacated from the frame. The drawdown time is somewhat longer with this particular style of vacuum frame, but the contact is the closest of all the systems. With any vacuum system, it is important that no air leaks exist. An air leak means that the contact between materials may not be adequate for high-quality

reproductions. A vacuum pump should be serviced regularly because an extended downtime can cause delays in contacting production flow. If possible, the vacuum pump should be located outside of the darkroom where it won't stir up dust and cause dust-related problems in the darkroom.

Acetate Overlay Vacuum Frame. The acetate overlay printing frame is similar to the glass-covered type in most design aspects: both have a base and hinged cover, and both produce contact pressure by vacuum means.

The major difference is that the glass cover has been replaced by an acetate overlay. (In many instances, because the overlay is flexible, no blanket is used on the frame base.) The overlay greatly reduces the weight of the printing frame.

Acetate overlay printing frame.

The acetate overlay (or other clear material) on a vacuum board has the advantage of quick drawdown time and is less expensive than the glass-covered variety. Lower cost is the major advantage if a larger-than-normal frame is needed for special jobs only on rare occasions. Also when the overlay sheet becomes dirty, it is quickly and inexpensively replaced.

One disadvantage of the overlay vacuum frame is that the overlay attracts dust, scratches easily, and requires frequent replacing if not used correctly. There are also problems if an exposure source high in ultraviolet radiation is used. This light source has a greater tendency to record the presence of dust, dirt, and scratches on the overlay sheet in the contact reproductions.

Glassless, or Open-Faced, Vacuum Frames. A glassless, or open-faced, vacuum frame operates on the same contact-producing principle as do overlay and glass-covered vacuum printing frames. Glassless frames achieve the close contact be-

Open-faced printing frame.

tween materials in one of two ways: the use of a clear film overlay, with a tape hinge, having a window cut out for the image area; or the use of the topmost film (the imaged film) to serve as an overlay to form the necessary vacuum seal.

The open-faced vacuum frame using a clear overlay is similar to the acetate overlay except that the center of the acetate is cut out. The window area keeps materials clean and avoids the problems of dirt and scratches encountered with the overlay method.

To ensure a seal around the materials, the window is cut slightly smaller than the film and contact materials. An advantage of an open-faced vacuum frame is that it eliminates the problems of breakage, scratches, and dirt. A drawback to this type of printing frame is that an overlay sheet with different size windows is needed for each film size if film size cannot be standardized for production purposes.

When the topmost film serves as the overlay, it must be at least 1 in. larger on all sides than the film underneath.

General Considerations for Printing Frames. The largest size film or flat used in production determines the size of the printing frame needed. A safe approach is to plan for future needs when selecting a printing frame. With this in mind, it may be desirable to purchase a frame one size larger than the size of the work you plan to do.

The surface of the contact frame affects the quality of the contacts. The surface must be black to prevent halation during exposure. If the printing frame surface is worn with age, it should be repainted with a dull, flat black paint.

The glass-covered vacuum frame has a smooth or ribbed black rubber blanket. The blanket aids in producing pressure for contacting. Sometimes the ribs affect the quality of the contacts. In such cases, a flat backing sheet is placed over the ribbed blanket. An acceptable backing sheet is a firm "matte black" material, such as matte black vinyl. Register pins or a register bar can be attached to this material. The backing sheet prevents high and low spots from occurring. The matte surface allows air to escape when pressure is applied and assists in vacuum drawdown.

Caution: Do not use heavy white cardstock, coated paper, goldenrod, or scrap film for this purpose. These materials increase the halation problem and interfere with the overall quality of the contacts.

LAMPS FOR CONTACT PRINTING

The second device required for contact printing is one that can expose the photographic material. Lamps in special housings are used for this purpose. They vary from simple lamps to more elaborate contact printing lamps, which are used in color separation work.

There are three basic types of exposure lamps used for contact printing: the point light source; the broad, or diffused, light source; and the high-intensity light source.

Point Light Source. The point light source is the most popular lamp for contacting. It is the ideal choice for insuring dot-for-dot quality. Most lamps scatter light, undercutting the contacting materials. The point light source is designed to avoid light undercutting.

The point light source is a tubular bulb in a modified housing. The bulb is clear with a small filament at the end of the tube. The lamp housing has a small aperture (opening) for light to pass through, or is itself tubular in shape. Whichever design is used produces a narrow travel path for the light, causing the light rays to be more parallel, which results in less undercutting and improved resolution. Consequently, point light sources have a tendency to record dust, dirt, lint, and other imperfections in the contacts.

To make the point source lamp more versatile, the lamp housing has a means for holding one or more transparent filters that are necessary with certain contacting techniques.

Broad Light Sources. A broad, or diffused, light source undercuts the dust on the printing frame glass or acetate overlay. This undercutting lessens the amount of pinholes caused by dust, while not affecting the quality of the image on the contact. For dot-for-dot quality in a contact reproduction, a broad light source is only used for emulsion-to-emulsion contacting. Scattering of light makes the broad source effective in eliminating dust but also prevents high-quality emulsion-to-base reproductions.

There are several designs for a broad light source. One consists of four miniature incandescent lamps in a square configuration mounted around a point light source. This configuration gives a broad light coverage that is less directional than that of a point source. Another design is a point light source with a diffusion sheet (matte sheet) placed in the filter holder.

A major application of the broad light source is the altering of line widths and dot sizes—spreads and shrinks—by the contact process.

High-Intensity Light Sources. A high-intensity light source is, simply, a very bright lamp. It is used for exposing specialized contact materials that are handled in normal room light. The low sensitivity of these materials to light requires that a high-intensity lamp be used to make exposure times short enough to be acceptable. In the darkroom, a quartz-iodine lamp is the usual high-intensity light source. It is mounted so that it swings beneath the point light source lamp when needed for making an exposure. When these specialized products are used in the stripping department, most plate exposure light sources emitting large quantities of ultraviolet light are acceptable as high-intensity light sources.

Location of Exposure Lamps. The lamp-to-printing-frame distance should be adjusted to provide even illumination and short but practical exposure times. Lamp height is determined by the size of the printing frame and the evenness of illumination.

If the height of the exposure lamp is changed, the new exposure time is based on the inverse square law. This law states that illumination is inversely proportional to the square of the distance:

$$\text{New Exposure} = \frac{(\text{New Distance})^2}{(\text{Old Distance})^2} \times \text{Old Exposure Time}$$

The inverse square law does not hold for extreme distance variations. Therefore, new exposure times should be determined by carefully performed exposure tests.

Section Nine: Line Photography

Line photography is the most simple of the three groups in which all graphic arts photography is customarily divided. Line photography is used for black-and-white copy that does not require tonal reproduction or the use of a halftone screen. This copy may be single-color or multicolor, it may be of a job that is completely done in line, or it may be part of a line-and-halftone combination job.

Operational Steps. The operational steps of line photography are: (1) Inspecting and scaling copy; (2) Placing copy on copyboard of camera; (3) Setting camera; (4) Loading film; (5) Exposing film; (6) Removing exposed film from camera; (7) Processing exposed film; and (8) Inspecting processed film. All of these eight steps are discussed in the following.

INSPECTING AND SCALING COPY

In inspecting copy for reproduction, the camera operator usually divides the work into groups depending on (1) the quality of the copy received and (2) the reproduction size or scale required for the copy. All copy should be in perfect shape when it is turned over to the camera department, but often this is not the case.

Both good and poor letterpress repro proofs, faded typewritten matter, copy with grayed or yellowed backgrounds, contrasty paste-ups of black ink or fine pencil drawings, and phototypeset matter are just some of a large variety of copy that the average camera operator receives. First, the photographer will divide this wide assortment into groups of the same reproduction size for scaling. For this purpose, a proportion scale or similar device is used to obtain the desired percentage of enlargement or reduction. Then the photographer will segregate copy into several groups depending on its quality. This organization is necessary, for it allows the photographer to group the copy according to reproduction size and copy quality, thereby improving work efficiency.

Quality of Copy. The quality of copy is determined by considering color, background, and line quality. The color of the copy is an important consideration, for ortho film will not photograph all colors as black and, consequently, certain types of colored copy will require the use of filters. The background of the copy is another factor that will determine the use of a filter. For example, in fine-line pencil drawings on paper or vellum, the contrast range of this type of copy may not be sufficient to produce good background density on the finished negative. In such a case, the use of contrast filters will greatly improve negative quality. The actual line work itself should be inspected; in particular, the fineness and blackness of letter characters.

Scaling Copy. The use of a proportion scale for calculating enlargement or reduction percentages is one of the most popular methods for scaling copy. The reproduction percentage can also be calculated by dividing the original copy size into the reproduction (or negative) size and multiplying by 100.

PLACING COPY ON COPYBOARD

Most copyboards are marked in some manner to help the cameraman position copy. The three most common markings are as follows: rectangles (corresponding to the standard film sizes), diagonals, and centerlines. The diagonals and centerlines are usually subdivided into inch or half-inch increments. With such copyboards, it is a simple matter to center copy.

Some copyboards are not marked for copy placement. If yours is not, you can make your own markings. Cut a piece of gray or black cardstock to the size of the copyboard. Then simply draw the markings you feel will be most usable. The markings can be made with pen or pencil, but the lines must be cleary visible; e.g., white ink when black cardboard is used.

SETTING CAMERA

The lens aperture, use of filters, lighting angles, and camera setting for proper reproduction size are the main considerations involved in setting the camera.

Reproduction Percentage	f/16 at Same size	f/22 at Same size	f/32 at Same size
25%	f/27	f/35	f/51
30	25	33	49
33	23	32	48
40	22	31	45
50	21	29	42
75	19	25	36
Same Size	16	22	32
150	14	18	25
175	12	16	23
200	11	15	21
250	9	13	18
300	8	11	16

F-stop chart.

For line work, the most common lens openings (f-stops) used at same size are f/16 and f/22 as process lenses have their best definition and resolution at these apertures. Our chart illustrates the extension of these f-stops for use at different reproduction sizes. By using this procedure, the aperture is varied according to the enlargement or reduction while the exposure time remains constant. In modern types of process cameras, the lens is equipped with a diaphragm chart mounted on the lensboard. A pointer, connected to the lens collar, extends from the lens to the diaphragm chart. For use, the pointer is aligned to the proper reproduction size on the scale selected, and the f-stop is automatically set. This diaphragm chart contains scales for all the f-stops and allows for selection of any desired aperture.

Filters. Filters used for black-and-white photography serve two purposes: to increase the contrast of the original and to render certain colors monochromatic, thereby holding or drop-

To Photograph	Pan Film Filter	Ortho Film Filter	Colorblind Film Filter
Blue as black	Red or orange	Yellow or orange	—
Blue as white	Blue	Blue	None or blue
Blue green as white	Blue or green	Blue or green	—
Blue green as black	Red	—	—
Green as white	Green	Green or yellow	—
Green as black	Red	—	—
Orange as black	Blue	Blue	None
Orange as white	Red or orange	—	—
Red as black	Green	Green	None
Red as white	Red or orange	—	—
Violet as white	Blue	Blue	None or blue
Violet as black	Green	Deep yellow	—
Yellow as black	Blue	Blue	None or blue
Yellow as white	Red or orange	Yellow or orange	—
Yellow green as white	Green	Green or yellow	—
Yellow green as black	Blue	Blue	None or blue

Film/filter chart.

ping them on the finished negative. Contrast filters are used extensively on poor copy, pencil drawings, and copy with a grayed or yellowed background. They comprise the yellow and light orange series, such as Wratten K1, K2, K3, and G. These filters are characterized by increasing blue absorption of the spectrum, thereby increasing contrast on ortho or pan film. In line photography, it is also common to photograph different colors in a monochromatic tone in relation to other colors; our chart illustrates the filter/film combination for this purpose.

Lighting Angle. The lighting angle of 45° at a distance of 3 ft. from the copyboard is considered normal for process cameras. Reducing the angle gives much flatter lighting, resulting in a reduction of light intensity on the copyboard. This may be desirable at times to increase the coverage of larger copy and also to eliminate "hot spots" or glare on the copyboard in the case of extreme enlargements. Increasing the light angle gives much greater intensity on the copyboard but should be done with discretion, for it usually results in copyboard glare and also in undercutting of weak or poor type characters in the copy.

Setting for Reproduction Percentage. The setting of the camera for reproduction percentage varies greatly according to the camera manufacturers. In some of the cameras, the actual reproduction percentage is also the setting of the camera; in others there are arbitrary systems in use. These require the use of a percentage scale (to obtain the reproduction percentage size) and reference to the camera scale for proper setting numbers.

We might consider another step in the camera setting, namely the focusing of the image on the ground glass. Here the photographer will check the sharpness of the image and adjust for positioning. In some types of process cameras, the lensboard is equipped for vertical and horizontal movement; in such a case, exact positioning of the copy on the ground glass is simply made by use of the handwheels for lensboard movement. The higher-priced precision-type cameras are equipped for electrically controlled movement of the copyboard, which greatly improves the ease of focusing and positioning on the ground glass.

LOADING FILM

After inspecting and setting the camera, the next step is the actual insertion of film in the camera. The film back of cameras can be one of several types.

The vacuum-type back is the simplest and most productive of these types and consists of an opaque metal or plastic back, with channels for vacuum, which is supplied by a motor pump. Vacuum backs are usually marked in some manner for easy placement of the film. The channels for vacuum are so designed that they are adjustable for various sizes of films.

EXPOSING FILM

During exposure, the photographic film receives the light reflected from the copy; the result of exposure is the formation of a latent image on the film. Exposure is actually equal to time multiplied by intensity. ($E = iT$, where E is exposure, i intensity of light, and T time.)

Mechanical timers for exposure control only take care of the actual time portion of the equation and make no measurement of light intensity values. Consequently, variations in line voltage may affect the exposure, but these variations are not discernible to the mechanical timer. The light integrator satisfies the measurement of intensity and time. The integrator measures not the time of exposure but the exposure—the product of light intensity and exposure time.

Exposure by Variation of Aperture. Exposure can actually be standardized by varying the aperture and maintaining the same exposure time or by using a fixed aperture and varying

time according to the enlargement or reduction. Variation of the aperture has already been considered above in the discussion on setting the camera. By using a fixed aperture, the exposure time is calculated according to the square of the proportional increase or decrease of the camera extension from same size.

Exposure Variation with Light Distance and Angle. Another variation of exposure by varying the light distance and light angle can be computed by the following formula:

$$\text{New exposure} = \frac{(\text{new distance})^2}{(\text{old distance})^2} \times \text{old exposure} \times \frac{\text{sine of old angle}}{\text{sine of new angle}}$$

The use of this formula makes it easier to obtain a new exposure when making a radical change in lighting and/or light angle.

REMOVING EXPOSED FILM FROM CAMERA

After exposure, the film is removed from the camera for further processing. Many cameramen doing mass-production line photography have some procedure of storing this film in a film cabinet and then developing it all together. The deterioration of the latent image on high-contrast films is small, but *prolonged storage* under varying temperatures and humidity conditions will affect the finished result.

PROCESSING EXPOSED FILM

During processing, the latent image is converted into a permanent visible image through the process of reduction in a solution called a developer. The developing agent reduces the exposed silver halides to black metallic silver, and the fixer dissolves those unexposed and underdeveloped areas of the film, thereby making the image permanent. Additional details on the chemistry of development and fixation are covered in the "Chemistry of Photography" section of this chapter.

Factors of Development. In line photograhy, the two controlling factors of developing are agitation and temperature. The litho-type developer used for high-contrast film contains an alkali capable of extreme contrast; consequently, contrast can be greatly affected by agitation. Still development will reduce the development action and considerably reduce contrast, whereas increased agitation will greatly exaggerate contrast and may cause the printing areas to fill in. The temperature of the developer affects contrast in much the same manner; that is, a cold developer will reduce contrast and a warm developer will increase it.

Film manufacturers usually recommend a developing temperature of 68°F for tray processing. Developing time varies according to the make of the film, with 2¼ to 2¾ minutes being most common for tray processing. With automatic machine processing, the developing temperature is usually 80°F or more, and the developing time is usually less than 2 minutes.

Powder-Type Developers and Fixers. One way to prepare the developer or fixer is by using a powdered concentrate. These powders, which are packaged in a box, must be diluted to working strength using water. The typical mixing temperature is between 90 and 100°F. The major drawbacks in using powders is that they are hard to mix and they must be prepared in fixed amounts (an entire box at a time).

Liquid Concentrate Developers and Fixers. Liquid concentrate developers and fixers are quite popular because it is so easy to mix them. After dilution, the liquid concentrate developers exhibit working characteristics similar to those developers supplied in powder form. Before dilution for use, the concentrates should be stored at temperatures above 40°F to prevent the components from coming out of solution.

INSPECTING PROCESSED FILM

After development, the negative is inspected. Some measures can be taken after development for corrective action. A common corrective measure is the use of Farmer's reducer. By means of Farmer's reducer, silver is dissolved through a complicated chemical reaction, thereby improving an overexposed or overdeveloped negative. Intensifying is basically the addition of silver to an underexposed or underdeveloped negative. This is a rather detailed procedure. When inspection is completed, the negative is dried and passed on to the stripping or contact printing department.

CONCLUSION

Line photography is considered by many cameramen as elementary and consequently not requiring much attention. But line work is, on the contrary, the basis of the photographic procedures and extremely important. With such products as autoreversal and prescreened films, the work and knowledge of the line photographer is broadened. In the future you can look to many other new products that will improve line photography.

Section Ten: Halftones with the Crossline Screen

The major requirement in reproducing continuous-tone copy by the lithographic process is that such copy be photographically translated into a discontinuous tone or gradation of dots.

The crossline halftone screen, placed in front of the film, provides a means for creating the required pattern of dots. The size and shape of the dots on the negative vary according to the amount of light reflected by the copy and transmitted by the screen. Small opaque dots on the negative produce shades of gray and darker tones, while the larger opaque dots produce the light tones of gray.

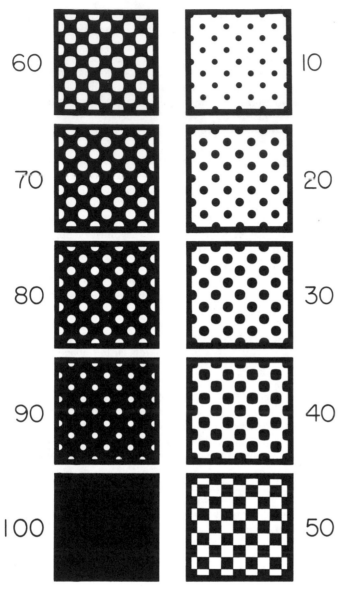

Dot size percentages.

negative by dots corresponding to the amounts of light reflected by such areas in the original, i.e., the light grays as small round transparent dots, and the dark grays as large transparent dots and smaller opaque dots. The *shadows,* or darker areas, in the copy appear in the negative as the most transparent portions. They take the form of small round, opaque dots surrounded by large transparent areas. All of these dot formations are the result of correct screen distance, sufficient exposure, and a suitable set of diaphragm apertures.

Classification of Screens. Crossline screens are classified according to the number of opaque lines ruled to the linear inch. For example, when there are 120 ruled lines to the linear inch, the screen is known as a 120-line screen. The 120- and 133-line screens are commonly used for black-and-white halftone reproductions. Finer screens, up to 300- and 400-line, are used only for the higher grades of work. (Halftone screens used for black-and-white reproductions are generally rectangular in shape. Circular screens are also used.) Glass screens consist of two pieces of ruled glass cemented together so that the opaque rules (lines) on one piece of glass cross the lines of the other piece at an angle of 90°.

Enlarged unit of crossline screen.

Making a Glass Screen. The rulings (lines) are put on the glass with a high-precision machine. These rulings are etched into the glass, and then the depressions are filled with a pigment. On the grating formed by the lines when the pieces of glass are placed face to face, the width of the aperture (opening) approximates the width of the line — sometimes being equal, other times unequal, depending on the tone reproduction characteristics required. Finally the two ruled (lined) pieces of glass are cemented together with the lines at right angles to form the screen.

Angle of Screen. In black-and-white reproduction work, the screen is so positioned that the ruled lines form a 45° angle with the base of the camera. This angle is chosen because, with it, the dot pattern is least noticeable in the halftone. Each dot on the negative represents a minute area of the original. It is inadequate just to say that each opaque dot in the negative must be dense and sharp, and that each transparent area glass clear. If highly satisfactory reproduction is the goal, then each dot must be of such size and shape that it is a true representation of the part of the original it is supposed to represent.

Transfer of Image. The photographic transfer of the image from the negative to the printing plate is possible because of the clearness of the transparent spaces between the opaque dots. The plate coatings require this clearness for the complete hardening of every dot, regardless of its size. A continuous-tone negative does not provide sufficient clearness, but progressively retards the light as its density increases; this produces a partially hardened, insecure plate image. Hence, a tone must be reproduced by a gradation of hardened dots whose size — in the final press plate — will carry ink according to the tone values of the copy. These dots must, of course, be small enough to be relatively invisible to the naked eye.

Appearance of Tones. The *highlight tones* in the original or copy appear in the screened negative as small transparent dots surrounded by large, round, opaque dots, whose edges overlap. These dots are the result of the greatest amount of light reflected by the copy. The *middetones* of the copy are represented in the

NATURE OF LIGHT

Before discussing the theories of dot formation by use of the glass screen, consideration should be given to the nature of light. We might therefore begin by asking the question "What is light?"

Definition of Light. Light may be considered as a form of radiant energy that acts upon the eye producing vision. According to the *corpuscular theory,* Newton considered light to be propagated as a stream of corpuscles, or "light bullets," emitted by a shining or luminous body. This theory does not present a suitable explanation for a major portion of the actions and characteristics of light, although it has been proven that, in some cases, light acts more as if made of particles than waves. The *quantum theory* states that light consists of bundles of light called *quanta* or *photons,* the energy of which depends on the frequency of the radiation. The *wave theory* states that light is propagated in waves that vary in length from 400 nanometers in the violet to about 700 nanometers in the red portion of the spectrum. This theory has to date achieved the widest acceptance due to its ability to explain a major portion of the complexities of the phenomena of light.

THEORIES OF THE HALFTONE SCREEN

The nature of light has been used as the basis of several theories explaining the effects of the halftone screen. These theories base themselves respectively on penumbra, pinhole, and diffraction phenomena. The *penumbra theory* of dot formation was presented in 1908 by Clerc and Calmels, following the investigations of Tallent, Dolland, and Deville. The *diffraction theory* of halftone images was investigated quite extensively by Fruwirth, Mertle, and Yule, and it explains dot formation by the phenomena of light diffraction of the screen ruling. The *pinhole theory*, also referred to as the Ives Theory, considers dot formation by the action of the diameter, or pinhole effect, of the lens on the halftone screen. Each theory has some merit toward an understanding of the theory of dot formation; consequently, each will be discussed here in some detail.

Penumbra Theory. When an opaque body is held in the light coming from a pinhole source, all light is cut off from the space behind it, and a sharp edged shadow called an *umbra* is formed. When the light source is broad, some of the light falls in regions from which other rays of light have been cut off, thus forming a *penumbra* (partial shadow) around the umbra. If the

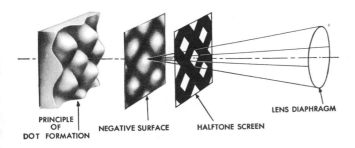

Dot formation with crossline screen.

opaque body is smaller than the luminous body, the umbra tapers to a point and disappears.

We can see, from this explanation of penumbra, that it actually consists of a continuous shadow varying in some degree of darkness and that the dot formation is caused by this vignetted effect of the halftone screen. The major critics of the penumbra theory state that it is based on the straight line propagation of light and does not take into account the diffraction caused by the halftone screen. The detail of the penumbral theory is quite complicated; geometrical optics are used for explaining the depth of darkness or shadow at any point causing the dot formation.

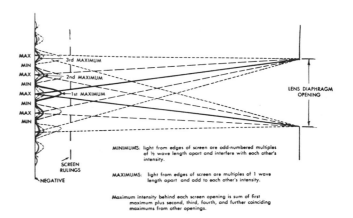

Diffraction theory of dot formation.

Diffraction Theory. Diffraction may be defined as the bending of rays of light from a straight course when cut off by an obstacle, such as the ruling of a glass screen. According to this theory, the halftone screen is considered to be a double-diffraction grating. The word "diffraction," as used in connection with grating, indicates a property of light of which the grating takes advantage in order to separate and recombine the light waves to produce spectra. Whenever light emerges from a narrow aperture, it spreads out much as a dense crowd of people spread upon emerging from a narrow gate.

Laws of Diffraction Theory. The diffraction theory was extensively investigated by Fruwirth, and it basically states that: (a) each screen has a definite focal length, and consequently its distance to the sensitized film varies according to screen ruling; (b) each screen has a speed ratio—the finer the screen ruling the faster the speed ratio; and (c) the lack of color correction of the glass screen requires an adjustment in screen distance when various filters are used.

Acceptance of Theory. The opponents of this theory state that Fruwirth uses the general equation of the penumbra theory to calculate the f-stop size in terms of camera extension. Proponents of both the diffraction theory and penumbra theory have been partly wrong in maintaining exclusive explanation of dot formation.

Diffraction plays the major role with fine screens, while penumbra shadow patterns are less modified by diffraction with coarse screens. The whole range of dot formations may be more easily related to both effects as modifying each other.

Pinhole Theory. This theory, investigated by Ives in 1889, considers the dot formation to be made by the diaphragm of the lens projected through the transparent mesh of the screen to the sensitized film. This theory is strongly opposed by many, with the primary argument being that no consideration is given to the relationship of the lens diameter to the screen distance. The main result of the investigation into this theory was the information published on the result of various diaphragm shapes on dot formation.

RELATION OF LENS APERTURE TO DOT FORMATION

The formation of dots on film is dependent upon: (1) the size and, to some extent, the shape of the lens apertures (stops), (2) the screen distance (measured from the screen ruling to the surface of the sensitized material or the ground glass), (3) the intensity of the reflected light, (4) the speed and contrast of the film, and (5) the duration of the exposure.

Equation for Dot Formation. Correct dot formation on all halftone negatives is the result of adjusting the lens aperture and the screen distances so that their ratios are balanced. This is shown in the following equation:

$$\frac{\text{Diameter of lens aperture}}{\text{Camera extension}} = \frac{\text{Screen aperture}}{\text{Screen distance}}$$

From this equation, you can note that there are two known factors (camera extension and screen aperture) and two variables (screen distance and lens aperture). The ratio 1:64 for this equation is widely used for average lighting conditions; however the 1:90 ratio (normally requiring twice the exposure of the 1:64 ratio) is convenient when the intensity of illuminaton is greater or the sensitive material is faster. When used for making projection positives from continuous-tone separations, the 1:45 or 1:32 ratios are best for overall performance.

IMPROVEMENTS IN THE CROSSLINE SCREEN

Improvements have been made to the original crossline halftone screen—two ruled glass plates at right angles, with the width of the transparent lines equal to the width of the opaque lines. One improvement has been altering the ratio of line widths to produce more pleasing and accurate reproduction.

Another improvement has been the introduction of a halftone screen that reduces light diffraction and shortens exposure times

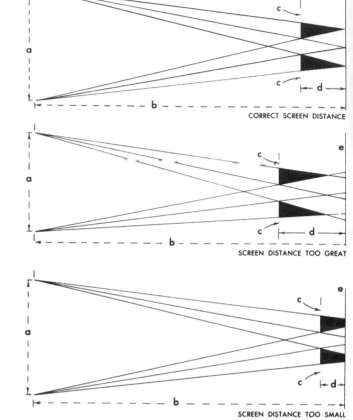

Correct and incorrect screen distances.

because it has a thinner base than earlier glass halftone screens. The screen also has different tone-reproducing characteristics than conventional glass screens because its lines are ruled with two distinct densities of magenta or gray.

The denser crossline is produced with a pale edging to give a vignetted line effect. The dyes used for the crosslines are transparent and nondiffusing. The lines are sharply defined, as opposed to the vignetted dots of a contact screen. To provide more latitude in exposure and development, this halftone screen carries additional elements of higher density that are located at the line crossings and that protect the core of the highlight dot. The "crossings" on the screen are not penetrated by light, and they project shadow cones onto the film; the peaks of the cones coincide with the center of the highlight dots on the film.

Section Eleven: Halftones with the Contact Screen

Our presentation of contact screens is divided into the following categories: (1) Contact screens and their calibration; (2) Main exposure technique; (3) Shadow flash exposure technique; (4) Highlight bump exposure technique; (5) Adjusting the magenta screen range using color-compensating filters; (6) Development techniques; (7) Combining development and expo-

sure techniques; (8) Highlight dropout technique; and (9) Choosing the right technique.

CONTACT SCREENS AND THEIR CALIBRATION

The development of contact halftone screens has greatly

simplified the techniques of making black-and-white halftones. Basically, two types of contact screens are used: the gray and the magenta. The illustration shows an enlarged view of a contact screen.

Both the magenta and gray contact screens form halftone dots on sensitized films through the modulation of light by the optical action of the vignetted dot pattern of the screen acting on the film emulsion. In other words, each dot on the contact screen is vignetted, which means it has varying density across its surface—highest in the center and lowest at the midpoint of two adjoining dots. The size of a dot produced on the film depends on the tone of the corresponding area of the copy. The lightest tones reflect the highest percentage of light and penetrate most of the screen dot's vignette, except for the areas of highest density. In a similar fashion, the darkest tones reflect very little light, perhaps an amount insufficient to penetrate even the vignette's lowest density areas. Tone areas between the extreme highlight and extreme shadow penetrate the dot vignette to varying degrees, depending on the amount of light reflected from the copy image area.

The dot-forming pattern of a magenta contact screen is a magenta dye image, while the pattern of a gray contact screen is a developed silver image. In use, the emulsion, or image, side of the contact screen is held in intimate contact with the lith film's emulsion during the dot-forming exposures.

The advantages of contact screens over glass screens are numerous, and the major ones can be listed as follows: (1) Easier and faster to use; (2) Better resolution; (3) No screen distance to consider or screen positioning mechanism required; (4) No special equipment required, only a camera equipped with a vacuum back; (5) Relatively simple and reproducible contrast control; and (6) Low initial screen cost.

Some of the disadvantages of contact screens are as follows: (1) Fragile and easily kinked, stained, and scratched; (2) Affected by dust, entrapped air, electrostatic charges, and Newton's rings due to the contact between the film and the screen; (3) Variances in density ranges and exposure factors from screen to screen and from manufacturer to manufacturer; and (4) Possible changes in the dye density of the dot-forming pattern during the life of the magenta contact screen.

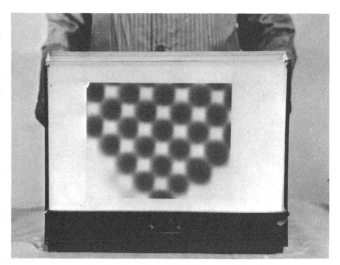

Contact screen, highly magnified.

The magenta screen is the most popular contact screen available, and it is used extensively for black-and-white halftone reproduction and for making halftone positives from color separation negatives. Gray contact screens are used mainly for specialized direct-screen color separation work. The remainder of this section will discuss the more important magenta screen techniques. Most of these techniques except, primarily, the use of color compensating filters to adjust screen density range also apply to gray contact screens.

Target for calibration procedure.

Halftone Screen Calibration. Before making an actual halftone exposure, it is necessary to first learn more about your contact screen.

First, each magenta contact screen will handle a given type (or density range) of copy most effectively. In order to make the best use of any particular screen, it is necessary to learn what its inherent working density range is under specific conditions.

Calibrating the halftone screen to establish its working range is a simple matter, if a reflection gray scale is used that has a density range of more than 2.0. The approximate density of each step of this original gray scale must be known for later use in the calibration procedure.

1. The density-calibrated gray scale and an average piece of original art are placed in the camera copyholder. The figure shows a typical "target" for calibration procedure.

2. The litho film is placed on the vacuum back with the emulsion side toward the lens, and the contact screen emulsion is placed in contact with the litho film emulsion. To insure proper contact between the magenta screen and film, a soft rubber roller or a photo chamois should be used to smooth the film surfaces together.

3. A series of test exposures is made until a 90% dot is obtained in step 1 (the highlight area) of the gray scale. Processing time should be in accordance with the halftone recommendations found in the direction sheet supplied with each box of film. The figure shows a typical halftone test result. The sole object of this test is to calibrate the screen with the gray scale; the photograph is used to simulate flare conditions and its

faithful reproduction is not a function of this test.

A close examination of the reproduction will show that the negative contained a 90% dot in step 1 of the gray scale and a 10% dot in step 8.[1]

Typical halftone test result.

Comparing the gray scale and halftone images, and matching the steps together, it is found that the negative from which this print was made had a 90% halftone dot coinciding with gray scale step 1, which has a density of 0.12. The 10% negative halftone dot that printed a 90% positive shadow dot correspond to gray scale step 8, which has a density of 1.52. The effective density range of our screen can now be determined by simply subtracting the minimum density that produced a 90% dot in the negative (0.12) from the maximum density step that produced a 10% dot in the negative (1.52). The effective density range of this screen according to this calculation is 1.52 minus 0.12, or 1.40. Remember this particular screen range value of 1.40 for it will be referred to frequently hereafter.

In terms of halftone practice, it can therefore be assumed that, when both the screen and the original art have equal density ranges (e.g., approximately 1.40), it should be possible to reproduce the picture in halftone form (carrying a 90% dot in the highlights and a 10% dot in the shadows of the negative) using only a main, or image, exposure with the magenta screen.

MAIN EXPOSURE TECHNIQUE

To further study the relationship of the halftone screen range and the copy density range, examine the halftone print made from copy that has a density range of 1.43 compared to the 1.40

[1] Dot sizes of 10% and 90% are illustrative but are not to be taken as absolute values. Actual highlight and shadow dot values will vary with individual shop requirements for plates, presses, and stocks.

density range of the contact screen. If the screen calibration procedure has been correct, it should be possible to make a magenta screen halftone negative of this photograph with only a main exposure and normal processing and to hold a 90% dot in the highlights and a 10% dot in the shadows of the halftone negative.

Halftone balance using only a main exposure.

With the relationship of film/plate halftone values in mind, note that the printed shadows are carrying approximately the desired 90% dot and the printed highlights are holding a 10% dot. Since these printing-dot sizes are exact reciprocals of the desired negative halftone dot values, it may be assumed that our plate exposure and printing controls have essentially reproduced the dot character of our halftone negative.

SHADOW FLASH EXPOSURE TECHNIQUE

You are given a photograph that is considered more or less average copy, with a density range of 1.63. The density range of the portrait is therefore 0.23 higher than that of our calibrated screen, which was 1.40. As a result, if the same screen exposure is given to this copy as that given to the laboratory copy, 0.23 density units of scene brightness will be lost somewhere within the density range of this picture. To show this loss, a halftone of this photograph was made using the same single exposure techniques. It is important to note that the halftone gray scales look very much alike, but the reproduced quality of the two pictures is in no way similar or satisfactory in this case.

Another halftone reproduction of the same photograph was made, but this time an additional shadow flash exposure has been added to extend the effective range of the magenta screen, thereby reproducing detail in the shadow area of the scene. This print now carries detail throughout the entire scale of the picture.

Digressing for just a moment, it should be pointed out that the inclusion of gray scales along with the copy is helpful in

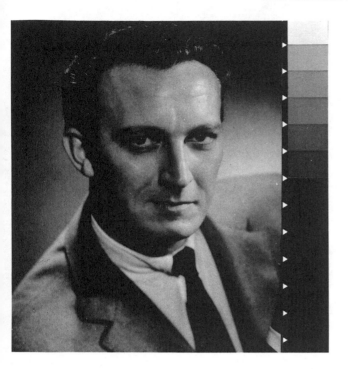

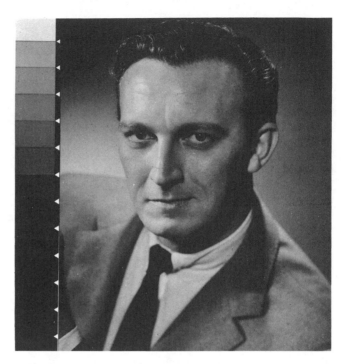

Result using only a main exposure when the density range of copy is higher than that of contact screen.

Result when density range of copy is considered and supplementary shadow flash exposure is used.

understanding and controlling camera halftone exposures *only when the critical highlight and shadow densities of each piece of copy are related to the corresponding density steps on the gray scale.*

When a shadow flash exposure is added, the halftone scale is extended to retain both the copy shadow detail and highlight detail as shown in the second illustration. Now look at the gray scale and observe that the halftone coverage has been increased (compared to first figure). In other words, copy and gray scale areas having the same density will produce comparable halftone dots.

Turning this statement around, use of a gray scale (or a reflection densitometer) to learn the density range of the copy will permit preselection of halftone screen techniques that will fit all types of original copy to the relatively fixed range of the contact screen.

The shadow flash exposure can be made either with a yellow-filtered flashing lamp on a process camera or by means of an auxiliary safelight holder set up near the camera back. Yellow-filtered light should always be used when shadow flash exposing a magenta screen to insure the hardest, smallest dots possible, and use of a Wratten Series OO safelight filter (or equivalent) over the light source is recommended.

In practice, assemble the safelight holder with a suitable yellow filter, and position it so that the opened camera back is uniformly illuminated. Under most conditions, the lamp will need to be a least 5 or 6 ft. from the camera back to insure even coverage, and average flash exposure should not be less than 10 seconds. (Use of a separate inexpensive exposure timer and a controlled voltage line for the light source is highly recommended to insure accuracy and reproducibility of flash results.)

To determine the average flash exposure that will be required with specific equipment, proceed with the following steps:

1. Place an unexposed sheet of litho film on the vacuum camera back, and cover the film with a magenta contact screen.

2. Make a series of "stepped" exposures with the yellow-filtered flash lamp. Usually a series of 5-second steps covering a range from 5 to 50 seconds will bracket the optimum exposure. If the optimum exposure is less than 10 seconds, reduce the light intensity level and run another set of test exposures.

3. Process the test sheet in fresh litho developer; fix, wash, and dry the film normally. It is important that the development time, temperature, and agitation be normal and consistent, so that this test is representative of average shop practice.

4. When the test sheet is dry, select the exposure time that produced the smallest shadow dot that will be successfully "held" by the printing press.

5. The full basic flash exposure value will rarely be used in practice because the litho film will usually have been given a preliminary threshold exposure by camera flare and a marginal amount of exposure from the copy shadows themselves.

Field experience has shown that with average copy and camera conditions, only about 50 to 60% of the basic shadow flash exposure will be required to put a pinhole (10%) dot in the shadow area of average copy.

HIGHLIGHT BUMP EXPOSURE TECHNIQUE

The serious printing quality problems that would be caused by use of a single main halftone exposure when the screen range exceeds the copy density range are best shown by a close look at the first baby picture, which was made in this manner. Note how flat and gray the overall picture looks. The range of dots is only from about 10% to perhaps a 70% dot! It is small wonder then that this copy looks flat.

Looking back at how our halftone exposure was made, it will

be found that the halftone negative was exposed to produce a good 90% dot in the picture highlight area. However, when this was done, the dot size in the picture shadow area was much too large—over 30%—and there was no way this could be prevented with a single-exposure technique. The answer to this printing quality problem will be to produce a full range of halftone dots in the negative—but the question is "How?"

One very effective method for handling copy whose density range is shorter than the screen range is to employ an auxiliary exposure technique arbitrarily called the *highlight bump,* or *no-screen, exposure.* It is given in the following manner.

Determine the main exposure that must be given to produce the proper shadow dot for the copy and give this exposure to the film. The camera back is then opened, the contact screen removed carefully to leave the litho film in exact position, and the camera back again closed. Now with no contact screen covering the film, give extra unscreened exposure to the copy, by trial and error, until a 90% dot is produced in the highlight area. (A highlight bump exposure of 5 to 10% of the main screen exposure is about average for most screen/copy conditions.) A proper highlight bump exposure will not change the size of the shadow dots appreciably.

The short unscreened highlight bump exposure technique selectively superimposes most of the unscreened exposure light on the already heavily exposed negative highlight dot latent image, causing these relatively large (70%) dots to spread and become even larger, approaching the 90% level that is required. Less light falls on the middletones, so only a small change in dot size takes place. Almost no unscreened light falls on the shadow dot latent image from the dark areas of the copy, so these tiny 10% dots do not change size appreciably. A no-screen highlight bump exposure has thus produced a full range of halftone dots with this short-range copy.

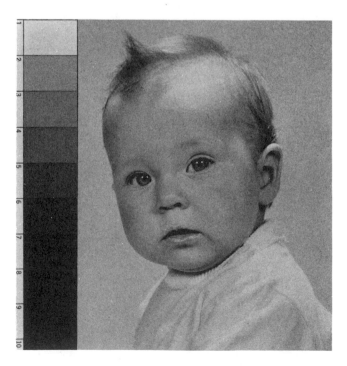

Result using only a main exposure when density range of copy is less than that of contact screen.

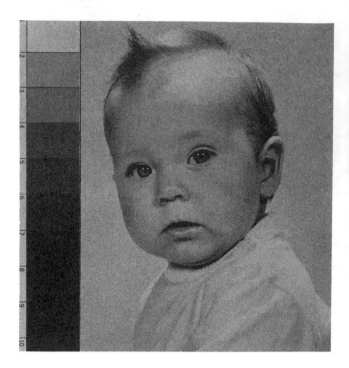

Result of adding a bump exposure to the basic main exposure.

Now that the camera technique of making a highlight bump exposure has been illustrated, the actual procedure involved in this technique can best be understood by studying the printed halftones. The unsatisfactory print carries a normal 10% highlight dot, but prints only 70 to 80% dots in the shadow region instead of the 90% dots that are needed to give depth. Obviously a single halftone screen exposure cannot successfully reproduce this kind of short-density-range copy, so the gray scale reproductions must be studied to reason out why and how the halftone bump flash exposure solves this common printing problem.

First, match the size of the shadow dot in the first print with the corresponding dot size in the printed gray scale reproduction. When this is done, it will be found that the equal size dots (80%) falls on the gray scale step 9, which had an original reflection density value of about 1.20.

By further examination of the printed halftone gray scale, it is also found that the shadow pinpoint dot (90%) wanted is in step 10, which has an original density of 1.35. The first step in solving this quality problem therefore must be to reduce the basic negative halftone exposure so that on the printed sheet the 90% dot is produced in step 9 of the gray scale rather than in step 10 of the gray scale. To do this, it will be necessary to change the basic halftone screen exposure by a considerable amount. The following calculation from the gray scale can give an idea of the exposure change that will be required.

Subtract the original density (1.20) of gray scale step 9, which produced too large a pinpoint dot (20%) in the negative, from the original density (1.35) of gray scale step 10, which produces the desired pinpoint dot (10%) in the negative. The answer is a density difference of 0.15 between gray scale steps 9 and 10. Based on simple sensitometry, it is known that changing exposure by a factor of 0.70 will produce a 0.15 density difference. Therefore, to remove the negative pinpoint dot from

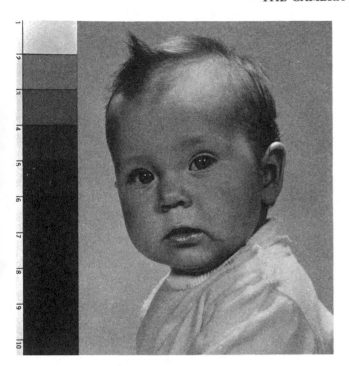

Result of combining a bump with a shortened main exposure.

step 10 to 9 will require that the basic exposure be reduced by a factor of about 0.70. When this is done, it will also be noted that shortening the main halftone exposure by a factor of 0.70 moves not only the 10% shadow dot into the proper position in the negative of both the gray scale and the picture, but it also shifts the highlight dot a corresponding amount, thus producing highlight dots on the negative that are far too open to make a good quality printing plate.

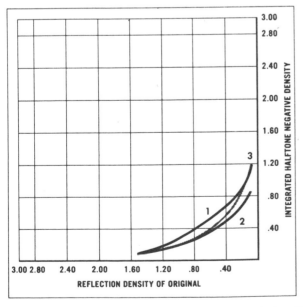

Characteristic curves of the three halftones of the baby: (1) halftone made using only a single main exposure, (2) halftone made by adding a highlight bump exposure to basic main exposure, and (3) halftone made by combining a highlight bump exposure to a shortened main exposure.

Having reduced the basic screen halftone negative exposure so that the copy shadows will print correctly, sufficient auxiliary highlight bump exposure is given to produce the 90% dot that is required in the highlight area. Since this highlight bump exposure will not affect the tiny shadow dots, the desired full range of printing dots is now produced.

Comparison of the three figures shows that this highlight bump exposure procedure has greatly improved the printed reproduction of this particular copy, and this technique is widely used whenever copy with a density range shorter than the range of the halftone screen is encountered.

ADJUSTING THE MAGENTA SCREEN RANGE USING COLOR-COMPENSATING FILTERS

Magenta and yellow color-compensating (CC) filters can also be used to adjust the effective range of the magenta screen to different kinds of copy.

When the copy range is longer than the normal range of the screen, use the yellow CC series to lengthen effective screen range. The change in effective screen range is directly related to the depth of the color of the CC filter, so the very light yellow CC-10Y will make a very small range change, the darker CC-50Y will make a substantial change, and the true yellow #12 filter will produce the greatest possible change in screen range.

Exact figures on the amount of change produced by each filter will vary with individual magenta screens, light sources, filters, and films, but the following ranges were found using a laboratory camera and litho-type emulsions:

	Effective Screen Range
No filter	1.40
CC-10Y	1.45
CC-50Y	1.60

Comparable information can be quickly gathered for your screen through the use of a gray scale.

When "copy range" is shorter than the "effective range" of the magenta screen, use the magenta CC series of filters. Effective screen range is shortened as the color of the CC filter becomes darker, as the following range progression shows.

	Effective Screen Range
No filter	1.40
CC-10M	1.35
CC-50M[1]	1.15

The following three halftone reproductions show the screen range change produced by 50Y and 50M filters.

At first glance, the preceding tables of CC filter screen range control would indicate that the "best" halftone technique would be to use the proper CC filter for each piece of copy and exactly

[1]Heavy magenta filters like the CC-50M should be used with caution since this heavy magenta screen/magenta filter combination may tend to produce soft gradient halftone dots that will cause problems in dot etching or platemaking operations.

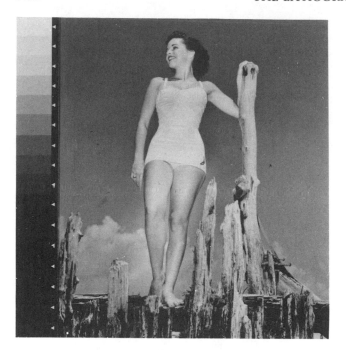

Result using a CC-50Y filter.

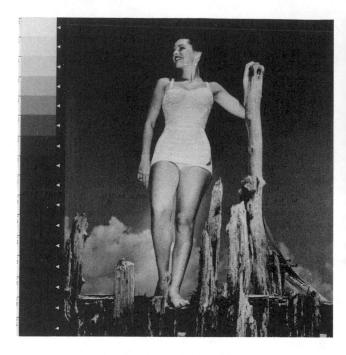

Result using a CC-50M filter.

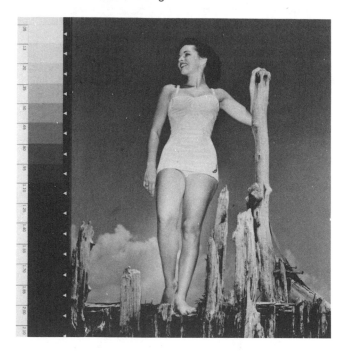

Result using no filter.

match screen and copy range. However, this approach is not necessarily correct for some types of pictures.

It is important to note that highlight dots of somewhat different character are produced when the screen range is shortened by highlight bump exposure as compared to use of CC filters. The use of a no-screen highlight bump exposure principally affects the highlight and near-highlight tones. This effect can be observed, with the aid of a magnifier, as a subtle veiling of density between the highlight dots. The veiling is lowest in the central "clear" area and reaches its highest value adjacent to

the base of the dots. This veiling is the optical mechanism that enhances highlight detail. Veiling's full effectiveness often may not be realized when the halftone negative itself is viewed, but its effect becomes very apparent when a contact positive is made or when the printed sheet is examined.

Excessive highlight bump exposure can cause complete veiling of the dots or a highlight dropout effect. In most cases, this exaggerated effect is undesirable and careful exposure control must be maintained. However, in some special cases, it is desirable to fill or plug the highlight dot; this technique will be discussed later.

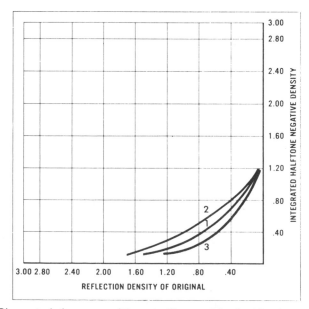

Characteristic curves of three halftones of the bathing beauty: (1) halftone made using no filter, (2) halftone made using a CC-50Y filter, and (3) halftone made using a CC-50M filter.

On the other hand, use of CC filters alters the effective screen range in quite a different manner and tends to keep the highlight areas of the halftone negative more open or unveiled.

DEVELOPMENT TECHNIQUES

The discussion and illustrations thus far have all been based on the use of constant development conditions, and only exposure procedures have been varied to change halftone quality. The effect of different developer agitation techniques on halftone quality (and their tone reproduction curves) can be studied in the next series of four halftones of the same subject that were all given the same exposure.

The four figures were made from a negative given (1) normal agitation, (2) brisk agitation, (3) modified still-development (the tray was rocked for 1¼ minutes, and still-developed for 1¼ minutes), and (4) complete still-development for 2½ minutes. Note carefully the differences in scale balance that are controlled by the rate of developer agitation. In general, still-development techniques tend to produce longer-scale halftones, while vigor-

Result using normal agitation.

Result using modified still-development.

Result using brisk agitation.

Result using no agitation.

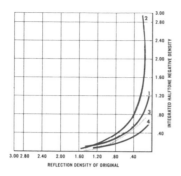

Characteristic curves of the four halftones of the chemist: (1) halftone made using normal agitation, (2) halftone made using brisk agitation, (3) halftone made using modified still-development, and (4) halftone made using no agitation.

ous agitation tends to shorten the halftone scale when exposure is altered to fit the development technique.

In the last figure, the scale appears to be shorter than in the first and third, which is due to the low rate of development coupled with the fact that the exposure was not increased to compensate for this method of processing. Had the exposure been increased to bring the highlight areas up to normal density, the lengthening of the scale with still-development would have been quite apparent.

COMBINING DEVELOPMENT AND EXPOSURE TECHNIQUES

In all previous halftones, the exposure or development conditions have been separately varied to control the range of reproduction quality of a halftone negative. Now look at print quality

changes that can be produced when both exposure and development procedures are varied.

The shop question that best sets the stage for illustration is the old one, "Where should the 50% dot fall in this copy?" A positive answer to this question is not possible because it depends on factors of copy, stock, and personal preference. However, the next three halftones illustrate the printing quality

Reproduction resulting from a 10% bump exposure, a 35-unit main exposure, a 5-sec. flash exposure, and normal-agitation development.

Reproduction resulting from a 300-unit main exposure, a 1-sec. flash exposure, 1 min. of normal-agitation development, and 1½ min. of still-development.

Reproduction resulting from a 100-unit main exposure, a 3½-sec. flash exposure, and normal-agitation development.

effects of differential placement of the 50% dot, both on the copy and on the gray scales. In this illustration the objective was to hold the same highlight and shadow dot sizes in all three reproductions, and to shift the 50% dot placement by deliberate variation of exposure and developer agitation procedures.

The tabulation below each halftone shows how the negatives for these prints were made. This data, of course, is applicable only to a particular camera/screen/film condition, but this information can be useful as a starting point from which to begin to develop your own halftone controls.

The tone reproduction curves of the gray scales dramatically illustrate the print quality changes that can be caused by selective shifting of the middletone of the picture.

Highlight dropout.

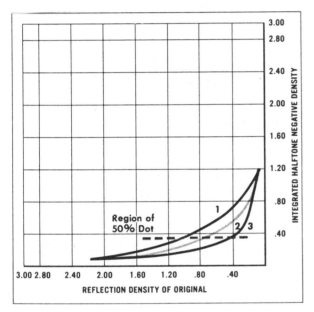

Characteristic curves of the three halftones of the city: (1) halftone made using a 300-unit main exposure, a 1-sec. flash exposure, 1 min. of normal-agitation development, and 1½ min. of still-development; (2) halftone made using a 100-unit main exposure, a 3½-sec flash exposure, and normal-agitation development; and (3) halftone made using a 10% bump exposure, a 35-unit main exposure, a 5-sec. flash exposure, and normal-agitation development.

HIGHLIGHT DROPOUT TECHNIQUE

The highlight dropout technique is simply an extension of the highlight bump exposure procedures. This exposure method is a shortcut procedure that can be used very effectively to drop out all dots in the background of an outlined photograph, thereby eliminating tedious opaquing or masking. It is also used by some shops to eliminate double printing when line type matter and halftones must be combined. Print quality standards with this procedure cannot match a good stripping job, and the final choice of procedure must be based on the cost/quality requirements of the job.

In usual shop practice, the original art is prepared with type matter stripped into position. The halftone exposure is made, the screen is then removed, and the no-screen image exposure or "highlight bump" is added to completely close the unwanted highlight dots. The results of such a technique can be seen in the figure.

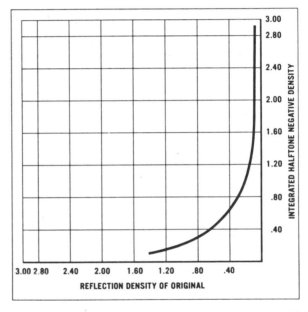

Characteristic curve of a halftone made using the highlight dropout technique.

CHOOSING THE RIGHT HALFTONE TECHNIQUE

Perhaps the choice of halftone technique will be clarified best by reviewing the overall effect of several halftone techniques on final "picture" quality.

Highlight Bump Exposure. A proper highlight no-screen exposure tends to emphasize or "hold" highlight detail and to make the highlights more brilliant. High-key copy—copy with considerable highlight detail—is especially benefited by this method.

Shadow Flash. The proper shadow flash insures the reproduction of the deepest shadow tones and does so by somewhat compressing the shadow scale of the print. This procedure also places additional density in the core of each dot, which helps insure good plate printing and dot etching performance.

Use of CC Filters. The CC filter method changes the overall working range of the halftone screen and affects the tonal gradation of highlights, midtones, and shadow regions in a somewhat similar way. The overall visual response to this type of control is the impression that the highlights have been somewhat flattened or grayed, while better shadow detail has been retained. Low-key copy—copy with considerable shadow detail—is usually best handled with the CC filter technique.

Use of Combination Halftone Techniques. It now becomes obvious that combination halftone procedures utilizing CC filter selection, highlight and shadow exposures, and even controlled agitation offer great flexibility for emphasizing highlight, shadow, or midtone detail, depending on the nature of the original copy. The photographs, therefore, have been reshot to illustrate the quality improvements that can be achieved by careful use of combination halftone techniques, when compared to the moderate quality produced by the simplest and most straightforward techniques.

For the following three photographs, a combination of all these techniques was used in different proportions depending on areas of importance in each of the illustrations. A 5% highlight no-screen exposure was used to compress the range and accentuate the highlight area, then the basic exposure was given followed by a shadow flash exposure to bring out shadow detail and add exposure to the core of each dot. These combination halftone procedures were best for one particular camera, plate,

and press relationship, and will undoubtedly vary for different shop conditions. Exposure and processing balance must be established in each individual shop to fit specific quality and equipment requirements.

Section Twelve: Practical Problems of the Cameraman

One of the biggest problems haunting the average photographer is correct tone reproduction. In attempting to reproduce an original by converting it into a halftone image, many faults

occur. For example, with normal copy a highlight negative will reproduce the shadows with a reasonable degree of correctness. However, the light areas of the image will appear too light, and

there will be poor separation between the various tones in these areas.

The main problem of correct reproduction is the halftone dot. It is not, however, a question of dot size alone; other aspects, such as dot density and tone density, must be considered. Tone reproduction is an important and complicated subject; it is extensively treated in other sections of the Lithographers Manual. Here, some aspects of tone reproduction and some methods of improving tonal quality are discussed.

DOT AREA, DOT DENSITY, AND TONE DENSITY

As an introduction to this problem, let us consider for a moment the question of dot size, or dot area as it is commonly called. The size of the halftone dot is determined by certain factors over which the halftone photographer has some control, namely the main, flash, and bump exposures. By varying each, or all, of these factors, the size of the dot can be changed. However, the tone of an image area is not dependent upon the dot size alone. In addition, there are the factors of dot density and tone density.

The term "tone density" means the optical density of a tone area—the overall density that takes into account both the dots within the tone area and the spaces between them. (Tone density is also called "integrated dot area.")

The term "dot density" means the optical density of the dots themselves.

The most convenient way of describing the size of halftone dots is by stating how large they are in relation to the white or transparent spaces between them. Dot size is measured in terms of dot area. The dot area of any tone region is the faction of the total area of the region covered with black dots.

HOW DOT SIZE AFFECTS TONE DENSITY

Now, in terms of practical results, here is a major point that has been learned from the study of tone reproduction.

The dot size and the tone density within an area are not proportional. This means that if the dot size is changed by equal amounts, there will not be equal differences in tone density. If dot sizes were changed an equal amount, it would be more noticeable in the shadow tones than in the highlight tones. If, for example, you wanted to show a tonal difference in a light-toned area, you would have to increase your dot size a greater amount than if you wanted to show the same tonal differences in a darker-toned area.

Remember that at this point we have been discussing only effect of dot size on tone density. Other important factors that we have not discussed will also vary the appearance of the final print. They include items such as the blackness of the ink, the whiteness of the paper, and the evenness of the dot, to mention only a few.

IMPROVING TONE REPRODUCTIONS

Having touched only ever so briefly upon one of the technical considerations of this problem, let us turn to some of the means available for improving tone reproduction.

Hand Retouching. This method can be used on both screened negatives and positives. Possibly the most common form of hand retouching is normally done on a screen positive and is known as dot etching. Here, the dot sizes are changed by etching in a mixture of ferricyanide and sodium thiosulfate (hypo). For localized etching, a brush can be used. If the film requires an overall etch, it can be dipped into a tray of the processing solution. Staging is done with an asphaltum mixture to protect the areas on which no etching is to be done.

On either screen positives or negatives, blocking-out can be done with the use of opaque. When opaque is applied to a negative, it will result in a perfectly clear white area on the final positive.

Stains or dyes can also be used in varying amounts to retard the passage of light through the screen negative or positive and, in this way, change the value of the tones in the following step of the process.

Halftone with Flash Exposure. The appearance of a halftone can be improved by making it using one or more auxiliary exposures in addition to the main exposure through the screen.

One auxiliary exposure is called the flash. It extends the tonal range and improves the shadows. Usually, a main exposure will not produce dots of the correct sizes in the shadows because light reflected from the shadows is insufficient to penetrate the screen's density to differentiate tones. The controlled flash, a nonimage exposure to yellow light, puts the correct sizes of dots in the shadows because the yellow light, not being reflected from shadow areas, can penetrate the screen sufficiently to produce shadow dots. (The initial, or main, exposure does penetrate the screen's density in the shadows, but an insufficient amount of light to cause a change strikes the emulsion. Additional exposure, to yellow light, does cause a chemical change in the emulsion because the minimum threshold exposure has been achieved.)

Exposure calculations are determined by relating the difference between image density range and screen density range to a flash exposure test.

Halftones with Bump Exposure. A halftone negative made with a bump (no-screen, or line) exposure in addition to the main and flash exposure will do the most for copy where there is a distinct difference in tone values between the whites and the lighter gray tones. The main and flash exposures are made first in order to faithfully record the shadow and middletone areas; then the halftone screen is removed and the bump (line) exposure is shot on the same film in register with the halftone image. The ratio of halftone-to-bump exposure time is very important and must be carefully worked out for the most satisfactory results.

Halftone Negative with Continuous-Tone Mask. Making a halftone negative using a continuous-tone mask is another method to improve the tonal quality of the image in the highlight area. At the same time that the screen negative is shot, a weak-image continuous-tone negative is also shot. These two images are superimposed to make the halftone positive, or they can be used directly to make a printing plate. The continuous-tone image adds more density to the highlights of the screen negative, and they are thus more correctly represented.

Filters and the Contact Screen. With a magenta contact screen, the magenta color allows certain general tonal corrections to be made through the use of the proper filters when making an exposure. A yellow filter will lower the contrast of the entire negative. With a magenta filter, the contrast is increased. In addition to a complete exposure through one of these filters, a partial exposure can be made through one of them for intermediary results.

These are only a few of the means available to the lithographic photographer to alter the tonal characteristics of his negatives and positives in order to get better reproduction.

ACHIEVING EFFICIENT OPERATION

The chances are that the layout of equipment and materials in your department were made before you ever came to work there. It is a little difficult, and in some cases impossible, to do very much about changing the position of heavy photographic equipment in order to operate more efficiently. You will therefore, in most cases, be limited to minor changes in your department. Do not, however, give up in disgust; for even small changes, if carefully worked out, can produce worthwhile improvements in efficient operations.

Let us see, then, what can be done in planning a department so that it can operate efficiently. In the first place, the equipment should be accessible. By careful and proper placement, walking distances and wasted motions will be tremendously reduced. Proper placement of equipment is one of the most important factors in increased productivity.

With the equipment go the tools. It is necessary that the proper tools be on hand at the place where they will be needed.

Just as you follow a planned step-by-step sequence of procedure in your operation, it is logical to have your equipment, tools, and supplies arranged in such a way that they will be readily available in the same order in which they will be used.

A check will immediately tell you if tools are missing or if new ones should be purchased. All tools should be checked to see that they are in operating order and suitable for the purpose. A reasonable amount of thought will be required to make certain that the way you are doing things is the best possible way to do them. Look at each step of your operation. Are you performing it efficiently? Does it logically follow the step that preceded it? Is the operation you are doing in its logical place of procedure when you consider the step that will follow?

All of these are questions that you will have to ask yourself and that you will have to answer truthfully in order to determine how well and efficiently you operate. You must stand mentally aloof and try to look at the situation with a detached eye. Try, if possible, to picture that you are watching someone else performing the operations that are being done. Is there a constant walking around from one side of the room to the other? If the answer to this question and to others like this are in the positive, it is time that you stopped in your tracks and reviewed your operations.

When you have seen that certain changes are desirable and have made them, operate under the new conditions for a period. Give yourself enough time to be at ease with the new order of operation or the new positioning of supplies, and then, once again, stand back and look over the whole situation. Were the changes that you made good? Do they seem to have made a noticeable improvement? If they have helped, try to look into the procedure a bit more closely, and see if there are other details that can be corrected at this time. In this manner, you should make a periodic recheck of the operations that you are performing. In some cases, once every year might be ample. In other cases, once every two weeks wouldn't be enough.

In all the photographic work that you do, there are certain things that remain constant and other things that vary. For the most efficient working conditions, it is necessary that you control the variables as much as possible. In many cases, the easiest and best method of control is to eliminate the human factor and substitute a mechanical one to do the work. So, from this point of view, let us discuss a few of the photographic variables and show how they can be controlled.

LIGHT AND LIGHT INTEGRATORS

One of the primary problems of the photographer is lighting. In order to calculate exposure properly, the photographer must know the light intensity, what quality the light is, and the exposure duration. Unless these factors are consistent, there will be a constantly changing exposure factor brought into the work.

Being able to measure how much light you are getting in a given situation is important. It is true that, with the proper optical formulas, the photographer can calculate how the light will change in quantity as the light sources are moved closer to, or further away from, the copyboard. But there is the factor of variability in the light sources themselves. When carbon arcs are used, the light could change in intensity as air drafts cause the arcs to flicker. So for fractions of a second, you could get little or no light on the copy. With enclosed light sources, the primary problem is voltage consistency. The line voltage that supplies the lamps with power can vary from second to second as heavy equipment on the same power line is put into operation.

The measurement of the intensity of the light source can be made with an exposure meter, of which there are many types available. But this leaves much to be desired: as soon as a measurement is made, conditions may change and another reading would be necessary. In a situation such as this, it would be impossible to make a constantly accurate measurement of the light source.

The actual time of exposure can be measured with one of the many photographic timers that are on the market. Almost all of them will give a very accurate measurement of the passing time, but with a varying light source, this of no particular use. It is, therefore, necessary to either keep the light source from changing in the slightest degree or to be constantly measuring its variation.

There is an instrument available that will continually measure the strength of the light source and simultaneously time the exposure. Such an instrument is known as a light integrator, and it is made by many manufacturers. It is one of the really basic instruments for high-quality photographic reproduction. Of course, it is still possible to produce faulty results in spite of using a light integrator, but if only one instrument was used with the camera to maintain consistent results, this instrument would be the choice.

The instrument is extremely simple in its use. It is set by the use of some type of calibrated dial or by a pushbutton board on which the exposure values are designated. These values are in

light units. The light from the source falls upon a photoelectric cell that is electronically hooked up to a timer mechanism. If the light falling upon the cell fluctuates, it will either slow down or speed up the timer mechanism, depending upon the type of fluctuation. The end result is that twenty units of light today will be the same as twenty units of light tomorrow, and, even though the exposure time may be longer on one day than another, the total amount of light reaching the sensitive emulsion will be the same as the setting of the dial. This consistency will help eliminate one of the most important variables in the photographic operation—exposure.

The light intergrator can help eliminate other variables. There are, however, some variables that are almost impossible to eliminate. Three of these are the differences of working techniques between camera operators in the same department, the variability of equipment, and the possibility of malfunctioning equipment. Still another variable is the change in performance of equipment over a period of years as the equipment is used more and more and as parts become worn.

Because it is not possible to completely eliminate this type of variation, the next best thing that can be done is to measure it. For, once you can measure your errors or variables, you have the foundation for an intelligent modification in order to make the end results what you want them to be. In this category comes the next important instrument that is of great importance: the densitometer. Depending upon the type of work that you do, it may well be the instrument of primary value.

Courtesy of Chesley F. Carlson Co.
Light integrator.

THE DENSITOMETER AND ITS FUNCTIONS

The densitometer performs one operation: it measures density. However, it can do it in a number of ways, and density measurements can be used for a wide variety of controls. But, before we go any further, let us define the term "density" so that we all will understand the same thing as we continue the discussion: *Density* is a standard means of expressing the value of a tone area in the form of a number. (Densitometry is discussed in Section Two of the chapter.)

This definition means that, with the densitometer, we can take two or more tonal values (from either reflection or transmission copies), measure them, and make a comparison between them. From density values we can determine: (1) The relative speed of a film; (2) The contrast of a particular emulsion; (3) Correct exposure values; (4) Correct development times; (5) Correct filter factors; and (6) The correct balance between a set of color separation negatives.

All of these and many other factors can be determined with

the help of the densitometer. Therefore the densitometer is one of the prime tools of the photographer. It will assist in the standardizing of operations and will permit results to be duplicated. Used properly, it will eliminate a great deal of guesswork, while increasing production. Wasted time and materials can be minimized, and the photographer can be confident of obtaining the desired results.

TROUBLESHOOTING FOR THE CAMERA OPERATOR

What exactly is meant by troubleshooting? It is the process, once a trouble is apparent, of locating the source of the trouble and remedying it so that the operation can proceed in a normal manner without an undue waste of time. The process of locating a trouble is based upon two general factors. One of these factors is a logical approach to solving the problem, and the other is a background of experience in the operation. The experience that a photographer needs cannot be given in a short article of this nature. It is something that must be acquired over a period of time after having worked on many types of jobs. However, one thing the photographer can do is to learn how to use the equipment. You, as a photographer, should become familiar with the camera that you are using. Learn what each part of it will do when you have the available time. Once your general knowledge of the equipment is reasonably complete, you can devise a logical approach to the question of problem solving. The basic idea behind such an approach is this: If your vacuum back does not hold your film snugly against it, it would seem foolish to look for the reason for this fault in the developer that you used. It would seem more logical to look for the trouble in the camera itself. Either the vacuum pump is not operating correctly or holes in the vacuum back might be plugged up. These would be the most likely places to look for the faults. If, in addition to noticing that the vacuum back is not holding the film, you noticed that the pump did not seem to be operating properly, the pump, then, would seem the best place to start your check of the faulty operation. This general procedure requires just a moment's time to mentally go over what seems to be the trouble and then to try to locate the fault. Toward this end, the following list of five common faults is supplied. It will give you a starting point on which to build your experience.

Poor Dot Structure. Dots may be fuzzy and will not stand up under the etching operation.

Most probably the fault will lie in camera operation. First, check for improper screen distance (if using a glass crossline screen) and for correct exposure; finally, check to see if the flash exposure was omitted.

If none of these things reveal the source of the difficulty, check development. Was there excessive development time? Was developer temperature too low? Was the developer mixed improperly?

Multiple Dots. Multiple dots are usually noticed as a small cluster of dots where a single dot should be. This pattern is especially noticeable in highlight areas. It is almost exclusively a camera fault. Check first for camera vibration, then possible film or screen slippage on your vacuum back.

Poor Duplication of Tonal Range. Negatives more con-

trasty or softer than the original art indicates poor duplication of tonal range.

First check the copy. Is its tonal range too great for your normal method of exposure? Then check exposure. Did you use only a main exposure when a flash exposure was necessary to cover the tonal range? Did you forget to flash?

If these camera items check, then go to the development operation. Was the developing temperature correct? Has the developer deteriorated due to too much use?

Pinholes. Pinholes are small little clear spots on the negatives. They are usually caused by dust or dirt on the copyboard or on the halftone screen. In this case, a second shot would show the spot in the identical place on the picture area.

Check the developer. Pinholes can be caused by air bubbles clinging to the surface of the film. Try a more careful develop-ment technique to eliminate this.

A third possibility lies in the emulsion of the film. Tiny air bells on the emulsion formed during the coating operation cause these spots. Pinholes due to air bells are readily recognized by a thin dark ring around a clear center.

Blotches and Streaks. Blotches and streaks are uneven tone areas that are found on the emulsion after fixing. They are due almost exclusively to faulty development technique. The first cause is uneven immersion in the development solution at the start of development. Poor agitation is a second cause.

Still another possibility is that a magnifier was placed against the emulsion surface during development in order to watch the progress of the development. This contact can cause a blotch.

A final cause is lack of sufficient developer in the tray to cover the film.

Color-Separation Photography _____

Section One: Introduction to Color-Separation Photography

Color pictures frequently contain hundreds of small areas of distinctly different colors. It would be impractical or impossible to print each of these separately. Fortunately, most colors can be reproduced by printing in their place some mixture of three selected colors, sometimes with the addition of black. The four colors commonly used in printed color reproductions are: (1) Yellow, (2) Magenta, also known as process red, (3) Cyan, also known as process blue, and (4) Black. The terms magenta and cyan are used in place of blue and red, not only because they describe the colors of the actual inks more accurately, but because this avoids confusion with the blue and red of the color-separation filters, which mean something quite different. This confusion becomes serious in discussing masking methods.

Each color will be transferred to the paper by a separate printing plate. To make these printing plates, we first need four negatives, each recording densities for the varying amounts of color one of the plates will carry. Making these negatives is called "color" separation."

The negatives are exposed through color filters consisting of dyed sheets of gelatin. The filter used in making each negative is one which will make the color of the ink to be carried by that plate photograph as if it were black and the other colors as if they were white.

A good understanding of the nature of light is a prerequisite for every discussion of color separation and the very closely related subject of color correction. Some information on color —its use and controls—must therefore be included in every introduction to color separation.

Our discussion is divided into the following main points: (1) The nature of light, (2) The nature of color, (3) Combinations of color, (4) Color separations, (5) Printing inks and filters, and (6) The inter-relatedness of color separation and color correction. Each of these subjects is discussed in the following.

NATURE OF LIGHT

Light is that form of radiant electrical energy to which our eyes are sensitive. It is a very narrow region in the wide range of the electromagnetic spectrum. This range extends from cosmic rays through and beyond radio waves. The narrow region of visible wavelengths stimulates the full spectrum of color that our eyes see in a rainbow or through a prism. The spectrum shows a gradual color change that blends one color into another. For purposes of identification we can divide the spectrum into six groups. The narrow region of visible wavelengths stimulates the full spectrum of color that our eyes see in a rainbow or through a prism. The spectrum shows a gradual color change that blends one color into another. For purposes of identification we can divide the spectrum into six groups of colors which we call violet, blue, green, yellow, orange, and red.

Controlling Light. Light, as energy, can be directed, controlled, dissected, and re-combined. The instruments used to control light are classified as optical. The use of light to record an image of itself is called photography. When photography is further used to prepare a printing form, the process is described as being *photomechanical*.

THE NATURE OF COLOR

Color is a personal, mental experience. It is received as light that is reflected, transmitted, or radiated from an object to our eyes. The way this light stimulates the nerve cells in our eyes is used to identify the color. Color identification is a language taught to us in childhood. Being a personal experience, it varies between individuals, as well as with the state of our health, its physical surroundings, and other physiological and psychological factors.

Individual Variations in Color Vision. The personal relationship to color is noticeable by differences of opinion between individuals in color matching. This is pronounced when one of the colors is a prime or pure color and the other color that may appear to be identical is composed of a mixture of colors. The variation between individuals stresses the importance of good eyesight and freedom from any degree of color blindness for satisfactory color correction. A partially colorblind color etcher cannot be expected to reproduce colors that he cannot see.

How We See Color. Scientifically, color may be defined in terms of wavelengths of light, or as combinations of wavelengths and relative intensities. When light reaches us, it stimulates nerve responses in the retina of our eyes. The nerve responses are received by two types of cells. One, consisting of

"rods," is colorblind yet is highly sensitive to blue-green light. The other group of cells, called "cones," have much less sensitivity to light.

The Color Response of the Cones. The cones consist of clusters of three types of cells that respond individually to the blue, green, and red color primaries. Consequently, if the light becomes dimmer, as may occur in the deep shadows or with low illumination intensities, these areas will appear grayer with incorrect brightness differences. The same color areas will become brightly colored under a more intense light.

Eye Fatigue and Color Vision. Fatigue of the nerve cells in our eyes also changes our judgment of color. Such fatigue can be to a particular color. When you look first at a bright color, and then immediately look at a second color of a different hue, the second color will temporarily seem to change its color as eye fatigue subtracts some of the first color from it.

The Color Composition of White Light. White light is made up of a balanced combination of all colors of the spectrum. This fact is demonstrated when a beam of white light is projected through a glass prism. If a colored filter is placed in the path of the white light, the light that passes through is changed in appearance. Some of the color is absorbed by the filter. The transmitted light is a combination of the remaining colors.

Pure Spectrum Colors. If the spectrum of light colors coming from a white light source is blocked off until only a single color, or a narrow band of wavelengths is transmitted, we see a "pure" spectrum color.

Reflection and Absorption of Light. If white light is directed against a sheet of paper, the reflected light will appear to be white if the sheet reflects all colors uniformly. When color inks are printed on this sheet, part of the white light will be absorbed by the ink. The remaining light that is reflected by the paper and through the ink is the ink color we see. When all light is blocked or absorbed, we define this absence of color as "black."

How We See Color In Things. The color sensation we get when viewing an object depends on the light reflected from the object to the observer. Colors can appear differently under different daylights as well as under different artificial lights. Fluorescent illumination is predominantly blue-green. It does not contain as much light in the red region as tungsten or daylight illumination. Therefore, red objects viewed under fluorescent lights will not appear as bright as when viewed under tungsten or daylight illumination. Tungsten light, having less blue than daylight, makes magenta appear redder and blues darker. When viewing colors, the observer must always keep in mind the light used to illuminate the object.

Color Identification. When describing a color, the following physical properties of the color should be given: hue, saturation, and brightness.

Hue. By hue we refer to the name of a color. Hue is the term that places the color in its correct position in the spectrum.

For example, if we describe a color whose hue is blue, we distinguish it from yellow, red orange, etc.

Saturation. Another attribute of color is saturation. Saturation is that quality which enables an observer to state how strongly colored it is; that is, how much it differs from a neutral gray. For example, a pure yellow can be distinguished from tan or brown. Or you might describe a tie as a dull green, bright green, or brilliant green. These distinctions are differences in saturation.

Brightness. Brightness is the term used to describe differences in the intensity of light reflected from or transmitted by the colored image. For example, we might describe a shirt as being dark blue or light blue. The hue or color of the shirt is blue, but the characteristic terms dark or light distinguish one shirt from the other.

In the trade, we more commonly use terms like "clean" or "dirty," instead of "saturation" or "brightness."

Color Notation. The use of such terms as hue, brightness, and saturation allows different observers viewing the same color to describe it in general terms. However, there are many times when this general description is not adequate. A paint or dye manufacturer trying to match a color described in this fashion would not be able to do it. To meet the demand of a more definite description, a number of color notation systems, complete with samples and charts, have been developed.

The most popular color notation system in this country is the Munsell System. "The Munsell Book of Color" contains opaque colored samples of stable pigments. These samples are made up in different hues, brightness, and saturation values. The Munsell System of notation has room for 100 different hues. However, The Munsell Color Tree contains 10 different hues spaced horizontally around the sphere. Each hue is given a number.

Radiating out from the center of the circle are series of samples with the same hue and value but different degrees of saturation, or chroma as it is called in this system. The different degrees are numbered from 0 at the center, which is a neutral gray, to steps as high as 14 or 16, whatever is the purest color possible with the given pigments. Some hues may only go as high as step 5 or step 6.

By matching a color with one of the samples, a numerical value can be given to each of the three attributes: hue, brightness or value, and saturation or chroma. Once the color match has been made and the numerical values given, other observers elsewhere can easily locate the designated color on the tree and know what color is being described.

The Ostwald System is another widely used color notation system. It was developed by Wilhelm Ostwald and improved by the Container Corporation of America. Their system is called the Color Harmony Manual. The Ostwald System is similar to the Munsell System in that it also has a central vertical gray tone scale which is surrounded by a color circle with complementary hues opposite each other. Instead of arranging the interior colors in horizontal and vertical rows, as in the Munsell System, Ostwald places them in angled rows. All colors between the basic hues, as well as the white and light grays, are arranged as tints made by the addition of white.

Shades are made by the addition of black, and tones by the addition of gray.

Both the Munsell and Ostwald Systems give orderly arrangement and are excellent reference standards. Munsell colors may be purchased separately as colored papers, while the Container Corporation's units are acetate hexagons with both a matte and glossy side.

COMBINATIONS OF COLOR

Colors can be combined to produce other colors. When light of one color is added to light of another color, such as by projection onto a white screen, the combination color is called "additive." When one or more colors is removed from white light (such as happens when white light passes through a filter or reflects from a colored surface) the colors that are not absorbed produce what is known as a "subtractive" color.

Additive Mixtures. The additive mixtures of colors is illustrated in the projection of the three primary colors of the spectrum. The additive primary colors of light are red, green, and blue. These colors cannot be produced by mixtures of other colors. Combinations of two of the primaries, red and blue for example, produce a third color called magenta. The combination of all three primaries produces white light. This is to be expected as we have already shown that white light is made up of all the colors of the spectrum from red to blue.

Another illustration of the additive process can be seen when a checkerboard pattern of two colors is viewed at a distance so that the eye can no longer distinguish the individual areas. The squares will fuse into one area of solid color. This new color will be the sum of the reflectance from the two color areas. If the two squares are colors such as red and blue, the resulting color sensation will be a magenta hue. Red and green squares will produce a yellow hue, while green and blue squares will produce a cyan hue. In this method, the color will appear darker than when using the projection method first described. This is due to the fact that in the checkerboard pattern the colors are side by side and not overlapping. As a result, you have only half the color intensity from a given area as compared to that produced by projecting the colors as light.

Another illustration of the additive process occurs when we view small elements of colors placed side by side without overlapping, such as halftone dots in the highlights and middletones of color reproductions. We see the combination of all the elements and not the individual dots. However, when the dots overlap, we see color combinations formed by the subtractive color mixture process if the colors are transparent.

Subtractive Primaries. These are the colors produced when the three colored beams overlap in pairs. When all three colored beams overlap, white is produced. When only red and blue overlap, the resulting color is magenta. Magenta is made up of red and blue, which is roughly two-thirds of the color spectrum. It can be described as white light minus green and, therefore, it is sometimes referred to as the minus-green color. When a magenta beam of light and a green beam of light are combined in the proper proportions, the result is white light. When the red and green light beams overlap, they form yellow. Yellow can be described as white light minus blue, or just minus-blue. When the green and blue beams overlap, they form cyan. If we subtract the red third of the spectrum from white light, the color obtained is cyan. Cyan is sometimes referred to as minus-red.

Subtractive Color Mixtures. In the additive-mixture process, we form new colors by projecting basic primary colors onto a screen. In the subtractive-mixture process we form new colors by subtracting parts of a white or colored light source. An example of subtractive color is seen whenever we place a filter in front of a light source. The filter subtracts certain colors and allows others to pass through it. The filter does not add anything to the light beam. It removes something from it.

Subtractive Color Mixtures With Additive Primaries. When a filter which has the same color as the additive primary colors such as red, green, or blue is placed in front of a white light beam, two-thirds of the light is absorbed and one-third is transmitted. For example, the red filter absorbs the blue and green portion of the spectrum, transmitting only the red portion. When another additive primary filter, for example blue, is placed over the beam of light transmitted by the red filter, no light is seen. The red filter transmits only red; however, the blue filter absorbs red. All three regions of the spectrum are absorbed by any combination of two additive primary filters.

Subtractive Color Mixtures With Subtractive Primaries. When a filter which has the same color as one of the subtractive primary colors such as cyan, magenta, or yellow is placed in front of a white light beam, one-third of the spectrum is absorbed and two-thirds transmitted. For example, the magenta filter absorbs the green third of the spectrum and transmits the red and blue portions. If another subtractive primary filter, for example the cyan, were placed over the beam of light transmitted by the magenta filter, we would see blue light. The magenta filter transmits the red and blue portions of the spectrum. The cyan filter absorbs the red portions, transmitting only the blue. In a similar fashion, the magenta and yellow filter combinations will produce red. The magenta filter absorbs green, and the yellow filter absorbs the blue portion of the spectrum leaving only the red to come through. The cyan absorbs the red portion of the spectrum, while the yellow absorbs the blue portion, leaving only the green of the spectrum to be transmitted. If all three filters were placed over a white light beam, we would not see any color.

We have seen that the additive primaries—red, green, and blue—cannot be used in the subtractive method of mixing colors because any combination of two would produce no color or black. When the subtractive primaries—yellow, magenta, and cyan—are used in the subtractive process of mixing colors, combinations of any two will produce a new color.

COLOR SEPARATION

To print a reproduction of a color original, it is necessary to prepare a set of press plates, one for each color to be printed. Each of these press plates will be used to print a specific color of ink, such as magenta (process red), cyan (process blue), or yellow. The printing design for each color must print the proportional amount of color in each area that is required to build up

the complete color combinations in the reproduction. To pre-pare these individual color printing plates, it is necessary to sepa-rate the colors of the original into three or more photographic images. Each image represents the proportional amount of a printing ink color to be used.

PRINTING INKS AND FILTERS

We have been describing the additive and subtractive color primaries with light sources and filters. We cannot use lights and filters for printing purposes. However, we can use ma terials which behave in the same manner. A sheet of white paper which reflects all the wavelengths of light can be our light source. Transparent ink films which absorb or transmit different parts of the spectrum can act as our filters.

When we put a thin transparent ink film on a sheet of white paper, we are not adding any color to the paper. The purest and brightest color hues that can be produced on that particular paper are already reflecting from the paper before we put any ink film over it. Any thin reasonably transparent ink film trans-ferred to paper can be no purer than the color already reflecting from the paper as part of the white light. This is very notice-able when the same ink is printed on a variety of papers such as cast-coated, coated offset stock, and yellowed newsprint.

Functions of Yellow Ink and Blue Filter. The best yellow inks available reflect almost as much red and green light as the paper they print on. However, this is only an auxiliary func-tion. The prime characteristic of a yellow ink, for a subtractive printing process, is that it absorbs blue light. It thereby con-trols where blue reflects from the white paper. If the remaining two-thirds of the spectrum reflects fully, the ink will be a clean, pure yellow. A blue filter, transmitting only its own third of the spectrum is thus the proper filter to use to provide correct filter separation tone values for a yellow printer. The desired effect is to record only where the blue light comes from the copy. When a positive is made from this negative it will be a record of the minus-blue (yellow) of the copy.

Functions of Magenta Ink and Green Filter. The func-tion of the magenta, or "process red," ink is to absorb green light only, without disturbing the reflectance of the red and blue light. Most magenta inks absorb some blue and red light. A green filter which transmits its own third of the spectrum will be the proper filter to use to make a record of the green areas of the copy.

Functions of Cyan Ink and Red Filter. The function of the cyan ink, or "process blue," is to absorb the red light with-out disturbing the reflectance of the green and blue light. Most cyan inks absorb some green and blue light. The red filter which transmits its own third of the spectrum should be used to control the red light reflected from the copy.

In the reproduction process we use the tri-color filters to separate the copy into its red, green, and blue components. We then combine these three components by controlling the red, green, and blue light reflected from the white paper. We use red-light absorbing ink (cyan), green-light absorbing ink (magenta), and blue-light absorbing ink (yellow).

Color Separation Filters. The color separation filters most commonly used are the Wratten Blue (47), Green (58), and Red (25). These divide the spectrum into approximately equal thirds which are complementary to the hues that printing inks should have. Unfortunately, with the exception of yellow, the best process inks are not close enough to the correct hue and purity. Because of the failure of the inks, color correction of the separation is necessary. It has been suggested that less correc-tion would be needed if the filters were changed to be the exact complements of the printing inks which are actually used. In some cases other filters do give greater saturation, but shifting their hues from strict thirds always degrades part of their separation.

The Red (25), Green (58), and Blue (47) filters are called the broad-band set because they actually overlap a little in their transmission. This gives the most complete record of where red, green, and blue reflect from the copy. A narrower band set has been recommended for color transparencies because of the nature of their dyes. These are the Red (29), Green (61), and Blue (47B). These will give a little more saturation with re-flected copy also. However, this is not recommended if mask-ing corrections are to be used because two-color mixtures will be over-corrected.

The Limited Accuracy of Color Separations. The accu-racy of these color separations is limited by two factors: (1) Each color filter cannot compensate for the ink and printing deficiencies; and (2) The photographic negatives do not record the exact ratios between color densities as they appear in the original.

THE INTER-RELATEDNESS OF COLOR
SEPARATION AND COLOR CORRECTION

In all known methods of photomechanical color reproduc-tion, there is a loss in color accuracy so that the colors of the reproduction do not match those of the original. This would be true even if a "perfect" set of separations could be made. The printing plates made from these separations would not produce the desired colors, because each of the commercially available inks act like a pure colored ink contaminated with small amounts of the other inks and therefore absorbs some of the light which it should reflect.

Magenta and Cyan Inks are Contaminated. The magenta ink absorbs some blue light in addition to green; that is to say, it is like a perfect magenta contaminated with yellow ink. In order to compensate for this absorption, less yellow ink must be printed wherever magenta is present. Similarly, the cyan ink absorbs some of the blue and green light which should be com-pletely reflected; that is, it acts as if contaminated with yellow and magenta ink, and therefore the yellow and magenta ink must be reduced wherever cyan is to be printed.

Manual Color Correction. In lithography, this can be done by local dot-etching on halftone separation negatives or posi-tives; in photoengraving, by local work on the plates; and in photogravure, by hand-retouching of continuous-tone negatives and positives.

Color Correction by Photographic Masking. A far better method, however, is to alter photographically the tone values of the separations from which the plates are made. Masks will do this job efficiently and without loss of detail. This is called "masking for color correction" and can result in changes in hue, brightness, and saturation of colors.

Undercolor Removal, and Tone Correction. Masks are also used for undercolor removal in four-color wet printing and for altering the tone scale of a reproduction, as in highlight masks and contrast-reducing masks.

Color Separation and Masking Are Siamese Twins. We mention the subject of masking advisedly at this point of our discussion. *The reader must accept the statement that color separation and color correction are most closely connected. It is not possible to discuss color separation as an independent operation.* Color-separation techniques depend on the kind of color correcting which is to be used more than on anything else.

Photographic Masking the Key to Color Reproduction. When we speak of color correcting we mean photographic rather than manual methods. These methods have become the most topical subject in lithographic color reproduction; they are extensively discussed in the "Photographic Masking and Color Correcting" chapter of the Manual. There you also find specific instructions for the making of color separations together with the masking process in which they are used.

In this chapter our discussion can therefore be limited to the most essential and most general points of color-separation photography.

Section Two: Color-Separation Essentials

Our discussion of color-separation essentials is divided into the following eight points: (1) The two main kinds of copy for color separation, (2) Camera essentials, (3) Lenses for color-separation work, (4) Filters, (5) Halftone screens for color separation, (6) Direct and indirect color-separation methods, (7) Arranging and illuminating of color copy, and (8) Gray scale and color patches. Each of these points is discussed in the following.

THE TWO MAIN KINDS OF COPY FOR COLOR SEPARATION

The two main kinds of copy for color separation are reflection copy and transmission copy.

Reflection Copy. Reflection copy is original material for reproduction which is normally viewed and must be photographed by reflected light. Examples include oil paintings, dye transfer and other photographic color prints, fabric swatches, watercolors, and pastels. It does not include transparencies, or color negatives.

Transmission Copy. Transmission copy is copy normally viewed and photographed by transmitted light. Transmission copy includes transparencies and color negatives.

CAMERA ESSENTIALS

Accurate register of images and correct transmission of colors are the underlying considerations in the selection and use of equipment for photomechanical color reproduction. The desired end result of the photographic steps is a set of balanced color-separation negatives or positives on which the images are exactly equal in size. Only by using good equipment properly can you be sure of accurate results on the printed page. This section of the Manual describes the precision equipment for photomechanical color reproduction and its proper use.

A discussion of process cameras for color separation can be found in Chapter Five of this Manual. In certain cases, particularly in that of the Kodak three-color process, specialized equipment may be needed. Such equipment is described as part of the specific method for which it is needed in the "Photographic Masking and Color Correcting" chapter of this Manual.

LENSES FOR COLOR SEPARATION WORK

No other single factor in color separation exceeds the lens in importance and for this reason we discuss the subject in great detail. Our presentation is divided into the following three points: (1) Lens requirements, (2) Testing a lens for color and separation work, and (3) Lens flare. Each of these points is now taken up in detail.

Lens Requirements. A good color-corrected or *apochromatic* lens must be used for all color work. Such a lens should produce separation negatives of equal size and sharpness regardless of the color of the filters used for exposing the separation negatives. An apochromatic lens for color separation work must be very highly color-corrected which involves two distinct characteristics: longitudinal color correction, which means that light of all colors must be brought to a sharp focus at the same focal plane; and lateral color correction, which means that light of all colors produces images of exactly the same size, suitable for registering in color printing.

Testing a Lens For Color-Separation Work. One of the simplest tests for lateral color correction of a lens can be made with a single exposure. The procedure is as follows:

1. Prepare an original with a white background and black lines: One method is to draw a series of india-ink lines on a

piece of white paper. Photograph this copy, using an 8 by 10-inch sheet of high contrast litho film, make a contact print of this negative to produce a positive image with black lines and a clear background.

2. Bind narrow strips of the color-separation filters over this positive, at right angles to the lines.

3. Place the above combination in the transparency holder of the process camera, but over to one side so that the image will be at the edge of the lens field and not on the lens axis. It should be placed so that the lines will be at right angles to a line drawn from the center of the test object to the center of the copyboard. Make a single exposure on a high contrast panchromatic litho film.

If there is any difference in size of the images, the sections of black lines masked off by the strips of filters will not be joined. They will appear out-of-line in proportion to the lateral color aberration of the lens. If there is only a slight departure from exact alignment, lateral color aberration may nevertheless be low enough for many types of work, and the lens should be tried on a typical subject.

If close-up work is contemplated, the performance of the lens should be checked at the greatest magnification expected in actual use.

Lens Flare. One of the notable causes of difficulty in color work is lens flare. This can be defined roughly as non-image light which reaches the film or plate through the lens. It can be caused by stray light entering the lens or by internal reflections from the lens-element surfaces or the lens mount. It is frequently unnoticed until a job is encountered that requires critical color reproduction or the reproduction of much fine detail. The effect of flare is to decrease markedly the contrast of the image especially in the shadows and lower the purity and saturation of shadow colors.

One of the most common causes of flare is dirt on the surfaces of the lens. This may be a thin, even film of dust and arc-lamp smoke. Front and back surfaces of the lens can be cleaned by careful polishing with a fresh piece of lens tissue. Avoid strong cleaners, abrasives, and ordinary wiping rags. One hard particle on a cloth can scratch the delicate lens surface. If the lens barrel has a slot for filters, keep a piece of tape over it when it is not being used. If the inner surfaces of the lens need cleaning, let the manufacturer do the job. The charge will be negligible compared to the cost of the lens. Modern lenses have their surfaces coated to eliminate reflections. Such lens coatings have a bluish-violet appearance which should not be confused with the hazy deposit of smoke and dust.

Stray light should be prevented from entering the lens during camera exposure. Bright room lights, windows, and reflections should be guarded against. Black paper over the outer edge of the copyboard will prevent direct reflection of the arc light into the lens.

FILTERS

In order to separate or divide the many colors of the original into the separate portions to be carried by each of the color printers, color-separation filters are required. These may be in the form of dyed gelatin sheets which are either unmounted or are mounted in glass. Unmounted Wratten filters are used ex-

tensively in the graphic arts. Most workers prefer them to glass filters.

Specially selected Wratten filters are now available for the critical requirements of the photomechanical reproduction of color. These are designated "Wratten Gelatin Filters for Use in Photomechanical Reproduction." They are particularly useful where partial exposures are to be made through each of several filters, as in the split-filter method of making a black printer. These selected filters are available in the following Wratten numbers: 8 (K2), 25, 29 (F), 33, 47, 47B, 58 (B), and 61 (N).

It is extremely important that the filters used for color-separation work have the proper transmission characteristics. The recommendations in this section are based on the use of Wratten filters, and the recommended filters for each exposure are stated in the following sections of this chapter. For further information on filters, see the Kodak Data Book "Graphic Arts Films and Plates."

HALFTONE SCREENS FOR COLOR SEPARATION

Our discussion of halftone screens* is concerned with various kinds of screens as well as their positioning for color separation. We present the subject under the following seven headings: (1) Glass crossline screens, (2) The magenta contact screen, (3) The gray contact screen, (4) The Moiré effect, (5) The purpose of different screen angles, (6) Using different screen rulings, and (7) Rotating contact and crossline screens. Each of these points is now discussed.

Enlarged contact screen pattern. Enlarged cross-line screen pattern.

Two Principal Types of Halftone Screens

Glass Crossline Screens. Glass crossline screens are widely used for the photomechanical reproduction of color artwork, for making direct-screen separation negatives, and for making screen negatives or positives from continuous-tone images. For process color work, a conventional screen should be set in a round frame which can be rotated in guides in the camera back. For further information on glass crossline screens consult the section on halftone photography of the Camera Department Chapter.

The Magenta Contact Screen. The magenta contact screen provides a flexible and improved means of making screened color-separation negatives or positives by the indirect method.

* A more detailed discussion of halftone screens is found in Section Eleven and Section Twelve of Chapter Five of this Manual.

That is, continuous-tone separations are made and, from these, screened images are made as required by the photomechanical processes. The magenta color of the screen makes possible the use of color filters to control contrast. It cannot be used for making direct separations because the magenta color interferes with the use of the separation filters. The magenta contact screen technique is applicable to surface and deep-etch plates, to photoengraving, and to some forms of gravure work.

Improved sharpness of highlight detail, simplified contrast control, and the elimination of the problem of screen-distance ratios encountered with conventional crossline screens are some of the advantages of magenta contact screens.

The Gray Contact Screen. The gray contact screen offers most of the advantages of the magenta contact screen and, in addition, the neutral color of the gray screen makes possible its use for the direct method of color separation. The chief difference is that color filters cannot be used for control of contrast. The three other methods of contrast control—controlled flash, controlled agitation, and supplementary highlighting exposures—make this a minor disadvantage, however. Complete directions are supplied with the screen.

The Moiré Effect. In all screened color-reproduction work, there is the possibility of a noticeable pattern, or "moiré" effect in the printed result. The most common causes of this pattern effect in color work are improper trapping of ink and improper screening. The latter possibility occurs whenever two halftone screen patterns are superimposed in printing. The moiré effect can be minimized by rotating, or "angling," the screen to a different position for each color separation. The angle between the vertical and one of the parallel lines or rows of dots of a screen is called the "screen angle." Certain combinations of screen angles can be selected to reduce or eliminate the moiré effect. The greater the angle between the rows of dots of the different color inks, the less chance there is for an undesirable moiré.

The Purpose of Different Angles. The purpose of selecting certain screen angles is to place the dots of the three strong colors—black, cyan ("blue"), and magenta ("red")—at angles

THREE-COLOR SCREEN ANGLES

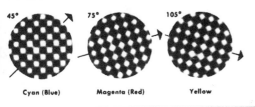

Cyan (Blue) Magenta (Red) Yellow

FOUR-COLOR SCREEN ANGLES

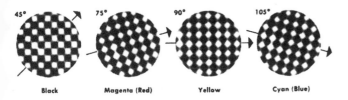

Black Magenta (Red) Yellow Cyan (Blue)

Screen Angles for Three- and Four-Color Printing

which will produce the minimum pattern. This condition is usually fulfilled when the screen angles of these colors are 30 degrees from each other. The screen angle of the black record in four-color printing remains the same as in a single-color job, that is, 45 degrees. Lines at the 45-degree screen angle are least noticeable to the eye. Therefore, the strongest color of a process set is usually screened at this angle. In color printing where each successive color is dried, or even when printing on two-color presses with drying after the first two colors, the black plate is often a weak image and should be screened at 105 degrees, with the cyan ("blue") then screened at 45 degrees. The usual screen angles for two-, three-, four-, and six-color reproduction work are discussed further down in this section.

Using Different Screen Rulings. Sometimes, to reduce the moiré pattern, it is desirable to use a different screen ruling for the yellow plate than for the other colors. For example, if a 133-line screen is used for the cyan ("blue"), magenta ("red"), and black, a 150-line screen yellow can be used to reduce the possibility of objectionable pattern.

Rotating Contact and Crossline Screens. In the case of contact screens, many cameramen find it convenient to mark the angles for rotation directly on the vacuum back of the process camera. A pair of reference marks should be placed on opposite edges of a contact screen which is to be used for color-separation work. These marks should be at the two ends of a line of dots running approximately through the middle of the screen.

To locate two opposite points, place a straight-edge on the screen over an illuminator. Using a magnifier, align the edge with a row of dots by sliding the magnifier along the straight-edge and observing whether or not the same line of dots follows the edge. When the correct position is found, scribe a mark on the margin of the screen at each end. This can be marked with a tab of white adhesive tape for better visibility in the darkroom.

A pair of corresponding tabs is placed on the vacuum back of the camera at each of the positions in which the screen is to be used. One of the tabs on the screen should be larger than the other or specially marked so that the screen can always be angled by reference to the same mark. This is also important with crossline screens, because a screen might have a slight departure from a perfect 90-degree relationship in its rulings, and a slight moiré pattern can appear if the same reference point is not used throughout in making a set of screened separations. (It is for this reason that we refer to a "105-degree screen angle" rather than a "15-degree screen angle" (105-90), as might be the case if we used two reference points 90 degrees apart on the screen.) *Under certain conditions in four-color work, an error of less than half a degree can produce a moiré pattern.*

DIRECT AND INDIRECT COLOR-SEPARATION METHODS

Color separation can be made by two methods: the direct and the indirect. In this section we present a general discussion of both methods; in the following sections you find detailed instructions for their execution.

Direct Method Color Separations. In this method, the

color-separation exposures are made through the half-tone screen onto high-contrast films or plates so that half-tone separation negatives are obtained in the first step. A glass crossline screen or a gray contact screen should be used in this method, but not the magenta contact screen. Printing plates for photo-engraving or surface photolithography are made directly from these screen negatives after any necessary handwork has been accomplished. For deep-etch photolithography, screen positives are made by contact printing from the screen negatives.

Indirect Method Color Separations. In the indirect method the halftone negatives or positives are not made directly from the original copy, but from intermediate continuous-tone separations. The use of the continuous-tone negatives makes possible the broader use of masking procedures for tone control and color correction, and eliminates the very long exposures which are sometimes needed for direct halftone work.

Retouching for color correction can be done on the continuous-tone images either by using retouching pencils or by staining with a neutral dye or neococcine. When any one of several masking methods is used, much of the handwork can be eliminated.

The indirect method is capable of improving the general rendering of detail and color separation in separation negatives. It also makes possible an improvement in the dot structure of photoengraving plates because less handwork is necessary. Most masking techniques are more practical when used with the indirect method.

ARRANGING AND ILLUMINATING OF COLOR COPY

Copy arranging and illuminating differs for reflection and transmission copy. We discuss the subject under the following five headings: (1) Arranging reflection copy, (2) Arranging transmission copy, (3) Illuminating reflection copy, (4) Illuminating transmission copy, and (5) Tone and color controls.

Arranging of Reflection Copy. Copy should be mounted firmly in a central position of the copyboard, with register marks placed on all sides or at the ends of the longest dimension of the copy. On rectangular copy, it is customary to use register marks on the vertical and horizontal center lines. The register marks can take several forms, but one which appears sharply defined in both positive and negative images is the most satisfactory.

Arranging of Transmission Copy. Separations from transmission copy are often made by contact printing, which offers several advantages and is described elsewhere in this Manual. When they are to be made in the camera, the copy is placed in a copyholder, a transparency frame which is very often also equipped with registering devices.

Illuminating Reflection Copy. Good color separation depends upon proper copy illumination. The illumination must be of even intensity over the entire copy surface, the direction of the light must be correct, and the light output of the lamps must be constant in quality and quantity. To obtain the most even illumination with double-deck arc lamps, the copy should be mounted on the copyboard with the longer dimension vertical. With single arcs, the copy, and particularly large copy, should be mounted with the longer dimension horizontal. The copy can be mounted under glass if desired.

The evenness of illumination can be checked by making incident-light readings with a photoelectric exposure meter in the four corners and the center of the copyboard. If a reflection measurement is made, a neutral gray or white card should be used for test readings, and care must be taken so that shadows are not cast on the reading area.

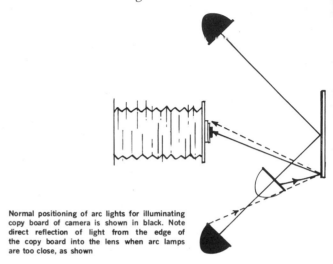

Normal positioning of arc lights for illuminating copy board of camera is shown in black. Note direct reflection of light from the edge of the copy board into the lens when arc lamps are too close, as shown

Proper and Improper Position of Arc Lights

Normally, the lights are placed at an angle of 45 degrees from the copyboard and back far enough to avoid reflection from the edge of the copyboard glass. This angle produces the maximum efficiency and is proper for all smooth-surfaced copy. In special cases, it is desirable to retain texture effects, such as the weave of cloth, brush marks in oil paintings, or chalk strokes. For this purpose, special or unequal lighting conditions will have to be set up by the cameraman. Texture effects and brush marks are usually best retained by evenly distributed lighting at unequal angles. One light can be placed at the normal 45-degree angle, while the other is placed at a more oblique angle to the copyboard. This second light produces the slight shadows under the brush and chalk marks which makes it possible to retain a greater feeling of relief or third dimension. The copy should be oriented so that its top is toward the light which produces the shadows.

High-intensity tungsten lamps (such as 3200-K lamps) are also satisfactorily used for illumination in continuous-tone color-separation work. Fluorescent light sources are also available. These can be used in making separations by the indirect method but require long exposures for direct color separation.

Illuminating Transmission Copy. This subject is discussed in the "Photographic Masking and Color Correcting" chapter of this Manual, in conjunction with the specific masking method.

Tone and Color Controls. Tone and color controls are essential elements in the arranging of copy for color separation. Their importance is sufficient to warrant a detailed discussion which you find in the following unit.

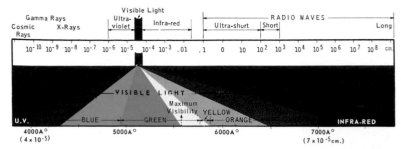

The Electromagnetic Spectrum

Prism Breaking Up White Light

The prism bends light of shorter wavelengths
more than light of longer wavelengths, spreading a beam
of white light out to a visible spectrum. (The beam extending
down is reflected from the surface of the prism
without entering it.)

Munsell Color Tree and Circle
Showing the Three Dimensional
Relationship of Hue, Value, and Chroma

Color Combination by Addition

Color Combination by Subtraction

A yellow filter absorbs blue light, transmitting green and red light

A magenta filter absorbs green light, transmitting blue and red light

A cyan filter absorbs red light, transmitting blue and green light

Transmission Range of Additive Primary Filters

Three Subtractive Primary Filters

FROM THE ORIGINAL TO THE FINAL REPRODUCTION
OF REFLECTION PROCESS COLOR COPY

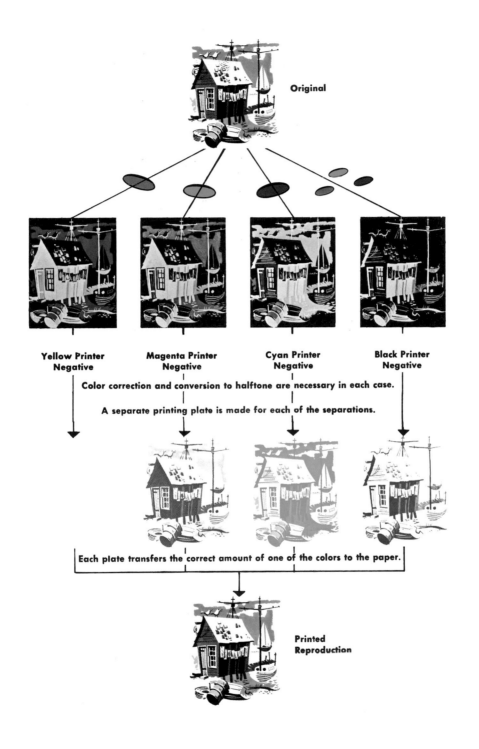

Original

Yellow Printer Negative **Magenta Printer Negative** **Cyan Printer Negative** **Black Printer Negative**

Color correction and conversion to halftone are necessary in each case.

A separate printing plate is made for each of the separations.

Each plate transfers the correct amount of one of the colors to the paper.

Printed Reproduction

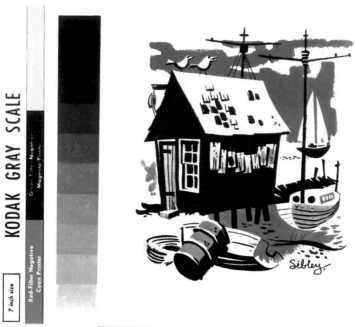

black 3-color white cyan violet magenta primary red yellow green

KODAK COLOR CONTROL PATCHES

These colors have been selected as representative of those inks commonly used in photomechanical reproduction.

Copy Ready for Camera

LOCAL SUBTRACTIVE
COLOR AREA

Additive combination with halftone dots (enlarged).

Subtractive combination with halftone dots (enlarged).

Enlarged Colored Halftones

GRAY SCALE AND COLOR PATCHES

The subject of tone and color controls is treated under the following thirteen headings: (1) The gray scale, (2) Balancing a set of separation negatives, (3) Contrast in different separation negatives, (4) Adjusting of contrast in direct method separations, (5) Adjusting of contrast for indirect method separations, (6) Selecting the proper inks, (7) Comparing inks and color control patches, (8) The color control patches, (9) Evaluating color-separation negatives by their control patches, (10) The wanted colors in the cyan printer, (11) The unwanted colors in the magenta printer, (12) The wanted colors in the magenta printer, and (13) The yellow printer and the black printer.

This unit transcends the subject of color separation in its most traditional sense by far. Here you can see how closely related color separation and color correction are! Study this unit and you will find the "Photographic Masking and Color Correcting" chapter much easier than you may fear. But back to business!

The Gray Scale. A photographic gray scale is a series of reflection densities, ranging from white to black, in a convenient strip on photographic paper. It is recommended that one of these scales be mounted along the edge of the original copy to be photographed. It must be placed so that it will receive the same amount of light as the subject, and so that there is no direct reflection from its semi-glossy surface into the camera lens.

Examination of the gray scale reproduced on each separation negative will give a visual indication of the tone separation in highlight, middletone, and shadow areas of each negative.

Balancing a Set of Separation Negatives. A "balanced" set of negatives is not necessarily one in which all the gray scales match, step for step. Such a set will not print a neutral gray scale with the commonly used process inks, but will result in a series of brown steps unless corrections are introduced at a later stage. Without further corrections, matching gray scales on the separations would reproduce as neutral gray only with a theoretically perfect set of process inks, not at present commercially available. *A "balanced" set of negatives is a set which will print a neutral scale of grays with a specific set of inks.* The gray scales on such a set will not match, but the differences between them will be much the same for every color job which is run with these same inks and printing conditions. The operator, then, instead of matching the separation gray scales to each other, matches the red-separation gray scale to other red-separation gray scales which he has found correct for his conditions, the blue to other good blues, and the green to other good greens.

Contrast in Different Separation Negatives. In general, the red-filter negative should be higher in contrast than the blue- and green-filter negatives, especially in the highlight end of the scale. Also, it may be found that the green-filter negative has too much contrast and the blue-filter negative not enough.

Adjusting of Contrast in Direct Method Separations. In the direct method of color separation, when using a glass screen, the contrast of the blue- and red-filter negatives can be increased by using a larger lens stop when using a one-stop exposing method or by giving a larger proportion of highlight exposure when using a two- or three-stop exposure. In the same way,

the contrast of the green-filter negative can be lowered by using a smaller lens stop for the one-stop exposing method or by giving a smaller proportion of highlight exposure when using a two- or three-stop exposure method. When using the gray contact screen, contrast can be controlled by flashing, still development, and supplementary highlight exposures, as described in the instructions supplied with the screen.

Adjusting of Contrast for Indirect Method Separations. In the indirect method of color separation, the contrast of the negatives can be controlled by varying the development times.

Selecting the Proper Inks. All masking procedures for photomechanical reproduction must be carried out for the specific set of inks which is to be used in the printing process. Since the need for color correction stems from the lack of color purity in all commercially available inks, it is important that the available inks be examined to select those which are best adapted for the method to be used for correction.

Comparing Inks and Color Control Patches. At the risk of being repetitious, it is again emphasized that ink and color control patches must match. If the inks used in a specific plant do not match the color control patches, patches made with these specific inks should be used. For further information on this subject consult the chapter "Photographic Masking and Color Correcting" of this Manual.

The Color Control Patches. These patches are supplied as part of color separation guides and kits available from graphic arts supply houses. The images of these patches on the negatives and positives provide measurable densities which indicate the effectiveness of the separation and color-correction methods being used. If the patches are correctly recorded, the balance of the copy will be also.

If the inks to be used do not match closely in hue, purity, and saturation, the inks of the color control patches, sample patches of the actual inks to be used should be substituted. If the reproduction is to be printed on other paper than glossy paper, these new ink patches should be printed on the paper being used. A four-color patch consisting of a three-color solid plus a 50-percent tint of black is also desirable and, of course, a more complete color chart will give additional useful information.

Evaluating Color-Separation Negatives by Their Control Patches. The appearance of the color patches in the masked negatives shows whether the color correction has been properly carried out. For a given color separation, the various patches may be divided into "wanted" and "unwanted" colors. For example, the unwanted colors in the cyan printer are yellow, magenta, and primary red. These require no cyan in their reproduction and, in order to achieve this result, they should match the white patch in density.

The Wanted Colors in the Cyan Printer. The "wanted" colors in the cyan printer—that is to say, the colors which should print solid—are cyan, blue, and green. These should all have equal densities, and, unless the original is so contrasty that its tone scale has to be compressed in the reproduction process, they should all print solid. Their color correction can be cal-

culated by comparing them with each other and with a black area. In a three-color printing, the wanted colors should definitely match in density the three-color solid patch; in four-color printing, they should be intermediate in density between the three-color patch and the black patch, the exact value depending on the quantity of black which is to be printed.

The object of masking is to equalize these patches as described above, and its effects are most clearly seen in the magenta printer.

The Unwanted Colors in the Magenta Printer. The unwanted colors in the magenta printer are yellow, cyan, and green. These three colors are almost exactly equal to the white patch in a well-corrected magenta-printer negative. Without masking, the cyan and green patches would lack density; in an overcorrected negative, they would be too dark, a condition which is sometimes described as "whiter-than-white." (Remember that we are talking about negatives.) The mask has

little or no effect on the yellow patch which needs practically no correction.

The Wanted Colors in the Magenta Printer. The wanted colors in the magenta printer are magenta, primary red, and blue, and these should be a little lighter in the negative than the three-color solid patch, to allow for the addition of a black printer on the latter. Without masking, the magenta and primary red would be too dark in the negative and result in lack of color saturation in these areas. With masking, they are often too light (overcorrected) when the mask is strong enough to correct the cyan and green patches.

The Yellow Printer and the Black Printer. In the yellow printer, the unwanted colors are cyan, blue and magenta; the wanted colors are yellow, orange-red, and green. These can be evaluated as described above for the magenta printer.

In the black printer, all six colors are unwanted, but this is difficult to achieve by photographic means.

Section Three: Direct Method Color-Separation Procedure

Our description of direct method color-separation procedure is divided into the following twelve points: (1) Photographic materials for the direct method, (2) General discussion of making direct separation negatives, (3) Filters for direct separations, (4) Order of exposure, (5) Exposure, (6) Example of procedure with the gray contact screen, (7) Example of procedure with crossline screen, (8) Processing, (9) General discussion of black-printer negative for direct separations, (10) The split-filter method, (11) The single-filter method, and (12) The infra-red method. Each of these is now individually discussed.

PHOTOGRAPHIC MATERIALS FOR THE DIRECT METHOD

High-contrast panchromatic materials which produce clean, sharp halftone dots, suitable for dot-etching, should be used for the direct method. The following materials are recommended: For general lithography and photoengraving—high contrast litho pan film. For extreme dimensional stability—polyester-based high contrast pan litho. For lateral reversal, a prism or image reverser can be used on the camera with the polyester-based pan litho emulsions. For lateral reversal without using image reversers, negatives made on the materials listed immediately above can be contact printed to obtain a laterally reversed duplicate on direct positive material on polyester-type base.

General Discussion of Making Direct Separation Negatives. Direct halftone separation negatives are made in essentially the same manner as black-and-white halftone negatives, but each is exposed through an appropriate filter. With a ruled glass screen, use either a one-stop exposure plus a flash exposure, or a multi-stop exposure plus a flash exposure. As in black-and-white halftone photography, the flash exposure is given in order to produce a hard shadow dot and to prevent excessive shadow contrast. In color reproduction, the shadow detail is reinforced

by the black-printer plate which receives a minimum flash exposure. When using a gray contact screen, follow the directions supplied with the screen.

Filters for Direct Separations. The following Wratten filters are recommended for color separation by direct method: Cyan ("blue") printer—Wratten Filter No. 25(A) (red); Magenta ("red") printer—Wratten Filter No. 58(B) (green); Yellow printer—Wratten Filter No. 47B or 47 (blue)*; Black printer—Wratten Filter No. 8 (K2) (yellow).

Order of Exposure. The separations can be exposed in any order, but most operators make the red-filter (cyan-printer) exposure first. When the correct exposure for the red filter has been determined, the approximate exposure for the green and blue filters can be determined quickly by multiplying the red-filter exposure time by the filter *ratio*. Filter ratios for the recommended materials are presented in the direction sheets supplied by the film manufacturers.

Exposure. The exposure indexes given in the direction sheets for use with standard photoelectric exposure meters can be used in determining the correct exposure for the red filter negatives.

The white-flame carbon arc was once the most commonly used light source for photomechanical color reproduction. Pulsed Xenon and Quartz-Iodine tungsten lights have become more popular now. They provide high intensity lights with a nearly continuous spectrum which approximates the wide range of the spectrum of the sun. The index numbers are usable directly with an incident-light meter or with a reflected-light meter when used to take a reading of light reflected from a

* The No. 47B filter gives more complete color separation than the No. 47, but some operators prefer the latter because of its shorter exposure time.

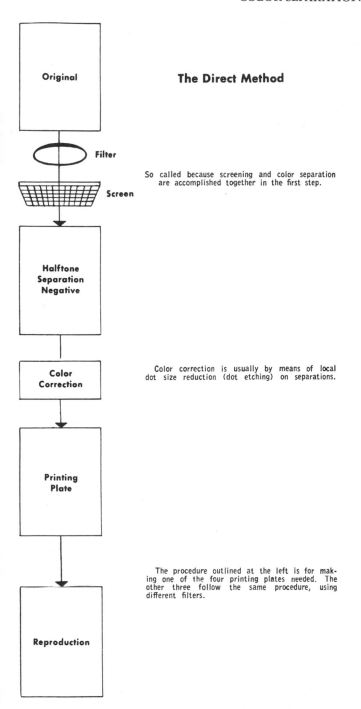

The Direct Method

So called because screening and color separation are accomplished together in the first step.

Color correction is usually by means of local dot size reduction (dot etching) on separations.

The procedure outlined at the left is for making one of the four printing plates needed. The other three follow the same procedure, using different filters.

Schematic Outline of the Direct Method*

neutral test card (18 percent gray side) placed in the position of the copy to be photographed. A matte white card may be used, in which case multiply the calculated exposure time by five. Remember, also, that the above exposure-meter calculation is for lenses set for infinity focus. When the camera is set for same-size (1:1), multiply the calculated exposure by four. For other camera settings, copying data-guides are available which will give the correct factors.

When a halftone screen is used in the camera, the light reach-

* By permission of Eastman Kodak

ing the film is greatly reduced. For the gray contact screen, the correct exposure time will be about 10 times the calculated exposure. For glass crossline screens, the factor is much higher and variations in method of use make a calculation of the factor really not worthwhile in most cases.

Example of Procedure with the Gray Contact Screen. For line negatives or halftone negatives made with the gray contact screen, the calculation of the correct exposure by means of an exposure meter can be summarized by the following typical procedure:

1. With the meter set for the correct exposure index, take a reading of the illumination at the copyboard if using an incident-light meter, or of the light reflected from a white or standard gray card at the copy position if using a reflected-light meter.

2. Read the meter as recommended by the manufacturer. The exposure time at any lens opening is given by the meter.

3. If a white card was used in taking the light measurement, multiply the exposure time indicated on the meter by five.

4. Adjust for image size. For example, if the reproduction is being made same size, then multiply the result by four.

5. If a gray contact screen is being used, then multiply the result by ten.

The result obtained from these calculations should be the correct exposure under average conditions. It should be noted that lights, lenses, and other equipment vary widely. If the operator finds that, under his conditions, the above procedure consistently yields underexposed or overexposed negatives, he can compensate by regularly exposing for a certain percentage more or less than the calculated amount. This percentage should remain the same as long as the same equipment is used.

Example of Exposure with Crossline Screen. With high contrast Pan litho film and Wratten Filter No. 25, the exposure for making a same-size direct-screen reproduction of colored copy with a crossline screen and a 1:64 aperture ratio will be approximately 4 minutes* at f/32 if two 35-ampere arc lamps are used about 48 inches from the copy.

If the 4-minute exposure through the No. 25 filter is satisfactory, the other exposures would be determined as follows: *Green-filter exposure:* the filter ratio for the Wratten Filter No. 58 will again arbitrarily be stated as 1.2. Therefore, the correct exposure through this filter would be 4 × 1.2 = 4.8 minutes, that is, 4 minutes and 48 seconds. *Blue-filter exposure:* The filter ratio for the Wratten Filter No. 47B is 2.5. Therefore, the correct exposure through this filter would be 4 × 2.5 = 10 minutes.

Processing. Recommendations for processing the materials for direct color-separation negatives are covered fully in the instruction sheet packaged with the material.

General Discussion of Black-Printer Negative for Direct Separations. A satisfactory black-printer negative is not easy to produce, and it is usually necessary to make a compromise

* This is an arbitrary figure used solely for illustration purposes. Actual exposure must be established under each shop condition.

between the rendering of the various colors. Further discussion of the black-printer problem will be found further down in connection with the indirect method. At this point, it is sufficient to remember that the chief difficulty is to record the grays without recording the pure colors too strongly.

The ideal black-printing plate is almost impossible to achieve photographically in the direct-screen method of color-separation work. There are, however, several methods of making black printers which need only moderate handwork and are used generally by the trade. We will here discuss the split-filter method, the single-filter method, and the infra-red method.

The Split-Filter Method. The split-filter method has some advantages. In this method, the black-printer negative is exposed successively through each of the three color-separation filters and on the same panchromatic material which was used for the other color-separation negatives. These partial exposures through each filter can be roughly proportional to the filter ratios and are usually between 30 and 50 percent of the exposures used in each case for the other three separation negatives. For example, if the exposure through the blue filter for making the yellow-printer-plate negative was 10 minutes, the blue-filter exposure for the black-printer negative would be 3 to 5 minutes.

High-Contrast Pan Litho Film High-Contrast Pan Litho Film Infrared Sensitive Plate
Split Filter Method No. 8 Filter No. 8 Filter

**Black Printers for the Direct Method (positives
from negatives made as indicated)***

Some operators prefer to give a full exposure through each of the three filters in making the black-printer negative. The advantage of the split-filter method over the single exposure

through a Wratten Filter No. 8 (K2), which is next described, is that it is possible to change the balance of exposures to suit the particular subject to be reproduced. For example, if the original subject contains no important red areas, use only the blue- and green-filter exposures to produce a better rendering of blues and greens. A red-filter exposure is not needed because there is no red to be recorded as white on the black printer.

The Single-Filter Method. Another method of making the black printer is to expose the same material through the Wratten Filter No. 8 (K2). This method records the various colors at about the same relative brightness as the human eye sees them. Thus, the neutrals are also rendered in normal brightness.

In both of these procedures, the neutrals are reproduced satisfactorily, but there will be too much black in the bright-colored areas. For certain types of copy, the method described below offers improvement in the rendering of dark-colored areas.

The Infra-Red Method. Infra-red sensitive films can be used for producing well-corrected black-printer continuous-tone negatives from suitable water-color or oil paintings. By using a somewhat special technique, these same films can also be used for making good black-printer negatives for the direct method of color reproduction. Briefly, the method consists in making a screen negative directly on an infra-red sensitive plate. The dots so produced are soft and ragged around the edges. However, by contact printing onto high contrast litho film, the dots can be sharpened to usable quality. A second negative is then made by contact printing from the screen positive.

The detailed procedure is as follows: Place an unexposed infra-red sensitive film in the plate-holder in the camera back. Exposure should be made through a Wratten Filter No. 8 (K2). The plate should be developed in a high contrast developer, full strength. This will produce a screened image with dots which have soft edges. The screen negative can then be printed by contact on a high contrast litho film. Contrast can be adjusted to some extent by controlling the agitation in the development of the screen positive. A contact negative is then made from the positive. The resulting halftone will have sharper dots than the original.

The chief advantage of this procedure is that, with suitable originals, the pure colors can be dropped out while the neutral or dark areas are recorded fully.

Section Four: Indirect Method Color-Separation Procedure

Our presentation of indirect color-separation procedure is divided into the following five units: (1) The color-separation negatives, (2) The black printers, (3) Continuous-tone positives, (4) The making of screened negatives and positives, and (5) Evaluating and changing various steps in the making of indirect color separations. Each of these subjects is treated in the following.

THE COLOR-SEPARATION NEGATIVES

Our description of color-separation negatives and their

making by the indirect method is divided into the following four points: (1) General discussion on the selection of photographic materials for the indirect method, (2) Exposure, (3) Example of exposure, and (4) Processing. Each of these is now individually discussed.

General Consideration on the Selection of Photographic Materials for the Indirect Method. Photographic materials should be selected to meet the requirements of the job at hand. The contrast of the original copy determines to a great extent the selection of the photographic materials. If the original copy is of high contrast, then a low-contrast, or "soft," negative material should be used. Similarly, if the original copy is of low

* By permission of Eastman Kodak

contrast, then a color-separation material of somewhat higher contrast should probably be selected. All of these materials are, of course, of considerably lower contrast than those used in the direct method. It should be pointed out that it is usually unsatisfactory to attempt to make low-contrast negatives on a basically high-contrast material by reducing the development time. This procedure usually makes the development critical and often produces a faulty tonal rendering, since it tends to flatten highlights.

LITHOGRAPHY*
Positive Processes (deep etch)

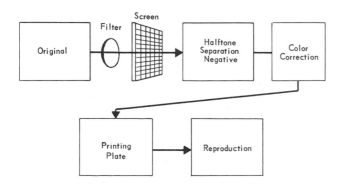

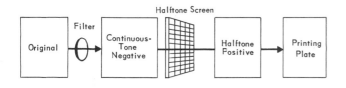

Schematic Outline of the Indirect Method

There are films and plates for each phase of photomechanical color-separation work. While no film manufactured can equal the dimensional stability of glass plates, more and more operators are finding that, when properly handled, film causes little or no difficulty in this respect. If, before use, film is conditioned for several hours in the same atmosphere in which it is to be used, and if all separations are treated in identical fashion according to recommended procedures, most register troubles disappear. Manufacturers who make both film and plates for color-separation photography list them. Their literature states which plates are comparable to each film emulsion. Although there are differences between each plate and its listed counterpart (such as in developing time, gamma, speed, etc.), the general photographic characteristics of the plate and film in each pair are quite similar.

Films with the new special bases are much more stable than

* Courtesy of Eastman Kodak

acetate-based film and require a great deal less special handling. However, even when using these stable-based films, it is desirable to make a set of separations with sheets taken from one package.

Exposure. Mount the copy and arrange the illumination as discussed later in this section. Select the proper material and expose the four separation negatives. The following filters are recommended: If the exposure for the red-filter (cyan-printer) negative is determined first by trial or by calculation or taken from the particular film or plate data sheet the exposures for the green and the blue-filter negatives can be calculated by multiplying the correct red-filter exposure by the ratios found in a table. The exposure indexes given in the table are for use with standard photoelectric exposure meters in determining the correct exposure for the red-filter negatives. The index numbers are usable directly with an incident-light meter when used to take a reading of light reflected from a neutral test card (18 percent gray side) placed in the position of the copy to be photographed.

Printer	Wratten Filter No.
Cyan ("blue")	25 or 29 (red)*
Magenta ("red")	58 or 61 (green)*
Yellow	47B (blue)
Black	2B, 8, or 88A‡ or by successive exposures through the red, green, and blue filters

*The No. 29 and 61 filters give more complete color separation and somewhat higher color saturation than the 25 and 58. This is useful when masking is not to be used for color correction, but the excessive color saturation causes trouble when masking methods are to be used.
‡For the special techniques involved in making the black-printer negative by infrared radiation, see page 6:12.

A matte white card may be used, in which case multiply the calculated exposure time by five. Remember, also, that the exposure-meter calculation is for lenses set for infinity focus. When the camera is set for same size (1:1); multiply the calculated exposure by four. For other camera settings, the copying data guide will give the correct factor.

Example of Exposure. Example of exposure with a continuous tone color-separation negative film and a Wratten Filter No. 25, for making a same-size continuous-tone negative of a color original with two single 35-ampere arc lamps 48 inches from the copy: about 15 to 30 seconds at f/32.

If a 20 second exposure through the No. 25 filter is satisfactory, the other exposures would be determined as follows: *Green-filter exposure:* If the filter ratio for the Wratten Filter No. 58 is 1.2, the correct exposure through this filter would be 20 × 1.2 = 24 seconds. *Blue-filter exposure:* If the filter ratio for the Wratten Filter No. 47B is .3, the correct exposure through this filter is 20 × .3 = 6 seconds. *Black-printer negative exposure* is fully treated below.

Processing. Processing of the recommended materials for the indirect method of color separation is covered fully in the instruction sheet packaged with the material. Tables or charts show best development times in recommended developers.

At this point manual color correction, when it's required, is usually performed. (Photographic color correction is discussed in Chapter Seven.)

Two extra steps (a contact negative and then a contact posi-

tive) are frequently added at this point to obtain sharper half-tone dots and provide more flexibility for layout and composition purposes.

THE BLACK PRINTER*

Our discussion of the black printer for indirect color separation comprises the following seven points: (1) General discussion of black-printer negative for the indirect method, (2) Black plates for dry printing on single-color presses, (3) Black plates for high-speed wet printing, (4) The three methods of making a black printer, (5) The single-filter method, (6) The split-filter method, (7) The infra-red method. Each of these is now individually discussed.

General Discussion of Black-Printer Negative for the Indirect Method. Most craftsmen have come to agree that the black-printer negative is the most difficult of all the color-separation negatives to correct properly. However, by the selection of the proper photographic material for each of the various types of copy, it is possible to make the job of reproduction easier.

The object of a black printer is to make up for the lack of detail and contrast in the three color-printers. Since there is a great variation in the amount of color that can be carried by the three color-printers, the requirements of the black printer will vary correspondingly. The two extremes are represented by (1) glossy inks on coated paper, each color dried before the next is printed, for which the black plate, if used at all, can be very weak, and (2) four-color wet printing in which nearly all the blacks and dark grays must be carried by the black plate.

Black Plates for Dry Printing on Single-Color Presses. In the first case, where the black plate is required only to add a little density and contrast to the extreme shadow areas, and sometimes to cover up a lack of balance in the printing process, there is little difficulty in making a satisfactory black printer. By suitable choice of filters and by underexposing the black-printer positive, the pure colors can be dropped out of the black printer so that their brilliance will not be obscured by the addition of black. In many cases, a Wratten Filter No. 8 will be satisfactory for exposing the black printer. Where deep blues predominate, a Wratten Filter No. 2B may be used. For maximum control of a broad range of colors, the split-filter method should be used. In general, to lighten a color in reproduction, use a filter of the same color in making the black printer.

Black Plates for High-Speed Wet Printing. In letterpress high-speed wet printing, however, there is at present no alternative to carrying most of the dark tones in the black printer instead of in the three color plates. It is not practical to lay down enough of the three color inks to produce a dark gray or black. In this case, the three color plates must be reduced to quite a light tone by some color-correction method, and the primary object of the black printer is to replace the tones that have been removed from the other three plates. This is called "undercolor removal." This substitution of black can take place

only in dark or near-neutral areas; otherwise, the colors will be degraded. The ideal black printer for this purpose would carry a full range of tones in neutral areas, but the pure colors would be dropped out. In offset, wet colors trap much better, but some undercolor removal is sometimes used to minimize smudging and offsetting (setting off) with heavy forms.

The Three Methods of Making a Black Printer. There are three methods of making a black printer—the single-filter method, the split-filter method, and the infra-red method. All of these usually require considerable handwork. For more perfect correction, a photographic masking method is usually required, although the scanning machines now provide an excellent result.

The Single-Filter Method. In the single-filter method, the same panchromatic material that was used for the other three color-separation negatives is exposed through a suitable filter; usually the yellow Wratten Filter No. 8. This records the different colors at about the same brightness levels as they are seen by the human eye and provides a black printer which usually requires extensive hand correction unless the positive is made to have no more than a 50-percent dot (checkerboard pattern) in the shadows.

With some originals, a yellow filter may not be the best choice. For instance, if blues and greens are absent or unimportant, the red-filter (cyan-printer) negative often makes a good black printer. If warm colors are absent, a green-filter negative may be used.

The Split-Filter Method. The split-filter method offers somewhat greater flexibility than the single-filter method. Three exposures are made on the same film or plate—one through each of the three color-separation filters, with the exposure through each filter usually being between 30 and 100 percent of the exposure for each of the corresponding color-separation negatives. A lower proportion of blue than red exposure is usually required, but the proportions can be varied according to the predominant colors in the original. The black printer should be just as sharp as the other color-separation negatives.

A well-corrected black printer may be made by using different masks during the various exposures of the split-filter method. This is described under the Magenta Masking Method for Reflection Copy and the Two-Mask Method for Transmission Copy in Chapter Seven of our Manual.

The Infra-Red Method. The infra-red method can be used only with certain types of originals but when the original is suitable, it produces an excellent result. It consists in exposing an infra-red-sensitive film or plate through a filter which transmits infra-red (usually Wratten Filter No. 88A), and its success depends on the fact that most bright-colored pigments transmit or reflect infra-red and therefore reproduce as light when photographed by infra-red radiation.

A few bright-colored metallic pigments which require little or no black in their reproduction absorb infra-red strongly so that a good black printer cannot be made by this method if such pigments are present in the original. These include the paris and chrome greens and prussian or iron blues. The result will

* A new technique for making the black printer has been developed by GATF. Since it is involved with photographic masking, it is described in Chapter Seven.

also be unsatisfactory if the artist has obtained his dark colors by mixing complementary colors, in which case there will be no infra-red absorption. Moreover, the dyes of color photographs (including, of course, the black mixtures of these dyes) are mostly transparent to infra-red radiation, and they cannot be photographed by infra-red. In some cases, the cyan dye absorbs infra-red slightly so that a weak record will be obtained, but this is similar to the red-filter negative which usually is not satisfactory for a black printer.

The use of infra-red for the black printer is therefore restricted to paintings and pastel sketches from which certain pigments are excluded. However, when the original is suitable, the result is excellent.

The infra-red black printer is very different from that obtained by the other two methods. With these other methods, there is usually too much black in the pure colors. With the infra-red method, the pure colors are dropped out completely, even in their darkest tones, and this often does not provide enough "drawing" in the black plate for certain types of printing, particularly high-speed wet printing. By use of different filters, somewhat more detail may be obtained in the black plate. For example, detail can be obtained in blue and green areas by the use of a red filter. For detail in flesh tones, use a green filter.

CONTINUOUS-TONE POSITIVES

Our discussion of continuous-tone positives covers the following eight points: (1) General discussion of continuous-tone positives, (2) The two methods of making continuous-tone positives, (3) Evaluating continuous-tone positives, (4) Color-separation positives on paper, (5) Working instructions for making positives on paper, (6) Contrast requirements of reflection positives, (7) Advantages of reflection positives for the artist, and (8) Advantages of reflection prints for the cameraman. Each of these is now individually described.

General Discussion of Continuous-Tone Positives. After the four continuous-tone negatives have been given their final check for accuracy, continuous-tone positives are made if screen negatives are needed for making the printing plate. Preparation of the positives involves the recording of black-and-white values only, and therefore does not require the use of panchromatic materials.

In order to maintain the color correction achieved in the negatives, the positives must be handled with equally great care because any variation in the tonal quality at this point makes considerable difference in the appearance of the final color reproduction. The use of a densitometer is recommended as an aid in maintaining the tonal quality from step to step. In using the positive intermediate step, the color retoucher is able to build up tones corresponding to the color values he wishes to achieve in the final printed reproduction. This technique of building up positive tonal areas is easier for most artists than etching down the similar areas of heavy density in the negatives.

The Two Methods of Producing Continuous-Tone Positives. Continuous-tone positives can be produced by two methods: by contact printing and by use of the process camera. In contact printing, the emulsion of the negative is placed in contact with the emulsion of the unexposed material, and the

exposure is made in a printing frame. Stable-based commercial emulsions are especially recommended for this type of work. When the positives are made in the camera, the negatives are placed in the transparency holder and the illumination is directed from the back of the negative with the emulsion of the negative facing the camera lens for normal orientation of the image. As indicated in the diagram, the area between the transparency holder and the lens should be covered. This cuts out stray light, reduces lens flare, and aids in obtaining consistent results.

Evaluating Continuous-Tone Positives. The continuous-tone positives should exhibit full shadow detail and show as much highlight detail as possible to compensate for the typical loss of detail in this area on the tone scale of the reproduction. This improvement can be made by increasing the exposure slightly so that the minimum density is not below .4, and, if necessary, by decreasing the development time.

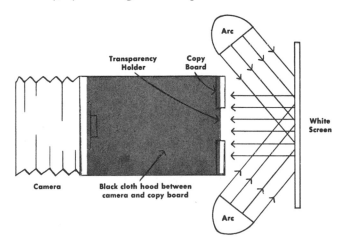

Set-up for Making Continuous-Tone Positives Using the Process Camera

Color-Separation Positives on Waterproof Based Emulsion.* Good-color separation positives on paper or film can be made for, and used by, those retouchers in photomechanical shops who prefer to work on prints rather than on plates. Waterproof based emulsions are coated on a special water-repellent base to permit rapid washing and drying, which contribute to excellent size-holding qualities during processing. These paper materials are obtainable for both contact and projection printing.

Working Instructions for Making Positives on Waterproof Based Emulsion. A separation positive is made directly from each of the separation negatives by contact printing or enlarging on the suitable emulsion. A safe-light filter, Wratten Series OA (greenish-yellow) is recommended for handling this material in the darkroom. Develop for about one minute in one part of Dektol Developer or 53D diluted with two parts of water. Rinse the paper in a suitable stop bath, 3% acetic acid,

* Kodak Resisto Paper
 Kodak Resisto Rapid Paper
 DuPont Cunapaque on Cronar®

for 10 seconds and bathe in a fixing bath for two minutes with continuous agitation. Washing and drying should be carried out in the same manner as used with regular photographic papers except that the washing time is only about four minutes with good agitation.

The prints dry in a very short time—approximately two minutes with ordinary darkroom conditions.

To keep dimensional changes low, do not use heat. Do not ferrotype. Any processing step prolonged beyond the recommended time will allow the base to absorb moisture, with the result that dimensional changes may be increased and drying will not be so rapid.

Contrast Requirements of Reflection Positives. Separation negatives for this method of working should be rather low in contrast and have a density range no higher than 1.10. The print quality should be rather flat, with good detail in both highlights and shadows. The contrast of the negative and the exposure of the prints should be adjusted to produce these characteristics when the prints are developed for the recommended time. After corrective local adjustment of tone values by the artist, screen negatives are made in the camera.

Advantages of Reflection Positives for the Artist. To the artist, the most marked advantage of using this method of reproduction is the ease of working on a positive print. An experienced artist can judge easily the tone value on separation-positive prints, and this means rapid production and accurate results for the photomechanical shop.

Advantages of Reflection Prints for the Cameraman. To the camera operator, there are also advantages of working by this method. The copy for screening is of the reflection type and therefore does not require the use of a transparency holder in the camera as does the screening of positives on film or plates. The operator can produce the type of print needed to meet any particular photomechanical requirements of the job or shop.

On the other hand, there is a little more danger of dimensional changes with paper prints and the relative short scale of photographic papers, as compared with film, may cause a loss of highlight or shadow contrast, if the prints are too contrasty or are under- or over-exposed.

THE MAKING OF SCREENED NEGATIVES AND POSITIVES

The final screen negatives or positives can be made by contact in a vacuum printing frame with a contact screen or in a camera with either a contact screen or a conventional glass crossline screen.

The contact screens provide an efficient method of making screen images by contact printing without tying up the process camera. Either a Gray Contact Screen or a Magenta Contact Screen can be used, but the latter provides more facility in the control of contrast in this step.

When a conventional glass screen is used in the camera, the same screen separations and stop ratios should be used as for black-and-white work.

EVALUATING AND CHANGING VARIOUS STEPS IN THE MAKING OF INDIRECT COLOR SEPARATIONS

Under this heading we are concerned with the following seven points: (1) General discussion of exposure changes, (2) General discussion of development changes, (3) Judging results and making adjustments, (4) Establishing a color reproduction procedure, (5) Tone reproduction curves and their interpretation, (6) Changing the reproduction curve by means of flashing, and (7) Equipment for flashing.

General Discussion of Exposure Changes. The blackening (density) of a photographic image is controlled in two ways: by the amount of exposure to light, and by the degree of development in suitable chemical solutions. A certain minimum amount of exposure is necessary to produce an image under any condition of development. The amount of exposure necessary to produce a recognizable image on a photographic material is more than this minimum amount.

To see what happens you make a series of different exposures of the same subject. As the exposures are increased, the images become stronger until sufficient detail becomes visible in the extreme shadows. This can be called a "normal" negative. If the exposure is increased very much beyond this point, an excessively dense negative which often will lack detail in the highlights will result. Notice that as the exposure is increased the densities of all tones are increased in the negative, and the detail and contrast in areas corresponding to the shadow or dark tones of the subject are improved.

General Discussion of Development Changes. Change in development conditions or time has a somewhat different effect on the appearance of separation negatives from that with a change in exposure time. As development is increased the main effect is seen in the dense areas of the negative, which represent the highlights of the original copy. Notice that as development is increased, there is relatively little effect on the lighter or shadow portions of the separation negatives. At the same time, the highlights of the original, represented by the darker portions of the separation negatives, are progressively darkened. *In other words, the amount of exposure of the negative tends to control the rendition of shadow areas of the original whereas the amount of development controls the density of the highlights.* This can be put to very good use when processing negatives. If the shadow areas appear weak, and detail is not discernible, the exposure should be increased. However, if the shadows appear correct, and highlights appear too weak, the development time should be increased to help produce a correctly balanced separation negative.

Judging Results and Making Adjustments. The examples given above are merely a guide. They are based on separations of equal contrast and nearly straight reproduction curves to be used as a starting point. It has been pointed out, however, in the discussion of the gray scale, that equal contrast in the separation gray scales is usually not desirable and modifications should be introduced to meet particular printing conditions. This is also true of straight line reproduction curves.

Establishing a Color Reproduction Procedure. In establishing a procedure for color reproduction, start with the given example, study the results, and then alter the procedure to improve the reproduction. For example, if the reproduction appears brownish in tone when the highlights appear correctly balanced, insufficient contrast in the cyan printer is indicated; if the shadows are bluish when the rest of the scale is correctly balanced, the yellow-printer negative is too flat in the shadows and requires more exposure; if the middletones are too light, although the ends of the scale are correct, a more strongly bowed curve (produced by longer development and less exposure, preferably with the addition of a flash exposure as described below) is required for the separation negatives.

Tone Reproduction Curves and Their Interpretation. A bowed curve is illustrated in the accompanying diagram. Although the desirability of straight-line characteristic curves is often emphasized in photographic work, they are not necessarily the best choice for separation negatives.

A characteristic curve like B is often necessary to compensate for the flattening of highlights, the lack of color in the middletones, and the frequently excessive shadow contrast produced by most photomechanical processes. Even if the shadow contrast is not excessive, a slight loss in shadow detail is usually less noticeable than a loss in highlight detail. The best adjustment of exposure, development, and flash exposure depends on the characteristics of the whole process and must be determined by experience.

There can be no exact specification unless platemaking, inks, paper, and presswork are all under control. Since all of these factors vary widely from shop to shop, these recommendations can be given only as approximate guides.

Changing the Reproduction Curve by Means of Flashing. The best method of changing the reproduction curve from a straight line to a bowed shape so as to increase the highlight contrast and obtain more color in the middletones is by means of flashing. A separate light source mounted on the

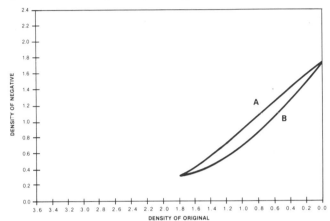

Diagram Illustrating a Bowed Curve

darkroom ceiling will be found most convenient for this purpose. By using this same light for all flashing, its effect on the film is quickly learned and thereafter predictable.

Equipment for Flashing. An arrangement satisfactory for making the flash exposure consists of a darkroom safelight lamp with a Wratten Series 2 filter and a 7½-watt, 115-volt frosted bulb. This lamp can be either suspended form the ceiling or mounted at a suitable distance in front of the vacuum frame.

Section Five: Electronic Color Separation

Electronic color separation, otherwise known as color scanning, has been used in the graphic arts for many years. However, many photographers have not yet been exposed to the operation of these precision instruments. As with most tools of the trade, once the photographer gets a brief education in their use, their advantages become apparent.

Scanners are primarily machines that separate color copy into its components so that it can be reproduced on a printing press. Although the scanners of different manufacturers vary, all of them utilize the three-color principle of color separation; that is, they separate colored originals using the three additive primary colors of light in the form of blue, green, and red filters. In addition, scanners are usually programmed to produce a black printer correctly balanced with the color separations.

The end products of the scanner are either continuous-tone intermediates or screened (halftone) printers. Continuous-tone intermediates can be used directly for conventional gravure or, with letterpress and lithography, can be converted into screened printers on a standard graphic arts camera or in a contact printing frame. If the scanning is done properly, these intermediates or printers will be completely color-corrected and properly masked and will have the proper amount of undercolor removal.

One big advantage of electronic color scanning is the consistency of reproduction. Scanned separations of matched originals will always match, provided the same information is given to the scanner for each original. They will match in optical density range, in the degree of color correction, and in sharpness, which means that separations can be made on the scanner uniformly from day to day.

SCANNER DEVELOPMENT

The concept of electronic scanning for producing corrected color separations started in 1937. At that time, Hans Neugebauer presented a standardized approach in the form of a set of equations that related the tristimulus values of original copy to the density of ink in a three- or four-color halftone reproduction.

At the same time, A. C. Hardy and F. L. Würzburg published a paper that dealt with the corrections that would be needed if idealized inks could be used. They constructed an experimental scanning machine to substantiate their theories. Eventually, the computer stage of this scanner was designed to provide corrections according the Neugebauer equations. Development continued in cooperation with RCA, which later took over research

on the project. At this stage, the scanner accepted a set of uncorrected separation negatives made in the camera with standard filters, which were scanned by a cathode-ray tube. The corrected signal was projected by a second cathode-ray tube, which exposed the film and provided continuous-tone negatives, one at a time. Research continued for several years, but it was eventually found that the purely theoretical approach of the Neugebauer equations did not yield acceptable separations. The project was suspended in the mid-1950s.

Others also became interested in the concept of electronic color separation. During the '40s and '50s, at least a dozen different types of scanners appeared. The first and most important of these was developed in the laboratories of Time-Life, Inc., based on research by the Eastern Kodak Co. This scanner was designed on empirical rather than theoretical data and proved to be more successful. It also introduced the principle of color scanning on a rotating drum, with glow lamps traveling across the width.

Rudolf Hell and Crosfield developed scanners that employed cathode-ray tubes to scan uncorrected negatives, producing corrected continuous-tone separation positives. Both of these firms eventually switched to rotary-drum scanners. Hell also produced the Vario-Klischograph, a device that for many years successfully engraved letterpress plates directly on metal and produced halftone positives on plastic foil coated with a nonactinic dye layer that could be converted to silver negatives for lithography. The principle of this machine involved scanning from a flat surface and engraving the plate or foil with a stylus. Several screen rulings could be used, and color and tone reproduction were quite good. Another advantage, in the case of letterpress plates, was that the camera and conventional plate-making were bypassed completely. After the plates were coated with a resist, they could be reetched for making corrections in the conventional manner.

Other scanners during that period included the Fairchild, Hunter-Penrose, Belin, and Miehle. The Miehle never got beyond the experimental stage, while the others were more or less successful for some time. These scanners were beset by many problems and therefore had difficulty in competing with conventional photographic methods—although scanners had certain advantages. The output of all of them, except the Vario-Klischograph, consisted of continuous-tone negatives or positives, which still had to be screened by conventional methods. Enlargement was difficult, scans took a long time, and the scanners were always expensive. On the other hand, they were capable of producing black printers that could not be matched by conventional photography. Their color correction capabilities were also better in many respects.

With the introduction of solid-state electronic circuitry, better light sources, and more suitable film materials, considerable progress was made. Direct screening and a wide range of reduction and enlargement, as well as special color correction features, became available. Scanning speed was also increased considerably, which helped to justify the high equipment cost.

SCANNER PRINCIPLES

The term "scanner" describes the manner in which copy is viewed (analyzed) and the way in which the light-sensitive material is exposed.

In the operation of a rotating-cylinder scanner, original transparency or reflection copy is mounted on a transparent analyzing cylinder, or drum, while one or more sheets of unexposed film are mounted, either manually or automatically, on another cylinder. With scanners that feature one cylinder for scanning and another for exposure, both cylinders rotate at the same speed.

A very small spot of intense light is projected through or reflected from the original copy. As the analyzing drum rotates, the original copy is scanned by the light spot, which travels in the direction of the axis of the drum. With each revolution, the light spot advances the width of a scan line. Although this light beam is extremely narrow, the mechanical design provides for slightly overlapping or adjoining scans. These scans are spaced close enough and the exposing beam is wide enough to give the effect of a continuous exposure.

Generally, the number of lines to the inch (or millimeter) is varied to reproduce as much image detail as is desired. Obviously, the more scans per inch or millimeter, the more detail that can be recorded from the original copy. These scanning lines may vary from a relatively coarse 250 scans/in. (10 scans/mm) to a very fine 2,000 scans/in. (80 scans/mm). It should be stressed that these rates do not refer to our usual halftone screen rulings. These scanning rates determine the **resolution**, or amount of detail, that can be picked up from the original and reproduced on the unexposed film.

Each spot on the copy is analyzed as light passes from the copy through a small aperture to the scanner's optical system. The exact design of the optical system varies somewhat from manufacturer to manufacturer, but it usually consists of some array of lenses, prisms, mirrors, and interference filters. The net effect of this system is to split the light into four optical signals, each of which passes through either a red, green, or blue separation filter or an aperture for unsharp masking. Each optical signal that passes through a color separation filter is focused on a photomultiplier tube that converts the optical signal into an electronic signal that is proportional to the amount of each color of light present in the scanned spot on the copy. (As shown above, scanners involve not only photography but also several forms of energy: light, electrical, and mechanical.)

These three electronic signals, which correspond to the magenta, yellow, and cyan printing inks, are directed into the **color computer** where the signals are modified to suit specific inks and are corrected for unwanted colors. Next, the signals go to the **tone and undercolor-removal computer,** which introduces the desired range compression, tone reproduction, and neutral gray balance and, at the same time, computes a signal for the black printer (which can be programmed to be either a full-tone black or a skeleton black).

Remember that there are four optical signals generated by the optical system. The fourth optical signal, the one generated by passing light through the aperture for unsharp masking, is utilized at this stage. Again, a photomultiplier tube is used to convert the optical signal into an electronic signal. In order to increase the apparent sharpness of the reproduction, a small fringe must be produced around areas of contrasting tones. This fringe is produced by using a larger aperture in the photomultiplier tube for the unsharp masking channel than is used in the other three photomultipliers. Contrast of the fringe can be controlled by the operator to suit the copy. Essentially, unsharp

masking by a scanner involves the same principles as unsharp masking by conventional photographic methods but uses data processing techniques for image enhancement.

Subsequently, the electronically generated and computer-modified signals are sent to a digital **scale computer** that controls reproduction size. Reproduction size in the circumferential direction of the exposing drum is altered digitally by extending or shortening, in time, the signal arriving at the exposure head. Reproduction size in the axial direction is altered by differing the feed rates of the scanning and exposing heads.

With the signals electronically modified, the next step—exposure—is performed. The method of exposure varies somewhat depending upon the sophistication of the scanner. Unlike a separation made on the camera, where the entire light-sensitive material is exposed simultaneously, a separation made on a scanner is exposed in one minute area at a time as the electronic signals are converted into light signals. This exposure occurs as quickly as the corresponding point of the original is scanned and analyzed.

If the output is a continuous-tone or contact-screened separation, the exposure intensity varies according to the relative image density of the scanned original. The dots of the screened separation are soft, with a fringe area. Some scanners do not require contact screens for making screened separations; rather, they use laser optics to generate an electronic dot pattern. The nature of the dot varies, depending upon the scanner. In one system, each dot is composed of several scans; each scan is basically an expose/no-expose situation, thus producing a hard-dot intermediate. Another system produces an etchable dot; a whole dot with a controlled fall-off, or fringe, around its edges is produced in one revolution of the exposure drum.

Types of Copy.

Most of the scanners on the market accept either color transparencies or flexible reflection copy. Transparencies are far more popular and usually easier to handle. Flexibility is necessary because the copy for practically all scanners is attached to a rotary cylinder, which automatically eliminates reflection copy that is too stiff. In some cases, special holders or drums are used for small transparencies, such as 35-mm transparencies, which are otherwise difficult to hold in position. Positive transparencies are more common, but negative transparencies can also be used on some scanners.

Originals are usually mounted with clear transparent tape. To eliminate or minimize Newton's rings, a special powder or oil is applied to the back of the transparency.

Many scanners are equipped with a pin register system to hold both the original and the light-sensitive material. Such a pin register system ensures that all separations are in register with each other and that they can be remade from the original, if necessary.

Size Reproduction.

Copy can be reproduced same-size on all scanners and, on most, can be enlarged or reduced. Reproduction size capabilities of different scanners vary greatly. With a scanner limited to a narrow range of reproduction percentages, a continuous-tone intermediate can be made with the screened separation sized photographically, or a resized duplicate transparency can be used as the original.

Continuous-tone separations made at 500 scans/in. (20 scans/mm) are suitable for enlargements up to three times as big.

Those made at 2,000 scans/in. (80 scans/mm) can be enlarged up to twelve times, when shooting the final printers. These restrictions on the degree of enlargement are necessary because of the lack of detail at the coarser scans. Obviously, if the copy has been scanned at 2,000 lines/in. it has considerably more detail than copy scanned at 500 lines/in. This extra detail in the continuous-tone separations allows greater enlargement.

A digital computer is used for enlarging or reducing the output. This is done not by changing the speed of the exposure drum, but by purely electronic means. In other words, the analog signals normally produced by the scanning head are converted into digital data using core memory and then played out at a faster or slower speed. Thus, enlargement or reduction in the drum's circumferential direction is controlled electronically, not mechanically.

Film and Film Processing.

In most cases, continuous-tone or high-contrast orthochromatic film is used, since sensitivity to all colors is not required. Dimensionally stable polyester-based film is the most desirable. When continuous-tone film is used, the emulsion should have straight-line tone reproduction—from approximately 0.30 to 1.80 density—so that tonal distortions are avoided. Since contact with the exposure drum is essential, a slightly matte surface aids in providing good adhesion.

Typically, the separation film is loaded into cassettes in the darkroom, or the scanner is located entirely within a darkroom. In the former case, a lighttight cassette is locked into position on the scanner. Its contents are then automatically attached to the exposure drum. After exposure, the contents are unloaded and removed to the darkroom for processing. To ensure the greatest consistency, all four separations should be processed at the same time. Automatic film processing is the most desirable, practically a necessity.

Courtesy Crosfield Electronics

Film Being Loaded in the Darkroom

Before the film can be exposed, however, the scanner must be calibrated to the film and film processing method. The calibration procedure is fairly simple. Four gray scales, each one corresponding to a particular printer, are scanned or electronically generated and exposed to the film. After processing, the exposed steps are measured on a densitometer, and the resulting densities or dot percentages are fed back into the scanner. For normal daily calibration, it is only necessary to reset the highlight, midtone, and shadow density steps of the gray scale.

Even if the separations are exposed properly and uniformly,

how the film is processed can drastically affect the final results. Therefore, uniformity in developing the film is essential. A properly operating processor ensures that all separations are developed equally and are balanced with each other. Tray development requires time and temperature controls, as well as uniform and constant agitation—and the latter is not easy to do. As can be seen, automatic film processors play an important role in conjunction with color scanners.

A word of caution: automatic lith film processors must be closely controlled to prevent the liquid chemistry from getting out of balance; getting a developer bath back to standard is difficult and time-consuming. Conditions must be closely controlled, which is usually achieved by making periodic measurements of standard gray scales and having good replenishment procedures. Preexposed gray scales should be run through the automatic lith film processor and measured densitometrically. These results are then used for controlling developer replenishment.

Scanner Output. Practically all scanners are designed to produce either negative or positive continuous-tone color separations. Reversing from negative to positive is simply a matter of adjusting the circuitry, as is changing the image orientation from right- to wrong-reading. To those familiar with characteristic curves such as the D log E plot, it is obvious that different response curves are necessary for negatives and positives. This capability is generally built into the computer portion of a scanner, making the changeover fairly easy.

Halftone separations are also feasible with most scanners. These are made either by using contact screens and high-contrast films or by electronic dot generation. Special filmholders, exposing methods, and electronic circuitry are needed for this purpose. One of the disadvantages of this system is that if the separation requires further enlargement, it cannot be used. However, most scanners have a more-than-adequate enlargement range. In many cases in commercial four-color printing, the same copy has to be reproduced to several different sizes. Obviously, it would be more practical to prepare continuous-tone separations and then enlarge or reduce them as required for the final screened printers.

There are two types of scanners on the market that do not make photographic negatives or positives, but instead produce engraved plates. One produces engraved letterpress halftones, while the other produces engraved gravure cylinders. These machines employ mechanical, instead of optical, means to produce the engravings. The color separation functions are essentially the same, however, since corrections such as contrast control and undercolor removal can still be made.

Scanners produce either one, two, or four separations at a time, depending upon the particular machine and the size of the intermediate needed. Producing four separations simultaneously is obviously a great timesaver. However, one-at-a-time separations have the advantage of lower machine cost, since duplicate exposure units are not required.

Many types of light sources are used to expose film, from glow lamps to lasers. It should be noted that the laser is used only to expose the separation (using fiber optics), not to scan or analyze the original. Several manufacturers now offer laser-equipped machines or can retrofit the laser attachment to some of their existing machines.

A laser is merely a different type of exposing light source. Certainly, it has many advantages over conventional light sources: high intensity, resulting in high exposing speeds and the use of less-expensive ortho lith-type films; more reliable operation; and longer operating life. The laser can be modulated far more effectively, even regarding the shape of the dot it exposes.

Newer scanners incorporate digital computers. All kinds of benefits result from capturing information in digital form. It is possible to record and store digital data on magnetic tape or disk for later use; to transmit it from one device or location to another; to control graphic placement of data by assigning x-y coordinates; to better modulate or control other devices, such as light sources; and to merge with other digitally stored data. Subsequently, scanner developments will take advantage of each of these benefits.

Scanners that can generate their own halftones without requiring a contact screen are the result of linking the laser with digital technology. A scanner is able to electronically generate a halftone pattern, beacause a separate digital computer stores information about the halftone screen, its rulings, and screen angles. Various screen rulings are available, all of which are switch-selected.

Some scanners use a command, or masking, drum. Such scanners have two scanning heads, one for the original and the other for the masking drum. In one system, by using this cylinder along with special instructions, any combination of several functions can be performed, including image placement, cropping, type or color panel insertion, and reversing out type. Although full use of the command drum and the special instructions can produce separations of fully composed pages, it is still a photomechanical process.

Courtesy Crosfield Electronics

Magnascan 520 Color Scanner Equipped with a Laserdot Electronic Dot Generating Unit

Another masking system—a digital, nonphotographic memory masking system—permits the operator (1) to gang up several separate originals for input at the same time, making an individual setup for each (highlight and color balance) so that the output from each will be unique; (2) to electronically crop originals and place the images on the output without using a photographic mask or masking drum; and (3) if necessary, in conjunction with photographic masks, to electronically control the insertion or reversal of type, borders, and color panels.

SCANNER PROGRAMMING

In reality, a scanner is fairly simple to operate and not much more complicated than a modern graphic arts camera.

Operators who have had no previous experience with scanners are trained for a period of two to four weeks. This training usually takes place during the programming period so that the operator can understand the various functions and learn how to program the scanner, and so that any deviations from the norm can be introduced, if necessary. The training usually includes a period in the manufacturer's own training center, in addition to working under production conditions after a scanner has been installed in a plant.

When a scanner is installed, it is programmed to accommodate the kind of work done in a plant. The program includes the following:

- Range compression
- Gray balance
- Tone reproduction
- Black printer characteristics
- Ink and paper densities
- Platemaking losses
- Screen and photographic emulsion characteristics.

Once the programs have been established and recorded, operation becomes standard for the majority of copy. As with any computer, however, these instruments can work only with the information that has been programmed into them. This constraint demands a high level of operator competence. The operator has to know how to evaluate the original and what the computer can do with the information. The operator has many controls at his or her disposal but must know how to handle them in order to produce excellent results.

SCANNER OPERATION

Once the scanner has been programmed and tested, a color separation can be made.

First, the original is mounted on the scanning drum. With a scanner that has a removable scanning drum, one original can be scanned while another is being mounted. Next, the required enlargement or reduction percentage is set on the scanner.

Before a separation is made, the copy is first evaluated by using densitometer measurements. Highlight and shadow densities are analyzed on an optical viewer and entered into the machine. Required densities or dot percentages are dialed into the scanner. Density values are typically 0.3 and 1.6, while dot percentages are typically 5 and 95. Normally they are not changed from one original to another, unless the type of original varies.

The computer takes over the calculation of range compres-

sion, cast removal, setting of correct middletone, end densities, gray balance, and color values.

The scanner operator decides how much color correction is needed, which colors to boost, whether shadow expansion is necessary, the amount of undercolor removal, and the amount of unsharp masking to use to emphasize details.

The operator has many controls available if special corrections or deviations from copy are necessary. Again, ability and experience dictate the course of action. It is possible to increase or decrease unwanted colors in each separation. Overprint colors of red, green, and blue can be adjusted separately, and flesh tones can also be treated specially—to name only a few of the possible adjustments. If necessary, the tone reproduction curve can be altered to favor detail rendition in any part of the scale. Undercolor removal and the black printer can also be varied. Many of these corrections cannot be made by photographic methods.

At this stage, the machine is ready to run, except for the loading of the unexposed film. If a contact screen is required to make a screened separation, it is loaded with the film. The emulsion side of the film is up, toward the light source.

Once the film is loaded, the scanner can be started. Depending upon the capabilities of the scanner and the reproduction size, one, two, or all four separations can be made simultaneously. At this point, since the scanner is already programmed, it is simply a matter of flipping the right switches or depressing the right pushbutton.

EVALUATION OF SEPARATIONS

After development and drying, scanned separations can be treated in much the same way as separations made in a process camera or enlarger are. Chemical etching on the continuous-tone separations or dot etching on soft-dot halftones can be performed as usual. One of the objectives of using scanners, however, is to minimize or even eliminate the need for handwork on the separations. If handwork is excessive, then the operator techniques should be modified; either the original evaluation of the color copy is incorrect, or the machine settings are not as ideal as possible. Both should be reassessed, and experiments should be conducted until a higher degree of perfection is attained. The scanner should practically eliminate hand corrections and dot etching, and the scanner operator should make a great effort to attain this degree of perfection.

WHAT'S AHEAD

During forty years of development, scanners have come a long way. All of the early goals have now been achieved: full color correction; complete control of range compression, undercolor removal, the black printer, and gray balance; almost unlimited enlargement and reduction without scanning speed being greatly affected; direct electronic screening with lasers; and composing images together. Scanning speeds have been tremendously increased, justifying the high investment. And, apparently, there is more to come.

One trend is indicated by the **separation previewer,** a display unit that enables the user to monitor the anticipated printing results on a color screen *prior* to scanning. Color correction adjustments can be made, and they are seen immedi-

ately on a screen approximately 8 × 10 in. (200 × 250 mm). Enlarged picture sections can be viewed with greater resolution via a zoom lens, and various sections can be compared with each other. The original can be either a color transparency or reflection copy. It is possible to view each printing color separately, either in color or in black and white.

The color screen reproduces the density of a printed picture. To provide a reference value for the eye, the color picture on the screen is surrounded by a white border, which is adjusted to the white of the paper. An impression of a picture printed on paper is thus simulated. The color computer incorporates a measuring instrument for adjustments and for checks on particularly important colors, which should not be evaluated by the eye alone. A small white mark is moved by a measuring rod to the color to be measured on the screen. This measuring instrument then indicates the density or screen tonal values of each separation of this color via four digital displays.

A previewer can be connected directly to a scanner. Once the "proof" on the monitor screen has been accepted, the appropriate values are set on the color computer of the previewer and the original is mounted on the scanner drum. After calibration of the picture highlight, the scanner can be started. Two changeover switches transmit the corrected signals from the scanner head via the preset previewer's color computer to the recording head, where the color separations are exposed. If a second computer is used, a second piece of copy can be analyzed and corrected while the first is being scanned. A previewer can also be used alternately with two scanners.

Another step into the future is complete electronic page composition in connection with scanners. One present system produces, at very high speed, a complete set of separations to single- or double-page size, with all illustrations and text components planned into their correct locations and ready for copying onto a plate or cylinder.

In addition to the scanner, the equipment consists of a magnetic disk recorder capable of storing all the information needed to produce a double-size page—including color separation, text matter of any color, tint areas, outlines, and placement of all elements.

A large digitizing layout table is connected on-line to the scanner and provides output position, overlay, and cropping coordinate data. Original transparency or flexible reflection copy is mounted on the analyzing scanner drum and the scanner is programmed in the usual way for size, tone, and color correction. A high-speed scan stores all this information on a magnetic disk and also produces a film separation with a superimposed grid, which is used only for plotting purposes on the digitizing table.

The plotting films are laid in their correct locations on the digitizing table, following the layout provided. A freely moving cursor is then used to define the relative locations of all pictures and their cropping outlines. Corners of pictures are used as coordinates, and the cursor need only be placed on two diagonally opposite corners to define a rectangular or square picture outline. In the case of irregularly shaped pictures, the cursor is traced around the outline. Using the cursor in association with a simple list of layout commands available on the digitizing table surface, the operator can define the dimensions, color, and positions of tint blocks, rules, borders, and backgrounds without needing to scan originals. All this information, in addition to the color separation data, is stored on the magnetic disk. To produce a completely assembled page, the scanner is loaded with unexposed film and the expose button is pressed. In a single operation, the page information is called forth from the disk storage and is fed into the exposing head of the scanner. One scanning pass is required for a single page; two passes are required for a double page. Black text can be inserted on the black printer by conventional photographic techniques. Colored text can be scanned from positives that have been stripped to layout position. This text will be merged with the picture data stored on the disk and can be reproduced in any desired color.

Photographic Masking and Color Correcting_____

Section One: The Principles and Techniques of Lithographic Process Color Reproduction

Lithography has always held important advantages over other printing processes in the reproduction of color. The first advantage was the straightforward simplicity whereby it was able to print from drawings, made by artists directly on stone or metal; another great advantage was its then unique ability of easily producing tints and tone values by crayon grain or stipple dots. The relative ease of producing large size printing images has always favored lithography for big pictures and posters, and the "offset" feature of transferring the ink from an intermediate rubber blanket surface has extended quality color printing to an important variety of surfaces which other processes could not handle as well.

Early lithographic color plates were drawn entirely by hand, and many more colors were used than are today. Ten to fourteen colors were commonly needed. These were selected to match important areas, and if the press run did not meet expectations, additional overprint color stones or plates were freely added. Photography has changed these procedures by radically reducing the number of colors required. To date, the importance of handwork and photography is almost completely reversed in color reproduction. The first help of photography to lithographic color work was to provide a more accurate detailed key image on stone, but the actual printing values were still created by hand art. This era, however, drew to a close when the halftone screen became practical, thereby providing an adequate substitute for hand-created tone values in color plates. The halftone screen broke lithography's virtual monopoly on picture reproduction by opening the door to photo-engraved letterpress color, but it also opened the era of photo-mechanical color for lithography which has steadily moved on towards always higher standards of perfection.

While letterpress was quick to take advantage of the fewer colors needed in process reproduction and soon did creditable work with only three colors or four, lithography continued the general use of at least six colors for many years. Recent times have seen the bulk of both lithography and letterpress standardized in four-color process with lithography now taking the lead in expanding the use of three-color systems.

COLOR VISION AND COLOR REPRODUCTION

The use of only three color inks to seemingly reproduce thousands of colors is possible because our eyes do not need to receive exactly the same wavelengths from copy and print to simulate a match. In fact, our eyes are very poor in analyzing light mixtures and we are entirely unconscious of seeing all the colors of the rainbow in every white surface we look at. Our eyes are basically responsive to only three broad sections of the spectrum, and the many distinctly different colors we seem to see are simply our mental interpretations of varying proportions of red, green and blue signals transmitted to the brain through the optic nerves.

The manner in which we experience color is of greatest practical importance for our technique of color reproduction. This manner makes it possible to reproduce our many color sensations with three printing inks, provided that the ink mixture reflection matches the red, green and blue balance of the original colors. The brightest colors we will print are already reflecting from the white paper in equal balance; to create any particular color does not require that we print an ink that matches this particular color, but that we print some proportions of three inks which act like partial filters to properly influence the red, green, and blue balance to that of the wanted color. This condition makes color printing with overlapping process inks essentially a subtractive process.

Because all possible colors are already reflecting from the white paper surface we will print on, and because thin films of process inks are almost perfectly transparent, the press operation is—expressed in terms of color science—not one of putting color on the paper but one of controllably taking color away.

COLOR SEPARATION

The first step in any color reproduction system is to isolate the information as to the proportions of red, green and blue light reflected from each area of the copy. This step is called color separation and explains why we use red, green, and blue

filters in their exposure. Many process workers think of color separation as trying to record the proper amounts of yellow, process-red, and process-blue inks which should print in each area of the reproduction. This is a practical thought but makes a misleading approach to the understanding of reproduction problems. *Color-separation negatives do not and cannot directly record the correct amounts of commercial process inks used to print.* This fact is often misinterpreted, leading to the false conclusions that the filters or plates are wrong and that color-correction steps must compensate for these separation errors.

Color separation is most generally accomplished in process cameras with arc-light illumination, although in recent years several new light sources have been developed to the point where they are practical as well as advantageous. The color separations are individual exposures through red, green and blue filters to panchromatic films or plates which are sensitive to all colors. Of course, color transparencies may also be separated in enlargers or by contact printing, and the light source may be a tungsten lamp. These two different light sources—arc light as well as tungsten light—are satisfactory for color separation because they both provide continuous radiation through the complete spectrum. Their difference in color temperature just changes the balance of exposure time through the different filters. The bluer arc light relatively shortens the blue-filter exposure while the yellower tungsten filament bulbs lower the red-filter exposure ratio.

The standard set of color filters, 25, 58, 47,* divide the spectrum into approximate thirds, each of them having a small overlap in the adjacent one. With modern panchromatic emulsions, these filters could give close to facsimile reproduction if we were able to carry out the following reproduction steps as efficiently as the step of color separation. This can be demonstrated by viewing positives of these separations by additive colored light either in a Chromoscope or on a screen by projection. Unfortunately, printing inks do not control light subtractively as well as filters do additively; in the process inks, as they transfer to paper, lie the sources of the most serious color reproduction errors which must be considered in correction methods.

REQUIREMENTS OF IDEAL PROCESS INKS

A simple statement of the requirements of process inks for subtractive color reproduction is, that they should each be complementary to the taking filters. More specifically, the ink which prints from the negative blue-filter record must be a positive image on white paper which locally shuts off the reflection of blue light to the same degree as it matches the blue reflectance of the copy. Black, red, green, or yellow all would perform this function equally well because they all absorb blue light. A most important second requirement, however, is that a process ink should completely reflect the other two thirds of

* These are Kodak filter designations. Other manufacturers of color separation film also have comparable color separation filters compatable with their film, and which carry their own designations. The manufacturers' published data should be referred to for this information since, normally, filters from different manufacturers are not likely to be interchangeable when used for full-color separation photography.

the spectrum while absorbing only one third. Only yellow—which reflects red and green while absorbing blue—meets these requirements.

The green-filter separation negative must print on white paper as a positive image which controls green light. Black, red, magenta and blue are equally efficient in absorbing green, but magenta alone meets the second requirement of reflecting blue and red. The red-filter separation negative record must be printed as a positive ink image which locally absorbs red light, and of course is transparent to the rest of the spectrum which is green and blue. This color is technically called cyan.

FAILURES OF COMMERCIAL INKS RELATED TO COLOR CORRECTION

Commercially-used process inks all fail to meet the described ideal of one-third spectral absorption and two-thirds reflection. This becomes obvious when we look at a reproduction printed from uncorrected separations, as all cold colors become warmer or grayer and warm colors lack full strength. These are failures of the process inks to fully reflect the colors that ideal inks would reflect.

While there has been some improvement in ink-hue purity in recent years, the best available cyan and magenta inks still absorb some blue light and the best cyans still absorb some green light. This means that more than one ink absorbs light in each third of the spectrum and that, consequently, the brightness of greens, blues and purples is limited to the reduced level that these ink mixtures can reflect. It also means that the purest colors these inks can reproduce will not be obtained without color correction of the separation negatives or positives.

COLOR CORRECTION

Color correction will be an important and critical step in lithographic color reproduction as long as we continue the use of inefficient process inks. Color correction will also remain an uncertain, time-delaying operation as long as the variables which create the necessity for it are not better understood and controlled. Color correction has the reputation of being one of the most misunderstood steps in graphic arts procedures. This is true because actually the whole process of color reproduction, too, is just as often misunderstood.

One of the clearest indications of this condition is in the names that most workers apply to process-ink colors. They speak of printing with yellow, red and blue. If we really printed with true yellow, red and blue inks, we would soon find that they are impossible to use as a set of process inks, as their overprints would produce no new colors. Yellow and spectral blue are complementary and subtractively produce black. Red and blue are spectrally exclusive colors and their overprints would also produce black, while red overprinting yellow would still be red. The subtractive primaries of ink which control the additive red, green and blue primaries of light, are called yellow, magenta and cyan. By tradition, we've used the terms "process red," and "process blue" because in most conventional inks these colors did look red and blue. As the whole process of color separation and correction became better known by more and more craftsmen, especially in the "integrated" litho plant, it became advisable to describe process red and process blue by their more

technically correct names of magenta and cyan, respectively. This helped to avoid confusion with the terms used to describe the colors of filters used in color separation work.

The major problems in color correction stem from the use of magenta inks which in fact are too red, and the use of cyan inks which are too blue. We have used wrong-hued process inks so long that most process workers would probably not know how to recognize the correct, pure hues if these existed or were available. It wasn't until GATF started a systematic study of inks being used, that the industry recognized the full impact of the problems caused by inks not properly balanced for full-color reproduction from photographically separated and corrected color printers. Eastman-Kodak's introduction of a system for producing "pleasing" full-color reproduction in three color printing lent the whole movement great impetus. The development of color scanners, which could do a good job only under standardized conditions, also pushed the work to develop and use more efficient process inks. Facsimile color printing from our tricolor separations requires a set of process inks in which each ink absorbs only one-third of the spectrum.

Most available yellow inks absorb principally blue and therefore come close to this requirement; but all magenta process inks also absorb some blue, typically from 30 percent to 70 percent as much as the yellow. Perfect magenta inks should only absorb green light; the added—but unwanted—blue absorptions shift their hue 30 percent to 70 percent towards red. Because a perfect yellow separation will print 30 percent to 70 percent yellow correctly in any color made with these reddish magentas, their blue absorption is doubled and all red colors become more orange whereas the blues and purples reproduce grayer.

While the fault lies entirely within the magenta ink because its absorption has gone beyond green to include some blue, the color correction is nevertheless applied to the yellow printer in order to reduce the doubled blue absorption wherever magenta and yellow would print together. Cyan inks also absorb some blue; consequently additional corrections must be made again to the yellow printer wherever cyan ink will appear in the reproduction.

Here is the root of the greatest misunderstandings in color correction. People who have not studied the subject cannot understand why we must apply the most correction to the yellow separation that prints with an almost perfect ink, with the result that we *then* need no correction on the cyan separation, in spite of the fact that the cyan separation is printed in a most inefficient ink. It is difficult for the theoretically un-informed to realize that cyan inks absorb light in all three-thirds of the spectrum and that corrections must therefore be applied in the other two separations. Nor do they understand that the red-light absorption of the cyan inks is not duplicated by good yellow or magenta inks and that, consequently, the red filter separation can fully control where cyan ink must print.

The most serious error of all available cyan inks is their considerable absorption of green light, which absorption is theoretically the sole function of magenta inks. This fault of cyan inks makes their hue bluer than it should be in a correct cyan, and this hue shifts even warmer when a magenta printer adds its own proper green absorption. Correction in the magenta printer consists in lessening the strength of magenta ink wherever cyan prints by the same amount that the cyan ink incorrectly absorbs green.

COLOR SEPARATION GUIDES

A valuable aid for judging color-separation negatives and color correction is a control strip such as GATF's Color Reproduction Guide. The suppliers of photographic materials make available color control patches of various designs. The most distinctive feature of the GATF guide is that the lithographer produces his color reproduction guide with the inks he will use and the paper on which he will print, and incorporates also his own peculiar press variables.

In a sense, GATF's Color Reproduction Guide can be considered a miniaturized representation of GATF's Color Chart, which, for some years, was in wide use. Since the GATF guide is produced in the plant, it will represent the variables in that plant's color separation process, something no ready-made standard color guide can do.

Solid Ink Patches. As in other color control guides, the solid ink patches of the GATF Color Reproduction Guide are used for the calculation of mask percentage, for the evaluation of ink trapping, and for the measurement of solid ink densities. In separation negatives or positives, the solid ink patches indicate the degree of color correction by the "Rule of Three." This rule requires that, in each properly corrected separation (except black), three of the six basic colors are as dense as black and three other colors as light as white.

Sometimes, it is convenient to have the three wanted colors side-by-side. With standard color guides, this is provided only in the yellow and magenta separations. In the GATF Color Reproduction Guide, the addition of a second green patch between cyan and white keeps the three wanted colors together in the cyan printer also.

Tint Patches. Each solid patch of the GATF Color Reproduction Guide is followed by patches of ¾, ½ and ¼ tints of 150 lines per inch. These tints represent the dark, medium, and light portions of the halftone scale. They will show what amount of dot gain is to be expected through each stage of reproduction. Another use of the tint patches is to calculate proportionality failure. Proportionality failure makes the hue and grayness of lighter tints look worse (further from ideal) than the hue and grayness of solid ink. To correct for this phenomenon, mask curves must depart from a straight line. Negative masks must have a higher slope in the highlights than in middle tones or shadows. Positive masks require a flatter slope in their higher densities. The tint patches help to predict the correct mask curves. In color separations, they will indicate if proper mask curves have been used and show if the proportionality failure has been corrected.

Moiré Patterns. The rescreening of any tint or halftone may, under some conditions, produce an objectionable moiré pattern. In some cases, this also may happen to the tint patches of the GATF Color Reproduction Guide. To avoid this difficulty, the angle of each color of the reproduction guide is turned 30 degrees away from its customary position. The new angles are as follows:

Black:	$45° + 30° =$	$75°$
Magenta:	$75° + 30° =$	$105°$ $(15°)$
Yellow:	$90° + 30° =$	$120°$ $(30°)$
Cyan:	$105° + 30° =$	$135°$ $(45°)$

When shot at regular screen angles, the tints of the reproduction guide will show only minimum pattern, visible through a magnifier as a slight irregularity in dot formation.

The precaution of adjusted screen angles may not prevent the appearance of moiré in some tints if the separations are not fully corrected and a tint appears where no tint of this color was present on the original color guide. We have a similar situation with tints of black. In the original, the black solid and tint patches print only black ink. In the standard color separation process, however, the black patches will reproduce in each separation. This makes is impossible to avoid moiré in each printer and it will be visible in some of them. The black printer is not important for color balance and the appearance of color moiré in black patches will do no harm because most of this pattern will be covered by the black printer with no pattern.

Most problems connected with moiré patterns can be eliminated when the copy and the Color Reproduction Guide are reduced.

Gray Balance. One of the basic requirements of the color reproduction process is to reproduce the gray scale with three process inks. Three-color overprints of tints of equal dot area will not produce gray but will look brown. To appear gray, the dot sizes of the gray scale in three-color printers should be properly unbalanced. The extent of the unbalance needed depends on the inks, paper, and press variables.

There are several ways to compute the gray balance requirements of color process reproduction. One method, for graphic solution, is to use the GATF Color Hexagon* to obtain color density measurements of a series of the following tints: (1) Yellow; (2) Magenta; (3) Yellow and magenta overprints; (4) Three-color overprints. GATF's Color Reproduction Guide includes all these tints and, consequently can be used with this method.

The new GATF color reproduction guide† contains all these patches. The guide also offers another simple way to find out the gray balance requirements.

The tints of each color in the original negatives or positives of the reproduction guide have equal dot area. The three-color overprints also originate from identical tints.

The original Reproduction Guide was printed with the thought that the final screened separation of the color copy and the guide would go through exactly the same reproduction stages. Consequently, to achieve facsimile reproduction, the final halftone negatives or positives of the color reproduction guide should be identical with the original negatives or positives. As a result, a simple rule can be applied. All three separations must be screened to equal dot size in the tints of three-color overprints.

*The method was described by Wulff, A, and Jorgensen, H. O. "An Analysis of the Controllability of the Separational Stages in Multi-Color Productions;" a report from the Graphic College of Denmark, Copenhagen, July 1964. While simpler than other systems which have been published, this method is still too involved for general use in the average plant.

† GATF's "Research Progress" No. 67, *The New GATF Color Reproduction Guide*, and *A Gray Balance Chart*, reported on in GATF's 1967 "Report of Progress," describe two other methods of computing gray balance.

If the brown three-color overprints will reproduce in the same manner as in the original color reproduction guide, the dot area of the gray scale tints will be unbalanced. This unbalance will be the gray balance requirements for a satisfactory reproduction of the gray scale.

In the evaluation of the final reproduction of all colors, we must try to reproduce the original negatives or positives of the GATF Color Reproduction Guide.

THE RULE OF THREE

The simple "rule of three" is derived from the way the six solid ink control areas were produced and how they, consequently, must be reproduced. Each of the process inks is printed solid in three of the six areas, and of course, not at all in the remaining three. A reproduced set of printing plates must repeat this condition. In our first color separation—the blue filter separation for the yellow printer—we must record where the yellow color block prints equally solid in the yellow, red and green areas as well as where no yellow is printed, namely in the magenta, cyan and blue areas. It is impossible to create this separation directly in one photographic step, no matter what color filter, spectral band of light or photographic emulsion is used. This is neither the fault of filters or photographic emulsions, nor that of yellow colorants (dyes or pigments); it is the fault of the two other inks.

Here, at the blue-filter separation, we are only concerned with the absorption of blue light by one ink and the reflection of blue by the other two inks. We can photograph yellow as black because yellow absorbs blue light, but we cannot record magenta and cyan inks as white because no available magenta and cyan inks completely reflect blue as they should. No conceivable blue filter can overcome this deficiency.

Color Patches of Ideal Yellow-Printer Negative

Color Patches of Actual Yellow-Printer Negative
(Blue filter separation)

By examining the six solid ink control areas in a blue-filter separation negative, you can see the failure to fully reflect blue light by the fact that magenta and cyan photograph less dense than the white paper; this failure can also be noticed where magenta and cyan overprint yellow to make red and green. Under normal conditions, red and green will photograph that much stronger than yellow, as magenta and cyan photograph

stronger than white. Perfect color correction for this condition would then require adding a controlled density to the separation negative in all areas where magenta and cyan inks will print. This correction density—whether applied by hand retouching or by photographic masking—must follow that "rule of three," thereby bringing up the densities recorded by the magenta, cyan and blue to equal the density from white, and therewith equalize the solid ink level in the yellow, red, and green.

Color Patches of Ideal Magenta-Printer Negative

Color Patches of Actual Magenta-Printer Negative
(Green filter separation)

The second separation negative, made with a green filter, strongly records the three areas, magenta, red and blue-violet—in which magenta is printed solid—but fails to bring up all densities of the other three colors—yellow, cyan and green—to the density photographed by white paper. These photographed densities are, of course, a measure of green reflectance, and while most yellow-process inks record almost as dense as white, all cyan (or process-blue) inks absorb half or more of the green light ideal inks would reflect. Correct separations will also carry this same intrinsic error wherever cyan over-prints other

Color Patches of Ideal Cyan-Printer Negative

Color Patches of Actual Cyan-Printer Negative
(Red filter separation)

colors. This will be most noticeable in the blue-violet control area which will be that much clearer than magenta, as the cyan area is clearer than the white density in the negatives. We may judge the green-filter separation fully corrected when this condition is equalized in the magenta, red, and blue-violet—while the yellow, cyan and green densities are equalized to the white density.

The third separation negative, made with a red filter, may be judged as correct if three areas are equally strong, namely the cyan, green and blue-violet—and if the yellow, magenta and red areas are equally dense to white paper. Actually this condition can be practically reached with most sets of process inks, although some magentas are noticeably grayed and their lower red reflectance records a little less dense than white. A red-filter separation may then merely need this slight correction to be fully color corrected. But if the cyan, green and blue control areas are not as strong as the black area, a contrast increase or saturation correction must be applied. For more complete masking control, GATF now further recommends the addition of a tint area with each solid color so that the masking color corrections can be judged at at least two tone levels. This GATF color reproduction guide is illustrated in the Research Progress #67. It illustrates the Rule of Three, with separate comparisons of each printer color.

HAND CORRECTION

Much of the color correction in lithography and other graphic arts processes has traditionally been done by hand-work of artists or etchers. Photo-engravers have long depended on local etching and burnishing of the copper printing plate to change color tone values with little or no work done on negatives. Early lithographic color printing in the "submarine process" also left much of the correction to the printing image. In the submarine process, direct halftone separation negatives were printed in bichromated albumin on lithographic stones, and left under water after inking and development. The name "submarine" was used because dot sizes were reduced by forced over-development consisting in locally rubbing with cotton while the albumin image was kept soft under water. Small runs were printed from these original stones while longer press runs were usually made from their images which were proofed and hand-transferred to larger stones or plates.

THREE-STEP, FOUR-STEP, AND TWO-STEP PROCESSES

The "three-step" process was one of the most used early hand-correction systems. In this process, most of the color correction was done on continuous-tone wet-plate positives made on ground glass. While tone values could easily be lightened by rubbing with pumice powder and erasers, by shaving, or by scratching or rippling with a needle, positives were also often made lighter than normal density. In this case, correction consisted in building up the wanted image by penciling, stumping with graphite, or opaquing. This was particularly good for reproductions needed in more than one size, such as calendars, and was still the best method when extensive changes in color or detail were needed. From the corrected positives, halftone negatives of any size were made.

When deep-etch plates, requiring positives, became more universally used, a fourth step of contacting the halftone negatives to positives was sometimes added. More generally, the practice has been to shorten the process to only two steps, halftone positives being made directly from the separation negatives. This technique began the new era in lithographic color correction known as dot-etching, in which much of the color correction is accomplished similarly to photo-engraving by chemically reducing dot sizes where less color is needed. In lithography these dots are, of course, on photographic positives rather than in the metal and cannot be enlarged by burnishing. Local strengthening of dot images is obtained by starting with fuller positives, staging-out certain areas and etching-back the remainder to proper strength. This local strengthening cannot be accomplished on negatives as fully or as easily as on continuous-tone positives; it has therefore been general practice to locally reduce or open up the separation negatives with Farmer's Reducer before they are screened for positive retouching. When more than one size reproduction is needed, it is customary to minimize the dot-etching and lighten these tones by dye-staining the gelatine of the separation negatives.

COLOR CORRECTING BY MASKING

While hand artwork has been the backbone of color correction for lithography in the past, photographic methods, called masking, are becoming better understood and are now taking over an increasing amount of this work load. With masking methods matched to selected inks and controlled press conditions, regular work is now being accomplished without hand corrections. This is only possible when the several important color errors of process inks are balanced and specifically corrected for. In a rapidly increasing number of jobs, hand correction is done only when the customer wants a change from what was in the original copy.

In the past, many of the correction systems using masking still left considerable error and required handwork for completion. Some of this was due to poor selection of process ink hues, uncontrolled press conditions, or failure to consider the differences in ink trapping and dot gain characteristics of single-color, two-color, and four-color presses. Some error was due to failure to recognize the significance of paper surface efficiency* as a factor in process color reproduction. However, too often, handwork was needed because the intrinsic errors and their correction had not been understood. All too often the approach to color separation and masking was in imitation of hand-worked sets. Dozens of different approaches to color correction by photographic means have been patented; in spite of considerable ingenuity shown in their many variations, most of these processes have failed to consider all of the variable and inherent errors that we are now learning to consider important.

ADDING LIGHT FOR COLOR SEPARATING

The most basic flaw of process inks is their inability to fully reflect the two-thirds of the spectrum that they should. This flaw becomes evident in two ways within separations: the copy colors similar to two of the process inks fail to separate out to the proper density, and the copy colors fail to record in areas where the third ink will print. The problem was recognized long ago; one early solution involved projecting more light onto the specific areas of the separation that needed more density.

To accomplish this effect, both Levy and Robertson built special cameras. They added small auxiliary camera projectors to standard gallery-type cameras. However, each used a slightly different approach. Levy mounted the auxiliary projector on tracks at a 45° angle to the copy, with the large separation camera directly facing the copy. Robertson, on the other hand, had the auxiliary projector directly facing the copy, with the large separation camera at a right angle to the copy and the auxiliary projector. His method provided more useful light and eliminated angular distortion and focus problems. The separation camera picked up the image through a prism that produced laterally-reversed negatives.

Levy's and Robertson's cameras made possible the application of Edward Gamble's 1912 patent (see: B. P. 6768). Gamble's patent entailed making red- and green-filter negatives in the auxiliary projector, then projecting arc light through them individually while exposing the magenta and yellow separations. The degree of correction was established by balancing the strength of the direct copy illumination and the projected light.

The Addmask camera (see: Frank Smith, "The Nicoll Addmask Auxiliary Unit," Process Engravers Monthly, May, 1952, pp. 148–49 and Frank Smith, "A New Colour-Masking Technique," Penrose Annual, Vol. 46, 1952, pp. 97–99) produced the same results more efficiently; it used a mirror system to project the added light image directly to the photographic plate instead of the camera.

FLUORESCENT DYE COPY

In 1938, Alexander Murray developed a method to replace projection as the source of locally added light. The original artwork had to be painted with a special pallet of watercolors, some of which contained fluorescent additives. These additives radiated blue or green light when stimulated by ultraviolet rays. The photographic density from these areas could then be made to match the density from white paper by controlling the ratio of ultraviolet to visible light. A special camera-light hood equipped with ultraviolet filters and variable slit widths passed only this balanced light on to the copy.

NEGATIVE MASKS

Another effective way of getting relatively more light to the exposing separation in the areas which otherwise would not be dense enough, is to put a mask negative in the camera back directly in front of the exposing separation. This mask is made with the same filter as though it were to be used to locally project added light to the copy. However, in this system the copy is evenly illuminated. Instead of actually adding light to the exposure, the mask here accomplishes the same purpose by holding back light in the white and the opposite color areas. For example, during a green-filter exposure, a red-filter negative mask holds back some light from white, yellow and red, and relatively more passes through the clear green and cyan areas.

*A discussion of paper surface efficiency and how to measure it is given in GATF's "Research Progress" No. 60.

If these masks are made as normal silver images they are best developed to fine grain, at correct strength, and used in contact with the exposing separation. If spaced in use, normal silver grains scatter light and diffuse the image. Negative masks when spaced may give clearer separations if used during only part of the exposure. This requires that they be made considerably too strong. Special cameras were built to facilitate removing the mask during the separation exposure and to substitute a compensating glass of equal thickness in the optical path. Raschke's camera (see: Emil Raschke, USP 1,373,020), patented in 1921, had two swinging frames, while the Levy-Hahn camera (see: Francis Hahn, USP 1,576,118) used an additional sliding plate holder positioned just ahead of the halftone screen position.

CAMERA-BACK MASKING*

Camera-back masking is a method that is used mainly for reflection copy. The masks are made directly from the copy and before the separations. They are exposed on the camera back through suitable filters. After being processed, the masks are returned to their original position on the camera back over a piece of panchromatic film. The color separations are then exposed onto this film through the mask. The separation is thus color corrected at the same time that it is exposed.

COLOR TRANSPARENCIES

The most universal use of negative-type masks has been with positive color transparencies, and the manufacturers of such color materials have helpfully published detailed instructions for handling them. When the first dye-coupled three-layer films came into use, color-separation negative emulsions did not linearly record their long scale of tone values. The first most important benefit of masking came from the tone compression of these originals to a shorter density range which passed through lenses with less flare, and better matched the straight-line acceptance of separation negatives. These masks also selectively increase relative color saturation.

Color correction is controlled by choice of filters and individual mask strength for each color separation. Tone control is often introduced in transparency masking to improve highlight contrast and increase middletone color strength. This can be done in two different ways. When principal or tone compression masks are made as negatives with a shouldering tone-reproduction curve, separations exposed through them and color transparencies have greater high-light contrast than when made with masks of straight-line densities. Still greater highlight contrast with wider range of control is obtained when an additional masking step is used. A highlight pre-mask is first contacted from the transparency, and the principal mask exposed through the highlight protected transparency.

POSITIVE-IMAGE MASKS

The most widely varied use of masking for color correction has been with positive-image mask systems. Positive masks

* This technique is treated in detail in the Eastman-Kodak Q-Sheet No. 7A.

give color correction to separation negatives by adding their densities to local areas from which too much of a color would print. They are most often made from the regular set of separation negatives but may also be made from differently filtered negatives to vary the correction. Most often a positive contacted from the green-filter negative is used to correct the blue-filter negative; and a similar contact from the red-filter negative corrects the green-filter negative. Positive masks, of course, also lighten the strength of the printing color in black and gray areas, and the first masking patent (see: Dr. E. Albert, DRP 101,379) of Dr. Albert described this in 1897. His second patent (see Dr. E. Albert, DRP 116,538) extended the system to fuller color correction.

MASKING PUT ON SCIENTIFIC BASIS

Many other variations of masking were patented in following years but masking did not attract wide attention until 1935 when Kodak published "The Modern Masking Method of Correct Color Reproduction." This described Alexander Murray's infra-red improvement (see: Alexander Murray, USP 2,161,378) of the black separation and introduced the proper use of a densitometer to relate separation negatives and mask densities. Murray's work demonstrated that color correction can be divorced from visual judgment and personal opinion when guided by instrument control standards related to measurements of the color reflectance of the process inks and the variables in the processing steps.

REVIEW OF MASKING PRACTICE

It is desired that each color-separation negative present an exclusive record for each of the three process inks and their appearance in the print. In practice, however, uncorrected separations always also partially record some ink colors in areas where either only one or both of the other color inks should be present. Masks made directly from standard separations are usually adjusted to correct for the larger of these two errrors, and then leave a residual error to be corrected by hand, or an additional mask. The magnitude and relation of the two errors in each separation varies with the relation of the individual ink hues. It is most desirable to select ink hues having either very low secondary errors, or inks having such hues that their errors balance out together with standard mask conditions.

Some variations in masking techniques aim to cancel both errors from unbalanced ink hues through use of special masks made from differently filtered or doubly-filtered exposures. For example, when an orange-shade chrome yellow ink is used, the magenta printer must be lighter in all oranges—and this correction may be included by a partial blue-filter exposure added to the normal red-filter mask exposure. If the blues need relatively more correction in a yellow printer than the magentas, the mask exposure should shift yellower from green, either by help of a yellow filter or by added red-filter exposure. These variations should not be used unless the measured hue balances of inks used in the particular case show that they are required.

Some process-ink sets have opposite hue differences than the described ones and need still more complicated treatment. No extra photographic plates are needed in color correcting for this type of process inks. In negative masking their correcting

means simply a different filter treatment, whereas positive masks may be made for this purpose by double-exposure from two separations.

THE PROBLEM OF OVERCORRECTING

Color correction from simple negative or positive masks has not always been satisfactory. A common failure is overcorrection of some color mixtures, such as removing too much yellow from browns or too much magenta from purples. The cause lies in the separation negatives rather than in the masks, but when it is present it may be controlled by use of two-stage mask systems. With positive masking, for example, to correct the yellow separation, a premask film positive is first contacted from itself to protect red and brown areas. It is combined with the magenta separation negative while the corrected mask for the yellow printer is being exposed. This "two-stage" mask will still fully correct single ink-color errors of magenta while retaining full-strength yellow in red and brown color mixtures.

When similar overcorrections occur with negative-mask systems, a thin positive-mask image of the printing color may be combined with the usual negative mask during the color-separation exposure. One application, called "counter masking," has been found useful for color correction in three-color processes where full strength of each color is desired in black. A related variation of this avoids use of two masks at one time in the camera by using a blue-filter premask negative, for example, during the exposure to make the usual green-filter mask that will be used during exposure of the yellow-printer separation.

The basic fault of separation negatives, which simple one-step mask systems overcorrect in two-color mixtures, is found in their failure to record ink color errors the same when overprinting as when printing alone. In other words, if with a blue filter, magenta photographs darker than the paper on which it prints, it must also photograph the same amount darker than any ink it overprints. Red must be as much clearer than yellow in a blue-filter separation as magenta is clearer than the density from white paper. Some separation negatives fail to accomplish this for different reasons.

Due to increasingly high hue error and surface-scattered light, some inks simply do not add their separate light absorptions fully when printed together. This situation can be measured with a reflection densitometer. If the measured difference between yellow and red is not as great as between magenta and white, a broader-band filter than the 47 used for measurement may compensate for this photographically. If the measured differences are equal, such inks will photograph unequally under differing conditions, such as the use of narrower-band filters, lens flare, or intentional underexposure in order to place color mixtures on the toe of the separation's reproduction curve. Separation negatives, made under these incorrect conditions for masking, look better and are actually better for hand correction, because the strong colors in which all inks should print equally are in closer balance.

Section Two: Process Inks and Color Correcting

In this section the relationship between the qualities of process inks and color correcting is discussed. The discussion is divided into the following three main topics: (1) the evaluation of process inks, (2) measurements of ink trapping, and (3) the GATF Color Reproduction Guide and its use for masking.

THE EVALUATION OF PROCESS INKS FOR COLOR CORRECTING

The range of colors that any set of process inks can produce, and the amount of color correction that they will require, can be judged from simple calculations. These calculations are based on reflection densitometer readings of the individual solid colors using filters over the densitometer aperture.

Four factors describe the most important working characteristics of a set of process inks: (1) strength, (2) hue, (3) grayness, and (4) efficiency.

To make an evaluation, first make reflection density measurements of solid yellow, magenta, and cyan. Measure the density of each ink with a red (A25), green (B58), and blue (C5–47) filter over the densitometer aperture. Make readings of colors in the same general area of the sheet. Assemble the figures in a table like the example below.

	Filters		
Inks	Red	Green	Blue
Yellow	.00	.10	1.20
Magenta	.10	1.30	.70
Cyan	1.50	.60	.30

Printed Ink Strength. To compare the printed strength of different inks of the same hue, you merely compare the highest of their three filter density readings. In the case of the inks in the example above, the yellow has a density value or strength of 1.20, the magenta, 1.30, and the cyan, 1.50.

The strength of an ink is important because it determines the range of colors and the depth of colors that you can produce with it. For example, the relative strengths of a yellow and cyan overlap will determine whether the green that is produced will be a blue-green or a yellow-green.

It is just as important to control the individual strengths of inks as it is their hues. In single-color presswork, it is especially important to measure the strength of at least the first color down. Use a densitometer to make sure it is correct for your standard printing conditions. Evaluations of the strength of the colors that follow can be made visually by checking the colors

produced by overlaps. For example, if yellow is down first and has the proper strength, you can check the strength of the magenta that follows by noting the shade of red produced by a solid overlap.

Color Hue and Hue Error. The hue of a color is determined by the colors of light that it absorbs and reflects. Perfect process inks would absorb one-third of the spectrum and reflect two-thirds. A perfect process magenta would absorb all green in the light and reflect all blue and red. A perfect process cyan would absorb all red and reflect all green and blue. Likewise, a perfect process yellow would absorb all blue and reflect all red and green.

The hue error of a color is determined by the extent to which the colors it reflects are not perfectly balanced. The ink hue number expresses this error as a percentage. A magenta with zero hue error reflects red and blue equally. If it had a 100 percent hue error toward red, it would reflect red and no blue. Such a color would, in fact, be red and not magenta at all. (Some plants are using "magentas" with hue errors as high as 90 percent.)

The hue error of a color can, therefore, be determined by measuring the amount of red, green and blue light that it reflects. As an example, consider the magenta shown in our table. This magenta had a density of .10 with the red filter, 1.30 with the green filter, and .70 with the blue filter. The red filter reading is the lowest of the three (L), the green filter reading is the highest of the three (H), and the blue filter reading is inbetween or medium (M).

To calculate the hue error, use the following equation:

$$\text{Hue Error} = \frac{M - L}{H - L}.$$

Using this equation and the figures in our example, we have:

$$\text{Hue Error} \frac{.70 - .10}{1.30 - .10} = \frac{.60}{1.20} = 50\% \text{ error.}$$

Grayness. The purity of a process color is judged by its freedom from gray. Colors become gray when they reflect less light of their predominant color than the paper that the color is printed on. For example, a process magenta should reflect all red and blue. It becomes gray to the extent that it reflects less red than the white paper it is printed on. The grayness of an individual color will, of course, affect the grayness of color mixtures in which it is used.

The equation to calculate grayness is:

$$\text{Grayness} = \frac{L}{H}.$$

In this calculation, we again use the highest density reading (H) and the lowest (L). Using the figures in our table for the cyan ink we find:

$$\text{Cyan Grayness} = \frac{.30}{1.50} = 20\%$$

The lower the percentage grayness of a process color, the higher its purity.

Efficiency. In the discussion of hue, it was pointed out that a perfect process ink should absorb one-third of the spectrum

and reflect two-thirds of it. How well it does this is a measure of its efficiency. A process ink's efficiency goes down in proportion to the amount of light that it should reflect but which it absorbs.

The efficiency of a process color can be rated from the percentage ratio of its incorrect light absorption to its correct light absorption. The equation is:

$$\text{Efficiency} = 1 - \frac{L + M}{2H}$$

If we again use the cyan ink in our table we have:

$$\text{Efficiency} = 1 - \frac{.30 + .60}{2 \times 1.50} = 1 - \frac{.90}{3.00} = 1 - .30 = 70\%.$$

The higher a process ink's efficiency number, the greater the range of pure colors it will produce with other process inks. Also, the higher an ink's efficiency, the less the color correction work that will be needed.

Efficiency values are perhaps the best single number to use in evaluating the color quality of a group of process inks. However, two different inks may have the same efficiency, but differ in their grayness and hue.

MEASUREMENT OF INK TRAPPING

Densitometer measurements of the single solid colors and overlapped solids in the GATF Color Strips can produce valuable data to check the trapping of your process inks. The procedure to measure trapping is described in this section.

Trapping of Magenta Ink. With a B-58 green filter over the densitometer aperture measure the density of: (1) The solid magenta patch; (2) The solid yellow patch; and (3) The overlap of solid magenta on solid yellow.

Subtract the yellow solid ink density from the red two-color overlap density. Compare number with the density of the magenta ink. For example: magenta density—1.22; yellow density—.07; subtraction number—1.15.

If undertrapping has occurred, the subtraction number will be less than the density number of the magenta's printed ink strength. You may assign an effective trapping percentage number to this magenta ink on yellow by dividing the subtraction number of red density (magenta on yellow) minus yellow density, by the magenta ink density. For example: subtraction number—1.15; yellow—.07; difference—1.08; 1.08 divided by 1.22; apparent trap—89%.

If the subtraction number of red minus yellow is equal to the magenta ink density the calculation will indicate 100% apparent trapping.

If the two colors together have printed with more gloss than the top ink, as printed separately, the calculated apparent trapping and its visual appearance may indicate 5 to 7% more ink than actually trapped. This is common on coated paper. If the calculated trapping is more than 107%, the overprint is physically overtrapping with more ink going to ink than to paper. This overtrapping surprisingly sometimes measures as much as 125 to 135%. This tendency is favored by low absorbent paper and also by highly absorbent matte yellow inks, particularly in the rotogravure process.

Trapping of Cyan Ink. With an A-25 red filter, make density readings of (1) the solid-cyan patch, (2) the solid-yellow patch, (3) the solid-magenta patch, (4) the patch where solid cyan overprints solid yellow, (5) the patch where solid cyan overprints solid magenta, (6) the patch where solid magenta overprints solid yellow, and (7) the three-color patch of solid cyan overprinting magenta on yellow.

To check the trapping of cyan on yellow, substract the yellow density from the green (cyan-on-yellow) density and compare this number with the cyan ink density. If it is smaller, there is undertrapping. To assign a percentage trap number, divide the subtracted number (green density minus yellow density) by the cyan density.

Similarly, judge the trapping of cyan on magenta by subtracting the magenta density from the blue (cyan-on-magenta) density and compare to the cyan density. The trapping of cyan on red (magenta on yellow) is typically the same as the trapping of cyan on magenta but is verified by subtracting the red (two-color) density from the three-color density and comparing that difference to the cyan density.

Photoengravers' color bars and the GATF Standard Offset Color Control Bars include a black-on-cyan area. This patch permits trap evaluation of black ink on cyan (also the equivalent of black trapping on the three-color patch). Use a blue filter in the densitometer and measure the three areas involved: black, cyan, and black-on-cyan. Subtract the cyan density from the black-on-cyan and compare to the black-alone density.

It is typical for single-color presses to trap on dried ink films within 5% or 10% of the normal 100% on bare paper. Usually, the trapping is a little more than this 100% normal and ranges between 100-105%.

If too much wax, compound, or drier is used, trapping may drop as much as 20-30%.

Many two- and four-color presses are also trapping magenta and cyan on yellow within the range of 90-110%.

If measurements of trapping conditions show that an ink is trapping below 90%, changes in the body or relative tack of the inks may improve it. The way that the ink is handled or "doped" between the can and the ink fountain affects trapping. Also, running with an excess of fountain solution will increase the ink's emulsification with the water and reduce its trapping ability.

In wet printing on four-color presses where the order of the colors is yellow, cyan, magenta, it is common for magenta to trap only 70-80% on the cyan.

Rotation of Color. This description of the trap-measuring procedure applies to the following overprints: magenta-on-yellow, cyan-on-yellow, cyan-on-magenta, and black-on-cyan. If the printing order of the inks in these overprints is reversed, the filter used in measurement is also changed. The basic rule is to use the filter that gives the highest density reading of the top color. With black ink on top, use the filter that gives the lowest density reading to the bottom ink.

THE ROLE OF THE GATF COLOR REPRODUCTION GUIDE IN MASKING

Color correction is (or should be) based on the inks being used—their hue, saturation, strength, and opacity. Other factors that affect the inks, like different papers or different trapping conditions, call for modifications of the basic requirements.

The goal in color separation photography is to produce three printers that are exclusive records of where yellow, magenta, and cyan should print. However, most process inks are not as pure as they should be. The result is that normal color separations always print some of their color in areas where it doesn't belong. In other words, some yellow may print in an area that should be only magenta or only magenta and cyan. Or, some magenta may print in an area that should be only yellow or only yellow and cyan.

Errors such as these can be analyzed by making density measurements of the colors on the GATF Color Guide. Such an analysis will permit you to set up the most efficient masking system for the conditions in your plant. Or, such information about the color errors that occur in your plant can help you select process inks that are more suitable for your work.

Measurements are made of the solid color patches on the GATF Color Reproductions Guide. It includes, in addition to the solid single-color, two-, three-, and four-color overlaps of solids, as well as overprints of one-quarter, one-half, and three-quarter tints.

The first step in a typical analysis is to make densitometer readings of the solid yellow, magenta, and cyan blocks in the strip. Measure each of these three colors with filters covering the aperture of the densitometer head. The filters that should be used are: Red (A25); Green (B58); and Blue (C5—47).

Let's suppose for a moment that we made these filtered densitometer readings of a set of perfect inks. If we then assembled the data in a chart it might look something like our table:

PRINTED INKS	FILTERS		
	RED (Cyan Printer)	GREEN (Magenta Printer)	BLUE (Yellow Printer)
Yellow Ink	.00	.00	1.60
Magenta Ink	.00	1.60	.00
Cyan Ink	1.60	.00	.00

These figures show that each of our theoretically perfect inks is strongly absorbing one-third of the spectrum and reflecting two-thirds of the spectrum. Reading horizontally across the chart we see that the yellow is absorbing no red light and no green light. It is strongly absorbing the blue light. Therefore, when blue is removed from white light the combination of the remaining red and green light produces yellow.

In the case of magenta ink, our theoretical figures show that it is strongly absorbing green light and is absorbing no red or blue light. So, when green is removed from white light, the remaining red and blue light combine to form magenta.

Likewise with the cyan ink. It is strongly absorbing red light and no green or blue. The reflected green and blue combine to form cyan.

Now let's read the chart vertically. The vertical columns show the relative densities that would occur in positives or printers from separation negatives. In the case of the red filter—cyan printer—no cyan will print in either the yellow or magenta image areas. Cyan will print only in the cyan areas.

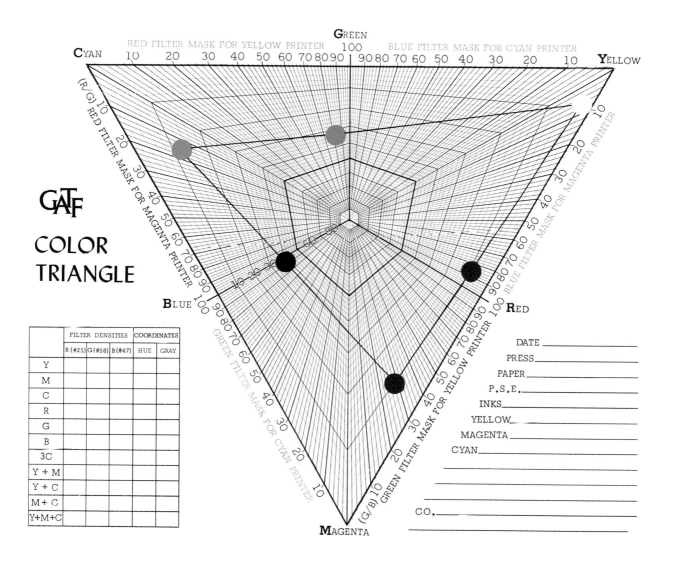

GATF
COLOR
TRIANGLE

	FILTER DENSITIES			COORDINATES	
	R (#25)	G (#58)	B (#47)	HUE	GRAY
Y					
M					
C					
R					
G					
B					
3C					
Y + M					
Y + C					
M + C					
Y+M+C					

DATE _____

PRESS_____

PAPER_____

P.S.E._____

INKS_____

YELLOW_____

MAGENTA _____

CYAN_____

CO._____

Note: Density measurements and plots are examples of the method of plotting ink on the GATF Color Diagram, and will only approximate the inks on these pages.

The GATF Subtractive Triangle is best suited to show (1) the gamut of pure color that is possible with a given set of inks, (2) under or overtrapping, (3) changes in gloss, and (4) to directly predict ideal overprint colors, (5) masking requirements for a given set of process inks.

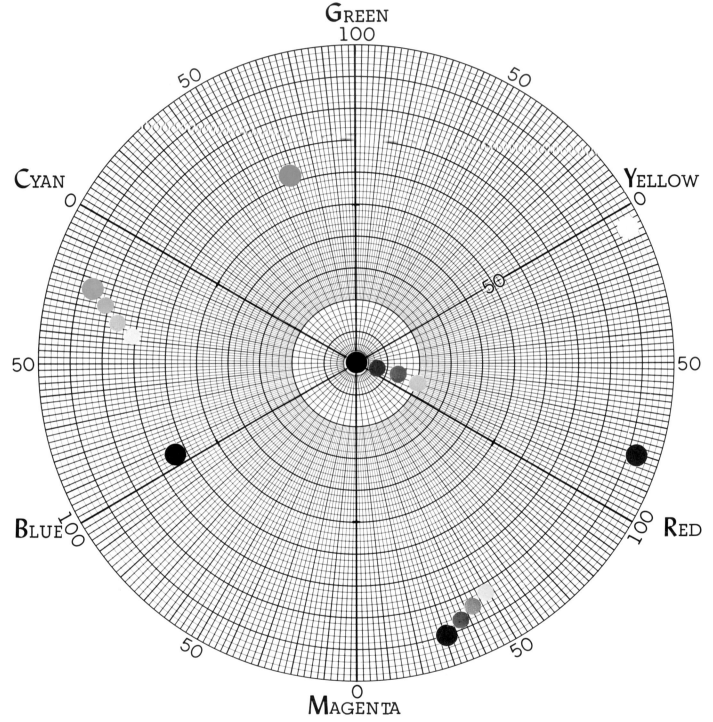

GATF COLOR CIRCLE
INK HUE AND PURITY CHART

Note: Density measurements and plots are examples of the method of plotting ink on the GATF Color Diagram, and will only approximate the inks on these pages.

The GATF Color Circle offers an easy way to visualize the hue error and grayness of a number of process inks. Plots are shown for solid yellow, solids and tints of magenta and cyan, solid overlaps of the primaries, and overlaps of three color tints of equal dot sizes (center).

GATF COLOR HEXAGON
INK HUE AND SATURATION CHART

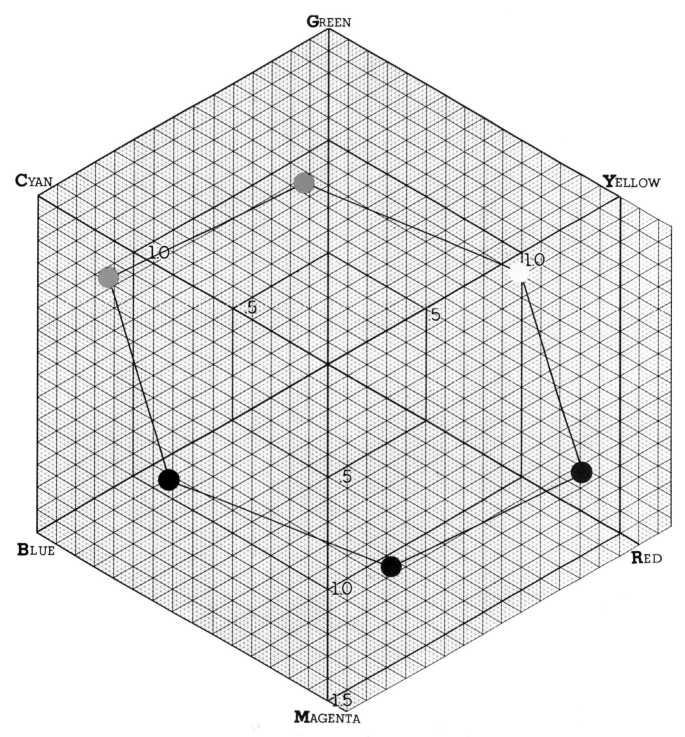

Note: Density measurements and plots are examples of the method of plotting ink on the GATF Color Diagram, and will only approximate the inks on these pages.

The GATF Hexagon is the only diagram that requires no mathematics, formulas, or computations to plot color strength and hue differences. It is the easiest and quickest to use and is best suited for quality control or press control of the separate primaries and overprint hues.

Reproduction of the same photograph with color correction by masking methods only. The clean colors more closely match those of the original.

Reproduction of a photograph made without color correction

With the green filter—magenta printer—magenta will print only in the magenta image areas. No magenta will print in the yellow and cyan image areas. Likewise with the blue filter—yellow printer—yellow will print only in yellow areas. No yellow will print in the magenta and cyan areas.

This is what we would have using theoretically pure inks. Such inks do not exist. As a result, the density measurements that we would be more likely to get using the inks that are available today would produce figures something like those in our chart.

PRINTED INKS	FILTERS		
	RED (Cyan Printer)	GREEN (Magenta Printer)	BLUE (Yellow Printer)
Yellow Ink	.00	.10	1.20
Magenta Ink	.10	1.20	.60
Cyan Ink	1.25	.40	.28

This more typical set of figures demonstrates errors in the light-absorption properties of inks. Any density in any area of the chart outside the diagonal lines represents additional light absorption of the inks that is incorrect and not desirable. It shows that inks can have two absorption errors. Again, reading across the chart, we see that the yellow is absorbing .10 of green light. This error is not too great. However, the absorption of some of the green light makes the yellow go very slightly toward orange.

The magenta ink in our example is absorbing .10 of red and .60 of blue which it should not do. The bigger error, the absorption of .60 of blue, adds yellow to the magenta which makes its hue shift toward red. The smaller error, the .10 absorption of red light, decreases the brightness of the magenta which makes it grayer.

The cyan ink in the chart is absorbing .40 of green light and .28 of blue light. The larger of these two errors, the absorption of .40 of the green light, adds magenta to the cyan which shifts

its hue toward blue. The smaller error, the absorption of .28 of blue, again decreases the brightness of the cyan making it grayer.

If these errors are greater than 10 percent of the ink's highest absorption, corrections either by masking or by handwork are necessary. The .10 magenta error in the yellow ink, for example, is less than 10 percent of the yellow's 1.20 blue absorption. There is little need for correction work in this case. Corrections are necessary, however, for both the other colors.

Reading the chart vertically, we see the relative densities that would occur in the positives or printers made from uncorrected separation negatives.

The figures for the yellow printer show that: (1) A density of 1.20 of yellow would print where yellow should be; (2) An additional .60 density of yellow would print where only magenta should be; and (3) An additional .28 density of yellow would print where only cyan should print.

In the green filter—magenta printer—column we see that: (1) A .10 density of magenta would print in areas that should be only yellow; (2) A density of 1.20 of magenta would print where magenta should be; and (3) A .40 density of magenta would print where only cyan should be.

The red filter—cyan printer—column shows: (1) There is no cyan printing where yellow should print; (2) A .10 density of cyan would print where only magenta should print; and (3) A density of 1.25 of cyan would print where only cyan should be.

The purpose of masking (or hand correction) is to correct for or cancel these densities which lie outside the diagonal lines in the chart. Masking systems usually correct a color separation for the larger of its two ink errors. At the same time, however, the mask may undercorrect or overcorrect the smaller error. This unbalanced condition most often occurs in the yellow separation because the average cyan and magenta inks do not reflect enough blue light. GATF's survey of color process work showed that with the inks now in common use, single masking would not be able to fully correct both errors in about 75 percent of the press runs represented. You can check your inks for their balance using the calculations for mask strength.

Section Three: GATF's Color Diagrams

In any study or analysis of color, the plotting of data on some sort of diagram is essential to visualize and evaluate the color. Through the years, many types of color-notation and color-diagram systems have been developed.

One of the best known of these is the CIE Chromaticity Diagram. This was developed by an International Commission of Illuminating Engineers. As shown in the figure, it takes the shape of a horseshoe within right-angle coordinates. Color values are plotted on it in terms of "x" and "y." The diagram uses red, green, and blue primaries that do not exist—primaries that are purer and brighter than any in the spectrum. However, it does show the properties of additive mixtures of different colors of light and the color differences as they appear to the eye.

The Munsell and Ostwald color systems are also well known. These are sets of standard colors to which other colors are compared or matched. They are useful in industry to identify colors wanted on merchandise, in artwork, etc.

The Maxwell Triangle, although related to the CIE diagram, is based on the use of real primaries. Plots are determined from densitometer readings made through red, green, and blue filters. This diagram is also good to show the properties of additive mixtures of colors of light.

One disadvantage of the CIE and Maxwell diagrams is that they require inconvenient calculations and plottings. Data for the CIE diagram, for example, has to be taken from spectrophotometric curves. Data for use on the Maxwell Triangle is based on percentage-reflectance densitometer readings. Some densitometers read this directly. However, it is much more common for the instruments to read in terms of density. The density readings must then be converted to percentage-reflectance values using tables. There are also important disadvantages that are inherent in any color diagram. None of the diagrams show all of the possible characteristics of a color because diagrams are limited to two dimensions.

The CIE Chromaticity Diagram

The Maxwell Additive Triangle

GATF Color Circle

Since the simplest description of any color requires three terms, conventional diagrams always omit at least one of the important qualities.

Still another disadvantage is that no one diagram is suitable for use with all types of color problems. When color is studied in different fields, new or different relationships of color properties become important. To best show these relationships, new diagrams are often required.

Until the introduction of the GATF Color Circle, this was the case in color studies for the graphic arts. None of the diagrams available before the Circle did a satisfactory job of picturing the special problems of color reproduction.

The main reason for this is that previous diagrams were mainly concerned with the effects of additive mixtures of different colors of light. The diagrams were therefore designed to show these effects and were based on the primary colors of light, red, green, and blue.

In graphic arts color reproduction, the conditions and needs are different. Here we are working primarily with subtractive color effects. In other words, and for example, yellow ink on paper looks yellow because it has subtracted or absorbed the blue from white light. The remaining red and green components of the white light are reflected from the paper and when combined, appear as yellow.

In studies of color reproduction, we want to be able to see and picture different qualities of the subtractive primary yellow, magenta, and cyan inks. A prime interest is to chart colors in terms of the way that they photograph and not necessarily as they appear to the eye. We want to be able to see what changes or corrections are required in photography to produce the best possible reproductions with different process inks, different halftone screens, different papers, etc.

GATF has developed three diagrams for this work. They are directly concerned with the special problems of color printing. As such, they are not intended to act as new color systems or substitutes for previous diagrams.

THE GATF COLOR CIRCLE

The GATF Color Circle, an ink hue and purity chart, was the first of GATF's diagrams. (It is described in GATF Research

Progress #38.) Its general appearance is shown in the figure; the intermediate plotting lines have been omitted.

The color circle is versatile. It will permit the plotting of a number of different pairs of factors.

In its most common use, the hue differences of inks are plotted around the circle, and the graynesses of the inks are plotted toward the center. The same diagram is also useful to plot hue and printed strength, or hue and another factor that is similar to saturation or chroma.

The two coordinates most commonly used to position a color on the color circle are called hue error and grayness. They are derived from red-, green-, and blue-filter densitometer readings by use of the hue error and grayness equations explained on page 7:9.

To position a color, take the hue error number and position it somewhere around the edge of the circle. The hue error number is a percentage between 0 and 100. There are, however, six pie-shaped sectors around the circle that are scaled down from 0% to 100%; you must determine in which one of these six areas the color should be plotted. This determination is done by comparing the red-, green-, and blue-filter density readings. The color of the filter that gave the highest density reading is complementary to the sample color. For example, if the ink's highest density reading is given with a blue filter, the color is basically a yellow. Therefore, in this case, start counting 2% hue error lines from the 0% yellow position (upper right on the circle diagram). To know whether to count toward 100% green or 100% red, again compare the red-, green-, and blue-filter density readings. A typical yellow process ink will have its red-filter density reading as the lowest of the three. If that is the case, count the hue line by going around the outer edge of the circle toward red.

In summary, a given color is plotted across from the color of the filter giving the highest density reading and then shifted away from 0% hue error toward the color of the filter with the lowest density reading. (These instructions are explained in GATF Research Progress #38.)

The closer a plot is to the "ideal" yellow, magenta, or cyan shown on the outer rim of the circle, the greater the purity of its hue, or the less its "hue error" in process-color printing. The farther a plot is away from the center of the circle, the less its grayness or contamination with the third primary.

The special features of the GATF Color Circle important in a study of process color reproduction are as follows: (1) the coordinate values of a color have a significant and understandable meaning in themselves (they quantitatively specify such factors as hue error or grayness, rather than relatively specifying them in terms such as "more of x and y"); (2) changes in the location of a plot for a color are easily interpreted to show what change is needed in the color system; (3) equal graynesses are symmetrical; (4) subtractive color mixtures are shown and related more logically between the primary colors; and (5) subtractive complementary colors (not additive colors) are shown directly opposite one another across a neutral center.

A special form developed for use with the circle organizes the data used to locate plots and to record mask factors. This form also provides information on hue shift, additivity, trapping, and other factors.

Despite the many advantages of the circle, there are two other desirable properties not shown well on it or previous diagrams:

GATF COLOR & PRINTING FACTORS DATA SHEET

Special Data Form for Color Circle

(1) the direct prediction of the color that can be produced by a two-color overprint and (2) the possible gamut of different sets of the three process inks. GATF has found an answer to these needs in a simple modification of the Maxwell Triangle.

SUBTRACTIVE COLOR TRIANGLE

The comparison illustration shows how the same set of three process inks and their in-between colors, plot on two different diagrams. The triangles are oriented so that the key colors have the same relative positions. Note: These diagrams omit the intermediate lines of the actual triangles.

Comparison of the Maxwell Triangle and the GATF Subtractive Triangle

The triangle on the left is a conventional Maxwell Triangle. The additive primary colors of light (red, green, and blue) are positioned at the corners. Positions for yellow, magenta, and cyan are centered on the three sides. Neutral is in the center, and is indicated by the letter "N."

Typical plots of yellow, magenta, and cyan are shown on the diagrams as the solid dots. In this type of diagram, additive complementary colors are on the side opposite the plotted color. The exact spot falls at the end of a straight line drawn from the plotted point through the center neutral point.

A straight line drawn between any two of the plots of the three ink colors locates the possible in-between colors of additive light mixtures of the two colors. The open circles shown on the diagram are plots of printed in-between colors, that is, subtractive overprints of pairs of the primary inks. It is easily seen that you can't predict subtractive mixtures from the plots of the primary inks in this type of diagram.

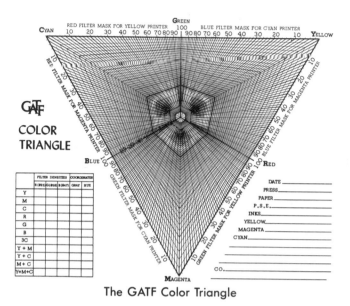

The GATF Color Triangle

GATF's diagram is shown in simplified form as the triangle above. It is called the Subtractive Color Triangle. The ideal subtractive primaries—yellow, magenta, cyan—are located at the corners. Ideal red, green, and blue that would be ideal pairs of yellow, magenta, and cyan fall in the centers of the side of the triangle.

Plotting Ink Colors. In using this or any of the other diagrams, the data is obtained from the GATF Color Test Strip or any of the color patches printed on the sheets. Patches of solids of the individual inks and overlaps of pairs of the inks are required.

The first step is to make densitometer readings of the color to be plotted through each of three filters (red 25, green 58, and blue 47).*

Next calculate the hue error and grayness coordinate percentage numbers as explained on page 7:9. These coordinates are also used for the Color Circle. Plotting on the triangle follows the same rules as plotting on the Color Circle, as described in the preceding section.

GATF's Research Progress #53, "New Color Diagrams," describes a different way of plotting on a triangle. Equations for the coordinates "C" and "M" are given. These may be used on

commercially available triangular-coordinate graph paper, used by engineers and chemists.

These charts do not directly show printing ink color properties, so GATF redesigned the triangle to show hue and grayness as the GATF Color Circle does.

How to Check Overprints. The example that follows, describes the procedure to show the trapping of cyan on yellow to produce green. The procedure for other pairs of the inks to produce red or blue is identical.

From the three filter densitometer readings, determine and plot the yellow and cyan hue and grayness coordinates on the triangle as shown in the Color Triangle. Draw a line connecting these two points. Possible ideal overprints of yellow and cyan should fall on this line.

To predict where on the line the expected green should fall, use the same densitometer readings already made. In the lower third of the chart are blocks for Y + M, Y + C, M + C, and Y + M + C. In this example, we are interested only in adding vertically the readings for the yellow and cyan ink solids.

So, the Y + C red filter prediction is .02 + 1.19 or 1.21. For the green filter, we add .08 and .37 to give .45. Likewise, for the blue filter, .97 + .13 = 1.10.

Now handle these figures the same as before to obtain hue and grayness coordinates. Omit the decimal points and add the three numbers (121 + 45 + 110). Divide the total first into the red value and then into the green value. Plot this point on the line connecting the yellow and cyan and indicate it as an "x." This shows where the predicted green should position on the diagram with ideal printing conditions.

The next step is to obtain the "actual" figures. This is done by making the three filter densitometer readings of the actual overprint yellow and cyan, that is, the green block in the test strip. Enter these readings (as well as readings for the other overprint colors) in the center blocks of the Color Triangle chart marked R, G, B, and 3 Colors.

Handle these figures exactly as before and plot where the actual overprint color falls on the diagram. Its position relative to the position of the ideal prediction (x) will give the following information. Assume here that yellow is first down:

(1) If the actual plot is the same as the ideal prediction, then the printing conditions are ideal. This doesn't happen very often.

(2) If the actual plot falls on the line, but is closer to yellow than the ideal x the cyan is undertrapping.

(3) If the actual plot falls on the line, but is closer to Cyan than the ideal x, the cyan is either overtrapping or the cyan ink is acting as though it is not fully transparent.

(4) If the actual plot falls outside the line (away from N), it indicates an increase or gain in the gloss of the over-printed inks.

(5) If the actual plot falls inside the line (toward the center), it indicates a loss of gloss due to possible excess drainage of ink vehicle or other causes.

It is possible to "predict" an overprint color only if transparent inks that are trapping properly are being used. However, the diagram is still useful to show the trapping of opaque inks. In this case, the original plotting would be made from the OK sheet. Later plottings during the run will show differences from the original. Opaque inks plot toward the top color similar to an overtrapping condition with transparent inks.

*The 29, 47B, and 61 filters should not be used. Values obtained with them will not agree with GATF standards. Some densitometers are equipped with these filters at the factory. Before you use your densitometer, check the filters in it against a set of filters known to be correct.

THE COLOR HEXAGON

Still another practically unfilled need has been a really simple way of charting color variations during a press run. To plot the printed strength of the separate primary inks (yellow, magenta, and cyan) only one number from a single densitometer reading is required. In process color reproduction, however, the accuracy or consistency of the overprint colors (red, green, and blue) are of even greater importance. This is because most of the colors in a reproduction are created by more than one ink. Changes in trapping or other press conditions may seriously shift the hues of the overprinted colors while the separate inks are still printing without change.

Although two different filter readings of overprint colors can detect shifts in their hue, we get the best information about changes from three filter readings. Getting these readings is now much more practical with modern densitometers that have push-button pre-zeroed filters. The problem then becomes one of how to chart hue and strength differences from these readings quickly.

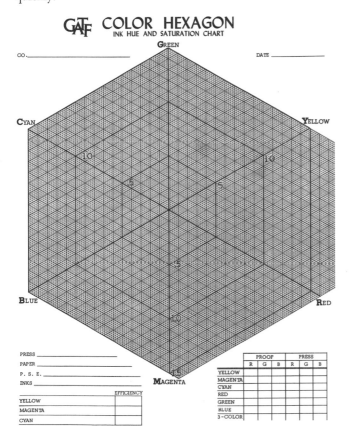

In reviewing the literature on color research, it was found that just such a system was already in existence. It had been used successfully in studies of Kodachrome film but had not been publicized to the Graphic Arts. It is a simple charting system in the form of a hexagon and is described in the book, "Principles of Color Photography," by Evans, Hanson, and Brewer*.

* Evans, R. M.; Hanson, W. T., Jr.; and Brewer, W. L., Principles of Color Photography, John Wiley & Sons, Inc., or Chapman & Hall Ltd., London (1953).

They called it a "Trilinear plot." We have adapted this chart to our requirements by modifying its range and working out the simplest alternative chartings.

The GATF Color Hexagon has separate lines which correspond to .02 increments of density. The single ideal primary inks—yellow, magenta, and cyan—plot along their radial lines from the center. The stronger the ink color, the farther away from the center it falls.

In using this diagram, no calculations, equations, or slide rules are needed. Color points are positioned directly on the hexagon according to the red, green, and blue filter density readings. To position a color, always start from the center of the diagram. First, use the red filter density and count toward cyan (away from red) the number of lines equal to this density. Now count downward the number of lines equal to the green filter density and then upward to the right toward yellow the number of lines equal to the blue filter density.

A slightly easier charting method is described in the book, "Principles of Color Photography," that was mentioned before. In this method, the lowest density reading is subtracted from each of the other two readings. In making the plot with the remaining two readings, again start from the center and count in the directions that are away from the remaining two filter colors. For example, suppose the three filter readings of the magenta are Red = .10; Green = 1.22; and Blue = .46. Red is lowest so subtract its value (.10) from green which leaves 1.12 and from blue, leaving .36. To make the plot, start in the center of the diagram and count down (away from green) to the 1.12 position and then upward to the right (away from blue) to the 0.36 position.

This diagram is particularly useful to check both trapping and the strength of the color being run while the run is in progress. To do this, make initial plots from the OK sheet. Make plots of the solid primary inks and the overprinted pairs of the primary inks that produce red, green, and blue. Then, as the run progresses, make additional plots onto the same diagram. Where these plots fall in relation to the original plots tells how close the printing is to the OK sheet.

If the plot for a primary color shifts outward, it indicates that the printed strength or density of the color has increased. A shift inward toward the center tells that the strength or density of the color is less than it was on the OK sheet. In either case, of course, the press ink feed or cylinder packing should be adjusted.

Suppose there has been no change in the densities of the primaries, but the plots for the overprint colors (red, green, and blue) have shifted toward one of the primaries. This tells that overtrapping or undertrapping is occurring.

A change in the printed strength of a primary color will naturally shift the hue of an overprint color produced with this primary. There may also be changes in trapping. This cannot be determined until the primary ink strength has been adjusted back to match the original plot from the OK sheet. The improved hexagon chart now has lines of .02 density difference to make charting more accurate. This is illustrated in the color section.

SUMMARY

GATF's Subtractive Color Triangle, Hexagon Color Charts

and Color Circle are three diagrams which can be valuable aids in comparing and studying important graphic arts color reproduction problems. They have been designed specifically for visualizing subtractive color properties of printing inks and are not necessarily suggested as substitutes for diagrams used in other fields.

The GATF Color Circle is best suited to: (1) Visualize the hue and grayness of actual ink colors in relation to ideal colors; and, (2) Visualize the requirements of a color correction system for different inks, papers, etc.

The GATF Subtractive Triangle is best suited to show: (1) The gamut of pure color that is possible with a given set of

inks; (2) Under or overtrapping; (3) Changes in gloss; and, (4) To directly predict ideal overprint colors.

The GATF Hexagon is the only diagram that requires no mathematics, formulas, or computations to plot color strength and hue differences. It is the easiest and quickest to use and is best suited for quality control or press control of the separate primaries and overprint hues.

None of these diagrams is necessarily in its final form. At the present time, there appears to be a need and a place for all three. The diagrams that are most important and useful can only be determined by their practical use in more plants. This will also help us to finalize their most useful format.

Section Four: Color Correcting by Photographic Masking

In this section you find a general and brief survey of color correcting by photographic masking. The subject matter is divided into the following six units: (1) What masking will do, (2) Masking Methods, (3) Types of masks, (4) Types of masking, (5) Masking Color Transparencies, (6) Recent masking developments.

Color separation negatives alone cannot give accurate color reproduction. Formerly, when the necessary added color correction steps were done entirely by hand retouching, color separation could be studied as an independent operation. Modern color reproduction processes now often use all photographic correction steps. So, it has become important to understand their relationship with separation negatives. This section is not intended to include complete working details of all correction methods, but sufficient description of most methods is given so that their purpose and control can be understood.

The term "masking," as we use it today, describes a photographic technique used primarily for color correction. It is neither new nor standard. As early as 1899, Dr. E. Albert was granted a German patent on a masking method to improve four-color reproduction. This method is only one of the many that have been proposed as a means of obtaining better color quality in reproductions at reasonable cost.

WHAT MASKING WILL DO

Briefly, a mask is a negative or positive image used with another negative or positive to modify the amount of light that passes through while exposing still another negative or positive. Masking methods can be used to correct colors and/or tones, to drop out backgrounds, etc. Photographic masking can do this without loss of detail. With the best inks and careful masking, plants are producing acceptable quality with a minimum of handwork. With balanced process inks and a moderate amount of care in the masking procedure, hand-correction time can be reduced by more than fifty percent in most cases. Specifically, masking may be used to accomplish the following:

Correct for the Deficiencies of the Process Inks. The failure of the magenta and cyan ink to reflect as much blue light as the white paper it is printed on is one of the reasons for color correcting the blue-filter separation. Masking adds density to the blue-filter separation negative (yellow printer) wherever

magenta and cyan are required in the picture and prevents excess yellow from printing in these areas.

The cyan ink does not reflect as much green light as the white paper it is printed on. We, therefore, have to add density in the green-filter separation negative (magenta printer) wherever cyan appears in the subject. This prevents magenta from printing in the areas that should be only cyan.

Color correction masking will also remedy some of the other minor ink deficiencies.

Correct for Deficiencies in Color Transparencies. A color transparency doesn't exactly reproduce the original scene. The yellows may be weaker, and the blues too strong. Other colors may also differ from the original scene. These differences may be due to the incorrect strength or hue of the three dyes in the transparency. Masking can be used to help bring the colors in the printed image closer to those of the original scene.

Reduce the Density Range of the Copy. Copy, such as dense oil paintings, transparencies, carbros, and dye transfer prints does have density ranges greater than those which can be printed by lithography. The effective density range of the copy can be compressed by using photographic masks.

Remove Undercolor in High Speed Wet Printing. In four-color wet printing it is sometimes difficult to trap three or four overlapping solids. Then, in the shadow areas, where yellow, magenta, and cyan would normally be printed, it helps to remove some of the color. Black is substituted for the shadow color removed. This undercolor removal, as it is called, can be done by masking.

Produce a Corrected Black Printer. Most of the separation methods will produce a black printer which will print some black in some of the pure colors. Masking the black printer can reduce the amount of black printing in these colors. A new method for doing this is described in Chapter 6.

Preserve Highlight Detail. In normal color separation and halftone procedures, the contrast of the highlights in the copy is generally reduced. When it is important to retain highlight detail, a highlight mask should be used. It maintains the highlight contrast of the copy.

Block Out White Highlights, White Backgrounds, Type Matter. An opaquer mask can be used to eliminate the need to opaque each of the separations. It blocks out parts of the copy, such as white backgrounds, highlights, type, etc., which would normally be opaqued on each separation.

MASKING METHODS

The most convenient way of classifying masking methods is according to the way that the masks are used, that is the mechanical arrangements of the various images. There are three principal ways of using masks. These are: (1) by projection, (2) in contact, and (3) in the camera back. A fourth class is the "integral" mask which is a part of the original art and not produced by the photographer.

Projected Masks. Projected masks were generally made in a special camera or camera attachment. They can be made from the original copy, or from the color separations. When made from the copy, filtered exposures are made on panchromatic plates. These masks are then projected to the copy or to the focal plane of the camera when the separations are made. When masks are made from the separations, they can be projected back onto the appropriate separations when the halftone or continuous-tone positives are made.

In the projection method, several special cameras have used masks projected in different ways. The Gamble process camera used an auxiliary small camera projector. This made 5" x 7" filtered negatives from the copy on an angle. Extra light was then locally projected to the copy through the mask negative during normal color separation with the large camera. The British Add-mask camera accomplishes this same effect by mirror projection to the exposing separation plate rather than to the copy. The British Multichrom camera uses light projection from either end and provides an excellent series of register positions to allow both projected masking and "distance" masking. The Nerot camera was more correctly a contact frame with same-size projection from positive masks to expose corrected positives.

Contact Masks. These can be made in a vacuum or pressure printing frame. They can be made from the copy (color transparencies) or from the separation negatives. When made from the transparency, filtered exposures are made on panchromatic emulsions. When masks are made from the separations color blind emulsions can be used.

Camera-Back Masks. These are made in the process camera from reflection or transparent copy. They are processed and replaced in the camera back. Additional masks or separations are made behind these masks. Both silver and dyed masks can be used.

Integral Masks. Integral mask layers are incorporated by the manufacturer in some color negative films. Integral color correction can also be obtained from reflection copy if it is prepared with special fluorescent water-color paints. When the copy is illuminated with ultraviolet light, the colors fluoresce and add extra density where needed in the color separation negatives.

Masks With Multi-Layered Color-Sensitive Film. These films, while similar to color-negative films, are designed specifically for color correction by photographic masking techniques. A single exposure of the film to the color copy through an ultraviolet filter, and color processing, results in dye masks for all three color separations in one piece of film. The color separation films are exposed to the copy, through the mask and normal color separation filters. How close to complete photographic color correction may be attained, by use of these materials, depends on how close to ideal are the inks and paper.

TYPES OF MASKS

There are many different types of photographic masks. They include highlight pre-masks, principal masks, dropout masks, shadow masks, and undercolor removal masks. Each type is used to produce a certain effect. Most of them can be made and used in projection, contact, and camera methods of masking.

Highlight Pre-Mask. The highlight pre-mask is a negative mask usually made from transparencies. It can be used to increase the highlight contrast of underexposed transparencies. It is a contrasty, short-density range mask. The density range may vary from .25 to .50 depending on the copy and the results desired. It records only the highlights. It is made on a high-contrast lith-type emulsion and developed in a diluted continuous-tone developer. This mask is used to protect the highlights when the principal or final mask is made. It is discarded after the final mask is made.

Highlight pre-masks can be made by projection, contact, or in the camera. When made in a contact printing frame, a contact negative is made from the transparency. The processed mask is then fastened to the transparency in register and the principal mask is contacted from the combination.

Highlight pre-masks can be made from either transparent or reflection copy in the process camera using a special plate bar or the halftone screen holder just ahead of the focal plane of the separation negative emulsion. The processed plate is then replaced in register in the camera back. The final mask can then be made behind the highlight pre-mask, but ahead of the position where the separation negative will be. The highlight pre-mask is discarded after the final mask is made.

Final or Principal Masks. When a mask is produced by the use of more than one step, such as the intermediate use of a highlight pre-mask, it is called a final or principal mask. The final mask for a transparency is a negative. It is used for tone and color correction. It may be made from the copy by any one of the three methods just described. It is generally an unsharp, full-tone scale, low-contrast negative. A continuous-tone panchromatic emulsion is used and processed in a continuous-tone developer.

When the final mask for a color transparency is made by contact methods, the combined transparency and highlight pre-mask are contacted to the panchromatic emulsion. This mask will compress the density range of the transparency so that the separation negatives can be developed to a higher contrast than would otherwise be possible. This will increase the saturation of colors in the final reproduction.

In the camera method, the final mask can be made from reflec-

tion or transparent copy. If a highlight pre-mask has been made, the final mask is made behind it, but ahead of the plane of the separation negative. The mask is then shot with the required filter. After exposure, it may be developed to produce either a fine grain silver image, or dye coupled to produce a magenta dye image. There is less light scattered from dyed images than from silver images. However, it is much easier to work with silver images and to obtain reproducible results. With either type, the mask is replaced in the camera back, and the separations are made behind it.

A second type of final mask is for separation negatives. These require a preliminary color-correcting pre-mask made from one of the other separation negatives.

Positive Masks. A positive overlay mask is a low-contrast, continuous-tone positive which is laid over a separation negative for the purpose of color correction. There are many variations in the way that they can be used. They are usually made by contact.

In the contact method, the masks are made from the color separation negatives. Colorblind or orthochromatic emulsions and continuous-tone developers are used. Positives made from one separation are placed over another separation in the set. For example, the blue-filter separation (yellow printer) is corrected by a positive contacted from the green-filter separation (magenta printer). The green-filter separation (magenta printer) is corrected by a positive contacted from the red-filter separation (cyan printer).

Highlight Mask. The highlight mask is a short-scale continuous-tone negative overlay mask. It is made to be used on separation negatives for the purpose of increasing the highlight contrast. It can be shot directly from the copy at the time that the separations are made, or a positive can be contacted from the separation negative containing the most highlight detail. This positive is then contacted back to a negative to make the final highlight mask.

Dropout Mask (Opaquer). This mask is a special form of highlight mask which is used to drop out white backgrounds that repeat in every separation. By making one mask which records only the white areas and then placing it over each separation when the positives are made, a considerable amount of opaquing can be eliminated.

One method of making a dropout mask is to make a strong contrasty, contact positive from the separation negative containing the most detail. All areas that are not dense enough on the positive are opaqued. This leaves only the white areas clear. A contact negative is then made on thin base film which is used as the dropout mask for all the separations.

A second method of preparing a dropout mask is to shoot a weak, contrasty, continuous-tone thin-base film negative at the time the separations are made. The purpose of this negative is to record only the white tones of the original copy. Any other tones held on the negative are eliminated with a standard reducer (such as Farmer's reducer). This negative is used as the dropout mask. If the camera has a reversing prism, the negative can be made so that it will be in emulsion-to-emulsion contact with the separation negatives. Even though the density of the mask is not as opaque as in the previous method, it is dense enough to work.

Shadow Detail Mask. This mask is used on continuous-tone positives when it is important to keep or improve shadow detail. It is a contrasty, short-density range positive made with the same materials, and similar in appearance to the highlight mask. It is a record of the shadows only. The mask is made from the masked separation negative and placed over the positive. It adds density to the shadow end of the scale (dense portion of positive), increasing the shadow contrast.

Undercolor Removal Mask. This mask is used to reduce the amount of ink printing in the shadow areas of the picture. It is valuable in printing with multicolor presses. When you can't fully trap four wet solids in one area, the general practice is to reduce the amount of colored ink printing in these areas and substitute black. A weak contact positive is made from the black separation negative on thin base film. The mask is then fastened to the color separations when the halftones are made.

TYPES OF MASKING

These many types of masks may be used in different combinations to provide a great variety of systems.

Basically, only four systems are now commonly used. These are (1) single-stage positive masking, (2) two-stage masking for separation negatives, (3) camera-back masking using either multilayer dyed films or silver masks, and (4) transparency masking.

Positive Masking. The simplest system, which has also been in use the longest, is commonly called overlay masking. This is now technically classified as positive masking. These masks, added to uncorrected separations, give complete correction for properly balanced sets of process inks when printed on coated papers. Experience at the GATF Laboratory has shown that this system gives the most accurate reproduction of the widest range of colors when used with (1) the standard broadband filters, (2) sets of compatible process inks whose magenta and cyan ink errors balance with these filters, and (3) separation negatives with straight-line gray-scale tone reproduction.

Positive masking is a contact method. The following procedure is used to make the masks:

1. Make continuous-tone separations.
2. Make weak contact positive masks from the separations.
3. Bind the positive masks in register to the appropriate separation negative.
4. Shoot halftone positive through combination mask and separation.

MAKING THE CONTINUOUS-TONE SEPARATION NEGATIVES. The separation negatives are made with wide-band filters (Nos. 25, 58, and 47). This was described in Chapter 6.

MAKING THE WEAK CONTACT POSITIVE MASKS FROM THE SEPARATIONS. Continuous-tone colorblind or orthochromatic emulsions on glass, or dimensionally stable film base, are generally used. They are processed in continuous-tone developers. It is also possible to use high-contrast lithtype emulsions developed in a diluted continuous-tone developer to make continuous-tone masks.

The positive masks are contacted from the separations and combined with the appropriate separation negatives. The following combinations of masks and separations are ordinarily used: (The percentage values are explained later and are for an average range of process inks.)

1. Blue-filter separation negative (yellow printer) and a 30 to 50 percent positive mask from the green-filter separation negative.
2. Green-filter separation negative (magenta printer) and a 30 to 50 percent positive mask from the red-filter separation negative.
3. Red-filter separation negative (cyan printer) and a 20 to 30 percent positive mask from the black-separation negative.
4. Yellow-filter separation negative (black printer) and a positive mask from the cyan- or magenta-separation negative.

The masks for the blue- and green-filter separations are used primarily for obtaining color correction. The red-filter separation generally does not need much color correction. However, a positive mask from the black separation will increase the color saturation of the red-filter separation.

The black separation can also be improved by using one of the masks already made for color correcting the yellow or magenta printers. If the mask made from the green-filter separation negative is used, less black will print in reds, warm colors, and flesh tints. If the mask made from the red-filter separation negative is used, less black will print in greens, blues, and cold colors. Unfortunately, these masks add more black to the colors that they do not lighten.

You can make a better single mask which lightens black in all colors with a special "X" filter. The desired property of this filter is that it be able to record all colors, except yellow, as black. No single gelatin filter does this as well as desired. However, two common filters used together approach this goal. These are the Orange (No. 22) and the Cyan (No. 61). These filters, when overlapped, transmit only a narrow wavelength band of light near spectral yellow. Because of the decreased light transmission, the exposure factor is larger than for single filters. Camera negatives, therefore, have to be made with large lens apertures and bright lights. Shorter exposures and still more complete correction is expected with new interference filters that are now being developed for black correction.

DETERMINING THE PROPER STRENGTH AND PERCENTAGE OF COLOR CORRECTION MASKS. The strength of the correcting mask is determined by the printing inks that will be used to print the job. Once the mask strength has been determined for a given set of process inks, the same percentage mask is used for all types of copy.

Ordinarily, instructions for masking methods refer to different strength masks in terms of percentages such as 30, 40, or 50 percent masks. Such percentages have sometimes been misunderstood, and unsatisfactory results have been produced without knowing the cause. *Percentage figures represent the desired black-to-white density range of the mask divided by the black-to-white density range of the negative it will be used with.* In other words, the density range of a 40 percent mask will have to be different from one set of separations to the next, if the density range of the color separations that the masks are used with also varies.

In commercial production work, the photographer does not have to figure these mathematical percentages if he photographs process ink color separation guides with his copy. If the color separation guide does not include good black and white patches, a gray scale should also be photographed with the copy. If this is done, the proper strength to make each mask can be determined directly from the separation negative in terms of density differences. The following examples will explain the procedure:

Example 1. *Determining the Mask Strength to Correct the Blue-Filter Yellow-Printer Separation Negative.* Measure the densities of the magenta-ink patch and the white patch as photographed on the separation negative. Subtract the magenta reading from the white reading to obtain the density difference. Make a positive mask from the green-filter separation. This mask will include the ink color separation guide that was photographed on the green-filter separation negative. Measure the densities of the magenta and white patches on the mask. Subtract the readings to obtain the density difference. The mask will fully correct the separation if the density difference of the mask is equal to the density difference of the separation. A quick visual check can be obtained by registering the mask over the separation. If the combined densities of the magenta and white patches are equal or appear equally dense, the mask strength is correct for this error.

Example 2. *Determining the Mask Strength to Correct the Green-Filter Magenta-Printer Separation Negative.* Measure the densities of the cyan-ink and white patches on the separation negative. Subtract the cyan reading from the white reading to determine the density difference. Make a positive mask from the red-filter separation negative. Determine the density difference of the cyan and white patches on the mask. The mask will fully correct the separation if the density differences are equal. As before, a visual check can be made by registering the mask over the separation to see if the combined densities of the cyan and white patches are equal.

While percentage calculations do not have to be figured each time the ink control patches are used, percentage strengths are important to know. They are especially useful when we wish to obtain these same degrees of correction for specific sets of process inks when the ink color guides are not photographed with the copy (such as transparencies).

The required percentage mask values may be calculated from previous sets which included color guides and a gray scale (if good black and white patches were not a part of the color guide), and which were satisfactorily masked. By "satisfactory" we mean that the masks raised the density of the magenta patch in the yellow-printer separation and the cyan patch in the magenta printer to exactly equal the density of the combined mask and separation white patch. The mask for the cyan-printer separation, made from the black separation, would be correct when the densities in black equal the density of the cyan-ink patch.

The percentage value of these satisfactory masks is calculated as described before. You measure the densities of the black and white patches on the mask and subtract one from the other to get the density range of the mask. Do the same thing for the separation that the mask will be used with. The density range of the mask divided by the density range of the separation is the mask's percentage value.

The alignment chart can be used to find mask percentages, or the required density range of the mask.

TO FIND MASK PERCENTAGES.

1. Measure the density range of the mask and the density

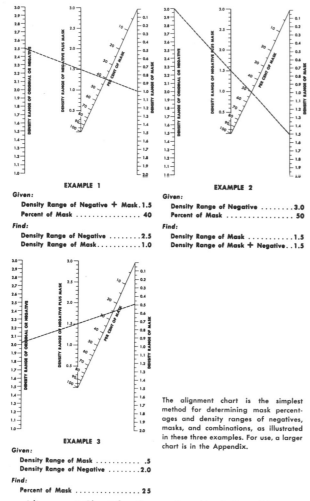

EXAMPLE 1

Given:
Density Range of Negative + Mask . 1.5
Percent of Mask 40

Find:
Density Range of Negative 2.5
Density Range of Mask 1.0

EXAMPLE 2

Given:
Density Range of Negative 3.0
Percent of Mask 50

Find:
Density Range of Mask 1.5
Density Range of Mask + Negative . . 1.5

EXAMPLE 3

Given:
Density Range of Mask5
Density Range of Negative 2.0

Find:
Percent of Mask 25

The alignment chart is the simplest method for determining mask percentages and density ranges of negatives, masks, and combinations, as illustrated in these three examples. For use, a larger chart is in the Appendix.

Alignment Chart for Converting Mask Densities to Percentages

range of the negative or transparency with which the mask is to be used.

2. Place one end of a straight-edge on the appropriate figure in the left-hand column representing "Density Range of Original or Negative."

3. Place the other end of the straight-edge on the appropriate figure in the right-hand column representing "Density Range of Mask."

4. Read the actual percentage of the mask by the figure at the point where the straight-edge intercepts the diagonal "Percent of Mask" line.

For example, a separation negative has a density range of 1.5 and the mask density range of .60. If a straight-edge is placed at 1.5 at the left-hand scale and at .60 at the right-hand scale, it will intersect the "Percent of Mask" scale at 40 percent. The density range of the negative and mask can be read from the center scale.

To Find Required Density Range of Mask:

1. Measure the density range of the negative or transparency with which the mask is to be used.

2. Place one end of a straight-edge on the appropriate figure in the left-hand column representing "Density Range of Original or Negative."

3. Place the other end of the straight-edge on the "Percent of Mask" scale.

4. Read the required "Density Range of Mask" from the right-hand column.

For example, a separation negative has a density range of 1.5 and the mask is 40 percent. If a straight-edge is placed on 1.5 at the left-hand scale and on 40 percent on the diagonal "Percent of Mask" scale, it will intercept the "Density Range of Mask" scale at .60.

The single-stage masking described here will not give completely satisfactory correction with all process inks and printing conditions. This will be recognized by too little yellow printing in browns, and too little magenta in blues. Sets of process inks, whose magentas are redder than the magenta of the color separation guide or whose cyans are bluer or grayer, may need two-stage masking to prevent these overcorrections.

Two-Stage Masking. Two-stage masks are so called because they are made in two steps. First, a film positive called a pre-mask is contacted from one of the separations. This is then registered with another separation through which the final or principal mask is exposed.

Two-stage masks for color correction of the yellow- and magenta-printer separations are made from the separation negatives which would be used to make corresponding single-stage positive masks. Their difference in correction comes from the use of a pre-mask. The pre-mask in each case (except for the cyan printer) is made from the separation which will be corrected by its final mask. The pre-mask can help control the amount of yellow that the final mask takes out of browns and reds and, similarly, the amount of magenta taken out of blues and purples. As most commonly made, two-stage masks leave the gray scale undisturbed with full solids of each color in black. A small amount of undercolor removal may be accomplished by giving longer exposure while making the final mask, or by using a lower contrast, non-canceling pre-mask. For a high degree of undercolor removal, an additional undercolor removal mask is preferable.

An outline of procedure is as follows:

1. Color separation negatives are made by exposure with the Nos. 25, 58, and 47B filters. Development is adjusted to give close to equal density range.

2. Positive pre-masks are made from the blue- and green-filter separations. These should have gray scale densities which will just cancel those of the separation they are applied to.

3. The pre-mask from the blue-filter separation is placed on the green-filter separation during the exposure for the final mask to correct the blue-filter separation.

The pre-mask from the green-filter separation is placed on the red-filter separation during exposure to make the final mask for correction of the green-filter separation.

These final mask exposures should be such as to give the right amount of correction in the wanted colors. Usually, this just creates a small density in blacks and whites. The length of development will control the contrast or amount of color correction in unwanted colors.

Suitable films for the pre-masks are continuous-tone commercial, or mask-type films capable of giving a straight-line tone reproduction at a gamma of 1.0. Most final masks may be made

with the same type of film or plates, but in some cases higher-contrast emulsions are used when stronger corrections are needed. More complete working details on two-stage masking and other types of masking, with specific recommendations of suitable emulsions, can be found in the film manufacturers' publications.

Camera-Back Masking. Camera-back masking is suitable for both reflection and transparent copy because it is done on the camera back. The masks are made on the camera back and processed. The separations are then exposed with the appropriate mask placed over the separation film. The use of a pin register system is necessary.

These negative masks are made by exposing through the back of film that does not have an antihalation backing. A mask and the separation film (and contact screen with direct-screen color separation) are positioned on the camera back, emulsion to emulsion. The exposure is made through the back of the mask. In this masking method, three such masks are typically made. For approximate corrections, these masks may be made with single-filter exposures: one with a red (25) filter, one with a green (58) filter, and one with an 80B or 85B filter. It should be noted that the masks and the methods used to make them vary somewhat depending on the film used; manufacturers' recommendations and systems should be followed whenever possible.

To make the corrected separation negatives, films are exposed through the following mask and filter combinations:

1. For the green-filter (magenta) separation negative, expose through the magenta-filter mask with the green (58) filter in the filter holder of the lens.

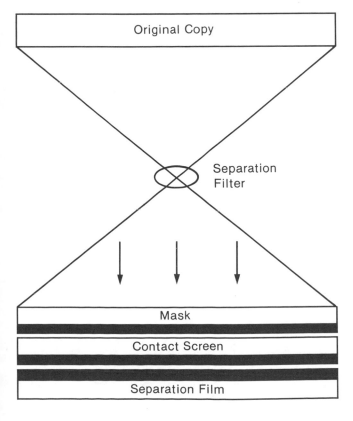

Camera-Back Masking

2. For the red-filter (cyan) separation negative, expose through the 80B- or 85B-filter mask with the red (25) filter in the filter holder.
3. For the blue-filter (yellow) separation negative, expose through the green-filter mask with the blue (47) filter in the filter holder.
4. Give the yellow-filter separation negative a double exposure. First, expose through the magenta-filter mask and then through the green-filter mask. Use the yellow (8 K2) filter in the filter holder.

Some sets of process inks will be better color-corrected by masks made with two filters. If needed, blues can be more strongly corrected in the yellow separation by adding a short red-filter (25) exposure to the green-filter (58) exposure when making this mask. Examine the color patches to judge the effect of the additional exposure. The aim is to eliminate yellow from both the magenta and cyan areas.

To correct more fully "orange" chrome yellow inks in the magenta printer, add some 47B blue-filter exposure to the 25 red-filter mask. Again, judge the effect of different exposure times with the two filters by examining the color patches on the magenta separation. The aim is to have both the green and cyan areas as dense as the white patch.

When the masks are being made, it is important that they be exposed at the same image plane that they will be used in making color separations. The masking film is therefore exposed while it is on top of one or two other pieces of film. If the indirect method of color separation is being used, the masking film should be placed over one spacer film that is the same thickness as the separation film. If the direct-screen method of color separation is being used, the masking film should be placed over two spacer films, one the thickness of the separation film and one the thickness of the contact screen. Spacer film should be fogged and developed so that it is completely black.

The masking film can be held in place over the spacer films by a large piece of thin film. An opening, about ½ in. shorter and narrower than the film being exposed, is cut out of the large piece of film. In other words, when the large "hold-down" film is in place, it will overlap the edge of the masking film being exposed by about ¼ in. on all sides.

After the mask has been exposed and processed, the fogged spacers are replaced by a piece of unexposed separation film, and by the contact screen in the direct-screen method. The mask is placed on top, and they are held in contact by the larger hold-down film and vacuum.

To ensure proper image registration, the masks and separations must be prepunched and mounted on pins when they are exposed. Several register punch and pin systems can be used for this purpose. In one case, a metal strip with the two register pins mounted on it is fastened to the camera back for this work. Some camera backs are equipped with several pairs of retractable register pins. The punched masks and separations are placed over the pins for all exposures.

MASKING COLOR TRANSPARENCIES

By a slight variation in the normal procedure, fuller color correction can be introduced into the separation negatives. The following procedure can be used when using the contact method:

Make Highlight Pre-Mask. To increase highlight detail from an underexposed transparency, a highlight pre-mask may be made.

The mounted transparency, along with the register marks and guides, is contacted to a high-contrast lith emulsion such as that used to make line or halftone negatives. The film is then developed in a diluted continuous-tone developer to produce a short-scale, contrasty negative. For data on the materials and procedure used to make the mask illustrated in figure see the table. Comparable materials are, of course, available.

	Film *	Wratten Filter No.	Exposure Time (in seconds) ‡	Development Time (in minutes at 68°F) **	Density Range of Mask
MASKS:					
Highlight (if necessary)	Pan Litho	.30 Neutral Density	3	2	.40
Principal	Pan Masking	85 B and .30 Neutral Density	3	2	30% to 40%
COLOR SEPARATION NEGATIVES:					
Cyan	Cronar Transparency Separation Negative	25	5	3½	
Magenta	"	58	10	3½	
Yellow	"	47B	60	3½	
Black	"	1.0 Neutral Density	10	4	

*Film used: Dupont
**Developer used: Dupont 16D diluted 1:2 with water.
‡Illumination: 7 footcandles at contact frame.

Masked Color Separation Data

A normal highlight pre-mask will have its maximum density in the range of .25 to .50. The density value needed in the mask will depend on the transparency and the effects desired in the

Mounting Transparency for Masking.

1. The first step in making masks is to bind the step tablet and register marks to the color transparency.
2. Fasten transparency to the glass of the printing frame using cellulose or glue tape.
3. In making mask, the unexposed masking film is placed emulsion-side down in printing frame.

highlights. For a given transparency, the higher the density of the highlight pre-mask, the greater the highlight contrast in the separation negative. However, if the highlight contrast is too great, the result produced may not look natural.

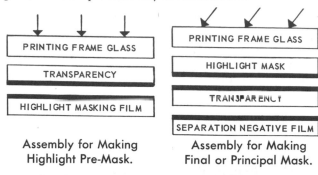

PRINTING FRAME GLASS	PRINTING FRAME GLASS
TRANSPARENCY	HIGHLIGHT MASK
HIGHLIGHT MASKING FILM	TRANSPARENCY
	SEPARATION NEGATIVE FILM

Assembly for Making Highlight Pre-Mask. — **Assembly for Making Final or Principal Mask.**

Principal Mask

Highlight Pre-Mask

Make Final Mask. An unsharp final mask is made with panchromatic continuous-tone film. It is exposed with a filter placed on the printing lamp. Three masks are made, one with a Magenta (No. 25) filter, one with an 85B filter, and the other with a Green (No. 58) filter. The film is processed in a continuous-tone developer to produce a low-contrast, full-tone scale negative. The density range of the masks should be approximately 40 to 50 percent of the density range of the original transparency.

Make Separations. The highlight pre-mask is removed from the transparency, and the appropriate principal mask is bound to the transparency to make the separation negatives. The separations are made with filtered light using the Red (No. 25), Green (No. 58), and Blue (No. 47) filters over the printing lamps as described below. The panchromatic separations are developed in a continuous-tone developer.

Combination of Masks and Filters. The following combinations of masks and filters are used to make the separations:

1. To make the red-filter separation, expose through the No. 85B filter mask with the Red (No. 25) filter over the light source.
2. To make the green-filter separation, expose through the Red (No. 25) filter mask with the Green (No. 58) filter over the light source.
3. To make the blue-filter separation, expose through the Green (No. 58) filter mask with the Blue (No. 47) filter over the light source.

4. To make the black printer, a multiple exposure procedure can be used. Make the first exposure with the Green (No. 58) filter over the light source and the Red (No. 25) mask on the transparency. Make the second exposure with the Red (No. 25) filter over the light source and the Green (No. 58) mask on the transparency. After the second exposure replace the red filter with a Blue (No. 47) filter and make the third exposure through the same green-filter mask.

A simpler way of correcting the black separation negative is to make a special mask with the "X" filter as described previously. Mount this mask on the transparency and expose the black separation negative through the pair. If tungsten light is being used, the exposure can be made either with no filter or through an 80B filter if cleaner blues are needed.

If arc lamps are being used, a "no filter" exposure is equivalent to a tungsten exposure with the No. 80B filter. Arc light through a No. K2 filter is equivalent to tungsten light with no filter.

Section Five: Equipment for Masking

Nearly all masks for transparencies are done by contact printing. But even with color separation and masking of opaque full-color copy, most of the actual masks will also be done by contacting.

In this section we are not concerned with the customary equipment for contact printing in general. Rather, we are concerned with such auxiliary equipment as is specifically needed for masking, over and above the usual contact room equipment.

CONTACT PRINTING LAMPS FOR MASKING

Contact printing lamps, in general, should evenly illuminate the entire printing area, with as small a light source as is practical. These requirements are essential for making masks. In addition, contact printing lamps for masking should be operated through a precise timer and reliable transformer, and be equipped with a filter frame holder.

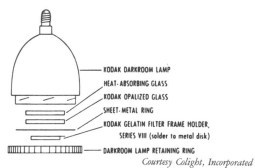

KODAK DARKROOM LAMP
HEAT-ABSORBING GLASS
KODAK OPALIZED GLASS
SHEET-METAL RING
KODAK GELATIN FILTER FRAME HOLDER,
SERIES VIII (solder to metal disk)
DARKROOM LAMP RETAINING RING

Courtesy Colight, Incorporated

Darkroom Lamp Converted to Contact Printing Lamp

In plants where color separation and masking are only done once-in-awhile, a Kodak Adjustable Safelight Lamp can easily be modified to fit the requirements listed above.* An ordinary Kodak type dark-room lamp can also be converted to a contact printing lamp. Where at least a fair amount of full-color reproduction is being done, there are several ready-made exposure units available on the market. The more sophisticated units incorporate voltage selection, timer, and remote-control filter wheels.

Register Marks, Gray Scales, and Color Blocks. Each piece of copy should have a set of register marks. Place reg-

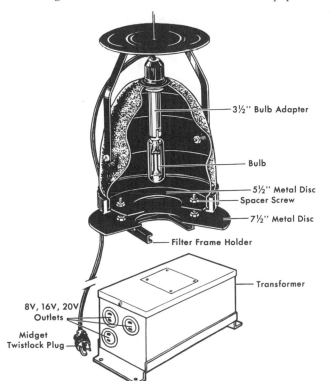

3½" Bulb Adapter

Bulb

5½" Metal Disc
Spacer Screw
7½" Metal Disc

Filter Frame Holder

Transformer

8V, 16V, 20V
Outlets

Midget
Twistlock Plug

Modified Kodak Adjustable Safelight Lamp

* Eastman Kodak's Q-80 Sheet describes this.

Courtesy Colight, Incorporated

Courtesy K & M Manufacturing Co.

Small-Source Contact Exposure Units with Filter Turrets and Electronic Timer Control

ister marks on the exact vertical and horizontal centerlines of the copy, making sure they are square. A photographic gray scale and color control blocks should be mounted next to the copy, but outside the crop marks. Transparencies should be mounted with transparent gray scales, register marks and, if possible, a transparency of the color block made with the same type of material as the transparency.

Attaching Color Guides. On reflection copy attach gray scales, color blocks, and register marks with masking or drafting tape. This tape can be removed more easily than transparent tape and without damaging the copy. Pressure-sensitive transparent tape can be used with transparencies. The gray scale should be mounted so that it receives the same illumination as the copy.

Color separation guides should include a photographic gray scale and process ink color blocks. Ideally, these ink patches should be sample printings of the same inks and ink strengths that will be used on the press. Color blocks that have been purchased should be used *only* to identify the various separation negatives. Only color blocks that match the inks that will be used to print the job can give an accurate indication of the color separation of the copy.

REGISTER DEVICES

When shooting black-and-white copy, requirements for the photographic equipment used for holding the negative or positive in position are not too critical. The only strict requirement is that it hold the sensitive emulsion flat in the focal plane.

When working with color, however, greater precision of image placement is necessary. When separations are made to be used in photo-composing machines, the centermarks of the copy should be within one-eighth of an inch of the center of the plate on all separations. Some masking techniques require that a mask be shot, processed, and replaced in the identical position within the camera, so that a negative can be shot through the mask. In this case, it is imperative that the mask registers with the image of the original art being shot.

Three-Point Register Bar

Three-Point Register System. Three-point register systems have been developed which will position a series of glass plates in exactly the same place in the camera back every time. The bar used in these systems is designed so that the glass plate rests on two elevated knife edges and butts up against a third. The plate makes contact with the holder at only three points.

Punch Register Systems. A number of registering devices have been designed for working with films. They range from a very simple punch and contact frame combination for small

Kodak Punch and Contact Frame

Berkey-Aldis Camera Punch

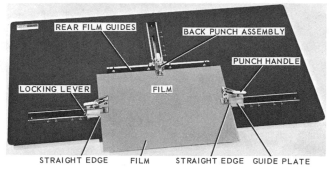

Kodak Register Punch

work, to elaborately designed and manufactured precision punch units which can handle up to 30" x 30" films, and even larger. These systems make it possible to pre-punch sets of films so that separations and masks can be made in perfect register with each other. Some of the more elaborate units can be correlated with pin set-ups which are permanently installed in the camera back, vacuum frame, or photo-composing machine.

Section Six: The GATF System for Calculating Mask Strength

In this section you find a presentation of the GATF system for calculating mask strength. The subject is divided into a discussion of single masking and two-stage masking.

SINGLE MASKING

Our presentation of calculating mask strength in single masking covers the following three points: (1) The yellow printer, (2) The magenta printer and (3) The cyan printer.

Yellow Printer. The redder the magenta (process red) ink being used, the greater the mask strength needed to correct the yellow printer (blue filter negative). The percentage strength of the mask for the yellow printer is usually determined by dividing the following densitometer readings of the magenta ink patch:

$$\frac{\text{Reflection density of magenta patch through blue filter}}{\text{Reflection density of magenta patch through green filter}}$$

= percentage strength of mask for yellow printer

If, for example, you get a reading of .60 for the magenta patch through the blue filter and a reading of 1.20 of the same patch through the green filter, then the percentage strength of the mask for the yellow printer should be:

$$\frac{.60}{1.20} \text{ or } 50\%$$

This mask should be made from the green filter magenta separation, and developed to 50 percent of the density range of the blue filter yellow separation negative.

Since the cyan ink also introduces an error in the yellow separation a calculation should be made to measure its extent.

Use the same formula as before. This time, however, substitute the density values that you determined for the cyan patch using the blue and green filters. If these values are those in the chart shown, the calculation is:

$$\frac{.28}{.40} = 70\%$$

The first calculation called for a 50 percent mask for the yellow printer. If the second calculation had also produced a value of 50 percent, then a single mask for the yellow printer would give perfect correction for both errors.

In this case, however, the second calculation produced a value of 70 percent. This tells you that a single mask cannot perfectly correct both errors. The residual cyan error will be 20 percent undercorrected if you match the magenta error which requires a 50 percent mask. Or the magenta will be 20 percent overcorrected if the mask is made to correct the cyan error which needs a 70 percent mask. Usual practice would leave one color undercorrected rather than overcorrected, and, in this case, an extra mask could be added from the cyan printer negative.

The term "balanced inks" has been applied to sets of process inks in which the magenta and cyan have close to a matching ratio of blue and green absorption, and thus color correct most efficiently with a single mask.

Magenta Printer. The percentage strength of the mask for the magenta printer (green filter negative) is computed by

dividing the following densitometer readings of the cyan (process blue) color patch:

Reflection density of cyan patch through green filter
———————————————————————————————
Reflection density of cyan patch through red filter

= Percentage strength of mask for magenta printer

For example, if the reflection density reading of the cyan patch through the green filter is .40 and 1.25 when measured through the red filter, the percentage strength of the mask for the magenta printer should be:

$$\frac{.40}{1.25} \text{ or } 32\%$$

This mask should be made from the red filter cyan separation negative, and developed to 32 percent of the density range of the green filter magenta separation negative.

Cyan Printer. The basic determination of a mask for the cyan printer is not similarly made directly from the set of color filters density numbers as the masks for the yellow and magenta printers were. All color correction masks, of course, are always expected to clean out the printing color in the unwanted color areas, such as yellow out of blue and magenta out of cyan and green. They also do other important things such as increasing the saturation of the printing color relative to black in the picture and may also adjust the gray scale tone values relative to the other color printers. In the uncorrected cyan printer the unwanted color areas of red and magenta need only a small degree of lightening but the cyan areas still need almost as much strengthening relative to black as the magenta printer does.

When using a Trimask Type of single film mask for camera back or transparency masking the degree of gray scale correction of the cyan separation is very much the same as its reduction of the magenta separations gray scale. The required imbalance of the cyan gray scale to the yellow and magenta gray scale for printed ink gray balance is then adjusted in the development of the three color separation negatives which can then be screened alike. With separate negative, silver, camera-back, or transparency masks, the same principle can be followed. Make the mask for the cyan printer the same percent density range as the mask for the magenta printer. This mask for the cyan is commonly made with an 85B filter to give approximately the low degree of color correction required in red. With typical positive masking of color separation negatives with equal density ranges, the mask for the cyan printer may be approximately 85% of the mask for the magenta to permit giving printed gray balance from equal positive screening.

TWO-STAGE MASKING

Our discussion so far has dealt only with single masking. Under certain conditions of printing, single masks may overcorrect and remove too much color. In such cases, twice as many masking steps or additional handwork will be needed to correct the separations. Just what the situation is for a given combination of paper and set of process inks can be determined by density measurements of the GATF Color Test Strip on the Color Chart. Keep in mind that the situation will be different for each combination of different papers or sets of process inks.

Yellow Printer. Measure the density of the solid area of yellow and the density of the solid area of magenta. Make these measurements with the blue filter over the densitometer aperture. Add these two density values. Then measure the density of the area where the solids of yellow and magenta overlap (the red block). If the sum of the densities of yellow and magenta when measured separately is higher than the density of the red overlap patch, then you'll know that a single mask will probably overcorrect the yellow printer. A single mask will take some yellow out of the reds and browns.

In such a case, you'll need a second mask or additional handwork on the yellow printer. This second mask is called a premask. It can be a 50 percent to 100 percent positive made from the yellow separation negative. A positive made from this combination is the final mask for the yellow printer.

Magenta Printer. To determine whether a single mask will overcorrect the magenta printer follow the same procedure just described for the yellow printer. In this case, however, use the green filter over the densitometer aperture. Measure the density of the solid blocks of cyan and magenta separately and add them together. Then measure the density of the block where the cyan and magenta solids overlap. (With ideal inks, the color produced by overlapped cyan and magenta will be blue. With commonly used inks, the color is usually a purple.)

If the density of the individual cyan and magenta blocks when added together is higher than the density of the overlap block, then a single mask would probably overcorrect the magenta separation. It is likely to take too much magenta out of the purples and blues and shift their hues toward green or cyan.

The pre-mask required in such a case is a 50 percent to 100 percent positive of the magenta separation negative. Make this positive and attach it to the cyan separation negative. The combination positive and the cyan separation negative are then used to expose the final mask for the magenta separation negative.

TONE REPRODUCTION CURVES OF MASKS

The formulas and procedure given to obtain the percentage strength of masks can also be used to prepare tone reproduction curves for the masks for the yellow and magenta separations. Briefly, the way that this can be done is as follows:

Mask for the Yellow Separation Negative. Make two sets of densitometer readings of the solid, three-quarter, one-half, and one-quarter magenta tints in the GATF Color Test Strip. Use the green filter over the densitometer head for the first set and the blue filter for the second set. Now make a graph on paper ruled with 20 lines to the inch and used sideways (see our illustration). Let each ruling represent .01 density unit. Set up these values on both the X (horizontal) axis and the Y (vertical) axis.

The X axis is used for density readings made with the green filter. The Y axis is for the blue filter density readings. One point for the curve is established by using the green and blue values of the solid patches, another by using the green and blue values of the ¾ tints, the third by using the values of the ½ tints, and the fourth by using the ¼ tint values.

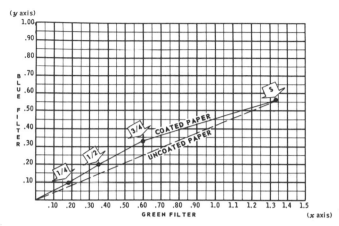

Proportionality diagram showing positive mask curves for reproductions on coated and uncoated papers. The ¼, ½, ¾ and "S" points represent reflection densities of ¼, ½, and ¾ tints; and magenta when measured through blue and green filters.

This proportionality curve now represents the green and blue filter tone values for magenta as they are printed in your plant and with the paper and ink used for this particular color chart. Your aim now is to prepare a mask for the yellow separation with tone values that match this curve.

Put a gray scale on the original copy so that it photographs in all of the separations and in the masks made from the separations. To check the tone reproduction curve of the mask for the yellow printer, plot the curve on the same graph that you prepared of the printed tint values. Use readings of the gray scale on the mask for the vertical Y axis and density readings of the gray scale on the original copy for the horizontal X axis.

Mask for the Magenta Separation Negative. Curves for the cyan tone values and the mask are prepared the same as for the mask for the yellow. In this case, however, you would measure the densities of the cyan patches on the GATF Color Test Strip using first the red filter over the densitometer aperture, and again using the green filter. Plot the red filter readings on the horizontal X axis and the green filter readings on the vertical Y axis.

Curve Patterns. In general, mask curves for 133- to 150-line screens are almost a straight line on offset paper. On coated paper, the mask strength is about 20 percent to 25 percent stronger in the middletones than in the solids. On metal, the middletone curvature is 30 percent to 40 percent stronger than the solids.

The curve for a good positive mask will have the same shape as the curve for the printed tone values. If you are using negative camera back or transparency masking, the curve should be proportionally opposite to the curve for the printed tone values.

The production of a positive mask that matches the curve for the printed tone values usually requires shouldering, that is, the use of overexposure and film that normally would produce high contrast, but which is developed with a weak developer.

The production of a negative mask is just the opposite. The usual need here is to create more of a toe in the curve by underexposing and using materials and methods that produce lower contrast in shadow tones than in the highlights.

For precise work, use a densitometer. Take density measurements of the colors or tints that you are concerned with from the master set of negatives or positives that were used to print your color charts. Compare these densities with readings taken from the job's halftones and adjust the halftones accordingly. *Do not* adjust the job's halftones to match density readings made from printed color charts. Printed densities have been affected by all of the variables involved in your plant's platemaking and presswork conditions.

Section Seven: Undercolor-Removal Masking for High-Speed Wet Printing

The masking methods described previously are designed, in general, for three-color printing or for four-color printing in which only a skeleton black printer is required. In these methods, no account has been taken of the darkening of the picture by the black printer because it will not cause trouble unless it is too heavy. In high-speed wet printing, where the piling-up of the three colors in the same area has to be avoided, special measures must be taken. Wherever ink would be deposited by all three color plates, the same effect can be obtained by carrying the image on the black plate plus a smaller amount of color on one or two of the color plates. A much heavier black printer is then substituted for combinations of the three colored inks, and it is necessary to compensate for this by reducing the amount of the three colored inks which print in neutral areas. The masking method described here, and known as "undercolor removal," takes the colors out of the grays. Our presentation of the subject is divided into the following six

units: (1) Outline of an undercolor removal masking method, (2) Making the color-separation negative, (3) Making the undercolor-removal mask, (4) Making the continuous-tone positives, (5) Making the halftone negatives, and (6) General considerations for undercolor-removal masks. Each of these is presented in the following.

OUTLINE OF THE KODAK UCR MASKING METHOD

This method is applicable to any kind of original and is quite simple in principle. The three color-corrected separation negatives, along with the separation negative utilized for the black printer, are made in accordance with any of the procedures described in this chapter. A positive, undercolor-removal (UCR) mask is then made from the corrected black-printer separation negative. This UCR mask is, in turn, registered

with the other three color-corrected separation negatives when the positives are being made.

The UCR Mask in its Relation to the Color-Separation Negatives. The UCR mask adds an equal amount of density to each of the three color-separation negatives wherever black is to be printed. However, to produce a neutral with conventional process inks, different amounts of density are required in the three printers. This is achieved either by adjusting the balance when making the color-corrected separation negatives so that the magenta and yellow printers have less contrast than the cyan, or by adjusting the contrast of the individual halftones made from a set of matched separation negatives.

Black-Printer Negative and UCR Mask. The chief secret of success with this method lies in making a good black-printer negative and in flattening the highlights of the UCR mask and the highlights of the black-printer positive. The tone gradation should be similar in the mask and in the positive, since the chief object of the black printer is to replace the amount of black that was taken out of the other three printers by the UCR mask.

MAKING THE COLOR-SEPARATION NEGATIVES

Any of the methods described in this chapter can be used for making the color-separation negatives. If the balance of the separation negatives is to be adjusted at this stage, the gray-scale density ranges of the negative printers including any color-correcting masks should be about 1.25 for the yellow, 1.25 for the magenta, and 1.4 for the cyan. In the case of the Two-Stage Masking Method, all should have density ranges in the gray scale of about 1.4. Exact values depend on subsequent steps of the process, particularly the balance of the printing inks.

The Black-Printer Negative. A well-corrected black-printer negative is essential, and it should be further corrected by hand, if necessary, to remove excessive black which may still be present in pure-colored areas. It has been found, however, that black printers which are corrected entirely by hand are unsatisfactory for undercolor masking.

Correcting the Black-Printer Negative. In correcting and retouching the black-printer negative, the chief object is to add density to the areas of pure color in the negative. The theoretically ideal black-printer negative for making a UCR mask would have a density in every area equal to the color-separation negative which is the darkest. If the negatives differ from each other in highlight density, allowance should be made for this effect. With such a perfectly corrected black-printer negative, it would be possible to carry all the gray component of the picture in the black printer. One advantage of this undercolor-removal masking system is, however, that minor errors in the black-printer negative are compensated for in the reciprocal action of the UCR mask and the black-printer positive.

MAKING THE UNDERCOLOR-REMOVAL MASK

A positive UCR mask is made by contact printing through the black-printer negative. If a color-correcting mask has been made for the black-printer separation negative, it should be used

while exposing the UCR mask. A diffusion sheet is used as a spacer to produce the desired unsharpness in the mask. The length of exposure that the UCR mask receives controls the amount of undercolor removal.

It is important that the proper amount of flattening of the highlights in the UCR mask be obtained. In this way, excessive undercolor removal is prevented in colors that are not perfectly rendered in the black printer. This flattening of highlights can be accomplished either by underexposing the UCR mask or by using a fogging exposure similar to that described in connection with obtaining bow-shaped separation negative reproduction curves—as presented in the "Color Separation Photography" chapter of this book. The latter method gives more definite control of curve shape. The amount of fogging exposure required can be estimated by determining how much fogging

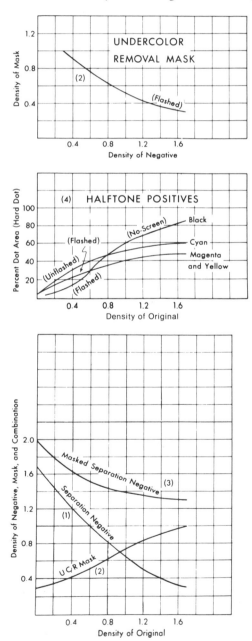

Undercolor-Removal Masking Reproduction Curves

exposure will give a density of 0.3, and then taking three-quarters of this value. The exposure through the black-printer negative and the development should be adjusted so that the UCR mask has a highlight density of 0.3 and a density range that depends upon the amount of undercolor removal desired.

MAKING THE CONTINUOUS-TONE POSITIVES

Using the color-corrected separation negative (yellow, magenta, or cyan printers) that contains the strongest color, register the UCR mask, and set it up in the transparency-holder of the process camera to make the positive. If this particular separation should contain any solid colors, the positive should be developed to a density range of 1.3 to 1.4 between white and the solid colored areas. If no solid colors are required in the picture area, the appropriate color patches in the color control patches (or, preferably, patches of the actual inks to be used) should then have this range. The highlight density of the positives should be no less than 0.4. Precaution should be taken to minimize lens flare in making the positives, as this might cause too much loss of highlight detail.

The UCR mask is next registered, in turn, with the other two color-corrected separation negatives, and the positives from them are made in the same manner. These positives should be developed for the same length of time as the first positive. (If the separation negatives do not all have the same highlight density, the exposure times for the positives can be calculated with the Kodak Graphic Arts Exposure Computer.)

The density range in the picture areas of the different positives may vary considerably and, if the subject does not require any solid colors in one or more of the printers, may be quite low. Do not attempt to equalize the density ranges of the three positives in the picture areas, as this may throw the whole picture off balance.

The black-printer positive is made without using the UCR mask. The highlights of this positive, much like those of the UCR mask, should be flattened by the use of underexposure or fogging. The fogging exposure is determined in the same manner as described above for the UCR mask. However, the development time, and hence the contrast, of the black-printer positive should be higher. A density range of about 1.3 to 1.4 can be obtained with tray development in Kodak Developer D-11 for about six minutes at 68°F.

The black-printer made in this way should have about the same amount of highlight detail as the UCR mask, or slightly more. Halftone, instead of continuous-tone, positives could, of course, be made at this stage.

MAKING THE HALFTONE NEGATIVES

The positives obtained by this method are very unusual in appearance, and some experience will be required in adjusting the balance of the halftone negatives. When working with a masking method, in which the relative contrasts of the separation negatives have been adjusted, the same screen-exposure conditions can be used with all the printers. It is suggested that the printer requiring the most solid color should be made first, and then the other two made in the same manner. For a masking method, such as the Two-Stage Masking Method, where matched separation negatives are used, the screening conditions of each printer must be adjusted to obtain a neutral gray scale. The cyan printer should have greater highlight contrast than the magenta or yellow printers. The exact balance depends upon the printing inks and the printing process.

GENERAL CONSIDERATIONS FOR UNDERCOLOR-REMOVAL MASKS

This method of undercolor-removal masking has sufficient flexibility so that it can be adjusted easily to suit the requirements of the operator. The gradation in the first few steps of the gray scale will be carried by the three color printers, the rest of the scale being supplied by the black printer. The middle-tones and shadows of the three color printers will be completely flattened or even slightly reversed by the UCR mask.

When reproducing copy of lower density range, such as watercolor drawings and similar artwork, and when printing on uncoated paper, the contrast of the separation negatives should be increased to avoid further compression of the scale. The color control patches should not be used in this case, but should be replaced by color patches printed with the inks to be used on uncoated paper. The density range of the color-corrected separations should be such that, when screened in the normal manner, the color patches are produced as solids. In original copy where color saturation of the shadows is especially important, less bowing of the separation-negative curve may be more desirable.

It is strongly recommended that, in the first few attempts to employ this method, curves of the negatives, positives, and masks be plotted, and a color proof be made from the plates, since their appearance is so unusual. Such a set of reproduction curves is shown. In photoengraving, the flat etched plates should be proofed. It is safe to carry the flat etch considerably further than with uncorrected color separations. The further the flat etch can be taken, the more benefit will be gained from the process.

The Litho Art Department

Section One: Equipment of the Litho Art Department

The litho artist or color etcher works with tone values on negatives or positives and interprets them in terms of color values in the printed job. Although there are instruments available to aid in this work, many of the corrections will require a visual evaluation of the color copy. He must also estimate allowances for the printing process variables. This dependence on his eyesight makes it important that working conditions and equipment be such that they will aid the color etcher's work. Our presentation of the subject is divided into the following three groups: (1) General considerations for the litho art department; (2) Furniture and fixtures; (3) Instruments and tools. Each of these is briefly discussed in the following. A more extensive treatment of the subject can be found in GATF Skilled Craft Text #510/11, *Tone and Color Correcting for Offset Lithography*, by Bernard R. Halpern.

GENERAL CONSIDERATIONS FOR THE LITHO ART DEPARTMENT

Some of the requirements for favorable working conditions are: (1) Color environment, (2) Good illumination, (3) Water supply, and (4) Proper working habits. Each of these points is now briefly discussed.

Color Environment. Walls, ceiling, large equipment, shades and other prominent objects should be neutral gray, white or black in color so that they do not add their reflected color values to that of the color original.

Illumination. General room lighting can be white or cool white fluorescent. It should, if possible, match the lighting used to illuminate the color copy. It has been customary in the past to locate the color-correction department with its windows facing north so as to reduce the variables caused by changes in sunlight. It is preferable to block-out all daylight and to use artificial lighting throughout the color-correction department in order to maintain constant light and color values.

Water Supply. Water supply for dot-etching sinks should be delivered through a temperature control valve set to 70° F. The water should also be filtered if sediment or rust is noticeable on the dried negatives or color printers.

Proper Working Habits. Cleanliness, the orderly arrangement of equipment and tools, provisions for temperature and humidity control, and clean filtered air are conducive to good workmanship and improved efficiency.

FURNITURE AND FIXTURES

The furniture should be simple and functional, preferably a neutral gray in color. It should be resistant to staining, warping, or rusting from the water, opaques, dyes, and the etching chemicals used. In the following you find a few notes on: (1) Artist's stand and stool, (2) Easels, (3) Light tables, and (4) Dot-etching sinks or stands.

Artist's Stand and Stool. Continuous, close concentration for color correction requires a stand and stool that

Courtesty Mueller Color Plate Co.

Artist's Stand, Stool and Easel.

will be comfortable and convenient. The working surface of the stand must be uniformly illuminated. A white reflector in the stand or an opal diffusing glass is best as neither causes glare, hot spots, or concentrated light bands to appear through the glass. The light source behind the glass surface may be variable in intensity or fixed at about 50 to 60 foot-candles. The lighting should be white or deluxe cool white fluorescent to agree with that used for illuminating the copy. A black roller curtain fastened to the top of the stand should be provided to confine the illuminated area to the height of the negative or positive so as to reduce glare and eyestrain.

Easel. The easel for holding artwork is best attached to the artist's stand so that it can hold the copy securely without interfering leg supports. It should be equipped with a pair of adjustable fluorescent fixtures to illuminate the copy uniformly. Deluxe cool white fluorescent lamps should be used for normal color judgment unless the customer's viewing conditions require special lighting. Provisions should also be made to house the transparency viewer when working from color transparencies.

Courtesy Zarkin Machine Co.

Dot-Etching Stand with Sink and Footvalve Controls.

INSTRUMENTS AND TOOLS

Satisfactory equipment and tools contribute to the color etcher's efficiency and good workmanship. Here we discuss the following nine kinds of equipment: (1) Equipment for inspection; (2) Color viewers; (3) Magnifiers; (4) Densitometers; (5) Gray scales; (6) Color combination charts; (7) Airbrushes; (8) Needles and knives; and (9) Trays and brushes.

Equipment for Inspection. As the color of the copy under inspection during color correction is directly altered by the type of illumination used, all lighting should be the

Light Table.

Light Table. A light table, similar to a stripping table, is used for squaring-up negatives, and to rule, opaque, border or add register, trim, and other reference marks. Its internal illumination should be uniformly diffused without hot spots or undue glare. Squared, machined edges and a stainless steel T-square are useful additions.

Dot-Etching Sink or Stand. As the dot-etching sink or stand is used for extended periods of time, its height and the location of the water controls must be convenient. Its housing construction should be of stainless steel to withstand the chemicals and the water. The internal lighting beneath its glass surface must be uniformly diffused to avoid glare and eyestrain. The sprinkler pipe and flushing hose are best controlled through foot-operated valves.

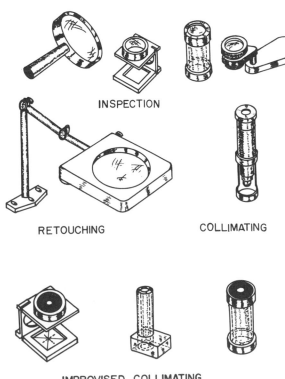

INSPECTION

RETOUCHING COLLIMATING

IMPROVISED COLLIMATING

Magnifiers.

same throughout the art department. The only exception is where special lighting must be used in a transparency viewer to provide a specific color temperature. Close, intricate work requires a level of illumination on the working surface of between 50 and 100 foot-candles. This is least tiring to the eyes.

Color Viewers. Color comparison is best judged and matched at the higher values of color temperatures, such as 7,500° Kelvin. However, color itself can be better interpreted as it will be seen by the consumer, when viewed at a lower color temperature, such as 4,500° Kelvin. Accordingly, this lower value is more commonly used in the color-etching department. The deluxe cool white fluorescent lamps are usually rated at about 4,500° Kelvin.

Magnifiers. Magnifiers are a useful extension of the eyesight in both continuous-tone and dot-etching corrections. Those used for dot-etching should be of at least 10-power to 15-power. The pocket microscope with magnifications from 20-power to 50-power, or higher, is excellent for judging dot size. High-powered magnifiers are essential for observing and evaluating dot size during the progress of the etching operation.

Using the Densitometer.

Densitometers. A transmission densitometer measures the proportion of light that will pass through selected areas of the separation negative or positive. It scales this transmission in terms of density units. The density scale runs from 0.00 to 3.00, or higher. A density of 0.00 represents a completely transparent area. A density of 3.00 is practically opaque.

Density values are calibrated to a logarithmic scale to keep the numbers low and in comparable proportions. The density numbers are the logarithm of the ratio of the percentage of the incident light that is transmitted through the negative. An area with a density rating of .30 will transmit twice as much light as .60 area, or five times as much as an area with a density of 1.00. Similarly, an area with a density of 2.00 will let through only one-tenth of the light that an area with a density of 1.00 will transmit.

Gray Scales. Where densitometers are not available, the commercial calibrated gray-scale filmstrip can be used as a simple comparison densitometer for approximate val-

Courtesty Mueller Color Plate Co.

Using an Airbrush.

ues. When using the gray-scale filmstrip, observations must be made over a light table having a uniformly diffused illumination. The neutral-gray spotting cards must also be used for comparing the density value in the subject with the gray scale.

Color Combination Charts. Several fairly complete color combination charts or "Color Atlases" are commercially available. They represent a range of color combinations of three selected process-ink colors and black, usually in ten-percent dot size steps. Similar color combination charts in a limited range are obtainable from some of the ink houses.

Every lithographic plant actively engaged in color work should have its own color chart. The most effective and the most economical way in which a color chart can be made is by following the GATF method. The Foundation provides the necessary negatives or positives as well as complete instructions for making of your own color chart. For further information consult the GATF publication, Bulletin #320, *The GATF Color Chart.*

Airbrush. The airbrush has limited application for adding density to continuous-tone negatives or positives. It provides the means for increasing density uniformly within the bounds of frisket-paper masks, or applying it gradually as a vignetted density change. Its principal applications are for adding density to required areas of con-

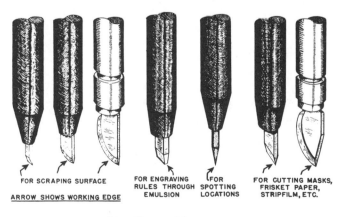

FOR SCRAPING SURFACE · ARROW SHOWS WORKING EDGE · FOR ENGRAVING RULES THROUGH EMULSION · FOR SPOTTING LOCATIONS · FOR CUTTING MASKS, FRISKET PAPER, STRIPFILM, ETC.

Needles and Scrapers.

tinuous-tone positives or negatives, for increasing contrast of curved surfaces where a gradual density change is required, or for adding or changing color values as applied to a transparent overlay over the copy.

Needles and Knives. Scraping and engraving tools are sometimes used for local partial removal of negative or positive densities. They can also remove the emulsion completely as when scribing line detail in negatives, or for cleaning up the highlight points in the positives. Knives

and needles used for scraping and engraving must be carefully stoned to provide clean, sharp edges. Round needles make poor engraving tools as they tend to furrow and tear the emulsion.

Trays. Enameled or plastic trays are preferred over stainless steel or Monel Metal trays for dot-etching purposes because of possible chemical reactions with the metal. Translucent or transparent plastic trays are particularly desirable for staging or flat-etching halftone printers.

Section Two: Materials Used in the Litho Art Department

Our discussion of the materials used in the litho art department is divided into two units. Materials used for manual color correcting and opaquing form the first group. Materials for dot-etching are described in the second.

MATERIALS FOR MANUAL COLOR CORRECTING AND OPAQUING

Hand color-corrections consist of physically adding or removing density from the photographic image. They require considerable skill and good tools to conform to the photographic detail and to produce the required color proportions in each element of the subject. Our discussion of the materials used in hand color correcting and the related opaquing includes the following ten items: (1) Stumps and graphite powder; (2) Pencils; (3) Dyes and neutral groups; (4) Red dyes; (5) Opaques; (6) Artist's brushes; (7) Farmer's reducer; (8) Abrasives; (9) Bleaching agents; and (10) Litho crayons and tint sheets.

Stumps and Graphite Powder. The stump consists of a roll of soft paper shaped like a pencil. It is provided with a blunt point. When rubbed into fine graphite powder, it picks up some of the graphite. This grapite is then applied to the negative surface. It is worked in gradually. Additional graphite is added a bit at a time to blend it into the subject detail.

Pencils. The pencils used may range in hardness from 4B to 6H depending on the amount of density to be added and whether fine lines or corrective re-working of areas are necessary. The pencils are sharpened with a long gradually tapered point to retain their working tips as long as possible. Small, circular-arc strokes usually are used and are blended together to avoid a visible pattern. Hard pencil lines can be used for delineating outlines, textures, designs, or highlight detail.

Stumps, graphite and pencils serve to increase the density on continuous-tone separations or positives. The dry plates that are usually used for making separations are provided with a fine matte surface on the emulsion. This surface will accept the retouching pencil or graphite. Where other negatives or positives are used, it is necessary to flow or wipe a thin coating of a commercial retouching fluid over its surface to provide a "tooth" to hold the graphite.

Dyes and Neutral Grays. Dyes and neutral grays are commonly used on continuous-tone separations and positives to add density wherever required. They can be applied more smoothly than pencil or stump and graphite. They are generally used for area corrections.

Red Dyes. Red dyes are still used as they provide a more readily visible record of the areas in which the corrections have been applied. The experienced color etcher can interpret the red application in terms of total negative density. This can be confirmed by looking at the negative through a green filter, and the total density in any area directly related to a corresponding step on the gray scale. Red will photograph the same as gray or black when the halftone positives or negatives are made.

Opaques. Opaques are used to border the printing subject and block-out the surrounding marginal non-printing areas of a negative. They are applied with brush and ruling pen. Opaques are also used to fill in solid color detail on positives and to provide clean highlights on both continuous-tone and halftone negatives. Colloidal graphite opaques are usually preferred since they can be applied as a thin, smooth coating, free from pinholes, granularity and lumps.

Artist's Brushes. Red sable and camel's hair brushes are used for applying dyes and opaques. Good quality, medium-sized brushes such as No. 4 or No. 6 are generally suitable. They can be used for applying fine detail, as well as covering larger areas, since they carry a good reserve of opaque or dye.

Farmer's Reducer. Farmer's reducer in reducing photographic density will also decrease the contrast range of detail, within the areas on which it is applied. It should, therefore, be used sparingly on continuous-tone negatives or positives.

Abrasives. Abrasive erasers and abrasive pastes are sometimes used for local reduction of density values. They are useful particularly where quick corrections are to be made, or where chemical reducers cannot be applied conveniently, as in working on the inclined surface of the artist's stand.

Bleaching Agents. Where complete removal of all photographic detail is required in large areas, common bleaching solutions of hypochlorite ("Chlorox" or equivalent) work fast and clean. Detail surrounding the area

to be cleared should first be painted out with a protective staging lacquer or asphaltum.

Litho Crayons and Tint Sheets. Texture effects can sometimes be applied when adding density to continuous-tone negatives or positives in fake-color work. The litho crayon, Ben Day tints, or commercially available screen texture patterns can be applied to the surface. When patterns are applied, they must be proportional for the color combination required. They must also be positioned so that the angle of the texture will not produce a moiré pattern when making the halftone.

MATERIALS FOR DOT-ETCHING

Dot-etching is the careful application of an etching solution to the exact areas and for the exact time that is needed to reduce the local dot size to that required so that it will produce the wanted color value. The materials used to control this operation are discussed under the following three headings: (1) Staging lacquers and resists; (2) Combining staging materials of different solubility; and (3) Etching solutions. Each of these is now individually discussed.

Staging Lacquers and Resists. Asphalt varnish is usually mixed with a small proportion of printing ink or varnish, to prevent embrittlement and improve its working properties. This is further thinned down with turpentine to a consistency suitable for application with a camel's hair brush. The asphalt resist is used widely for staging-out areas so as to control density reduction on continuous-tone images or dot size by dot-etching. Lacquers are also available for staging. Staging lacquers are usually transparent red in color. Their transparency makes errors in staging readily visible. Many of the lacquers can be stripped off the emulsion surface after use, without requiring a solvent.

Combining Staging Materials of Different Solubility. Several staging resists can be used together advantageously to reduce correction time. The areas requiring the least etching can first be bordered with a lacquer resist. The areas requiring slightly more etching are then bordered with an asphalt resist. After the first etching the asphalt is washed off with a solvent that will not dissolve the lacquer. The second etching is then made.

Etching Solutions. Farmer's reducer is most commonly used. It is safe, can be easily controlled, and exhausts itself after use so that etching is definitely stopped. Some plants use a cyanide-iodine etch for fast work. This etch has some disadvantages and the trend has been away from its use.

Other reducing solutions are sometimes used for their particular properties. Their formulation and action are described in folders or booklets issued by the graphic arts film manufacturers. However, it is best to become thoroughly familiar with the working of Farmer's solution and adhere to it so that a uniform and efficient control over color correction is maintained.

Section Three: Opaquing

Almost every lithographic job needs opaquing of some kind or another. For this reason the subject is treated here rather extensively. Our presentation of opaquing is divided into the following seven main points: (1) Spotting and patching; (2) Eliminating unwanted areas and lines and adding wanted ones; (3) Opaquing for silhouettes and highlights; (4) Adding register and trim marks; (5) The use of stains, pencils and stumps; (6) Opaquing of positives; and (7) Opaquing troubles.

SPOTTING AND PATCHING

Spotting and patching is treated under four headings: (1) Spotting of type negatives; (2) Spotting of line negatives; (3) Repairing breaks and holes in halftone negatives; and (4) Patching breaks in halftone negatives.

Spotting of Type Negatives. A common form of opaquing is the spotting of type negatives. When these negatives come from the camera, they usually have fine, white pinholes scattered throughout the type. These pinholes would reproduce as spots, if they were not spotted-out. If the pinholes are numerous and no corresponding specks appear on the original copy, then check with your cameraman to see if there is dust on the copyboard glass, or if the darkroom area is dusty. Either condition can cause excessive pinholes. For display type use a #2 or a

Defective Lettering and Pinholes.

#3 brush and follow the type line-for-line. Remove scratches and cuts as around letters A and F and above J in our illustration. As you follow along, look for letters that are misformed or broken, as in letter D. Use your brush first to clean up the excess white areas around the letters; then finish by scraping with the round or oval needle. When working on fine type, the use of a crowquill pen under an enlarging glass will enable you to do the job more accurately.

Spotting of Other Line Negatives. Line negatives may be handled in the same manner as type negatives. First spot out all the pinholes in areas that will not be later covered by goldenrod or other masking. Then check for broken or fogged-over lines. These should be cut open with a fine, flat needle that is sharpened for engraving lines. Fit the size of the needle to the work at hand. When the line is badly broken in a section, it is sometimes advisable to paint over that area with red stain or a thin coating of red opaque, just light enough so that the lines show through faintly and then cut in the faulty section. Curved or irregular lines may be cut by hand, but a curve will help a lot. Straight lines can best be cut with the help of the ruler or straight-edge. A ruling pen will also be found handy in straightening ragged edges.

Repairing Breaks or Holes in Halftone Negatives. Repairing a break or hole in a halftone or screen negative is one of the most difficult things to do. The mechanical formation of dots is such that the slightest irregularity of

Damaged Halftone.

spacing in a repair is immediately visible. A break in the screen tint can be patched in a number of ways. If the black dot is very small, it can best be repaired with a fine, stipple or crowquill drawing pen and thinned black opaque. Work under a magnifier. Be careful to put the dots in perfect alignment with the other dots. It will take a great deal of practice and steadiness of hand to accomplish this. See *"Retouching and Adding Detail"* in Section Five of this chapter.

Patching Breaks in Halftone Negatives. If the dots are large and it is not a rubber-coated negative, you can patch the break by drawing fine parallel lines of the same width as the dots, following the dot line in any one

direction. These parallel lines can then be cut through with an engraving needle under a magnifier so as to form square dots. Do not try to cut in both directions on a dry plate; because of such cutting, the emulsion will separate from the glass.

ELIMINATING UNWANTED AREAS AND LINES AND ADDING WANTED ONES

Eliminating unwanted and adding wanted areas and lines is discussed under the following four headings: (1) Opaquing for key-outline jobs; (2) Eliminating unwanted tint areas; (3) Opaquing on color separations; and (4) Adding solid areas or lines on screened negatives.

Opaquing for Key-Outline Jobs. A set of negatives to provide individual color separations are made from original color artwork or from key drawings with color overlays indicating where the different colors are to be placed. It is the job of the opaquer to separate the colors on the negatives by opaquing the areas or lines not wanted on each negative. This work is then completed on the contact positive that is made from the negative by filling in with opaque those solids not already created in the negative stage. Sharpness and accuracy are vital. Where color overlap between adjacent color areas is not provided for, this can be added on the positive. Where colors run into heavy, black lines or black solids, the amount of overlap can be more than where color meets color, or color meets a thin, black line. Judgment and experience are the best guides for the amount of color overlap to be used.

Eliminating Unwanted Tint Areas. Where original key drawings are provided, tones of the solid colors are made by flat, halftone tints placed on the negative or perhaps on the positive. If put on the negative, the excess may be opaqued off sharply to the outlines. If put on the positive, the excess may be scraped off, trimmed off, or the tint may be staged-out with asphaltum or lacquer and the unwanted part etched away. Where different strengths of tones are desired, a stronger tint can be placed down and by successive stagings and etchings the different tones can be obtained.

Opaquing on Color Separations. When you have become very proficient at opaquing, the retouchers will probably call upon you to do some of the opaquing necessary on their color-separation negatives. Black water opaque is most often used. Be careful and accurate. Do not touch the work area with your hands as fingermarks will show up on the positive. Use an arm board or ball-stick, or a piece of clean paper for resting your arm while working. Usually lettering, panels, or background sections must be opaqued out. Be accurate when following contours.

Adding Solid Areas or Lines on Screened Negatives. If there are solid blacks in the copy, they can be reproduced by scraping away the dots on the negative. Even fine lines can be cut in with the aid of a fine, flat needle. Only as much need be done as is required by the customer for whom the job is being done. Some will not expect every tone or line, but others will. When positives are to

Separate Pieces of Copy Grouped.

Opaque Masks.

be made, all lines and solids can be put in with india ink or opaque much easier than they can be scraped in. Red or black water opaque may be used, as may stain, tinfoil, and masking paper, according to conditions.

OPAQUING FOR SILHOUETTES AND HIGHLIGHTS

Opaquing for silhouettes and highlights requires exceptionally high skill. Here we discuss the following three points: (1) Opaquing for highlights; (2) Opaquing the background of silhouetted negatives; and (3) Making opaquing masks for multiple use.

Opaquing for Highlights. Most pictures, particularly pictures of mechanical subjects, have numerous highlights. Since the normal halftone reproduction gives a dot all over the negative, it is necessary in reproducing such pictures to opaque out all highlights. It takes considerable skill to do the job cleanly and sharply. Any roughness or carelessness will detract from the quality of the finished reproduction. The larger white areas of the original copy (the dark parts on the negative) can best be stopped-out with a brush. Use your opaque just heavy enough to completely cover the dot. Any excess amount of opaque that dries as a ridge or lump will hold the negative out-of-contact in making the positive, whether on glass or plate. For irregularly shaped highlights, use a fine, pointed brush; for straight lines, guide your pen or ruling pen along a straight edge.

Opaquing the Background of Silhouetted Negatives. Some drawings are silhouetted against a white background. In this case the background must be opaqued out in the negative. Use a #3 or #4 brush and opaque up sharply to the picture, taking care to retain the character of the original. Where there are soft, blend-out tints in the original, opaque them a little way from the margin where they fade out, so that the fine dot can be blended off. This blend-off can be accomplished in a number of ways. You might use lithograph crayon, or spatter applications by airbrush. With a little practice with the crayon, you will be able to produce quite satisfactory results.

Making Opaquing Masks for Multiple Use. Some color jobs are made up of elements which are silhouetted against a white or a one-color background. Other jobs have numerous white highlights. It is unnecessary to repeat the same opaquing on each negative. One mask may be prepared and used on each of the color negatives in turn, thus saving the time required to opaque each of the color negatives. The mask is clamped, or taped, in register with the continuous-tone negative and does not interfere with any previous retouching.

Because of the fact that the opaquing is done only once, each of the plates is identical and the finished positive is much sharper than if each had been worked on individually. This mask plate is made on a continuous-tone positive obtained by contact. Use the negative that shows the best outline for making this contact positive. Opaque out all the parts that are to be white with a turpentine or lacquer base opaque. Then etch out all the tones not wanted. Be sure not to disturb the opaque during this etching operation.

ADDING REGISTER AND TRIM MARKS

Register and trim marks are discussed under the following four headings: (1) Register marks; (2) Corner marks and bleed marks; (3) Marks for double and for multiple exposures; and (4) Indicating the top of the sheet.

Register Marks. The marks for any job that is to go in the photocomposing machine should be in the exact center on all four sides of the sketch and should be at right angles to each other. They should be made as fine as possible, since the engraved lines in the register device of the

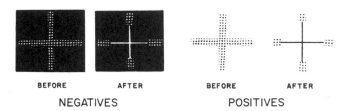

BEFORE AFTER BEFORE AFTER

NEGATIVES POSITIVES

Re-worked Register Marks.

photocomposing machine to which they are positioned are very fine. Registering to either side of such a mark may cause a discrepancy of as much as .005 of an inch. These marks are called centermarks. They are used to position the print on the plate. They are also used by the prover and the pressman when registering the printed sheets. Therefore, the necessity for fine accurate marks cannot be over-emphasized. If a lineup table is available, be sure to rule in the marks with the aid of this machine.

Corner Marks and Bleed Marks. Marks indicating the extreme size of the job are called corner marks. If there is to be a bleed (an extra amount of area to allow for folding and trimming variation), there will be a second mark called a trim or bleed mark beyond the corner mark. This outside line is a guide for opaquing away the waste area on the outside of the job. The corner marks along with the centermarks help in laying out the job on the photocomposing machine, and guide the pressman, the folder, and the cutter in their operations.

Marks for Double and for Multiple Exposures. When double or multiple exposures are made, there are identical extra long marks placed on each blueprint glass to make it easier for the registry of the separate exposures. If diecutting is to be done later, as on display work, outside guide lines may be put on. To help in folding, special marks may be put on also.

Indicating the Top of the Sheet. It is advisable to ring three of the four centermarks or to opaque out the fourth mark so that the same top is always taken. As the four marks are seldom square with each other, this will assume that the same three marks will be used on each color to provide a good color fit.

THE USE OF STAINS, PENCILS AND STUMPS

If you are going to use stain, do all the staining before starting to opaque. If you use either stain or airbrush, be sure the surface of the negative is free of grease or finger-

prints as they will make the finished job spotty. Here we discuss first the application of stains, and then the use of soft pencils and stumps.

The Application of Stains. To use stain take a small wad of damp cotton and moisten the surface to be worked. Any surplus water left on the negative will cause the stain to run. Use the stain greatly reduced to avoid steps in the blend-off. Hold the brush in one hand, the damp cotton wad in the other. Apply the stain and immediately wipe it off. Apply the stain again, just a little back from the edge of the first application, and wipe again. Each application increases the density of the stain and, if you repeat this process carefully time after time, you will get a smooth, even blend from a tone that is barely perceptible to the full strength of the stain. Do not be discouraged if your first attempts are rough and irregular. It will take a great deal of practice to do the job smoothly, but it can be done. Blending can also be done with an airbrush, but that is a job for a litho artist.

The Use of Soft Pencils and Stumps. If the negative has a matte or ground glass surface, a soft pencil can be used. A paper or chamois stump and graphite, or lampblack, will do a very smooth job. Some use the stump dry, while others prefer an oil stump. Be sure to do your opaquing before using the lampblack or graphite, as they will repel the opaque.

Courtesy Colorcraft Litho Plate Co.

Applying Graphite with Stump.

OPAQUING OF POSITIVES

A positive is the exact reverse of the negative. The areas which were transparent in the negative are solid black in the positive. Most of the things that you have learned in handling negatives can be used equally well on the positive.

All areas which should print as solid color must be opaqued if they are not already solid in the positive. This includes panels, outline lettering, or halftone lettering which should be solid and solid shadows in the design. Whenever possible, use black water opaque on positives as it is thinner,

lies flatter and smoother, and will not pick off on the print. When blending a strong halftone into a solid, the same methods can be employed as were explained in handling blend-offs on the negative. See "Blending" in Section Five of this chapter.

OPAQUING TROUBLES

No matter at what trade you work, they all have their troubles, and the lithographic trade is no exception. Here are some of the difficulties you will encounter and also the remedies. As you gain experience, other little tricks of the trade will suggest themselves to you. We discuss the following five kinds of opaquing troubles because they are the most common ones: (1) Greasy negatives; (2) Powdering of greasy negatives; (3) Dirt spots; (4) Loose ends; and (5) Re-coating troublesome negatives.

Greasy Negatives. First we will discuss greasy negatives. Occasionally you will run across a negative which seems to have a greasy film over the surface which repels or fights the opaque. You will make a stroke with the brush and the opaque immediately creeps back, leaving you a rough or saw-toothed edge. When you use the ruling pen, the fluid is reluctant in leaving the pen, and when it does, the line is not sharp and clean, but broken or ragged.

Powdering Greasy Negatives. The cause of this greasiness is either in the making of the negative, excessive handling, or a condition of the coating. When you run across one, first try cleaning the negative with cotton or tissue and a grease solvent. Commercial negative cleaner solutions are available for this purpose. If still slightly greasy, try powdering the negative with powdered talc (french chalk). Dust off the excess powder and try opaquing again. If that doesn't work, add a few drops of a wetting agent to the opaque dish and stir it in. Or use acetate or turpentine opaques that will adhere better to greasy surfaces.

Dirt Spots. Sometimes in going over a negative you will find dirt and lint specks adhering to the emulsion. In most cases they can be removed with a little piece of cotton on the handle of your brush, and water. If that doesn't remove it, test a little gasoline or alcohol on the outside edge of the negative and, if they do not affect the negative, try removing the spot. Be very careful not to use a solvent on a plate which will dissolve the coating or the emulsion of the negative.

Loose Ends. On all stripped jobs it is good practice to examine the negative carefully for loose ends and corners before starting to opaque. If you find any, take the plate back to the stripper and he will cement these down. If the corner or edge is such that it can be removed without losing work area, it can be trimmed off with a sharp razor blade or cutting needle. Be very careful not to cut into the work.

Re-Coating Troublesome Negatives. When you have a stripfilm negative assembly that repeatedly gives you trouble, it can sometimes be given a top coat of rubber and collodion. Better let the man who does the coating do this. He will know whether it can be done without ruining the negative. When opaquing a stripped negative, use your opaque as dry as possible as this will help to prevent the opaque from creeping under the film. When using the ruling pen, use as little pressure on the pen as possible as you might cut the film.

Section Four: Procedure for Manual Color Correction

Manual hand methods of color correction are used on continuous-tone negatives and positives. They consist of adding or subtracting density to the photographic separations in proportion to the ink-color density required in printing. Even where most of the shop procedure is based on dot-etching, some preliminary work on the continuous-tone separations can reduce the amount of etching required. This is especially true where color changes are specified in local areas that cannot be done by photographic masking techniques.

Work on continuous-tone separations is also needed where retouching is done to remove blemishes in skin tones, wrinkles, photographic defects, or unwanted spots on objects. Where a color job is to be reproduced in several sizes, the total correction time can be reduced materially by partial corrections on the continuous-tone separations. Details for planning the amount of hand correction to be done, and the procedure, follow. They are discussed under the following seven headings: (1) Evaluating a set of color separations for manual color correcting; (2) Inspecting for manual color correcting; (3) Establishing job standards; (4) The black printer; (5) Subtracting densities from separations;

(6) Adding density to separations; and (7) Density corrections on continuous-tone positives. Each of these subjects is briefly discussed in the following. (Readers interested in more detailed information are advised to consult the GATF Skilled Craft Text #510/11, *Tone and Color Correcting for Offset Lithography*, by Bernard R. Halpern; chapter IX in particular.)

EVALUATING A SET OF SEPARATIONS FOR MANUAL COLOR CORRECTING

The main source for job evaluation is the job jacket; it should contain the following minimum information: (1) Kind of plates to be made; (2) Number of colors to be printed; (3) Size of final job; (4) Kind of paper to be used; (5) Type of color correction and degree of photographic masking to be used; (6) References to previous printings of the same job; (7) Special instructions; and (8) Time schedule. Most of these points do not need further discussion for the purpose of our presentation. Several points to be checked are:

Number of Colors to be Printed. Determine whether standard three-color-and-black printings are to be used, or if additional printings are required. If special colors are to be used in place of the standard process colors, they must definitely be established and agreed upon before color correction can be undertaken.

Type and Degree of Photographic Masking. Determine whether masking corrections have been used or are to be used on all separations. Also if highlight and other additional corrective masking will be provided. Usually all such corrective masking is agreed upon in advance and accompanies the separations. However, the color etcher may be required to specify the exact type of masking that will be needed for a particular job.

Special Instructions. Determine how much color-correction work is required. This should be stated as total number of man-hours or cost allowed in the estimate. This may also be coded by the job quality symbol. Are there any general and local color changes specified? Is the entire copy to be reproduced? Will it be cropped down to a selected portion? What particular color areas must be held? Few color jobs are accurately reproduced in entirety or the cost would be prohibitive. Accordingly, important color areas must be established. Is special lighting to be used for viewing the transparency or copy?

INSPECTING FOR MANUAL
COLOR CORRECTING

The separation negatives must be inspected for the following four points: (1) Defects; (2) Registration; (3) Density range; and (4) Color change areas. Each of these points is briefly discussed.

Inspecting for Defects. Study each separation carefully. Compare them with the copy to make certain that there are no serious physical defects such as scratches or tears. Look for photographic defects such as blocked-out areas due to light reflection; out-of-focus areas due to copy movement, negative movement, or an off-square camera; slurred detail due to out-of-register masking; or development defects such as clear spots due to air bells; or cloudy, discolored, or stained areas. If these defects cannot be corrected the separation should be replaced.

Inspecting for Registration. Separations that are exposed on film, or made in part on different days, or temporarily interrupted by other camera work before the set was completed, may not agree with each other in size or proportions. A quick visual check for register between film separations can be made on a light table. If the separations are on glass, the thickness of the glass may make such a comparison difficult. A collimating magnifier can be used to align the register marks and the detail through the thickness of the glass.

When any serious questions arise concerning the possible misregister between a set of separations, such as may be due to the copy shrinking or stretching during the exposures, a photographic check gage should be made. This consists of a photographic contact print that is made from one of the separations. It can be exposed on film or on a dry plate depending on the degree of accuracy that is required between the separations. The contact print gage is used to check each of the separations in succession by registering it with them on a light table.

Inspecting for Density Range. Check the gray scale and color patches on each separation, or masked separation, with the densitometer. Make certain that the range of densities of the gray scales are in agreement between the set. Check the color patches, where masking has been added, to see how effective the photographic color corrections are in neutralizing the unwanted color. The amount of under-correction as well as over-correction can be measured from the total densities of the masked color patch areas.

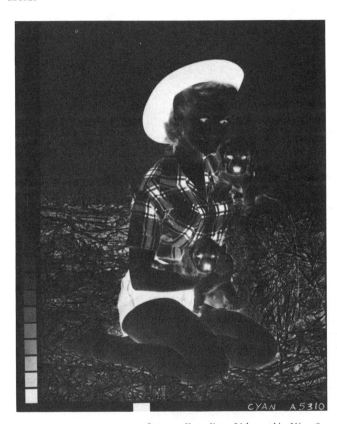

Courtesy Ketterlinus Lithographic Mfg. Co.

Color Separation Negative with Color Controls.

Inspecting Color Change Areas. In areas where color changes have been specified, make certain that the amount of density correction will not be so great that extensive etching or added dye will flatten or obliterate the subject detail. Except in flat color areas, a great density change on a separation will usually require complete reworking of the subject detail and texture by hand-retouching.

The alternatives are (1) obtaining a new separation made through a different filter; (2) masking locally during photography or by use of a special contact mask; (3) combining areas of the subject by double-exposure methods of stripping. These should be weighed against the hours of retouching work that would be necessary otherwise.

ESTABLISHING JOB STANDARDS

Under this heading we discuss the following four points: (1) The standard color chart; (2) Compensating for non-standardized inks; (3) Wet printing and dry printing; and (4) Charting density and dot values. Each of these points is now briefly discussed.

The Standard Color Chart. If possible, obtain a color combination chart prepared in your own plant with the standard process-color inks to be used, and on the grade of paper stock specified. Such a chart can be made by following the instructions of the Graphic Arts Technical Foundation and with material supplied by it. (See the GATF Bulletin #320, *GATF Color Chart Book*.)

If such a chart is not available, any color combination chart will be helpful for interpreting approximate color values. If no commercial color chart or atlas is available, some guidance can be obtained from a previously printed color job whose colors and tone values are similar in range.

Compensating for Non-Standardized Inks. If the color process-inks are standard and have been used to prepare the color combination chart, no ink compensations are necessary. If the inks are not standard, then printed samples of the solid ink colors with percentage tint blocks of each ink must be used to guide in the allowances to be made for their use. These can be taken from the ink supplier's specimen book, if the inks have not been used before.

Wet Printing and Dry Printing. If allowances must be made for wet printing and only a dry color combination chart is available, the gain to be allowed may range up to 25 percent of the printing value in all areas. Approximate allowances for color gain can be made proportional through the range of color values.

	PER CENT										
Desired Color Value	5	10	20	30	40	50	60	70	80	90	100
Dot Size Required	4	8	16	24	32	40	48	56	64	72	80

Color Gain in Wet Printing.

Color gain in wet printing is greatest with the first color printed, and least with the last, usually the black. This is due to the dot size spread caused by the wet ink on the sheet transferring to the blanket of the following press color units.

Charting Density and Dot Values Required for the Job. Draw a rough sketch of the color job; obtain a light photoprint from the black or blue separation; or use a transparent overlay sheet attached to the copy to chart the color corrections to be made. Start with a principal color area on the copy. Use standard or specified illumination. Select a pure color spot that is not textured or variated with shadows and highlights.

Directly compare this spot with the color combination chart. Use the neutral-gray spotting cards for viewing to avoid the influence of adjacent colors. When a close match has been found, note the percentages of ink composing the color block.

Add or subtract to these ink percentages any allowances necessary for the difference between inks that will be used on the job and those used to prepare the chart. Make similar adjustments for the paper stock, overprint varnish, or other factors such as wet printing. Write the final halftone printing dot size values of each ink color for this area on the sketch. This can be simplified by using code numbers in sequence, such as 641P to show that the color desired will consist of 60 percent yellow, 40 percent red (magenta), 10 percent blue (cyan) and a pinpoint dot in black.

Repeat the same procedure for all other principal color areas until a fairly good charting of the desired dot size values for the job has been prepared.

THE BLACK PRINTER

Our short discussion of the black printer is restricted to the following points: (1) Black in three-color printing; (2) Black used for type; (3) The effect of overprinted black on colors; and (4) Black in dry printing and in wet printing.

Black in Three-Color Printing. Dense blacks cannot be obtained by overprinting the three process colors. Fine outline detail that is not printed in black would require the overprinting of the three colors in exact register. A black printer is therefore used for extending the shadow density range and for providing the fine detail outlines to simplify the register problem in printing.

Black Used for Type. As most color jobs are printed together with type composition, the black printer is usually available for use in the color reproduction. While three-color printings may provide satisfactory reproduction, the added black printing will improve the appearance and tone range of the job with no need for an additional press run for this purpose.

The Effect of Overprinted Black on Colors. When black is overprinted on a color it changes the value or brilliance of the color. It does not change the color hue aside from the slight undertone, usually blue, that may be incorporated into the black ink. If a particular area has a mixture of all three colors, the black printer can be used to substitute in part for these colors. In so doing, each of the three color densities should be reduced in proportion to the gray balance value of the process color inks used and to the extent that the black will substitute for the colors.

Black in Dry Printing and in Wet Printing. For runs on single-color presses the use of the color inks in the highlight and lighter tone areas and the practical elimination of the black, other than for outline detail, results in cleaner and more brilliant reproductions. In multicolor wet printings, however, the greater gain in the dot size of each color will gray the highlights.

For wet printing it is best to remove from the highlights the common gray value in all three colors, and leave only the excess of the predominating color or two colors. The black printer is then used to provide all of the common gray value of the three color printers, plus the usual detail and modeling outlines or texture.

SUBTRACTING DENSITY FROM SEPARATIONS

Our discussion of the subject is divided into the following three points: (1) General exposition of subtracting density; (2) Procedure for subtracting densities by chemical etching; and (3) Subtracting density by scraping. Each of them is taken up in the following.

General Exposition of Subtracting Density. A decrease of negative density on continuous-tone separations can be done chemically by use of Farmer's reducer, assisted by some local fine detail work with a scraper. Density corrections are usually limited to those separations where such corrections have not been made by photographic masking. Such work on separations, sometimes called "back-etching," is also done where important color changes are to be made, or where several different sizes of reproductions are required.

With the indirect method of color correction, it is usually better to limit the density changes made on the separation negatives to the major corrections. Further density corrections are more easily made later on the continuous-tone positives that are made from the separations.

Where masking corrections have been used, the added density corrections (such as for local color changes) must apply to the total densities of the separation and its mask. Density can then be added or subtracted from either the separation or mask, or from both, depending on which is easiest to do.

Procedure for Subtracting Density. Here we list the many steps taken in the subtracting of density. The reader can find their detailed discussion in the already mentioned GATF Skilled Craft Text #510/11, *Tone and Color Correcting for Offset Lithography,* by Bernard R. Halpern, P.115-118. First, the overall density range of the separations is checked. Then the density scale relationship to dot size value is established. Finally the required density for the first control area that will produce the desired color value is determined. Then determine the required density in all the other control areas that have been charted.

Next, decide whether local or general density reduction is needed. If the entire subject has excess density, flat-etching can be applied until the area with the least density difference is brought into line. If some density areas are already low or correct in value, these will be staged-out so that the excessive density areas can be reduced to the desired values. The treatment with Farmer's reducer is applied in several stages until all areas are reduced in density to agree with the charted density values. This is repeated for the other separations. Washing and drying are the final steps in the process.

Subtracting Density by Scraping. Following density reduction with Farmer's reducer, study the separation carefully, comparing it with the copy, to see if important fine detail in the highlights and elsewhere has been subdued by the etching. If the highlight detail contrast is partly obscured, or if the shadow outlines are veiled, proceed to clean them out with a scraper. Do not try to remove too much at each stroke. When sufficient density is removed to provide the highlight contrast or shadow detail outlining required, proceed with the next area. After all areas have been cleaned out, dust off scrapings with a wide camel's hair brush.

ADDING DENSITY TO SEPARATIONS

Our discussion of adding density to separations is divided into the following three points: (1) General exposition of adding density; (2) Procedure for adding density; and (3) Adding detail density. Each of these points is now discussed.

General Exposition of Adding Density. When all density reduction operations have been completed, study the first separation again. Compare it with the chart. Use the densitometer again to check areas that require an increase in density. Mark these areas on the chart, preferably with a red pencil, noting the density values that are needed.

Density can be added by use of neutral gray or red dyes, pencil, graphite and stump, or opaque. If areas are to be made denser, dyes should be applied by artist's brush or airbrush. If outline detail or highlight points are to be intensified, a pencil or a fine artist's brush with dye or opaque is used.

Procedure for Adding Density. After preparing the dye solution and adjusting it to the proper concentration the required density is slowly built up by repeated application of light washes of the dye, blotting with damp cotton and by checking the increase in density. Apply the dye to blend gradually with the work detail. The gray scale on the negative can serve as an approximate guide in checking the density obtained.

After the first area in work is built up to the required density, the other areas are treated in the same manner. If the dye application increases the density beyond that needed, some of the density can be removed by wiping the surface lightly with a tuft of cotton that is dampened with the solvent. This may be water or alcohol, depending on the solvent required for the dye in use.

Adding Detail Density. Density additions to detail such as may be needed to add texture contrast or highlight points, or to retouch negative defects, cannot easily be measured. Their areas are too small to read with a densitometer. The color etcher must judge such additions by visual comparison with the gray scale. Brilliant highlight points may be completely opaque, but all other added density for texture contrast will be in various densities of gray. Prepare the diluted grays. Then place opaque, spotting brushes, crowquill pen in holder, wiping tissue and other materials needed on the table or stand where they will be convenient. A magnifier on an extension arm stand or a spectacle magnifier is helpful for applying grays or opaque to fine detail in the approximate density values needed.

DENSITY CORRECTIONS IN POSITIVES

Our discussion of density corrections in positives is divided into the following three points: (1) General exposition of density corrections in positives; (2) Procedures for density corrections in positives; and (3) Finishing and checking the work. Each of these points is now discussed.

General Exposition of Density Corrections in Positives. The indirect method of color correction, where continuous-tone positives are made from the separation negatives and the final halftone negative printers are made from these positives, usually requires much of the density corrections to be applied to the positives.

The correction of positives is easier to master as density increases are *directly* related to the increase of the printing color needed. The subtraction and addition of density to continuous-tone positives require the same techniques as are used in making such corrections on continuous-tone separation negatives, except that the density values will be reversed.

Procedures for Density Correction in Positives. The first step is to prepare a chart of halftone printing values required for each important color area in which color is to be held. Then this chart is marked with the related positive density values required to produce the correspond-

ing dot size. For removal of density as well as for addition of density the same techniques are used on positives as were previously described for negatives in this section.

Finishing and Checking the Work. After all required changes in density values have been made to the point where the remaining color corrections needed can be more easily completed by dot-etching, check the work done. Re-calculate and re-check several important color areas as well as color change areas. Then prepare a chart or note for the process cameraman to inform him what dot sizes are required on the halftone printers. Show these in two or more important color areas or for specific density steps on the gray scale. Try to extend this across a maximum range of important densities.

The dot size requested must allow for any final dot-etching planned for the halftone negatives. Where the halftone negatives are later to be contact printed to provide positives, the negatives will be laterally reversed.

Section Five: Dot-Etching

Dot-etching for color correction consists of reducing the dot sizes of the halftone printers to provide the printing values desired. Dot-etching is generally done on halftone positives. This accords with the deep-etch platemaking process where halftone positives are required. For surface or other plates where halftone negatives must be used, they are usually prepared by contact from reversed halftone positives after corrections have been made by dot-etching. Positives agree in dot size to printing value and so are easier to correct.

Our subject is discussed under the following eleven headings: (1) Suitability for dot-etching; (2) Charting a color value; (3) Dot size and integrated density; (4) Flat-etching; (5) Staging and etching; (6) Local reduction; (7) Blending; (8) Intensification; (9) Retouching and adding detail; (10) Checking the progress of correcting; and (11) Negative color printers. Each of these points is here discussed in full detail.

SUITABILITY FOR DOT-ETCHING

To permit any etching whatsoever, the entire halftone dot must have a density greater than .80 over its entire effective dot size, if it is not to print through in platemaking. This corresponds to holding a solid 6 on the GATF Sensitivity Guide in platemaking. This dot density can only be measured with a micro-densitometer. Such an instrument is not normally available to the color etcher.

Comparing Dot Density. An approximate indication of the dot density can be obtained by direct comparison of the dots with a continuous-tone gray scale on film, as seen under a good microscope. The more a dot is to be reduced in size, the greater its central density must be. The normal camera halftone dot increases in density towards its center. Dot-etching dissolves the silver off the top as well as the sides of the dot in reducing its size.

Different Types of Halftone Screens Produce Different Dots. A halftone dot made through a glass screen may be prepared with one or more exposures. Usually a "flash" exposure is added to produce a hard central core. A glass screen dot has a relatively steep density gradient from the core to the dot margin. A halftone dot made with a contact screen is usually softer. The density

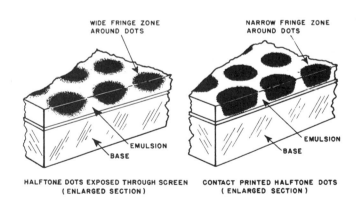

Halftone Dots. Camera and Contact.

gradient between its center and margin is much less. Consequently halftone dots prepared with the ruled glass screen are usually capable of greater size reduction by dot-etching.

Dot Size Reduction. Reductions as great as 40 percent to 50 percent of dot size would be necessary for some color printers such as in the yellow, if masking corrections or back-etching have not been applied to the separations. Extensive dot-etching could also be needed for some specified color changes from the copy if compensations have been omitted in the masked separations. However, in most work where masking has been used, the dot size reduction will seldom reach 40 percent. A good contact screen halftone is then also satisfactory for dot-etching.

Making Duplicate Positives by Contact Printing. If the corrected dots, after dot-etching has been completed, have an insufficient density so that doubtful printing values will result, it is best to duplicate the positives by contact printing. Halftone positives, that are duplicated by contact printing, have a very dense dot structure with a very narrow fringe border. They are preferred in platemaking as their dot size or color values are less altered by exposure or other variations in platemaking.

Halftone positives made by contact printing have too dense a dot structure to be suitable for further important corrections by dot-etching. This dense structure will seldom permit more than a 10 percent to 15 percent further reduction without destroying the central density of the dot itself.

CHARTING A COLOR VALUE

In the preceding section we discussed the subject of charting density and dot values in general; here you find specific step-by-step information on procedure.

Preparatory Steps for Charting Color Values. Obtain an outline chart or use an overlay sheet on the copy on which to chart the required color combination values. Select the first principal area on the color copy. Use spotting cards and the specified illumination for color matching. Locate the color block on the chart that closely matches this

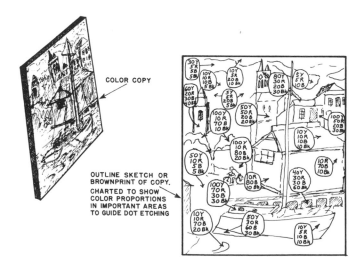

COLOR COPY

OUTLINE SKETCH OR BROWNPRINT OF COPY. CHARTED TO SHOW COLOR PROPORTIONS IN IMPORTANT AREAS TO GUIDE DOT ETCHING

Charting Color Proportions for Dot-Etching.

area. Note on a scratch pad the percentages of color required to print this color. Allow for differences if an exact match is not obtained. If one or more of the inks were nonstandard, note also the color composition of each. If an allowance is to be made for wet printing, refer to the chart for proportional dot-size reduction to be allowed for each color.

Color Sequence. Color density gain is greatest for the first printed color and least for the last. If black is to be used to replace a portion of the gray component produced by the three colors in this area, note the percentage of black to be used.

Special Considerations. Finally, note any special allowances to be made for overprint varnish, tinted stock, color overprints, or plastic laminates.

Calculating Color Percentages. Then calculate the percentages of each color required in this area. This will require starting with the three-process color dot-size values of the color block on the chart that matches the copy area. Subtract from each color (where non-standard inks are used) the proportion of this color contained in the other color inks to be printed in this area. Then subtract the proportion of color to be carried by the black. If wet printing is to be used, the net dot size is further reduced to allow for gain on the press.

Noting Color Values in Code Form. Write this final set of color values in the circle for the first principal area: Y stands for yellow, M for magenta, C for cyan, BK for black. A coded notation of the required color values may read, for example: Y-80, M-30, C-20, BK-10; it may also be expressed in figures alone in the following form; 8321.

Repeat this for all the other important color areas on the copy until the entire job has been charted.

DOT SIZE AND INTEGRATED DENSITY

Dot-size measurements can be made either by direct comparison with a halftone gray scale or by use of a densitometer A halftone gray scale for dot-size measurements can be prepared on the process camera by exposing a calibrated ten-step gray scale onto film so that the steps range in dot size from a pinpoint dot to a pinpoint opening with a 50 percent dot in the center step.

Dot-Size Measurement by Comparison. For accuracy the halftone scale should be prepared by contact printing from the camera scale so it will have opaque dot formation. The steps are then numbered as to their dot size. Dot-size measurement can be made with this scale by direct comparison under a high-powered magnifier.

The Extinction Method of Dot Measuring. The extinction method can also be used to select the step that just blanks out the space between a set of dots. The scale must be rotated to the same screen angle as the halftone for taking dot-size readings.

Densitometric Measurements of Integrated Dot Density. Densitometer measurements of integrated dot density are more accurate for contact halftones than for camera halftones. Camera halftones may transmit less or more light due to the wider fringe areas on the halftone dots and the lower dot density. This is particularly noticeable in the highlight areas on positives. However, this condition will be fairly uniform in any particular plant. A dot-size-to-density-value chart can be prepared for use with the densitometer that is based on integrated light transmission through a halftone area.

FLAT-ETCHING

If the halftone positives have a slight general fog, particularly in the shadow areas, or if the highlight dots are

generally too large and the shadow dots are almost closed up, an overall etch in Farmer's reducer will be helpful. Farmer's reducer should be mixed just before use. It is self-exhausting and its activity declines rapidly after mixing.

Technique of Flat-Etching. First paint out half the length of the halftone gray scale with staging asphaltum or lacquer to provide a record of the amount of etching done. Dry thoroughly. Then immerse the positive in a tray of water containing a few drops of a wetting agent (at about 70°F) for about one or two minutes. This softens the emulsion and aids in uniform penetration of the etch.

Pour out the water, and pour in sufficient Farmer's reducer to completely cover the positive. Rock the tray in alternate directions or swab lightly with a tuft of cotton. Every 15 or 20 seconds remove the positive, flush with water and examine under a magnifier.

When the etching has proceeded far enough, immerse the positive in a tray of running water for about three to five minutes. Remove it and dry. Overall etching may be used to reduce the printing density of the black printer if exposed too full on the camera.

As the smaller or highlight dots reduce more quickly, there will be a slight increase of overall contrast as the flat-etching proceeds.

STAGING AND ETCHING

Dot-size reduction by staging is carried out in trays with the etching confined to specific areas. The procedure is as follows:

Preparations for Staging. Place the first halftone positive of the set on the light table. The positive must be thoroughly dry. Put the asphaltum varnish or staging lacquer solvents, brushes, lintless rags or wiping tissue, rule, arm board, and other materials required in a convenient position.

Planning Staging to be Done. Refer to the prepared dot size chart. Check the dot size for the first color positive in all the principal areas marked on chart. Use the film halftone scale or densitometer for the dot-size measurements. Opposite each charted dot-size value for the first color, write the percentage of dot-size reduction necessary.

Starting Staging Work. Apply the staging asphaltum or lacquer with the brush. Apply it first to the border areas around the subject. Also cover register, corner and trim marks. Leave half the length of the halftone gray scale uncovered.

Applying First Stage. Next paint out all areas where an "O" has been marked on the chart. These are areas where the dot size is correct and no etching is required. If the edges of these areas follow the borders of the subject, the staging asphaltum or lacquer can follow their outlines. (If the edges must be graduated, as in following the folds of drapes, break the sharp edge of the staging by use of a litho crayon or grease pencil so that its texture will gradually reduce the etching action towards the staged area.) Fan the asphaltum or lacquer dry.

Prepare for Etching. Place trays for Farmer's solution, hypo solution, and running water in the etching sink or on the etching stand. A translucent tray for Farmer's reducer solution is desirable. Have stock solutions ready for use. Note the minimum dot-size reduction required for the positive as noted on the chart.

Condition Positive for Etching. Place the halftone positive in water containing a few drops of wetting agent. Allow it to soak for a minute. Then transfer the positive to the etching tray.

Mixing Etch, First Etching. Mix Stock A of Farmer's reducer into the required quantity of water, and then add Stock B. Stir rapidly. Then pour the solution over the positive in the etching tray. Rock the tray gently and alternately in different directions to etch uniformly. If the first dot-size reduction is five percent, watch the highlight dots and the five percent step of the halftone gray scale. These will show the etching action first. When the five percent dot is noticeably reduced in size, transfer the positive quickly to the water tray and wash it thoroughly with water. Then examine the five percent dot as well as the lightest tone areas on the positive to see if the dots are sufficiently reduced.

Checking Extent of First Etching. Examine the other areas requiring the same minimum dot-size reduction (such as five percent). Depending on their area and nature, decide whether these will be reduced to size by a further staging and partial etching, or whether this etching can be completed more easily by local brush application.

Second Staging. If the examination shows that further etching is required for the darker tone areas of the first staging, you repeat the steps outlined previously under "Applying First Stage." First dry the positive thoroughly. Then stage-out the areas that have been sufficiently etched.

NOTE: The positive must be thoroughly dry each time the staging is applied. The grease pencil or litho-crayoned edges in areas that are to be staged again should first be wiped off with a suitable solvent.

Second Etching. Etch again by repeating the steps outlined previously under "Mixing Etch, First Etching." Stop the etching every 15 or 20 seconds by dipping the positive into a tray of water for 10 to 15 seconds. Then examine the dots in the lightest of the darker areas. Check to see if they have been reduced to the desired size. If etching is insufficient, repeat the etching operation for another 15 to 20 seconds. Continue until the dots in these areas have etched down to the required size. Then wash the positive well in water and dry.

Checking Extent of Second Etching. Examine the dots under a magnifier again. Note what additional etching may be required in the shadow areas. Also check other highlight areas that originally required more reduction to see whether the second etching has brought their dot sizes close to the desired values. Check the dot size with the halftone dot size strip or the densitometer.

Third Staging. Again paint in all areas that have been etched sufficiently. Also those that can be finished up more easily by local etching with the brush after the staging op-

erations are completed. Blend-off hard edges where necessary.

Sub-Staging. Refer to the chart again. If the next stage is 5 percent or less, it can be worked as in first etching. If the next stage calls for a ten percent or greater dot reduction, it is best to work it in three or more sub-stagings. In each sub-stage, work in the bordering edges slightly to graduate the edges to the staged areas, so that noticeable density changes along the etched margins will be avoided.

Etching and Staging to Final Values. Repeat the etching, staging, and inspection until the entire positive has been fully etched to provide dot sizes indicated by the chart.

Removing Staging. Strip or wash off staging lacquer or asphaltum varnish with a solvent. When using a solvent, wipe off the surface of the positive at least four or more times, after the staging has been removed. Use clean solvent and tissues each time to be certain that all lacquer or asphaltum has been wiped away. Remaining traces of the staging resist will interfere with subsequent local etching or corrections.

Checking for Satisfactory Etching. If the staging and etching operations have completed all necessary dot-etching, and corrections and local etching are not required, wash the positive thoroughly and dry. Check the highlight dots under a high-powered magnifier to see if they are still sufficiently opaque for platemaking. If they are not, then request a duplicate contact positive to be made from the etched positive. Check to see that the duplicate positive retains the same dot-size values that were obtained by the etching corrections.

LOCAL REDUCTION

For finishing corrections after staging, or where further local dot-etching is required, Farmer's reducer can be applied with an artist's etching brush. Small quantities of the solution can be mixed every 15 or 20 minutes as the work progresses. For extensive small etching corrections, some color etchers prefer to keep Stock Solutions A and B in separate containers as the mixed solution rapidly loses its strength.

When used separately, the hypo solution is first applied to the area to be etched with a brush. The excess is blotted off. Another brush is then dipped lightly in the ferricyanide solution (Stock A diluted down in eight parts of water). The excess solution is wiped off the brush, and the brush then applied to the area to be etched. Work the etch from the central uniform color area outward, gradually enlarging the etched area so that no etched outlines will show. Every 15 or 20 seconds, stop the etching action with a swab of cotton wetted with water.

Whether Farmer's reducer is mixed or used in separate parts, the action is approximately the same. Examine the dots under a magnifier between each etching cycle, or use the densitometer for measurement. Continue the etching cycle until the desired dot size has been obtained. When all the local reductions have been completed, wash the positive in running water for at least five minutes. Then dry.

BLENDING

Large displays, pictorial subjects, or posters are sometimes split up into two or more joining sections, when limited by the size of the camera, the halftone screen, or by the size of the negative-holders used on the photocomposing machine. These sections are later recombined during stripping or platemaking. In reconstructing the subject, the joining edges must blend together so that the finished reproduction will not show the joining line. The satisfactory re-combination requires careful consideration of the following points.

Size Agreement. Exact register must be held between sections. Additional center and fine register marks are usually placed on the copy before the separations are made. If the subject is to be recombined by stripping, these marks are located along the margins adjacent to the dividing line. If the photocomposing machine is to be used, the marks must be located along the centerlines of the split portions, so that they will be centered on the individual negatives or positives in photography. When intended for stripfilm, the marks may also be within the subject, along the joining line. When so used, they are kept small and located in inconspicuous variegated color areas. They are later retouched out by the stripper or platemaker after they have served their purpose for registration of the adjoining portions.

Register marks must be clearly visible to the stripper or platemaker. When exposing halftones on the camera, the marks are broken up by the screen pattern and are spread out in area. Whenever possible, the cameraman should double-expose the marks in position on the camera, so that they will appear as line instead of halftone marks. Otherwise it may be necessary to re-work the halftone marks to permit accurate registration. When re-working register and centermarks, it is advisable to allow portions of the original screened marks to remain, so that the accuracy of the rules or scribed marks can be checked.

Matching of Detail. Subject detail must fit together along the joining edges. An out-of-square camera will distort the image on the negatives or positives. Separate exposures of the sections of the copy will not provide matching detail along the joining edges. This condition can be checked by placing the positives over each other, or by double-printing the negatives down on brownprint paper. The photographer can sometimes compensate for such distortion when exposing the halftones, by reversing the original heads-up or heads-down placement of the copy on the copyboard or on the transparency-holder. He should then have his camera squared-up for later jobs.

Uniform Density Values. Slight variations in tone or color values will show up prominently when flat tint color areas extend across both portions. Flat color areas, or similar critical color value detail on adjacent sections, will require very close tolerances in holding the exact printing dot size across the joint. The use of the densitometer, and direct comparison of the dot sizes under a high-powered magnifier, are advisable. Halftone positives can be placed emulsion-to-emulsion for dot size study under the microscope, so that the adjoining dots will both be in focus.

Invisible Joint. The joining line of each section of the color printers should follow detail borders if at all possible. The joining line should also be displaced irregularly between the individual halftones in the color set, so that they will be diffused between the different colors and will not coincide in printing.

Blending Procedure. Before the halftone printers are made, make certain that the adjoining sections of the continuous-tone separations are identical in density and contrast range so that the dot size along the adjoining edges and the color values throughout the subject will be in balance with each other. When the halftones printers are received, study them carefully under a magnifier or with the densitometer to make certain that the balanced relationship has been retained.

When preparing the dot size chart of important color areas, include additional control areas for any color combination that extends across both sections. Then make a note of the actual dot size on these areas on each of the adjoining halftone printers for the first color in work. This will show whether one section is consistently fuller than the other, so that flat-etching can be applied, or whether the dot-size difference varies along the joint and necessitates local corrections.

If flat-etching is indicated, check the other important color control areas on the slightly fuller printing section to determine whether flat-etching is also required in these areas. If the dot-size values in the other important color areas are correct, then the blending must be confined to the areas along the joint. The boundaries of subject detail are the preferred limit of such blending. Otherwise a gradual blending of tone values will be necessary. This blending should extend over a sufficient width so as not to be readily noticeable. In such blending, it will be necessary to repeat the operations in the other color printers, so that the color proportions will remain consistent between them. Normal dot-etching techniques are used. As the tolerances for dot size are very close, it is better to dilute the etch further so as to slow its action, and thereby prevent over-etching.

INTENSIFICATION

Intensification of halftone positives has limited usefulness. Dot size can be increased a few percent by intensifying the fringe area. Once the dots are intensified they are not as suitable for later dot-etching. Where dots are weak, and may print through in platemaking, intensification may help if the lack of density is only slight, and the dots are sharply defined. Otherwise it is better to duplicate the positive by contact-printing methods, particularly where the subject size is small; where color values are not too critical; and where the halftones are on film. With large glass positives, and where a small amount of local intensification is desired to increase color printing value, chemical intensification can be used. The positive must be thoroughly washed, before intensification, if stains are to be avoided.

For intensification, commercial dot size intensifiers are available through suppliers. Immerse the halftone positive in a tray of intensifier or apply the solution locally with an inorganic plastic-fiber etching brush. Do not use hair brushes or cotton swabs. Circulate the solution over the area until sufficient intensification has been obtained. Then flush the positive with water and place it in a tray of 25 percent hypo solution for two or three minutes. Rock the tray to circulate the solution. Intensification should not be carried on in direct sunlight. The intensifier solution will stain the hands. Film tongs or rubber gloves should be used for handling the positives.

Intensification by Local Staining. Some increase of the apparent dot size is sometimes obtained by local staining with light washes of dye. This means is not desirable. Dyes tend to concentrate around the dot so as to hold back the light during exposure in platemaking. In this way the reduced exposure light intensity will print a larger dot due to the extended effective zone of the fringe area. Some dye will also remain between the dots, to under-expose these areas during platemaking.

Airbrush Spatter Techniques. Dot value intensification can be obtained by spatter technique with an airbrush. The nozzle and distance are adjusted so that fine droplets are produced instead of a spray. This is tested first on a clear film. When satisfactory opaque droplets are produced, that have a diameter approximating the pinpoint highlight dots on the positive, the color etcher can apply them to the areas needing intensification. He can control the airbrush to apply the random droplets in direct ratio to the increase in printing value required as well as to smoothly blend-off subject contours. The densitometer can be used to check total printing value. The use of spatter technique is limited to last-minute corrections of halftone printers. The resulting dots are printable in platemaking and on the press, but as they are irregular, and sometimes very small, there is more difficulty in holding their values through the press run.

Local Photographic Intensification. Local photographic area intensification can sometimes be provided by the cameraman through dodging methods, particulary when large areas are involved. Such dodging is best made on continuous-tone conversions from negative to positive. Once the halftones are made, the dodging method can still be used, but to a much lesser degree. When making duplicate positives through an intermediate contact negative, the use of dodging methods, during the exposure of the intermediate, can hold back some of the light in the required areas, so that the fringe areas of the dots will add their value to the dot sizes. The intermediate halftone negative is then printed down by contact to produce the contact positive needed for platemaking.

RETOUCHING AND ADDING DETAIL

Finishing operations on halftone positives may require adding line detail as well as halftone dots. This may be needed to emphasize subject outlines, or to correct photographic defects. The artist's brush, ruling pen, crowquill pen, needles, opaque, and a high-powered magnifier are usually required.

Adding Line Detail. Line detail, such as ship's rigging, machinery component outlines, type matter, or the product being merchandised, can be retouched on the appropriate color printer with pen or brush where such outlines or areas can print as solids. Opaque is usually used, slightly thinned down, so that it will flow freely from the pen or brush, and yet leave an opaque deposit on the emulsion. Where less than solid printing values are required, or where some dots are missing because of photographic defects, the crowquill pen, with slightly thinned down opaque, can also be used. Work under a high-powered magnifier. First test the pen on a clear piece of film, and when the correct size dots are produced, apply the pen immediately to the area in work. Match the dot spacing and pattern, so that the retouching blends inconspicuously into the subject.

Adding Halftone Detail. Halftone detail can be added with greater accuracy with a needle than with the crowquill pen, but errors in such work are more difficult to correct as the emulsion is engraved. Skill should be acquired on waste positives before working the needle on a job. In the highlight and under 25 percent areas, a sharp pointed round needle (or one with the point slightly stoned-off flat to increase dot size) is used to prick through the emulsion.

Work under a high-powered magnifier. Follow the dot pattern for spacing and size in agreement with the printing values desired. Then rub in black litho crayon, and wipe the surface clean with the finger or preferably with a clean tissue or cotton to remove the excess of crayon. For values larger than a 25 percent tint, apply a thin coating of black (colloidal graphite) opaque to the area. In the areas where disconnected dots having less than 50 percent value are required, use a needle sharpened for ruling lines in negatives. Rule through the opaque in agreement with the screen angle, so as to produce dots that have the same area (even if not the same shape) as the adjoining dots they are to match.

For printing values of 50 percent or greater, the ruling needle, or the square needle, sharpened diagonally to provide a triangular point is used. For these values, a flake of opaque with some of the underlying emulsion is removed for each dot to be formed. Follow dot line and spacing along a straight edge. Dig the cutting edge slightly into the emulsion where the dot is to begin, and lift out where the dot is to end.

Random Stippling. Random stippling with pen and opaque, or scraping with a needle is sometimes used for fast work. Much depends on the skill of the color etcher to provide a uniform-appearing tint to the unaided eye. The color etcher should retouch and correct dot-by-dot under a high-powered magnifier where good workmanship is required. Carefully worked dot corrections are necessary to prevent such retouching from showing up on the press after the run gets under way.

CHECKING THE PROGRESS OF CORRECTING

Proof plates should be made and progressive proofs pulled as each corrected halftone color printer is completed.

Don't wait for the set. In this way, color errors that develop may sometimes be compensated for in the later color printers. Where possible, the defective halftone should be corrected before the balance of the progressive proofs are printed, and a new proof made. In this way, the complete re-proofing of the job can be avoided. Any color errors noted should be checked immediately to learn whether any of the control equipment, charts, inks or variations in proofing are at fault. In this way their recurrence can be prevented.

Photographic color proofing methods are sometimes used to check the progress of dot-etching corrections. Since their color values do not agree with printing ink values, their color combinations must be interpreted so as to avoid errors in color judgment. These newer color proofing methods are available in a wide range of materials, techniques and processes. Each has its advantage in some type of color procedure. Learning to handle them properly can lead to much saving of labor as well as improved quality. One important key to their use is proper evaluation. This is easily mastered with some attention and experience.

Finishing a Set of Color Printers. Bordering, opaquing, emphasizing register marks, introducing trim or fold marks, stripping in type matter, and adding job number and other identification markings are necessary to complete the set of color printers. In many plants this work is assigned to the stripping department. Because of job load division, or for other reasons, part or all of these finishing operations may be assigned to the color etcher. Details are given in the GATF Skilled Craft Text #512, Color Stripping.

Additional Corrections Before Platemaking. Before releasing the set of color printers for platemaking, certain additional corrections may be necessary. These may be indicated by the progressive proofs themselves, or the customer's markings on the color proofs. Where such corrections are minor, they can usually be made without re-proofing. The color etcher must then doubly check such corrections to be sure they will provide the right color printing values or other details. Otherwise costly press-plate makeovers, lost press-time, and wasted paper stock may result.

Re-Checking the Color Printers in the Absence of Proofing. Where proofing facilities are not available in the plant, the color etcher should re-check each color printer. Repeat the process of selecting the important color areas on the color copy, re-evaluating them for dot size by comparison with the color chart, and re-calculate any necessary dot-size allowances. The color etcher should then check the computed dot sizes with the corresponding dot-size values on the color printers.

Here, too, the gray balance proportions, that were removed from each color printer and added to the black printer, should also be checked to make certain that all compensations in each printer have been completed. The additional time that is spent in re-calculating and checking the color values, before releasing the set of printers, is small when compared with the possible added costs and lost time that result when some serious error is discovered after the job has gone to press.

NEGATIVE COLOR PRINTERS

Negative halftone color printers are required for surface plates; some types of bimetallic plates; or where the positive color printer is to be prepared by contact from the halftone negative. In low-cost color reproduction, the separation negatives are screened directly during photography, so that they can be used for platemaking of surface plates. The color correction procedure for halftone positives that is covered in this chapter also applies to corrections on halftone negatives. Where an intermediate continuous-tone positive is made from the color-separation negatives, most of the corrections will be made in the density values of the positives. The same techniques are used as were applied to continuous-tone negatives except that the density values will be reversed.

The Quality of Dot-Etched Negatives. The halftone negatives that are made from the corrected continuous-tone positives are finished by using dot-etching methods as described in this chapter. The dot-size values will be inverted as will the allowances made for color value gain on the press. The shadow areas will usually carry an opaque ten percent or slightly larger dot that will not fill up in printing. The highlight pinpoint dots must be completely transparent when viewed with a high-powered magnifier against a diffused white light source. Any fog or extended dot fringe area can result in these dots going blind in platemaking or on the press. Brilliant highlight points can be opaqued-out by artist's brush or pen, so that only pinpoint dots of the principal reflected color will print in these locations.

Color Combination Charts for Negatives. The color combination charts that are used for charting and dot-etching negative halftone printers should be prepared by using the platemaking method and inks that are scheduled for the job. GATF masters for preparing color combination charts are available as either positives or negatives. Where both surface plate and deep-etch plate methods are in use for color process jobs, separate charts should be prepared. Printing dot sizes will be inverted from those obtained on the halftone negative.

Color Correcting on Direct Negatives. Where direct halftone negative separations are supplied for low-cost color reproductions, work by the color etcher may not be required, or it may be limited to approximately correcting one or two principal color areas. Fast working techniques, using the artist's brush and Farmer's reducer to open up areas for increased dot size, or the use of dye, crayon, or splatter tints to add density and reduce printing dot size, may be applied. The dot structure in direct halftone separations is frequently soft with a wider fringe zone than on other process halftone jobs. This results from the use of faster negative emulsions that are required for making the separations. The dots will etch faster and they cannot be reduced as much in size. They are far more critical to exposure time and other conditions in platemaking. The GATF Sensitivity Guide must be used with such negatives to control the required color printing values.

Checking Contact-Printed Negatives. When the negative halftone printers are made as photographic contacts from color-corrected halftone positives, the color etcher must check the dot-size values in all principal color areas. Variations during contact printing exposure and development can change the printing dot-size values just as it does in platemaking. This is particularly important in the highlight areas.

Section Six: Manual Color Separation Techniques

In this section we discuss some of the commonly used manual color-separation techniques. Our presentation is divided into the following four points: (1) Key-line jobs; (2) Pre-separated film-pack transparencies; (3) Fake-color separations from black-and-white photographs; and (4) Duo-tones. Each of these subjects is briefly presented in the following. A more extensive treatment of these subjects can be found in the GATF Skilled Craft Text #510/11, *Tone and Color Correcting for Offset Lithography,* by Bernard R. Halpern.

KEY-LINE JOBS

Non-process color reproductions, such as are used for the preparation of maps and fake-color work, represent a simple separation and combination of color printings. The colors are usually printed as solids or as uniform area tint values. Color combinations are obtained the same as in process-color work, by proportioning the dot-size values for each color of printing ink. Our discussion of key-line jobs is divided into the following four main points: (1) Color-separation drawings; (2) Charting the key-line separations; (3) Making the individual separations; and (4) Making the final separation negatives and their treatment.

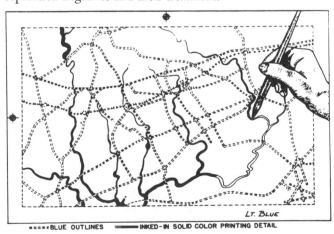

LT. BLUE

····· BLUE OUTLINES ══ INKED-IN SOLID COLOR PRINTING DETAIL

Inking-in Blue Board for Light Blue Plate.

Color-Separation Drawings. The copy furnished for most map work and for simple color jobs such as for labels, posters and displays, usually consists of a black-and-white key outline drawing. The required colors are either marked on an overlay sheet, or shown on an accompanying sketch. When the color etcher is required to prepare the separation drawings, he must obtain a set of identical blueline prints. These blueline prints are made by first preparing a line negative from the key outline drawing.

Each of the blueline prints is then marked for one of the printing ink colors. The first of these color drawings is then inked in wherever the color is to print. Solid color areas are inked in solid with india ink or covered with red acetate overlays. If the color tints all have a common value, such as a 25 percent blue, a separate drawing will be inked in solid or covered with red overlays wherever these tints are to appear. A variety of different tint values may be necessary in a printing color, such as in fake-color work, so as to build up different color combinations in various areas on the job. These tint values are added to the same drawing on which the solid color areas were filled in with india ink.

The percentage values of the tint sheets correspond to dot-size values. The tint values can be printed down with ink into masked areas using Ben Day screens. More commonly, the tint sheets are procured through supply houses as a thin cellophane or plastic sheet with uniform rated tint values printed on them, such as 10 percent, 25 percent, and 50 percent. These sheets are backed with a pressure-sensitive adhesive so that they can be attached directly to the drawing. The fineness of the texture is chosen so that the printed tint values in the final size of the color reproduction will be similar to the halftone screen rulings that would be used.

Charting the Key-Line Separations. Chart the colors to be obtained for the job in terms of percentages of ink-color values. Study the colors on the sketch, swatches, color notation system, previously printed job, or whatever material is furnished to identify the required colors. If the inks to be used for printing the job are the standard process-inks used in preparing the color chart, the dot-size values on the chart will be used. If the inks differ in hue or value, a printed color sample of the ink should first be compared with the color chart to determine its color composition. The color values of the ink will then be divided between the printing values of the process-inks as obtained from the chart.

Making the Individual Separations. The making of the individual separations includes a variety of steps such as the inking in of borders and reference marks, as well as of solid areas; the selecting of the tint values; the preparing of the tint sheets; the setting of the screen angle; the applying and adhering of the tint sheets; and the trimming of the sheets to the required outline.

Making the Final Separation Negatives and Their Treatment. When the color-separation drawings are completed, the process photographer will prepare a line negative from each drawing. The color etcher will retouch these negatives where tint sheet cut-marks or other defects

may print. These negatives can be slightly modified in dot-size values by dot-etching techniques if necessary. Camera exposures from line copy usually provide a slight vignetted density edge around the printing detail. Such vignetted detail permits some size reduction by dot-etching.

Dot-etching on the line negatives may also be desired for a gradual increase of tint values. Any such work on one color printer must be duplicated on the other color printers to keep the color hue in balance. If a wider latitude for dot-etching is desired, as for modeling curved surfaces, the photographer can usually provide a more suitable variable density dot.

PRE-SEPARATED FILM-PACK TRANSPARENCIES

Pre-separated color transparencies are sometimes furnished for reproduction. They consist of a set of three or more colored films on a clear base that are fitted to each other through register marks or perforated holes. The printing design on each film is prepared in a single color. This colored design may be obtained through photographic dye-coupling methods, or be applied as hand-drawn artwork. Color changes can be made by the removal of color or the addition of similar dyes or transparent inks.

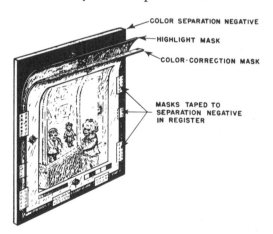

Masked Separation Assembly.

Pre-separated color transparencies, prepared with colors to match the printing inks for the job, will require little masking or color etching. If the colors on the overlay films do not match the ink colors to be used, the photographer can prepare compensating masks when making the separations. If masks are not prepared, the color etcher should regard the color pack as full-color copy. He will then chart the color proportions for the inks in each important color area. Color correction will consist of normal density compensations by back-etching or additions on the separations, and by dot-etching on the halftone printers.

FAKE-COLOR SEPARATIONS FROM BLACK-AND-WHITE PHOTOGRAPHS

A black-and-white photographic print may be furnished as "color" copy, accompanied with a sketch or instructions

as to the colors desired. Most of the color values must be obtained by extensive density changes on continuous-tone "separation" negatives or positives. Back-etching is usually preferred instead of adding density, especially where considerable detail is involved. The negatives, therefore, will usually be shot higher to allow for density reduction. Such reduction of density must be controlled through density measurements so that the final halftone printers made from them will provide the correct color proportions needed to fake the colors that are required. Most of the outline detail will be carried in the black printer.

Our very condensed discussion of the procedure is restricted to the following seven main points: (1) Selecting color values; (2) Charting color values; (3) Relating color values to densities; (4) Reducing density; (5) Etching highlight areas; (6) Adding density; and (7) Finishing. Each of these steps is now individually described, if ever so briefly.

Selecting Color Values. Refer to the accompanying dummy color sketch or instructions for color values desired. If the sketch or instructions are vague, obtain some other color copy that has similar subject matter so that color values can be approximated from it. Study the photoprint for clues as to color tones.

Charting Color Values. Use the ink color combination chart, preferably prepared with the standard process-inks and the paper stock used in the plant. Based on the color sketch, or other considerations, select a color square on the chart that will provide the required color combination. Then mark the color proportions in the selected areas using the color code in *"Charting a Color Value,"* Section Five of this chapter.

Relating Color Values to Densities. Refer to our "Continuous-tone density and dot-size" table which charts the continuous-tone density values required to produce corresponding dot-size printing values. Select a density range than can be held on the set of negatives after the density corrections have been made. Then mark the chart of the job with the density values that are necessary to obtain the dot sizes that were circled.

Reducing Density. By either staging or local application of Farmer's reducer, reduce the density of the first area charted. Work gradually with diluted solutions so that the density reduction can be safely watched without its acting too fast. Continue until all required density reductions have been obtained.

Etching Highlight Areas. Finally study the local detail, particularly in the highlight areas (densest areas on the negative). See if contrast can be added to local detail by fine etching with the brush and Farmer's reducer.

Adding Density. Next study the areas where density must be added. This may be required in local areas where

etching has been excessive; where an increase of subject brightness requires a reduction of color; and for highlighting texture detail. Density can be added with neutral grays, with pencil, or with stump and graphite, depending on which is best suited to the work required.

DENSITY					DOT SIZE	
					POSITIVE %	NEGATIVE %
2.55	2.20	1.55	.	.	5	95
2.45	2.07	1.45	.	.	10	90
2.30	1.88	1.30	.	.	20	80
2.15	1.68	1.15	.	.	30	70
2.02	1.50	1.02	.	.	40	60
1.91	1.36	.91	.	.	50	50
1.80	1.22	.80	.	.	60	40
1.66	1.03	.66	.	.	70	30
1.48	.64	.48	.	.	80	20
1.25	.50	.25	.	.	90	10
1.10	.30	.10	.	.	95	5

Continuous-tone-Density-to-Dot-Size.

Finishing. Finish the negative by opaquing the borders. Mark the job name and printing color along one edge.

DUO-TONES

Duo-tones are two-color printing jobs. They consist of a principal darker color, and a lighter color that may be of the same or a different hue. The two colors increase the density range of the printed job; provide better detail modeling, particularly in the highlights; and add an undertone of color to the job. The principal color is usually screened at 45-degrees. The lighter color of the duo-tone is normally prepared with its screen angle displaced by 30-degrees from the principal color, either to 15-degrees or to 75-degrees.

Where possible, separation negatives are first made for duo-tones. The principal negative will be exposed and processed for normal contrast, but somewhat higher (denser) to allow for some back-etching. It will retain only outline values in the highlights. The lighter printing color separation will be exposed with the highlights more open to provide good contrast of detail, particularly in the lighter or highlight areas. The color etcher's work will be limited to adding detail contrast and further dividing printing values between the two separations to accord with their nature on the copy.

The Stripping and Photocomposing Departments—

Section One: Review of Modern Stripping Techniques

Stripping formerly referred to the removal of sections of the photographic emulsion from wet-plate or dry-plate negatives. These emulsion sections were then transferred, assembled, and adhered in position on a glass plate. The stripping of emulsions off of photographic plates was discontinued when manufactured stripping films became available.

In stripping films the photographic emulsion is applied to a thin membrane. This membrane is temporarily adhered to a heavier film or paper support. The membrane remains attached to its base for the exposure and processing of the negative. The membrane with its photographic image is removed from the base when it is stripped to a new support. Stripfilm is currently used for the more intricate jobs. This is usually limited to older established plants where personnel skilled in its handling are available.

Stripping is now commonly used to describe the methods for splicing cut films together. This serves the same purpose as a stripfilm assembly. Stripping operations include the preparation of the layout for stripping; the cutting and attachment of the films; the addition of printing controls; and the necessary corrective or supplementary work on the films that may be needed to complete the printing detail. In popular stripping procedure, the cut films are usually attached to a supporting sheet of goldenrod paper or plastic film.

Tabs of pressure-sensitive cellophane tape are applied to hold the films in position. Such stripping with cut film sections is easier and less costly than when stripfilm is used. Cut film assemblies are also suitable for a large proportion of all lithographic stripping requirements.

In this section we first review the main kinds of stripped-up assemblies, and then discuss the subject of negatives and positives as it relates to stripping.

THE MAIN KINDS OF FLATS

The stripped-up assembly of film sections is called a flat. There are many types of flats in use. Here we present the following six kinds of commonly used flats: (1) Goldenrod flats, (2) Film flats, (3) Blueline flats, (1) Partial or sectional flats, (5) Complementary flats, and (6) Miscellaneous film assemblies.

Goldenrod Flats. These are an assembly of film negatives on a sheet of goldenrod or orange-colored paper. The goldenrod paper serves three purposes. It is used as (1) a drawing base to indicate the subject locations on the printing layout; (2) a support to hold the individual films in correct location; and (3) a mask to prevent the exposure light from reaching the non-printing areas of the press plate during platemaking.

Film Flats. Films can be joined to each other to produce a flat, without using a goldenrod or plastic supporting sheet. This can be done when the available film sections will cover the entire printing area of the press plate. Film flats may consist of assemblies of negatives or of positives. The individual films are positioned and attached to each other with strips of tape directly over a prepared layout. Holes can be punched in each film in register location in advance to permit rapid and accurate assemblies of film flats to pegboard layouts.

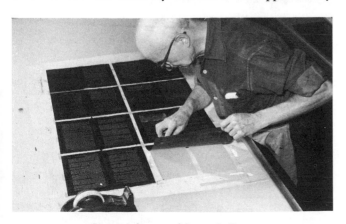

Stripped-up goldenrod flat.

Blueline flat.

Blueline Flats. For the highest degree of stripping accuracy, with stripfilm, the film sections are attached in position to blueline images. These images are photographically printed down on a set of sensitized plate glass or plastic sheets. The prints are made from a master or key flat. This key flat consists of an assembly of films or register marks that include all the location detail needed to fit the films on each flat.

The blue image serves as a visible guide for accurately locating each film. Its blue color is transparent to the actinic exposure light used in platemaking. For this reason, the blue image does not show up on the press plate. Acetate, vinyl, and polyester plastic sheeting are also used for preparing blueline flats. The vinyl or polyester sheeting has better accuracy where plant humidity variations are experienced. Plate glass is used where the highest degree of location accuracy and register is required from a flat.

Partial or Sectional Flats. A flat may be prepared to cover only a part of the press plate. This is common

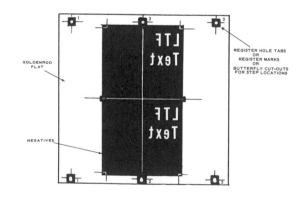

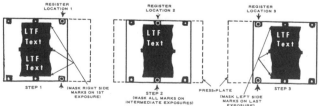

Partial flat.

practice when printing subjects are to be duplicated by step-and-repeat methods on the press plate. Such flats are provided with marks or mechanical attachments. These positioning guides enable the platemaker to accurately step the flat across the press plate on the photocomposing machine or in the vacuum frame.

Partial flats may be stripped-up as related sets of small groupings of films. The printing detail from the several partial flats are then combined together on the photocomposing machine when making the press plate.

Complementary Flats. It is frequently desirable to divide the printing detail for a press sheet between two or more flats. This is commonly done when the printing detail consists of many small illustrations with close-fitting text.

Set of complementary goldenrod flats.

In such work the films would be troublesome to splice together and could cause platemaking difficulties. The division of detail is also necessary where printing is to surprint or print over other printed matter.

The complementary flats are exposed successively in register with each other so as to combine their detail on the same sensitized press plate. Location register between the flats is obtained by adding register marks, by use of butterfly cutouts, or with the aid of plastic hole tabs attached to each flat.

If hole tabs are used, mating sheet-plastic dowels must be temporarily secured to the press plate so as to register the two flats to the same location.

Miscellaneous Film Assemblies. Stripping practices are used for combining films together when assembling transparencies as camera copy. Acetate pulls from type composition can be combined with each other or with films. This is done to eliminate camera work when no size changes are required in the text. They may be used directly as positives or be contacted if negatives are needed. Galley lengths of photocomposition on film are usually cut apart into column or paragraph sections. They are then combined with other films of running heads, borders, or display matter to obtain page make-up. Spreads, chokes, and outline characters of display type or line-color printing areas are also produced with film assemblies. Many of these practices require the use of photographic contact-printing facilities to produce the final films that will be used for stripping-up the flat.

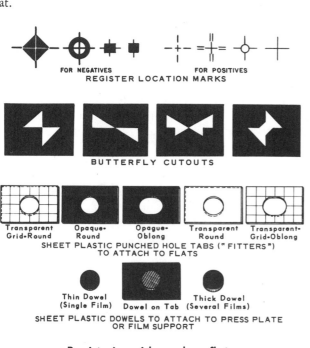

Registering aids used on flats.

NEGATIVE AND POSITIVE STRIPPING FLATS

Negatives are required for preparing flats that are to be used for making surface or albumin press plates. Positives are used when the press plate is to be made by deep-etch or reverse methods.

Surface Plates. In making a surface plate, the image is exposed through the transparent portions of the negatives. This image becomes the ink-receptive printing design. Accordingly all the printing detail in the negatives must be completely transparent. The remaining areas of the flat must then completely block out the exposure light. The blocking out is obtained from the opaque portions of the negatives. The area surrounding the work detail on each negative is then masked by cutting away portions of the goldenrod paper. The remaining paper then serves as a mask. Further detailed masking is obtained by using pressure-sensitive red or black cellophane tape, with the aid of masking foils, or by opaquing.

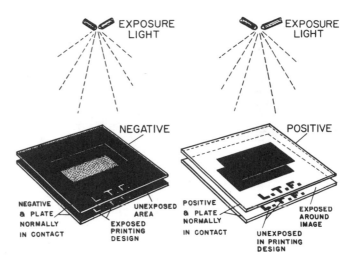

Schematic comparison of surface and deep-etch platemaking.

Deep-Etch Plates. When making deep-etch or other reverse plates with the use of positives, the areas that surround the printing detail are exposed in platemaking. Development dissolves away the unexposed image detail and so uncovers the metal surface of the intended printing areas. The remaining exposed and insoluble coating then serves as a temporary stencil resist for etching. The uncovered metal printing areas are next treated to make them ink-receptive.

Positive Flats Are Very Critical. Positive flats that are used for making deep-etch plates must consist of opaque printing design areas on a completely transparent support. Any foreign material, stains, deep scratches, or cut edges on a positive flat that cause shadows during platemaking exposure, can introduce printing defects. Some such edge shadows are unavoidable and must be staged-out by the platemaker to prevent their printing. The edge effects can also be eliminated by double exposing the press plate with a mask flat. A second exposure made with the mask flat will "burn-in" the defective markings between film sections and unwanted detail. Positive films are stripped by attaching them together or to a transparent plastic or glass base with

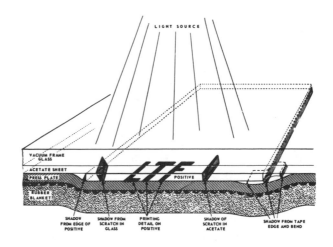

Difficulties with positive flats.

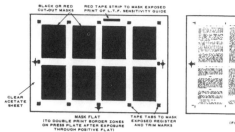

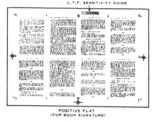

Mask flat.

tabs of transparent pressure-sensitive tape. If stripfilm is to be applied to blueline flats, a stripfilm cement is used to adhere the stripfilm membrane to the glass or plastic sheet.

Combining Positives and Negatives. Positives may be combined with negative film sections. This is done to produce reverses, such as when white display characters are required on a solid, tinted, or halftone background. Negatives and choked positives are also combined to prepare outline display characters.

Section Two: Layout and Equipment

As the stripping department is a production department, it should be arranged to facilitate production. This is more easily done in the planning stages of a new plant, or at periods when major plant expansion moves and reorganization are in progress. In some of the older plants, many of the preliminary processing departments such as camera, color correction, stripping and platemaking have been considered as secondary to the press department. They were, therefore, crowded into undesirable and limited space with poor production facilities. Even under such conditions it is possible to gradually modify and improve the efficiency of the stripping department.

The Small Stripping Department. The small stripping department is frequently required to do a variety of work that may extend into copy preparation, contact printing, proofing, and other fields. As the department increases in size, the stripping operations become more specialized. Additional operators and departments are introduced to perform the different operations.

The Large Stripping Department. In the larger plants each operation for inspection and spotting out films, preparing the layout, stripping the flat, proofreading, and checking are assigned to different individuals. The stripper is then responsible only for assembling and securing the films to the flat, and for masking between the films. Opaquing is limited to that required after the films are assembled, such as the removal of register marks or other detail that was required for stripping, but which are not to print on the press plate. The layout is prepared by a layout man, and preliminary opaquing and retouching are done on the individual films by artists before releasing them for stripping.

In this section you find a presentation of the layout and the equipment for a black-and-white as well as for a color-stripping department.

THE LAYOUT OF A STRIPPING DEPARTMENT

The layout for the stripping department depends on a variety of factors. The exact location selected, the separation between supporting columns, the plumbing facilities, windows, and the relation to adjacent departments will all influence the preferred floor plan arrangement.

In the following you find a discussion on several points essential for the efficient functioning of a stripping department. These points are: (1) Flooring, (2) Walls and ceiling, (3) Windows, (4) Lighting, (5) Ventilation, and (6) Plumbing.

Flooring. Preferably covered with linoleum, rubber, wood, or other resilient material. Concrete floors are tiring to the stripper who usually is on his feet all day. Concrete is also injurious to instruments or films that may be dropped accidentally and is a source of grit and dust.

Walls and Ceiling. These should be sealed and painted in any light color to aid in providing a clean, cheerful area.

Windows. Preferably sealed-off, if a filtered air supply is provided. Venetian blinds or other light screening shields should be used to block direct sunlight from entering.

Lighting. A uniformly distributed, relatively shadowless lighting preferably cool white in color, is essential to efficient operation. The illumination level of the room should be in balance with the internal lighting in the layout, stripping, and retouching tables. A satisfactory balance would provide about 25 to 35 foot-candles from room illumination on the table tops when the internal lighting of the tables ranges between 100 and 150 foot-candles. Doubling this by use of higher intensity lighting in the tables, ranging between 200 and 300 foot-candles, will also permit an increased room illumination level of about 40 to 60 foot-candles. This is less tiring to the eyes. If the tables have too low an intensity, such as under 75 foot-candles, it is preferable to increase their internal lighting by the addition of strips of fluorescent lamps rather than to reduce the general room illumination.

Ventilation. The best working conditions combine air filtration with humidity and temperature control. They also extend these conditions to the camera, stripping, and platemaking departments, so that all phases of copy, film, and flat handling are kept under size control. Complete control should be included in the plans for any new plant. In existing plants, the high installation costs for adding ducts, insulation, vapor seals, and for clearing existing structural members and production facilities, may dictate a gradual improvement of atmospheric conditions over a long range program, in keeping with financial considerations.

Plumbing. The black-and-white stripper has very little need for water supply in flat preparation, and a small sink

can supply these requirements. If the water supply contains rust or other undissolved solids, a small filter is advantageous. If brownprints are to be made in the stripping department, then a large trough with water supply and drain are essential. In such instances the water supply should include a temperature-control water valve that is either manually or thermostatically controlled. Normal drainage facilities are usually adequate in accordance with local plumbing codes, as the limited range of chemicals used are non-corrosive and are also greatly diluted in water. Where photographic contact prints must also be made, the water supply and drain must be adequate to meet these additional requirements.

EQUIPMENT FOR STRIPPING

The equipment selected for stripping must be in keeping with the quality levels required for the class of lithographic printing normally produced. The cost of equipment in the stripping department is relatively low in relation to the labor costs, as compared to other departments. The additional investment for high-quality equipment is also relatively low, especially when this is compared to the cost of lost time that results from the breakdown, inaccuracies, and inefficiency of cheaper equipment.

In the following you find first a description of the equipment for black-and-white stripping, and then a description of the additional equipment needed for color stripping.

EQUIPMENT FOR BLACK-AND-WHITE STRIPPING

The main items of equipment for black-and-white stripping are stripping tables, layout and line-up tables, worktables, shelves, cabinets and racks. All of these are now individually discussed.

Stripping Tables. The primary function of the stripping table is to provide an illuminated working surface on which films can be positioned and stripped-up to make a flat. The working surface is a sheet of plate glass, usually grained on the underside to diffuse the internal lighting. The internal lighting usually consists of several fluorescent lamps, located to provide a fairly uniform distribution of light under the area of the glass top. Internal reflectors and diffusers may be used to help improve the uniform quality of the light.

Many stripping tables are equipped with straight-edges on two or all four sides. If these edges are machined or ground true, and adjusted to square, they permit the stripping table to serve also as a layout table, particularly where small forms are concerned. Straight-edges should be checked for accuracy, as some commercial equipment uses strips of cold rolled or formed steel for this purpose. The irregular edges of such inaccurate straight-edges can cause much trouble in positioning and alignment.

Layout and Line-Up Tables. A precision layout and line-up table is almost indispensable for the efficient and accurate preparation of layouts, and for checking the accuracy of the completed flat. Commercial line-up tables range from modified stripping tables equipped with straight-edges or steel scales, to rigidly constructed units that in-

corporate micrometer-adjustable straight-edges and that have carriages to hold scribing, ruling, and locating attachments. In selecting a line-up table, the highest level of accuracy normally encountered in stripping should be the determining factor. In specialized plants, where ruled-form or similar ruled jobs are produced, the ruling and scribing attachments available with some machines will permit this unit to serve also as a production unit. When selecting equipment having lower levels of accuracy, the straight-edges and positioning scales should be checked with a precision scale, straight-edge, and square to determine if they will be acceptable for the class of work to be done.

Worktables. A worktable should be located close to every stripping table. The worktable serves as a safe location for temporarily placing completed flats, dummy layouts, complementary flats, and other reference material. Shelves underneath the table serve to carry a working stock of goldenrod, vinyl, and other flat materials, as well as tint sheets and masking supplies. Metal, plywood, pressed-board or linoleum-topped tables are available in most large industrial centers. In remote areas, where shipping costs are important factors, such tables are usually constructed locally.

Shelves, Cabinets, and Racks. All necessary stripping supplies and tools should be accessible and placed in individually-marked compartments or hangers in which the tool outlines are painted.

Storage cabinets for completed flats can consist of horizontal shallow drawers or shelves. The flats themselves should be held in fiberboard folders. Each folder should hold from ten to twenty-five flats. The folders should be indexed with numbers that correspond to filing locations. A routine inventory system should be established to eliminate "dead" flats from cluttering up the storage facilities.

EQUIPMENT FOR MAKING PROOFS AND FOR COLOR STRIPPING

The equipment needed for black-and-white stripping is augmented by many other items when brownline or other proofs are to be made and when color stripping is to be done. To make proofs from flats, the normal platemaking units consisting of troughs, whirlers, vacuum-printing frames, and printing lamps are required. These may be duplicated in the stripping department when the normal platemaking units are already used to capacity. Color stripping on glass may necessitate carriers for glass flats, troughs for glass salvage, and storage racks for glass flats. If contacts or duplicates are to be made, a contact-printing frame with controlled exposure light and darkroom facilities are needed. Production setups may require pegboard assembly equipment. Each of these subjects is described briefly in the following.

Trough. Glass flats require thorough cleaning prior to sensitizing with the blueline coating. This is best accomplished in a trough provided with an inclined platform, drain, and flushing facilities. The platform should consist of slats, or be covered with a white vinyl or rubber-ribbed matting, to prevent suction adherence in lifting the glass. The same or a similar trough is required for making brown-

lines or other proofs. If used solely for making proofs, the trough should be equipped with a tilting tray instead of slats.

Whirler. The whirler is required for sensitizing glass or vinyl blueline flats. When glass is used the whirler should be selected with a large cover opening to simplify insertion and removal of the plate glass, as well as to permit cleaning and processing of the flats in the whirler when necessary. The whirler bed must be level. When used for glass flats, the rotating bed should be provided with intermittent supports, or with a ribbed rubber or vinyl blanket, to prevent suction adherence and to permit finger space for lifting the glass. Stop pins or guards are essential for glass flats, and hold-down clips must be used on the corners of vinyl sheeting.

Vacuum-Printing Frame. The glass-side-up vacuum frame is the type preferred for proofing and duplicating from flats. It is used for the ease in handling flats and avoids scratching the glass. The glass-side-down frame is advantageous where a set of blueline flats are to be made from a key or intermediate. The key flat can be left in position on the glass in the frame for the exposure of the entire set of bluelines.

If the vacuum frame is to be used exclusively for blueline flat preparation the glass-side-down frame is the preferred unit in the color stripping department.

Printing Lamps. An arc lamp similar to that used in platemaking will be needed for exposing the blueline flats in the vacuum printing frame as well as for making proofs from flats.

Carriers for Glass Flats. Caster-mounted carriers, slightly larger than the largest glass flat and provided with wood or rubber strip for finger clearance, are desirable for movement of glass flats between departments. If constructed locally they should be provided with two fixed wheels and two caster wheels. The wheels should be rubber- or fiber-tired and at least three inches in diameter. Where subjected to rough flooring, or movement on elevators, a canvas safety strap with end clasp should be incorporated to secure the plate glass.

Trough for Glass Salvage. Where a separate department is provided for removing stripfilm and work from "dead" flats, a soaking trough is needed. This trough can be similar to that used for press plates, or improved by equipping it with a mechanically tilting or elevating tray or platform. The platform can be ribbed or dimpled or provided with glass support strips. The movable platform permits the glass flat to be successively immersed for soaking and raised out of the bath for cleaning and flushing. A standpipe drain, equipped with a large diameter screened overflow to catch stripfilm waste, is required for the trough.

Storage Racks. Large glass flats should be stored in racks with individual slots. The slot runners and base are preferably constructed of hardwood. The baseboard should extend at least six inches outside the rack to support the tail end of the glass on removal. There must be no exposed screws, nails or other possible glass-to-metal contact that may cause chipping or cracking of the glass. A small rubber-topped dolly about $\frac{1}{4}$ inch higher than the baseboard, with two fixed non-swiveling wheels and two caster wheels, will aid in storage and removal of large glass flats. The surrounding flooring should be wood, linoleum, or rubber-covered to minimize accidental glass damage.

Contact Printing Frame. The vacuum printing frame used in platemaking or for making intermediates or blueline flats can also be used for occasional photographic contact printing when necessary. However, a darkroom contact printer provides a more versatile and efficient unit and produces a better quality film. As a considerable percentage of contact printing involves exposing the image through the thickness of the film base, or simultaneouly through several films, a point source of light, such as the GATF Contact Printing Lamp, described in *GATF Research Progress No. 20,* is essential for retaining dot size and image detail. An alternate diffused light source can also be used for line work where emulsion-to-emulsion contact is obtained. The diffused source will undercut dust and other defects on the glass and so reduce the amount of opaquing needed on the contacts. All contact exposure lights should be equipped with an electrical interval timer to control the exposure. The remaining equipment needed in the contact darkroom will be the same as is used with the process camera.

Pegboard Assembly Equipment. Pegboard assemblies are usually a plant specialty. They are used for standard production work such as signatures or forms. The pegboards are constructed to meet the job specifications. The positioning pins, or pegs for locating the films may be installed in the tabletop itself where a standard layout is in continuous use. However, they are more frequently mounted in hardboard, aluminum sheets, or in sheets of heavy rigid plastic $\frac{1}{8}$ inch to $\frac{1}{4}$ inch thick. The plastic is preferred for use over a layout table as it permits inspection of the films by transmitted light. The pegs are usually $\frac{3}{16}$-inch diameter pins that are shouldered and threaded for screw installation. The register punch fixture that is used in conjunction with the pegboard perforates two or more holes along one margin of the film. These holes fit on the pin sets on the pegboard. One of the punched holes is usually round, and the other is slotted so as to allow for dimensional changes in the films.

Section Three: Tools for Stripping

Good tools contribute to efficiency and good workmanship. Tools are required to drawn upon, measure, scribe and cut films or flats. A good cutting tool that is correctly sharpened will, for example, turn out better work in less time, and with less effort than a dull or improperly sharpened one. Descriptions of the various tools used by the stripper follow:

Rules and Scales. These are primarily intended for measurement and not for drawing straight lines. At least one good precision steel scale should be in every stripping

department. Steel or stainless steel scales with fine etched or engraved divisions are preferable. The heavily etched, printed, or plastic rules cannot be relied upon for accurate settings. Numbered "easy reading" fractional graduations in 32nds, 64ths, or 100ths of an inch aid in reducing measurement errors. The pocket rule is a useful asset for rapid checking of dimensions but should not be used for laying out a flat. The glass scale with graduations on its underside is a valuable addition in specialty plants where accurate measurements must be taken without injuring the copy.

Straight-Edges. Straight-edges are used for scribing or drawing straight lines. The better quality straight-edges are made of steel or stainless steel. They have beveled edges that are machined or ground true. Some straight-edges are graduated to serve as a scale also.

T-Squares. T-squares can be used for squaring-up small sections of film, such as bodies of text or display type matter, or for ruling borders or blocking out the margins of illustrations. Few T-squares are true or square enough for preparing accurate layouts. Long T-squares in particular can produce serious errors. A good T-square should have its straight-edge secured to its head by machining or doweling. The straight-edge of the T-square and the contact face of its head should be machined or ground true. In use the T-square should be held with its head firmly against the straight-edges of the layout table when it is positioned.

Triangles. A variety of triangles are available to the stripper. These range in construction from transparent plastic cutouts to stainless steel triangles with accurately squared edges. The plastic triangles are useful for squaring-up small sections of negatives or for penciling location lines wherever high accuracy is not required. They should never be used to guide razor blades, steel needles, or scribers. The best triangles have ground edges that are true and square. One or more of the edges may be beveled. The 30-60 degree triangles are most popular in the stripping department. A 45 degree triangle should also be available.

Protractors. The small 3-inch or 4-inch semi-circular protractors are of little value to the stripper. They are difficult to use, and lines extended from them are frequently in error. Where angled lines are occasionally drawn and are different than those obtainable with standard triangles and their combinations, the adjustable protractor triangle that can be set to the required angle is preferred. Where the highest accuracy of angle position is required, the calculated coordinates that are based on trigonometric tables should be used.

Irregular Curves. Two or three plastic irregular curves belong in every stripping department. They permit more accurate opaquing of curved lines or irregular shapes than is possible by freehand means. They are available in a wide variety of shapes for special applications.

Dividers. Dividers are useful for locating small sections of films so that their printing detail is parallel to each other before taping them down to the flat. They are also used to transfer small measurements accurately from the scale to the flat or film. The most convenient dividers have thumb-screw adjustment to permit setting their points accurately to the scale.

Beam Compass and GATF Register Rule. Wherever longer dimensions than those possible with a divider must be transferred accurately from the scale to the flat, the beam compass or the GATF Register Rule can be used. Although a precision layout and line-up table will supply most of the needs for locating lines accurately on the layout, the GATF Register Rule and the beam compass are still valuable instruments. They are portable and can be used to compare measurements between flats, press sheets, and press plates.

They also serve to check the source of difficulty when a deviation has occurred between measurements on the flat and on the printed sheet. They are desirable for angled measurements, and for drawing accurate angles or squares. Detailed instructions covering the use and adjustments on the GATF Register Rule can be obtained from the Graphic Arts Technical Foundation Inc.

Ruling Pens. The ruling pen is used principally to draw border lines for cropping down illustrations with opaque, for retouching solid printing detail on films, or for drawing rules on positives. The stripper's ruling pens should be reserved for this purpose and must not be used for tusching in lines on press plates.

When ruling pens become dull so that they show a noticeable flat spot, they must be carefully sharpened on a fine oil stone. When correctly sharpened, they will neither cut the film when ruling a line, nor show a flat shiny surface around their inking points. The better-quality ruling pens have inlaid tool steel or carbide tips.

Compass. The draftsman's compass can be used instead of the dividers for transferring small measurements, dividing lines or angles, or marking parallel locations on the flat. With its inking pen attachment, the compass also serves to outline or border circular illustrations. For larger circles, the beam compass is used.

Pencils and Ballpoint Pens. Hard lead drawing pencils are used for penciling lines in layout preparation. These usually range from 4H to 8H in hardness. They are sharpened to a chisel point for increasing their useful life between re-sharpenings. The ballpoint pen is becoming increasingly popular for drawing layout lines. It produces uniformly thin lines at a fixed distance from the guiding straight-edge. These lines provide more contrast and so are easier to register to than penciled lines in assembling films on the flat.

Needles and Scribers. Lithographic needles are available in different diameters and cross-sectional shapes. These are sharpened by the stripper by grinding and then stoning them to the desired shape. The round needles are usually sharpened to a gradually tapered point. They are used to mark locations on a film or flat along a thin scale, and to transfer locations from one flat or film to another that is placed in register beneath it.

By stoning the point of a tapered needle so that it is flat, it can also serve as a scribing tool on film. As a scriber, it is generally not as satisfactory or as uniform in scribing width as are tools intended for scribing purposes. Needles with square or flat rectangular cross-sections are usually ground-down and honed to a sharp edge to serve

as scrapers for removing photographic defects in the film emulsion.

For scribing lines in films, commercial scribing tools are available. They are sharpened to specified widths and are usually better than hand-sharpened tools. They are often less costly, if the time spent in sharpening the tools is considered. Scribing cutters are also available as attachments to some of the precision layout and line-up tables.

Screen Tint Ruling Measurement Scale. While the black-and-white stripper is not ordinarily concerned with the ruling used in halftone screens, some means for measuring screen rulings are helpful in selecting tint sections. Commercial scales are available for this purpose. They consist of a series of screen patches of different rulings or a scaled set of radiating lines. The correct ruling is determined by the patch that shows the largest moire pattern to the point that it disappears, as the scale is rotated slowly over the halftone film. The radial line indicator curves the moire pattern to the number of the screen ruling.

Screen Angle Indicator. A screen angle indicator is useful in black-and-white as well as color work where flat tint sections are to be used, and where overlapping tint or halftone areas might otherwise produce a moiré pattern. It also can be used to check or determine the color separation of a halftone printer. Some screen angle indicators are available commercially.

If not readily obtainable, an improved screen angle indicator can be made from a piece of a uniform screen tint of the same ruling as used for halftones or tints. A section should be selected with the value of a 20% or 25% tint (75% or 80% printing value if negatives are normally used). With the aid of a magnifier and a straight-edge, a line is drawn across this tint, in line with a row of dots. This line will be the 45° angle line and will be used for black or for single-color printing. Based on this line, the tint section will be trimmed as a polygon with angles differing by 30°, 45°, and 60° from the 45° line. The edges are then marked with the screen angles.

For use, rotate this indicator over the halftone or tint section until the largest moiré pattern forms and almost disappears. The screen angle of the film can be read off directly at the top of the indicator.

Dot-Size Measuring Scale. A scale for measuring dot sizes of screen tints is helpful to the stripper for laying down tint areas specified on the copy. Such scales are not available commercially at the present time, and are accordingly improvised in many plants. The cameraman can prepare an approximate scale that is satisfactory for most measurements.

He does so by exposing a halftone from a calibrated ten-step gray scale. He controls his exposure for straight line reproduction and development so that he obtains a square 50 percent dot for the middle step and a fine pin-point dot or opening at the end steps of the scale. This is then contacted onto another piece of film to provide a hard dot structure with the same dot-size range. The stripper can then approximately number these steps as 5%, 10%, 20%, 30%, 40%, 50%, 60%, 70%, 80%, 90%, and 95%. If a densitometer is available, the steps can be measured for integrated dot value and then accurately numbered. This scale is used in contact with the tint sheet and the value of the tint is determined by direct comparison under a high-power magnifier.

Razor Blades and Knives. Most strippers prefer to use single-edged, metal-backed razor blades for their cutting operations. These blades are convenient, relatively inexpensive, and are discarded when both ends are dull. The thin, double-edged safety razor blades should never be used, even if in holders. They are dangerous and brittle, and may break off or twist when making a cut. The artist's knife or frisket knife, with replaceable blades, is convenient for certain operations, such as cutting intricate outlines in masking materials, or marking locations from a scale on a film or flat.

Magnifiers. The stripper requires several types of magnifiers to aid him in his work. A low-power stand magnifier with an adjustable arm is useful for spotting pinholes and defects in printing areas, such as between rows of type composition. A higher powered magnifier from 9X to 15X, extending from a supporting base, is helpful for fine-detail work with a scraper or pen. This is useful for repairing halftone dots or fine type matter. A pocket-type or shop microscope, with a magnification of forty or fifty diameters, is invaluable for examining halftone dots. Such a microscope can show if the dots have adequate density. It can also be used to determine the dot size or printing value of screen tints.

Brushes. It is advisable for each stripper to have his own set of brushes so that he can care for them properly and keep them in good shape and ready for use. A suggested set of brushes includes:

2 — No. 0 Red Sable Water Color Brushes; 2 — No. 2 Red Sable Water Color Brushes; 2 — No. 4 Red Sable Water Color Brushes; 2 — No. 6 Red Sable Water Color Brushes; 1 — One-half inch flat red sable lettering brush; 1 — Two and one-half or three inch wide camel's hair dusting brush.

Brushes for rubber cement, non-water soluble lacquers, and opaques for vinyl application, plus a stiff one-inch wide bristle brush for cleaning the layout and line-up table racks, should also be available in every stripping department.

Section Four: Materials and Supplies for Stripping

The materials used by the stripper can be divided, according to their application, into the following four main groups: (1) Base materials for flats, (2) Photographic ma-terials, (3) Masking materials, and (4) Miscellaneous supplies. Each of these four groups is now discussed and described.

BASE MATERIALS FOR FLATS

The four most commonly used base materials for flats are: (1) Goldenrod paper, (2) Tracing paper, (3) Plastic sheets, and (4) Plate glass. The choice depends on the type of flat prepared, the degree of accuracy desired, its quality level and its costs. Some data on each of these materials follow.

Goldenrod Paper. Goldenrod paper is the most popular stripping material for negative flats. It serves the several functions of providing a drawing surface for preparing the layout, as a satisfactory support for holding the film assembly together, and as a mask for the non-printing areas of the press plate. Its color prevents the passage of nearly all actinic light during platemaking exposures. Its weight, usually seventy or eighty pound stock (25″ x 38″ basis), provides durability and flatness.

The difficulties with its use are largely due to its thickness and its size variations with changes of moisture content. Its thickness can cause out-of-contact areas between the film and the press plate when fine printing detail is close to the goldenrod paper. The safe clearance limit for goldenrod paper masking will depend on the thickness of the press plate used, the degree of vacuum in the vacuum frame, and the nature of the exposing light.

Double thicknesses of goldenrod paper, or the reinforcing of goldenrod paper with tape close to fine line detail or half-tones must be avoided. The added thickness aggravates the out-of-contact condition. The result of using goldenrod paper to crop halftones to size is usually a thickening of dots from negatives (a loss of dots with positives), along the paper margins.

Goldenrod paper, red masking paper, red pressure-sensitive tape, and strippable red-coated plastic sheets are normally safe for masking the flat for one or several exposures. However, they may let enough light through to scum the plate when four or more exposures are made on a step-and-repeat or surprinted jobs. Such multiple exposures overlap their masked areas and accumulate their effect.

Goldenrod paper will change its size with changes in temperature and humidity as can be seen from our table: "Dimensional Characteristics of Base Materials for Flats." Goldenrod paper is satisfactory for stripping use in hu-

midity-controlled plants, or for making small flats. It is not suitable for precision stripping, particularly where humidity control is lacking.

Tracing Paper. Tracing paper is used as a substitute for plastic sheets when preparing low-cost positive flats. It is also used as a flat base material for paper negative assemblies, or for film negative assemblies when the goldenrod flat, after cutting, would normally be too flimsy for handling.

The layout on tracing paper is prepared with light-blue pencil or light-blue ink lines. The blue lines serve for positioning the films or paper negatives but will not hold back the exposure (actinic) light in platemaking. A good quality tracing paper is relatively free from mottling or dense spots. It may be plasticized or otherwise treated to increase its transparency and size-holding properties.

The use of tracing paper usually requires an increased exposure time in platemaking. This may range from 25 percent to 50 percent over that needed without its use. When tracing paper is used for paper negative or film negative flats, the masking needed between negatives is completed by adding strips of red pressure-sensitive tape or red masking paper.

Plastic Sheets. Plastic sheets are used principally for the preparation of positive film flats. They are sometimes used for negative assemblies when size and register must be closely held. This is more likely to occur in plants experiencing considerable humidity variations. Plastic sheets are available in several types of acetate film, vinyl film, and polyester base. They are also stocked in several thicknesses.

Acetate is the least costly and is used where humidity variations are not a problem. The .0075″ thickness is usually satisfactory. Low-shrink acetate sheeting (acetate butyrate) is more stable dimensionally. Vinyl sheeting is widely used where high dimensional stability and accuracy is required from a film flat. The .010″ thick sheeting is popular as it lies flat and provides a substantial working base. The .007″ thick polyester sheet is also used for high accuracy and durability. Plastic sheets coated with a red strippable lacquer are time savers for intricate or exacting masking operations in flat preparation.

Glass. Plate glass is rarely used for black-and-white stripping in the lithographic industry. When used it is to combine stripfilm sections of highly accurate and close-fitting work. Such stripping is usually done to blueline images printed down on the glass. Details covering this use are to be found in the GATF Skilled Craft Text No. 512, "Color Stripping."

PHOTOGRAPHIC MATERIALS

The most important photographic materials used in the stripping department are: (1) Photographic films, (2) Stripfilms, (3) Paper negatives, (4) Brownprint paper, (5) Diazoprint paper, and (6) Tint sheets. Each of these is now briefly discussed.

Photographic Films. The black-and-white stripper normally works with film negatives or positives. These are usually exposed in the camera so that their emulsion side

Dimensional Characteristics of Base Materials for Flats		
Material	Approximate Expansion	
	(1)	(2)
Goldenrod Paper	.006″ (3)	.0015″
Goldenrod Paper	.020″ (4)	
Acetate Film	.007″	.0035″
Vinyl Sheet	.001″	.0038″
Polyester Film	.001″	.0015″
Plate Glass	.000″	.0005″
(1) In 10″ for a 10 percent increase in RH.		
(2) In 10″ for a 10°F increase in temperature.		
(3) With grain (4) Across grain.		

will be in contact with the press plate. The image will, therefore, be reverse-reading on the emulsion side. When mounting films on goldenrod or plastic sheets in flat preparation, the emulsion side will be upward. The back of the film will be in contact with the goldenrod or other flat material.

Films are commonly available in two thicknesses. The "regular base" material is about .005" to .0075" thick. It lies flat and is also thick enough so that it is not easily cut through when cutting out the goldenrod exposure windows in the assembled flat. Thin base films are about .0035" to .004" thick. They are gaining in popularity and are also used when it is necessary to assemble two films over each other or to expose through its base thickness with its emulsion side out-of-contact with the plate. Polyester based films are preferred whenever accuracy in dimensions or location is essential for the job.

Stripfilm. Stripfilm has similar photographic properties to the other films. They are supplied as laminates that consist of a thin removable emulsion membrane that is temporarily attached to a sheet plastic support. The thin emulsion membrane can be removed or "stripped off" and adhered to clear areas on other negatives or positives. This is sometimes done when adding halftone illustrations to close-fitting line detail.

Stripfilm can be attached to film, sheet plastic, or blueline glass. Its adhesion is aided with a liquid stripfilm cement. When the stripfilm section is placed in position on the film or flat, it is wiped down in registered location by using small squares of lintless blotting paper. Working details for the use of stripfilm are covered in the GATF Skilled Craft Text No. 512 "Color Stripping". The black-and-white stripper in a small or medium-size plant will rarely use stripfilm.

Paper Negatives. Paper negatives are used for low-cost flat production. Such work will consist largely of line detail, though halftones may be included if their resulting printing values are not too critical. These jobs are largely of the store bill, direct mail, railway tariff, and throw-away handbill varieties.

Brownprint Paper (also called Silverprint or Van Dyke paper). Brownprint paper is commonly used to prepare positive proof prints from negatives or negative flats. Brownprints are used for proofreading and for checking the lay and arrangement of the flat before platemaking. In this way the customer can approve or request changes in the job without the added costs of preparing proof plates and printing a short run on a lithographic proof press or on a production offset press.

Diazoprint Paper (also called Whiteprint, B. & W., Ammonia Process and by various trade names). Diazoprint papers are direct-positive light-sensitive papers. They are used for producing positive proofs from film positives. They are exposed in the vacuum frame, under conditions similar to that used for brownprints. Development of the exposed image is obtained either by moistening the surface with a special developer, or by subjecting the exposed sheet to warm ammonia fumes, depending upon which commercial product is used.

Tint Sheets. Tint sheets carry uniform dot-size values over their entire area. They are used by the stripper to introduce tinted backgrounds as different shades of black or color in printing. Tint sheet are prepared photographically on thin base film. Commercial tint sheets in graded tint values are available. The cameraman also prepares such tint sheets by making contact prints on film from uniform halftone tint masters.

MASKING MATERIALS

The masking materials used by the litho stripper can be divided into these kinds: (1) Red masking paper, (2) Masking foils, and (3) Pressure-sensitive masking tapes.

Red Masking Paper. Masking is usually applied over the face of the films. It should be as thin as possible to prevent out-of-contact conditions and embossing of the plate in platemaking. This is particularly important when a small flat is prepared for use on the photocomposing machine.

Red masking papers have the advantages that goldenrod paper has in low cost and in permitting penciling the outlines of the section to be cut out. It also has sufficient translucency to show if work detail has been accidentally masked-out. Several types of red masking paper are in use by strippers. These include the lightest weights available of deep-red or maroon glazed label paper (about 13 lb. to 16 lb.), and similar lightweights of machine-finished red sulphite stock.

Masking Foils. Thin metal and plastic sheets are used for close masking to work detail to reduce the amount of opaquing otherwise required. Tin or aluminum foil is used for accurate masking or cropping of halftone areas, particularly on small flats intended for the photocomposing machine.

Metal foils are not normally used on goldenrod flats as they are easily damaged in the normal handling of these flats. Metal foils are about one-thousandth of an inch in thickness. When removed from the roll they are relatively free of pinholes. However, pinholes develop if the foil is wrinkled or mishandled. Thin red acetate films are also suitable for masking.

A red coated clear plastic sheeting is commercially available that is suitable for the rapid preparation of complementary and mask flats. The red coating can be outlined with a knife in the intended exposure areas. The coating is then lifted and peeled away.

Pressure-Sensitive Masking Tapes. Pressure-sensitive cellophane or polyester tapes in red, brown, or black coloring offer a fast and effective means for securing film sections together and masking the film joint at the same time. The red and brown tapes are translucent and so permit seeing the sections that are masked while the tape is applied to crop printing detail areas to size.

These colored tapes are also useful for blocking-out words or other detail where two identical negatives are to be masked-out as complementaries, so as to separate the color areas between them. This is frequently done to print paragraph headings, or display lines or trade names in a different color than that used for the text. Red and brown

pressure-sensitive plastic tapes can also be used for cropping or vignetting illustrations so as to closely outline printing detail. In many instances this method is faster and more easily applied to negatives than is opaquing.

MISCELLANEOUS STRIPPING SUPPLIES

The black-and-white stripper uses a variety of expendable materials in his work, such as inks, adhesives, opaques and register marks or holes. The color stripper will also require blueline solutions and stripfilm adhesives. Some of these supplies are briefly discussed in the following.

Transparent Tapes. Transparent, colorless pressure-sensitive tapes are used to attach positives to plastic flats, and negatives to goldenrod flats. The cellophane-type tapes are satisfactory for most goldenrod flat preparations. The polyester tapes are somewhat more difficult to use, as some of them may be electrostatically charged when they are removed from the roll. However, they are more transparent, more durable, and are preferred when the tape must extend across image areas, and where flats must be stored for extended periods of time.

Cements. Rubber cement is used for attaching masking materials, principally on positive flats, where it is undesirable to permit the tape to extend beyond the masked areas. Rubber cement should always be applied sparingly. It should be allowed to set for fifteen or twenty seconds before applying the mask.

India Ink. India ink is a dense black ink. It can be applied with brush, ruling pens, or special fountain pens. It serves to provide improved visibility of layout lines, particularly when such layouts are to be used repeatedly.

Plastic Drawing Inks. Special "acetate" inks are available that will take to films, acetate, vinyl, and other plastic sheets. Black, blue, and red are the preferred colors. Black is used for permanent markings that are required to hold back light. A light-blue ink is used wherever non-printing marks are needed for positioning films on plastic flats. Red is used to block-out areas on positive flats, particularly on complementary flats or in color jobs.

Marking Inks. These are intended for and commonly used with felt-tipped marking pens. They are desirable for prominently marking flats with such information as job number, job name, printing color, and direction of movement for a step-and-repeat job.

Opaques. Both red and black opaques are used by strippers. They serve to block-out defects or unwanted printing detail on negatives and are used to retouch printing detail defects in positives. The black colloidal-graphite opaque is preferred for fine work. It covers well, and is extremely thin.

Red opaque is somewhat easier to apply over large areas and is less likely to stain the emulsion when errors in opaquing are corrected. The black opaque is better for scribing purposes. In such work the negatives are spotted-out before scribing. Red opaque must be applied carefully and uniformly. If it is permitted to dry in lumps close to halftone areas or to fine line detail, the lumps can cause an out-of-contact condition similar to that produced by heavy masking papers.

Register Mark Tabs. For the average run of commercial stripping, register marks can be applied to the flat as small tabs of film. These marks can be made photographically in quantity by first preparing master groups of positives or negatives of such marks. These groups are then cut into strips and scored so each can be broken off as needed. A desirable type of mark consists of cross lines with segmented portions of a surrounding heavy circle.

Register Hole Tabs and Dowels. Plastic register hole tabs and dowels are commercially available. They provide a fast means for positioning complementary flats on a press plate or on brownprint paper so that they can be successively exposed in register with each other. They are also used for simple step-and-repeat jobs.

Color Blocks. Color blocks are small rectangles applied as an opaque area on each positive flat, or as a transparent opening on each negative flat. They are located in the trim area of the sheet. Each is positioned so that it will print adjacent to the color blocks for the other colors. These blocks show the colors already printed and guide the pressman in determining whether he is carrying a full body of ink.

Halftone Step Scale. Also located in the marginal trim area, the gray scale is an added guide to the pressman. It provides a visual check of the ink control and density for each color. Any tendency towards filling in shadow detail or blinding the highlights can readily be detected with such a scale. These scale strips may appear on the separation films where they have served as controls for the photographer and dot-etcher.

The GATF Sensitivity Guide. The GATF Sensitivity Guide consists of a continuous-tone gray scale with numbered step densities. It should be temporarily applied to every flat as an aid to the platemaker for determining whether his exposure and development are correct. This guide helps in establishing standard controls for uniform color reproduction. It also informs the platemaker if any of his operations are deviating from their best conditions. (See GATF Research Bulletin No. 215, "The Sensitivity Guide").

Blueline Solutions. The blueline solution is applied as a light-sensitive coating to glass or plastic sheeting. Exposure through the key or intermediate flat and development produces a blue image that can be registered to in stripping, yet will transmit actinic light. The color stripper positions his films to this blue image. The blue image can be converted to brown or black by a local or general application of a stain or developer. The brown or black image will reproduce in platemaking. A flat so prepared can serve as intermediate in printing down blueline flats.

Stripfilm Adhesives. Stripfilm, when applied wet, will adhere well to clean glass, acetate, or film base if it is "flopped" so that its emulsion side is in contact. When stripfilm is transferred to the flat without "flopping," an adhesive must be used.

Cleaning Solutions. Before cleaning a film with a solution, first dust off any surface particles. Use a wide camel's hair brush. This removes abrasive particles that could scratch the emulsion if they were wiped with a rag or tissue. For cleaning films, toxic solutions such as carbon tetrachloride and benzol have been replaced with safer proprietary solvents. These are available through most suppliers. A good cleaning solution should evaporate completely without leaving a greasy film or other residue.

Scratch Fillers. Scratches or accidental lines cut into the exposure areas of negatives or positives can cast shadows during platemaking exposure or contact printing. These shadows will show up in the reproduction. Minor hair scratches on films can usually be ignored, as the exposure light will burn through them. Major scratches or accidental razor blade cuts in work areas will require correction. If they are on the back of the film, they can be wiped over with commercially available film-scratch fillers.

Section Five: Auxiliary Stripping Operations

In simple jobs the negatives or positives delivered to the stripper are ready for stripping-up a flat without any additional work. In many cases they will require intermediate steps to prepare them for stripping. Here we discuss six types of such auxiliary stripping operations: (1) Inserting negative sections, (2) Adding rules and borders, (3) Adding tints, (4) Fake color work, (5) Double printing and surprinting, and (6) Making corrections and changes. Instructions concerning each of these operations follow.

INSERTING NEGATIVE SECTIONS

Negative sections can be inserted into a larger negative by various methods. Here we present the following three in detail: (1) Use of stripfilm, (2) Attaching the negative to the surface of the larger film as an overlay-insert, and (3) Cutting an opening and splicing-in the insert, or window-inserts. Double-printing methods can also be used to obtain the same results. These techniques are presented later in this section.

Inserting Negatives by Use of Stripfilm. To use stripfilm, or to attach a film to the surface of a larger negative, the area it is to occupy must be clean and transparent. This can be anticipated in copy preparation by attaching red or black cutouts that are cut to size and mounted in position on the paste-up copy. These blocked-out areas will remain clear on the developed negative.

If the areas are not completely transparent they can be cleared by local removal of the silver image. An emulsion remover such as commercial sodium hypochlorite solution ("Chlorox" or equivalent), a concentrated Farmer's reducer, or a cyanide etch, as may be used by the camera or color correction departments, is carefully applied to the area. The chemicals are then removed by washing the film in water and drying. Stripfilm requires highly skilled handling techniques. Its application is described later in this chapter, Section Seven, and in GATF Skilled Craft Text #512, *Color Stripping.*

Overlay-Inserts. Overlay-insert sections are prepared on thin base film. This reduces the out-of-contact image spread of adjacent printing detail. The overlay-insert should always carry the halftone or the finer printing detail. This permits the detail to be in contact with the press plate in platemaking. The insert films should be cut to a size slightly larger than its printing area. The extended border

permits taping the film down without running the tape over the image area.

If the overlay-insert is a halftone and is to be cropped down to size, this should be done first. Masking is applied

Opaquing to crop illustration to size.

to the back of the film. This is usually done by first ruling in opaque border lines to the crop marks. Additional opaque is then applied by brush up to these border lines.

Cropping can also be done with strips of red or brown pressure-sensitive cellophane tape. While this method is faster than opaquing, it must be used cautiously as some marginal dot spread could result from its added thickness.

If the overlay-insert has register or other crop marks for use in positioning it on the larger negative, these marks are allowed to remain until after the insert is taped down in

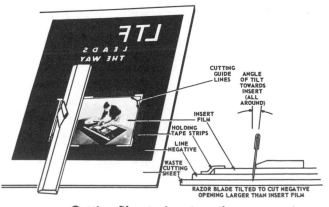

Cutting films to insert section.

position. If no location guides are provided on the copy or dummy, the stripper must square-up the insert to important detail. In cropping unmarked inserts to size, the detail must be selected to provide good composition that is centered and balanced on the subject matter. When attaching the overlay-insert, it may be necessary to first cut the tape into narrow strips so that these strips of tape will not overlap printing detail.

Window-Inserts. If both the insert and the adjacent film areas have close-fitting and fine printing detail, it is best to insert the film into an opening cut into the larger negative. This aids in obtaining good contact in plate-making. To produce a good fit in a minimum of time, both films are cut together.

First square-up the insert with the large film and attach it in position. Use strips of pressure-sensitive tape. Then place the attached films, emulsion-side down, on a waste cutting film. Position a steel straight-edge or triangle to the first edge to be cut. Use a sharp razor blade or frisket knife. Make several light cuts until both films are cut clean through, up to and slightly past the intended corners.

It is best to tilt the knife slightly in, away from the insert. In this way the opening in the lower film will be

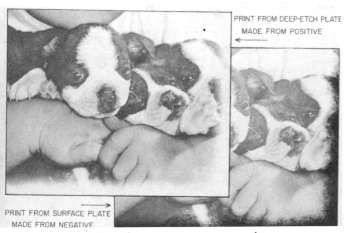

PRINT FROM DEEP-ETCH PLATE
MADE FROM POSITIVE

PRINT FROM SURFACE PLATE
MADE FROM NEGATIVE

Out-of-contact image spread.

slightly larger than the film to be spliced in. Otherwise it may be necessary to double-trim two sides of the insert to prevent an interfering overlap of the insert edges. Then use strips of red or brown pressure-sensitive cellophane tape to secure the insert in place. This will also mask-out the cut edges.

When taping the insert in location it may be necessary to first slit the tape into narrow strips so that the tape will not overlap the printing detail. If the printing detail comes very close to the joint line in places, a wider red or brown cellophane tape can be applied that covers some of the detail. Then, using a sharp razor blade, cut lightly through the tape. Cut to a straight or irregular line that clears the printing detail. Lift away the interfering tape. Avoid overlapping tape in the corners where possible as the added thickness can produce an out-of-contact condition in plate-making.

ADDING RULES AND BORDERS

The transparent areas on negatives will transmit light to produce the printing image. Wherever the blackened emulsion is removed from a film, light can pass through to expose the press plate. To produce rules, grids, or borders on a negative, strips of emulsion are shaved away with a scribing tool to form transparent lines.

Good scribing tools are ground to the correct widths for

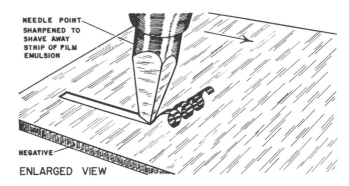

NEEDLE POINT
SHARPENED TO
SHAVE AWAY
STRIP OF FILM
EMULSION

NEGATIVE
ENLARGED VIEW

Scribing lines in negative.

specified line thicknesses. When drawn across the emulsion side of a negative they will shave away a strip of the emulsion and produce a sharply defined rule. A needle point or a blunt tool will furrow the emulsion and produce a ragged line. The emulsion for ruling must be clean and dry. It should not be excessively hardened in fixing or excessively dried by forced heating. The scribing tool should always be tested along the waste margins of a film for its ability to shave away a clean ruled line, before it is used in the work areas. Some emulsions are better scribed when slightly damp.

To Add Rules on a Negative. First square-up the negative to the layout table. Select a table area that is clean and free from scratches. Then tape the film down securely and flat with strips of pressure-sensitive tape. Mark the location of the lines to be scribed along the margins of the negative, outside of the trim area of the job.

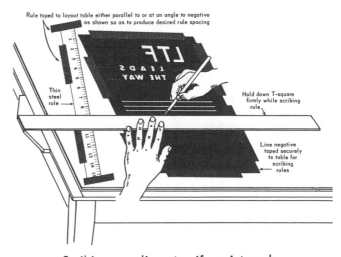

Rule taped to layout table either parallel to or at an angle to negative as shown so as to produce desired rule spacing

Thin steel rule

Hold down T-square firmly while scribing rule

Line negative taped securely to table for scribing rules

Scribing or ruling at uniform intervals.

Ruling Uniformly Spaced Rules. If the rules are to be uniformly spaced, a thin steel rule can be taped down alongside the form. The T-square or triangle is then positioned to the scale graduations for each line to be ruled. If the uniform spacing is not a full fractional value of an inch, such as when 21 rules are to be spaced uniformly in $5\frac{1}{4}$ inches, the steel rule can be tilted at an angle and taped down.

The angle is selected so that the space is divided into the desired number of full graduations.

Duplicating a Previously Printed Form. If a previously printed form is to be duplicated, the form can be squared up and taped down alongside of the negative. The T-square is then positioned to the printed rules. Before scribing the rules, pencil in an outline on the negative to show the limits for the lengths of the rules. Then spot out any large pinholes or other defects in the area to be ruled. Set the T-square to the location for the first rule. Hold the scribing tool perpendicular to the edge and slightly inclined in the direction of ruling.

Start slightly beyond the penciled limit and scribe with a steady uniform stroke across the negative to slightly past the other limit line. If the stroke was too light so that all of the line is not cleanly removed, repeat the stroke without disturbing the T-square or the angle of the scriber. Continue with all the remaining lines to be scribed.

Scribing Horizontal and Vertical Rules. If both horizontal and vertical rules are to be scribed, first make certain that the two edges of the layout table are square with each other so that the rules will be at right angles. Otherwise it is best to release the negative, rotate it 90 degrees, square it with the T-square and steel triangle, and tape it down again, before scribing the other set of rules.

Opaquing the Ruled Negative. After all the rules are scribed in, release the film and flop it over, emulsion-side down. Square it to the layout table and tape it down. Use a ruling pen and opaque to draw the marginal borders that will mask-out the ends of the successive ruled lines. Red or brown pressure-sensitive cellophane tape can also be used for this purpose if it is carefully applied and guided straight along the edge of the T-square or triangle.

To Border an Illustration. The same procedure is used as in scribing rules on a negative. First lightly pencil in the border on the negative. This will locate the lines and prevent scribing short or long lines. Apply a thin covering of a colloidal-graphite opaque with a brush to any pinholes or unwanted transparent areas in the location of the intended border lines. When the opaque has dried, carefully scribe in lines of the required thickness. Follow the procedure previously detailed for adding rules. Opaque out the excess lengths of the border rules at the corners. This is best done on the back side of the film. If opaque is applied to limit the length of a scribed rule on the scribed side of the film, the opaque may creep in along the line.

Bordering Halftone-Inserts. When bordering halftone-inserts, the scribed border may be applied either to the large negative or to the insert. This will depend on its required location and in providing adequate clearance for

the tape that is used to secure the insert. If the fit is so close that it will not permit scribing the border on the negative or insert, it may be possible to double print the border in location. This can be done by use of a flap section on the flat or by preparing a complementary flat.

Adding Rules to Positives. Rules can be added to positive films by drawing them in with opaque and a ruling pen. First lay out the rules on a sheet of paper. Then position the positive over the layout and tape it down. Always test the ruling pen for its ruling properties immediately be-

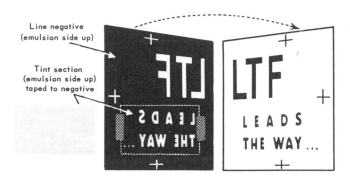

Line negative (emulsion side up)

Tint section (emulsion side up) taped to negative

Applying tint sections to negative.

fore drawing on the positive. The positive should be clean and free from greasy fingerprints. If difficulty is experienced with ruling on positives, it is advisable to use "acetate inks" for such ruling. If only a few short lines are to be added to a positive such as register or trim marks, the scriber can be used to engrave these marks. The scribed lines are filled in by rubbing them with a black crayon or litho crayon. The excess crayon is then wiped away with a soft clean tissue.

ADDING TINTS

Tints are added to negatives or positives to produce uniform tone values of the printed color. Several different tint or tone values may be used for a single color. A color combination of tint values in two or more colors can also be applied to any area.

This is done in fake color preparations. The use of tint values makes possible the printing of a job in fewer press-runs. Otherwise each shade of gray or color would require a separate press-run to be printed with a specified ink.

Selecting the Required Tint Value. The percentage steps in an ink specimen book or the color blocks in a color combination chart will guide the stripper in selecting the required tint value whenever the values are not specified on the dummy or copy. This requires that he match the color swatch or spotted colors on the dummy with the chart to determine the dot size needed in each color. Tint sheets can be prepared photographically by the cameraman or are available commercially. They come in standard screen rulings and are rated in nominal values such as 10, 20, 25, 30, 40, 50 percent etc. If the values of the tint sheets are not marked, the dot-size measuring scale previously described should be used.

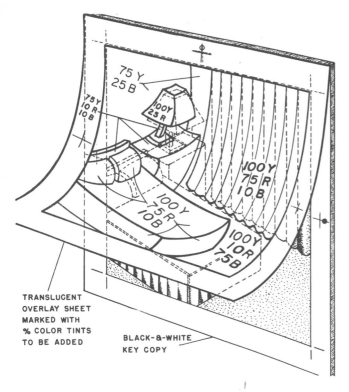

Copy marked for fake color tints.

Dot-Size Gain. When working with negatives, the dot size on the tint sheet will be the reciprocal of its printing value. That is, if a 60 percent tint is to be printed, the dot size on the tint sheet will be a 40 percent dot and cover 40 percent of the area. Whenever the specified tint value is greater than 50 percent, it is desirable to know the dot-size gain that is experienced on the press on which that job is to be printed. For example, it may be necessary to use a 65 or 70 percent tint if an 80 percent printing tint is specified.

Locating the Screen Angle on Tint Sheet. It is also important to locate the screen angle of the tint sheet section to be used. When the printing is to be done in black or with a single color, the screen angle of the tint section

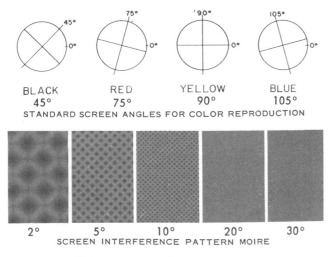

Color screen angles and moiré.

should be selected for use at 45 degrees. If several tint values of different colors are to overprint each other, the angle selected for each color should be the same as that used in a color process job. Popular angles are: black-45°; red-75°; yellow-90°; blue-105° (15°). These angles are selected to avoid a moiré pattern from forming in the overprinting color tint areas. The same applies in single-color work when a tinted background bleeds into a halftone illustration.

Reducing an Area to a Specified Tint Value. If an area on a flat or on a negative is to be reduced to a specified tint value, it is usually photographed clear. This is anticipated in copy preparation by attaching a red or black cutout to the copy.

Any defects in this area on the negative such as fog, specks, or streaks must first be cleared by using the sodium hypochlorite solution or the concentrated Farmer's reducer, as previously described.

The bordering areas are then opaqued-out where necessary so as to limit or crop the tint areas to size. A section of the tint film that has the required printing value is inspected and selected for uniform dot value and freedom from de-

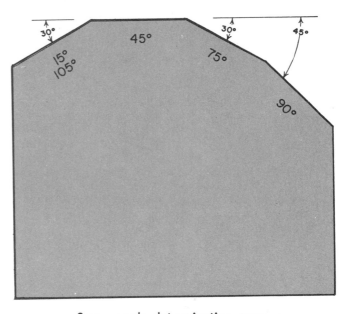

Screen-angle determination gage.

fects. Its angle is determined. It is then placed emulsion-side up and at the correct angle over the negative area it is to occupy. A light line is penciled or scribed on the tint sheet about ³⁄₁₆ or ¼ inch outside the tint area limits. This excess margin will be trimmed closer along those edges where the tint may overlap adjacent printing detail.

The tint sheet is then cut to size. It is finally secured in place on the negative, emulsion-side up. Use tabs of cellophane pressure-sensitive tape. Cut the tape into narrow strips, if necessary, so that it will not extend into the tint area. It is not advisable to cut away openings in a larger film to provide clear areas for receiving tint sheets. If this is done the unbacked margins around the tint area may result in a thickened printed border due to an out-of-contact condition in platemaking.

Preparing Tint Sheets for Positives. In cutting tint sheets for use on positives, the tint sheet is selected to have the same dot size that is to be printed. Its angle is selected, and its edges cut cleanly to the exact size of the tint area it is to print. In attaching it to a positive, it is advisable to use a thin application of a clear rubber or film cement to hold it in place. Clear tape that is attached to the surface of tint sections can result in printing defects.

FAKE-COLOR WORK

Tint sheets can be used to produce fake-color jobs for some classes of work by the methods described in the previous section. Wherever the color areas are of uniform tone value, color can be added and limited in its coverage so that it will follow detail outlines. The tint sheets applied to negatives can be opaqued locally to produce clear areas or highlights in printing. The dots can also be removed locally by brush application of sodium hypochlorite or concentrated Farmer's reducer (as previously detailed) to form solid-color printing sections in the tint areas.

With some experience in dot-etching techniques, the dot-size values can also be modified locally. The dot sizes can then be made to conform with the subject modeling and with required changes in color values. For such work, color process procedures are followed. The printing dot size for each color on each section of a color combination area must first be determined. This is done by spot color matching with a color combination chart. The color combination chart should be prepared in advance with the inks that are to be used for printing the job.

DOUBLE PRINTING AND SURPRINTING

Double printing and surprinting are photographic procedures that are used to combine the detail from two or more films into a single film. This is done to simplify stripping practices. By combining printing detail into a single film it is possible to eliminate the close-fitting of film sections and the need for complementary flats. This is used for combining close-fitting line and halftone detail. The photographic combination also improves the quality of the printed reproduction. The single film eliminates out-of-contact difficulties, and provides a more opaque dot structure than can be obtained from the original camera halftone negative or positive.

Equipment for Double Printing and Surprinting. Double printing and surprinting require darkroom processing facilities; a vacuum-contact printer; and a point-source exposure light. The darkroom methods for exposure and development of the film are described elsewhere in this manual, as they are usually done by the cameraman or by a specialized contact man. The stripper is required to prepare the negatives or positives so that they can be double printed or surprinted accurately in relation to each other. He does this by using one of the following methods:

Flap Methods. This requires a supporting base, such as a sheet of $\frac{1}{8}''$ thick plastic, pressed-board, or a section of metal press plate that is free from kinks. The base size must fit within the contact frame. The two negatives to be double printed (or surprinted) are first registered to each other. They are then trimmed if necessary so that each negative has one side that projects beyond the margin of the other film.

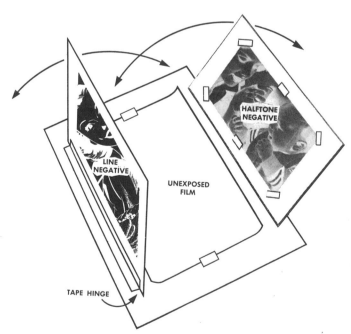

Flap method of double printing.

A white sheet of paper, the size of the film that will be exposed, is placed on the base. The two films are then carefully registered to each other in position on the paper. Each film is then taped to the baseboard along its extended side. In this way each negative will be hinged to the supporting base. If the negatives are small, the hinged sides can be opposite each other. If the negatives are large and nearly fill the contact frame they are usually hinged

Copy with blank cutouts for illustration strip-in.

along the same side with separate strips of tape. In use, darkroom safelight conditions are employed.

The sensitized film to be exposed is placed emulsion-side up on the base in place of the white sheet of paper. It is taped down securely. The first flap negative is lowered over the film. The vacuum frame is closed, the air exhausted, and the first exposure made. Vacuum contact is then released. The second flat is lowered against the sensitized film in place of the first, and the second exposure is made.

If the negatives were large and hinged along the same side, the sensitized film is secured only along the opposite side to that used for the negative sections so that it also is hinged to the base. The sensitized film is first interleaved between the top and lower film and the first exposure is made. For the second exposure, the top film is removed and the sensitized film is hinged below the second film.

Punched Hole Methods. Registration for double printing or surprinting two films may use standard peg-

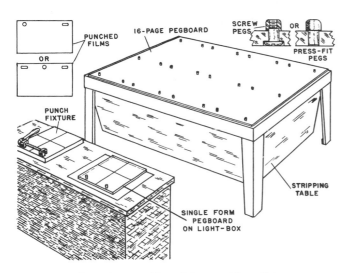

Pegboard assembly with punching fixture.

boards and a punch fixture for punching the films. Punched holes and plastic dowels can also be used. The two films to be double printed or surprinted are first registered to each other over a light table. They are then taped securely to each other to hold register.

The two films are next punched together along a waste margin, to obtain two register holes. (Three holes can be used for large films. When three holes are used, a combination of one round and two slotted holes, or three slotted holes are desirable. When three slotted holes are punched the intermediate slot is at right angles to the others.) To use the punched films, a pegboard with spring-loaded or removable pegs is required.

The peg locations must match the hole locations on the films. These holes permit the successive exposure of each negative in registered location on the sensitized film. The sensitized film can be taped in exposure position to the pegboard. Holes can also be punched in the sensitized film (under safelight conditions) so that it can be mounted on the same pegs. If plastic dowels are used, they are located

and attached to the baseboard through the punched holes of one of the negatives. This is then used as a pegboard.

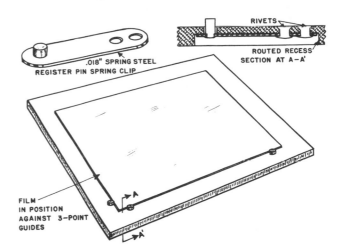

Three-point register for double printing.

Edge-Register Methods. Edge register or "three-point register" is sometimes used for positioning each negative in register when exposing them to the sensitized film. This is done by first registering the two negatives together over a light table and taping them to each other. Two of the adjoining edges of the negative assembly such as the top and left hand side are then trimmed off together. The other edges are notched or the opposite corner clipped off so that the correct edges will be used for locating the negative in the contact frame. Positioning each negative for contact printing is done by pressing it against the three pins. The negative is then temporarily taped down in register location to secure it for the exposure.

There are other methods for double printing or surprinting. Some utilize specialized equipment, such as the double-negative printer. Under suitable conditions, the photocomposing machine can also be used for this purpose.

Double Printing with Positives. When double printing with positive films, it is necessary to mask-out each positive in the areas that the other positive will contribute its printing detail. Otherwise the double exposure will blank out printing detail. When surprinting with positives, both positives are first registered and taped to each other. They are then exposed simultaneously to the sensitized film.

MAKING CORRECTIONS AND CHANGES

When combining new film sections with older films, it is essential that the printing detail in each be similar if the new section is to be inconspicuous in printing. This is especially important where text matter is involved. Changes in exposure times or in development conditions in preparing the film can result in noticeable changes in the body weight between the older and the new text matter. The stripper should not try to compensate for such differences. He should request new negatives that are made to match the old printing detail whenever this is possible.

Compensating for Differences in Type Body Weight. If the cause of the difference in body weight is directly due to the reproduction proofs used for copy, and new proofs cannot be readily obtained, the cameraman can determine how much compensation he can provide in sharpening or thickening up the text by photographic methods so that it will be less conspicuous in printing.

Replacing Lines of Type or Paragraphs. When introducing a new line, paragraph, or illustration to replace an old one, it is best to attach the new film in register over the older film. Then carefully cut through both films as was described for making an insert. If the new text matter differs in composition and arrangement from the old, the old film area can still be used to locate and line-up the new printing detail, before it is cut away.

Some corrections, such as changing the typeface of scattered display material throughout a text, are more easily made by stripping-up a complementary flat or flap section with the new film sections in location. The words to be deleted on the first negative are then opaqued out.

Section Six: Goldenrod Flats for Black-and-White Stripping

Our discussion of goldenrod flats for black-and white stripping is divided into these major parts: (1) Securing the essential information and the materials for the job, (2) Preparation for stripping, and (3) The assembly of the films in stripping-up the goldenrod flat.

ESSENTIAL INFORMATION AND MATERIAL FOR STRIPPING

Under this heading we discuss six points: (1) The layout of the job, (2) Dimensions of each form, (3) Press requirements, (4) Quality control standards, (5) A complete set of negatives, (6) The necessary equipment, material and supplies for stripping.

A Layout of the Intended Printing Arrangement. This may consist of a visual, mock-up, or dummy, or it may be specified on the job jacket as consisting of a definite number of pages or forms on the press sheet.

Dimensions of Each Form. The trim size, bleed allowances, and double trims needed must be known. Signature lays are prepared for correct imposition of both sides of the press sheet. They must allow for folding, wraparound, binding, and other finishing requirements. This subject is discussed in Section Eight, *Imposition,* of this chapter.

Press Requirements. Flats must be prepared for the particular model and size of offset press to be used. Each press has its own requirements for gripper distance, nonprinting gripper margin, and printing conditions. These requirements may indicate a change in layout to accord with ink distribution limitations, to compensate for shrinkage or stretch of the paper stock, or to circumvent specific press difficulties. Some pressmen use a system of pins or scribed marks for positioning the press plate when clamping it to the cylinder so that they can reduce press adjustments. These reference points must then be used when preparing the flat for a specific press.

Quality Control Standards. The job jacket should indicate the quality level and accuracy specified for the job. If too much time is applied to a competitively priced job it can easily result in a financial loss. Too little time and inferior handling in flat preparation can result in a disappointed customer and a loss of further business. Good stripping practices require the best degree of workmanship and the use of expedient shortcuts that will produce a satisfactory job within the limits of a specified quality level.

A Complete Set of Negatives. Each negative should first be checked for correct size, its provisions for register, and for errors and defects. Corrections are best made on the individual negatives before they are stripped-up on the flat.

The Necessary Equipment, Materials and Supplies for Stripping. The equipment must provide the degree of accuracy in alignment and register position that is required of the printed job. T-squares or layout tables that are out-of-square, or straight-edges that are not true will result in inferior workmanship. Good tools and equipment will provide a much better job for the same amount of work. A good craftsman first checks that all the needed supplies are on hand. He locates each item in an established convenient position where it can be reached with a minimum of effort.

PREPARATION FOR STRIPPING

The stripping layout is usually decided in advance by the agency, office, or the job planning department. A dummy of the job or the required dimensional data is furnished. These include all normal printing allowances. The stripper can sometimes use the dummy directly to strip up part or all of a flat. He does so by assembling the negatives over the dummy, placing the negatives emulsion-side down. If the dummy has not been accurately drawn, as is frequently the case, the stripper must prepare an accurate layout to which he can position the negatives.

The exact procedure for preparing a stripping layout will vary with the available equipment. It must also be guided by the accuracy required in the imposition of the forms. The general procedure follows:

Preparing the Goldenrod Base. Place a sheet of goldenrod paper on the layout table. Square-up its leading edge (the gripper edge) to the straight-edge, front stops, or with the aid of a T-square. Then tape the sheet down with tabs of pressure-sensitive tape. Make certain that no waves exist or appear when the sheet is taped down. The

goldenrod paper should be purchased or cut to a size equal to or slightly larger than the press plate. For certain plate sizes, the paper may be an inch or two less than the around-cylinder dimension of the plate. This may permit economical use of standard goldenrod sheet sizes. The platemaker will later cover this area along the back edge of the press plate with a strip of goldenrod paper after he positions the goldenrod flat on the press plate. NOTE: Where higher accuracy in location is required, orange colored plastic sheets are used in place of the goldenrod paper.

Drawing the Basic Reference Lines. Draw the basic reference lines.

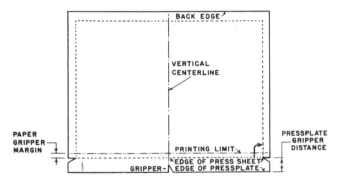

Reference marks used on flats.

This consists of the gripper-edge line and the vertical-center line. The gripper-edge line is the location of the front or gripper edge of the press sheet in relation to the press plate. It varies in distance for each size or model of press. Also draw a second line parallel to the gripper-edge line to represent the non-printing gripper margin of the press sheet. This will also be determined by the press to be used. This gripper margin distance ranges from $\frac{3}{16}$ to $\frac{3}{8}$ inches.

Selecting the Gripper Edge. If no printing detail comes within the gripper-margin distance, the gripper edge of the sheet can be used as part of the printed job. This is necessary when the full sheet size must be used. If the sheet is larger than needed for the forms, it is best to allow for trimming away the gripper edge. This will help prevent press markings such as gripper finger-marks and ink or dampener roller slur from showing up on the trimmed forms along the gripper edge of the press sheet.

The Vertical-Center Line. The vertical-center line must be exactly at right angles to the gripper line. This is very important for work-and-turn or other backed jobs. An off-vertical line will double its error in backing when the other side of the sheet is printed. The gripper-edge line and the vertical-center line are the basic lines from which all the other lines on the layout will be measured. This will avoid accumulated errors that may result if the measurements are taken from subject to subject in preparing the layout.

Center Line on Work-and-Tumble Jobs. For work-and-tumble jobs, draw another horizontal line to locate the horizontal-center line of the press sheet. This center line will be used as the basic reference line in place of the gripper-edge line. Its use will reduce the amount of

press adjustments that are otherwise necessary for printing the back of the sheet.

Indicating the Margins of the Press Sheet. It is also advisable to add lines on the layout that show the margins of the press sheet. The press sheet outlines will show if the trimmed forms and all printing detail are correctly placed on the sheet. The sheet-margin lines also serve to guide in locating the centermarks, trim and fold marks, color blocks or bars, halftone scales and other controls, so that they will print in the waste trim margins of the press sheet.

Locating the Layout Position of the First Subject. Lay out the location of the first subject. This is usually the central form, or it may be another form that is located along the gripper margin. If the negative has centermarks, the positioning lines will be drawn to locate the first form to the centermarks.

If centermarks are not provided and trim marks are used, the positioning lines will be drawn to locate the negative by its trim marks.

If no marks are provided, or irregularly located register marks are used, the form outlines should be drawn to the form size that is indicated on the job jacket or dummy. Where positioning marks are omitted, each film must be stripped-up by squaring to work detail, and by measurements taken from the mechanical, dummy, or copy.

When trim marks on the negative are to be used for positioning, always measure the separation between them, and check these measurements with the specified trim distance on the job jacket. These marks are frequently incorrectly spaced on the negative. This may be due to errors in copy preparation or to size changes resulting from relative humidity variations.

Layout Techniques for Different Levels of Accuracy. With the average stripping job where high accuracy in register or position is not essential, the layout lines should be drawn to the correct dimensions as specified

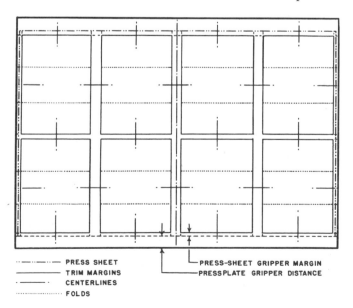

Layout locations for negatives.

rather than to measurements taken from the films. When stripping-up the films, the difference between the drawn and actual film dimensions can be approximately split up between the marks. For accurate register jobs, additional marks should be added at the corners of each subject location on the layout to agree with the negative measurements. The negatives can then be exactly aligned to these marks. The highest degree of accuracy in layout preparation is obtained by working to subject center lines.

Handling Asymmetrical Forms. If the first form is not centrally located along the gripper edge, make certain that its location lines are drawn in a laterally-reversed position, so that it will print correctly on the press plate.

Locating Adjoining Forms on the Layout. Lay out the location lines for the adjoining forms to either center or trim marks as provided on the negatives. Include all the specified allowances for double trims, folds, wraparound, or other cutter and bindery requirements. Calculate all distances from the basic reference lines. Measure and mark down the position of each layout line from these reference lines.

Continue to draw in the lines until all of the locations for each negative have been laid out.

Adding of Additional Location Marks. Locate and add the marks that are needed to strip in the center or trim marks that are to be printed on the press sheet. Also mark the location of the color blocks, color bars, halftone scale, GATF Sensitivity Guide, and other reference controls that are to be printed down on the press plate.

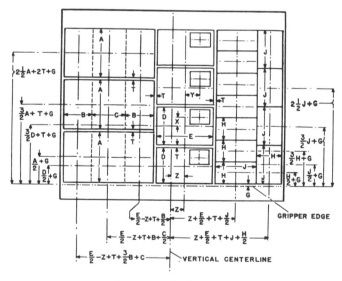

Layout calculations.

Checking the Completed Layout. Check all principal dimensions. It is best to check with another steel scale or tape than was used to draw the layout. This will disclose errors such as those that may result when the one-inch mark of a scale, rather than its zero end, is used for marking the layout.

ASSEMBLING GOLDENROD FLATS

The procedure by which goldenrod flats are assembled is

described in our Manual in all detail, as you can see from the listing in the following paragraph.

Stripping-Up the Goldenrod Flat. When the stripping layout has been completely drawn, prepare to strip-up the negatives. Place the tape dispensers, razor blades, brushes, and opaque in established, convenient locations. Put the negatives in their approximate locations on the layout with their emulsion-side up. If additional register marks, register hole tabs, masking foils, tint sheets, or other materials are required, make certain that they are on hand. Then proceed to strip up the goldenrod flat by taking the following steps: (1) Trim the negatives to size, (2) Strip-in the first negative, (3) Strip-in the second and the following negatives, (4) Add controls, (5) Add notches to the flat, (6) Check the taping of negatives, (7) Cut windows in goldenrod base, (8) Check for loose masking, (9) Check all printing areas, (10) Mark the flat, (11) Make brownprint proofs, and (12) Transmit the completed flat to the platemaker. Each of these steps is now individually discussed.

Trimming the Negatives to Size. Note the overlapping areas of adjacent negatives as temporarily placed in location on the flat. Mark each negative where it should be trimmed off so that it will not overlap the adjoining negative when they are stripped-up. Select a trim location that is midway between the work detail on each negative, or that is at least $\frac{3}{8}$-inch away from any fine printing detail or halftones on either negative when this is possible.

Then trim the negative if register or other reference marks are not removed in so doing. If needed marks are in the area to be trimmed, do not cut the film. This edge can be trimmed off later after the negative is attached in location on the flat.

In simple jobs where only trim marks are used and where printing detail does not come close to the trim margins of the form, it may be expedient to trim each negative down to the trim size. This is done by first taping down a waste clear plastic cutting sheet and then squaring the negative over it on the layout table and taping it down. Using the T-square, a steel square, and a sharp razor blade or frisket knife, cut through the film in line with the trim marks. Do not trim off the margins that will extend along the outside edges of the flat.

Stripping-In the First Negative. Start with any negative. Locate it accurately so that its center or trim marks align with the positioning lines drawn on the layout. Then attach it in position with tabs of cellophane pressure-sensitive tape. Locate one tab near the center of each edge. Make certain that the negative is flat against the layout and that no waves or twists are evident.

Stripping-In the Second and the Following Negatives. Register the next negative alongside the first one. If the negatives do not overlap, tape it down as before. If the second negative overlaps the first, as may occur when register marks are retained, position the second negative in register with its layout lines. Then tape it down on the three non-interfering sides.

Applying a negative to a flat.

Next insert a heavy strip of waste film under the intended cutting line below both negatives. Using a straight-edge or steel triangle, hold it down firmly with its edge along the intended cut. Then cut through the negatives with a sharp razor blade. It is usually better that the apprentice use several light strokes instead of one heavy stroke to cut through both films. This will avoid twisting a film or cutting too deeply into the underlying waste film.

Do not release the straight-edge until the cut is completed. Test this by lifting the cut edge. Then remove the cut-off strips and the waste strip underneath. Apply tabs of pressure-sensitive tape to secure the newly trimmed edges.

Repeat this operation for the remaining negatives, until all are attached in position to the goldenrod flat.

Adding Controls. If prepared press-sheet register marks on film tabs are used, strip these in place. If the non-printing margin of the negative interferes with locating these tabs, cut away a slightly larger section of the negative. The register mark can then be positioned to the layout without overlapping the negative. Attach the mark in position with several tabs of pressure-sensitive tape. Most other marks for trim and fold locations can be scribed into the outside margins of the negatives that are stripped-up on the flat.

Carefully scribe each in location as a short mark ($\frac{1}{8}$- or $\frac{3}{16}$-inch long). Line up each scribed mark to the trim or fold lines that were drawn on the layout. Scribe each mark so that it will print on the trim margins of the press sheet. If the negatives do not extend into the area where the marks are required, attach small sections of negatives in location, emulsion-side up. The marks can then be scribed in each section as previously detailed.

In recent years, presses have been equipped with pins over which the plates are placed. This facilitates obtaining correct lay on the sheet. There is supplied, for such "pin register" systems, punches which will perforate the leading edge of the plate corresponding to the pins set in the plate cylinder clamps. Plastic strips attached to the flat are also punched in the same device; or the flat itself is punched. Flat and plate are registered by visually lining up the holes or by the use of dowel pins.

Adding Notches to the Flat. Notch out the half "V" cutouts at the ends of the gripper-edge line and the vertical-center line of the flat. These will be used by the platemaker when he positions the flat to lines that he will scribe or pencil on the press plate. The notches should extend to about $\frac{1}{4}$-inch to $\frac{1}{2}$-inch inside the edges of the press plate. For more accurate positioning where stop pins are used to locate the press plate on the plate cylinder of the press, the notch locations should also agree with these pins. In notching the flat, add two notches that are positioned to exactly match the locations of the pins on the press. This is especially desirable when using re-grained plates, whose edges have previously been distorted on the press.

Checking the Taping of Negatives. Check to see that all negatives are securely attached. Then release the flat from the stripping or layout table. Flop it over, negative-side down.

Cutting Windows in Goldenrod Base. Using a sharp razor blade or frisket knife, carefully cut out the exposure openings behind each printing area.

First test the cutting pressure on a waste piece of goldenrod paper placed over a waste film. A single cutting stroke should cut clean through the paper but only lightly mark the film.

When cutting the exposure openings try to clear all fine printing detail and halftones by at least $\frac{3}{8}$ inch. This reduces or eliminates the thickening of printing detail due to out-of-contact undercutting of the exposure light in platemaking. If narrow paper strips remain between negatives, cut them away. Replace them with strips of red or brown

Exposure cutouts on goldenrod flat.

pressure-sensitive cellophane tape so that they cover the exposed gap between the negatives.

Also, cut the goldenrod paper away behind register, trim, halftone gray scale, and other marks or controls that are to print on the press sheet. Finally cut an opening in the flat for attaching the GATF Sensitivity Guide so that it will be exposed on the press plate outside the press sheet area.

Checking for Loose Masking. Note any loosely attached edges around the cutout openings. Fasten them down with tabs of pressure-sensitive tape so that the flat assembly will be securely held together.

Checking All Printing Areas. Check the detail of the entire flat against the dummy and copy. Make certain that no work detail is covered by the goldenrod paper, opaque, or by bits of tape that may accidentally have adhered to the film surface. If pinholes or light exposure gaps remain, spot them out with opaque or cover them with tabs of red or brown pressure-sensitive cellophane tape. If large

areas require spotting-out and do not contain printing detail, time can be saved by covering them with thin red masking paper or foil.

Marking the Flat. When the flat is satisfactory, mark the job name, number, and other required detail on the margins of the flat. Then enter the job time records. Make notes of any difficulties or defects that required additional time, or that will detract from the quality of the job.

Making of Brownprint Proofs. If the job jacket requires brownprint proofs, make them, or have them made by the platemaker. This will depend upon the location of the vacuum frame and other equipment that is required for this purpose.

Transmitting the Completed Flat to the Platemaker. If the flat is large or must be transported some distance, use a heavy manila or fiberboard folder to protect it in transit.

Section Seven: Color Stripping

Our presentation of color stripping is divided into the following six subjects: (1) Introduction to color stripping, (2) Color flats on goldenrod paper, (3) Flats on plastic or plate glass, (4) Blueline flats, (5) Blueline stripping with stripfilm, and (6) Final inspection of color flats. Our discussion is restricted to the essentials of the subject, a much more detailed treatment can be found in GATF Skilled Craft Text No. 512, *Color Stripping for Offset Lithography,* written by the author of this study.

INTRODUCTION TO COLOR STRIPPING

In multicolor reproductions, it is usually necessary to prepare a set of flats. A separate flat is made for each color to be printed. For some simple color jobs where color overlap is not required, a single flat can be used for all colors. This requires changes in masking to separate the colors when making each press plate. Where a set of flats must be prepared, it is important that all of the printing detail in each color flat be in register with the detail on the other color flats. This is necessary not only at the time the flats are made, but also at the time each flat is used to print down the press plate.

Where a high degree of register accuracy is required, it is essential that humidity control be provided in the stripping and platemaking departments. If such control is not possible, the materials used for stripping must be selected so that they will be dimensionally stable with the humidity variations that are experienced.

A set of color flats can be made to register with each other by either of the following methods:

(a) Stripping-up the first flat to a drawn layout. Then using the first flat as a key; the other flats are stripped directly to agree with the locations of the films on the first flat.

(b) Using identical blueline images on a set of plastic or plate glass sheets; the films for each color are then attached to a separate blueline flat.

These methods require that the blueline key, or the first flat stripped-up, must carry all of the necessary positioning marks or detail that will be needed for the other flats. The key flat may therefore carry a combination of detail that are to print in several colors. This may require duplicate negatives or positives of this detail for use on the key. If the key flat is also to be used in platemaking as one of the color flats, this additional color register detail or films must be removed or masked out after the set of bluelines has been completed, and before the key flat is sent to the platemaker.

COLOR FLATS ON GOLDENROD PAPER

The stripping of the first of a set of color flats on goldenrod paper is similar to the procedure used for preparing a goldenrod flat for single-color printing. The layout is first drawn (laterally reversed). The negatives for the first color, usually the black printer, are stripped-up in position. The exposure openings are then cut through the back. The sheet centermarks can also serve as the color register marks. Sheet corner marks, that may also be trim marks, are helpful to trace the cause of fanning out, or other misregister difficulties that may show up on the press sheet.

Using First Flat as Key. After the first color flat is completely prepared, it is again squared-up with the layout or stripping table, emulsion-side up, and taped down securely. A sheet of goldenrod paper for the second color flat is then placed over it. The sheet is squared to the first flat, and then taped down. Make certain that no waves or other distortions exist in either flat.

Handling Close Fitting Color Jobs. If a close color fit is necessary, first cut small openings through the top

goldenrod flat in spot register locations where the subject register marks or fitting detail are located. Slip a waste plastic cutting sheet between the flats in the area each cutout is to be made, so as not to damage the negatives on the lower flat. If close register is not essential, the upper negatives can be located to the lower through the thickness of the goldenrod paper.

Collimating for Close Register Jobs. When positioning and attaching the negatives to the second color flat, be careful to sight straight down over each register mark or matching detail. Otherwise the combined thickness of the film and the goldenrod paper may permit a parallax displacement. A small sighting tube or collimating magnifier is desirable to direct the line of sight straight down.

Registering a film by superimposition.

This helps to avoid misregister errors. The sheet color register marks are also attached to the second flat. Identify each flat by its printing color, such as "Yellow," "Blue," or "Cyan." Then cut away the exposure openings for each as previously described.

The remaining color flats will be prepared similarly. Use the first flat as a key on which to assemble the negatives for each of the other colors by superimposition. Identify each flat by name and job number.

FLATS ON PLASTIC OR PLATE GLASS

If goldenrod flats cannot provide the required accuracy, or if positive flats are to be stripped-up, it will be necessary to use sheet plastic or plate glass as the base material. The layout can be drawn directly on the plastic or glass base by using a light-blue transparent "acetate" ink. This ink will guide in placement of the films but will not interfere with exposure in platemaking.

More commonly, the layout is first drawn on a sheet of white paper or tracing paper. The plastic sheet is then se-

cured in position over this layout. The films are attached to the plastic sheet with tabs of pressure-sensitive tape. If the films are positives, a transparent tape is used. The spaces between positive films are left uncovered. If the films are negatives, the gaps between the films are blocked-out with strips of red masking paper or tape. Alternately orange colored vinyl plastic sheets are available and can be used the same way as goldenrod paper.

Standard stripping practices are used to prepare the layout, and to position and attach the films. As the thickness of the plastic sheet can cause a parallax displacement, it is essential to sight straight down in positioning each film. A sighting tube or collimated magnifier will aid in such registration as was previously described.

BLUELINE FLATS

For high accuracy stripping, particularly if plate glass is to be used as the flat material, color register is best obtained by printing down the same blueline guide image on each of the set of plastic or glass plates to be used for the color set. To make a set of blueline flats, several steps are necessary. These are described in the following:

Preparing the Key Flat. Prepare a key flat that carries all the register marks and detail that is needed to position all of the films on every color flat. Either negatives or positives may be used on the key flat. Negatives are preferred. If the key is to be used solely as a key, its layout must be correct-reading.

The bluelines printed down from a correct-reading key flat will then be laterally reversed, as is required for stripping.

Blueline Keys for Plate Glass and for Plastic. A correct-reading key or intermediate should always be used for making bluelines on plate glass. If the key is prepared on a sheet plastic base, it can serve as one of the color flats and also as a master to print down bluelines on the other flats. When this is done the key is laid out and stripped-up in the laterally reversed arrangement.

Printing Down the Bluelines. In printing down the bluelines the key flat is placed on the sensitized blueline sheet or plate with the film side towards or away from the sensitized blueline surface depending on the reading order required in the flats. By using a single-arc lamp for printing down, the bluelines for the remainder of the set made from a key flat with its film side out-of-contact with the bluelines will also be sharply defined and will also be laterally reversed as is required for stripping.

Sensitizing the Plastic or Plate Glass. Sensitize each of the plastic sheets or plate glass with a blueline solution. While this solution can be mixed to formula, it is better and more economical (time considered) to purchase prepared solutions for this purpose. Each sheet surface must be thoroughly cleaned to de-grease it and to remove foreign material. This can be done by washing with a fine scouring powder, or with any good water-soluble glass cleaner, followed by flushing with water. The blueline sensitizer is

applied to the plastic or glass sheet in a whirler at about 35 to 40 rpm and dried.

Exposing the Sensitized Plastic or Plate Glass. Each sheet is then exposed. The exposure time is about the same as that used in platemaking. Development is done under running water, assisted by light circulation of a cotton wad. The image can be intensified by flowing a one percent solution of hydrochloric acid over the developed image. Then flush the blueline with water and dry it. Exact procedure may vary slightly with the proprietary solutions used. Detailed instructions are usually available from the supplier.

BLUELINE STRIPPING WITH STRIPFILM

If stripfilm is to be used to strip-up a set of blueline flats, the cameraman will supply the film in either dry or wet condition. For immediate stripping, they are usually supplied wet just as the films are removed from the wash water after development and fixing. More commonly, the cameraman will dry the stripfilm and turn over the complete set of dried films to the stripper.

Materials and Tools for Working with Stripfilm. Before working with stripfilm, all the necessary materials must be obtained and placed conveniently for use. This includes: (1) *Acetic acid solution.* You need a photographic tray containing a three percent solution of acetic acid. The tray should be slightly larger in size than the largest stripfilm section to be used. (2) *Blotter squares.* These should be cut to about two by two inches in size from lintless photographic blotting paper. The squares are used as squeegees to wipe down the stripfilm in position and to remove the excess water or cement. (3) *Stripfilm cement.* A cement is necessary if the stripfilm is to be attached emulsion-side up, or if the film is to be applied to a vinyl or polyester base. (4) *Miscellaneous tools.* Razor blades, artist brushes, litho needles, dividers, straight-edge, and other tools should all be ready before you begin to work.

The Wet and the Dry Technique of Handling Stripfilm. Stripfilm will usually adhere well to clean glass or acetate flats or to the emulsions of other films when it is transferred and flopped emulsion-side down. For wet application the stripfilm may first be soaked in the acetic

acid solution for about fifteen seconds to soften the gelatin emulsion.

In dry stripping, the stripfilm membrane is carefully released from its base by the stripper. Depending on the technique used, either the released dry stripfilm or the soaked stripfilm on its base is then placed in approximate position over the blueline image on a small puddle of stripfilm cement.

In the wet stripping technique a razor blade or a frisket knife is used to separate the stripfilm from its base along one edge. The base is then carefully peeled away, leaving the stripfilm membrane section on the flat. (Some stripping films require a warm water solution to aid in their separation.) The blotter squares are then used to carefully shift the stripfilm membrane by light wiping action so that it registers with the blue image. Light wiping strokes are further applied from the center of the film outward, so as to squeegee out the excess water or cement and to secure the stripfilm in registered position to the blueline base.

Joining Stripfilm Sections. It is usually advisable to leave an excess margin around each film section if it does not interfere with the adjoining film sections. If printing detail between adjoining sections is to be closely fitted, both sections should be applied in position to overlap each other. The two stripfilm membranes are then trimmed together. This is done while they are still damp, immediately after they are squeegeed down. Use a sharp razor blade and a straight-edge or steel triangle, if necessary, to obtain a clean cut. Then remove the waste film strips. Squeegee the released margins down once more. A little additional cement can be applied sparingly along the margins with a brush, if the stripfilm edges are too dry to adhere properly.

Using Stripfilm Emulsion-Side Up. When applying stripfilm emulsion-side up, it is necessary to use stripfilm cement to securely adhere the film to the flat. The procedure is similar as when flopping the film. In wet stripping the membrane is made to slide off its base into location. If stripfilm is to be applied to a vinyl or polyester base to obtain increased accuracy of location, the plastic base should be purchased already coated with a gelatin substratum. This will aid in obtaining good adhesion of the stripfilm. Otherwise special stripfilm cements must be used. Stripfilm applied directly to uncoated vinyl and without special cements will usually come loose after drying.

Opaquing Stripfilm Flats. When applying opaque to stripfilm flats, use single brush strokes. Thick opaque applications or repeated strokes in an area that is already moistened with opaque can release the stripfilm edges. For this reason, non-water soluble opaques that are made with an alcohol, turpentine, or petroleum solvent are preferable for use on stripfilm flats.

Applying a stripfilm section.

FINAL INSPECTION OF COLOR FLATS

After any flat or set of color flats is completed, they must be thoroughly checked against the job jacket, dummy, copy, and other instructions for completeness and accuracy. Ex-

cept in simple or low-cost jobs, it is usually advisable to make brownprint proofs from the flats. These proofs should simulate the press sheet. They may consist of a single print for a simple one-side printed job. A partial flat should be

Brownprint proof.

repeated when printing down the brownprint just as will be done for its step-and-repeat use in platemaking. Alternately blueprint paper can be similarly used for negative flats.

If the job is a work-and-turn or work-and-tumble job, two brownprints can be made for pasting together. It is better to use a brownprint paper that is sensitized on both sides. The prints are made on the opposite sides of the brownprint paper and are keyed to each other through butterfly cutouts or through punched holes.

In a multicolor job, each of the color flats is successively exposed to the same sheet of brownprint paper in register with each other. Butterfly cutouts, register marks, or plastic hole tabs and dowels can be used to obtain this register between successive exposures. The exposure times used are different for each flat. The black printer is given the full exposure time. Those for the other colors are reduced by about 50 percent or more each time. In this way there will be a noticeable difference in the shades of brown that are developed from each color flat that was exposed.

These brownprints serve the same purpose as galley and press proofs in printing. They are used for editing and for checking folding and other finishing operations. Needed corrections are then added to the flats before the press plates are made.

Section Eight: Imposition

Imposition is the arrangement and positioning of pages, checks, labels, bags, box covers or other units of a job on a sheet or section of a web of paper to meet the requirements of the job. These requirements vary with each job depending upon specifications. Without some systematic approach to certain fundamentals, the matter remains confusing regardless of the amount of experience we may have had.

Our study of impositions is divided into the following seven points: (1) Basic information, (2) Arrangement of pages, (3) Positioning of pages, (4) Kinds of binding, (5) Kinds of impositions, (6) Units other than pages, and (7) Summary. Each of these seven points is individually discussed in the following.

BASIC INFORMATION

One of the first things that must be determined is the stock size. If this has been determined, we arrange the units on this size to the best possible advantage to meet the requirements. If the stock size has not been determined, then someone must figure the minimum stock required for each unit and how many such units can be run together on a sheet or section of web, allowing for essential trims and gripper edge, and considering the length of run, the limitations of press, cutting, folding and other finishing equipment.

Basic Information for Jobs to be Folded. Let us first consider the imposition of pages of a job which must be folded so that the pages appear in numerical order with proper margins after the job is bound and trimmed. The information we must have is as follows: (1) Type page size, (2) Trimmed job size, (3) Trims — top, outside and foot, (4) Untrimmed page size, (5) Kind of binding: Saddle stitch, side stitch, sewed, pasted or glued, and (6) Margins — position of type page on trimmed stock for one page.

A Typical Example. Let us fill in the above items of information for a typical job:

1. Type page size: $4'' \times 6\frac{1}{2}''$
2. Trimmed size: $6'' \times 9''$
3. Trims: Head $\frac{1}{4}''$, outside $\frac{1}{4}''$, foot $\frac{1}{4}''$
4. Untrimmed page size: $6\frac{1}{4}'' \times 9\frac{1}{2}''$
5. Saddle stitch (no stock allowance for binding)
6. Margins: Bind $\frac{3}{4}''$, top $1''$, outside $1\frac{1}{4}''$, foot $1\frac{1}{2}''$.

With $6\frac{1}{4}'' \times 9\frac{1}{2}''$ of stock required for each page, it is a simple matter to figure the amount of stock required for any number of pages. We could print 16 pages on one side of a $25'' \times 38''$ sheet — 32 pages on both sides. Maximum sheet size is determined by press and folder capacities. Let us assume that our press size confined us to 16-page plates and that our folder confined us to a 32-page signature. A signature is the folded sheet as it comes from the folder. This would require $25'' \times 38''$ stock.

In some plants all the foregoing information is shown on an exact size page layout.

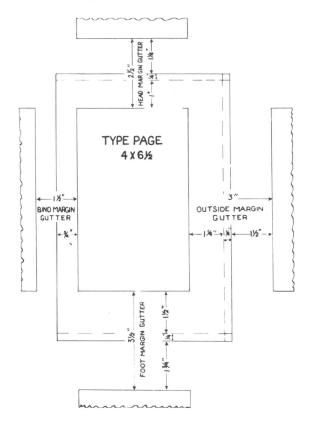

TYPE PAGE
4 X 6½

Page layout containing all information regarding the individual page and its position in relation to surrounding pages.

ARRANGEMENT OF PAGES

Before we can position the 16 pages in a form, we must determine where and how to place each page so that the head will come at the top of the book and so that the page numbers will appear in consecutive sequence. To do this, we must have a folded dummy, folded in the same way that the printed sheet will be folded and with the folder guide edges marked. This should be made or approved by the person in charge of the folding operation.

Making a Folder Dummy. The binding edge and the top of this dummy will be evident. With scissors, cut a notch in the top to show page heads and trim along dotted lines so corners can be folded back for numbering.

Arrangement of Signatures. Before numbering the dummy, we must determine whether the signatures are placed on top of one another as for a side stitch or sewed book or whether one signature is inserted inside another as is required for a saddle stitch job. For this job, we are considering a saddle stitch, one signature inside the other, and the first signature would contain the first 16 and last 16 pages of the job. If the job was 64 pages this dummy would be numbered 1 to 16 on the first half and 49 to 64 on the last half.

Outside Plates and Inside Plates. This 32-page signature is to be printed with two 16-page plates, each

containing the pages shown on one side of the dummy. The plate containing the low page of the signature is called the "outside" plate because this low page is always on the outside of the folded signature. The plate containing the next to the low page is called the "inside" plate because this page is always on the inside of the folded signature.

Bind Edge

Folder dummy with notch cut in top to show heads. Dummy is trimmed along dotted lines so corners can be folded back for numbering.

Folder Dummy. The folder dummy shows us the following: (1) Press gripper edge and side guide. These correspond with folder guides on dummy. (2) Which way to place page heads. (3) Which pages go into each 16-page plate. (4) How to arrange the pages for consecutive pagination of the finished job.

POSITIONING OF PAGES

Each page is positioned at the head and binding edge. As we examine a 16-page print, plate or one side of a folder dummy, we observe two head-margin gutters (space between heads of type pages) and two bind-margin gutters. We need only locate the centers of these gutters.

For the job under consideration each page requires $6\frac{1}{4}''$ x $9\frac{1}{2}''$ of stock or a 25" x 38" sheet for a 16-page plate. The centers of the head-margin gutters will be $9\frac{1}{2}''$ from the center of the 38" dimension. The center of each bind-margin gutter will be $6\frac{1}{4}''$ from the center of the 25" dimension.

The Lay-Sheet. To position the pages for an offset plate, we first prepare a lay-sheet. A sheet of 70- or 80-lb. coated yellow or orange masking paper slightly larger

than the press plate is used for this. One edge is marked to identify the gripper edge.

Paper Line, Gripper Edge, and Clamp Margin. Next mark the "paper line" across the gripper edge of the lay-sheet. This shows the position of the gripper edge of the printed sheet in relation to the gripper edge of the press plate. This information should be available for each press. If not, obtain it from the pressroom or from the manufacturer. This is different on each press but let us assume that it is 2″ back from the edge of the press plate. We measure and mark the lay-sheet two inches back from the gripper edge to show the position of stock in relation to the press plate. This is called the clamp margin. Later when we position the lay-sheet to the press plate in the printing frame, we simply make the front edge of the press plate flush with the front edge of the lay-sheet.

Bind Margins. To find the center of the bind-margin gutters, we measure $12\frac{1}{2}$″ back from the paper line and mark the center of the 25″ sheet dimension. The centers of the bind-margin gutters will be $6\frac{1}{4}$″ in both directions from this center of the 25″ sheet dimension.

Head Margin. To find the center of the head-margin gutters, we mark the center of the lay-sheet crosswise, at the gripper edge. The centers of the head-margin gutters will be $9\frac{1}{2}$″ in both directions from the center of the sheet crosswise.

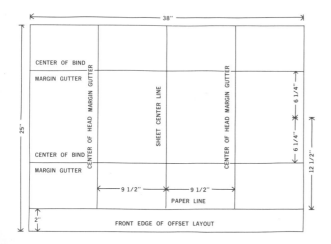

Lay-sheet showing paper line; center of head-margin gutters, $9\frac{1}{2}$″ from center — crosswise; and center of bind-margin gutters, $6\frac{1}{4}$″ from center of 25″ dimension.

Page and Marks. Next select the pages for the plate you plan to make as shown on one side of the folder dummy. These pages should have marks showing the centers of the head-margin gutters and the bind-margin gutters.

Indicating Page Marks. They can be printed with hairline rules when pulling reproduction proofs. Usually two or four pages are proofed together. They can be drawn on positives or scribed through the opaque area on negatives. The bind-edge marks are on the left of odd numbered pages 1, 3, 5, etc. and on the right of even numbered pages, 2, 4, 6, etc.

Marks on each page showing centers of bind-and-head-margin gutters.

Positioning of Pages. The pages are placed for proper arrangement and each page is positioned by registering the marks on the negatives or positives with the bind- and head-margin gutter centerlines on the lay-sheet.

For an 8-page plate the feet of pages will be to the gripper edge. We locate the center of the head-margin gutter by measuring back from the paper line a distance corresponding with the total length of stock required for each page, $9\frac{1}{2}$″. For 32 pages we have two head-margin gutters parallel with the gripper edge. The center of this second head-margin gutter would be the amount of paper required for three page lengths or $28\frac{1}{2}$″ from the paper line. The centers of the bind margins on a 32-page plate would be $6\frac{1}{4}$″ and $18\frac{3}{4}$″ (3-page widths) in both directions from the center mark.

The side of the lay-sheet to which the negatives are attached must be against the coated side of the press plate. It is customary to secure the page negatives on top of the

Finished lay-sheet with masking paper cut out over type pages.

lay-sheet, emulsion-side up, to correspond with a face-down folder dummy, and then turn the lay-sheet over before exposing the plate.

After the negatives for a plate are all arranged and positioned in the above manner the lay-sheet is turned over and the lay-sheet masking paper is cut away over each type page.

It is sometimes possible to attach the negatives to the bottom side of the lay-sheet. When this is done, the lay-sheet is not turned over and the page numbers must correspond with the face-up folder dummy.

Lay-Sheets for Surface Plates and for Deep-Etch Plates. The foregoing applies specifically to the positioning of negatives on a lay-sheet for surface plates. When positives are used for deep-etch plates, a transparent key sheet is sometimes used in place of a lay-sheet but the fundamentals of imposition (arranging and positioning the pages) require the same detailed information and involve identical figuring.

Regardless of page size or number of pages, the fundamentals are the same. We need a page layout or equivalent information shown in any way. We need a folder dummy, made or approved by the person in charge of folding and showing the best way to fold a sheet containing the specified number of pages. We prepare a lay-sheet showing the paper line and the centers of the head-margin gutters and the bind-margin gutters. We place the pages to correspond with the face-up or face-down folder dummy depending on whether the negatives are attached to the top side or bottom side of the lay-sheet. We position each page at the head and bind edge.

Imposition, Stripping and Paste-Up. There is a tendency to confuse imposition with stripping and paste-up. Generally stripping and paste-up are involved in making up a page or unit; imposition is the arrangement and positioning of the made-up units.

However, there are other factors we need to consider, specifically: (1) Different kinds of binding, and (2) Different kinds of imposition.

KINDS OF BINDING

The various kinds of binding are of interest to the man who prepares the page layout depending on whether or not they influence the visible margin at the bind edge.

The saddle stitch, sewed job or glued job permits the bound job to show the entire bind margin. These require no consideration with one exception — the saddle stitch "push-out."

Saddle Stitch Push-Out. When a number of signatures are inserted, one inside the other for a saddle stitch,

each folded signature is pushed out slightly, about $\frac{1}{32}''$ for each 16-page signature of .003″ stock with a resulting loss of the outside margin. Allowance is made for this by reducing the bind-margin gutter and adding this amount to the outside-margin gutter every three or four signatures on a many-signature job.

Extra Bind Margins on Side-Stitched Binding. On a side-stitch, pasted binding or fastener that does not permit the job to open up to the fold, allowance must be made in the page layout for the amount of bind margin that is lost (for example, on a side stitch where the stitches are placed in the stock about $\frac{1}{4}''$ from the binding edge). We must allow for this $\frac{1}{4}''$ plus extra bind margin lost.

Preparing a Binding Dummy. The best way to determine how much is lost is to make up a blank dummy and stitch it, then observe just how much of the bind margin is lost. Such jobs require more stock, less margins or narrower type pages than if saddle stitched, sewed, glued or spiral bound. Many side-stitched jobs must allow $\frac{3}{8}''$ extra for lost bind-edge margin.

KINDS OF IMPOSITIONS

Different kinds of impositions are employed depending upon press and folder sizes, length of run, nature of job and other factors. Those most commonly employed are as follows: (1) Sheetwise, (2) Work-and-turn, and (3) Work-and-tumble.

Sheetwise Impositions. When a different plate is used for each side of the sheet with the same gripper edge, the imposition is termed sheetwise.

Two 4-page sheetwise plates for an 8-page booklet.

Work-and-Turn Impositions. When one plate is used for both sides of the sheet with the same gripper edge, the imposition is termed work-and-turn.

Work-and-Tumble Impositions. When a sheet is turned for back-up so that the gripper edge on the first side becomes the tail edge for backing up, this is termed work-and-tumble. It can be printed with one plate for both sides or a separate plate for each side depending on the nature of the job.

Any job with pages on both sides of the sheet can be printed with two sheetwise plates. Most such jobs can be printed with one work-and-turn plate. We illustrate this with an 8-page booklet. The folder dummy is 8 pages. The job could be printed with two 4-page sheetwise plates or one 8-page work-and-turn plate.

Back-Up on Different Impositions. It will be observed that with the two sheetwise plates, pages 2, 3, 6 and

Illustrating the push-out on a saddle-stitched booklet.

One 8-page work-and-turn plate for an 8-page booklet.

7 on one plate back-up pages 1, 4, 5 and 8 on the other plate. Now on the 8-page work-and-turn plate, observe how pages 2, 3, 6 and 7 on half of the plate back-up pages 1, 4, 5 and 8 on the other half of the plate when the sheet is turned over.

The work-and-turn plate produces two printed copies and after backing up, the sheet is cut in half.

Folder Dummy and Imposition. One 8-page folder dummy is used for either the sheetwise or the work-and-turn impositions. For sheetwise impositions one side of the folder dummy shows the pages that go into one sheetwise plate. The press guide edges should be the same as the folder guide edges. For the 8-page work-and-turn imposition the short dimension folder guide edge becomes the press gripper edge and the long dimension folder guide edge becomes the cut edge in the center of the press sheet. Each side of the folder dummy becomes half of the work-and-turn plate.

ᗱ		᱙	‾
�01		ㄥ	12
ᕼ		8	11
ꝉ		�.�142	2

A work-and-tumble sheet printed with one plate. This is a 12-page booklet on 17" x 28" stock. The back edge of the first side becomes the gripper edge for the back-up so that page 1 will back-up page 2. After printing, the sheet is cut on the heavy line, producing two identical 12-page sections. Two sheetwise forms would have to run on a strip of paper 8½" x 28" and would double the impressions.

Work-and-tumble sheets are printed only when conventional impositions are not practical. Work-and-tumble sheets should be trimmed to produce uniform size around the cylinder.

Selecting the Right Kind of Imposition. The choice between sheetwise and work-and-turn impositions involves number of pages, sheet sizes, length of run, press and folder capacities and any other factors which determine the number of press impressions and the number of sheets to be folded. With few exceptions, the aim is to produce the job on the equipment available at the lowest cost and this is basically a matter of mathematics.

Reduced Spoilage. In some cases the matter of keeping spoilage at a minimum is a factor in choosing work-and-turn impositions. With sheetwise impositions more allowance must be made for spoilage to avoid re-runs when the back-up spoilage is excessive. With a work-and-turn imposition any shortage on back-up can be immediately made up with the plate on the press which prints both sides of the sheet. This permits reduced allowance for spoilage.

UNITS OTHER THAN PAGES

The arrangement and positioning of units other than pages require a unit layout or equivalent information. We must have the following: (1) Trimmed or diecut shape and size of unit, (2) Stock required for unit — allowance for bleeds and diecutting, and (3) Position of printed matter on unit stock.

On work where there is white space on all sides of printed matter, we need only know the unit stock size and the position of the print on this size, as a 3" x 5" print centered on 4" x 6" label.

Where bleed edges come together no extra stock need be allowed. A continuous print produces two bleed edges when two units are cut apart. Where a bleed comes next to an unprinted edge some extra stock must be allowed for cutting off the printing beyond the bleed. Sometimes the unit is composed of two or more individual units as in checkbooks, stamps, and cigar bands.

Unit Size and Stock Size. An individual check and stub may require $3\frac{1}{16}$" x $10\frac{15}{16}$" of stock. When this check is to be printed and bound in books, three to a page, the trimmed size would be $9\frac{3}{16}$" x $10\frac{15}{16}$". If $\frac{1}{16}$" trim was allowed for head, outside and foot of each book, the stock required for each untrimmed page of three checks would be $9\frac{5}{16}$" x 11". In this case a 3-check unit size would be practical. We could get 6 such 3-check units out of a 22" x 28" sheet as follows:

$$\begin{array}{l} 9\frac{15}{16}"\ \text{x}\ 11"\ \text{unit size} \\ \underline{3\qquad \text{x}\ 2 = 6\ \text{out}} \\ 27\frac{15}{16}"\ \text{x}\ 22"\ \text{press sheet}\ (28"\ \text{x}\ 22") \end{array}$$

With small units like stamps or cigar bands a number of individual units are positioned on a negative. This group of images is a practical unit size and involves less figuring. Stamps $\frac{3}{4}$" x $\frac{7}{8}$" may be grouped 100-up on a negative, ten rows in each direction, requiring $7\frac{1}{2}$" x $8\frac{3}{4}$" of stock. It is a simple matter to figure how many $7\frac{1}{2}$" x $8\frac{3}{4}$" units come out

Stock 8″x24″　　　Stock 12″x24″　　　Stock 8¼″x24½″

One Up
Requires 192 square
inches of stock for
each pennant.

Two Up
Requires 144 square inches of
stock for each pennant.

Two Up
Requires 101+ square
inches of stock for
each pennant.

Laying-out triangular shapes efficiently.

of any sheet or what stock size would be required for any number of units this size.

Keystone-Shaped or Triangular Designs. With many keystone-shaped or triangular designs to be diecut, a unit of two or more represents a great saving of stock. The value of different layouts for 8″ x 24″ pennants is evident from the illustration of imposition for pennants.

Diecut Folding Boxes. Diecut boxes present an interesting challenge in arranging and positioning several units on a sheet for greatest economy. The first step is to reduce a box to a flat diecut section or sections. The next step is to see how multiple boxes or sections can be arranged on minimum stock, making sure that bleeds and cutting and creasing can be handled with this arrangement.

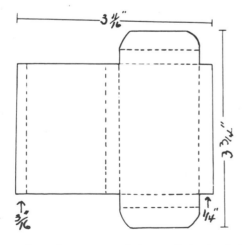

A one-piece box opened to a flat sheet 3¾″ x 3 11/16″. Solid lines are die-cut edges. Dotted lines are creased for folds. The 3/16″ strip, on left, folds under and is pasted to the ¼″ strip at right.

Nesting for Economy of Stock. It will be observed that the shape of each diecut box or section presents all kinds of possibilities for arrangement that results in economy of stock. This requires accurate sheet layout which should always be approved by the die-maker.

Bags must be reduced to flat sheet by opening them up at the glued edges. Then we can see exactly what operations were necessary to produce them and make the unit layout accordingly.

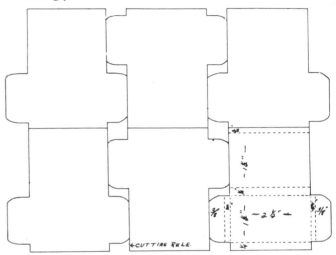

CUTTING RULE.

Six boxes arranged for greatest stock economy. This box could be arranged in a similar manner for 8, 9, 10 or 12 up. After figuring such an arrangement, check any bleed edges. Also check with die-maker.

Layouts for Straight Cutting. Wherever a sheet must be cut in a straight line as with a conventional cutter or chopper be sure a straight line cut can be made. This limits us on certain arrangements that would otherwise be possible.

Margins on Gripper Edge Sheet-Fed Jobs. All sheet-fed presses require blank margin at the gripper edge. This normally is somewhere from $\frac{5}{16}$″ to $\frac{1}{2}$″ depending on press size. We can only print so close to the front edge of the blanket and this front edge of the blanket must clear the grippers which hold this sheet. Where the print on the unit layout allows less than this, extra stock must be allowed. Many check jobs do not have enough margin at head, outside or foot. However, at the bind edge, there is adequate margin. On check jobs, we must run the bind edge to the gripper or allow extra stock for gripper bite.

Press-sheet guide edges should correspond with the two edges to which these sheets must be jogged for cutting, binding or other operations. On checks the head and bind edges are used for cutting and binding. The units should be arranged and press guide edges used so this is possible.

Impositions for Roll-Fed Jobs. Imposition for roll-fed presses is basically the same as for sheet-fed presses. We must have a page or unit layout or equivalent information. We must have a section of a web equivalent to one full cylinder revolution. This must be marked showing the specific pages or units that must appear on one or both sides of this web section and how they are arranged. Where

multiple rolls are used a web section for each roll must be marked. The web sections used for imposition are obtained from or approved by the person in charge of the press.

SUMMARY

Imposition as used herein implies the arrangement and positioning of pages or other units on a sheet or web section: (1) We need a page or unit dummy containing all the information pertaining to the individual page or unit; (2) We need a folder dummy or a web section showing what pages go on each side of the stock and where and how these pages are arranged; (3) The page or unit dummy is prepared from the job specifications; and (4) The folder dummy is determined by the stock used, the size of the job, the press and folder limitations.

Like anything else, we learn from practice. Study one step, practice it, then go to the next step. This will make each step clear and give you the fundamentals of all imposition.

Section Nine: Photocomposing

Photocomposing in the original sense of the word is a lithographic technique for combining many images according to a predetermined plan into a single unit. In the more recent time, photocomposing has become a vague term because the same word is also promiscuously used to indicate the setting of type by means of photography. In this study the word photocomposing is exclusively used in its original sense of combining many images other than letter forms into a single unit.

The Products of Photocomposing. The products of photocomposing can be divided into two kinds: (1) press plates, and (2) multiples of images on a photographic material such as film or plates. Each of these two kinds of products is arrived at in a different way and is used for different purposes.

Kinds of Photocomposed Press Plates. Press plates with many exposures on them fall into two main categories. A press plate where many images of the same subject appear is called a step-and-repeat or "duplicate" plate. The press plate that has many images, all different, is called a "combination" plate.

Some plates are a combination of both, such as those found in label shops. A plate may have four labels for one customer, six for another, and two for another. Thus when this plate is put on the press for a twenty-five thousand run, one customer will get 100,000 labels, another 150,000 and another 50,000.

Photocomposed images on Photographic Materials. The photocomposing machines are also used for making multiple images on photographic film or plate. In such cases the product of the photocomposing machine is known as a negative or positive assembly, or as multiple negatives or multiple positives. Negative or positive assemblies are often intermediates to be further used in the photocomposing of press plates. But they can also be used directly for stripping or platemaking.

How Images Were Assembled in the Past of Lithography. The need for combining several images was recognized very early in the history of lithography, and a means of making duplicates was soon found. This was very important to lithography because in those days the lithographic process was devoted almost entirely to pictorial subjects. The method for making multiple images was termed "hand-transfer" and resembled the decalcomania method of transferring images.

The original was drawn by hand on a flat grained limestone. The image was inked-up and several impressions made on transfer paper. The several images were then transferred to a larger stone which became thereby the press form made up of multiples of the original. In multicolor work, register was accomplished by fitting to register marks by eye.

During the transition from handwork to the present photomechanical method, certain shortcomings became apparent in the hand-transfer method of making multiples. The greatest shortcoming was the difficulty of exact register. Another was that there were certain losses of tone between the negative and the final images on the plate. As long as originals were made by crayon, fine details of drawing did not reproduce in all colors. But now the camera picks up such details in every color. Exact register, to pinpoint accuracy, must be obtained between the black and the color plates. Tone loss became important because lithographers wanted to print in fewer colors.

Shortly after the turn of the century, these facts were recognized by William C. Huebner, a lithographer who was gifted with a tremendous inventive and mechanical talent. He envisioned a means of making every duplicate a perfect reproduction of the original and of positioning these reproductions on the plate with precise mechanical accuracy. This aim would require a machine that would expose a negative directly upon the press plate many times and in exact predetermined positions: expose-and-shift; step-and-repeat. By 1915 such a machine was put into operation. The photocomposing machine was born.

At the present time photocomposing is one of the important lithographic techniques. Our study follows the GATF Skilled Craft Text No. 515, Photocomposing, originally written by the author of this section. The reader finds the following subjects discussed: (1) the Rutherford Precision Photocomposing Machine, (2) the Lanston-Monotype Huebner Vertical Photocomposing Machine, (3) the layout of a photocomposing department and the maintenance of its equipment, (4) job layouts for photocomposing, (5) operating procedure, (6) register, (7) making multiple negatives, (8) contact, (9) nesting forms, (10) troubles in photocom-

posing, and (11) other modern machines. Each of these eleven points is individually presented in the following.

THE RUTHERFORD MACHINES

Two models of the Rutherford Photo-Composing Machine are manufactured. One is the standard semi-automatic model and the other is the fully automatic Ruth-O-Matic. Both models can be furnished either in the RM series in four different sizes, or in the PL series in three different sizes.

The Rutherford PL is a semi-automatic model. This is an upright machine made in three sizes. The PLB takes plates up to 48" x 60", and negatives or positives up to 28" x 32" standard and 32" x 32" special. The PLC takes plates up to 50" x 69", and transparencies up to 28" x 32" standard and 32" x 32" special. The PLD takes plates up to 58" x 78", and transparencies up to 30" x 40" standard and 40" x 40" special.

Plate Movement and Register Carrier Movement. On this machine the negative carrier moves only up-and-down, for vertical positioning. The plate moves sideways for horizontal position. Movement is accomplished by large precision screws, and the amount of movement is controlled by the number and fractions of turns of these screws. The screws are manufactured either for power operation, or for hand. The number of turns is counted by devices that indicate a movement of .001".

Courtesy Rutherford Machinery Co.

Rutherford Photocomposing Machine

Two-Movement Measuring Devices. The Rutherford Precision Composing Machine has two measuring devices. Each consists of a Veeder counter that counts inches and tenths. The dial registers hundredths and thousandths of an inch; the hand wheel is used for the final few thousandths of movement.

Centralized Control Board. The machine has a centralized control board with valves for the vacuum and for the air cylinder that moves the plate bed back. There is a gage for indicating the amount of vacuum and also a timing device. At top center of our illustration three push-buttons can be seen. The top button raises the negative carrier, the

bottom one lowers it, and the middle one stops it. Right below these buttons are three more. The left button moves the plate to the left, the right button moves it to the right, and the center one stops it. Other buttons are for vacuum pump and other auxiliary equipment.

Registering on a Rutherford Precision Photo-composing Machine. Register is accomplished between colors and to the register device by fine register marks that must be put on the original copy before photographing. These marks are carried through each step and are used in the final positioning of the negative in the machine chase. After that, they are covered up and ignored because a series of registering dowel pins and bushings take care of the rest of the registering steps.

Our description covers merely a few of the more important features of this machine.

THE RUTH-O-MATIC PHOTO-COMPOSING MACHINE

The Ruth-O-Matic machine is fully automatic. It is just like the standard semi-automatic model, except that the setting of the layout positions is also automatic.

The Ruth-O-Matic is an automatic photo-composing machine that is operated from a pre-punched tape or by simple dial controls. It is capable of vertical and horizontal positioning accurate to .001 inch throughout the entire range of the machine. All spacings are measured from the zero reference and not as a distance from the last position. In other words, the machine will programme any number of regular or irregular steps in any manner desired and with an accuracy within .001 inch.

The macine operates much faster than a conventional photo-composing machine as both the vertical and horizontal settings are made simultaneously and the complete exposure cycle is automatically handled by mechanical and electrical controls with no need for attention from the operator.

Perfect register of all plates in a color set or similar layout is assured, regardless of the operator or the shift, since all the plates are produced from the same tape.

The entire step-and-repeat pattern is contained on a 4-inch wide roll of plasic tape. The tape is prepared with a manual punch and punchboard containing 140 hole positions. Each hole is numerically identified and represents a vertical or horizontal coordinate point for positioning the negatives on the plate. Numerical settings, corresponding to the positions of the image drawn on the layout sheet, are transferred to the tape by a punching operation. Additional instructions can be noted on the tape, regarding the chase to be used, number of exposures, top to bottom or to either side, positioning, etc. After punching, the tape can be inspected visually for accuracy. Corrections, if necessary, can be made by patching unwanted holes with pressure sensitive tape and repunching with either a common paper punch or the manual tool. The spool of tape snaps into place in the tape reader and is driven through the reader by a motor.

All operations which the machine can perform automatically are punched on the tape. The tape can also be punched

to start a buzzer which signals the operator to perform a manual function, such as inserting a negative or positive or changing its position. While the buzzer is sounding, if so desired, the macine can be programmed to lower the chase automatically to a convenient loading height and held at that position until the operator does his job. Then the chase automatically returns to the proper position for the next shot. The tape is not affected by oil or dirt. The same tape can be used over again to duplicate the original layout with perfect uniformity and accuracy.

The Ruth-O-Matic reader is the control center of the automatic positioning system. The reader contains 140 spring loaded pins which sense the information being fed through it on the tape. The reader automatically controls all vertical and horizontal movements according to the data placed on the tape.

When the sequence of exposure is completed, the reader automatically rewinds the tape, the vacuum holding the press plate is released, and the machine is ready for a new job. If the number of exposures is small, the tape does not have to be used. Coordinates can be taken from the layout sheet and fed directly into the reader by manually dialing the proper settings on the reader control panel. From this point, the machine will position and expose automatically. The Ruth-O-Matic also can be operated manually if this is desired for any reason.

THE LANSTON M-H MACHINES

These are upright, pedestal machines in which the negative carrier moves both vertically and horizontally. The plate does not move. The plate is put into position from the front. The Lanston M-H machine is a fast, entirely hand-operated machine that takes up little room.

Courtesy Lanston Monotype Co.

The Lanston Vertical Photocomposing Machine.

Our illustration shows the machine with a plate in place and the lamp moved out of the way on its overhead rail.

The negative holder is shown, supported by the cross rail and carriage saddle. The chase, with negative, is shown clamped in the carriage. The vacuum pump and motor can be seen behind the machine and the gage at the top. The foot-treadle near the floor applies the vacuum. The vacuum hose to the saddle is not connected in this picture. No timing device is shown.

The Movement of the Negative Carriage. Vertical rails and slides upon which the cross rail is supported may be seen at each side of the backboard. Gear racks on the vertical rails and gears on the cross rail are used for the vertical movement of the negative carriage. The gears are actuated by a hand crank on the right side of a horizontal shaft. The carriage is moved sideways by a gear running on a rack. The rack is fastened to the cross rail.

There are one inch spacers called notch bars on all three rails. Notch segments or keys on each end of the cross rail engage vertical notch bars exactly to the inch position desired. The notch bar assembly runs in a groove and has a one-inch controlled movement. The movement is controlled by a screw at the top of each assembly. These screws are operated by the crank at the upper right corner. One turn of the screw and the micrometer-type cylindrical dial moves the notch bar $\frac{1}{10}$th of an inch. The dial is divided into one hundred scale divisions, therefore, each division represents $\frac{1}{1000}$th of an inch.

The sideways movement of the negative carriage is obtained in the same manner. The saddle is moved by a hand crank, a gear and a rack to the desired notch. The notch bar assembly is then moved by a screw, and readings are made on the $\frac{1}{10}$th scale and the thousandths dial.

The Negative Holder. On this machine the negative holder is made up of a two piece metal frame. One piece is movable within the other and moves with the glass. There is an air-seal frame that also serves as a rest for the glass negative. This may be adjusted for various thicknesses of glass. The movable part of the frame contains the glass clamps and has a rubber air seal that contacts the plate. This inner frame is the one that can be adjusted so that it carries the glass into register.

Registering on the Lanston M-H Photocomposing Machine. Placing the negative in the frame and leveling it is the first step toward register. The glass is then clamped in securely. The frame is placed in the register device using the dowel pins for positioning. A lever is used to move the frame towards the ground glass. The emulsion side of the negative is thereby put in contact with the ground glass. The ground glass has a fine etched, vertical center-line and a series of horizontal lines, one for each size frame. The inner frame and negative is now registered to the lines by using the thumbscrews, and is then locked into position. The images or at least the marks on the negative are now in register relationship with the dowel pins of the negative holder. As these pins fit into identically located bushings in the machine saddle, the register of the negative to the notch bar key is complete.

Making Multiple Negatives on the Lanston M-H Photocomposing Machine. Multiple negatives may be

made right on the Lanston M-H machine. If regular film is used, it is necessary that the machine be placed in a darkroom. If some type of slow emulsion film such as Kodak Autopositive is used, orange illumination, as normally found in most photocomposing rooms, is suitable.

When a step-up positive or negative is to be made on glass, an aluminum mask is used so that the glass may be recessed into it, affording a flush surface. The glass fits snugly into the opening of the aluminum plate and is taped around the edges. If the step-up is to be made on film, it is fastened to a plate with sticky-back and put into the machine in the usual manner. The original is set up in the chase in the usual manner. A small bulb or contact lamp with a split-second timer should be used for the exposure. The step-up may then be made exactly like a plate.

Our description of the Lanston M-H machine is not more detailed than the preceding description of the Rutherford product.

THE ATF-GERSON MACHINE

The ATF-Gerson Multiplater is a medium-duty piece of equipment designed for a wide variety of the work most commonly done in moderately sized plants.

The equipment is 6'10-1/2" high, 6'3-1/2" wide, and 34-1/2" deep. It can mount a plate up to 48" x 52" and can expose a maximum of 40" x 50" of this area. The maximum size of the flat or negative that can be placed in the chase is 22" x 28" of which an area of 19" x 25" can be exposed at one time. A smaller chase is also available — 15" x 22" with an exposure area of 12" x 19". Each chase has its own matching arc-lamp hood.

The arc lamp used with this equipment has motor-driven carbons and is separate from the machine itself. It is mounted on wheels and is moved into position for each exposure. The lamp hood fits into the chase so that light curtains or masking screens are not needed. Exposure times are controlled by an automatic reset timer.

The chase can be moved both vertically and horizontally in increments of 1/16th inch. Each increment position is accurate to .001 inch. Built-in controls eliminate any possibility of accidentally scratching the plate. The chases use an acetate cover instead of glass. The manufacturer claims that this makes for better vacuum, less refraction, and easy access for changing flats without removing the chase.

Plates are accurately positioned in the back-board by a horizontal and vertical hole/pin arrangement. The stripping department is provided with a layout grid that mounts register pins. Negatives are stripped onto special, dimensionally stable plastic sheets. These are pre-cut to fit the chase and pre-punched to fit (1) the pins on the layout grid, and (2) matching pins on the chase. This simple pin-hole system matches the layout grid to the chase. If the negative is accurately registered on the grid, it will be registered with equal accuracy when the flat is mounted in the machine chase.

Shooting layouts of machine positions are calculated from a zero reference point on the machine. The conventional center-to-center machine layout calculation method is not used.

The arc lamp used with this equipment has a reversible reflector that is white on one side and black on the other. The black reflector, which tends to make the arc more of a point light source, provides the best quality of exposing light. It is suggested for use with grainless plates such as the presensitized and wipe-ons. The more diffuse light that results when the whiter reflector is used, provides a faster exposure that is sometimes desired when exposing grained plates.

The Multiplater is also suitable for making multiple negatives or positives on film. For film exposure, a special "pinpoint" lamp is available.

Because of its simplicity, the manufacturer claims that a competent platemaker can be trained to use the equipment in less than a hour.

Larger sizes of the equipment and equipment for special applications can be built on order. An example is the Model FP Multiplater which was developed for forms printing. The horizontal movement increments of this model have been modified so that they are more suitable for production on standard rotary forms printing presses. In addition, a special micrometer-equipped horizontal chase carriage can be furnished for applications that require vernier compensations between steps.

CONSOLIDATED STAR STEP-AND-REPEAT PHOTOCOMPOSER

This machine is fully automatic and suited for multiple negative work up to the capacity of the machine which is 26" x 32" and, with a pin indexing system, step and repeat work up to 32" x 50".

Courtesy Consolidated International Corp.

Auto-Stepper Step and Repeat Photocomposer

The machine requires two settings for the movements of the vertical and horizontal steps. Programming of the machine is accomplished by setting dials which give the exact number of steps required in each row and the total amount of steps for the entire job. An illuminated, visual counter indi-

cates, at all times, which step is being exposed so that on combination jobs, the operator can stop the machine, and handle set-ins etc. Pushing the start button starts the machine and it operates independently and automatically without any assistance of the operator. When the steps for the entire job are completed, a bell will ring.

The lighting system is of the indirect type using a pinpoint light source which is reflected off the surface mirror at 45 degrees to the negative holder, giving a uniform, sharp exposure. A precision-built register frame registers the negatives to fine scribed lines. The movements are operated and affected by hydraulic cylinders and valves which move the register frames. Original settings are set on dials graduated in thousandths of an inch and can be set to accuracies of a split thousandth of an inch.

Another feature built into the new machine is the interchangeable plug-in type system so that two spare relays can be used to service all twelve relays in the machine. The photograph displays a read-out device which tells the operator at any time, the number of steps the machine has made and the exact location. The machine has a larger 8" x 10-1/2" negative chase size, with a 27" x 33" table size, which can be increased to 33" x 50" when equipped with an extension table.

THE LAYOUT OF A PHOTOCOMPOSING DEPARTMENT AND THE MAINTENANCE OF ITS EQUIPMENT

The layout of the department can do much to save work, steps, time and mistakes. It is of course possible to make plates in a room just containing a whirler, a printing frame, one sink and one table. But the efficiency of such a room is very low. No flow chart of any value can be devised for such a layout, and when the platemaker needs a helper, it is impossible to use him to full advantage.

Essentials of a Good Photocomposing Department Layout. Besides equipment and work space, a good layout will provide ample storage space and a specific place for all utensils needed, such as rags, wipers, graduates, spare equipment and chemicals. These things must be kept

DOTTED LINES INDICATE FLOW OF WORK

1 Freshly grained plate rack
2 Sink for washing and c'etching
3 Vertical plate whirler
4 Plate conditioning rack
5 Neg. register device
6 Lanston photo-composer
7 Work bench and cabinets
8 Vac. frame—overhead lamp
9 Developing inking table
10 Vertical soaking tank
11 Developing and clearing sink
12 Chemical and supply cabinet
13 Etching and gumming table
14 Finished plate rack

Layout for a photocomposing department.

conveniently at hand, and yet not be in the way during working.

A Schematic Floor Plan. Our diagram shows a compact plateroom with a vertical whirler, an overhead lamp on the printing frame, and a Lanston Photocomposing Machine. Where space is at a premium, this layout is very practical, even for two men. The flow of work, shown in dotted lines on our diagram, is excellent. One worker can follow the other worker from station to station and yet never cross his path.

Air-Conditioning. Note that only the photocomposing room is air-conditioned, and also note that there is a plate-conditioning rack in this room. When a plate is taken right from the heated whirler it may have a relative humidity of 30 percent; some ammonia will also still be present in the coating. If a plate is placed in the photocomposing machine in such a condition and if exposures start immediately, either the first shots will be underexposed or later shots will be overexposed.

Therefore, we provide a rack where plates can come up to room humidity and where they can be left until the ammonia has completely evaporated. The room is air-conditioned to slow up dark reaction while the plate is being shot. In such a set-up, plates can be almost fully controlled as to quality. It is understood by itself that the plates to be exposed in the printing frame also partake of the advantage of air-conditioning.

Where the entire lithographic plant is not air-conditioned, the photocomposing department should have a small air-conditioning unit in the room where the photocomposing machine stands. The wet end of platemaking does not require air-conditioning. In fact the sinks, whirler, and heaters put a heavy load on an air-conditioning machine, and the little good that might be derived by air-conditioning would be very expensive.

Cleanliness and Lubrication. Cleanliness, lubrication and frequent testing and adjustment are very essential to good performance on precision equipment such as a photocomposing machine. The negative frames must not be handled roughly and stored carelessly, or they will become burred, scratched and their fine adjustments and fit will be impaired. The adjusting screws must not be allowed to become rusty, bent or noticeably worn; air seals must neither be damaged nor allowed to become oily, dirty, or hard and cracked.

Keeping Check on Wear and Looseness. All dowel pins and bushings, particularly, must be kept in like-new condition. Screws, gears, racks and other fine mechanical parts of the machine must always be meticulously clean and well-oiled. Any looseness or play must be taken up as soon as discovered. There are many means provided in these machines for compensation of wear; they should be used.

Instruction Manuals. The book of instructions for the care, maintenance and lubrication of the machine should be kept handy and used frequently. A well-kept and well-adjusted machine saves the operator a lot of annoying troubles and saves the plant a lot of lost time.

The operator should feel a responsibility for his machine

and department. Cleanliness and order are important to accuracy, quality of work and safety of operation. Carelessness with equipment and the work in general can only lead to sloppy results.

Good Housekeeping. A man can be judged by the house he keeps. Men who work in cluttered surroundings often have the same mental condition. That there is no time to clean up is just a poor excuse. Does lack of time account for disorder? Isn't it rather the other way around? Isn't the lack of order responsible for the lack of time? Good housekeeping in the photocomposing room, as everywhere else, will pay off in better work and less fatigue.

JOB LAYOUTS FOR PHOTOCOMPOSING

The photocomposing machine operator must have a layout of moves before beginning to shoot the plate. He generally makes this layout himself from the layup that appears on his shop order. Some photocomposing layouts are quite simple while others can be very complicated. But a few basic rules apply to all layouts.

Basic Rules for Photocomposing Layouts. The first rule is that all figures on the layout refer to the centers

A typical job layout.

of the images. Not necessarily the centers of the pictorial work but rather to the centers of the trimmed or folded piece or page. Another rule is that all vertical movements start with zero and at the gripper edge of the plate, while all horizontal movements start with the center of the machine.

A Typical Example. For a simple layup of eight pieces $8'' \times 10''$ with $\frac{1}{4}''$ trim between, the layout is made as follows:

Let us assume that we are using a 70-inch machine and that the horizontal movement is 64 inches. Then, our center reading for all layouts will always be 32 inches. We work both ways from this center line in calculating our readings. An 8×10 inch piece then will be centered on the machine center at 4 inches plus half the trim—in our case one eighth of an inch. The unit to the left of center will be shot at 32 minus $4\frac{1}{8}$ or $27\frac{7}{8}$ or 27.875.

Layout Figures Must Be Carried to the Third Decimal. All machine layouts must be indicated in decimals carried out to three places, because machine indicators

read to thousandths. The succeeding horizontal moves are each one full trim size plus one full trim-off size away from this first position.

Locating the Vertical Centers. To locate the vertical centers, we must now allow for the gripper-edge margin of the paper. Presses cannot print right out to the gripper edge of the sheet. There must be some white paper left for the grippers. As our example is a trim-to-bleed job, we

A final layout for photocomposing.

must allow for both a gripper margin and $\frac{1}{8}$ inch trim. Suppose our gripper-margin allowance on the press is $\frac{1}{4}$ inch. Then we must have a plate "set-back" to take care of the margin of the plate required for plate clamps. Assume this margin to be 2 inches. Our total set-back, etc., comes to $2\frac{3}{8}$ inch. We add this figure to half the trim size (10 inches) of our piece and come up with $7\frac{3}{8}$ inch for the reading of the first-row centers. The center of the second row will be $10\frac{1}{4}$ inch away. The final layout for shooting looks like our diagram.

Combination Forms. On combination forms, and where two or more jobs or sizes are put on the same negative, the layout becomes quite complicated. The method of making the layout remains the same but there are more opportunities for making mistakes. Combination sheets, turnover jobs and work-and-flop back-ups are discussed in detail in the aforementioned GATF Skilled Craft Text No. 515, *Photocomposing*, chapter four, pages 37 to 42.

Cutting Difficulties Must be Considered. There is more to making a layout than just getting the images on

This layout is impossible for guillotine cutting.

the sheet. A layout man must pay attention to any possible difficulties in cutting. It is quite possible to make a layout that cannot be cut in a guillotine cutter.

The "Far Corner" of the Sheet. A good layout man will also pay attention to where, on the sheet, he places very fine register work. The most difficult part of the sheet to control in the press is the "far corner." This is the corner that is farthest away from the front and side guides. When possible, work that is not too critical will be placed in this corner. Small detail and fine register pieces are put close to the guides, when there is a choice. Heavy work will be placed to avoid ghost images.

Developing a Layout. A complicated layout is something to be studied and worked out. It should not be made by the photocomposing machine operator who has a full day's work laid out for him. When the operator is working on layouts, his machine is idle. The hourly rate of a photocomposing department may be three times as much as that of someone in the production department. If there is not enough work to keep the machine busy, and if there is idle time for the operator, he will probably make his own layouts. But when his department is busy, someone else should make them.

Whoever makes a photocomposing layout should have all the information available. Any information lacking on the shop order may lead to expensive mistakes. The person concerned should have a drawing board or a layout machine and a quiet place to work.

OPERATING PROCEDURE

The operator first reads the shop order. It will give him the required information so that he will know what size plates to use and how many, where to put cylinder marks, size of paper, size of units and layup of the job.

Preparing Negatives and Press Plate. On simple film jobs the operator may mount the negatives to a suitable glass. If it is a combination job, it will have been stripped to glass in the stripping department and will be ready to go into the chase. Busy operators and platemakers should not do their own stripping.

If the operator coats his own plates, he will select a fresh plate of proper size, counter-etch it, wash it and coat it. He will check his plate bed for dirt or tape residue. Dirt under the plate can cause trouble.

Operating the Rutherford Machine. He will choose the proper size chase and place it in the register device, insert the negative, square it to register and lock it up. He then inserts the three positioning pins in the plate bed and positions the plate to them. He tapes the edges of the plate down firmly. The plate bed may now be swung up into position and locked

Going to the front of the machine he attaches the chase, the vacuum sealing frame, and the hose, and then moves the carrier to position for shot number 1. In making his moves he will run the plate by power to the right side; then run it back to take out backlash. He will use power most

of the way and then give it the last slight movement by hand. Next, he runs his carriage to the bottom and brings it back by power, again making the last adjustment by hand.

He now checks his carbons and swings the lamp into position, starts his vacuum pump, pulls in the back for contact, and checks vacuum gage. When all is in order, he sets the timer and presses the switch for the first exposure.

Operating the Lanston M-H Photocomposing Machine. The operator places the proper size negative-holder on a table, face-side-up, while the plate is whirling dry. The negative is placed in the inner frame and leveled with a piece of plate glass. The clamps are then set-up tight and the whole frame put on the dowel guides of the register device. The frame is moved into contact with the register glass. The inner frame, with the negative, is now adjusted to register with the fine lines on the glass.

The plate is punched, put into the machine with screws and taped down. The negative chase is removed from the register device pins and set into the saddle carriage of the machine on corresponding pins. The hose is attached to the saddle. Then by use of hand cranks the whole assembly is moved to the first shooting position which on this machine is the upper left corner.

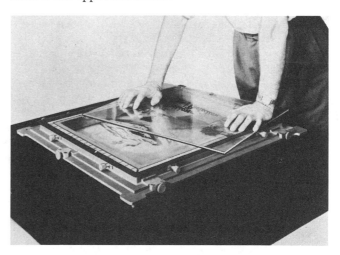

Preparing the negative holder.

To position the chase, first the saddle is moved to the correct notch on the cross bar and locked in. Then the micrometer screw is turned to the correct thousandth. To position vertically, the cross bar is run up by crank to the proper notch and the screw turned to the right thousandth.

After the operator starts the pump, checks carbons, tests vacuum etc., he positions his lamp, installs the hood and starts shooting. After the plate is fully exposed, it is removed from the machine and put through the usual procedure of finishing exposed plates.

REGISTER

On plates made for color work, each color must be exactly superimposed upon the other in perfect register. Some sort of guide to register must be used and this consists of

cross marks or register marks. They have been used since the beginning of hand-transfer and for photocomposing are placed on the copy by the cameraman. In this way we are assured that every color image will have a guide that is in perfect relationship with the image on every negative. But we cannot position a negative directly to a plate by the use of register marks alone, because there are no marks on a freshly coated plate to which to register.

Registering Both Negative and Press Plate With the Photocomposing Machine. In order to make a negative register with the plate it is necessary to register each with the machine. That is, the plate must register with the plate bed and the plate bed must register with the machine frame. Also, the negative must register with its chase and the chase must be made to register with the machine frame. Things that correspond to the same thing will correspond to each other.

Register Marks and Dowel Holes. So we start out by putting register marks on the copy before the first negative is made. We now must establish a perfect relationship between these marks and the dowel holes in the chase. This is done in the registering devices as previously described.

There is a set of dowel pins on the carriage of the machine that exactly duplicates and corresponds to the set on the registering device. These pins are made to register with the machine frame through large screws in one case and notch bars on the other. We therefore get our register between register marks on the copy to the machine frame and to the plate.

Sequence of Positioning. When a negative-holder is positioned in the register device and its negative is positioned to the scribed lines, all succeeding negatives can be positioned to the same exact position. And when successive negative-holders are placed in the machine and moved to the same numbers, each color negative will occupy exactly the same spot as every other color negative, no matter how many color plates are made.

Causes of Inaccuracies. There are only a few ways in which inaccuracy can occur on any machine that is kept in good condition. One cause may be that the register marks are not exactly on each color. Another cause may be that the operator is careless in lining them up. Still another cause may be carelessness in making movements to the wrong number on the counter, or a mistake in the layout.

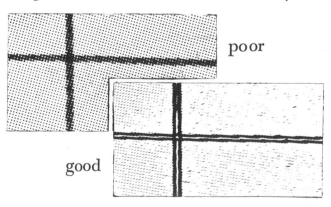

Poor and good register marks.

Register marks themselves cause the most common error. This is so because many workmen who have something to do with register marks develop careless habits. But register marks are the heart of register; if they are not perfect, no machine can compensate for the ensuing errors.

Alignment and Placement of Register Marks. Starting with the copy, the marks must be thin and of a type that will not distort and are easy to see, even in half-tone negatives. The marks must be aligned and placed squarely with the work or with the cutting lines. Register marks must not be cocked; they should really be put on in a line-up machine. The register marks must also be placed both ways in the exact center of the unit trim size.

Although the operator uses only three, there should be four marks put on the copy. The operator will use the two marks that are farthest apart and select as the third the more convenient of the remaining two marks. The scratching-in of these marks by the retoucher should be done under strong magnification. The retoucher should use a sharp needle and he should split the mark exactly in half.

The photocomposing machine operator must use care in lining-up the negative register marks with the marks on the register device. He should use a magnifier of the columnar type.

Registering Head-to-Head Forms. Anyone who has ever had anything to do with photocomposed plates of the head-to-head type knows of the trouble they can cause. One row of images can be made to fit perfectly while the opposing row may be over $1/16$th" out between the red and the blue or black. This lack of fit seldom is the fault of the machine or the registering device but nearly always that of the register marks. The register marks are either too thick or they do not show up sharp in a halftone, or they are not cut in accurately.

Small Mistakes Add Up to Big Ones. Marks that are sloppy, or cocked, or a poor type of mark to start with, may be cut-in by the retoucher a little low or high on a straight plate without causing serious consequences. It just means that the images will all be off in one direction; the pressman simply makes a shift that fixes everything. But suppose that, on a head-to-head job, the retoucher scratches his marks one line low on the blue negative and one line high on the red. A line is only about .010 inches wide. Then the blue rows will be .010 inches too close to the center line which makes them .020 inches too close together. But the red images will be .020 inches too far apart. If the pressman fits the blue and red on one row, the other row will misregister by .040 inches. If the photocomposing machine operator is also careless, the total error can easily amount to 1/16 inch.

Plate-To-Press Register. The series of images on a press plate do not have to register closely with the edges of the plate. Re-grained plates seldom have straight edges. A small discrepancy is easily compensated for by the pressman in adjusting his clamps. However, much press time is lost during makeready in trying to put the plates into register with the plate cylinder.

The photocomposing machine operator can be of great

help to the pressroom in cutting down press makeready time. This may be done in one of two ways. One is called the pin method and the other the cylinder-mark method.

Registering With the Pin Method. The pin method consists of having corresponding pairs of pins on the presses and on the photocomposing machine. If the operator is always careful to see that his plate registers with his pins, and if the pressman sets the plate to his pins, positioning is almost perfect on the first try.

Registering With the Cylinder-Mark Method. The cylinder-mark method consists of carrying register marks to the press cylinder. Here the machine operator shoots marks to the edges of the plates that are a specified distance back from the gripper edge. The pressman then lines-up these marks with two cylinder marks that have previously been put on the cylinder. This method eliminates much shifting of plates during makeready, and the saving of expensive time on four-color presses makes such practice worthwhile.

MAKING MULTIPLE NEGATIVES

When the subject to be photocomposed is so small that shooting it one at a time would take too many hours on the machine, the negatives are grouped. The hand-transferrer used to do this too by transferring the original to an intermediate plate ten or twenty times. He then had only to pull a reasonable number of groups for the press stone.

Making Multiple Negative Assemblies by Stripping. The grouping of multiple negatives may be done in several ways. A simple way to do it in single-color work, is to make several negatives in the camera of the same copy and to strip them up on the photocomposing machine glass. Or, from one negative, several paper-prints can be made, and these grouped on the copyboard for one large negative.

Making Multiple Negatives in the Camera. Some cameras have step-and-repeat backs. With this arrangement, an exposure can be made in one corner of the film, and then by moving the negative a measured distance each time, succeeding exposures can be made for a group of negatives. The arrangement is the same as that used on the photocomposing machines.

Making Multiple Negative Assemblies in the Photocomposing Machine. Both the Rutherford and the Lanston machines have special auxiliary equipment for making multiple negatives and positives in the same manner as plates are made. In making a step-up positive from a single negative, the negative is registered in a special frame on the register device and placed in the carriage. Next, a large unexposed film is fastened to a press plate with sticky-back; this plate, with the film on it, is in turn mounted to the back of the machine. From there on, the step-up is made exactly like a press plate except that a small lamp is now used in conjunction with a fine-setting timer.

Making Step-Up on Glass. If a step-up is wanted on glass, the Rutherford machine has a segment of the back than can be removed to accommodate the glass. The Lanston machine has an aluminum plate with a segment cutout that serves the same purpose. Where only a few step-up nega-

tives are made, and where they are to be used for color work, they are generally made in the regular photocomposing machine as just described.

Special Photocomposing Machines for Negative Assembly. Where a great amount of this work has to be done, special machines are used. These are complete photocomposing machines in miniature. They are placed in a darkroom and are used only for multiple negative and positives. These can be made either on glass or film. Several companies make such machines, as you can see from the descriptions contained in the "Resources Section" of this chapter.

CONTACT

Perfect contact is necessary for obtaining good sharp prints between negative and plate. The pressure must be firm, but gentle and evenly distributed or the glass will crack. Contact on some of the older machines was obtained with mechanical pressure, and it was never entirely satisfactory. On present machines a vacuum is used to exhaust the air between negative and plate. This allows atmospheric pressure, acting on the outside surfaces only, to force the inner surfaces together with an even pressure of as much as twelve pounds to the square inch. This insures good contact unless there is foreign matter between the inner surfaces.

Watch Out for Air Leaks. To obtain and maintain vacuum between negative and plate, all possible air leaks must be sealed off.

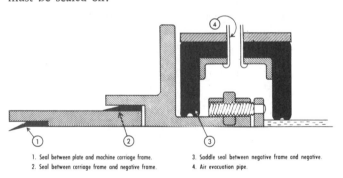

1. Seal between plate and machine carriage frame.
2. Seal between carriage frame and negative frame.
3. Saddle seal between negative frame and negative.
4. Air evacuation pipe.

Four areas that must be sealed on a photocomposing machine.

There must also be channels to allow trapped air to bleed off. These channels or grooves, which can be seen in several of our illustrations, prevent accumulations of air from holding the plate and negative apart.

Rubber Gaskets and Their Placement. Air leaks are sealed off with rubber gaskets. They must be placed on the negative frame at a point where air would normally enter between plate and frame. They must also be placed where air would leak between the negative glass and the frame. Very little mechanical pressure is used to obtain contact between the rubber seals and the glass or metal. The actual sealing edges of the rubber gaskets are quite thin, so that atmospheric pressure acts to make the sealing contact.

The Vacuum Gage. Because these gasket edges actually do the work of sealing they have to be thin and pliable. If

they are allowed to be damaged or become hard and stiff they will not work. The vacuum gage is the best indicator of whether or not the gaskets are doing their work. If perfect contact is not obtained a condition called undercutting will occur. This means that the light will penetrate inward from the edges of the dots, thus exposing a greater area of plate than was intended. It will cause thickening of tones on surface plates and sharpening on plates using positives.

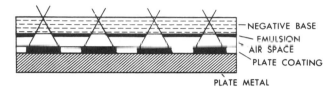

NEGATIVE BASE
EMULSION
AIR SPACE
PLATE COATING
PLATE METAL

Undercutting.

NESTING FORMS

One of the most difficult jobs to do in a photocomposing machine is the multicolor job where the images are placed head-to-head. This is sometimes done on cutout pieces in order to nest them together and get more pieces on the sheet. As a rule, the first time it is tried there will be a wide discrepancy in fit between the upright pieces and the upside-down ones. Generally the machine is blamed and a serviceman is called in to tighten it up.

Causes for Misregister on Nested Forms. What is the answer to misregister on nested forms? It can be cured with better register marks and more care in scratching and aligning, but most of all, everyone concerned must know how it occurs. The reader who is interested in this subject can find a detailed discussion of it in the already mentioned GATF Skilled Craft Text No. 515, *Photocomposing.*

Forms With Units Turned at Various Angles. Probably the most difficult of nested forms are the ones that are turned at various angles. Two pieces are seldom at the same angle. These forms occur with envelopes and some bottle labels. Because these forms are so intricate it requires special machines to make the layout, to photocompose them, and to check the plate later for possible errors.

Nested layout.

Special Equipment for Nesting. Of course, to shoot a plate with such a layout requires a photocomposing machine with a rotating negative-holder like the Huebner Rotary Head machine or the Rutherford circular negative-holder. After the plate is shot it can be put in the layout machine for checking. If the register marks on the plate correspond to the machine readings of the layout, the plate is okay. This machine can also be used to check the accuracy of hand-transferred plates.

Due to the cost of special equipment, most lithographers make these intricate layouts by the stripping or hand transfer methods rather than photocomposing.

Photocomposed Press Plates for Stretched Sheets. It often happens that paper stretches in the press around the cylinder. Usually the pressman can compensate for this by shifting the packing from its position under the plate to a position under the blanket. This makes the press "print longer" and therewith possible to maintain register. But making the press print longer than normal is equivalent to the inviting of slurs. If the paper stretches a little too much, for example on a job that has large areas of three-quarter flat tints and where the paper has a high finish, the third or fourth color may slur badly.

Elongated Press Plates. It is up to the photocomposing machine operater to make an elongated plate so that the pressman can run with normal packing on his latter colors. If there are four or more rows of images on a step-and-repeat plate, the problem is quite simple. It is only necessary for the pressman to go back to a normal packing under the plate in the press and then to print a few sheets. These will indicate the amount of stretch that is in the sheet. The stretch on the longest sheet pulled with normal packing must be measured. Thereafter, look at the layout and add a portion of the stretch to each vertical move. If the stretch is .060 inch, for example, and there are four rows, add .020 inch to each distance between rows.

How the Amount of Stretch Must be Established. Do not try to find paper stretch by comparing a sheet with a plate. All plates print longer than their image size. This would just confuse the issue and result in more lost time. Measure the actual stretch on the printed sheet after going back to normal packing. Measure it with a fine transparent scale showing divisions of .010 inch. The photographer can make such a scale on film from a one-tenth ruler. Every operator should have such a scale. Or, use a pair of sharp dividers to measure the error on the sheet and then lay the points of the dividers on a fine scale.

Using a Register Rule. In shops that check all of their first printed sheets with a Register Rule and record the readings, set-out plates are easy to make. By this method, not only can paper stretch be found but "fan" across the back as well. When the image "fans across the back," the corner images can be set out to fit in the same general manner.

TROUBLES IN PHOTOCOMPOSING

In this our final unit on photocomposing, we discuss the following five kinds of photocomposing troubles: (1) plate

embossing, (2) poor contact, (3) insufficient vacuum, (4) poor register, and (5) uneven exposure.

Plate Embossing. A plate is said to be embossed when, after exposure, ridges appear in the surface of the plate. This is caused by atmospheric pressure behind the plate pushing it into an unsupported area around the frame or glass. Using too small a piece of glass can cause a wide gap around the glass, and embossing will result. Use only full-size glass.

It is dangerous to use too high a vacuum on thin plates. Even though the gaps around the frame are small, a high vacuum on a thin plate will cause embossing. Thin plates, if there are no kinks in them, need only a light vacuum for good contact.

Poor Contact. Poor contact is possible even with a high vacuum. A plate embossed on a previous job will give trouble unless the graining has removed the ridges. Plates should be inspected before and after coating with a low-level reflected light. Plates carelessly handled get kinks that are difficult to remove. With such plates contact good enough for fine halftone work is not possible.

Dirt on the bed or on a plate may cause pimples and prevent contact. Dirt in the plate coating or on the face of the negative will do the same thing. Poor stripping practices or the use of improper front masking can ruin a job.

Whenever contact is questionable, a pen-type flashlight held at an angle with the glass will throw shadows of the dots than can be seen with a magnifier.

It is also important that the glass be flat in the negative-holder. It has been explained how the glass is leveled in the different frames. This should be done carefully and re-checked after the clamps are tightened. Dirt must not be allowed to accumulate at the base of dowel pins, as this keeps the whole frame out of level with the plate. Contact must not be forced by raising vacuum excessively. If everything is in good condition, fifteen to twenty inches of mercury is sufficient.

Insufficient Vacuum. If the gage registers a low vacuum, this means pump trouble, motor trouble or an air leak. An air leak may be in the relief valve that is stuck open due to dirt. Or, the leak may be in the hose or the hose connections. Such leaks can usually be heard and easily located.

The leaks most often occur around the gaskets on the chase. This may be the case when the seal extends beyond the edge of the plate. If plate edges have been damaged by rough handling or are not taped down carefully, a leak will occur.

A leak may be between glass and frame or between chase and plate if the gaskets are not kept in a soft and pliable condition. Rubber surfaces become hard due to oxidation and do not seal properly in such a condition. Or, the seals may be damaged by careless storing of the frames. In storage, nothing should touch the thin edges of the seals as this will put permanent waves in them. Hard or distorted seals should be replaced.

Poor Register. Reading the dials incorrectly causes much of the poor register. Another cause of poor register is failure to keep out backlash errors due to not always approaching the final mark from the same direction on every plate. Dials should be kept clean and well-lighted.

Misregister is also caused by worn or dirty dowel pins and bushings. These should be periodically tested for any play; when worn, they must be immediately replaced as they are the heart of register.

As a rule there are two adjusting nuts on every lead screw arranged so that they take up excessive backlash. These should be tightened and oiled occasionally. The lead screws also have some type of thrust bearing and take-up that need periodic attention.

It is also possible for dowel pins to become loose on a chase or on the register device. Sometimes the lined glass on the device becomes out-of-square with its pins. A check should be made of everything that affects register when poor register occurs. Then test the machine by making a cross-mark check. Use a negative that has a perfect cross mark on it in addition to very accurate register marks. Lock it up, put it into the machine and step it up on a plate or Vandyke Paper. Calculate the steps so that the lines of each cross printed just touch those of adjacent crosses. Step-and-repeat both up and down. An error, if it exists, will be clearly shown.

Uneven Exposure. If possible, all arc lamps should be on separate power lines of ample capacity, running back to the source of electrical power in the building. Lamps must be kept free of arc dust and rust. The carbon clamps must be free of pits and burned spots, and in good working order.

Uneven exposures may be caused by fluctuations in light intensities or color. If arc lamps are on the same circuit with other equipment of high electrical consumption, fluctuations in line voltage will occur. After a few months use, any lamp can lose some of its compensating ability. A compensating, integrating light control is a big help provided it is maintained in good working order.

Dark reaction is a frequent cause of uneven exposure on warm, humid days. The plate starts to harden or to tan as soon as it dries, and this continues until it is developed. As dark reaction progresses the plate becomes more sensitive. If a plate stays three or four hours in the photocomposing machine the first exposure will be different from the last. This error in uniformity can be eliminated by air-conditioning. Many of our pre-sensitized plates do not have the tendency to dark reaction.

The Platemaking Department ————————————————

Section One: Introduction

The offset lithographic plate is the hub around which the lithographic process revolves. Platemaking is the step at which the lithographic process clearly demonstrates the principle that grease and water generally do not mix. A lithographic plate must consist of two kinds of areas: the printing areas, which accept grease and repel water; and the nonprinting areas, which accept water and repel grease. The wider the difference between the ink-receptivity of the image and the water-receptivity of the nonimage areas the better the plate and the easier it will run on the press. Many plates prior to 1948 were difficult to run because of the small differences between the ink-receptive areas and the water-receptive areas.

Some of the most significant developments in lithography since World War II have been made in the area of platemaking. Practically all of these developments have helped to increase the difference between the ink- and water-receptivity of the image and nonimage areas; they have improved platemaking to such an extent that plates are no longer the serious source of trouble they used to be. Science has given the lithographic craftsman materials, techniques and knowledge which makes possible the present state of the art, *where there is little excuse for bad plates to go to press.*

There are a number of ways of putting an ink-receptive image on a lithographic plate. Plates are generally classified according to the method used.

Original Plates. Original plates are plates on which the artist has drawn an image with a greasy crayon or a special ink called *tusche*. The artist may also apply a mechanical dot pattern, or *benday*, with a greasy ink. This technique provides a method for creating various tone values. Most original plates were on stone. Some artists still use stone as their medium, and stone lithography is taught in many art schools. The modern "direct image" plates are, strictly speaking, original plates. However, they are so different from lithographic stones that discussion of the direct image plates is combined with other contemporary plates in Section Nine.

Hand Transfer Plates. When two or more identical images were to be printed from the same plate, the artist did not draw the same image two or more times. Instead, he drew a single design from which the required number of ink impressions were duplicated on hand transfer paper. Hand transfer paper is coated on one side with a gummy or gelatinous layer. The duplicate transfers were then laid face down in the proper positions on a new plate, and their ink images were pressed against the plate. The transfer paper was then soaked with water and peeled, leaving the inked images on the plate. This was the procedure used for the first metal printing plates.

CONTEMPORARY LITHOGRAPHIC PLATES

Original and hand transfer plates are seldom used today. They have been almost entirely replaced by photomechanical plates made from negatives and positives. Direct image plates, discussed in Section Nine, are also in current use, but not to the extent of photomechanical plates.

The Photomechanical Principle. A photolithographic plate is a metal, paper, or plastic plate that is cleaned, treated, and coated with a thin film light-sensitive material. This material is naturally soluble in some solvent such as water, but becomes insoluble after it is dried and exposed to light. A negative or positive of the image is placed in close contact with the coated plate, usually under vacuum, and then exposed to a controlled light source. The light that goes through the transparent parts of positive or negative hardens the plate coating and makes it insoluble. Where the coating is shaded by the opaque parts of the negative or positive, the coating remains soluble. After the light exposure, the plate is developed to make the image areas ink-receptive; then it is treated to make the nonimage areas water-receptive. (For positive-working presensitized and wipe-on plates, discussed more fully in Section VI, the solubility is reversed by selective solvents. On these plates, exposed areas are rendered soluble, while unexposed areas become insoluble.)

THE MAIN TYPES OF CONTEMPORARY PLATES

For the purpose of this manual, lithographic plates are divided into four groups: (1) Surface plates—albumin, presensitized, wipe-on, and photopolymer; (2) Deep-etch plates; (3) Bimetal plates; and (4) Direct Image, Projection, and Electrostatic plates.

Each of these is briefly described in this introduction and more fully discussed in following sections.

Surface Plates—Albumin, Presensitized, Wipe-On, Photopolymer. On surface plates made from negatives, the light-sensitive coating becomes the printing surface. In the *albumin* type plate, the light-sensitive coating may consist of albumin, casein, or soybean protein, sensitized with ammonium bichromate.

Cross section of a surface plate.

Presensitized plates provide the ultimate in simiplicity in platemaking. They are called presensitized because they are sensitized when purchased. They will generally keep their sensitivity for six months to one year or more. Presensitized plates consist of a thin film of a light-sensitive material, usually a *diazo* compound, which is coated on a specially treated aluminum or paper base plate. Both negative and positive types are available.

Wipe-on plates are chemically similar to presensitized plates, but they are coated in the plateroom by hand, or in a simple roller coater. A specially treated aluminum is coated with the diazo coating, exposed through a negative, and developed. Positive wipe-on plates are also available.

Photopolymer plates consist of cinnamic acid esters and a sensitizer that combine during exposure to produce a tough, long-wearing image area. Photopolymer plates are made with negatives. The exposed coatings require special organic solvents for processing. There are presensitized and wipe-on photopolymer plates. Photopolymer plates developable in water-soluble solutions have also been developed.

A full discussion of these and other surface plates is contained in Section Six of this chapter.

Deep-etch plates are based on a light-sensitive coating that serves as a stencil to produce the printing image. They are made from positives. After the image is produced, the stencil is removed. Most deep-etch plates are coated in the lithographic plant. The coating for in-plant-produced deep-etch plates is a mixture of gum arabic or polyvinyl alcohol (PVA) with ammonium bichromate. A full discussion of deep-etch plates is contained in Section Seven of this chapter.

Bimetal plates are excellent for exceptionally long runs and for printing with abrasive inks, papers, or boards. Bimetal plates

Cross section of a deep-etch plate.

have the widest difference obtainable between the ink- and water-receptivity of image and nonimage areas. All of the plates described previously—surface plates and deep-etch plates—have been single-metal plates. Bimetal plates consist of two different metals, one for the image areas and the other for the nonimage areas. *The metals of bimetal plates are chosen so that the image metal is ink-receptive under the same conditions that render the nonimage metal water-receptive.* All bimetal plates in present use, except one, have copper as the image metal. The one exception uses brass (alloy of copper + zinc) as the image metal. The usual nonimage metals are aluminum, chromium or stainless steel. When copper and chromium are used together, they are usually electroplated as layers on a third metal such as aluminum, mild steel, stainless steel, or zinc. Such plates are often called trimetal or polymetal plates even though the third or base plate metal takes no part in the formation of the printing of the image.

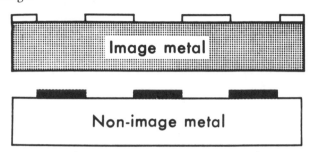

Cross sections of the basic types of bimetal plates.

There are two basic types of bimetal plates: Type I, which has the image metal above the nonimage metal; and Type II, which has the image metal below the nonimage metal. Examples of the first type include copper on stainless steel and copper on aluminum. These plates are usually processed with negatives, but some are also available as presensitized plates for processing with positives. Examples of the second type include chromium on copper or brass, and chromium and copper on a zinc, mild steel, aluminum, or stainless steel base. These plates are always made from positives. A full discussion of bimetal plates is contained in Section Eight of this chapter.

Direct-image, projection, and electrostatic plates are generally used for offset duplicating or on small offset presses.

DIRECT-IMAGE PLATES are made of a specially coated paper that permits direct use of the plate in the typewriter for applying the greasy printing image. Direct-image plates are used extensively in systems printing and in encoding checks for magnetic-ink character recognition (MICR) sorting.

PROJECTION PLATES are the simple means for making printing plates directly from other copy. They can be made directly in a camera or projector and a special processor in approximately 1 min. Projection plates eliminate the intermediate step of making a photographic negative, and the image can also be an enlargement or reduction of the original copy.

ELECTROSTATIC PLATES are made with the Xerographic and Electrofax processes.

Direct image, projection, and electrostatic plates are discussed in detail in Section Nine of this chapter.

Section Two: Equipment for Platemaking

The platemaking room should be large enough to provide ample space for all equipment. It should be well ventilated to remove fumes from evaporation of lacquers, alcohol, and other solvents, and should be air-conditioned.

Hot and Cold Water Supply. The plate room should be so situated that ample supplies of hot and cold running water are readily available. Water temperature as high as 120°F (50°C) is occasionally needed. Many plate troubles, and even failures with some processes, have been traced to the lack of a sufficient supply of hot water.

Illumination. Room lighting is also important. Plate coatings are sensitive to ultraviolet and blue light. When coated plates are being handled they should not be exposed to any stray blue or ultraviolet light. Direct daylight or sunlight should be blocked out or filtered, as by fastening yellow or orange plastic sheets over the windows. Yellow insect bulbs or yellow fluorescent tubes make suitable safelights for the plate room without sacrificing good viewing conditions. The plate room should also be wired so that the yellow lights are always lit when the room is in use; regular white lights should either have individual switches or be wired to a separate switch.

PLATEMAKING SINKS

Sinks for platemaking are generally made of stainless steel or plastic-covered wood or steel. If stainless-steel sinks are used, the steel should be a good grade of 18-8 stainless steel with a high-gloss finish. A polished surface resists corrosion much better than a rough surface. Wood, plywood, or steel sinks that are covered with fiberglass or polyvinyl chloride materials are also satisfactory.

The sink should be approximately 1 ft. larger in each dimension than the largest plate used. A flat platform should cover the entire area inside the sink. This platform should be placed about 3 in. below the rim of the sink, and should be sloped away from the working side of the sink.

Mixing Valves. The water supply to the sink should come through a thermostatically controlled mixing valve. A movable pipe about 2 ft. above the sink, to which is attached a cheese-cloth sock, is preferable to a perforated pipe along the front edge of the sink, as iron and other minerals collect in the perforations and may cause corrosion streaks on the plates.

WHIRLERS

Plate whirlers are gradually going into disuse as a result of the increasing use of presenitized, wipe-on, and precoated plates. But whirlers are still needed for conventional deep-etch and bimetal plates.

The plate whirler is designed to coat lithographic plates. The whirler is actually an oversized turntable. The plate is fastened or mounted on the turntable; the sensitized coating is poured on and centrifugally distributed over the plate while it is turning. The whirler should be equipped with a positive variable-speed drive and accurate controls for setting and measuring whirler speed. The coating is dried by heat and/or forced air as the plate revolves.

There are two types of whirlers in general use—horizontal and vertical. The horizontal whirler distributes the coating solely by centrifugal force. The vertical whirler, which has the turntable placed at an angle of 15° to the perpendicular, distributes the coating by a combination of centrifugal force and gravity. There is little difference in the quality of the coatings produced by these two types of whirlers; neither produces a perfectly even coating over the entire plate. Coatings are generally slightly thicker in the centers and on the edges of the plates. The vertical whirler has the advantage of taking up less space. The horizontal whirler is better suited for coating fragile materials such as plastics and glass.

Whirlers should be equipped with thermostats to control inside termperatures. They should also be equipped with thermostats for controlling the temperature of the water used to flush the plate immediately prior to coating. If a thermostatically controlled water valve is used in the plate sink, the same control can be easily connected to the whirler by running a special line to it.

Roll Coaters. Simple two-roll coaters, with the coating pan under the lower roller, are used for coating wipe-on plates. The machine consists of two soft synthetic-rubber rollers mounted one over the other. The lower roller rotates partly submerged in a trough containing the coating solution. The plate is passed between the rollers face down. Adjustments on the upper roller help govern the thickness of the coating applications. The coating is dried under a fan. These coaters are very effective, productive, and economical with regard to consumption of solution if a large number of plates are coated. It is wasteful, of course, for coating single plates intermittently.

Coating a plate with a roll coater.

VACUUM PRINTING FRAMES

The vacuum printing frame holds the negative and plate in intimate contact during exposure. The frame consists of two wooden or metal frames, one of which holds a corrugated or channeled rubber blanket with a rubber-bead gasket around its

edges; the other frame contains a sheet of flawless plate glass. In smaller vacuum frames the two frames are usually hinged together on one side. The rubber blanket is connected to a vacuum pump by a flexible rubber tube. Special frames with glass on both sides are also used.

Operating the Vacuum Frame. When the printing frame is open, the blanket is horizontal and the glass is raised up out of the way. The sensitized plate is laid on the blanket with the coated side up. The positive or negative, or a stripped-up flat, is laid on the plate in exact position, emulsion side down. The glass frame is lowered and the two frames are locked together. The vacuum pump is then turned on. The pump sucks the air from between the blanket and glass, thus forcing the sensitized plate and the negative or positive together. A reading of from 20 in. to 28 in. of vacuum is considered satisfactory. When this has been done, the printing frame is rotated so that the glass faces a controlled light source which, when turned on, gives the necessary exposure. On a flip-top frame, the glass is inverted through 180°, since the exposing light is underneath.

Making Good Contact. Good contact between the negative or positive and the plate is absolutely essential; otherwise undercutting or spreading of the light during exposure will occur. This is a serious problem with aluminum plates, especially the thin presensitized plates. To ensure good contact, the frame must be checked periodically for air leaks. The reading on the vacuum gauge does not necessarily correspond to the actual vacuum in the frame, and a high reading on the gauge could still not indicate an air leak between the gasket and the glass. The gaskets must be kept smooth and clean and replaced immediately if they dry out, crack, or chip.

Another way to insure good contact between the flat and the plate is to cover the flat and plate with a thin sheet of clear flexible plastic, such as polyethylene. The plastic should be large enough to cover the gasket areas of the frame. When the frame is closed, the glass is above the plastic. The air is exhausted between the plastic, flat, and plate. Because the plastic is flexible it conforms to the irregularities in the thickness of the flat, resulting in much better contact between the flat and the plate than is possible with glass alone.

Testing Contact. An easy way to test the contact between the plate and the negative or positive in a vacuum frame or on a photocomposing machine is to illuminate the area to be

Checking contact between flat and plate.

checked with a pen flashlight. The light is held at a 45° angle to the glass and the area examined with a magnifying glass. If there is enough vacuum for good contact, there will only be one image. If a sharp shadow appears along the side of each dot or line, the contact is poor and the exposure should not be started until the shadow disappears.

Photocomposing. The photocomposing machine, sometimes called the step-and-repeat machine, is used for exposing lithographic plates. The machine produces a series of exposures in register on the same plate or successive plates. The same precautions as described for conventional vacuum frames holds true for the photocomposing machine. The types of machines and the techniques for using them are described in the chapter on "The Stripping and Photocomposing Departments."

LIGHT SOURCES

A number of light systems are available for exposing lithographic plates. The following factors govern the choice of a good light source:

SPECTRAL DISTRIBUTION. Most light-sensitive coatings are only sensitive to blue and ultraviolet light. Sources which are rich only in ultraviolet light are not ideal because the frame glass and some photographic film bases absorb much of this spectral energy. The light source used for exposure should have appreciable energy in the near-ultraviolet and blue part of the spectrum. Special *water-white glass* should be used on printing frames as this glass transmits more ultraviolet light than ordinary plate glass.

LIGHT INTENSITY. The stronger the light the shorter the exposure time.

POINT SOURCE VERSUS DIFFUSE SOURCE. A point source of light produces sharp shadows and reduces risks of undercutting. Diffuse light, or light from a broad source, can give trouble with undercutting when there is insufficient vacuum or poor stripping.

EVENNESS OF ILLUMINATION OVER THE EXPOSURE SURFACE. Light intensity from a point source will vary in illumination from the center to the edges of the image. This can be corrected somewhat by reflector design. A common rule is to place the light at a distance from the plate equivalent to the diagonal of the plate. Greater distances will produce more even illumination but lengthen exposures since light intensity varies inversely as the square of the distance.

CLEANLINESS. Dirt is a platemaker's worst enemy. A light source should be used that creates a minimum amount of dirt. Where open-flame carbon arc lamps must be used, they should be so vented as to exhaust as much of the carbon ash as is practical.

Arc Lamps. A lamp with a single arc is preferred for exposing the plate. Multiple arc lamps or banks of fluorescent lights usually undercut the negative or positive, especially when there is a lot of tape on the flat or layout. Multiple arc lamps and banks of fluorescent lights tend to spread the image areas, plug

the shadows in halftones located near masking paper and tape on surface plates, and sharpen deep-etch plates. There are two general types of arc lamps.

Solenoid Arcs. In the older type of arc lamp two carbon rods are used as electrodes for creating a spark gap. The gap, or length of the arc, is controlled by an electromagnet, or solenoid. As the carbon ends burn, the gap becomes longer. At a given distance in the gap, the solenoid acts to shorten the gap, where it then holds the carbons in the new position until the gap again reaches its maximum length. This intermittent adjustment of the carbons causes a periodic variation or flicker in the light intensity. These lamps are practically obsolete.

Motor Dirven Arcs. Motor driven carbon arcs were introduced in 1947 to overcome the variation in light intensity of the solenoid arc. An electric motor gradually moves the carbons as they burn down. The length of the gap remains practically constant. The light output from the motor-driven carbon arcs is, therefore, more constant in intensity and color quality than the light from solenoid models.

Maintenance of Arc Lamps. Arc lamps may be a source of considerable trouble if they are not properly maintained. The manufacturer's instructions should be followed carefully. An occasional check of the arc length and the steadiness of the light should be made. Check for excessive friction in the mechanism and readjust the length occasionally. Only the carbons that are recommended by the manufacturer should be used. The reflectors must be cleaned often.

Pulsed Xenon. Pulsed-xenon lamps, high-pressure discharge (arc) lamps, which largely replaced carbon arc lamps in process photography, have also gained acceptance in platemaking. The 4,000-w. and 8,000-w. helical pulsed-xenon tubes, mounted in suitable reflectors, are being used extensively on photocomposing machines and on vacuum frames.

Metal Halide. Metal halide lamps are mercury vapor lamps with certain metallic compounds added. This type of lamp is sometimes referred to as the "diazo" type, since it is particularly efficient for the exposing of the diazo type of coating. In this use, a metal halide lamp gives about twice as much actinic light as a conventional mercury vapor lamp, $2\frac{1}{2}$ to 3 times as much as a carbon arc lamp, and 4 times as much as a pulsed-xenon lamp, compared on an equal-wattage basis.

Other Lights. Photoflood lamps and quartz iodine lights provide enough light to expose presensitized and other smaller offset plates. There are also available special ultraviolet tubes which are mounted so that they travel across from the face of the vacuum frame. The stripping operation and the vacuum become more critical with these broad-source lights, as undercutting of the image may occur.

Important advantages of these newer light sources are that they are much cleaner than carbon arc lights, and do not change in light intensity or color temperature as much as carbon arc lights do.

Integrating Light Meters. Integrating light meters for controlling platemaking exposures were used as early as 1940, but did not come into general use until after World War II. Integrating light meters adjust the exposure in terms of light units reaching the plate, integrating the light intensity with time much as a water meter measures water volume in cubic units

Integrating light meter photocell on vacuum frame.

regardless of its rate of flow. All lights are influenced by line voltage variations. When arc lights are used, or when exposure times are critical, it is desirable to have a light integrating meter for controlling the exposure times.

Light Lines and Power Lines. In some areas, power companies have separate service lines for light and for power. The voltage in the light line is usually more stable than the power line. If the plant happens to be in one of these areas, it should operate the arc lights from the light line. The intensity of the light will not vary nearly as much as it will when the arc lights are supplied from the power line.

DEEP-ETCH DEVELOPING TROUGHS AND PADS

The deep-etch developing trough has a level grid or island in the center of which is laid the exposed deep-etch plate for the developing and deep-etching operations. The trough should be about 12 in. larger in each dimension than the largest plate. Since the tray is used for both developing and deep-etching, it should be lined with an acid-proof material. The drain and trap should also be acid-proof.

The Exhausts. The trough should be in a well-ventilated area and should preferably have its own exhaust system. A down-draft or surface type of exhaust is safer and more efficient than an overhead type, since the vapors of platemaking chemicals are all heavier than air.

The Grid. The grid, or island, which sits inside the trough should be 1 in. smaller at each edge than the plate. This allows the platemaker to squeegee off the spent developer or deep-etching solution without the danger of dragging the chemicals back onto the plate. If plates of different sizes are made, it is a good plan to have the grid the same size as the largest plate. For smaller plates, individual pieces of $\frac{3}{4}$-in. marine plywood for each plate size should be placed on the grid to raise and support the plate on a suitable-sized smaller platform.

Provision should be made for a water tap either in the trough under the grid or close by so that the trough can be washed after each use. Drenching the waste developer and deep-etching solutions will dilute them and therefore reduce the danger of corrosion to the water drain line. Care should be taken that the water does not splash or leak on the plate during processing.

Deep-Etch Pads. The deep-etch pad is a plush-covered wooden or plastic block. The platemaker should have separate special pads for development and for deep-etching. After each plate is finished, the pads should be rinsed thoroughly with alcohol, squeegeed as dry as possible, and placed in a rack to dry. At the end of the day, the pad should be thoroughly washed with water, squeegeed as dry as possible, and left to dry overnight. The pads should not stand with developer or deep-etching solution in them, as these solutions absorb moisture from the air. The excess water in the pad could damage the next plate by speeding up the reaction rate of the chemicals in the solutions.

Automatic Plate Processors. Equipment for processing plates automatically has come into widespread use and is

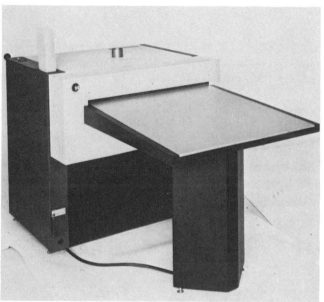

© *Eastman Kodak Company, 1979.*

Plate processor with straight-through roller transport.

continuing to grow in variety and versatility. Interest in automatic processors increased as the use of presensitized plates increased. Most useful in high-volume situations, automatic processors may increase productivity, improve consistency, and reduce chemical consumption. Their use is valuable where speed of production is vital, as in the case of web offset newspapers, which work on edition deadlines. Automatic processors reduce downtime as well as the number of makeovers of plates already on the press.

Some plate processors are designed for plates of specific manufacturers. Others can process the plates of various manufacturers. Some processors take advantage of the economies of standard conditions for a specialized situation. Others have the versatility to handle a wider variety of plate characteristics and sizes.

A plate processor may be automated to the extent that it will develop, desensitize, finish, and dry; it may have chemistry applied automatically and an automatic replenishment system; it may have continuous filtration and recirculation. Each type of equipment must be operated and maintained according to the instructions of its manufacturer.

Air Conditioning. Air conditioning is almost a necessity in plate rooms where bichromated coatings are used since these coatings are affected by both temperature and relative humidity. The system should have provisions for controlling both temperature and relative humidity. Good conditions are 75° ± 3°F (24° ± 2°C) and 45% ± 5% RH in the United States and Canada. In Europe, coatings are designed for use at relative humidities as high as 85%.

Air conditioning is not as necessary where presensitized and wipe-on plates are being made exclusively, except that if film negatives and positives are used they can change size before and during exposure. Film size is extremely important for color separation in the camera, stripping, and platemaking operations. All three departments should therefore be at the same conditions for optimum register or fit of images on the plates.

Section Three: Platemaking Materials

The materials for platemaking consist of the metals used for lithographic plates, the mixture of substances used for coating them, and the chemicals used for processing the plates.

Unlike letterpress, flexography, or gravure in which the difference between image and nonimage area is accomplished mechanically, lithography maintains this difference chemically by the principle that grease (ink) and water generally do not mix. So that the platemaker can understand what is happening in this process, an examination of the properties of the materials and solutions used may be helpful.

LITHOGRAPHIC PLATE METALS

Today, lithographic plates are all thin metal sheets except some direct-image and similar special-use plates. Aluminum is used in most plants, but some plants use zinc as well. Bimetal

and trimetal plates are also used. Plates are the full size of the press cylinder, and must be thin and flexible enough to wrap snugly around the cylinder. The thickness of regular zinc and aluminum "lithoplate" used for surface and deep-etch plates varies with the press size. Standard thicknesses range from 0.0055 in. to 0.020 in. (0.14–0.05 mm), and sizes go up to 59x78 in. (1.5x2.0 m).

Metal litho plates are made in rolling mills and are reduced to their final thickness by cold rolling. Cold rolling makes them harder. They are then carefully inspected to be sure that (1) they meet the required gauge tolerance; (2) they are flat; and (3) at least one side is free from scale, dents, and scratches.

Uniform Thickness and Flatness. Uniform thickness and flatness of plates are extremely important. Plates should not vary in thickness more than ±10%.

Flatness is important to insure good register. If there are any buckles or waves in the metal plate it will not lie flat on the photocomposing machine, the vacuum frame, or the press cylinder. Any movement of the buckle or wave will result in misregister on multicolor work, or misfitting where die cutting is involved. Vacuum backs on photocomposing machines are a must when making plates for multicolor close register work, especially when using aluminum.

SOME COMPARISONS OF POSITIVE- AND NEGATIVE-WORKING PLATES

A review of some of the features, advantages and disadvantages of negative- and positive-working plates may be of some value at this point.

Costs. Plates made from negatives are almost always cheaper from the standpoint of labor and material.

Dirt Spots. Positives that have been used over a period of time will become marred and dirt-infested, requiring excessive staging and dirt-picking, particularly on multi-image deep-etch plates. Negatives can be kept clean by opaquing out dirt and pinholes so it would not be necessary to clean up negative-working plates.

Photocomposing. On certain combination press layouts, masking must be done while the material is locked in the machine. Positive-working plates permit the operator to see the last exposed image. Also, white lettering in multicolor areas can be shot out in exact register by superimposing.

Press Life. With the exception of bimetal negative plates and some photopolymer plates, the deep-etch or positive-working plates are completely acceptable for long-run jobs.

Press Performance. Deep-etch or positive-working plates have the capacity to carry excess ink and still print reasonably sharp.

Plates for Web Presses. Baked positive-working plates and bimetal positive and negative plates will give better performance than most other plates. However, because of high operating cost of a web press, negative-working presensitized and wipe-on plates are often used since these plates can be made faster and thereby reduce downtime. One-piece negatives of the full press form are used so that the plates can be made quickly in a vacuum frame.

COATING MATERIALS

Ammonium Bichromate. Ammonium bichromate is the main ingredient of plate coatings made with albumin, casein, soybean proteins, gum arabic. It is the sensitizer of the coating and it is responsible for producing the image through the action of light. Ammonium bichromate is the result of reacting chromic acid with ammonia. The chemical is poisonous if taken internally and can cause dermatitis—skin irritation—to personnel with specific sensitivity to bichromates. The "Photo Grade" is considered satisfactory for lithographic use.

Albumin, Casein, and Soybean Protein. These proteins are used on certain types of surface plates, most of which are now practically obsolete.

Albumin is a protein derived from the whites of eggs. It is sold as spray-dried powder and as dried scales in a variety of grades. The best form for lithographic use is "edible" egg albumin scales. The powders do not work as well.

Casein is a milk protein. Because it has a much higher molecular weight than albumin, casein is not as readily soluble in water and must be dissolved in an ammonia solution. Satisfactory grades of casein for lithographic use must also be fat-free.

Soybean protein, like casein, has a large molecule and must also be dissolved in an ammonia solution. Since it is considerably cheaper than albumin or casein, one of its major uses is as a substitute for casein in paper coatings.

Gum Arabic. Gum arabic is the main organic ingredient of deep-etch coatings. It is also the main ingredient of plate etches and gums. Gum arabic is a natural gum that comes from acacia trees in the Anglo-Egyptina Sudan area of North Africa. Clean gum arabic is an edible product used extensively in the manufacture of candies. It comes either in lumps or as a powder. The type preferred by lithographers is called "Select Gum Arabic Sorts." There are two crops of gum arabic annually, and some of the early crops show a characteristic known as stringiness. Solutions of stringy gum are unsatisfactory for preparing coatings but can be used in etches and as plate gumming solutions.

Glue. Glue has also been used for deep-etch coating and, sometimes, as a mixture with albumin for surface plates, but these uses are almost obsolete. Fish glue is most commonly used. The glue is a specially prepared fish glue known in the trade as liquid photoengraver's glue. The main advantage of glue coatings for deep-etch was that they were water-developable; but this made it difficult to control tone values.

PVA. Polyvinyl alcohol (PVA) is used extensively in Europe for making deep-etch coating. PVA is very similar to photoengraver's glue in that it can be developed with water and does not require special developers or alcohol. However, as with glue, tones made on a PVA coating cannot be controlled by development. Processes using PVA have not been very popular in the United States, and although it is used to some extent in photoengraving and in the production of printed electrical circuits, it has not found acceptance in lithography. Some work is being done in Europe to make PVA plates solvent-developed in the same way as gum arabic coated plates so that tones can be controlled to some extent during the development step.

Diazo. Diazo sensitizers are used for presensitized and wipe-on plate coatings. Most of the diazos in use are condensation products of formaldehyde and diazo diphenyl amine stabilized with a compound like zinc chloride. Some diazo oxides are also used. Diazos differ from colloids such as albumin, casein, and gum arabic in that they are themselves light-sensitive. Exposure to light converts them directly to insoluble resins that have good ink receptivity and reasonable wear characteristics for printing.

Photopolymer Coatings. One type of photopolymer coating for surface plates is a cinnamic acid ester of an epoxy resin sensitized with a suitable organic compound. This coating is insoluble in water but soluble in organic solvents, and can be used for presensitized or wipe-on plates. On exposure to light, the exposed parts of the coating become insoluble in the organic solvents which dissolve the unexposed portions. The resultant images are very tough, and the plates generally withstand long runs. Since photopolymer coated plates are not affected by temperature and relative humidity, the plates can be precoated and stored for long periods of time prior to use. The process, however, suffers from high cost of materials and the necessity of using organic solvents in processing. Photopolymer plates are used extensively for making printed circuits for electronic components. Photopolymer coatings of the water-developable type have also been introduced.

PROCESSING CHEMICALS

A number of chemicals are used in making a lithographic plate and in running the plate on the press. "Chemically Pure (C. P.)" grades of chemicals are always acceptable for use, but they are too expensive for large quantities when a cheaper grade will do equally well. A published formula will usually state the quality level required of the ingredients. The most commonly used and most important litho platemaking chemicals are listed below under their chemical types, such as acids, alkalies (bases), and salts. For specific information about the availability of the chemicals, refer to any of the standard references published annually by the major chemical houses. Some of these are: The Merck Index of Chemicals and Drugs (Rahway, N. J.: Merck & Co.); Fisher Chemical Index-67-C (Pittsburgh, Pa.: Fisher Scientific); Eastman Organic Chemicals (Rochester, N. Y.: Eastman Kodak Co.); Aldrich Chemical Catalog (Milwaukee, Wis.: Aldrich Chemical Co.)

Acids. A number of acids are used in lithographic platemaking. All of these acids are corrosive in their purchased form, and MUST be handled with extreme safety precautions.

Acetic Acid, Hydrochloric Acid, and Hydrofluoric Acid are acids used as counter-etches to clean litho plate metal. Hydrochloric acid is used as an ingredient of etches for zinc, aluminum, and chromium-copper, bimetal, and trimetal plates.

Nitric Acid is used to some extent in the treatment of bimetal plates on the press.

Phosphoric Acid is one of the most important ingredients of most plate etches and fountain etches. It is used as a counter-press for aluminum. Phosphoric acid is used extensively as a press treatment for bimetal plates.

Sulfuric Acid is an ingredient of surface treatments and is also used for cleaning aluminum, bimetal, and anodized aluminum plates.

Carbolic Acid (Phenols) are used as preservatives for gum.

Lactic Acid is used in deep-etch developers as a solvent for unexposed gum arabic.

Oxalic Acid is used as a treatment to eliminate ink-dot scum on aluminum plates on the press.

Tannic Acid is used in the fountain solution to help the gum desensitize the plate. It is also used in plate etches.

Alkalies (Bases). Two common alkalies are used in lithography:

Ammonium Hydroxide (Ammonia) preserves the coating solutions by keeping the pH high. It is also used to assist the development of surface plates.

Sodium Hydroxide (Caustic Soda) is used to clean zinc plates prior to graining, and as a counter-etch for aluminum plates.

Salts. Many salts are used in the various treatments on lithographic plates, both during platemaking and on the press.

Alums. Ammonium alum is an ingredient in surface treatments. When mixed with hydrofluoric acid it is used as a special counter-etch before adding work to aluminum plates.

Chrome Alum is used in desensitizing plate etches to help harden the gum arabic so that it will not dissolve readily from the plate, and yet allow the gum to hold the water. It is also used in fountain solutions.

Bichromates. *Ammonium bichromate* is used as a coating sensitizer (see Coating Materials), as an ingredient of plate and fountain etches, and as a corrosion inhibitor in surface treatments for zinc and aluminum plates.

Sodium Bichromate is also a corrosion inhibitor and may be used in graining and in surface treatments.

Chlorides. *Calcium chloride, magnesium chloride, and zinc chloride* are used in deep-etch developers and deep-etching solutions.

Ferric Chloride is used in deep-etching solutions. By itself, it is used as an etch for copper on stainless-steel bimetal plates.

Aluminum Chloride is an ingredient of chromium etching solutions.

Cuprous Chloride is an ingredient of chemical copperizing solutions for aluminum and steel.

Nitrates. *Ammonium nitrate* and *zinc nitrate* are ingredients of press fountain etches.

Magnesium nitrate is an ingredient of plate etches made with cellulose gum (carboxymethyl cellulose) and is also used in press fountain etches.

Ferric nitrate is used as an etch for copper on copper-aluminum bimetal plates.

Phosphates. *Ammonium dihydrogen phosphate*, or *ammonium phosphate (monobasic)* is used in many press fountain etches.

Trisodium phosphate (TSP) is used as a cleaner for plates during graining. It is also used as a counter-etch of pretreatment for aluminum.

Cellulose Gum, the sodium salt of carboymethyl cellulose (CMC), is a synthetic gum that is used as a substitute for gum arabic in press fountain solutions.

Gum Arabic is used in plate etches, as a gumming solution, and in press fountain etches.

SOLVENTS

A number of solvents are used in lithography. They are divided into three classes: (1) solvents for chemicals; (2) lacquer solvents; (3) ink and grease solvents.

Solvents for Chemicals. Alcohols are used as solvents for chemicals where water might have some effect on the process.

Anhydrous ethyl alcohol is used in the deep-etch process to dissolve and remove the salts left from the developing and deep-etching solutions. It is also used as a main ingredient in chemical copperizing solutions.

Anhydrous isopropyl alcohol may be used for the same purposes as anhydrous ethly alcohol. Isopropyl alcohol (not anhydrous) is also an ingredient of fountain solutions for the Dahlgren, Miehlematic, Dampen-Orr and other new dampening systems. Concentrations up to 25% of alcohol are recommended for these systems.

Ethylene glycol is a dihydric alcohol which absorbs water and holds it like glycerin. For this reason it is used in the copperizing solution for steel, where some water is needed to get good deposition of copper. Ethylene glycol is also used in some press washup solutions to dissolve and remove gum from the rollers.

Cellosolve is a combination of alcohol and ether. Its chemical name is ethylene glycol monethyl ether. It does not evaporate as readily as alcohol and is a substitute for alcohol in the deep-etch process. With the use of nonblinding vinyl lacquers, it has been found that the use of Cellosolve must be followed with anhydrous alcohol prior to applying the lacquer, or the lacquer will not adhere properly to the image areas.

Secondary Butyl Alcohol is used as a solvent for hydroquinone in the manufacture of Litho-Kleen. Litho-Kleen is a preparation for preventing glazing and tackiness of rubber blankets.

Lacquer Solvents. The solvents for vinyl lacquers are ketones. Ketones are organic liquids with varying rates of evaporation. Acetone evaporates extremely rapidly. Methyl ethyl ketone (MEK) dries less rapidly, as does hexamone; isophorone is the slowest drying ketone used in lacquers. Because ketones are expensive, lacquer thinners often contain other less expensive chemicals such as toluene, butylacetate, and others. These liquids are not solvents for the lacquer, but they are compatible with the lacquer and with the other solvents. These liquids are used to control the evaporation rate and working properties of the lacquer. Since they are considerably cheaper than the pure ketones, their use helps reduce the price of the lacquers.

Ink and Grease Solvents. The most common solvents for ink and grease are the petroleum solvents. These, too, have different evaporation rates and are classed by flash point, or the temperature at which the vapors will ignite in the air. Their use is regulated by fire departments and insurance companies.

White gasoline has a flash point below 0°F (−18°C) and is considered an extremely dangerous fire hazard. Benzine (VM & P Naphtha) has a flash point of about 45°F (7°C). It is safer than white gasoline but is still considered hazardous. *Stoddard solvent* has a flash point of over 100°F (38°C) and is considered safe for use if kept in safety cans.

Chlorinated solvents like carbon tetrachloride, monochloroethylene, and trichloroethylene, are good solvents for grease and ink. They are nonflammable but are vey toxic. *Carbon tetrachloride is a deadly poison and should never be used under any circumstances.* The other chlorinated solvents are less toxic, but they should be used with extreme caution and only where the area is very well ventilated.

Turpentine is a natural solvent obtained from the resinous wood of southern pine and is used for washing out plates in platemaking and on the press. It is available either as gum spirits of turpentine or steam distilled wood turpentine, both of which are satisfactory for lithographic use. Although it is an excellent solvent, turpentine is a skin irritant to many people, and its use should be avoided.

Lithotine is a solvent developed by GATF as a substitute for turpentine. It consists of a mixture of pine oil, castor oil, ester gum, and petroleum solvent. Lithotine works exactly like turpentine but is not an irritant to the skin.

Air Pollution. Many solvents are considered causes of air pollution and many regulations have been put into law to restrict their use. Plants with many presses using large quantities of solvents will be required to install expensive exhaust and/or catalytic oxidation systems.

OTHER MATERIALS USED IN PLATEMAKING

A number of other materials are used in platemaking. Most of these materials are proprietary or ready-made. They are described in general classes without reference to different brand names.

Abrasive Sticks are used to remove unwanted areas from plates. There are two types: snakeslips and scotch stones. Air erasers are also available. These are an airbrush type of gun which uses compressed air and pumice. The air eraser does an excellent job of removing unwanted work in platemaking and on the press, and still leaves a grained surface to carry water. The trouble with most abrasive sticks is that they polish the metal and affect the ability of the treated area to carry water, thereby possibly causing a scum or tint in the polished area.

Asphaltum-Gum is an emulsion of asphaltum and gum arabic solution used in place of the gum solution. When used properly, the solution applies a film of protective gum to the nonprinting areas while the asphaltum imparts good grease receptivity to the image areas. The emulsion helps to eliminate the failure of plates to roll up properly on the press due to gum laying on the image or developing ink rubbed down too thin. The asphaltum-gum emulsion can be used on all types of plates.

Developing Inks are used in platemaking to apply a greasy surface to the image areas. They are essentially stiff, nondrying greasy black inks thinned with solvents so that they can be rubbed to a smooth, even film on the plate. Developing inks are commonly available in different consistencies. Surface plate inks are rather thin; deep-etch inks are thicker. Special heavy-bodied inks are also supplied in tubes for use on bimetal and fine-grained plates.

Lacquers are used to strengthen the image and to make it resistant to solvents, acids, and gum. Lacquers were formerly made of shellac, nitrocellulose, Bakelite, and other synthetic

resins. Practically all such lacquers have been replaced by new ones made from vinyl resins. These form the basis of the modern nonbinding lacquers.

Lacquer Emulsion is used extensively on presensitized and wipe-on plates, and consists of an emulsion of a lacquer resin and a desensitizing gum. Plates on which lacquer emulsion is used are sometimes difficult to roll up on the press.

Staging Lacquer, or stopping-out lacquer, is used on deep-etch plates to block out unexposed areas in order to prevent them from developing. As staging lacquers are composed mainly of shellac, which is alcohol-soluble, the staging lacquer is removed in the alcohol wash.

Tusche is used for adding work to plates. There are two basic types. One is formed by rubbing litho crayon in water. The soap in the crayon emulsifies the wax and grease and produces an emulsion with the approximate consistency of heavy coffee cream. Tusche can be applied to a cleaned plate with a brush to produce solids, or with a pen to draw lines. Before it can produce a printing image, however, the tusche must be dried thoroughly on the plate and reacted upon by the plate etch; otherwise it will be soluble in water. The acid in the etch converts the soap to a water-insoluble fatty acid that is ink-receptive.

The other type of tusche is used when images are added to aluminum presensitized plates. This tusche is applied to a dry plate by rubbing the solution on the area and then tapping in press ink. The plate is then etched.

Image Remover is a thickened solvent used for the removal of unwanted image. The formula varies with the type of plate—positive-working, negative-working, zinc, or other metal. The remover is applied to the area with a brush or swab, and after allowing the solution to react for approximately a minute, the plate area is flushed with water or the area is wiped dry.

Section Four: Chemistry of Platemaking

Chemistry is the foundation of platemaking. Chemical reactions are involved in: (1) the production of the image by light; and (2) wettability of the image area by ink and the nonimage areas by water.

CONTROL OF THE PLATEMAKING VARIABLES

The GATF Sensitivity Guide. Most of the factors affecting plate coatings cause trouble only when they get badly out of hand. Usually this appears when the temperature and relative humidity suddenly become high or vary considerably from day to day. During most the year the effect of most of these variables is hardly noticed.

The biggest source of trouble in the past was the lack of some way of measuring the total effect of all the variables. Most plates looked good in the platemaking department. Their appearance, however, was deceiving. It was never really known whether the plate was acceptable or whether it would print satisfactorily until the plate was on the press and running; too late for corrective action.

GATF's research changed this situation when it developed the Sensitivity Guide for platemaking. The Sensitivity Guide is a simple photographic measuring device which integrates the effect of all the variables affecting the plate coating, its exposure, and the development. As soon as the plate is developed, the Guide tells the platemaker if the image areas are properly exposed and developed and if the nonprinting areas are apt to cause trouble.

The GATF Sensitivity Guide is a narrow strip of special continuous tone transparent gray scale about ½ in. wide and 5 in. long (12½ x 125 mm). There are 21 different density steps in the Guide. These steps are numbered from 1 to 21 with the low numbers at the clear end of the scale. The gray scale is so selected that the density difference between steps is about 0.15, and 0.30 between every other step. This means that the light transmission of every other step is cut in half or doubled depending on whether the numbers increase or decrease. Step 7 on the scale has about one-half the light transmission of step 5, step 4 lets through about twice as much light as step 6.

The GATF Sensitivity Guide; a 21-step gray scale.

HOW THE GUIDE IS USED. To use the Sensitivy Guide, it is stripped into the flat or onto the photocomposing machine glass. Any prominent place on the plate is satisfactory; some plants use several guides on different parts of the plate.

On surface plates—when the plate is exposed, inked, and developed—a number of steps of the Guide will also show. Ordinarily, step numbers 1 to 5 or 1 to 6 are solid black. If step 5 is the highest-numbered solid-black step, steps 6, 7, 8 (and perhaps more) will show as a gray tone. These gray tones get weaker and weaker as the numbers go higher.

THE CRITICAL STEP. The highest numbered solid black step is called the critical step. This is the one to watch. With the same exposure time, the critical step will change when the sensitivity of the coating changes, or when changes in the amount of dark

reaction have occurred. The more sensitive the coating, the higher the number of the critical step that will appear. A difference of two steps means that the coating was twice as sensitive as it should have been, or that the exposure should have been cut in half. In addition, the number of gray steps that show on the plate should be checked. Too many gray steps are a warning that a plate may be sensitive to scum or sharpening on the press.

THE GATF GUIDE ON DEEP-ETCH PLATES. On deep-etch plates the Guide is even more important than on surface plates because it can be used as a control in compensating for slight errors of exposures or changes in sensitivity. When the Guide is used properly, deep-etch platemaking with the bichromated gum process becomes an exposure/development process like ordinary photography with silver halides. Changes in sensitivity, or errors in exposure, can be compensated for by changes in development. This is true also for bichromated PVA processes, which use solvent developers.

Appearance of the Sensitivity Guide: left, on a developed deep-etch plate; right, on a finished surface plate.

The Guide on deep-etch plates is reversed in appearance to a Guide on a surface plate. The high-numbered steps are solid and the low-numbered steps are clear, with possibly one or two gray steps in between the gray area and the solid black areas. Development is usually carried to approximately one step from the critical step. Deep-etching removes the one step. The ideal critical step is determined by experience but here, again, it has been found that a critical step of 5 or 6 is satisfactory under most operating conditions.

WHAT THE GUIDE TELLS. The GATF Sensitivity Guide is the most important tool the platemaker has. He has a device by which he can exercise control over the platemaking process. It will tell him when a change in coating sensitivity has occurred and how much of a change has taken place. It will not tell him what has caused the change. For this he must depend on his experience.

CONTROL OF TONE VALUES IN PLATEMAKING

The GATF Star Target. The GATF Star Target is a small (⅜ in.—9 mm diameter) circular pattern of solid and clear pie-shaped wedges. When correctly reproduced on the plate, the center of the target will be open, just as it is on the original film. If the center of the target appears filled in on the plate, dot spread is indicated; if the center of the target appears broken or enlarged, dot sharpening has occurred. The actual amount of spreading or sharpening is magnified 23 times. This requires the use of a magnifying glass or microscope with a calibrated reticle, if specific calculations are to be made.

GATF Star Targets: left, positive; right, negative.

The GATF Dot Gain Scale. The GATF Dot Gain Scale is a small (¼x2 in.—6x50 mm) strip, available in either negative or positive. The Scale consists of numbers from 0 to 9 in a fine-screen pattern against a coarse-screen pattern. The dot values on the numbers vary in increments of 3% to 5%. In the original negative or positive the number "2" appears to have exactly the same density as the background, at normal viewing distance, and therefore is "hidden." When the Dot Gain Scale is reproduced on a plate, one number blends with the background tint; higher numbers are lighter, lower numbers are darker. The number that disappears is a measure of dot-size change. If the hidden figure advances a single number from one plate to the next, the dots have spread about 3%-5%.

Printed images of Dot Gain Scale: top, sharp; center, shows dot gain without slur; bottom, dot gain caused by slur.

WETTABILITY OF IMAGE AND NONIMAGE AREAS

The principle on which lithography is based—that grease and water don't mix—is not completely true. Grease and water do mix under certain conditions. We also have evidence indicating that a plate will not print if ink and water do not mix to a slight degree on the press. The process, therefore, seems to work within limits. These limits cannot be too narrow, or the process would never work as successfully as it does. If the limits within which the water and grease mixes gets too wide, then we run into trouble.

While it has been found that some mixture of water and ink is necessary in printing on the press, in platemaking, nevertheless, any such tendency must be prevented. If the image areas could be wet *only* by ink and not by water, and the nonimage areas *only* by water and not by ink, the ideal lithographic plate would be the result, and such a plate would run with the least amount of trouble. When the image areas are wet by water and not by ink, trouble results with "blinding." There is trouble with "scum" when the nonimage areas are wet by ink and not by water. The wettability of the image and nonimage areas, by ink and water respectively, is related to the physical chemistry of the surfaces.

INK-RECEPTIVITY OF IMAGE AREAS

Different kinds of image areas are used in lithography depending on the type of plate. Each type of plate has a different kind of image, and each kind of image may have different characteristics with respect to ink receptivity.

Presensitized Plates. The image areas on most presensitized plates in commercial use consist of diazo compounds that are either polymerized or reacted upon in some other way by light. In general, these materials have excellent ink receptivity and resistance to wetting by water or gum. They have, however, poor resistance to abrasion, especially with the thin coatings which can be produced on these relatively smooth plates. Images wear more rapidly on these relatively smooth plates unless pressures are watched carefully and abrasive conditions are kept to a minimum.

Wipe-on Plates. The images on wipe-on plates are similar to those on diazo presensitized plates. The images, however, are more resistant to abrasion because wipe-on plates are grained. This condition is also true of those presensitized plates that are grained.

Photopolymer Plates. The image areas on photopolymer plates of the cinnamic ester type consist of an organic resin insolubilized by light. The material is completely insoluble in water and has excellent resistance to wetting by water and gum. The resin also has good resistance to abrasion, so that long runs are one of the characteristics of these plates. The image areas on the water-soluble type of photopolymer plates also have good ink receptivity and resistance to wear if the images are treated before the plates are put on the press.

Deep-Etch Plates. The image areas on deep-etch plates consist of a chemically etched metal to which a lacquer and an ink are applied. The ink-receptive properties of the image seem to be related to the surface characteristics of the chemically etched area and to the chemical nature of the lacquer.

If the coating has not been completely removed from the image area by the developing and deep-etching operations, the lacquer does not adhere well, and the image blinds in printing. The same thing will happen if moisture is allowed to condense on the image areas during the alcohol wash or after the water wash on PVA plates. Leaching of bichromates from the stencil can also cause similar trouble. These image areas will corrode or oxidize, and corrosion prevents good adhesion of the lacquer.

Another cause of poor adhesion of the image on aluminum deep-etch plates, especially copperized images, is the presence of loose iron. Iron is deposited in the image wells as a result of the chemical reaction between the ferric chloride in the deep-etch solution and the plate metal itself. Some of the iron is tightly bonded to the aluminum, but some is rather loose and spongy. Copper will deposit on this iron, but because the iron is loosely bonded to the surface it dislodges when the plate is running on the press. The result is "spotty blinding." Some chemical suppliers try to eliminate the iron by recommending a redevelopment step after deep-etching, but this does not completely remove the iron deposit. GATF has found that the iron deposit can be completely removed with a solution of nitric acid and Cellosolve. Another remedy for the problem is to use a deep-etch solution that does not contain ferric chloride. Still another method is to eliminate the deep-etching step. When this is done, development must be extended approximatley one-half step further on the GATF Sensitivity Guide. Recently, modified iron etches have been developed which, when properly used, do not leave loose iron on the image area.

Lacquers are used primarly to make the image resistant to acids and solvents. The first lacquers were of the nitrocellulose type. Although these were resistant to acids and solvents, they were readily wet by water and gum. Many deep-etch plates went blind because of gum sticking to such lacquers. The introduction of vinyl lacquers eliminated this problem because vinyl lacquers have much less tendency to be wet either by water or gum. Formulation of the lacquer, however, is important. If the dye, pigment, plasticizer, or solvent mixture is incompatible with the other chemicals in the lacquer, even a vinyl lacquer may show poor resistance to blinding. Dyes, pigment, or plasticizers, which float to the surface of the lacquer on drying, can readily be wet by water or gum. The solvent mixture should be so balanced that all solvents evaporate together, leaving a hard, tough film of lacquer on the image. If one of the solvents dries more slowly than the others, it either allows too much of the lacquer to be rubbed off or the slow-drying solvent gets trapped in the lacquer film so that the lacquer film remains soft and has little resistance to abrasion.

Bimetal and Copperized Deep-Etch Plates. The image areas of all but one of these plates consists of copper covered with a lacquer. Copper has two main advantages as a printing surface: (1) it is very ink-receptive and water- or gum-repellent in the presence of nitrates and phosphates; (2) it has greater resistance to abrasion than have the lacquers. Lacquers are used on copper images mainly to protect the copper during platemaking and to start the plates printing faster on the press.

One of the main reasons bimetal plates have been so successful is that copper *is ink-receptive under the same conditions that render the nonimage metal water-receptive*. In the presence of nitrates and phosphates, the copper is ink-receptive, while aluminum, chromium, and stainless steel are water-receptive. This means that if the image areas start taking water, or if they become blind, and if the nonimage areas start taking ink, or if they scum on the press, a single treatment with a fairly strong (10%–25%) solution of phosphoric acid is usually sufficient to bring both areas back to their original printing condition. Copper can be readily blinded by exposure to sulfur compounds, chromic acid, or excessive bichromates. Copper

will also corrode quickly if exposed to the air. The corroded copper becomes dull and dark when the oxide forms, and then interferes with the ink receptivity. The copper image areas, therefore, should be protected as much as possible. If by accident corrosion does occur, the oxide can easily be removed with a treatment of weak nitric acid and a solution of phosphoric acid, or a good commercial preparation. A small amount of bichromate in the fountain does not seem to hurt the copper and even seems to help bimetal plates on the press. However, an excessive amount of the bichromate can cause blinding.

By far the greatest advantage of copper is its resistance to abrasion. Lacquers are somewhat brittle, and when printing under abrasive conditions (too much pressure, abrasive inks, papers, or sprays), images will blind when the lacquers are worn off. Copper, on the other hand, is rather ductile and is not as easily worn off the plate by abrasive printing conditions. There are instances on record where, with just the use of chemical copperizing on aluminum deep-etch plates, *all other conditions being equal*, the life of the plates on the press were increased as much as tenfold.

Other Types of Plates.

The image areas of direct image plates consist of carbon black in wax transferred from a special paper typewriter ribbon. These images are easily abraded so that the plates do not have a very long life.

The image areas on projection plates consist of tanned gelatin, which is not especially resistant to blinding or wear, and these plates are also short-lived.

The image areas on plates made by the electrostatic processes of Xerography and Electrofax consist of baked organic resins. These resins can be selected so as to have good ink receptivity and resistance to blinding and abrasion.

WATER RECEPTIVITY OF THE NONPRINTING AREAS

The water receptivity of the nonimage areas is affected by the metal used in the plate and how that metal has been treated. As in the case of image areas, water receptivity is dependent on the type of plate. The items that most affect the water receptivity of nonimage areas are: (1) the metals themselves; (2) the surface treatments given the metal; (3) the desensitizing process; (4) the fountain solutions with which the plate is run; (5) the gumming.

Differences in Water Wettability of Metals.

Metals that form hard, tenacious oxides, such as aluminum, chromium, and stainless steel, are easily wet by water and retain their wettability for a long time. Anodized aluminum is especially superior in this respect. Metals such as zinc or iron, which form loose corrosion products similar to rust, are not wet as readily by water. The wettability of these metals changes as they go through different stages of corrosion.

In lithography, the ability of a metal to be wet with water is further enhanced or reinforced by the application of a solution of a gum—for example, a gum arabic etch. How well the gum or etch sticks to the metal depends on the composition of the etch and the condition of the metal surface. Metals such as aluminum (especially anodized aluminum), chromium, and stainless steel hardly need the gum to be water-receptive. Zinc

could not be used at all as a lithographic metal without the use of gum. Many troubles are encountered with zinc because the adherence of the gum and its ability to be wet with water (desensitized) is affected by the presence of other materials and by corrosion. If the zinc is clean, gum sticks to it very well and the zinc becomes very water-receptive (well desensitized). If the zinc is corroded, of if a foreign material like unremoved or residual albumin is attached (adsorbed) to its surface, the gum will not stick; then the zinc is not water-receptive, or it is said to be poorly desensitized. Residual coating will also affect the desensitization of surface plates on aluminum.

Surface Treatments.

Surface treatments have been developed to: (1) eliminate difficulties caused by residual coatings and corrosion; (2) improve the wettability of metals. A surface treatment is a combination of chemicals which react with the metal, leaving a stable, tenacious coating. A surface-treated metal does not corrode, does not react with coatings like diazos, and is not affected by the solutions used in the lithographic process; coatings and gum stick very well to the treated metal.

The first of the surface treatments used was for zinc. The Cronak process, as it was called, was originally developed by the New Jersey Zinc Company and modified for lithographic use, in the mid-1940s, first at the Army Map Service in 1944 and then at GATF in 1946.

Surface treatments have been developed for aluminum, but largely for a different reason. Aluminum does not corrode or rust like zinc; it does form a hard, tenacious oxide. When the oxide film is continuous and unbroken, it is an excellent water-receptive surface. If this film of oxide is damaged in any way, minute corrosion pits form at the points of damage. The aluminum is soon covered with a peppery type of ink-receptive corrosion pit that we call "ink-dot scum." It has been found that this type of corrosion can be inhibited or stopped by the use of the Brunak treatment.

It is believed that the Brunak treatment of aluminum distributes a mixture of chromic oxide and chromium trioxide on the aluminum oxide, and that these compounds inhibit the electrolytic corrosion of the aluminum when the aluminum oxide surface is damaged. If ink-dot scum forms on the press, the scum can usually be removed by a 5% phosphoric or oxalic acid solution.

Aluminum must be surface-treated before it can be coated with the type of diazos used for negative presensitized or wipe-on plates. The diazos, which become ink-receptive when exposed to light, react with metal. Several types of surface treatments are used; the most popular seems to be a silicate treatment. A number of other treatments have been developed and used for this purpose. Anodizing is one; potassium zirconium fluoride is another; a third makes use of an organic phosphoric compound. These are just a few of the metal treatments used. (See Section Five.)

Anodizing is a means of electrolytically producing a film of aluminum oxide of controlled thickness on the surface. This film is highly water-receptive and resistant to chemical and abrasive attack on the press. It is used primarily for deep-etch plates, but is also used for presensitized and wipe-on plates.

Composition of Etches.

The purpose of an etch is to deposit a water-receptive material on the nonimage areas of the

plate. A good etch should leave a film of water-receptive material which lasts for a long time on the press, and wets with a minimum of water.

An etch usually consists of a gum, an acid, and one or more salts. The main ingredient of the etch is the gum, usually gum arabic. Only one other material has been found that works as well as gum arabic, and this is cellulose gum (carboxymethyl-cellulose) (CMC). It works well as an etch on zinc, but not on aluminum. However, it is used effectively in press fountains on plates of both metals.

Much searching has been done to find a substitute for gum arabic. In the first place, the industry is entirely dependent on a foreign source of supply; in the second place, since gum is a "natural" material, it varies widely in composition and purity. But gum arabic is a very unusual material; it has a low viscosity for a gum; has good adherence to metal; forms a highly water-receptive film. Gum arabic is the major ingredient of etches, gumming solutions, and deep-etch coatings. It is believed the reason gum arabic sticks so well to metal is that it contains free organic acid groups in the molecule. These groups are commonly referred to as carboxyl groups. A firm bond is made between the gum and the metal, through these carboxyl groups. The gum swells in the presence of water, but the carboxyl bond keeps the gum from dissolving away from the metal.

The acid commonly used in plate etches is phosphoric acid. The purpose of the acid is to convert more of the groups in the gum molecule to carboxyl groups in order to improve the adhesion. There is a limit to the amount of acid that can be used because too much acid attacks the metal. In this case, instead of forming a film on the metal, the etch removes metal. Much more acid can be used in plate etches for aluminum, without danger of the plate metal being attacked, than can be used for zinc. Anodized aluminum is an exception to this because the acid can attack the anodized oxide layer. A good plate etch for aluminum is the so-called 1:32 etch, which consists of 1 oz. of 85% phosphoric acid to 32 oz. of 14° Bé gum arabic.

Caution: *This etch should not be used on anodized aluminum plates as the acid will destroy the oxide surface.*

With all plate etches, except on anodized, presensitized, and wipe-on plates, it has been found that the etches must be dried on the plate to produce a good water-receptive layer. When materials composed of very large molecules like gum arabic, cellulose gum, albumin, or casein are dried, they undergo a physical change which makes it difficult to dissolve them on re-wetting. Thus, nonprinting areas on which etches have been dried will wet well with water, but the gum layer adsorbed to the metal will not be removed by the water. This explains, too, why freshly made albumin or casein plates might blind if put on the press immediately, and might run for 100,000 impressions if allowed to stand overnight. Light-hardened albumin and casein absorb some water in processing. If the plate is put on the press immediately, the image areas continue to absorb moisture and swell until they lose their affinity for ink and are easily destroyed by abrasion. The images go "blind" or "walk off." If the moisture is removed from the image by standing or heating, the images are toughened and refuse to absorb water unless extreme conditions of excessive water and acid are encountered in printing.

Fountain Etches. Fountain etches are similar in composition to plate etches, but much less is known about their action on the plate than is known about plate etches. It is known that if plates are properly desensitized in platemaking, they can be run on the press with just plain water in the fountain. Water has been used in spray and other types of dampening systems; but with the conventional system, using molleton, cloth, or parchment paper covers, the dampeners grease rapidly when only plain water is used in the fountain. Greasing of the dampeners causes poor wetting as well as spreading of the ink into nonimage areas, especially in halftones and reverse lettering. The use of solutions containing 1 ounce of 14° Baumé gum arabic, or one-half ounce of a 6% solution of cellulose gum in one gallon of water, as a fountain solution greatly reduces this tendency of dampeners to grease. Greasing of the dampeners in a conventional dampening system, however, always occurs to some extent. The addition of a small amount of acid such as phosphoric acid, at a pH value of 4.0 to 5.0, and salts such as nitrates, phosphates, and bichromates to the fountain solution seems to overcome greasing and promote better wetting.

With alcohol fountain solutions the amount of gum should be reduced to one-half this value, since gum is not as soluble in alcohol and can cause glazing of rollers and blankets.

There are a great number and variety of fountain etch formulas. They are not divided by classes or types for different kinds of plates, as are plate etches. As long as the fountain etch formula contains a nitrate salt, it can be used on zinc or aluminum surface and deep-etch plates, presensitized and bimetal plates. For some unknown reason, fountain etches do not work well on aluminum plates unless they contain a nitrate salt. While bichromates are undesirable in fountain etches because of their tendency to cause dermititis, they are of help in preventing the stripping of steel rollers on the press. With the introduction of hard rubber, nylon, and copper rollers, as well as copperizing treatments for steel rollers, this stripping tendency has decreased considerably. Many plates now are running successfully with etches of zinc nitrate, phosphoric acid, and either gum arabic or cellulose gum. This eliminates the necessity for bichromates in press etches with a resultant decrease in the incidence of dermititis.

Gumming. Gum is normally applied to the nonprinting areas of lithographic plates to protect them against accidental damage from fingerprints, air, dirt, and grease. There is evidence to indicate that gumming also adds to the desensitization of the plate. A plate which is etched and gummed is always better desensitized and always prints cleaner with less water on the press than a plate which is just etched and not gummed. Gumming on the press helps to reinforce the water receptivity of nonprinting areas. Care should be taken, however, not to gum plates too frequently on the press. Gum arabic works best as a gum when thinned to a Baumé of 7°-10°. This will help prevent gum streaks. Cellulose gum has been used; but if it is not used properly it can cause gum streaks, blind images, and/or difficulties in washing off asphaltum after plates have been stored. Larch gum, mesquite gum, and arabogalactan have been used successfully for gumming plates on the press. These gums do not adhere as tightly as gum arabic and are therefore less likely to produce gum streaks. Also, they do not serve as desensitizers for plates.

Section Five: Graining or Surface Preparation of Metal

Before a metal can be used as a base for a lithographic plate its surface must be properly prepared. This can be done by roughening the surface mechanically, or treating it chemically or electrolytically. If this is not done, the plate will not coat or perform properly in the lithographic process. The roughening process, whether it is done mechanically or chemically, is called graining. The only exceptions are anodizing and the chemical treatments used for presensitized plates.

Graining. There are a number of mechanical methods for roughening a metal surface. They are "rotary tub" graining, "sandblasting," "dry brush" graining, "wet brush" graining, and a combination of rotary tub and wet brush graining called "ball-brush" graining.

Rotary tub graining is sometimes called ball graining, because it is done in a graining machine which consists of a tub with a rotary motion. Small steel marbles, which are usually reject ball bearings, are rotated over the surface of the plates. Water is added and then an abrasive material. The actual roughening is done by the abrasive. The character of the grain is determined by: (1) the hardness of the surface of the metal; (2) the amount of water used; (3) the weight and uniformity of the marble load; (4) the nature, amount, and size of the abrasive, (5) the speed of the grainer. The problems with this type of grain are inconsistency from plate to plate, scratchiness, dirt, and imbedded abrasive.

Sandblasting is used for roughening plates both for wipe-on and other platemaking processes. The plates are mounted on a rotary drum and a dry abrasive is impinged on the surface at an angle to the plate at right angles to the direction of rotation of the plate. Nozzle wear can cause variations in grains with this method, and imbedded abrasive can also be a problem.

Dry Brush Graining is used for treating some plates prior to presensitizing. This can be done with brass or steel wire brushes. The main advantage is that dry-brush graining can be done in line with the treating and coating of presensitized plates.

Wet Brush Graining takes a special machine in which the plates are fed onto a conveyor belt under nylon brushes and the graining is done with a mixture of pumice and water. Even with new aluminum plates, several passes through the machine are needed to get an evenly grained surface without indications of rolling-mill streaks. The grain is very fine and is satisfactory for presensitized and wipe-on plates. This type of grain is usually too fine for good moisture control on larger presses.

Ball-Brush Graining is a combination of rotary tub and wet brush graining. In this type of graining good depth is obtained in the tub graining operation and a fine, even texture is produced by the wet-brush technique. These plates have the texture for good-quality printing and the depth for good moisture control on large presses.

Chemical and Electrochemical Graining. Several methods of roughening plates chemically and electrochemically are in commercial use. They are used primarily for treating plates prior to coating in the manufacture of presensitized plates. The most widely used method is the electrochemical treatment of aluminum in a solution of hydrofluoric acid. This produces a fine grain which is used as a base for wipe-on and presensitized plates. It is also used as a preliminary treatment to anodizing.

Aluminum Anodizing is a process by which a uniformly controlled thickness of oxide is produced electrolytically or chemically on aluminum. When produced, the oxide surface is very sensitive and must be sealed. Usually hot water is the sealant. The sealed surface is very inert to most chemicals, hard, and abrasive-resistant, and highly water-receptive.

Chemical Treatments. In addition to roughening the surface, chemical treatments are also needed for some processes, especially negative diazo presensitized plates. The diazo compounds used for sensitizing these plates, which are ink-receptive when exposed, will in themselves react with metals. The diazo compounds can only be used if the metals are specially treated to prevent or inhibit this reaction.

When positive presensitized diazo plates are made, special surface treatments are not necessary, although cleaning and usually some type of fine graining precedes the application of these positive-working diazos.

Section Six: Surface Plates—Albumin, Presensitized Wipe-on, Photopolymer

Surface plates are defined as those plates on which the exposed coating becomes the printing image. Plates of this type include albumin, casein, presensitized, wipe-on, and photopolymer. With the exception of positive presensitized and wipe-on plates, all are made from negatives.

Historically, albumin surface plates were the first photomechanical plates used in lithography. They have always been the most difficult to make from the standpoint of quality and consistently satisfactory performance. Albumin and casein plates are now essentially obsolete.

PRESENSITIZED PLATES

Presensitized plates are so called because they come already coated and are ready for exposure and processing when purchased. Presensitized plates are used for the making of one press plate if they are coated on one side, or for two press plates if they are coated on two sides. These plates are not regrained and coated again, but they can be stored after use for later reprinting of the same image.

Presensitized plastic coated plates were originated in Germany by Kalle and Company just prior to World War II. The base of the plate was plastic-coated paper. These early plates, and those which are now used, are coated with a diazo sensitizer. Such sensitizers are not affected as much by temperature and relative humidity as bichromated coatings, as long as temperatures do not exceed 120°F (49°C).

Presensitized plates on aluminum are available with a variety of treatments of the aluminum. The earliest presensitized metal plates were made on aluminum with an electrolytically produced grain. Recently, plates with this type of surface have been marketed in the larger sizes. Presensitized plates with chemically produced and mechanically produced smooth grains are also available. For longer runs, presensitized plates on which the surface of the aluminum has been mechanically hardened are also available.

Courtesy 3 M Company.

Processor automatically develops, rinses, and gums.

Presensitized plates are sometimes designated by the manufacturers as being *additive* or *subtractive*. These terms are descriptive of differences in the processing procedures. A presensitized plate is an "additive" type when the platemaker adds image-reinforcing materials to the image areas during processing. The coating on nonimage areas is either removed or rendered water-receptive during processing. With some additive presensitized plates, image reinforcing is optional; if the run is short this step in processing may be skipped. A presensitized plate is a "subtractive" type plate if it comes to the platemaker with the image-reinforcing material already on it (applied at the time of manufacture). During processing, the platemaker removes the unexposed coating from the background. The image-reinforcing material on the unexposed coating comes away at the same time.

Negative-Type Presensitized Plates. The steps in making the "additive type" of presensitized plates from negatives are as follows:

Exposure is made through a negative. Diazo coatings have higher speed than bichromated coatings. Less exposure is required to produce step 5 or 6 on the Sensitivity Guide.

Developing is accomplished with a special acidified gum solution that either removes the unexposed diazo coating or renders it water-receptive.

Application of Lacquer is required to assure good image life. A special lacquer emulsion to improve image life is applied to the plate so that the image areas are covered by lacquer.

Gum is applied to the plate and dried down. This is a special gum solution.

All manufacturers market single solutions for processing presensitized plates. These solutions combine the developer and lacquer emulsion.

The general procedure for making a "subtractive" plate is as follows:

Exposure is made through a negative. Exposure time, on these plates, is about the same as for deep-etch plates—1½ times the exposure normally required for the presensitized plates described above—to step 5 or 6 on the Sensitivity Guide. On subtractive plates, exposure is somewhat more critical, and plate life on the press may be affected. The manufacturers exposure recommendations must be followed to obtain the best possible results.

Developing is accomplished with special developer that removes the lacquer applied when the plate was originally coated by the manufacturer. This developer also renders the unexposed diazo water-receptive. The plate is thoroughly rinsed with water to remove residual chemicals from both the background and image areas.

Gum is applied to the plate and rubbed down smooth and completely dry. A special gum solution is used.

Positive-Type Presensitized Plates. On positive-type plates, the unexposed areas which form the image are ink-receptive. However, the exposed areas, which are the nonimage areas, must either be removed or converted to water-receptive surfaces during development. The processing includes one more step than in the negative process, as the image must be "fixed" to render it insensitive to light.

The steps in processing the positive presensitized plates are as follows:

Exposure is the same as negative plates except that positives are used.

Developing is accomplished with a special developing solution that is wiped over the plate until all the exposed sensitizer is removed; the plate is then washed with water.

Fixing is done with a special solution that is applied to stop the action of the developer.

Gumming is done with a weak gum arabic solution.

More complete information on the various presensitized plates is available from the manufacturers of the individual plates.

WIPE-ON PLATES

Wipe-on plates are similar to presensitized plates in that specially treated metal is needed and diazo coatings are used.

They differ in that coatings are applied by hand or with a special roller coater, and either aluminum or zinc can be used. Also, the plates used for wipe-on coatings all have comparatively fine grains. The graining can be done in graining machines, by dry sandblasting, and by brush graining. The grained plates offer more latitude in printing than the grainless presensitized plates, without appreciably sacrificing printing quality.

Negative-Type Aluminum Wipe-On Plates. A number of wipe-on processes are available for use with negatives. They are all similar.

Coating is first prepared by mixing the diazo powder with the liquid base solution immediately before use. The coating is applied to a dry aluminum plate. All aluminum plates sold for wipe-on procedures are pretreated and sold ready-to-use. The pretreatment produces an inert barrier between the metal and the diazo coating. Diazo coatings require such a barrier. Using a cellulose sponge, cheesecloth, or cotton swab, the coating is spread with long strokes in both directions to make sure that the entire surface is covered with coating. Some wipe-on processes require wiping down until dry; others are dried, after spreading, by use of a fan. The manufacturers instructions must be followed for optimum results with their particular process.

Exposure is through a negative. Exposure time is about the same as for presensitized plates. Exposure to steps 5 or 6 on a GATF Sensitivity Guide is considered satisfactory.

Developing is done by one of two methods. One uses a desensitizer as in presensitized plates. This is followed by an emulsion lacquer. The plate is finished with another application of the desensitizer, which is dried down.

Another method uses a lacquer emulsion that removes the unexposed coating from the nonprinting areas and desensitizes the background while the lacquer deposits on the exposed image areas. This operation is followed by the application of a gum etch or an asphaltum-gum emulsion.

Screenless Lithography. Presensitized and wipe-on plates became possible largely as a result of three developments. They were: (1) The discovery of light-sensitive coatings other than bichromated colloids such as gum, albumin, casein; (2) Improved desensitizing materials and techniques as well as plate-surface treatments; (3) The ability to successfully run a lithographic plate with little or no grain.

During some of this development work it was discovered that under certain conditions the combination of very fine grain and new-type coatings produced a plate capable of holding up to ten steps on a 21-step wedge as compared to three steps with a conventional, surface or deep-etch, plate. This phenomenon gave rise to the thinking that screenless lithography could be done if photographic methods could be adapted to platemaking procedures. Some very fine color lithography has been done using "continuous-tone" plates exposed to suitably produced continuous-tone positives. As of this date, however, the process has not proven itself commercially feasible except for special applications.

PHOTOPOLYMER PLATES

For many years, organic coatings such as Syrian asphalt, or asphalt sensitized with iodoform, have been known and used in lithography and as resists for etching metals. These coatings were not very successful in commercial lithography because they were slow and required organic solvents for development. These shortcomings, in turn, made the process inconvenient and expensive.

In recent years, considerable work has been done on synthetic photopolymers that are light-sensitive in themselves, or can be sensitized to enhance their own light sensitivity.

The photopolymers most used presently in lithography are light-sensitive cinnamic acid esters, usually of epoxy resins modified with hydrocarbons, amines, nitro compounds, ketones, quinones, and various other organic compounds. These are organic-soluble compounds that require special solvents for development. In this sense, they are inconvenient and expensive like the old Syrian asphalt processes. But the new photopolymers do have many advantages. The photopolymers are exposed to light through a negative, and during exposure the cinnamate units in the polymer chain are cross-linked to form a rigid, insoluble structure with excellent acid and abrasion resistance, while showing good ink receptivity. Photopolymer plates of this type have produced runs in excess of a million impressions. In addition to wear resistance, they have excellent shelf life and they are hardly affected by changes in temperature and relative humidity. Their acid resistance has made them very popular in the production of printed circuits, now almost exclusively used for making electronic components for radio, TVs, computers, etc. The availability of photopolymer plates gives the lithographer another method for making a long-run plate that can be made from negatives. Presensitized photopolymer plates of this type are also offered to the industry. These plates combine the long-run advantages of the photopolymers with a potential processing ease comparable to the popular diazo-type presensitized plates.

Lithographic photopolymer plates of the cinnamic ester type can be coated in many ways: roller coater; the wipe-on method; whirler; spraying. The procedures for making these plates are slightly different than those for other plates.

Counter etching is done with the same technique and solutions used on deep-etch plates except that aluminum must have a special pretreatment before coating.

Coating with a roller coater may require that the sensitized photopolymer be thinned, prior to use, with a special thinner. For wipe-on coating, the techniques are the same as diazo coating, since a fine grain is required for the photopolymer plate.

Exposure is made through negatives, and the exposure time is about the same as for presensitized and wipe-on plates.

Development is done with chlorinated solvents such as trichloroethylene, and is best done in a vapor degreaser. It is absolutely essential that the work areas be properly ventilated, as trichloroethylene is very toxic.

Sensitizing and Inking require a special etch that contains glycerine and is used in place of the gum. This is necessary because there is no ink to protect the photopolymer image areas. The special etch keeps the image from blinding, yet prevents the nonimage area from greasing while the image areas of the plate are being rubbed up with ink.

Etch and Gumming are done after inking. The plate is etched and gummed like any other plate. Any regular etch can be used.

Photopolymer Presensitized Plates. There are two types of photopolymer presensitized plates: a cinnamic ester type, and a water-soluble type. The cinnamic ester type is similar to the plate just described and is developed in organic solutions. One manufacturer of these plates uses an automatic processor, which is essentially a vapor degreaser, for development. Another uses a lacquer emulsion. The steps in making these plates are simple. The plate is exposed, developed, etched, and gummed. The plate has good ink receptivity, wear resistance, and long life on the press.

Courtesy Master Sales & Service Corp.

News Speed plate processor.

The water-developable type of presensitized photopolymer plate is developed in a water-base solution. After exposure, the plate can be developed in one minute, after which it is gummed. A post exposure, of four to five minutes, to a strong light source, or a heat-treatment is required to ensure long life on the press. The image is very ink-receptive and has good chemical and wear resistance. The nonimage areas have good water receptivity. Runs up to 250,000 have been reported for these plates.

Courtesy Richmond Graphic Systems, Inc.

Processor for metal diffusion transfer plates.

REMOVING AND ADDING WORK

Removing Work from Surface Plates. Small areas up to two square inches can be erased with a snake slip, scotch stone, or an air eraser. This is done as follows:

1. The ink or asphaltum is washed off the unwanted work area with naphtha or gasoline.
2. The gum arabic is then washed off the immediately surrounding area with water.
3. While the area is wet, the unwanted work is polished out. The area is cleaned with a water sponge and blotted dry.
4. *On zinc plates,* the area is regrained with a flat-sided glass marble and 240- or 300-mesh aluminum oxide abrasive or fine graining sand, moistened with hydrochloric acid counter-etch. A mushroom-shaped glass bottle stopper is even handier than a marble. The abrasive is washed off and the area blotted dry.

 On aluminum and stainless steel surface plates, hydrochloric acid counter-etch, acetic acid counter-etch, or weak nitric acid (one ounce concentrated nitric acid in a quart of water) is used when regraining the cleared area. For stainless steel plates either hydrochloric acid counter-etch or weak nitric acid may be used.
5. The cleaned area is desensitized with the appropriate plate etch. On zinc, the etch is applied twice, and dried down both times. On aluminum, only one application is made.
6. The entire plate is washed and re-gummed.

If the image area to be deleted is large, the following method is more practical and effective:

1. The ink or asphaltum is washed off the unwanted area.
2. The lacquer is removed with a lacquer solvent. The area is gone over several times with the solvent to be sure it is clean, then the area is blotted and dried.
3. The gum arabic is washed off the surrounding areas with water and blotted dry.
4. *On zinc plates,* lye solution (two ounces of lye to a pint of water) is applied. This is done by use of a stick with a wad of cotton rag tied firmly to one end. The lye solution is allowed to act on the image for a few minutes and then blotted off.

 On aluminum and stainless steel surface plates, concentrated sulfuric acid is applied. To do this a stick with a wad of wool flannel tied firmly to one end is used. The acid is permitted to act on the image and then blotted off.
5. *On zinc plates,* the area is rubbed with wet cotton to remove as much of the image material as is possible.

 On aluminum and stainless steel surface plates, the area is scrubbed several times with wet cotton. A little pumice powder can be used to remove all traces of the image.
6. *On zinc plates,* lye solution is applied a second time and the image is scrubbed with a rag wad until all traces of the image are gone. A little powdered pumice helps.

 On aluminum and stainless steel surface plates, the cleaned area is counter-etched with acetic acid counter-etch and blotted dry.
7. *On zinc plates,* the lye solution is blotted and the area scrubbed several times with wet cotton.

 On aluminum and stainless steel surface plates, a piece of flannel dipped in aluminum plate etch is used to go over

the area thoroughly with pumice or fine graining abrasive. This is done with a circular motion. The abrasive is then washed off, and the area blotted dry.

8. *On zinc plates,* the cleaned area is then counter-etched. Several applications are made, each one being blotted. The lye will neutralize the first applications of counter-etch.

9. The cleaned area is etched with the appropriate etch. On zinc, two applications are made, each being rubbed down dry. On aluminum, only one application is made.

10. The entire plate is washed and regummed.

Work Additions on Surface Plates. The method used in adding work depends on the plate metal and the type of image to be added. Of the metals zinc, aluminum, and stainless steel, zinc is naturally the most ink-receptive. Therefore, direct additions of work with tusche or greasy ink are easiest to make on zinc plates, and are more durable on zinc than on the other metals. On the other hand, additions of solids with lacquer hold equally well on all three metals provided the metal surface has been properly prepared. Since photographic additions (shooting in of halftones or line work) require a localized surface plate-making procedure, there is essentially no difference in the results obtained with the three metals, when additions are "shot in."

ADDING TUSCHE WORK. The procedure in adding tusche work is as follows:

1. The gum is washed off an area considerably larger than that to be occupied by the new work. This is done with a clean water sponge or wad of cotton, and the area is blotted dry with newsprint or blotting paper.

2. *On zinc surface plates,* the washed area is treated with a strong counter-etch (three ounces of concentrated hydrochloric acid to a gallon of water). This is applied with a wad of cotton for about one minute, then blotted dry. The treatment is repeated once again.
 On aluminum and stainless steel surface plates, the following counter-etch is used:

Ammonium Alum, $NH_4Al(SO_4)_2 \cdot 12HO$	Metric units 7.5 g.	U.S. Units 1 avoir. oz. (28 g)
Hydrofluoric Acid (HF), 48%	7.8 cc.	1 liq. oz. (29 cc)
Water to make	1000 cc.	1 gallon

The area is treated three times, blotting off after each application.

3. Desired additions are made with tusche in the counter-etched area. The tusche must be allowed to dry thoroughly.

4. The added work is powdered with a 50-50 talc-rosin mixture.

5. The entire area, from which the gum was originally removed, is etched with the appropriate plate etch; two applications on zinc, one on aluminum.

6. The entire plate is washed thoroughly, and regummed in the usual way. The plate image is then washed out with Lithotine and put under asphaltum.

ADDING SOLIDS WITH LACQUER. To produce a solid with lacquer, the gum is first removed from an area somewhat larger than the solid to be added. The area is then counter-etched with a counter-etch appropriate to the metal being worked on. The procedure is the same as steps 1 and 2 in adding tusche work (above). After this has been done, the desired solid is outlined with gum arabic solution, using a pen or brush; the surrounding area is then painted out with the gum arabic. The entire area that was counter-etched, outside the outline, should be covered with the gum. After the gum has dried thoroughly, a nonbinding deep-etched lacquer is applied. The lacquer is rubbed down and dried, then developing ink is applied and powdered. The entire area is washed with water to remove the developing ink and gum from the areas around the added solid. Finally the area is reetched with the appropriate etch, the etch being dried down, and the entire plate washed with water and gummed.

ADDING HALFTONES OR TYPE MATTER. Images containing halftones or type matter have to be added (usually as the result of an error) by the regular photographic platemaking procedure. Following is the procedure:

1. The ink is washed off the unwanted work with naphtha or gasoline.

2. The lacquer is removed with a lacquer solvent. The lacquer supplier can recommend the best solvent to use. The area to be removed is gone over several times with solvent to be sure it is clean, then the area is blotted and fanned dry.

3. The gum is washed off the area and its margins with water, and the area blotted dry.

4. *On zinc plates,* lye solution (two ounces of lye to a pint of water) is applied. To do this, a stick with a wad of cotton rag tied firmly to one end is used. The lye solution is allowed to act on the old image for a few minutes, then blotted off. The area is scrubbed several times with wet cotton to remove as much of the lye as possible.
 On aluminum or stainless steel plates, a concentrated sulfuric acid is used and applied with flannel instead of a cotton rag.

5. Using powdered pumice or a fine graining abrasive, the deleted image area is rubbed with a piece of flannel or felt dipped in the plate etch appropriate to the metal being worked on. This is done with a circular motion.

6. The plate is placed in a whirler, the gum washed off, and the entire plate coated in the usual way.

7. The negative of the new work is placed in correct position, with the remainder of the plate being covered with masking paper or foil. The exposure is made.

8. *On zinc plates,* lacquer and developing ink are applied and the plate developed and finished just as is done in making the original plate. The lacquer and developing ink are applied only in the new image area.
 On aluminum and stainless steel plates, the plates should be post-Brunaked after development.

9. The entire plate is etched and gummed up. The appropriate etch for the metal being worked on is used.

Removing and Adding Work from Presensitized and Wipe-on Plates. Deletions and corrections on presensitized and wipe-on plates are relatively easy to make. Unwanted work can be removed with an eraser, scotch stone, or snake slip,

dipped in plate etch or fountain solution. Suppliers also furnish image-removing solutions under such names as stop-out solution or image eradicator, with instructions for their use.

Repairs to image areas are made by scratching with a needle, stylus, or sharp pencil, followed by an application of tusche, special ink, or even press ink.

If the repairs or additions needed are extensive, it is less expensive and less time-consuming to make a new plate.

Section Seven: Deep-Etch Plates

Deep-etch plates are defined as single-metal plates made from positives in which the exposed coating serves as a stencil to protect the nonprinting areas while the image areas are produced on the metal base. Several presensitized deep-etch plates have been developed. To make these plates, the manufacturers' chemicals should be used and their directions followed carefully.

There are two processes for making conventional deep-etch plates: one using bichromated polyvinyl alcohol (PVA) as the coating; and the other using bichromated gum. The gum process is most widely used in the United States (see Coating Materials). Therefore, this section deals primarily with the gum process. Instructions on the processing and use of PVA-coated plates are available directly from the manufacturer.

THE GUM-BICHROMATE PROCESS

The steps in deep-etch platemaking using bichromated-gum coating are counter-etching, coating, exposure, stopping out, development, deep-etching, alcohol wash, copperizing (optional), lacquering, inking, clearing, etching, and gumming. Each of these steps is discussed in some detail in the following.

Counter-Etching is cleaning the grained plate surface without damaging the grain. The counter-etch is usually a weak acid solution, preferably one ounce of hydrochloric acid in a gallon of water for zinc, and four ounces of phosphoric acid in a gallon of water for aluminum.

Coating. A number of commercial deep-etch coatings are available. A typical formula for a deep-etch coating follows:

DEEP-ETCH COATING SOLUTION

Gum Arabic Solution,		
14° Baumé	3 quarts	(1000 cc)
Ammonium Bichromate,		
20% stock solution	1 quart	(340 cc)
Ammonium Hydroxide, 28%	4¾ liq. oz.	(50 cc)

Exposure. To expose deep-etch plates, the plant must have an arc or other intense light source and a vacuum printing frame or a photocomposing machine. The positives must be clean, dense, with sharply defined lines, and without fog. If possible, two or more GATF Sensitivity Guides should be included in the layout.

Stopping-out Before Development. To protect unexposed borders and unwanted work areas during development and deep-etching, one of the commercial stop-out shellacs or lacquers available from suppliers should be used. The unexposed borders and unwanted areas should be exposed out or painted with the stopping-out shellac or lacquer, using a soft camel's hair brush.

Development. The developer removes the unhardened bichromated gum from the image areas in preparation for deep-etching. Numerous commercial developers are available. A simple deep-etch developer formula follows:

REGULAR DEEP-ETCH DEVELOPER

Calcium Chloride Solution		
40°-50° Baumé	1 gallon	(1000 cc)
Lactic Acid, 85%	6¾ liq. oz.	(53 cc)

The action of the regular developer changes with temperature. Therefore, the Baumé should be adjusted for the room temperature. Most commercial developers are stabilized so they are not affected as much by temperature. If commercial coating is used, the developer designed for the particular coating should be used. The sink or deep-etch developing trough should be clean, have a level grid or island, and a clean, dry developing pad should be used.

To develop a plate, it is placed in the deep-etch developing sink and a liberal quantity of the developer poured over it. This developer is worked evenly over the entire surface with the developing pad, using moderate pressure. In two to three minutes the image areas should clear. The development should be stopped when Step 8, or possibly Step 7 has appeared on the image of the GATF Sensitivity Guide. The developer is squeegeed off the plate and a fresh supply poured on. This fresh developer is worked over the plate until Step 6 is cleared.

The GATF Sensitivity Guide step numbers mentioned above are examples only. Sensitivity Guides vary somewhat in light transmission. The platemaker can vary his development one step in either direction from the figures given, depending on what exposure he finds best for his positives.

In developing plates on which it was impractical to include the Sensitivity Guide, the following method may be used:

The developer is poured on and worked over the plate with the developing pad. In two or three minutes the image areas should begin to clear. A note of this time is made. The developer is squeegeed off the plate and a fresh supply poured on. This is worked over the plate for exactly the same length of time as the first application. This second application of developer is squeegeed off and one more application is made for the same length of time. When this third developer is squeegeed off, the plate is ready to be deep-etched. Normally, *complete* development should take from five to eight minutes.

Deep-Etching. The purpose of deep-etching is to etch the image areas slightly below the nonimage areas. If the plant uses a commercial deep-etch coating solution, the deep-etching solution designed for that coating should also be used. The formula for a typical deep-etching solution for aluminum is:

ALUMINUM DEEP-ETCHING SOLUTION

Calcium Chloride		
40°-41° Baumé	1 gallon	(1000 cc)
Zinc Chloride, Technical	51 av. oz.	(380 g)
Iron Perchloride		
Solution 50°-51°, Baumé	36¼ liq. oz.	(285 cc)
Hydrochloric Acid 37%-38.5%	1¾ liq. oz.	(14 cc)
Cupric Chloride	3½ oz.	(27 g)

This type of solution can cause problems with spotty blinding due to loosely bonded iron deposits. To help avoid these problems, the plate can be redeveloped (with the deep-etch developer) after deep-etching for approximately one minute. Nicohol can also be used. Some chemical manufacturers have formulated deep-etching solutions without ferric chloride to avoid the iron deposit problem. These solutions, as well as the new modified iron etches, are quite satisfactory.

Alcohol Wash. Anhydrous (water-free) denatured alcohol is used to remove the deep-etching solution and to prepare the image areas to accept copper, lacquer, and ink. Other materials like Cellosolve can be used, but anhydrous alcohol should always be used as a final wash. Some anhydrous alcohol is poured on the plate while it is still in the developing sink. With a wad of deep-etch paper wipes, the plate is rubbed evenly and thoroughly over the entire surface. As much of the dark deposit as possible should be removed from the image areas. This wash will remove any stop-out shellac or lacquer. The alcohol is wiped off and the plate is washed with the alcohol an additional three times, using fresh alcohol and clean paper wipes each time. After the fourth wash, the work areas are rubbed thoroughly with clean paper wipes to remove as much of the alcohol as possible. Then the plate is fanned dry.

Paper wipes are better than a squeegee which slides over the surface and leaves some alcohol in the image areas, particularly in halftones. Paper wipes absorb the alcohol and leave the image areas dryer and cleaner. The alcohol should be poured on the plate without spattering to prevent spots in halftones. A good way to avoid spattering the coating is to lay one or more paper wipes on the plate and pour the alcohol on the wipes. The same wipes are used to rub the alcohol over the plate.

Copperizing. Copperizing is an optional step that deposits a thin layer of copper on the deep-etched image areas. A typical formula for a copperizing solution follows:

COPPERIZING SOLUTION FOR ALUMINUM

Isopropyl Alcohol, 99%	1 quart	(1000 cc)
Cuprous Chloride	1 av. oz.	(31 g)
Hydrochloric Acid,		
37%-38.5%	1 liq. oz.	(32 cc)

To copperize a plate, some copperizing solution is poured on it and spread over the entire surface with a plush-covered pad.

The solution is worked over the plate for three to ten minutes, or until a reddish copper deposit is formed on the image areas. The time depends on the solution used and the conditions of temperature and relative humidity. Some fine-grain coppers can take as long as ten minutes to deposit. The plate is given one or two washes with anhydrous alcohol to remove the copperizing solution and then wiped dry. Cleanliness is very important here. Let the plate warm to room temperature before applying the nonblinding lacquer.

Applying Nonblinding Lacquer. Nonblinding lacquer is used to coat the deep-etch areas with a strongly ink-receptive material. This material forms a base for the printing image: one that is not affected by the usual cleaning solvents and will not become water-receptive.

The nonblinding deep-etch lacquer is applied to the image areas of the plate by spreading the lacquer over the plate with a paper wipe, then rubbed down smooth with a soft, lintless rag. As much lacquer is left on the plate as possible, but not enough to interfere with removing the gum stencil.

In drying the lacquer, the manufacturer's instructions must be followed. The improved nonblinding lacquers generally work best if they are dried thoroughly before applying the developing ink.

Applying Developing Ink. Developing ink coats the lacquered image areas with a film of greasy ink that prevents the lacquered image areas from being covered with gum during the etching and gumming operations. For fine-grained plates, a heavy deep-etch developing ink is needed. There should also be on hand a 50:50 mixture of French chalk (powdered talc) and powdered rosin.

Some developing ink is poured on the plate and spread over the image areas with a soft rag or paper wipe. Then, with a clean, soft rag, the ink is rubbed down to a smooth, even film and fanned dry. Finally, the ink is powdered with the French chalk-rosin mixture.

Clearing the Plate. Clearing the plate is the operation of removing the light-hardened gum stencil from the nonimage areas. Warm water at 90°-100°F (32°-38°C) and a bristle brush are used.

After the stencil has been removed with warm water, turn on the cold water and rub the image with a clean deep-etch pad. The cold water sets the ink and rubbing sharpens the image by removing the feathery edges of ink caused by scrubbing in the clearing operation.

Etching. Etching forms a water-receptive film on the nonprinting areas. A good etch for aluminum is the "1:32" etch which consists of 1 ounce of phosphoric acid to 32 ounces of 14° Baumé gum arabic.

Plate etching (and gumming) should be done on a separate table, reserved for these operations. If the plate has been tusched, or any corrections have been made, the plate will be dry. The etch can be applied directly to the dry plate. If the plate is wet, all excess water is removed with a clean squeegee or sponge before etching. Any excess water remaining on the plate surface will dilute the etch and make it less effective.

If a good developing ink was used and applied properly, the image will be ink-receptive and refuse to be wet by etch. If the image does wet with etch, the plate will be difficult to roll up on the press. To avoid this difficulty, the plate can be rubbed with developing ink while it is under etch. The same rag that was used for applying the developing ink is rubbed over the image areas of the plate while the etch is on the plate. After the image is thoroughly rubbed up, the ink and the etch are rinsed off with water and another application of etch is made and dried down. If asphaltum-gum emulsion is used for gumming, the rubbing-up is not necessary as the asphaltum makes the image ink-receptive.

Gumming the Plate. Gumming the plate applies an additional coating of gum. This additional coating protects the nonimage areas of the plate while it is being handled and when it is washed out and put under asphaltum. A gum arabic solution at 8°-10° Baumé, or asphaltum-gum emulsion, can be used. Plates should be gummed on a table reserved especially for the etching and gumming operations.

The etch should be washed off with water, before gumming, with a "wash off" sponge reserved exclusively for washing etch or gum from the plates. The plate is sponged two or three times with fresh applications of water each time. The plate should be only slightly damp, after each sponging, especially the last one.

DEEP-ETCH PLATES ON ANODIZED ALUMINUM

The steps in making deep-etch plates on anodized aluminum are similar to those followed on untreated aluminum. Special chemicals are used and no copperizing of the image is done. Manufacturers' instructions for use of the plates and chemicals should be followed carefully. In this process perhaps more than any other, the chemicals are closely related to the metal treatment used.

Preparing the Plate. Anodized aluminum plates are not counter-etched prior to coating. They only need to be scrubbed well, using a soft bristle brush and tap water.

Coating the Plate. The plate is coated using the same techniques as with a conventional deep-etch plate. However, the coating is poured while whirling about 45 rpm, but then the whirler is speeded up to about 100 rpm and dried with moderate heat.

Exposing the Plate. Exposure time is generally less than for copperized aluminum deep-etch plates. Correct exposure time is easily established by test shots through a GATF Sensitivity Guide.

Stopping Out. A special stop-out solution is recommended, using the same techniques as for conventional deep-etch plates.

Developing. Developing of anodized aluminum deep-etch plates is somewhat faster than with conventional plates: four to five minutes using three applications. Clearing of the unexposed areas will usually be reached at about two minutes. Again, the GATF Sensitivity Guide can be very useful in establishing

standard development times. Where long intervals between coating and development are unavoidable, as with a long step-and-repeat job, a "fast" developer is available. The developer, however, is more sensitive to high humidity than the standard developer. Where development is excessively long, it is a clear indication that coating is too thin, over-exposure has occurred, or dark-reaction has been encouraged. Incomplete development will show up as excessive image sharpness, loss of highlight dots, partial blinding.

Deep-Etching. When development is complete, the excess developer is squeegeed off and a special deep etching solution is poured and spread quickly and uniformly over the plate. A cotton wool swab or a brush should be used. From three to six minutes should be allowed, with several renewals of the deep-etching solution. The time required is dependent on type of work and length of run. When etching is complete, spent etch is squeegeed from the plate.

Alcohol Wash. This is carried out on an anodized plate just as on a conventional deep-etch plate. The purpose is the same, procedure is the same, possible troubles from high humidity are the same. After the alcohol wash, stopping-out may be required again. A special stop-out solution for use at this particular stage is recommended. The plate must be thoroughly dry before proceeding to the next step—lacquering.

Lacquering. This step is carried out exactly as with conventional deep-etch plates. Several lacquers are available; they differ primarily in their rate of drying.

Inking-in. This step is also identical to its counterpart in conventional deep-etch platemaking. Powdering the dried-down ink film with French chalk is also recommended.

Removing the Stencil and Desensitization. This is a combined operation when making deep-etch plates on anodized aluminum. The plate is soaked in warm water until the stencil begins to lift. Then the plate is scrubbed lightly with a fine bristle brush until all the stencil has been removed. Under no circumstances should any acid be used since this would destroy the anodized surface treatment. This also holds true for the 1:32 phosphoric acid-gum etch even though it is the best etch for aluminum. The plate is now rinsed with clear cold water and gummed up. No further desensitizing is normally necessary.

Gumming. As with conventional deep-etch plates, final gumming serves to protect the nonimage areas while the plate is handled through mounting in the press. Gumming is also required if the plate is to be washed out by the platemaker.

DEEP-ETCH PLATES WITH PVA

One direction in which much effort has been expended to simplify the deep-etch platemaking process has been to find a coating that does not require special solvents. During the 1930s the glue-reversal process, using photoengraver's glue as the coating colloid, was developed. This has been successful, but only in highly standardized applications in certain specialty fields. For general commercial lithography the process suffers from the fact that it does not offer the platemaker any latitude

in development to sharpen the image on the plate or make it fuller.

Polyvinyl alcohol is easier to use than photoengraver's glue for making the coating solution. PVA lends itself to better manufacturing controls than photoengraver's glue, which frequently yields a coating with considerable amounts of undissolved particles. PVA is developable in water, and the entire platemaking process is simpler than in the gum process. However, as with glue, there is no development latitude. There is no need for an alcohol wash, and copperizing is optional. As with anodized aluminum, all chemicals and solutions used are specially formulated for the process.

The latest work with PVA is leading in the direction of development with materials other than water. The result sought is to give the platemaker some controllable latitude to compensate for unintentional changes in sensitivity or exposure, as well as to make up for minor deficiencies in the position. It should be kept in mind that in general practice the platemaker needs latitude to adjust his procedures to meet specific press requirements. Quite often halftone color separation positives are completed before a decision has been made as to the press on which the job will run or the type of plate or paper to be used. Sometimes the sequence of colors hasn't been determined. These decisions will affect the degree of sharpness or fullness which the platemaker will strive for during development.

A final outcome of all this development work, with PVA, could be the establishment of two PVA processes: one for a highly standardized operation using water as the developer, and another for use where platemaking flexibility is desirable.

REMOVING AND ADDING WORK

Removing Work. Small areas of unwanted work, up to one or two inches square, can be erased with a snake slip, scotch stone, or an abrasive air gun. The following are the steps:

1. The ink or asphaltum is washed off the unwanted work area with naphtha or gasoline.
2. The gum arabic is washed off the immediately surrounding area with water.
3. While the area is wet, the unwanted work is polished out. The area is thoroughly cleaned with water, using a sponge, and blotted dry.
4. *On zinc plates,* the area is regrained, using a flat-sided glass marble and 240- or 300-mesh aluminum oxide abrasive, or fine graining sand, moistened with hydrochloric acid counter-etch.
 On aluminum plates, an acetic acid counter-etch or weak nitric acid is used.
5. The area is desensitized with an etch appropriate to the metal being worked on. *On zinc,* the etch is applied twice, rubbing down each application. *On aluminum,* only one application is made.
6. The entire plate is washed and regummed.

If the image area to be deleted is large, the following method is more practical and effective.

1. The unwanted work area is cleared of ink or asphaltum by using naphtha or gasoline.
2. The lacquer is removed with a lacquer solvent. The unwanted area is gone over several times with the solvent to be sure it is clean. It is then blotted and fanned dry.

3. *On zinc plates,* the cleaned area is double-etched, each application being dried down.
 On aluminum and stainless steel, the cleaned area to be etched is first gone over thoroughly with pumice or fine graining abrasive, using a piece of flannel or felt dipped in aluminum plate etch. The scrubbing should be done with a circular motion. Then the area is washed clean of abrasive and a single application of etch is dried down thoroughly.
4. The entire plate is washed and regummed in the usual manner.

Work Additions on Deep-Etch Plates. Solids can be added on deep-etch plates by hand, using tusche or deep-etch lacquer. To add type matter or halftones, however, it is necessary to repeat the deep-etch platemaking process locally, since these additions can best be made photographically. Broken lettering or lines and spots in solids can be repaired by scratching through the gum layer with a needle and applying developing ink or press ink directly to the uncovered metal. The method, therefore, in adding work depends on the type of image to be added. Of the three metals, zinc, aluminum and stainless steel, zinc is naturally the most ink-receptive. Therefore, direct additions of work with tusche or greasy ink are easiest to make on zinc plates and are more durable on zinc than on the other metals. On the other hand, additions of solids with deep-etch lacquer hold equally well on all three metals provided the metal surface has been properly prepared. Since photographic additions (shooting in of halftones or line work) require a deep-etching procedure and the application of deep-etch lacquer, there is essentially no difference in the results obtained with the three metals when additions are "shot in."

ADDING TUSCHE WORK. This is accomplished as follows:

1. The gum is washed off an area considerably larger than that to be occupied by the new work. This is done with a clean water sponge or wad of cotton, and the area blotted dry with newsprint or blotting paper.
2. *On zinc plates,* the washed area is treated with a strong counter-etch (three ounces of concentrated hydrochloric acid to a gallon of water). This is applied with a wad of cotton for about one minute and then blotted dry. The area is counter-etched again for one minute and blotted dry. The counter-etch should not be washed off with water.
 On aluminum and stainless steel plates, the special counter-etch should be used.
 The counter-etch is applied three times, and blotted off after each application.
3. The desired additions are made with tusche in the counter-etched area. The tusche is allowed to dry thoroughly.
4. The added work is powdered with a 50-50 talc-rosin mixture.
5. *On zinc deep-etch plates,* the entire area from which gum was originally removed is double-etched with a zinc plate etch, each application being dried down.
 On aluminum and stainless steel deep-etch plates, an aluminum plate etch is used, but only one dried-down application is made.
6. The entire plate is washed thoroughly and regummed in the usual way.

The plate image can now be washed out with Lithotine and put under asphaltum.

ADDING SOLIDS WITH DEEP-ETCH LACQUER. To produce a solid with deep-etch lacquer, the gum is first removed from an area somewhat larger than the solid to be added, and then counter-etched. This is done in the same way as when adding tusche work; the appropriate counter-etch is used depending on the metal being worked with. Next the solid is outlined with gum arabic solution, using a pen or brush, and all the surrounding area is painted out, also with gum arabic. After the gum has dried thoroughly, the nonbinding deep etch lacquer is applied. The lacquer is rubbed down and dried. This is followed by an application of developing ink. The developing ink and gum from the areas around the newly added solid are washed off with water. Finally the area is reetched with an etch appropriate to the metal being used and with the technique appropriate to that metal. Then the entire area is washed with water and gummed up.

ADDING HALFTONES OR TYPE MATTER. Images containing halftones or type matter have to be added by the regular photographic platemaking procedure. The steps to do this are as follows:

1. The ink is washed off the unwanted work area with naphtha or gasoline.

2. The lacquer is removed with a lacquer solvent. The area is gone over several times with the solvent to be sure it is clean, and then the area is blotted and fanned dry.
3. The gum is washed off the area and its margins with water.
4. With a piece of flannel or felt dipped in the appropriate etch, the deleted image area is rubbed, using a circular motion, with pumice or fine graining abrasive.
5. The plate is placed in the whirler, all the gum washed off, and the plate coated with deep-etch coating solution in the usual way.
6. The positive is placed in the correct position, the remainder of the plate covered with masking paper or foil, and the exposures made. This can be done in either the vacuum printing frame or the photocomposing machine, depending on the job itself.
7. The new image area is developed, deep-etched, and finished locally, just as in making the plate originally. The appropriate chemicals are used, depending on the plate metal.
8. The plate is put under running water and the new gum stencil scrubbed off.
9. The plate is etched and gummed up in the usual way, using the chemicals and techniques appropriate to the metal being worked on.

Section Eight: Bimetal Plates

As was stated in Section One, bimetal plates are composed of two metals, one of which forms the image areas and the other the nonimage areas. The metal forming the image areas is selected for its ability to take ink. The metal forming the nonimage areas is selected for the ease with which it is wet by water and its ability to be desensitized to ink under the same conditions that render the image metal ink-receptive. To simplify the discussion, these two metals will be referred to as the image metal and the nonimage metal, respectively.

Theoretically there are four possible types of bimetal printing plates. These are best classified by the methods used to manufacture and process the plates.

TYPE I. An image metal is electroplated on a plate of a nonimage metal; an acid-resistant positive image is formed on the layer of image metal; the image metal is etched away from all areas except the image areas; the acid resist is removed from the image areas.

TYPE II. A nonimage metal is electroplated on a plate of an image metal, or on a plate which carries a surface layer of an image metal. A stencil or negative image is formed by means of acid-resistant coating on the layer of nonimage metal. The nonimage metal is etched away to lay bare the image metal in the positive image areas. Then the protective stencil is removed from the nonimage areas.

TYPE III. An acid-resistant positive image is formed on a plate of an image metal; a nonimage metal is electroplated on the remaining areas; and finally the acid resist is removed from the image areas.

TYPE IV. A stencil or negative image is formed by means of an acid-resistant coating on a plate of a nonimage metal; an image metal is electroplated on the bare image areas; and finally the protective stencil is removed.

While all four types have been tried, only Type I and Type II have been generally successful. Types III and Types IV gave trouble because of difficulties in finding photo-resists that could withstand the electroplating operation, and because of the inability to obtain uniform electro-deposits of metal.

Trimetal and Polymetal Plates. So-called trimetal and polymetal plates are made with more than two metals. The most common consists of three metals: (1) a base plate of zinc, mild steel, stainless steel, or aluminum; (2) an electroplated layer of copper (image metal) on the base metal; (3) an electroplated layer of chromium (nonimage metal) on top of the copper layer. However, only the electroplated layers of copper and chromium are affected by the platemaking process, and take part in the printing process. For all practical purposes, therefore, trimetal and polymetal plates are the same as Type II bimetal plates. The advantages of using zinc, steel, stainless steel, or aluminum

instead of copper or brass as the base plates are that these metals reduce the weight and cost of the plates, and the plates are easier to handle both in platemaking and on the press. For use on web offset presses, some of these plates are backed with mylar to keep them on the plate cylinder if they should break at the clamp edges.

Several plates have been made using more than three metals. One has two platings of copper, one from an acid solution and the second from an alkaline solution; each is claimed to have different degrees of adhesion and ink receptivity. Another plate has coatings of silver and antimony, in addition to copper and chromium, on a base metal.

MAKING BIMETAL PLATES

Type I Bimetal Plates. Bimetal plates of Type I are available with the copper protected with a gum, or as presensitized plates on stainless steel or aluminum. These bimetal plates are similar to surface plates because they are made from negatives, and because their copper image areas are very slightly raised above the nonimage areas. However, the process and

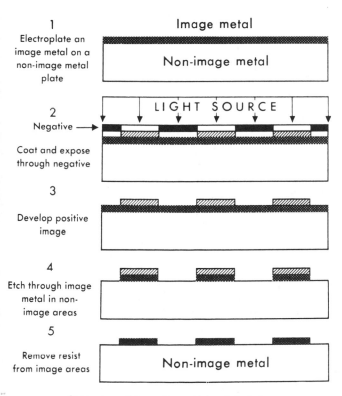

1
Electroplate an image metal on a non-image metal plate

Image metal
Non-image metal

2
Negative →

LIGHT SOURCE

Coat and expose through negative

3
Develop positive image

4
Etch through image metal in non-image areas

5
Remove resist from image areas

Non-image metal

Steps in making a Type I bimetal plate.

materials used in making them are much the same as for deep-etch plates. The following steps briefly describe the processing of Type I bimetal plates.

Counter-etch. The copper coating of the plate is cleaned by counter-etching with a diluted acid, usually sulfuric or nitric acid.

Coating. The cleaned plate is coated in the usual way with regular deep-etch coating solution and dried. The same techniques and precautions are used as with deep-etch plates. Since most of these plates are relatively smooth, coating solutions

with lower density (Be') should be used. Otherwise the dried coatings may be too thick.

Exposure. The coated plate is exposed through a negative with a GATF Sensitivity Guide attached. Generally, higher guide numbers are used than on deep-etch or surface plates. This means longer exposures.

Development. The plate is developed with deep-etch developer to remove the unhardened coating from the nonimage areas. The Sensitivity Guide and the manufacturer's instructions should be followed carefully.

Copper Etch. The copper is removed from the nonimage areas by means of a special etch that has only a small effect on the stainless steel or aluminum underneath. The etch on stainless steel plates is essentially ferric chloride solution; for aluminum base plates, it is mostly ferric nitrate.

Clearing. The hardened coating, which protects the image areas, is removed by scrubbing and coating with a soft bristle brush and the nitric or sulfuric acid counter-etch.

Sensitizing the Copper. The copper image areas are sensitized to ink with sulfuric or nitric counter-etch, or with one of the several proprietary products on the market especially designed for this purpose. In addition, these products will serve the dual purpose of removing the stencil and rendering the copper ink-receptive.

Rubbing Up. The image areas are then rubbed up with ink.

Etch and Gum. The plates are etched and gummed as in other platemaking processes.

Techniques have been developed for making Type I bimetal plates from positives, but this is a rather complex operation. More information about this and other procedures are available directly from the suppliers or manufacturers.

Courtesy Printing Developments Inc.

Processor for bimetal plates. Shown is the developing section; a similar section, hooked up in tandem, takes care of finishing.

Presensitized Bimetal Plates already have a light-sensitive coating applied to the plates by the manufacturer. Usually, the presensitized coating is such that the plate is exposed through a positive transparency. The basic steps in presensitized bimetal platemaking are given below.

Exposure. The plate is exposed either through a positive or negative transparency, depending on the specific light-sensitive coating. A GATF Sensitivity Guide should be used.

Development. The plate is developed with a special developer that removes, or at least makes water-receptive, the unhardened coating in the nonimage area. With some plates, it may be necessary to apply a resist to the image area.

Stage. The light-sensitive coating is removed from any unwanted areas: film edges, dirt, etc.

Copper Etch. The copper is removed from the nonimage areas by swabbing a special etch over the plate. The etch does not attack the stainless steel or aluminum backup metal.

Clearing. Clearing is normally not necessary, as the resist in this case is ink-receptive. However, the resist may be removed by a solvent. If the resist is not removed, the copper need not be sensitized or the image rubbed up. However, if alcohol is used in the fountain solution on the press, the resist should be removed.

Gumming. The plates are gummed as in other platemaking processes.

Detailed instructions and information are available from the manufacturers.

Type II Bimetal Plates. Type II bimetal plates are closely related to deep-etch plates because they are made from positives, their copper image areas are very slightly recessed below the non-image areas, and the process and materials used in making them are similar.

Bimetal plates, which have a solid copper base, are electroplated on one side with chromium to a thickness of 0.00005 to 0.00007 in. (0.0013 to 0.0018 mm) These plates are available in

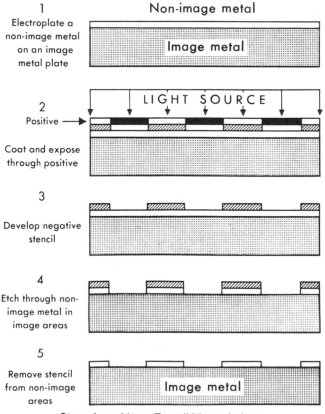

1
Electroplate a non-image metal on an image metal plate

Non-image metal

Image metal

2
Positive →

Coat and expose through positive

LIGHT SOURCE

3
Develop negative stencil

4
Etch through non-image metal in image areas

5
Remove stencil from non-image areas

Image metal

Steps in making a Type II bimetal plate.

the smaller sizes on special order only, from one manufacturer. Another manufacturer produces plates with chromium plated on a solid brass sheet. These plates are used mainly on web offset presses.

Trimetal plates usually have a zinc, steel, stainless steel, or aluminum base. These plates are electroplated on one side, first with copper and then with chromium. These layers are extremely thin: the copper thickness ranges from approximately 0.0001 to 0.0003 in. (0.0025 to 0.0076 mm); the chromium from approximately 0.00005 to 0.00007 in. (0.0013 to 0.0018 mm). As mentioned above, some plates are also available with an additional sheet of mylar laminated to the base aluminum sheet.

Suppliers can furnish trimetal plates either grained or ungrained. The ungrained plates are made by electroplating ungrained base plates. To make grained trimetal plates, the base plates are first grained in the usual way and then electroplated with copper and chromium.

The chromium layer on trimetal plates is not like the bright chrome plating on an automobile bumper; instead it has a dull matte appearance, even on ungrained plates. This is necessary for the plate to carry water properly during the printing operation.

Again, as we have mentioned above, the process of making a trimetal plate of this type is essentially the same as that for making a deep-etch plate on a single metal. There are, however, a few important differences, pointed out in the following brief instructions.

Plate Treatment Prior to Coating. Trimetal plates come with a protective coating of gum arabic on the chromium layer. This gum layer should be removed, before applying the coating, by scrubbing the plate with a brush under running water. Under certain conditions, however, the chromium surface may need to be counter-etched or chemically cleaned after the gum is removed. The supplier should be consulted regarding this and the chemicals required.

Coating and Drying the Plate. The regular bichromated gum deep-etch coating solution is used on trimetal plates to produce the light-sensitive coating. For grained plates the full strength coating is used, the same as for grained zinc or aluminum plates. For ungrained plates the coating should be diluted with water to make it thinner. Otherwise the thickness of the dried coating on the plate will be too great.

Good, sharp positives are required but, for the best results, halftone positives should be made a little "higher" than for deep-etch plates. By "higher" is meant that all tones should be lighter or sharper. The reason for this is that in etching through the chromium layer, after the image has been developed, there is a slight sidewise etching that enlarges the dots. So, to produce the same tone values on a trimetal plate as on a deep-etch plate, the halftone dots on the positive must be slightly smaller. If the same positives are used as for deep-etch platemaking, the halftones will print heavier or darker. The GATF Sensitivity Guide should be used, since it is important to control the exposure. The GATF Star Target and GATF Dot Gain Scale are also helpful in controlling dot size.

Stopping-out Before Development. Unexposed borders and other unwanted areas that can be seen easily, after the plate has been exposed, can either be stopped out with shellac or lacquer, or exposed out. Minor imperfections such as dust spots and tape marks that are not easily seen at this point should be stopped out after development.

Developing the Plate. The developing solution and method of development are in every way the same for trimetal plates as for aluminum deep-etch plates. Use of the GATF Sensitivity Guide is essential in securing proper development.

Etching Through the Chromium Layer. Etching through the chromium layer, to bare the copper in the image areas, corresponds to the deep-etching operation. To do this, a special chromium etch is required. A suitable etch and the instructions for its use can be obtained from the plate supplier.

Clearing the Copper Image Areas. Removing the chromium etch from the copper image areas is done by washing the plate three or four times with anhydrous alcohol in exactly the same way as cleaning the image areas on a deep-etch plate.

Sensitizing the Copper Image Areas to Ink. After the copper image areas have been washed with alcohol, they are immediately coated with a thin film of straight asphaltum or asphaltum containing a fatty acid like oleic acid. From this point, the treatment may vary, and it is best to follow the recommendations of the plate supplier.

Removing the Gum Stencil. The gum stencil is removed by soaking the plate in warm water and then scrubbing with a bristle brush in the same way as for deep-etch plates.

Desensitizing the Nonimage Areas. Since the nonimage areas on bimetal plates are chromium, which is very easily desensitized, there is no need to remove the residual stencil or to give these areas any sort of post-treatment. Therefore, immediately after scrubbing off the gum stencil, apply a desensitizing plate etch and gum up the plate.

REMOVING AND ADDING WORK

Work can be removed from or added to finished bimetal plates. It is advisable to consult the platemaker about this as he will have the most up-to-date methods for the particular type of plate and process.

Small spots that show up on the finished plate can be removed by polishing with a snake slip or pencil eraser. Even though this abrasion bares the copper, the copper can be desensitized with a plate etch and should stay clean for some time. However, a more permanent repair can be made by electroplating chromium on the bared copper spots. This can be done by applying chromic acid solution and using a pencil- or spatula-type electrode. The plate supplier can advise on this type of equipment.

Broken lettering or lines, and spots in solids, can be repaired by scratching through the chromium layer with a needle and applying ink.

If it should be necessary to remove one image area and replace it with another, this can also be done. The procedure is as follows:

1. All ink is washed off the area to be corrected with gasoline or naphtha.
2. The surrounding area is painted or staged out with stopout shellac or lacquer so that it will be protected.
3. Chromium etch is applied to remove all the chromium in the bare area.
4. The area is washed thoroughly with alcohol to remove the chromium etch. The alcohol will also remove the shellac or lacquer from the surrounding area.
5. The bared copper is scrubbed with fine pumice and water, using a felt pad. This slightly roughens the copper. The pumice is washed off and the area dried.
6. With a roller-type electrode and chromic acid solution, the bared copper area is replated with chromium. The plate supplier can advise where this equipment may be obtained.
7. The area is washed with water to remove the chromic acid.
8. Deep-etch coating is applied, the new work is shot in, the area is developed, etched, and finished locally in the same way the plate was originally made.

Section Nine: Direct Image, Direct Photographic and Electrostatic Plates

Direct image, camera or projection, and electrostatic plates are presently being used for duplicating or reprography on smaller presses. The quality and wear-resistance requirements for such lithographic work are not as demanding as for plates for larger presses. It should not be assumed from this, however, that these plates do not represent a large sales market, and are not capable of excellent quality or longer runs. Direct image plates are used extensively in bank check printing, especially for encoding in magnetic ink character recognition (MICR) printing. The specifications for this type of printing are quite restrictive. The photographic plates (camera and projection), which are relatively new, are of value to a sales market that may be larger than all other duplicating printing plates combined. Electrostatic printing offers many possibilities for future development.

DIRECT IMAGE PLATES

The direct image process is similar to the old "original plates" (see Introduction) in that the greasy image is applied manually or mechanically to the printing plate. The plates are called "masters" and can be made of specially coated paper or plastic, or of specially grained aluminum foil laminated to a paper base. The image can be drawn, lettered, painted, ruled, traced, typed or written on the master by using pencil, crayon, ink, carbon paper, fabric or carbon paper ribbon, rubber stamp, numbering machine, brush, or air-brush. The image can also be printed directly on the plate by offset or letterpress. Only oil base materials can be used for producing images from which we can print. If guide lines and instructions are required on the master, they are applied with water color inks so that they will not print.

Most direct image plates are made directly on the typewriter and are used on offset duplicating presses. An increasing number of plates are being made by transferring the image from existing letterpress plates or standing forms. These direct image plates are used for reprinting books, price lists, and rate books where only minor changes are needed. Such plates have also been considered for printing publications and newspapers in an

effort to combine the use of existing typesetting and stereotyping facilities with the speed and other advantages of offset reproduction.

Direct image plates are ideal for systems work since they eliminate the need for preprinted forms. All of the information that would normally be on the form can be preprinted on the master, and the last minute data can be typed or drawn in. When the master is printed, all of the information prints at the same time. This is the way most MICR printing is done.

Direct image plates for offset duplicating use are made in different quality and price ranges, depending on the number of copies expected from the plate. In general, quality of the plates is determined by the number of sheets required to print before a readable image can be obtained. With the best plates, a readable image is obtained with the first or second sheet printed.

Making Direct Image Plates is very simple. The steps are essentially the same for all manufacturers' plates.

1. The image is transferred to the plate by any of the methods mentioned above. Care in handling the plate is extremely important. The plate surface must be protected from grease spots such as fingerprints, or grease and oil from the machine, as these spots will print.

2. Paper and plastic base plates are mounted on the press, the plate surface wiped with a special etch, the press started running, the ink and dampening rollers dropped on the plate, and the printing started. The etch and fountain solution used must be those specifically designed for the plate.

Detailed information on individual plates and processes is available from the manufacturers.

DIRECT PHOTOGRAPHIC PLATES

Photographic plates can be produced in either projection or camera types of equipment.

Projection Plates. Projection plates are lithographic plates made in a projector similar to an enlarger, or in a camera. The original image is projected onto the photosensitized plate *through a lens system.* This is the feature which distinguishes so-called "projection" or "camera" plates from conventional lithographic plates which are made by *contact* exposures. The use of the term "projection," in this section, does not cover *poster plates,* which have been made by projection for many years. Poster plates use bichromated albumin or casein coatings, and require very long exposures to 125-150 ampere arc lamps through condenser-projection lens systems.

The new projection plates have photographic-type emulsions whose speeds are high enough to make possible reasonable exposures in cameras equipped with light sources of average energy. They can be considered as direct-image plates in that the original reflection copy is photographed directly on to the plate. These plates are used on small lithographic presses. Two systems have been developed for this process; one utilizes a paper-based plate, the other a plastic-based plate.

The paper-based camera plate is coated with three layers: (1) a photographic developer suspended in a gelatin emulsion; (2) a silver-sensitized coating similar to that used on photographic print paper; (3) a silver-sensitized preexposed, or fogged, coating. This last layer becomes the printing surface of the finished plate, after the processing steps have been completed.

On exposure to a positive, in a camera, the light reflected from the white portions of the copy penetrates the fogged layer and exposes the silver salts in the second emulsion layer. The areas corresponding to the black portions of the copy do not reflect any light and do not expose. When the plate is placed in

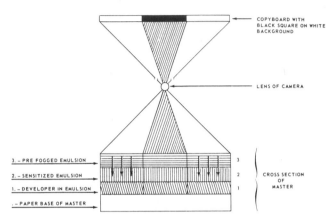

Courtesy Addressograph-Multigraph Corp.

Relationship of copy, lens, and master in a typical direct photographic platemaking unit.

an activator solution after exposure, the activator penetrates all coatings and starts migration of the developer in the bottom layer into the other layers. In the areas that were exposed the developer is exhausted in the second layer. In the areas that were not exposed the developer penetrates to the prefogged top layer and develops it. Putting the plate in the stop bath stops the action of the developer. The top layer then contains areas of

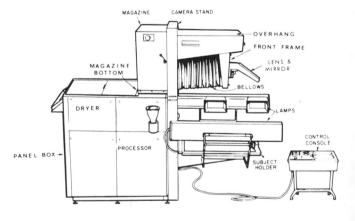

Courtesy Itek Corp.

Complete diagram of a direct photographic platemaking unit.

developed silver which are ink-receptive and correspond to the image areas or black portions of the copy; and undeveloped emulsion which is water-receptive corresponds to the nonimage or white areas of the copy.

Because there is only a small difference between the ink- and

water-receptivity of the image and nonimage areas on this plate, it is rather critical with respect to exposure, processing, and printing on the press. A special ink and fountain solution are desirable as well as a clean press with proper roller and cylinder pressure settings. Some inks give more latitude in exposure and printing than others. With a little experience excellent results can be obtained with these systems as long as the contrast range of the copy is not too great. It is difficult to mix line, halftone, and solids on one plate as each requires different levels of exposure or different inks for optimum printing results. For best results manufacturers' instruction should be followed carefully.

A modification of this material is used for reproducing enlargements from microfilm. The material is designed to work from negatives. As with the positive-working plate, these plates are exposed and processed in specially designed projection and processing equipment. The plate is ready for press as soon as it comes out of the processing machine.

The plastic-based camera plate features a plastic base and a nonprinting area from which all the emulsion-imaging layer has been removed. Prescreened halftone copy—up to 110 line—can be reproduced. This makes possible the use of a much broader range of copy than is presently possible on the paper-based camera plate.

While the plate must be started up by wiping with a special "starter" solution, conventional dampening solutions and standard inks may be run on the press.

Courtesy 3 M Company.

A direct photographic platemaking unit.

ELECTROSTATIC PLATEMAKING PROCESSES

To date two electrostatic processes for making printing plates have been developed—Xerography and Electrofax. The Xerographic process was invented by the patent attorney Chester F. Carlson and developed by Batelle Memorial Institute. It is marketed by the Xerox Corporation. Electrofax is an electrostatic process developed by the Radio Corporation of America.

In both processes an image is produced by the action of light on a photo-responsive surface which has been charged by static electricity. The areas affected by light lose their charge, leaving a photographically positive image on the charged surface which attracts a special oppositely charged powdered resin.

Xerography. In the Xerographic process, the photo-responsive surface is selenium, which is a photoconductor. A positive charge is produced on the selenium surface by a corona discharge source. The charged plate is exposed to the light image in a camera. The charge leaks off in the areas of exposure, leaving a charged positive image on the selenium. The plate is developed by cascading a negatively charged resin powder over

it. The resin powder image can be transferred to a paper or metal lithographic plate and fused to the plate with heat or a solvent vapor. The image may also be transferred to a transparent or translucent material and fixed. This material can then be used as a positive for exposing positive-working presensitized plates.

Complete information on this and other applications of the Xerox process are available directly from the manufacturer.

Electrofax. In the Electrofax process, the photo-responsive surface consists of zinc oxide photo-conductor in a resin binder which is coated on paper on a lithographic metal. A corona ion source produces a negative charge on the zinc oxide. Like selenium, the zinc oxide loses its charge on exposure to light. The image is dusted with a positive charge resin powder. The powdered image is then fused on the paper or metal, by heat. No transfer is required.

To make a lithographic plate with an electrofax sheet, the zinc oxide and binder must be removed in the nonprinting areas and the plate etched and gummed, or the zinc oxide and binder must be made water-receptive.

Section Ten: Platemaking Troubles

Intensive research in platemaking has resulted in knowledge which gives the platemaker excellent control of his craft and its product. Improved materials and supplies also help assure consistently good plates. The variety of platemaking methods now available makes it easy to choose the best possible plate for a particular need. But despite all this, troubles in platemaking do

occur. The following is a brief discussion of the more commonly experienced troubles, their probable causes, and suggested remedies.

PRESENSITIZED PLATES

Presensitized plates are one of the types that have gone far to make albumin, casein, and similar surface plates largely obsolete. Presensitized plates lend themselves to greater consistency because the supplier treats the metal and coats the plate under mass manufacturing procedures which lend themselves to excellent quality control. In addition, the manufacturer supplies processing chemicals that he developed to work easily and well with his particular plate. Following are brief discussions of some of the more commonly experienced troubles with presensitized plates.

Scummy Background on Negative-Working Plates. There are three likely causes of this trouble: plate was exposed too long to daylight or room light; rubbing up of the developed plate with lacquer was continued until it got too dry; lacquer sponge not clear of old lacquer.

Lacquer Comes Off During Rub-Up. This is caused by excess lacquer in the rub-up sponge.

Halftones Are Plugged or Bridged. Working the lacquer too long or until it is dry will cause such plugging. When this problem is faced, it may be overcome by squeegeeing excess water off the plate, then applying a liberal quantity of fresh lacquer to dissolve the previously applied lacquer. The plate should be washed out with water using a thoroughly rinsed-out sponge. The excess water should be squeegeed off and the usual lacquer rub-up started and properly done.

Mottled and Spotted Halftones and Screen Tints. A likely cause of mottling and spotting is poor contact during exposure. It is essential, because presensitized plates are so smooth, that the vacuum frame be in good working order. When the photocomposer is used, it must also provide proper vacuum, especially when large chases are being used. Poor contact will aggravate problems when overexposing. Exposure should be held down to the time necessary to produce an even screen. Placing a sheet of grained or frosted plastic between the flat and cover glass may improve contact. The frosted side of the sheet should be toward the negative.

WIPE-ON PLATES

Wipe-on plates have become very popular in recent years, partially because of their simplicity. As is the case with presensitized plates, the supplier furnishes a treated plate along with chemicals compatible with a specific process. This lends itself to the possibility of completely standardized procedures. Some troubles do occur now and then. Following is a discussion of the more commonly encountered problems.

Streaked and Chalky-Colored Coating. This is the result of too thick an application not being wiped and rubbed

down properly. Excess coating should be wiped off the plate and the coating rubbed down until it is uniform and clear. The individual manufacturer's instructions should be closely followed with respect to coating the plate, especially the wiping and drying of the coating.

Applying a wipe-on coating.

Fibers or Lint in the Dried Coating. The lint or fibers come from the paper wipes or cloth. Care should be taken not to use a paper wipe which shreds, or a linty cloth. Proper wiping technique will tend to remove lint.

Weak Image. Excess water in the rub-up sponge, an oxidized plate, or a plate that has not been pretreated are the causes of a weak image or one which refuses to accept lacquer or ink during the developing procedure.

Plates which have not been pretreated will not work with the diazo coatings used for most wipe-on processes. The pretreatment is best done by the plate supplier, and should be compatible with the coating and developing chemicals. Pretreated plates have an indefinite shelf-life provided they are not stored in a damp atmosphere which can deteriorate the pretreated surface.

When applying the lacquer-developer emulsion, care should be taken that the rub-up sponge does not contain too much water. If it does, a dilution of the lacquer-developer occurs that upsets the chemical balance of the emulsion.

Scummy Background. A scummy background, after processing has been completed, may be caused by too long exposure to room light of the dried coating, insufficient lacquer-developer used during development, or too coarse a grain for wipe-on coatings, which are normally quite thin.

DEEP-ETCH PLATES

The copperized aluminum deep-etch plate was once the work horse of the lithographic industry. Many color and medium-to-long-run jobs (50,000–500,000) are still produced from these plates. The research and development of the late 40s and early 50s resulted in controls, techniques, and materials which, in turn, made possible consistently good deep-etch plates. These, in turn, contributed significantly to the growth of web offset. The deep-etch process is still, however, a complicated one as compared to presensitized and wipe-on methods.

Following are brief discussions of the more commonly encountered troubles when making deep-etch plates. Many of the problems parallel experiences with negative-working surface plates. All that has to be kept in mind is that the deep-etch plate is positive-working.

Plate Coating is Not Uniform. A deep-etch coating that is not uniform may be due to making the coating with a "ropy" gum or gum that contains suspended gelatinous material. Where a plant makes its own coatings, care must be taken in selection of the gum arabic sorts. The gum solution should be thoroughly strained before it is used in making the final coating solution, and the finished coating strained again when poured into the coating pot.

Plate Requires Prolonged Development. Dark reaction, excessive exposure to room lights, or too high a developer Baumé will result in prolonged development. The Baumé of the developer should be adjusted to give complete development in 5 to 8 minutes with two or three applications of developer.

Plate Develops Too Fast. Too fast development is due to too low a developer Baumé for the existing conditions of temperature and RH. A developer with a higher Baumé should be used.

Broken Halftone Dots. Grain, dark reaction, and dot fringe in camera films are causes of broken dots. In addition, broken dots may result from incomplete development or lack of good contact during exposure. Poor contact will cause thickening of the image. With deep-etch plates (positive-working), poor contact may result in a broken image.

Some judgment, and use of the GATF Sensitivity Guide, should prevent trouble with broken dots due to incomplete development. If coating and exposure have been properly standardized (see Section Seven), then the developer Baumé should be adjusted to produce clear work areas in two to three minutes after the first application of developer.

Excessive Dirt Spots. Spots may be due to bubbles in the coating, and dirt or dust from the whirler itself as well as from the room. In addition, specks of dirt on the clear areas of the positive will result in dirt spots on the finished plates. Positives should be clean when they come from the camera or stripping departments.

"Spider-Web" Scum. This type of scum is caused by excessive drying of the coating, which results in shrinkage cracks. This is not likely to happen in an air-conditioned plateroom. Thinning the coating should help. Another remedy is to add up to two ounces of glycerin to a gallon of coating solution. When handling the coated plate, avoid (as much as possible) bending it.

Fine, Over-all Scum. Scum may be due to too thin a coating failing to sufficiently protect the grain peaks from the developing and deep-etching solutions. Another possible cause is excessively high humidity resulting in a coating not completely dry. Too thin a coating is best remedied by a thicker coating, a longer exposure, or both.

Scum Areas Where Masking Tape Contacted the Coating. Masking tape may be a source of such trouble.

Plates Cannot Be Washed Out. Inability to wash out is usually due to dried gum over the image, or developing ink drying so hard it cannot be dissolved by the regular solvent.

Oxidation Scum on Aluminum Plates. Oxidation scum may be caused by the preservatives used in the gum arabic solution. The preservative used must be mercury-free.

Embedded abrasive may also contribute to oxidation scum. After counter-etching, the plate grain should be examined for embedded abrasive. If any is detected, the plate should be discarded.

BIMETAL AND TRIMETAL PLATES

Most of the troubles encountered with multimetal plates are similar to those encountered with surface and deep-etch plates.

In tracking down the trouble, it is necessary to consider whether the plate is negative-working or positive-working. The parallel discussions, in this section, under surface and deep-etch headings, cover most of the commonly encountered troubles in bimetal and trimetal plates. However, when working with these plates, it must be borne in mind that two different metals are always involved: the image-bearing metal (copper), and the water-carrying metal (chromium, stainless steel, etc.).

Refusal of the copper to take ink is one of the more common troubles. On a negative-working plate, this is usually due to incomplete removal of the light-hardened gum coating from the image areas. This can be overcome by application of an image remover, which the plate supplier can furnish. Sometimes a repeated acid-sensitization of the copper image may do the trick.

On a positive-working plate, this same trouble with the copper image area is caused by failure to remove all the chromium etch from these areas. A thorough washing of the plate with anhydrous alcohol, followed by an application of asphaltum or lacquer, should eliminate this problem. In those platemaking procedures which call for removing the stencil by scrubbing under water, but omitting the alcohol wash, an application of a sensitizing solution followed by a rub-on with ink should bring the image up satisfactorily. The rub-up should be carried out while the plate is wet by the sensitizing solution.

Section Eleven: Handling Plates on the Press

This section should rightfully belong in Chapter Twelve: Lithographic Presswork, as it applies to operations which the pressman performs. It is included in this chapter on platemaking (1) to complete the information on plates, their behavior on the press, and the problems associated with their use; (2) to acquaint the platemaker with conditions plates encounter on the press; (3) in the hope that it will encourage pressmen who refer to and read this chapter to learn more about the plates they run.

To get the best results from any printing plate, the plate must maintain the best possible press conditions. Bearer pressure and packing of the plate and blanket should follow the press manufacturer's instructions. All ink rollers should be free from glaze. Form rollers should be set lightly, with slightly more pressure against the ink drums than against the plate; the rollers should be set firmly against the plate, but should not bounce at the gripper edge. Dampener covers, when used, should be clean and resilient. The blanket should be free from glaze and embossed areas. The back-cylinder pressure should be just enough to produce a good print—no more than that.

Unless the press conditions are right, no plate will produce the quality and length of run of which it is capable.

CHECKING THE PRESS

Printing from fine-grained or ungrained plates requires particular care and precision when adjusting pressures and setting rollers. Since the plates are relatively smooth, there is less traction between plate and form rollers, as well as between plate and blanket. Therefore, there is more tendency to skidding. Form rollers and dampeners must, therefore, be more nearly perfect and must be set with a minimum of pressure against the plate.

Checking Form Roller Setting. The best way to check form roller settings is as follows:
1. Gum up the plate and dry it.
2. With a normal amount of ink on the form rollers, and the press standing still, drop the form rollers onto the plate and immediately raise them.
3. Jog the plate around and inspect the bands of ink that the rollers have left on the plate. The ink bands should all be the same width and should be uniform from one end of the cylinder to the other. For grained plates they can be $\frac{1}{4}$ to $\frac{3}{8}$ in. (6 to 10 mm) wide, depending on the size of the press. For ungrained plates, $\frac{1}{8}$ to $\frac{3}{16}$ in. (3 to 5 mm) is sufficient. If the form rollers cannot be set this lightly to get uniform ink bands, the chances are the rollers need to be reground or replaced.

Dampening Rollers. The dampening rollers should also be set as lightly as possible, as smooth plates take less roller pressure than grained plates, in order to obtain uniform plate dampening.

The Blanket. A hard blanket gives the best reproduction from fine and ungrained plates. The squeeze between plate and blanket should be kept to a minimum. Ordinarily packing for 0.003 in. to 0.004 in. (0.08 to 0.10 mm) squeeze for grained plates

is sufficient, but the closer to 0.002 in. (0.05 mm) squeeze as is possible is best for smooth plates.

STARTING PLATE ON THE PRESS

Plate Image. When the pressman receives the plate, the nonimage areas will be under gum, and the image areas will be either under developing ink or asphaltum. Plates under developing ink are generally preferred because they are easier to check. Covering the plates with developing ink is acceptable as long as the developing ink does not dry hard or is not covered with gum. The plate can then be washed out easily and completely with Lithotine. Broken lines, lettering, and spots in solids can be repaired by the pressman by simply scratching through the gum with a needle and dabbing ink on the uncovered metal. Depending on whether the plate is for black ink or color, different treatments are recommended for starting the press run.

TREATING BLACK PLATES ON THE PRESS

The gum should be washed from the plate with the water sponge, inked up, and the lay (position or register on the sheet) obtained. When the sheet position is satisfactory and the image is printing satisfactorily, the run is started. On the other hand, if the image is not printing properly, the plate should be wet-washed before proceeding to print. To wet-wash the plate, first the plate is washed with the water sponge. While the plate is still wet, the ink is washed off with Lithotine. Then the plate is wiped twice with a clean water sponge to remove the solvent. The press is started, and the form rollers dropped. Washing the plate with water removes any gum that may have been covering work areas and causing blindness, broken dots, or streaks. The ink can then be washed off easily, and the image should roll up and print properly.

TREATING COLOR PLATES ON THE PRESS

Depending on various conditions, one of the following two methods should be used in starting color plates. As the governing conditions lie mainly in the press washup preceding the job, these two methods are distinguished as A and B.

Method A would be used under the following conditions: (1) if there will be no change from the previous color run on the press; (2) if the change will be to a color that will not be altered or dirtied if the press washup hasn't been very thorough, as in going from a light to a dark color; (3) if an improved press washup method is used and the press rollers are thoroughly clean.

The procedure is as follows: (1) after checking the work, the developing ink is washed out with Lithotine and asphaltum applied, the asphaltum being rubbed down smooth and thin; (2) the plate is put on the press; (3) the press is inked up; (4) the gum is washed off the plate; (5) the form rollers dropped, and lay okay obtained; (6) the plate is wet-washed, and a color okay obtained.

The final wet wash before printing is worth the extra effort. It

makes clean, sharp printing possible from the start. Without it, tone values may change somewhat after the run has been started.

If a delicate color such as light yellow or a tint is run, the asphaltum on the plate image may dirty the print. In this case asphaltum should not be applied after the developing ink is washed out. Instead, press ink of the color that is to be run is applied and rubbed down with a clean rag.

Method B should be used if there is a change of color that will alter or dirty the job if the press washup has not been thorough—for example, from a dark to a light color.

The procedure for method B is as follows: (1) after the work is checked, the developing ink is washed out with Lithotine, asphaltum applied and rubbed down smooth and thin; (2) the plate is put on the press; (3) the press is inked up with as little ink as possible; (4) the gum is washed off the plate; (5) the form rollers dropped and an okay on the lay obtained; (6) the press is washed up and fresh clean ink applied; (7) the plate is wet-washed and color okay obtained.

CONTROLLING INK AND WATER

An important part of the pressman's art is his ability to balance the ink and water. Poor plates make this very difficult, but with well-desensitized plates that resist blinding, it is relatively easy. Here are a few general rules that should be followed:

1. Enough ink is run to print good solids without noticeably squashing the halftone dots. Printed halftone dots should be sharp and clean, and close to the same size and shape as those on the plate. The amount of ink needed will vary with the ink requirements of the paper. High-finish coated papers require the least ink, rough uncoated papers the most. The shadows should not be filled in or the dots slurred.

2. Crowding the ink to get color should be avoided. It is better to mix the ink stronger and run an amount that will print the halftones right without squashing and filling in. The use of GATF's Star Target, Quality Control Strip, and Dot-Gain Scale enables detection of these troubles.

3. Running the ink too spare should be avoided. If the color is too strong, a reducer like alumina hydrate may be added to the ink. If quickset or heatset ink is being run, the ink supplier should be consulted for the proper reducer to use. There must be enough ink on the plate image to protect it from any blinding action of the fountain solution.

4. Excessive additions of compounds and driers to the ink should be avoided. These may cause the ink to waterlog, which, in turn, may cause blinding of the plate, improper ink transfer, piling, or stripping of the rollers.

5. A minimum of dampening water should always be run. Well desensitized plates require very little moisture to keep them clean. Poorly desensitized plates need excessive moisture, which makes it necessary to crowd the ink, thereby causing a series or chain reaction of troubles. Excessive water slows ink drying, causes register troubles and curling of paper.

6. Well-desensitized plates need very little acid in the fountain water (pH 5.0 to 6.0) to keep them clean with most inks. For very soft or greasy inks, the pH may have to be considerably lower. Fountain waters more acid than pH 4.0 will slow the drying of conventional inks. With well-desensitized plates, acid and gum in the fountain water are needed mainly to keep dampening rollers clean.

The grain on the usual lithographic plate acts as a reservoir for water. It carries more water than is actually needed in printing and, because of this excess water, more ink must be run than is actually needed to print the density of color that is wanted. But when printing with a very fine-grained or smooth plate there is no such reservoir, and the water feed must be cut back. The following suggestions should be of help in adjusting the water feed and getting the proper ink-water balance on fine-grained and smooth plates, especially presensitized and wipe-on plates.

When a fine-grained or smooth plate is started, an excess of water will show up in two ways: (1) Rivulets or drops of water will be seen along the back edge of the plate and blanket; (2) Beads of water will be seen riding between the ink rollers. In this case, the water feed should be cut back until this evidence of excessive moisture disappears.

When the water has been cut back, it may appear that too much ink is being fed. If halftone dots appear to be squashed, or if shadows are starting to fill in, the ink feed should be cut back a notch or two. Compensating for too much ink by feeding more water will lead to trouble or result in poor print quality.

As the run is continued with less ink, beads of water may again show up on the rollers, because there is less ink to take up the water. In this case, the water feed should be cut back still more. When the water beads disappear, the halftones should be checked again. It may be that the ink can be cut back still further.

By following this system it is possible to reach the proper balance between ink and water for the particular plate. Of course, if cut-backs are carried too far, the plate will catch up. But the idea is to run with as little water as possible. A pressman may be surprised at how little water and ink fine-grained and smooth plates require, and how much their printing quality is improved by proper water and ink adjustments. Colors will print brighter, and conventional inks will dry faster.

This system of water and ink adjustment is helpful not only with smooth plates but with all types of grained plates as well. With well-desensitized plates of any type, it will help to get the maximum in printing quality.

GUMMING UP AND ETCHING PLATES ON THE PRESS

It is not as easy to gum up or etch a plate properly on the press as it is in the plateroom. Many plates are damaged or ruined because the pressman will not take the time and precautions to do a careful job. While properly made plates will stand more abuse and careless treatment, certain precautions are necessary if the best results are to be obtained in day-to-day production. The following suggestions are made for avoiding trouble and saving time when plates are etched or gummed up on the press.

When Plates Should Be Gummed Up. Plates made with modern techniques and materials do not need to be gummed up for stops up to 15 to 20 min. while getting started on the press. For longer stops and shutdowns during the run, they should be gummed up and left under the press ink. For stops longer than 1 hr., plates should be washed out and put under asphaltum;

otherwise, the press ink is likely to dry. By avoiding gumming up for short stops at the start of the run there is a saving of time and much less chance of plate damage.

Gumming Up a Plate. To gum up plates on the press, the first thing done is to protect the printing image with enough ink to resist gumming or etching. To do this, the dampeners are first lifted, and then after about three cylinder revolutions, the form rollers are lifted and the plate allowed to dry. This will leave a good charge of ink on the work areas. In order to dry the plate as rapidly as possible (to avoid oxidation), the press should be running while the plate is drying. Fanning the plate while the press is rolling will hasten the drying.

Since press ink is relatively soft and smears easily under the gum sponge, the next thing that is done is to powder the image. This is accomplished with a mixture of half-and-half French chalk and powdered rosin. (French chalk alone can be used, but it tends to make the image hard to wash out.)

For gumming up the powdered plate, gum arabic solution at 6°-8° Baumé is used, and the plate fanned dry. The rub-down should be made thin enough so that none of the image areas are left covered. The gum should be thin because gum that dries over the image will make it hard or even impossible to wash out. If necessary, the work areas should be gone over with a slightly damp cloth just before the gum dries to remove any overlying gum film.

Press ink contains drier and will often dry if left on the plate longer than about two hours. So, if the press is to be shut down much more than an hour, it is advisable to wash out the plate and put it under asphaltum. Otherwise, the work may not take ink unless the area is washed with a special solvent mixture.

Etching a Plate on the Press. Correctly made plates seldom need etching on the press. However, if a plate shows a tendency to scum, the pressman should try etching it a few times before increasing the strength (lowering the pH) of the fountain solution.

To etch a plate on the press, the image is first rolled up with ink, and powdered in the same way as for gumming up. For best results, the same etch which the platemaker uses should be used. The etch is applied just like plain gum solution, rubbed down thin, so it does not cover any work areas, and dried. The etch is washed off thoroughly with water before proceeding to print. If this washing is not thorough, the phosphoric acid left on the plate may cause the steel ink rollers to strip. If the plate is to stand longer than one hour, the etch film should be washed off and the plate gummed with gum arabic; then the ink is washed out and asphaltum applied.

If the scum comes back, it is usually because the ink is too soft, or the dampeners are too greasy or improperly adjusted. In any case, the fountain solution should not have a pH lower than 3.8. It is better to clean the dampeners, check the rollers, and stiffen the ink, if at all possible.

CHAPTER ELEVEN . .

The Proofing Department_____

Section One: The Purposes and Methods of Proofing

The risk of error is high in all manufacturing processes, but it is nowhere higher than in printing, and particularly in lithography. Almost every job is custom-made, almost every job is produced under enormous time pressure, almost every job is a composite of many pieces that must be properly related by the lithographer. Add to these conditions the fact that imperfections are more detrimental to the printed product than to many other ones, and you realize the hazards of this business. The main purpose of proofing is that of catching errors and mistakes before they become fatal.

PROOFING HAS MANY PURPOSES

But proofing has many other purposes and reasons, in addition. Most jobs are turned over to the lithographer in many pieces out of which he must make a harmonious whole. Very often the customer, a busy advertising agency, for example, wants to see how the job will look before it goes to press.

Customers may demand proofs for many other reasons, too. Very often they want to send advance copies of forthcoming sales literature to salesmen, distributors or dealers. Or, they may need proofs for the purpose of guiding other people who supply material belonging to a specific campaign in their work.

PHOTOMECHANICAL PROOFING AND PROOFING WITH INK

How are lithographic jobs proofed? The posing of this question may sound silly to letterpress printers or photo-engravers to whom proofing means clearly the taking of a few prints in a proof press. Things are very different in lithography. Here jobs are proofed in many techniques of which the proofing in proof presses is only one, and—to say it right away—by no means the most important proofing technique at all.

It can be stated—with all due reservations—that proofing with ink is much less common and much less generally used in lithography than photomechanical proofing. The use of photomechanics for proofing is an achievement of lithography and peculiar to it. The use of photomechanics for lithographic proofing is closely connected to the methods and procedures of lithographic platemaking and must be discussed in relation to platemaking itself.

In letterpress printing the final printing form consists either of original material, or of duplicate plates or of a mixture of both. The printing form for a flatbed cylinder press may combine type set in any hot metal machine technique, original photo-engravings, electrotypes or stereotypes. All these elements are physically assembled during imposing and fastened into proper position by lock-up.

In lithographic platemaking the assembly precedes the making of the physical printing plate. Stripping has the function of assembling the material — negatives or positives — and of putting it in its correct place. As the material consists of photographic images, it is suitable for photomechanical proofing. Photomechanical proofing aims at paper-prints on which the transparent image of the photographic material is recorded in an opaque form. Like every other generalization — and definitions are nothing but a special kind of generalizations — this one too tends to cause trouble. How is the image recorded? As a negative or a positive? How accurately is it recorded? These and several other questions will be discussed in the following sections of our study. But, no matter how critical we may be toward our definition of photographic proofing, no matter how many holes we may be able to tear into this fabric of words, one fact should emerge clearly: A photomechanical proof is a paper-print and not a transparency.

Even this very restricted assertion needs qualification. As you will see further down in the discussion of photomechanical proofing for full-color printing, some very useful photomechanical proofing methods produce transparent images on clear plastic sheets where each of the process colors is recorded in color. But, our definition holds nevertheless because these images are placed on white paper and viewed on it as if they were directly made on the paper.

SUMMARY OF PROOFING PURPOSES AND TECHNIQUES

If we want to summarize the preceding paragraphs we may state that lithographic proofing serves a variety of purposes and utilizes a variety of techniques. The two main purposes of proofing are: (1) proofing for production control or proofing for internal use in the lithographer's own plant; and (2) proofing for submission to the customer or for other external use. The two main techniques of proofing are: (1) proofing with ink; and (2) photomechanical proofing. We might add two additional distinctions that cross the lines of purposes and techniques. These are: (1) proofing for register; and (2) proofing for color. All following discussions of proofing are made with these six points in mind.

CRITERIA

If we ask ourselves what proofing indicates we can generalize again by saying that proofing conveys information on two groups of criteria which are essential for the evaluation of a lithographic job. These criteria are: (1) quality; and (2) accuracy. Both of them need to be discussed.

Few words cause more heated arguments in the printing business than the word quality. Every printer and lithographer, and most certainly every printing salesman, speaks of his firm as a "quality" house! Everybody sells "quality," everybody considers his own jobs quality jobs and those of his competitors something different, to say it mildly. Quality is a term that expresses our personal judgment; it is not an objective term but a highly subjective one, if used in this manner.

Like many other "value" words, quality, too, has become almost meaningless in this world of exaggerated advertising. In most cases a quality printer is merely a printer who knows his business but by no means a printer of outstanding performance. Those who still hold that it is no merit to know one's business, but something understood by itself, will object to being thrown into this undistinguished quality barrel.

In this study the word quality is used in a different and very special sense that must be explained to the reader. We understand by quality the degree to which a lithographer has achieved the result desired by the customer and promised by the lithographer to his customer. Thereby we want to emphasize that many lithographic jobs are problems of intuition and interpretation rather than tasks of exact and faithful reproduction. There are, of course, many cases where facsimile reproduction is demanded. But the majority of commercial lithographing, for advertising in particular, is neither prepared for facsimile reproduction nor so intended.

QUALITY IS A SUBJECTIVE TERM

Commercial lithographing is highly competitive business. Advertising is a Moloch with never-ending appetite. Every advertising job is a problem of getting the results of which the customer dreams with the least possible expenditure. Advertising has the taste of a millionaire and the means of a miser. The individual lithographer proves his mettle by ingenuity with which he bridges this constant gap.

Quality is, therefore, in our eyes a relation more than anything else. It is the expression of the extent to which the lithographer has been able to achieve what he set out to do. Used in this sense, the word quality is highly subjective; only the parties concerned in a specific transaction are capable of making such quality judgments.

Seen in this manner the experience and wisdom of lithographer and customer alike are the main criteria for quality. Intuition, psychology, knowledge of the customer's business are not less important for the quality lithographer in our sense than his standing as a technician in lithography itself. If such a lithographer meets an equally equipped buyer, the highest quality becomes possible.

ACCURACY CAN BE CLEARLY DEFINED

Accuracy, the other kind of information conveyed by proofing is the supplement and in a sense even the contrary of quality. There is nothing vague about accuracy; it can be clearly defined. In the following discussion of proofing you will meet many aspects of lithographing that can be accurately described and discussed in the terms of their own accuracy.

Finally, a word on the division of this study into single-color and multicolor proofing on the one hand and full-color proofing on the other. Full-color is used in this study as a more precise synonym for what is often called process work. Full-color printing is so very different from other kinds of lithographic printing that it must be treated by itself.

Single-color and multicolor proofing comprise in this study the vast bulk of line and halftone printing in one or several colors. Single-color and multicolor proofing are of the greatest importance to the average lithographic plant. A thorough understanding of this subject is also a prerequisite for the understanding of full-color proofing.

Section Two: Single-Color and Multicolor Proofing

At the outset of this discussion we want to emphasize that there are no generally accepted rules or techniques for proofing in the lithographic industry. Every shop, every organization has its own problems, its own equipment and its own techniques. Every organization develops in its own particular way. The kind of work done by it is responsible for the method developed in it. Price, delivery requirements, nature and purpose of jobs, equipment and personnel are all important factors that vary from company to company.

The lithographic industry is not a staid, saturated guild but a living and vigorously growing organism. For this reason it is still far from uniformity. The following discussion of proofing is not a statement of generally valid and ubiquitously applicable practices but rather a loose description of methods and techniques that are more or less consistently used by lithographers in many cases. The purpose of this study is stimulation of the reader. The practical lithographer will be the best judge as to how other people's experiences can be applied to his own benefit.

Our presentation covers the following four main groups: (1) Accuracy as it is related to proofing; (2) Photomechanical proofing techniques; (3) Proofing with ink; and (4) Special proofing techniques. Each of these groups is now individually discussed.

ACCURACY

The four main aspects of accuracy in single- and multicolor proofing are: (1) Accuracy of the assembled material; (2) Accuracy of position; (3) Accuracy of imposition; and (4) Accuracy of register. All four aspects of accuracy are closely connected. Serious errors in accuracy are inexcusable and must be caught before they cause real damage.

Accuracy of the Assembled Material. Lithographic jobs are often turned over to the printer in fragmentary form. Some pieces can be photographed as they are, others must be scaled. It is often necessary to make intermediate composites out of various art and copy elements for the final assembly of a job. The accuracy of the assembled material must be checked in several respects. One pertains to its completeness, including the elimination of not-belonging matter. Another aspect of accuracy is that of the size of each individual element. Photomechanical proofing permits control of this kind of accuracy, but it must not be overlooked that not all photomechanical proofs are of exact dimension. Where this point counts, blueprints, for example, must not be used indiscriminately.

Accuracy of Position. Accuracy of position seems implied in the preceding aspect of accuracy. But this is often not so, particularly in multicolor jobs. There it happens very often that various copy or art elements in one color cannot be checked for correct position without reference to other colors. Where accuracy of relative position counts, multiple exposure proofs are required, if photomechanical proofing is used. Accuracy of position will again attract our attention at the discussion of proofing with ink, and also under the heading of special proofing techniques.

Accuracy of Imposition. The accuracy of imposition is much too often neglected. Many lithographers are much more concerned with the quality of their print than with its proper imposition. But the imposition must not be neglected; it is a most essential consideration in all jobs that are printed on both sides and must be folded before they attain their final form.

Impositions are particularly exacting in book work. The position of the page on the sheet, its back-up, the inside and outside margins, head and foot trims, and last but not least, shingling, are all items with which a lithographer should be thoroughly familiar. Proofing is the last opportunity for making sure that the job is imposed according to the bindery imposition which should always be the basis of the lithographer's plate layout.

Accuracy of Register. Register is another essential of all lithographic printing that can be checked in proofing. To quote Mr. Charles Latham (GATF Skilled Craft Text #505/6, "Lithographic Offset Press Operating," p. 67) "The term register is loosely used to denote the position of the image on the sheet or the position of one color with respect to another. *Technically there should be a distinction between register and fit, or external and internal register.* If every sheet goes through the press and is printed in the same position relative to the gripper edge and the guide side, the press is printing 'in register.' If the plate has been made incorrectly, or if the paper distorts and some of the images are out of place in relation to others on a sheet that are printed in register, then the term should be 'misfit' or *internal misregister.*"

Photomechanical proofing is an excellent check for internal register, at least inasmuch as the plate is concerned. Paper shrinkage, of course, cannot be controlled in this manner. External register cannot be checked by photomechanical proofing but only on the press. The checking of external register is normally not a task of proofing but constitutes one of the responsibilities of the pressman and is considered part of makeready on the press previous to running.

PHOTOMECHANICAL PROOFING TECHNIQUES

Photomechanical proofing techniques are in general executed by contact printing. We can distinguish three main kinds of materials used for photomechanical proofing of single- and multicolor work. (The photomechanical proofing techniques for full-color work are discussed in section three of this chapter where you find several other processes described.) The three most commonly used materials for photomechanical proofing are: (1) Blueprint papers; (2) Brownprint papers; and (3) Diazo papers. Each of them is discussed in the following.

Blueprint Papers. Blueprint papers are commercially available products. They are widely used by architects and engineers for photomechanical copying of plans and technical drawings. Blueprints are based on the light-sensitivity of organic iron compounds, in particular of potassium ferricyanide to change into ferric ferrocyanide, a compound commonly known as prussian blue. Blueprint paper is exposed together with negatives, in most cases a stripped flat, in a vacuum-printing frame to arc light. The transparent image areas of the negatives permit light passage and therewith the formation of prussian blue. The result is a photomechanical positive proof showing the image areas in dark blue on a more or less white or light blue background. The exposed blueprint paper is developed in water and air-dried.

Blueprints are not dimensionally stable, nor do they retain their original color during aging. They are, neverthe-

less, very widely used because they are very inexpensive and very easy to make. Blueprints afford sufficient information on three aspects of accuracy, that of the assembled material and its position as well as of the imposition. As to the fourth type of accuracy with which proofing is concerned, namely, the accuracy of internal register or fit, blueprints may or may not be sufficiently indicative. By and large, blueprints are considered satisfactory in most simple jobs, particularly in single-color book work.

Brownprint Papers. Brownprint papers are known under a variety of other names such as Van Dyke, Solar, silver print, print-out or P O P and developing-out papers. Brownprint papers are silver salt papers. But their image is formed very differently from that in bromide papers — our most common kind of photographic printing papers. In bromide papers the visible image is obtained by development of the latent image. In brownprint papers there is no latent image; here the image is formed entirely by exposure to light. The longer a brownprint paper is exposed, the darker becomes the exposed image. This fact is of greatest importance for photomechanical proofing, as you can readily see.

Brownprint paper is used for making positive photomechanical proofs from negative flats. The paper is exposed together with the stripped flat in a vacuum-printing frame to arc lights. The exposure time is approximately the same as for albumin or surface plates. The exposed brownprint is developed in water, fixed with hypo, and dried after rinsing. It should be remembered that brownprints change dimensions, just like blueprints.

Brownprints afford information on all aspects of accuracy, not only that of the assembled material, its position and imposition, but also that of internal register or fit in multi-color jobs. This feature we owe to the peculiar way in which the brownprint image is created that permits us to identify various flats on the same brownprint in different tonal values.

The following discussion of brownprints and their use is quoted from the GATF Skilled Craft Text #507, "Offset Stripping (Black and White)," by Bernard R. Halpern (Chapter X).

"For simple color jobs, the brownprint proof can show the fit and relationship between the several printing colors. In such work, the flat for the darkest printing color, or black, is exposed first. The full normal exposure time is used. The next lighter color flat, such as a blue or red printer, is registered in position and exposed for about half the time. If a third color is to be printed, its flat is also exposed in register with the others for a still shorter period of time. Such a series of exposures may be 2½ minutes for the black, 1 minute for the blue, and 30 seconds for the yellow. Upon development, the different exposure times produce different shades of brown on the paper. Color overlap areas produce darker lines. Halftone or tint areas may be confusing due to their tones being lighter than the solid printing color. Such areas should be noted in pencil with the color they are to print.

"For proofs of publications, work-and-turn jobs, and similar work, the brownprint is folded and cut up to simulate the format of the printed job. Jobs printed on both sides of the sheet can be prepared by pasting sheets of brownprint paper together to represent the front and back printings. This pasting can be done with rubber cement. Or the two-sided brownprint paper can be used. When exposing each side of the double-coated brownprint paper, butterfly cutouts along the brownprint sheet centerlines or punched holes are used so that the exposures on the two sides will register with each other. In development, both sides are developed simultaneously."

Diazo Papers. Diazo papers are also known as ozalids (even though this name belongs to the Ozalid Company), white-prints, ammonia-prints and gas-prints. Similar to blueprints, diazo papers, too, produce, under the influence of light, images of colored pigments. The exposed diazo print must be treated either with a liquid or a gaseous chemical for development of the colored image. In many cases, diazo prints are developed with ammonia fumes, hence the colloquial designations of gas-prints or ammonia-prints.

Diazo prints are distinguished by two features: (1) They produce positive images from photographic positives and are therefore used for the photomechanical proofing of positive flats, and (2) they do not change their size during development. The procedure of exposing is the same for diazo papers as for the other two described kinds: They are contact-printed in a vacuum frame with strong lights. Diazo prints afford information on all other aspects of accuracy than internal register or fit. For this purpose brownprints remain unsurpassed. But diazo materials play another very important role in photomechanical color proofing. In the following section on full-color proofing you will meet them again.

PROOFING WITH INK

Proofing with ink can be divided in many ways, according to the kind of equipment, the kind of plate and last but not least the point at which proofing takes place in the production of a job. Let us first take a look at the equipment. Proofing can be done on special proof presses or on

Proofing on a Hand-operated Proof Press.

regular production presses. The plate used in proofing can be either an intermediate plate or it can be the final press plate. Proofing can be done at different stages of production, either as a step preliminary to putting the job on the press or as part of the presswork.

If we look at these six points we see that some of them can be combined with others in several ways. A press plate can be proofed either on a proof press or on a regular production press; proofing with a press plate can be an independent preliminary step or it can be done as part of presswork. For practical reasons we divide the subject in the following three groups: (1) Proofing on proof presses, (2) Preliminary proofing on production presses, and (3) Proofing as part of presswork. Each of these subjects is now discussed in detail.

Proofing on Proof Presses. Proofing on proof presses is not too important in the average lithographic plant for single and multicolor work. Proof presses are much more important in full-color printing. For this reason, they are not discussed in this section of our study but rather in the following section on full-color proofing. It should not be assumed that single- and multicolor production does not use proofing on proof presses at all; this is not so. In many specialized cases such as label work, for example, it is customary to proof the intermediate plates on proof presses before the final press plate is made.

Another and quite different use of the proof press in single and multicolor work should not be forgotten. Presentations and other very short runs are sometimes produced on proof presses rather than on production equipment. In these cases the proof press functions not as a proof press but as a production machine. (You can see how difficult it is to generalize in our so very highly diversified industry. Now the proof press has at last changed its function completely!)

Preliminary Proofing on Production Presses. Proofing on production presses is much more often done in single- and multicolor printing than proofing on proof presses. In some cases the plate to be used for proofing is not the final press plate but an intermediate or unit plate. Such plates are proofed before the final press plate containing several times the material of the unit plate is made. Proofing of intermediate unit plates is a safety measure primarily. It is much easier to correct the small unit plate than to remake the final and much larger press plate.

Proofing of the final press plate preliminary to the running of single- or multicolor jobs can have many reasons. The customer may request proofs because he wants to see finished prints before the run is started. Or, the customer may need samples for advance distribution. But preliminary proofing is also often done because the lithographer himself desires information that cannot be provided in any other way. We are referring here to all cases where a job is either very critical, or where some of its component elements are unknown to the plant where the job is produced.

In many cases proofing is the only way in which the necessary information on paper, ink, overprinting, and so on can be obtained. It is always dangerous to rely on verbal information alone when new materials must be used. Even

if we give everybody connected with the asking and answering of such questions the benefit of the doubt, there are still too many points that cannot be taken care of by verbal means. How new materials will behave under very specific job conditions can in most cases only be found out by trying. Preliminary proofing is often the best and least expensive way of experimenting with new materials and techniques.

Proofing on production presses requires accurate setting of the press and does not become conclusive before approximately 500 waste sheets are run. At this time, hickeys and gear- and roller-streaks will show up. After the job is perfectly adjusted, final proof sheets are taken for customer submission.

Proofing as Part of Presswork. Whether a job should be proofed or not depends entirely on the case and on the terms of sale. Most lithographers do not include press proofs in their contract price but charge extra for such services. In some cases, particularly where the lithographer and his customer know each other well and are used to cooperating smoothly with each other, a customer representative is invited to the plant at the beginning of an important run, particularly in case of a difficult color. Such a procedure saves the customer the expense of proofing, but it is obviously only workable with highly experienced people on both sides.

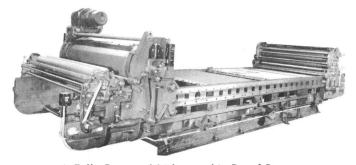

A Fully Powered Lithographic Proof Press.

The press is inked, and the color is adjusted in cooperation between plant personnel and customer's representatives who are very often artists. But care must be taken not to waste too much time in this procedure. Many firms make extra charges for idle time of their presses; such charges have often rather surprising effects — colors that needed a lot of adjustments become passable if it costs a lot to work on them. Many a job is improved by a more strict procedure; very often long fooling around with colors does make the result worse rather than better.

SPECIAL PROOFING TECHNIQUES

Under this heading we want to discuss two techniques that have proved their usefulness in many cases. One is proofing by means of the strike-sheet, the other is proofing for pre-separated artwork.

Proofing by Means of the Strike-Sheet. Proofing by means of the strike-sheet can almost be classified as part of starting certain jobs on the press rather than proofing. The purpose of this kind of proofing is control of internal

register or fit in multicolor jobs. The strike-sheet is a print of the key color, mostly but by no means necessarily, the black.

Proofing by means of the strike-sheet is done on production presses with actual press plates. The first step consists in printing a good and sufficient number of sheets from the key-color plate. These are the strike-sheets. After the strike-sheets are printed, the key plate is taken off the press and the job is started. Every color is first printed on strike-sheets where it is possible to check its relation to the rest of the job and to make sure that all colors fit as they should. The strike-sheet technique is particularly valuable in such artwork where color is used discontinuously and where it is impossible to tell from an individual color print whether it is in register or not.

Proofing for Pre-Separated Artwork. In this technique, proofing is used in the making of pre-separated artwork. The artist makes a drawing of the key color; a plate is made from this drawing and prints are taken in a "non-photo blue." The artist uses these prints for making finished artwork. As the key color does not photograph, each of the separation sheets can be used for the camera without further preparation.

This technique concludes our discussion of single- and multicolor proofing. Our next subject is proofing for full-color reproduction.

Section Three: Full-Color Proofing

Proofing for the process color work, or as we prefer to say, full-color reproduction shares many problems and techniques with single- and multicolor proofing but has in addition many aspects peculiar to itself. It might be stated that proofing for full-color reproduction is that operation where all phases of full-color printing meet; color separating, color correcting, platemaking, presswork, ink and paper, and last but not least, the viewing of the full-color proof in comparison with the original. All play their role in this seemingly simple and innocent step of proofing.

The reader who wants to follow the discussion of the subject must be at least superficially conversant with the main steps and problems of full-color printing. Readers lacking this background will not be able to absorb the meaning and implications of many points discussed in the following.*

Full-color printing is here discussed under the following six main headings: (1) Photomechanical proofing; (2) Standardization and controls for full-color printing; (3) The scope of color proofing with ink; (4) Proofing on proof presses; (5) Proofing on production presses; and (6) Proof plate and press plate. Each of these six topics is individually treated in the course of this study.

PHOTOMECHANICAL PROOFING

Photomechanical proofing for full-color printing utilizes of course many techniques of single-color and multicolor proofing. These are described in the preceding section of our study. Here, we do not need to repeat this information but will rather concentrate on photomechanical proofing techniques in color. The color-separated and color-corrected material from which the plates are made is, as the informed reader knows, not in color but in the form of photographic images having different tonal values or densities of the black silver deposit. It is very difficult to interpret these black-tone images, or halftone images, as colors — and it is

even more difficult to "visualize" them as full-color reproductions. Experienced litho artists have acquired a measure of this ability, but it is nevertheless even for the most experienced, not possible to be sure and precise in their interpretations. The densitometer is in many cases the most reliable guide, but instrument readings are confined to very small areas.

It is easy to see why workers in the field have persistently tried to find ways for providing images in color that correspond to the resulting prints which will finally be made from corrected separations, after these have been converted into press plates and the latter have been printed. But, there is many a slip betwixt cup and lip, and full-color printing drinks from many different cups! For this reason, many systems that looked "ideal" to their proponents have come and gone in the years. At the time of this writing, several systems are on the market. Here we will discuss two types of such systems: (1) colored-diazo transparencies; and (2) pigmented light-sensitive materials. It must be emphasized that all such systems have their value in the hand of the well-informed worker who knows their nature and limitations. But none of these systems produce true replicas of the future press print. They provide guides for the litho artist or color etcher but nothing else.

Colored-Diazo Transparencies. Diazo materials are, as you remember, direct positive materials meaning that they produce positive images from photographic positives. For this reason, diazo transparencies are not suitable with negatives but are mainly used with continuous-tone positives before they are screened or with halftone positives to be used for deep-etch plates.

Colored-diazo films are available in a variety of colors; the diazo films closest in color to the inks selected for a specific job are used for the proofing of this job. You notice that we speak of diazo films closest in color to the selected ink colors. Keep this in mind: Diazo films are close but almost never a match of our inks. The importance of this fact must not be forgotten.

The detail of operation is not presented in this part of our study but can be found in the following resource

* For a discussion of process color work, see chapters six, seven and eight of this Manual.

section. Here we merely give a brief summary. The diazo film is first flashed in a vacuum-printing frame for a pre-determined time. Then it is exposed together with its own color-separation positive, e.g., the yellow diazo film is exposed with the yellow positive printer, the magenta with the magenta printer, and so forth. Development takes place either in a diazo machine or in another suitable manner by impingement of ammonia fumes on the exposed diazo films.

Diazo color proofing is not a replica of the future print, nor can it be — of course — a replica of the original. Diazo proofs are guides and must be evaluated with their limitations in mind. One of them is the difference in color, another is the fact that three or four diazo films are put over each other for viewing. The color of the transparent material has a graying effect as you can easily see by comparing densitometric readings of the paper on which the job will be printed and of the paper plus the three or four diazo foils, read in a totally clear area.

Pigmented Light-Sensitive Materials. Pigmented light-sensitive materials are used for photomechanical color proofing of negatives. Such materials are available in a variety of colors and different tradenames. Photomechanical color proofing with pigmented light-sensitive materials avoids the superimposing of several plastic sheets because here each colored material lies directly on the base plastic and on the preceding color layer.

Pigmented light-sensitive materials are sold as liquids suitable for whirling. Color proofing takes place on a sheet of white opaque plastic. This white opaque plastic — mainly a vinyl — stands for the paper to be used in printing. The different pigmented solutions stand for the printing inks; the negative-stands for the press plate and whirling; exposing and developing stand for making the impression in the press.

First the solution colors are compared with the ink colors to be used on a specific job; then the closest pigmented light-sensitive solutions are selected. Now a sheet of clear white plastic is put in the whirler and coated with that color solution corresponding to the first ink color of the future run, yellow, for example. After coating, the plastic sheet is exposed with the yellow printer to arc light in a vacuum-printing frame. Then the exposed sheet is developed with ammoniated water. The image appears in yellow, and is an assimilation of the yellow to be printed on the press.

After the development of the first color coating, the plastic sheet is again put in the whirler and again coated, this time, of course, with the next color solution, the magenta, for example. Exposure and development follow with the result that both colors are now deposited over each other in direct contact on the plastic sheet. The procedure is repeated as often as is necessary; in three-color printing, the cyan is the last; in four-color printing, it is followed by the black.

The finished result is a photomechanical color proof that serves many useful purposes if its limitations are understood and if it is interpreted with them in mind. For detailed instructions of execution see the resource section of this chapter.

STANDARDIZATION AND CONTROLS FOR FULL-COLOR PRINTING

Full-color printing or process work is the most intricate and the most sensitive kind of printing. This holds true for all branches of the industry, letterpress and gravure not less than lithography. In full-color printing we reproduce an enormous gamut of colors by the use of very few inks — three, four, five or six — as the case may demand. It is not possible to produce faithful reproductions of full-color jobs unless every detail is very strictly controlled. If a single element is left uncontrolled, the harm resulting must obviously be much greater in full-color printing than in any other kind of printing where we do not try to obtain such a wide range of effects with such a narrow selection of means.

This study is not concerned with the fundamental problems of full-color printing. Here it is assumed that the reader is familiar with the subject. For the sake of continuity and completeness, several points bearing on the subject matter of this study of full-color proofing are briefly discussed. They are six: (1) The role of paper and inks; (2) The GATF Sensitivity Guide; (3) The GATF Color Chart; (4) The GATF Color Test Strips; (5) The use of the densitometer; and (6) The comparative viewing of original proofs and press sheets.

The Role of Paper and Ink. In the context of our subject we are not concerned with the general problems of ink and paper as related to full-color printing. Here we are only concerned with the correspondence of proofing and production. Many and diversified reasons may move the management of a lithographic plant to select a given set of process-color inks as standard for this particular plant. In the proofing department we are not concerned with these reasons, but we are vitally concerned with staying within these selected standard inks. It cannot be said too often that a set of standard inks is an absolute necessity if full-color work is to be produced and proofed with economy, accuracy, and reliability time and time again.

While the foregoing is true, in general, it is based on the comparatively young concept of using "balanced" process colors in printing because this simplifies the problem of color correction. However, this concept may be comprised when unusual demands in a specific job either preclude use of the "standard" set of balanced inks or require use of specially formulated inks to meet either end use demands of the particular piece of printing, or the nature of an unusual surface on which the printing is done. In such cases, both the inks and paper to be used for the job should also be used for proofing. Whenever possible and practical, color proofs should be pulled using the combination of special inks and papers. This can serve to guide the preparatory department during color-separation, masking and/or hand color-correction. During such proofing it is possible that the ink maker may better see where he can come closer to a balanced set of process colors without sacrificing the special demands which required unusal ink formulations in the first place.

If the process inks change from job to job, each full-color job, and each proofing with it, becomes a new venture into

the unknown. Such ventures may appeal to people who are bored by the humdrum existence of our times. But lithographers do not fall into this category, for them — and particularly for those engaged in full-color work — life is one challenge after another. They aim at speed, accuracy and reliability, and therewith at low cost, more than at a romantic experience.

Nor should we forget the role of paper over the so very important part played by the inks. Every job must be proofed on the paper on which it will finally be printed. It is impossible to enumerate and describe all the points where paper tells in a printed job. But things become very simple the moment you see the same job proofed on different papers. Plates, inks, press, the work itself can all be the same — but you see a world of difference if you look at proofs pulled on different papers. If proofing is to be representative for final production, the paper must be the same here and there.

The GATF Sensitivity Guide. The GATF Sensitivity Guide should be incorporated into all proof plates in such a manner that it will appear in all colors on the finished proof. The presence of the Sensitivity Guide in all colors enables you to judge whether all plates were produced in a standardized manner. Standardization by means of the Sensitivity Guide is a must for reliable plate production. The GATF Sensitivity Guide is the most valuable tool in every effort of compensating for variations between proof plates and press plates. Additional information on this subject can be found in the "Platemaking Department" chapter of this manual and in the GATF Bulletin #215, "The Sensitivity Guide."

The GATF Color Chart. With the publication of the GATF Color Chart the industry has a very simple and most effective tool for standardizing proofing of full color work. The proofing department should use the sets of positives and negatives supplied by GATF and make proof plates from them. The proof plates made should include every kind of plate made in a particular plant. These various proof plates should be proofed with the standard set of inks as they are selected for a specific plant on all kinds of paper used for full color printing in this plant.

The proofs should be combined into proof-books by kind of plate and kind of paper; they can be bound in looseleaf binders for protection. These books of progressive proofs should become the standard source of reference for all future jobs. Such proof-books are standard setting for everybody concerned, for the proofer, but not less for photographers, color etchers, platemakers, and pressmen, all of whom can use them for visual or densitometric comparisons. For further information on this subject see GATF Bulletin #320, "The GATF Color Chart Book."

The GATF Color Strip. The GATF Color Strip, as described in the already mentioned Bulletin #320, contains 21 blocks. Listed from left to right they are:

1, Solid yellow.
2, Solid yellow and solid magenta producing red.
3, Solid magenta
4, Solid magenta and solid cyan producing blue or purple.

5, Solid cyan.
6, Solid cyan and solid yellow producing green.
7, Solid cyan, magenta and yellow producing black or brown.
8, Solid cyan, magenta, yellow and black producing maximum black.
9, Black
10, 11 and 12, three-quarter, one-half and one-quarter tints of yellow.
13, 14 and 15, three-quarter, half and quarter tints of magenta.
16, 17 and 18, three-quarter, half and quarter tints of cyan.
19, 20 and 21, three-quarter, half and quarter tints of equal dot sizes of yellow, magenta, and cyan.

The inclusion of the GATF test strip on every proof makes it possible to check ink-film thickness and ink distribution across the sheet either by eye or with the aid of a reflection densitometer. Variations in ink balance on the press are immediately visible by studying the last three blocks, #19, #20 and #21 on the Color Strip. These three blocks are, as already listed, the three-quarter, one-half, and one-quarter equal dot-size blocks of yellow, magenta and cyan. The GATF Color Strip should, of course, also be put in the press plate and appear on the press sheet. By assembling duplicate films a row of test strips can be made to print across the back of the sheet.

The Use of the Densitometer. The densitometer plays a very important role in evaluating proofs and press sheets. For this purpose a reflection densitometer is needed. It is used for checking the thickness of the ink film during proofing by reading the solid squares of the yellow, magenta and cyan color strip with the blue C5 or C47 filter, the green B58 filter and the red A25 filter, respectively. It is, of course, understood that every ink must be read with the complementary filter.

By keeping records of these densitometric readings it becomes possible to set densitometric or numerical standards for each color ink. Proofing has then the task of taking the readings of the color blocks, adjusting the ink until the proper reading is obtained and making sure that the readings are uniform throughout the sheet.

There should be no tampering with the ink balance by running different amounts of ink in different areas of the sheet. If the positives or the plate is faulty it should be changed, but the amount of ink being run on the sheet should be the same throughout the total sheet area for every color. Many plants use a long color bar for each color across the back of the proof sheet; the GATF Color Strip is preferable because it occupies less space and because it affords additional information. (See GATF Bulletin #320 for further detail.)

The Comparative Viewing of Originals, Proofs and Press Sheets. The lithographer and his customer should have an understanding on the light in which the reproduction of a full-color job, in particular a job made from color transparencies, is to be viewed. Here we are not very much concerned with the best kind of light and the

most advisable color temperature of a light source; here we want to emphasize the necessity for using the same light source by customer and lithographer for the viewing of all elements having a role in full-color printing.

Eastman Kodak's #1 viewer is inexpensive, not heavy and easy to carry around. The Macbeth (Philadelphia, Pa.) Chromocritic Viewer contains two light sources that can be mixed and measured and the pair of readings can be given to the lithographer by his client for each color transparency. This enables the lithographer to view the job in the same light in his own plant.

Most plants use various kinds of daylight fluorescent lighting for the viewing of artwork and proofs. It is better to depend on artificial light for this purpose because daylight varies too much. Care should be taken to make certain that the same kind of lighting is used throughout all departments where color work is produced in a lithographic plant.

The Macbeth Corporation of Newburg, New York, sells a packaged lighting system usable for viewing transparencies as well as proofs or press sheets. This seems — to date — to be the best approach to the problem because it makes it possible to view transparencies, artwork, proofs and press sheets under similar lighting conditions.

THE SCOPE OF COLOR PROOFING WITH INK

Color proofing with ink is a complex subject with many ramifications. It is full of ifs and buts because it has so very many variables. Our first step in the study of color proofing with ink consists in isolating four groups of variables for an introductory discussion. These four kinds of variables are: (1) The plate used in proofing; (2) The press used for proofing; (3) The purpose of proofing; and (4) The evaluation of the proof. Each of these four kinds of variables is now discussed in some detail.

The Plate Used in Proofing. We distinguish between two kinds of plates for proofing: (1) The unit or intermediate plate; and (2) the final press plate. The unit plate or intermediate plate is a plate made for the purpose of proofing exclusively. In full color proofing we mean, of course, a set of plates when we speak of a plate. Unit plates proof the result of color separation and color correction. In many cases the final press plate is not made by the same organization that took care of color separation and color correction. This situation prevails very often when a trade shop is involved. The trade shop supplies a set of color-corrected halftone negatives or positives to the lithographer who will print the job. The final press plate is very often not supplied by the trade shop but made in the lithographic plant. This is particularly so when jobs are printed "many-up."

In the case of such jobs we may have several proofings for the same job. The first proof may be a unit or intermediate proof. This proof may or may not be made in the lithographer's own plant. Assuming the best case, namely that the first proof needs no corrections and that it is enthusiastically approved by the customer, the final press plate is made from the same negatives or positives which were used for the making of the intermediate plate.

The final press plate can have a variety of proofing experiences. We must number the cases because they become too unwieldy by themselves. We distinguish four possibilities: (1) The final press plate is not proofed at all; (2) The final press plate is used for preliminary proofing, independent of presswork; (3) The final plate is proofed as part of presswork; and (4) The final plate is proofed two times, preliminary to presswork as well as in the course of presswork. These four possibilities do not include makeover and other contingencies.

The last ten years has witnessed an enormous change in lithographic plate-making materials and techniques. While this has been a boon to the industry, it has tended to complicate proofing. This is especially so where proofs are not merely a guide to how the final job should look but an absolute standard to be followed. The problem of matching wet-printing to dry proofing has always been recognized. But the problem of matching press prints made with one type of plate on the press, to proof prints made with another type of plate has not been carefully thought out except in rare instances. This problem has been aggravated by the practice of using low-cost platemaking materials and techniques in proofing jobs which are to be run from deep-etch or other long-life plates on the press.

A bit of thought, planning, and some cost can reduce this problem to a minimum, and often eliminate it completely. Despite the wide variety of plates available, most plants do standardize on from one to three plates depending on the range of work done in the plant. For an investment in a proof plate and several press plates made up of a series of halftone scales, or the GATF Color Chart, the differences between a proof print and press print can be calculated. This in turn serves to guide the proofer in how to distort his plates and proofing techniques to match what the press plate and press combination will produce under production conditions.

The Press Used for Proofing. Proofing can be done on five kinds of presses. Three of these are proof presses and two are production presses. The three kinds of proof presses are discussed in the unit on proof presses; the two kinds of production presses are: (1) production presses used for proofing but not for the final running of a job; and (2) production presses used for the final running of a job.

The variety of proofing techniques becomes clear — or should we rather say bewildering — when we combine the possibilities discussed under the preceding heading with those of presses used in proofing. Then we arrive at the five following major groups: (1) Unit plates proofed on proof presses; (2) Unit plates proofed on production presses; (3) Press plates proofed on proof presses; (4) Press plates proofed preliminarily on production presses; and (5) Press plates proofed as part of presswork. Each of these groups will be discussed in the course of this study.

The Purpose of Proofing. Proofing of full-color jobs has the same purposes as proofing of single and multicolor jobs, namely, proofing for internal and for external use as well as proofing for accuracy. But full-color proofing has one additional purpose which is so important that many

people believe it to be the only purpose of full-color proofing — this purpose is, of course, color fidelity. Color fidelity is the most important single feature of a finished full-color job. But it is by no means the only feature of importance. In ganged-up jobs accuracy of register is just as important if not more so than fidelity of color. Accuracy of register is a paramount requirement in all jobs for packaging, particularly if the press sheet must be diecut in the course of production. This kind of accuracy must, of course, be incorporated into the final press plate.

The Evaluation of the Proof. Whatever other purpose a proof may have, in some manner it must also serve as a guide for final production — if this is not its main purpose. It is most important to understand that various kinds of proofs must be evaluated in various ways. Lithographic production is a very intricate and sensitive process. Variables in plate, ink, press and atmospheric conditions, all express themselves in the finished product. Whether lithography is more sensitive than other high-speed color printing processes or not is a moot question that has no bearing on the subject of our discussion. Here we want to point out that great care and circumspection is needed for highest quality results. Lithography has demonstrated its capabilities time and time again and has therewith attested to the high qualities of its craftsmen, their sense of judgment, and their concern for very small detail. A proof will serve its purpose better, the better informed the people are who must read and understand it. You will read more on this subject as our discussion progresses.

In recent years, there has been considerable increase in knowledge concerning full-color reproduction. Coupled with this there have evolved improved inks, especially in the area of process colors. These two factors among others, have made it possible to vary color sequences when running. Sequences are varied not only to meet the color demands of a specific job, but to accomodate differences due to running dry or wet, or a combination of these. In some cases, color sequences may be determined by the type of press being used. This is especially true with some of the newer two-color presses which pose different trapping problems than older, conventional press designs.

PROOFING ON PROOF PRESSES

Three kinds of presses are available for proofing of lithographic plates: (1) Hand proof presses; (2) Power proof presses; and (3) Automatic proof presses. Each of them is briefly described in the following:

The Hand Proof Press. The hand proof press is a simple machine made up of two metal beds positioned side by side. Two gear racks are so situated that a rubber-covered cylinder can be guided by hand back and forth across both, carrying ink from the plate attached to one bed to a sheet of paper located on the other.

The plate is lightly dampened with a sponge and while still wet with water, ink is applied with a hand roller. When the plate is fully charged with ink, the excess water is fanned dry and the cylinder is rolled over the plate bed. Here the ink impression is picked up on the rubber blanket cylinder as it rolls over the sheet of paper on the impression bed and leaves the ink image there.

The dampening and inking operation has to be repeated for each sheet to be printed. When hand proofing a four-color job, fifty sheets is the usual number used. This number should be sufficient to yield two proof-books and half a dozen proofs for the customer.

The Power Proof Press. The power proof press is operated in the same way as the hand proof press, but the movement of the blanket cylinder back and forth from plate to paper is motor driven. Dampening and inking is still done by hand.

There are two advantages in the use of a power proof press: (1) The rate of speed the blanket cylinder moves from plate to paper has some bearing on print quality and ink-film thickness. The power press enables the proofer to maintain a uniform printing speed and consequently higher quality and more uniform proofs. (2) The increased efficiency of the power press makes longer proofing runs possible.

The Automatic Proof Press. The automatic proof press prints from two flatbeds just as do the two already described presses, but now the inking and dampening systems are automatic just as they are on production presses. The automatic proof press has a set of dampening rollers and a water fountain, a set of ink rollers and an ink fountain. Uniformity of proof sheets is assured and production speed is increased enough to make short edition runs possible. Sheets are hand-fed, however. The speed of an automatic proof press is consequently much slower than that of a production press.

The usual proofing procedure in use in most plants is to proof color work on proofing equipment smaller than the final press size. When full-size press plates are made after proofs have been okayed, the register and color accuracy of these press plates can only be checked by going to press.

An automatic proof press large enough to accommodate full-size press plates can be used to check their register and color accuracy without taking up valuable production press time.

PROOFING ON PRODUCTION PRESSES

Proofing on production presses can be divided into two groups: (1) Proofing of unit plates; and (2) proofing of the final press plate.

Proofing on Unit Plates. A single-color press, generally a smaller one than the final production press, is set aside for proofing. This press is used in the same way as any of the previously described flatbed proof presses. Here, too, units or section of a job are proofed for color and register. These units or sections are later stripped and assembled for photocomposing onto the final press plates.

Proofing of the Final Press Plates. In this kind of proofing, a set of finished press plates is proofed preliminary to the press run. Preliminary proofing will be done for particularly fussy jobs or for particularly long runs. Proofing of final press plates can be handled in several ways.

On single-color presses there is no other choice but to proof all four plates in succession; generally the order is (1) yellow, (2) magenta, (3) cyan, and (4) black. On two-color presses, however, it is very often possible to use a technique similar to the "strike-sheet" described under the heading of "Special Proofing Techniques" in the preceding section of this study. On two-color presses the plates to be run as the third and fourth (the third and fourth *down* plates to use the pressman's language) are put first on the press. After printing sufficient sheets for register and uniform color, the press is worked up and the plates exchanged for the first and second plates of the job. Thereby it is possible to check all four colors before the beginning of the run. If everything is okay the saving is considerable because the first and second plates are already on the press, ready to run.

PROOF PLATE AND PRESS PLATE

The result of printing a plate on a hand proof press and on a production press is not the same. The press plate tends to print heavier than the proof plate, particularly when the proof plate was printed on a hand proof press. This fact must not be ignored in the planning of the press plate. If it is neglected, you are headed for trouble: Either the whole set of plates must be re-made or every plate must be run with less ink than normal. The result of running with insufficient ink is, of course, a flat and unattractive job.

The technique whereby you compensate for this consists in making press plate and proof plate intentionally different. The proof plate is made full and the press plate is made sharp. An example explains what we mean by full and sharp. In the case of deep-etch, the proof plate is made to have a reading of 5 to 6 on the GATF Sensitivity Guide. The press plate will be made to have a reading of 8 or 9 on the same guide.

If a color is too heavy or too full on proofing, the positives should either be re-etched or made over in order to obtain a lighter image. It is not advisable to re-make the plate from the same positives and to reduce the image by overexposure.

Another point worth remembering is the difference between camera positives and contact positives. On contact positives there is very little halation present around each dot. Small variations in plate exposure have, therefore, little effect on the dot size of the plate. This is not the case when camera positives are used because camera positives have a softer dot formation; press plates made from camera positives are very noticeably different if made with different exposure times. It is therefore a good principle to use contact positives for platemaking and to stay away from camera positives. The problem of matching proof sheets and press sheets is thereby greatly simplified.

Lithographic Presswork ————————————————

Section One: Introduction to Presswork

In all the graphic arts, with only a few exceptions, the equipment that produces the printed substrate is the focal point of a particular process. This situation is true even though the printed or lithographed material is very often processed in some finishing steps, and even though the finishing may be an expensive procedure during which the appearance of the lithographed substrate may be completely changed in order to attain its final product form. All preparatory steps, while they are designed to utilize the inherent advantages of the lithographic process as much as possible, are determined nevertheless largely by the capacity of the pressroom equipment. It is true that the choice of press may depend on the demands of the finishing processes. However, once this choice has been made, all further activity is aimed at deriving maximum output from the lithographic press at the least possible cost.

This chapter is devoted to an analysis of the lithographic offset press. The stress will be on the general capabilities and characteristics of the lithographic offset press and how it functions as a part of the closely integrated lithographic process.

The presentation considers the many types of presses and their particular features, but stops short of one particular subject: No attempt is made to indicate the superiority or inferiority of various press designs. Discussions of this kind are omitted; they are left to the buyer and seller of printing equipment.

The lithographic offset press is described in terms of utilization and operating principles of the various press designs; operating details may be included only where the writer's considerable contacts with plants indicate a definite need for such information. How each press design handles the material being lithographed will be explained. Essential press components—cylinders, inks, dampeners, feeders (sheet and roll), deliveries—will also be covered, as will the more common auxiliary devices. There will be no less concern with the many control methods used throughout the printing operation. The description will not be made in the sense of an instructional manual for prospective operators, but rather for the purpose of imparting general information on what to expect from a press, on how to achieve those expectations, on which factors to consider when planning the purchase of a lithographic offset press, and on understanding the production of printed material on press equipment with which a plant is equipped.

Omission of the small "duplicator" type of offset press is not due to an oversight. It is admitted that such presses are widely used and capable of doing an excellent job in their own field; they are even used for fine work in some special cases. The fact remains, however, that they are essentially office and "quick" printing equipment rather than production machines for a commercial printing plant. There is no denying that they are limited in ink-covering power, impression rigidity, and pinpoint register when compared to the production type of equipment.

The general framework of this chapter has been described in the preceding paragraphs. From what has been said there, it could be assumed that the web lithographic offset press is discussed simultaneously with the sheetfed press. This treatment would be logical if the chapter was confined to printing by the lithographic process—lithographic inking and dampening techniques are pretty much the same on both sheetfed and web presses; the "offset" method is also the same. However, there is no commonality between feeding and delivery in web printing and sheetfed running. While there is a great deal in common between web and sheet printing so far as the offset printing method is concerned, the handling of plate and blanket cylinders and the way they function on a blanket-to-blanket press requires a discussion completely independent from printing with "hard" impression cylinders. This requirement is true despite the fact that many forms printing presses do use a hard impression cylinder and may, therefore, be considered as akin to sheetfed presses.

It will be obvious that the writer deliberately avoids the use of the term "offset" when discussing our printing process. The reason is that "offset" as such merely describes one method by which lithography can be produced. The "offset method" can be, and is indeed, used in other printing processes as well—in both relief and intaglio printing, for example. Therefore the distinguishing characteristic is not offset, but "lithographic" or "lithographic offset." Since the offset principle is the most common one used in lithography, this chapter primarily discusses presses that print by the offset method.

It is customary to discuss presswork under three separate headings: makeready, operation, and maintenance. From a

management point of view, this breakdown is essential, in order to accurately allocate costs and determine selling price. In a discussion such as this, however, it is impossible to draw a sharp line of demarcation between these three phases of presswork. Is the checking and setting of cylinder pressures, for example, better discussed under maintenance or makeready? Or, take the case of a job that is already running but not printing as it should, and where it is discovered that the pressure between plate cylinder and blanket cylinder is not quite right. Is the checking and adjusting a part of makeready or of operation? For the sake of readability as well as efficient production, all aspects of getting good quality and high production out of a lithographic offset press must be considered in every single step of presswork: during checking, adjusting, and setting of the press no less than while getting the press ready to run; during the running no less than at the final delivery of the job.

Before going any further, it should be understood that the material in this section covers specific points concerning generally accepted principles of pressmanship. However, the details of operating a particular press cannot be included here. Such information can be found in the manufacturers' manuals.

It should also be kept in mind that the writer's point of view demands the unceasing efforts of everybody concerned to come as close to perfection as is mechanically and humanly possible. This viewpoint may sound at first glance like a blue-sky illusion on the possibilities of practical operation. However, the writer firmly believes—and has so proven through many years of practical printing experience—that it does not take any longer to do the job right than it does to do the job in a slipshod manner. In the long run, it always costs less, and costs are, in today's competitive world, of paramount importance for the prospering and growth of every lithographic business.

Section Two: Describing a Lithographic Press

In general, lithographic offset presses are described by using as criteria their size, number of colors, sheet or roll feed, and whether or not they are perfecting.

Size. When the size of a press is stated, reference is being made to either the maximum size sheet that can pass through the press, or the largest optimum size. Largest optimum size is seldom more than ½ in. smaller than the absolute maximum size, and almost always in the longer dimension. This dimension is the one parallel to the axis of the press, sometimes described as the "across-the-cylinder" direction. For example, the ATF "Chief 22" handles a maximum size sheet of 17½ × 22½ in. Its optimum size is 17 × 22 in. The range of standard sizes in lithographic offset presses, other than duplicators, runs from a 14½ × 20½-in. capacity to 54 × 78 in. Special presses have been built in larger sizes, but they are not available as standard models.

Webfed press sizes are generally stated in much the same way as sheetfed presses. However, while sheetfed press sizes are given as the maximum size sheet which can be fed through the press, all these presses can handle sheets which are smaller in both directions. For example, a 17½ × 22½-in. press can handle a sheet as small as 8½ in. in the around-the-cylinder direction and 11 in. in the across-the-cylinder dimension. A webfed press is

quite different; the around-the-cylinder direction, referred to as the "cut-off," is fixed. The across-the-cylinder direction is usually given as the maximum width roll which can be handled. For example, a 22⅝ × 38-in. press will deliver a sheet (or signature) exactly 22⅝ in. in the around-the-cylinder direction, with the 38-in. dimension flexible up to a maximum of 38 in. In most cases the shorter dimension stated is the cutoff length.

Courtesy Rockwell International

An integrally built two-color unit.

Number of Colors. When discussing a press in terms of "number of colors," reference is being made to the number of printing units, if it is a sheetfed press. (The term "unit," as synonomous with "color," is not technically correct in many cases, as explained in the following paragraphs.) It is understood, of course, that each printing unit will be run with a different color and that the number of colors describes how many separate colors can be printed on the sheet with one pass through the press. It is obvious, of course, that a "split" ink fountain on one or more of the units results in more "colors"

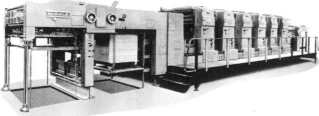

Courtesy Rockwell International

A six-color sheetfed press. Note two-pile delivery.

being laid down during one pass through the press. The considerations in such cases must then include the ability of the particular press to handle the job requirements and the imposition.

The design of multicolor presses has followed two basic approaches. As the lithographic process grew, multicolor presses developed primarily by assembling single-color units in

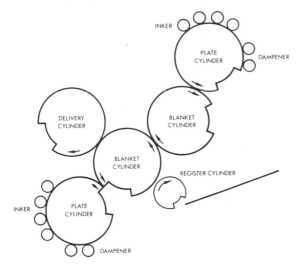

Schematic of a perfecting press.

tandem with transfer devices between units. This "open" unit design was originally available only in larger press sizes, but this design is now used in multicolor presses as small as 26 in.

In recent years, integrally built two-color presses have been developed. One company incorporates the "common-impression" cylinder in its design. Others utilize a "transfer" cylinder between each of the two printing sections; two such integrally built units are set up in tandem with a transfer device between them to become a four-color press. Three such units become a six-color press.

The range of colors on most presses used for the general run of lithographic work is from a single color to six colors. In the metal decorating field, there are presses that "roller coat" a lacquer or base tint on the metal blank before it is passed into the first printing unit.

Feeding. One criterion for describing a press is whether the press handles sheets or rolls of paper. This criterion designates whether the press moves cut sheets through the feeder or is fed by threading a web of paper from a roll through the press. Hence "web press" is the common term for a press that prints on paper fed directly from a roll and threaded through the press. Sheetfed presses that utilize a roll sheeter in place of or to supplement a sheet feeder are best described as

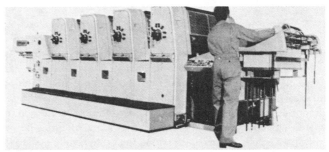

Courtesy HCM Graphic Systems, Inc.

An open-unit four-color press.

"roll fed through a sheeter." This terminology leaves much to be desired, but as this feeding technique becomes more widely used, a less confusing description may develop.

Perfecting. The last criterion to be considered is that of perfecting. A perfecting press is one which prints on both sides of the paper in one pass through the press. Perfecting presses may be sheetfed or webfed, single-color or multicolor. Most webfed presses are perfecting multicolor presses of the "blanket-to-blanket" design. However, if equipped with the necessary

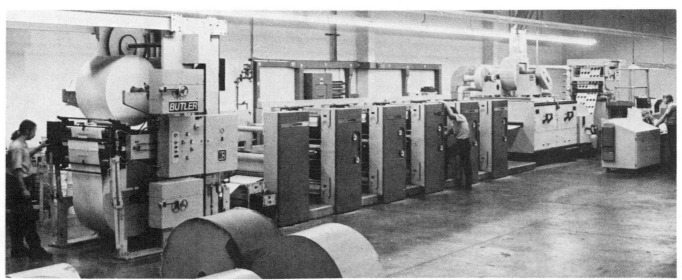

Courtesy Harris Corporation

A six-unit web press that can run two webs at once in various combinations.

white-roll stands, these presses can be used for single-color perfecting. For example, a four-unit blanket-to-blanket press can run four colors on both sides of a single web (split-fountain running is not being considered here), or this same press can run one color on both sides of four separate webs if the press is equipped with four white-roll stands. Between these two extremes, a variety of combinations is possible on the same press.

Most sheetfed perfecting presses are basically one-color presses. Interesting combinations, however, are available. In one instance, it is possible to use the same press as a two-color (on one side of the sheet) press or as a one-color perfecting press. In another case, single-color and perfecting units are tied together in such a way as to produce both perfecting and color during one pass of the sheet through the press.

Terminology. The terms used up to this point to describe a press are both generally known and yet somewhat arbitrarily employed by this writer. There are a number of reasons considered valid by him for this. In the first place, more and more presses are being designed and built to do a special job or a special type of printing. In the second place, presses may be described with respect to special auxiliary features in addition to the four criteria used in the preceding paragraphs. And, in the third place, there are many variations and combinations possible within the basic criteria. For example, mention was made previously of six- and eight-color presses. A sheetfed press could print six colors in one pass of the sheet through the press, or it could be a six-color perfecting press that prints four colors on one side of the substrate and two on the reverse side during one pass of the paper through the press. A five-unit drum-type press running from a half-width roll with a "double-ender" principle can print five colors on one side and five on the reverse side using split fountains on all five units. An eight-color web press, in actual practice, is usually two four-color presses

printing four colors on both sides of two webs and running both printed webs into a common folder. And so on, ad infinitum.

Common and Technical Designations. The matter of describing a press in greater detail by reference to special auxiliary features can also become complicated because of the myriad of combinations possible. Some of the simple, more frequent descriptions state whether a sheetfed press feeds continuously or whether the press delivers sheets in a single or double pile. But whether a perfecting press prints blanket-to-blanket or whether a multicolor press uses a common impression cylinder goes beyond the commonly known and carries us into the realm of technical and engineering detail. These points, too, will be covered later in our chapter.

Auxiliary Features on Web Presses. There is one particular time when it is important to describe a press with reference to its special auxiliary features. This is the case when web presses are being discussed. There it is important to know immediately—in addition to size, colors and perfecting—the manner of delivery and what special attachments exist between the last lithographic unit and the actual delivery. Special attachments may include such items as perforators, slitters, numbering heads, punches, etc. Delivery may cover such systems as rewinders, sheeters, and folders, or the subject may even lead us into a completely different operation, such as a continuous cutter/creaser attachment. These attachments will help produce such items as multiple forms, interleaved sets, spot-carboned leaves, cellophane-windowed pieces, insertions, and cartons.

Auxiliary Features on Sheetfed Presses. Such features are limited, up to this time. Units are added to lithographic offset presses which will perform such auxiliary operations as bronzing, perforating, slitting, folding, etc.

Section Three: Sheet Feeders

The lithographic offset press can be either sheetfed or rollfed. Roll feeding, as generally thought of, is in Section Ten of this chapter as part of the web offset press discussion. This section is exclusively concerned with sheet feeding. The presentation is divided into two main parts. First, the different types of feeders are presented, and then the setting of feeders is discussed.

TYPES OF FEEDERS

Sheet feeding is accomplished in one of two ways, either as successive-sheet feeding or stream feeding. Either of these two methods can be combined with one of two means in which the paper can be placed in the press. These are known as pile feeding and roll feeding. The presentation is therefore further divided into the following four subjects: (1) Successive-sheet feeding; (2) Stream feeding; (3) Pile feeding; and (4) Roll feeding. Each of these is now presented individually.

Successive-Sheet Feeding. In this method of feeding, the

top sheet is separated from the paper supply (almost always a pile) and advanced to the feed board, table, tapes, or ramp (depending on feeder design). The following sheet is not separated from the pile or main supply until the tail end of the preceding sheet has cleared the advancing mechanism. There is therefore a distinct space and time interval between sheets. In successive-sheet feeders the original advancing of the sheet almost always takes place at the gripper edge of the paper. The significant point to observe in this type of feeder is that *the sheet must travel forward at approximately the same speed as the press operates, since one full sheet is advanced at a time to the registering and/or insertion device.*

The speed of the moving sheet is, consequently, very rapid, and special attention must be paid—especially on lightweight, large-size sheets—to holding the sheet down during forwarding and to keeping it moving at press speed without any drag or cocking. Successive-sheet feeders generally employ some kind of a "slow-down" or preregister device just ahead of the

registering or insertion point. These devices are used to prevent the sheet from buckling or bouncing as a result of the momentum built up during the rapid speed of the forwarding operation.

A successive-sheet feeder with one sheet on the ramp.

Stream Feeding. In this system a continuous flow of sheets is separated from the supply and advanced to the forwarding mechanism. In stream feeding, however, the separation *and* original advancing of the sheet takes place at the back end of the paper. As soon as one sheet is advanced onto the forwarding devices, the following sheet is separated and also advanced. Thus a number of sheets are moving forward all the time. The sheets overlap each other by some part of their length, and the speed of forwarding is proportionately reduced in comparison with the forwarding speed on successive-sheet feeders.

Because of this overlapping, as one sheet is drawn into the nip by the impression cylinder grippers, the following sheet has only several inches of travel to reach the registering device. This slow travel of the sheet to the registering position on stream feeders simplifies some of the sheet control problems prevalent on a successive-sheet feeding mechanism. Another important advan-

tage of stream feeders is that preceding sheets themselves tend to control the following ones as a result of their large overlap.

The guide edges of each sheet are under control of the preceding sheet almost to the very point of register. This control

Loading a pile feeder.

coupled with the slow rate of travel almost completely eliminates the problem of bounce or buckle at the register point. The stream feeder is used on almost all presses with the exception of some small job and paperboard presses.

In some cases, the feeder is so designed that it can be converted very easily from successive-sheet feeding to stream feeding, and vice versa, depending on the needs of a particular job. This convertibility is a feature of some advantage when running heavy board stock.

Mention should be made of one precautionary, but debatable, point with respect to stream feeders. There appears to be a tendency for static to develop, especially when such a feeder is operating in a very dry pressroom; for example, one located in a building that is heated in the winter but not humidified. Where

A stream feeder. Note the overlap of sheets on the ramp; from front stops to forwarding wheels, generally four sheets.

Modern sheet separator for stream feeding.

it is ascertained that static is developing in the feeder, neutralizing bars should be installed.

Pile Feeders. This type of feeder is simply described as its name is very indicative of its nature. Here, the paper to be run is piled on a platform in the press feeder. This pile must, of course, be straight and neat and it must be positioned in correspondence with the settings of the register and insertion devices. All these points are covered more extensively in the discussion on the setting of feeders.

The pile feeder raises the paper automatically to a constant level during printing. The pile feeder is the most versatile and flexible method for handling sheets. The main disadvantage of the pile feeder lies in the fact that the press must be stopped or idled for its loading. In very long runs this drawback is a very important one. In short-run work where the total quantity of the paper to be lithographed does not exceed the capacity of the pile feeder, this limitation does not count at all. Attempts to reduce this drawback to an irreducible minimum resulted in means for loading a succeeding pile in the press before one pile is exhausted. The new pile can then be started with no time loss.

Continuous Feeding. Continuous feeding as such is not new. The larger folding machines are equipped with continuous feeders. These feeders, however, haven't proven practical for lithographic presses. They are not sufficiently flexible for the wide range of sheet calipers run on lithographic presses. On large-size presses, extra paper handlers are required to keep the press running continuously. In recent years, the need for continuous feeding has been met by making it possible to load a pile feeder while the press is running and bringing the fresh load into feeding position before the preceding load has run out.

The fresh load is placed into elevating position when the preceding load still has some time to run. By means of supplementary elevator bars, the weight of the small load is temporarily supported on rods inserted under the bottom of this load. The pile elevator bars are lowered to the fresh load and this is elevated up to the bottom of the preceding load. The rods are withdrawn; there is now a single pile in the feeder. If care is used in this series of operations, all comparatively simple, there is no interruption to the running of the press.

While the advantage of increased productivity is self-evident, there are important advantages to continuous feeding that are overlooked by those contemplating the purchase of a modern lithographic press. The advantages referred to are lower spoilage and consistent quality. It is well recognized that the more steadily a lithographic press runs, the easier it is to maintain consistent color. In critical work, it is not necessary to pull the off-color sheets that are produced as a new pile is started in a press not equipped for continuous feeding.

Sheet Feeding from Rolls. Of even more recent date is the development of sheet feeding directly from a roll. As everyone knows, paper is manufactured in rolls at the mill and is converted into sheets thereafter. Then, if mill trimming is specified, the sheets are trimmed on two or four sides as specified. One of the important advantages of rollfed presses— web presses—is the fact that paper bought in rolls is significantly less costly than sheeted paper. However, sheetfed presses are the backbone of the lithographic industry and their flexibility is a factor that will, in all likelihood, keep them in this status. Some plants buy paper in rolls and sheet the rolls in the plant.

The interest is, therefore, in how to cut costs on sheetfed equipment. One way to do this is to replace our present feeders with sheeters. In this case, a roll of paper is placed into running position in a sheeter. There, the web of paper is converted into individual sheets, and the cut sheets are fed directly into the press. In addition to the savings in paper costs, there accrues also the advantage of nearly continuous operation. This advantage so far can only be realized where continuous feeding is used. Sheeters are available that can be tied into the press as an auxiliary device to the standard pile feeder. This sheeter design makes it possible to feed from rolls or cut stock. The press, then, retains the flexibility of running the full range of paper sizes and weights with the sheeter being utilized for a few "standard" sizes and weights, thus minimizing the roll storage problem.

Sheeters are designed for side or tandem installation. A side-mounted sheeter will make possible "grain-long" running of the paper; that is, the grain of the cut sheet is parallel to the axis of the press cylinders. Running grain long is most desirable when register is critical, or when the printed sheet will be passed through a press more than once, such as for additional colors or for backing-up.

Tandem-mounted sheeters are an advantage in book work, especially where large-format books are run on large-size presses. Very often, the imposition for such books require running grain short. In many cases, these presses are perfecting

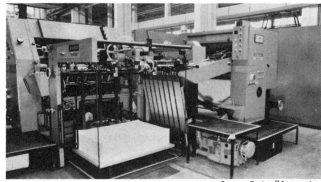

Courtesy Rockwell International

Sheeter on a rollfed press.

presses, which eliminate the problem of running a grain-short sheet through the press more than once.

It should be borne in mind that the difference in cost between roll and sheet stock is about 12%. The higher cost of sheeted paper is due to the cost of inspecting and sorting as well as sheeting and trimming. Inspecting and sorting of paper may be important for certain classes of jobs. In these cases, sheetfed running is, of course, indicated.

SETTING THE FEEDER

Following is a discussion on the setting of feeders. The discussion begins with the loading of a feeder and ends at the point where the sheet is forwarded down to the guides and/or registering devices. These are not included in this section but are treated in "Section Four: Guides, Grippers, and Insertion Devices" following immediately after this section.

This presentation concentrates on the following three topics: (1) Loading the feeder; (2) Pile-height governor and sheet detector; and (3) Separating and forwarding.

Loading the Feeder. On smaller presses, the paper is loaded into the feeder directly. On larger pile feeders, a platform or skid is piled with the paper, away from the press, and when required this skid is wheeled into the feeder. Also on these larger presses, the skids of paper, as received from the mill, may be wheeled directly into the feeder. In all of the above mentioned cases, the side-guide edge of the sheet is placed in such a position as to reach the front guides or insertion devices within the area in which the side guide operates. For example, on a press equipped with a rotary (roller-type) guide, the edge of the sheet must be between the lower roller and upper roller so that the upper roller—when it comes down—can pinch the sheet and pull it against the face of the side guide.

There is either a pair of matching scales across the feed board near the side guide, and across the front of the feeder, on the feeder platform, or simply a scribed centerline. A side pile guide is set at the point corresponding to the operating area of the side guide and the paper piled against it. Where the paper is being piled away from the press one of two methods may be used to pile the stock properly on the skid or platform. In one case, a vertical line is drawn on the wall or a special back jogging board. The skid is placed in such a way that its center matches the center of the sheet when measured from the vertical guide line. The other method is to build a piling jig similar to those used for large-volume padding work.

In any case, it is imperative that the pile be perfectly straight and even. At the gripper edge of the pile there must be no overhanging or mutilated edges. And the stock must be carefully and thoroughly winded, especially if the paper has gone through the press before and is now to receive a succeeding color and/or be backed up. The skid or platform is now positioned in the feeder and the chains and supporting bars fastened into operating position.

At this point the pile is raised, in the manner prescribed by the manufacturer, to a point a little below the normal operating height. If the feeder is equipped with a side pile-guide on both sides of the pile, the one away from the guide side is set against the pile. Now, the devices supplied for holding the back edge of the pile in place are set. Then the separator and sheet-advancing devices are set to the operating position recommended by the manufacturer. On smaller presses, where separating and advancing devices are one unit, there may be little or no setting required unless changing from a minimum size sheet to a maximum size. On other presses the separating device and back-edge pile controls may be one unit. At this point, the contour of the pile is noted, especially on presses with capacity for large sheets. The importance of this will be discussed later in this section.

Pile-Height Governor and Two-Sheet Detector. The press is now started and run at idling speed until the pile reaches its normal operating height. On all feeders, this is automatic but requires proper setting of the pile-height governor in accordance with the manufacturers' instructions. The two-sheet detector device, sometimes called the "choke," is now set. On successive-sheet feeders, this is done by inching the press to the tripping position as indicated in the manufacturer's instruction book. A 2-in.-wide strip of the stock being run is torn to a length of 6 in. This strip is folded so that a single thickness about 1 in. long protrudes beyond the double thickness. The single thickness is inserted into the choke, which is then adjusted so that the single thickness of stock just slides freely under the choke but the double thickness jams, or trips the detector.

The position of the two-sheet detector on stream feeders is usually such that in normal operation there are several sheets under the choke at the same time. In this case, the device is set exactly as described but with the normal number of sheets under the test strip in the choke.

Separating and Forwarding. When automatic feeders were described earlier in this section, it was stated that the feeder functions by accomplishing two things: (1) It separates the top sheet from the pile; and (2) It forwards the separated sheet to the guides and/or insertion device. In order to have the separator devices function properly, the pile must be at the proper height in the feeder, and the contour of the top of the pile must be reasonably flat. This is especially important on presses with the capacity to handle large sheets.

Separation and forwarding is accomplished entirely by air. Air-blast nozzles fluff the rear edge of several sheets on the top of the pile. Suckers drop down and pick the top sheet up. Another set of air-blast nozzles comes under this top sheet and floats it on a cushion of air. Then the same suckers, or a set of separate forwarding suckers, guide the sheet into the forwarding devices at the top of the feed ramp.

It is obvious that control of the amount of air and control of the direction of the blower tubes or feet is critical. The sheet must be positively floated without riffling, waving or flapping. The sheet being forwarded must be completely separated from the pile so as not to drag the next sheet, or stumble on its leading edge, especially in feeders where no blower foot device is provided. The sheet must be under such positive and complete control that it reaches the forwarding devices at the right time and in a straight position. If both of these conditions are not met, in the first instance proper timing of the sheet is lost, and in the second place a sheet coming down the ramp in a cocked position will either jam at the side-guide mechanism or reach the guides or insertion devices in such a way that it will jam and trip the press.

After the first sheet is separated and advanced to the forwarding wheels, the press is inched and all parts of the forwarding system are checked for proper operation. The term most commonly used for the forwarding controls of the sheet is "table trims." The operator should especially note whether the sheet is coming down straight, whether it is balanced on the tapes, and whether it is being held down without dragging. The sheet is inched until its leading edge is in the side-guide mechanism. The operator notes whether it clears the side-guide face-plate but not by so much as to miss being guided. On all presses, except the smallest ones, there is provision for moving the pile slightly in either direction to make up for any error in judgment at the original setting of the side pile-guide. On the smaller presses, the pile stock can be pushed to the proper position without seriously upsetting the condition of the pile.

The sheet is advanced by continual inching, and the operator makes sure that it arrives at the guides or stops of the insertion device before the side guide starts its cycle of operation. The feeder has then accomplished its mission.

Section Four: Guides, Grippers, and Insertion Devices

In the preceding section on feeders, the concern was with the separation of each sheet of paper from the pile and with its forwarding to the registering position. Once this forwarding has been accomplished, the feeder has fulfilled its function. At this point, a completely different set of devices takes over control of the sheet. Among these devices, great differences are found between equipment of various manufacturers as well as between some models of the same manufacture. This presentation divides the subject into several groups. Discussed first is the most important problem of register and fit. Thereafter, reviewed are the main types of insertion devices, guides, and grippers in general. A discussion of the setting of all these devices concludes this section.

REGISTER AND FIT

Before going further, it is necessary to clearly understand the true meaning and significance of register.

Register. The term "register" as used in lithography means the positioning of the sheet with respect to the image on the blanket. Fit has a different meaning, which is explained further down. During the registering operation, the press aligns the sheet in such a manner that when the impression-cylinder grippers take hold and draw the sheet through the printing nip, the front edge of the paper will be a set distance from the image. This distance is determined when the plate is clamped into proper position and the front guides set. In addition to the front edge of the paper, one side edge is also a fixed distance from the image edge. This distance is also determined when the plate is put on the press and the side guide set in its proper position. The purpose of all these operations is a most important one: each and every sheet must be aligned *exactly* alike. With the sheets under proper control, and the registering devices properly set and operating, register will be accomplished.

Fit. Proper register does not guarantee "fit," but misregister makes the problem of fit a strictly academic subject. One can talk about fit but cannot do anything about it in such a case. The term "fit" is used to describe the *juxtaposition of all image elements in the printing area without regard to the sheet margin* (determined and maintained as a result of registering the plate and sheet). This difference is best clarified by using an example with figures.

For example, a job on the press has front- and side-guide margins that are exactly 1 in. In running the job, the sheets are checked, and each one has *exactly* these margins without *any* variation. The job is therefore registering. However, further checking indicates that the image on the plate measures 40 in. across the back edge, whereas the image on the sheet shows a distance of 39.98 in. Fit is not attained. While this slight variation may not be significant on the average black-and-white job, it could be important if the job were a close-tolerance piece to be diecut. This variation would certainly be noticeable on a four-color process job.

This section of the chapter is primarily devoted to the problem of register and how it is achieved on the modern lithographic offset press. Fit will be mentioned once in a while, but the discussion of the overall problem is not in this section. Further discussions of fit are in the sections on "Cylinders" and "Running the Press" in this chapter.

REGISTER AND INSERTION METHODS

In general, register and insertion methods are classified in three groups: (1) The simple three-point guide system; (2) Feed-roll insertion; and (3) Transfer gripper insertion. It should be pointed out that the simple three-point guide system is not an insertion device. But, the system does fix the sheet in printing position just as is done for any insertion device. However, on presses equipped with insertion devices, the positioning of the sheet before the insertion device starts its cycle of operation is generally referred to as "preregistering." Therefore, the three-point register system is discussed from two points of view: (1) A simple three-point register system, where the impression-cylinder grippers *take* the sheet directly from the front guides; and (2) Where the three-point register system preregisters the sheet in proper position for an insertion device. Front guides are frequently called "stops."

Three-Point Register System. In this method, the sheet is forwarded to front guides (two to four, usually), and while it is held against the front guides, a side guiding mechanism pushes or pulls the sheet into proper side alignment. In the simple three-point register system, the sheet is held in this position until the impression cylinder grippers take hold. At this time the front guides or stops are lifted out of the sheet's path of travel. As soon as the entire sheet clears the feedboard, the guides drop back into position to align the following sheet.

In the simple three-point register system, the guides are mounted on a shaft, which is above the feedboard. The guides can be moved sideways along this shaft in order to properly balance the particular size of the sheet being run. The guide itself is essentially a flat faceplate. In the registering (lowered) position of this guide its bottom edge straddles a metal tongue protruding under the feedboard or a register plate. Very often the guide has built-in devices for preventing buckling of the sheets against the plate. Buckling happens either if the sheet comes down too fast or if the sheet is very lightweight. The guide may also have built-in slowdowns (they may be a separate mechanism) that not only prevent the sheet from buckling but also prevent the bouncing of heavyweight or stiff sheets. Sheet detectors (not two-sheet detectors or chokes) may also be built into the guide; they trip the press if a sheet is not where it should be when the impression-cylinder grippers come into their taking position. The guide is designed for forward-and-back adjustment along the tongue or register plate. This design feature serves the purpose of obtaining desired position when only a small shift is required. Even though this adjustment is built into the guide, it should be used with great care. Any change in the guide affects the amount of gripper bite. Too much gripper bite may cause trouble when the sheet is transferred to the delivery-

chain grippers. Too little gripper bite is not less dangerous; sheets may be pulled out of the grippers when going through the nip or when separating from the blanket after the impression has been transferred to them. If the sheet is too far out-of-square, it may buckle against the side guide or be pulled away from the far stop by the action of a pull guide.

Feed-Roll System. In the feed-roll system, the impression cylinder grippers do not take the sheet from the feedboard. The device actually inserts the sheet into the grippers of the impression cylinder or an intermediate device. After the sheet is forwarded down the feedboard, it is preregistered against a number of stops (front guides) spaced across the entire width of the feedboard. While the sheet is held against these stops, it is side-guided.

While the sheet is at rest, it is firmly gripped in its preregistered position by being pinched between "upper" and "lower" feed rolls, or "cams." The front guides then drop down. As soon as they are clear one set of the feed rolls (upper or lower depending on individual press design) starts rotating and positively drives the sheet against gage pins (or stops), which are located on either an intermediate cylinder (sometimes called a feed or transfer cylinder) or the impression cylinder, depending on the model or make of press involved. These stops may be nothing more than slight lips protruding above the gripper pad. When the sheet is inserted into the grippers, it is held against these cylinder stops until the grippers have closed firmly on the

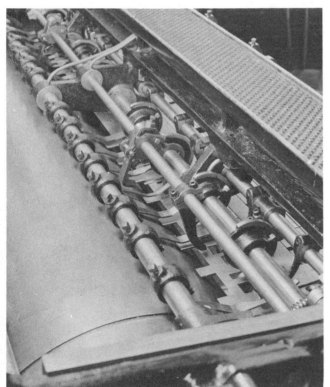

Courtesy Harris Corporation

A feed-roll insertion device.

sheet. At this instant, the pinch is released, and the sheet is completely under the control of the grippers. Where an interme-

diate feed or transfer cylinder is used between the feedboard and the impression cylinder, complete control of the sheet is maintained by having the grippers of the intermediate device positively grip the sheet while the impression cylinder grippers close on it. For a short distance of travel, both sets of grippers are actually holding the sheet. This point is worthy of special note, because on all presses where a sheet is being transferred from one set of grippers to another, transfer is never accomplished "on-the-fly." At some point during the transfer both sets of grippers are actually holding the sheet.

Swing-Feed, or Transfer-Gripper, System. Where the three-point register system is supplemented by an insertion device, the general principle and construction are similar. However, in this case, the front guides are generally constructed so as to drop *down* out of the forward path of the sheet *after* the grippers on the insertion device take hold of the sheet. Another point that should be noted in this case is the likelihood of less freedom for sideways movement of the guides. In the simple three-point register system, the position of the impression cylinder grippers is the principal limiting factor to such movement. With an insertion device, additional clearances must be taken into consideration that may seriously limit, if not completely prevent, such freedom of movement.

In a swing or transfer system, the sheet is forwarded down to the feedboard and brought to rest against front stops. Then it is side guided. After being properly guided, the sheet is picked up by a set of grippers usually mounted over the feedboard, and the front guides move out of the forward path of the sheet. This pickup mechanism is called a swing-feed, transfer cylinder, or transfer-gripper assembly, depending on detail of design. After the sheet has been picked up, the mechanism forwards the sheet and inserts it into the impression cylinder grippers. In this system, positive control over the sheet is maintained during the transfer of the sheet from the insertion device to the impression cylinder.

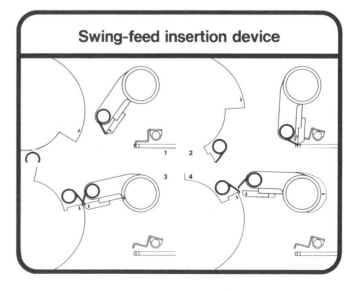

Swing-feed insertion device

SIDE GUIDES

Guides are divided into front and side guides. Front guides are classified as multiple-stop, or two-point drop guides or

stops. As known, front guides may form part of insertion devices; they are discussed earlier in this chapter. Side guides operate completely independent of the front guides or guiding device, and they are the subject matter of the following presentation.

Neither the design of the side guide or the cycle of its operation are affected by the type of front guiding, insertion device, or gripper action on the press. Side guides can be described according to their motion or by the manner in which they operate. As far as their motion is concerned, side guides can be either push-guides or pull-guides. This is true disregarding the side edge (left or right) of the sheet to be guided. Some presses are so equipped that when one side guide is pulling, the guide on the opposite side may be set to push at the same time.

Push Guides. All push guides are essentially the same. The sheet is forwarded into the front guides or insertion device. Then the side guide acts by pushing the sheet into its predetermined position. Whether the side guiding is done at the near side, or at the far side of the press, does not alter the actual guiding operation.

Push guides are generally found on smaller size presses and those running heavy, rigid material such as metal and cardboard. They do not function very well where large-size, lightweight paper must be handled. Along with the push-guide type of mechanism on paper presses, we usually find some type of corrugating or stiffening device. This device serves to put a slight buckle in the sheet to stiffen it against the action of the push-guide.

Pull Guides. Pull guides are of three general types: (1) The finger type; (2) The rotary type; and (3) A combination of these. In all types, the side-guide plate is fixed in the desired position, and the sheet pulled up against it after the sheet has been positioned at the front guides or stops.

Finger-Type Pull Guide. The finger type of guide advances over the sheet, closes on it by pinching the sheet against a lower plate and pulls the sheet to the side-guide plate. The tension on this finger is adjustable. The finger must be so adjusted that it slips over the surface of the sheet without buckling it once the sheet is stopped by the side-guide plate. This adjustment of the finger pull guide is possible for any weight stock. Even though the mechanism is rather simple, the adjustment is, nevertheless, quite critical.

Rotary or Roller Guides. The rotary or roller guide is prevalent on most presses. Built into this mechanism is a lower roller that constantly rotates when the press is running. The sheet is forwarded to the front stops in such a position that the side edge rides over this lower guiding roller. After front register has been accomplished, a second spring-loaded roller, mounted above the lower one, drops down and pinches the sheet against the rotating lower roll. Friction causes the sheet to be pulled against the side-guide plate. As with the finger-type of side guide, the tension is adjustable in order to accommodate a wide range of paper calipers.

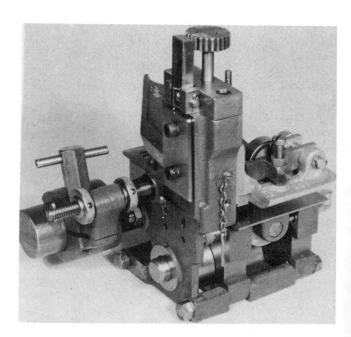

Courtesy Rockwell Graphic Systems

Cross-section schematic of a push-type side guide: (1) push plate; (2) side guide bar; (3) adjusting nut; and (4) corrugating bars.

A rotary or roller side guide assembly, with the locking device and the vernier adjustment on the left; the rollers on the right.

Roller-Finger Guide. In this type of side guide, a finger slides under the front-guided sheet. When it has reached the end of its forward movement, a spring-loaded upper roller pinches the sheet against the lower finger. Then the finger starts to move back and pulls the sheet with it until the side edge of the sheet is stopped by the faceplate of the side guide.

GRIPPERS

Grippers are classified either as tumbler grippers or as grippers. Presses using a three-point register system without an insertion device require tumbler grippers. Presses that embody either a feed roll or swing-feed (rotary-gripper) insertion device employ a "low-lift" gripper. Each of these two types, as well as the general construction of grippers themselves, is discussed in the following.

Tumbler Grippers. A tumbler gripper rotates through a rather large arc when it opens and actually drops back into the impression-cylinder gap below the level of the impression cylinder body. It must do this in order to clear the gripper edge of the sheet as the impression cylinder comes around to its sheet-taking position. At this point, the gripper rotates into the closed position, pinching the sheet against gripper pads and pulling the sheet into the impression nip. The term "tumbler" is derived from the mechanism that imparts the opening and closing motions to the gripper shaft on which the impression-cylinder grippers are mounted.

"Low-Lift" Grippers. ("Low-lift" is not a term used in the trade. It has been adopted here only for convenience.) Presses with insertion devices almost always have a gripper motion in which the grippers open just enough to allow the sheet to be inserted.

Instead of a mechanism that imparts a complete "tumbling action," low-lift grippers are mounted on a shaft that is rotated slightly through a cam and cam-roller device set at the end of the gripper shaft.

Construction of Grippers. Grippers may be of one-piece or two-piece construction. A one-piece gripper has its "finger" part constructed as an integral part of, and an extension of, the base or gripper clamp. In some cases, the base is a solid piece of metal drilled to fit snugly on the gripper shaft. A setscrew is installed into the base in such a way that when the setscrew is tightened it clamps the gripper firmly on the shaft. In other cases, the base may be split forming an open collar around the shaft. The setscrew, instead of being turned down directly on the gripper shaft, or a gripper-shaft shoe, is threaded through both ends of the collar. When the setscrew is tightened, it closes the collar around the shaft thereby clamping the gripper firmly to the gripper shaft. In this case, the finger itself may be an extension of one side of the collar, or the collar is formed on the opposite side of the gripper shaft from the gripper finger.

In two-piece construction, the finger and the collar are actually two separate pieces. They are so assembled that, while the finger opens and closes as an integral part of the assembly, provision is made for spring loading the gripper finger itself. This design feature tends to simplify attaining a more nearly perfect, uniform gripper-bite pressure on the sheet. This same

Three common types of gripper construction. Top: a one-piece gripper; left: a two-piece spring-loaded gripper; right: a one-piece gripper with a spring-loaded gripper pad.

aim is accomplished in the case of some one-piece grippers by spring loading the gripper pad set in the top of the gripper post.

An important detail in construction and functioning of grippers is the character of the gripping face of the gripper finger or the top of the gripper pad. It is obvious that there is considerable pull on the sheet as it passes through the impression nip. Not only must the grippers guide the sheet through the nip but they must also hold the sheet against the pull of the nip. Quite often, the pressure of the gripper against the pad may not be enough. Too much bite pressure may mar the sheet and cause difficulty in later passes of the sheet through the press.

Several techniques have been used to accomplish this. Some newer presses have grit-faced grippers to prevent slippage of the sheet during the critical printing cycle. Others will face the gripper pad to accomplish this. On older presses, the grippers or gripper pads may be faced with lightweight emery cloth if

Grit-faced gripper.

proper bite pressure cannot be developed through the spring-loaded grippers or gripper pads.

The significance and importance of gripper bite and gripper-bite pressure are discussed in this section under the heading of "Setting the Grippers."

SETTING AND OPERATING THE SIMPLE THREE-POINT REGISTER SYSTEM

The three-point register system is here extensively discussed. First the travel of the sheet from the moment when it arrives at the guides to the point when it is carried into the impression nip is followed. Then, the setting of front-guiding devices is discussed and finally attention is turned to the adjusting of the gripper bite.

The Functioning of the Simple Three-Point Register System. Analysis is started with the front- and side-guided sheet. As the impression cylinder comes around to its sheet-receiving position, the grippers start to rotate backwards (toward the leading edge of the cylinder) to the closing position. They reach the point of actually closing on the sheet. But while they are doing this, the cylinder is rolling in its forward motion toward the impression nip. The sheet is held motionless in its guided position. As the grippers actually close on the sheets, the front guides lift clear of the sheet's path of travel to the impression nip.

Sheet Control in the Simple Three-Point Register System. Two things have happened that are important and critical. For a very brief instant, the sheet is not under positive control. This instant of nonpositive control is due to the fact that the guide must clear the sheet before it starts its forward motion. Since the gripper action and the cylinder travel are continuous, there is no way for the gripper to firmly close on the sheet before the guides are lifted. In actual practice, proper timing and setting prevents loss of register during this brief instant. In addition, on presses equipped with a corrugating device, timing of this device is such that it tends to control the sheet during this critical period.

However, something else happened at the same time. The sheet was lying at rest in the guides when the grippers took hold of it. Immediately, the sheet was then jerked into full press speed. On small presses, running at slower speeds, this may not be too important. But on large presses, overcoming the inertia of a large motionless sheet is a serious problem. It is for this reason that larger presses have true insertion devices as standard equipment. Even smaller job presses (under 29 in.) designed to run at high speed (over 7500 iph) feature some type of insertion device.

Setting Front Guides on Three-Point Register System. On smaller presses, there are two guides, or stops; larger presses may have three or four. (The simple three-point register system is not found on any modern press over 29 in., for the previously discussed reasons.) The front guides are set across the press to align and balance the sheet while it is side-guided and at the same time held against the front guides. The guides can be moved across the press on their mounting shaft. They must be carefully set to come down properly on the register plate or tongue. They are always placed *between* a pair of grippers and not over a gripper. And they must be so positioned, in the case of an insertion device, that the stops will clear the motion of the swing or transfer assembly.

They should be so set that they do not bounce on the register plate or guide tongue when they descend, but meet it gently.

Where the guides are mounted with a keyway on the shaft, correct setting for easy seating is almost automatic. After the guides are set, a sheet should be placed against them and slid back and forth as a test that the contact of the sheet and the front faceplate is smooth.

When setting the guide tongues or register plate, it is important to note that they do not cause a bulge in the sheet when the impression-cylinder grippers take it. These tongues should be set to make the gripper edge of the sheet perfectly flat. The tongues should not be depressed when the guides come to rest on them. If the tongues give, they will rise when the guides do and cause misregister or a bulge in the paper. Such a bulge can easily lead to a wrinkle when the sheet goes through the printing nip.

Antibuckling Devices. Antibuckling guides of this type always have some kind of adjustable metal plate that holds the sheet down in order to prevent buckling against the guide. The space should be set to permit free movement of the sheet by the side guide without permitting buckling.

Timing the Front Guides. Now the press is inched forward until the guides just begin to lift. Here, perfect timing is essential. The timing should be such that the faceplate of the guide *just* clears the sheet as the impression-cylinder grippers finally close. If the front guides are set too late, the edge of the sheet is nicked or torn; if they rise too early, there is loss of register.

A typical front guide of a simple three-point register system. A: setscrew for locking guide assembly on shaft; B: anti-buckle plate; C and D: anti-buckle adjustment; E and F: face plate adjustment.

Adjusting the Gripper Bite. These guides can also be adjusted to increase or decrease gripper bite or head margin. This adjustment, however, should be used only as a last resort. *The guides should be set to give exactly the gripper bite recommended by the press manufacturer.* If the gripper-bite adjustment must be used, the faceplate should be returned to its recommended position as soon as the job is finished. Actually, the primary purpose of this adjustment is to make certain that the sheet is taken by the impression-cylinder grippers with a uniform bite across its entire front-guide edge. Improper gripper bite can cause trouble at three points: where the grippers first take the sheet; at the impression nip; or at the point where the sheet is transferred from one set of grippers to another, for example from impression-cylinder grippers to delivery-chain grippers.

SETTING AND OPERATING THE FEED-ROLL INSERTION SYSTEM

The feed-roll system is a true insertion device because here the sheet is *inserted* into the impression-cylinder grippers (directly or indirectly), whereas it is *taken* by them in the simple three-point register system. For the purpose of illustration, the travel of the sheet will be followed for our operational analysis of this device.

The Functioning of the Feed-Roll System. When the sheet comes down the ramp it is preregistered against a series of stops spaced across the press and mounted on a common shaft. The sheet is held against these stops and side-guided. At the proper time, the upper and lower feed rolls pinch the sheet, holding it firmly. The stops now drop out of the forward path of the sheet. The driven cams rotate and pinch the sheet against the free-rolling cams, exactly when the impression-cylinder, feed-cylinder, or transfer-cylinder grippers reach the sheet-receiving position.

Sheet Control in the Feed-Roll System. The cams themselves are so designed that they start the sheet slowly and then accelerate it to a speed *slightly faster* than the surface speed of the cylinder. *As a result, the edge of the sheet is driven positively*

into the grippers and against another set of stops built into the impression, feed, or transfer cylinder, either along a separate bar or as part of each individual gripper pad. The sheet actually buckles slightly, just as the gripper closes.

This action is called overfeed, and the amount of this overfeed is adjustable in order to accommodate papers of varying thickness or stiffness. This method of forwarding and inserting assures consistent register, because it is possible with such an insertion device to have the cylinder grippers close positively on the sheet before the insertion device releases it. It is important that the surface of both upper and lower rollers be absolutely clean. They should ride directly over each other. The free-turning feed rolls should be constantly checked to make sure that they are turning freely.

SETTING AND OPERATING THE SWING-FEED INSERTION SYSTEM

The swing or transfer insertion system is also a true insertion system. In this system, just like in the previously described feed-roll system, the sheet is *inserted* into the cylinder grippers, not *taken* by them. Again, the travel of the sheet is followed for our operational description of this insertion device.

The Functioning of the Swing-Feed, or Transfer-Gripper, System. This system is so designed that the sheet is forwarded against a set of front stops as in the simple three-point register system. The sheet is preregistered and is side-guided, and then a set of grippers take hold of the sheet. When the grippers close, the stops move out of the forward path of the sheet. The transfer mechanism starts slowly to rotate and accelerates until it reaches the same speed as the impression cylinder. At this time, the impression-cylinder grippers are in their sheet-receiving position and the sheet is inserted into them. Also, at this point, the transfer mechanism is momentarily locked into the impression-cylinder motion so that both sets of grippers travel together while the impression-cylinder grippers close on the sheet. At the actual point of transfer, both sets of grippers are holding the sheet, guaranteeing positive control.

Schematic of an insertion device. A: feed roll cam; B: lower feed wheel; C: corrugating bars (if push guide); D: side guide bar; E: guide stop fingers; F: upper guide fingers; G: conveyor rollers; H: feed plate; J: sheet holddown fingers.

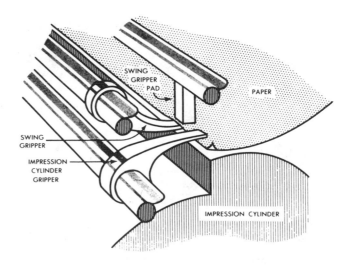

Schematic of a swing-gripper device.

Timing and Gripper Bite on Swing-Feed, or Transfer-Gripper, Insertion Devices. It is important that timing on this device be checked periodically. The bite of all grippers should also be checked. Checking is best done by inserting strips of tissue paper, or a 0.001-in. feeler gage, into each gripper and by closing them for testing. A strip 0.003 in. thick should first be inserted between the cam and stop pin of the gripper shaft. (The thickness of this strip is specified by the press manufacturer; a thickness of 0.003 in. is common.) By feeling the pull on each strip of tissue or feeler, it is possible to make certain that the tension is equal on all grippers. The tissue strip or feeler should barely pull out if everything is set right. (The manufacturers' instructions should of course always be followed in resetting and timing insertion devices.)

CHECKING SHEET CONTROL AT THE POINT OF GUIDING

When the sheet is against the stops, all sheet-control devices used for controlling the sheet at this point should be checked. For example, on successive-sheet feeders are the tail brushes riding on the *end* of the sheet? Are the drive-up wheels, or balls, riding free? It is important to make certain that the sheet is held in its forward position and still sufficiently free to be smoothly side-guided.

IMPRESSION-CYLINDER STOPS AND IMPRESSION-CYLINDER GRIPPERS

Impression-cylinder stops and grippers are the last subjects presented in this section.

Impression-Cylinder Stops. Presses using a feed-roll insertion device have stops in the impression feed cylinder. The shaft or bar on which these stops are mounted is capable of being bowed. Bowing then makes it possible to accommodate, to some extent, paper that has a bow cut into it. The bowing adjustment can also help to some extent when wavy- or tight-edged paper must be run. (For a discussion of various paper conditions as they influence presswork, see the "Ink and

Cylinder stops for a feed-roll insertion device. Note the stop adjacent to each gripper.

Paper" chapter of this Manual.) A sheet whose cross-grain edges (i.e., as when running grain long) are wavy tends to compress at the back end, as it goes through the nip. Checking the image with a precision calibrated metal rule across the back corner marks, and comparing this measurement with that made of the corresponding back corner marks on the plate, shows this distortion. Bowing the stops—so that a slightly greater gripper bite is possible towards the ends of the sheet—tends to minimize the problem of fit. Always start a new job by making certain that the stops are set straight and parallel to the leading edge of the cylinder, unless cross-grain wave in the paper is almost always prevalent.

Some of the presses using swing-feed, or transfer-gripper, systems offer the possibility of easily cocking the gripper edge of the sheet when this is unavoidable. It's important, of course, that this be done carefully to make certain that neither too little nor too much gripper bite is developed across the sheet. To handle the possible need for bowing on the larger presses equipped with swing-feed, or transfer-gripper, systems, the two outer of the four stops are dropped slightly away from the lead edge of the sheet (to create a concave bow) or pushed slightly ahead of the center stops (to create a convex bow). Some presses have a "bustling" device at the back edge of the feed ramp that, when lifted slightly above the plane of the ramp, will create a convex bow at the lead edge of the sheet.

Impression-Cylinder Grippers. The setting of impression-cylinder grippers demands particular care because they are damaged and go out of adjustment very easily. The manner of setting is carefully outlined by the manufacturers in their instruction manuals. Here, merely a few general points are stressed. When a gripper closes on the sheet, it must do so firmly. To check for this, the press is inched as the grippers are closing on the sheet. Just before they completely close, the inching is slowed to a minimum so that the behavior of the gripper, when it actually closes, can be observed. If they appear to "duck," either up or down, it is a clear signal that the grippers are set wrong. During this same observation, the motion should be watched carefully for any jerking; the entire closing cycle must be smooth. If it is not, there is clear evidence that the gripper shaft is binding somewhere in its supports. Each gripper should be checked for even pressure; the press manufacturer's instruction manual tells how best to adjust the grippers on a particular press.

On tumbler-gripper mechanisms, with one-piece grippers, it should be borne in mind that even one gripper set too tight will cause the other grippers to have a looser bite. All grippers should, consequently, be checked carefully.

While the bite on impression-cylinder grippers gives trouble if it is set too tight, no less serious consequences result from too weak a gripper setting. It should be realized that there is a considerable pull of the sheet by the blanket—especially on coated stock—and even more so when coated stock is printed with a heavy lay of ink. If, as the sheet leaves the nip there is the slightest tendency for the sheet to pull out of the grippers, there will also be trouble at the point of transfer to the delivery grippers or a transfer device on multicolor presses. Delivery grippers are discussed in Section Seven of this chapter, which treats deliveries. It is important to realize that impression

cylinder grippers are set quite differently than the grippers of a swing-feed or similar insertion device. The reason is that there is comparatively little tendency for a sheet to pull out of swing, rotary, or transfer grippers unless there is something radically wrong. The same holds true for grippers on a transfer or feed cylinder. However, there is tremendous drag on the sheet as it passes through the impression nip. The impression-cylinder grippers must hold the sheet without any slip and yet do this without in any way marring the gripper edge of the sheet. A very heavy bite is not the answer. Rather, what is required is a firm bite—absolutely even—completely across the sheet. And this firm bite must be accomplished in a smooth operation, free of any binding or springing of the gripper mechanism or any of its parts. These requirements explain why the manufacturer's instructions must be followed explicitly. Gripper motions of different design require different handling as do grippers of different construction. Gripper pads, where used, also affect the manner of setting the grippers.

Discussion of guides, grippers, and insertion devices ends here. The following section covers the three cylinders of the printing unit where the sheet is placed by means of feeder and insertion devices.

Section Five: The Printing Unit, I: Cylinders

The printing unit is the heart of the lithographic press. (It is sometimes—particularly on multicolor sheetfed presses—referred to as "the frame.") Discussion of the printing unit is divided into two sections. In this section, the three cylinders are discussed. In Section Six, the inking and dampening systems are discussed.

THE THREE CYLINDERS AND THEIR FUNCTIONS

Everything about the actual printing cycle in the process centers around the three cylinders in the printing unit: the plate cylinder, the blanket cylinder, and the impression cylinder. The "offset" method makes possible "blanket-to-blanket" perfecting. Blanket-to-blanket presses do not have impression cylinders; the blanket cylinder of one couple acts as the impression cylinder for the opposing couple in each blanket-to-blanket unit. (A fourth assembly, called the delivery or skeleton cylinder, is not a true cylinder, nor does it function as part of the actual printing cycle. It merely serves to guide the printed sheet away from the impression cylinder, helping the sheet to change its direction of travel without being marred, marked, buckled, or whipped.) Set against the plate cylinder is a dampening system and an inking system. These are so placed as to permit the plate to be dampened before it is inked.

Arrangement of the Cylinders. In general, the three cylinders of the printing unit of a one-color press, or a multicolor press of unit construction, are positioned with the plate cylinder uppermost, the blanket cylinder under the plate cylinder, and the impression cylinder behind the blanket cylinder. One important exception to this general scheme is found in metal-decorating presses. There, the cylinders are mounted in a vertical row to increase the pressure between blanket and impression cylinders. Another reason for this design can be found in the necessities of handling metal blanks, which cannot be wrapped around an impression cylinder. Lithographic presses for the printing of paper, however, benefit by the flexibility of paper. Placing the impression cylinder behind the blanket cylinder makes possible a lower overall height and a simpler design for feeding and inserting the sheet. In addition, such a design makes it mechanically simpler to "trip" the press; this is discussed under the heading of "The Blanket Cylinder." All three cylinders are similar in the materials from which they are made, the manner in which they are made, and the manner in which they are mounted in the press. The differences are due to the function of each cylinder, as well as whether or not a cylinder must be rigidly mounted in the press.

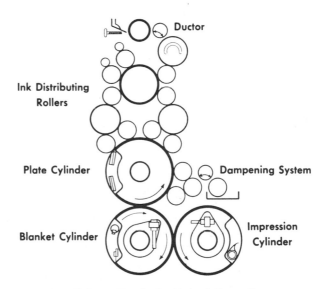

Schematic of a typical printing unit.

The Printing Cycle. During running, the plate cylinder revolves in a counter-clockwise direction—as shown in the schematic—as viewed from the operator's side of the press (feeder to the right). The direction of rotation causes the form rollers of the dampening system to contact the plate before the form rollers of the inking system deliver a charge of fresh ink to the image. During actual operation of a single-color press, the sheet is drawn around the impression cylinder, brought into contact with the blanket cylinder, and then transferred to the delivery chain that carries the sheet around the skeleton or intermediate cylinder to the delivery. Some presses employ intermediate or transfer cylinders between the impression cylinder and the skeleton or delivery cylinder. In multicolor presses, the last unit of the press transfers the printed sheet to the delivery chain grippers; on most presses, transfer between units is accomplished via transfer cylinders equipped with gripper

assemblies that take the sheet from one impression cylinder and transfer it to the succeeding impression cylinder grippers.

The plate cylinder, blanket cylinder, and impression cylinders will now be individually discussed. The discussion is confined to the one-color press because the wide variety of designs found in multicolor presses would make a clear-cut discussion impossible to achieve.

THE PLATE CYLINDER

As the name implies, the plate cylinder is designed to carry the lithographic plate. For this purpose, the plate cylinder on sheetfed presses is considerably larger in circumference than the plate itself. The cylinder is not a continuous, complete surface but one that has a gap in its surface where plate-clamping devices are installed. These are used to mount the plate on the cylinder.

Position and Mounting of the Plate Cylinder. The plate cylinder is, as already noted, the uppermost cylinder. In addition to the already stated reasons, this arrangement is necessary because of the inking system design and, last but not least, for convenience of operation. Since much work is done with the plate when it is on the press, placing it toward the top of the press makes the work more convenient. The inking system, too, is more easily designed for a position over the plate cylinder. The mounting of the plate cylinder is rigid in a fixed position in the press frames and cannot be adjusted for either pressure or alignment. However, it can be rotated independently of its gear.

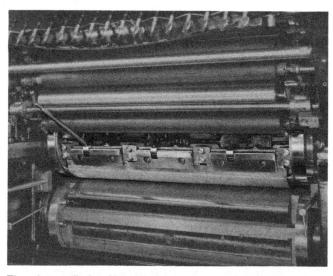

The plate cylinder. Note the bearers at each end, the groove between bearer and cylinder body, and the plate locked in plate clamp.

Plate-Cylinder Bearers. The true shape and size of the cylinder is noticeable when looking at the bearers. (In actual practice there is no way to look at the entire bearer on an assembled press. However, enough can be seen so that *watching* the bearer while slowly turning the press will accomplish the same purpose.) All American presses and most presses of foreign manufacture are built so that the plate and blanket cylinders run on their bearers; that is the bearers are in firm

contact when the impression is on. Bearers are rings of hardened steel that are pressed on the cylinder body and are an integral part of the complete cylinder. The plate cylinder gear is bolted to the cylinder through slots rather than holes. This means of attachment is done to facilitate forward or backward movement of the cylinder and also the image, without opening or shifting the plate clamps. This plate-cylinder movement is one which is time consuming as well as wasteful in terms of paper wasted to achieve proper position of the image on the sheet. In many presses, this movement is also a limited one; therefore it is wise to establish standard print and plate-clamp margins for the stripper and platemaker to follow. With a little care, by all concerned, very little time need be spent in getting a plate into its correct position with respect to the gripper edge of the sheet. Correctly positioning a plate is greatly facilitated by the use of pin-register systems.

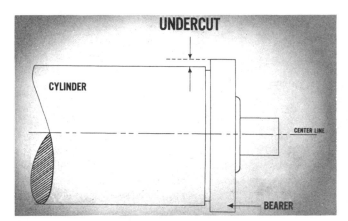

Schematic showing cylinder bearer, groove, body, and undercut.

The Undercut of the Plate Cylinder. The surface of the bearer is the pitch line of the cylinder. All plate cylinders have their body cut down below the level of the bearers. The difference between bearer and cylinder radius is known as the undercut. The undercut serves to accommodate the plate and whatever packing may be required in order to bring the plate surface up to the correct printing height, which is specified by the press manufacturer. The press manufacturer has established "standard" undercuts for each size in the press line. However, the purchaser can specify the undercut if a specific undercut is desired for some special application, such as the running of relief plates whose caliper is considerably greater than even the thickest lithographic plate.

The Plate Clamps. The plate clamps are so set that one clamps the leading edge of the plate while the other holds the tail end of the plate firmly. Both clamps are designed for a slight sideways, or cocking, movement of the plate when it is necessary that a plate be shifted to attain its proper register or fit. There is also some leeway for forward and backward movement. But care by the stripper and platemaker can and should hold such shifting operations to a minimum. To say it again: Total downtime during makeready can be considerably cut by a little standardized care on the part of everybody. Intelligent use of available pin-register systems accomplishes the desired standardization.

THE BLANKET CYLINDER

Immediately below the plate cylinder is the blanket cylinder. In general appearance, it is pretty much the same as the plate cylinder, consisting of a heavy metal body with a gap across its length and with bearers fixed to each end. The gap accommodates bars for attaching the blanket, the bar at the tail end usually being so designed as to make possible winding of the tail end of the blanket for tightening purposes. On some presses the blanket is actually tightened at both ends.

The Mounting of the Blanket Cylinder. The blanket cylinder is mounted in the press in a manner quite different from that of the plate cylinder. Blanket cylinders are, generally, mounted by means of double eccentric bushings in the press frames. On such installations, if one bushing is turned, the blanket cylinder can be moved toward the plate cylinder or away from it. The possibility of this motion facilitates adjustment of bearer pressure between plate and blanket cylinders. This adjustability is important because in time, no matter how carefully maintained, bearings and bushings will wear. Such an adjustment is also necessary in order to achieve and maintain proper parallel alignment of the plate and blanket cylinders.

Disengaging the Blanket Cylinder. Because of the relationship between the three cylinders, the blanket cylinder is so mounted that it can be pulled into contact or out of contact with the plate and impression cylinders while the press is operated. This feature is necessary for makeready and, of course, essential during running. When a sheet is missed or when the press operator desires to idle the press, the blanket cylinder is moved away from both the plate and impression cylinders, automatically.

Blanket-Cylinder Bearers. Like the plate cylinder, the bearers on the blanket cylinder are rigidly attached to the cylinder body, but the blanket-cylinder gear is permanently

Courtesy Harris Corporation

A typical blanket cylinder mounting. Note adjustments on the eccentrics.

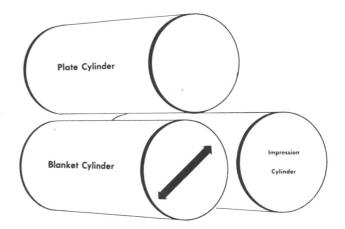

Schematic showing relationship of three cylinders when press is tripped.

bolted because a forward or backward adjustment is here undesirable. The reason for this method of attachment is the need for exact timing between the blanket cylinder and the impression cylinder.

Blanket-Cylinder Undercut. The blanket cylinder is undercut in exactly the same way as the plate cylinder. However, the depth of the undercut is much greater since blanket thicknesses averages from 0.055 in. to 0.070 in. depending on size, ply, etc; lithographic plates range from 0.008 in. in the small sizes to only about 0.022 in. in the larger sizes. As with plate-cylinder undercuts, the press purchaser may order a special undercut. Special undercuts are very common on presses especially adopted for running paperboard; many board printers prefer to mount two blankets on their blanket cylinders. The undercut is always sufficient to allow for some packing in addition to the blanket itself. Like the plate-cylinder bearers, the bearers of the blanket cylinder represent the true circumference or diameter of the cylinder.

THE IMPRESSION CYLINDER

The impression cylinder is different from the plate and blanket cylinders. Like them, it has a gap. It accommodates a gripper shaft, sometimes a gripper pad shaft, and/or a stop shaft for control of gripper bite on the sheet. However, the relationship of the impression-cylinder body with that of its "bearers" is quite different. In the first place, usually no provision is made for packing the impression cylinder. In the second place, provision must be made for changing the distance between the blanket and impression cylinders in order to achieve transfer squeeze on the particular paper caliper being run. For example, if we run our press with a transfer squeeze of 0.003 in., and if the paper being run calipers to 0.003 in., then we set the distance between blanket and impression cylinders to give us no clearance or squeeze between the surface of the blanket and the body of the impression cylinder when the impression is on and no sheet in the impression nip. When sheets are run, the caliper of the sheet will build up the required transfer squeeze. If the stock being run is 0.005 in. in caliper, the clearance between blanket and impression cylinder surfaces with impression on and no sheet in the nip would be 0.002 in. (The figures used above are

Courtesy Harris Corporation

The impression cylinder. Note apparent lack of undercut.

Pressure adjustment on impression cylinder. This method is generally confined to smaller presses.

only for illustrative purposes; actual transfer squeeze will vary depending on type of job and especially on type of paper being run and type of blanket.)

The Ends of the Impression Cylinder. The impression cylinder does not have bearers in the same sense that we have them on the plate and blanket cylinders. Ground and polished steel rings are on the ends of the impression cylinder, either pressed-on and bolted to the impression-cylinder body, or as an integral part of the body itself. But these steel rings do not ride the bearers of the blanket cylinder. These impression-cylinder ends are nevertheless generally known as "bearers" in the lithographic industry. The term "bearer" is used in the course of this study, but the reader should keep in mind that the so-called impression-cylinder bearers are not bearers in the true sense of the word.

The impression-cylinder bearers are used for the alignment of the impression cylinder, though merely as reference points. The alignment is made by setting the space between blanket-cylinder bearers and impression-cylinder bearers so that they are exactly equal at both ends. It is worth noting at this point that some foreign-built presses have plate and blanket cylinders that do not ride on their bearers. The bearers are used as reference points when cylinder pressures are being adjusted and set, just as we do with the impression cylinder on American-built presses.

Pressure Adjustment of the Impression Cylinder. On most smaller and some older presses, the impression cylinder is adjustable, for obtaining squeeze pressure against the blanket cylinder. This pressure adjustment is done from the operating side of the press. With the impression on—blanket cylinder in contact with the plate cylinder—the impression cylinder carries the sheet into contact with the blanket cylinder and through the printing nip. On presses where the impression cylinder is in a fixed position, the blanket cylinder is mounted in a second set of eccentric bushings which allow for adjusting of the *blanket-to-paper* squeeze without changing the *blanket-to-plate* squeeze.

This matter of blanket-to-impression-cylinder adjustment is extremely critical, not because it is difficult to accomplish but

because neglecting it leads to many troubles. The press operator must always keep the necessity for blanket-to-impression-cylinder adjustment in mind. For example, every change in the blanket-cylinder diameter caused by shifting the packing between plate and blanket cylinder must be accompanied by a change in the impression-cylinder squeeze adjustment. This subject is discussed in detail further down in our section.

THE BLANKET

The blanket is the heart of lithographic offset. That it is so is not always realized by many people, be they experienced or inexperienced in the lithographic process. But it is an undisputable fact that the transfer of very fine images onto a wide variety of paper finishes, including cloth and other materials, is best accomplished by the "offset" method. A lithographic plate is capable of retaining and transferring very fine images, up to 400-line halftones. The combination of the lithographic process with the offset method gives us indeed a superb printing technique.

The modern offset blanket gives us very little trouble other than that caused by improper selection and handling. This presentation of the blanket is, corresponding with the great role played by the blanket, quite extensive.

The following twelve points are individually discussed in the course of this section: (1) Type of blankets; (2) Selecting the blanket; (3) Checking a new blanket; (4) Preparing the blanket for mounting; (5) Mounting the blanket; (6) Adjusting blanket tension; (7) Breaking-in the new blanket; (8) Leveling the new blanket; (9) Treating a battered blanket; (10) Restoring the blanket; (11) Compatability of blanket, inks, and solvents; and (12) The spare blanket.

Types of Blankets. Two basic types of blankets are available to the press operator: compressible and noncompressible. (The noncompressible type is frequently known as a "conventional" blanket because the compressible blanket, by comparison, is relatively new.) A variety of blanket surface formulations are available to meet special requirements of some ink formulations and required solvents.

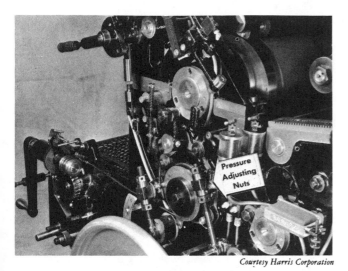

Courtesy Harris Corporation

Pressure adjustments on blanket cylinder. The adjustment to left of cylinder mounting is for alignment between blanket and impression cylinder.

The terms "compressible" and "noncompressible" are descriptive of how the blanket behaves under the squeezing action of the printing nips—plate/blanket nip and blanket/substrate nip. The noncompressible, or conventional, blanket when squeezed in the nip bulges out on either one or both sides of the nip. This bulging is due to the fact that the materials from which a conventional blanket is made cannot be compressed; rather, they are displaced. This displacement is illustrated in the sketch of the action in the nip. Excessive plate/blanket squeeze causes a rubbing action against the plate as the blanket tries to recover its original shape. This rubbing action will result in a shortened plate life. In the blanket/substrate nip, excessive squeeze will result in a slurred print. It should not be assumed from this that the noncompressible blanket should never be used; there are jobs where a *controlled* amount of slur will produce a print more satisfactory to one that is not slurred.

The materials used in the construction of a compressible blanket will compress in the printing nips. This design makes it possible to take advantage of greater squeeze pressures (within reason) that, in turn, usually result in improved ink transfer.

Selecting the Blanket. Different types of blankets are available. For example, some work better with coated papers. Specially formulated blankets must be used with some inks; heatset inks are one example. As has already been stated, specially formulated blankets are available in either compressible or noncompressible construction; it is the material (usually rubber) in the face of the blanket that is formulated to meet special requirements. Therefore, we have two responsibilities governing the blanket itself: (1) We must select the blanket best suited to the paper and ink being run; and (2) We must handle it properly. It should not be inferred that this is time-consuming or costly. One doesn't change the blanket for every change of paper. In actual practice, a plant that only occasionally runs a coated paper job will do well to have a special blanket available for that purpose. As we previously stated, some of the newer ink formulations require special blankets. Which blanket is best for

these should be determined by discussing the problem with the suppliers.

Checking a New Blanket. When a new blanket is received, it should be checked immediately for proper size, with the warp line or directional arrows (on the back of the blanket) in the around-the-cylinder dimension. Then, it should be checked for squareness of the across-the-cylinder edges with the warp lines. Next, it should be checked for any obvious defect on either side, and finally, for correct caliper. The best blanket thickness for a particular press is the thickness recommended by the press manufacturer. Checking caliper is best done with a blanket thickness gauge. In the first place, gauges are so designed as to indicate the caliper that the blanket will have after stretching around the cylinder. In the second place, measurements can be taken over the entire surface of the blanket. Thereby, it is possible to arrive at an average figure for calculating the proper amount of packing. The conventional machinists micrometer is not a reliable instrument for accurately determining the caliper of a resilient material such as the blankets used on the lithographic press.

Preparing the Blanket for Mounting. Most presses require that blankets be mounted in blanket bars for use on the press. Some presses are so designed that the blanket, once it is cut properly for size and squareness, is mounted directly into blanket clamps built into the blanket reels.

Blankets that are prepunched to match specific blanket mounting bars are available from the blanket manufacturers. The bars are mounted by the press crews. Premounted blankets are also available.

Unless otherwise specified, the holes in a prepunched blanket will fall on a straight line across both ends of the blanket, at a right angle to the directional arrow (around-the-cylinder direction) stamped on the back of the blanket. The two rows of holes are parallel to each other. There is some question on this last point. On larger presses (over 35 in.) when a "normally" punched blanket is tightened on the cylinder, there may be greater pull on the outer edges of the blanket than in the center; the larger the press, the greater is the difference in achieved tightness. This uneven tension is counteracted by having the holes punched along an "offset" line at both ends. This line is illustrated in the accompanying sketch. Experience has demonstrated that on presses 40-in. or less in size, the offset should be 1/8 in.; on 45-in. to 63-in. presses, the offset should be 3/16 in.; on larger presses, the offset should be 1/4 in.

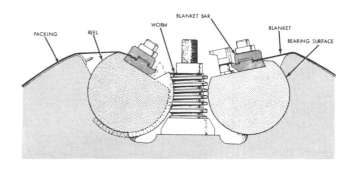

Blanket reel tightener and support.

Mounting the Blanket. Mounting begins by loosely screwing the blanket into its bars. The blanket is held up by one set of bars and shaken so that it seats smoothly. One end of the blanket is laid on the table with the other end hanging down. This position applies some tension to the blanket. Next, the screws in this pair of bars is tightened, starting from the center out, with each screw tightened successively, a little at a time until all are tight. When one end has been finished, the blanket is reversed and other end is tightened.

Soaking the fabric back of the blanket.

The new blanket should now have its back—the fabric side—washed thoroughly with water, soaked well, and hung for a few days to dry out. This treatment will bring all fibers of the fabric back to their original size, should they have been compressed in shipment or during the mounting operation. If blanket mounting in bars is not required, the back of the new blanket should be washed thoroughly and hung to dry, as mentioned above, before it is installed in the press.

Tightening the blanket on the press.

Adjusting Blanket Tension. The described method of mounting assures a smooth, even pull on the blanket when the blanket-cylinder reels are tightened. When tightening the blanket on the press, follow the manufacturer's instructions for applying the proper tension.

Neither a show of brute strength nor a scientific knowledge

Pumicing the surface of the blanket.

of leverage guarantees the proper working of the blanket when it is tightened on the press with excessive force.

Breaking-in the New Blanket. A new blanket requires one further treatment. After it is installed on the press, the surface should be scrubbed with pumice, blanket solvent, and water. The rubber is wet with water, pumice is sprinkled on it, and the rubber is scrubbed with a clean soft rag that has been wet with a blanket solvent. Scrubbing is continued until a smooth, even "satin" finish is attained. (Scrubbing is done with a side-to-side motion, rather than a circular action.) The pumice is washed off with water. Then, the blanket is washed again with blanket solvent and is dried. Now it is ready to print. When doing this kind of work on the blanket, care should be used to avoid soaking the ends of the blanket. Such soaking will cause the edges of the fabric to swell.

Leveling the New Blanket. A new blanket requires one further test to make sure that it is in printing condition. An amount of packing equal to about one-half of the squeeze pressure is removed. (Squeeze pressure is discussed later in this chapter.) The plate is rolled-up solid and printed on the blanket. Ink transfer is checked. The slightest thickness deviations will

Checking the blanket for levelness. Note that this should be done with less squeeze pressure than is normally used for running.

now show up as light areas on the printed blanket. To make certain whether the blanket is at fault, it is removed from the press and reinstalled in the reverse position. It is printed on again, in the same manner as above. If the cylinders are okay, the weak areas will still be in the same areas of the blanket.

According to the result of this test, either the cylinders or the blanket, or both, need patching. Patching must be done with great care and precision. Shellac is used to patch cylinders. Shellac makes the patching reasonably permanent and avoids repeating this operation when blankets are changed. When patching the blanket, the rear bar is removed from the press, and the low spots are traced with a pencil pressed against the back. The face of the blanket will serve as a guide for correct marking. A low spot should be built up gradually with thin tissue, preferably 0.0005 in. thick. The tissue should be torn rather than cut. The feather edge of the tear prevents the edge of the patches from showing when solids are printed. The same caliper of tissue and tearing technique are used for patching the cylinder.

This same procedure also applies to an old blanket that has been treated and given a rest off the press.

Treating a Battered Blanket.

Battered blankets can usually be restored to a like-new condition provided the carcass has not been cut or torn. The blanket is washed with blanket wash and water to remove all ink, solvents, and gum. The blanket is removed from the press and soaked in water for several days. If soaking the blanket in a container is not practical, the blanket can be hung but kept moist by periodically swabbing it with water from a sponge.

When a batter occurs on the press, the rubber is seldom damaged unless something like a piece of wood or metal goes through the press from the feeder. If this happens, not only is the rubber cut but the fibers of the backing cloth are also damaged. But a batter this serious is the exception. In the usual paper batter, the cloth fibers are merely compressed, and soaking the blanket in water will almost always bring them back. After the blanket has hung sufficiently long, the face is given a good pumice treatment and dusted with the talc and sulfur mixture. The blanket is then stored in a cool, dry place, with the rubber rolled in, for a rest and future use.

Restoring the Blanket.

Using a blanket continuously until it is worn out is neither a recommended nor acceptable practice. Blankets should be removed in time from the press and treated as outlined in the preceding paragraph for a battered blanket. Treating them this way periodically gives them a good rest and preserves the fabric as well as the rubber. In addition, the solvents, ink vehicles, etc., are dispersed throughout the material, and the surface can become again like new. Running blankets too long causes permanent embossing. Embossing is caused by concentration of absorbed materials—ink, vehicle, and solvent—in the image areas. Besides becoming embossed, blankets that are run too long can become so badly glazed and oxidized that no amount of pumicing and rest can restore them.

There are a few other steps that the press operator can take to assure a long life and excellent behavior by a blanket while on the press. When a rested used blanket is put back on the press, its position should be reversed. (This reversal also means the other leading edge will be used.) Another helpful precaution is to release tension on a blanket if the press is stopped for more than a day. The blanket reel should only be loosened by backing off a few teeth, and the starter button should be "flagged" to remind the next press operator of the exact number of teeth backed off. This procedure should be skipped if the long press stop occurs within the run of a "close-register job."

Compatibility of Blanket, Inks, and Solvents.

A word of caution on materials for the treating of blankets as well as their selection is in order. Attention must be given to the recommendation and instructions of your suppliers. Then, and only then, can they be held responsible for results. *The blanket manufacturers, ink makers, and suppliers of solvents will fill the printer's needs satisfactorily, if the needs of the printer are defined accurately.* The suppliers cannot produce miracles, although on occasion it may appear as if they could. The printer should not expect more from the supplier than they promise, unless the printer is looking for trouble.

The Spare Blanket.

In every pressroom, there should always be at least one extra blanket for each press size—in perfect condition and fastened in its bars—ready for immediate use. If a blanket gets battered on the press it should *not* be patched up on press, but replaced. A spare blanket, if previously mounted in the blanket bars, can be installed just as quickly as the blanket that has been battered can be patched up. The battered blanket can usually be restored to a like-new condition—if it is not further mutilated by running it with patches. Properly handled blankets will last a really long time and make possible trouble-free, good-quality printing, as well as very high production. Having a spare blanket, completely mounted in its bars, reduces the tendency to run any one blanket too long.

PRINTING TRANSFER SQUEEZE PRESSURE

The squeeze pressure required to transfer printing ink from the press plate to the blanket depends on two things: (1) Bearer pressure, and (2) Height to which blanket and plate are packed. On presses that do not run on bearers, the clearance between their pseudo bearers—when impression is on—is the determining factor; assuming, of course, that the total thickness of the press plate with its packing and the total thickness of the blanket with its packing are in accordance with the manufacturer's instructions. Emphasis on manufacturers' instructions for presses without bearers should not be misunderstood to mean that presses with bearers can be operated without regard for the instructions of their manufacturers. All presses, with or without bearers, must be operated by closely following the instructions of their makers.

The section is not concerned with particular presses and their features. The press manuals available from the manufacturers amply fulfill this task. Interest here is with the principles of printing squeeze pressure and their various aspects. These are divided into the following ten points: (1) Impression squeeze; (2) Cylinder undercut; (3) The packing gage; (4) Packing and transfer squeeze; (5) Plate and printed image size; (6) Measuring the plate and printed images; (7) Preparing for bearer-contact check; (8) The thumbprint test; (9) Too much squeeze pressure?; (10) Checking impression-cylinder squeeze. Each of these ten points is individually discussed in the following.

Impression Squeeze. It is known that more than ink itself is needed to transfer ink from the press plate to the blanket, and from the blanket to the paper. The cylinder surfaces must be "squeezed" quite a bit to get the proper ink transfer. It is generally accepted, as a result of experience and research, that the plate-to-blanket squeeze required on small presses (up to 30 in.) is 0.002 in. to 0.003 in.—0.002 in. on smooth and fine grain plates and 0.003 in. on coarser grained plates. Medium-sized presses (up to 50 in.) should be packed for 0.003-in. to 0.004-in. transfer squeeze; presses over 50 in. should be packed for 0.004-in. to 0.005-in. squeeze. The above applies only to presses using conventional blankets, additional packing is required with compressible blankets. A general rule for this setting is as follows: the smoother the plate the less pressure required, and the coarser the grain (of a grained plate) the greater the pressure required. If a deep-etch plate is etched too deeply, even greater pressure may be required for the blanket to pull out the full ink charge. Plates used on poster work often require considerably more than 0.004-in. squeeze pressure since much of this work is done from coarse-grained plates. The important points to bear in mind are: (1) The less pressure that is used, the longer the plate life will be; and (2) The plate-to-blanket squeeze pressure must be sufficient to pull out from the plate a clean, full charge of ink. It is important, also, to consider the type of blanket being used.

Plate and blanket packing alone do not guarantee adequate pressure. If a press has worn cylinder journals whose play has not been taken up properly, good ink transfer will be unattainable. The problem is to hold the cylinders together when the pressure is applied, because the squeeze pressure is trying to force the cylinders apart. Assuming the cylinders are holding true as a result of proper setting at the cylinder journals, and that the amount of plate and blanket packing are correct according to the manufacturers specifications, all is well. But if overpacking is resorted to in order to counteract loose or improperly set cylinder bearings (not the bearers), then not only may quality of ink transfer suffer, but the cylinder circumferences are affected. If the packing of both cylinders is not reasonably close to manufacturers' specifications, the cylinder circumferences will be out of balance. Although there is some leeway, any approach to either extreme of the available leeway may cause loss of fit as well as poor image transfer and premature plate wear.

Schematic of cylinder relationship.

Cylinder Undercut. The plate and blanket cylinders are so designed that the body of the cylinders is below the level of the bearers for presses with bearers as well as for those without

bearers. The difference in height between the surface of the bearer and the surface on the cylinder body is called the undercut. Each manufacturer's instruction manual lists the exact undercuts. But on old presses, it may be necessary to check the undercut. Measuring is best done with a packing gage.

Using a packing gage to check plate packing.

The Packing Gage. A packing gage is essentially a height gage. The body of the gage is held against the cylinder body, and the gage itself is zeroed. Then the instrument is moved so that its body rests against the cylinder body while the gage itself is over the bearer. The reading shows the height difference between bearer and cylinder body. In addition to being useful for checking cylinder undercut, the packing gage is even more useful for checking the exact height to which either the blanket or plate cylinder have been packed. This measurement is most critical.

Packing and Transfer Squeeze. The amount of undercut on the plate cylinder is always more than the thickness of the lithographic plate itself. The same condition holds true on the blanket cylinder, to deliberately allow for shifting of packing from one cylinder to the other in order to affect a change of printed-image size in the around-the-cylinder dimension. Transferring packing from under the blanket to under the plate produces a shorter image on the printed sheet, and *vice versa*. But the total thickness of the plate with its packing and of the blanket with its packing must always be the same in order to produce the desired transfer squeeze pressure.

The following example demonstrates this rule. The undercut of the plate cylinder is 0.025 in., the plate thickness is 0.020 in. In order to bring the plate to *bearer height*, 0.005 in. of packing material must be put under the plate. The undercut of the blanket cylinder is 0.070 in. and the blanket thickness is 0.065 in. In order to bring the blanket to *bearer height*, 0.005 in. of packing material must be put under the blanket. But the total thickness of plate and blanket, plus their respective packings is not sufficient to produce image transfer. Therefore, an additional 0.002 in. to 0.005 in. (depending on press size, kind of blanket, and plate) must be added to the packing material. Where this additional material is put depends on the specific press design. This additional material *must* always be added

where the manufacturer specifies—at least to start the job. If, after starting, change of image size is required to attain *fit*, then the appropriate packing shift is made. On a large sheet, the image can be elongated or shortened ⅛ in. to ³⁄₁₆ in. before bad effects are visible.

Plate and Printed Image Size. In connection with change in image size, it is important to understand that the printed lithographic image tends to be longer than the image on the plate when the plate is lying flat, that is, before it is curved around the plate cylinder. This size difference is due to the elongation—not the stretching—of the face of the plate as it is wrapped around the cylinder, which, in turn, results in a lengthening of the image on the plate in the around-the-cylinder direction. In addition, the nature of the lithographic press tends to stretch the sheet during printing, due to the ironing action in the nip as well as moisture pickup by the sheet. A heavy form running on paper will also cause paper stretch due to the pull of the ink as the paper comes through the blanket/impression cylinder nip. It may appear as if all these factors would prevent good, controllable printing. However, this assumption is far from true if these factors are controlled. The "Ink and Paper" chapter has a discussion of paper and its control on the press. Control of the size of the printed image is the concern here.

The only way to be certain that a job starts with a printed image of the correct size on critical work is to check the image size at the very beginning. Checking the image size is especially important with color jobs and work to be diecut, embossed, etc. Multicolor printing in one pass through the press will show immediately whether image length between the first- and last-down color requires adjustment. But if more than one pass is required—e.g., four-color printing on a one- or two-color press—it is advisable to make sure that the first-down color is printing as close to plate image size as is possible. If the first color is not printed to correct size, each succeeding color becomes more difficult to fit. Size checks should be made even on black-and-white jobs that are backed-up.

Measuring the Plate and Printed Image. The most practical way for checking size is to use a precision calibrated metal rule. The plate image is measured both in the around-the-cylinder direction as well as across the back end before the plate is put on the press. These measurements are best made against the trim or corner marks. The measurements are noted. When the first "try" sheets come off the press, the same measurements are made against the printed image. Any difference in image size, in the around-the-cylinder direction, calls for a shift in packing to attain proper image size. If there is a difference in the across-the-cylinder direction, we are faced with an entirely new set of problems that will be discussed later in this section, as well as in the "Ink and Paper" chapter.

The same *distance* comparisons can be made by use of a strip of stripper's plastic that has a scribable coating. This plastic can be laid across the appropriate marks on the plate and accurately scribed. (A magnifier is used to achieve maximum possible accuracy.) The scribed strip can then be laid on the printed sheet for the comparison of the distance between the marks on the plate and the distance on the sheet.

Preparing for Bearer Contact Check. With the proper

Using the GATF register rule.

packing on the cylinders, it is now essential to determine if the bearers are riding in proper contact. A new press, installed by the manufacturer, is not likely to require any attention to this point. But the test for proper bearer contact is a simple one; it should, therefore, be made periodically, especially on older presses. First, the plate and blanket are packed exactly to the correct *printing* height. After making sure that the plate is properly gummed, the plate is rolled-up solid, and the blanket contacts the plate for one revolution. The blanket is examined for any areas where ink transfer seems to be weak. These areas should be underlayed with tissue until a uniform print is produced on the blanket, as described in the section on "Leveling the Blanket." The blanket and plate are washed with an ink solvent. Apshaltum is applied to the plate and rubbed down smooth and dry.

The Thumbprint Test. Next, a good thumbprint of ink is

Thumbprints on one set of bearers and position of sheet before test.

Thumbprints after test.

placed on each of the blanket-cylinder bearers, a few inches back of the lead edge of the gap. The thumbprints must be equal as to amount of ink and sharpness. If the bearers are perfectly clean and dry, it will be easy to get a nice, sharp thumbprint on the bearers. Another set of thumbprints is placed on the same bearers but about 6 in. further back. A sheet of 0.004-in. stock that is wide enough to go clear across the blanket is placed with its lead edge halfway between the pairs of thumbprints; the edge is tacked down with thin tape.

The tripping mechanism is released, the inker is locked out, and the press is run for one revolution; the cylinder will trip at that point. The press is inched until the thumbprints come into view. Plate cylinder bearers are examined to see whether a clear set of prints has been transferred from the sets that were put on the blanket cylinder bearers. What has been done is an attempt to transfer one set of thumbprints with normal squeeze pressure and another set of thumbprints with 0.004-in. excess squeeze pressure. If both sets are not fully transferred, it means that the bearers are not riding in firm contact. In such a case, they should be set by following the manufacturer's instructions for this particular press, or a manufacturer's press technician should make the adjustments.

Too Much Squeeze Pressure?　It is often asked, "How about too much pressure?" Too much pressure is not likely to develop; presses wear, bearings become loose, and the result is to lose pressure, rather than to gain it. But, if by some chance the cylinder adjustments have been brought up too far, resulting in excess squeeze at the bearers, there will be a noticeable slowing down of the press when it goes on impression.

Checking Impression-Cylinder Squeeze.　Earlier in this section, the reasons for lack of "riding" bearers were discussed. It is timely, at this point, to go into greater detail on the subject of impression-cylinder squeeze. Many people in the industry use the term "back-cylinder pressure." In the previous section there was a detailed discussion of pressure adjustment and maintenance between plate and blanket cylinders. The following

presentation is concerned only with the relationship of blanket and impression cylinders; it is assumed that plate and blanket cylinders are properly set.

On many smaller presses, but not all, a simple means of moving the impression cylinder toward or away from the blanket cylinder is provided. With the impression on, and with a sheet of the job being run in the nip, an experienced press operator can "feel" when the proper pressure is attained. On some presses, calibrated scales mounted on the press will show the amount of movement being made. However, before this movement can be measured, the impression cylinder must be perfectly parallel to the blanket cylinder. Feeler gages inserted between blanket- and impression-cylinder bearers, with the impression on, will verify parallelism. This paralleling adjustment must be made following the manufacturer's instructions, since the details of construction are quite different on presses of different make and even on presses of the same make but of different size or model.

On the larger presses, and some of the smaller ones, the impression cylinder is rigidly mounted in the frame and all adjustments between blanket and impression cylinders are made at the blanket cylinder. The design of presses has taken this factor into consideration, and these adjustments can be made without upsetting the relationship between plate and blanket cylinders.

The most important thing to remember about back-cylinder pressure is that it is critical. The fact that it is an easily made adjustment is no reason to change this pressure in the hopes of overcoming poor printed-image quality due to some other cause. The good press operator develops skill in running with minimum squeeze and constantly checks the printed image with a glass. The operator, upon spotting a fault that might be due to incorrect pressures, checks pressure settings *before* changing them. If they are correct, the press operator looks elsewhere for the trouble. It is important to beware of excess squeeze at the impression cylinder; excess pressure will *not* hide print defects resulting from other faults but causes other troubles, mainly resulting in poor image transfer. Steps taken elsewhere to counteract the effects of excess squeeze will only compound the troubles.

Transfer squeeze at the plate/blanket nip can be easily and accurately calculated and measured. To measure transfer squeeze at the blanket/impression cylinder nip is quite cumbersome despite the scale that all presses have at the adjustment for this squeeze. The principle factor that contributes to this difficulty is the paper surface. It requires less squeeze to print satisfactorily on a smooth coated paper than on an uncoated one; the "rougher" the finish, the greater the squeeze required to effect satisfactory ink transfer. The experienced press operator will back-off the impression adjustment and then bring the squeeze up until the print quality is satisfactory. The press operator makes certain that ink-film thickness is correct before the final squeeze adjustment is made. It should be recognized that, as a result of experience on a particular press, the press operator can set squeeze to the dial setting that has produced good printing in the past.

PUTTING THE PLATE ON THE PRESS

It is assumed that the reader understands the nature of the lithographic plate, if not from experience then from reading

"The Platemaking Department" chapter of this manual. Every lithographic journeyman press operator should have this knowledge, although it is not expected that the press operator actually knows how to make a plate. By watching the making of a plate, it is clear that the plate is of a planographic nature because the image and the nonimage areas are essentially on the same plane. Observing platemaking makes it obvious that either the printing or the nonprinting image area of the plate is protected at each step in preparation for the next operation on the opposite area. The same alternating protection takes place on the press too, during printing. The dampening system protects the nonprinting area before the plate passes under the inking form rollers. Since the ink film on the image is split during transfer to the blanket, the ink remaining on the image protects it against the dampening solution. Neither of these protective treatments are effective for any length of time if the plate is not made well. However, there is little excuse for a poor plate with today's techniques and materials.

The presentation of plate handling on the press is divided into five parts: (1) Handling the plate; (2) Calipering the plate; (3) The micrometer; (4) Determining the packing height; (5) Inserting the plate in the plate clamps. Each of these points is discussed in the following.

Handling the Plate. The basic rule for handling plates on the press is to maintain the qualities of printing and nonprinting areas. The first consideration is the base material of the plate itself—the metal. Regardless of the metal used, with the possible exception of steel, a lithographic plate is rather unlike the boiler plate used to build a battleship. The plate metal is quite thin (presensitized plates are as thin as 0.005-in.) and therefore easily injured. The plate, to avoid kinking, should be handled very carefully. And, of course, the face of the plate should be neither scratched nor exposed to any moisture—not even perspiration.

Miking the plate.

Calipering the Plate. When the plate leaves the plateroom, it will be under gum and sometimes under asphaltum. Some presensitized and wipe-on systems are so designed that some protection of image and nonimage areas results from the normal plate processing step. This protection is adequate, when

the plate manufacturer so states in his instructions, in the case where the plate goes to press shortly after it is made. The gum protects the nonprinting area and the asphaltum or lacquer, which is applied after the plate has been processed, has replaced

Packing the plate.

the developing ink. The press operator should first check that the clamping edges of the plate show no signs of breaking if the plate metal has been used before. The next operation is to caliper the plate; the micrometer will do a good job, if properly handled.

The Micrometer. The successful operation of an offset press is almost impossible without the proper use of the micrometer. Packing of plate and blanket must be accurate within a tolerance of approximately 0.0005 in. The micrometer is a simple precision tool; its use, with a little practice, is easily mastered.

The mechanics of the micrometer is a screw that turns through a fixed nut to vary the opening between the two measuring faces. The graduations on the barrel and thimble indicate precisely the amount of the opening between the measuring faces. Graduations on the barrel conform to the pitch of the measuring screw, one line for every revolution. The graduations on the beveled edge of the thimble accurately subdivide each revolution of the screw so that readings may be taken in units of 0.001 in.

Each line on the barrel represents 0.025 in. Each line on the thimble represents 0.001 in., as already stated. Each visible line is counted and added to the figure on the thimble. The result is a reading in thousandths of an inch. If, for example, there are 9 lines on the barrel, then the measurement component contributed by the barrel is 0.225 in. (9 x 0.025). If there are 16 on the thimble, the result is 0.225 plus 0.016 (16 x 0.001), which equals 0.241 in. Beginners are advised to practice on paper or any material under 1 in. thick. A proper understanding of the micrometer is essential for the skilled offset press operator. A plate being "miked" is either on the table lying flat or hanging straight in the front clamps. Any flexing of the plate during miking gives a reading greater than the actual caliper of the plate.

Determining the Packing Height. The difference obtained by subtracting the thickness of the plate from the plate-cylinder undercut is the required packing to bring the plate to bearer height. The manufacturers' instructions dictate whether or not the plate is to be packed above bearer height. In either case, the required thickness of packing is added. Before actually mounting the plate, any foreign material, such as paper, grease, and ink blots, are removed from the back of the plate. The plate cylinder is checked to make certain it is clean. Plate clamps are centered and the lead clamp is up against the face of the gap. Starting every plate at the same point makes it easier to obtain lay, especially if the platemaker has a standard distance for each press. This distance can be agreed on, for example, as the paper line on the flat. Lines scribed in the groove between bearer and cylinder body can be used by the press operator to align the plate marks. Most of these precautions are unnecessary on presses equipped with pin-register systems, provided that preparatory work is standardized to such a system and that plates are punched and accurately lined up with the punched flat.

Inserting the Plate in the Plate Clamps. The plate should be inserted in the lead plate clamps and locked. Then, the packing sheets should be placed behind it in such a way that the front edge of the sheet or sheets extends beyond the edge of the cylinder body. This procedure will lock-in the sheets and prevent their shifting or wrinkling. The sheets should be a trifle narrower than the plate. With some pull on the tail end of the plate (to make certain that the front plate clamps are up against the lead wall of the cylinder body), and with the impression on with the inker locked up, the press is inched until the tail clamps are in a convenient position. The squeeze of the blanket cylinder helps wrap the plate snugly around the cylinder. Then, the back edge of the plate is slipped into the clamps, and the plate is drawn up tight. In this step, the press operator should use judgment. It is not necessary to exert such a strong pull that the threads of the tightening screws are stripped or the plate torn. The press is inched off impression, and the lead clamps are checked to make certain the front clamps are solidly against the cylinder wall. At this point, the plate marks are checked against the marks scribed in the cylinder, or against the scales with which some presses and pin-register systems are equipped. The press is then inched forward until the tail clamps are in view, and they are given a final check to make sure the plate is tight and smooth completely around the cylinder body.

On small size presses, the angle between the plate clamps and the cylinder body is rather acute. In such cases, it is helpful if the clamping edges of the plate are bent before mounting the plate on the cylinder. Bending is best done by using a plate-bending jig similar to that illustrated. The dimensions are those for an ATF Chief 22. The measurements for any other press are easily obtained by measuring a plate that has been removed from the press; the press manufacturer's instructions always include this distance.

Section Six: The Printing Unit, II: Inking and Dampening Systems

In this section, the second half of the printing unit, the inking and dampening systems, is presented. Each of the two systems is first described and then operationally discussed.

THE INKING SYSTEM

The lithographic process makes more demands on its inking system than does any of the printing processes. Some people have said that the size of roller train and the number of rollers are due only to traditional beliefs. The fact is, however, that all attempts to simplify the system have so far failed. This fact is still true, even though the working and running properties of today's inks are vastly improved over those existing when the lithographic offset press entered the printing field. However, considerable work to improve the inking system continues and a breakthrough could come along at any time.

Ordinarily, one might think of an inking mechansim as a device whose function is to deposit ink on the printing image. This notion is true in all printing processes, but on a lithographic press the inking mechanism must perform other functions too, and with far greater efficiency than is demanded of the inking units of the intaglio or relief presses. The lithographic image carrier is planographic; its image area is on the same plane as its nonimage area. The form rollers of the ink train, therefore, contact both image and nonimage areas at the same time. This condition imposes in itself a severe demand on the image-inking operation.

The Five Main Functions of the Inking System. The inking system on a lithographic offset press must perform the following functions: (1) It must "work" the ink by conditioning it from what is essentially a plastic state to that of a semiliquid; (2) It must distribute a small, comparatively thick band of ink on the ductor roller to an even, thin film around all the form rollers; (3) It must deposit a uniformly even, thin film of ink on the image; (4) It must pick up fountain solution from the lithographic plate, emulsify some of this into the ink, and evaporate the rest into the atmosphere; (5) It should pick up from the lithographic plate any loose particles of foreign matter and hold them in suspension until the entire mechanism is cleaned.

The Controversial Role of Water. Much of the above may be open to argument. Some say that emulsification takes place when the press is not being operated properly. Others say that the lithographic process itself would not function if a controlled amount of emulsification did not take place. It is stated here, as a fact based on experience, that the above listed

functions must be accepted until some breakthrough is made. Experience and much research have proven that this approach to handling the lithographic inking system does result in efficient press operation. Then, and only then, does the lithographic process realize its full potential of quality and quantity of production.

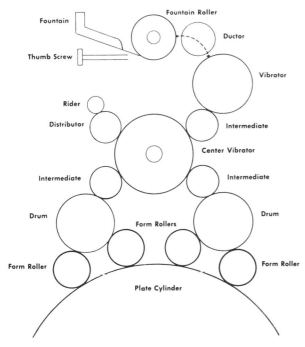

Schematic of typical inking system.

THE THREE MAIN SECTIONS OF THE INKING SYSTEM

For convenience, the inking system of the lithographic offset press is considered as having three distinct sections: (1) The ink fountain, or reservoir, section; (2) The distribution section; and (3) The form roller section. Each of these three sections is individually discussed in the following.

The Ink Fountain Section. The ink fountain is a reservoir for the ink supply. Its peculiar shape and position—a "V" lying on its side—is not accidental. One leg of the "V," the upper one, is actually a steel roller and is called the fountain roller, or fountain ball. The other leg of the "V" is a blade set to have one edge very close to the fountain roller and capable of having the space between blade and roller adjustable. The fountain roller is rotated intermittently against the blade and draws ink through the gap set between the roller and the blade.

Ink fountain systems are becoming available that improve considerably on this very old design, but the principle of drawing ink through an adjustable gap is still a feature of these new ink fountain designs. Only a completely new approach to inking the lithographic image could result in a radical change in the ink-feeding system.

When the fountain roller rotates, a resilient ductor roller is held against it and picks up a supply of the ink drawn through

the fountain. The amount of fountain roller rotation and the gap set between roller and fountain blade combine to give control of the amount of ink that the ductor roller picks up and carries to the distribution section. Changing the amount of fountain roller rotation, while the ductor roller is in contact with it, governs the supply of ink across the entire roller train. Changing the gap between fountain roller and fountain blade can be accomplished in order to control the amount of ink flow within a specific area along the horizontal dimension of the plate.

The Ink Distribution Section. The distribution section usually comprises metal drums (sometimes called storage rolls) and a series of resilient rollers in conjunction with metal. Some of the smaller-sized presses, especially those of the duplicator type, use hard rubber or Bakelite instead of metal rollers. Many modern presses use copperplated metal rollers since copper is one of the most ink-receptive metals. Where a press is not equipped with copperplated rollers, the press operator may chemically copperplate them periodically. Examination of a roller train will show that there is always a resilient roller between any two hard rollers (metal, rubber, or Bakelite). The train itself is driven through gears or chains that connect the driven metal drums to the main drive of the press. The design of the drive is such that the "surface" speed of the rollers is exactly that of the lithographic plate when it is packed to proper printing height. All the resilient rollers are driven through friction contact, directly or indirectly derived from the drums. It is extremely important to know, and remember, this point. Under no circumstance should a condition be permitted to exist where the form rollers are driven as a result of friction between them and the plate. These rollers must be driven through friction between them and the press-driven metal drums.

The distribution section is so designed that between fountain and form rollers the ink is "worked" considerably. The form rollers, consequently, receive a constant and prorated supply of properly conditioned ink for each impression the press makes.

In the designing of the inking unit, attention has been paid to the number of separate rollers required. This number is important because the number of times the ink film is split when transferring from one roller to another roller is a factor in conditioning the ink. Another design feature that should be noticed is that the driven drums oscillate sideways. This motion assists in working the ink because it is an action similar to grinding. This oscillation helps prevent "ridging" of the ink by accomplishing lateral distribution. The circumferential distribution is accomplished by the use of drums and rollers of different diameters. Last, but not least, if the flow of ink from the ductor roller to the form rollers is traced, it will be noted that the feeding and working of the ink is accomplished in such a way as to result in a uniform film of ink around the vibrating metal roller immediately above the soft form roller and uniformly distributed across that same hard roller. Thus far, it has been impossible to attain an ideal condition of complete uniformity. The press manufacturers, however, have always striven and still are striving to achieve such a system.

The Form Roller Section. The form roller section consists of two to four form rollers, depending on the press size. Some of the presses with four form rollers have, in addition, one intermediate hard roller, sometimes self-oscillating, between the

two pairs of form rollers. This arrangement is another attempt to achieve an ink film of prorated thickness on all form rollers at all times. The form rollers are sometimes more resilient, by comparison, than those used in the distribution system and are made of rubber or synthetic composition. Each form roller is driven by one of the metal drums and is, of course, so set that it makes proper contact with the lithographic plate when the press is running. The form rollers are, as previously explained, not driven by the plate but through the drums if set properly.

In general, the form rollers are usually of differing diameter. It has been established that uniform form roller diameter leads to "ghosting" problems, especially when light tints are being run. For this reason, in recent years, the inking system has been so designed as to accommodate form rollers of different diameters. Sometimes all four form rollers are different; in other cases, the first and last roller have one size, while the in-between rollers are each of a smaller size. On a press not supplied with form rollers ground to different sizes, the rollers maybe changed, provided the press design permits accommodation of a roller size different from the manufacturer's original specifications.

The inking system is here described in more detail than might be expected. However, the author feels that a thorough knowledge of the subject, particularly of the design features, is a necessity for understanding the discussion on handling the inking system, which follows the presentation of the dampening unit, our next topic. It is understood, of course, that this discussion of the inking system, like all others in this chapter, is general in nature. Each manufacturer has expended large sums in research, engineering, and development. It is imperative that the press operator who is running the press follow the manufacturer's instruction manual for the mechanical details of handling its specific inking system.

THE DAMPENING SYSTEM

Of all the printing processes, only lithography requires a plate-treating system in conjunction with inking. It is easy to understand the reason for this requirement if one keeps in mind the peculiar nature of the lithographic plate. It is planographic, which means the image areas are on the same plane as the nonimage areas. The image areas are hydrophobic, which means they are not receptive to water. They do, of course, accept greasy ink. The nonimage areas are hydrophilic, which means they are receptive to water but resist greasy ink. It must, however, be understood at the outset that both image and nonimage areas must be continually treated during running to retain their individual properties.

It is true, of course, that the ink-receptive properties of the lithographic plate are quite difficult to destroy—if the plate is properly made. However, the water-receptive characteristics of the nonimage areas can be destroyed within a matter of seconds if, during running, the dampening rollers are kept from contacting the plate. A well-made plate, running on a properly operated press, will print a strong sharp image while retaining perfectly clean nonprinting areas for extremely long runs. This clean printing is true even in the infinitesimally small, clear spaces between dots of a 300-line halftone plate.

The Main Components of the Conventional Dampening System. The conventional dampening system of the litho-

graphic offset press consists of three basic components: (1) The water fountain; (2) A vibrating distributor roller; and (3) The form dampeners. The water fountain, generally called the pan, is a reservoir for the dampening solution applied to the plate. In it is a roller that may be either brass, chrome plated, or cloth covered. In rotating, this roller lifts some solution out of the pan. Another roller, the ductor, rests intermittently against the water pan roller. The ductor roller is generally covered with a fairly thick, absorbent cloth, known as molleton; it soaks up solution from the water roller. The ductor oscillates between the pan roller and a metal distributing roller. When the ductor roller contacts the metal distributor roller, some of the surplus water is transferred. The distributor roller, in turn, spreads this solution evenly over the entire surface of two dampening form rollers with which it is in constant contact. These are also covered. The dampening rollers deposit solution in the nonprinting areas of the plates just before the plate passes the inking form rollers.

This description makes the dampening system appear to be a rather simple device. This conception is admittedly true. However, the tremendous improvements in lithographic plate-making techniques made in recent years seem to justify the feeling that the dampening system was not the cause of many of our troubles in the past. The basic fault was poorly made plates resulting in unduly severe demands on the dampening system.

In recent years, more has been learned about making better plates and also about the chemistry and mechanics of dampening. In addition to research on dampening itself, much work has been done to find another and better method of dampening to

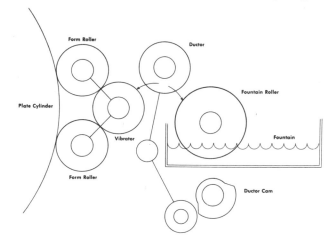

Schematic of a conventional dampening system.

keep the nonprinting areas of the plate absolutely clean during extended periods of running.

The reader must always keep in mind that just as the inking form rollers contact both the image and nonimage areas of the plate, so do the dampening form rollers. While the form rollers of the inking system *tend* to resist water, especially because they are covered with greasy ink, they will pick up some dampening solution, especially if an excessive amount is being supplied to the plate. The dampening rollers are not too well protected because of the very slight amount of solution carried by them. Therefore, they are easily greased by the ink on the plate unless both the inking and dampening systems are very carefully handled. A greasy dampening system will not function with even the slightest degree of efficiency and consistency.

New Dampening Systems. Most of what has been written here is oriented to conventional dampening, that is, a system employing a water pan (the fountain), water pan rollers, ductor roller, vibrator, and dampening form rollers. It is, by far, the widest used system. Over the years, much work has been done in three directions: (1) To improve the materials used in the system; (2) To improve the system by modifying designs; (3) To change, entirely, the dampening method. (Technically, there is even a fourth—to eliminate dampening completely—but this is still a dream for the future.)

The most important recent changes in materials are the development of paper covers and soft rollers with no covers (bareback) for the dampening form rollers. These developments are discussed more fully in the section on handling the dampening system. Recent modifications in the system have been aimed at improving the feeding of water to the vibrator. In one method, a constantly revolving brush (or assembly of narrow brush wheels) replaces the ductor and, through contact with the pan roller, flicks water to the vibrator. The speed of the motor-driven pan roller and the pressure of the rotating brush against the pan roller are variable for controlling the amount of water distributed to the dampener form rollers. One adaptation of this system uses a series of "flicker" fingers mounted above the brush and spaced across the full length of the brush or assembly of brush wheels. With this device, zonal control of water fed to the plate may be controlled by independently adjusting pressure of individual flickers against the constantly rotating brush. Another method feeds water to the plate dampening segment of the system by throwing water from the spinning action of a series of rotors combined with vanes for directional control. A similar system uses a series of jets across the dampening system through which water under pressure is sprayed into the plate dampening section of the system. Another technique for feeding water uses a rotating shaft on which flaps of leather or molleton are mounted. This assembly replaces both the ductor and pan roller. As the shaft rotates, the flappers pick up moisture from the pan and wipe the moisture on the vibrator rollers. The two common features of all these approaches to dampening are: (1) The feeding of water into the system is constant rather than intermittent, as is the case with the pan roller/ductor roller assembly of a conventional dampening system; (2) There is no direct line of contact from the plate back to the water supply, which prevents contamination of the dampening solution by ink that may be picked up from the plate by the dampener form rollers. In all other respects, dampening is by the "conventional" system.

The conversion of newspaper letterpress printing to lithography has fostered a number of unique approaches to dampening. In addition to adapting newer dampening systems that had been successfully applied in commercial lithography, these unique systems ranged from spraying dampening solution directly into the inking system to mixing dampening solution directly into the ink and applying the ink/water mixture through the existing ink feeding systems. Whether these "unique" systems could be utilized on commercial lithographic offset presses is not known at this writing.

Within recent years, the Dahlgren dampening system has gained acceptance and, in fact, stimulated most of the new approaches to dampening that have been described. The basic principle of the system is not new. It is based on using the inking system to carry the required moisture to the plate, as well as the ink. But until Harold Dahlgren, a press engineer, tackled the problem, the basic principle was used only in the offset duplicator field. The Dahlgren dampener retains the familiar water pan with its water pan roller. However, this roller runs in constant contact with another roller. One of these two rollers is a chrome-plated steel roller; the other is a soft roller. Which of the two is the pan roller depends on particular press requirements. Another feature, peculiar to the system, is that the rollers are driven completely independent of the press and that their surface speed is not the same as that of the plate. The hard roller in the system rubs against a special no. 1 inking form roller. In systems supplied by Dahlgren, their special roller replaces the press manufacturer's no. 1 form roller. One adaptation of this system retains the original no. 1 form roller but includes a separate roller that is in constant contact with the chrome roller in the water fountain section of the system. The rubber roller meters the water film on the steel roller. The steel roller runs against the form roller, which usually serves also as the first form roller. The direction of rotation of the plate cylinder in relation to the form roller is such that water deposited on the ink roller contacts the plate first, rather than being carried up

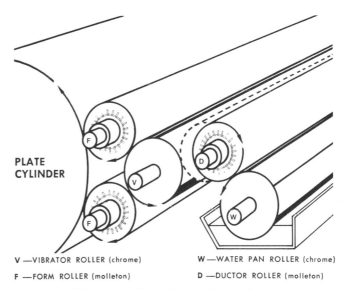

V —VIBRATOR ROLLER (chrome) W —WATER PAN ROLLER (chrome)

F —FORM ROLLER (molleton) D —DUCTOR ROLLER (molleton)

The conventional dampening system.

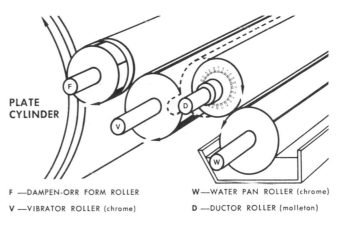

F —DAMPEN-ORR FORM ROLLER W —WATER PAN ROLLER (chrome)

V —VIBRATOR ROLLER (chrome) D —DUCTOR ROLLER (molleton)

The Dampen-Orr system.

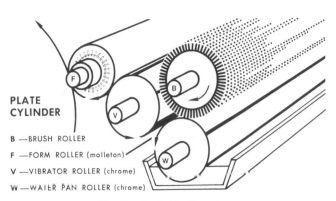

PLATE CYLINDER

B —BRUSH ROLLER
F —FORM ROLLER (molleton)
V —VIBRATOR ROLLER (chrome)
W —WATER PAN ROLLER (chrome)

The Harris-Cottrell system.

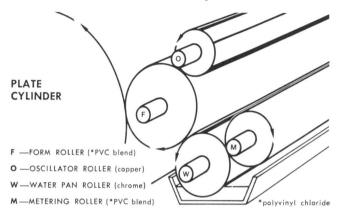

PLATE CYLINDER

F —FORM ROLLER (*PVC blend)
O —OSCILLATOR ROLLER (copper)
W —WATER PAN ROLLER (chrome)
M —METERING ROLLER (*PVC blend)

*polyvinyl chloride

The MiehleMatic system.

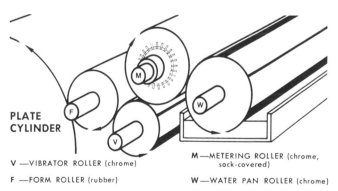

PLATE CYLINDER

V —VIBRATOR ROLLER (chrome)
F —FORM ROLLER (rubber)

M —METERING ROLLER (chrome, sock-covered)
W —WATER PAN ROLLER (chrome)

The miller-meter dampening system.

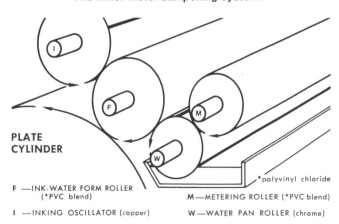

PLATE CYLINDER

F —INK-WATER FORM ROLLER (*PVC blend)
I —INKING OSCILLATOR (copper)

*polyvinyl chloride

M —METERING ROLLER (*PVC blend)
W —WATER PAN ROLLER (chrome)

The Dahlgren dampening system.

into the ink train. Control of water supply is attained through speed control of the pan roller as well as the adjustable squeeze between the rubber roller and the intermediate steel roller.

The Dahlgren approach to dampening introduced several new features: (1) Replacement of some of the water—usually 20% to 25%— with isopropyl alcohol; (2) Carrying the plate dampening solution on an ink-covered form roller; (3) Dampening solution recirculating systems in which it is simple to incorporate temperature control, filtration, and automatic alcohol and fountain solution concentrate ratios.

A description of the inking and dampening units is now completed, and the handling and operating of both systems can be discussed.

HANDLING THE INKING SYSTEM

The general characteristics and functions of the inking system are described in the previous section. Insofar as selection and principles of handling rollers are concerned, the problems here are similar to those discussed in connection with the offset blanket. "Soft" rollers (all those other than steel, hard rubber, and Bakelite) are available in synthetic rubber and various plastics. These materials have special properties and will very satisfactorily do the job for which they were designed, provided they are selected intelligently and handled properly. The best advice is, again, to pay heed to the press manufacturer, the roller maker, the ink maker, and your supplier of solvents and similar materials. Their advice and instructions must be followed; then, and only then, can they be held responsible for results.

If the system is adjusted to the press manufacturers' specifications, if it is kept clean with hard rollers properly sensitized (ink receptive) and the surface of the rollers properly conditioned and not too hard, and if the proper kind of rollers are used with the particular kind of ink, the system will perform. It is assumed, of course, that ink and water are in proper balance and that the dampening solution is compatible with the plate and ink being run.

The handling of the inking system is divided into the following seven points: (1) Keeping the fountain clean; (2) Setting the fountain blade; (3) Regulating the ink flow; (4) Adjusting and setting of rollers; (5) Washup procedures; (6) Steel drums and rollers; and (7) Storage of rollers. Each of these points is now discussed.

Replacing the fountain blade.

Checking aperture between fountain blade and fountain roller with feeler gage.

Keeping the Fountain Clean. As simple as the fountain is, it is very often seriously damaged because of improper handling. There is no excuse for this because it does not take any longer to handle it properly than improperly. A fountain in good condition is actually not only a timesaver, but a back saver. The need for cleanliness is not difficult to understand when a job printed in black ink is followed with a process yellow ink for a four-color process job. But a sloppy washup can result in an aggravating amount of trouble caused by dirty fountain keys, a buckled fountain blade, or a scored fountain roller. When a fountain is cleaned, it is important to see that *all* parts of the fountain are clean. The keys should be clean of ink and solvent. The base of the fountain and such rods or bars as may be located under the fountain should also be clean and dry. Periodically, all keys should be taken out, and both keys and keyholes should be carefully cleaned. Where grease is allowed, to prevent ink from drying in the side blocks, it should be used as directed.

Setting the Fountain Blade. After cleaning, the blade is put back in the fountain. Some presses have fountain blades that are not removed from the press. The blade is so mounted that it drops back and down, away from the fountain roller. However, after cleaning, the blade is swung back to its operating position and then handled as described here. The press operator makes certain that it is seated in accordance with the manufacturer's instructions. Now, all keys are started in their respective holes. The center key is turned up until it just touches the blade and starts to push the blade towards the fountain roller. The same is done with all other keys—working from the center out. Now the gap between blade and roller is gradually achieved, always working from the center out to both ends.

Judgment, developed through experience, is the only real

Schematic showing how a buckle may be developed in the fountain blade.

guide for this operation. However, a good start is often possible by setting the blade using a 0.005-in. feeler gage. From this original setting one comes up again gradually, always working from the center to either end. If the gap between blade and roller appears to change at some other point than at the particular key actually being set, it signifies that the blade is buckled. In this case, the blade should be replaced since these buckles cannot be overcome by setting the keys.

After the initial setting, ink is put in the fountain and the roller turned continuously. Now, the amount of ink flow can be further adjusted for the job on hand. Where overall adjustment is required, the press operator works again from the center out when closing the gap and from the ends to the center when opening it. Following this rule will go a long way toward preventing buckles in the blade. One thing that should never be done when setting the fountain blade is to set any part of the blade so tight that it actually scrapes the roller clean. In this case, the roller may be scored and will definitely grind the blade because there is no lubricating action by the ink. Regardless of how little the required ink flow may be in a particular area, it can always be achieved without ever scraping the roller clean.

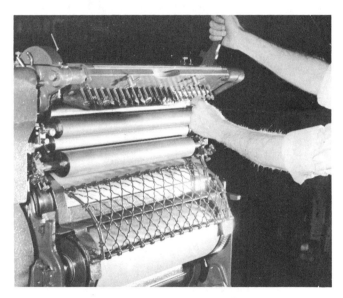

Final setting of the fountain.

Regulating the Ink Flow. The amount of ink flow from the fountain is governed by two things: (1) The amount of ink passing between the blade and fountain roller; and (2) The distance through which the roller turns during the time when the ductor dwells against the fountain roller. This distance is adjustable by a ratchet or some other device at one end of the fountain. The fountain should be set in such a way that the device is set at about three-quarters of the full swing—the bigger the swing the better! In other words, a thin film of fresh ink deposited around one-third of the ductor roller surface is better than a thick film deposited around one-sixth of the ductor roller surface. The reason for not setting the fountain feed for the full swing is easy to see: if it is necessary to increase the overall ink flow, there would be no adjustment left at the fountain ratchet and the press operator would be forced to make the adjustment at the keys. The key adjustment is, of course, far more troublesome and time consuming.

When an extremely light flow of ink is desired over the entire plate, a spiral may be cut out of a spare ductor roller. This roller can be kept in roller storage for use whenever needed. A spiral cut out of the ductor leaves a smaller area for contacting the fountain ball. Then the fountain ratchet can be set for a good swing of the roller and not feed too much ink. Finally, the ductor roller must be checked for parallelism with the fountain as well as with the ink train. The fountain is usually so mounted that it can be shifted slightly to be made parallel with the ductor roller after the ductor roller has been paralleled to the ink train.

Adjusting and Setting of Rollers. On the lithographic offset press, the soft rollers are usually adjustable in at least one direction. In some cases, they may ride free and depend on their own weight for proper contact. This situation is especially true with riders and distributors in the ink train; none of these are driven by the inking system drive. They are driven by the friction between soft and hard rollers in contact with each other, or contact between a soft distributor or rider with a driven drum or vibrator. The manufacturers' manuals give clear instructions on this point. In this Manual, concentration is on general problems in order to provide some practical hints on the handling and setting of rollers.

The universally accepted method of setting the rollers in the inking system is by inserting a set of thin paper strips. This set is made of two strips about 2 in. wide and a third strip about 1 in to 1½ in. wide.

The narrower strip is sandwiched between the two wider strips. These three strips are inserted between the rollers to be adjusted, or between roller and plate. A set of strips is inserted near each end of the roller being tested. By pulling on the center strip, a fairly accurate and even setting can be made. What amount of tension on this center strip is required for a good setting is learned by experience. Size and hardness of the rollers are two factors that determine the pressure required. When rollers are changed in the press, this adjustment procedure should be used before any attempt is made to ink up the system. This procedure assures a sufficient squeeze between rollers to satisfactorily distribute ink and, at the same time, prevents the damaging of composition rollers as a result of excessive squeeze even though, at this point in the procedure, the press won't be run for any length of time or at high speed.

After the fountain has been set for even inking across the press, and the rollers have been checked with the paper strip sandwich, the system is inked by idling the press with the fountain trip released so that ink will feed into the system. When the ink film on the rollers appears to be of normal running thickness, the fountain is tripped off and the ink train is dropped to the plate. The plate should be one that is "dead" or, at least, has been carefully gummed up before the roller setting procedure was started. To help assure proper roller setting, the plate must be packed to normal height.

When the plate is solidly rolled up, the press is stopped in such a position that the form rollers are resting on the plate. This position *must* be reached without jogging the press. The press is allowed to stand for a few seconds. This procedure allows for "beads" to form at each roller nip. The roller-setting system being described makes it possible to actually measure the nip widths (the distance between the beads) and, as a result, achieve accurate settings. Viewed from the operator's side of the

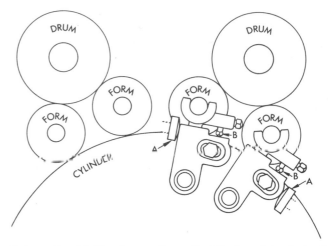

Schematic of inking form rollers. A: Adjustment to drum. B: Adjustment to plate.

press, the plate cylinder rotates in a counter-clockwise direction, the form rollers rotate in a clockwise direction; and the vibrators immediately above the form rollers rotate in a counter-clockwise direction. By reverse jogging the press, the bead formed between the no. 1 form roller and its vibrator will be brought into view. The distance between the beads should be measured and the roller-to-vibrator adjustment made to result in the desired line width between the beads. Rollers of the proper durometer should be so set as to give a nip of 1⁄16 in. per inch of soft roller diameter. All the form roller/vibrator nips should be based on this calculation whether the form roller diameters are the same or differ, as they do on most presses.

A brief study of the inking system on the particular press should indicate to the press operator the easiest sequence for exposing all the form roller/vibrator nips to minimize the number of times the rollup must be repeated and should indicate the form or distributor rollers that may have to be temporarily lifted out of the way in order to expose a particular nip. With a little practice, the procedure becomes quite simple.

After *all* form roller/vibrator nips have been set, basically the same procedure is followed to make the form roller/plate nip adjustments. The press is idled with the inker down on the plate.

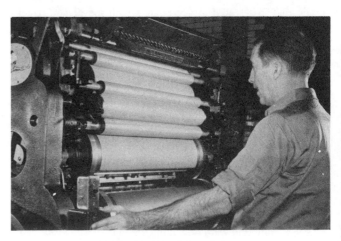

Preparing for picture test.

Picture on plate of two of the form rollers.

Picture of form roller-to-drum bite.

When the rollup appears to be smooth—all the earlier beads smoothed out—the press is stopped with all form rollers on the plate. As stated earlier, this position must be reached without jogging. The press is permitted to stand for a few seconds, and then the roller train is lifted. The press is then jogged to bring into view all the form roller/plate beads. These are measured, and the required adjustments are made.

There is considerable divergence of opinion about how wide these nips should be. However, one cardinal rule *must* be followed: *The form roller/plate nip should never be wider than the form roller/vibrator roller nip;* better yet, it should be a bit smaller to make certain of the previously stated condition. One school of thought advocates setting the nips at $\frac{1}{32}$ in. smaller than the form roller/vibrator nip. Another school of thought believes that the plate nip width at the no. 1 form roller should be just a trifle smaller than its vibrator nip, with the plate nip of the other rollers successively smaller; the no. 4 form roller will have the smallest nip. Whichever system is used, the plate nip for each roller *must* be no greater than its respective vibrator nip; a bit narrower nip is preferred to make certain that no form roller is being driven by the plate.

It was mentioned earlier that composition-roller hardness is one of the factors determining the amount of pressure between soft and hard rollers required to produce a desired nip—the harder the roller, the greater the pressure required. However, rollers that are too hard should be changed. While this requirement has always been known and generally accepted, the industry has tended, in the past, to overlook this requirement. Recent research has proven that soft roller durometer is, in fact, very critical. New form rollers should have a Shore A durometer of 25 and be taken out of the press when they have hardened to a reading of 35. Depending on how well the inking system has been maintained, the pulled rollers may be brought back to an acceptable durometer by hand cleaning and scrubbing or surface grinding. Soft rider and distributor rollers should have a durometer of 35 when first received and will perform satisfactorily up to a durometer of 45.

Washup Procedures. Modern washup materials and techniques considerably reduce the need for pulling rollers out of the press for hand cleaning. Rollers also do not require washing with harsh solvents, scraping, and, as used to be sometimes the case, even grinding. The newer materials dissolve all gum out of the roller's pores as well as remove all ink, varnish, and resin off the rollers. In fact, they do such a perfect job that old rollers, often only held together by dried gum, ink, and varnish,

Comparing roller bite on plate with that on drum.

Pumicing an inking roller.

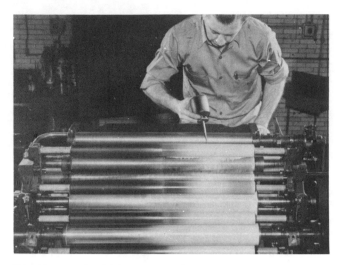

Washing up the inking system. Note that only one-half at a time is done.

Chemically copper-plating the steel rollers.

practically disintegrate when cleaned by these methods. But such rollers should not be in the press anyway! Again, the supplier should be relied on for the proper materials and instructions. Then, the supplier may be held responsible for the results, or a switch to another material can be made.

These newer washup materials generally require a two- or three-stage washup procedure. To really clean the rollers in an ink train requires more than a single solution or a one-stage procedure, since getting dried gum out of the ink rollers presents an entirely different problem than cleansing the train of ink. These multistage materials, as a general rule, are not used for routine washups. If used once a week, they will keep the system really clean and the rollers in good condition, thereby eliminating an important cause of hickeys and roller stripping. These materials will also prevent excessive emulsification, to some extent at least. These characteristics, however, don't permanently eliminate the need for periodic hand-cleaning of rollers removed from the press.

A prolific source of hickeys in the print—they look and test like "inkskin" hickeys—is the "cuff" of the ink/solvent combi-

Stripped rollers.

nation that forms at the end of all rollers during washup. The formation of these cuffs is inherent in the design of the ink train and the mechanics of the "washup" machine. The cuffs should be wiped off the roller ends at the end of each washup. If the cuff is never allowed to build up in the first place, cleaning off the fresh, wet cuff is quite easy and not too time consuming. Jogging the press while holding a washup rag against the ends of the no. 4 form roller will draw the cuff-forming material completely out of the system. If the cuffs are allowed to build up, they eventually start to chip; the chips often become inkskin hickeys. In addition to this problem, as the cuffs build up, they cause deterioration and cracking of the roller ends. Once this starts, there is no saving the roller, it must be re-covered.

A most important factor in the maintenance of a good inking system, which, incidentally, will also minimize formation of cuffs, is the technique of the washup (regardless of solvent(s) used). Just enough solvent should be applied at the top of and completely across the ink train to start dissolving the ink. The washup blade should be brought into contact with the drum after the loosened ink begins to flow down the train. After the washup machine is engaged, just enough solvent is applied to continue the flow of dissolved ink and solvent. A minimum amount of washup, applied in a series of steps, will clean the system more thoroughly and quickly than a large amount of solvent applied just a few times. If free solvent splashing around is noticed in the nip where it's applied, it means too much solvent is being applied. Some of this splashing results in accumulations of dried ink on tie and support bars in the train. This splashing is also a source of inkskin hickeys. Too much solvent applied at any one time causes the friction driven rollers to skid, and some damage to the face of the rollers results. These results have been proven through exhaustive tests by both GATF and the solvent manufacturers.

Steel Drums and Rollers. Another important factor in good inking is the nature of the metal rollers in the train. The driven rollers—vibrators, drums, etc.—are usually copperplated. Copper is highly ink-receptive and resistant to sensitizing by the gums and acids in the fountain solution. The metal riders and distributors are usually steel. Steel has quite an affinity for water,

and after a time, gum from the fountain solution begins to dry on steel rollers. This condition is especially true if too much acid or gum is used in the fountain solution. Another source of this trouble is the bad habit of permitting the strong acids from the plate etches to get into the ink train. This situation occurs if the plate etches are not rinsed off the plate thoroughly when starting the press. When this contamination happens, steel rollers lose their affinity for ink.

GATF has developed a method of chemically copperplating steel rollers during the washup operation. The plating lasts quite a while, except on the roller that contacts the scraper blade of the washing machine. However, since chemical plating is done so easily and the materials are so inexpensive, this single disadvantage is very inconsequential.

Storage of Rollers. Spare form rollers, whether new or old, should never be stored without first being thoroughly cleaned and conditioned. This condition should be similar to that of a restored blanket. If proper, modern washup techniques are not being used, this conditioning operation may be a lengthy and vigorous one. If the inking system is handled properly, all that may be required is to powder the roller and stand it in the roller locker. If harsher methods must be used, the advice of the supplier of the rollers is to be followed.

Rollers should never be stored in a horizontal rack. They should always be in an upright position. When handling them, care must be taken not to bounce them on an end or drop them. A large roller, especially, can be easily bent, and the slightest bend will make proper setting in the press impossible.

Rollers should be stored in a locker that can be kept closed. If this arrangement is not possible, the roller rack should be in a dark, cool area. Sunlight should never fall, for any length of time, on "soft" rollers. When a roller is put into storage, its surface should be protected. Whether to use only powder or vaseline, or similar products, should be determined by discussion with the roller manufacturer.

HANDLING THE CONVENTIONAL DAMPENER

The "conventional" dampening system is still the most widely used one and is pretty much the same as that used since the times of stone lithography. This lack of essential change is true in spite of the fact that the dampening function is the one area of press design that has received considerable attention, by engineers and chemists, to find a better way of maintaining clean nonprinting areas of the plate.

The purpose and problem of dampening, discussed earlier, is worth repeating again, before discussing the actual handling of the conventional dampening system. When the functions of the inking system were described, in the preceding subsection, it was mentioned that some dampening solution is picked up by the inking system. It was pointed out that this pickup was not harmful within certain limits. In fact, if this pickup didn't happen, it wouldn't be possible to print lithographically with any high degree of success. However, the dampening system—unlike the inking system—has just one, and really only one, function. This function is to dampen the nonimage areas of the plate. And the conventional dampening system must do this nonimage area dampening while, at the same time, resisting the picking up of any ink from the image areas. The conventional dampening system and the dampening solution do this resisting

A dampener roller washing machine for molleton-covered rollers.

by a combination of mechanical actions and a chemical reaction with the chemical nature of the nonprinting area's surface.

In actual practice, this resisting is virtually impossible. But if the fountain solution is compatible with plate, paper, and ink used on a specific job, if the inking and dampening systems are properly adjusted, if the correct amounts of ink and water are fed to the plate, then there should not be too much trouble with the form dampeners becoming dirty and greasy too quickly. If and when they do, the dampening rollers should be pulled out of the press and cleaned immediately. For this reason, a spare set of dampeners should be available at all times for each press. The changeover does not take too long, and the dirty set can be washed away from the press.

In recent years, dampener washing machines have been developed that do an excellent job of cleaning, provided that ink has not been permitted to dry on the molleton with which the dampening rollers are usually covered. These washing machines are also excellent for "running-in" a freshly covered dampener, if molleton is being used as the cover. They save time and trouble on the press by removing the lint, fuzz, and loose fibers from freshly covered dampeners, preventing these materials from reaching the ink train or the plate. Once a dampener has been used, it must always be put back in the press without turning it end for end. If it is put in wrong, the twist of the covering, caused by its original use, will be reversed and the whole cover becomes loose and baggy.

Many of the press troubles in the past have been blamed on the need for, and the method of, dampening the lithographic plate. However, the problems have decreased, although it is hard to tell how much of this decrease is due to improved plates. But work is constantly going on to improve dampening methods. One simple improvement, the use of paper or thin cloth dampener covers to replace the molleton, is mentioned further down in this presentation.

The details of handling the conventional system is treated as follows: (1) The water fountain; (2) The ductor roller (3) The dampener vibrator; (4) Care and adjustment of dampening form rollers; (5) Dampener covers; and (6) Starting the dampening system.

Typical dampening system. Note bare pan roller and molle-
ton-covered ductor and plate-dampening roller, water pan.

Several types of pan roller motor drives.

The Design and Functioning of the Water Fountain.
The fountain of the conventional dampening system has the
same function as the ink fountain. However, because of the
nature of the fountain solution—usually over 98% water, local
controls across the plate are crude by comparison to the
controls available for handling the ink fountain. As stated
above, however, work is constantly being done to improve the
operation of dampening.

The fountain roller revolves constantly, and part of its surface
is always immersed in the fountain solution. The fountain roller
is a metal roller, sometimes used bare and sometimes covered
with cloth. A ductor roller, covered usually with a molleton
sleeve, oscillates between the fountain roller and the dampening
vibrator roller, which is also a metal roller. The length of time in
which the ductor roller "dwells" against the fountain roller
governs the amount of water that will be fed to the vibrator

periodically. Like ink, fountain solutions are not always fed with
each revolution of the press. On some presses the fountain roller
is driven by its own motor. This arrangement gives additional
control over the amount of fountain solution.

The Dampener's Ductor Roller. The ductor roller of
the conventional dampening system transfers dampening solu-
tion from the pan roller to the vibrator. It should be recognized
that this system of feeding water results in some surging of
dampening solution to the plate since the feeding of solution is
intermittent rather than continuous. Traditionally, the ductor
roller is molleton-covered with a rubber or other soft base.
Increasingly, press operators are favoring the use of a "bare-
back" ductor, the body of which is a rubberlike plastic formu-
lated to be hydrophilic. The manufacturers subject the surface
of the roller to a grinding treatment that produces a roughened
grainy surface; this treatment improves the roller's water-
carrying characteristics.

Courtesy Harris Corporation

Another dampening system. Note water stops and cloth-
covered pan roller.

Setting dampening form roller to plate.

Setting dampening form roller to vibrator.

The Dampener Vibrator. The vibrator roller is always gear-driven through the main drive of the press, and its surface speed is identical to that of the cylinders. This roller does two jobs: (1) It drives the dampening form rollers; and (2) It equalizes the water feed across the dampening system through a considerable sideways oscillation. The two dampening form rollers are generally covered with molleton and, while driven by the vibrator, contact the plate with just enough pressure to dampen it. They must neither miss any part of the plate nor squeegee the plate because of excessive pressure.

Care and Adjustment of Dampening Form Rollers. Improper care and handling of the dampening form rollers is the most important cause of dampening troubles. When they are molleton covered, a perfectly true, even, and level surface is impossible to attain on these rollers. Therefore, and particularly if a light and even roller pressure on the plate is desired, every slight unevenness of the molleton-covered roller will immediately show up as a point of too much or too little pressure. Reasonable care when covering the rollers with molleton can help prevent these troubles. At the time when the covers were still sewn on, a great deal of skill was required to make a really good roller. Now, however, the dampener covers can be bought as presewn or prewoven sleeves. This situation, of course, simplifies the task but does not eliminate the need for good care.

Roller adjustments, as has been said repeatedly, should be checked periodically to make sure they have held their original setting. The manner of adjustment is generally similar to that of the inking form rollers: first to the vibrator, then to the plate, and the plate *must not* drive the form dampening rollers.

Dampening Roller Covers—Molleton. Molleton is a soft woven cotton fabric with a very high nap; the material is quite similar to turkish toweling and, like such toweling, the nap gradually wears out. From the lithographic point of view, the most important characteristic of molleton is its ability to hold a considerable amount of water. When molleton is wet, it will tend to resist being inked. However, it is not impervious to ink even when wet. Over a period of continuous running, especially

on heavily inked forms, the molleton-covered rollers will become contaminated. Many shops minimize downtime due to poor dampening performance by changing the rollers for each shift whether in a single-shift or multishift operation. A spare set of clean form dampeners is always available for this purpose. The form dampeners pulled from the press are cleaned in time to go into the press on the next shift. The cleaned dampeners may appear to be dirty. Unless ink has been allowed to dry on the molleton, because of running too long or improper cleaning techniques, this "dirty" appearance is due to staining of the molleton and does not affect plate dampening performance. With proper maintenance, a molleton-covered dampener will run a long time before the covering requires replacement. Such re-covering becomes necessary only when the nap has actually worn away.

The manufacturers of molleton do try to make the covering material as lint free as is possible. But some linting almost always occurs when newly re-covered molletons are put in the press. Rinse-washing a freshly covered set of dampeners in the roller-washing machine will remove most, if not all, the lint. If a washing machine is not available, a newly covered dampener should be thoroughly soaked with water, the excess should be squeezed out, and the roller rolled out on a clean sheet of uncoated paper that has no alum content. This procedure helps to get rid of some loose fibers and lint and also tends to condition the undercover—if one is used. As soon as the rollers are put in the press, they should be adjusted according to the manufacturer's instructions. Then the press should be idled, off the impression, until no more lint appears on the dampener vibrator. Lint, if it gets on the plate or up in the inking system, causes a defective printed image on the sheet, just as will a hickey stemming from any cause.

Thin Cloth Sleeves. Thin cloth covers come as prewoven sleeves that are pulled over specially rubber-covered or cloth dampener base material. The aim of these materials is to combine the advantages of the paper and conventional molleton-type covers. Sleeves of this type, however, are not available for larger presses.

"Paper" Covered Dampeners. These coverings are not paper, but do have the look and feel of heavyweight parchment paper. The coverings are a nonwoven material that is highly water-absorbent and ink-repelling. Originally, this covering material came as a 3-in.-wide roll and was applied by spirally winding the continuous strip on a specially made soft roller similar to an inking form roller. While some lithographers still use the strip covering, more easily applied sleeves of similar material are available.

When the sleeves appear to become dirty (with ink), they are easily wiped clean with a non-oily solvent, such as Stoddard solvent. After cleaning, the roller should be rinsed by wiping it clean with a water-soaked cloth. The roller may appear to be still dirty, but this is actually only a stain.

This paper covering is generally considered to have numerous advantages over cloth-covered dampening form rollers. The paper is considerably less costly than molleton or other cloth covering materials despite the fact that a paper cover does not last as long. Wrapping a fresh paper cover is much faster than putting on a cloth cover, even the sleeve-type cloth covers.

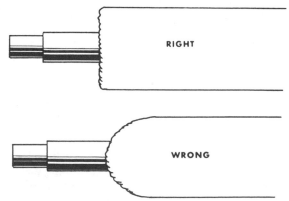

Molleton-covered dampening rollers. Top: tying the end of the sleeve-type molleton; Bottom: comparison of good and bad roller ends when using molleton-type sleeves.

Because the paper is not costly and because it is so easily replaced, there is no tendency to run a cover too long. Whenever a newly covered cloth dampener form roller is installed, the roller must be set for proper contact with plate and vibrator. These adjustments may have to be changed during the life of the cover because there is some decrease in overall roller diameter. This diameter decrease is not the case with a paper-covered dampener. With the fine-grain plates so widely used, the paper-covered dampener is able to lay down a more controllable thin film of water, which such plates require. With just reasonable care, these covers will not become greasy.

Experience has shown that best results are obtained with these paper covers when only one of the dampener form rollers is so covered. This roller should be run in the low position in the dampening system. A conventional cloth-covered dampener form roller is used in the upper position. However, this roller is so set that it touches the vibrator but not the plate. It performs the function of a storage roller. By putting it in the upper position, with the paper-covered roller in the lower position, the bead of water fed by the ductor roller is spread out before the vibrator feeds to the paper-covered form roller.

Some General Observations on Conventional Dampening. Some general comment is in order on this business of dampener covers. The author does not presume to be an all-knowing expert. And even if the author were, he would not flatly state a preference. What is said **emphatically** is that management as well as the person-on-the-bench should always be alert to new methods, materials, and equipment. Coupled to this alertness should be a real open-mindedness toward claims for new things. They should be tried, and in all fairness to everyone concerned, the trial should be an accurate one as well as one of sufficient duration. Those who introduce or try to sell "new" things should not be considered as peddlers, rather they should be looked on as technical advisors or ambassadors

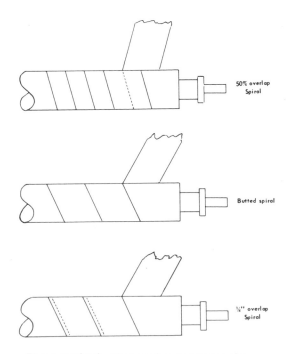

Three methods of wrapping paper covers.

representing the best that supplier research and development has to offer.

Starting the Dampening System. When starting the press, it is best to give the dampening system a priming by squeezing fountain solution from a sponge across the dampener vibrator roller while feeding from the fountain with the press idling. At this point, it should be noted whether the film of water on the vibrator (always a metal roller) is a continuous one. If the film is broken, it means the roller has a greasy area. Such an area must be cleaned immediately. How this is done depends on the metal used for this roller. The manufacturer's instructions for cleaning should be followed. If this roller is not chrome covered, it can be plated with a "porous" chrome plating. Chrome, under the proper condition (porous) is naturally water-receptive and resists becoming greasy. If the fountain roller is one that runs without a cloth cover, it should be treated like the vibrator roller. If it is cloth covered, it should be watched for any tendency to develop a broken film of water. If this break happens, the roller should be re-covered.

Auxiliary Conventional Dampening Systems Aids. While much time and effort has gone into attempts at radical changes in the dampening system, there has been developed and put into use a number of devices to improve the performance of the conventional dampening system. Among the oldest of these devices are those aimed at selectively changing amounts of water fed across the length of the water pan roller. For many years, press operators attempted to vary water feed with simple techniques using materials usually at hand—pieces of blanket, etc. But then, engineered devices were introduced such as squeeze rollers, metal scrapper fingers, squeegees, etc.

It has long been known that the level of water in the water pan should be kept constant as one of the necessary procedures to help maintain consistent dampening. This necessity meant constant attention and frequent addition of fountain solution to the pan. Simple devices to maintain the level of water automatically were developed rather early in the introduction of small offset duplicators. The success of these led to the development of fountain water level devices for larger presses. Today, it is rare to see any press not so equipped.

NONCONVENTIONAL DAMPENING SYSTEMS

While the press manufacturers and suppliers of press supplies have made great strides in recent years to generally improve the lithographic offset press, the one press area where the most radical improvement has occurred is in plate dampening. The one feature common to all of these newer dampening systems is that they are "continuous feed." It should be recalled, from what was stated earlier in this section, that water feed is intermittent in the conventional dampening systems; the resultant "surging" of water to the plate is measureable and, fortunately, tolerable so far as the effect on print quality is concerned. Continuous feeding of water eliminates this variable.

One of the more common ways of achieving continuous feeding of water is by replacing the ductor roller of the conventional system with a rotary brush roller or series of narrow rotary brushes assembled on a shaft. The brush roller is

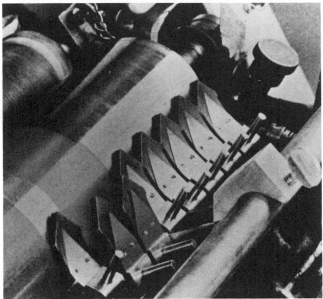

Courtesy Baldwin-Gegenheimer Div.

Variable dampening control across press.

mounted above and in contact with the pan roller. Pressure of the brush roller against the pan roller causes the bristles to deflect and then snap straight as they pass through the nip. The snapping action flicks water from the surface of the pan roller onto the vibrator of the dampening system. Amount of water fed to the dampener forms is controlled through speed and squeeze of the pan/brush roller combination.

The first application of continuous feeding of dampening solution accompanied the reintroduction of a totally different dampening procedure. This procedure involved carrying water from the pan to the plate via an ink-carrying form roller. The original concept dates back to the 1930s, when Sgt. Godike of the U.S. Army developed a system that performed fairly well on small duplicating systems. Making such a system work on

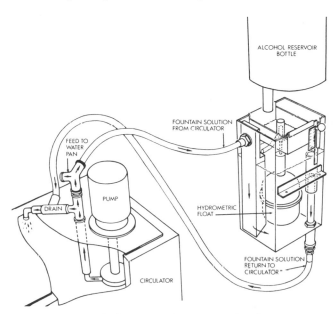

Baldwin circulating water level.

commercial presses—sheetfed, webfed and di-litho newspaper presses—was accomplished by Harold Dahlgren, a former press engineer and currently president of Dahlgren Manufacturing Company. The Dahlgren system is the most widely used of the nonconventional systems; several other available systems are patterned on Dahlgren's basic system.

To make such a system work, Dahlgren discovered that including isopropyl alcohol in the fountain solution (about 1 part alcohol to 3 parts water) made the system not only workable but a considerable improvement in the dampening phase of the lithographic press.

The use of alcohol in dampening solution formulation accelerated work in the chemistry of dampening generally. Part of this stimulation came about as a result of the rapidly increasing cost of isopropanol, partly as a result of the inherent toxicity and flammability of alcohol.

Another approach to continuous feeding is the use of spray devices, both mechanical and pneumatic. A radically different approach is being taken in the lithographically printed newspaper field. In this field, the fountain solution is continuously fed directly into the ink train, by either brush or spraying methods.

Handling Nonconventional Dampening Systems. Some detailed attention is given here to the Dahlgren system since, of all these newer systems, it is the most popular. With all these systems one rule is paramount. The manufacturer's instructions must be read, completely understood, and explicitly followed.

In the discussion on handling conventional dampeners,

considerable stress was given to the matter of cleanliness. Cleanliness is one of the three most critical factors in successful operation of a Dahlgren-type dampener. The entire solution-handling system must be cleaned periodically, at the very least when the press is shut down for a long period such as overnight or over a weekend. In addition, every press washup should include cleaning of the Dahlgren metering and chrome rollers in their respectively required manner.

A second important factor in achieving best possible performance of a Dahlgren dampener is the relative softness of the metering on Dahlgren form rollers. The recommended durometer (Shore A) of the metering roller is 12-15. When the roller becomes excessively hard, water bonding will occur. When this happens the roller must be removed. Depending on how well the system has been maintained, this roller may be thoroughly hand-cleaned, and its hardness brought back to a satisfactory durometer reading. If this is not attainable, the roller must be recovered. The same holds true for the Dahlgren form roller. This roller, when new, should have a durometer of 25-30. Up to a 10-point hardening may be tolerated before this roller must be reconditioned or recovered. These hardness/softness limits are especially critical where alcohol substitutes are being tried or used. Isopropyl alcohol is more "forgiving" than are solutions which substitute for the alcohol or a considerable portion of it.

The third critical factor in successful Dahlgren performance is roller setting. The manufacturer's instructions must be adhered to. The operator must recognize that the settings of the soft rollers in the Dahlgren system are quite different from the settings of the ink train rollers. If alcohol substitutes are used, the roller settings are more critical.

Section Seven: The Delivery

All sheetfed lithographic offset presses deliver the printed sheet by finally transferring it to a set of grippers moving on a continuous chain. The transfer may be direct from the impression cylinder to the delivery grippers or through intermediate transfer cylinders. But in general, behind and slightly below the impression cylinder (the last one on a multicolor press) is a

so-called "skeleton" or delivery cylinder. Actually, the delivery cylinder is not a cylinder but a pair of sprockets for driving the delivery chains, with segments and special devices for preventing the sheet from rubbing, whipping, or waving spaced between the sprockets. The travel of the sheet is so designed that it comes to the delivery pile faceup and with gripper edge

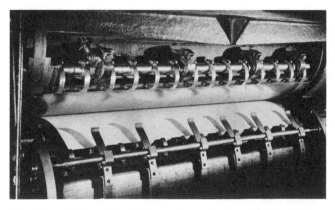

Sheet just taken from impression cylinder and in delivery grippers.

Delivering the sheet. Control of this curl is essential for good jogging.

toward the front of the press. The chains carry delivery gripper bars. These are so spaced that one of them is always in the taking position for each impression.

On smaller presses, the delivery pile itself is an integral part of the press. This arrangement, therefore, limits the number of printed sheets that can be piled on the delivery dolly without changing dollies. On larger presses, the delivery is built as an extension to the press permitting the delivery pile to generally be the same height as the feed pile.

Two-pile deliveries can be quite useful in some classes of work. They make possible alternate delivery of sheets to one pile and then the other. This alternation allows greater ink-setting time between delivered sheets. Such a delivery setup also permits removing a printed skid load without breaking the run. Two drawbacks to a two-pile delivery setup are: (1) The space required for the second delivery; and (2) The cost of the extra delivery. In recent years, the press manufacturers have developed simple and inexpensive devices that make it possible to remove a load from the delivery without stopping. These devices are quite similar to those used for continuous feeding in pile feeders, described in the feeder section of this chapter.

Some of the medium-sized, and even smaller, presses can be equipped with extension pile deliveries on special order.

DELIVERY GRIPPERS

Delivery grippers have the same problems as discussed in Section Four. But delivery cylinder grippers have an additional and most critical problem: that of perfect timing with the impression-cylinder grippers. If any appreciable gap exists between the closing of the delivery grippers and the opening of the impression-cylinder grippers, the sheet will be pulled away by its tendency to stick to the blanket. This pulling away leads to battered blankets and is the cause of ripped paper in the inking train. All makes of lithographic presses are provided with means for adjusting the delivery gripper timing, especially on such presses where the impression cylinder is adjustable. The necessity of this adjustment is the fact that blanket-to-impression-cylinder pressure must be adjustable in order to accommodate paper of a wide variety of calipers. In those cases where the impression cylinder is the press member that is so adjusted, adjusting the impression cylinder for change of paper thickness causes a change in the sheet transfer point. Where the change is a radical one, it becomes necessary to check transfer timing in order to assure good delivery transfer.

From watching the operation of the delivery, it may appear that the setting of delivery grippers presents about the same problem as the setting of grippers on a swing or transfer device. This notion is not true. The bite of delivery grippers must be as firm as the bite of the impression cylinder grippers. This requirement is because, at the time the sheet is transferred from impression cylinder to the delivery, the tail end of the sheet may still be in the nip or trying to follow the blanket. Any tendency to pull out may lead to a damaged sheet gripper edge or faulty delivery.

Because of differences in design, the manufacturer's instructions should be followed explicitly for setting delivery grippers and timing the delivery gripper bars.

SETTING THE DELIVERY

When the delivery is set, two things must be accomplished: to jog the sheets as perfectly as possible and to float the printed sheets onto the pile in such a way as to prevent smudging, smearing, or setoff. The adjustable joggers, usually on three sides of the sheet, should be so set that the sheet falls exactly between them when it drops down. Then, the sheet requires a minimum of movement to be jogged straight with the pile. But this aligning is often more easily said than done.

If static is present, the sheets may tend to drag at the back end

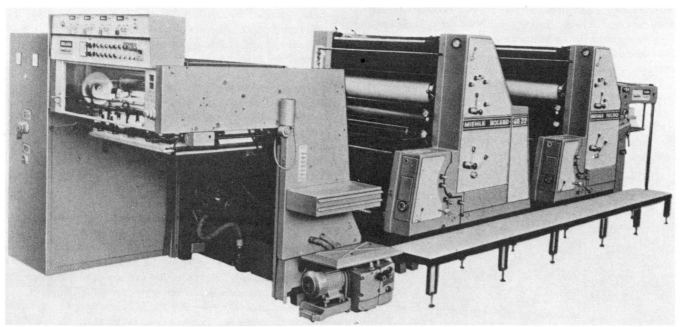

Courtesy Rockwell International

Two integrally built units can provide four colors. Note operating controls at end of press.

and therefore drop some distance from the front gate. In this case, the sheet must slide forward because of the action of the rear joggers (where they jog) and some smudging may result. Static can cause the sheet to "jump" to the pile rather than to float down on it, and this jumping will cause setoff.

Normally, static will not cause trouble in a properly conditioned plant. But in the dry atmosphere of a heated but not humidified pressroom, static can be a constant source of trouble during that period of the year when heat is required. There are several palliatives against static, but at best they are temporary and makeshift. For example, running the sheet over or under Christmas tinsel (but in contact with it) tends to bleed off the static. (Specially made tinsel woven on copper wire instead of twine is available for this purpose.) Antistatic chemicals are also available. About the only known cure for static, other than air-conditioning, is to equip the press with electrical or radioactive neutralizing bars. In extremely bad conditions, such bars may be required at both the feed ramp and the delivery. Sheet heaters are also useful in fighting static, but they can cause other problems that outweigh their usefulness.

Another most important factor is sheet curl, or tail-end hook. This trouble is caused by the peeling action when the sheet is pulled away from the blanket. There are any number of auxiliary devices to help overcome these delivery problems. The press operator, left to his own devices, can do very little about them. One simple trick at the operator's command is to place stock wedges in judiciously chosen spots. These wedges tend to guide the sheet without causing it to move unnecessarily. For example, if a bad tail curl is present, a wedge under each rear corner of the pile will tend to overcome trouble from curl during jogging.

Section Eight: Running the Press

In the preceding sections of this chapter, the handling of the main press units, with emphasis on preparing them to perform their functions in running, is discussed. This section on running the press is really an extension of these preceding discussions because running is the culmination of all those operations.

The problem of running is to see to it that all press units perform as they should. The ink fountain must deliver, consistently, the set amount of ink; the inker must unfailingly deliver for each impression the proper charge of ink. The dampening system must do the same with the fountain solution. From the very end of the feeder to the very front of the delivery, everything must function perfectly. Nor may the human element be overlooked. The performance of the press must be supervised by a human being. Supplying paper at the right time and in the proper condition for feeding is up to the press crew, which is also seeing to it that the water and ink fountain are properly charged.

This discussion of running centers, first, on three preparatory steps: the checking of paper, the preparing of the plate for running, and the getting of lay and fit. Thereafter, running itself is discussed in terms of maintaining the preparatory settings and the required quality throughout the total run, or for the complete production of a job.

CHECKING THE PAPER FOR RUNNING

It is assumed here that the requirements concerning paper (as discussed in the "Ink and Paper" chapter) are met by the paper to be used for running. This assumption implies that the grade, size, and quantity of the paper are correct. It is also assumed that paper conditioning, so far as moisture content is concerned, has been taken care of within the limitations of the plant. Under the worst conditions, the paper has, at least, been in the pressroom long enough to reach a temperature balance. This conditioning period is especially important in areas where winter temperatures are low enough to require heating of the plant. Even though the subject of paper is outside the scope of this chapter, four points very important to the subject of running are discussed: (1) Protecting paper before running; (2) Paper moisture content; (3) Protecting paper during running; (4) Lithographic quality control and paper testing.

Protecting Paper before Running. The paper should be in moisture-proof sealed wrappings. If the stock, as originally received, must be cut before going to press, it must be kept in its wrapping up to the moment of cutting and then resealed. This procedure is not as difficult as it seems. Plastic covers, which are designed for this specific purpose, are available in a variety of sizes. They come in two parts: (1) A bottom sheet, which is put down on the skid or platform; and (2) A top envelope section. The paper is piled on the bottom sheet, the top envelope is brought down over the pile, and the edges of the bottom sheet are brought up around the envelope and sealed with a pressure-sensitive adhesive tape. Thereby, the edges of the piled paper are exposed to the atmosphere for as short a time as is possible. This precaution can appreciably decrease the amount of press trouble due to tight- or wavy-edged paper.

Skids of paper that are going to run "as-delivered-by-the-mill" are easily protected between passes through the press or between final printing and subsequent processing. If the skid wrapper is carefully removed, it can be used as a skid cover. Slit

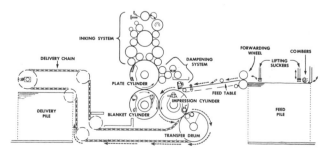

Schematic of the lithographic offset press.

the tape that fastens the upper wrapper to the base sheet and lift it off. When the printed pile is removed from the delivery, the upper wrapper is pulled over the skid and, if desired, can be taped to the original base sheet or a new one placed on the skid when it was placed in the delivery.

Paper Moisture Content. It is assumed that the paper has been tested for moisture balance with the pressroom atmosphere. Very few plants are equipped to do anything about attaining a proper moisture balance between paper and the pressroom atmosphere. However, if the press operator knows which way and how far the paper is out of balance with the pressroom atmosphere, the operator can take some steps to minimize the subsequent problems. For example, if a sheet is entirely too dry in comparison with the pressroom atmosphere, and if it is going to pass through the press several times, an experienced press operator knows that at least the edges will pick up moisture very rapidly and may become extremely wavy. (The press operator also knows that the entire sheet will pick up some moisture, up to a point, with each printing.) While picking up more moisture may tend to flatten out the wavy edges, this benefit is derived at the cost of overall growth of the sheet, in the across-the-grain direction especially. In this case, the press operator will have a problem of fit on subsequent printings. Perhaps this condition can be met by printing as "short" as is possible without reaching the point at which good quality suffers. "Short," as used here, is a relative term. "Printing short" implies that the plate and blanket cylinders have been packed in such a manner as to counteract the tendency of an offset press to produce an image on the paper that is longer than the image on the plate, as measured on the plate *before* it was put on the press.

Protecting Paper during Running. All these factors are covered in detail in the "Ink and Paper" chapter. Now, that the paper is on the press, it must be controlled whatever its condition may be. An important factor is the length of time the paper will be exposed to the atmosphere between printings. In an air-conditioned pressroom, with preconditioned paper, this exposure is not a problem. But in the average pressroom, steps must be taken to reduce the time of this exposure. The same covers as recommended previously for covering the paper between cutting and putting it to press can be used between runs too. Every pile of printed sheets must be sealed between printings, assuming that there is more than one pass through the press.

Lithographic Quality Control and Paper Testing. Paper testing must be an integral part of any quality control program. Much of the information required for paper testing is covered in the following chapter on paper and ink. Here only the basic concept will be introduced as part of running the press.

Paper usually represents the largest single item of "outside purchases" in a piece of printing. Paper unsuited to the job, or not properly handled, can represent not only a costly waste in cash dollars but, also, in lost press time, which can be even more costly when total costs of producing a piece of printing are determined.

There are a number of tests that can be made in the plant

Wet washing the plate. First the plate is sponged with water, then the image is washed out with solvent; the plate is then rinsed thoroughly to remove all trace of solvent, and finally the image is rolled up.

without the need for large investments in sophisticated and elaborate equipment. These are discussed in the following chapter.

PREPARING THE PLATE FOR RUNNING

At this point, it is assumed that the plate is already on the press and that it was under gum and asphaltum, or a built-in protective coating (by the plate manufacturer). The plate may have been rolled up solid in order to test the evenness of the blanket; then it may have been washed with an ink solvent and placed under asphaltum. The packed plate may have been used for setting the inking form rollers as well as to develop the proper transfer squeeze.

Bringing the Plate to Running Condition. The wide variety of presensitized plates available from a considerable number of suppliers, and the chemistry peculiar to each brand of plate, makes it impossible to lay down specific procedures for opening a plate after it has been mounted on the press. The best procedure is to follow the individual manufacturers instructions for the specific plate. For deep-etch and bimetallic plates, the following procedures are well established.

In actual practice, after the plate is mounted the press operator washes it with water and a sponge. The water dissolves the gum (even if asphaltum was applied over it) and lifts off the asphaltum from the nonimage areas. The press operator wipes the plate with a squeezed-out sponge to remove excess water, starts the press, and drops the inker for one or two revolutions, unless the plate manufacturer expressly warns against this procedure. Then the inker is lifted, the press stopped, and the plate examined. First, the image is examined carefully to see whether the amount of ink on the inking system appears to be about right for the job at hand.

The plate is dampened with a squeezed-out sponge, the press is started, and the dampeners are dropped. The plate is watched carefully to see that sufficient dampening is being done. The inker is dropped, and again the plate is watched to see that there is no tendency to "catch-up." Catching-up is the term commonly used to describe the condition where ink sticks to the nonprinting areas of the plate. If water and ink appear to be right but the plate starts to catch-up, the press is stopped (after lifting inkers and dampeners) and the plate is wet-washed.

Wet-Washing the Plate. First, the plate is wet down with water, washed with the regular ink solvent on a rag, and quickly rinsed with water to remove the ink solvent. Then, the plate is wiped with a squeezed-out sponge, the press started again, and the inkers dropped for one or two revolutions. The inkers are lifted, the press is stopped, and the plate is examined carefully. The image should be well inked and the background should be absolutely clean.

The plate is carefully dusted with a wad of cotton dipped in a half-and-half mixture of talc and powdered rosin. The plate is dampened with a squeezed-out water sponge and etched with a regular plate etch. This etching is carefully done, and the etch is rubbed down smooth and dry. The press is rolled, and the plate fanned if necessary. On a large plate, the etching operation may be repeated. When the etch is *dry*, the plate is washed with the water sponge, and the excess moisture wiped off making sure

that the dampeners have enough water in them. Finally, the press is started, the dampeners and inkers dropped, and now the plate should stay clean.

The above procedure is, in general, suitable for most jobs. Several points, however, should be made with respect to special cases. Developing ink is alway black. If the plate is going to run with black ink, and the plate has not been waiting for any appreciable time between platemaking and going to press, the procedures previously suggested hold sway. If the plate is not freshly made, the developing ink should be washed out. The best procedure is to wash the plate with a solvent to remove the ink. Then a smooth, thin, even film of asphaltum is rubbed down. The plate is washed with water. Water will dissolve the gum and lift the asphaltum except where it is on the image. The press is run, and the inkers dropped for a few revolutions. The inkers are lifted, and the press stopped. The image is examined carefully for any faults.

If the plate is to run with color, and even though it may come to press under the asphaltum, it is advisable to wash it out completely and rubup or rollup the image with the press ink. The plate is put on the press, the asphaltum washed off (for a color job, the platemaker has, in all probability, replaced the developing ink with asphaltum) with solvent, the solvent rinsed off, and then the plate is rubbed up with some press ink. An alternate method is to follow the solvent wash with water to remove the gum and then roll up the plate by running the press and dropping the ink rollers.

An important point to remember is that press ink should be removed, after the plate is gummed, and replaced with asphaltum if the plate is to stand for any length of time, especially overnight. Once press ink dries on the image, it may be impossible to wash out, and it is not grease-receptive. When gumming the plate on the press, a gum solution of about 8° Baumé should be used. Using a 14° Baumé solution (usual stock solution) may easily lead to a poorly rubbed down film and blinding.

GETTING LAY AND FIT

In getting lay and fit, many of the factors previously mentioned in this chapter should be kept in mind. It must be made certain that the gripper bite is correct and that the sheet is separating, advancing, and forwarding at the correct time and to correct position for registering. It should be kept in mind that the lay may vary with the speed of the press on a press having a simple three-point register system (without an insertion device). In other words, lay sheets pulled at idling speed may not register with sheets pulled at full running speed.

Plate Shifting. In Section Six, handling of the plate to the point of mounting it on the cylinder is discussed. At that time, it was mentioned that cooperation among strippers, platemakers, and press operators would result in short downtime for obtaining proper lay. But plate shifting does sometimes have to be done due to no fault of the people involved with preparing the job or putting it on the press. Modern pin systems, which include pins in the plate cylinder that match plate and flat punches in the prepress departments, can eliminate most of the time spent during makeready in attaining proper lay. All that is required is strict adherence to standard operating procedures, and cooperation, by strippers, platemakers and press operators.

If the plate is reasonably close to its proper sideways position, setting the side guide for proper positioning of the sheet involves no trouble and very little time. There are several means available to obtain correct front-to-back position. Shifting the plate cylinder by changing the position of the cap screws that fasten the plate cylinder to the plate cylinder gear takes care of gross shifts. Coupled to this feature on practically all plate cylinders is some type of vernier adjustment for fine movements. In this case, the cylinder can still be moved with respect to the gear, but the plate-cylinder-locking cap screw remains in the same hole. Both of these shifts move the plate image forward or back, but in a straight line.

A third method available for shifting the plate is to slide the plate around the cylinder by use of the space between the plate clamps and the plate cylinder body. Shifting at the clamps makes possible "cocking" or "twisting" of the plate, as well as side shifting if for some reason the side guide cannot be adjusted for side margin.

The matter of cocking or twisting a plate calls for some special comment. Many operators do not visualize what is happening to a plate when it is being cocked. They develop the bad habit of trying to bring into proper position an isolated area of the plate, and they fail to realize that this area is inseparably tied into the entire plate.

A simple trick in visualization handles this problem. One need only remember that a plate can be twisted around the cylinder in one of two ways: (1) By imagining that the plate is fastened to the cylinder at the exact center of the plate, and when twisting the entire plate revolves around this center point; and (2) By imagining that the plate is fastened to the cylinder at one corner, and that when the plate is being cocked, it is pivoting at that corner.

The important thing to bear in mind is that, when twisting a lithographic plate, the *entire* plate must be cocked in order to guarantee that it will continue to hug the cylinder smoothly when the clamps are pulled up tight after the shift is made.

It should also be kept in mind that radical shifts in packing may require rechecking of the inking- and dampening-roller settings. Such shifts should always be compensated for by the necessary change in the squeeze applied at the back cylinder. If on a first color, or first-time-through on a back-up job, or on a once-through-the-press critical register job, exact fit can be checked for by using a register rule on the printed image and by checking these measurements against those that were taken off the plate before it went to press. If the first color or first-side-down isn't to correct size, getting fit on subsequent printings will be very difficult if not impossible. If the manipulations required to get subsequent fit are too radical, the quality of the printed image must suffer, and sometimes the plate life itself can be seriously affected.

Waste Sheets. Obtaining lay should be done with waste sheets, if they are available. Sheets pulled for lay, fit, color okay, etc., on the first time through the press should be saved for use as waste sheets on the succeeding passes through the press. When getting ready for the next pass, "books" can be made out of waste sheets and good sheets by taking four or five waste sheets and then two good ones, etc. These are piled in the feeder on top of the pile and flagged to separate the books from the pile. Each time a book is pulled, the set of waste sheets followed

Schematic showing one way of considering plate cocking. Note that here one corner is considered as being anchored and is the pivot point.

Shifting the plate cylinder.

by the good ones is run and followed by one more waste sheet. In this way, waste is cut down, and by the time lay and fit are okayed, enough sheets have been run to indicate how well ink and dampening fountains are functioning for this job.

The press is started and one book is printed. While one good sheet is being checked for proper lay, the other is examined for quality of print. Permitting the ink fountain and water fountain to feed only while pulling sheets during the positioning stages is a check on the accuracy of their setting. One precaution may be indicated at this point. If the press with a conventional dampener stands for an appreciable length of time, it may be

necessary to apply extra water to the dampeners because of water loss due to evaporation. This extra dampening should be done carefully. When the press is stopped, while getting lay or waiting for position okay, the plate cylinder gap must be opposite the dampeners. If the downtime is likely to be of appreciable length (over fifteen minutes), the plate should be gummed. If the downtime goes to an hour or more, the plate should be put under asphaltum.

RUNNING THE PRESS

The time has come when the job is ready for running or final production. The main concern during running is fast, trouble-free, quality production. All units are set for this purpose, and in running the aim is to keep them at their original setting. For this reason, running is discussed with the main idea of maintaining the predetermined setting of the five press components: (1) Handling the feeder; (2) Handling the dampener; (3) Handling the inker; (4) Handling the printing unit; and (5) Handling the delivery.

HANDLING THE FEEDER

At the time the feeder was set for this job, the pile should have been checked for its "contour." It was stated, then, that the pile should be flat and level. Satisfying that condition is not always possible, especially on a pile that has passed through the press previously.

Pile Contour and Its Problems. On a job with a very heavy ink lay across the back end, there is bound to be a decided curl. All the sheets, of course, will be curled the same way, fortunately, and therefore can be uniformly treated. One method is to roll out the curl while the pile is loaded in the press or on the skid. This technique may produce a reasonably flat pile at the back end of the sheet, but the whole back end may be higher than the front of the pile. If the difference is not too great, the rear of the pile can be permitted to come higher than normal in order to get the front of the pile to the proper height for good control of the sheet advancing cycle.

However, it should be borne in mind that, as the pile gets smaller, the front of the pile will reach a level higher than the recommended height. Therefore, constant attention should be given to the feeder when running a pile that has been *manipulated* into proper contour. If wedges are used get the top of the pile, or some part of the pile (corners especially) to correct height, the position of the wedges and the depth of their insertion will have to be adjusted constantly while the press is running, to prevent misfeeds. Also, when wedges are used, they should be watched constantly to prevent their getting into the press as a result of working loose or reaching the top of the pile as the run proceeds. On presses equipped so that the skid or platform can be manipulated to bring the gripper edge of the pile to the recommended height, the adjustment itself will have to be changed as the pile runs down.

Checking the Forwarding Mechanism. Forwarding devices will have to be checked constantly to make sure that the original position has not been altered. Some jockeying of these devices may be required if the sheets are not perfectly trimmed

or there is considerable curl or wave present. The action of the side guide should be watched. What happens here is a good signal of the adequacy of the sheet's control. The gripper and tail ends of the sheet are watched very closely for any evidence of sheet buckling or bouncing. Special attention should be given to the position of tail brushes, drive-up wheels, and balls, if they are being used.

Gripper Edge Register. The best way to check register is to have adequate register marks print on the sheet. Near the gripper edge there should be marks running off the sheet at both sides. They must not appear within the work area, of course. Everytime a sheet is pulled for inspection, the position of these marks should be compared with those on the okay sheet. If the pile is jogging properly, this mark can be watched for alignment as a signal against inconsistent register.

Stream feeder, showing tail-end wheels and brushes.

Side-Guide Register. Side-guide register can be better watched if a small mark is permitted to print half off the sheet. Any slight variation of this will be noticeable. This mark should be put on the plate at exactly that point where the side-guide edge of the sheet touches the side-guide faceplate. If the mark is placed at this point it will always appear the same, even if the sheets are out-of-square. An elongated wedge-shaped mark at the side-guide edge makes checking even easier for both side and up-and-down register.

HANDLING THE DAMPENER

Following the sheet through the press, checking the mechanical controls of the sheet for satisfactory functioning, leads to the printing unit. Here it isn't possible to isolate every point completely. Everything is so interlocked and interdependent in the printing unit that, with few exceptions, one can never talk about a single point concerning the actual running, without also including some others. For convenience, the dampening system is a good starting point. Assuming that all adjustments have been properly made and are holding their setting, concern is

with the three following items: (1) Composition of the fountain solution; (2) Its level in the water pan; and (3) Its reaction with ink, plate, and paper.

The Composition of the Fountain Solution. The composition of the fountain solution is determined by experience, whether it is a proprietary product or a formula made up in the plant. In formulating a specific fountain solution, the kind of plate to be run and the composition of the ink is, of course, considered. Both of these factors can be eliminated as troublesome if the pressroom is cooperating with the plateroom and with the suppliers of both platemaking materials and inks. Regardless of what solution is used, once a solution has been standardized in a particular plant, there must be no deviation except by deliberate design, due perhaps to the need for accommodating a new ink or paper.

The control technique available for acidic fountain solution is the measurement of pH. pH is the term used to describe the acidity or alkalinity of a solution. pH is represented by a scale that measures from 0.1 to 14.0; 7.0 is the neutral point. Theoretically, pure distilled water that has not been exposed to the atmosphere has a pH of 7.0.

Measuring pH. There are several ways of measuring pH. The simplest is by the use of indicator strips whose color is changed on immersion in the solution being tested. A range of indicator strips is available for different areas of pH readings, depending on the class of solutions being controlled. These strips are simple and fairly accurate but their use is limited to the testing of solutions whose color doesn't mask that of the dyes in the indicators. Bichromate solutions, unfortunately, usually have this effect.

Color comparators are another device for measuring pH. But they, too, may be affected by solutions that can act to mask the color of standard solutions used in the test. In addition to this limitation, the color comparator is somewhat cumbersome to use. In recent years reasonably priced, and yet accurate, electrically operated pH meters have become available. Any plant preparing its own solutions should have one in the chemicals-mixing room. One such device, which is operated by a self-contained battery, is most convenient for use at the press on fountain solutions.

Courtesy Varn Products Co. Inc.

Indicator sticks for measuring pH.

Need for Constant pH Control. The question may arise, Why test proprietary solutions or solutions prepared in a well run chemicals-mixing room? The answer is that fountain solutions may change on the press during the run. If printing trouble develops, the easiest step is to find out whether the pH of the fountain solution is correct; doing this first can save time otherwise spent in looking for the causes of a problem. The people responsible for fountain solution formula, or the manufacturer of a proprietary solution, will indicate the pH to be maintained. It is worth repeating that the *formula* as well as its pH must be compatible with the ink, plates, and paper being run; especially the inks.

The Level of the Fountain Solution in the Pan. With conventional dampening systems, it is important that the solution be maintained at a consistent level in the pan during operation of the press. This is now best done automatically by installation of a water leveling device on the press. This is simply an auxiliary tank that keeps the solution in the pan at a predetermined level. The capacity of the tank is generally sufficient to run for quite a length of time. The tank can be kept full without stopping the press or disturbing the level of solution in the pan.

The unique design of the Dahlgren and most modern dampening systems introduced the concept of recirculating the fountain solution. This recirculation has now been adapted to the conventional dampening system. A recirculating system makes it possible to easily maintain consistency in pH of the fountain solution, proper water level in the water pan, and a generally cleaner system. In addition, the old bugaboo of too warm a solution during hot weather in a non-air-conditioned plant can also be eliminated.

Schematic of the pH scale.

Courtesy Baldwin-Gegenheimer Div.

Fountain level device installed on two-color press.

Ink-Water Balance. One of the basic problems in handling the lithographic press is that of ink-water balance. The attainment of maximum print quality in tonal reproduction depends on running the thinnest possible film of ink. This latter statement, as it stands, is largely theoretical. It presumes use of the strongest inks that can be manufactured and a perfectly smooth surface on which the ink is to be applied. Practical considerations make both of these conditions virtually impossible to achieve. But, the theoretic basis can be modified by adding to the statement "under the conditions imposed by the particular job."

Theory aside, getting the "proper" ink film to the lithographic print depends not only on the ink and how it is handled, but on the dampening solution and how it is handled. The key to this is just the right amount of water depending on the ink used, the amount of ink required for the plate and paper being run, and the area of ink coverage required by the particular design of the printed piece. To accomplish this operation requires a high degree of craft skill usually acquired only as a result of long experience.

Many years ago GATF designed the Bench Inkometer. This inkometer is the standard instrument used by ink-makers to determine and control ink tack. In recent years, GATF's Research Department has adapted the principle of the Bench Inkometer to develop a Press Inkometer. This device makes it possible to measure ink-water balance as a deviation from the desired balance established by the press operator when he finally completes his makeready and has his color set. Watching a meter connected to the Press Inkometer warns the press operator when the balance is being lost. The device is so sensitive as to show this even before the printed sheets reflect the changed condition.

Efforts are now being made to establish automatic control of the ink-water balance as an adjunct to the Inkometer. Once the press operator has attained proper color and dampening, the device could be set to increase or decrease water-feed as the inkometer registers a need for such change.

The problem of ink-water balance is discussed a bit further at the end of the subsection "Handling the Printing Unit," which follows this subsection.

HANDLING THE INKER

Ink Agitation. The condition of the ink in the ink fountain also requires some attention. Since lithographic ink is more like a plastic than a liquid, it will not flow without being worked. Generally the action of putting the ink in the fountain and spreading it with the spatula while turning the fountain roller makes it flow. Working the ink is further accomplished by periodic agitation with the ink spatula while the press is running. This agitation serves also to break up any skinning tendency as well as to keep the ink up against the fountain roller. An ink fountain should never be permitted to run nearly dry. Such dryness can be a great source of hickeys on the press.

Agitation can also be accomplished automatically and continuously by installation and use of ink agitators. Agitators are quite common on presses today. However, their usefulness has led to the bad habit of allowing the level of ink in the fountain to become very low before the fountain is recharged. On critical work, this can result in a lowering of the color on the sheet. This lowering of color has been proven by many studies, and has led to the development of ink pumps controlled by devices that activate the pump when level of ink in the fountain falls. Wherever long runs are prevalent, automatically activated ink pumps are a very useful addition to press controls.

Oscillation of the Drums and Vibrators. As one goes down across the ink train, another source of possible trouble may be noticed, at least on certain types of jobs. This source is the oscillating ink drums. The amount of trouble due to the axial oscillating action of these drums is very limited on modern presses if the inking system is kept in good condition and all rollers properly adjusted. It may be necessary to time the oscillation—if this is permitted by press design—to change direction at the point where the form rollers are over the plate cylinder gap.

It may also be necessary, at times, to control the amount of oscillation if a split fountain is used. One other trouble caused by metal rollers in the inking system was covered previously.

Courtesy Baldwin-Gegenheimer Div.

One type of ink agitator.

This trouble appears on presses using steel rollers that have not been copper-plated, or otherwise treated. Another possible cause of trouble here is end play of the form rollers. This *must* be prevented. The best way to reduce the likelihood of developing such end play is to make certain that the pressure between form rollers and drums is not excessive, and to be certain that the roller spindles and sockets are properly lubricated.

Ink Skin and Other Foreign Matter. A general precaution with respect to running the inking system is that of maintaining absolute cleanliness. The cleanliness referred to in this paragraph is not the aspect discussed under the washing of the inking system. Here, cleanliness refers to freedom of the ink from any trace of skin, foreign particles, or abrasive materials. The possibility that abrasive materials may be present as a result of ink formulation is remote if one is dealing with reputable suppliers. But skin will be found around the top edge of almost any can of ink. When emptying a can of ink into the fountain, the operator must be absolutely certain that no skin passes his scrutiny. Another possible source of ink skin is in the fountain itself. If the press runs any length of time, some ink may dry at the back end of the blade or on the faces of the side blocks. When agitating the fountain by hand, the operator should be careful *not* to scrape any of this dried ink into the ink supply.

Water-in-Ink Emulsification. At several points in this chapter emulsification has been mentioned. Emulsification can take place in two ways: (1) Water may be emulsified into the ink; (2) Ink may be emulsified into the water. As has been previously stated, a certain amount of water emulsified into the ink will not cause trouble. But too much emulsification of water in the ink will waterlog the ink and produce a poor print. Too much of such emulsification prevents the ink from properly transferring between rollers and plate, between plate and blanket, and between blanket and paper. Once the ink becomes waterlogged, the press must be washed up, and the ink in the fountain thrown

WATER-IN-INK
EMULSION

INK-IN-WATER
EMULSION

Schematic of two ways in which emulsification may take place.

away. This should not happen if a minimum amount of water is being fed to the plate. The proper amount of water is just barely enough to keep the plate from scumming, but not more. One of the dangers with water-in-ink emulsification is that this type of emulsification may not be noticed for some time. If the print begins to gray, most press operators automatically increase the ink flow. If the print begins to look fat and mushy, most press operators automatically increase the water flow. Each of these changes only serves to compound the original fault; a perfectly good plate image may be irreparably damaged before the basic cause—*emulsification* or waterlogging—is noticed.

Ink-in-Water Emulsification. Ink-in-water emulsification is also a tricky thing. The cause here is usually a poor match of ink type and fountain solution formula. Ordinarily one would expect such a condition to show up immediately as ink on the dampeners. This is not so. When dampeners show signs of greasing or accepting ink, it means faulty handling of the dampening system or flooding of the plate by ink. An ink-in-water emulsification may be recognized by the appearance of tinting on the plate. Sometimes this tinting is mistaken for a scumming and the flow of water increased. Such a mistake only aggravates the condition.

Tinting and Scumming. Tinting and scumming are easily recognized conditions. Scumming results when the nonimage areas of the plate accept ink from the inkers. Tinting is a deposit of water into which ink has been emulsified, or ink pigment has deposited itself as a result of the action of the fountain solution on the ink. This condition may be caused, also, by surface-active materials in the paper.

A simple test will indicate whether the trouble is scum or tint. If a plate is tinting, the tint can be wiped off from any area of the plate by a light touch of the finger or sponge. But one single revolution of the press *with the dampeners on* re-tints this same area. Scum cannot be wiped off the plate easily, and when it is wiped off will not come back again immediately unless a dry plate is contacted by the inkers.

When tinting occurs with a conventional dampening system, the three covered rollers should be removed and thoroughly rinsed in clear water. The water pan should be emptied and rinsed, and the oscillating roller also rinsed and treated in the manner recommended by the manufacturer. Then the press operator starts up again with a different fountain solution. If the tinting soon comes back, the paper should be tested for the presence of any surface-active material that tends to combine with the dampening solution and to break down the ink. This subject is discussed in detail in the "Ink and Paper" chapter.

Automatic Ink Fountain Control. The inking system of the lithographic offset press leaves much to be desired, from engineering and theoretical points-of-view. A great deal of time, effort, and money have gone into attempts to devise more efficient inking systems and controls.

The most that has been accomplished, to date, is the adaptation to the ink fountain of automatic overall control. This is, in a sense, not much different from the kind of control being developed for the dampening system. The press operator attains the desired color and, with it, the desired ink-water balance. This balance is usually attained by use of a densitometer, which measures, by reflection, the density of the ink film on a reference block of the solid color printed in the trim area of the sheet. A scanning device is attached to the press which, through a photo-electric cell similar to that in the press operator's densitometer, reads the density of a target block as the block passes under the scanning head while the press is running. The device "compares" the readings on the printed sheets with the desired reading established by the press operator when the run started. Through the hook-up to the fountain mechanisms, the overall amount of ink being fed from the fountain is increased or decreased automatically.

HANDLING THE PRINTING UNIT

Watching the Run. Watching the run on a lithographic offset press involves more than maintaining specific settings and adjustments. The problems concerning specific segments of the press have been discussed in the preceding paragraphs of this section. Here the concern is with maintaining the appearance and quality of the print as produced on the press. It is assumed, of course, that for purposes of this discussion the mechanical aspects of running the press have been attended to: feeder is functioning properly; the sheet is registering with good fit; the color is okay; and the printed sheets are delivering and jogging in a satisfactory manner. Watching the run, then, involves seeing to it that no hickeys or spots appear on the print and that the proper amount of ink is being deposited on the sheet.

Hickeys and Spots. Under magnification, hickeys and spots look somewhat like doughnuts in reverse, although they are not always round. Once they appear, they repeat on sheet after sheet in the same places and increase in number as the run progresses. They are caused by solid, more or less ink-receptive particles that are stuck to the blanket or plate, and that are not transferred to the paper or dislodged by the form rollers. It takes a wash-up to get rid of them, but unless their source is removed, they start coming back as soon as the run is resumed. The figure gives a rough idea of why hickeys print the way they do.

White or light spots in the work can, like hickeys, be caused by particles or fibers stuck to the blanket or plate. The only difference is that, instead of being ink-receptive, these particles are water-receptive. In fact, some particles start out printing as hickeys, but as they become saturated with water the solid center spot tends to fade out and disappear.

It is interesting to select a particular spot or hicky and thumb down through the pile of printed sheets till one finds the sheet on which it first appeared. Doing this, and examining the spot under a glass or miscroscope will generally give a clue to the source of the hickeys or spots, or both, that are ruining the quality of the job.

The main sources of particles that cause hickeys and spots are ink and paper. But a dirty press, a dirty ceiling, or bad rollers can also supply particles of foreign matter.

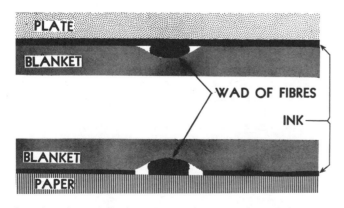

Greatly enlarged diagram showing how a solid particle like a wad of paper fibers, piece of ink skin, or dirt on the blanket produces a hickey on the printed sheet.

Ink Particles. More hickeys are probably caused by ink skin (dried ink) than by anything else. This topic was discussed in this section under the heading "Handling the Inker."

Hickeys caused by dried ink, or skin, can usually be recognized by their shape and appearance. The figure shows one very much enlarged. Notice that the spot inside the white ring has an irregular shape and sharp edges. The edges are also slightly denser than the center.

If one selects a particular hickey of this type and thumbs down through the pile until one finds the first sheet on which it appeared, one will notice that there has been practically no change in its appearance.

If one locates the particle on the blanket or plate, one can pick it off and examine it under a microscope. By feeling it with a needle one will find it soft and pliable, with no fibers present.

These things are characteristic of ink skin or dried particles. Once the particles are identified, the only thing to do is wash up the press, discard the ink, and load the fountain with a fresh, skin-free batch of ink.

Greatly enlarged photo of a typical hickey caused by a particle of ink skin.

Paper Particles. Despite all the precautions taken by the mills, paper is second to ink as a source of hickeys. It can produce hickeys as well as several kinds of spots. More knowledge and experience are necessary to identify the defects in paper that cause them. These defects are as follows:

PAPER DUST. When paper is slit and cut to sheet size in the mill, a certain amount of dust is formed. Some of this dust is likely to get between the sheets and remain there. In most mills, some attempt is made to get rid of this dust by means of compressed air or vacuum, but this attempt is not always completely successful. If only one or two particles remain on each sheet, printing a thousand sheets can produce a lot of hickeys and spots.

PICKING OF THE PAPER SURFACE. Small areas of surface fibers or coating are sometimes picked, generally in the solid areas. These fibers stick to the blanket or plate and produce hickeys or spots that repeat sheet after sheet.

LINT, FUZZ, OR WHISKERS. Slitting and sheeting of paper sometimes sets free individual fibers that get trapped between

Greatly enlarged photo of a typical hickey caused by a loose particle of paper several sheets after it first appeared.

the sheets. Lint, however, is usually due to fibers being loosely bonded in the paper surface. It is usually worse on the wire side than on the felt side. These fibers are pulled out of the sheet by the ink, but they quickly become saturated with water, refuse to take fresh ink, and leave white images of themselves in the printed work. They are, of course, most apparent in solids.

HOLES IN THE PAPER SURFACE. These are holes resulting from air bubbles in the fiber furnish when the paper is made, or bubbles in the coating mix when the paper is coated. These holes are deep enough to prevent the blanket from depositing ink in them. Spots due to such holes occur on only one sheet and do not repeat. In other words, the distribution of spots on each sheet will be different.

Spots caused by slitter and cutter dust can be any shape from that of individual fibers to that of slivers. If one thumbs down through the printed sheets to where a spot first appeared, the original spot will be white and show no evidence of picking. On succeeding sheets, the spot will be a hickey, but the center spot will be gray or a tint, not a solid. The spot will tend to get lighter on succeeding sheets. This phenomenon and the absence of a sharp edge around the center spot will distinguish paper dust from ink skin. The figure shows how a hickey of this type looks several sheets after its first appearance.

Spots due to picking of the paper surface of coating can be any shape. If one locates the sheet where the spot first appeared and examines it under a glass, one will see that the surface was picked. Hickeys will appear on succeeding sheets, but their center spot will lack the sharp edge of an ink-skin hickey, and may print lighter on succeeding sheets as the fibers become water-soaked. One figure shows a spot in a solid on the surface of the sheet that picked. The other figure shows how such a spot may appear on sheets that follow the picked sheet and after a number of them have been printed.

Particles From Other Sources. Hickeys can also be produced by particles of dust or dirt falling from a dirty ceiling or dislodging from a dirty press or disintegrating rollers. Dust on overhead pipes and ductwork are another prolific source of hickeys. Ceilings should therefore be cleaned and painted at regular intervals. Press members should be cleaned at least once a week. They must be kept free from oil or grease that can accumulate dust and nonoffset spray or powder.

Fiber-shaped spots can be caused by shedding dampener covers. These have the same appearance as spots caused by lint or fuzz, but are generally much longer, since the dampener fibers are cotton. Newly covered dampeners, if not thoroughly washed before being installed on the press, can cause these spots. Old dampener covers may become rotten and shed fibers.

Maintaining Proper Color. Depositing the amount of ink on the sheet is a complicated problem involving considerable judgment as well as experience. To the assumptions listed previously, there should be added one more: that the plate has been well made. This assumption implies desensitization by the most modern techniques as recommended by the Graphic Arts Technical Foundation, Inc., and the plate manufacturer, and includes a wet-wash as described previously. This procedure produces a clean, sharp image and a really tough nonprinting area. A "sharp image" means an image on the plate that is a faithful reproduction of the flat from which the plate was made. "Sharp" does not mean an image that has been "sharpened" as a result of improper handling by the press operator. Such a plate is printing less than the full image produced by the platemaker.

One of the first items to consider here is the "color strength" of the ink. If the color is weak it may be necessary to run an excessive amount of ink to produce the desired color on the sheet. This "crowding" may lead to several problems. In the first

Greatly enlarged photos. Top shows a picked spot on a coated sheet. The coating and some fibers stuck to the blanket leaving a crater in the paper. Bottom shows a typical spot in a printed solid on sheets following the one that was picked.

place, the print produced on the sheet will begin to appear heavier than that which was originally produced on the plate. The entire job will look too "full." At first the job may look fine. But as the run progresses the appearance will gradually change from a nice full print to a "squashed out" print. When this happens the plate has been damaged to the point where usually it cannot be brought back to its original degree of sharpness. If this is a full-color process job, the finished product will show up as a finished piece with the particular color run too fully. But even on a black-and-white type job, running this way will show up as a poorly reproduced version of the original type style and, in all probability, an entire book printed this way will show variation from page to page as the binder gathers the first sheets from one signature with later sheets of other signatures.

Another problem that must be faced, when a plate is crowded, is the difficulty of running clean. In the attempt to meet this problem, the amount of water being run is increased or the pH of the fountain solution is lowered. While either or both of these steps may lick the symptoms, the basic fault still remains and all that is accomplished is a compounding of several faults.

The only real cure is to prevent the need for crowding. Crowding can be avoided by running an ink of the same color but with stronger color or better covering qualities. The ink man can solve this problem quite easily.

When running with too strong a color, the job will also suffer. First, the press operator tries to run his ink "spare." That is, he runs with too little ink. As a result the plate begins to sharpen. Then, in an effort to produce a full print, ink and water flow are increased. Too much water and too little ink may damage the image as a result of insufficient protection to the image afforded by a proper charge of ink. Running excess water for any length of time must also lead to waterlogging.

Again, the symptoms can be eliminated, but only temporarily. The only real cure here is to cut down the strength of the ink. In this case, judicious addition of laketine, or some other approved reducer, to the ink can cure the original fault. However, the ink man should first be consulted. It may be better in this particular case to have the ink man formulate a new batch of ink for this job.

The adoption, in recent years, of instrumental techniques to attain and maintain desired color is one of the most significant developments of recent years. Photography as an instrumentally controlled process, is quite old. By the end of the 1940s, GATF had succeeded in bringing lithographic platemaking to the point where a properly made plate was no longer a "by-guess-and-by-gosh" operation. But only within the past ten years has the point been reached where instruments and highly developed technical concepts were made available to the press operator.

A well-run pressroom, especially where color is critical, no longer depends entirely on the craftsman's eyes to assure that a near-perfect match of the color O.K. sheet is being maintained. Color blocks, and various target and tint patterns have been designed for inclusion somewhere in the trim margins of the sheet. When the color has been O.K.'d for running, certain of these blocks or tints are "read" with a reflection densitometer. As the job is running, sheets pulled from the press are read with the instrument and checked against the recorded readings of the O.K. sheet. Some of the target and tint patterns are so designed that print quality factors, other than ink-film thickness, can be

either measured instrumentally or easily judged by eye if they drift from the established O.K. sheet. It is quite likely that the next several years will see almost completely automatic ink and dampening control.

GATF's Star Target.

The Ink-and-Water Balance. Earlier in this discussion the need for judgment and experience was mentioned. It is extremely difficult to describe in words, or show by examples, what is meant by proper ink-and-water balance. In an effort to discuss this, one other assumption to the long list already made in this subsection on "Watching the Run" should be made: the ink on the press does have the proper color strength and covering power.

In order to print, the nonimage area of the plate must be dampened and the image areas inked. What may happen when running too much ink or too little ink has been discussed. In both cases it was pointed out what may happen when curing the symptoms by changing the amount of water being fed to the plate. With the proper ink, the trick to be learned is that of "balancing" the amounts of ink and water being fed to the plate.

The basic rule is to run sufficient ink to give full color to the job and as little water as possible to keep the plate clean. Watching the plate and the printed sheets carefully, at the start of the job, will facilitate reaching the ideal balance on the job. The important point to remember is that when either the ink flow or the water flow is changed, the reason for the change *is* the needs of the plate. A change to meet a poor condition in one or the other of the inking or dampening systems should not be made.

The matter of plate needs requires that the pressman keep in mind the demands of different types of plates. A coarse-grained plate will require more water than a finely grained plate, assuming all other conditions remain the same. A smooth plate, such as the bimetallic or presensitized plates, runs best with a very small amount of water. If the pressman notices water collecting at the back end of the plate and/or blanket, it is a sure sign of too much water.

In order to cure a symptom of insufficient dampening, the tendency to increase the fountain acidity (lower the pH) must be avoided. Unless there is absolute proof that the job demands a pH of less than 4.5, maintain the pH at somewhere between 4.5 and 5.5. Too low a pH will retard drying of the ink on the paper. It may also damage the image, especially on surface plates. Actually it is known that the *primary* reason for acid and gum in the fountain solution is to help keep the dampeners clean.

HANDLING THE DELIVERY

If it is assumed that the press is now running and printing properly, the last point of concern is the delivered sheets. Jogging has been previously discussed, but setoff was merely mentioned and needs further comment. Setoff may occur not because of poor pressmanship, but because a particular job on

the press is taxing the capacity of the press to deliver a smooth, uniform but thin film of ink. It must be borne in mind that the offset method itself contributes to the inability of the lithographic process to lay down a thick film of ink. This is a principal reason why a lithographic ink must be formulated with strong color and covering power. This situation is aggravated when overprinting two or more colors. The best way to overcome setoff is by the installation of antisetoff devices.

Antisetoff Sprays. A variety of antisetoff sprays are on the market to choose from. There are two dangers to watch out for in the use of these sprays. Too many pressmen rely on antisetoff sprays almost completely and acquire the habit of running too much ink, in their dependence on the spray to prevent setoff. Another bad habit is that of running too much spray to the detriment of the equipment. Actually, if the pressman runs so much spray that it is clearly visible as it comes out of the nozzle, too much spray is being used. A barely visible spray, properly directed, and from the proper height (depending on area to be covered by the gun) will do just as effective a job of setoff prevention as an excessive amount of spray. Spray guns that use a liquid spray should be carefully controlled to prevent any of the liquid itself from reaching the sheets and thereby causing them to stick together.

Piling the Delivery. Regardless of how carefully a job is run, and despite anti-static devices, spray guns, etc., some jobs cannot be piled too high. This is especially true with varnishes, metallic inks, and, very often, high-gloss inks. Experience will dictate how high the lifts should be. Such lifts must be constantly winded, while drying, in order to prevent their sticking together. In a similar vein, certain inks will permit piling a delivery to full capacity but will still require winding shortly after coming off the press. Experience and your inkmaker can tell you which inks to watch. What happens is that during drying certain inks generate considerable heat. This process may cause sheets to stick or have the equally dangerous result that

A well-jogged lift.

the inks change color. This can be prevented only by constant winding during the drying period. It is obvious, of course, that all such winding must be done with care to prevent setoff and/or smudging.

Jogging. It has been previously mentioned that jogging of the sheets in the delivery should be accomplished in a manner preventing setoff. This task directly concerns the pressman. He should also be concerned that jogging may not cause damaged sheet edges, especially if the sheet has to be put through the press again. Also, he owes it to the finishers (diecutters, binders, etc.) of the job to deliver a well-jogged pile to make their work easy.

Before a job is permitted to leave the pressroom, it should be properly flagged and identified in accordance with whatever system has been installed for this purpose.

Section Nine: Multicolor Presses

It is generally accepted that the ultimate in full-color (process) printing is attained by running the colors "dry." This is true in all printing processes. However, the advances made in recent years through research in techniques, materials and equipment have brought the lithographic process to a point where it can employ "wet" printing techniques and equal, at the very least, the very finest of "dry" printing in the other printing processes.

Dry Printing and Wet Printing. "Dry" printing means that each color is printed and permitted to dry on the sheet before the succeeding color is run. "Wet" printing means that two or more colors are printed with a single pass through the press with no appreciable drying time between color lays. It is possible, of course, to intermingle the two methods. For example, if a four-color process job is run on a two-color press,

then the first two colors are being done wet and the last two are being done wet. But the last two colors are printed on the first two *after* the first two have had the opportunity to dry.

In web offset operation the possible combinations of wet and/or dry printing are limited only by the press design, especially the placement of drying units between the printing units in the press. If the drying is done *only* after all the printing is completed, then a totally wet method is being used.

There are four basic problems in multicolor press operation which are common to all processes. These problems are: (1) register; (2) fit; (3) trapping; and (4) color contamination. The manner in which color contamination appears in lithography is commonly referred to as "counter-etching." This subject is, therefore, in our Manual, discussed under the heading of "Counter-etching" rather than color contamination.

REGISTER

The problem of register is not different on multicolor work—wet or dry—from on black-and-white work; but register is here more critical and has, in most cases, a much smaller tolerance of variation. A properly handled press always registers, and it may be taken for granted that all presses should be properly handled be they used for single-color or for multicolor work. In some ways the multicolor press is easier to handle with regard to attaining and maintaining register; in other ways it is more difficult.

An important way in which wet multicolor operation simplifies matters is that the sheet is inserted into the press a lesser number of times. It is obvious that the more times a sheet is handled the greater the likelihood of mutilated gripper edges. It is equally obvious that the more times a sheet goes through the press, the less likely it is that the pile in the feeder will retain a nice, flat contour. On the other hand, transferring a sheet from unit to unit increases the points at which trouble with register may be encountered. And, by the very nature of the beast, it should be obvious that it is much more difficult to build and synchronize a press with two or more units, each of which must register perfectly, than it is to build a single unit that registers perfectly. The fact that our presses achieve such fine results is something for which we must praise our engineers and manufacturers without stint.

FIT

The problem of fit is considerably affected by multicolor printing. It has been said repeatedly—in this and in other chapters in this Manual—that sheet distortion due to change in moisture content of the sheet is one of lithography's most difficult problems. Ways and means of controlling the moisture content have been described. One great contribution to alleviating this problem is the ability of a multicolor press to put down two or more colors within so short a space of time that the sheet has no opportunity to give up or take up any appreciable amount of moisture. If the stock is kept in moisture-proof wrappings up to the very time it is put on the press, even unconditioned stock running in a nonconditioned plant will hold size satisfactorily. Of course, if the sheet is going through the press more than once, it is essential that the stock be protected between printings. The best method for doing this has been described previously.

In multicolor work, dry or wet, it is imperative that the first color down be in register and fit perfectly. The easiest way to check fit of the first color is by comparing the image size on the first plate with the printed image size on the sheet. This is best done by using a register rule, as described previously. The rule will show the amount of error, and the nature of the error usually indicates its cause. Because the remedies at the pressman's disposal—shifting of packing, bowing of stops, or deforming the sheet contour on the feedboard—good fit within narrow limits will be attained. If the sheet is too wavy, or too tight-edged, little or nothing can be done—short of conditioning the stock.

There is another precautionary step that should be taken when preparing to run a multicolor job. The temperature and moisture balance of the pile should be tested—*before the wrappings are removed*. Details of this technique are discussed in the following chapter, "Ink and Paper for Lithography."

TRAPPING

Trapping is an important item to consider whether running wet or dry multicolor work. It is essential, here, that the lithographer work closely with the inkmaker because the ink man does have at his disposal the materials and knowledge to cope successfully with the problems of trapping. Trapping, on the press, describes the phenomenon of a printed film of ink accepting a subsequently applied ink film. Two prime factors generally affect trapping. They are the absorbing characteristics of the paper and the relative tack of the inks being superimposed on each other.

An ink maker having adequate samples of the stock to be run can match an ink vehicle to it. GATF's Inkometer, which most ink houses have, makes possible accurate determination of ink tack before it goes to press. In this respect, it is important to assume, on principle, that the ink maker is knowledgeable. The lithographer should never dope an ink unless the ink maker has approved the materials used, the quantity to be used, and the circumstances of its use. In general, each succeeding color has less tack than the preceding one.

COUNTER-ETCHING

A fourth problem is the contamination of succeeding colors by those previously run. This problem applies almost entirely to wet multicolor printing. The way in which the problem of color contamination affects the actual printing operation is, however, quite different in lithography. It must be remembered that a planographic plate is being handled, a plate where both image and nonimage areas are on the same plane; that the inking and dampening form rollers contact both the image and nonimage areas; that the blanket, when receiving the inked image from the plate, also contacts image and nonimage areas of the plate; and that the paper also contacts the image and nonimage areas of the blanket.

A fresh, unprinted sheet is followed through a two-color press, for the sake of simplicity. The press is running, and both blankets have been charged with their respective images. The sheet goes into the first unit where the first image is transferred from the blanket to the paper. Then the sheet passes to the second unit where it is again pressed in contact with a blanket. *But now the sheet is not blank anymore.* Now it has an inked image from the first unit. As is known, the image elements of a full-color process job do not always completely superimpose on each other. Therefore, part of the first image is pressed against areas of the blanket which correspond to nonimage areas of the second plate. The blanket, of course, is ink-receptive. It must be so in order to be usable as a blanket at all. Some ink, and be it only the slightest amount, *always transfers from the paper to the blanket.* When this second blanket contacts its plate for a fresh transfer of the image, the ink from the preceding impression that was pulled from the sheet is now pressed against nonimage areas of the second plate.

The immediate reaction is to say: "So what? Are the ink rollers not always contacting the nonimage areas of the plate?" But the effects of the blanket and the ink rollers on the plate are vastly different. The inking form rollers *roll* against the plate,

and they do so without too much pressure. The blanket cylinder, on the contrary, is squeezed against the plate with tremendous pressure. This factor would be troublesome enough by itself; but compression must also be considered. The plate compresses the blanket. This may bring about a change in surface speed.

Because materials that cannot be fabricated as accurately as optical mirrors, or Johannsen gage blocks are used, even greater possible variation in surface speeds between the plate and blanket surfaces exists. This speed difference causes a rubbing action. Even if the rubbing action be comparatively slight, it has a great effect on the plate; the ink transferred from the first impression is literally *ground* into the second plate. On presses with more than two color units, the problem is further compounded by the time the last frame is reached. If the second plate begins to hold the ink from the first image, it is said to be "counter-etched" by the first image. What has happened is that the water-receptive layer on the nonimage area of the plate has been broken down to the point where it becomes "sensitive" or ink receptive and prints a scum of the second color on the first.

There are three mitigating factors that make good reproduction possible under what appear to be impossible conditions. The first is a contribution by the ink maker, who has been able to contribute immeasurably by formulating inks that—when laid on the paper, or over previously printed inks—want to stay there rather than lift off. *These inks have trapped perfectly.* Therefore, the author advises, even at the risk of being repetitive, that the press operator must not interfere with the ink, but rather should use materials and techniques as prescribed.

Another, and possibly equally important, factor is plate research. Plate research has made plates possible whose non-image areas just won't break down. The pressman should make all changes under the guidance of the supplier of the materials and techniques.

A third factor that makes it possible to produce full-color printing on multicolor equipment is our advanced knowledge of the dampening procedure and the means to better adapt the composition of the solution, as well as its pH, to the particular ink, paper, and plate being run.

Planning the Production of a Color Job. Regardless of whether a full-color job is to be printed dry (on a single-color press), or wet (on a multicolor press), or by a combination of the two methods, it is imperative to understand that the press can, at best, only reproduce what is on the plate, and in the color that is on the press. It is true that some manipulation on the press is possible. We can run the plate sharp or full. We can run the ink spare or heavy. We can also change the ink in the fountain. But either or all of these steps should not be resorted to as a *planned* procedure of operation. Either or both of the first two procedures leads to early deterioration of the image or nonimage areas of the plate, or both. Efforts by the pressman to prolong the life of the plate, under these conditions, lead to a variation in tone and color throughout the run.

Techniques have been developed whereby the exact reproducible results obtainable on the press can be known in advance. Then all the preparatory steps should be planned around this knowledge. The ink should not be manipulated to change tone or color that was photographed in the original color separation negative. Rather, the negative should be so shot as to produce the desired tones and colors as can be derived from the ink to be run. This is exactly the opposite of what is done in most cases, but all evidence to date indicates that this is the correct method.

Simple tests run on the presses in the plant will tell the photographer, artist, and platemaker exactly what a particular press and its crew will produce. Such tests will show what a single-color press will produce, in the way of tones, as compared to a multicolor press. It will also show what to plan for if a four-color process job is to be run on a two-color press, where wet-and-dry printing are combined. And the preparatory departments can prepare their part of the job to meet these standards. Not only can they do this, they must if the full advantages of the lithographic process are to accrue to the benefit of the plant.

Section Ten: The Lithographic Offset Web Press

At the beginning of this chapter it was pointed out that reference to specific presses or types of presses would not be made within this chapter. However, this section is included because of the tremendous interest—an ever-increasing one—in the specific area of webfed lithographic offset presses.

Generally speaking, the operation of such equipment is little different from that of sheetfed presses. The general principles and practices of cylinder pressures, plate handling, blankets, inking, dampening, etc., are practically identical. A transition from sheetfed into webfed is not as staggering a change as it may sound. Webfed operation is not new. Therefore, the lithographer who is planning to go into web printing has a tremendous body of existing knowledge from which to borrow and receive assistance. Even webfed lithographic offset operation is not new. It dates back to at least 1916. In this field, a large volume of knowledge has been developed.

WEB PRESSES ARE SPECIALIZED

The transition to web offset poses much less of a problem on the pressroom level than on the management level. The main consideration need not be whether the plant can operate the equipment, but whether the sales force can sell the production facilities offered by such equipment. In this respect, management must recognize that the factors determining the purchase of a webfed press are quite different from the factors on which the selection of sheetfed equipment is based. A sheetfed press, single or multicolor, can be selected on the basis of its ability to handle the widest range of jobs actually produced by a plant, or on the kind of work that the sales department thinks it can sell.

But a webfed press is by nature a piece of specialty equipment. It is designed and purchased to handle a specific job or type of job. While it is true that width of the roll can be any

size up to the maximum of the particular press, the around-the-cylinder direction cannot be changed except on still more highly specialized equipment, that is, on **specially designed** specialty presses. In other words, a webfed press rated as a 22¾ × 35-in. press can print any width up to 35 in., but can only deliver a 22¾-in. unit in the around-the-cylinder direction. Smaller jobs can, of course, be printed too, but the difference between their size and 22¾ in. is wasted paper, unless the 22¾-in. cutoff length is an exact multiple of the smaller size or sizes. "Ganging" is, of course, possible on webfed equipment just as it is on sheetfed, but the flexibility still isn't too great.

STANDARD SIZE WEB PRESSES

As a result of experience, three general groups have evolved. One is the "commercial" web offset press. The commercial press is sometimes called a "full-size" or sixteen-page press. Its basic characteristic is that it will run a sixteen-page 8½ × 11-in. trimmed-size signature. The cut-off dimension of the commercial press is about 22¾ in. and across-the-cylinder the size ranges from 35 in. to 38 in. A second group is referred to as a "half-web," "mini-web," or "eight-page web;" the basic characteristic is that it will run an eight-page 8½ × 11-in. trimmed-size signature. Before discussing the third group, newspaper web offset press, some further points should be made about the first two groups.

The term "commercial" implies much more than sixteen-page size. A commercial press—full-size or half-web—will print four colors on both sides of the web and dry the ink prior to passing the web, in-line, to a finishing operation, usually a folder but may be either a sheeter or a rewind station. Therefore, a commercial press is equipped with means for drying. In most cases, drying is accomplished after the web comes out of the last printing unit. However, many full- and half-size webs are purchased without dryers. In such cases, the printer has a market for printed products that fit the printing dimensions of the press but do not require drying before the finishing operation.

The newspaper web offset press is one that is sized around standard newspaper page sizes. The most common configuration of a newspaper press unit prints a four-page newspaper signature in one color. As many units as are required may be set in line to produce the complete newspaper or a section of it, satisfying the needs of the small-town or suburban publisher. Four-page-across newspaper presses are also available. The web is slit and the two four-page sections are collated before being folded into an eight-page signature. The manufacturers have designed these units so that they can be assembled in a wide variety of ways, including additional units that may be used to print some pages in full-color or run additional pages in black-and-white.

The possibilities of what may be done by web offset are myriad. Nobody has as yet exhausted them. Some day, soon, we may see the printed web go from the folder into a gatherer if necessary, be bound, trimmed, packed, labeled, and mailed—all in one continuous operation. In the case of specialties such as folding boxes, an in-line setup can be devised producing completely folded and glued cartons in one continuous operation. In the case of business forms, the web can be numbered, punched, perforated, slit, collated with other webs, pasted, stitched, accordion-folded, and so on *ad infinitum;* again in one

continuous operation. The key to the selection of a web press, or to entering the field of web offset, is, therefore, management's ability to sell its productive capacity in competition with those already in the field, as well as in competition with the other printing processes.

RECENT PROGRESS IN WEB PRINTING

It is worth asking why at this time we find such an increased interest in web offset. The answer is the tremendous growth of lithography in general, as compared with the growth of the other printing processes. The reasons for this growth of web offset lithography are still more improved materials, techniques, and equipment. To make this even more clear, consider the plate cylinder gap of a sheetfed press.

The Plates. On a sheetfed press the cylinder gap takes up about one-fifth of the total surface area of the cylinder, and measures many inches. But the corresponding gap on webfed equipment is not more than a fraction of an inch on any size press. The narrowness of the gap on web presses posed a serious problem because of the necessary sharp bend. On a sheetfed press, especially when we get over 17 in., the plates are not very sharply bent for mounting, and yet plates do not break at the clamps. But on the webfed press the plates are bent at an angle over 90° and then "jammed" into the gap. This problem is no longer a serious one; excellently engineered plate-bending devices and cylinder plate locks make it possible to wrap a plate snugly around the cylinder and the cylinder gap edges. Eliminating the possibility of the plate's flexing as the edges of the gap contact the blanket has greatly reduced the incidence of cracked plates.

Let us consider the plates themselves. We need go back only a few years when 100,000 impressions on a "good" deep-etch plate was considered a wonderful figure. The webfed press is by its very nature long-run equipment; what good would such equipment be if the plates would not stand up? (As production techniques have improved, many printers are utilizing "commercial" webs for short runs, profitably.) There are now cases on record where the image outlasted the ability of a *steel-based* plate to withstand the hammering at the gap: several millions of impressions. An incidental but important benefit of steel-based plates is that, like any bimetallic plate, they produce excellent dot structure not obtainable on grained aluminum. This should not be interpreted to mean that only steel plates can be used successfully on web offset presses.

Paper. Let us next consider paper costs. Two comparable grades of paper, one offset and one letterpress, sell for a difference of about 13%, with the offset paper being the more costly. Now, considering the fact that lithographic plates are cheaper than letterpress plates, and that the makeready on a lithographic offset press costs a fraction of the makeready on letterpress, the question is how long a run must be before offset begins to cost more because of the differential in paper costs. To cut down this paper cost differential, or eliminate it, has been the aim of all interested in offset lithography. Less costly lithographic papers are becoming more and more available.

Another improvement of the paper situation is connected with the plate. The modern lithographic plate requires very little water to run clean. This reduces the high water-resistance

requirement of paper for the lithographic process. Improvements in litho inks have also helped to reduce this requirement, and so have improved blankets. In consequence of all these accomplishments by the industry and its suppliers, lithography has not merely retained its quality superiority, it has actually increased it. All this becomes still clearer if we consider the basic reason for choosing gravure in large-volume catalog, news supplement, and magazine production. In gravure, good pictorial reproduction is possible on very low-cost paper. The paper cost can be decisive if the runs are long enough to more than absorb the phenomenally high original cost of gravure cylinders.

THE FOUR BASIC TYPES OF WEB PRESSES

There are four basic types of webfed lithographic offset presses, as follows: (1) blanket-to-blanket unit type; (2) drum type; (3) unit type; and (4) single-plate job press. The latter is used for high-speed production of small handbills, throw-aways, etc., printed on one side, and of standard size such as 8½×11 in.

Blanket-to-Blanket Type. The blanket-to-blanket press is most common. Each blanket cylinder acts as the impression cylinder for its mate in the pair. The paper passes between the two blanket cylinders and is perfected simultaneously. In a press of this type the paper generally passes from roll stand to delivery in a straight line. Register is maintained by tension control of the web in both the lateral direction as well as in the running direction. These controls can be installed at the infeeding point, between units, and at the delivery. Some of this is controlled by graduating the cylinder pressures—the first unit is designed for the lowest pressure and the last unit for the highest. The difference between units is very slight—on the order of 0.0005 in. to 0.00075 in. This difference is just enough to prevent the

web from trying to follow the blanket, as the paper does on sheetfed offset presses. The cylinders on these presses are laterally adjustable while running, to maintain register to accommodate any weaving motion of the web. The cylinders can also be advanced or retarded, as on a sheetfed press, in order to get original register and to help maintain it during the run without downtime. Both of these shifts are limited. Therefore, when originally started, all cylinders should be set at the center point of the adjustment. At the roll end of the press, any one of a number of tension devices is available for control of register. To compensate for action of the tension device at the infeed end of the press, there may be a device between the last unit and the folder, sheeter, or rewinder, whichever happens to be installed on the particular press. Where both of these devices exist, they must be handled together if register is to be maintained and web breaks prevented. While the blanket-to-blanket type of press is referred to as a "unit" type, it should not be confused with the true unit type of press described later in this section.

Drum Type. The drum type press is an attempt to obtain better web control than is theoretically possible with the blanket-to-blanket unit type of press. In the drum-type press the web is wrapped almost completely around a large impression cylinder (the "drum"). Mounted around the drum are individual printing units, each consisting of a plate cylinder, blanket cylinder, inking system, and dampening system. The fact that the paper is wrapped around the drum under tension resists the tendency of the web to follow the blanket. On some presses of this type, additional control is attained by graduated cylinder pressures. And as in all web presses, tension devices at the

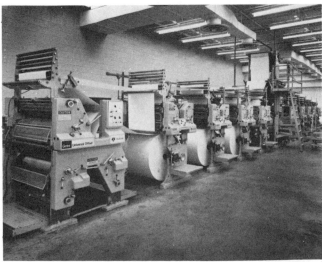

Courtesy Rockwell International

A typical small web offset newspaper installation. Note the paper rolls mounted under individual units. With five units on each side of the folder, this installation can print 40 one-color newspaper pages at a time.

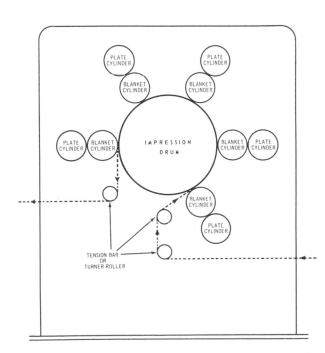

Schematic of a drum-type press. This shows four colors being printed on one side of the web. The web could then be turned and passed into a second similar unit for perfecting. Or, using the "double-ender" principle, a half-width web could be perfected in four colors on this one unit.

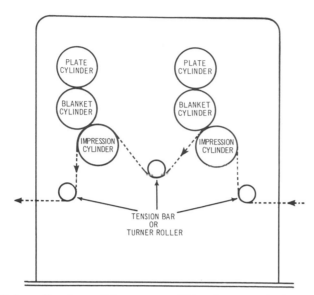

Schematic of a unit-type press. This shows a single web running two colors on one side. If web is turned between units it would be printed both sides in one color. Or, two webs could be run printing one color on one side. The double-ender principle can also be utilized.

infeeding and delivery points are available. The one problem on this type of press, and largely a theoretical one, is that large-sized cylinders, or drums, produce a wide printing nip. It is held by many authorities that the narrower the nip the sharper the print, with resultant gain in quality. On the usual drum type press, the web is completely printed on one side, is threaded through a drying unit, and is fed to a second drum to be perfected, or it may go over the same drum, to be "double-ended."

The Unit Type. The unit type of press is essentially the same as the blanket-to-blanket type except that the web is perfected in a different unit. It is generally differentiated from the blanket-to-blanket type of unit press by referring to it as an "open" unit type. The word "open" signifies that each completely individual plate-printing unit can be handled separately from every other plate-printing unit. In the blanket-to-blanket unit, a pair of plate-printing couples have to be handled together. Unit-type presses are generally used in forms printing.

INKS FOR WEB OFFSET

In addition to the problems mentioned above, there is one which is universal with all web printing. This is the problem of ink drying. It should be realized that we are trying to completely dry the ink at high speeds and within a limited distance of web travel. This creates a tremendous problem for the inkmaker, the paper manufacturer, and the press engineers. Inks must be formulated that can be dried quickly without changing color while still being workable in the lithographic process. Paper must be manufactured that meets the requirement of the offset method and yet will withstand the harsh action of an efficient drying system. To date, heatset inks are used almost exclusively in web offset. Until some new technique for drying the printed ink film proves feasible, the web offset method will require

drying ovens, or tunnels, through which the printed web travels between the last printing couple and the folder. Today's dryers make use of several techniques to accomplish drying; sometimes techniques are combined. The most common drying technique utilizes open gas flame. Another popular method utilizes the impingement, on the web, of super-heated air forced against the paper at high velocity. Some dryers combine open flame heat and super-heated air. But all the work in this area requires close cooperation between inkmaker and dryer engineer. As long as high heat is required for ink-drying, some device for chilling the web before folding is essential. Unless the web is sufficiently cooled, breaking at the folds cannot be prevented.

A great deal of work is going on in the area of ink handling on the press. A comparatively minor item is that of pumping ink to the inking system. This is, actually, not new, since the technique has been used in other printing processes and methods for many years. Of great importance is the control of temperature in the ink system. The fact that a conventional inking system on a high-speed press will develop heat has long been known. What needs to be known is just how much heat (or lack of heat) is beneficial. Most of the work to date has been in the direction of cooling the ink system. This is accomplished by building into the ink-drums provision for circulating cool water.

PAPER FOR WEB OFFSET

While paper in rolls costs less than sheet paper, the economies of purchasing in rolls are quickly lost in inefficient operation. This is most readily grasped if the reported figures on paper waste are examined. The best available information shows a range of about 5% up to 25% for spoilage. Three percent is generally accepted as the irreducible minimum and covers core weight, waste at core, wrapper weight, and waste at outer layers of a roll. With possible savings of up to a maximum of 13%, there isn't too much margin for paper spoilage.

Some explanation of the 5% to 25% spoilage experience is in order. A simple throwaway in a long run can very well be accomplished with very little more than the basic 3% waste. With low-quality demands, many pieces that would not be acceptable for some runs can be used. The web press operation in a plant that produces a product for its own use (a comic book publisher, for example) can set minimum standards for its class of publication and thereby prevent gross waste from going above 5%. However, an experienced web offset plant doing a high-quality advertising brochure or magazine insert in full-color may easily experience a waste above the 13% cost savings of rolls over sheets. The savings to the customer are not found in lower cost of paper but in production economies possible with a web offset press. Profits, of course, can go far above industry average where the fine-quality web offset plant succeeds in holding waste down to a point close to the irreducible minimum of 3%.

A skillfully operated web offset press can run papers that cost less than true lithographic grades of equivalent quality. This is due to the fact that it is possible to maintain closer dampening control and run with less water on a web press, where the cylinder gap is virtually nonexistent. This characteristic of the web offset press offers another opportunity for reduced costs without sacrifice of paper quality. In the past decade, the paper

industry has contributed enormously by developing papers that are suitable for web offset at little if any increase in cost over an equivalent letterpress paper. This is true in all grades, from newsprint to the finest uncoated texts and coated book papers.

Where a plant must use so-called letterpress papers, the troubles that may arise are not always costly. For example, a letterpress coated paper will produce some piling of dissolved coating on the blankets. If the press is not equipped with a flying paster, the time during which the next white roll is being loaded can be used to wash the blankets, thereby preventing the coating piling from reaching a point where quality of print drops below the required standard. If a press is equipped with a flying paster, then it is generally required that paper that will cause minimum downtime be purchased.

Of the more serious problems associated with paper in web offset operation are shut-downs due to linting, surface dust and dirt, slitter dust, and similar paper characteristics. There is a considerable amount of give-and-take between paper mills and web offset operators at to how this group of problems can best be handled. It's not possible, as yet, to make perfect paper. More and more printers are recognizing this fact and assuming part of the responsibility. The most common technique is to pass the web of paper through a preconditioning phase between infeed and the first unit. Generally, a preconditioner is a simple oven where open flame is utilized to burn off loose paper materials. Another approach is to pass the web through a set of cleaners that brush the sheet lightly and then, by use of vacuum, draw off the materials loosened by the brushes. The oven-type preconditioner is the more popular. Many printers believe that there are several other benefits gained by the warming of the web before it passes into the printing unit. This is a subject of some controversy, and considerable research is now being devoted to learning the true facts about preconditioning with heat.

In the following chapter there is information on ordering paper in rolls, handling roll stock, and record keeping.

Section Eleven: Safety in the Pressroom

Every person who operates a press must learn that it can be done safely. The *right way* of doing a job is the *safe way*. If one starts out by always doing a job the right way, doing it the right way will become a habit. Accidents are the result of doing a job the wrong way. A smart operator recognizes that it is just as important to follow the safe practices and procedures already developed for a particular operation, as it is important to follow the mechanical details of that operation.

First aid should be obtained for all injuries, no matter how small. This serves as a guard against infection and prevents delay in healing.

HOUSEKEEPING

Poor housekeeping in and around the press contributes to many accidents, especially trips and falls. For carrying out the personal responsibility for your own safety, and those who work in the pressroom, a check of the press area should be made for the following points:

1. Are the oil drip pans emptied periodically?
2. Do you have safety containers for solvents?
3. Are metal containers for cleaning rags available?
4. Are waste containers for paper provided?
5. Are there no ink cans on floor or platforms?
6. Are no tools left on walkways?
7. Is no wearing apparel hanging on control boxes or on press frames?
8. Are rollers properly racked so they cannot be accidentally knocked from their positions?
9. Are the floor, platform, and steps free of grease and oils?
10. Are there any empty skids standing on edge or leaning against equipment, walls, or columns?
11. Are the air hoses in reels or racks?
12. Are all aisles free of trucks and empty skids?

And do not forget that men assigned to empty the disposal containers should wear gloves and safety goggles.

FIRE PROTECTION

There are safety factors pertaining to the hazards of smoking and the handling of solvents. Fire prevention emphasizes the importance of good housekeeping and the safe handling of flammable chemicals. The personnel of a lithographic pressroom should also know what fire protection measures exist. Everyone should be familiar with the following:

1. How to report a fire.
2. What to look for in making a fire prevention inspection in your immediate work area. In the event you are called upon to make a fire prevention inspection in the department or plant, a Safety Instruction Card is helpful.
3. How to use the fire equipment that is available.
4. How to evacuate the building.

HANDLING OF MATERIALS

Dollies and lift trucks are often used at a press to put loads in and to take them out. Injuries can be avoided in this work by wearing safety-toe shoes, and by observing the following precautions pertaining to the trucks themselves.

1. Keep trucks and their handles out of aisles and walking areas.
2. Return trucks to a designated area when not in use.
3. Do not ride on these trucks nor stand on them at any time.
4. Do not use a truck unless you have learned how to operate it and have been authorized to do so.
5. Report any operating difficulties you might notice. Leaky cylinders on a hydraulic pump type truck, for example, may cause handles to fly up and to injure the operator. Latches and catches on the ratchet type truck should be in good condition to prevent loads from dropping suddenly.
6. Make sure that all the wheels on trucks are always in good condition.

Piling stock often requires handling of skids or lifts of sheets. The following practices should be observed in lifting:

1. Keep load close to body.
2. Get good footing and solid grip on object.
3. Bend knees and keep back straight.
4. Lift with leg muscles.
5. Get help for heavy or awkward loads and lift as a team.

The following practices should be observed in handling skids:

1. Do not lean against the press.
2. Do not leave skids standing on edge.
3. All skids should have a definite place and should not extend into aisleways or gangways.
4. Empties should be transported on dollies if possible.
5. Empties should be stacked one up and one down, so that the pile is stable. Pile should not be more than 5 ft. high.
6. Obtain help in handling large skids.
7. Do not drop skids. The noise is distracting and may be the cause of injury at the press. Dropping also may cause wood to splinter and create the additional hazard of slivers.
8. In loading skids, make sure the load will not topple or slide when bumped accidentally.
9. Steel strapping on skids of paper should be removed in such a way that the strapping will not spring when cut and possibly penetrate an eye or the operator's flesh. Clawhammers, crowbars, or similar tools should not be used to apply leverage for breaking the steel strap. Use the steel strapping cutters with extension handles. These cut in such a way that it is impossible to get sharp ends. The device illustrated can be used to place over steel strapping to keep it from springing after being cut. This is an L-shaped piece of sheet metal (16-gage or lighter steel), 6 in. wide, with a handle riveted on the 12-in. section. The top extension measures 7 in. long.
10. Make sure that proper disposal is made of the scrap metal as it is cut off. Curved or bent pieces are tripping hazards when left on the floor.

In hanging sheets at paper-conditioning machine, watch finger clearance and head clearance so as to avoid bumping against the frame of the machine.

OCCUPATIONAL DERMATITIS

In the preface of the Graphic Arts Technical Foundation's Technical Bulletin No. 6, *Prevention of Occupational Dermatitis in Lithography*, Robert F. Reed states: "The health hazards in lithography are very few, relatively. However, chemical dermatitis, generally referred to in the trade as 'chromic poisoning,' still does exist among a small percentage of lithographic workers. It is now known to be caused not only be chromium compounds, but also be solvents and certain ink ingredients...." The bulletin suggests these main principles for protection of skin:

1. Try to avoid unnecessary contact of skin surface with irritants and sensitizers.
2. Keep workrooms as clean as possible.
3. Keep skin soft and clean, avoiding dryness, cracking, or splitting.
4. Be careful when mixing or pouring materials.

5. Use funnels or any other apparatus that will help prevent spilling.
6. See that the outside of the bottles and other containers are not splattered over with materials, especially chromates.
7. Wear neoprene gloves whenever handling or using solvents. Never spill anything over the cuffs into the gloves. Do not use gloves with cracks or leaks. When materials such as the bichromates get inside the gloves, the gloves are even more dangerous than none at all. Be sure your hands are clean before you use gloves. Inspect the gloves regularly because even contaminated dust from the workroom may get into them. When you are wearing gloves do not touch other parts of your skin with the soiled gloves. Do not contaminate with gloves objects that you later may have to touch with your bare hands. Cleanse the gloves frequently.

If you protect your skin as a daily routine and follow the routine faithfully, there is little chance of skin irritations resulting from the fluids or chemicals you handle in the lithographic pressroom.

SAFETY IN PRESS OPERATION

Safe press operation means that the press is always operated in the correct way. Personal safety factors, as well as mechanical and general shop conditions, should be considered. Check your procedures to see that you observe the following practices:

1. Nothing that can catch in the moving machinery, or that can trip the wearer, should be worn in the plant. Short sleeves, tucked-in shirts with no tie, cuffless trousers, and safety-toe shoes are recommended. If an apron is needed, it should be snug-fitting and fastened lightly enough to be torn off quickly if caught in the press. Protective gloves and eyewear should be worn when required.
2. Jewelry, especially watches and rings, should not be worn when working around the press. The desire to keep one's hands intact should take precedence over any sentiment.
3. Hand-holds and hand-rails should be used in going up and down the press.
4. A person should not jump from one elevation to another, or from press to press.
5. Eye clearance should be considered when removing printed sheets for inspection.
6. A person should not lean against the press or rest the hands where there is any chance of getting them caught in moving parts. Hand-holds should be used whenever they are provided, particularly when working at the ink fountain. It is a good habit to keep the hands on the hand-hold bar whenever walking between units.
7. Knives should be placed in sheaths when not using them for cutting, packing, or other pressroom operations. If razor blades are used, they should have holders on them.
8. Carrying tools in pockets should be avoided to prevent the possibility of dropping them into the press or hazardous locations.
9. Proper-size tools should be used whem making adjustments. Wrenches and other hand tools should be kept in good condition.

10. Unauthorized operation of a press that an operator has never run before is dangerous and should not be attempted.

11. Finger clearance should be considered when putting rollers into or taking them out of the press and at similar operations. Edges of the plate need inspection before it is handled on press, especially if it has been cut down from a larger size to a smaller. Rough edges should be filed smooth to avoid cutting fingers or hands.

12. Oiling the press should not be attempted unless the press is standing. Oil should be wiped up from floors and platforms to reduce slipping hazards.

13. No one should reach into the press while it is running. A machine must be stopped to clear jams, to oil, to set and to make adjustments, and to make repairs, or to clean. No attempt should be made to scrape ink off drums while the press is running. The same is true in picking off hickeys.

14. All guards should be in place before the press is started.

GUARDS

Lithographic presses are equipped with adequate mechanical safeguards when they are shipped by the manufacturer. However, in the process of transferring equipment from one owner to another, the guards may become misplaced or lost. Also, through experience and use, the operator may find additional areas which may need mechanical protection. The wise pressroom worker will learn what kind of mechanical protection his machine provides, noting especially such points as:

1. In-running cylinders and rollers.
2. Between the blanket cylinder and the plate cylinder.
3. Gears at edge of plate and blanket cylinder; near the bearers.
4. At the foot-board; rear of the blanket and plate cylinder.
5. At feeder end over insertion devices.
6. Chain delivery.
7. Cam that controls height of pile in feeder.

PRESS CONTROLS

Whatever the control system, the operator should thoroughly acquaint himself with it before attempting to operate it. Know where the master switch, the fuse box, and the speed control are located.

Before pressing the "run" button, make sure everyone is in the clear. Anyone who is working on a press should make sure that he is protected against accidental starting of the press. This means having the safe button in before starting any work such as makeready, cleaning, etc.

Gumming the plate requires teamwork and coordination for safety not only to the operator but his helper as well. If the press is small, the person doing the gumming should inch his own press while he is performing the operation. He should make sure that he presses the "inch" button and not the "run" button.

On larger presses when two men are gumming up the plate, the person controlling the inch button should make sure that he does not press the wrong button through error, for not only is his own welfare at stake but that of his coworker as well. Multicolor presses should be equipped with approved signal systems thoroughly understood by all press crews.

Coordination has been established to such preciseness that some pressrooms are able to have one man at the control station inching the press while he and a crew gum up plates on more than one unit simultaneously. This shows the extent to which teamwork can be developed and still provide safety for all concerned.

Putting on plates and blankets requires teamwork when two men are doing this work. The press should be inched slowly so that the men have control especially when nearing the back clamps or blanket reel.

In backing up the press to take the blanket off, the "reverse" button must be hit and not the inch or run, otherwise fingers may get pulled in. Control stations that conform to the Safety Code, previously mentioned, will have the reverse button equipped with a guard, if this button is adjacent to the inch button. In some pressrooms, these guards on the reverse button are in the form of swing plates that have to be pushed aside before the button can be pressed. This fact makes it difficult to press the button by mistake. Other pressrooms have made the reverse button inoperative on the control station and, instead, have an arrangement whereby the reverse button is on a pendant attached to a reel. The reel makes it possible to move the pendant control from one unit to the other. When this particular work is being done, it is, therefore, the only button being used. The press should be backed up slowly.

FEEDERS

The space between the points where the press ends and where the feeder begins should be covered to prevent the possibility of the foot slipping between them. In some pressrooms, protection has been provided by extending the guard over the feeder.

The length of large offset presses, especially web and multicolor, introduces the need for additional safety buttons on both sides of the feeder. The location should be learned, if they are provided, so that they can be reached readily when necessary.

The following precautions concern loading feeders of large presses:

1. Chains and cables should be free of kinks.
2. They should be properly positioned in their drum pulleys.
3. They should be securely fastened to the bars.
4. The rods should be in place and secure.
5. The platform should be in proper position for lifting.

When raising and lowering loads, the press operator must watch fingers on feeder or delivery elevators that must be turned manually. The operator should never get under loads either at feeder or delivery elevators.

WASHING OPERATIONS

Washing operations may include cleaning blankets, plates, rollers, or parts of the press such as the ink fountain, and they require the following precautions:

1. Do not smoke while using solvents.
2. Take only small amounts of solvent to the press and then only in approved safety cans.
3. Avoid spilling flammable liquids—vapors may flow long distances along floor or ground before they are ignited and flash back.

4. Do not pour used solvents down drain or sewer. They should be transported in a closed container to a safe dump or open area where they will not contaminate streams or drinking water supplies or be accessible to children. Then, they should be dumped in small quantities and burned, with someone standing by until the solvents are all burned out.

5. Observe health measures such as protection against inhalation of fumes, do not use solvents on the body, and always use neoprene gloves when handling solvents.

6. Place rags and materials used with solvents into self-closing approved safety containers.

There are two final points. For removing sheets stuck to the blanket, water is used with the sponge and then the solvent with a rag. The power must be turned off before beginning. On fountain (dampening) solutions, operators using bichromate fountain solutions should report promptly any skin irritations noticed. Nonbichromate fountain solutions, suggested by the Graphic Arts Technical Foundation for use with zinc or aluminum plates, are helpful to those people sensitive to bichromate.

Ink and Paper for Lithography ————————————

Section One: Printing Inks

Lithography uses a planographic plate to separate the image from the nonimage areas. The image area of the plate is preferentially wet by ink, and the nonimage area is preferentially wet by water. Therefore, unlike other inks, lithographic ink must be formulated to work with water. In offset lithography, the ink on the plate is transferred to a blanket; in direct lithography, the ink is transferred directly from the plate to the paper or other substrate.

During printing, the ink must remain sufficiently fluid to transfer properly, and the printed film must afterwards dry to a solid. How fluid the ink must be and how it dries depend on the printing process, the material being printed, and the press speed.

Ink is a complex mixture of pigment, varnish or vehicle, modifiers or additives, and drier. The important properties of ink are color, color strength, opacity or transparency, body or working properties, and drying properties. All of these properties must be selected to suit the particular job; most importantly, they must suit the paper or other material being printed.

Drying of sheetfed inks is affected by temperature, moisture, acidity of the fountain solution, and absorbency of the paper or other substrate. Since web offset inks dry principally by evaporation, the situation is much simpler.

Printing problems are often blamed on ink when the real cause lies elsewhere, such as with poor plates, dirty dampeners, or improperly set rollers. But ink can be made or adjusted to suit almost any paper, as long as the paper meets the normal requirements of pH, stiffness, and strength and as long as it is free from lint, dust, dirt, and debris. Most of all, good printing always requires good control of the raw materials and the process.

Good lithography requires good plates, good press conditions, good paper, and good ink. The purchase of low-cost inks is often a false economy. It is best to deal with reliable suppliers and depend on them for help when problems arise. It does not take much press downtime to overcome the difference in the cost between a cheap ink and a higher-priced quality ink.

Much of this section concerns pressroom practices as they

exist. It is often necessary to add compounds to the ink to overcome specific problems. Sometimes they help, more often they do harm; sometimes additives are just plain wasteful. The best all-around rule in this respect is to have the inkmaker formulate inks "press-ready" for the job. If it is believed that some doctoring must be done, it should be done only on the inkmaker's specific advice. When inks must be altered, the additives should be recommended by the manufacturer of the specific ink. Homemade remedies should never be applied, because they can be harmful and are most often unnecessary.

Formulas and compositions of lithographic inks vary to meet the requirement of the press and the substrate. Sheetfed and web offset inks require fundamentally different vehicles. Variations are made for printing on uncoated, enamel, and cast-coated papers, film, or foil and for printing on metal decorating substrates. Formulation of a printing ink is a complex problem, and printers should not alter printing inks without consulting the inkmaker.

A lithographic ink is made from a pigment or from a blend of pigments dispersed in a viscous liquid called the vehicle. Sheetfed inks consist of a pigment, a modified drying oil, a drier, and additives or modifiers. Web offset inks consist of a pigment, a modified rosin or a hydrocarbon resin, a hydrocarbon solvent, and additives. Metal decorating inks consist of a pigment dispersed in a heat-curing resinous vehicle and additives. Lithographic news inks contain pigments dispersed in a vehicle consisting of a nondrying hydrocarbon oil and a resin.

Additives include such materials as waxes to provide slip, surfactants to improve dispersion of the pigment, and many other ingredients. Ultraviolet-curing inks include a pigment together with an acrylic varnish, a photoinitiator, and an inhibitor. These inks cure (polymerize) under ultraviolet light. Electron-beam drying inks are similar except that they do not require an initiator.

Infrared drying inks can make use of several different types of formulas. In fact, heat alone dries web inks and speeds the drying of sheetfed inks, although it can create a number of problems or hazards.

Section Two: Properties Required of Litho Inks

Many factors influence the printing performance of an ink. To meet all of the required characteristics, an ink must contain pigments, resins and/or varnish, drier, and additives carefully selected by the inkmaker. Inks must remain stable on the press but must dry on the paper. They must be suited to the substrate being printed, they must provide the required product resistance, and they must provide all of these properties economically. Of the greatest significance are color and color strength, drying properties, and emulsification properties.

COLOR

The color properties of an ink, which depend largely on the pigments, are known as "masstone," "undertone," and "tinting strength." Associated with these color properties are transparency or opacity.

"Masstone" is the hue or color of a thick film of the ink. It is the color of the bulk ink in the can. It is the color of light reflected by the pigment. "Undertone" is the hue or color of a thin film of the ink. It is the color of light reflected by the paper and transmitted through the ink film. "Tinting strength" is coloring power, or the amount that an ink can be reduced or diluted with a white pigment dispersion to produce a tint of a given density or saturation.

Brilliance and Hue of Pigments. Pigments vary in brilliance and in hue. Few inorganic pigments—pigments not derived from dyestuffs—have acceptable brilliance. Inorganic pigments are generally low in color strength and are therefore often blended with organic pigments to increase their color strength. Organic pigments are very numerous, quite brilliant, and available in a broad range of hues. Because of their many useful properties, organic pigments are widely used in lithographic inks.

All of these properties affect the appearance of a print. No printed ink film is completely opaque or completely transparent. As a result, what one sees on a printed sheet is a combination of light reflected in different ways. Part of the light is reflected by the ink, and part is reflected by the paper through the ink. Therefore, masstone, undertone, and tinting strength must all be matched to obtain an exact ink match. How to observe the masstone, the undertone, and printing strength is discussed later under "Making a Drawdown."

Color and Color Match. The color of an ink is imparted mostly by the pigment; different pigments give different colors. For example, the rubine pigments are less blue than the rhodamine pigments. These in turn are greatly different from red pigments such as red lake C or permanent red 2B. It is therefore a mistake to call the magenta pigment "red" although this is commonly done in the printing industry. This error may be laid partly to the fact that commercial magenta pigments are typically more red than blue.

Similarly, phthalocyanine pigments give different hues. Even blacks have different colors; specifically, carbon blacks are too brown, and when used in inks, they are made blacker by adding a blue toner.

It should be obvious at this point that matching the color of one ink with another ink is a craft that requires a great deal of skill, training, and experience on the part of the inkmaker. It may also be obvious that it is impossible to match certain natural colors with existing pigments. The inkmaker and the printer must arrive at the best possible compromise under these circumstances.

Color Strength. Because the ink film is split between the plate and the blanket and again between the blanket and paper, printed litho ink films are very thin. In fact, they are the thinnest films printed by any conventional process. To produce adequate color in such a thin film, pigments of high color strength are required.

Color strength of the ink is determined partly by the amount of pigment used in manufacturing the ink and partly by the efficiency with which this pigment is dispersed. Since the pigment is usually the most expensive component in the ink, it is easy to make "cheap" inks by reducing the amount of pigment used. Grinding on the three-roll mill is an expensive part of inkmaking, and reducing or omitting this grind not only cheapens the ink but also reduces the dispersion of the pigment and reduces the pigment strength. This reduced dispersion helps to explain why "cheap" inks are seldom bargains.

FLOW PROPERTIES

A lithographic ink must be sufficiently fluid to travel from one roller to another as it passes from the ink fountain to the plate and the blanket and thence to the paper. It must also adhere to the image areas of the plate and not to the nonimage areas, which have first been made wet by the fountain solution. Once the ink is on the substrate, it must not set off or strike through, and it must dry satisfactorily.

Body, consistency, or viscosity is the resistance of a fluid to flow under a force or shear. For practical purposes, the inkmaker and printer often consider body as a combination of ink tack, length, and fluidity or viscosity. In the can, ink becomes quite stiff, but when it is worked with a knife (or on the press rollers), it quickly becomes softer and more fluid. The change in viscosity with working is known as shear thinning, or "thixotropy." The precise and significant measurement of viscosity is, therefore, a highly technical problem. The finger tests for flow, tack, and length must always be comparison tests made against inks that are known to work properly.

For record keeping, one needs an accurate instrument that gives numerical values. There are many such instruments available. The most commonly used in the ink industry are the Laray viscometer for measuring viscosity and the Inkometer for measuring the tack on rollers at printing speeds. These are discussed later in this chapter.

Tack. Tack is the resistance of a thin film to rapid splitting. It is sometimes estimated by a tap-out test with the finger, usually in comparison with another ink that is to be matched. It can be determined on the tack-measuring instruments. An ink that is not tacky enough may not print clean and sharp. An ink with too much tack will pick and sometimes tear the paper.

On a multicolor press, the tack of the ink on each succeeding press unit should be less than on the previous unit so that the last-down ink actually has considerably less tack than the first-down ink. It is advisable, though, not to go too low because soft inks mix too readily with the fountain solution. Because thick films split more readily than thin films, the color requiring the heaviest coverage should be run last. This order will give better "trap"—the acceptance of a second-down ink by a first-down ink.

EXAMPLE OF TACK SEQUENCE

	First Down	Second Down	Third Down	Fourth Down
Sheetfed	16	14	12	10
Web Offset	10	9	8	7

It is possible, with the use of quicksetting inks, that the first-down ink sets sufficiently between units to trap the next-down ink from the blanket. This setting permits the printer to use inks all of the same tack on the various units of his press. The printer, then, does not need a separate set of inks for each color sequence, each sequence having selected inks with descending tack values. This represents a considerable convenience to the printer, but he pays for it in poor trap. To get the best trap (and consequently the best color), it is highly desirable that inks of the proper tack sequence be employed.

Length. Length is the ability of an ink to form a string when pulled out by the finger or a spatula. A certain degree of length is necessary to make an ink feed properly to the fountain roller and transfer without piling. Too much length can cause an ink to fly or mist. Both the apparent tack and length of an ink change when it is worked with a knife or on the ink rollers.

As fountain solution is emulsified by an ink, the tack and the viscosity of the ink go down. The quantity of the fountain solution fed on the press must be controlled so as not to lower tack excessively. The fountain solution affects not only the vehicle but also the pigment used in a lithographic ink.

Lengths and viscosities of familiar materials are illustrated in the accompanying table.

FLOW PROPERTIES OF FAMILIAR MATERIALS

	Short	Long
High Body	Putty	Petroleum Pitch
Low Body	Mayonnaisse	Syrup

DRYING

The ink must remain stable in the ink fountain, and it must dry suitably after it is on the paper or substrate. There are two widely different ways of achieving this in common lithographic inks: oxidation/polymerization and evaporation.

Inks for sheetfed presses dry by a complex chemical process called oxidation/polymerization. The reaction occurs in the presence of a catalyst, which is called a "drier." When properly formulated, sheetfed litho inks should dry in two to four hours in the pile. If the inks are formulated to dry in less than two hours, they may dry up on the press, requiring the press operator to clean up the press. Removing dried ink from a press is a tedious, difficult job. If the inks do not dry fast enough, for example four hours, work in the pressroom is delayed.

The ease with which an ink dried depends to some extent on the pigment in the ink. Some pigments promote drying, and inks containing them need less drier than inks containing pigments that dry poorly. Inkmakers are well aware of this, and they add suitable amounts of drier for the pigment used in the ink.

Inks for web offset presses dry by evaporation. If the inks are formulated with solvents that are too volatile (solvents that evaporate too readily), the inks may dry up on the press. If the solvents are too "slow," the ink is not suitably dried by the dryer at the end of the press. Resins with good "solvent release" are used so that the ink is set reasonably hard as it comes off the press. Use of resins with poor solvent release is an important cause of smudging.

Courtesy of F. S. Lincoln
Finger tapout and bleeding tests.

Comparison of long ink and short ink.

Influence of Acidity on Drying. Uncoated papers are usually acidic because aluminum sulfate (papermaker's alum) is added during papermaking. The alum is an acid, setting the rosin size that provides the water resistance required in lithographic papers.

Lithographic fountain solutions are, for the most part, acidic. Acidity is required to put the gum arabic in the proper form for retention by the plate. At high pH values (that is when the fountain solution is neutral or alkaline), gum arabic is not retained by the plate, and it does not protect the nonimage area.

With stone and with zinc plates, the acid actually etches or eats away the surface of the printing plate exposing fresh water-receptive surface to the dampener. The surface of aluminum plates is actually aluminum oxide. It is not etched or eroded by fountain solutions that have pH values between about 1 and 12. Therefore, the name "etch" is incorrect chemically. It is a carry over from use in the older forms of lithography when stone and zinc plates were used. Unlike zinc, aluminum is a highly reactive metal, and it oxidizes immediately upon exposure to air during the manufacturing process. Aluminum oxide is a form of emery or corundum. The coating of aluminum oxide is transparent and very hard, and it adheres to the aluminum quite unlike iron oxide, or rust, which is opaque, reddish yellow in color, and readily removed from the surface of the iron. (There is a corrosion problem of aluminum lithographic plates that is often called, incorrectly, "oxidation.")

The above reasons explain why excessive acidity (low pH) is undesirable with aluminum plates. A properly formulated fountain solution is more important than high acidity in keeping aluminum plates running clean.

On damp days or when large amounts of fountain solution are used, delayed drying or complete failure to dry can occur because, at high relative humidities, acid attacks the drier. The graph shows that neither high relative humidity nor high acidity (that is low pH) by itself prevents the drying of properly formulated ink. However when the fountain pH runs below about 4.0 or 4.5, drying problems occur frequently in the printing plant. Even in an air-conditioned printing plant, the humidity within the skid may rise to high levels as a result of water evaporating from the ink film. Therefore the best way to avoid ink drying problems is to keep the pH of the fountain solution high enough so that changes in relative humidity do not cause ink drying problems.

The graph also shows the effect of pH and relative humidity on ink drying. For example, when the pH is greater than about 3.5, inks dry well at any RH. *However,* as inks dry, the fountain solution emulsified in the ink becomes more acidic (the water and alcohol evaporate, the acid does not), and the evaporating water increases the relative humidity in the pile of prints. The Graphic Arts Technical Foundation recommends that the lithographer use a fountain solution with a pH of 4.5 to 5.5 in order to achieve best results. Experience shows that drying problems increase as the pH is lowered below 4.5.

Effect of Alcohol on Drying. The amount of water emulsified in the ink influences its drying. Adding alcohol to the fountain solution reduces the water in the ink, increasing the drying rate of inks that dry by oxidation/polymerization. Generally, a fountain solution concentration of 18% to 25% isopropa-

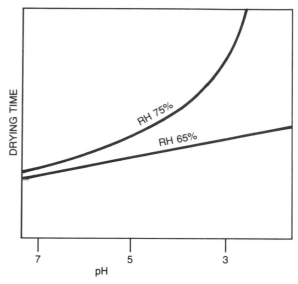

Effect of pH and RH on ink drying.

nol is recommended. A number of alcohol substitutes have been developed and marketed. Many of these depend upon the wetting characteristics of various surfactants. Others depend upon an understanding of the plate chemistry or the function of isopropanol.

Alkaline Fountain Solutions. Alkaline fountain solutions have been used, especially in web offset news, in place of the acidic fountain solutions containing phosphoric acid and gum arabic. These solutions contain no gum because gum would be ineffective at pH values between 10 and 11. The fountain solutions depend upon the action of various phosphates on the aluminum plate. Because of a chemical behavior known as "buffering," the pH of the resulting fountain solution does not vary with the concentration of phosphate, and the pH meter cannot be used to measure the concentration. On the other hand, the pH of the fountain solution is much less critical on the alkaline side than it is on the acid side, where excess acidity retards the drying of the ink. Alkaline fountain solutions have been used little except for web offset news, where they speed production by permitting the press to be started up without washing plates and blankets. In addition, there are reports that alkaline fountain solutions reduce the linting of newsprint.

There seems to be no particular advantage in using alkaline fountain solutions in commercial and publication web offset printing. The high pHs used promote ink emulsification if the inks contain any significant amount of free fatty acid. The fact that these alkaline fountain solutions are little used in commercial printing leaves little basis for observation of their effectiveness in publication and commercial web offset printing.

OTHER PROPERTIES

Gloss. Paper is the most important factor in the printing of gloss inks; best results are obtained with high-grade coated and enamel papers. But inks greatly affect the gloss of the print. The resin component, the oil or solvent, and the pigment all affect

gloss. Generally, synthetic resins of high molecular weight that do not penetrate the paper pores provide good holdout enhancing the gloss. Inks made from flushed colors often yield a higher gloss than inks made from dry pigment.

Emulsification. The formula for a good working ink may contain twelve to fifteen different ingredients, and it is developed only after many trials and experiments. The principle reason that lithographic inks differ from inks used in other processes is that litho inks must work in contact with water.

The inkmaker, therefore, must select materials that are more readily wet by varnish than by water. The pigments in litho inks must not dissolve in water or separate out in the presence of water. Likewise, the varnish must not mix into the water. Furthermore the combination of pigment and varnish must not emulsify or mix excessively with water. Ink mixing into the dampening water produces a disastrous overall tint on the printed surface.

Bleeding in the Fountain Solution. Pigments for lithographic inks should not bleed in the fountain solution, although there are some exceptions. Because isopropanol is commonly used in lithographic dampening, lithographic inks must also be resistant to alcohol. Some pigments bleed more at lower pH values. Peacock blue, calcium litho rubine toner, and permanent red 2B tend to bleed when the pH becomes low. A large increase in the acidity of the fountain solution causes even more severe consequences.

Interaction with Plates. There must be nothing in a litho ink that can react chemically with the plate or that can dissolve the image from the plate. Undesirable chemical reactions between ink ingredients and the plate can cause scum, can discolor the plate, or, by dissolving the image, can cause blinding. Finally, an ink should contain no abrasive particles to wear the plate. Grit is sometimes detected by a fineness-of-grind test described later in this chapter.

Section Three: Ingredients of Litho Inks

PIGMENTS

Pigments vary in several ways: specific gravity, particle size, wettability, opacity or transparency, color and tinting strength, and their effect on drying. Inks of different colors, therefore, cannot be built on any one standard formula. Each pigment has its own characteristics, and its ink must be formulated to accommodate those characteristics.

Pigments are classified as organic or inorganic depending upon their chemical nature. The organic pigments are often manufactured from BONA (beta hydroxy naphthoic acid), organic amines, or substituted anthraquinones. Inorganic pigments are often based on salts of lead, cadmium, and mercury. Owing to the high toxicity of these metals, their use in recent years has been severely restricted or eliminated by government regulations.

Ink pigments are often produced by a process called "laking." The pigment manufacturer adds a precipitating material to the solution of the dye so that an insoluble pigment is formed and precipitates out.

Except for iron blues, inorganic pigments have a higher specific gravity than the specific gravity of organic pigments. In addition, inorganic pigments often are opaque while the organic pigments are usually transparent.

Pigments are either supplied as "dry colors" or as "flushes." Most pigments are made by mixing two or more chemical solutions. These solutions react to form tiny solid particles of pigment, which are then filtered out. The filter cake is collected and pressed to remove as much water as possible. If the filter cake is put into an oven to evaporate the water, the product comes out as dry color. If, on the other hand, the filter cake is put into a mixer and mixed with a varnish, the pigment "flushes," that is, becomes wet with the varnish and leaves the water. The water is then poured off or evaporated, leaving the pigment well dispersed in an organic varnish. This product is called a flush, and flushed pigments are much more easily dispersed in inks than are dry pigments. Inks made from flushes are easier to grind and therefore are likely to have higher color strength and to contain less grit. Although flushes cost somewhat more than the corresponding dry color, the ease of dispersion and the superior properties of product make them the preferred way of handling pigments. A few familiar ink pigments are listed in the accompanying table.

INK PIGMENTS

Color	Organic	Inorganic
Yellow-Orange	Diarylide Yellow Hansa Yellow	Lead Chromate Molybdate Orange
Cyan-Blue	Phthalo Blue Peacock Blue	Ultramarine Iron Blue
Magenta-Red	Rubine Rhodamine	Vermilion Cadmium Red

Resinated Pigments. Pigments are often treated with resins during manufacture in order to make them more easily dispersible. The resinated pigment is more easily wet by oleoresinous vehicles. Calcium, barium, or aluminum resinates, used originally, have been replaced with thermoplastic synthetic resin latices and emulsions. The pigment precipitates on the surface of the resin. This precipitation prevents the agglomeration of pigment particles during drying. When the resinated pigment is mixed with an oleoresinous vehicle, the resin of the pigment dissolves and the pigment is rapidly dispersed.

Lightfastness. Most lithographic pigments are affected by light in some manner. This characteristic makes it imperative

that the degree of permanency required for each application, as well as the lightfastness rating of each pigment at different pigment concentrations, be known. Among the pigments with excellent light resistance, both indoors and outdoors, are carbon black, lampblack, phthalocyanine blues and greens, and many iron oxides.

Lightfastness is often required of litho inks; the degree of lightfastness depends upon individual end-use application. The effect of light, be it sunlight or fluorescent electric light, depends on the concentration of the pigment in the ink film and the intensity of the light. Tints, whose pigment concentration is low, tend to fade rapidly, whereas inks with high concentration of the same pigment are less affected.

Outdoor Exposure. When lithographic inks are exposed outdoors, as on posters, they encounter both light and rain. Laked pigments are unlaked by rain, yielding their original dyestuffs. As these dyestuffs are soluble in water, they are removed by the rain, fading the ink.

VEHICLES

"Vehicle" is the liquid into which the pigment is dispersed. It consists of a varnish and additives. The varnish may be a modified drying oil (in which case driers must be added), it may be a solution of a resin in a solvent, or it may be a combination of these. Litho inks were first made from heat-treated drying oils, but today, drying oils are chemically modified. These chemically modified oils are sometimes called "100% synthetic."

Besides carrying the coloring matter from the ink fountain to the paper, the vehicle serves, when dry, to bind the ink film to the substrate. Drying can be accomplished either by oxidation of the modified drying oils, by the evaporation of the solvent, or by both evaporation and oxidation. News inks dry primarily by absorption, while some of the newer ultraviolet inks dry solely by polymerization. Vehicles must provide the proper degree of water resistance.

Vehicles for Sheetfed Inks. Sheetfed inks are made from varnishes such as linseed oil and alkyds or other resins that dry by oxidation/polymerization. Quicksetting or gloss varnishes may be used. A drier is added to convert the liquid ink to a solid after it has been printed on a sheet.

Vehicles for Web Inks. Vehicles for web inks most commonly are prepared from a modified rosin; for example, a pentaerythritol ester of rosin or a rosin-maleic resin. Hydrocarbon resins, produced by polymerizing low-molecular-weight olefins, are finding increasing acceptance in production of ink vehicles for web offset inks. These materials show somewhat poorer "solvent release" than do the rosin esters.

Vehicles for Ultraviolet (UV) and Electron-Beam (EB) Curing. Vehicles for inks that are to be cured with ultraviolet radiation contain acrylic prepolymers (also called oligomers) and a photosensitizer (photoinitiator). Upon exposure to UV, the photosensitizer is activated, the energy is transferred to the prepolymer, and polymerization occurs in a fraction of a second. Photoinitiators are not required for curing with electron beams because electron beams are more energetic

than UV. These inks have outstanding rub, scratch, and skinning resistance, but cannot be deinked by conventional methods. With compact curing units installed between the printing units of a press, "dry trap" printing is possible.

Infrared Vehicles. There are several ways to make inks that will set and/or dry rapidly under infrared (IR) radiation. In the first place, IR warms the print, and heat alone accelerates both drying and setting of conventional inks. Heat also lowers the viscosity of the ink, and excessive or uncontrolled use of IR can damage the prints.

Infrared-curing varnishes therefore may be nothing more than conventional varnishes or perhaps conventional quicksetting varnishes. However, new varnishes formulated specifically for use with IR have recently been introduced, based on the limited solubility of certain acrylate resins in hydrocarbon solvents. Other techniques are also under development.

Lithographic Varnishes. The commonly used materials now are linseed, tall (from manufacture of kraft pulp), dehydrated castor, chinawood (tung), or soya oils reacted with an alkyd or other synthetic resin. Modification of the drying oil generally enhances ink holdout and finish and improves setting, drying, and gloss. Because the synthetic resin replaces part of the drying oil, less oxygen is required for drying.

The properties of a dried alkyd film are dependent on the type of oil and the nature of the alcohol and acid from which the alkyd was derived. The oil in combination with polyol (glycerol or pentaerythritol) is heated and the mixture is esterified with an acid, usually phthalic anhydride or isophthalic, to form the alkyd. Formulation of inks with isophthalic alkyd resins gives excellent pigment wetting properties and drying performance.

Modified oils are called short, medium, or long depending on the amount of oil in the oil-resin mixture. The short-oil alkyds have small amounts of drying oil; the long-oil alkyds have large amounts of drying oil in the mixture. Generally, the less drying oil, the higher the viscosity is, although the type of oil, polyol, and acid are all influencing factors. For best color retention, resins based on soya and dehydrated castor oil are favored. Linseed oils have a tendency to darken.

Tung oil vehicles dry harder, become more insoluble, and are more alkali resistant than linseed oil varnishes. Tung oil tends to form a very hard impenetrable film that resists dry trapping of subsequently printed inks. Such an ink is said to have "crystallized."

In addition to alkyds, important synthetic resins used in lithographic inks include phenolics, urethanes, maleics, acrylics, and epoxides. Oil-modified phenolic resins impart good drying speeds, film toughness, and excellent gloss and resistance to alkali. Maleic improves adhesion, quicksetting and hardness during the early life of the film. Acrylics and epoxides provide good chemical resistance to the dried film.

DRIERS

Driers promote the oxidation/polymerization of inks containing drying oils or drying oil derivatives. They are soaps of such metals as cobalt, manganese, lead, cerium, or zirconium. Liquid driers are available as the salts of octoic, rosin, naphthenic, tall-oil, and linseed fatty acids. Since different driers promote

drying by different mechanisms, blends of the driers are often used. Because of its toxic properties, use of lead has been virtually discontinued; mixed driers of cobalt and manganese are commonly used. These are sometimes called "two-way driers."

Paste driers are prepared by grinding inorganic salts of lead and manganese in linseed oil varnishes. Lead acetate or lead borate and magnesium borate are commonly used. Cobalt is not normally used in paste driers.

INK ADDITIVES

As stated earlier, ink formulation requires special skill and experience. The printer should not try to formulate or modify his inks but should consult the inkmaker. New types of ink formulations are particularly complex and improper additions can significantly alter their intended properties.

Waxes. Waxes are used in vehicles to impart slipperiness and rub resistance to the dried ink film. Waxes also reduce setoff, improve water resistance, and slow drying. They can reduce tack without appreciably altering other flow properties. Excessive wax softens the ink and reduces viscosity.

Regardless of its initial solubility, the wax will not function properly as a slip agent unless it is partially insoluble in the final dried ink film, migrating to and remaining on the surface. Some drying oils tend to keep the wax in solution after drying, giving an ink with unsatisfactory rub resistance. Waxes are preferred only in the last-down ink since they migrate to the surface of the ink during drying, making it difficult to trap other colors.

Antiskinning Agents. Antiskinning agents are useful additives in lithographic inks because they have a tendency to reduce the skinning and the drying of the ink while it is still in the fountain and on the press. If a volatile antiskinning agent is selected, the drying of the ink on the paper is only moderately affected since the bulk of the antiskinning agent leaves the film by evaporation.

Antioxidants. Just as oxygen tends to promote the oil drying process, antioxidants are used to retard such drying where warranted by the printing operation.

Antioxidants are occasionally added to ink to retard the rate of drying. Surfactants may be added to improve the dispersion. Extenders are occasionally added to reduce color strength.

Defoamers, plasticizers, and flow agents round out the list of additives that are sometimes used in the formulating of printing inks.

Plasticizers. A plasticizer is added to the ink to make the resin softer and more flexible and, therefore, more binding to the substrate. Its selection is based upon the printed product, the type of substrate, and compatibility with the resin.

Wetting Agents. Wetting agents such as fatty acids and alcohols lower the surface and interfacial tension by orientation of the molecules at selected surfaces and interfaces. Certain forms of wetting agents are used to promote pigment dispersion.

Considerable progress has been made in producing easily dispersible pigments. Where necessary, dispersion can be enhanced by use of surfactants. For example, kneading an alkyl amine with diarylide (benzidine) yellow forms a chemical bond, and the amine hinders reagglomeration of pigment particles.

Solvents. The most commonly used solvents in the manufacture of lithographic inks are petroleum hydrocarbons called heatset oils. When used to make web offset inks, the rate of evaporation must be controlled, and the oils are carefully fractionated to yield a product boiling over a narrow range. These fractionated hydrocarbons are often referred to as "Magie Oils." The lower the number of the oil, the lower its boiling range is. The simplicity and low toxicity of these solvents gives web offset an advantage over rotogravure where a wide variety of solvents are used, some of them rather toxic.

The inkmaker has at his disposal a number of heatset oils differing in their boiling range (rate of evaporation). The heatset oils can be treated to remove smog-forming components.

Heatset ink systems have been specially formulated to reduce or eliminate air pollution. One system uses a dual solvent to reduce the heatset oil content by more than one third, thereby reducing the amount of solvent vapor discharged to the air. Complete drying occurs at web temperatures of 250 to 275°F (120 to 135°C).

Solvents for offset inks must be compatible with blankets. Solvents that extract plasticizer from the blanket make it extremely smooth. Very smooth blankets have been shown to cause more picking than blankets with a rougher surface.

Section Four: Manufacturing Litho Inks

Formulation and Mixing. The actual process of making an ink is relatively simple, but formulation is a complex problem depending partly on science and partly on skill, craft, and judgment. The varnish and the pigment or pigments are weighed and stirred together in a tub using high-speed dispersion equipment to mix the pigment with the varnish. The mixing operation, by wetting the pigment and mixing the ink ingredients thoroughly, saves subsequent milling time. The mixture is then ground on a three-roll mill, where it is sheared as it passes between rollers.

Milling. The rollers of the three-roll mill turn at different speeds and thus severely shear the ink film between them. This shearing breaks up the pigment agglomerates into microscopic particles so that each becomes completely surrounded and wet by the varnish. The mill also "classifies" the pigment, permitting

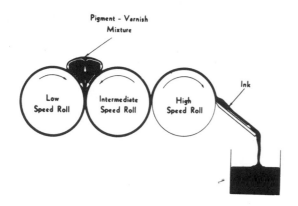

Three-roll ink mill.

finely dispersed pigment to flow through the mill and retaining or holding back coarser pigment particles. The ground ink is taken off the high-speed roll at the right by a doctor blade. A thorough job of grinding may require as many as three passes over the mill, depending on whether the pigment is soft or hard and how easily it is wet by the varnish.

Milling is a costly procedure, and inks can be cheapened by reducing the amount of milling. This causes several problems including lower color strength. Since the pigment is the most expensive part of the ink, the printer naturally wants to receive an ink of full value, which is developed by milling.

Continuous Manufacture of Inks. It is impractical to manufacture most paste inks in a continuous process. News inks, flexo, and gravure inks, which have low viscosity, are now manufactured by a continuous process.

Stability of Packaged Inks. Progress in recent decades has given inks that have good stability in the can. "Livering," a large increase in body resulting from reaction of pigments with vehicles of high fatty acid content, has been virtually eliminated by producing vehicles with very low fatty acid content.

False body, which may look like livering, occurs when inks are stored for a very long time. But if the thickened batches are worked with a spatula or run through a three-roll ink mill, they revert to their original flow and body. Choice of suitably treated pigments together with good wetting techniques reduces the formation of false body.

When inks are stored for a long time, driers often become ineffective. Any ink that has been stored for one year or more should be checked before putting in on the press. If it fails to dry satisfactorily, drier can be added, or sometimes the ink can be returned to the inkmaker for reformulation.

A better technique is to use a "first-in, first-out" system so that all old inks are used before their replacements are used. New inks arriving in the ink room should not be placed in the front of the shelf and used first, because inks at the back of the shelf become too old for use, and they must be discarded or wasted.

Section Five: How Inks Dry

There are seven different methods or mechanisms by which printing inks dry: absorption, oxidation/polymerization, evaporation, solidification, polymerization, gelation, and precipitation. All except precipitation are mechanisms used for setting and/or drying of litho inks.

SEVEN MECHANISMS BY WHICH INKS SET AND DRY

	Examples
Absorption	News, Quickset
Oxidation/Polymerization	Sheetfed Offset
Evaporation	Web Offset
Solidification	Heatset
Polymerization	Metal Decoration, Ultraviolet
Gelation	Quickset
Precipitation	Moisture-set

Absorption. News inks dry primarily by absorption. The vehicle drains into the sheet, leaving the pigment trapped by the fibers in the surface of the newsprint. There is no true drying in this mechanism, and the black pigment in the news ink comes off on the reader's fingers the next morning or weeks later.

Absorption, however, is also important in the setting of inks that dry by other mechanisms. For example, quickset inks set by phase separation absorption of solvent from the ink by paper. Accordingly, quickset inks will not function on nonabsorbent surfaces—an example of the importance of having inks formulated by the inkmaker for the job.

Absorption, like other physical and chemical phenomena, is accelerated with heat. At least one of the means by which infrared radiation speeds the setting of ink is by increasing the rate of absorption of solvent from quickset inks.

Oxidation/Polymerization. The exact chemical reactions by which oxidation/polymerization inks dry are unknown. There have been a number of mechanisms proposed, but none explain all of the facts. For example, none explain why cobalt is a "top drier" while manganese is a "through drier." In paints as well as in inks, cobalt causes the film to skin over very rapidly while manganese provides drying throughout. Basically, the reaction is initiated by the attack of oxygen on a carbon atom adjacent to a double bond in the drying oil part of the varnish. This reaction forms a structure, known as a hydroperoxide, that decomposes in the presence of the drier and forms a free radical that attacks another double bond. The attack upon the double bond forms a new chemical link between two molecules and also generates an additional free radical that can attack still another molecule—the reasons that these reactions are called "chain" reactions. Oxidative drying inks generate an "allylic"

free radical, a relatively stable, slowly reacting species. These characteristics of the free radical explain why oxidative drying inks can remain stable on the press for many hours and take hours to dry on the printed stock.

Ultraviolet radiation and electron beams generate "acrylic" free radicals, which are unstable and react very rapidly. Ultraviolet-curing and electron-beam-curing inks dry in a fraction of a second. None of the published mechanisms for the drying of ink explains the obvious differences between the rates of reaction of allylic and acrylic monomers.

The oxidation/polymerization reaction is affected by many factors: the kind of pigment, the kind and amount of drier, and the type of varnish in the ink; the absorptivity, pH, and RH of the paper; and the pH of the fountain solution. Consequently, drying problems often cannot be blamed on one particular material. Ink, paper, and fountain solution must all contribute to good drying performance.

Evaporation. Webs printed by any process usually dry by absorption or evaporation. In heatset web offset printing, the absorption of some of the vehicle by the printed sheet may assist in the setting of the ink, but evaporation of solvent is of prime importance.

Solidification. The ink on a printed paper leaving the dryer of the web offset press is hot and melted. It must be chilled or frozen by the chill rolls to solidify it.

Usually, several mechanisms are involved in drying. For example, in a quickset web offset ink, drying may include absorption, evaporation, gelation, and solidification. If an oxidation/polymerization vehicle is included in the formula, a fifth drying mechanism may actually be introduced.

Polymerization. Metal-decorating inks, heat-curing varnishes, and ultraviolet-curing inks dry by polymerization processes very different from the oxidation/polymerization characteristic of sheetfed offset inks.

The heat-curing varnishes and the metal-decorating inks dry by a process known to the polymerization chemist as "condensation polymerization." The reaction is fairly slow, and it requires large amounts of heat. UV-curing and electron-beam-curing inks dry by a process referred to as "additional polymerization." The acrylic prepolymers used for these inks cure very rapidly.

Gelation. Gelation is a mechanism by which quickset inks set. Quickset inks contain a gel varnish that has been cut to desirable body with a small amount of solvent. When the solvent is absorbed by the paper, the gel varnish reverts to its original high body, and the ink has "set."

Precipitation. Precipitation is a mechanism that is never used in conventional lithography. It depends upon the precipitation of resin from the ink vehicle by addition of moisture. It is obvious that such inks are incompatible with the dampening solution on the offset press. Moisture set or steam set inks were at one time used commonly for the printing of bread wrappers, now printed largely on polyethylene by flexographic inks.

Section Six: Printing Ink Problems in the Pressroom

The following discussion highlights problems commonly encountered in the lithographic pressroom.

DRYING OF SHEETFED INKS

The immensely complicated chemical reaction by which sheetfed lithographic inks dry is responsible for many drying problems. Perhaps the most common drying problem is simply slow drying of the ink. Lithographic sheetfed inks should dry sufficiently in two to four hours so that the sheets can be rerun or sent to the bindery. When the drying time stretches out in excess of four hours, production schedules are interrupted, or it may be necessary to rerun the job. There are two common causes of drying problems: (1) the ink was not suited to the substrate, and (2) the pH of the fountain solution was too low and the relative humidity was too high. Fountain solutions with pH lower than about 4.5 contribute to drying problems.

Ink may be unsuited to the job because the ink was not formulated properly, the ink may have been ordered for a different job or the printer may not have given his inkmaker enough information, or the properties of the ink may have been altered in the pressroom. Variations in absorptivity, relative humidity, and pH of the paper can aggravate drying problems.

Mottle. Mottle is caused by an imbalance in the ink and the paper. All paper has nonuniform absorptivity, although some textbooks state that handmade paper is uniform. Fibers from which the paper is made cannot be distributed completely uniformly. If the ink is absorbed more by one part of the sheet than by another, nonuniform penetration may yield a visible pattern called "mottle." One way to overcome mottle is to select an ink that is uniformly held out or uniformly absorbed by all areas of the sheet. If the sheet is reasonably uniform, this will not be a difficult task. However for some types of substrates, especially paperboard, differences in absorptivity may be so great as to make the selection of a suitable ink virtually impossible.

Mottle is also aggravated by the responses of the eye. Variations in brown and green solids are more visible than are variations in other colors. Pattern prints show less mottle than do solids. Inks that set and dry quickly probably cause less mottle than those that set and dry slowly. The longer it takes for the ink to dry, the more time there is for differences in the absorption to become apparent.

Chalking. Sometimes the dried ink pigment does not adhere to the substrate. It can be brushed off with the finger. If

Chalking, resulting when the vehicle separates from the ink and leaves dry, unbonded pigment on the sheet.

the ink varnish is too thin or is improperly formulated for the paper or if, for some reason, drying is delayed too long, the pigment will not be bonded to the sheet. To prevent chalking, the ink can be stiffened with a binding varnish. Before doing this, however, pH of the fountain water and the paper should be checked. If the relative humidity is unusually high, more drier or a stronger drier may help. Unfortunately, chalking is usually not noticed until the job is off the press, and then the only remedy is overprinting with a transparent size or varnish.

Use of a drying accelerator (a salt of cobalt) in the fountain solution will accelerate drying where drying problems can be anticipated, but they usually are not anticipated and are discovered only after the job is completed.

Chemical Ghosting. Also known as "gloss ghosting" and "fuming ghosting," chemical ghosting is found most frequently on enamel papers using quickset inks where a high gloss is desired. There are a number of different mechanisms proposed for gloss ghosting, but it is suffice to say that the drying ink on one side of the sheet affects the drying of the ink on the other side creating an image on the second side. According to one theory, vapors given off by the drying ink film change the rate of drying of the ink film on the backup side of the sheet.

A number of factors work together to cause the problem. The problem usually occurs on a prestige job in which the smallest defect is intolerable. Furthermore, small differences in gloss are readily detected on glossy jobs. GATF laboratories showed that a high concentration of drier, required if the job is to be run in a hurry, promotes gloss ghosting. Backing up the prints that have dried less than 24 hours also promotes the gloss ghosting. Gloss ghosts often occur in annual reports where prestige, high gloss, and fast turnaround come together.

Little can be done to overcome gloss ghosting. Lacquering, varnishing, and heating the print have all been observed to reduce gloss ghosting on occasion, but more frequently they accomplish nothing or make matters worse.

Since cures are ineffective, the printer must prevent ghosting by recognizing conditions under which gloss ghosting is likely to occur. The following steps are recommended: (1) Ink should be carefully formulated to suit the job. No changes in ink should be made in the pressroom, especially no additional drier should be used. (2) The job should be scheduled so that it is not necessary to rush through. The first side of the print should be allowed to dry at least 24 hours before it is backed up. (3) The printed skid should be carefully winded to eliminate any moisture or vapors that are by-products of the drying of the ink. (4) The printed sheets should be stacked in small lifts that are easily winded and that will dissipate the heat generated by the oxidation/polymerization reaction. (5) Printers normally like to print the light form first and the heavy solids second. However, if the heavy first-down film develops patterns in the light second-down film, they will be invisible. In addition, of course, if the heavy solids are printed first, the first-down side must be thoroughly dried before it is backed up. This in itself helps to eliminate the gloss ghosting. (6) In severe cases, it may be possible to slip-sheet the printed sheets. Slip-sheeting is a slow, extravagant means of preventing gloss ghosting. It is completely effective, however, and many printers who have lost jobs because they were not able to correct the gloss ghost would have been economically ahead had they used slip-sheeting.

DRYING OF HEATSET WEB OFFSET INKS

Because heatset inks dry primarily by evaporation, problems are much simpler than with sheetfed inks. In addition, because the inks normally dry while the job is on-press, the pressman can take immediate steps should problems arise.

Temperature control is of prime importance. To make sure the inks are dry, web offset dryers usually run too hot, often as much as 50°F above requirements. This practice not only wastes expensive gas but deteriorates paper, causing cracking and brittleness. As the web emerges from the dryer, it is still hot and the ink is melted. The web must be cooled by passing it over the "chill rolls," hollow cylinders cooled with brine or cold water, to solidify the ink. If the chill rolls are not functioning properly, the print will still be "wet" when it goes to the folder.

OTHER PROBLEMS

Hickeys. Hickeys are caused by dirt: dirt from the ink, dirt from the paper, and dirt from the press or the pressroom. Controlling hickeys means keeping the press and the pressroom scrupulously clean, making sure that the paper and ink are clean, and handling the ink with care. Ink returned to the can by the pressman must be handled with care to keep dirt and air out of the ink.

Dry Trapping. Sometimes it is difficult or impossible to trap an ink over a dried print, creating a dry-trapping problem. Dry-trapping problems arise from the use of hard-drying varnishes in the ink, such as those involving chinawood oil, from the presence of nondrying oils in the ink, and from the use of hard waxes in the ink. Hard waxes, such as carnauba wax, give a hard, resistant finish to the ink, and the printer must specify to his ink supplier the printing sequence so that hard

waxes are incorporated only in the last-down ink, especially if the print is to be dried before subsequent inks are printed.

Nondrying components incorporated in the ink or the varnish will bleed to the surface during drying and present a low-viscosity film that will not accept ink on subsequent printing.

Trapping problems are one of the most serious causes of color variation, one of the major problems with lithography.

Wet Trapping. Failure of ink on one blanket to adhere to the print from a previous unit on a multicolor press is called a wet-trapping problem. Wet trapping is accomplished by control of the ink tack and the ink film thickness. The Inkometer is used to determine the tack (the force required to split the ink film). However, thick films split more easily than thin films, and it is extremely difficult to trap a thin film over a first-down thick film.

To improve wet trapping, GATF has always recommended use of a tack sequence of about two tack or Inkometer units between each press unit of a multicolor sheetfed press and about one Inkometer unit between each unit on a web press. Absolute tack values will depend on many variables, the press, the paper, and the ink.

Picking. If the ink tack is too high and the speed of the press is too great for the paper being run, bits of paper may be picked out of the surface, dirtying the ink and spoiling the print. In extreme situations the sheet tears. Picking has become increasingly serious as ink coverage and press speeds continue to increase. Picking can be reduced by using stronger paper, by slowing down the press, by softening the ink, by reducing back cylinder squeeze on the press, and by increasing ink film thickness.

Piling. Failure of the ink to transfer from the blanket to the paper is called "piling." Piling occurs when ink is made short on the press by emulsification with water and by mixing with dust or pigment from a paper coating containing insufficient adhesive or from filler pigment or bits of paper fiber from uncoated paper. As these are worked into the ink, transfer properties change, sometimes enough to prevent adequate ink transfer. Ink, paper, fountain solution, and blankets are among the causes of this very complex phenomenon.

Ink Setoff. Ink setoff, occurs when too much ink is run, when the ink is too soft, or when the ink does not set quickly enough. To avoid setoff, the ink can be made stronger in color and run in a thinner ink film, and the height of the delivery pile should be decreased. Setoff is less likely when the ink has been made for the paper or board being printed. Most commonly however, the printer solves setoff problems by using more spray powder or a coarser powder.

Tinting. Tinting is caused by ink emulsifying in the dampening solution and results from a poorly formulated ink or one that has been softened excessively. The usual remedy is to change inks. It is also possible to stiffen the ink with a binding varnish. Soaps and detergents should be avoided in fountain solutions. If wetting agents are required, the printer should secure an approved compound from his local supplier of lithographic chemicals.

Scumming. Scumming occurs when the background area of the plate takes ink instead of remaining clean. The ink adheres to the plate and is not readily wiped off with a cloth. Bad ink formulation, poorly chosen pigment, dirty dampeners, improperly set from rollers, too much pressure between blanket and plate, a poorly desensitized plate, unsuitable paper, and improperly prepared lithographic film are among the causes of scumming.

Stripping. A lithographic ink must emulsify fountain solution moderately so that the ink continues to follow the rollers. If fountain solution replaces ink on the rollers, the phenomenon is called stripping. Stripping usually occurs first on the vibrator roller. Some inks can absorb as much as 30% of their weight of fountain solution and still be sufficiently fluid to travel from one roller to the next and finally to the plate. The problem is solved by changing ink-water balance or by changing inks.

Mechanical Ghosting. Mechanical ghosting results from uneven ink take-off from the form rolls. Ink removed from the ink form roller by the image on the plate is not completely replaced by the ink on the vibrator, which means that the form roller carries insufficient ink to the plate. Since the area that carries insufficient ink exactly corresponds to the image on the plate that removed it on the prior revolution, the image is reproduced and a ghost appears. Mechanical ghosts are always on the same side of the page as the image that is ghosted, unlike chemical ghosts that will always appear on the opposite side. Mechanical ghosts appear in both sheetfed and web lithography. Chemical ghosts occur only in sheetfed lithography.

Increasing the ink film thickness, adding an opaque ink, and reducing the amount of water on the plate help to reduce mechanical ghosting. Some presses cause much less ghosting than others. Good layout of the form also keeps mechanical ghosting to a minimum.

Section Seven: Testing of Litho Inks

Ink tests are carried out either on the ink itself or on a printed sheet. Standard methods are described in *NPIRI Standard Test Methods*, obtained from National Printing Ink Research Institute of Lehigh University, Bethlehem, Pa. 18015.

The Drawdown. One of the simplest and most useful tests of an ink is to draw the ink down on a sheet of paper; a soft, white, rag bond; or on the paper that is to be printed. To make a drawdown, place a pea-sized lump of standard ink on

An ink drawdown.

the upper right-hand corner of the test sheet and place next to it a similar lump of the ink to be tested. Draw a wide, smooth steel blade or spatula across the pair of inks, drawing down in one even motion, first a thick film 1-in. long and then a thin film for the balance of the drawdown. The films should join to facilitate comparison. The drawdown shows the operator the comparison of the masstone and the undertone, the color match, and the comparative color strength of the prints. If the ink is drawn down on the paper to be printed, judgments can be made concerning gloss, mottle, and drying characteristics of the ink on the sheet.

Quick Peek Tester. Drawing ink down on a coated sheet is difficult, and the Thwing-Albert Quick Peek Tester is a simple device for applying ink to any sheet. A specific amount of ink is measured and rolled onto a stainless steel plate. Once the ink is properly distributed and worked, it is rolled onto the paper sample. As with drawdowns, the Quick Peek test is useful for observing drying time, gloss, mottle, and color of the print.

Ink Drying. The finger test can be used to determine how long it takes an ink to dry. There are, in addition, several laboratory instruments for measuring drying time. They depend on rubbing or scratching, or they determine setoff. The ink to be tested is drawn down on the sheet of paper, or the sheet is printed using a Vandercook Proof Press or other suitable equipment. Drying time is measured by drawing the finger over the print at intervals of 15 or 30 minutes until they no longer smear. The ink is now dry, and the drying time is noted.

Tinting Power. Tinting power is determined by weighing a sample of the ink and diluting it with a large amount, usually fifty times as much, of a white ink or "tint base." The ink is then thoroughly mixed. A similar amount of a standard ink is also weighed and mixed with the tint base. The two inks are then drawn down side by side, and the color is observed. Additional tint base is now added to the darker sample until the lightness of the two mixtures match. The relative amount of tint base required to give a match is noted.

Viscosity. There are a number of devices for measuring viscosity of fluids. Any viscometer must be carefully thermostated because viscosity changes dramatically with small changes in temperature. The most common viscometer used for measuring ink viscosity is the Laray Viscometer. The Laray Viscometer consists of a rod that drops through a film of ink held in a cuff surrounding the rod. The more viscous the ink, the longer it takes the rod to drop. Various weights are placed on the rod, and the time is measured accurately with an automatic timer. As the weights change, the time changes, and the results are plotted on a suitable graph. The graph gives three values, the viscosity, the yield strength, and a measure of thixotropy of the ink.

GATF Inkometer. The Inkometer is useful for testing the tack of the ink, that is, the force required to split a film of ink. On a multicolor press because there are many variables, such as the speed of the press, the surface of the paper, and the use of inks in the sequence, different tacks are required depending on the job. The Inkometer is used for determining comparative

A viscometer.

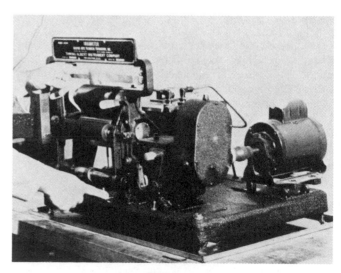

The GATF Inkometer.

standards. The Inkometer is useful for determining whether batches of inks delivered from time to time are uniform. It can also be used to determine whether or not the process colors have the proper tack sequence. Because of difficulties in standardizing the test, absolute values are often misleading. Other tack testers are made by Prufbau, IGT, and the Metal Box Company.

Emulsification. There are several tests for emulsification of ink; unfortunately none of them are highly reliable. The Pope and Gray Litho-Break-Tester, which works ink and water together, is probably as good a test as any. After running the

inks together with the water, the amount of water in the ink can be measured by evaporation or by chemical methods. Inks can also be worked with water by hand or with a high-speed mixer. Inks can be taken from a form roller on the press and analyzed for water.

Product Resistance. There are many tests for determining the resistance of inks on packages to products in the packages such as alkali, soap, alcohol, and varnish. Tests are described in publications of the Packaging Institute. Procedures are available from Packaging Institute—USA, 342 Madison Ave., New York, N.Y. 10017.

Section Eight: Papermaking

Papermaking is a blend of ancient craft and modern science. Chemistry and engineering are making major contributions, and in the last half of the twentieth century, pulp and papermaking are becoming increasingly automated through an understanding of the process and through techniques and instruments for measurement and control of products and processes.

The word "paper" is derived from "papyrus," the reed that grows along the Nile River. Papyrus was woven into mats used for writing by the ancient Egyptians. Paper originated in China, about the first century A.D. Bamboo or mulberry were beaten in water, and the resulting suspension of fibers was formed into a sheet by filtering through a screen. The invention of paper is traditionally ascribed to an imperial officer named Ts'ai Lun in A.D. 105.

Paper pulp has been made from trees, rags, sugarcane, straw, grasses such as esparto and kenaf, and other vegetable substances. Other materials used to make paper include polyethylene and acrylic polymers. However, the modern papermaker depends principally upon fibers from trees as the source of paper pulps.

WOOD

Trees are divided into two groups: softwoods and hardwoods. Softwoods are coniferous trees and include pine, spruce, balsam, and fir. These are called gymnosperms (naked seed) by the botanist. Their most important characteristic from the papermaker's point of view is that their relatively long fibers—3.0 to 4.5 mm (0.12 to 0.16 in.)—yield paper of high strength. Hardwoods, including maple, oak, gum, and birch, are deciduous trees, or angiosperms (enclosed seeds). Their fibers are about one-third as long, contributing smoothness to the paper.

Since strength and smoothness are both desired in a printing paper, hardwood and softwood pulps are blended, usually in the ratio of about two parts hardwood to one part softwood.

Wood is composed of cellulose, lignin, and hemicellulose. Approximately one half of the tree is cellulose (the fibers used for making paper), about one quarter is lignin (the adhesive that holds the fibers together), and about one quarter is hemicelluloses (by-products of the growth of the cellulose). Hemicellulose contributes to paper strength, but much of the hemicellulose content is lost during pulping by chemical processes.

Throughout most of the world, the supply of pulpwood exceeds the demand, and in the United States we have been growing more wood than we have harvested for several decades. Forest industries are making increasingly complete use of the tree, using large trees for lumber and pulping the sawdust and trim for paper. Waste, bark, and leaves are burned for power at the mill or they are returned to the soil.

PULP

The character of the fibers in different woods varies considerably, and trees of the same species from different parts of the country have fibers that are different in character. Consequently, it is difficult to describe and classify all of the fiber differences that occur in pulp. However, important classes of pulps in common use can be grouped as follows: mechanical pulp (groundwood), chemical wood pulp, reclaimed paper pulp, and rag pulp.

Mechanical Pulp (Groundwood). In the conventional method for producing groundwood, a peeled log is pressed against a grindstone. The friction generates heat that softens the lignin, and cellulose fibers are pulled out of the log. The fibers

Outlines of a coniferous tree (left) and a deciduous tree.

are mixed with water, and they begin their trip to the paper machine. The grinder significantly damages and weakens the pulp. On the other hand, mechanical pulp gives paper with outstanding opacity, smoothness, and ink receptivity.

Newer techniques involve a machine, called a refiner, that is fed with chips. The refiner reduces the chips to mechanical pulp. Thermomechanical pulp (TMP) is made from chips that have been steamed. Steam softens the wood chips before they are defibered; the fibers are more easily removed and therefore are damaged less during pulping. This pulp has considerably more strength than the conventional groundwood, and it actually replaces chemical pulp in the manufacture of newsprint and other groundwood-content papers.

The groundwood process is simple and, historically, inexpensive. However, it yields no by-products that can be used as fuel, and the increasing cost of electricity has reduced the economic advantage of producing pulp in this way. Nevertheless, because lignin and hemicelluloses are not dissolved in the pulping process, most of the wood is converted to pulp, and the yields are very high. In addition to being rather weak, groundwood has poor light stability. All of the lignin of the tree is included in the pulp, and lignin darkens very rapidly on exposure to light; less rapidly when stored in the dark. Groundwood-content papers are generally not suitable for printed products such as encyclopedias, dictionaries, ledgers, or other items that must remain useful over the years.

Coated groundwood paper has somewhat better brightness and better brightness retention than the uncoated product, and it is used for printing magazines, catalogs, and other low-cost publications.

Chemical Wood Pulp. In conventional pulping, peeled logs are reduced to chips and cooked with alkaline or acid materials to dissolve and remove the lignin. Recent practices in North America and much of the world involve the use of whole-tree chipping. The entire tree (except for the roots), leaves, branches, and all, are chipped and fed to the digester. This procedure gives a higher yield of fiber, but it requires more chemicals to remove the dirt and more electric power for screening and cleaning. Chemical pulp is also being made increasingly from by-products of the lumber industry. Any logs large enough to yield lumber are usually cut into lumber, and the slabs and sawdust are used for pulp.

Three kinds of chemical pulping will be discussed here: sulfate, sulfite, and semichemical.

Sulfate, or Kraft, Pulp. The word "kraft" is German and Swedish for "strength." The process produces fibers that are relatively undamaged and therefore very strong. Sulfate pulp makes strong papers with especially good tear and tensile strength. The kraft pulping process is now the leading chemical pulping process.

The pulp is produced by cooking wood chips with sodium hydroxide and sodium sulfide (which is produced from sodium sulfate, hence the name). The pulp is used to make kraft paper for grocery bags, wrapping paper, and corrugated board. It has been, historically, difficult to bleach, but work done in the mid-twentieth century has developed bleaching processes that yield a strong, bright pulp.

The kraft pulping process converts parts of the lignin into dimethyl sulfide, dimethyl disulfide, and methyl mercaptan, three of the foulest smelling chemicals known to man. When these are discharged into the air, the "papermill smell" can be detected for miles. It has been said, probably correctly, that more attention has been paid to this environmental problem than to any other. Tiny traces, less than one part per billion parts of air, of these materials create a strong odor, and it has not been easy to reduce the material escaping from the mill to quantities less than this.

Sulfite Pulp. Sulfite pulp was the first chemical pulping process. Sulfite pulps are easily bleached, but less strong than kraft pulps as the pulping process causes significant damage to the fibers. The pulp was once produced by cooking the chips with calcium bisulfite made from a mixture of lime and sulfur dioxide. But the spent pulping liquors from this process have been virtually impossible to reclaim. Use of ammonia or magnesium in place of lime gives spent liquors that are more tractable. Calcium bisulfite pulping has faded into disuse. Sulfite pulping is unsuitable for pulping resinous woods, such as Southern pine.

Neutral Sulfite Semichemical Pulp. Caustic soda is reacted with sulfur dioxide to produce a liquor that is nearly neutral in pH. Cooking is carried only part way, and pulping is completed by use of a refiner. The process is particularly favorable for pulping hardwoods that yield a pulp somewhat stronger and more dense than when they are pulped by the kraft process. The paper however is somewhat less opaque. This pulp is widely used for corrugated board.

Rag Pulp. There has always been a shortage of rags; in fact it was this shortage that prompted Mitscherlich to develop the sulfite process in the early nineteenth century. Cotton or linen fibers are much longer than wood fibers, and they yield a paper that is much stronger than can be obtained from wood pulps. The expensive product is usually restricted to paper for banknotes, high-grade bond, and map paper.

New cotton rags that have never been dyed or colored yield a very strong paper that folds well. Colored rags and used rags make an inferior pulp and paper because the cleansing process weakens the fibers. Cotton linters, the fibers that remain on the seed after the cotton has been ginned, are used to make paper. The raw linters do not bond well, but after chemical treatment, they yield a strong sheet.

Recycled Paper. Wastepaper is defibered by heating and by cooking in chemicals that dissolve or disperse the printing ink. The ink and other impurities are separated from the fiber by washing, and the pulp may also be bleached or whitened. Chipboard, the type of material used for tablet backing and for clothing boxes is often not deinked. On the other hand, because unprinted trimmings from paper plates, envelope manufacture, and computer cards contain no ink, they are easily bleached to give a high-grade printing paper.

Reworking the paper usually reduces its opacity, strength, and folding endurance. Smoothness is enhanced. However, the main driving force for using recycled paper is economic, and because collection and handling costs for recycled paper make it more

expensive than virgin paper, it has not become a major source of paper in the United States. Also, much of the wastepaper found in solid waste is unsuitable for recycling into white printing and writing paper. About 80% of recycled paper is used to make paperboard products.

North American forests are growing more rapidly than they are being harvested, and only about 25% of the paper and paperboard in the United States is recycled. Some 35% of the paper in Germany and about 42% in Japan is recycled.

Chlorination and Bleaching. After the wood has been converted to pulp, the pulp is washed with water to remove the chemical solution in which the nonfibrous materials are dissolved. The pulp is then screened to separate it from undigested knots and shives (undigested fiber bundles).

The next step is to bleach the pulp if it is to be used for white paper. In the case of virgin pulp, it is still dark (called brown stock). In the case of recycled wastepaper, color depends upon the source of wastepaper.

The pulp is treated with chlorine (which reacts with residual lignin) and then with caustic. To bleach the pulp without unduly attacking the cellulose fibers, bleaching is normally carried out in several steps, with the pulp growing brighter after each operation. The removal of lignin improves the brightness of the fibers, improves their color stability, and decreases their opacity. The actual treatments depend on the type of pulp and the method of its preparation. Kraft or sulfate pulps are difficult to bleach; sulfite pulps are easily bleached.

Chlorine dioxide bleaching, as a part of multistage bleaching, removes the dark kraft color without destroying the strength of the fiber and produces clean, white kraft pulp suitable for manufacture of printing and writing papers.

Newsprint, which typically contains 75% to 80% groundwood, is frequently sold without bleaching; however, if it must be bleached, chlorine cannot be used because chlorine reacts with the lignin. Sodium or zinc hydrosulfite and sodium or hydrogen peroxide are used to bleach groundwood pulps.

PAPERMAKING

Refining. If a sheet were made from bleached or unbleached pulp, it would be very weak. The fibers must be refined to make them suitable for papermaking. Beating, or refining, makes the fibers more flexible and increases their surface by fibrillating (roughening or fraying) them so that more area is available for bonding. Fibrillating generates tiny paper fibrils by abrading and unraveling the cellulose fibers. The fibers are also cut or shortened. Although cutting decreases their strength, it produces a sheet with better formation (more uniform distribution of fibers).

There are several types of equipment for refining pulp. The old, long-used "beater" has an oval tub around which the pulp is circulated. At one point, the pulp passes between a beater roll and a steel bed plate. In large mills, beating of pulp in batches has been replaced by continuous refining using disk refiners. Beaters remain in the smaller, specialty paper mills.

The Jordan, or conical, refiner is used for additional refining after the beater or disk refiner. It has a conical rotor (plug) with metal bars attached along its length, and it revolves inside a conical shell also lined with bars. The stock enters the small end and is forced through the cone, passing between the opposing rows of bars. The clearance between the bars is set to cut, brush, or bruise the fibers, depending on the nature of the stock and the requirements of the paper to be produced.

Effect of Refining. Pulp is refined or beaten primarily to increase the bonding of paper fibers. It increases the Mullen or bursting strength, folding strength, tensile strength, smoothness, and density of the paper. Tearing strength is increased initially, but it soon decreases. Refining always decreases brightness, opacity, porosity, bulk, and softness of the sheet. Carried to the extreme, refining produces a glassine paper that has high transparency, high tensile strength, poor tearing resistance, and other properties predicted from excessive beating. Paper made from unrefined pulps is bulky, weak, soft, and absorbent, has high opacity, and tends to fluff and lint.

Refining ruptures the outer wall of the fiber, and the internal fiber walls absorb water and swell. An actual chemical change occurs in which internal hydrogen bonds are broken, generating free hydroxyl groups that can form new hydrogen bonds when the paper is dried. The strength of paper depends on this chemical bonding. Cellulose sheets prepared from alcohol, acetone, or other organic materials have much less strength than papers formed in water.

The papermaker controls paper quality by controlling the refiner. If the machine is set tightly, it tends to cut pulp fibers giving a very smooth, weak sheet. If the machine is set less tightly, the fibers are not cut and the pulp produces a paper with higher tensile and tearing strength. Various types of paper are produced depending upon the amount of work put into the paper during refining and upon the way the refiner is set. Bulky, soft grades such as antiques require only a small amount of refining, whereas others like bonds that need rattle are given more refining. Transparent papers such as tracing paper or glassine are refined very extensively.

PAPER ADDITIVES

During or following refining, a number of materials may be added to the fibers to achieve the properties desired in the final paper.

Starch. Cooked starch is added to the paper stock furnish to increase strength and "rattle." Starch also increases stiffness, but decreases opacity. Starch increases the number of chemical bonds in the paper. The most commonly used starch is corn starch, but potato and tapioca starches are also used.

Fillers. Clay, calcium carbonate, titanium dioxide, or other pigments may be added to improve dimensional stability, opacity, brightness, and printing smoothness. Clay is aluminum silicate, a natural product obtained from the earth and refined to remove grit and brown color. It is used primarily to make the paper smoother and to improve its affinity for printing ink. Calcium carbonate is brighter than clay and has a high affinity for ink. Titanium dioxide is brighter than either calcium carbonate or clay and excels in improving both the brightness and opacity of paper.

Retention Aids. To improve retention of pigments, especially titanium dioxide, the papermaker may add retention aids,

which are synthetic polymers or chemically modified natural polymers.

Dyes and Pigments. Most papers are dyed or colored to match some predetermined color specification. Adding blue or red dyes improves the visual "brightness" of white papers by overcoming the natural yellow color of the fibers. Color may be incorporated by using either a dye that attaches itself to the cellulose or by using a pigment that is retained by the sheet. If the sheet is to be dyed a deep color, a dye may be added after the sheet has been formed, such as at the size press or the coater.

Internal Sizing. Internal sizing is added to the papermaking furnish to control the penetration of liquids, primarily water. Stocks for offset lithographic papers are sized to reduce the penetration of water. Sheetfed papers require more sizing than web papers. The most common materials used for sizing paper are alum and rosin, but synthetic sizing materials are also used for special purposes.

Rosin is an acidic material obtained from pine trees, and when reacted with caustic, it forms a rosin soap. The water-soluble rosin soap is added to the paper stock and "set" on the fibers with an acid salt (aluminum sulfate, or papermaker's alum).

When alum is used, the paper is slightly acidic. In addition to bonding the rosin to the cellulose, the alum greatly accelerates the aging of paper. Where archival properties are required of paper, new synthetic-polymeric sizing agents are incorporated without the use of alum.

Sometimes synthetic latexes (latices) are added to increase strength or flexibility or chemical resistance of the paper. They are more commonly added at the size press than to the papermaking furnish.

SHEET FORMATION

The material is now referred to as "stock" or "stuff" or "paper machine furnish," and it is ready to go to the machine. Printing and writing papers, newsprint, and most other papers and some paperboards are made on Fourdrinier machines, but some tissue papers and some paperboards are produced on cylinder machines.

When the Fourdrinier machine is used, the stock is pumped into the "head box," the box that maintains head or pressure to assure an even flow of stock to the "wire." The wire is actually a metal or plastic screen. Brass and bronze screens, used for decades, have now been largely replaced by plastic screens, which are still referred to as "wires." The stock, which has been diluted to a consistency between 0.5% and 1% fiber by weight flows onto the wire, and the water drains through the wire.

Modern paper machines making tissue paper run at speeds as high as 5,000 feet per minute (25 meters per second). Twin-wire machines for making newsprint may run in excess of 3,000 feet per minute, and modern machines making fine papers run over 2,000 feet per minute.

Modern paper machines use hydrofoils instead of table rolls to support the wire, thus reducing the amount of disturbance that occurs during drainage, thereby making a more uniform sheet. Table rolls tend to cause a greater loss of fine fibers from the wire side of the paper and make that side of the sheet rougher. Absence of the "fines" also makes the wire side somewhat stronger. Therefore, "the wire side is stronger, the top side is smoother."

Following the table rolls or hydrofoils, suction boxes produce additional drainage.

In the few seconds in which the forming sheet flows down the wire, its solids content is increased from 0.5% to about 20%. The water drained from the sheet is called "white water" because it contains fine fibers and traces of other materials added to the paper.

Modern paper machines are often "twin-wire machines" in which the stock enters between two wires and in which the water is drained from both sides of the sheet simultaneously. Twin-wire machines operate at higher speeds than single-wire machines, the forming unit is usually much shorter, and the resulting sheet is more uniform; that is, it is less "two sided."

As the paper reaches the end of the wire, it has already achieved enough strength to be lifted off the wire and fed into the press section without tearing or "breaking." Additional water is pressed out of the sheet between synthetic-fiber blankets, which are called "felts."

After coming out of the press section, the sheet still contains two tons of water for every ton of stock, and the remaining water must be evaporated. This procedure requires high amounts of steam or energy, and it contributes significantly to the cost of the paper. The paper passes through the dryer

Courtesy of Beloit Corporation

"Wet" end of a Fourdrinier paper machine.

Courtesy of Beloit Corporation

Twin-wire paper former.

Courtesy of Beloit Corporation

A part of the dryer section of a papermaking machine.

section, which consists of cylindrical dryers called "cans." Although the paper tends to shrink as it dries, the machine applies tension to the web throughout its travel. This practice means that the paper is significantly stretched during manufacture, and this is one of the factors contributing to the "grain" of the paper.

THE SIZE PRESS

The size press, or coating machine, is located about two thirds of the way through the dryer section. Starch, latex, or other surface-sizing materials may be added to the sheet at this time. Sizing carried out at the size press is referred to as external or surface sizing, while sizing added before the sheet is formed is referred to as internal sizing or beater sizing.

Starch is added at the size press to control ink penetration, pick resistance, dimensional stability, surface smoothness, finish, and appearance. It also reduces the tendency of the paper to fluff or lint on the offset blanket. Clay or other pigments are sometimes added to the starch for better printability and ink holdout. Starch improves the "rattle" of paper and the erasibility of bond papers that are highly sized. The size press may be replaced by an "on-machine" coater that applies a pigmented slurry to the paper. The difference between a pigmented size and a paper coating is difficult to detect. The coating has higher pigment content. There are advantages to coating on the machine and also advantages to coating off the machine, and both processes are used in modern papermaking.

The sheet now continues through the remainder of the drying section, passes between machine calenders, and is wound up in a "log."

Before being wound, the sheet may be monitored with devices that determine the amount of water in the sheet, the amount of filler in the sheet, the caliper of the sheet, and its basis weight, brightness, and opacity. These devices can be connected to computers for a closed-loop, on-line control of properties to improve the uniformity of the paper.

The moisture content of the paper should normally be about 5% to 6% of the weight of the cellulose. That is, for an uncoated, unfilled sheet, the moisture content will be about 5%, and for a filled or coated sheet, the moisture content will be proportionately less depending upon the amount of filler or coating

Courtesy of Beloit Corporation

A size press.

present. If the paper manufacture is completed at this point, the paper is called "machine-finished." If a higher finish is required, the paper is run through a supercalender.

PAPER COATING

A pigment coating improves the printing qualities, and a specialty or conversion coating provides the sheet with chemical resistance and/or other functional properties. A starch/clay coating is an example of a pigment coating that improves printing qualities. A polyethylene coating is a conversion coating that gives a paper a resistance to water and grease. Pigment coatings give good gloss and ink receptivity; specialty coatings provide resistance to chemicals, water, grease, solvents, and physical damage (abrasion, folding, and scuffing).

Good quality coated paper for printing requires a good body stock. Coating will not cover up sheet defects. The body stock must have sufficient overall strength for the coating and the printing processes, and its surface smoothness and absorptivity must be uniform.

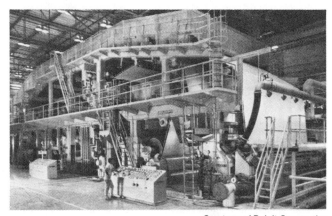

Courtesy of Beloit Corporation

Air knife and flooded nip coaters seen from the end.

Air knife and trailing blade coaters seen from the inside.

The first pigment coatings were applied by equipment resembling paint brushes or printing presses. Brush coaters brushed out coating, which then flowed onto the paper. Roll coaters applied coating to the paper much as a press applies ink. Modern equipment uses an air-knife or a trailing-blade coater.

Like printing inks, coatings consist of a pigment and a vehicle. Clay is the most widely used pigment. There are several types of clays, but for paper coating, only kaolinite (which has tiny platelet-shaped particles) is used. Kaolinite bonds easily and gives a low-cost, smooth, glossy surface. Calcium carbonate, which may be ground limestone but is more commonly manufactured or precipitated, gives greater brightness and opacity than clay and tends to give a matte or dull finish. Calcium carbonate is acicular, that is, needle-shaped. It is often used together with clay to produce a coating with high brightness and a remarkable affinity for ink. Titanium dioxide has a cubic structure that cannot be calendered to give high gloss. Titanium dioxide (TiO_2) is especially noted for its brilliance and high opacity.

Pigment coatings are always applied from water. The most commonly used adhesive is starch or a starch derivative. Proteins, including casein and soya protein, are sometimes used as adhesives, but synthetic polymers are now used increasingly. Polyvinyl acetate and styrene butadiene are the most commonly used polymeric adhesives. Acrylates are sometimes used, especially in paperboard.

Printing papers are normally coated on two sides (C2S). Papers for labels and for some other specialty products are coated on one side only (C1S). Double-coated papers receive two coatings. The first coating, perhaps an air-knife coating, prepares a smooth surface for the second coating, which may be applied with a trailing blade. Double coating produces the most desirable combination, giving precise control and a thick smooth layer of coating.

Cast Coating. An exceptionally high gloss finish is characteristic of cast-coated papers. Generally, the process involves coating a base stock in contact with a highly polished metal drum. Upon drying, the paper is released from the surface to produce a paper with an extremely high gloss.

Conversion Coating. Polymeric coatings are applied to paper after the sheet is formed to give special performance characteristics and are therefore called conversion coatings. The coatings are used for decorative effects, high gloss, protection against chemicals, and environmental factors. The coatings comprise melted polymers or organic substances dissolved or dispersed in volatile organic liquids. Primary film formers generally are high-molecular-weight polymers such as cellulose compounds, polyethylene, and rubbers. The organic solvents include aliphatic aromatic hydrocarbons, alcohols, and ketones.

Solventless coatings are applied from the melted resin. The most common material applied in this way is polyethylene. Polyethylene-coated papers and boards are widely used for packaging. The polyethylene may be compounded with a wax, giving a highly water-resistant product such as is used in manufacturing milk cartons.

FINISHING

After the paper has been rolled up at the end of the machine, it must undergo a number of finishing operations. These operations include calendering, slitting and rewinding, sheeting, and packaging.

Supercalender stack.

Calendering. Supercalendering of uncoated papers greatly improves their smoothness. The smooth, glossy appearance of enameled stock is obtained by supercalendering clay-coated paper. A supercalender is a stack of rolls supported in a frame. The rolls "iron" or polish the paper, giving it a very smooth surface. The rolls are alternately hard and soft; hard rolls are made of steel, and the soft rolls are made of compressed paper or cotton. Paper rolls are typically used for uncoated papers, and cotton rolls are typically used for coated papers.

Supercalendering paper is much like the process of pressing a pair of pants. The pants are laid on a padded ironing board, covered with a damp cloth to soften and prevent burning, and pressed or ironed with a hot iron. In the calendering of paper, the soft rolls serve as the ironing board, steel rolls serve as the iron, and steam is usually used to slightly soften the paper or coating.

The bottom roll in the stack is a geared drive roll, but all the other rolls run free and are rotated only by friction, resulting in some slippage. The effect is to smash the high points and fill in the surface pits and hollow areas. The smoother the paper is initially and the heavier its coating, the smoother and glossier it will be after calendering.

In addition to smoothness and gloss, calendering increases sheet density while reducing caliper. By densifying the sheet and reducing the voids, the opacity of the sheet is lowered, as is the amount of light refracted within the sheet, thereby also reducing brightness. In fact, if too much pressure or moisture is used, the sheet becomes darkened—a defect referred to as "calender blackening."

Slitting and Rewinding. Some paper machines are as wide as 300 in. (7.5 m). Since the paper produced is wider than any press can handle, it must be slit to the specified width. The papermaker must figure out the trimmed roll widths in such a way that a maximum amount of the "log" (roll) is used. What is left over, referred to as "stub" rolls, is sent back for remaking.

If the paper is to be used for web offset printing, it is essential that it be rewound very evenly. If the center of the roll is wound more loosely than the outside, a considerable jerk will occur when the inside of one roll is spliced to the outside of the next roll on the press. This jerking can cause a number of web printing problems, including web breaks. Uneven winding is a major cause of web breaks.

Single- and multiple-roll sheeting.

Furthermore, the paper must be of very uniform caliper. If one side of the web, for example, should be 3% greater in caliper than the other side, when the roll is wound, the thicker side of the web makes one side of the roll tighter than the other. Such rolls do not feed evenly on the press. Variations in moisture content across the web also result in differences in roll tightness and paper performance on press. Use of automatic web monitoring devices discussed above reduces the variations in paper.

Sheeting. The finished rolls of paper are cut into sheets on a rotary cutter. A steel cutting edge is fastened along the length of the cylinder. The web of paper is fed to the cylinder. Each time the cylinder makes a revolution, the cutting edge cuts a sheet of paper—not a very efficient way of cutting the paper. So in practice, several rolls are usually fed into the cutter at once. The papermaker makes every effort to make sure that the rolls are highly uniform: the same run of paper, the same paper machine, and the same position of the log. Nevertheless, variations do sometimes occur, and these then show up as a periodic variation in the skid of paper produced from the log. For example, if three rolls were used in sheeting and one of them had a different finish, then every third sheet in the skid would have a different finish.

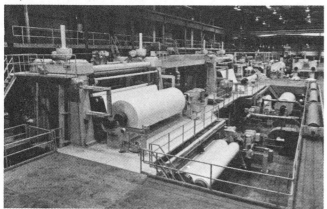

Courtesy of Beloit Corporation

Front view of supercalender.

Courtesy of Mead Corporation

Guillotine-trimmed paper.

Courtesy of Mead Corporation

Precision-trimmed paper.

Precision Trimming. Precision trimming machines are becoming popular because they produce paper with better uniformity at lower costs. These machines are used to make cut-size sheets (such as 8½×11 in.), and they are also available for making production-size sheets. In principle, they are similar to conventional sheeting machines, except that they are designed to give very highly reproducible sheet dimensions. Each sheet must lie flat and smooth at the time it is cut. Total variation in sheet dimensions from precision trimmers is much less than that observed with guillotine-trimmed sheets. However, the observable variations in guillotine-trimmed sheets occur only from one lift to the next. Variations in precision trimmed sheets occur from sheet to sheet, and although it may look as if the sheets have not been trimmed; sheet dimensions are very consistent throughout the load.

Trimming. The sheeted paper is now trimmed on a guillotine cutter, often controlled by computer to trim the paper rapidly and accurately. Cutting knives are kept sharp at all times. Trimming must be done by skilled operators who have been trained to exercise great care. Paper that is trimmed at the mill will be more accurately trimmed, on the average, than paper trimmed in a printing plant.

Statistical Quality Control. For many decades, top grades of printing paper were inspected and sorted by hand. It has been fully demonstrated that higher quality paper is produced by the use of statistical quality control than by sorting and inspection. In addition, sorting and inspecting every sheet by hand added a great deal to the cost. Inspection and sorting can only remove defective sheets; it cannot build quality into the sheet. Modern statistical quality control in the paper mill builds quality into the sheet.

Nevertheless, highly skilled and motivated people are required to watch the process and to make sure that nothing goes wrong. An alert, well-trained crew is the basis of any process quality control program: in the printing plant, in the paper mill, or in any other manufacturing operation.

Section Nine: Properties Required of Printing Papers

Cleanliness and Uniformity. Some of the printer's greatest troubles occur when paper is dirty or nonuniform. Trimmer dust, slitter dust, or paper or coating dust that gets into the offset press can ruin the runnability of the paper.

Any kind of loose dust or dirt on the surface of the paper will get into the ink and cause press contamination, requiring the operator to shut down and clean up. If this occurs only after 10,000 or 20,000 sheets on a sheetfed press or after 50,000 to 100,000 impressions on a web press, the problem is not usually considered very serious. However, if the press operator must clean the press after every few hundred impressions on a sheetfed or every few thousand on a web press, the runnability of the paper is severly impaired.

As important as cleanliness is uniformity: uniformity from sheet to sheet, uniformity from roll to roll, and uniformity throughout a skid or a roll. When variations occur in finish, absorptivity, moisture content, or formation, paper will not produce a high-quality printed product. Variations in finish, for example, cause variations in absorptivity and differences in color or gloss of prints.

Short sheets, dog ears, bowed edges, and other defects produce a product extremely hard to run. Paper rolls that are unevenly wound, telescoped, starred, crushed, or flat on one side will not perform well on press.

Uniform Moisture Content. Control and uniformity of moisture content are vitally important if paper is to perform well on either the sheetfed or the web press. Paper changes dimensions rapidly when it is exposed to a drier or a damper atmosphere than the air with which it is in equilibrium. If paper is exposed to a damper atmosphere, it expands; if exposed to a drier atmosphere, it contracts. However, if two samples of the same length, cut from the same sheet, are conditioned, one at higher humidity, the other at lower humidity, and then brought back to the same intermediate humidity, they will not come to exactly the same length. The one conditioned at the higher humidity will be somewhat longer.

This conditioning behavior is called "hysteresis" (from the same root as our word "history") because the equilibrium moisture content and the length of paper depend on prior conditions—"its history." This dependency helps account for the fact that wavy-edged paper can never be made really flat.

Similar considerations explain the importance of making a uniform sheet in the first place. If the dryers on the paper machine do not produce uniformly dry sheets, the paper will not perform properly on press.

Strength. The surface strength of paper must provide adequate pick resistance. Pick resistance is particularly impor-

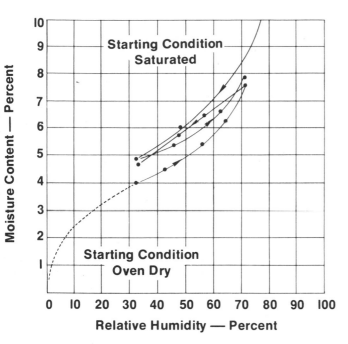

Hysteresis curve for paper.

tant in offset printing. The tackiness of inks and the thin ink films used in offset printing tend to disrupt the paper surface as the sheet or web is peeled off the blanket cylinder of the offset press. Paper is said to pick when the coating, fiber, or small bits of the paper itself are separated from the sheet as it is printed. The tensile strength is closely related to the surface strength. Other strength properties commonly measured are Mullen or bursting strength, folding strength or folding endurance, and tearing strength or tearing resistance.

In general, refining of paper stock, which increases tensile strength and bursting strength, decreases the tearing strength. Therefore, tensile strength and tearing strength are good examples of properties that must be compromised in papermaking. It is not possible for the papermaker to treat a stock mixture so as to obtain a sheet having, simultaneously, maximum tensile and maximum tear strength.

Folding endurance is important if the printed paper is to be folded. Folding endurance degrades rapidly on aging or on heating—as in the dryer of a web offset press. Folding endurance is used to study aging of paper.

Smoothness. Because the offset blanket conforms to rather rough surfaces, smoothness of paper is less important for offset printing than for direct printing. Offset gravure and offset letterpress printing have been used to print on paperboard, which is especially apt to be rough. However, rough papers usually have nonuniform absorbency, and smoothness, therefore, contributes to good printability by any method. The papermaker makes a sheet smooth through choice of fiber and filler, by the use of refining, and by calendering.

Printability and Runnability. "Printability" and "runnability" are terms carried over from letterpress printing, where paper could run well (if it was strong) but print poorly (if it was not smooth). Since printability problems in offset lithography

(such as picking and piling) required the operator to stop the press and clean up, printability and runnability are harder to distinguish in lithography. A strong, clean sheet usually runs well and prints well by offset lithography. Web offset requires, in addition, well-built rolls for runnability.

Stiffness. As customers demand lower-basis-weight sheets, the paper has become thinner and thinner. It is a fundamental relationship of engineering that the stiffness is proportional to the cube of the thickness: $S \sim t^3$.

Thickness of the paper cannot be maintained as the amount of material in the sheet is reduced. By reducing sheet density, reduction in basis weight can be overcome without loss of caliper. However, the procedure can be carried out only to a limited extent. Lightweight sheets are very hard to handle. A web press is more successful in handling lightweight paper, because the paper is held at both ends as it goes through the press.

Furthermore, the less the stiffness of the sheet, the greater is the rollout, or increase in size, as the paper is printed. Lightweight sheets, therefore, are not only difficult to feed, but it is difficult to maintain register on them.

Roll Condition. Good roll condition is at least as important as good paper in achieving good runnability on the web press. Of course, if the paper is not well made, good rolls are hard to make. The paper web must have uniform caliper and moisture content. The rolls must be wound uniformly. If the roll is wound too tight, the paper is stretched, and it loses some of its resiliency and breaks more readily. If the roll is not wound tightly enough, it can telescope (the core can drop out) while it is being handled. If the roll is wound unevenly from side to side, it feeds unevenly. If the roll is wound unevenly from inside to outside, sudden changes in tension near the splice create web breaks, doubling, and register problems. Flat spots originating during manufacture, shipping, or storage greatly increase web breaks.

Roll condition is everyone's responsibility: the papermaker's, the shipper's, and the printer's.

A telescoped roll with a flat spot.

When the printer encounters problems with roll paper, he should report it to the papermaker. The roll card, which accompanies each roll, must be used so that good communications can be maintained.

Basis Weight. According to manufacturing tolerances, papermakers supply paper within ±5.0% of the nominal basis weight. For sheet papers that are sold by sheet count, this is satisfactory, provided the proper number of sheets are in the carton or skid. For web papers that are sold by weight, this may be entirely unsatisfactory. If the paper supplied to a printer were consistently 2% too heavy, the printer would be 2% short in the length of paper, meaning the printer either must deliver a short count or buy more paper. This inaccuracy can cost the paper buyer tens of thousands of dollars per year.

For example, if a printer estimated the amount of a 50-lb. paper needed for a job but received the ordered weight of paper as 51-lb. paper, the printer would have to go out and buy 2% more paper to complete the job.

Papermakers do, in fact, supply paper well within the 5% allowed by manufacturing tolerance, but printers must carefully monitor the paper they buy. Some papermakers indicate the length of paper in each roll, allowing the printer to calculate the usable area.

Formation and Absorbency. Paper formation is affected by the type of fibers that are used, by the way they are refined, by the use of fillers, and by the paper machine. If the paper stock is not properly prepared or if the paper machine is not operated properly, the fibers clot, agglomerate, or "flocculate," and the sheet is lumpy: it has a "wild formation." The longer the fibers and the greater the percent of long fibers used, the greater is the tendency to flocculate and the poorer the formation is. Paper with poor formation causes mottle and unevenness in prints or in paper coating.

Variations in absorbency affect printed gloss and sometimes even the color of the print. If absorbency varies from place to place within the sheet (owing to poor formation), prints will not be uniform. The heavier the sheet, the greater the variation. It is more difficult to manufacture a uniform board than to manufacture a uniform publication paper. Variations in absorbency within a given lot of paper causes mottle or poor match in color or gloss. Variations from one lot to another make it difficult to match one job with a repeat job run later, which is common for labels and packaging.

To some extent the printer can overcome variations in absorbency by making the ink or varnish stiffer so that it will hold out uniformly or softer so that it will penetrate uniformly. Sometimes the variations are too great to be handled this way, and often the problem does not become visible until the job has dried.

Flatness. Problems of flatness sometimes occur with sheeted paper. They are uncommon with web paper. Curl and waviness originate in several ways. Wavy and tight edges originate when paper is exposed to air that has higher or lower relative humidity than that of the paper. In the winter time, the air in North American pressrooms becomes extremely dry if moisture is not added. Paper opened in a hot, humid atmosphere can swell and develop wavy edges. More often, however, wavy edges result from condensation of moisture on cold paper. Thus, tight and wavy edges are more commonly seen in winter than in summer. One way to avoid wavy edges is for the printer to specify that the paper for the job be stored in a heated warehouse and be delivered on the day of the job. Another way is to keep the paper package at room temperature for a sufficient number of hours before being opened.

Tight- and wavy-edged paper can also result from poor paper manufacture: the paper was made too wet or too dry. Instrumentation on modern paper machines has made this source of tight- and wavy-edged paper increasingly uncommon.

In view of the fairly simple prevention of the trouble, it is surprising how often serious problems with tight- and wavy-edged paper occur.

Other problems with flatness or curl occur when two-sided paper (paper with nonuniform sides) is moistened by the lithographic press. Since C1S paper used in labels is very two-sided, special manufacturing precautions must be taken, or labels will curl and fail to feed in automatic labeling machines.

With heavy stocks, cover stock, or, more commonly, paperboard, sheets will sometimes fail to lie flat after they have been sheeted. This problem is called "reel curl" or "roll set." It is a

Automatic water-spray humidifier.

Tight-edged paper.

Wavy-edged paper.

manufacturing problem, but there are sheet decurling devices that are helpful in flattening out the curl.

Optical Properties. It should be obvious that the color of the paper affects the color of the print, just as does the color of the ink. The optical properties of the paper must be taken into account in planning the printing job. Five properties are especially important: brightness, whiteness or hue, gloss, opacity, and fluorescence.

Brightness, whiteness, and reflectance are often confused. Brightness is defined as the blue-light reflectance (BLR). Whiteness results from the uniform reflectance of all wavelengths of light. The same amount of red, green, and blue light must be reflected.

Brightness can be measured at a single wavelength, but whiteness requires a minimum of three. The table gives the reflectances of three hypothetical sheets, one has the greatest brightness, another has the greatest whiteness, and the third reflects the most light.

	Percent Reflected Light		
	Red	Green	Blue
1. Brightest	85	85	90
2. Whitest	85	85	85
3. Most Reflectant	90	90	85

Of the three sheets described in the table, the first would be called a "blue" or "cold" sheet, and the third would be called a "warm" sheet. The first has a blue hue, while the third has a warm hue.

Glossy prints require glossy paper. As described under "papermaking," gloss is achieved by coating and by calendering or by the special technique of manufacturing a cast-coated sheet.

Opacity is obtained by reflection of light from voids and interfaces in the sheet. If the sheet is heavily beaten and supercalendered so that no air remains in the sheet, the product is glassine, a highly transparent paper used for windows in envelopes. The transparency can be reduced by incorporating clay or another pigment into the paper to retract light or by allowing air to remain in the sheet. This, of course, reduces the tensile strength of the sheet. Titanium dioxide produces opacity more effectively than clay.

Another effective way to increase opacity is to put a little groundwood into the furnish. If high permanence and brightness are not required in the product, groundwood improves opacity, smoothness, and formation.

Compromises in Papermaking. It is not often possible to make a perfect sheet, because when the papermaker changes conditions to alter one property, other properties are also changed. And, of course, improving the properties of paper often increases the cost. It has already been pointed out that decreasing the basis weight decreases the caliper and consequently the stiffness of the sheet.

The gloss of a paper can be increased by supercalendering or by calendering. Both treatments reduce the opacity by eliminating voids that refract light. Reducing the light-refracting surfaces also reduces the brightness.

The strength of a sheet can be increased by using greater amounts of softwood kraft pulp, but this increases the roughness of the sheet and adversely affects its printability.

Selecting the best paper for a job thus is a complicated problem, and much like selecting the best ink, it requires skill, judgment, and experience. The printer pays for this service when

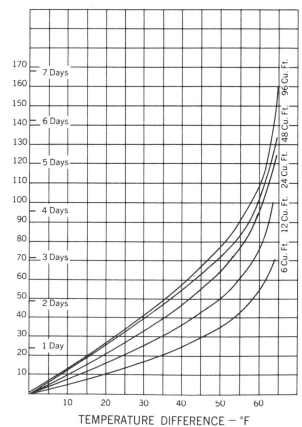

Time required for paper to come to pressroom temperature.

he (or the customer) buys the paper. He owes it to himself to be sure that the paper salesman is fully informed of his needs and is, in fact, supplying him with this service.

Even under the best of circumstances, faulty paper is some-times delivered from the mill. Here, again, the assistance of the salesman or technical representative in resolving the problem is part of the price paid for the paper. The printer should take steps to assure he is getting this assistance.

Section Ten: Paper Problems in the Pressroom

This section briefly describes some common problems in the pressroom. The GATF text *Lithographic Pressman's Handbook* discusses these problems in much greater detail. It also lists steps that can be taken to overcome the problems and discusses additional problems that may arise if these changes are made.

Papermakers report that the most frequent problems with paper are "people" problems. The next most frequent are problems of press contamination, which cause by far the greatest amount of trouble. In third place are problems of roll condition.

People Problems. These are caused by carelessness or lack of proper information or instruction. Problems such as paper cut to the wrong size, the wrong basis weight, grain wrong, short sheets or waste in the skid, dog ears, wrong color, and lost or late delivery are "people problems." Many paper defects could be prevented or eliminated if papermill operators better understood the need for clean, uniform paper.

As mentioned above, the first line of defense in any quality assurance program is an alert, well-trained, and well-motivated crew. When people are not observant and concerned, "people problems" occur. Most "people problems" are easily corrected because it is obvious what is wrong.

Press Contamination. When paper is dirty or contains weakly bonded or other foreign material that gets onto blankets and into the ink, the result is press contamination. One of the most frequent sources of press contamination is dirty paper: slitter dust, cutter dust, or mill dirt. Calender scale, bits of coating or paper, vessel segments, and other loosely bonded particles also cause press contamination. In one illustration, the cause of press contamination was identified as "calender scale" resulting from coating that accumulated on the supercalender and then broke loose. It was scattered over the web and calendered into the surface. Calendering the loose scale into the

Courtesy of Herbert Products, Inc.

Sheet cleaner.

Coating scale.

Calender scale.

surface makes it stick sufficiently to stay put until the paper runs through the press.

If the dirt is truly loose, it can be removed with a sheet-cleaning device. Dirt, shown in the illustrations of calender scale and loosely bonded particles, has been calendered into the paper, and sometimes nothing less than lithographic ink will lift it out. Calender scale and paper dust can frequently be seen by a careful and observant paper handler or press operator. If the paper mill crew is alert, they can often see the scale before the paper gets shipped.

Picking differs from paper fluff or calendered paper scale in that the pick-out was reasonably well bonded to the sheet. Note, in the illustration, that paper fibers have been pulled out of the surface. Picking occurs when the force of the splitting ink film is greater than the strength of the paper. Obviously the problem can be solved by going to a stronger paper, but usually it is less costly to solve the problem by adjusting the ink or the printing press. Pressmen often solve picking problems by adding a solvent or tack reducer or viscosity reducer to the ink. Adding materials of this sort often increases the drying time and is apt to change color and gloss of the print so that other solutions may be more desirable. Reducing the speed of the press reduces the force of the ink, and reducing the pressure between the impression cylinder and the blanket reduces the force on the paper. Another way of reducing the force on the paper is to increase the ink film thickness. At first glance, this may appear to go in the wrong direction, but it is well known that thick films split more easily than thinner films. Increasing the ink film thickness often helps to overcome a picking problem.

Linting, like picking, occurs when an uncoated sheet is too weak to withstand the force of the inked blanket. Linting is particularly troublesome with web offset news, which contains a large fraction of often weakly bonded groundwood fibers. It is sometimes impossible to get a linty paper to run well, but in order to help it to run and perhaps solve the problem, the pressman can decrease the ink tack, decrease the press speed, and increase the amount of water. Some blankets have better release than others, and using a quick release blanket or other blanket with good release can help to improve the performance of linty paper.

A pick-out on uncoated paper. Note the disturbed fibers.

Dusting is the appearance of pigment from paper fillers or paper coating on the blanket. Sometimes tiny bits of cellulose fiber will also give a dustlike appearance. The dust eventually works its way into the print, filling in shadow dots or blurring lines. When the dust appears in the nonimage area of the blanket, changing the ink cannot be very helpful. Increasing water feed, decreasing the speed of the press, or reducing back cylinder squeeze can reduce dusting that occurs in the nonimage area. If the dust is completely loose, a sheet cleaner may remove it before the sheet gets to the blanket.

Piling is an extremely complex interaction between ink, water, and paper. If the ink is poorly ground or high in pigment concentration, there is a tendency for the ink to become short or puttylike. Working water into the ink increases the shortness. Short inks do not transfer as well as long inks or lay as well on the blanket, plate, and surface of the paper. To the ink that already has a tendency to become short is now added a bit of dust from paper coating or from paper fillers, and the ink becomes too short to transfer. This "reaction" occurs first at the blanket-paper interface where the pigment from the paper first works its way into the ink. In severe cases, the pigment may work its way back to the plate and cause shadow dots to fill in and halftone dots to grow. In severe cases, it even works its way back to the ink rollers, causing ink caking.

If the ink becomes short and transfers poorly after 15,000 or 20,000 impressions on a sheetfed press or after 75,000 to 100,000 impressions on a web press, the printer usually does not consider piling to be a problem. If it occurs after only a few hundred impressions on a sheetfed press or a few thousand on a web press, the paper may be considered to be unrunnable. Owing to the complicated nature of this phenomenon, it sometimes appears to come and go almost by magic. Sometimes the problem can be solved by sending the paper back to the warehouse and getting fresh paper. By the time the faulty paper is again brought from the warehouse, the problem has vanished. Increasing the amount of ink on the press may help to wash pigment through the press and onto the paper. Reducing back cylinder squeeze, slowing the press, or reducing the force between the blanket and the paper may help to solve the problem. One research lab has identified twenty-one different factors that contribute to ink piling. Pigment filler from paper and weakly bonded paper pigment coatings are among them.

Spot left from loosely bonded paper.

In order to give a bright, ink-receptive sheet, the papermaker adds as little adhesive to the pigment coating as possible. However, if too little adhesive is used, the pigment can work its way into the ink causing severe piling problems. This fact is another example for the need of judicious compromise in papermaking.

Roll Condition. Paper that is poorly made, rolls that are poorly wound, and rolls that are mishandled during shipping or storage can greatly reduce press runnability. Telescoped, starred, and crushed rolls will not feel properly on the press. Paper must be slabbed off from rolls that have paper gouged out of them. Slabbing paper off the outside of a roll is an expensive proposition as the table shows.

Even slabbing 0.5 in. from the outside of a 45-in. roll increases paper costs by 2.5%. One way of improving roll runnability is to install a good tension control device on the press. These devices greatly improve paper performance and print quality and reduce downtime. Investment in tension control devices usually pays off very well.

Roll Diameter		Amount Slabbed Off		Percent Wasted
Inches	(Centimeters)	Inches	(Centimeters)	
36	(91)	1.0	(2.5)	10.0
36	(91)	0.5	(1.3)	5.0
45	(114)	1.0	(2.5)	5.0
45	(114)	0.5	(1.3)	2.5

Handling and Shipping Damage. The printer owes it to himself to inspect paper carefully before it is unloaded from the car or truck. Any damage should be photographed using an

Roll damaged in shipment.

instant camera to document the damage, and it should be reported to the common carrier, at once. Otherwise, the printer pays for the damage.

Many printers equip their paper handlers with instant cameras and instruct them to routinely take pictures of the condition of all shipments. This greatly helps in documenting shipping problems. If concealed damage is discovered while the shipment is being unloaded, the paper handler should take another picture showing the extent and nature of the problem.

Moisture Problems. Moisture conditioning of paper is no longer practiced in the United States. At one time, lithographers used to hang paper in the pressroom or in a paper conditioning machine in order to bring it to the proper moisture. Paper machine controls now control the relative humidity of paper much more accurately, and the slow, expensive practice of paper conditioning is no longer required. If an error occurs and the paper is too dry or too moist, it must be reported to the supplier of the paper.

As stated previously, problems with tight and wavy edges are very common, but these are mostly caused by improper handling of the paper during shipment or storage or in the pressroom.

Static. Paper with a relative humidity greater than 35% usually does not cause static problems. Static is thus observed mostly in the wintertime when paper is allowed to dry out before going to the press. Static is somewhat less serious in lithography than in other methods of printing because the lithographic press adds water, which is usually the best static eliminator, to the paper. In unusual situations, where plastic

Roll damage.

sheets are being printed, static eliminators can be used. These are very effective.

Dirt held on the sheet by static forces can sometimes be virtually impossible to eliminate, and the sheet cleaner in the picture combines the use of a brush with a static eliminator and a vacuum to reduce the amount of loose dirt on the sheet.

Problems of Web Papers. In addition to roll condition, web breaks, blisters, and fiber puffing cause problems on the web press. Extensive studies support the belief that web breaks are usually a 50-50 proposition between the papermaker and the printer. The paper web itself, roll condition, and shipping problems generate a great deal of trouble. Breaks, which can shut a press down for several minutes, add greatly to the printer's costs. The best runnability records have been achieved where printers and papermakers maintain good communications and where each works to reduce his contribution to the problems. Poor winding, calender cuts, slime holes in the sheet, and bad splicing are the responsibility of the papermaker. Improper ink, poor tension control, and improper press adjustments are the printer's responsibility.

Blisters are not the problem they once were. Blisters occur when coated paper is subject to a sudden, sharp temperature rise in the dryer section of the web press. (The dryer should be used as a dryer and not as an oven: "Dry the print, don't cook the paper.") Blisters arise from the combination of many factors: temperature of the dryer, speed of the press, properties of the paper, ink coverage, and, even, ink color. The printer can reduce the dryer temperature; if this means that the press must be slowed unacceptably, he can use a faster ink (one that dries at a lower temperature).

Fiber puffing, which produces a print looking like sandpaper, occurs with coated groundwood content papers that are heated too fast. Careful control of dryers will reduce this unsightly occurrence.

Cracking. Cracking of paper at the fold can produce an unsightly cover and can cause sheets to drop out of a bound book. Cracking occurs when the sheet is too dry, as it is when it has been dried out by the dryer of the web press. When the design calls for a dark ink to be printed right over the fold, the least bit of cracking becomes readily apparent. A job that would be satisfactory in white becomes unsatisfactory in black or green or brown. Cracking occurs more frequently with heavy papers such as cover stock and board, and these should be scored

before folding. When the paper is folded against the grain, the fold is stronger, but cracking is greatly aggravated. Cracking can sometimes be avoided by applying moisture to the score line before folding.

Tail-End Hook. Tail-end hook and waffling occur in sheetfed papers when the force to pull the sheet from a heavily inked part of the blanket stretches the sheet, and permanent waffle or embossing occurs as shown in the accompanying illustration. The problem can occur at any part of the sheet, but it is especially bad at the tail end, hence the name. Using a stiffer sheet or improving the release of the blanket or decreasing the viscosity of the ink or decreasing the press speed all help prevent tail-end hook. If it occurs anyway, the print can often be flattened with the use of a sheet decurler, a device available from a number of companies.

Setoff. Setoff is discussed under ink. It occurs when the ink does not set properly before the next sheet is delivered onto the pile. Using a quickset ink helps to reduce the problem, but if the paper is not properly absorbent, the ink will not set fast enough. It is most troublesome with plastic sheets. The printer can use a heavy spray of antisetoff powder, but such a spray roughens the surface and detracts from the smooth, glossy varnish film.

Register. Register problems are caused by unsatisfactory paper or an improperly adjusted lithographic press. The lithographic press causes the paper to roll out and stretch, particularly as it goes through the first unit on the press. To get register on subsequent units, the press operator packs the press so that the first unit prints somewhat shorter than subsequent units.

Paper expands more across the grain than it does with the grain. For this reason, paper is usually fed into the sheetfed press grain long; that is, with the grain running along the axis of the cylinder. Plate and blanket packing compensate for instability across the grain.

Mottle. Mottle is discussed under ink. It arises when there are significant differences in the ink absorptivity in various parts of the sheet. Mottle is found more commonly with paperboard than with paper. If the ink cannot be adjusted to hold out uniformly (or to penetrate uniformly), it is sometimes necessary to replace the paper or board.

Front Edge ⟵————— Back Edge

Embossing, or waffling.

Roll set.

Section Eleven: Paper Testing

Introduction. The basis of all quality control is an alert, observant crew. This is true in the printing plant as well as in the paper mill. Most paper mills have large, well-organized quality control programs involving a fair amount of laboratory testing. Nevertheless, the ultimate test of paper is the lithographic press. Putting the paper on press and observing whether or not it will run is the ultimate test for most paper mills, as well as for the printer.

Laboratory tests do not correlate perfectly with press performance. A battery of tests will give a profile of the paper, but interpretation is still needed. For this reason, careful inspection and observation of the paper followed by putting it on the press to see if it will run is about all of the routine quality control that can be justified by most printers. This section outlines additional tests that can be run for diagnostic purposes and to give the student an opportunity to learn how the tests are performed in the research laboratory.

It is not practical here to go into a detailed discussion of each of the many paper properties and their testing methods. Standardized methods for testing paper are developed and maintained by the Technical Association of the Pulp and Paper Industry (TAPPI), One Dunwoody Park, Atlanta, Ga. 30341; by the American Society of Testing Materials (ASTM), 1916 Race Street, Philadelphia, Pa. 19103; by the American National Standards Institute (ANSI), 1430 Broadway, New York, N.Y. 10018; and by the Packaging Institute—USA, 342 Madison Avenue, New York, N.Y. 10017. Before starting a testing laboratory, the TAPPI, ASTM, ANSI, and PI—USA methods should be obtained from the associations.

TAPPI—NBS Collaborative Testing. Cooperation between the American National Bureau of Standards (NBS) and TAPPI in developing collaborative tests helps the testing laboratory determine which of its tests give results similar to those obtained by other cooperators and which of its tests show wide deviation. Where a laboratory finds that its results deviate significantly from all other laboratories, there is presumably something wrong in its procedure or instrumentation.

Differences between laboratories are often more important than differences between different kinds of instruments. For example, nonstandard reflectance meters often given very good agreement with other laboratories in measuring brightness, while standard meters occasionally give very wide deviation and require calibration.

It is recommended that graphic arts laboratories investigate this collaborative testing procedure to make sure their results are in reasonable agreement with others. Information is available from TAPPI.

Readers who are not well acquainted with the properties of paper and the methods for testing will find it helpful to read ASTM Special Technical Publication No. 60, *Paper and Paperboard—Characteristics, Nomenclature, and Significance of Tests.* For a concise description of paper tests and more about paper, see GATF's textbook *What the Printer Should Know about Paper.*

Sampling Paper for Testing. As difficult and costly as testing is, it is no more costly than adequate sampling. There is no point whatever in testing paper unless an adequate sample has been chosen. If the sample is not representative, the test is wasted or, worse, misleading. Whether the testing is done by the manufacturer for control purposes or by a consumer for the purpose of determining whether the paper meets his requirements, it is essential that the paper sample used for testing be truly representative. Sampling is described in detail in TAPPI T 400 and ASTM D 585.

Standard Conditions. When paper testing is done regularly, and the results are recorded for future reference, it should be done under standard conditions of temperature and relative humidity. The testing room should be maintained at $23 \pm 1°C$ ($73.4 \pm 1.8°F$) and $50 \pm 2\%$ relative humidity. All paper samples are conditioned in this atmosphere before the tests are made because properties of paper vary with its moisture content. (TAPPI T 402 for paper and paperboard; ASTM D 685 for paper and D 641 for paperboard.) Inks and oils used in testing lose viscosity rapidly with increasing temperature and must be tested at constant temperature.

When controlled testing conditions are not available, it is possible to test an unknown sample against a test sample at ambient conditions. The absolute numbers are of doubtful significance, and cannot be compared with tests carried out under other conditions.

Grain Direction. Sheet paper for multicolor work should be printed grain long; that is, the grain of the paper should run parallel to the axis of the cylinder of the press. Web papers, obviously, must be printed grain short; that is, the grain of the paper runs at right angles to the axis of the cylinder of the press. There is no problem determining grain direction of web papers, but sheetfed papers can be cut with the grain direction either parallel to the long side of the sheet (grain long) or the short side of the sheet (grain short).

The simplest way to determine grain direction of a paper is to determine the direction of curl. A piece approximately 2 in. square is cut from the sheet to be tested, and a line is drawn with a pencil parallel to the long edge of the original sheet. The small square is floated on water or is wet with the tongue, and the direction of the axis of curl is noted. The axis of curl is the machine or grain direction of the piece. If it runs parallel to the mark on the paper, the paper has been cut grain long. If it runs perpendicular to the mark on the paper, the paper has been cut grain short. Additional methods are described in TAPPI T 409 and ANSI-ASTM D 528.

Felt and Wire Side. All paper and board is two sided. With most boards, this is obvious since they are made to be printed on one side only. The same is true of C1S papers. With papers designed for printing on both sides, the two sides should be as much alike as possible. Modern papermaking machines, which use hydrofoils to support the wire, or twin-wire machines

make paper with little difference between felt and wire sides. Consequently, it is sometimes difficult to tell which is the felt side and which is the wire side. Standard methods for determining felt and wire sides are given in TAPPI T 455 and ASTM D 725.

Perhaps the easiest way of determining the felt and wire side is to cut two squares about 2 in. on a side, noting, of course, which side is up in the sample. The two squares are placed in the oven: one with the same side up, and the other with that side down. After heating for a few minutes at 100°C (212°F), the curl should be observed. Paper tends to curl toward the felt side, which contains more fine fibers.

Moisture and Relative Humidity. The sheetfed printer is usually more interested in the relative humidity at which paper is in equilibrium than its absolute moisture content. The web printer is more interested in absolute moisture content. Absolute moisture content of paper in equilibrium with room air varies depending upon the type of paper. It is obvious that uncoated paper contains more moisture than coated paper, where perhaps one-third of the sheet is pigment that does not absorb moisture.

Relative humidity of paper is determined with an electronic device that measures whether the paper will pick up moisture from the air, whether it will lose moisture to the air, or whether it is in equilibrium with the air.

As a matter of fact, modern papermaking instrumentation has greatly improved the uniformity of moisture in paper, and this test is not usually required. Once in a while, mistakes occur, or the paper will have been badly handled, so that it is desirable to determine the relative humidity of the sheet.

As paper is manufactured on the paper machine, its moisture content is controlled by the dryers. Automated devices measure and control the moisture content, but moisture content of the paper can change quickly if finishing rooms do not have humidity control.

The absolute moisture content of a sheet of paper is deter-mined by drying it to constant weight at 105°C as described in TAPPI T 412 and ANSI-ASTM D 644. Strength, pick resistance, hardness, static, paper curl, and dimensional stability all depend upon moisture and moisture equilibrium.

Basis Weight and Grammage. The measurement of basis weight and grammage of paper is described in TAPPI T 410 and ASTM D 646. Sheets of known area must be conditioned under standard conditions and then weighed very accurately. From the weight and area of the sheet, the basic ream weight or grammage is calculated for the basic size.

Paper Caliper and Bulking Thickness. The standard procedures for determining thickness or caliper of paper are described in TAPPI T 411 and ASTM D 645. The thickness of paper or paperboard is the thickness in thousandths of an inch of a single sheet of paper or board. Thickness is determined by calipering individual sheets of paper or board after conditioning. A paper micrometer, shown in the figure, with standard jaws and exerting a standard pressure is used. Bulking thickness must not be confused with calipered paper thickness. Bulking thickness, or book bulk, refers to the average thickness of paper in a pile, in books and magazines for example. The standard procedure for determining the bulking thickness of paper is described in TAPPI T 500 and in ASTM D 2175.

Squareness. Because sheets that are not cut square cause great trouble with registration and later in binding, it can be useful to observe the squareness of paper with the use of a carpenter's square or by using a printer's layout table. The printer more frequently folds the paper together to see if the two opposite corners and edges coincide exactly. If they do not, the paper has been cut out of square.

Strength. There are a number of more or less related properties referred to as paper strength: tensile strength, bursting strength, tearing resistance, folding endurance, the surface

Courtesy of E. J. Cady and Co.

Two versions of a common type of basis weight scale.

Courtesy of E. J. Cady and Co.

A bench micrometer of the type that meets TAPPI standards for measuring paper thickness.

Paper out of square.

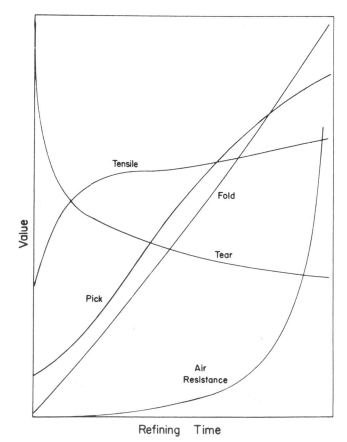

the breaking length; that is, the calculated length of paper that weighs enough to break the sheet. For example, if a strip of paper 2.0 cm wide requires 2.0 kg to break and the basis weight is 50 g/m^2, the breaking length is 2,000 meters.

 a. 1 m^2 = 10,000 cm^2.
 10,000 cm^2 ÷ 2.0 cm = 5,000 cm.
 Therefore, *50 g* of 50 g/m^2 paper that is 2.0 cm wide has a length of 5,000 cm, or *50 m*.
 b. 50 g ÷ 50 m = 1 g/m.
 c. 2.0 kg = 2,000 g.
 2,000 g ÷ 1 g/m = 2,000 m.

The standard procedures for measuring tensile strength are described in TAPPI T 404 and in ASTM D 828.

Paper Stretch. Stretch is defined as the percentage elongation of a strip of paper at the time of rupture under tension. The stretch of paper is important when a web is handled under tension. Together with tensile strength, the stretch is related to the toughness of the paper. Stretch affects the ability of a sheet to fold well and to resist the concentration of local stress.

The stretch of paper also relates to its stiffness and its runnability on sheetfed presses. When a piece of paper bends, one side compresses and the other stretches. Therefore, it is easier to feed stiff sheets on a press than to feed soft or flexible ones.

Measurement of stretch is described in TAPPI T 457.

Load-Elongation Curve. The most complete information on the behavior of paper under tension is given by the

strength or picking resistance, and internal bond. These characteristics depend upon the extent the paper is refined. The greater the refining, the greater the tensile, bursting, fold, and picking strength are, but tearing strength falls off after an initial very rapid rise.

Tensile Strength. The tensile strength, stretch, and the general load-elongation characteristics of paper affect its ability to perform in many end-uses. The tensile strength of paper is the force, parallel to its plane, required to break a specimen of specific width and length. The tensile strength is often expressed in pounds per linear inch; that is, the force required to break a strip one inch wide. The tensile strength is often converted into

Courtesy of Instron Corporation

Tensile strength tester.

Effect of refining on paper strength.

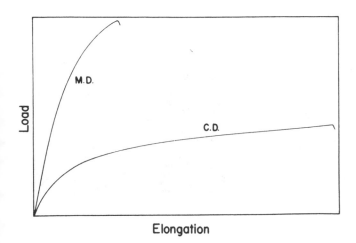

Load

M.D.

C.D.

Elongation

Load elongation curve for machine direction (M.D.) and for
cross direction (C.D.) of a ledger paper.

load-elongation curve. The load-elongation curve is obtained
with a machine that automatically plots the force (or load)
applied to the strip against the increase in length or elongation
of the specimen. The maximum load—that is, the load at the
time of failure of the strip—corresponds to the tensile strength
as measured by the usual tensile strength tester. In determining
tensile strength, it is usual to determine also the stretch and the
load-elongation curve. Tensile energy absorption is described in
TAPPI T 494.

Tearing Resistance. There are a number of ways of
measuring tearing strength of paper, but the most commonly
used one is the Elmendorf Tear, which is the force required to
tear a specimen under standardized conditions after the tear has
been started. It is sometimes called "internal tearing strength."
Procedures are described in TAPPI T 414 and in ASTM D 689.

Bursting Strength. The tester used to determine bursting
strength is a Mullen Tester. Bursting strength is an entirely
empirical test intended to define the usefulness of a paper when

Courtesy of B. F. Perkins & Sons, Inc.

Bursting strength tester.

resistance to bursting is an end-use requirement, as in packag-
ing. Although widely used, its principal value is as a control test
in the paper mill. Bursting strength of paper is defined as the
hydrostatic pressure required to rupture it under specified
conditions. The sample is clamped over a rubber diaphragm
under a ring, and hydrostatic fluid is pumped under the
diaphragm until the sample bursts. A dial shows the pressure at
the time of rupture. Procedures for determining bursting
strength of paper are given in TAPPI T 403 and in ASTM D 774.
Procedures for paperboard are given in TAPPI T 801 and in
ASTM D 2529, and for corrugated board in TAPPI T 810 and in
ASTM D 2738.

Folding Endurance. This test measures the ability of
paper to withstand repeated folding. Folding endurance is
defined as the number of folds, under specified conditions, that
a specimen withstands before failure. The Schopper folding

Courtesy of Thwing-Albert Instrument Co.

Tear tester.

Courtesy of Testing Machines, Inc.

Folding endurance tester.

endurance test is specified in TAPPI T 423 and ASTM D 643. The M.I.T. folding endurance test is described in TAPPI T 511 and ASTM D 2176. The folding endurance test is particularly sensitive to aging of the sample, and experiments on the aging and aging resistance of paper frequently involve the effect of variables on folding endurance. The stability of paper to heat is tested for by TAPPI T 453 and ASTM D 776.

Surface Strength. There are a number of tests for surface strength, a property that is particularly important in lithography. Lithography places greater surface strength demands on paper than do other printing processes. Unfortunately, none of these tests adequately predict the way paper will perform on the press.

For one thing, surface strength of paper varies widely from point to point on the sheet or on the web. None of the procedures described here tests a sufficiently large area to give a good picture of the ultimate weaknesses of the paper. To find out how the paper actually behaves under press conditions, the paper mill quality control testing laboratory uses some type of an offset press, very often a production-size offset press.

Nevertheless, these tests are used for a variety of reasons, routine quality control and laboratory evaluation of new products being two examples.

Dennison Wax Test. The Dennison waxes are a series of hard resin-wax sticks numbered from 2A to 26A. The higher the number, the greater the adhesiveness is. The test specimen is placed on a table top. A stick of wax is heated over an alcohol flame or Bunsen burner by rotating the wax slowly. The melted end of the wax is then placed quickly on the paper surface and pressed firmly against the paper with the stick in a vertical position. After cooling, a wooden yoke is placed around the wax, and the wax is quickly pulled away from the sheet. If coating particles, fibers, or bits of paper adhere to the end of the wax at this point, the paper has "picked" (failed). If nothing adheres to the wax, the test is repeated using waxes with higher numbers. The pick resistance of the paper is the number of the highest numbered wax that does not disturb the surface of the paper. The highest numbered wax is called the critical wax number. Normally, both felt and wire sides are tested.

The test is used widely in paper mills, where it is performed quickly and where changes in the critical wax number suggest changes in paper properties. The test is of little use in the

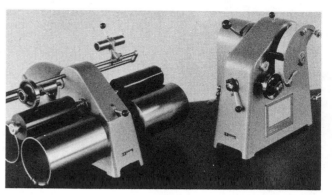

Printability tester.

printing plant because the numbers obtained from the Dennison wax test have little correlation with runnability of the paper. The test is described in ASTM D 2482 and TAPPI T 459.

IGT Surface Strength Tester. The IGT surface strength tester, called the IGT Printability Tester, measures surface strength somewhat more realistically than do the Dennison waxes. It is possible to test both with and across the grain and to test both machine and counter-machine directions. In this surface strength test, a strip of the paper specimen is cut in the desired direction and mounted on a cylindrical surface. An ink film of controlled thickness is applied to the surface of a disk that rolls against the paper. The disk and cylinder are driven with an accelerating motion so that the speed of printing varies from 0 ft./min. at the beginning of the print to over 600 ft./min. (183 m/min.) at the end of the print. Tack-graded inks have been used for this test; however, the reproducibility of these inks leaves a great deal to be desired. In addition, they are thixotropic, so that their viscosity depends upon the work done on them before and during the test. More reproducible results are obtained if a dyed test liquid is used. The surface strength test is described in TAPPI T 499.

Other surface strength testers are available from Prufbau and from Testing Machines, Inc., who sell the GFL (Swedish Graphic Arts Laboratory) Tester. All of these testers permit differentiation between pick resistance of paper in the machine direction and in the cross-directions—corresponding to the picking conditions in a webfed press or a sheetfed press with the conventional grain-long sheets.

Internal Bond. The internal bond is a measure of the resistance of the paper to picking and to delamination under stress. It is also called "z-directional tensile strength." The measurement of internal bond strength is described by TAPPI T 506.

SMOOTHNESS, POROSITY, AND DENSITY

Smoothness. The smoothness of paper relates to the deviations of the actual paper surface from an ideal plane. Because paper deforms and is compressible, the smoothness of a sheet as it lies on a table is not the effective smoothness at the actual time of ink transfer in printing. Smoothness, in the sense of printing smoothness, is most important in rotogravure

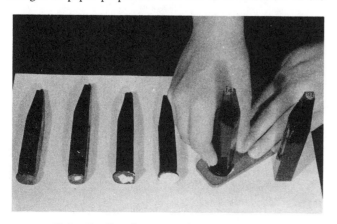

Using the Dennison waxes for pick testing.

printing, important for letterpress printing, and least important but not completely unimportant in offset lithographic printing.

The older and more commonly used methods of measuring smoothness of paper are the air-leak methods. One method involves measuring the time required for a given volume of air to leak between the paper surface and the polished reference surface (glass or metal) pressed against the paper. This method is described in TAPPI T 479. A second method measures the rate at which air flows between the paper's surfaces and a reference surface when they are pressed together. Methods based on the rate of air flow are described in TAPPI UM 518 and UM 535.

There are many other methods that have been proposed for measuring smoothness of paper. Methods for comparing smoothness of papers involve printing thin ink films and judging the relative smoothness of the papers on the basis of the relevant uniformity of solid or screen-tint prints. There are also profile-tracing procedures in which the profile of the paper surface is obtained by drawing over the surface a needle whose vertical displacement is amplified and automatically recorded as a trace. Another type of test measures the smoothness as the percentage of paper contacting a glass plate. The paper is held against the glass under pressure corresponding to printing conditions, and the measurement is made by light reflection.

Porosity. The porosity of paper is measured by its resistance to the passage of air. One method (TAPPI T 460 and ASTM D 726) determines the time required for a given volume of air to pass through a given area of paper. Another method (TAPPI UM 524) measures the rate of air flow through a given area of paper.

Density. This is often confused with porosity, and there is some inverse relationship since, in general, the denser the sheet, the less the porosity. Other things being equal, apparent density is the weight per unit volume, and it is commonly calculated by dividing the basis weight of the paper by the caliper.

OPTICAL PROPERTIES

Brightness is measured with a standard brightness tester. In the United States, this tester is calibrated by monthly checks with the Institute of Paper Chemistry. As a result of continuous monitoring, the brightness test is one of the most precise and reproducible tests used in the paper industry. The brightness is measured at 457 nm, a blue wavelength, chosen because it is especially effective in measuring the yellow color that is characteristic of bleached fibers. The standard brightness test is TAPPI T 452 or ASTM D 985. The hue or color of a paper can be measured using a reflectance meter as described in TAPPI T 524 or, better, by a spectrophotometer as described in TAPPI T 442. Reflectance must be measured at a minimum of three wavelengths. Specifying the color of paper by the Munsell system is described in ASTM D 1535.

Gloss is the specular (mirror) reflectance and is measured with one of several gloss meters. Gloss is usually measured at a 75° angle as described in TAPPI T 480 and in ASTM D 1223. Highly glossy prints are better measured at 20° as described in TAPPI T 653.

Opacity of paper is determined by measuring the reflectance of the paper against first a white background and then against a black background. The opacity is $100 \times (R_B/R_W)$, where R_B is the reflectance of the paper against the black background and R_W is the reflectance against the white background. Contrast ratio opacity, measured in this manner, is described in TAPPI T 425 and ANSI-ASTM D 589.

Fluorescence of paper can be important in determining the color or the apparent color of the print. It can also interfere with optical character recognition (OCR) and with instruments that measure fluorescence of inks. Fluorescence is observed with a "black light," a lamp that emits ultraviolet radiation but no visible light. A darkroom is necessary for examination except for the most brilliantly fluorescing materials. Instrumentation is used to measure the amount of fluorescence. Tests are described in TAPPI UM 547 and UM 548.

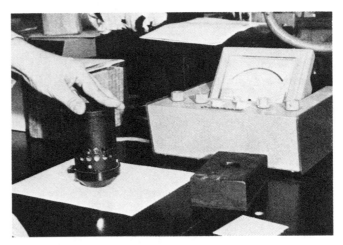

Reflectance meter.

Paper pH. In measuring acidity or alkalinity, chemists usually report the pH. The pH affects the drying rate of sheetfed inks and influences other paper properties including permanence.

The pH is a logarithmic measure of the acidity. Each unit decrease in pH below 7 means a ten-fold increase in the acidity. Thus, a pH of 4 is 100 times more acid than a pH of 6. A pH of 7 is neutral, and each unit increase in pH above 8 represents a ten-fold increase in the alkalinity.

The procedure for determining the pH of paper by water extraction is given in TAPPI T 435 and ASTM D 778.

There are also pH meters that have flat electrodes that permit measurement of the pH of the surface of the paper (TAPPI T 529).

The pH test may be of value in diagnostic situations and in problem solving, but it has not proved useful in routine quality control testing.

Sizing and Water Resistance. There are numerous tests for determining the resistance of paper and paperboard to water and aqueous fluids. These include the contact angle test (TAPPI T 458), the dry indicator test (TAPPI T 433), the ink flotation test (TAPPI UM 481), the ink resistance test (TAPPI T 530), the degree of curl test (TAPPI T 466), the Cobb size test (TAPPI T 441), and the water immersion test (TAPPI T 491).

Ink Absorbency of Paper. The most commonly used tests to measure the absorbency of paper for printing inks are

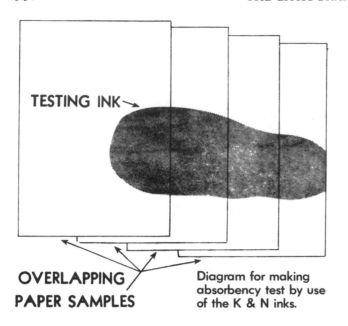

TESTING INK→

OVERLAPPING
PAPER SAMPLES

Diagram for making
absorbency test by use
of the K & N inks.

Absorbency test using K & N inks.

the K & N ink absorbency test, the Vanceometer method, TAPPI UM 519, and those tests using laboratory printability testers or proof presses.

The ink absorbency of paper determines its ability to absorb or hold out the printing ink film or a varnish. Absorbency is important in controlling the setoff, finish, and gloss of the dried ink or varnish. Ink absorbency of paper is not the same as its porosity. It is primarily a surface characteristic, depending on the degree of surface sizing and on the nature of the coatings. It can be measured by the rate at which a film of viscous oil loses gloss after being applied to the surface or to the stain remaining after a pigmented fluid has been applied to the surface.

The Vanceometer method depends upon the fact that immediately after a film of oil is spread on paper, its surface is highly glossy. As the oil is absorbed by the paper surface, the gloss decreases. Timing the rate of gloss decrease gives a measure of the absorbency of the sheet. The Vanceometer is an instrument designed specifically for this test.

K & N testing ink has an oil-soluble dye in its vehicle. The ink is spread in a thick film on the paper surface and allowed to

remain there for exactly 2 min. It is then wiped off with a cloth. The depth of color of the stain, measured with a densitometer, is proportional to the absorbency of the paper.

The K & N test is most useful in comparing the absorbency of coated and smooth-surface uncoated papers. When the test is made under standard conditions of temperature and relative humidity, it is possible to obtain reproducible results and to record them.

The K & N test is also valuable as an indication of the uniformity of absorbency of paper coatings. Mottled color or variations in density of the color of the tested area indicate nonuniform absorbency, which can result in mottled printing or mottled varnish in the finished sheet.

Paper Surface Efficiency. The paper surface efficiency is a measure of the ability of a sheet to reproduce halftone or process color. Print color depends on both the absorbency of the paper and its gloss. To determine paper surface efficiency, the operator measures gloss and K & N ink number and plots them on a paper surface efficiency chart, such as that available from GATF.

Paper Formation. "Formation" is the uniformity of the distribution of fibers in a sheet. The distribution depends on the stock used for making the sheet and on the paper machine itself. Formation is usually judged on a relative basis by comparing two sheets with each other. Formation is commonly observed by looking through the paper towards a strong light.

Ash. The percentage of ash in a sheet of paper is determined by the amount of filler or the amount of coating used. Standard chemical determinations for ash in any combustible material are applied. The paper is dried under standard conditions and ignited in a crucible in a furnace. The amount of ash is weighed and calculated as a percent of the dry paper. Determination of ash is described in TAPPI T 413 and ASTM D 586.

Abrasion Resistance of Paper or Prints. There are two devices commonly used for measuring abrasion or rub resistance: the Sutherland Rub Tester and the Taber Abraser.

The Sutherland Rub Tester is normally used to determine the

Courtesy of Hillside Laboratories

Absorbency tester.

Rub tester.

resistance to rubbing between two printed boxes (TAPPI UM 487). One printed sheet is placed against the face of another printed sheet, and they are rubbed under a given weight (1 or 2 kg). The operator notes whether or not any of the ink has rubbed off. The number of rubs and the weight of the load on the paper are reported.

The Taber Abraser is a turntable that rolls a paper or a varnished or printed sheet under a grindstone. Either the amount of scarring of the sheet is observed or the abraded material is washed off and weighed (TAPPI T 476).

Groundwood Content of Paper. To determine whether or not a sheet of paper contains groundwood, a phloroglucinol stain is applied to the sheet. The stain is prepared by dissolving 1 g of phloroglucinol in 50 ml of alcohol and 25 ml of concentrated hydrochloric acid. It produces a bright red or magenta color on papers containing groundwood.

Dust, Dirt, and Lint. Dust, dirt, and lint are often best observed just by looking at the paper. Trimmer and slitter dust can be observed around the edges of the skid or the roll. Wiping a black velvet cloth against the edges of the paper picks up bits of lint or dust that are readily seen on the black background.

Lint can be observed by inspecting the sheet under opaque illumination. Observation can be assisted if a sheet of paper is bent and held under a bright light. The observer looks across the sheet towards a dark background and any lint or whiskers will be seen standing up from the surface of the paper. Paper is more likely to show lint on the wire side than on the felt side.

The Landsco light is helpful in observing dirt, lint, and surface defects. The GATF dry dusting test is described in *Research Progress Report* No. 103. When the test is properly standardized, it is remarkably reproducible. A black blanket that has never had ink applied to it is placed on the press, and the press is packed to exert 0.007-in. squeeze against the paper. One-hundred sheets are run through the press. Now, the reflectance of the blanket is measured and compared with the color of a clean spot on the blanket. If the optical density has decreased by as much as 0.10, the paper is dusty enough to cause problems in printing. Further details are given in this *Research Progress Report*.

The black blanket is also observed for specks of debris, and if there are as many as 10 specks on the blanket after running 100 sheets, the runnability of the paper is questionable.

For papers that are to be processed by optical character recognition (OCR), freedom from bits of black dirt is critically important. Dirt content is determined using TAPPI T 437 or ASTM D 2019.

Permanence. The presence of groundwood fibers and acidity, particularly when accompanied by aluminum and other metallic ions, causes paper to yellow and degrade very quickly. The lightfastness of a sheet can be determined by exposing it in a Fadeometer as described in TAPPI UM 461.

A more common method for measuring the accelerated aging of paper is to expose it at 105°C in an oven for various intervals and to measure its folding endurance. Folding endurance decreases with paper aging (TAPPI T 453 and D 776).

Specifications of permanence of paper are described in ANSI-ASTM D 3208, D 3290, and D 3301.

Roll Hardness. The hardness of a roll is of considerable importance in its runnability on a web press, but the uniformity of hardness is much more important. Rolls that are wound too loosely tend to telescope; that is, the core is apt to drop out when the roll is lifted. Rolls that are wound too tightly may burst, and in any case, much of the resilience and stretch of the paper is permanently lost.

Use of process control instrumentation on the papermaking machine and automatic roll hardness control devices on the winder have enabled papermakers to greatly improve the uniformity of roll hardness as paper is rewound at the mill.

Product Resistance. Packaging materials and sometimes other printed materials must resist products to which they will be exposed. Printed materials exposed to water must resist water or water vapor transmission. Materials exposed to fats and oils must resist them also. There are a number of standard tests for measuring the bleeding in spirit varnish and for measuring the resistance to solvents, oils, fats, proteins, acids, waxes, alkalis, soaps, and detergents. Resistance to hot-iron sealing is also important if the package is to be sealed using a hot iron. Most of these are described in the tests of the Packaging Institute and TAPPI.

Press Testing. The ultimate test of paper for printing is how it prints. Testing of paper on the press is as complex a subject as is printing itself. Suffice it to say that the operation of the press should be highly standardized, that the operator should be highly skilled, and that control sheets must be run frequently.

Selecting control sheets is troublesome in itself, because paper may change as it ages. Control sheets, today, may not be the same as they were six months ago.

Correlation with Pressroom Conditions. The ultimate goal of paper testing at the paper mill is to predict the performance of the paper when it reaches the pressroom. In order to correlate papermill tests and pressroom performance, the quality control section at the mill must have reports from printers about the runnability of their papers. The data are also used by research and engineering to make better paper.

Landsco light.

Processing of Complaints. It is extremely important for printers to document and report promptly and effectively any complaints they have with the performance of paper. The paper mill personnel have no way of improving their paper if they do not know how it actually performs in their customers' press-rooms.

Documenting Paper Complaints. It is amazing how often papermakers receive complaints that are completely unsupported by any evidence. The very least the printer can do is to save a dozen faulty prints and a few sheets of the troublesome paper. Blankets, ink, plates, and anything else involved in the problem should also be saved. Use of an instant camera will give helpful records. Records of the job also contain important evidence of the origin of the problem. If the printer has little or no evidence of his problem, he has little chance that the papermaker will make an adjustment or pay for the paper.

Papermakers are understandably reluctant to pay for lost press time. If a paper problem develops, the printer should immediately contact his paper supplier and make arrangements to have the paper replaced or to get an agreement regarding an adjustment before proceeding further.

Section Twelve: Ordering Paper for Lithography

Pressworthiness of papers has increased as a result of paper-makers' improvement programs. These programs are reflected in papers' greater resistance to linting, picking, wet rubbing, expansion, and contraction. Advanced engineering practices reduce variations in moisture, basis weight, caliper, and other properties. As a result, reproduction qualities improve demonstrably, and press performance reveals greater economies.

To get the best results when ordering paper, the lithographer should buy and study GATF's textbook *What the Printer Should Know about Paper*. Another useful book is *Handbook for Paper Salespeople and Buyers of Printing Paper* from the Walden-Mott Corporation, 466 Kinderkamack Road, Oradell, N.J. 07649.

KINDS OF PAPER

The accompanying table lists some kinds of papers according to their general use. Within this classification, there are countless grades and finishes of paper that can be lithographed successfully.

The term "offset paper" is trade nomenclature for uncoated, smooth, wove, machine-finish paper that is surface-sized during manufacture to prevent lint and loose fibers. Offset papers resemble bond papers used for business correspondence; they are sized extra hard. One can write on bond and offset papers with pen and ink without blurring, blotting, or scratching.

Impregnated Offset Papers. Impregnated offset papers, during manufacture, receive a mineral film coating that is more or less invisible. One manufacturer calls this process "pigmentizing." Claims for these papers are worth noting: (1) the surface of the paper is more uniformly smooth and ink receptive, and (2) reproduction values are improved, because the coated film is a superior base for pictures, type, and color.

Embossed or "Fancy-Finish" Offset Papers. Embossed offset papers are decorative. After offset papers are made, they can be embossed with attractive fancy finishes (handmade, linen, leather patterns, woodgrains), dozens of different surfaces to make paper and the print more interesting. The offset method of printing makes it possible to print fine detail on the "rough" surfaces.

Text Papers. Fancy grades of offset are referred to as "text." Text papers are functional and beautiful. They may have a laid or wove finish. Lithographers can produce halftones on both rough and smooth paper surfaces. The smoothest surfaces—coated, for example—represent most desirable backgrounds for halftones. Good quality pictures are also lithographed on the textured surfaces of text paper that vary from "offset paper" smoothness to "turkish towel" roughness. (Surfaces of some test papers resemble turkish towels and terry cloth.) Lithographers use these surfaces as design elements for distinguished advertising literature.

Coated Papers. The list of coated papers for lithography is long. Most suppliers of these papers provide more than one grade. Today, colored coated papers are also manufactured for lithography. Great strides are made in the manufacture of glossy, matte, and dull-coated papers to be run on lithographic presses. From the standpoint of fidelity of halftone reproductions, truest colors, and blackest blacks, lithographers recognize the value of the coated printing surface. Coated papers are also embossed or fancy finished.

Dull-Coated Papers. To the eye and fingertips, these grades do not appear to be coated. There is no evidence of coating on the unpolished surface. But these papers are coated, with as much coating material as on "enamel" papers. Dull coated papers include dull-finish enamels and the matte-type coated papers.

Premium Papers. Most standard offset papers have been improved, and current qualities are far superior to those known a few years ago. Papers are brighter and whiter. They are also more opaque; that is, they have a higher opacity-to-weight ratio. Papers are cleaner and have a better appearance before printing.

"Plus" values of premium papers are superior opacity, whiteness, and brightness. Premium qualities of opacity, brightness, and an overall rich appearance contribute "eye appeal" to vellum and opaque papers. Colors of ink sparkle more brilliantly. Blacks are jet. Type is said to increase in legibility.

Various grades are made with matching cover weights. This matching quality is an essential "design" element for advertising

printing. Designers like the whites of covers and texts to be identical. Some of these grades are made of pastel tints.

Cast-Coated papers. These patent-leather-like papers have an exceptionally high gloss finish. Their development provided opportunities to expand the lithographic art deeper into the areas of commercial and specialty printing. As a "bonus" of their development, color lithography has blossomed to almost unbelievable proportions, as new uses for color lithography have been created. The mirrorlike printing surfaces of cast-coated papers are available in book and cover weights, such as gummed papers, folding box boards, and match-pack stock. Demands for cast-coated papers is growing for box wraps, commercial printing, and gift wraps.

Cover Papers. Designers of booklets, annual reports, catalogs, recipe books, and instruction manuals create attractive and functional covers. Longer useful life is built into books by the addition of strong and more-serviceable covers.

Consequently, cover paper is a big business. Most of the coated cover papers match the whiteness and surface character of coated-two-sides (C2S) book papers. Designers, to repeat, like this matching quality in papers they select for cover and text pages of booklets.

Postcard-thickness papers often serve as cover papers. For instance, the heaviest coated cover papers, 20 × 26 basic size with a basis weight of 100 lb., is 10 points thick (1 point = 0.001 in.). Postcard stock may be obtained 12 points thick. Designers frequently prefer the extra bulk for their covers. The table of "Equivalent Weights" shows the equivalent weights of many paper sizes.

The heavy weights of most text papers make them useful as cover materials. These lovely patterns offer designers unique backgrounds, colorful deckle edges, interesting duplex treatments, and just plain, old-fashioned, rich-looking antique surfaces of great character.

Some mills include cover papers and postcards in a single line, with cover and postcard weights being companions.

Colored Coated Cover Papers. Colored coated cover papers are not numerous—the reason designers use colored coated postcard as cover papers. Some grades are duplex in nature; pleasing color combinations are on opposite sides.

Uncoated Cover Paper. Uncoated papers are functional and decorative. Uncoated covers—principally antique finish and wove, finishes resembling the smoothness of typical offset papers—are favorites of lithographers. Various standard grades are made in white shades and in an array of colors.

Many grades are available in embossed patterns—leather, linen, and handmade, for instance. Other covers, in frequent demand by lithographers, are pyroxylin-coated leather-embossed papers of great serviceability and rich appearance. Most are moisture-proof and alcohol-proof. They may be cleaned for extra service.

Plastic Laminated Papers. Some cover papers are plastic-topped. The plastic coating may be dull instead of high in gloss. All are hardy and durable.

Covers with a Novel Appeal. Novel covers are available with special designs printed overall or with special embossing patterns, such as woodgrain, leather, pearlescence, iridescence, and embossing.

Metallic Covers. There are metallic covers: gold, silver, bronze; plain and embossed; one-side and two-side. Other cover papers are made with a suede flocking as the printing surface.

Printing Bristols. As postcard stocks are used sometimes for cover papers when coated surfaces are required, printing bristols are often used as heavyweight cover papers—antique and plate finish. Bristols are best distinguished from covers by comparing them side by side.

Coated-One-Side (C1S) Litho Papers. With lithographers being important producers of package wraps and labels, C1S litho papers are used in large tonnage. White or colored lines of label paper are available.

Chemical Wood Bond Papers. High on the list of papers processed through litho plants in great tonnage is bond of the sulfite variety. Sulfite bond looks like wove offset paper. Certain grades, generally numbers 1 and 2, are watermarked. They are good quality papers, used for business correspondence. The grade commonly called "plain bond," or "number 4 bond," is not watermarked and is used for forms work, principally one-color; for long-run, direct mail letters; and for bulletins.

Mimeograph and Duplicator Papers. A large percentage of mimeograph and duplicator papers is lithographed before processing through stencil or spirit duplicating machines. Bulletin heads, letterheads, special forms, and special notes are first lithographed. Modern office duplicators are largely offset machines.

Translucent Papers. Translucent papers are used as masters for copy to be reproduced on various machines. Translucent papers are often lithographed as letterheads, forms, statements, and reports to be filled in further by pen and ink or by typewriter before copies are made.

Safety Papers. Safety papers are designed to prevent attempted alteration of any applied writing or printing. Though most safety paper is used for checks, drafts, and other negotiable instruments or documents, the product has a multitude of other uses. Receipts, notes, business forms, licenses, permits, transportation tickets, and many other legal forms requiring protection against fraudulent alteration and counterfeiting are commonly produced on safety paper.

Manifold and Onionskin. Manifold and onionskin "copy" papers are used frequently for special forms, airmail stationery, lightweight reports, and catalogs. (Incidentally, order manifold and onionskin should be ordered with grain direction in the short dimension of the press sheet, rather than customary long dimensions.)

Ledger Paper and Index Bristol. Ledger paper and index bristol are grouped together because index represents the

TABLE OF APPROXIMATE BULKS

	Basis (lb.)	Thickness (in.)		Basis (lb.)	Thickness (in.)
Bond			Index		
(17×22)	9	.002	(20½×24¾)	58½	.007
	13	.0025		72	.008
	16	.003		91	.0105
	20	.004		111	.0135
Bristol—Plate				143	.0175
(22½×28½)	100	.008	Ledger		
	120	.010	(17×22)	24	.004
	140	.012		28	.005
	160	.014		32	.00525
	180	.017		36	.00575
Bristol—Antique				40	.0065
(22½×28½)	100	.012		44	.007
	120	.014	Offset		
	140	.016	(25×38)	50	.004
	160	.018		60	.0045
	180	.020		70	.005
Coated—(Book)				80	.006
(25×38)	60	.003		100	.0075
	70	.0035		120	.009
	80	.004	Super		
	100	.0055	(25×38)	50	.0025
	120	.006		60	.003
Coated Cover				70	.004
(20×26)	50	.00475	Tag		
	60	.006	(24×36)	80	.006
	65	.0065		100	.0075
	80	.0075		125	.009
	100	.0095		150	.011
Cover				175	.0125
(20×26)	50	.007		200	.015
	65	.009		250	.018
	80	.0105		300	.0225
	100	.0135	Text—Smooth		
	130	.018	(25×38)	60	.005
Eggshell				70	.0065
(25×38)	50	.0045		80	.007
	60	.005	Vellum		
	70	.006	(17×22)	20	.004
	80	.0065		24	.005
English Finish				28	.006
(25×38)	45	.0025		32	.0065
	50	.0035		36	.0075
	60	.004		40	.0085
	70	.0045			

heavy weights of ledger papers. Both are used in accounting forms—sometimes in ledger books and in stand-up files. Heaviest weights are used when forms must stand up in trays.

Cotton-Content Papers. Principally used for business stationery, cotton-content bond papers are also used for insurance policies, stock certificates and banknotes, certificates, and other important documents when longevity is an important factor. Lithographers prefer machine-dried cotton-content papers rather than air-dried cotton-content papers. The former are free from cockle and less susceptible to the vagaries of the weather.

Tag. Strong stocks such as jute, rope, and sulfate tags are used when extra service is expected from the paper selected.

Blanks. Used principally for display, blanks are heavy-weight stocks that range from 15 to 48 points in thickness. Some grades are coated, some are uncoated, and some are made in colors. Four- and five-ply thicknesses of coated blanks may be used.

Gummed Papers and Heat-Seal Papers. Gummed paper tonnage runs into substantial quantities for such applications as merchandise labels, tip-ins for books, merchandise stamps, and direct mail premiums. Heat-seal labels are important in mass merchandising, phonograph record production, and a variety of other uses.

Poster Paper. Poster papers, used by the billboard and outdoor advertising trades, are printed by specialists among lithographers.

Parchment Papers. Parchment papers are used for wrapping foods. Use of special inks is essential when printing these papers.

Diploma Papers. Diploma papers are used for certificates, warranties, and diplomas. Some brands are 100% cotton content; others are vegetable parchment papers that resemble real parchment papers.

BASIS WEIGHTS

There are many ream sizes; the most common are book, cover, bond, and metric. The basic size for book is 500 sheets, each 25×38 in., designated 25×38. The area is 3,300 sq. ft. Cover stock is 20×26, with an area of 1,800 sq. ft. Bond and ledger papers are 17×22, with an area of 1,300 sq. ft. Board is usually sold by the thousand square feet (1,000 sq. ft.).

Therefore, 1 sq. ft. of a 70-lb. cover, designated 20×26—70, as the same weight as 1 sq. ft. of a 128-lb. book paper, designated 25×38—128. Similarly, 1 sq. ft. of a 16-lb. bond paper weighs the same as 1 sq. ft. of a 40-lb book paper.

All metric basic weights are expressed in grams per square meter (gsm): tissue, newsprint, book, cover, board, and the rest.

EQUIVALENT WEIGHTS OF PAPER (lb.)
(Basis Weights in Bold,
All Weights Are for 500-Sheet Reams)

	Bond (17×22)	Book (25×38)	Cover (20×26)	Bristol (22½×28½)	Bristol (22½×35)	Index (25½×30½)	Tag (24×36)
Bond, Ledger, Mimeo, Duplicator, Writing	**13**	33	18	22	27	27	30
	16	41	22	27	34	33	37
	20	51	28	34	42	42	46
	24	61	33	41	51	50	56
	28	71	39	48	59	58	64
	32	81	45	55	67	67	74
	36	91	50	62	76	75	83
	40	102	56	69	84	83	93
	44	112	61	75	93	92	102
Book, Offset, Text	12	**30**	16	20	25	25	27
	16	**40**	21	27	33	32	36
	18	**45**	24	30	37	37	41
	20	**50**	27	34	41	41	45
	24	**60**	32	40	50	49	55
	28	**70**	38	47	58	57	64
	31	**80**	43	54	66	66	73
	35	**90**	48	60	75	74	82
	39	**100**	54	67	83	81	91
	47	**120**	65	80	99	98	109
	59	**150**	80	100	124	123	136
Cover	29	73	**40**	49	61	60	66
	36	91	**50**	62	76	75	82
	43	110	**60**	74	91	90	100
	47	119	**65**	80	98	97	108
	58	146	**80**	99	121	120	134
	65	164	**90**	111	136	135	149
	72	183	**100**	124	151	150	166
Mill Bristol	58	148	81	**100**	123	121	135
	70	176	97	**120**	147	146	162
	82	207	114	**140**	172	170	189
	93	237	130	**160**	196	194	216
	105	267	146	**180**	221	218	242
	117	296	162	**200**	246	243	269
Printing Bristol	52	133	73	90	**110**	109	121
	59	151	83	102	**125**	123	137
	71	181	99	122	**150**	148	165
	83	211	116	143	**175**	173	192
	95	241	132	163	**200**	198	219
Index bristol	43	110	60	74	91	**90**	100
	53	135	74	91	112	**110**	122
	67	170	93	115	141	**140**	156
	82	208	114	140	172	**170**	189
	105	267	146	182	223	**220**	244
Tag	43	110	60	74	91	90	**100**
	54	137	75	93	114	113	**125**
	65	**165**	**90**	111	137	135	**150**
	76	**192**	**105**	130	160	158	**175**
	87	**220**	**120**	148	183	180	**200**
	109	**275**	**151**	186	228	225	**250**
	130	**330**	**181**	222	273	270	**300**

COMPARISON OF BULK-TO-WEIGHT RATIO BETWEEN LIGHTWEIGHT PAPERS AND OFFSET

Ream Weight (lb.) (25 × 38)	Paper Type	Pages Per Inch
24	Lightweight	1184
45	Offset, Smooth Finish	588
30	Lightweight	1030
50	Offset, Smooth Finish	533
35	Lightweight	888
60	Offset, Smooth Finish	444

COMPARISON OF OPACITY-TO-WEIGHT RATIO BETWEEN LIGHTWEIGHT PAPERS AND OFFSET

Paper Type	Ream Weight (lb.) (25 × 38)	B&L Opacity Reading
Lightweight	24	81
Offset, Smooth Finish	50	92
Lightweight	30	87
Offset, Smooth Finish	60	94
Lightweight	35	89
Offset, Smooth Finish	70	96

The 70-lb. cover has a basis weight of 190 gsm, and the 16-lb. bond has a basis weight of 60 gsm.

To convert a basis weight to the equivalent book basis weight, multiply the basis weight by 1.83 for cover stock, by 2.54 for bond, by 3.30 for board, and by 0.674 for metric. To convert a basis weight to its metric equivalent, multiply the basis weight by 1.48 for book, by 2.71 for cover stock, by 3.75 for bond, and by 4.88 for board. For example, to convert 50-lb. book to its metric equivalent, multiply 50 (basis weight) by 1.48 (conversion factor). The metric equivalent is 74 gsm (50 × 1.48). To convert a 100-lb. cover stock to its equivalent book basis weight, multiply 100 (basis weight) by 1.83 (conversion factor). A 100-lb. cover has a basis weight equivalent to a book paper with a 183-lb. basis weight (100 × 1.83).

Equivalent weights for common reams and weights are tabulated in another table.

PAPER SAMPLING PROGRAM

Experienced buyers of papers have files of grades in principal use. Quality changes and competitive advantages are watched with vigilance. Professional buyers recognize trends, sense superiorities, and capitalize on them. This technique of professional buying pays off. It is highly recommended. Professional sampling is a step in the right direction.

How can lithographers learn about changes? How can they retain and use the knowledge? First, printers should indicate to suppliers their principal interest in printing papers—coated book, offset, cover, or any other classifications, and they should ask for a complete review—samples and manufacturing data—covering latest developments mill by mill. Second, they should ask for a continuous flow of such information.

Knowledge is stored using a workable sample system, based on standards, that considers all pertinent qualities, characteristic by characteristic, for all paper grades and that catalogs the information in a useful format.

The following practical sampling method is suggested,

together with a series of checklists and rating charts. It must be emphasized that lithographers, however seasoned as paper buyers, are not expected to be paper technicians and researchers. Therefore, their methods of keeping tab on changes in paper qualities must of necessity be based on personal preferences—whiteness, surface characteristics, and other optical values—until evidence of pressworthiness or end-usage supplements opinions. Any such practical shop information should be included then.

A genuine desire to "keep tab" on quality changes is the only requisite for a successful and effective sampler.

Evaluating the samples is more difficult, but it is a fascinating chore. The system is not likely to be abandoned once started.

Method of Sampling Changes in Paper Qualities. First, all samples of white printing papers on hand should be thrown away. A new file of up-to-date whites should be built. Then, a form of sampling best suited to the company's needs should be selected. One could follow or adapt this plan:

1. File whites by classification: coated book, offset, vellum and opaque, cover, text, bristol, and bond.
2. Obtain a 9 × 12-in. three-ring binder. Dividers can be cut from heavyweight cover paper or strong bristol. Index tabs can be cut out by hand. Tabs can easily be labeled and protected by acetate, or standard dividers can be purchased. Fill the various sections—by paper groups named above—with the single-sheet samples, the largest of

SUGGESTED CHECK-LIST TO HELP KEEP TAB ON OFFSET PAPERS

(1, 2 and 3 indicate standing in relation to *standard* you select as first choice.)

Grade:

Manufacturer:

Merchants:

Ream Weights, 25 x 38: _____

Whiteness: ☐ Cream; ☐ Blue
☐ 1 ☐ 2 ☐ 3

Brightness: ☐ 1 ☐ 2 ☐ 3

Finish:
☐ Smooth ☐ Smooth-Vellum
☐ Vellum ☐ Antique

Pigmentized: ☐ Yes ☐ No

Bulk: ☐ Single Sheet ·——— ; ☐ 2 Sheets ·——— ;
☐ 4 Sheets ·———

Opacity: ☐ 1 ☐ 2 ☐ 3

Dimensional Stability: ☐ 1 ☐ 2 ☐ 3

Likesidedness: ☐ 1 ☐ 2 ☐ 3

Foldability: ☐ 1 ☐ 2 ☐ 3

Stiffness: ☐ 1 ☐ 2 ☐ 3

Fibre Content:
☐ With Sulphate ☐ Without Sulphate
☐ With Titanium Oxide ☐ Without Titanium Oxide
☐ With old papers ☐ Without old papers
☐ Groundwood ☐ Other Fibres

which should be 8½ × 11 in. Then swatch all other papers in the section in widths 8¼, 8, 7¾, 7½ in., etc. One can see at a glance the varying whiteness of different brands. It is easy to select whiteness from a file like this.

3. Ask paper suppliers to furnish the samples required. Have them cut to an 8½ × 11-in. size. Be sure to insert them in your sample book felt-side up. Ask the paper supplier to punch the samples with three standard round holes to fit the binder. Be sure felt sides are identified.

4. Ask suppliers to accept responsibility for keeping the files up to date. Quality and appearance changes occur frequently enough so that constant updating of the samples is necessary. Furthermore, paper changes color with handling, age, and exposure to light.

5. Identify and date each paper along the stepped-off end of the sample.

6. Make this sample file in duplicate so that sales and production departments have copies and can intelligently discuss identical papers.

Choice of Standards. The evaluation may be based on a set of standard qualities and characteristics for each grade. Choice of standards may be based on nothing more than personal opinions of special values—eye tests and fingertip tests—for grades in given price brackets. Or, the choice of standards may be based on laboratory reports provided by paper suppliers. Printers fortunate enough to obtain quantitative information to help them establish their standards will discover that the supplier's evaluation will be more accurate and more effective than values obtained by eye and fingertip testing. However, for printers' practical purposes, personal or plant preferences do offer a strong basis for the adoption of standards.

The two forms "Suggested Checklist to Help Keep Tab on Offset Papers" and "Suggested Checklist to Help Keep Tab on Cover Papers" can be used as guides for the serious study of general paper-quality changes and for the development of proper evaluations.

The examples shown present the kind of information to seek when analyzing the usefulness of various offset and cover papers, which are used in large tonnage by lithographers.

Use of Quality Checklists. The checklists are self-explanatory, but some reference to them could be helpful. Each paper grade provides its own quality points and special benefits. As each of the points is recognized for its superiority, that point becomes the standard in judging all other papers. In offset papers, brightness, whiteness, smoothness, opacity, finish, bulk, foldability, and strength are among the major points to be considered.

For example, an offset sheet chosen as a standard is more bulky than other grades tested; consequently, it has a low finish. It is good in folding strength, is high in brightness, and rates "excellent" in likesidedness and opacity.

Smoothness, one important consideration, lends itself neither to high bulk nor strongly to exceptional opacity. Smoothness is associated with superior detail in halftone illustrations, bright colors, sharp blacks, and well-defined middletones.

Keeping Tab on Paper Quality Changes. Competitive advantage is a sufficient reason for continuously studying the paper market for changes in qualities and characteristics. (Paper-

SUGGESTED CHECK-LIST TO HELP KEEP TAB ON COVER PAPERS

(1, 2 and 3 indicate standing in relation to *standard* you select as first choice.)

Grade:

Manufacturer:

Merchants:

Ream Weight, 20 x 26: _____

Whiteness: ☐ Cream; ☐ Blue
 ☐ 1 ☐ 2 ☐ 3

Brightness: ☐ 1 ☐ 2 ☐ 3

Color:

Finish:
☐ Smooth Antique ☐ Light Felt Finish
☐ Vellum Antique ☐ Heavy Felt Finish
☐ Rough Antique ☐ Extra Heavy Felt Finish
☐ Extra Rough Antique ☐ Laid Antique
 ☐ Coated ☐ Duplex ☐ Embossed

Likesidedness:
 ☐ Finish: ☐ 1 ☐ 2 ☐ 3
 ☐ Color: ☐ 1 ☐ 2 ☐ 3

Foldability: ☐ 1 ☐ 2 ☐ 3

Strength: ☐ 1 ☐ 2 ☐ 3

Caliper Thickness: ._____ ☐ 1 ☐ 2 ☐ 3

CHECK LIST FOR ORDERING PAPER IN FLAT SHEETS

GRADE
QUANTITY (Sheets) (Pounds)
SIZE & WEIGHT M; basis weight
COLOR FINISH DESIGN
CALIPER THICKNESS 1-sheet 4-sheets pages-to-inch
☐ WATERMARKED ☐ UNWATERMARKED
GRAIN DIRECTION ☐ long ☐ short ☐ optional (one dimension)
DESIGN OR PATTERN NUMBER ☐ long ☐ short ☐ optional (one dimension)
TRIMMING ☐ machine ☐ trimmed-2-sides
TO ONE SIZE ☐ trimmed-2-ends ☐ trimmed-4-sides
PRESS SHEET ☐ Sheetwise ☐ Work-and-Turn ☐ Work-and-Tumble

REPRODUCTION METHOD (indicate which)
 ☐ Letterpress ☐ 1-color ☐ 2-colors ☐ 3-colors ☐ 4-colors
 ☐ wet ☐ dry
 ☐ Lithography ☐ 1-color ☐ 2-colors ☐ 3-colors ☐ 4-colors
 ☐ wet ☐ dry
 ☐ Gravure ☐ High-gloss inks ☐ Metallic inks
 ☐ Photogelatine ☐ Finishing ☐ Varnishing ☐ Lacquering ☐ Embossing
 ☐ Acetate laminating ☐ Liquid laminating ☐ Polyethylene laminating
PLANT HUMIDITY REQUIREMENTS
PURPOSE FOR WHICH THIS PAPER IS INTENDED
PACKING ☐ Ream-marked in cartons ☐ Ream-marked in bundles
 ☐ Ream-sealed in cartons ☐ Ream-marked on single-tier skids
 ☐ Ream-marked on double-tier skids ☐ Ream-marked on 4-tier skids
 ☐ Felt-side-UP ☐ Felt-side-DOWN ☐ Cast-side-UP ☐ Cast-side-DOWN
SKID SPECIFICATIONS ☐ 4-way-entry ☐ 2-way-entry
 runners ☐ short-way ☐ long-way
 minimum distance between runners .. inches maximum height .. inches maximum weight .. pounds
 Note — MARK SKID NUMBER AND ORDER NUMBER ON RUNNERS
SHIPPING siding on RR
 plant can accommodate trailers up to feet long
 ☐ sidewalk delivery by winch-truck
 Most satisfactory delivery hours .. AM to .. AM .. PM to .. PM Receiving platform closed .. to ..
SPECIAL MARKINGS ON SKID-WRAPPERS
SPECIAL INSTRUCTIONS NOT IDENTIFIED ABOVE
SAMPLE FOR MATCHING ACCOMPANYING

Courtesy of Walden-Mott Corp.

makers never stop "scouting" competitive products.) Knowing the existence of superior grades and brands and exploiting them marks experienced printers.

Working with the sampling and study methods suggested here can stimulate interest in personal study and can pay off in competitive advantages and improved quality production.

ORDERING PAPER IN SHEETS

The checklist for ordering paper in flat sheets presents a foolproof form for writing specifications. Followed to the letter, paper suppliers—merchant and manufacturer—are provided with all the information they need to deliver satisfactory paper at a competitive price, to the assigned destination, at the proper time.

In the itemized list of specifications that follows, the importance of clear inquiry-and-order writing is emphasized.

Quantity. Do not write "so many cases," "so many cartons," or "so many skids." Specify number of sheets with number of pounds in parentheses. For example: 175,000 sheets (62,300 lb.).

Size and Weight. Specify dimensions and weight per 1,000 sheets. To prevent misunderstanding show ream-weight in parentheses. For example: 44×64—356M (25×38—60). "M" in the size-and-weight designation means "per 1,000 sheets."

Grade and Color. Specify by brand names, not by number or letter; identify color in correct mill terminology. Do not write "white" when you know the paper you are ordering is made cream-white and blue-white. Do not write "blue" when you know there are two blues in the line.

Finish. Identify by name when there is any possibility of misunderstanding. For example, Laurel finish is like a handmade finish in one grade of offset. Write Laurel finish to be sure. No two handmade finishes are identical in texture or character.

When finish is a design, identify it by name or number. When paper is safety paper, indicate direction of the chain line or pattern. When paper is text or text-cover, indicate dimension of grain, chain line, and deckle. Do not leave anything to conjecture at the mill.

Intended Finishing. When paper is to be varnished, lacquered, laminated, embossed, or finished in any other manner after printing, be sure to designate the finish clearly. Many standard papers are not suited to varnishing or lacquering, but when specially treated, they are perfectly satisfactory. Spell out your exact requirements. Failure to mention additional properties necessary for effective production will lead directly to problems.

Indicate the Use of Special Inks. If paper is to be printed with metallic inks, high-gloss inks, heatset inks, or other special kinds of inks, be sure the paper manufacturer knows the facts. For further precautions, identify the ink by maker and the number.

Grain. Specify grain direction—grain-long or grain-short. When grain direction is not important, specify "grain optional."

Trimming. Specify squared-four-sides when you mean just that. Although many grades of paper are standard trimmed four-sides, do not take it for granted.

When you know that paper trimmed one side and one end is perfectly satisfactory for the production purposes, say so. Also instruct the mill to mark the squared corner. When you need text paper with a plain edge, be sure to say so. If you fail to mention it, you may receive paper with a lovely, feathery deckle edge—beautifully ornamental, no doubt, but not useful.

Packing. Identify exact packing required: standard size in cartons, or junior size (10 reams of cut sizes 8½×11 in. or 8½×14 in.) in cases, or skids. Whatever the packing, be sure to specify whether the paper is to be sealed in packages or unsealed (marked).

Be sure to underscore weight limitations of the shipment, if any. Many printing and lithographing shops are situated in loft buildings, and weight and size limitations are bound to arise. Skid loads of anything less than the standard 3,000-lb. weight should be so identified. When elevator capacity and width of elevator or plant doors make it necessary to pack paper on single-tier skids, say so in capital letters. When skids must be double-tiered for practical reasons, say so. If skids should be double-wrapped to maintain the moisture content, make the point clear. When relative humidity of your plant is known, be sure to specify RH maximum and minimum for the time of the year. Always specify type of runners or legs on skids, clearance between them, and clearance from floor. If overall height is important, specify this also.

Special Requirements. When special manufacturing requirements are important, itemize them property-by-property, characteristic-by-characteristic. When strength is the factor, emphasize this by listing a measured reading value for the folding strength, the tearing strength, or the Mullen, whichever properties are essential to the job. When the opacity of the paper being considered is acceptable, be sure to make it clearly part of the order. Write out the caliper thickness desired. If bulking thickness is important, specify the number of pages to the inch.

The more complete the specifications are, the fewer are the chances of mistakes.

Bulk Determination Scale. Fold a sheet of paper twice, thus making four thicknesses, or eight pages. Using a micrometer or calipers, read the thickness of four sheets in thousandths of an inch (points). In the column headed "Pages per Inch," you will find the number of pages per inch corresponding to the micrometer reading.

TAG STOCK

Size (in.)	Ream Weight (lb.)						
24×36	90	100	125	150	175	200	250
	Equivalent Weight per 1,000 Sheets						
22½×28½	134	148	186	223	260	297	371
24×36	180	200	250	300	350	400	500
28½×45	268	296	372	446	520	594	742

BOOK PAPERS

Size (in.)	Ream Weight (lb.)											
25×38	30	35	40	45	50	60	70	80	90	100	120	150
	Equivalent Weight per 1,000 Sheets (lb.)											
17½×22½	25	29	33	37	41	50	58	66	75	83	99	124
19×25	30	35	40	45	50	60	70	80	90	100	120	150
23×29	42	49	56	63	70	84	98	112	126	140	169	
23×35	51	59	68	76	85	102	119	136	152	170	204	
22½×35	50	58	66	75	83	99	116	133	149	166	199	249
24×36	54	64	72	82	90	110	128	146	164	182	218	272
25×38	60	70	80	90	100	120	140	160	180	200	240	300
26×40	66	76	88	98	110	132	154	176	198	218	262	328
28×42	74	86	100	112	124	148	174	198	222	248	298	372
28×44	78	90	104	116	130	156	182	208	234	260	312	390
30½×41	78	92	106	118	132	158	184	210	236	264	316	396
32×44	88	104	118	134	148	178	208	238	266	296	356	444
33×44	92	106	122	138	152	184	214	244	276	306	366	460
35×45	100	116	132	150	166	198	232	266	298	332	398	498
36×48	108	128	144	164	180	220	254	292	328	364	436	544
38×50	120	140	160	180	200	240	280	320	360	400	480	600
41×54	140	164	186	210	234	280	326	372	420	466	560	700
44×64	178	208	238	266	296	356	414	474	534	592	712	888
35×46	102	118	136	152	170	204	238	272	306	338	406	
38×52	124	146	166	188	208	250	292	332	374	416	500	
41×61	156	184	212	236	264	316	368	420	472	528	632	
42×58	154	180	206	230	256	308	358	410	462	512	615	
44×66	178	208	238	266	296	356	414	474	534	592	712	
46×69	201	234	267	301	334	400	468	534	602	668	802	
52×76	250	292	332	374	416	500	582	666	748	832	998	

BOND, LEDGER, SAFETY AND WRITING PAPERS

Size (in.)	Ream Weight (lb.)								
17×22	13	16	20	24	28	32	36	40	44
	Equivalent Weight per 1,000 Sheets (lb.)								
8½×11	6½	8	10	12	14	16	18	20	22
8½×13	7½	9½	12	14	16½	19	21½	23½	26
8½×14	8½	10	13	15½	18	20½	23	25½	28
11×17	13	16	20	24	28	32	36	40	44
16×21	23½	29	36	43	50½	57½	65	72	79
16×42	47	58	72	86	101	115	130	144	158
17×22	26	32	40	48	56	64	72	80	88
17½×22½	27	34	42	51	59	67	76	84	93
17×26	31	38	47	57	66	76	85	95	104
17×28	33	41	51	61	71½	81½	92	102	112
18×23	29	35½	44½	53	62	71	80	89	97½
18×46	58	71	89	106	124	142	160	178	195
19×24	32	39	49	58½	68½	78	88	98	107
20×28	39	48	60	72	84	96	108	120	132
21×32	47	58	72	86	101	115	130	144	158
22×25½	39	48	60	62	84	96	108	120	132
22×34	52	64	80	96	112	128	144	160	176
22½×22½	35	43	54	65	76	87	97	108	119
22½×34½	54	66	83	99	116	133	149	166	183
22½×35	56	67	84	101	118	134	152	168	186
23×36	58	71	89	106	124	142	160	178	195
24×38	64	78	98	117	137	156	176	196	214
24½×24½	42	51½	64	77	90	103	116	128½	141
24½×28½	49	60	75	90	105	119½	134½	149½	164½
24½×29	49½	61	76	91	106½	122	137	152	167
24½×38½	66	81	101	121	141½	161½	182	202	222
24½×39	66	82	102	122	144	164	184	204	225
25½×44	78	96	120	144	168	192	216	240	264
26×34	62	76	94	114	132	152	170	189	208
28×34	66	82	102	122	143	163	184	204	224
34×44	104	128	160	192	224	256	288	320	352
35×45	109	135	168	202	236	270	303	337	371

For example, what is the number of pages per inch for a book in which four thicknesses measure .020 in. (20 points)? In the column headed "Pages per Inch" opposite .020, you will find the answer—400 pages.

Bulk Determination Formula. To determine the bulk of a given number of pages, caliper eight pages, and multiply the amount of points by the given number of pages, and then divide by eight. For example, suppose eight pages caliper .020 in. What will 320 pages bulk? The answer is:

$$\frac{320 \times .020}{8} = \frac{6.400}{8} = .800 \text{ in., or slightly more than } \tfrac{3}{4} \text{ in.}$$

To determine the number of pages per inch, caliper the eight pages, and then divide that number into 8. For example, suppose eight pages caliper .016 in. How many pages per inch are there? The answer is:

$$\frac{8}{.016} = 500 \text{ pages per inch}$$

ORDERING PAPER IN ROLLS

No Simple Rules for Ordering Paper in Rolls. There are no simple rules for ordering paper in rolls because: (1) there are no established standards for paper in rolls; (2) every order for paper in rolls is tailormade; (3) operators of web presses must have the paper designed to make the most profitable use of their machinery's facilities, width cut-off, and accessories.

An experienced manufacturer of web offset presses, talking about paper requirements for them, said, "Paper must be fitted to the job. Selection of paper should be determined by speed of the press, by the number of after-printing operations that paper must endure, kinds of ink, number of colors to be applied one over the other, area of coverage, whether printing one or two sides of the sheet, and quality of results desired."

Another manufacturer said: "Rolls that might be entirely satisfactory for letterpress printing will not get by on precision lithographic presses. Be sure the paper manufacturer knows what process of reproduction will be used and on what particular press the paper will be run. While all rolls should be wound accurately and trimmed accurately, it is especially important that rolls for high-speed offset presses be handled with extra care and precision."

The "job-determines-the-paper" theory, therefore, is an important consideration when ordering paper in rolls. It is not unusual for roll paper to pass through several operations after printing. For instance, in addition to being printed with up to four colors, paper is punched for all sorts of business systems, numbered, perforated (lengthwise and crosswise), rewound, slit, and folded. That kind of single-flow processing represents a severe test of paper properties. In addition to having tensile, tear, surface, and bursting strength, paper for web offset must have a high degree of folding strength and resistance to blistering, delamination, and water.

Here, though, is a bright note. Papers used on web presses are chiefly limited to a few classifications: book (coated, English finish, antique), bible, C1S label, bond, writing, ledger, and thin papers. Bristol, index, tag, and board are more commonly printed in sheets.

SPECIFYING PAPER IN ROLLS

In ordering roll stock, follow the checklist for ordering paper in rolls and remember the following points:

1. Order rolls made to maximum diameter. Fewer roll changes in a run mean fewer press adjustments and a more profitable operation.

2. Limit the number of splices per roll. A greater number of splices results in a greater number of press adjustments. These cause lost press time and increase paper waste. More important, there is a possibility of running into splices that are not flagged and suffering the consequences—smashed blankets, smashed plates, even damaged presses. An operator tells how one of his major producing machines was out of operation an entire week because a splice on a roll was not flagged. The overall loss to the operator mounted into the thousands of dollars.

3. Specify the maximum basis weight required. The operator buys yardage, not pounds of paper. When ordering 17×22 —20 bond paper without stipulating "not heavier than," buyers may receive 21-, 22-, or even 23-lb. paper. Consequently, yardage is decreased, yielding fewer forms, letterheads, and envelopes than estimated.

4. Allow for at least 5 to 7% spoilage when estimating. The weight of the roll always includes the outside wrapper and the core; also because in unwrapping the roll, the paper is invariably damaged in some degree. In transit, rolls get dropped or otherwise knicked. Almost always—depending on the weight of paper—the ten to fifty pounds of paper nearest the core are worthless. The paper is curled beyond value.

BULK DETERMINATION SCALE

Micrometer Reading	Pages per Inch	Micrometer Reading	Pages per Inch	Micrometer Reading	Pages per Inch
.007	1142	.019	420	.031	258
.0075	1066	.0195	410	.0315	254
.008	1000	.020	400	.032	250
.0085	942	.0205	390	.0325	246
.009	888	.021	380	.033	242
.0095	842	.0215	372	.0335	238
.010	800	.022	364	.034	234
.0105	762	.0225	356	.0345	232
.011	726	.023	348	.035	228
.0115	696	.0235	340	.0355	224
.012	666	.024	332	.036	222
.0125	640	.0245	326	.0365	218
.013	614	.025	320	.037	216
.0135	592	.0255	314	.0375	212
.014	570	.026	308	.038	210
.0145	552	.0265	302	.0385	208
.015	532	.027	296	.039	204
.0155	516	.0275	290	.0395	202
.016	500	.028	286	.040	200
.0165	484	.0285	280	.0405	198
.017	470	.029	276	.041	194
.0175	456	.0295	272	.0415	192
.018	444	.030	266	.042	190
.0185	432	.0305	262	.0425	188

5. Specify "free from slitter dust." Slitter dust causes all sorts of trouble with spots in print when the job is being produced. Dust piles up on the blanket of offset presses, and contaminates the inking systems. The result is spoilage and lost time for washups. (Note: Most mills wind satisfactory rolls. They have overcome the "slitter dust" trouble by installing special vacuum cleaning units on papermaking and slitting machines.)

6. Stipulate "tightwound rolls." Soft, unevenly wound rolls are useless. They are likely to telescope in transit. When rolls are slightly uneven—high on one side—the paper can be run, but only with care and at a great loss of time.

7. Provide the proper "core" information. There are no standard-size cores. Weights of paper and board dictate diameter and style. Three-inch cores are in most general use. Some operators want nonreturnable cores; others want returnable cores. Some want slotted cores, others do not.

8. Stipulate "rewound" when rolls are narrow width. Narrow-gauge equipment is high-precision equipment. Slitting must be exact. Winding must be firm and uniform.

9. Estimate carefully. Do not take anything for granted. Allowances—differentials between standard-packed sheets and rolls—are not standard with all paper manufacturers. Until buyers establish an expert working knowledge of mill practices, it is wise to investigate each purchase. For instance, some mills deduct different amounts from prices for paper packed in cartons to arrive at cost of roll merchandise. Some mills make no additional charge for winding rolls larger than 11 in. Other mills charge an additional sum for rolls between 12 and 17 in. in width. Still another charge is added for rolls narrower than 11 in. Weight per roll also determines pricing. Some mills price rolls of 250 lb. higher than 500 lb. rolls. It is, therefore, best to check when ordering. Take nothing for granted.

10. Specify "wire-side out" or "felt-side out." Since most paper is C2S, this specification is often unimportant.

11. Specify "directional arrows to appear on wrappers." This detail is important to minimize roll-handling time.

12. Give handling instructions for shippers. Stipulate "load on side" or "load on end."

13. Specify "for four-color web offset printing on four-unit press." Here again, this instruction seems unnecessary. But, as in all good order writing, take nothing for granted. Also, paper manufacturers do like to know on what presses their rolls are being printed.

14. Be sure to stipulate that the mill "number all rolls and show roll weights on wrappers," since no two rolls are identical in weight. Then as you receive the shipment, inventory the paper, and select rolls for press, you can easily identify them and easily fit their contents into each job requirement.

15. Be sure to ask for shipping papers with roll numbers and weights. Shipping, stock, and accounting departments need this information.

16. On the side of each roll, near the core, mark lot number, roll number, roll weight, and manufacturers' code. All buyers of roll paper should follow this procedure.

Points to Remember. The weight of roll includes outside wrapper and nonreturnable core. You are billed for gross weight of the roll—paper, wrapping, and nonreturnable core. Weight of returnable core is not charged. When estimating, be sure to allow for spoilage.

Determining Weight of Paper in Rolls. An example showing the approved method of figuring the approximate weight of paper in rolls follows: To determine the weight of a roll of *bond paper* that is 30 in. in diameter and 12 in. wide, (1) square the diameter, $30 \times 30 = 900$; (2) multiply by the width, $900 \times 12 = 10,800$; and (3) multiply by the factor 0.027, $10,800 \times 0.027 = 291.6$ lb.

These are the factors to use to determine the approximate weight of a roll of paper: antique finish, 0.018; machine finish, English finish, offset, bond, ledger, writing, manifold, onionskin, 0.027; super, 0.030; coated two sides, 0.034; coated one side, 0.030; newsprint, 0.0162. These factors, an average among paper manufacturers, apply for all weights.

For any given diameter, lighter weight papers will bulk less. More of it, therefore, will be wound on a roll.

Determining Approximate Linear Yardage in Paper Rolls. An example showing the approved method of figuring approximate linear yardage in a roll of paper is as follows: (1) multiply the weight of the roll by 12,000, 100 lb. \times 12,000 = 1,200,000; (2) multiply roll width by basis weight, 24 in. \times 50 lb. = 1,200; and (3) divide the product obtained in step 1 by the product obtained in step 2, $1,200,000 \div 1,200 = 1,000$ yards.

Determining the Number of Reams in a Roll of Paper. The approved method of determining the number of reams in a roll of paper is to divide the approximate weight of

CHECK LIST FOR ORDERING PAPER IN ROLLS

GRADE	
QUANTITY pounds	Type of Press
Maximum Basis Weight pounds	Speed of Press
Maximum thickness pages-to-inch	Maximum ink drying temperature
Maximum Roll Width inches	Type of Delivery
Maximum Roll Diameter inches	
Core Inside Diameter inches	

Type of Core
- ☐ returnable ☐ non-returnable
- ☐ slotted ☐ not-slotted
- ☐ slots in juxtaposition ☐ Dimensions of Keyway x

Roll-winding ☐ felt-side OUT ☐ felt-side IN

Note — MARK DIRECTIONAL ARROWS ON WRAPPERS

Splicing
- flag ☐ one-side ☐ two-sides Maximum acceptable to roll
- ☐ diagonally across roll
- ☐ use 3-M splicing material for heat-set reproduction

Wrapping ☐ moisture-proof ☐ non-moisture-proof
Delivery ☐ on side ☐ on end

PLANT HUMIDITY REQUIREMENTS
Special instructions
- ☐ Rolls must be wound uniformly firm ☐ Indicate weight of each roll on wrapper
- ☐ Surface of paper must be free from lint and other extraneous materials ☐ Indicate roll-number and winding direction on ends of rolls
- ☐ Provide roll cards in core of each roll ☐ Provide packing slips complete with roll-number, weight-per-roll and number-of-splices-per-roll
- ☐ Number each roll on wrapper

SHIPPING ☐ siding on RR
- plant can accommodate trailers up to feet long
- ☐ sidewalk delivery by winch truck

Most satisfactory delivery hours AM to AM PM to PM Receiving platform closed to

SPECIAL MARKING ON ROLL WRAPPERS ..

SAMPLE FOR MATCHING ACCOMPANYING
NOTE — Be sure to send out-turned samples in advance of shipment.

Courtesy of Walden-Mott Corp.

the roll by the weight of the ream. The result is approximate because the weight of core and plugs is not considered.

Paper Spoilage Allowances. In both letterpress and offset, presswork and binding spoilage are based on sheets of stock required for the job and not impressions for the job. A work-and-turn job of 5,000 quantity printed in one color is calculated as 2,500 sheets (quantity required for work-and-turn form, which will allow two out of a sheet).

Care should be taken to make certain to use the correct figure when determining the number of sheets. For instance, 5,000 press sheets of 25×38 in. would take the 5,000 figure for press work, but it would be 10,000 when figuring folding, etc., if this sheet has to be cut in half (to 19×25 in.) before the binding operation.

Based on the experience of each plant, these figures should be modified where troublesome stocks are used.

The percentage of spoilage can be reduced slightly on large runs where plant experience so dictates.

PAPER SPOILAGE ALLOWANCES

	1,000	2,500	5,000	10,000	25,000 and over
Single-Color Equipment					
One color, one side	8%*	6%	5%	4%	3%
One color, work and turn or work and tumble	13	10	8	6	5
Each additional color (per side)	5	4	3	2	2
Two-Color Equipment					
Two colors, one side	—	—	5	4	3
Two colors, two sides or work and turn	—	—	8	6	5
Each additional two colors (per side)	—	—	3	2	2
Four-Color Equipment					
Four colors, one side only	—	—	—	6	5
Four colors, two sides or work and turn	—	—	—	8	7
Bindery Spoilage					
Folding, stitching, trimming	4	3	3	2	2
Cutting, punching or drilling	2	2	2	2	2
Varnishing and gumming	7	5	4	3	3

*Percentage represents press-size sheets, not impressions.

The above figures do not include waste sheets used to run up color, as it is assumed that waste stock is used for this purpose.

Use the next higher percentage for the following papers:

1. Coated papers when plant does not usually run coateds.
2. Papers that caliper .0025 in. and less.
3. Difficult papers, such as foil, cloth, plastic, etc.

NOTE: This paper spoilage chart has been reproduced through the courtesy of the Printing Industries of Metropolitan New York.

The Bindery

Section One: Introduction and Overview

The bindery is often the location of all types of production operations occurring after press operations, only one of which is actually binding. Thus, an appropriate term for work done in the bindery (e.g., folding, binding, trimming, thumb-indexing) is *finishing*. Finishing operations also include work done in line with the press but subsequent to actual presswork. This chapter covers the various finishing operations: the methods and equipment used to accomplish cutting, folding, assembling, binding, trimming, and book covering. The type of binding is the key to associated operations.

MAIN TYPES OF BINDING

Binding can be categorized into several types according to the end product. Most binderies are involved in only one or two of these types: (1) pamphlet binding, (2) case binding, (3) mechanical and loose-leaf binding, (4) manifold binding, and (5) blank-book binding.

Pamphlet Binding. Pamphlet binding is a widely used term that is somewhat inaccurate because it involves the binding of leaflets, folders, booklets, magazines, soft-covered books, even telephone books. Many of the binderies that handle this type of work are trade binderies.

Case Binding. Casebound books are still what we tend to think of when we hear the term "books." The covers, or "cases," consisting of rigid or flexible boards that are covered on both the outside and on the edges ("covers-turned-over-boards") with cloth, leather, or other material, are made separately from the books. Then the books are bound ("cased in") in such a way that the covers project beyond the edges of the pages.

Casebinding can be conveniently divided into three different branches: (1) edition binding, (2) job binding, and (3) library binding. These terms refer to both quantity and the nature of binding provided. Edition binding is the binding of casebound books in relatively large quantities. Because edition binders use mostly automatic and semiautomatic equipment, they rarely handle runs smaller then 1,500.

Job binding is the binding of small quantities of casebound books. It involves considerable amounts of handwork and is also used for books that cannot be handled by automatic equipment, such as Bibles and prayer books bound in limp leather.

Library binding is a special service rendered to libraries and includes prebinding, rebinding, and general repair work. Library binders, like job binders, deal with small quantities and use considerable handwork. The main purpose of library binding is to provide books that are sturdy enough to withstand the wear and tear to which books are exposed in public libraries.

Mechanical and Looseleaf Binding. Mechanical and looseleaf binding is the binding of individual leaves of paper by means of an independent binding device. In mechanical binding, the leaves are not interchangeable, the cover is often soft, and the binding device is usually a plastic or metal backbone—either a spiral, a comb, or a series of parallel rings—that is inserted into holes punched through both the covers and the pages. Mechanical binding products include advertising and sales literature, stationery items, calendars, and cook books.

In looseleaf binding, the pages are interchangeable, the cover is usually fairly sturdy, and the binding device is almost always riveted into or otherwise attached to the cover. Prongs, rings, or posts that can be opened and closed are inserted through holes punched in the pages. Looseleaf binding products are used wherever information must be continually added to or changed (e.g., manuals, catalogs, financial records).

Manifold Binding. Manifold binding is the binding of multiple business forms, such as purchase orders, sales records, or billheads. It may also include the punching of custom-made forms that are kept in looseleaf binders.

Blank-Book Binding. Blank-book binding is the manufacture of books having either blank or ruled pages. Ruling may be done either at the bindery or in the pressroom. Because blank books must be sturdy, they are often casebound. Blank books are mostly used for accounting and record-keeping purposes, but also include albums and scrapbooks.

STAGES OF FINISHING

The remainder of this chapter deals with the various stages of finishing, which are briefly outlined here.

Planning. Finishing must be considered from the very beginning, even if the job is to be bound outside of the printing plant. If a printing job is not well planned, it may not be suited to the available equipment, resulting in loss of time, money, or even the entire job.

An important planning tool is the imposition layout, which is a diagram indicating the positioning of pages to be printed on a sheet. This is important in determining how a sheet is to be folded. There are many imposition manuals available from binderies, folder manufacturers, and the U.S. Government Printing Office.

Sheet Cutting. Sheets are usually cut before printing, before collating, and/or before folding or diecutting. The most common type of cutter is the guillotine, or straight cutter, which is available in various sizes and models, from small, operator-powered cutters to large, computer-controlled models.

Folding. Most books consist of sections called signatures. The signature starts out as a single large sheet on which many pages are printed. After printing, the sheet is folded into pages (some or all of the folds may later be trimmed off). The folding is usually accomplished on either a buckle folder, a knife folder, or a combination of the two. Other jobs that require folding include pamphlets, maps, and mass mailings.

Assembling. Most books have several signatures. After they are folded, they are assembled either by gathering or by inserting. In gathering, the signatures are stacked, one on top of the other. In inserting, the signatures are inserted, one into the other. Another method of assembly, collating, involves the stacking of individual cut pages, one on top of the other. All of these processes are usually performed on high-speed automatic equipment.

Binding. After the signatures are assembled, they are fastened together. There are many ways to do this, and the method depends on the way the book was assembled and on the desired end result. Gathered books are usually either Smyth-sewn (threads sewn through the centerfold and also linking signature to signature) or adhesive-bound. Sometimes they are side-sewn or side-stitched. Inserted books are usually saddle-sewn or saddle-stitched; collated books are usually side-stitched or adhesive-bound. In mechanical and looseleaf books, the binding device is generally inserted into holes punched in the leaves. Binding is usually performed on high-speed machines, many of which also incorporate assembling, trimming, and covering.

Trimming. When trimming is performed in line with binding, it is usually done with a three-, four-, or five-knife trimmer, which trims three sides of the book (or two or three books) in two or three successive cuts. Sometimes the job is trimmed on a guillotine cutter.

Covering. Saddle-bound and mechanical-bound books are often covered during assembly, the cover being attached during the binding process. Most books, however, are covered after they have been bound. First, the book is usually subjected to preparation processes, which may include nipping or smashing, edge treatments, rounding, backing, backgluing, backlining, and headbanding.

Because the main purpose of covering is to protect the book, covers are almost always made of a sturdier material than the rest of the book. Covers for casebound books, called cases, are some of the sturdiest; they consist of boards covered with cloth or other material. Loose-leaf and some mechanical binders are also made of covered boards into which the binding device is incorporated. Adhesive-bound books are usually covered with a heavy grade of paper that is attached by means of a hot glue. Pamphlet covers, which are also of a heavy grade of paper, are attached by means of wire stitches or special thread. All of these processes can be, and often are, done in line with the assembly, binding, and trimming of the book.

Section Two: Planning

COMMUNICATION

All too often printers consider finishing a separate process that occurs after printing. This leads them to disregard the restrictions and capabilities of the bindery while planning a job. It is better to view finishing, as well as printing and prepress production, as part of the total system of graphic arts reproduction.

Finishing must be considered from the start, even when the job is not bound in-plant. The customer must specify what he wants and the printer must discuss it with the binder to determine not only if the job can be finished on his equipment, but also the best, most economical way to do it.

If this type of communication does not take place, the consequences can be quite serious: loss of time because extra steps must be taken, handfed equipment must be used, the job must be sent elsewhere to be bound, or the job must be redone; loss of money because extra time is required, expensive equipment must be used, the job must be sent out, or the job must be redone; and, perhaps, loss of a customer, especially if the job must be scrapped or redone.

IMPOSITIONS

The subject of impositions is extensively discussed in Section Eight of Chapter Nine, "The Stripping and Photocomposing Departments." However, since it is so important to the bindery, a brief overview is given here. Imposition is the arrangement and positioning of units of a job (e.g., pages, labels, checks) on a sheet or section of web of paper to meet the requirements of the

job. It is important to coordinate design, printing, and finishing so that, once printed and finished, the units appear in the proper order and positions.

An important consideration in design, printing, and finishing is the placement of the sheet both on press and in the folder. Most sheets are oblong, and one long edge is designated the gripper edge and one short edge, the guide edge. On press, the sheet is positioned so that the gripper edge, which is clamped by grippers during printing, is aligned against the front guides and the guide edge is aligned against the side guides. The first-printed surface is called the face and the other side is called the back. Printing the second surface is called perfecting or backing up.

There are four standard impositions: sheetwise, work-and-turn, work-and-tumble, and work-and-twist.

Sheetwise Impositions. In sheetwise impositions, half of the total number of units to be printed on the sheet are printed on each side. This method requires two plates for every color, one each for the face and the back.

Work-and-Turn Impositions. In work-and-turn impositions, all the units to be printed on both sides of the sheet are

Two four-page sheetwise plates for an eight-page booklet. The double "x" indicates the gripper edge, and the single "x" indicates the guide edge. When the sheet is turned over in such a way that the same two edges are used for the gripper and side guide, page 2 backs up page 1, etc.

An eight-page work-and-turn plate for an eight-page booklet. When the sheet is turned over so that the gripper edge remains the same, the guide edge on the right will appear on the left, and the press guide is changed accordingly. The sheet is cut along the dotted line.

placed in such a way that when the sheet is turned over and the same gripper edge is used, one half of the sheet automatically backs up the other half. The side guide is moved to the opposite

An eight-page work-and-tumble plate for an eight-page booklet. When the sheet is turned over so that the guide edge remains the same, the gripper edge is switched to the opposite side. Thus page 2 backs up page 1, etc. The sheet is cut along the dotted line.

A work-and-twist imposition for a single sheet printed on one side only. The sheet is twisted around so that both the gripper and the guide edges are switched to opposite sides. A cut parallel to the guide edge (dotted line) will produce two identical pages.

side of the press during backup, which, in effect, keeps the same edge of the sheet as the side guide edge. When the sheet is cut in half parallel to the guide edge, two identical sheets are produced.

Work-and-Tumble Impositions. Work-and-tumble impositions are like work-and-turn impositions except that the gripper edge is changed when backing up. This method is not recommended unless the stock is accurately squared, otherwise changing the gripper edge will result in loss of register. When the sheet is cut in half parallel to the gripper edge, two identical sheets are produced.

Work-and-Twist Impositions. In work-and-twist impositions, the sheet is not flipped to the back. Instead, it is twisted so that the image that was printed on the left side is printed on the right and vice versa. In this method, both the gripper and the guide edges change; thus, it should not be used unless the stock is perfectly square. This imposition is very rarely used.

IMPOSITION TOOLS

Several useful tools aid in the coordination of the different phases of a job: the page layout, the imposition layout, the folder dummy, and the binding dummy. They are used as models, aiding the planners in visualizing the finished product or any intermediate process. Not all of these layouts and dummies are used for every job; which ones are necessary is determined in the planning stage.

Page Layout. The page layout is a blueprint of the page. It indicates the type page size, trimmed job size, top, outside, and foot trims, untrimmed page size, and head, foot, outside, and bind margins. (See first illustration, page 9:26.)

Imposition Layout. The imposition layout is a diagram indicating how a sheet of paper must be folded to obtain a specific result. It indicates the folding sequence, number of pages, and type of signature thus created, guide and gripper edges, and cutting and scoring lines. Manufacturers of folding equipment usually have available manuals that show the types of impositions that their folders are capable of. Places such as large binderies, book printing plants, and the U.S. Government Printing Office also provide imposition books. The designer need not use a standard imposition; however, he had better consult with the person in charge of folding before designing a new imposition.

Folder Dummy. The folder dummy resembles a folded version of an imposition layout. It indicates the placement of page heads, the binding edge, the gripper and side guide edges, as well as page sequence, arrangement of signatures, and which pages go on which plates. The folder dummy should be made or approved by the person in charge of folding. (See second illustration, page 9:26.)

Binding Dummy. The binding dummy looks like a bound version of the folder dummy. The main purpose is to help determine how much of the bind margin is lost on account of the binding, especially side-sewn or -stitched bindings.

10-PAGE, ACCORDION FOLD

Parallel: 1,2,3,4

May be run two or more up and cut apart

12-PAGE BOOK, SADDLE STITCH

Parallel: 1,3
8-Page: 1

12-PAGE BOOK, SADDLE STITCH DOUBLE IMPOSITION

Parallel: 1,2
8-Page: 1,2,3

16-PAGE, PARALLEL — BOOKLET

Parallel: 1,2,4

Some representative fold impositions.

PAPER CONSIDERATIONS

Paper and how it affects finishing must also be considered from the beginning. If suitable size and type of paper is not in stock, it must be ordered or the plan must be changed. Consideration of size, grain, and weight is important, as are squaring and shingling considerations.

Size. Paper comes in several standard sizes. Selection of paper should be based on available press size and folder size as well as the size and number of units to be printed on the sheet. Made-to-order paper is also available but is more expensive and is mainly used for special long runs.

Grain. The job should be planned so that the grain of the paper runs parallel to the binding edge; otherwise, the paper will tend to crack at the folds. The grain should also run parallel to the axis of the cylinder of a lithographic press. These two requirements may sometimes conflict and, if so, a solution must be worked out ahead of time.

Weight. The weight of paper must be considered when determining the number of folds per signature because lighter paper can accommodate more folds than can heavy paper.

Squaring. For work-and-tumble and work-and-twist impositions, the design must allow for squaring of the entire sheet of paper. For the others, only the gripper and side guide edges must be at right angles.

Shingling. In saddle-stitched books, especially those made of heavier paper and/or having many leaves, the outside edges of the pages project out more the nearer they are to the center of the book, a condition known as creep, or pushout. If this condition is anticipated during planning, the designer can plan for shingling, a method whereby the margins are adjusted from page to page to counteract creep.

Pushout on a saddle-stitched booklet.

Section Three: Sheet Cutting

Because printing is often done on large sheets of paper, usually several units per sheet, the paper must be cut at some point in the process. That point is determined by the purpose of the cut. There are four major purposes of sheet cutting: (1) squaring blank sheets before printing, which is usually done in the bindery even though it is a prepress operation; (2) dividing printed sheets prior to folding or diecutting; (3) cutting sheets into individual leaves prior to collating; and (4) separating sheets into individual units to be shipped as such.

Sheet cutting in the bindery is done on guillotine cutters, which operate on the same principle as the original guillotine used for beheading people. A long, heavy, sloping blade, each end in a vertical track, descends to a table, or bed, slicing through a stack or lift of paper. Guillotine cutters are available in a number of models and sizes, but all share several characteristics: knife, bed, side and back gauges, and clamp.

Knife. The knife, which is bolted to a knife bar, is mounted near the front of the cutter. The cutting edge is sharpened in a bevel shape, the length and angle of which should be suited to the type of material being cut, harder materials requiring a sharper angle and longer cutting edge.

Bed. The bed is a flat metal table on which the paper is placed for cutting. It is positioned at a convenient height so as to minimize operator fatigue. Some guillotine cutters, especially

Courtesy Rockwell Graphic Systems

Wohlenberg cutter with microcomputer.

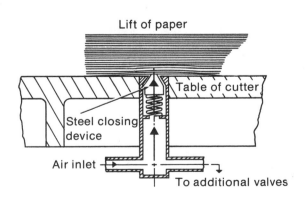

Air film valve in cutting table.

those with automatic spacing (back guide placement), are equipped with air-float tables.

Side and Back Gauges. Sheet positioning, which is important for accurate squaring and cutting, is achieved by means of side and back guides. The side guides, perpendicular to the knife, are stationary and the back guide can be moved to accommodate various cutoff lengths.

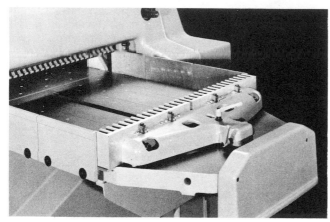

Courtesy Rockwell Graphic Systems

Side and back gauges of cutter.

Clamp. The clamp is a metal bar that is positioned parallel to the knife and precedes it in its downward motion. It has a twofold purpose: (1) it compresses the pile, forcing the air out from between the sheets, and (2) it holds the pile in place during cutting.

The most basic guillotine cutters are operator-powered. The clamp and back guide are set by hand and the operator uses a lever to manipulate the knife. Because manual sheet cutters can accommodate only relatively small lifts and manual operation is very fatiguing and time-consuming, they are generally used only by small shops.

Most binderies use power cutters in which the action of the knife is electrically powered, either directly or indirectly. In addition, the clamp and/or back gauge may also be automated, and the position of the back gauge may be indicated by a display. These cutters are very fast and precise.

Many power cutters, today, also have automatic spacing, which substantially increases productivity for long runs requiring

many cuts. The operator presets the spacing of the back gauge for the total sequence of cuts, which are then performed automatically for all subsequent lifts. Automatic spacing is usually controlled by magnetic tape, but the latest high-speed cutters have microcomputer-controlled spacing. Some even have memory for storage of programs to be used later. Because these cutters are designed for high-speed, high-volume production cutting, it is very beneficial—almost imperative—to use with them devices such as stack lifts, automatic loaders and unloaders, sheet joggers, conveyer lines, and waste chutes.

Because guillotine cutters are powerful cutting machines, they must and do have built-in safety features, such as two-handed operation, nonrepeating knife, electric eyes triggering a dead stop, and safety bolts. They should be operated in careful accordance with the manufacturer's instructions.

To cut sheets, first a cutting layout must be prepared, indicating type of cutting machine to be used, height of lift, sequence and position of cuts, margin sizes, final size, and other pertinent information. After the sheets are checked in, they are placed on a stock table, press skid, or automatic lift so as to be readily accessible to the operator. The cutter is then set, either for the first cut or for the whole sequence (in the case of cutters with automatic spacing), and the first lift is winded and jogged, to avoid sticking and align guide edges, and stacked against the side and back gauges. The clamp and knife are then activated and the sheets cut. Cutting produces a lot of waste paper, which must frequently be removed from the bed; sometimes it is sold to a paper mill.

Courtesy Heidelberg Eastern, Inc.

Interchangeable memory of Polar EMC cutter.

Section Four: Folding

TYPES OF FOLDS

There are two types of folding sequences that are basic to folding: parallel folds and right-angle folds. In parallel folding, all subsequent folds are parallel to the first fold. In right-angle folding, at least one subsequent fold is at right angles to the first one.

Using these two basic folds, then, one can achieve a wide variety of configurations. Some of the most common are

accordian folds, signature folds, gate or panel folds, over-and-over folds, French folds, and letter folds (see illustration).

FOLDING MACHINES

There are two main types of folding machine: the knife folder, which is best suited to right-angle folding, and the buckle folder, which is best suited to parallel folding. Some folders combine both knife folding and buckle folding.

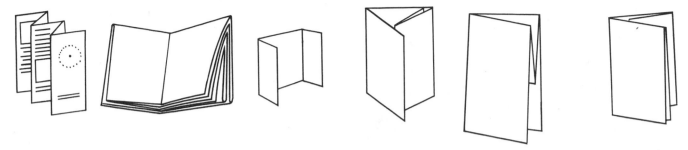

Some common folds are (left to right) accordian, 32-page signature, gate, over-and-over, French (heads in), and letter.

Knife Folders. Knife folders are constructed in levels, usually three or four, that are set at right angles to each other. Some models have additional parallel sections on at least one of the levels. After a sheet is fed into the folder, moving canvas tapes convey it into the first fold level, where it is stopped by a gauge, positioned against a side guide, and thrust between two counter-revolving rollers by a folding knife. The folded sheet has, thus, descended to the next level, where canvas tapes convey it to the next fold station, and the process is repeated until the desired number of folds is made. Most folders are also equipped with perforators, which perforate the folds, allowing air to escape and, thus, preventing wrinkles. Other attachments include slitters, pasters, and trimmers.

There are three main models of knife folder—the jobber, the double-16/double-32, and the quadruple—each differing in its configuration and the jobs to which it is suited.

Principle of knife folding.

The *jobber* has four folding levels and one or two parallel sections, enabling the production of up to four right-angle folds, or two right-angle folds with a third fold parallel to the second, or three right-angle folds with a fourth fold parallel to the third. The jobber is the most popular of the knife folders because of its flexibility; it is a general-purpose folder.

The *double-16 folder* is specially designed to produce two 16-page units, either separately or inserted for a single 32-page signature. The addition of a double-32 section enables the production of two (smaller) 32-page signatures. The double-16 is used mostly for publication work.

The *quadruple folder*, commonly called the quad, is specially designed to produce four 16-page units, either separately or inserted to make two 32-page units. The advantage of the quad is that the four units are produced from a single sheet and that they

have closed heads, which aid greatly in subsequent binding operations. It is used mostly in edition binding.

Buckle Folders. In buckle folding, diagonal rollers both position the paper against the side guide and convey the paper to the folding mechanism. For each fold, two feed rollers push the sheet between two metal plates collectively called a fold plate. When the sheet encounters a stop placed in a preset position inside the fold plate, it begins to buckle at the entrance of the fold plate. The buckle is then seized by and pulled between a third roller and the bottom feed roller. These two rollers act as the feed rollers to the next fold plate, which is inverted.

Four-pocket section of a buckle folder. Such a section can make up to four parallel folds. Letters indicate the four fold plates, figures indicate the six rollers involved. The sheet has received its second fold in "B" and is being moved into the third fold plate "C."

Buckle folders are designed to be modular, each section consisting of one to four consecutive, parallel fold plates. Right-angle folds are made by joining the section at right angles. In each section, one or more of the fold plates can be bypassed, using a deflector at the opening of the plates. These folders can also be equipped for pasting, slitting, and perforating.

Courtesy Baumfolder Corporation

Model 730 Commercial folder.

Combination Folders. Combination folders, as the name implies, combine both fold plates as used in buckle folding and knives as used in knife folding. In the most common configurations, the first section consists of several fold plates, and subsequent levels contain right-angle folding knives. Most combination folders are also equipped for perforating, slitting, and pasting.

MAIN STEPS OF FOLDING

The proper, efficient operation of a folder requires careful preparation and adjustment. First, the sheets must be fanned and loaded into the feeder. There are two basic types of feeders—the continuous feeder and the pile feeder—and within these two categories there is some variation. However, all feeders require adjustment to achieve proper separation, positioning, and feeding of the sheets.

Next, the first folding section must be adjusted for proper positioning and folding. This includes the feed tapes or rollers, side guides, deflectors, fold stops, knife impact, scoring or perforating members, and folding speed. All subsequent folding sections to be used must be similarly adjusted, bearing in mind that with every fold the sheet gets increasingly bulky.

Various attachments, such as parallel sections, pasters, slitters, and trimmers, must also be set if they are to be used. Finally, the output of the folder must be regulated according to the handling method, be it packing, stacking, or bundling.

When all the adjustments are complete, a slow trial run is made to assure that the desired fold is achieved as perfectly as possible. Throughout the folding run, the feeder must be constantly loaded and the folder should be checked by periodically pulling a few signatures to proof. Any significant deviation requires an adjustment.

Section Five: Assembling

Bringing the pages of a printed piece together in proper sequence—assembling—may be accomplished in a number of ways, depending on the nature of the unit to be assembled. If all the pages of the total piece are on one sheet that is to be folded, the folding operation itself brings all the pages together in proper sequence. But the term "assembling" as used here applies only to the bringing together of separate units, either a set of individual sheets or a set of sections—signatures—to be combined into a larger whole.

Assembling individual sheets is called *collating*. (It must be pointed out here that the term "collating" is also used in other ways, sometimes in connection with its second meaning of verifying a sequence.) Assembling signatures one on top of another in proper sequence is called *gathering*. This requires signatures whose pages are consecutively numbered. Assembling signatures one inside another in proper sequence is called *inserting*. This requires signatures whose page numbering sequence leaves a gap for the other signatures to be inserted.

COLLATING

The assembling of individual sheets may be performed by hand or by using semiautomatic or automatic equipment.

Collating is often used in the assembly of loose-leaf or mechanically bound books.

Hand Collating. For hand collating, piles of each different sheet are arranged sequentially around a table or in vertically stacked bins, a lazy susan, or some rack arrangement designed to save space and reduce operator movements during assembly of sets. Some racks have foot-operated or automatic ejection of sheets.

Courtesy Michael Business Machines

Hand collating with automatic ejection of sets.

Semiautomatic Collating. One type of semiautomatic collator uses a single-sheet feeding system, similar to those on duplicators, to insert sheets into vertical or circular moving bins. The material to be collated is loaded, one pile at a time, into the feeder, which inserts one sheet from the pile into each bin. A sheet from each succeeding pile falls onto the preceding sheets in each bin.

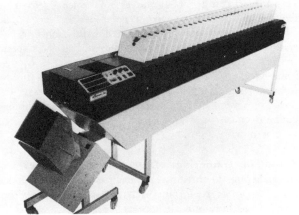

Courtesy Michael Business Machines

Automatic 30-station collator with gravity feed.

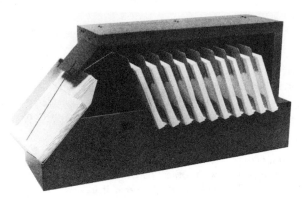

Courtesy Michael Business Machines

Fully automatic ten-station tabletop collator.

Automatic Collating. Automatic collators have feeding stations for each pile of material. One type drops different sheets through individual channels, which come together at the exit point below. Another type feeds by lifting each sheet with vacuum suckers and dropping it onto a raceway moving at right angles to the direction of feeder placement. Still another feeds from the bottom of the pile in the same direction as the movement of the sets being assembled, while the piles are replenished from the top. Both of the latter types feed continuously from all piles onto the accumulating sets moving by. Some automatic collators also gather signatures.

GATHERING

Gathering is the same as collating except that signatures instead of single sheets are assembled on top of each other. It is the most frequently used assembly method. As in collating, gathering methods range from mechanically unassisted hand methods to highly automated operations.

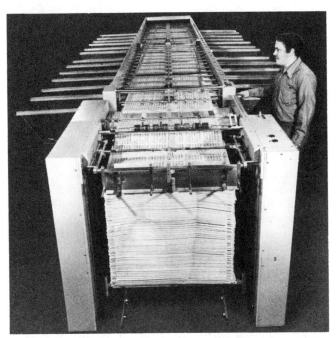

Courtesy Michael Business Machines

Large-sheet automatic collator.

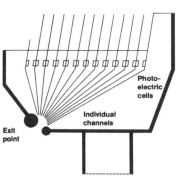

Courtesy Michael Business Machines

In loading position

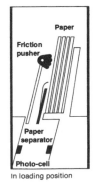

Friction pusher lifts first sheet

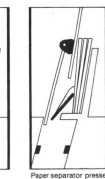

Paper separator presses stack of sheets

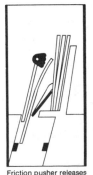

Friction pusher releases sheet and gravity takes over

Sheet drops down each individual channel through photoelectric beam

Mechanism of gravity feed system. Friction pusher lifts front sheet, paper separator presses stack of sheets, friction pusher releases sheet, which drops through photoelectric beam in channel.

Hand Gathering. Long tables on which piles of the different signatures are arranged in the proper sequence provide the layout for mechanically unassisted hand gathering. The operator simply walks around the circuit, adding one signature from each pile to the accumulating book.

Some *mechanical assistance* is provided to the manual operation by a rotating circular table with signature trays. One operator or several may be seated at the table, each taking a signature from each tray as it passes. The speed of rotation can be regulated.

Automatic Gathering. Mass production requires automatic gathering. Gathering machines have a feeding station, called a *hopper* or *pocket*, for each different signature. Some machines have thirty or more hoppers.

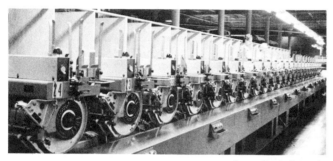

Courtesy Harris Corporation

Harris rotary gathering machine.

The machines have a segmented conveyor, or raceway, moving past the feeding stations. Each hopper deposits a signature onto the conveyor segment passing it at the same time that the other hoppers are depositing their signatures onto other segments. Thus, complete books are assembled on the moving conveyor: one complete book for each one-segment conveyor advance.

To provide for continuous operation, signatures are fed, either manually or mechanically, into one end of the hopper while the machine removes signatures from the other end. One type of mechanism for removing a signature from a hopper and depositing it on the raceway is a rotary drum with grippers. A detecting

mechanism determines whether any signature was missed, doubled, or incomplete, in which case either the machine stops or the defective book is ejected while the operation continues. Collating marks on the backs of the signatures provide a visual check on the correctness of the signature sequence in the assembled book.

Automatic gatherers are often run in line with binding equipment, as described subsequently.

INSERTING

Assembling signatures by placing one inside another is called inserting. Inserted books are bound by saddle stitching—putting wire staples through the fold—or center sewing. There is a practical limit to the thickness—generally considered to be about ¼ in. open or ½ in. folded—of a magazine or book to be bound in this manner.

Unlike gathering, inserting can be a complete assembly, including cover, in the case of soft-covered items. If the cover is printed together with other parts, the book is said to be *self-covered*. The book is called *covered* if its cover is separately printed, sometimes (but not necessarily) on a stock heavier than that of the book.

Hand Inserting. Inserting, like gathering, can be a hand operation without any mechanical assistance, or it can involve hand feeding onto a saddle-bar over a moving conveyor chain. In the latter case, sometimes called semiautomatic inserting, there must be a feeding station for each different signature and an operator feeding at each station.

The conveyer chain, a continuous loop, is divided into segments by means of adjustable pins. As feeding operators at the various stations open the signatures to their centers and place them over the saddle-bars, the pins on the moving chain sweep the signatures off the saddle and onto a chain segment over other signatures from feeding stations upstream. Thus an entire book is assembled during a one-segment advance of the chain.

Automatic Inserting. The continuous-loop pin-segmented conveyer chain, with the addition of mechanical feeding stations, manually or mechanically replenished, is the essence of the automatic inserting machine. Automatic inserting is commonly used in line with automatic stitching, trimming, and sometimes other operations, as discussed subsequently.

Signatures to be fed mechanically must have either a *lip,* or *lap*—the additional portion of one half of the signature that extends somewhat (about ⅜ in.) beyond the edge of the other

Courtesy Harris Corporation

Feeding stations of rotary gathering machine.

Courtesy Harris Corporation

Inserting stations for saddle-stitched books.

half and is gripped to open the signature—or a closed head so that the signature can be opened at the center by means of suction applied to the outer surface. The opened signature is dropped on the proper segment of the chain over other signatures. Again, an entire book is assembled during a one-segment advance of the continuously moving chain.

Section Six: Binding

The term "binding" as used in this section refers to the wide variety of ways in which the sheets comprising the body of a book, magazine, or similar graphic arts product are held together. It does not include affixing the cover of a casebound book, which is an essentially different operation, but does include self-covering, as part of the body of the book, as well as the attachment of soft covers. It includes the attachment of hard covers only when they are an essential element of the page binding, as in the case of loose-leaf ring binders.

WIRE STITCHING

One of the simplest methods of joining sheets is by means of wire staples, as with the little office stapler. Bindery production machines operating on the same general principle are called *wire stitchers,* or simply *stitchers.* ("Stitching" in binding implies the use of wire, the term "sewing" being applied to joining with thread.) Wire stitching through the side of a book near the backbone is called *side stitching.* Wire stitching through an insert-gathered book's centerfold is called *saddle stitching.*

Side Stitching. The level of mechanization of bindery stitchers starts with *hand-* or *foot-operated models,* hardly larger than an officer stapler, mostly used for making samples. Table models are operated by a lever arm, floor models by treadles, and both use preformed staples. The book can be moved to different positions on the stitching table for any desired number of stitches.

Power-operated stitchers usually form their own staples during operation from rolls of wire. Simple single-head stitchers require movement of the book to different positions on the stitching table for multiple stitching, with use of a pedal to actuate the powered stitching.

These smaller, simpler stitchers are generally adaptable for either side stitching or saddle stitching. But high-production stitchers are not designed for such adaptation, since they are in-line components of special purpose production lines.

Side stitching produces a very strong binding. Furthermore, it doesn't have as great a book-thickness limitation as that of saddle stitching. Disadvantages, however, include its inability to be opened fully and to lie reasonably flat, with consequent inconvenience in handling during reading and loss of inner margin space. Side-stitched books are not well adapted to self-covering, and with some kinds of attached soft covering, the stitches may press through to the detriment of appearance. This last objection is diminished by the use of flat wire, a practice that is especially common for the heavier wire sizes. The staples are placed parallel to the binding edge about ⅛ to ¼ in. inside.

Saddle Stitching. The manually operated and the simple single-head pedal-actuated power stitchers can be adapted from side stitching to saddle stitching by substituting a saddle for the table.

Courtesy F. P. Rosback Company

Automatic saddle stitcher.

Multiple-head saddle stitchers operate automatically, usually inserting the required two or three (or more) staples in one stroke. However, if more stitches are needed than the number of stitcher heads available, the machine will automatically reposition the book for a second stroke.

For high-volume production work, automatic stitchers are combined in line with such equipment as automatic inserters and multiknife trimmers. See Section Seven.

Courtesy Michael Business Machines

Electric tabletop stitcher in side stitch mode.

Courtesy Michael Business Machines

Electric stitcher in saddle stitch mode.

ADHESIVE BINDING

Padding. The simplest form of adhesive binding is the application of glue to the edges of sheets for the purpose of holding them together temporarily so that individual sheets can be readily removed from the resulting pad as needed. Counted sets of sheets separated by some stiff divider material such as chipboard have a flexible adhesive applied to a trimmed edge of the stack. This animal glue or synthetic adhesive may be spread on with a brush or paint roller. A piece of cheesecloth is sometimes placed over the first coat of glue before application of a second, but no such reinforcing sheet is required when plasticized polyvinyl acetate emulsion is used. After drying, the pads or groups of pads are separated at the chipboard with a knife. Further cutting or trimming may then be done.

Adhesive Bookbinding. Most bookbinding methods use an adhesive somewhere in the process, but in *adhesive binding* (sometimes called "perfect binding") there is no other binding material. While in padding the intent is to hold the sheet edges with a relatively loose grip, in bookbinding it is to hold them as permanently as possible while still permitting the book to open easily and lie flat. The strength of adhesive binding was increased during its development by improvements in binding-edge treatments and adhesive formulations.

In *manual adhesive binding,* the only binding-edge treatment is trimming. The book is then clamped in a way that permits

fanning of the trimmed binding edge in both directions. Adhesive is applied with a brush while the edge is fanned first in one direction and then in the other. Thus adhesive is made to surround the binding edge of each sheet.

In *semiautomatic adhesive binding,* the operator places the book with its trimmed binding edge down into a device that clamps it by lever action and applies the adhesive automatically. Such a device permits use of the improved hot-melt adhesives, which can't be applied manually.

Courtesy Armarco Marketing Co., Inc.

Bind-O-Mat 200 adhesive binder.

High-volume adhesive binding requires *fully automatic adhesive binding* equipment. Such equipment is always part of a continuous production line that includes other operations, and the functional details depend partly on the type of book produced by that line. All saddle-stitched books are very much alike in structure; but adhesive-bound books may be anything from square-back with a simple wraparound paper cover to rounded-back and casebound.

Courtesy Muller-Martini Corp.

The Express modular adhesive binder.

Binding-edge treatment often includes trimming followed by milling and roughening to provide adhesive-absorbing sheet edges. A system called *burst binding* does not trim off the folded backbone edges of signatures but perforates them to permit the penetration of adhesive while retaining bridges of paper. *Notch binding* is a similar system that starts with notched binding edges.

A variety of adhesives have been developed for the varied needs of adhesive binding. Animal glue is satisfactory for many

Model M-81 spine miller.

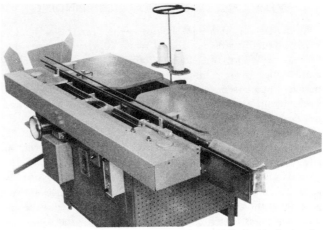

Library semiautomatic side sewing machine.

telephone directories and catalogs; hot-melts have proved more effective for some production systems in the binding of periodicals, catalogs, and paperbacks; polyvinyl acetate (PVA) may be used for edition bindings, catalogs, and paperbacks; both hot-melts and PVA are used in connection with burst binding and notch binding systems.

The attachment of a wraparound paper cover to a square-backed adhesive-bound book is a simple operation that can be performed immediately after the pages are bound.

SEWING

Thread sewing has two major categories: sewing through the side of the binding edge, called *side sewing;* and sewing through the centerfold, which can be called *saddle sewing,* a term parallel to "saddle stitching" in the wire stitching area. But the general term "saddle sewing" is not much used, the main types being better known by the name of the machine most commonly associated with each type: the Singer saddle sewer, which sews through the centerfold of single-signature books; and the Smyth sewer, which uses through-the-centerfold threads not only to hold the sheets of the signature together but also to link the signatures one to another.

Side Sewing. Side sewing, like side stitching, provides a very strong binding. *Manual side sewing* in its various forms is mostly used for library and repair work, so will not be further discussed here. *Machine side sewing* with a single thread, sometimes called *McCain sewing,* is a fast system suitable for production work. The thread is carried through drilled holes by a needle and looper in a square stitch pattern. Double-thread sewing, called *Singer side sewing,* uses a needle and bobbin system basically similar to household sewing machines except that holes are punched for the needle. It is often used for repair work.

Saddle Sewing. *Singer saddle sewing* joins together at the centerfold the pages of single-signature books only. For the

saddle sewing of books having multiple signatures, a linked-signature saddle sewing system was developed commonly called *Smyth sewing.*

In Smyth sewing, the thread is carried in several parallel rows through the centerfold of each signature and also from one signature to the next. This network of threads binds the pages of each signature together and the signatures one to other.

For each set of stitches (there are several sets—up to six—along the backbone of a book), two holes are punched through the centerfold; a needle carries the thread down through one hole at the same time that a hook descends through the other; a "looper" moving inside the signature engages the thread near the needle's eye and carries a loop of it to the hook; and the needle and hook rise, the hook pulling the loop through the hole and also through the loop from the preceding signature. The sewed signature is pushed back and the next signature is placed on the saddle and into sewing position.

Principle of Smyth sewing.

The operation forms a continuous string of stitched and linked signatures. In the *semiautomatic machine,* the signatures are hand-fed to the saddle and the machine operations—which include, in addition to the sewing, attaching with a strip of paste the first signature to the second and the next-to-the-last to the last, and cutting the threads between books—are actuated by foot pedals. In the *fully automatic machine,* used in production lines, the gathered books are inserted into a feeding station, and all operations are performed automatically.

MECHANICAL AND LOOSE-LEAF BINDING

Some bound items are held together not by a binding *material*, such as adhesive, thread, or stitching wire, but by some mechanical *device*, often in the form of rings. In most cases, gathered leaves are trimmed prior to binding and are drilled or punched with a series of round, square, or oblong holes as part of the binding operation, depending on the requirements of the device used.

An advantage of most of these devices is a binding that lies open and flat more freely than does any other kind, and without any appreciable strain on the binding.

The variety of devices is so great that a general discussion can be useful only in terms of basic types. The first distinction made is between those that do not provide a means for removing and inserting pages at will and those that do. Only the former are generally referred to as *mechanical binding;* the latter, while also "mechanical binding" in a sense, are known as loose-leaf binding.

Courtesy Hans Sickinger Co.

Semiautomatic speed punch.

Mechanical Binding. *Spiral binding* requires the threading of a wire or plastic coil into prepunched holes. The coil insertion may be performed by hand, may be started by hand and completed by pressing the coil against a revolving rubber cylinder, or may be accomplished by automatic insertion machines.

There are also several kinds of *ring-type devices*. The plastic *comb* device is first diecut from a rigid plastic sheet in a form with

Courtesy General Binding Corp.

Electric punch.

Courtesy Sloves Mechanical Binding Co., Inc.

Plastic bound easel (left) and double spiral wire binding.

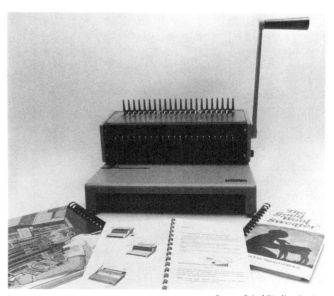

Courtesy Spiral Binding Co., Inc.

Kombo plastic binder and some of its products.

Courtesy Spiral Binding Co., Inc.

Elektro Kombo electric plastic binder.

comblike teeth, which are then formed into rings. It is inserted by a device that rolls the teeth backward and inserts them into punched holes in the book's binding edge. *Closed-ring* devices consist of continuously connected parallel wire loops or metal rings on a backbone. The loops or rings are crimped shut by a closing die after having been inserted by hand into the book's punched holes. Some comb and closed-ring devices, instead of being continuous the full length of the binding, consist of individual two- or three-ring segments, and there are some individual-ring devices.

Another type of binding consists of a plastic strip carrying spikes, or posts, which pass through holes in the sheets and attach to another strip on the other side. This system is adaptable to a wide variety of covers.

Courtesy Velo-Bind, Inc.

Plastic strip-and-spike binding.

Covering Mechanical Binding. Covers for mechanical binding may be two-piece, with the book's backbone exposed; one-piece, scored wraparounds, punched or slotted in the backbone to accommodate the binding device, called semiconcealed binding; or covers that, when closed, completely conceal the mechanical binding.

Two-piece covers can be gathered in the same operation with other sheets of the book. They can be "self-covers"—printed at the same time and on the same stock as the main body of the book—but more commonly they are of a heavier stock. One of the advantages of collated books, as most mechanically bound books are, is that the body leaves themselves can be of freely mixed stocks.

With semiconcealed bindings, the wraparound covers must be put in place after the pages have been assembled but before the binding is accomplished. Some of the concealed bindings use covers that are constructed of boards or other materials and may be as well crafted as those of any edition binding. Such covers are applied in a separate operation as with other hard-cover books.

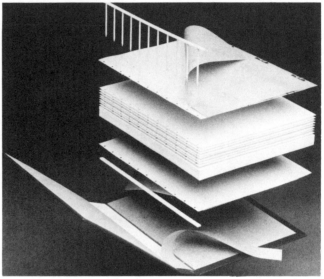

Courtesy Velo-Bind, Inc.

Plastic strip-and-spike binding with hard cover.

Loose-Leaf Binding. A plastic *slide-on clip* of the full backbone length is the simplest means for holding sheets together with reasonable security while enabling additions or removals to be made. Slide-ons are often used with transparent wraparound covers. There are merely protective covers while the front (and perhaps back) pages assume the informational function of a cover.

A *spring-back binder* holds the binding edge of sheets together in basically the same way that a slide-on clip does: with tension

Courtesy Spiral Binding Co., Inc.

Plastic slide-on binding.

pressure. The two have another common feature: they require no preparatory operation, such as punching, for application of the binding device. But the spring-back binder alone of the two has a feature that is common to nearly all loose-leaf binders: it has a cover that is an integral part of the binding device. The hard covers, turned back and pressed, serve as levers to hold open the tensioned backbone to receive the gathered sheets.

Another type of loose-leaf binder is basically similar to the plastic comb mechanical binder while providing a convenient means for opening the bindings to remove and add pages. The backbone is a track into which a comb with curved teeth slides.

But the major categories of loose-leaf binders are the *ring binders* and the *post binders*. The multiple rings (often three) of a

Speed punch.

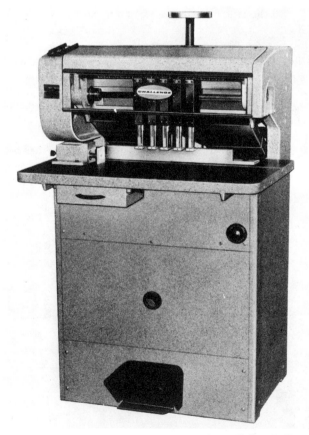

Vinyl loose-leaf binder and index tab dividers.

ring binder are fixed in a housing inside the backbone of the cover. Each ring is split into two segments that the tensioned housing permits to remain only fully open or tightly closed. In some types, opening or closing any ring causes the others (or at least one set of the others) to open or close simultaneously. In other types, the opening (and sometimes the closing) is effected by levers. While most rings are of metal, some are of a rigid plastic.

Post binders often have an expandable capacity and can hold a large quantity of pages very securely. Their disadvantage is that they don't have the random-access feature of ring binders that permits quick and easy addition or removal of pages at any points.

Some post binders have covers containing telescoping posts and a curved back to provide for expansion. Some very heavyweight covers with screw posts are used to hold thick and heavy accumulations of pages.

Model MS-10A multiple spindle drill.

Aluminum screw posts.

Section Seven: Trimming

Except for mechanical and loose-leaf binding, the trimming operation generally follows the binding operation. Its purpose is to bring the bound material to its exact predetermined dimensions ("trim size") with cleanly even edges. Trimming also removes the closed edges of folded signatures and separates magazines bound two- or three-up (two or three copies connected end to end).

Typically a bound book is trimmed on head, front, and bottom edges, but this is not always the case. Sometimes, for example, an edge or two may be left untrimmed as a design feature, or the aligning of trimmed edges may be accomplished before binding. Trimming may be done by means of cutting machines or multiknife trimmers.

Cutters. When general-purpose cutters, such as guillotines on which sheet cutting is done, are used for trimming, the smaller-size machines are more convenient for the operator.

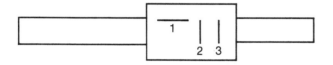

Courtesy Harris Corporation

Knife configuration, Model VT-1 three-knife trimmer.

Courtesy F. P. Rosback Company

Model CB automatic three-knife trimmer.

Guillotines with three-part split back gauges permit one part to be set for trimming the tail, one for the front, and one for the head.

A special model guillotine cutter is the Brackett Trimmer, which has its movable gauge in front of the cutting blade, giving the advantage of easier loading for narrow-book trimming.

Multiknife Trimmers. The *duplex cutter*, which cuts two sides at a time, was the first of the multiknife cutter/trimmers. *Three-knife machines* trim three sides in a combined operation: first the front, and then the head and tail (or vice versa). Two-

Courtesy Muller-Martini Corp.

Three-knife trimmer with attached counter stacker.

and three-up books require additional blades. In continuous operation, the operator feeds piles of untrimmed books into one side, and completely trimmed books are delivered at the other; the machine may be trimming the front of one stack of books while trimming the ends of another. When trimming is part of a finishing sequence having other in-line operations, the bound material is fed automatically from the binder into the trimmer.

Notcher

Courtesy Harris Corporation

Knife configuration Model VT-II five-knife trimmer.

Section Eight: Finishing Lines

Various combinations of finishing operations are done in line. Slitting and folding of printed material into signatures may be done at the end of a web press. Flat four-page sections of press sheets may be collated, center-stitched, then folded, and front-trimmed. But three combinations of in-line finishing lines are of such major importance as to be given separate treatment here: (1) the inserter/saddle binder/trimmer line, (2) the gatherer/adhesive binder/soft cover/trimmer line, and (3) the case binding/covering lines.

Each of these three combinations starts with properly folded signatures brought to the assembling stations of the line. This is

an appropriate point at which to discuss certain operations occasionally performed between folding and assembling as well as the various technological levels of materials handling used at this point.

Tipping. Attaching end papers or separately printed inserts to signatures with a thin strip of adhesive is called *tipping*. Outside tips (attachments to the front or back page of a signature) can be made by machine, but tips inside a signature must be made by hand. (Outside tips with some equipment can be made during the gathering operation.)

Courtesy Heidelberg Eastern, Inc.

Tip-on machine (doing continuous tipping pack-to-pack).

Bundling. Instead of folded signatures simply being stacked on a skid with a platform affixed on top for transportation and in-process storage, bundles of signatures several inches

Courtesy Stobb Incorporated

Stacker / bundler with bundle crane.

Courtesy Stobb Incorporated

Bundle tilt table.

high may first be tightly compressed on a hand-operated, electric, or hydraulic bundling press. This bundling process provides not only more compact loads but also signatures with tighter folds.

Automatic Bundling, Bundle Distribution, and Bundle Loading. In highly automated systems, the concept of bundling is sometimes extended to the use of signature *logs*—signatures compressed into long (about 3 ft., or 1 m) stacks—which facilitate computer-controlled in-process storage, transport, and continuous assembling-machine feeding. The log form also improves signature runnability by squeezing out air and tightening the fold, and it helps protect the signatures from damage during handling. A crane may be used to put the log onto the bundle loader (an extended feeder table) for continuous feeding into gathering machines or even inserters.

Courtesy Stobb Incorporated

Automatic hopper loader (fold trailing).

INSERTER/SADDLE STITCHER/TRIMMER LINE

The in-line combination of automatic inserters, saddle stitchers, and trimmers is very common for the binding of magazines and pamphlets. Sometimes other in-line operations are included at the delivery end of the trimmer: numbering, punching, addressing, sorting by ZIP, automatic bundling, and the like.

The problem of downtime as more operations are added in-line (increasing the frequency of the entire line being down), as well as the problem of line imbalance, may be met by the use

Courtesy Stobb Incorporated

Stacker/bundler with automatic bundle palletizer.

Courtesy Consolidated International

Saddle-stitching line with traveling folder-feeder.

Courtesy Harris Corporation

Inserter/saddle stitcher/trimmer line.

Courtesy Muller-Martini Corp.

Saddle stitcher with portion of inserter line.

of divided (parallel) lines. For example, the output line from a bindery operation may be divided into three separate lines: two separate trimmer lines and an escape line to handle overflow if one trimmer goes down.

GATHERER/ADHESIVE BINDER/SOFT COVER/TRIMMER LINE

The in-line combination of automatic gathering, adhesive binding, cover feeding, and trimming is regularly used for the production of paperback books, telephone directories, and some catalogs and magazines.

Courtesy McCain Manufacturing Corp.

Inserter/saddle stitcher/trimmer line.

Waste may also be reduced by computer-assisted bindery control. A light beam can monitor the feeding of signatures from a feeder station onto the chain. If an individual signature is not fed, or is not hanging properly on the chain, the feeding of subsequent signatures and the stitching of the book before it is ejected will be prevented.

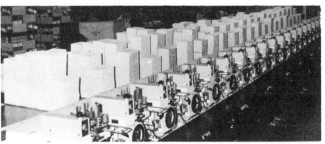

Courtesy Harris Corporation

Model RG-1 gathering machine.

Different systems vary with respect to the backbone treatment, and different types of adhesive are used for specific purposes, as previously discussed. Also, a coarse cloth called *crash* is sometimes applied to the backbone before the cover is attached.

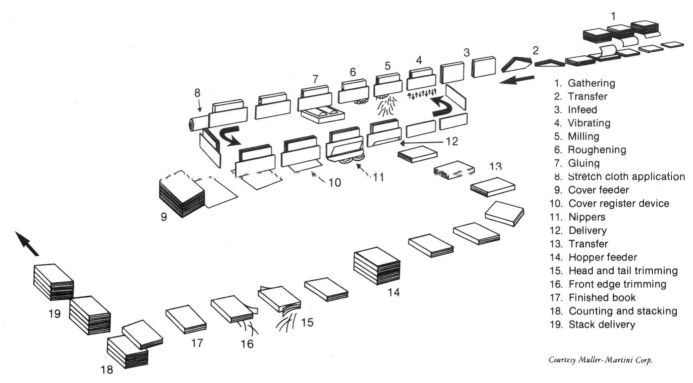

1. Gathering
2. Transfer
3. Infeed
4. Vibrating
5. Milling
6. Roughening
7. Gluing
8. Stretch cloth application
9. Cover feeder
10. Cover register device
11. Nippers
12. Delivery
13. Transfer
14. Hopper feeder
15. Head and tail trimming
16. Front edge trimming
17. Finished book
18. Counting and stacking
19. Stack delivery

Courtesy Muller-Martini Corp.

Gathering / adhesive binding / covering / trimming line.

Adhesive-bound books are sometimes hard-covered, generally requiring a number of additional operations, such as rounding and backing and casing-in, as described in the following subsection.

CASE BINDING AND COVERING LINES

Binding Line. A book to be casebound has *end papers* attached to front and back signatures, either before or during the gathering operation, for later attachment to the covers. The books, following the binding operation (usually adhesive binding or sewing), are *nipped* (they have pressure applied along the

Sewn book with bulk and swelling in the back reduced by smashing.

sides of the backbone) or *smashed* (they have pressure applied over the entire front and back surfaces), depending on whether they are printed on hard-surfaced or soft, bulky papers, respectively. After the trimming operation, the books are forwarded through a series of other finishing operations (some of the following are optional) before merging with the cover-making line.

Edge Treatments. Most books don't receive any edge treatments, but occasionally one or more edges of books are stained

or gilded. Most other edge treatments, such as marbling, are now very rare or nonexistent.

Back Gluing. To keep the binding edge even, and to hold its rounded shape after rounding and backing, the binding edge is coated with glue or a flexible resin film.

Application of glue with a roller to the backbone so that it penetrates between the sections.

Rounding. The improved structure given to a book by rounding—a convex binding edge and concave fore-edge—is achieved by running the book binding-edge-forward between

Backbone shaped by rounding and backing.

Courtesy The de Florez Company

Case stamping machine.

steel rollers rotating in opposite directions. Side-stitched or side-sewn books cannot be rounded.

Backing. The operation of backing—clamping the book and flaring the back outward from the center over the clamped edges—provides greater flexibility and permanence for the rounded back and the ridges against which the hinged covers swing. Rounding and backing are generally parts of the same machine operation.

Head Banding. Head and tail bands are often used as a decorative touch. They may be attached to the paper lining before it is glued to the back, or to the book itself.

Courtesy Smyth Manufacturing Co.

Lining and headbanding machine.

When the "forwarding operations" (a traditional bookbinding term) are complete, the book encounters the casemaking line for the covering operation.

Casemaking. *Boards* for casemaking are cut first by a machine that slits a large board into strips and then by one that crosscuts the strips to book board size. Casemaking machines are fed boards completely cut to size; some of them accept

covering material (such as cloth) in web form, while others require precut cover blanks. Covers are often preprinted, most commonly by offset lithography. Others are stamped after casemaking, instead of or in addition to preprinting, with ink, foil, or genuine gold.

Case stamped with cover and backbone design.

The *casemaking machine* automatically glues the covering material, affixes boards and backlining paper in place, turns the covering material in over the boards, and presses the completed cover. After any required stamping, the case is ready to join the bound book at the end of the forwarding line.

Covering. The covering process consists of two operations, casing-in and binding-in. *Casing-in* is the operation of attaching the cover to the body of the book. The free halves of

Courtesy Smyth Manufacturing Co.

Casemaker.

Application of paste to the endsheets.

Finished books under pressure: building-in.

Building-in is the traditional bookbinding term for drying the case's adhesive under pressure. In small operations, the books are placed around the edges of a wooden board, backs outward, with the cover's joint resting on a brass strip fastened to the edge of the board. Stacks of boards and books in alternating layers are held under pressure for a period of time, such as overnight.

Courtesy Heidelberg Eastern, Inc.

Sulby 10 binding / covering machine.

the four-page end papers are coated with paste on their outsides. The case is placed over the book in such a way that when the covers are pressed against the end sheets, the edges of each cover will project uniformly beyond the edges of the end sheet. A *loose-back* casing-in is one without glue on the book's backbone, permitting the back part of the cover to curve out from the backbone when the book is opened. Some books, mostly those side-sewn or side-stitched, are given a *tight-back* casing-in by means of glue on the backbone.

Building-in machines hold the cased-in book between pressing plates that apply pressure and heat. With such equipment, building-in can be accomplished in less than a minute while the book is passing along through the machine.

In-line equipment for high-volume work permits combining all the forwarding and covering operations—rounding, backing, casing-in, building-in, and even jacketing—into one completely mechanized production line.

Various Supplementary Processes⎯⎯⎯⎯⎯⎯⎯⎯

Section One: Bronzing and Varnishing

Varying with the end use of a lithographed product, the sheet is subjected to different operations supplementary to lithographing. In label work these supplementary operations consist of bronzing, varnishing, embossing and die-cutting for example. In this section we present bronzing and embossing. Varnishing and coating of lithographed papers is the subject matter of the following section; die-cutting of labels is presented in section three of this chapter.

BRONZING

Bronzing is the technique whereby metallic powders are applied in the form of a design to a sheet of paper. Even though it is possible to bronze a blank or unprinted sheet, almost all bronzing is done on printed or lithographed sheets. The sequence of operation is such that the sheet is first printed or lithographed and bronzed thereafter. If a sheet is to be bronzed and varnished bronzing always precedes spirit varnishing in some plants; other plants prefer the reverse order. In the case of print varnishing, which is usually done on a lithographic press, the print varnish is either applied before or after bronzing.

Our presentation of bronzing is divided into the following five points: (1) General discussion of bronzing, (2) Bronzes, (3) Applying the adhesive for bronzing, (4) Applying the metallic powder, (5) Burnishing. Each of these points is now discussed.

General Discussion of Bronzing. Bronzing consists of three related operations. First an adhesive known as gold size is applied to the sheet, then the sheet is exposed to the bronze powder in a bronzing machine, finally the bronzed sheet is run through a burnishing machine.

It is possible to obtain effects similar to bronzing by lithographing metallic ink. But bronzing is still the preferred technique for obtaining the effect of gold on a sheet of paper. Bronzing is not restricted to gold, even though most bronzing has this purpose.

Bronzes. Gold bronze takes the place of gold leaf which was used in the past. Gold leaf is much too expensive and its application much too slow for mass production and has therefore fallen into disuse. Gold bronze is used in its place for label and similar quantity work.

Gold bronze powder consists of fine flakes of brass. Brass is, as the reader may know, an alloy of copper and zinc. Different proportions of the two metals produce bronzes of different colors. The specifications of bronze powders are rather technical; here we merely mention that they include shades or color of the bronze, size of particles, grease content and bulking density.

Applying the Adhesive for Bronzing. Before the adhesive can be applied, care must be taken that all colors printed on the sheet are thoroughly dry. Still wet or tacky inks will have a similar result as the bronzing adhesive. The application of an adhesive is the first step in bronzing. The bronze powder is applied to this adhesive and therewith permanently attached to the sheet. The bronzing adhesive is called *size* or *gold size* by the trade. Gold size is a tacky ink ranging in color from yellow to a dark green according to the color bronze used and the effect desired. Gold size is applied to the sheet on a lithographic press.

Applying the Metallic Powder. The metallic powder is applied to the sheet in a bronzing machine. As the powder must be applied to the still-wet size, the sheet travels immediately after application of the size into the bronzing machine. There bronze is dusted over the entire surface of the sheet; where the sheet is printed with size the bronze adheres; dusting pads dust off the excess bronze before the sheet leaves the bronzing machine. The sheets should be allowed to dry for at least 24 hours and then re-dusted to remove remaining unwanted or unadhered bronze whenever this is the case.

Burnishing. Burnishing has the purpose of endowing the bronzed sheet with extra luster or high sheen. This effect is obtained by flattening and polishing the bronze particles until they form a very smooth surface. Burnishing machines have one or several pairs of calender units. Each of these consists of a steel roller and a composition roller. The steel roller runs faster than the composition roller; friction is caused whereby the bronzed sheet is polished. The

pressure between the rollers controls the degree of sheen and smoothness given to a sheet. After burnishing the bronzed sheet is ready for further processing.

EMBOSSING

We can define embossing as an industrial way of creating relief images on printed, lithographed or blank paper or similar material in order to create a beautifying effect. Our presentation of embossing is divided into the following eight points: (1) The two main kinds of embossing, (2) The effect of embossing on the handling of the embossed product, (3) Roller embossing or pebbling, (4) Plate embossing, (5) Embossing dies, (6) Assembly of embossing dies, (7) Makeready for embossing, (8) Presswork for embossing. Each of these points is now described in detail.

The Two Main Kinds of Embossing. There are two types of embossing; they are used for different purposes and executed on different equipment. These two types are roller embossing and plate embossing. Roller embossing is used for all-over patterns, plate embossing for individual unit patterns.

The Effect of Embossing on the Handling of the Embossed Product. Embossing breaks, stretches, and separates the fibres of the paper. It thereby increases the flexibility of the paper and makes it much more easy to apply it to curved surfaces. This is a very important consideration in labeling which is done on high speed machines.

Roller Embossing or Pebbling. Roller embossing is also known as pebbling. It is done on a cylinder machine having two rollers. The embossing roller is an engraved steel roller, its mate a smooth cotton or papier-maché roller. The paper is run between both rollers, their pressure is adjustable and produces the required or desired depth of embossing. Pebbling designs commonly used are known as eggshell, moiré, crash, stucco, skytogen, linen and other patterns.

Plate Embossing. Plate embossing is used for most label work but also for many other purposes. Plate embossing is also called spot embossing. In it such images and designs as medals, heads, reading matter, scrolls, frames and many, many others are produced. The same embossing plate can of course include background pattern or overall designs. Plate embossing is executed in presses having two parallel platens. One of these holds the embossing plate, the other receives the makeready and the paper. For print-ing, the bottom plate moves up in contact with the top plate holding the embossing plate assembly.

Embossing Dies. Embossing dies are made in a variety of techniques. They are supplied to the lithographer by companies specializing in their making. The technique used depends on the detail of the job. Some dies are hand-engraved, others are made by means of the pantagraph or by etching for example. In many cases various techniques are used in combination.

In label work, where a large number of units is embossed in one operation, duplicate embossing dies are needed. These are made by electrotyping; if the runs are very long, electrotypes can be nickel-surfaced (commonly called steel-surfaced) or chrome-plated.

Assembly of Embossing Dies. The assembly of embossing dies for a large size job is a very exacting task. First each electro is glued to a piece of strawboard in order to give it a base for the later gluing on the main head plate of the embossing press. Then this head plate is removed from the press and prepared for the mounting of the electros which serve as embossing dies. The electros are placed in register with the sheet layout on the head plate. This job must be done with the greatest care.

Once the electros are in position they are glued to the head plate. The assembled electros are inserted (on the head plate to which they are attached) into the head of the embossing press, facing down toward the bottom plate.

Makeready for Embossing. The makeready for embossing produces a male bottom plate corresponding to the female electros. The first step consists in preparing the bottom plate of the press by pasting several layers of strawboard or approximately 60-point Draftboard down to it. A mixture of gum arabic and barium sulfate is used as adhesive. This mixture has the advantage of producing a workable surface when the glued board is wet and a hard surface when the board is dry.

This prepared plate is shaped into a male counter plate of the assembled electros by forcing these into the plate. Once this is done, the male bottom plate is covered with a French folio tissue stock and all unembossed areas of the plate are cut away. After the composition has properly set, the press is ready for embossing.

Presswork for Embossing. Once the press is ready, embossing has fewer problems in presswork than in printing. This does not mean that the pressman and his assistant can be careless. All parts of the press must be maintained in best order just like in any other kind of presswork.

Section Two: Varnishing and Coating of Lithographed Papers

Not all products of lithography require finishing, but in many instances there is a demand for a surface finish that imparts resistance to chemicals, heat, scuffing etc., that provides smoothness and lustre, and thereby enhancement of color values. All these requirements can be met by one or more finishes available to the lithographer today. In the following, some of the major categories of finishes will be discussed.

PRINT VARNISH

It is the oldest and most commonly used finish consisting of drying-oil lithographing varnish, modified with driers, synthetic resins (for instance alkyds), waxes, and compounds to form a slow-drying, protective film printed on the lithographic press.

The Advantages of Print Varnish. Its advantages

are: (1) Easy and speedy application, using little material, often from a solid plate without the use of dampeners; therefore, it is very economical. (2) The possibility of spot varnishing is important in spacing out areas for gumming, stamping etc. (3) Producing the flattest type of labels, due to the absence of a heating operation. (4) Can be run together with colors as a last print on multicolor press. (5) Alcohol resistance.

The Disadvantages of Print Varnish. Its disadvantages are: (1) Tendency to after-yellow within a few months. (2) Thin film, which has the least scuff resistance of all finishes. (3) Requires high-grade coated papers; on absorbent papers it will produce a muddled, dull and ungainly finish.

VARIOUS KINDS OF COATINGS

All the finishing materials discussed on the following pages can best be classified as coatings, i.e. film formers dissolved in solvents, because in contrast to the print varnish, they are applied on a roller-coating machine and dried by forced evaporation of a solvent, leaving a dry film on the face of the lithographed sheet. Limitation of space necessitates that only the major items in this field can be mentioned.

Spirit Varnishes: This group has been an old standby and still proves very valuable in spite of the modern synthetics. It dries by evaporation of alcohol (spirit), and leaves a film on the paper which is shiny and hard, but of course, never resistant to alcohol. They all are imprintable.

Copal Varnishes: The best-known of these spirit varnishes are the so-called Copal varnishes. They consist of a solution of about 40 percent to 50 percent of Copal resin (a fossil and semi-fossil gum, for instance, found in the Philippines) in denatured alcohol. The good grades of this resin have a light color, and deposit a practically colorless film on the paper.

Advantages of Copal Varnishes: The advantages of copal varnishes are: (1) Quick and thorough drying due to fast solvent (alcohol) release, using only moderate heat (approximately 180° F); therefore having good stacking qualities. (2) Good lustre. (3) Good scuff resistance. (4) Light color. (5) Good moisture resistance.

Disadvantages of Copal Varnishes: The disadvantages of copal varnishes are: (1) Has a tendency to be easily marred by scratches on the surface. (2) Very limited chemical resistance (no alkali resistance).

Shellac Solutions. In this group of spirit varnishes belong shellac solutions made of various types of shellacs dissolved in alcohol. This natural resin originates from insects (India), and has been famous for many years for its smooth finishes; lustre from satin finishes to high gloss, slip and scuff resistance. Its high sensitivity to water and to mild alkali solutions have made it rather undesirable compared with other coatings. Other natural resins sometimes used in combination spirit varnishes are Mastic and Sandarac.

Zein-Rosin Solutions. We may also list as spirit varnishes the alcoholic solutions of *ZEIN-ROSIN*, which made their appearance in large volume during the last war, and which have since kept a definite position in the field of coatings. Zein, the protein of corn, forms a very tough and highly scuff-resistant film which obtains lustre, and some flexibility through the addition of rosin, which in itself is not a film former. This combination is widely used as a finish which gives satisfactory scuff resistance and lustre. It has a certain water sensitivity and thereby resembles shellac. The color of the dried film is slightly on the gray-green side.

Polyamid Resins Solutions. Recently promoted as protective coatings in alcoholic or alcohol-hydrocarbon solution. For good results they have to be modified with other resinous material.

Maleic Ester Solutions. Purely synthetic are the maleic esters which are used in alcoholic solutions for their good lustre, but they have poor water and alkali resistance.

Naphtha Varnishes. They are similar to the spirit varnishes in performance, but their resins are dissolved in low boiling naphtha, instead of alcohol. Typical for such a varnish is a solution of modified rosin (zinc or calcium salt, plus wax as a scuff-resistant binder) in V.M. & P. Naphtha.

The advantages of these types of coatings are, above all, the low price due to inexpensive resinous material, and cheap solvents. They are used where a certain amount of protection is required, at the lowest possible price. They have a good lustre, but their scuff resistance is very limited — in fact, the lowest of all coatings. They resist imprinting.

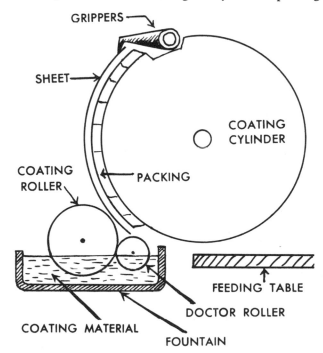

Schematic Cross-Section of a Coating Machine.

Lacquers. This term is foremostly applied to the first synthetic finishes ever made. They consist of solutions of nitro-cellulose (also called pyroxylin) in special solvents (esters, alcohols and hydrocarbons). They are modified with resins and plasticizers and have been widely used as high-quality finishes of good lustre, light color, and good

scuff resistance. (Lately, the word "lacquer" is being used in a broader sense for quick-drying high-grade synthetic film formers.) A certain after-yellowing under the influence of light is often observed on these otherwise very useful coatings. Inhibitors can improve this. Their alkali resistance is poor; their heat resistance is good; solvent release is very good. Imprintable.

Ethyl Cellulose Coatings. Other cellulose compounds forming useful lacquers are based on ethyl cellulose (in alcohol-toluene solutions). It forms an alkali-resistant coating of medium lustre and good scuff resistance.

Cellulose Butyrate Coatings. Cellulose Butyrate, a recent development, shows an improved light transmittance and light resistance (no after-yellowing). Colors are being well preserved in their original beauty under this type of lacquer.

Vinyl Coatings. These synthetic film formers have assumed eminent importance in the field of coatings during the last decade. This is due to their light color, good lustre, and high scuff resistance (chemically they are vinyl-chlorides, vinyl-chloride-acetate copolymers dissolved in ketones, and aromatic solvents). They show very good all-around chemical resistance; a certain after-yellowing due to influence of heat and light can be reduced by stabilizers. Their solvent release is good, they can be stacked well and handled easily; they can also be imprinted.

Coatings Made With Acrylic Esters and With Cellulose Acetobutyrate. Coatings which have been used for their specific property of high light transmission and light fastness are based on Acrylic esters and to a lesser degree on Cellulose aceto-butyrate. Their formulation requires careful balancing with other resinous materials.

Coatings Made With Rubber Derivatives. Rubber derivatives such as chlorinated rubber dissolved in toluene blended with lustre-producing resins and plasticizers make useful finishes of good gloss, scuff and chemical resistance. They require protection against after-yellowing and embrittlement due to the influence of light.

Styrenated Alkyds, Vinyl-Compounded Alkyds and Other Film Formers. Recent developments in synthetic film formers comprise styrenated alkyds, vinyl-compounded alkyds and others. They have the desirable property of forming solutions of high concentration without substantial increase in viscosity. Therefore, they can be applied in very heavy films on printed sheets and produce finishes of extreme lustre ("liquid lamination"). Some show good mar and scuff resistance, others do not. The solvent is toluene, which is inexpensive. Care is needed in letting coated sheets "breath" for twenty-four (24) hours, stacked low, or standing in rolls. Some of these coatings can be imprinted.

Coatings Made With Polyesters. Another group of coatings recently developed for quick-drying purposes are known under the name of *"Polyesters."* They consist of a mixture of highly reactive chemicals which, under the influence of heat and a catalyst (a trigger-action material), become polymerized (forming long-chain molecules) or "cured," and produce a heavy film which has a very high lustre, high scuff resistance and high chemical resistance. Even the original solvent, or stronger ones, no longer affect the cured film. These coatings, too, are being used in "liquid lamination." Other chemical compounds called Epoxy resins, react in a similar way and produce similar finishes.

Not all of these new synthetics do what their well-spoken salesmen promise they will. Some, for instance, show after-yellowing, others demand very high heat for curing and therefore are inclined to become brittle. Others do not possess the scuff resistance indicated. It is important to try out these new synthetics — let them age for at least six months — subject them to light, heat, scuff, and chemical tests, and then pick the best one for future use.

Section Three: Diecutting of Labels

Various methods of diecutting are used in the production of fancy outline labels. In this study we discuss two of them, high-diecutting and PMC cutting; this is not to imply that other methods and equipment cannot be used for the diecutting of labels. Our presentation of the subject is divided into the following eight points: (1) General exposition of the label requirements; (2) Straight-cutting; (3) Various kinds of dies; (4) High or hollow dies; (5) The two kinds of presses for high-diecutting; (6) Allowance for trim; (7) Diecutting on descending type presses; and (8) Diecutting on PMC presses. Each of these points is discussed in the following.

General Exposition of Label Requirements. These are very will stated by Robert F. Reed, Senior Research Consultant, GATF, in a study of "Size Variations in Diecut Labels" made by LTF in 1948. We quote from Modern Lithography, June 1948: "Diecut labels usually are applied by means of automatic labeling machines. The labels are stacked face up in a hopper in which they are retained by holding fingers at the bottom. The machine picks the bottom label, coats it with adhesive, and applies it to the package by one of several methods. Unless the labels are reasonably uniform in size, they will either fail to feed to the retaining fingers or drop through them. Dimensional uniformity is of such importance that bottlers have established specifications for maximum allowable variation."

Straight-Cutting. As labels are printed very *manyup* on a sheet, but cut individually though in lifts, the printed and otherwise processed sheets must be straight-cut before high-diecutting. Straight-cutting is done on guillotine cut-

ters, and is in principle not different than described in the Bindery chapter of the Manual.

Various Kinds of Dies. The dies used for the stamping of paper, cardboard and similar sheet material can be divided into two kinds, steel rule dies and high or hollow dies. Steel rule dies are discussed in the following section of this chapter. Here it must suffice to say that steel rule dies are used for very intricate shapes and that the number of sheets that can be cut with them in one operation is very small, rarely more than five to ten sheets; in most cases steel rule dies are used for individual cutting.

High or Hollow Dies. High or hollow dies are made of cold-rolled steel, forged and welded to the required shape. High-dies vary in height; those used on PMC machines must not be higher than $2\frac{3}{8}$ inches and not lower than $1\frac{3}{8}$ inches; they may be as small in area as 1 square inch and as large as 36 square inches. Their inside is parallel for approximately 1-inch height, beyond that height the inside of the die may funnel out. From this description you can see why the term high-die or hollow die is used for them.

The Two Kinds of Presses for High-Diecutting. High-dies can be used on open presses having two flat surfaces. In one kind of press, such as a punch press, the die moves and the stack of paper to be cut is stationary. In the other kind of press, the PMC press, the die is stationary and the paper stack is moved against it. These two kinds of presses are also described as presses with descending cut-

ting member and presses with ascending materials to be cut. Both kinds of presses use, by and large, the same dies. PMC presses, so known by the initials of Printing Machinery Company, their builders, are used where large run and high precision cutting is needed.

Allowance for Trim. In both kinds of diecutting, sufficient space must be allowed between the labels for clean cutting. The trim space allowed is usually between one-eighth and three-sixteenths of an inch.

Diecutting on Descending Type Presses. For diecutting on descending type presses, the sheet is first cut into sections of appropriate size; quarters, for example. A lift of such sections, varying with the job from 25 and up, is placed on the bed of the press which has a wooden base. The high-die is carefully registered manually on this lift by the operator. The down-stroke of the machine causes the die to penetrate the stack of labels. The diecut material as well as the cutting waste is removed and the operation repeated until the required quantity is cut.

Diecutting on PMC Machines. On PMC machines the labels must be accurately square-cut before diecutting. The die is positioned in the head of the machine, the lifts of square-cut labels which may contain as many as 500 units, are fed into the machine, positioned to guides and automatically forwarded into cutting position. The diecut labels come up through the hollow cutting die and are removed by the operator.

Section Four: Steel Rule Diecutting of Cardboard Displays

Diecutting is an intermediate process in cardboard display production. It comes after the mounting of the printed sheet and before the finishing and packing of the display. Diecutting is a stamping process whereby cardboard and many other stocks can be cut, scored and creased and thereby made to assume almost any desired shape.

The most important steps in diecutting are the following three: (1) Diemaking, (2) Presswork, and (3) Stripping. Each of these subjects is discussed in the following.

DIEMAKING

Diemaking is the operation where the tool is made by which the display is shaped. This tool is known as a *steel rule die* and must be custom-made for each job. The steel

rule die combines several functions in a single unit. Cutting, but also the less obvious scoring, creasing and punching can all be performed at the same operation with a steel rule die.

The Composition of Steel Rule Dies. A steel rule die is a cutting tool consisting of three materials, quite dissimilar: steel, rubber and wood; soft and hard, rigid and

Jigsawing the Dieboard.

Complete Section of a Steel Rule Die.

resilient. The steel does the cutting, the rubber pushes the cut pieces away from the die, and the wood acts as a base for steel and rubber.

Jigsawing the Dieboard. The plywood base — known as the dieboard — functions like our fist: it grabs the handle of the knife and leaves the cutting edge free to do its work. To this end, the dieboard is jigsawed and the cutting knife inserted in the saw-tracks.

The next question is: what will keep the dieboard in one piece if we make a full circle? The inside of the board will surely fall out! We take this hurdle in a simple manner! The dieboard is kept together by leaving a wooden bridge unsawed.

A Bridged Dieboard.

The problem of holding the dieboard together is solved by leaving wooden bridges; the next problem is that of fastening the cutting die where the dieboard is not sawed out. This problem is solved by notching the cutting knife in the corresponding places.

A Notched Cutting Rule for a Bridged Dieboard.

Now we have a technique for making a steel rule die that will cut everywhere and will stay together solidly. Our next topic is the shaping of the cutting knife.

Types of Rule. (A) Cutting; (B) Cut Scores; (C) Creasing; (4) Perforating.

Various Kinds of Rule. The cutting knife, known as rule, is a strip of rather soft steel. Rule is available in many profiles: for cutting, creasing and perforating. Height, width and hardness are all selected to fit the job. Very often, the rule for display jobs is approximately one-inch high and one thirty-second of an inch wide.

Male and Female Die-Sets. The rule is put in shape by bending it between the male and female parts of die-sets which are much harder than the steel rule itself.

Male and Female Die Sets.

The diemaker has several dozen die-sets to choose from. His job requires skill and ingenuity. The die-press, known as bender, is hand operated and permits rapid changes of dies.

Completing a Steel Rule Die. After bending, the rule is inserted right into the saw-tracks of the dieboard. Gluing the rubber on completes the job. The rubber serves to push the cut stock away from the die; the detail of the job governs how much, and what kind of rubber is used.

Inserting Cutting Rule into Saw-Tracks of the Dieboard.

The making of steel rule dies is an art in itself. It requires long experience and considerable skill, like all precision work. The field is very big since steel rule dies are used for the cutting of any number of materials in addition to cardboard. Linoleum, fabric, rubber, felt, cork, plastic, masonite, and rawhide — all are cut with steel rule dies.

PRESSWORK

Several types of presses have been developed for steel rule diecutting. Each of these has its definite place and

function. Which press should be selected as the most efficient, cost- and production-wise, depends on the nature of the job in hand.

The Four Types of Diecutting Presses. The most important types of presses are: (1) The open cutter and creaser, (2) The flatbed-cylinder press, (3) The up-and-down press, and (4) The automatic cutter and creaser. Each of these is discussed in the following.

The Open Cutter and Creaser. The open cutter and creaser is a very common type of diecut press for display work. It is a platen press of very rugged construction and it looks very much like a job press stripped of its inking mechanism.

Open cutters and creasers are manufactured in a wide range of sizes. Presses for sheet sizes up to 28 x 42 inches are found in most display finishing houses. Larger presses of this type exist but are much less common. The rate of production depends on many factors; for heavy display work it is between 500 and 1,000 sheets per hour, depending on size and caliper of the stock.

The Vertical-type Cutting and Creasing Press.

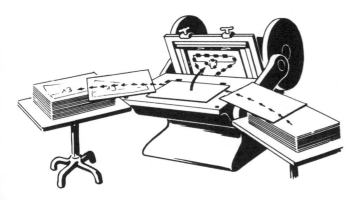

The Open-type Cutting and Creasing Press.

The Flatbed-Cylinder Press. Diecutting presses developed very much in the path of printing presses. Here too, the cylinder press came into use after the platen press, and for exactly the same reasons as in printing. Platen presses print by bringing two flat surfaces in overall contact. This principle is practical for small sizes but not for large ones; the pressures required for large sizes are too tremendous.

The cylinder press solved the problem of large size printing by introducing a new principle: line-pressure instead of full area-pressure. In cylinder presses, the type form is carried on a flat surface — the bed of the press — where the stock is wrapped around the circumference of a cylinder which rides over the bed and is called the impression cylinder. The sliding motion of the bed is perfectly timed with the rotary motion of the cylinder, and the necessary pressure is now exerted along a constantly shifting line across the bed. This construction made the printing of large size sheets possible and practical.

Cylinder presses are used in large sizes and primarily for such jobs as cannot be put on flatbed presses. Well-equipped finishing houses have presses that will take sheets up to

44 x 64 inches. but, as cylinder presses are very often rebuilt printing presses, one can find a variety of sizes that defies classification.

The Up-and-Down Press. In this type of press, which is also classified as a vertical diecutting press, display work requiring exceptionally strong pressure is produced.

Up-and-down or vertical presses are manufactured in a variety of sizes, but are not nearly as common in display plants as open presses and flatbed-cylinder presses.

The Automatic Cutter and Creaser. Automatic cutters and creasers are primarily used for folding cartons and other long run jobs. These machines are flatbed-cylinder presses specifically designed for diecutting.

The sheets are automatically fed, cut and creased, and piled after cutting; some makes even have automatic stripping equipment at the delivery end of the press. Makeready is made in a manner similar to that described for cylinder presses. Press sizes range from sheet size 22" x 28" up to sheet size $46\frac{1}{4}$" x $69\frac{1}{2}$"; press speeds vary between 2,000 and 4,000 impressions per hour.

An Automatic Flat-Bed Cylinder Cutting and Creasing Press.

The Die Has Cutting Rule on Four Sides and Creasing Rule in Center. Makeready for Creasing Rule is on Cutting Plate, for Cuts It Is Under the Cutting Plate.

The Three Main Steps in Presswork. Even though each type of press requires a specific technique in operation, all presswork has nevertheless three steps in common. These are: (1) Lock-up, (2) Makeready, and (3) Cutting.

Lock-Up. Lock-up is the first step; it consists in placing and positioning the steel rule die in the press. It is a much simpler job than the following makeready.

Makeready. Makeready is a preparatory act of the greatest importance because it is decisive for the quality of the final result. Makeready is first concerned with register, as the concordance of print and cut is called and also with the quality of the cut itself. But the most difficult part of makeready is posed by creases and scores because they can be very intricate and fragile. This makeready on various kinds of presses is of course done in various ways.

Makeready on Flatbed-Cylinder Presses. In flatbed-cylinder presses the steel rule die is placed on the bed of the press, and the stock is cut by the inter-action of impression cylinder and flatbed. The makeready is made on the cylinder and requires considerable skill and patience.

Underfed and Overfed Flatbed-Cylinder Presses. Feeding of lightweight stocks and of heavyweight stocks on flatbed-cylinder presses is done in different ways. Lightweight stocks that bend around the circumference of

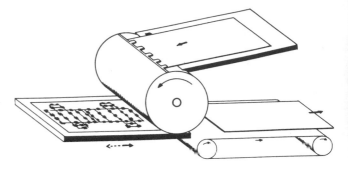

Schematic of the Over-feeding Method.

the cylinder are fed from the feedboard on top of the press. This feeding technique is known as *over-feeding* by the trade.

Heavy boards, such as are used for counter or window displays, cannot be wrapped around the cylinder and are therefore fed directly on top of the steel rule die, or under the cylinder.

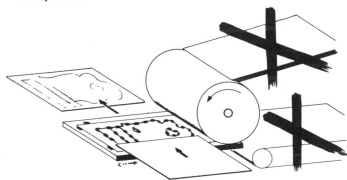

Schematic of the Under-feeding Method.

This technique is called under-feeding by the trade. Underfed flatbed-cylinder presses run intermittently, or stop-and-go. The operator feeds the sheet manually and removes it manually after cutting.

STRIPPING

On presses not equipped with automatic stripping devices, stripping remains to be done after cutting. The cut and scored sheet "is still in the waste" as the trade says. The waste must be removed by stripping. Stripping of display work is mostly done by hand; stripping of folding cartons can be done by one of several mechanized procedures.

Section Five: Mounting and Finishing of Cardboard Displays

The mounting and finishing of displays is here divided into the following three units: (1) Mounting, pasting and easeling, (2) Trimming of cardboard displays, and (3) Display finishing. Each of these is discussed, if ever so briefly, in the following.

MOUNTING, PASTING AND EASELING

The combining of a sheet of paper with a sheet of cardboard is called mounting. If parts of a display are glued to each other, the term pasting is used; if one of these parts

is an easel, the word easeling is preferred. These operations differ widely, but nevertheless have one common denominator: They all require an adhesive. The adhesive is, in most cases, a product containing a considerable amount of water, but otherwise specifically formulated for the particular purpose. Adhesives are applied by one of the following five means: (1) By brush, (2) Through a silk screen, (3) With a margin gluer, (4) On a gluing machine, and (5) In a mounting machine.

Applying Glue by Brush. Applying glue by brush is the most primitive technique and nowadays avoided wherever possible. But there are always cases that cannot be fitted into one of the many highly developed and mechanized techniques. Such cases can be tackled more successfully by a hand skilled in the use of brush and glue; nor has the time-honored hand gluing of easels died out completely.

Hand Easeling.

Applying Glue by Silk Screen. Silk screen is another technique of applying the glue by hand — though indirectly. Glue screens are excellently suited wherever ad-

A Glue Screen Set-up Including the Squeegee.

hesives must be applied in irregular shapes or on many small areas. The screen is the same as that customary in silk screen printing, just as the application of the adhesive follows the standard procedures of silk screen printing.

Applying Glue with the Margin Gluer. The margin gluer is a machine for edge gumming and for applying glue to single wing easels. The machine is power driven and applies a glue strip, adjustable in width and thickness, on the easel.

The operator pushes the easel through the machine; a ductor roller transports the adhesive from the enclosed reservoir to the underside of the easel. The wet easel is passed to workers who put it on the back of the display.

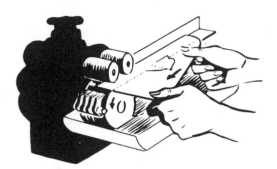

A Margin or Easel Gluer.

Hand Mounting. Hand mounting is very economical for small runs — up to several thousand units. It consists of the following three operations: (1) Gluing, (2) Combining, and (3) Pressing.

The Gluing Machine. The gluing machine applies a controlled and uniform film of adhesive to the paper. It has a tank, with or without heating arrangements. A regulator roller determines the thickness of the glue film which the ductor roller transfers from the tank to the underside of the paper. Two pressure rollers force the paper against the ductor, and a series of strippers separate it finally from the machine.

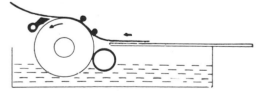

Schematic of Gluing Machine for Paper.

The operator guides the sheet until it is removed from the machine, where it is coated all over, and passes it on to other workers for combining.

Sizes of Gluing Machines. Gluing machines are available in a remarkable variety of makes and sizes. In display mounting plants, 32-inch machines are quite common, but even 46-inch machines, where the largest standard sheet, 44 x 64-inch, can be processed, are frequently seen.

Gluing of Cardboard. Cardboard is glued on a different version of the gluing machine. Now the pressure rollers are much bigger and also in a different position, directly

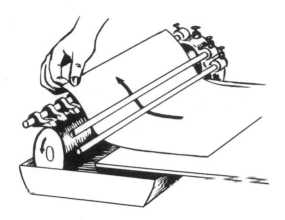

A Paper Gluing Machine in Operation.

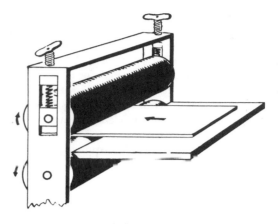

Wringer.

above the ductor roller. Glued paper is moved out of the machine, upwards, at an angle to the table; cardboard, parallel to it.

Because it is obviously easier to handle wet cardboard than wet paper, the glue is applied to the cardboard wherever possible, particularly on large size jobs. Which of the two, cardboard or paper, is glued depends upon the job. Generally speaking, the smaller sheet is glued and the bigger sheet left dry.

The Corner Box. The corner box is a simple gage for maintaining register in mounting. The printed sheet is combined with the board by pushing its guide corner — as that corner of the sheet is called where guide side and gripper side meet — into the corner box. Register must be maintained in mounting, or else! How would it be possible to maintain register in a subsidiary operation, diecutting or trimming, if it were lost in mounting?

Stock Table.

Pressing. Pressing is the final operation in hand mounting. By pressing, the entire inside area of both combined sheets is firmly bonded. The two most common types of presses are: (1) Rotary presses, and (2) Hydraulic presses.

Rotary or Squeeze Presses. Rotary presses are colloquially known as "squeeze presses" and "wringers."

The press is power driven, and the rollers adjustable for stocks of different thicknesses. The combined sheets are fed through individually and then piled until they are dry. Rotary presses are manufactured in almost as many sizes as gluing machines, up to the very largest.

Hydraulic Presses. Hydraulic presses are capable of developing tremendous pressures; they are also manufac-

tured in large sizes and are therefore very useful in a mounting and finishing plant.

The combined sheets are piled in lifts, several inches high, on the bed of the press. A hydraulically powered cylinder forces the bed and its load against the top plate of the press and holds it there until the motion of the ram is reversed. Even the shortest dwell is sufficient for a thorough pressing of most cardboard displays.

Automatic Mounting Machines. The automatic mounting machine performs automatically in one unit the three operations which are separately executed in hand mounting. It glues the printed sheet, combines it with cardboard, and presses it as well. Our drawing explains the functioning of the machine schematically. The printed sheet enters the machine on one side, the cardboard on the other. The mechanically glued and aligned sheet is combined in register with the cardboard and passes a rotary press before leaving the machine.

The automatic mounting machine is operated by a crew of 3 to 5 men, takes a maximum sheet of 44 x 72 inches and, generally speaking, is not used on runs smaller than several thousand sheets as its set-up is costly.

Schematic of Machine Gluing and Mounting.

The Duo-Mounter. The duo-mounter is the most highly developed type of mounting machine, and is used exclusively for very large runs. It combines not only the printed sheet with the cardboard, but also attaches a back liner in the same operation.

TRIMMING OF CARDBOARD DISPLAYS

The printed and mounted display is either trimmed or diecut. If all edges of the finished job are straight and at right angles to each other, the display is trimmed or straight-cut on the guillotine or power cutter.

The Power Cutter. The power cutter has a table equipped with side guide and back gage. The back gage determines the location of the cut and is controlled by the operator from the front where an indicator rule at eye level informs him about its position. The stock is jogged in the corner formed by side guide and back gage, then clamped either manually or automatically and cut when the operator engages the controls which are so arranged, for safety reasons, that he is forced to use both hands in this act. The knife returns automatically and, on the fully automatic

Schematic of a Guillotine Cutter.

models, the clamp must be raised by turning a hand wheel.

Power cutters are all built to square the sheets and come in a wide range of sizes from 34 inches up. Well-equipped display finishing plants have cutters up to to 64 inches; the 85- and 94-inch machines are rarely found outside of paper and board mills.

Trimming or Diecutting? The question whether trimming or diecutting is indicated is asked repeatedly. Whenever a job can be straight-cut, trimming is considered more economical for the following three reasons: (1) In diecutting, the cutting tool is a steel rule die which must be custom-made for each job. In trimming, the cutting knife is a permanent part of the power cutter and is, therewith, the same for every job. (2) The makeready on a diecut press takes much more time and skill than the setting of the power cutter. (3) Cardboard is diecut one piece at a time, but trimmed in lifts of many sheets. On the other hand, in diecutting, all four sides of the sheet are cut in one operation whereas in trimming, each side required a

separate operation. In most cases, trimming is, nevertheless, the cheaper technique of the two.

DISPLAY FINISHING

The term finishing covers a variety of operations of which the following three, as the most important ones, were selected for brief discussion. These are: (1) Varnishing, (2) Laminating, and (3) Stapling, wire-stitching, eyeleting and riveting. Each of them is briefly discussed in the following.

Varnishing. Varnishing and laminating both aim at improving the printed surface by making it shiny and more serviceable. Varnishing, the older of the two processes, consists in coating the sheet with one or several coats of a film-forming liquid. This liquid is known as gum or spirit varnish, lacquer or synthetic, according to its chemical composition.

The varnish can be applied by different means. The most efficient equipment is the varnishing machine which feeds, dusts and varnishes the sheet automatically and delivers a completely dry sheet in one operation. But varnishing is also done directly on printing presses, by roller coaters, and last but not least, by silk screen — the only way for handling heavy boards. The varnishing machine, designed for paper and lightweight stocks, is limited in general to calipers up to 30 thousandths.

Laminating. Laminating consists in applying a sheet of transparent plastic to the printed stock. This application can either utilize adhesives or heat and pressure. Various kinds of plastics are used in laminating according to the nature of the job and equipment available.

(1) A Stapler; (2) A Wire Stitcher; (3) An Eyeletting Machine; (4) Riveter.

Stapling, Wire-Stitching, Eyeleting and Riveting. Stapling, wire-stitching, eyeling and riveting are techniques for attaching display parts and protecting holes. The stapling machine utilizes individual staples; the wire-stitcher forms its own out of wire; the eyeleting and riveting machines are provided with automatic feeding mechanisms. The functioning of these machines is self-evident, but one point is frequently neglected. Each of these machines has a throat which limits the distance of the stitch, eyelet or rivet from the edge of the sheet. It is well to remember this little detail in the planning stage; otherwise one can be in very unpleasant trouble where one expects it least.

Section Six: Folding Box Making

"A very large portion of American business rises or falls on the ability of the package to translate billions of dollars' worth of sales effort, advertising, merchandising and promotion into ACTION at the point-of-sale."

That statement by Norman F. Greenway, President of the Folding Paper Box Association of America, at the Seventeenth Annual Packaging Institute Forum significantly points up the situation that today we are in the midst of a tremendous marketing revolution — one which has been accelerating for the past quarter century because of the increasing emphasis on packaging — packaging in cartons, in cans, in tubes, in glass and in film.

The most widely used package is the folding paper box — over 115 billion being produced annually to protect, preserve, carry and help merchandise food, drugs, hardware, beverages, textiles — almost every type of item used in the home, office or factory. They are the end product of that segment of the great paper-converting industry which utilizes bending grades of paperboard as the primary material in their manufacture.

SOME ADVANTAGES OF FOLDING CARTONS

Some of the advantages of folding cartons are enumerated below: (1) They provide the best in printing — producing pictorial results as slick and attractive as any magazine cover. (2) They easily combine various materials — foils, films and other laminants. (3) They provide premiums as cutouts, recipes and directions which are incorporated into the carton design. (4) They provide a variety of styles and constructions — over 200 in common use. (5) They are made with close tolerances for use on high-speed filling machines which require extreme uniformity and dimensional stability. (6) When filled, they ship and handle efficiently and stack well for display purposes. (7) They are the key to new outlets in the traditional service stores and for self-selection super-markets and similar establishments. (8) They are supplied folded, but unopened, to the customer and, therefore, require minimum space for shipping and storing.

Folding Cartons Can Be Manufactured by Use of Lithography. Since the pictorial reproductions and designs on countless millions of folding cartons are striking examples of the lithographic process, a discussion of folding box manufacture seems in order in this Manual.

Other chapters cover in detail the technical phases of the offset process; here attention will be given primarily to those other operations relating to carton production as are essentially different from the production of other products of lithography.

FACTORS TO BE DISCUSSED IN THE MANUFACTURING OF FOLDING CARTONS

The satisfactory performance of a folding carton depends upon four factors: (1) The proper choice of the appropriate structural style; (2) The use of a boxboard having the required protective and functional properties; (3) The effectiveness of the design and the suitability of the reproduction process selected; and (4) The quality of manufacture as shown in the end product.

These four factors are discussed under the following headings in our study: (1) Styles of folding boxes; (2) Materials for folding boxes; (3) Design of folding boxes; and (4) Manufacture of folding boxes.

Definition of Folding Cartons. That we may have a common understanding of the nature of the packaging medium called the folding carton, or folding paper box, the following definition will precede our discussion: *The term folding carton designates containers converted from bending grades of paperboard, diecut and creased in a variety of styles and delivered — with or without printing — to their users either in a glued and collapsed form or as flat blanks, ready for mechanical or manual setup and use.*

Folding cartons are distinguished from setup boxes which are supplied in a rigid or erected form with stayed corners, and generally covered with a decorative or printed paper wrapping.

CARTON STYLES

Folding cartons are made in a multitude of one-piece, two-piece telescope, display, and carrier styles. No complete list of carton constructions has ever been compiled as new ones are being continually designed to meet new requirements. Hundreds of patents have been issued; however, there are many carton designs which are merely adaptations or combinations of the elements found in a number of basic constructions. These cartons are commonly designated as follows:

1. Seal end
2. Tuck end (reverse or straight)
3. Brightwood blanks
4. Cracker style
5. Friction end
6. Diagonal infold or outfold
7. Automatic/snap lock bottom
8. Tube and slide
9. Carriers
10. Folders

The Two Primary Concepts of Folding Cartons. The above-listed cartons, and for that matter all carton constructions, have evolved from the two primary concepts of the tube and the tray which are explained as follows: (1) *The tube* — The tube is a diecut sheet of boxboard, folded over and glued along two parallel edges to form a hollow tubular shape, usually rectangular, the ends of which can be sealed, tucked or locked in a variety of ways. (2) *The tray* — The tray is a sheet of diecut boxboard with its edges folded at right angles and locked, stitched or glued together at the corners. One panel can be extended to form the

DIAGRAM FOR "PRINTING BLEEDS" AND PANEL ARRANGEMENT USUALLY USED FOR A REVERSE TUCK-END CARTON

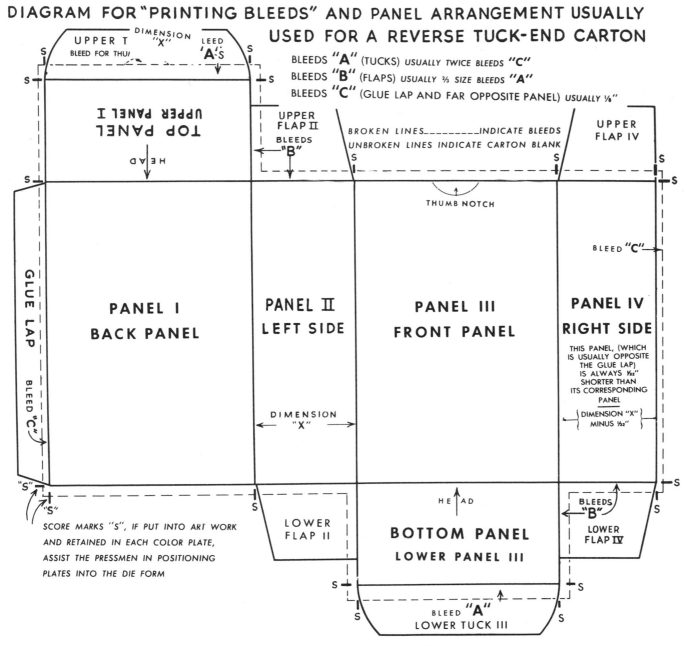

BLEEDS "A" (TUCKS) USUALLY TWICE BLEEDS "C"
BLEEDS "B" (FLAPS) USUALLY ⅔ SIZE BLEEDS "A"
BLEEDS "C" (GLUE LAP AND FAR OPPOSITE PANEL) USUALLY ⅛"

BROKEN LINES _____ INDICATE BLEEDS
UNBROKEN LINES INDICATE CARTON BLANK

Diagram of a Folding Carton (Flat).

cover or two trays fitted together to form the top and bottom of a complete box.

The structural complexities of certain styles warrant the designation of a "specialty" classification for folding boxes such as multiple unit carriers and flip-top cigarette boxes.

Folding Cartons are Made for Various Kinds of Loads. With the wide variety of styles available, carton buyers can choose one or have a basic style adapted to suit their individual needs, be they for a non-supporting load or free-flowing product, such as soap powder; a semi-supporting load, such as a tube of tooth paste; or a rigid, full-supporting load, such as a bar of soap.

Specifying Dimensions. The dimensions of a folding carton are given in inches in the following sequence: length, width and depth. In this context *length* is the larger

dimension at the opening of the carton when it is assembled and presented for filling; *width* is the smaller dimension at the opening of the box; *depth,* the remaining dimension, is the distance from the opening to the bottom panel, or the distance between the openings in a carton blank such as a reverse tuck end style.

All dimensions are measured from the center of the score to the center of the adjacent parallel score.

Carton Styles Are Numerous, Their Designation Sometimes Confusing. A certain amount of confusion arises in applying name designations to carton styles other than some of the more basic ones. Even then local designations are given to component parts or members of a carton that are not recognized in other geographical areas. Many

patented styles use the inventor's name; some companies have created their own trade labels.

Nomenclature Charts Published by the Folding Paper Box Association. In an attempt to help clear up the situation, the Folding Paper Box Association of America published a series of 18 nomenclature charts for the more common basic constructions, and distributed them widely several years ago. Since then these charts have been reproduced in several books and manuals. They are currently out of print but are being revised; it is expected that they will be available again for distribution late in the fall of 1958.

Federal Specifications for Folding Boxes. Federal specification "PPP-B-566" covering folding paperboard boxes was issued February 14, 1955 for the use of all Federal agencies and is available from the Government Printing Office, Washington, D.C., for 20¢. The diagrams showing ten of the styles covered in the specifications are similar to the drawings for similar constructions, used commercially or in non-governmental business.

Folding Box Constructions for Automatic Machinery. Even with the increasing use of automatic cartoning machines in packers' plants, many basic styles can be handled on the filling equipment that is generally available to load cartons and close or seal the same after filling. There are some special constructions designed to be used only on machines built to handle them. Many are patented and their manufacture is restricted to the patent owners or their licensees. Since a number of packaging lines operate at speeds up to and over 300 per minute, extreme care must be exercised in designing and producing dimensionally uniform cartons.

MATERIALS FOR FOLDING CARTONS

Any consideration of the production of folding cartons should undoubtedly begin with a review of information about the principal material used — folding boxboard. For the most part it is made specifically for each order of cartons so that it may embody the proper characteristics required for the item being packaged.

Description of Boxboard. This material, usually referred to as boxboard, is one of the bending grades of paperboard generally ranging from .012 to .045 inch in thickness and is expected to score, bend or fold without cracking or breaking, in addition to providing a suitable printing surface. Boxboards are obtainable in a wide variety of finishes and are usually made on cylinder board machines, although an increasing amount of tonnage is now being turned out on Fourdrinier machines.

Characteristics Required of a Boxboard. The chief qualities looked for in the grades of board selected for folding cartons are: (1) *Strength* — to protect adequately the products packaged; (2) *Flexibility* — to permit bending up to 180 degrees without cracking or breaking where creased; (3) *Appearance* — to enhance the "eye appeal" of the package; (4) *Printability* — to possess a suitable surface for printing; (5) *Stiffness* — to have rigidity sufficient to hold required shape and to function satisfactorily on automatic

filling machines; (6) *Resistance* to penetration or absorption of moisture, grease, or other specified elements.

Other Materials and Their Properties. In addition, today's packaging requirements frequently necessitate the application of special additives, surface treatments or laminated materials to provide a satisfactory board for the container. A number of other materials such as foil and "polyethelene" are being laminated. Some of these additional functional properties that can be provided include:

1. Moisture-vapor barriers
2. Moisture-water barriers
3. Grease barriers
4. Rust preventatives
5. Tarnish inhibitors
6. Wet strength
7. Insect repellency
8. Mould inhibitors
9. Flame retardancy

Lithographing Method of Printing Must be Indicated When Board is Ordered. When the stock is to be lithographed, that fact must be stated so that the mill can furnish board whose printing surface is suited to lithographic printing.

The bulk of the boxboards used for folding cartons comes within the following grades, each with almost innumerable furnishes and densities:

Bending Chipboard. Bending chipboard is the lowest grade of folding boxboard made principally of reclaimed waste paper. It is usually dark gray in color and unsuitable for multicolor printing.

Single Manila-Lined Board. This is a commercial grade of board having its top liner made of unbleached sulphite and ground wood pulp and the balance composed of news or mixed papers. It is distinguished by its manila color.

Bleached Manila-Lined Board. This board is of a higher grade, produced from the same ingredients but whiter in color. It is extensively used for folding boxes of all kinds and sizes.

White Patent Coated Board. This board is made with a top liner of bleached chemical wood pulp mixed with white shavings, aspen or soda pulp to produce a good white surface suitable for multicolor printing. It is used extensively for high grade carton manufacture. (The name of the board is a misnomer as it is neither a patented nor a coated board.)

Clay-Coated Board. This is a high-grade folding boxboard sheet on which a coating of white clay or other mineral substance is applied to the top liner to produce a hard, smooth, white printing surface.

Solid Board (now more commonly called food board). This is produced entirely from virgin pulp of either bleached or semi-bleached kraft, or sulphite or a mixture of either with ground wood and used extensively for packaging food products.

Board for Folding Cartons Must be Carefully Selected and Exactly Specified. When one considers the wide variety of boxboards available for conversion into

folding cartons, it becomes obvious that much thought and care as well as considerable research must go into writing specifications for the mills to use in manufacturing an order. To insure a satisfactory end product requires some real team play between the ultimate user, the converter and the board supplier, with experienced and qualified men in all three positions cooperating to the fullest extent.

Printability, a Most Important Characteristic of Boxboards. Not the least of the requirements are those affecting the printability of the board, whether it's done by letterpress, gravure or offset.

DESIGN OF FOLDING CARTONS

Although the construction or style of a carton is of primary consideration and the board specification is essential, the design factor as it applies to the size, shape, identifying and informative copy, pictorial art and color scheme of the package is certainly of as great importance.

Design Grows in Importance with the Spread of Self-Selection. This is especially true as the trend to self-selection is compelling many consumer goods industries to change their entire merchandising concept. It is imperative that swift and easy identification of a packaged product tie-in with advertising and sales promotional efforts; *the carton on the shelf must be a salesman as well as a container.*

Package Designing, a New Specialty. Out of the need to make packages successful, merchandising has grown a new profession: the package designer. A group of specialists who have acquired considerable proficiency in solving the related problems of their clients are active in this field.

Manufacturers of Folding Cartons Render Design Services. Also, almost all carton manufacturers are qualified and equipped to help their customers to increase the eye-appeal and sales pull of the cartons they make together with recommendations for improved constructions and better functional properties in the board.

Today's beautifully printed food product containers, for example, with tantalizing appetite appeal in their pictorial

Courtesy Ace Carton Co.

A Miehle 76 5-Color with Double Pile Delivery.

realism and color dominance are a far cry from the simple, one-color, product identification labeling that was prevalent a couple of decades ago. Offset lithography in particular lends itself to this kind of carton printing.

Various Printing Processes Used in the Making of Folding Cartons. It is true that the great bulk of folding cartons is still printed by letterpress but an increasing volume is being done by both gravure and offset lithography. Much has already been written and published about the relative merits of these processes. The advantages and disadvantages of each, with respect to the character and quality of their reproductions and the resulting economics from their use, are well known, so there is no need to repeat them here.

A Multicolor Harris Offset Press Installation at the Rochester Folding Box Company Plant.

Art Preparation for Folding Carton Reproduction. The correct preparation of the artwork and drawings for cartons has long been a problem, regardless of the printing method employed. Artists not experienced in doing carton work, fail to realize that a carton has three dimensions and usually six abutting panels or sides and ends to reckon with. Since most designs extend across two or more of these, allowance for the bend or fold at the corner must be provided according to the caliper of the boxboard used.

A sample carton made to the exact size and of same-caliper stock is essential to preparing correct working drawings. Again close cooperation between the parties involved is necessary to avoid corrections when the design goes into production. This is especially so when offset plates are being supplied through trade sources.

THE MANUFACTURE OF FOLDING CARTONS

The fact that the carton industry is supplying its products at a quality level higher than ever before attests to the better production facilities, improvements in method and the competency of the skilled craftsmen in performing the converting operations involved. Space will not permit a detailed discussion of them; however, some of those peculiar to carton production will be highlighted in the following paragraphs:

Die Making. After the hand-cut sample has been approved, the planning department determines the number and arrangement of the flat blanks to be run on the sheet of stock. Wherever possible the protruding or irregular-shaped members of the carton are interlocked to save material. Because most cartons are generally printed in multiples and then die cut and scored for subsequent processing, the first step is the preparation of a steel rule cutting die.

Two Kind of Dies. There are two types of dies — the unit or block die and a "jigged" die. The unit die consists of the required number of component parts of each carton usually cut from plywood and assembled together in a form or chase with pieces of the steel cutting rule shaped to the contours of the edges of the carton and scoring rule of the desired kind inserted where the attached elements of the carton join. In a jigged die a skilled operator saws a pattern in the die block material in such a way that the die generally remains in one piece and the cutting and creasing rules are inserted in their proper place. The accuracy and uniformity of the work is of the utmost importance because the die cut blanks must be similar and as uniform as possible, especially when the cartons are to be run on automatic filling machines that require close tolerance in their dimensions.

The Rub-Off Sheet. From the assembled dies a rub-off is made on an oiled paper sheet or a vinyl sheet in order to provide a pattern for use in laying out and registering the images of the cartons to be produced. For lithographed work the images on the press plates must be accurately positioned with each other and in register with the creasing die because there is no way to shift them individually later on to register with the die.

Double Knifing. For some types of designs space must be left between the several units in the form, necessitating double knifing. This permits the units in the die form to be shifted into position for the cutting and creasing operation, but it does involve considerable additional stripping to remove the extra scrap thus created. Many carton plants doing lithography successfully use step-and-repeat camera equipment.

Materials Used for Making Cutting Dies. The steel rule cutting dies are generally made from pieces of plywood, but in some instances to insure the utmost accuracy and no distortion with changing climatic conditions, metal, specially impregnated wood composition, or plastic "fill-ins" may be used.

Presswork. As mentioned before, the great bulk of carton printing is done by letterpress, and smaller amounts by gravure and lithography. In this Manual lithographed work is covered.

There has been a tendency for carton plants doing lithography to use the larger sizes of offset presses and in most instances to make four- or five-color installations. Some firms, however, are beginning to use smaller presses for shorter and medium length runs, believing that the higher speed at which they operate and the smaller die forms more than equal the advantages found with the larger presses. The practices followed in setting up and operating lithographic equipment for carton work are quite similar to the

Diecutting Makeready.

steps for label and other lithographic work which are described in other sections of this Manual. Because of the thicker caliper of boxboard, considerable more floor space for work in process is required than for paper.

Cutting and Creasing. This is essentially a finishing operation and, together with the die making is peculiar to this industry. Cutting and creasing equipment, as far as lithographed work is concerned, is operated separately and not in-line as with flexographic or gravure. It is done on platen presses, cylinder type cutters and creasers or reciprocating bed machines using an inverted die. The cutting die is locked in a chase or on the bed of the press and a counter prepared on the impression plate or cylinder which functions as a female pattern to facilitate scoring the paperboard to the desired depth or cutting through the stock along the edges of the carton blank. These presses are either hand or mechanically fed.

Stripping. Small nicks are made in the die form to hold the cut pieces together for delivery from the press. After the work has passed through the machine it is necessary to remove the scrap stock or skeletons from around the

A Folding and Gluing Machine.

outline of the blank, and between the flaps, locks and other elements. This is generally referred to as "stripping" or "picking" and can be done by hand, with the aid of pneumatic or electric hammers or specially built mechanical stripping machines, some of which permit in-line operation with the cutting and creasing press.

Gluing. Some customers buy their cartons in blank form, or die cut and scored but not glued into a tubular or tray shape as their own automatic cartoning equipment will assemble and glue the carton as part of the loading or filling operation. For the most part, however, tube types and many special tray designs have a glue lap or flap on which glue is applied automatically and to which the opposite carton edge is folded and adhered. These machines operate at very high rates of speed and on medium size cartons, it is not unusual to glue upwards of 75,000 units an hour. As the cartons are delivered in collapsed form from this equipment they are inspected, counted and packed in master shipping containers for delivery. The majority of carton constructions require only gluing the overlapping strip to a side panel on straight-line equipment but the more complex styles require right-angle gluing machinery in which the direction movement for the carton is changed in order to glue spots at right angle to the first gluing.

Finishing Operations. A number of special operations may be performed on cartons to increase their utility in addition to the ones mentioned below — metal closures, handles, pouring spouts, etc.

Windowing. In many instances it is desirable to show the product packaged, so cutouts or windows are frequently made in the carton blanks over which there is attached a thin sheet of transparent film — acetate, cellophane, mylar, etc. This is done prior to the gluing operations described above using special high-speed automatic equipment. In cases where very large volume and speed are important, windowing can be done as part of an in-line operation.

Waxing. A protective coating of paraffin wax is frequently applied to carton blanks to give added functional

A Windowing Machine.

properties to the carton. This is done by several methods utilizing hot or cold wax applications.

Varnishing. For appearance as well as protection against rubbing and scratching, many cartons are given a protective coating of spirit or overprint varnish. This is applied in some instances on printing equipment as an extra operation or under some conditions at the same time as printing, but in many plants special varnishing machines with drying equipment have been installed.

Lithographic Trade Customs_____

Section One: Court Cases and Their Decisions

A trade custom is an established method of dealing between persons engaged in a particular vocation or trade. Like most legal terms, "customs and usages" uses two words where one would do. "Custom" and "usage" are synonymous terms. Some customs have been in use for so long they have acquired the force of law. However, to vary the ordinary meaning of words used in a contract by proving there is a "usage," it must be well-established that both parties can be presumed to have known the usage. Custom and usage do not spring up overnight but take time to become accepted.

Back in 1843, a usage of carpenters in New York City, to charge a day and a quarter's wages for $12\frac{1}{2}$ hours of work, was held valid.

To establish a custom, it is not enough that an act is frequently done. It must be recognized, so that the parties to the contract must tacitly agree that their rights and responsibilities shall be determined by it.

An individual custom is of no value here, since a custom to be admissible in evidence must be general. Also, a custom, to be admissible in evidence as such, must be uniform. It must also be reasonable.

Of course, a custom which conflicts with an established law is invalid. Evidence of custom is not permitted to accomplish an unfair or immoral construction of a contract.

It is well to be familiar with the custom and usage of a profession or trade, because the law holds that a person is presumed to know the customs and usages of the business in which he is engaged. In order that you may become acquainted with what the courts have said from time to time regarding trade customs in lithography, here are some of the more important decisions, in abridged form.

WHO OWNS LITHO STONES?

Back in the Gay Nineties, one Samuel Knight agreed that the Hatch Lithographing Company would engrave stones from Knight's designs, he to own the engraving, and the Company the stones. The Company afterwards let the stones get into the hands of another company. When Knight found out about this, he offered the value of the stones and demanded delivery. New company said: NO—and a law suit was started, which the Court dismissed, stating that while the original Hatch Company was exposed to a suit for breach of contract, Knight could not follow the stones into the hands of strangers.

This case (*Knight* v. *Sackett & Wilhelms Lithographing Co.*), the report of which is found in 141 New York "Reports" at page 404, contains an interesting opinion by Judge Gray, who argues that the dismissal of the complaint was undoubtedly right because Knight failed to show that he had any right to the possession of these stones. He never had any interest in the stones except under his oral contract with the Hatch Company, which gave him the right to have prints made from them. The contract between Knight and the Hatch Company was one which bound the Company to render services for a fixed compensation. Knight calculated that he had a right based upon a theory that the stones were jointly owned by him and the Company, but he couldn't prove this. All he showed was that the stones belonged to the Hatch Company and that they would not print from them for anyone else. The Judge held that Knight never had any title to, or any right to the possession of these stones and the agreement was one for the performance of services in the making and transferring of lithographic engravings.

PRESS PLATES BELONG TO THE LITHOGRAPHER

In 1949, Mr. Justice Capozzoli decided the first case covering lithographic press plates. Universal Map Co. Inc. had brought suit against the lithographic firm of Lutz & Sheinkman for the value of such plates. In all but one of the orders between the parties, the written quotations contained the statement in writing that no charge is made for the stones, dies or plates on which the work is drawn or engraved and these stones, dies and plates remain the property of Lutz & Sheinkman. Assuming that there was no writing controlling the disposition of the plates, there was offered uncontradicted proof that it is the custom of the trade that the plates belong to the lithographer.

In arriving at his decision dismissing the complaint of the map company against the lithographer (194 misc. 938), the Judge reviewed several decisions in the New York courts, including the Knight case referred to in this article. Another case was that of Colten v. Jacques Marchais, Inc. (61 N.Y. Sup. 2nd 269), decided by Mr. Justice Watson in the New York City Municipal Court in 1946. Colten, a professional photographer, has sued to recover for professional services and the Marchais company counterclaimed for the return of over 400 negatives which, it was orally agreed between the parties, were to be delivered to the customer. The Judge pointed out that the relationship between photographer and customer is that of employee and employer and the customer obtains all proprietary rights in the negative as well as the photographs purchased by him. According to the judge in this case, if the photographer failed to show that he was given the right to have and keep the negatives, he had to surrender them to the customer, to whom belongs the absolute legal ownership.

The photographer claimed there was a custom and usage in the field of commercial photography which gives the photographer the right to own and possess the negative of photographs made for his customer. The Judge said that custom and usage could not be set up to alter a general principle of law and make the legal rights of the parties other than they are fixed by the circumstances of the transaction.

Still another case discussed by Mr. Justice Capozzoli was that of *Hochstadter* v. *H. Tarr* (68 N.Y. Sup. 2nd, 762), in which three Justices of the Supreme Court in New York State decided that where a customer employs a photographer to make pictures of him, the photographer, in the absence of an agreement to the contrary, has the right to retain the negatives. The fact that this determination was made by a higher court than that in which Mr. Justice Watson was sitting, would indicate that, had the Colten case been appealed, a different decision would have been reached. At any rate, the prevailing legal opinion is that, in the absence of an agreement to the contrary, a lithographer's press plates belong to the lithographer and not to the customer.

A case which was decided squarely on trade customs was tried in the Superior Court in New Jersey several years ago. (*Yogg* v. *Reproduction Offset Printing Corporation*). The facts as set forth in the pre-trial statement in that case are as follows:

The customer claims that between April 14, 1947 and Jan. 3, 1952, he engaged the defendant to do certain lithographic printing. It is conceded that defendant conducts a printing plant and lithographic and platemaking shop. It is agreed also that in order for defendant to do plaintiff's work, it was necessary for the lithographer to make certain lithographic plates.

The customer claims that in order for defendant to do the work contracted for, it was necessary for defendant to make lithographic plates, for which the customer paid the defendant the sum of $12,423.34. This figure includes $172 representing the value of one plate which the customer furnished to the defendant. The customer claims that

upon payment to the defendant for the plates and upon delivery of the one valued at $172 the plates became and remained the property of the customer. Upon completion of the work, the customer demanded the return of the plates which the defendant has refused, and the customer therefore seeks a recovery representing the value of the plates. The invoices covering all of the plates involved in this action are marked P-1 for identification.

Defendant admits the engagement to do lithographic work, that it made certain plates in connection with the plaintiff's work, that it received one plate from the plaintiff which it did not make, that it received payment for the plates which it did make; and that it still has in its possession all of the plates either made for the customer or furnished to it by the customer.

Defendant claims that the plates are its property; it claims that although there was no express written or oral agreement with respect to the ownership, the plates became its property by reason of universal custom or practice in the trade, which practice was or should have been known to the customer. Defendant's answer is amended to add as a separate and special defense that the plates in question became its property by reason of the custom or practice in the trade.

The printer has filed a counterclaim seeking recovery for the balance due from the plaintiff for certain printing work. The amount claimed is $932.70 and the customer concedes that this sum is due.

The issues to be determined at the trial are: 1. Ownership of the plates in question; 2. Existence of a custom or practice in the trade with respect to ownership; and 3. Nature of the custom and whether the plaintiff had actual or constructive knowledge of the custom.

The jury heard the testimony of experts on the customs and usages in the trade and found in favor of the defendant printer and lithographer; that by reason of the custom in the trade the plates became the property of the printer.

In the brief submitted for the defendant, its attorney pointed out that in a previous case decided in 1938 in the New Jersey Supreme Court (*Greenberg Publishing Co.* v. *Jersey City Printing Co.*), where, as here, a printer was sued for the value of lithographic plates prepared by the printer for work produced for its customer, the jury decided in the printer's favor after four days of trial. The Court in that case had charged the jury that in the absence of a definite agreement concerning the disposal and ownership of plates on which work has been done, the trade customs would prevail.

REPRODUCTION OF COLOR—HAND-SEPARATION PROCESS

A case which went all the way to the highest court in New York State determined the question of what the customer is entitled to in a color job (Duenewald Printing Corporation v. G. P. Putman's Sons, 301 N.Y. 569). Where the customer's primary concern is not accuracy of reproduction of

colors but cheapness of price, he cannot complain of less than perfect results. Where the printer produces a job which is good and acceptable under the process employed, which in this case was the hand-separation process, the customer cannot successfully complain. Where such process is employed, variations in color are to be expected and the final product of the printer is an acceptable standard of such process. Expert testimony in behalf of the printer showed that it had produced a book acceptable in the trade as good in the reproduction of colors as could reasonably be expected in the light of the inexpensive process that the customer had agreed should be employed.

It is significant that this case when tried before the trial justice resulted in judgment for the printer; when it was appealed by the customer, the Appellate Division found in favor of the customer; and when the printer appealed from this reversal to the Court of Appeals, that court rejected the determination of the Appellate Division and upheld the original judgment in favor of the printer.

A Justice of the Appellate Division who dissented in the finding of that Court, said that the ultimate test is whether the result as a color lithographing job by the hand-separation process is as good as could reasonably be expected. Such questions should be determined by the testimony of experts in the craft familiar with lithographic reproduction in colors by the hand-separation process.

WHO IS LIABLE FOR MISTAKES IN OKAYED PROOFS?

Where a printer received from his customer an order "subject to the customer's acceptance of the finished proof" and a proof sent the customer came back to the printer marked "okay" and signed by the customer, the fact that two words were transposed in the proof and had been overlooked by both printer and customer was not the responsibility of the printer.

The Court decided that the printer's contract was to furnish cards according to the finished proof. If there was an error in the sample, the customer was not obliged to accept it, but once okayed, the customer must be considered to have ordered cards corresponding to the sample. (*Gills Lithographic & Liberty Printing Co.* v. *Chase,* 21 N.E. 765).

If the customer does not okay the proof but merely selects the type, the customer may, according to a legal decision in Illinois, object to the quality of the printing because the appearance of the work depends not only on the style of type but upon the inking and other acts in the printing process. The printer would have to show that he had substantially performed his contract or the customer can rescind the same, and refuse to pay for the order.

A court was asked to define a proof in a case where the customer okayed proofs but asked the printer to rough or emboss the prints to see how they would look. The definition was: "An impression taken from an engraved plate to show its progress during the execution of it." (*Turner* v. *Osgood Art Colortype Co.* 125 Ill. App. 602).

The author of a famous legal textbook on sales says that as a general rule all the buyer is entitled to in case of a sale or contract to sell by sample is that the goods shall be like the sample. He has no right to have the goods saleable if the sample, which he has inspected, is not (*Williston Sales* (Rev. Ed.) Sec. 257).

New York courts have ruled that a deliberate, intelligent and intentional acceptance of property manufactured under contract after inspection, precludes the customer from claiming damages for any visible or discernible defect in the property sold.

Where the printer invited the inspection of the goods, so as to obtain authority to deliver the goods to the parties who had agreed to print and bind the plates into books, the customer who has actually made the inspection cannot thereafter claim that there was no acceptance of the property sold or to claim damages for defects in the articles so accepted. (*Studer* v. *Bleistein,* 22 N.E. 243.)

LIMITATIONS ON REJECTION OF GOODS

A printer who delivers stationery and nine months later finds himself suing for payment of goods sold and delivered, which, of course, the customer tries to defend, has the right to a judgment against his customer, even though there was a claim by the customer that the printer was supposed to hold the job until the customer furnished a new address to which he was moving. In his defence the customer claimed the stationery was useless.

The court which decided in favor of the printer said that in view of the fact that the customer had accepted the goods and had never given the printer notice that they were objectionable and not acceptable, but remained silent for six months or until he was sued, by so doing he acquiesced in the quality of the stationery as being according to sample given the printer at the time the order was placed. (*Leigh* v. *Cornelius,* 15 S.E. 2nd 827.)

In another instance of this character an order for illustrated advertising pamphlets was in part, "Please enter our order for 160,000 copies as per dummy submitted, divided into eight issues of 20,000 per issue. Paper stock subject to okay. Envelopes subject to okay. All artwork, copy, editorials and proofs subject to okay before each issue goes to press." (*Hollidge* v. *Gussow Kahn & Co.,* 67 Fed. 2nd 459.)

After the first issue of 20,000 leaflets had been delivered the purchaser refused to continue the contract, contending there had been no acceptance of its order and hence no agreement under which it was liable. (*Mason* v. *Valentine,* 168 N.Y. Sup. 159.)

Said the court, "When the order for 160,000 copies was made," in holding the purchaser liable under this agreement, "and acted upon by the printer, we think it clear that both parties regarded themselves bound." (*Uniform Sales Act,* Secs. 48, 49.)

Late Delivery. In another controversy a printer accepted an order for the manufacture of 63,500 picture postcards for use at a summer resort. Shipment was delayed from three to six weeks. However, the cards were accepted

when delivered and retained without objection. In spite of monthly statements the bill remained unpaid for six months when the customer sued the printer claiming damages for failure to deliver the cards on the agreed date.

In its decision the court said: "Retaining the cards without objection and entering upon the sale of them were acts radically inconsistent with the ownership of the seller. Fair dealing and proper regard for the rights of the printer also required the customer, if he had objections on account of any delay in shipment, to notify the printer within a reasonable time of such objection and thus save it from loss in continuing to manufacture and ship cards."

In most of our States, the printer is protected by the Uniform Sales Act. It is the law in the States which have adopted this statute that the customer is deemed to have accepted the goods when he intimates to the seller that he has accepted them or when the goods are delivered to him and he does nothing inconsistent with the ownership of the seller, or when after lapse of a reasonable time he retains the goods without notifying the seller he has rejected them.

In the absence of expressed or implied agreement of the parties, acceptance of the merchandise by the customer shall not discharge the printer from liability for breach of contract. But if, after acceptance of the merchandise the customer fails to notify the printer of the claim of breach of contract within a reasonable time after the customer knows —or ought to know of such breach—the printer shall not be liable.

THE CUSTOMER IN BANKRUPTCY

Trade customs, if set forth in estimates, may preserve the printer's right when a customer goes into bankruptcy and a trustee is appointed. In a case decided in a Federal Court (*Berger* v. *Kingsport Press, Inc.,* 89 F. 2nd 444), a firm had contracted with a printer for a large order of books. The customer delivered to the printer the paper and plates for the printing and the dies for embossing the cover.

When the customer became bankrupt, the printer claimed a lien on all the plates and dies furnished by the bankrupt customer. In the correspondence leading to the order, the printer had given an estimate which referred to Trade Customs set forth on the back of the first page of the letter to the customer. This provision was included in the Trade Customs:

"Manufacturer's lien attaches on all goods in our possession until delivery to customer, notwithstanding the giving of credit or the accepting of notes or guarantee of payment."

The estimate was held to be part of the contract and the Trade Customs governed its terms. A lien therefore was reserved to the printer by express contract.

The court found that the printer was entitled to a lien upon the manufactured goods or materials in its possession at the time the customer was adjudicated a bankrupt.

The importance of this decision is that a printer who takes the precaution to include in his estimate reference to Trade Customs obtains maximum protection in cases where insolvent customers are involved.

BAILMENTS: ELECTROPLATES
DOES THE PRINTER HAVE TO STORE THEM

The Appellate Division of the Supreme Court in New York has ruled that where electroplates are left with a printer under certain conditions and cannot later be found, the printer is not liable to the customer, provided the printer can show that he has made a search for them and has been unable to find them and that he himself did not misappropriate them. (*E. P. Dutton & Co.* v. *Goldman.* 277 App. Div. 556.)

The situation came about in this way. A book publisher delivered to a printer of illustrations some electroplates. The illustrations were printed and delivered to the printer of the book. About three years later, the publisher asked for the electroplates and the printer said they could not be found. He could give no explanation of their disappearance although the printer claimed he used due care in keeping them.

An important part of this case was that both the printer and the publisher introduced testimony that a custom existed covering this situation. The testimony for the printer was that one year was the customary maximum time to keep plates; whereas, the publisher had a witness testify that 27 years was not an unusual length of time to keep such property. Further, the publisher claimed that custom is to retain such plates perpetually and the printer should be regarded as having been obligated to store these plates forever. The Court said assuming there was such a custom, either party could terminate the relationship at any time.

In this case when the work was billed there was a written notice in red ink on the invoice that all plates were held in stock at the owner's risk. This was held to be equivalent to notice to the publisher to come and get the plates and if he did not do so within a reasonable time, the printer would not be responsible for taking care of them any longer.

The Court in this case held that three years was longer than a "reasonable" time.

Although the printer was held to be not liable in this matter, it was necessary for him to account for his failure to produce the plates, at least to the extent of showing that he did not take them himself. When the printer had shown that he did not willfully misappropriate these plates, the claim of the publisher was dismissed.

Section Two: Suggested List of Terms of Sale

The following trade customs have been generally recognized by the courts in interpreting contracts between printer and customer and some of them have been cited in legal decisions. Reference to them is essential to avoid misunderstandings and in some cases litigation between the printer and his customer.

Orders. Regularly entered orders cannot be cancelled except upon terms that will compensate the lithographer against loss.

Experimental Work. Experimental work performed at customer's request, such as sketches, drawings, composition, plates, presswork and materials will be charged for.

Sketches and Dummies. Sketches, copy, dummies and all preparatory work created or furnished by the lithographer, shall remain his exclusive property and no use of same shall be made, nor any ideas obtained therefrom be used, except upon compensation to be determined by the owner.

Drawings, Negatives and Plates. Artwork, drawings, negatives, positives, plates, and other items when supplied by the lithographer shall remain his exclusive property, unless otherwise agreed in writing.

Alterations. Proposals are only for work according to the original specifications. If through customer's error, or change of mind, work has to be done a second time or more, such extra work will carry an additional charge at prevailing rates for work performed.

Approval of Proofs. If proofs are submitted to the customer, corrections, if any, are to be made thereon and the proofs returned to the lithographer marked "okay" or "okay with corrections" and signed with the name or initials of the person duly authorized to pass on same. If revised proofs are desired, request must be made when proof is returned. The lithographer is not responsible for errors if work is completed as per customer's okay.

Press Proofs. An extra charge will be made for press proofs, unless the customer is present when the plate is made ready on the press, so that no press time is lost. Presses standing awaiting okay of customer will be charged for at current rates for the time so consumed.

Color Proofing. Because of the difference in equipment and conditions between the color proofing and the pressroom operations, a reasonable variation in color between color proofs and the completed job shall constitute an acceptable delivery.

Quantities Delivered. Overruns or underruns not to exceed 10 percent of the amount ordered shall constitute an acceptable delivery and the excess or deficiency shall be charged or credited to the customer proportionately.

Customer's Property. The lithographer shall charge the customer, at prevailing rates, for handling and storing customer's paper stock or customer's lithographed matter held more than thirty (30) days. All customer's property that is stored with a lithographer is at the customer's risk, and the lithographer is not liable for any loss or damage thereto caused by fire, water, leakage, breakage, theft, negligence, insects, rodents, or any other cause beyond the lithographer's control. It is understood that the gratuitous storage of customer's property is solely for the benefit of the customer.

Delivery. Unless otherwise specified, the price quoted is for a single shipment, F.O.B. customer's local place of business. All estimates are based on continuous and uninterrupted delivery of complete order, unless specifications distinctly state otherwise.

Terms. Net cash thirty (30) days, unless otherwise provided in writing. All claims must be made within five days of receipt of goods.

Delays in Delivery. All agreements are made and all orders accepted contingent upon strikes, fires, accidents, wars, floods or other causes beyond the lithographer's control.

Paper Stock Furnished by Customer. Paper stock furnished by the customer shall be properly packed, free from dirt, grit, torn sheets, bad splices, etc., and of proper quality and specifications for the lithographer's requirements. Additional cost due to delays or impaired production on account of improper packing or quality shall be charged to the customer.

Glossary of Lithographic Terms_____

Aberration. General term for various optical errors in photographic lenses which prevent the lens from giving good definition.

Absorption. Optical term for the partial suppression of light in passage through a transparent or translucent medium or material.

Achromatic. Without color. A lens which refracts light of all colors equally is said to be achromatic.

Across the Grain. The direction opposite to that of the paper grain.

Actinic Light. Chemically active light obtained from arc lamps, mercury vapor lamps, photo-flood bulbs (gas filled tungsten filament incandescent lamps) and used to harden light-sensitive plate coating solutions in photographic platemaking techniques.

Affinity. Natural attraction for, as salt for moisture.

Air Eraser. Miniature sand-blasting hand appliance, used for removing superfluous lithographic images from the plate. Also used in erasing art without destroying the texture of the medium.

Albumin. A natural protein soluble in water and most commonly found in the whites of eggs; the colloid used for certain bichromated sensitizers employed in photomechanics.

Albumin Process. That procedure of photomechanics utilizing a coating of bichromated albumin as a sensitized surface, whereon images are made by exposure under a line or halftone negative, followed by subsequent development of the inked image with water.

Alkyd Resin Drying Oils. Synthetic drying oils made from glycerine or glycols by combination with various organic acids.

Aluminum Plate. A thin sheet of aluminum used in lithography for some press plates; image applied photographically; used for both surface-type and deep-etch offset plates.

Ammonium Dichromate. A salt formed by neutralizing chromic acid with ammonia, commonly used in photolithography as a sensitizing agent; also know as *Ammonium Bichromate.*

Angstrom Unit. A unit of measurement of the length of light waves. It is equal to 1/10 of a millimicron, or one ten-millionth of a millimeter. There are approximately 254,000,000 Angstrom units in an inch.

Anhydrous Plate Wash. An anhydrous alcohol, a water-free alcohol used in lithographic deep-etch platemaking to wash the plate before applying the lacquer image base.

Antihalation. The property of a film or plate, usually with an opaque backing, which prevents halation. *Antihalation Backing,* a coating on the back of a film containing a dye or colored pigment for the purpose of absorbing light rays, thus preventing their reflection from the back surface of the film base.

Aperture. A small opening in a plate or sheet. In cameras, the aperture is usually variable in the form of an iris diaphragm and regulates the amount of light which passes through the lens. *Working Aperture* — diameter of that part of the lens actually used.

Asphaltum. A naturally occurring bituminous mixture of hydrocarbons and complex derivatives thereof, used in various inks and varnishes, and as an acid resist or protectant in photomechanics. In lithography, used to make printing image on press plate permanently ink-receptive.

Autoscreen (Film). A photographic film embodying the halftone screen; exposed to a continuous-tone image, produces a dot pattern automatically just as if a halftone screen had been used in the camera.

Back-Etching. Opening up or lessening of density in a negative. Used extensively in lithographing for color correcting continuous-tone negatives.

Backing-Up. Printing the other side, of a printed sheet.

Back Pressure. The squeeze pressure between the blanket (offset) cylinder and the impression cylinder; sometimes called "impression pressure."

Base Color. A first color used as a background on which other colors are printed.

Baumé Hydrometer. A special hydrometer invented for industrial use by Antoine Baumé and designed for determining the specific gravity of liquids. Of the two types available, the one measuring liquids heavier than water is most generally employed in photomechanics and electro-typing. For lithographic plate-coating solutions, the specific gravity is referred to as density of solution. This varies according to the temperature of the solution.

Bearers. Rings of steel at the ends of the plate cylinder, the blanket cylinder, and sometimes the impression cylinder. On American offset presses the bearers make rolling contact for proper meshing of the driving gears. On all presses, bearers provide a fixed base for determining the packing of plate and blanket.

Ben Day Process. A method of mechanically transferring line, dot or texture patterns to paper, metal or glass by general or local pressure on the back of an inked Ben Day screen

(film), the screen bearing the particular pattern in relief on one side of the film. Invented in 1879 by Benjamin Day for introduction of shading effects in line drawings and reproductions therefrom.

Ben Day Tints. A term used for simulated Ben Day screens, applied by the artist by means of stock transparent sheets with printed patterns or screens being pasted on top of artwork, or by using a patented drawing paper with invisible patterns which are developed by artist's application of developing chemical. Also a term erroneously applied to halftone tints which are added to indicated areas by the stripper to give a tone in gray instead of solid.

Bimetal Plates. Lithographic plates in which the printing image base is formed of one metal and the non-printing area of a second metal. Generally, the printing area is formed of copper, while the non-printing areas may be nickel, chromium, or stainless steel. Some plates employ a third metal as a base or backing and could be regarded as trimetallic, multimetallic or polymetallic. Both surface and deep-etch platemaking techniques are used in the making of such plates. With a plating of chromium on copper sheet, the resist stencil of deep-etch method permits etching chromium from image to reach copper for base of lithographic image; with plating of copper on stainless steel base, surface platemaking methods temporarily protect the image while copper is etched away to give stainless steel for non-printing areas of plate.

Bite. A surface characteristic of paper which causes it to accept ink, pencil, or other impressions. (2) An etching bite operation on metals. (3) Gripper bite, the amount of paper that extends beneath the press gripper, sometimes called *gripper margin.*

Black-and-White. Said of originals and reproductions displayed in monochrome (single-color), as distinguished from polychrome or multicolor.

Black Printer. The black plate made for color reproductions to give proper emphasis to the neutral tones and detail; made frequently by exposure of copy on panchromatic emulsion through a yellow filter (K2 or K3 Wratten).

Blanket. A fabric coated with natural or synthetic rubber which is clamped around the blanket cylinder and which transfers the ink from the press plate to the paper.

Blanket Creep. The slight forward movement of that part of the blanket surface that is in contact with the plate or paper.

Blanket Cylinder. The cylinder where the blanket is mounted. This cylinder receives the inked design from the plate cylinder and "offsets" or transfers it onto the surface to be printed.

Blanket Thickness Gage. A special micrometer for measuring the offset blanket under uniform pressure.

Bleed. An extra amount of tone added to edges and contours of the sketch that is later to be diecut into a conforming shape. Window displays and contour cards are usually cut to shape to make them look more realistic. This "bleed" permits the slight variations that occur when the reproduction is being diecut. (2) Term applied to a lithographic ink pigment which dissolves in the fountain etch and causes tinting.

Blind. A dot on a photographic negative or positive, which lacks density and has become so transparent that any light going through it falsifies the values desired. To be photographically effective all dots must be opaque and all transparent areas must be absolutely clear.

Blind Image. In lithography, an image that has lost its ink-receptivity.

Blocking-Out. The operation of eliminating undesirable backgrounds and portions of negatives by opaquing the image.

Blue Key. A blueprint on glass or a vinyl plastic sheet of a basic design containing all elements with register marks, and used as a guide for stripping a flat of photographic elements of other colors to register. For deep-etch plates, positives are usually stripped to flats made of vinyl plastics.

Blueline. A drafting surface mounted on metal or board, then coated with an iron sensitizer, yielding a non-photographic blue image after contact exposure to a negative and development in water. (2) Some form of blueprint on an offset plate to be used as a guide in applying tusche or crayon handwork. (3) A blue on white print made by exposing sensitized paper to negative in contact.

Blueprint. A photographic print, usually by contact with negative, on paper, glass or metal. Serves as a guide for artist in making "keyed" art for multicolor; also used as a method of securing a copy of unit negatives or of flat for checking layout and imposition. Ozalid prints used for prints from photographic positives.

Brightness. Referring to the light being reflected by the copy to the lens of the process camera. Not to be confused with *illumination* which is the light falling on the copy on the copyboard of camera.

Bronzing. The application of a metallic powder, known as bronze, to the press sheet, usually by a bronzing machine. A sticky base of clear or yellow varnish is applied by the press just before the sheets are fed to the bronzer. There the powder is sifted onto the sheet where it adheres to the sticky image.

Brownprint. A silverprint or photograph of brown color, made of sensitized paper. Not to be confused with a sepia print, or black photograph which has been chemically converted (toned) to a brown color.

Brunak. A treatment for aluminum litho plates, using a solution of ammonium bichromate and hydrofluoric acid, to make them non-oxidizing.

Burn-Out. To overexpose in such a way on a press plate that no tints come up. This is done on deep-etch plates where positives are used. Edges can be sharpened up, while lettering can be obtained in toned areas by burning-out or by double shooting.

Caking. Caking is the collecting of pigment upon plates, rollers or ink table caused primarily by the inability of the vehicle to hold the pigment in suspension.

Camera Back. The back of the camera which holds the photographic material. With a darkroom process camera the camera back holds the plateholder, the ground glass, and the halftone screen. Special purpose camera backs have special equipment such as micrometer adjustment of plateholder for step-and-repeat negatives.

Camera Copyboard. That part of a process camera on which copy to be photographed is placed. Frequently it has a hinged glass cover to hold copy flat, can be tilted to horizontal position for placing copy, and may have a removable section in which a transparency holder can be positioned for back-lighting illumination.

Camera Extension. In photomechanics, the distance between the lens diaphragm and photographic surface

in process cameras at any definite scale of reproduction.

Carbros. Reproduction color prints made by superimposition of color pigments transferred from carbon tissues whose differentially hardened image areas were made insoluble in hot water by contact with enlarged photographic bromide prints made from the color-separation negatives. The name is a hybrid of carbon and bromide, distinguishing the process from regular carbon prints which were limited to contact print size of the separations because of the low sensitivity of the bichromate sensitizer used.

Casein. A product of skimmed milk used for sizing and as an adhesive in the manufacture of coated papers. In lithography casein can be used in place of albumin for making surface plate coatings.

Catching Up. A lithographic term used to indicate that the non-image areas of a press plate are beginning to take ink.

Cellulose Gum. A water-soluble gum made from wood fiber cellulose, chemically designated as carboxymethylcellulose. In lithography, a substitute for gum arabic and synthetic gums.

Chalking. A lithographic term referring to the improper drying of ink; in chalking the pigment dusts off due to lack of binding vehicle; caused by too rapid absorption of vehicle into paper.

Chalk Offsets. Impressions on super paper, dusted with red chalk, and pulled over on stone or metal as a key or guide for the artist. This technique is limited in its use to poster hand plates to be run on a direct rotary lithographic press.

Chase (Lithographic). The negative (or positive) frame with glass face scribed with register lines on which photographic film or plates are positioned to register in a photocomposing machine. The frame or chase is attached to the register device, a jig-type fixture which establishes uniform register relationship between all images being photocomposed on offset press plates by the step-and-repeat method.

Chromic Dermatitis. A skin affliction resulting from attack on human tissues by salts of chromium and chromic acid. Commonly termed *chrome poisoning.*

Circular Screen. A circular-shaped halftone screen which enables the

camera operator to obtain the proper screen angles for color halftones without disturbing the copy.

Clean Up. An offset plate is cleaned-up when the non-printing areas which have begun to become ink-receptive are made to be ink-repellent again.

Clearing. The operation of applying a very light flat bleaching etch to negatives or positives to remove a fog or scum (slight silver deposit). (2) *Clearing the plate,* the lithographic term for removing the light-hardened gum stencil from the non-image areas of a deep-etch press plate.

Coating. Term applied to the mineral substances such as china clay, blanc fixe, satin white etc., used to cover the surface of paper, thus making the coated surface of enamelled papers. (2) The operation of applying the mineral substance to the surface of the sheet of paper. (3) In photography and photomechanics, application of varnishes and other mixtures to plates and negatives; also application of light-sensitive solutions to plate surfaces, usually by means of a plate whirler.

Cobalt Drier. A type of liquid drier used in lithographic inks; a very strong surface drier.

Cold (Color). A color which is on the bluish side.

Cold Type. A trade term denoting the use of composition methods not involving hot metal type. Most common forms are typewriter composition, paper letters, photocomposition on photo paper and mechanical lettering instruments. Photographic composition on film is a form of cold type composition.

Collotype Printing. A printing process akin to lithography but employing bichromated gelatin images as the printing surface where detail and tone values depend on the degree to which different plate areas have been made water-receptive and ink-repellent. Collotype is capable of printing continuous-tone images; it is mainly executed as a direct printing process and used for fine art reproductions and other pictorial jobs in comparatively short runs. Collotype is known by a number of names; the most familiar American synonym is photogelatin printing.

Color Correction. Any of various methods such as masking, dot-etching, and re-etching, intended to promote improved color rendition. Can be done on screened or continuous-

tone separation negatives, or by corrective work on the halftone printing plates.

Color Filter. A sheet of dyed glass, gelatin, plastic or dyed gelatin cemented between glass plates, used in photography to absorb certain colors and permit better rendition of others. A color filter permits certain wavelengths of light to pass through and absorbs others.

Color Patch. A small pre-printed card showing the inks being used for process color work and attached to the original art when photographed for color separations. An aid to the correction artist when analyzing his tones.

Color Process Work. Also called Process Color. A reproduction of color made by means of photographic separations. Also the method or the copy requiring such operation.

Color Proofs — Progressive. A set of color proofs consists of color proofs of each plate, singly and in combination with other proofs as the job will be printed. For example, yellow by itself; magenta; yellow and magenta; cyan; yellow, magenta, and cyan; black by itself; and all four colors combined.

Color Separation. A photographic negative exposed through one of the tri-color filters and recording only one of the primary colors; in platemaking, manual separation of colors by handwork performed directly on the printing surface. The pre-separation of colors by the artist using separate overlays for each color executed in black or gray tones ready for the camera.

Color-Separation Negative. A photographic negative exposed through a color filter and recording only one of the primary colors in full-color work or one of the two colors in two-color work; in platemaking, manual separation of colors by handwork performed directly on the printing surface. The negative is a gray tonal record of the intensity and the color it is reproducing, being light where the color is strong in the copy, dark where the color is weak in the copy.

Color Swatch. A small, usually square solid print used with the sketch, negative, positive or printing plate to identify it and furnish a sample of the actual ink colors used. A guide in color separation and correction operations.

Color Transparency. A full-color photographic positive on a transparent support. Ektachrome, Flexichrome for example.

Combination Plate. In lithography, the joining of halftones and line negatives or positives in position to appear on the plate as combinations.

Complementary Colors. Any two opposite (or contrasting) light colors which when combined produce white or gray. A mixture of any two primary colors is the complement of the remaining primary. In printing, complementary colors have the power to either neutralize or to accentuate each other; thus to diminish or enhance the attention value of the print.

Contact Print. A photographic same-size copy made by exposure of a sensitized emulsion in contact with the transparency, a negative, or a positive; the exposing light passing through the master image.

Contacts. Same-size negatives made by exposing light-sensitive material in contact with a positive and subsequently developing. (2) Same-size positives made by exposing light-sensitive material in contact with a negative and subsequently developing.

Contact Screen. A photographically made halftone screen having a dot structure of graded density and usually used in vacuum contact with the film or plate.

Continuing Reaction. In an exposed light-sensitive emulsion or coating, the chemical reaction, similar to the light reaction but slower, that occurs in the time between exposure and development.

Continuous Tone. Said of those images (wash drawings, oil paintings, photographic negatives and positives) in which the detail and tone values of the subject are reproduced by a varying deposit (density) of developed silver in the picture. Photogelatin or collotype reproductions duplicate continuous-tone copy without use of a screen and are said to be continuous-tone reproductions. In lithographic color correction, continuous-tone color separation negatives are stained locally by gray dyes to add density, or treated by chemicals to lessen density.

Contrast. Tonal comparison of highlights and shadows in an original or reproduction. The tonal difference in detail, i.e., contrasty copy refers to accentuated detail in both light and dark areas.

Copy. The manuscript or text furnished to printers. Although the term "copy" is widely applied to photographs and different types of artwork submitted for reproduction, a better term for these items is *"original"* because it is from them that the reproduction originates. In photographic platemaking there are two kinds of copy — *line* and *tone,* photographed without and with the halftone screen, respectively. *Line copy* is that in which the design or image of the original is composed of lines or dots of solid color. *Tone copy* is that in which tones or shades of solid color appear.

Copyfitting. Calculations made in order to determine the proper size of type and width of line to fit the copy into a given area of space.

Copy Preparation. In photomechanical processes, the directions as to desired size and other details for illustrations and the arrangement into proper position of the various parts of the page to be photographed for reproduction. Also the work of preparing copy in paste-up form of text and art as a unit, termed a mechanical paste-up. (2) In typesetting, the careful revision of copy to insure a minimum of changes or corrections after type is set.

Core. In lithography and other photomechanical operations, the center portion of the halftone dot. (2) The cylindrical metal bar upon and around which the composition is molded in the making of an ink roller. (3) A cardboard, wood or metal tube on which the rolls of paper are wound.

Counter Etch. The first step in preparing to coat a grained offset metal plate. The purpose is to clean the metal of dirt and oxides without damaging the grain; a weak acid solution is used, such as 1 oz. hydrochloric acid in a gallon of water.

C.P. Abbreviation for "Chemically Pure."

Crayoning. In lithography, the use of a crayon for retouching on direct handmade or on photographic plates.

Creep. Forward movement of the blanket surface during operation of offset press due to improper pressure or stretch of offset blanket.

Cronak Process. The process of treating zinc plates with a mixture of sodium bichromate and sulfuric acid to make them resistant to oxidation.

Crop. To cut off an edge or trim.

Crossline Screen. A standard halftone (glass) screen with the opaque lines crossing each other at right angles, thus forming transparent squares, or "screen apertures."

Crossmarks. Register marks to make possible the accurate positioning of images in composing, double-printing and multicolor printing, and in superimposing overlays onto a base or to each other. Commercially available in a variety of forms, for pasting on copy.

Cross Rail. The horizontal element of the registering mechanism of a photocomposing machine on which the negative carrier travels.

Crowd (ink). A term meaning to ink the plate (offset) heavily in an attempt to print a darker tone; applying too heavy an ink film to plate.

Cutting (of negatives). In lithography, making the density of a negative or positive less by etching. Accomplished in halftone by reducing dot size. Cutting (of Negatives), a term used to refer to the opaquer's work of cleaning up bad negatives by use of needle or scraper.

Cyanide. The short name for sodium or potassium cyanide. It is used to remove the product of the silver bleaching action caused either by ferricyanide or by iodine. It is a much better solvent than hypo but it has a softening effect on gelatin emulsions and is very poisonous. Extreme care must be taken when using it.

Cylinder Gap. The gap or space in the cylinders of offset presses where the mechanism for plate clamps, blanket bar and tightening shaft, and grippers is housed.

Cylinder Guide Marks. Marks on the offset press plate to match corresponding marks on the plate cylinder of the press, so that each plate will be positioned the same on the press.

Dampeners. Cloth-covered rollers that distribute the dampening solution received from the ductor roller of the dampening unit to the lithographic press plate.

Dampening Solution. A solution of water, gum arabic, and various types of etches used for wetting the lithographic press plate (grease-water principle of lithography). Also termed *fountain solution* or *dampening etch.*

Dark Reaction. With light-sensitive plate coatings, the hardening action which takes place without light; this action is greater with high humidity and temperature.

Deep-Etch. An embracive photolithographic term for a process of platemaking, a type of printing plate. Deep-etch plates are made by contact photoprinting of line and halftone positives on grained metal plates sensitized with special solutions, the final printing areas of the plate etched into the sensitized surface to hold the lithographic image. To deep-etch, the application of various etches, depending on metal of plate, to etch the metal (about .0003 inch deep) in order to provide space for the lacquer base of the ink-receptive printing image.

Deep-Etch Pad. A plush-covered wooden block used for applying the deep-etch solution in platemaking. Separate pads used for each operation.

Deep-Etch Stencil. The light-hardened bichromated gum resist which protects the non-printing parts of the plate from the developing and deep-etching solutions.

Densitometer. An electric instrument designed to accurately measure optical density, or tone values, and used in place of the human eye for such purposes. Two general types: visual and photo-electric; transmission densitometers measure the full density range of negatives, and reflection densitometers measure the reflection range of opaque copy. If a photocell "search unit" is provided the instrument can be used as an illumination meter on the ground glass of camera.

Density. A photographic term often confused with "opacity" but correctly applied to the quantity of metallic silver (or dyes) per unit area in negatives and positives.

Dermatitis. A skin disease, characterized by an itching rash, swelling or roughening of the skin, or watery pustules; in lithography, caused by photographic developers, chromium compounds, and solvents.

Desensitize. In lithographic platemaking, to make the non-image areas of a lithographic plate non-receptive to ink through chemical treatment of metal. (2) In photography, a desensitizer is an agent for decreasing the color sensitivity of a photographic emulsion to facilitate development under comparatively bright light. The action is applied after exposure.

Developer, Development. The chemical agent and the process employed to render photographic images visible after exposure to light. (2) In lithographic platemaking, the removal of the unhardened bichromated coating; with a surface-type plate, the non-image areas; with a deep-etch plate, the image areas.

Developing Ink. A greasy liquid applied to plate images in photolithography to protect the image and keep it ink-receptive while the plate is being developed, etched and gummed. For some surface plates the developing ink is relied on to make the image ink-receptive.

Developing Pad. Usually a plush-covered wooden block used for working the developing solution over the surface of a deep-etch lithographic plate to remove the unhardened image areas.

Dimensional Stability. Ability to maintain size; resistance of paper or film to dimensional change with change in moisture content.

Direct Halftone. A halftone negative made by direct exposure of an object through a halftone screen.

Direct Lithogaphy. The method of printing lithographically by direct transfer of the ink from the plate to the paper; the use of a direct rotary press as distinguished from use of an offset press which has an intermediate offset cylinder between the plate and the paper. The rubber (blanket) surface of the offset cylinder picks up the ink and deposits it on the paper or other surface.

Direct Photography. Direct photography designates the making of halftone images by photographing the object to be reproduced rather than by re-photographing a continuous-tone picture of the object. Direct photography is frequently used in the reproduction of jewelry, cutlery, shoes, textiles, etc.

Direct Separation, also Screen Separation. A separation negative made with halftone screen from copy.

Distributing Roller. The rubber-covered roller which conveys the ink from the fountain onto the ink plate of the printing press; its purpose is also to lengthen the path of ink travel, thereby distributing it more evenly; (2) on an offset press, the rollers forming part of a nest of rollers and contacting the vibrating drum roller.

Dope. Water fountain solution; general term applied to litho ink conditioning compounds, reducers and varnishes.

Dot-Etching. Tonal correction of halftone positives or negatives in photolithography by judicious and controlled reduction of dot size through the action of chemical reducers. Tray etching for all-over reduction of dots; local etching done by an artist with a small soft brush.

Double Exposure. In photography and photomechanics, a supplementary exposure given the main image to obtain special effects.

Double Print, Double Printing. The effect and operation of photo-printing different line and halftone negatives in succession and register on the same sensitized surface.

Drag. Register trouble, in lithographic printing, when the dot is enlarged toward the back (non-gripper end) of the sheet. Also called *Draw*. (2) Term for a slur.

Draw-Down. A term used to describe an ink chemist's method of roughly determining color shade by placing a small glob of ink on paper and with a putty knife spatula spreading it by drawing down with edge of spatula to get a thin film of ink on the paper.

Drier. A substance added to inks to hasten their drying. It consists mainly of metallic salts which exert a catalytic effect on the oxidation and polymerization of the oil vehicles employed. Driers are often called *siccatives*.

Dropout Halftone. A halftone reproduction in which highlight effects have been introduced either by treatment of the halftone negative, or by etching the printing plate to eliminate dot formation in the pure highlights. In lithography the dropout is obtained photographically by use of contact halftone screen or manipulation of the camera exposure through cross-line halftone screen.

Drums. Metal inking rollers that furnish power and aid in ink distribution by lateral as well as rotating movement in contact with other rollers of the inking unit.

Dry Brush Drawing. A drawing made with a brush and only slightly moistened with india ink, the aim being to secure a vigorous execution of a character between a bold crayon drawing and pen work. A difficult and highly distinctive technique.

Dry Offset. A process in which a metal plate is etched to a depth of approximately 0.006″, making a "right-reading" relief plate, printed on the offset blanket and then to the paper without the use of water.

Dryplate. A photographic negative material consisting of a glass plate coated with gelatino-silver emulsion and exposed in a dry condition.

Ductor Roller. On an offset press, the roller in both inking and dampening mechanism which alternately contacts fountain roller and vibrating drum roller. Length of contact or "dwell" of ductor can be adjusted.

Dummy. The preliminary drawing or layout showing the position of illustrations and text as they are to appear in the final reproduction. (2) A set of blank pages made up in advance to show the size, shape, form, and general style and plan of a contemplated piece of printing, such as a book, booklet, etc.

Duotone. Term for a two-color halftone reproduction from a monochrome original and requiring two halftone negatives for opposite ends of gray scale at proper screen angles. One plate usually is printed in dark ink, the other in a lighter one.

Dwell. The length of "dwell" or contact between the ductor roller as it alternately contacts fountain roller and vibrating drum of offset press ink and dampening distributing mechanism.

Egg Albumin. The white of a bird's egg often supplied dried. Commercially, the white of a hen or duck egg. Used for making albumin-type surface offset press plate.

Ektachrome. An Eastman Kodak color film now used for commercial color transparencies; produces a positive.

Embossing. Blanket embossing: The swelling of the image on an offset blanket due to its absorbing solvents from the ink is termed embossing. (2) Plate embossing: Offset plate embossing is the result of atmospheric pressure of the vacuum contact in the photocomposing machine causing ridges to appear on the surface of the metal plate.

Emulsion. A mixture of two mutually insoluble liquids in which one liquid is finely dispersed as droplets in the other. (2) Photographic term for a gelatin or collodion solution holding light-sensitive salts of silver in suspension; used as the light-sensitive coating on glass photographic plates, film or metal plates in photomechanical printing processes. (3) High contrast emulsions, which give either completely transparent or opaque areas on exposure, are used for line and halftone photography. Normal contrast emulsions, which have a tonal range of density on exposure, are used for continuous-tone negatives and positives in lithography and in gravure.

Engraved Blanket. A condition that arises when the image area surface has sunk below the rest of the blanket surface as a result of disintegration of the blanket due to ink ingredients.

Etching Operation. The application to the lithographic plate of a solution of various chemicals for the purpose of producing a surface in the non-printing areas capable of being wet by water and not wet by greasy inks. Also in deep-etch platemaking, the application of a solution of acids for the purpose of removing the light-hardened gum stencil from the non-printing areas of the plate.

Excess Pressure. Any squeeze pressure that causes distortion or undue tension, e.g. between plate and offset blanket.

Exposure Chart. In lithographic platemaking, a table or chart of one or more variables which may be used to determine the exposure required under various conditions of temperature and humidity.

Exposure Meter. An instrument which measures light intensity and provides a calculator for determining proper exposure. Calibrated for different emulsion speeds.

Extended Color. The extra area of color necessary for trimming or die-cutting when the printed image goes to the very edge, to avoid a white area due to inaccurate cutting of paper.

Fadeometer. An instrument used for determining the light-fastness of inks and other material under predetermined controlled conditions.

Fake-Color Process. Production of halftone color plates from monochrome originals, whereby the color effects are introduced by retouching of photoprints, and by skillful re-etching and finishing of the halftone plates. For lithographic reproduction, the artist pre-separates colors by mechanical overlays, working in gray tones, to provide tone copy for the camera.

Fanning. Expansion of an offset press sheet across the back edge as it goes through press; caused by sheet not being flat due to edges drying and contracting.

Farmer's Reducer. A solution for reducing the density of developed negatives, invented by Howard Farmer, and containing principally potassium ferricyanide and sodium thiosulfate. It tends to increase the contrast of the reduced negative. A strong solution of Farmer's Reducer is used in lithography to dissolve and remove the black silver of negatives from unwanted areas.

Filter Factor. A number indicating, by multiplication, the increased exposure required when a particular color filter is used during the camera exposure.

Fixing. The application of a chemical solution which removes the unexposed silver salts in an emulsion without affecting the metallic silver which has been deposited by the developer. Fixing renders the photographic image permanent.

Flash Exposure. The supplementary exposure given in halftone photography to strengthen the dots in the shadows of negatives. This exposure is made with a small lens stop to a sheet of white paper hung over the original, or to the rays from a flash-lamp.

Flat. In lithography, the assembly of photographic negatives or positives on goldenrod paper, glass or vinyl acetate for exposure in vacuum frame in contact with sensitized metal press plate. Equivalent to a typographic form and containing text as well as art.

Flat Etching. The chemical reduction of the silver deposit in a continuous-tone or a halftone plate, brought about by placing it in a tray containing an etching solution. The etching solution is made up of a bleaching chemical and one that removes the product of this bleaching action. The plate is first immersed in water to saturate the emulsion evenly, then it is put into the etching bath. The same effect can be obtained by holding the plate in the hand and flowing the etch over it. The tray method is the more reliable. It is called "flat" because it is an all-over etch.

Fluorescent. Fluorescent tubes sometimes used for illumination or light source in offset platemaking. (2) Fluorescence Process (Eastman Kodak Company) employing special fluores-

cent watercolor pigments by the artist to simplify separation of watercolor art by photographic methods using special lights in the camera color-separation work. (3) Kemart Process uses fluorescent white pigment for artist's use of highlights or for special drawing paper surface; special "flashing" lights used during camera exposure cause pigments to fluoresce and burn-out highlight dots on negative.

Focal Length. A photographic term for the distance between the optical center of a lens and the point at which an object image is in sharp or critical focus. Focal length is usually engraved on the front of the lens barrel by the maker.

Focal Plane. The surface (plane) on which camera images transmitted by a lens are brought to sharpest focus, the surface represented by the light-sensitive film or plate.

Focus. In photography, the point at which rays of light passing through a lens, converge or seem to converge to form a sharp image of the original.

Fog. A photographic defect in which the image is either locally or entirely veiled by a deposit of silver, the defect due either to the action of stray light or to improperly compounded chemical solutions.

Foot-Candle. A unit for measurement of light intensity.

Form Rollers. The ink and dampening rollers which contact the press plate.

Forwarding Mechanism. Conveyor arrangement to carry the sheet from the feeder to the front guide.

Fountain Roller. In the water motion of a lithographic press, a non-ferrous roller which revolves in the fountain. This roller in conjunction with the ductor roller meters the water or fountain solution to the press plate.

Fountain Solution. Commonly called "the water"; a solution of water, gum arabic, and other chemicals used to dampen the lithographic plate, and keep the non-printing areas from accepting ink.

Fountain Stops. Movable riders—rollers or strips of material—sometimes placed to rest on the fountain roller of an offset press dampening system to cut down on the amount of water supplied to the corresponding area of the press plate.

"F" Stops. Fixed sizes at which the aperture of the lens can be set, the values of which are determined by the ratio of the aperture to the focal length of the lens.

Gamma. Photographic term for negative contrast resulting from development and not the contrast of the subject itself; a numerical measure of contrast in the development of a negative.

Gang Negative, Gang Plate. In photomechanics, a negative bearing a number of properly positioned images, and a printing plate made therefrom. A Gang Negative is also known as a *Multiple Negative;* multiple negatives are the method of handling many small images as one unit in the step-and-repeat machine used in lithographic platemaking for making multiple images.

Gear Streaks. Parallel streaks appearing across printed sheet at same interval as gear teeth on cylinder. Caused by improper underpacking or defective press conditions resulting in difference of surface speed between cylinders and pitch diameter of gears.

Glue (Bichromated). Used for the glue deep-etch platemaking process in lithography. Process still used considerably in Europe and the Far East.

Goldenrod Flat. The method of assembling and positioning lithographic negatives (or positives) for exposure in contact with light-sensitized press plate. The goldenrod paper used is translucent enough to see penciled layout on underside, or master layout on separate white paper beneath, so film negatives can be attached in proper position with red scotch tape. The goldenrod paper beneath image areas is cut away before flat is reversed to place emulsion-side of negatives to emulsion on metal plate. Flat is also used for making blueprint of form for checking imposition. Sometimes referred to as a "form." A lithographic flat corresponds to a typographic form.

Grain. The distribution of silver particles in photographic emulsions and images. (2) The roughened or irregular surface of an offset printing plate.

Graining. Subjecting the surface of litho metal plates to the action of abrasive, the operation performed in a special machine for the purpose and imparting greater water-retention to the otherwise non-porous surface.

Graining Machine. A machine used for producing the grain on lithographic plates by oscillating the plate, under wet abrasive and marbles or steel ball-bearings to give weight to abrasive.

Grainy Printing. Printing characterized by unevenness, particularly of halftones.

Gray Scale. A strip of standard gray tones, ranging from white to black, placed at the side of original copy during photography to measure tonal range obtained, and in the case of color-separation negatives for determining color balance or uniformity of the separation negatives. A commercial product available either on paper or on transparent acetate for use with transparencies.

Gripper Bite. The amount of paper that extends beneath the press gripper. Sometimes called *Gripper Margin.*

Gripper Edge. On a sheet, it is that edge of the paper which is fed to the press gripper. With an offset press, image must not extend into gripper edge or margin, about $\frac{3}{8}$ inch.

Gripper Margin. An unprinted area between the edge of the sheet and lead edge of the printing area, allotted for the press grippers to hold the sheet.

Guide Marks. A method of using crossline marks on the offset press plate to indicate trim centering of sheet, centering of plate, etc., as well as press register in multicolor work. Not to be confused with register marks used for stripping elements to register.

Gum Arabic. A gum obtained from either of two species of Acacia trees, used in all branches of the graphic arts. There are a number of different gum arabic varieties which are known in commerce under the various names, Turkey gum, Egyptian gum, etc. Gum arabic solutions are used to desensitize or remove any affinity for ink in the non-printing areas of lithographic plates. Gum arabic also forms a large part of the fountain solutions used on lithographic presses.

Gumming. In lithography, the treating of surfaces with a thin coating of gum arabic as a protection against oxidation and ink-receptive coatings for image, and as an aid to desensitizing the plate.

Gum Stencil. The acid-resistant stencil formed in deep-etch platemaking in non-copy areas of the plate when gum arabic is a constituent of the coating solution. The stencil protects non-image areas while image areas are developed and etched.

Gum Streaks. Streaks, particularly in halftones, produced by the uneven gumming up of plates.

Halation. A photographic term for spreading of light action beyond proper boundaries in negatives, particularly in the highlight areas of the image. The dots on every negative or positive, when shot through the halftone screen, have a soft, fuzzy perimeter known as a halo. This is due to the fact that less light has reached the edge than the center of the dot. The silver deposit on the edge of the dot is therefore weaker and shows a corresponding transparency. It is this halation that permits chemical reduction, as in dot-etching. A blurred effect, resembling a halo, usually occurring around bright objects; caused by reflection of rays of light from the back of the negative material.

Halftone. Any photomechanical printing surface and impression therefrom in which detail and tone values are represented by a series of evenly spaced dots of varying size and shape, the dot areas varying in direct proportion to the intensity of the tones they represent.

Halftone Color Printing. The planographic process of printing depends on the deposit of a greasy ink in the form of dots or lines for its tonal interpretation of the sketch. The eye blends these fine lines or dots with the spaces between them and sees tones that vary with the proportion of dots to spaces between. At first, the greasy ink dots were stippled in with brush and pen; later, mechanical means, known as Ben Day screens, were used. With the introduction of photography and the halftone method, tones were interpreted by photographic dots. Small dots represent the light values; large dots, the stronger values. As individual dots are not easily visible, they appear as continuous tones of color. To achieve the varied color results, three or more colors are used.

Halftone Tint. A solid area of a plate is transformed into a gray tone of any desired density by stripping in a piece of film with uniform halftone density, i.e. 25%—50%, etc.; either negative or positive stock sheets of halftone material are used; avoids necessity for preparing art where uniform tone instead of solid background is wanted.

Halo. The circle or aura of lesser density around the core of the halftone dot.

Hand Proof. In offset lithography, a proof of plate made on a hand proof press where operations are manual for inking, dampening and taking the impression.

Hard (Dot). A halftone dot, negative or positive, characterized by a sharp, clean cut edge. Photographically, the term *hard* denotes excessive contrast.

Hickeys. An imperfection in lithographic presswork due to a number of causes such as dirt on press, hardened specks of ink, or any dry hard particle working into the ink or onto the plate or offset blanket.

High Contrast. Refers to the relationship of highlights to shadows on a negative, whether continuous-tone or halftone. In such a negative the highlights are very black and the shadows very open according to the tonal scale.

Highlight. In photomechanics, the lightest or whitest area of an original or reproduction, represented by the densest portion of a continuous-tone negative, and by the smallest dot formation in a halftone negative and printing plate.

Highlight Halftone. A halftone reproduction in which the highlights are devoid of dots for accentuation of contrast.

Hue. That attribute of colors which permits them to be classed as reddish, greenish, bluish, yellowish, etc.

Hydrometer. Generic term for various instruments designed to determine the strength or specific gravity of liquids.

Hydrophilic. Water-loving; preferring to be wet by water rather than by oils; water-receptive.

Hydrophobic. Water-hating; preferring to be wet by oils rather than by water; water-repellent.

Hygrometer. An instrument for measuring atmospheric moisture.

Hypo. An abbreviation for sodium thiosulfate, also named sodium hyposulfite, a chemical used to fix the image on a photographic plate after it has been developed. One of the ingredients in the hardening bath. In reducing or etching solutions such as Farmer's Solution, it is the substance which dissolves and removes the silver ferricyanide formed when the plate is placed in a bleaching bath of potassium ferricyanide.

Imposition. Arranging and fastening negatives or positives to a supporting flat for use in offset lithography platemaking. Multiple imposition—the exposure of the same flat in two or more positions on the press plate.

Impression Cylinder. On an offset press, the cylinder that carries the paper sheet into contact with the blanket.

Indicator. A dye that indicates changes from acidity to alkalinity, or vice versa, by changing its color.

Ink-Dot Scum. On aluminum plates, a type of oxidation scum characterized by scattered pits that print sharp, dense dots.

Ink Drum. A metal drum either solid or cored, a part of an inking mechanism. Used to break down the ink and transfer it to the form rollers; on certain types of proof presses, it is used in lieu of a fountain. The ink is supplied to the drum manually. On an offset press the ink drums are vibrating rollers (move back-and-forth sideways) and aid in ink distribution.

Inking Mechanism. On a printing press, the ink fountain and all the parts used to meter, transfer, breakdown, distribute, cool or heat, and supply the ink to the printing member.

Inkometer. An instrument that measures tack and length of printing and lithographic inks in numerical terms.

Ink-Receptive. Having the property of being wet by greasy ink in preference to water.

Ink-Repellent. Having a surface which will attract water and repel greasy inks.

Inserting. The fitting of one negative into another or the assembling of a number into a definite relationship to each other by the accurate cutting and fitting of the photographic films. Usually films can be thus advantageously handled.

Integrating Light Meter. An instrument which measures intensity of light exposure as well as length of exposure according to predetermined setting.

Intensification. A photographic term for the operation of increasing the density of negatives by chemical treatment of the image after fixation and washing.

Iris Diaphragm. Term applied to the adjustable aperture fitted into the barrel of photographic lenses and socalled because the contraction of the aperture resembles that of the iris (pupil) in the human eye. It consists of a series of thin metal tongues overlapping each other and fastened to a

ring on the lens barrel, the aperture made smaller or larger by turning the ring backward or forward.

Kemart. A patented process for use by the artist for highlighting or dropouts, and silhouetting. In the Kemart process a fluorescent white pigment is applied to dropout areas by artist, or a special fluorescent coated illustrator's board is used for silhouetting. When copy is photographed, special flash lights cause the pigment to fluoresce and burn-out the coated areas of copy.

Key. In color art preparation, an image used as a guide for further work as keyline drawing. (2) In photography the emphasis on lighter or darker tones in a negative or print; *high key* indicates prevalence of light tones; *low key* prevalence of darker tones.

Keylining. A technique used in copy preparation by the artist to handle copy for some simple types of color separations, or for indicating reverses or outline of backgrounds. The purpose is to provide copy for the camera which avoids excessive opaquing of photographic negatives or positives.

Kiss Pressure. Kiss pressure is the minimum pressure at which proper ink transfer is possible.

Lacquer. A solution in an organic solvent of a cellulose ester such as nitrate or acetate, or a cellulose ether such as ethyl, benzyl, etc., together with modifying resins and plasticizers. They are used on paper for glossy, decorative and protective effects. In lithography, lacquers are used to form the base for the ink-receptive and water-repellent image in deep-etch platemaking.

Laketine. A colorless reducer (magnesia in linseed oil) used in lithographic inks to reduce color strength.

Lap. The slightly extended areas of printing surfaces in color plates which make for easier registration of color.

Lateral Reversal. Turning of a photographic image as to right and left position, achieved either with optical reversing devices, by "flopping" the negative for stripping, or by placement of the image in a transparency-holder during photography therefrom. Frequently used to get emulsion-to-emulsion in contact printing of lithographic press plates.

Layout. Preliminary sketch or arrangement showing the size, position and colors of illustrations and text matter in advertisements and other printed matter, and also including special in-structions to platemakers and printers. (2) The lithographic stripper's layout drawn in pencil on goldenrod paper flat for positioning photographic negatives (or positives) of units or pages. Made from original layout or dummy. (3) The printed form used for writing in the instructions for positioning the negative (positive) on a photocomposing machine for exposing each "step" of multiple images.

Lens. A photographic lens made up of several prisms or elements, both negative and positive, and separated in the lens barrel at definite distances by an air space. A negative converging lens element is double concave (resembling two prisms placed apex to apex); a positive lens element is double convex (resembling two prisms placed base to base) which brings the light rays to a focus.

Lifting. The proper adhering of one color (ink) to a previously printed color, or to the sheet in lithography.

Light Integrator. An instrument which measures a predetermined amount of light by taking into consideration both intensity and time of exposure.

Line Copy. Any copy suitable for reproduction without using a screen; copy composed of lines or dots as distinguished from copy composed of continuous tones. Lines or dots may be small and close together so as to simulate tones, but are still regarded as line copy if they can be faithfully reproduced without a screen.

Lines To The Inch. Crossline halftone screens are made up of opaque lines ruled at right angles to each other. Some screens have more or less lines to the inch than others and are accordingly classified. The 120- and 133-line screens are the ones most commonly used. In large size work the screen ruling may be as coarse as 40 lines to the inch; in very fine detail work screens with 250 lines or more to the inch are successfully used. The number of dots to the square inch is the square of the lines to the inch of the screen. A 133-line screen, for example, produces 17,689 dots per square inch.

Litho Crayon. A pencil-shaped stick consisting of soap, tallow, shellac, wax and lamp-black used for execution of crayon sketches on grained paper, also for direct drawing on litho stone and metal plates, and as a delicate staging medium in halftone relief etching.

Lithographic Artists. Crayon artists who draw on litho stones or plates. Negative retouchers who work on glass or film negatives and positives. Artists or stainers who work on continuous-tone negatives with dyes to adjust density of selected areas as a method of color correction.

Lithographic (Halftone) Conversion. The employment of relief halftone plates or proofs for the photographic production of litho printing plates.

Lithographic Images. An ink-receptive image on the lithographic press plate, either photographic or direct hand or transfer image. The design or drawing on stone or metal plate.

Lithographic Roller. A term that should be properly restricted to leather-covered (nap) rollers for hand rolling (inking) of litho printing surfaces but is also used for various types of rubber and metal inking rollers suitable for lithographic inks.

Lithographic Transfer. A proof of design or type matter pulled with special transfer ink on transfer paper from a lithographic image or a relief image. Such proofs are used to transfer an image to the press plate or stone.

Lithotine. A lithographic solvent developed by LTF to replace turpentine; less toxic and irritating to the skin; its use helps avoid dermatitis.

Livering. An irreversible increase in body of inks as a result of chemical change during storage or hot milling.

Long (Ink). A term used to describe consistency of lithographic inks. Inks are called *"long"* if they stretch out into stringy consistency when tapped between fingers; *"short"* if the ink breaks off short like lard. Both long and short inks can be either stiff or soft.

Magenta Contact Screen. A contact film screen composed of magenta dyed dots of variable density used for making halftone negatives in the camera. Used mostly for lithographic negatives.

Makeovers. A trade term used in lithography meaning the making of various sizes of screened positive separations from a single set of continuous-tone negative separations. A negative is photographed in several different foci to get the positives in different sizes.

Makeready. On an offset press, the adjusting of feeder, grippers, side guide, pressure between plate and offset blanket cylinder, putting plate on press and ink in fountain to be ready to run the press. (2) On a photocomposing machine, the preparatory work of positioning negative in holder, plate on back, and getting ready to start exposures in step-and-repeat operation of platemaking; the "set-up" work.

Makeready Tissue. A tissue paper of standardized caliper, usually 1/1000, 1.5/1000 and 2/1000 inch thickness, used to adjust diameter or plate of offset cylinder by placing under plate or offset blanket in making ready offset press for operation. Used only when necessary to compensate for variables.

Mask (Unsharp or Diffused). In the masking method of color correction used in lithography, an unsharp photographic mask is sometimes made in a printing frame by placing a thin sheet of acetate between the separation negative and the material for the positive, with the illumination placed off-center and the frame whirled during exposure.

Masking (Photographic). Application of a mask to certain areas of orginals to promote better halftone reproduction; use of corrective photographic images on separation negatives for improved color rendition.

Masstone. Color of ink in mass. May differ from the printed color of the same ink.

Mechanical (Paste-Up). A method of assembling all copy elements into a unit for photographic platemaking (copy ready for the camera). May include all copy except text, or be complete with text as well as line and tone copy, proportioned and positioned.

Mechanical Color Separations. The pre-separation of colors for line color or fake-color art by the artist, executing the art for each color in black or gray tones, usually separate overlays of "key" copy, ready for the camera. Either line or tone separations. *"Keylining"* is a method of separating each color area by a line for copy executed in one piece and opaquing areas to ⅛ inch of division line. Color tissue overlay is the color guide for the opaquer who, with duplicate negatives or positives, makes a negative or positive for each color. The width

of the dividing line (common to adjoining color areas) is the overlap of the inks.

Mercury Vapor Lamp. An enclosed light source containing mercury, sometimes used to expose sensitized plates.

Middletone. In halftone, any neutral tone intermediate between the highlights and shadows of an original and reproduction therefrom.

Moiré. Undesirable patterns occurring when reproductions are made from halftone proofs or steel engravings, caused by conflict between the ruling of the halftone screen and the dots or lines of the original; a similar pattern occurring in multicolor halftone reproductions and usually due either to incorrect screen angles or misregister of the color impressions during printing.

Molleton. A thick cotton fabric similar to flannel, having a long nap, and used on damping form rollers.

Montage. A series of related pieces of copy appearing as one to tell a complete story.

Needles. Sharp pointed, needle-like tools, used by lithographic artists for making corrections on plates, glass or film negatives or positives (scraping away, hand-lettering or ruling).

Negative Carrier. That part of the mechanism of a photocomposing machine which holds and positions the photographic image being exposed, and includes the carriage saddle, the register device and the negative frame.

Negative Grouping Machine. A miniature photocomposing machine used for making multiple negatives (positives).

Nesting (forms). Term used for positioning irregular shapes on an offset press plate by means of a photocomposing machine. Nesting is used to avoid waste of stock for diecut forms such as envelope blanks.

Notch Bars. Measuring bars with notches on one-inch centers on both the vertical and horizontal (cross) rails of a photocomposing machine. Registering mechanism is moved and locked into closest notch, and micrometer adjustment positions between notches to 1/1000 inch.

Offset. Wet ink transferred from one sheet to another in a load of freshly printed sheets. (2) Lithographic images printed on an offset press.

Offset Lithography. Lithography produced on an offset lithographic press, the modern commercial printing

method. A right-reading plate is used, and an intermediate rubber-covered offset cylinder transfers the image from the plate cylinder to the paper, metal or other material.

Opaque. Not permitting the passage of light. The opposite of *Transparent.* (2) In photography, a non-transparent pigment applied to certain areas of negatives to prevent passage of light through the particular areas. (3) A water soluble solution used to cover light pinholes or to alter negatives used for lithography.

Opaquing. Local application of opaque to photographic negatives or positives; blocking-out.

Open Up. To render less opaque so that more light may pass through areas intended to appear more open.

Orthochromatic. Said of photographic surfaces sensitive to ultraviolet, blue, yellow, green and orange rays. Insensitive to red rays.

Outline. A silhouetted piece of copy or reproduction.

Overpacking. Packing the plate or blanket to a level that is excessively above the level of the cylinder bearer.

Overprinting. In lithographic platemaking with surface plates, the exposure of a second negative on an area of the plate previously exposed to a different negative; a method of combining line and halftone image on the plate.

Packing. In lithography, the paper used to underlay a blanket, plate or proof to bring the surface to the desired height, the method of adjusting squeeze pressure. The act of inserting the packing material under the blanket or plate.

Packing Gage. A steel block with a special dial gage mounted on one end. When the block is clamped on plate cylinder of press, and the gage button permitted to rest against the bearer, a pointer indicates the difference in height between the two. This measurement helps in computing the amount of packing needed. The same procedure is used for determining blanket underpacking needed.

Panchromatic. A term applied to photographic materials possessing sensitivity to all visible spectral colors, including red.

Paper-Conditioning. The process of adding moisture to or taking moisture out of paper, to attain proper paper condition for press operation.

Paper Hygroscope. A sword hygrometer instrument for measuring

moisture content of a pile of paper relative to humidity of pressroom; an aid in determining whether paper-conditioning is necessary.

Parallax. The displacement of one object to another when viewed from different positions. (2) The difference in position of the images obtained by the finder and the lens in a camera.

Paste Drier. A type of ink drier used in lithographic inks, usually a combination of lead and manganese. Paste drier tends to dry ink throughout with tough surface film but less gloss than cobalt drier. Manganese drier is seldom used alone except for non-scratch inks. Some paste driers are known as "tri-metal" driers, and contain cobalt, manganese and lead.

Paste-Up. The preparation of copy, putting each component element in proper position before photographing. The usual method of assembling copy elements including text for reproduction by offset lithography.

Pen and Ink Keys. A key tracing of the subject made on a transparent plastic sheet with pen and tusche. Sometimes used for transferring key outline of artwork to litho plates for making hand plates for posters.

Pen Drawing. Made by pen and india ink, in lines, dots or stipples, being a copy purely of black-and-white.

pH. A scale used for expressing the acidity or alkalinity of solutions. The degree of acidity or alkalinity present in a solution is determined by its hydrogen ion content: A pH value of 7 is considered neutral; solutions of a lower value are considered acid, while those higher than pH 7 are alkaline in nature. The pH scale ranges from 0 to 14, and determination is made by various electronic and colorimetric devices designed for the purpose.

Photocomposer. A machine for making multiple-image plates or negatives, by step-and-repeat action, from one or more negatives or positives. The machine is equipped for vertical and horizontal make-up in accurate spacing and register. Some types of machines are for making multiple negatives only, which in turn are used as the unit positioned in the step-and-repeat platemaking composing machine.

Photographic Proofs. Photographic prints made from negatives or positives. Various forms of blueprints and silver prints are used to check layout and imposition; silver prints approximate quality of halftones; various forms of diazo prints in color are used to approximate quality of process color plates sometimes termed print proofs.

Photolithography. That branch of lithographic printing in which photography is employed for production of the image on the final printing surface. The original printing surface, lithographic stone, has been almost completely displaced by thin and flexible sheets of metal (zinc, aluminum, stainless steel, bimetallic plates, polymetallic plates), bearing a mechanically abraded (grained) surface for retention of moisture on the plate during offset printing therefrom. The oldest photolithographic procedure still in practical use is the albumin process in which light-hardened and inked images of bichromated albumin serve as the actual printing surface. Deep-etch plates are a modern form of photolithographic surface, as are also bimetallic plates and those of the plastic type.

Photomechanical. Generic and broadly applied term for any reproductory process in which photography is employed in the production of a printing surface. The term embraces collotype, photoengraving, photogravure, photolithography, rotogravure, silk screen photostencil printing, etc.

Picking. Removal of part of the surface of paper during printing. Picking occurs when the pulling force of the ink is greater than the surface strength of the paper, whether coated or uncoated.

Pick Tester. An instrument designed to measure the pick resistance of paper through the use of inks with varying standardized tack.

Pigments. Manufactured chemical colors, inorganic or organic; the former generally opaque and produced from basic materials including metals; the latter include coal tar dye lakes formed by precipitation on alumina hydrate and widely used for lithographic transparent inks.

Piling. The sticking or caking of ink pigment on plate or blanket instead of passing on readily to the intended surface.

Pitch Diameter. Rolling diameter of a gear. On offset press, same diameter as cylinder bearers.

Planographic Printing. A generic term used for any and all printing processes in which a flat surface is used—i.e., where the image sections are in substantially the same plane as the non-image sections (such as direct and offset lithography, or collotype). Erroneously, some have tried to apply the term planography in a more restricted sense using it only for the simpler types of photolithography, such as black-and-white line and halftone reproduction.

Plate Cylinder. That cylinder on a rotary press to which the printing plates are attached.

Polish Out. Meaning to erase a design image or unwanted marks on a lithographic plate with a snake stone or similar abrasive.

Polychromatic. Many colors.

Post Treatment. A treatment of the non-image areas of the metal plate after image development. A step in producing maximum desensitization.

Pre-Etching. Applying a thin film of gum on an offset plate before coating it. The purpose of pre-etching is to make it easier to develop the plate in hot, humid weather and to decrease the amount of residual coating, the thin film of coating left in the non-image areas of the plate after developing. The etch used for desensitizing the plate is generally used for pre-etching.

Press Proofs. Actual press sheets to show image, tone values and colors as well as imposition of form or press plate.

Pre-Treatment. The treatment of the offset-lithographic plate before graining to remove old ink and image substance. Counter-etching, pre-etching, Cronak, and Brunak are pre-treatments in platemaking.

Printing Pressure. The force at the interface of the printing member and the paper which is required to transfer the ink from the printing member to the paper.

Process Colors. Yellow (lemon), magenta (cold red), cyan (blue-green), are the three process colors. They are so selected because when combined they produce black and when used in various strengths and combinations they make it possible to reproduce thousands of different colors with a minimum of photography, platemaking and presswork.

Process Lens. A highly corrected photographic lens for line, halftone and color photography. A camera lens used for photographing flat copy; it

is used in lithography for line and halftone photography, continuous-tone and color separation for line; usually not sufficiently color corrected for process-color separation.

Progressive Proofs. Proofs made from the separate plates used in color process work, showing the sequence of the printing and the result after each additional color has been applied. They are furnished to the printer by the engraver.

Projection Printing. A system of lenses and lamps which can be used to project an image upon a sensitized plate. Hence the image may be formed larger (or smaller) than the negative or positive which is projected. Used for large halftone work on some types of lithographed posters.

Proofing. Frequently used instead of "prooving," denoting the operation of pulling proofs of plates for proofreading, revising, trial, approval of illustrations, and other purposes preliminary to production printing. In lithography print proofs (photoprints) are used to check layout and imposition when plates are made from flats and colors.

Proof Press. A printing machine used for making proofs, usually has most of the elements of a production machine but not for automatic sustained production. An offset proof press has provision for transferring printed image to offset blanket and from that to the paper. Hand and power models, single and multicolor, as well as special presses for transparent proofs are available.

Psychrometer. A wet-and-dry bulb type of hygrometer. The two thermometers suitably mounted and with swivel handle are whirled vertically in area for reading. Considered the most accurate of the instruments practical for industrial plant use; for determining relative humidity.

Reducers. Varnishes, solvents, or oily or greasy compounds, employed to bring ink or varnish to a softer consistency for use on the press. (2) In photography, the term refers to chemicals used to reduce the density of negative or positive images or halftone dots.

Refraction. Deviation of a luminous ray of light in passing obliquely from one medium to another, or in traversing a medium of uneven density.

Register. Exact correspondence in the position of pages or other printed matter on both sides of a sheet or in its relation to other matter already ruled or printed on the same side of the sheet. (2) In photo-reproduction and color printing, the correct relative position of two or more colors so that no color is out of its proper position.

Register Marks. Small crosses, guides or patterns placed on originals before reproduction to facilitate registration of plates and printing therefrom

Register Rule. A metal measuring rule with vernier to measure in $\frac{1}{1000}$ inches; designed by LTF especially for the accurate measurement of image dimensions on the offset press plate and on the printed sheet to avoid misregister difficulties.

Reproduction Ratio. The term used to denote the amount of enlargement of reduction in scaling copy when photographed; defined as any linear distance on the image divided by the corresponding distance on the copy. Same-size copy would be 1.0 expressed decimally, a reduction would be less than one.

Repro Proof. Trade term for reproduction proof, a clear-type proof of superior quality for photographing; used for assembling type elements with photos and art on the mechanical paste-up for photographic platemaking by all processes.

Residual. The very thin film of plate coating always left on the metal of a lithographic plate after development. Post-treatment of the plate with various solutions removes this film and better prepares the non-printing areas of an albumin plate after development.

Resist. In deep-etch offset platemaking, the non-image plate coating hardened by the action of light on bichromated gum or other coating solution; keeps developing solution from contacting metal of these areas; such solutions etch metal of plate slightly.

Restrainer. The ingredient of a developer which prevents too rapid development and chemical fog; usually potassium bromide.

Retouching, Photographic. Corrective treatment of photographic negatives and prints by means of pencils, reducers, transparent shading sheets, airbrush or application of aniline dyes for removal of blemishes and improvement of tone value, detail and photographic quality.

Reverse Plates. Plates which are negative in tone values to copy.

Reversing Prism. An optical prism used in combination with a camera lens to "reverse" the image from right to left, or to make it read "right" when it would read "wrong" with the lens alone. A reversing prism requires that the copyboard be placed at right angles to the plate or film in the camera.

Rider Rollers. Metal or rigid plastic rollers in the inking mechanism which contact one or more soft (glue, glycerine, rubber, etc.) rollers and serve to break down, transfer and distribute the ink. Soft rollers are sometimes used as riders on large metal ink drums and serve to break down the ink.

Roller Stripping. A lithographic term denoting that the ink does not stick to the metal ink rollers on the press.

Rolling Up. In lithography, the inking of the finished plate without taking a proof or impression. Usually done by hand to protect the image or to render inspection easier.

Rub-Proof. Meaning the ink has about reached maximum dryness and the printed surface resists all normal abrasion.

Safelight. In photography, the special darkroom lamp emitting illumination wherewith sensitized materials can be handled without danger of fogging by action of light.

Scale. A rule of graduated dimensions; a device on process cameras for mechanical focusing of images; (2) The ratio of enlargement or reduction of an original to the final reproduction; (3) A table of percentages.

Scanner. An electronic device for scanning color transparencies and separating the colors for photographic separations to be used in the reproduction processes, or in other types of scanners; an electronic device for integrating color separations made in the camera and color correcting them by integrating a color separation with the particular ink to be used for each color.

Screen Angles. In halftone color reproduction, any of the particular angles at which a halftone screen or the original itself is placed for each of the negatives comprising the set of color plates, in order to avoid formation of displeasing dot patterns in the completed color reproduction.

Screen Compensator. A piece of glass positioned in front of the process camera lens when making combination line and halftone negative with two exposures. When halftone screen is removed, the compensator is positioned to allow for the difference in light refraction.

Screen Distance. In halftone photography, the separation or space between the surface of a glass halftone screen of specific ruling and the photographic surface during the halftone camera exposure. This distance permits the rays of light passing through the screen to diffuse before striking the film or plate. Extent of diffusion of rays is in proportion to their intensity which in turn is determined by the reflection of light from the original copy. The variation in diffusion is what produces dots of different sizes on the film or plate.

Screened Photo Prints. A photo print made through the halftone screen giving a screened print instead of a continuous-tone print. Can be photographed as line copy.

Screening. A halftone negative or positive that has a large dot in the highlights and a large white opening in the shadows is said to be "screeny." This is often due to the screen distance being too short or to the use of too small a lens opening.

Scriber. A small hand tool used for drawing lines on the emulsion of an exposed photographic negative, the tool scraping off the black emulsion; the operation is termed "engraving" negatives and is used for fine ruled-form work.

Scumming. A lithographic term referring to the press plate picking up ink in the non-printing areas for a variety of reasons; basically due to spots or areas not remaining desensitized; filling in of halftone dots, spreading of image, streaks are often caused by scumming.

Sensitivity Guide. A narrow, calibrated continuous-tone gray scale with each tone scale numbered. In the platemaking operation the gray scale is exposed on the sensitized press plate along with the rest of the work. The number of steps in the scale showing as solids on the developed plate determine the sensitivity of the plate coating and measure the tone values that were reproduced on the plate.

Sensitizer. Embracive term for the chemical compounds (salts of iron, silver and chromium, also diazo compounds and dyes) utilized to render photographic surfaces sensitive to light and color. With lithography, also used in plate coatings to make them light-sensitive.

Separation. In color photography, the isolation or division of the colors of an original into their primary hues, each record or negative used for the production of a color plate. The act of manually separating or introducing colors in printing plates. In lithography, direct separations are made with the use of the halftone screen; indirect separations involve continuous-tone separation negatives and screened positives made from these.

Setback. In offset platemaking, the distance from the front edge of the press plate to image area to allow for clamping to cylinder and also to allow for gripper margin; this distance varies with different makes and press sizes.

Shading Sheets. Art material, usually patterns or tones on acetate sheets which can be positioned on line artwork in selected areas to avoid tedious hand detail; special drawing paper containing invisible patterns which can be developed to black by chemical on artist's brush. Not to be confused with halftone tints which are only indicated on the art, and inserted by stripping negative.

Shadow. General term for the darker areas of an original, negative and reproduction.

Shadow Stop. The small lens aperture used for the flash exposure in halftone photography.

Sharpen. To decrease in strength, as when halftone dots become smaller; opposite of "thicken."

Sharpness. Photographic term for perfectly defined detail in an original, negative, and reproduction.

Sheet-Wise. The use of a form or offset plate which prints just one side of the sheet when both sides are to be printed; a method of press production.

Short Ink. A descriptive term used to describe quality of lithographic inks; short or buttery-ink when tapped between the fingers, does not draw out into a thread. Inks are described as being "short" or "long," as well as stiff or soft.

Silhouette Halftone. A halftone illustration plate from which the screen surrounding any part of the image has been cut or etched away.

Silhouetting. Opaquing out the background around a subject on a halftone or a continuous-tone negative. On a positive this can be achieved by staging the subject and by flat-etching the background until it is entirely transparent.

Silver Print. Photographic print on paper which has been sensitized with silver chloride salts.

Size (for bronzing). A sticky ink printed as a base to hold bronze powder or flock.

Skeleton Cylinder. A cylindrical framework used in the transfer and delivery mechanism of a printing press, usually having rings of star wheels or similar shape, which contact the printed sheet in the margins.

Smearing. A condition in which the impression is slurred and unclear because too much ink was run or sheets were handled or rubbed before ink was dry. (2) Spreading the ink over areas of the plate where it is not wanted; wiping the ink off the image areas and onto the non-image areas of a plate.

Snakeslip. A stick compounded of pumice powder and flint, used for removing dirt spots or unwanted objects on the lithographic pressplate.

Soft (Ink). Descriptive of consistency of lithographic inks. Inks can be either soft or stiff, as well as long or short.

Soft Dot. When the halation around the edge of the dot is excessive and almost equals in area the dot itself, the dot is called soft. When the amount of halation is so slight as to be barely noticeable and the dot is very sharp, the dot is called hard. Sometimes these terms are used improperly to indicate the ease with which the dots yield to chemical reduction. A contact negative has a harder dot than a negative made in the camera.

Soybean Plate Coating. Soybean, introduced to lithographers about 1949, is a substitute for albumin.

Spectrum. The rainbow-like band of visible colors formed when a ray of light is separated into its constituent colors after undergoing dispersion by a diffracting grating or prism.

Speed of an Emulsion. Degree of sensitivity to light. The time factor in sensitivity of light. The amount of moisture picked up by lithographic plate coating solutions affects their speed of action; a 30° change in

humidity can make the speed of a solution twice as fast. For this reason platemaking departments are frequently air-conditioned.

Spotters. Pieces of white or black paper in which small holes have been cut. Used for comparing areas on the sketch with tints on the chart. (2) Term applied to workers doing simple opaquing operations to eliminate defects in negatives.

Staging. Applying a protective coating in selected areas so that these are protected when chemicals are applied to the general area. Normally the staging is removed at a later operation, leaving the protected areas in their original form.

Staining. Corrective treatment or retouching of photographic images with dilute solutions of aniline dyes. Staining negatives lightens tones in printed reproduction. Staining positives produces darker tones in printed reproduction. Dye retouching. In lithographic color correction, the method of adjusting density of local areas on continuous-tone negatives. The use of a gray dye is general practice because the negatives are in gray tones.

Static Neutralizer. A printing press attachment designed to remove the static electricity from the paper to avoid ink offsetting and trouble with the paper.

Stepover. In multiple imposition on a lithographic press plate, the procedure of repeating the exposure of a flat by stepping it along the gripper edge; side-by-side exposure.

Step-Up. In multiple imposition on a lithographic press plate, the procedure of repeating the exposure of a flat by stepping it back from the gripper edge of plate; up-and-down positioning.

Still Development. The development of photographic emulsion in tray without agitation or rocking of tray.

Stipple. Term applied to originals and reproductions in which lights and shades are produced or translated by irregularly spaced dots instead of lines and cross-hatchings. A technique used for getting tone by hand methods on lithographic plates.

Stop. Photographic term for any type of lens aperture or diaphragm. For example, Highlight-, Middletone-, Detail-, Shadow-, Iris-, Waterhouse-Stops.

Stopping Out. In photomechanics, application of opaque to photographic negatives; staging of halftone plates

during relief etching; protecting certain areas of deep-etch plates by applying gum solution prior to the application of plate bases, so that no ink attracting medium will be deposited on the protected areas.

Stream Feeder. A type of press feeder which keeps several sheets of paper, overlapping each other, moving toward the grippers.

Stripfilm. A process film for line and halftone photography consisting of a gelatino-silver emulsion coated on a temporary support, which permits stripping or lifting of the negative image from the base support after fixation and washing.

Stripping. The act of positioning or inserting copy elements in negative or positive film to a unit negative; the positioning of photographic negatives or positives on a lithographic flat for form imposition. (2) The condition under which steel rollers fail to take up the ink on lithographic presses, and instead are wet by the fountain solution.

Surface Plate. One of the two basic types of lithographic press plates; a colloid image is formed on the light-sensitized metal plate by the action of actinic light through photographic negatives. The albumin plate is the most common form of surface plate, but there are others, including some of the bimetal or polymetal plates on which the image acts as a resist for the removal by acid of the surface metal to get down to the base metal which tends to resist ink.

Surprint. In photomechanics, a print from a second negative superimposed upon a previously printed image of the first negative, and differing from a double print (q.v.) in that one image is superimposed on the other rather than being photo printed into or around the first image. Surprinting is commonly used to superimpose the print from a line negative on a previously made print from a halftone or other line negative. Line work surprinted will reproduce as solid black and with no screen.

Sword Hygroscope. A special hygrometer invented by the Lithographic Technical Foundation for measuring the interior moisture content of a pile of paper in comparison to that of the air surrounding. An aid in determining whether or not paper-conditioning is necessary.

Tack. The resistance to splitting of an ink film between two separating surfaces, i.e. stickiness. This ink property is of great importance at the moment of printing since it controls picking of the paper and trapping of colors. (2) The quality of adhesion of an offset blanket; when the blanket has been used to a point that the rubber starts to disintegrate, the blanket is said to be tacky.

Thicken. To increase in strength, as when halftone dots become denser and larger; opposite of "sharpen."

Thixotropy. The property of some lithographic inks of becoming fluid when worked and setting to a semi-solid state when at rest; the cause of some inks tending to back away from the ink fountain roller.

Tight (negatives). In lithography, a negative so over-exposed that the lighter tones are very dense and will come through very light on the positive. Also, the shadows will come through noticeably lighter than they should.

Tinting. An all-over color tint on the press sheet caused by the ink pigment dissolving in the dampening solution of a lithographic press. Not to be confused with scumming which is more local and due to other reasons.

Tint Laying. The operation of transferring Ben Day tints to plates, drawings or other mediums.

Tints. Various tones (Strengths) of a solid color. For rough work, sometimes handled on the copy by pasting down a piece of stock shading sheet and handled as line copy; or patented drawing board is used by artist and tint areas are developed with chemical. Photographic (halftone) tints are stock developed film (negative and positive) in various strengths of tone (25 percent, 50 percent, etc.) and usually 133-line screen prepared by the camera department and inserted by stripper as indicated on copy.

Tone Density. The optical density of a tone area. With halftones, the over-all density which takes into account both the dots within the tone area and the spaces between them.

Toners. Highly concentrated colors made from "double strength" pigments; both transparent and opaque; used to get greater tinctorial strength in printing inks.

Transfer. A lithographic image transferred from one surface to another;

e.g., from a designer's stone to the printing press plate by means of a proof on transfer paper; a transfer plate has the images transferred to it.

Translucent. Said of materials which transmit light without permitting the objects beyond to be distinctly visible nor clearly seen.

Transparency. A monochrome or full-color photographic positive or picture on a transparent support, the image intended for viewing and reproduction by transmitted light. In photography, also refers to the light-transmitting power of the silver deposit in a negative and is the inverse of opacity. (2) Inexpensive, semi-permanent window posters printed on high grade onionskin paper for application to glass surfaces. (3) The property of an ink which permits light to pass through it. Lack of hiding power.

Trapping. The ability of an already printed ink film to accept a succeeding or overprinted ink film.

Trimetallic Plates. A type of lithographic press plate, consisting of a base metal of stainless steel, aluminum or other metal on which other metals are plated, usually copper and then chromium. Lithographic platemaking techniques are used to etch the surface metal of image to reach the copper for image base; surface metal remains for the non-printing areas. The nature of the surface metal with the dampening solution helps in repelling the ink from non-printing areas. Such plates have a long life and no mechanically grained surface.

Tusching. The operation of adding work to the image on a lithographic press plate, correcting lines and lettering and adding solids by means of a liquid greasy substance known as *Tusche.*

Two-Sheet Detector. A device for tripping the press when more than one sheet attempts to enter the press at one time.

Under Asphaltum. The operation in making a deep-etch offset plate consisting in removing the developing ink from the image areas and then coating these areas with asphaltum to make them permanently ink-receptive. With a surface plate the ink of the image is removed and the image put under asphaltum if a plate is to stand more than 24 hours, or if it is to be stored for a rerun.

Undercut. In printing presses, the difference between the radius of the bearers and the radius of the cylinder body; the allowance for plate or blanket plus a margin for packing adjustment.

U.S.P. Abbreviation for United States Pharmacopoeia, the American Standard for purity and strength of many chemicals.

Vandyke Print. A silverprint or photographic image made on inexpensive photopaper sensitized with a mixture of iron and silver salts; a brownprint. Frequently used by offset lithographers as a proof from a negative to be sent to the customer as a means to check layout or other corrections.

Vari-Typer. A special typewriter with interchangeable type faces used for reproduction work.

Vehicle. The fluid varnish or oil in which pigment is suspended in printing inks.

Velox Print. Name for one of the chloride printing papers made by the Eastman Kodak Co., and sometimes erroneously used as name for similar developing papers.

Vibrator or Vibrating Roller. A metal or hard roller in an inking or dampening system.

Vignette. A relatively small decorative design or illustration of any kind put on or just before the title page, or at the beginning or end of a chapter of a manuscript or book. It is usually a fine, delicate design representing a vine or tendril. (2) An original piece of copy, halftone printing plate or impression in which the background or a portion of the illustration gradually shades off until the lightest tones or extreme edges appear to merge with the paper on which they are printed. A halftone illustration showing a vignetted finish or edge.

Viscosity. Resistance to flow; the opposite of fluidity. A physical characteristic which allows material to be drawn out into threads; viscosity can be coarsely compared for practical purposes by the length of the strings at the time of breaking.

Walk-Off. Failure of part of a lithographic image to adhere to the metal plate; parts of image disappear during press run.

Warm Color. A color on the red or yellow side. Red, yellow and orange are regarded as warm colors.

Wash Drawing. Made by a brush in washes with a single pigment of black or dark color soluble in water, to be reproduced by the halftone.

Washing Out. The removal of an image coating which has been applied to the plate, such as developing ink or asphaltum, by use of turpentine or other solvents.

Wash Off Relief. Photographic sketches made by superimposing three color images. Positives with relief gelatin images are made from separation negatives. The positive absorbs dye in proportion to the amount of gelatin in any area. Dye can be transferred to paper base. All three dyes transferred in register, produce full-color prints. This process has largely been replaced by the *Dye Transfer Process.*

Water Fountain. The metal trough on a lithographic press which holds the dampening solution.

Waterhouse Stop. A diaphragm for photographic lenses devised by John Waterhouse in 1856, the aperture taking the form of a thin sheet of metal or paper bearing circular or irregular openings of a definite size, and intended for insertion in a slot cut into the barrel of a lens.

Water-Resistance. Papers for lithography require a fairly high degree of water-resistance. Writing papers usually are heavily sized to permit the use of aqueous writing inks and to facilitate erasing. For packaging and for maps or posters subject to outdoor use, papers have been developed that do not disintegrate even when exposed to sea water.

Wax Test. A pick test for paper. The use of a series of waxes in stick form which are graded in adhesiveness. To test surface strength of paper (pick) several grades of wax are heated and pressed against paper surface; after cooling the wax sticks are pulled away from paper vertically, the first of the grades of adhesiveness to cause paper surface to adhere to it determines the picking (by number) quality of the paper.

Wet-Plate. A photographic negative or positive produced by wet collodion photography.

Work-and-Turn Imposition. Work-and-turn is a printing imposition, where the form contains the material to be printed on both sides of the sheet. The entire form first prints on one side of the sheet for half the number of impressions desired, then the sheet is turned over sideways from left to right and the run is completed on the reverse side.

Selected List of References

For the reader's convenience there is presented here a list of books which is by no means complete, but may be helpful in the further study of lithography and its related fields. The list was prepared by the staff of the Technical Information Division of the Graphic Arts Technical Foundation's E. H. Wadewitz Memorial Library. This library is probably the most comprehensive source of scientific, technical, and educational information on graphic communications and related subjects to be found anywhere in the western hemisphere. Every effort is made to keep the library up-to-date through constant direct contact with publishers, and through the review of the publishers' trade lists.

Allen, Edward Monington, ed. *Harper's Dictionary of the Graphic Arts.* New York, Harper and Row, Publishers, 1963.

Apps, E. A. *Ink Technology for Printers and Students:* Volume I; *Manufacture and Testing.* New York, Chemical Publishing Co., Inc., 1964.

Apps, E. A. *Ink Technology for Printers and Students:* Volume II; *Inks for Major Processes.* New York, Chemical Publishing Co., Inc., 1964.

Apps, E. A. *Ink Technology for Printers and Students:* Volume III; *Special Applications.* New York, Chemical Publishing Co., Inc., 1964.

Arnold, Edmund C. *Functional Newspaper Design.* New York, Harper and Row, Publishers, 1956.

Arnold, Edmund C. *Ink on Paper.* New York, Harper and Row Publishers, 1963.

Baker, Elizabeth Faulkner. *Printers and Technology: A History of the International Printing Pressmen and Assistants' Union.* New York, Columbia University Press, 1957.

Banks, W. H., ed. *Printing Inks and Color:* Volume I; *Advances in Printing Science and Technology.* New York and other places, Pergamon Press, 1961.

Banks, W. H. *Halftone Printing:* Volume III; *Advances in Printing Science and Technology.* New York and other places, Pergamon Press, 1963.

Barnett, Michael P. *Computer Typesetting: Experiments and Prospects.* Cambridge, Mass., The M.I.T. Press, 1965.

Biegeleiser, J. I. *The Complete Book of Silk Screen Printing Production.* New York, Dover Publications, Inc., 1963.

Billmeyer, Fred W., Jr. and Satzman, Max. *Principles of Color Technology.* New York, Interscience Publishers, 1966.

Bragdon, Charles R. *Metal Decorating from Start to Finishes.* Freeport, Me., The Bond Wheelwright Co., 1961.

Brookes, B. C., ed. *Editorial Practices in Libraries.* London, Aslib, 1961.

Burt, Cyril. *A Psychological Study of Typography.* Cambridge, England, The University Press, 1959.

Carroll, John S., ed. *Photo-Lab-Index.* Hastings-on-Hudson, New York, Morgan and Morgan, Inc.; London, The Fountain Press, 1965.

Casey, James P. *Pulp and Paper: Chemistry and Chemical Technology.* 3 vols. New York, Interscience Publishers, Inc., 1960. Volume I. *Pulping and Bleaching;* Volume II. *Papermaking;* Volume III. *Paper Testing and Converting*

Cartwright, H. M. *Ilford Graphic Arts Manual:* Volume I; *Photo-Engraving.* Essex, England, Ilford Limited, 1961.

Cleeton, Glen V., *et al. General Printing.* Bloomington, Illinois, McKnight & McKnight Publishing Company, 1963.

Cogoli, John E., *Photo-Offset Fundamentals.* Bloomington, IL, McKnight & McKnight Publishing Co., 1960.

Computer Information Service. *Glossary of Automated Typesetting and Related Computer Terms.* Los Angeles, Composition Information Services, 1966.

Deller, Jack. *Printer's Rollers: Their Manufacture, Use and Care.* London, Charles Skilton, Ltd., 1959.

Department of the Air Force. *ACIC (Aeronautical Chart and Information Center) Ink Specifications.* St. Louis, Mo., Headquarters Aeronautic Chart and Information Center, 1965.

Division of Air Pollution, U.S. Dept. HEW. *Air Pollution Publications: A Selected Bibliography 1963–1966.* Washington, D.C., 1966.

Flexographic Technical Association. *Flexography: Principles and Practices.* New York, 1962.

Gerber, J. *A Selected Bibliography of the Graphic Arts.* Pittsburgh, Pa., Graphic Arts Technical Foundation, 1967.

Government Printing Office. *Theory and Practice of Bookbinding.* Washington, D.C., 1962.

Government Printing Office. *Theory and Practice of Presswork.* Washington, D.C., 1962.

Government Printing Office. *Typography and Design.* Washington, D.C., 1963.

Halpern, Bernard R. *Color Stripping.* Pittsburgh, Pa., Graphic Arts Technical Foundation, 1955.

Halpern, B. R. *Offset Stripping—Black and White.* Pittsburgh, Pa., Graphic Arts Technical Foundation, 1958.

Halpern, Bernard R. *Tone and Color Correcting.* Pittsburgh, Pa.; Graphic Arts Technical Foundation, 1956.

Hartsuch, Paul J. *Chemistry of Lithography.* Pittsburgh, Pa., Graphic Arts Technical Foundation, 1961.

Hattery, Lowell H., and Bush, George P., eds. *Automation and Electronics in Publishing.* Washington and New York, Spartan Books; London, Macmillan and Co., 1965.

Holmes, Raymond G., ed. *Air Pollution Source Testing Manual.* Los Angeles, Los Angeles Air Pollution Control District, 1965.

Hurst, C. A. and Lawrence, F. R. *Letterpress Composition and Machine Work.* London, Ernest Benn Ltd., 1963.

Hutchings, R. S., and Skilton, Charles, eds. *Modern Letterpress Printing: Materials and Methods in the Machine Room.* London, Charles Skilton, Ltd., 1963.

Jaffee, Erwin, *et al. Color Separation Photography with an Introduction to Masking.* Pittsburgh, Pa. Graphic Arts Technical Foundation, 1959.

Jaffee, Erwin. *Contact Printing.* Pittsburgh, Pa., Graphic Arts Technical Foundation, 1964.

Jaffee, Erwin. *Halftone Photography for Offset Lithography.* Pittsburgh, Pa., Graphic Arts Technical Foundation, 1960.

Jaffee, Erwin, and Reed, Robert F. *The Science of Physics.* Pittsburgh, Pa., Graphic Arts Technical Foundation, 1964.

James, T. H., ed. *The Theory of the Photographic Process.* New York. The Macmillan Company; London, Collier-Macmillan Limited, 1966.

Jorgensen, George W., and Bruno, Michael H. *The Sensitivity Guide.* Pittsburgh, Pa., Graphic Arts Technical Foundation, 1959.

Karch, R. Randolph, and Buber, Edward J. *Graphic Arts Procedures: The Offset Processes.* Chicago, American Technical Society, 1967.

Karch, R. Randolph. *How to Recognize Type Faces.* Bloomington, Illinois, McKnight & McKnight, 1952.

Kasloff, Albert. *Photographic Screen Process Printing.* Cincinnati, The Signs of the Times Publishing Co., 1965.

Katz, Irving. *Adhesive Materials: Their Properties and Usages.* Long Beach, California, Foster Publishing Co., 1964.

Kenneison, W. C., and Spilman, A. J. B. *Dictionary of Printing, Papermaking, and Bookbinding.* London, George Newnes Limited, 1963.

Kosar, Jaromir. *Light-Sensitive Systems: Chemistry and Applications of Non-silver Halide Photographic Processes.* New York, John Wiley & Sons, Inc., 1965.

Lasky, Joseph. *Proofreading and Copy-Preparation: A Textbook for the Graphic Arts Industry.* New York, Mentor Press, 1964.

Latham, C. W. *Advanced Pressmanship—Sheetfed Presses.* Pittsburgh, Pa., Graphic Arts Technical Foundation, 1963.

Latham, Charles W. *Offset Lithographic Press Operating—Sheetfed Presses.* Pittsburgh, Pa., Graphic Arts Technical Foundation, 1963.

Latham, Charles W., and White, Jack W. *Photocomposing.* Pittsburgh, Pa., Graphic Arts Technical Foundation, 1964.

MacKay, Robert, and Cartwright, H. M. *Rotogravure: A Survey of European and American Methods.* Lyndon, Kentucky, MacKay Publishing Co., Inc., 1956.

Messner, Richard. *Selling Printing and Direct Advertising.* New York, Fred W. Hoch Associates, 1947.

Miller, C. William. "Benjamin Franklin's Philadelphia Type." *Studies in Bibliography: Papers of the Bibliographical Society of Virginia:* II, 179–206 (1958).

Neblette, C. B., and Murry, Allen E. *Photographic Lenses.* Hastings-on-Hudson, New York, Morgan & Morgan, Inc.; London, The Fountain Press, 1965.

Noemer, Ewald Fred. *The Handbook of Modern Halftone Photography.* Demarest, New Jersey, Perfect Graphic Arts, 1965.

Printing Industries of America. *A Composition Manual.* Washington, D.C. Printing Industries of America, 1953.

Pulp and Paper Research Institute of Canada. *Thesaurus of Pulp and Paper Terms.* Pointe Claire, Quebec, 1965.

Purves, Frederick, *et al. The Focal Encyclopedia of Photography.* New York, The Macmillan Company, 1956.

Radford, R. G. *Letterpress Machine Work,* London, Staple Press Ltd., 1957.

Ratliff, Floyd. *Mach Bands: Quantitative Studies on Neural Networks in the Retina.* San Francisco and other places, Holden-Day, Inc., 1965.

Reed, Robert F. *The GATF Pick Tester for Offset Papers.* Pittsburgh, Pa., Graphic Arts Technical Foundation, 1953.

Reed, Robert F. *Instruments for Quality Control.* Pittsburgh, Pa., Graphic Arts Technical Foundation, 1963.

Reed, Robert F. *Offset Lithographic Platemaking.* Pittsburgh, Pa., Graphic Arts Technical Foundation, 1967.

Reed, Robert F. *Offset Press Troubles—Sheetfed Presses.* Pittsburgh, Pa., Graphic Arts Technical Foundation, 1962.

Reed, Robert, F. *Web Offset Press Troubles.* Pittsburgh, Pa., Graphic Arts Technical Foundation, 1966.

Reed, Robert F. *What the Lithographer Should Know About Ink.* Pittsburgh, Pa., Graphic Arts Technical Foundation, 1960.

Reed, Robert F. *What the Lithographer Should Know About Paper.* Pittsburgh, Pa., Graphic Arts Technical Foundation, 1959.

Robinson, Karl Davis. *Line Photography for the Lithographic Process.* Pittsburgh, Pa., Graphic Arts Technical Foundation, 1956.

Rodriquez, Cesar, and Humphrey, George H., ed. *Bilingual Dictionary of the Graphic Arts.* (English-Spanish, Spanish-English). Farmingdale, Long Island, New York, George H. Humphrey, 1966.

Roy, Robert H. *Management of Printing Production.* Washington, D.C., Printing Industries of America, 1953.

Senefelder, Alois. *The Invention of Lithography,* trans. J. W. Muller. London, Fuchs & Lang Manufacturing Co., 1961.

Steffens, Robert N. *Engraved Stationery Handbook.* New York, The Cronite Press, 1950.

Strauss, Victor. *The Printing Industry.* Washington, D.C., Printing Industries of America, 1967.

Teddington, Eng. *Visual Problems of Color: Symposium.* Volume II. New York, Chemical Publishing Co., Inc., 1961.

Tinker, Miles A. *Legibility of Print.* Ames, Iowa, Iowa State University Press, 1963.

Updike, Daniel Berkely. *Printing Types: Their History, Forms, and Use: A Study in Survivals.* Cambridge, Mass., Harvard University Press, 1963. 2 vols.

Weiner, Jack, and Wroth, Lillian, *Institute of Paper Chemistry: Bibliographic Series, No. 164, Paper and its Relation to Printing.* Appleton, Wisconsin, 1962.

Wright, W. D. *The Measurement of Colour.* New York, D. Van Nostrand and Company, Inc., 1964.

Wroth, Lawrence. *The Colonial Printer.* Charlottesville, Virginia. The University Press of Virginia, 1938.

Yule, J. A. C. *Principles of Color Reproduction.* New York, John Wiley & Sons, Inc., 1967.

INDEX

Appendix

The appended Research Progress Reports and Technical Services Reports give useful information derived from recent studies. Other such reports are issued from time to time by the Graphic Arts Technical Foundation.

Number 7225

Technical Services Report

© Graphic Arts Technical Foundation, Inc. 1979

Infrared Drying and Setting of Inks

By Nelson R. Eldred

Summary
Infrared (IR) radiation accelerates the setting and drying of printing inks in several different ways. This fact has caused confusion regarding the use and limitations of IR. In simplest terms, IR generates heat, which accelerates the setting and drying of inks. Because it can also cause problems, IR must be applied under controlled conditions.

How Printing Inks Dry and Set
There are at least six different mechanisms (that is, methods or processes) by which printing inks dry. These are summarized in Table I.

Polymerization. Polymerization is a chemical reaction in which many small molecules join together to form one large molecule. Conventional sheetfed letterpress and offset inks dry by polymerization, or more specifically by "oxidative polymerization," because oxygen in the air is required for the polymerization to proceed. As the small molecules polymerize, or join together, they become large, branched molecules that do not flow readily. Eventually they are so resistant to flow that we call them "dry."

Within recent years other polymerization reactions have been applied to printing ink, most notably the polymerization of acrylic-type monomers initiated with ultraviolet light (UV). Unlike the oxidative polymerization, these reactions occur in a fraction of a second, and the inks are effectively dry when the prints come off the press.

Other polymerization reactions that have been used to dry inks include the polymerization of isocyanates to form urethanes. In fact, this type of chemical reaction was used to make the first infrared drying inks. The isocyanate was modified, or "capped," to make it unreactive in the can and in the ink fountain. Under intense heat from IR, the capped isocyanate reverted to the free form (it became "uncapped") and reacted very rapidly with other parts of the printing inks. These heat-reactive inks have fallen into disfavor because the high temperatures re-

quired to activate the polymerization "cooked" the paper, making it brittle; and furthermore, the inks had poor working properties.

Absorption. It is sometimes said that inks dry by absorption. This is not strictly true: newspaper inks never fully dry although the newsprint's absorption of the oil leaves the carbon black fairly well fixed to the paper.

Table I
How Printing Inks Dry

1. Polymerization
 - Oxidative Polymerization
 - Radiation-Induced Polymerization
 - Other Polymerization
2. Absorption
3. Evaporation
4. Solidification of a Melt
5. Precipitation
6. Gelation

As we shall see, absorption plays a part in the setting of letterpress and offset inks in both sheetfed and web printing.

Evaporation. Perhaps the most common method of drying inks is by evaporation. The solvent is evaporated from the ink in a dryer, leaving the ink solids on the print. This action is the main mechanism of drying for web processes: letterpress, offset, rotogravure, and flexography. (In web letterpress and offset, much of the solvent is known to remain in the print, and if enough solvent remains, it softens the ink and makes it smear easily.)

Solidification. However, evaporation of solvent from letterpress and offset inks leaves a hot, soft resin on the print, and it can be readily marred or scratched. Chill rolls are required to solidify the melted resin, and the drying of web letterpress and web offset inks thus requires two mechanisms: evaporation and solidification.

Precipitation. Less commonly used now than formerly, the mechanism of precipitation of a resin from a water-miscible ink was the basis for drying of the steam-set and moisture-set inks used for printing bread wrap. These inks are not widely used today.

Gelation. It is also possible to devise inks that dry through gelation; that is, the absorption of the vehicle in which a latex or polymer is suspended in the ink. When the ink is heated, the solvent swells the polymer particles, which form a film.

Gelation is rarely used to dry inks, but the rapid increase in viscosity (sometimes called "body") that results when solvent drains out of a gel varnish is responsible for the setting of "quickset" inks. A gel varnish is manufactured by blending and cooking suitable components. The varnish is diluted with enough solvent so that it flows smoothly on the press. When part of the solvent drains into the sheet, the ink quickly reverts to its gel form; that is, it "sets."

Since quickset inks depend upon absorption of solvent from the gel varnish, they are not practical on film, foil, or on other nonporous substrates. To avoid disasters, the printer must contact his inkmaker before printing on materials with which he is unfamiliar.

What Is Infrared Radiation?

IR, like visible light, is a form of electromagnetic radiation. We cannot see IR, but we can sometimes feel it if it falls on and warms our skin. IR is less energetic than visible light and is not particularly hazardous. Workers must be shielded from ultraviolet (UV), though, and the even more energetic X rays and gamma rays, which cause various problems in the body. The position of IR in the electromagnetic spectrum is illustrated in the figure.

How Infrared Accelerates Drying and Setting of Inks

IR can be used to speed up polymerization, absorption, and evaporation. Since most chemical reactions are accelerated as temperature increases, the oxidative polymerization reaction, by which sheetfed inks dry, goes faster when the print is warmed. Printers and equipment manufacturers report that ink that will dry in 2 hours at room temperature can be made to dry in 15 to 30 minutes if the temperature is raised with an IR radiator. It is a general rule that chemical reactions go about twice as fast if the temperature is raised about 18°F (10°C). Thus an ink that would dry in 2 hours at 70°F (20°C) would be expected to dry in about 1 hour at 88°F (30°C) and about 1/2 hour at 106°F (40°C).

Warming the print accelerates absorption, and this is most important in the setting of quickset inks. A small increase in temperature increases the rate of absorption more than it does the rate of chemical reaction. If an ink normally sets in 10 to 15 minutes, it can be made to set in a couple of minutes by raising the temperature of the print. "Infrared-setting inks" are usually carefully formulated quickset inks that will set much more rapidly when warmed (with infrared radiation or any other source of heat).

Because heat accelerates most physical and chemical processes, IR should be expected to accelerate the setting and drying of most inks.

The Electromagnetic Spectrum

Like any other source of heat, IR can be used to evaporate the solvent from inks. Direct-flame-impingement web dryers often had ceramic radiators and relied to some extent on IR to supply the heat to evaporate the solvent. It is technically feasible to replace natural gas with electrically generated IR in a web dryer. This method of producing IR and hot air is impractical, however, since using electricity is much more expensive than using natural gas. One IR drying system overcomes this problem by heating the ink only and then blowing away the evaporating solvent.

Neither IR nor any other source of heat will promote solidification. This process is speeded by cooling; hence the use of chill rolls on web presses. Similarly, IR does not effectively accelerate the drying of moisture-set inks.

Increasing the temperature of prints may cause problems, and the printer must not use IR unwisely or haphazardly. When properly used, IR accelerates the setting and drying of ink, but excessive heat aggravates blocking, setoff, mottle, loss of gloss, and loss of halftone dot definition or sharpness. These problems are much the same as those resulting from insufficient drying. For this reason, GATF urges printers to cooperate with their inkmakers to be sure that the ink chosen will yield benefits instead of creating troubles.

Even if the ink and the paper have been properly selected, the printer can still get into trouble if he does not control the process. Pressmen have often been heard to remark, "If a little is good, more must be better." They seem to believe that if a little IR accelerates setting and drying, then a whole lot must do even better. This is frequently the cause of disasters such as scorched or blocked prints. The printer must control the use of IR as he must control all of the other variables in the printing plant.

Other Radiation Sources

It may be appropriate at this point to mention other radiation sources used to dry or cure ink. Ultraviolet (UV) promotes the polymerization of special types of chemicals called acrylates. When properly formulated and irradiated, UV inks dry or cure in a fraction of a second.

There is a lot of talk about electron-beam radiation. The energy of electron beams, like UV energy, polymerizes acrylate monomers very rapidly, and it is technically feasible to use electron beams to dry prints.

However, there are a number of economic and safety problems involved, and, to date, electron beams have not been used commercially for drying printing. Electron beams are used commercially to dry coatings on metal, building materials, and other substrates.

Microwaves have been discussed as a source of energy for drying printing inks, but they have a number of drawbacks. Microwaves are effective in heating water, and this is how they provide heat in the microwave ovens used in the home. The water

inside the vegetable, bread, cake, or other food is rapidly heated and cooks the food in a fraction of the time required in an oven fired by gas, electricity, or wood. Microwaves, however, are not particularly effective for warming or heating oil-based inks. Microwave radiation would be more practical for drying water-based inks. Microwaves do heat paper as well as the water in the paper and make the sheet hot enough to evaporate the ink.

Infrared Inks

As with other new technologies, IR ink must be properly formulated and used on the correct equipment to achieve satisfactory results. GATF urges the printer to work closely with his suppliers to make sure that the ink, paper, and equipment are properly selected to give good results.

The most commonly used IR drying or setting inks are now specially formulated quickset inks. When warmed with IR (or any other source of heat, for that matter) the solvent which suspends the quickset varnish drains away more rapidly, accelerating the rate of setting of the ink. One of our members told us of his confusion because he was using IR inks without any radiation and getting excellent results, while one of his friends was using conventional quickset inks with IR and getting equally desirable results. The above explanation should make it clear how the use of either a quickset formulation or IR accelerates the setting of inks. Using both of them together should give even greater acceleration in the setting of the ink.

It was mentioned above that "capped" isocyanates had been used for making heat-reactive inks. The development has not proven commercially successful, but the search continues for chemicals that can be made reactive under IR. One of the remaining problems is to find a chemical that is equally reactive in yellow, magenta, cyan, and black inks. Because black absorbs IR more effectively than the other colors (especially yellow), the problem is a challenge to the scientist.

Infrared Dryers

Compared to other methods of accelerating the drying of inks without the use of natural gas, propane is costly, and UV requires a high investment and expensive inks. Investment for IR drying is relatively low, hazards are not unusual or great, and inks are priced about the same as conventional inks.

All modern IR systems have the notable advantage of not depending on natural gas, which has become increasingly expensive and may be in short supply during the winter. Furthermore, investment and operating costs for IR are more modest than for UV systems. There are a number of companies supplying equipment for IR drying and setting of printing inks. We make no effort to supply a complete or critical evaluation and will mention only three of the more popular systems. The oldest and most widely used IR radiator is the Herbert Hi-Ray Dryer. This electrically warmed quartz-panel radiator accelerates both the setting and the drying of the ink in the pile. The manner in which the radiator does so has been discussed above. Herbert has recently introduced a tubular medium-wave system that employes quartz tubes. The manufacturer says: "We intend to replace the modular design with the tubular system, which enables us to provide high-powered systems in the available press space and gives a rapid on-off feature."

More recently introduced is the Flynn Drying Systems Radiant Heatset Dryer, which uses medium-wavelength IR to dry black, yellow, and other colors at nearly the same rates. The system radiates the print, then blows away the evaporating solvent and removes it from the dryer with a positive exhaust. According to the manufacturer, this system uses energy more efficiently than if the entire print, paper and ink, were heated. Consequently, it may prove as economical to dry a print with electrical radiation as it is to use a conventional gas-fired, high-velocity, hot-air dryer.

The Herbert Dryer has commonly been used on sheetfed presses, although it has also been used on web presses. The Flynn Drying Systems dryer is designed primarily for use on web presses.

The INOR Infrared Dryer with Philips lamps uses medium-wavelength IR to dry black, yellow, and the other colors. It differs from the Herbert Dryer in wavelength because of the difference in the radiator. Its outward appearance is something like that of the Herbert Dryer. The Philips system has its peak radiation at about one micron; that is, in the short-wavelength infrared. Radiation is emitted from Philips lamps assembled in a panel rather than from a quartz panel as in the Herbert Hi-Ray Dryer.

The amount of power required to dry the print varies greatly according to specifics of the press and the job. Power consumption should be discussed with the manufacturer.

We are frequently asked: "Which wavelength is best, shortwave infrared or medium-wavelength infrared? The answer is that they are both useful in different situations. Shortwave IR is more intense, and it dries black ink much more rapidly than medium-wavelength IR. On the other hand, the medium-wavelength IR is more evenly absorbed by all colors of ink and is therefore more useful on multicolor printing. Table II, which was furnished us by Robert W. Pray of Flynn Drying Systems, illustrates the difference between these wavelengths.

Table II
Relative Drying Rates of Inks with IR[1]

Wave-length	Temperature of Radiator		Relative Drying Rate		Difference in Drying Rate (%)	Energy (%)
	(°F)	(°C)	Black	Yellow		
Medium (3.2 microns)	1,150	620	100	92	8	100
(2.8 microns)	1,380	750	115	103	10	135
(2.6 microns)	1,490	810	122	104	15	173
Short (1.15 microns)	4,000	2,200	burned	not dry[2]	—	—

1. With one type of ink; other types will vary slightly.
2. Black burned before yellow dried.

Conclusions

IR accelerates the drying and setting of inks in a number of different ways. Although, at first, this fact makes the subject appear confusing, it gives engineers and ink chemists and formulators a number of different ways through which to approach the goal of a safe, low-cost ink that, without using natural gas, will dry instantly on the web press or in a few minutes in the pile.

20:5

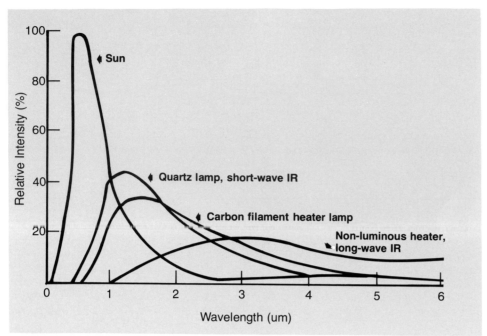

Figure 1. Wavelength and intensity of radiation.

Figure 2 Installation of IR dryer on the delivery of a sheetfed press.

Number 7226

Technical Services Report

© Graphic Arts Technical Foundation, Inc. 1979

Handling High-Key Copy For Black-and-White Halftone Reproduction

By Dennis Kaliser

Halftone reproductions of copy whose main interest area is in the highlight to midtone areas, that is, high-key copy, can often be improved by altering exposures. The addition of a bump, or no-screen, exposure has the effect of increasing highlight to midtone contrast. A reduction in main exposure usually increases the highlight printing dot. By combining an additional or increased bump exposure with a reduced main exposure, increased contrast and detail in the highlight to midtone areas can be achieved.

When making a halftone, the camera operator normally chooses a main exposure or main and bump exposure set that will match the minimum printing dot on the negative to the *diffuse* highlight of the copy. A flash exposure is usually then added to match the maximum printing dot on the negative to the shadow of the copy. If both contrast and detail are to be increased in the highlight areas through exposure alone, then the effect of properly integrating the main, flash, and bump exposures will be to move the 50% dot toward the highlight without changing the dot areas matched to the copy extremes.

To move the midtone, that is, the 50% dot, without changing dot sizes in highlight and shadow areas may require complex calculations. Accurate calculations necessary to accomplish this must take into account many input variables such as the effect of each exposure over the entire tone range, flare, reciprocity response, and others. More commonly, the right combination of three exposures is found by trial and error.

A simplified procedure for achieving increased highlight to midtone detail and contrast is shown here. This procedure is designed to allow the camera operator to come reasonably close to the exact exposures needed so that trial and error will be reduced to a minimum. A three-step calibration procedure must be performed before calculations for integrated exposures can be made. This calibration procedure need be performed only once for any film/processing combination.

1. A basic flash exposure must first be established. The film and contact screen are placed on the camera back with the vacuum on. Using the flash lamp only and a cardboard mask, a series of increasing test exposures are made, normally in five-second increments. After processing, the largest printing dot (or the smallest negative dot) that can be held on plate and press is chosen. The exposure used to produce this dot represents the basic flash time.

The basic flash time is then noted on a shadow flash computer or chart available from film manufacturers. Reference to this chart will be made later when the new flash exposure is to be found.

2. Using established shop procedures, a "good" halftone should be produced from the copy with highlight and shadow dots in their desired positions. The exposures used should be noted. This negative will be used for highlight and shadow reference and will provide a good starting point from which further calculations can be made. A 16- or 20-step continuous-tone gray scale should accompany the copy.

If the operator is starting from scratch, that is, if exposures have not been calibrated for a basic halftone, the operator should refer to any text on halftone photography for basic halftone procedures. The operator should know the screen range in order to calculate a new flash exposure. Screen range or basic density range tests are described in these same texts.

3. The introduction of an additional bump exposure will increase highlight to midtone contrast by shortening the screen range. The amount of screen range shortening is known as screen compression. This screen compression will vary with the amount of bump exposure used or with changes in processing and external conditions. For any chosen bump exposure, the screen compression must be found.

The amount of bump exposure is expressed as a small percentage of the main exposure and is chosen subjectively by the camera operator. For the purpose of practicality, a choice of two bump exposures, 3% or 6%, is suggested. If a magenta positive screen is being used, these bump exposures are to be added to the bump exposure already used with routine copy.

A 1.00 ND filter is suggested for use when making bump exposures to help insure repeatability. This filter allows only 10% of the light entering the lens to reach the film. Calculated bump exposures are then multiplied by 10 when using this filter. For instance, a two-second exposure becomes a twenty-second exposure.

Two additional halftones should now be shot, one with the additional 3% bump and one with a 6% bump. Main and flash exposures are *not altered from step 2.*

The movement of the highlight dot with respect to the original gray scale reflection density may be referred to as the screen compression for that percent bump exposure.

For example:

1. Main and flash	**0 bump**
2. Main and flash	**3% bump**
3. Main and flash	**6% bump**

Calculating Exposures

1. Note main and flash (and bump if already used) exposures used to produce a "good" halftone as described in step 2 of the calibration procedure.

2. Choose a 3% or 6% bump exposure. From step 3 of the calibration procedure, note the expected screen compression. Find the exposure factor associated with the expected screen compression from the table below.*

3. Divide the original main exposure by the exposure factor. This will be the new main exposure.

4. Multiply the percent bump chosen by the new main exposure. This will be the bump exposure. With a 1.00 N.D. filter this exposure is multiplied by 10.

5. Refer to the shadow flash computer or chart mentioned in step one of the calibration procedure. Add the screen compression to the original excess density range (difference between screen range and copy range) to find the new flash exposure. A sample calculation may be as follows:

(a) Original "shop standard" halftone using a negative screen.

Main Exposure	30 seconds
Flash Exposure	15 seconds
Basic Flash	30 seconds
Copy Range	1.40
Screen Range	1.10
Excess Density Range	.30

(b) A 6% bump is chosen. From a sample test (as in step 3 of the calibration procedure) the screen compression is found to be .25. A .25 screen compression requires a 1.78 exposure factor adjustment (see table).

(c) $\frac{30}{1.78}$ = 17 seconds new main exposure.

(d) 6% × 17 seconds = 1 second, or 10 seconds with a 1.00 ND filter.

(e) A .25 screen compression added to .30 excess density range for .55 new excess density range.

The film manufacturer's shadow flash computer or chart will show that the new flash is 22 seconds.

The new exposure set with a 6% bump will be as follows: Main 17 sec.; Flash 22 sec.; Bump 10 sec. w/1.00 ND.

Examples of this technique are shown here.

1. Main and flash	**0 bump**
2. Main and flash	**3% bump**
3. Main and flash	**6% bump**

The camera operator should remember that this calculation technique is designed for simplicity. It allows close approximation of exposures needed to move the midtone without changing the highlight or shadow. Additional factors, such as cumulative exposure effect and flare, which complicate calculations, have the effect of *adding* exposure.

It may be most useful, then, for the camera operator to slightly shorten exposures from the calculation. Photographic and press conditions must remain constant for the technique to work well.

Camera operators using light-integrating exposure computers normally have basic exposure calculations made by the computer. To use the calculation technique described in this report, the following procedure is suggested:

1. Adjust highlight indicator to the copy highlight as usual.

2. Adjust for new main exposure by changing the unit indicator. Calculation for new main exposure is based on the light units used.

3. No flash computation is necessary. Simply add the screen compression to the shadow density indicator dial.

4. Be sure to account for unit-time interval differences when the optional exposure mode is used for bump exposures. To avoid confusion, the main exposure unit indicator may be adjusted to the calculated bump exposure when the bump exposure is made. The main exposure mode is used for both main and bump exposures.

Screen Compression	Exposure Factor	Screen Compression	Exposure Factor
.05	1.12	.19	1.55
.06	1.15	.20	1.58
.07	1.17	.21	1.62
.08	1.20	.22	1.66
.09	1.23	.23	1.70
.10	1.26	.24	1.74
.11	1.29	.25	1.78
.12	1.32	.26	1.82
.13	1.35	.27	1.86
.14	1.38	.28	1.91
.15	1.41	.29	1.95
.16	1.45	.30	2.00
.17	1.48	.31	2.04
.18	1.51	.32	2.09

This table is based on a D log E relationship. In actual practice, the exposure factor will be slightly different due to reciprocity response, process changes, flare, etc.

20:8

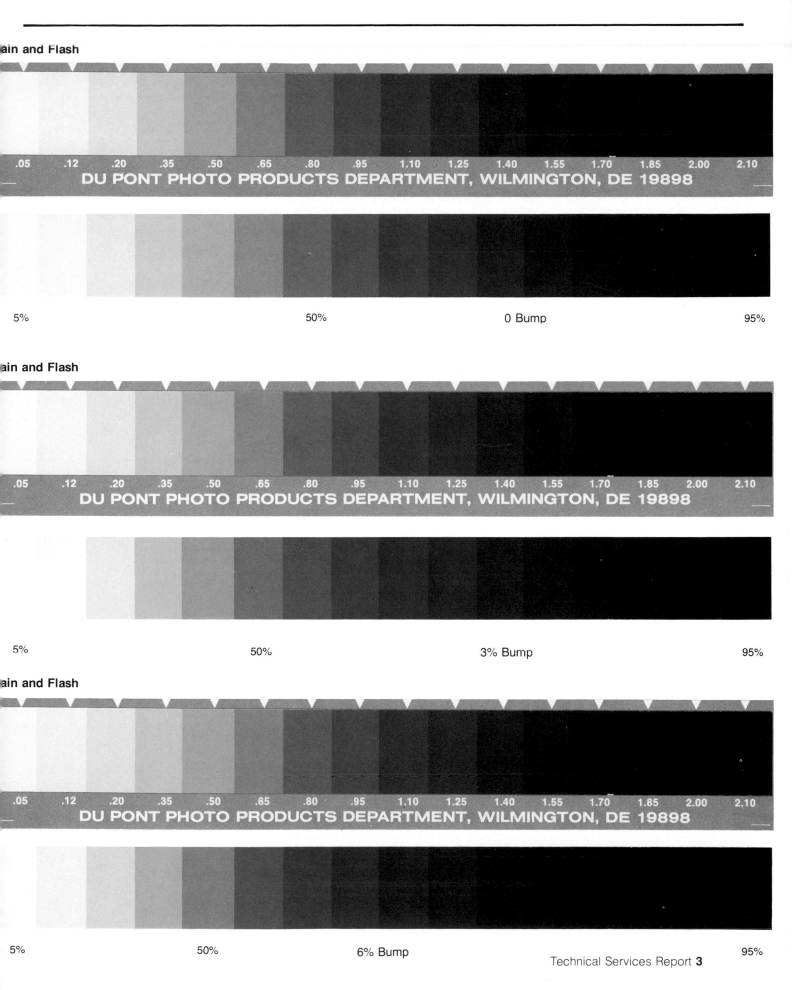

ain and Flash

.05 .12 .20 .35 .50 .65 .80 .95 1.10 1.25 1.40 1.55 1.70 1.85 2.00 2.10
DU PONT PHOTO PRODUCTS DEPARTMENT, WILMINGTON, DE 19898

5% 50% 0 Bump 95%

ain and Flash

.05 .12 .20 .35 .50 .65 .80 .95 1.10 1.25 1.40 1.55 1.70 1.85 2.00 2.10
DU PONT PHOTO PRODUCTS DEPARTMENT, WILMINGTON, DE 19898

5% 50% 3% Bump 95%

ain and Flash

.05 .12 .20 .35 .50 .65 .80 .95 1.10 1.25 1.40 1.55 1.70 1.85 2.00 2.10
DU PONT PHOTO PRODUCTS DEPARTMENT, WILMINGTON, DE 19898

5% 50% 6% Bump 95%

Technical Services Report **3**

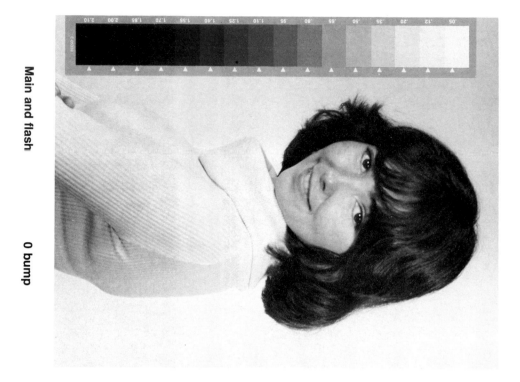

Main and flash 0 bump

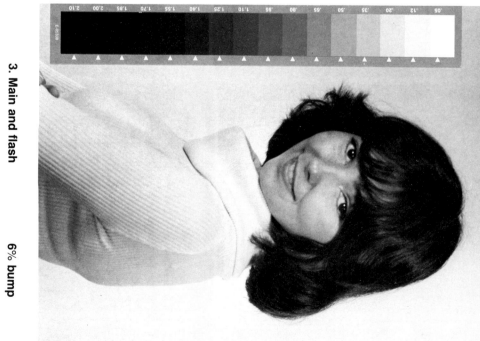

3. Main and flash 6% bump

20:10

Number 7227

Technical Services Report

Controlling the Quality of Pressroom Materials

by A. John Geis

Abstract

Printers can reduce the variations and defects in purchased materials by controlling plates, blankets, rollers, paper, ink, solvents, and lubricants. Control must be exercised in procurement, receiving, storage, and use. The real differences between a testing laboratory and a production floor atmosphere must be recognized.

Introduction

There are no more than a handful of printing companies in the United States that can profitably conduct extensive, instrumental analyses of papers and inks. The majority find these tests are totally impractical on a routine basis, in a production-oriented environment. There are a variety of reasons:

1. Many laboratory procedures are simply too expensive and time-consuming to be practical. Tests of light fastness or drying time and gloss of an ink on a finished job are examples. Sometimes shortcuts can be used, but these are of limited value.

2. Seals and/or wrappings should be left intact until containers are opened for use. Cans and kits of ink, and skids and rolls of paper are examples of materials which should be protected. A large printer can request and receive papermill out-turns and quality-control reports.

3. Many materials (paper, films, presensitized plates, chemicals, blankets, and fountain concentrates) are selected and purchased by brand name, and most reputable manufacturers do a better job of quality control than the printer can afford to do.

There are nevertheless, many things the printer can and should do. To begin with, printing management should exercise control of materials in four general operating areas:
· Selection and purchase
· Receiving, handling, and inspection
· Proper storage
· Proper use, including some inspection and accurate records of performance

Five Basics of Quality Control for Management

Standardization. Management should standardize on a few sources of supply and select materials on the basis of performance, delivery, and costs. Ideally, the printer who can operate with one good set of process inks, one type of plate, one kind of blanket, and one fountain solution formulation on a minimum number of different kinds of paper is working with the fewest number of variables and has the best chance of operating successfully. However, a printer should not normally rely on a single supply source for each material—a secondary supplier is usually desirable.

Specifications (which can be simple or elaborate) should be established for materials before an order is placed, and these specifications must be conveyed, completely and clearly, to the supplier on or with the purchase order. Standard specifications can be prepared and referenced in each purchase order for those materials.

Inspection of materials is an essential quality-control activity. To many people, the word inspection means quality control! However, inspection plays only a limited role in controlling the quality of materials entering a printing plant. Inspections performed in a receiving department for example, must often be limited to verification of size, quantity, and/or weight, and detection of externally visible damage. Some inspecting and testing (such as calipering blankets and inspecting paper) should be done in the pressroom itself. These tests can be meaningful if adequate specifications have been given to the supplier in the first place.

Proper handling and storage is as important as proper specifications and inspection, because the finest inks, plates, blankets, paper, and chemicals can be ruined by careless handling, improper ambient conditions, and age. It is recommended that a first-in, first-out inventory system be used. Dated materials such as paper, inks, plates, and light-sensitive chemicals that stand on the shelf for months and even years, while using fresher, easier-to-reach materials placed on top of the pile when received, create problems that are easily avoided.

Records of condition and performance of materials are essential feedback to suppliers. It is essential to collect evidence confirming the existence of defects and deviations from the specifications. Without records and/or evidence, it is usually impossible to obtain replacement of unsatisfactory materials, or reimbursement for losses they cause.

These basic principles of quality control should be remembered as we review the detailed considerations for printing materials.

Plates

The lithographic printing plates should be limited to two or three types to

accommodate the required short, medium, and long press runs. In selecting plates, the printer should evaluate the fidelity of reproduction and performance under pressroom conditions. The selected plates should be as compatible as possible in terms of exposure requirements and development chemistry. Every purchase order should carry the complete trade name (e.g., Brand X, negative, photopolymer, Type "Q"), the caliper, the size (including dimensional tolerance, because some types of presses, particularly web presses, are quite critical in this respect), quantity, and packaging instructions. Packaging instructions should be tailored to suit the rate of use, handling equipment, and storage facilities available. Packaging specifications should be specific, such as, "50 plates in dated cartons, with an outer moisture barrier, and with paper (or plastic) slip sheets between."

Inspection of plates by the receiving department should consist of verifying quantity, type, and size of plates called for on the purchase order and on shipping papers. The shipment should be checked for external damage. If any deficiencies are detected, the shipment should either be rejected or, if accepted in damaged condition, the fact noted on the delivery receipt, the supplier and/or carrier notified, and a Polaroid photograph taken for future evidence.

Plates should be stored at normal room temperature in sealed cartons in moderate-size piles on racks or shelves. Individual cartons are delivered, still sealed, to the plateroom. The warehouse is responsible for issuing cartons of plates with earliest dates first. This "first-in, first-out" inventory assures that outdated plates will not accumulate in the system.

The plate department should routinely run an exposure and development test, using continuous-tone step scales (Fig. 1) and an abridged tonal scale, at the first shift, every working day. Step scales should be placed in the center and on all four corners of the plate. This test serves to check not only the light sensitivity of the plate coating itself but the current performance of the exposure light source, the plate processor, and processing chemicals. Presensitized plates are sensitive to light and must be kept covered until ready for use. Yellow lights should be used in any area where unexposed plates are handled. Good

handling includes thorough mechanical inspection of finished plates, protecting the image with a plate-size sheet of paper, and hanging the plates on well-designed storage racks.

To reduce waste time and lost profits requires the preparation of a comprehensive record of all plate problems. This means a plate remake record system that requires a written request for every plate that must be remade for any cause with an explanation of why the remake is necessary, and with corroborating evidence (such as a press

Figure 1. Step-scale exposure guide

sheet, or the plate itself) to substantiate any claim against the plate supplier. The plate record is essential if the printer is to reduce plate problems in the printing plant.

Blankets

Blanket specifications should include the trade name, type (compressible or noncompressible, three-ply, four-ply), size and squareness (with tolerances), bar specifications, and the process for which the blanket is to be used, etc., such as conventional lithography, heatset, nonheatset, newspaper, ultraviolet (UV), etc. Upon receipt of shipment, the receiving department should check labels and shipping records against the order.

Acceptable thickness variations within a single blanket should be specified. Some printers, particularly those who purchase a large number of blankets from a single supplier, have found they can specify that every blanket must be consistent in all areas within ±0.001 in. or even tighter. If this specification appears routinely on all purchase orders, every blanket should be

Figure 2. Blanket gauge

checked in the pressroom by measuring at least all four corners and the center with a bench micrometer. (Fig. 2). Any blanket whose caliber is outside the specified tolerance should be rejected and returned to the supplier for replacement or credit.

Records of blanket performance should be kept in a logbook in the pressroom. Records should include the shift and date on which the blanket was installed and removed, number of impressions printed, the type of blanket involved, its location in the press, its caliper, the amount of packing used, and the reason for removing the blanket. The pressroom superintendent will find this record valuable in tracking down and isolating blanket problems.

Rollers

Like blankets, rollers wear out and deteriorate and must be replaced. Roller specifications are furnished in the operating manual that comes with the press. Printers who do not know the proper roller specifications for their presses cannot give their roller supplier the diameter and run-out tolerances or durometer when placing an order. Rollers should not be sent out for recovering without proper instructions. The quality of press rollers can and should be controlled through procurement, receiving, storage, and use — the same as all other pressroom materials.

Few printers own and use a durometer gauge (Fig. 3). Roller hardness should be checked when new rollers are received and periodically after they are installed on the press. Hardened rollers do not effectively distribute ink on the press.

New rollers should fall within the recommended range. On use, they will soon harden to the higher reading. When rollers exceed the "old" value, it is time to replace them with cleaned, reground, or new rollers. (The metering rollers used in continuous-flow dampening systems will have significantly lower durometer values: 18-24.)

Paper

Testing. Many variables in paper affect its printability and performance and the appearance of the end product. Printers

Figure 3. Durometer gauge

would like to measure or test paper for all of these characteristics. Unfortunately, there is relatively little real correlation between the measurement of most of the characteristics and the ultimate performance of paper. Papermakers themselves rely largely on the printing press for testing the performance of paper, but do make routine tests for process control, product variability and prediction of functionability, runnability, and end use performance. Print testing however, remains the best evaluation and indication of performance in the pressroom.

If he is purchasing a specific brand of paper, the average printer is, in effect, purchasing certain characteristics which are inherent in the brand, and are, therefore, controlled by the manufacturer. Some paper mills are equipped to make mill runs to the customer's specifications on orders of only a few tons of paper, but this is obviously a costly way to order paper. The average printer finds himself in an untenable position if he tries to reject a shipment of paper on the basis of any in-plant tests of paper other than actually trying to print it.

What can the average printer do to minimize losses stemming from paper? Proper and complete specifications are the printer's most valuable tool in controlling the quality of paper. At the very least, these specs should include:

- Brand Name
- Color
- Type of paper (bond, uncoated offset, coated two sides, coated one side, label, or newsprint)
- Grain direction, basis size, and basis weight (such as 17x**22** - 20#, 25x**38** - 50#; the long-grain dimension is italicized)
- Sheet size or roll width
- Quantity in sheets or pounds (in the

case of roll stock) and trimming for work-and-tumble forms
- Method of packaging (cartons or skids, including construction and specifications)
- Maximum outside roll diameter and roll core specifications: inside core diameter, slot specifications, splicing requirements, and whether cores are returnable or non-returnable
- Special labeling instructions (such as indication of mill log position on the outside wrappers of roll paper)
- Delivery instructions (date by which delivery is needed, where it is to be delivered, shipment by truck or rail, and loading instructions: rolls on side, rolls on end, on skids or pallets)

In addition, a printer is well advised to give the paper supplier tolerance specifications that will work to his advantage. The paper industry tolerance standard for basis weight is ±5%. If you prefer your paper order to be light or heavy, you can specify the basis weight not to exceed—or to be less than—an order weight. Web printers can sometimes specify a maximum number of mill splices per roll. Sheetfed printers can specify that stock be squared four sides if it is to be used on close-register work and/or a work and tumble form.

It is sometimes necessary to give special specifications to meet special end use requirements. Paper to be used for public school books must meet certain abrasion and flex standards, conforming to NASTA specifications, and some publishers of large catalogs and directories require that their papers conform to limiting specifications on caliper.

Unless all pertinent specifications are given to the supplier when paper is ordered, the printer legally assumes a share of responsibility when things go wrong. The specifications the printer provides his paper supplier are things the supplier needs to know over and above his own manufacturing standards in order to deliver a satisfactory product in satisfactory condition. The use of a check list containing all possible information needed will avoid errors and omission of information that will otherwise result in later problems.

Inspection. Since the external wrappings on paper should be left intact until it is ready for use, there is a definite limitation on the amount of inspecting that can be performed when paper is received:

- Check for visible external damage (such as crushed rolls and torn wrappings) and concealed damage (such as crushed cores). Take photographs of all damaged paper, and have a carrier representative inspect the order before it is totally unloaded and before it is accepted from the carrier.
- Verify basic specifications on labels (size, basis weight, lug position, quantity of paper, and color).
- Verify quantity (some printers spot check the gross weight of roll paper when received).
- If desirable, the printer may cut through the wrapper of one roll or skid in a shipment of paper and remove small samples of paper for visual inspection. If this is done, the hole in the moisture barrier should be immediately resealed. Some paper manufacturers claim that this can affect the efficiency of a moisture barrier. It may be more practical to request a mill out-turn for inspection.
- Basis weight can also be checked in this manner if the sample is sufficiently large to be representative and accepted measuring procedures are used. But since basis weight is most important in its effect on mileage in web printing, and because it will vary throughout a mill run, this characteristic can best be monitored at the press as the paper is unwrapped for use. Samples should be taken from all rolls immediately after wrapping and should be placed in plastic bags to prevent changes due to pressroom conditions.

Proper handling and storage. It is especially important that handling equipment be kept in very good condition (roll clamps padded and clamp pressure regulated). Storage space should be adequate and well organized to eliminate unnecessary handling and minimize damage to paper during storage and removal. Plastic wraps and plastic covers should be put on all opened loads and partially used rolls.

If you can see it before opening, it isn't hidden! Hidden damage is revealed only when skids or rolls are opened at press. If any sign is found that the load has shifted, there is a chance that concealed damage will be revealed at press. A railroad inspection prior to unloading a suspect car would strengthen any claim that might be necessary at a later date. At the press, all of the accurate receiving

records and good warehousing and handling procedures practiced become extremely important, because no paper supplier is going to listen to complaints about wavy edges on sheet stock or damaged ends on rolls if handling and storage procedure or pressroom conditions are remiss. Specs such as number of mill splices per roll are confirmed at this point. Good handling procedures at press (such as leaving circumferential wrappings on rolls until they are loaded into splicers) and good records of paper usage (including paper waste by cause) are essential to the overall control of paper waste and to substantiating the existence of paper defects. In reporting damaged paper, the printer should furnish samples of the damaged stock and pictures of the damaged shipment, together with records of the skids or rolls that were damaged.

The roll card, illustrated in Figure 4, gives the papermaker complete information, making it possible to trace the roll back to the paper machine. The more information the printer furnishes, the easier it is to process a claim for damaged paper.

Ink

Ink chemistry, like papermaking, is a tremendously complex process that the average printer has neither the training or time to understand well enough to critique. His surest means of quality control is to tell his supplier exactly what he needs, take proper care of it when it arrives, use it properly with no modifications, and notify the supplier immediately of ink performance problems.

Standardization may be more important in the quality control of ink than in any other pressroom material. A prudent printer should work with a small number of ink suppliers who will supply those inks that work best for him, on his kind of work, and in his pressroom environment. The "specifications" the printer gives when ordering ink are then very basic: quantity, descriptive title (i.e., color), formula number, type of containers desired, delivery date, tack, and price.

Even small commercial printers who produce a wide variety of work on many different kinds of paper can profit, from a quality and productivity standpoint, by standardizing on the fewest possible number of inks that will meet their needs. It is suggested that doctoring inks in an attempt to make the "right" for a wide

variety of jobs be eliminated.

When a special-purpose ink is required, the specifications given to the ink manufacturer should be as complete as possible. Specs should include color swatches (if appropriate) or an ink color specified in a system such as PMS, color sequence, tack, wet or dry trap, kind of paper to be used (with sample), printing process to be used, kind and size of dryer (if any), press size and speed, and special end use requirements such as scratch or rub resistance, light-fastness, gloss, and resistance to specific chemicals.

Figure 4. Roll card

Incoming inspection of inks is normally limited to checking for quantity and for visible damage to the shipment and to checking the label for adherence to basic specifications: color, formula number, etc. Laboratory testing is, of course, possible, but it is difficult and expensive. The mere fact that the printer is sampling and testing his ink is often enough to improve the quality.

The following steps will reduce ink problems:

· Use first-in, first-out inventory.
· Avoid doctoring.
· Reseal partially used containers.
· Call the ink manufactrurer immediately when a problem develops.
· Specify requirements for density, hue error, grayness, tack, and ink film thickness.

Other Materials

The final items include fountain concentrates, press chemicals, solvents, lubricants, and even splicing tape and

wiping rags. The same viable principles of standardization, specification, and proper handling and use apply.

A couple of examples illustrate the kind of problems that arise from careless handling of materials:

· A printer once had a rash of plate scratching and tracking problems which were finally traced to metal fragments in wiping rags. This occured after the purchasing department, in all innocence, had changed to a cheaper supplier and received inadequately cleaned rags that had previously been used in a machine shop.

· Another improbable, but true, situation involved a printer who sustained substantial mechanical damage to his web press because, instead of lubricating oil, fountain concentrate was poured into the lubricating sump of the printing units. This sounds like an idiotic mistake, but it happend because containers which looked somewhat similar were all stored in the same (inadequately lighted) area and because responsibilities were assigned to unskilled or untrained people. Similarily, because gum arabic solutions look oily, putting them in the wrong containers can cause serious problems.

Conclusions

A quality assurance program includes the practices and principles of quality control and applies to almost all aspects and functions of a printing operation.

There are very few tests that will predict, with reasonable accuracy, how a material will perform on press. The subject thus becomes *quality assurance*. It differs from the traditional concept of *quality control* in that it involves an all-out effort to prevent problems before they happen, rather than detecting impending problems at the last minute by inspection or testing.

Number 7228

Technical Services Report

© Graphic Arts Technical Foundation, Inc., 1981

Image Control Marks System

by Jerry Cozart and Lloyd DeJidas

INTRODUCTION

A common practice in printing production is to produce register marks, trim marks, and side-guide marks for each job by hand-ruling, cutting, scribing, or scratching. Each artist, stripper, and press operator has a different technique of producing the marks. The resulting marks vary in size, thickness, edge sharpness, and position. This report discusses the advantages of using four standardized image control marks—OK register marks for camera copy; T-marks for trims, centers, and bleeds; side-guide marks for sheet-to-sheet register; collating marks for signature identification—and illustrates how to apply the marks at each stage of printing production. Using image control marks properly is an important part of achieving smooth production flow from copy preparation to binding operations.

OK REGISTER MARKS FOR CAMERA COPY

OK register marks are attached to camera copy to be reproduced in two or more colors or tones. The marks combine positive and reverse lines that simplify registration of film negatives during stripping (film

assembly). The "OK" configuration provides film assemblers with a quick way of identifying the film image as

"right-reading" or "wrong-reading" in relation to the film's emulsion. The large positive crossmarks in the "O" provide excellent visual advantage in registering film negatives by eye and with a magnifier.

Fasten the marks in the nonimage area, or border, in the approximate center of the copy, with the crossmarks aligned squarely to the illustration and to each other. Four marks should be placed on each photo. This practice ensures that film assemblers will have at least two registration marks on each film, even if the films must be trimmed during assembly. A GATF master film includes three different-size marks to accommodate image reductions, enlargements, and approximate same-size reproductions. The use of OK register marks on all camera copy to be reproduced in two or more colors can help improve registration consistency on every set of films furnished to the stripping department.

T-MARKS FOR TRIMS, CENTERS, BLEEDS

The T-mark consists of a configuration of thin, accurately ruled lines used in printing production to identify image centers, folds, trims, and bleeds.

The T-shaped centerlines signify final trims, folds, or center-of-image. The cross stroke of the "T" is positioned 1/8 in. (3 mm) outside of the work area so that the mark will not be visible on the finished job.

The set of outer marks indicate standard bleed or trim allowance. In negative form, these marks provide an accurate reference for film assemblers when cutting bleeds in cropping masks. In printed form, these marks guide the press operator in lineup or

image fit and bindery operators in trimming press-sheet signatures prior to folding and gathering.

The reverse-image crossmarks appearing in the small squares at the end of the T-marks indicate vertical and horizontal center-of-image of films prepared for multiple repeat imaging with a step-and-repeat machine. Machine operators precisely align

these marks with centerlines of a registration frame (table) when attaching films to the machine's film holder.

Film negative T-mark images are positioned on master marks flats (key sheets) by film assemblers. For a four-color process job, for example, the master set of marks is exposed on each plate representing a process color, thus ensuring identical marks on each plate of the four-color set. These marks aid press operators in achieving initial color register and in monitoring register during the pressrun.

SIDE-GUIDE MARKS FOR PRESS-SHEET REGISTER

The side-guide mark is a vertical line approximately 7/8 in. (22 mm) long with a 3/16-in. (5-mm) horizontal line used for monitoring sheet-to-sheet register during a pressrun.

In film assembly, the side-guide mark is attached to the master marks flat (key sheet) and then exposed on the plate in precise location related to the guide edge of the press sheet. **Caution:** The alignment block—the solid square in the side-guide mark—must not be reproduced on the plate.

During press makeready, the press operator adjusts the side-guide until

the vertical mark is positioned on the sheet edge with half the thickness of the mark bleeding off. By jogging several sheets on a square surface and then fanning them sheet-to-sheet, the operator can determine if the side-guide mechanism is "pulling" (functioning) properly. (See illustration A.) Illustration B shows the result of an "over-pulling" side-guide. The vertical

mark and two dots under the mark are showing. Illustration C shows the result of an "under-pulling" side-guide. The horizontal mark above and

the single dot below the vertical mark show, but the vertical mark itself is missing. The horizontal stroke of the side-guide mark forms a straight line when the sheets are fanned. This straight line indicates proper

circumferential (gripper-to-tail) register. A similar horizontal mark positioned on the opposite edge of the press sheet will monitor gripper-to-tail register on that side of the sheet. Any misregister of sheets, caused by sheets bouncing out of the front guides, will show as a jagged line as shown in illustration D.

In most cases, a single side-guide mark is adequate for single-color and multicolor printing. The mark is positioned back from the gripper edge 4–6 in. (100–150 mm) to correspond with the position of the press guide. Exceptions to this would apply to any two-, three-, or four-color jobs printed with a single-color press. Separate side-guide marks are provided for each successive printing color as shown in the illustrations.

The printed side-guide marks also help bindery operators to identify side-guide and gripper edges of press sheets ready for trimming and folding. As illustration E shows, the guide edge of a printed pile can be quickly identified by the appearance of a 1-in. (25-mm) vertical bar running from top to bottom of the load. In addition, the side-guide mark identifies the sheet gripper edge by the use of an arrow.

The use of side-guide marks will help to improve press makereadies, monitor sheet-to-sheet register consistency, and provide a good means of identifying guide edges of printed piles delivered to the bindery for finishing.

COLLATING MARKS FOR SIGNATURE IDENTIFICATION

Collating marks are control guides used in bindery operations to check printed signatures (sections) of books for proper sequence and completeness. The marks are used as a guide in loading folded signatures in correct order into pockets of the gathering machine, and the marks provide a visual check of sequence of gathered signatures.

The marks are small rectangular images, about 3/32×5/16 in. (2×8 mm) in size, numbered for signature identification. For saddle-wire signatures, the marks are printed on the lip edge of the high or low folio page, depending on the type of equipment. For side-wire, sewn, and adhesive-bound signatures, the collating marks are printed on the spine between the high and low folio pages (first and last

pages) of each signature. Collating marks are especially helpful to press and bindery operators in printing and binding signatures that have no folios. The marks are not visible to the reader once the signatures have been covered and bound or, in the case of saddle-stitched signatures, trimmed.

Proper positioning of the collating marks is the film assembler's responsibility. If the job has five

signatures, then a total of five marks are required. As each signature is plated, the appropriate mark is opened up (masking material cut away) to allow that mark to expose on the plate. The mark for signature 1 is at the top, and the marks for succeeding signatures are placed progressively lower on the lip or spine. Thus, when a book is correctly gathered and bound without a cover, the collating marks form a regular stepladder pattern down the backbone of the book. Any omission or improper sequence of signatures is easily seen.

The practice of using collating marks for identifying book signatures will result in better work flow and reduced errors in producing finished books.

COLLATING MARKS

**VIEW OF BACKBONE
CORRECTLY GATHERED**

**VIEW OF BACKBONE
INCORRECTLY GATHERED**

SUMMARY

The image control marks discussed in this report are just a few of the many effective control marks used in the printing industry. The object of any image control mark is to aid in achieving accurate control of images as they progress through the production sequence from copy preparation to bindery operations.

A set of four master films with multiple repeat images of the control marks covered in this report is available in 8×10-in. (203×254-mm) sheets from GATF. A folder containing the four negatives and a copy of this report can be ordered under the title of Image Control Marks System 7134.

The T-mark and collating mark designs were supplied to GATF by Richard A. Trankle, technical consultant to GATF and graphic arts manager of DLM, Inc., Allen, Texas.

Any comments or questions concerning this report should be addressed to the Technical Services Department, Graphic Arts Technical Foundation, 4615 Forbes Avenue, Pittsburgh, Pennsylvania 15213.

Number 7230

Technical Services Report © Graphic Arts Technical Foundation, Inc., 1982

Sheetfed-Press Preventive Maintenance

by A. John Geis

A press never breaks down when it's idle, only when it's running. Breakdowns usually happen when they are least affordable—on a rush job, creating overtime, delaying other jobs, which thereupon become rush jobs.

The solution to press breakdowns is preventive maintenance, which can be given a simple definition:

"Efforts to keep equipment in top operating condition and prevent breakdowns."

Without a preventive-maintenance program, printers operate in the WIBFI syndrome:

"When it breaks, fix it!"

In addition to the primary objective of keeping equipment in top operating condition and preventing breakdowns, a preventive-maintenance program has several sub-objectives:

- Less downtime
- Less overtime pay
- Fewer large-scale repairs
- Fewer repetitive repairs
- Lower repair costs
- Less standby equipment needed
- Reduced maintenance costs

- Identification of high-maintenance items
- Shift from inefficient "breakdown" maintenance to less-costly preventive maintenance
- Better work control
- Better spare-parts control
- Safer working conditions
- Improved cost control
- Increased employee morale
- Lower unit cost
- Longer equipment life
- Maximum equipment availability
- Minimum pollution
- Reduced maintenance inventory

But interfering with maintenance objectives are many deterrents such as:

- Indifference on the part of supervision
- Lack of qualified mechanics
- Inadequate maintenance facilities
- Lack of planned maintenance
- Divided responsibilities for maintenance
- Improper specifications and applications of equipment
- Inadequate operator training
- Management unawareness
- Inaccurate records
- Employee attitude
- Lack of policies, plans
- No clear-cut responsibility
- Maintenance information not available

The responsibility for a successful preventive-maintenance program is that of management. A printer's reputation for high and consistent quality results from a management commitment to that goal. A printer's being known for high employee morale and few labor grievances results from a management commitment. The management commitment is needed in order for a printer to develop a successful preventive-maintenance program. It is far too easy to start a PM program, then ignore a scheduled shutdown for maintenance because a rush job must be printed immediately. Scheduled preventive maintenance must be adhered to; time allocated for this function must be just as important as a rush job. And management must make that type of commitment if a PM program is to succeed.

There are four essential steps to installing a PM program:

1. Locate and maintain a central file of all press manufacturers' manuals.
2. Develop a preventive-maintenance checklist from the manufacturers' recommendations, or use the enclosed checklist.
3. Institute a Malfunction Report, a means for the press crews to itemize press problems that require maintenance attention.
4. Schedule preventive maintenance on the planning board just like any job — and stick to the schedule.

GATF has reviewed maintenance programs in hundreds of plants and studied service manuals provided by many press manufacturers.

From this experience, we have prepared five time-related preventive-maintenance checklists:

1. Daily. This list is the reminder of maintenance items that must be performed each day.
2. Weekly. This list requires that each function be performed some day in the week and initialed by the crew member who performed that function.
3. 500-hour. The 500-hour list is based on 8-9 weeks, assuming a two-shift operation; on a single-shift operation, this period would be extended to 16-18 weeks, or compressed to 4-5 weeks for a three-shift operation. The use of an hour meter to record press run time would be an ideal recording instrument to assure accurate timely maintenance. Initialing is required by the performer of each function.
4. Semiannual. This list specifies items that must be added to the 500-hour maintenance procedure every third time.
5. Annual. This list specifies items that must be added annually to all previously mentioned maintenance. Initialing is required by the performer of each of these additional functions.

It is very important to point out that, in addition to specified press maintenance for these time periods, maintenance of other areas must also be accomplished. Specifically, we refer to such areas as platemaking, lift trucks, air conditioning, humidification, and spare parts. Through GATF's Technical Plant Audits, we have discovered that approximately 75% of printers' vacuum frames create press misregister problems; 90% of these problems are a result of inadequate maintenance of the vacuum pump. Failure to maintain lift trucks properly could result in the unavailability of paper at the press, or finished product not being removed to the bindery. Consistent air conditioning and humidity control is essential to sheetfed offset press operation. If this equipment is not properly maintained, paper stretching or shrinking is inevitable, which, of course, leads to misregister problems. Adequate spare parts are essential for the quick repair of printing presses, as of any machines.

Some special suggestions regarding maintenance include the color-coding of all lubrication points that require daily, weekly, and 500-hour lubrication. Different colors for each time period can readily identify these lubrication points. Furthermore, any special lubricant for specific functions should be clearly identified, and the location for use of this special lubricant should be clearly marked.

The key to productivity is preventive maintenance. The keeper of the key is management. With management's commitment, a successful preventive-maintenance program will be achieved.

DAILY

Daily Maintenance Checklist

Press No. _____

1. Review malfunction report for last 24 hours.
2. Oil daily lubrication points.
3. Grease dampener roller bearings.
4. Check oil level in **all** gear boxes, machine drives, central lubricators.
5. Clean and desensitize all chrome rollers in dampening systems.
6. Clean plate and blanket bearers.
7. Clean electronic detector eyes.
8. Check cleanliness of dampener covers.
9. Check condition of blankets.
10. Check condition of plates.
11. Check level of dampening solution in reservoirs.
12. Measure pH and conductivity of dampening solution.
13. Measure alcohol percentage (Dahlgren).
14. Measure plate-to-blanket squeeze.
15. Measure ink film thickness.
16. Clean sponges and pails. Refill pails.
17. Refill solvent containers.
18. Pick up waste paper.
19. Dispose of empty ink containers.
20. Clean up oil and ink spills.
21. Return all tools to proper locations.

End of Shift

22. Empty and clean ink fountains.
23. Clean ink roller train.
24. Clean impression cylinder.
25. Check malfunction report.
26. Stripe ink form rollers.

WEEKLY

Weekly Maintenance Checklist for Month of _____ , 19 _____

Press No. _____

(Person performing maintenance must initial each operation on date performed.)

Operation	Date	Date	Date	Date	Date
1. Drain and flush all dampening systems and recirculators.					
2. Inspect all covered dampener rollers.					
3. Inspect all ink and dampening form rollers and check form roller settings.					
4. Wash all plate cylinders and impression cylinders with solvent and wipe down with lightly oiled rag.					
5. Blow off entire press (dry) and wipe down with clean rags.					
6. Clean all filters in feeder, delivery, decurler, and vacuum cleaner systems.					
7. Wipe down feedboard and wax, check feeder valves, replace suckers if worn, inspect feeder tapes for wear. Replace worn tapes; clean glazed tapes.					
8. Blow off delivery bars and wipe off spray powder. Clean and check all suction wheels.					
9. Brush spray powder off unit and check tube gap.					
10. Wash out all open feeder and delivery gears.					
11. Oil and grease all weekly lubrication points.					
12. Lightly oil all feeder tape conveyor rollers and all cams and cam followers that are not automatically lubricated. Oil blanket lockup reels.					
13. Grease infeeds and all grippers in impression cylinders, transfer cylinders, and delivery gripper bars.					
14. Lubricate delivery chains.					
15. Lubricate ink fountain rollers.					
16. Lubricate inking and dampening systems.					
17. Grease and oil feeder heads and all side guide and front guide mechanisms.					
18. General Cleanup. Pick up all trash around press and on platforms. Sweep floors and platforms, wipe up all oil, and clean up ink spills. Clean drip pan dry. Empty rag cans and trash cans.					
19. Clean shelves; return chemicals, tools, and ink to proper location for use. Clean washup trays, buckets, and sponges and return to proper location for use.					
20. Fill washup bottles and solvent containers. Refill grease guns and oil cans.					
21. Check supply of spare blankets and covered dampening rollers.					
22. Update information on Malfunction Report.					

500-HOUR

500-Hour Maintenance Checklist

(Still perform weekly PM)

Press No. _____

Date Performed: _____, 19_____

Operation	Performed By	Remarks and Additional Repairs Required
1. Check durometer and condition of all ink and water rollers. Replace all damaged rollers and remove glaze from hardened rollers. Clean roller ends and check journals for wear before installing.		
2. Clean press side frames and roller sockets while rollers are out of press and apply light film of oil.		
3. Reset all ink and dampening system rollers.		
4. Check oil level in all self-oscillating ink and dampening vibrator rollers.		
5. Remove all ink fountain blades, inspect for wear and damage, and replace with new or reconditioned blades where necessary. Clean all keys, lubricate key screws, and parallel blade.		
6. Clean and inspect all washup blades.		
7. Clean all cylinder bearers and check for proper bearer pressures. Reparallel cylinders and reset bearer pressures.		
8. Clean ink, rust, gum, etc., from the body of all plate, blanket, and impression cylinders and apply a light film of oil.		
9. Clean cylinder gaps and cylinder ends. Clean plate clamps and reset.		
10. Spray clean all pickup, impression, transfer, and delivery grippers. Clean gripper pads and check settings. Reset as necessary. Replace badly worn gripper pads. Check for broken compression springs and replace as necessary.		

(Cont'd on other side)

Operation	Performed By	Remarks and Additional Repairs Required
11. Clean all oil pump filters. Clean regulating valves on all suction and air blast pumps.		
12. Vacuum dust from all electric motors and wipe clean. Clean dust filters on electrical controllers and press control consoles.		
13. Remove powder from antisetoff spray unit; blow out powder and air lines; clean nozzles. Clean etched roller, set tube gaps, and check tubes for brightness. Clean or replace tubes as necessary.		
14. Clean feeder pickup, forwarder, and side guide mechanisms; lubricate side guide positioning shaft.		
15. Check sensitivity of sheet detector; clean and lubricate.		
16. Clean and lubricate jogger mechanisms.		
17. Clean and inspect hoist mechanisms and chains in feeder and delivery.		
18. Grease and oil all 500-hr. (red) lubrication points.		
19. Clean and lightly grease all exposed springs and spring rods.		
20. Clean and lubricate all exposed gears on cylinder ends and elsewhere.		
21. Spray-clean and lubricate delivery chains. Check chain tension.		
22. Complete all repairs on malfunction list since last major maintenance period.		

SEMIANNUAL

Semiannual Maintenance

Press No. _____

Date Performed: _____, 19_____

(Every third 500-hour maintenance and in addition to that maintenance)

Operation	Performed By	Remarks and Additional Repairs Required
1. Drain oil in feeder and delivery pumps and refill. Inspect for wear and repair as necessary.		
2. Remove feeder separator pistons and air valves. Clean, lubricate, and re-install.		
3. Clean and lubricate feeder clutch; clean and repack feeder universal joints.		
4. Check oil levels in **all** gear boxes. Add or replace as needed.		
5. Inspect brakes and brushes on all press drive motors. Clean interior of all electrical controllers, drive cabinets, and press control consoles.		

ANNUAL

Annual Maintenance

Press No. _____

Date Performed: _____, 19_____

(Every sixth 500-hour maintenance and in addition to that maintenance)

Operation	Performed By	Remarks and Additional Repairs Required
1. Inspect press by a qualified machinist (might be manufacturer's machinist) for overall wear.		
2. Drain all press oil reservoirs, clean filters and pumps, and refill.		
3. Drain and refill all gear boxes in main drive.		

MALFUNCTION REPORT

Press No. _____

Keep this form at press at all times.
Write down all repairs and special maintenance required.

Date	Operator	Problem, or Work Required

Number 7231

Technical Services Report

©Graphic Arts Technical Foundation, Inc., 1982

Noise Control in the Web Pressroom

By Howard Routson

This report describes the corrective action taken by the Graphic Arts Technical Foundation to overcome the excessive noise level of a web press operation at the Foundation.

The only location available for the installation of the Harris M-110 four-unit, single-web offset press was a room with concrete ceiling, floor (vinyl covered), and block walls. The room was 23 ft. (7 m) wide and 81 ft. (24.7 m) long with a maximum ceiling height of only 9 ft. 4 in. (2.8 m).

HRA, Incorporated, a firm specializing in noise control, was contracted to perform a before-installation measurement of the reverberant conditions of the location and a noise level survey and reduction study after the press was installed. The reverberant conditions measured by the continuation of sound reflections within a space after the sound source has

GATF's Web Pressroom before the Harris M-110 was installed. Concrete walls and ceiling and the tile-covered concrete floor can be seen.

ceased were found to be extremely long. The time for 90 dB* noise to decrease to 60 dB varied from 6.2 to 5.6 sec.

The consultant's first recommendation (to reduce the reverberation time) was to

***decibel** (dB): the unit of measurement of sound levels. When decibels are being measured on the A scale (dBA) of the sound level meter, the instrument reacts in much the same way as does the human ear.

apply a 1/8-in. (3-mm) thickness of high-quality damping material to the ceiling and walls. Sound-Off 200 noise and vibration damping material was selected. The material is a semi-fluid composition and is applied by spray equipment; it is a light beige color, blending well with the surroundings. After application of the damping material, the reverberant condition was remeasured and found to have been reduced from 3.1 to 2.8 sec. Upon completion of the press installation, a noise level survey of the press was performed. The study consisted of obtaining A-scale readings in the area, especially at the press operator's control console. Operational noise levels ranged from a low of 80 dBA (at the splicer) to a high of 102 dBA at the outfeed side of the folder unit. The main concern was the 92 dBA measured at the operator's console, where press operation is controlled and pressmen gathered.

An octave band analysis to determine the primary disturbing frequencies contributing to the high noise level was performed at 17 locations at a distance of 3 ft. (0.9 mm) from the envelope of the press. Data analysis showed that three frequencies (250, 500, and 1,000 cycles/sec. were contributing the highest levels in the overall noise. Following the request of GATF not to enclose the press, the decision was made to install as much sound-damping absorption material as practical into the area and on the sheet metal covers of the press.

The first step was to apply a 1/16-in.-thick (1.6-mm-thick) coating of a high-quality noise and vibration damping material to the inside surface of all sheetmetal covers and access doors enclosing the drive gears, solenoids,

etc., and to the underside of the steel decking on the press main frame. The damping material applied to the housings and doors reduced the excitation (oil canning effect) and provided a dead surface facing the noise sources, thereby reducing the reflection of noise into the original noise surface.

The steel decking was excited by the vibration generated by the press operation. It moved up and down on the main frame, causing metal-to-metal contact—another noise source. The damping material (applied to the underside of the steel decking) reduced excitation, acted as a decoupler to the two metal surfaces, and thus substantially reduced the noise generated.

The next step was to install a 1-in.-thick (25-mm-thick) acoustical foam liner on the interior surface of all enclosure doors on the operating side of the press.

The acoustical, noncombustible foam had an aluminized 0.002-in. (0.05 mm) Mylar facing to prevent the wicking of lubricants, inks, dust, and other contaminants and give it extra resistance to tears and abrasion. The Mylar facing did not affect the sound-absorption performance of the foam.

Since the open areas between the print towers, dryer, chill rolls, and folder could not be enclosed, it was necessary to install noise-absorption panels on the concrete wall, behind the press, at the end of the folder, and within the cavities of the concrete waffle configuration of the ceiling.

"Unisorber I" acoustical panels were selected since they afforded good sound absorption, met all existing fire standards, and complemented the decor. The panels' ribbed ridge configuration improved the retention of the sound within the acoustic pad, which is contained within the perforated metal skin.

The gray material on the blue door is the acoustical foam liner that absorbs noise generated inside the housing.

"Unisorber I" panels are mounted in the waffle configuration in the ceiling by the roll splicer. All panels are painted to match the Sound-Off 200 dampening material.

20:28

"Unisorber I" panels are mounted on the wall along the gear side of the press. These are also mounted on the short wall by the folder.

The flexible, transparent bronze-tinted vinyl strips are on the inside of all five windows.

For the ceiling application a special size—26x26x3 in. (660x660x76 mm)—Unisorber I panel was fabricated so that the panel would fit within the cavity, yet not protrude below the low point of the ceiling. Z-shaped mounting brackets were used to provide the proper 2-in. (50-mm) clearance (open space) between the perimeter of the panel and the inside edges of the cavities in the concrete waffle configuration of the ceiling. A "flame guard" of 0.002-in.-thick (0.05-mm-thick) polyethylene wrap was used to prevent paper dust from collecting on the acoustic pad and improved the sound absorption at critical frequencies. The "Unisorbers" were painted a light beige to match the damping material on the walls.

For wall application behind the press and at the delivery end, "Unisorber I's" that were 15-in. (380 mm) wide and 5 ft. (1.5 m) long were installed horizontally, to a height of approximately 6 ft. (1.8 m). An 18-in. (460-mm) space was used between the horizontal and vertical edges of the panels, and mounting brackets provided a 3-in. (76-mm) space from the hard-surfaced wall. This spacing allows noise that filters through the acoustic pad to reflect off the wall into the pad for reabsorption.

Twenty-five percent of the wall and ceiling area was covered with "Unisorber I" panels. They can be removed from the wall and the wrapped acoustic pad removed and cleaned, then remounted.

The last step was to install flexible, transparent bronze-tinted vinyl strips within the frame of five windows located behind the press. An 8-in.-wide (200-mm-wide) by 0.080-in.-thick (2-mm-thick) strip material was selected for its noise damping characteristics. Each strip overlapped adjacent strips by 25%, providing a 50% overlap system to act as a noise barrier. The strip barrier was installed on the interior side of the window, thus preventing noise generated by the press from reaching the hard surface of the glass and reverberating. The bronze color selected filtered out the ultraviolet and near-ultraviolet rays of the sun, providing thermal insulation both in summer and winter, thereby allowing better temperature control.

Upon completion of the noise control steps, new noise level readings were taken in the same locations as before.

Data showed reductions in noise levels up to 11 dBA, with the greatest reduction at the folder area (from 102 dBA to 91 dBA). Operator exposure at the console was reduced from 92 dBA to 88 dBA. Since current standards are based upon exposure time vs. exposure level, and GATF's pressruns are of short duration (never for 8-hr. continuous operation), the potential noise exposure of personnel does not approach a time-weighted average (TWA) of 85 dBA; therefore, no hearing conservation program is required. However, even though hearing protection is worn, a hearing conservation program for press personnel may be necessary in the future.

NOISE LEVEL READINGS
(3 ft. from press and 5 ft. above floor)

Location	dBA reading		
	Before	After	Reduction
Splicer	80	80	
Between Splicer and Infeed	86	83	3
Between Infeed and 1st Unit	89	88	1
Between 1st and 2nd Units	91	89	2
Between 2nd and 3rd Units	93	90	3
Between 3rd and 4th Units	93	91	2
Between 4th Unit and Dryer	96	92	4
At Dryer	94	92	2
At Chill Rolls	96	91	5
Between Chills and Folder	95	92	3
At Folder's Stacker	102	91	11
Between Folder End and Wall	96	93	3
Gear Side—Folder	101	94	7
Gear Side—Dryer	94	91	3
Gear Side—Drive Motor	95	93	2
Gear Side—Infeed	92	89	3
Console	92	88	4

20:30

Number 105

Research Progress Report

©Graphic Arts Technical Foundation, Inc., 1976

Improved B&W Halftones

by George W. Jorgensen

The full tone range in a photographic print (the shades from the very lightest to the very darkest) is usually too great to be photomechanically reproduced by a halftone process that uses a single ink film impression. The printer, when he reproduces the photograph, has to compress its tone range to fit within the range of his printing process. Not only is the printing process itself a limiting factor, but the way the press is setup and the substrate being printed also limit the tone range which can be reproduced. This RPR suggests how the printer can best make this compression in his halftones so as to achieve the most satisfactory reproduction of a black-and-white photograph — especially satisfactory to the ultimate viewer (the printing buyer's audience).

This research project report is based on a research study of "Quality Criterion for Tone Reproduction." The full study will be published in the near future.

The concept of the tone reproduction curve as a tool for comparing the original photograph to its halftone is introduced. This is followed by sections on: the selection of criteria for evaluating tone reproduction; the need for more than one kind of tone reproduction curve; the main interest area in a photograph; multiple interest areas; the tone reproduction curves for the halftone negatives; general purpose curves; tolerances in halftones; and finally, applications of tone reproduction curve analyses to non-photographic originals.

The Tone Reproduction Curve

A very convenient device for discussing and comparing the tone values in the original photograph to tone values in its halftone reproduction is the tone reproduction curve. The curve compares, in a concise graphic manner, the tone values of corresponding areas in the original and its reproduction. A tone reproduction curve is constructed by first measuring the tone areas with an optical reflection densitometer to determine their optical densities. The measuring procedure is simplified if the original photograph contains a gray scale step tablet. Or, a gray scale whose tone range is comparable to the tone range of the photograph, can be placed alongside the photograph on the copy board and included in the halftone.* In either case, the measured reflection densities of the

*Most commercially-available gray scale step tablets will satisfy this requirement.

Figure 1: Original Photographs and Gray Scale Compared to their Halftone Reproductions on a Press Sheet.

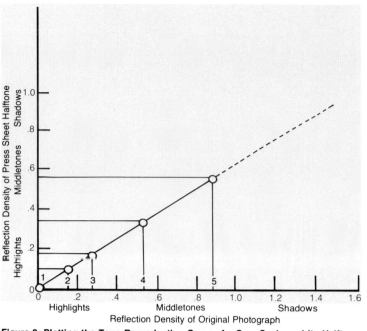

Figure 2: Plotting the Tone Reproduction Curve of a Gray Scale and Its Halftone Reproduction.

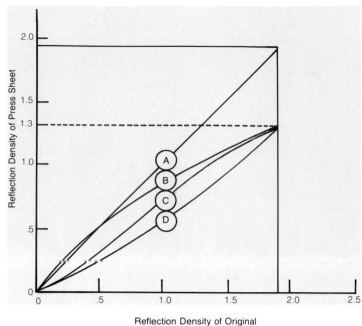

Figure 3: Sample Tone Reproduction Curves.

steps of the gray scale in the original and in the halftone reproduction give all the data needed to construct the tone reproduction curve.

Making the Tone Reproduction Curve

Using a sheet of graph paper, the reflection densities of the original gray scale step wedge are plotted along the horizontal axis. (See Figure 2.) Reflection densities of the halftone press-printed gray scale are plotted along the vertical axis. The numbers 1 to 10 (inside the graph) locate the reflection densities of the 10-step gray scale that was included with the photograph. From the reflection densities of the gray scale steps of the original, perpendicular lines are extended upward to the points of intersection with horizontal lines extended from the reflection densities of the corresponding gray scale steps in the halftone print. This results in a series of

intersection points. A smooth line connecting these intersection points gives the tone reproduction curve of the press sheet image.

Interpreting the Tone Reproduction Curve

To interpret a tone reproduction curve, we must study both the height (density) and slope (contrast) of the curve as it proceeds from the highlights, through the middletones, and finally to the shadow tones of the scene in the photograph. For example, if the points of intersection form a straight line inclined at an angle of 45 degrees, as does curve A in Figure 3, the press sheet is said to have the exact tone reproduction of the photograph. That is, the densities of tone areas in the original photograph and their corresponding tone areas in the press sheet image are the same. In such a case, if all other factors, such as whiteness and gloss, are equal, the press sheet image is an exact facsimile of the original photographic print.

A printed halftone reproduction curve that exactly duplicates an original rarely occurs in practice. The tone or density range of the photograph is usually much larger than can be produced by a single ink impression on paper. Usually the tone range of the press sheet is smaller. It is, therefore, necessary to

compress the tone scale of the photograph to fit that of the press sheet. For example, if the density range of the photograph is 0 to 1.90, and that of the press sheet is only 0 to 1.30, the tone reproduction curve will have to be compressed in some manner so that it will fit within the confines of the box as far up as the dotted line in Figure 3. Curves B, C, and D illustrate some of the different ways the required compression might be made. Curve C, for example, is lower and flatter than Curve A in the highlights. This means the highlights in the reproduction are lighter and less contrasty than those in the original photograph. In the middletones, Curve C is lower but with about the same slope as Curve A. This means the middletones are lighter but have the same contrast as those in the photograph. In the shadows, Curve C is lower and flatter than Curve A, which means the shadows are lighter and less contrasty than those in the photograph. Similar analyses can be made of Curves B and D.

Caution: These density curves give only rough approximations of the viewer's perception of lightness and contrast in the halftones. There are other kinds of lightness scales which give a better representation of the tone reproduction curves. These scales will be discussed in the complete report. For our purpose here, the density scale is adequate.

3 4 Photographs courtesty of Eastman Kodak Co.

Figure 4: Sample Photographs, Illustrating Normal-Key at Left (Number 3), and High-Key at Right (Number 4).

Criteria for Selecting the Preferred Tone Reproduction Curve

The problem of determining the best-compressed curve to fit a given density range in the press sheet has long received the attention of researchers in the graphic arts. One of the difficulties, recognized by Horgan and Ives*, was the selection of a criterion or standard for judging results. For example, a press sheet produced with a given tone reproduction curve might be visually compared against the original photograph. If the original photograph is not available, it might be visually evaluated on its own merits. This is the way the general public evaluates a press print, therefore, this was the basis for the criterion selected in GATF's studies. While several other criteria were studied, it was felt that the results from judging press sheet tone-reproduction curves on their own merits would lead to curves that have the widest general applications in graphic arts reproduction.

The mental criterion used by the public to evaluate press sheet halftones in the absence of the original photograph is not known. In experimental studies using this kind of criterion, excellent agreement in what they consider good quality in printed reproductions is shown by groups of observers representing a sample of the general public. There are some indications that the observers' evaluations are based on a memory of a scene similar to that in the halftone; that is, the observers are comparing the halftone to their recalled memory of a scene.

The Need for Two Tone Reproduction Curves

Early in our studies it had been assumed that the type of scene in the photograph might be a factor in the selection of the shape of the tone reproduction curve. That is, a seashore or landscape might require a curve different from that for a portrait or studio scene. In one experiment, four photographs were used to prepare a variety of halftone prints with different tone reproduction curves. Two of these photographs*, Numbers 3 and 4, are shown in Figure 4. A group of observers assigned scores to the prints from each photograph, and the curve that gave highest scores in Photographs 1, 2, and 3 is shown in Figure 5. However, the highest score curve for Photograph 4 was quite different and is shown in Figure 6. In addition, the curves that gave the highest scores to Photographs 1, 2, and 3 gave low scores to Photograph 4, and the converse was true for the highest score curve of Photograph 4.

Studies using other photographs seemed to confirm the need for one or the other of these two tone reproduction curves, depending on

*Stephen Horgan invented a straight line screen in 1880, and Frederick Ives developed the crossline screen in 1885. Both recognized the problems of tone reproduction.

*Reproduction clearance could not be obtained for two photographs.

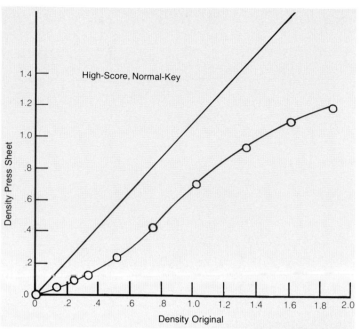

Figure 5: Tone Reproduction Curve of Highest Score Prints of Photographs 1, 2, and 3.

Figure 6: Tone Reproduction Curve of Highest Score Print of Photograph 4.

the photograph. Further, the studies indicated it was the photographer's treatment of the tone values in the subject, rather than the subject matter, which determined the type of tone reproduction curve required.

Not all the tone areas in the scene carried equal weight in this determination; the tones in those areas where the observer tends to center his attention carried the most weight.

Main Interest Area

The main interest area of a photograph is the area on which the observer tends to center his attention. Generally, the main interest area contains the main subject or theme elements featured by the photographer. When the photographer makes the photograph, he chooses where on the tone scale of the photograph he will place the main interest area. Depending on esthetic considerations and the desires of his client, the photographer may use either parts of the tone scale or the entire tone scale. For example, he can place the subject on the highlight end of the tone scale, in which case it would be called *high-key*. Conversely, if he places the main interest area in the shadow end of the tone scale it is called *low-key*. If he uses the entire scale it is called *normal-key*. Applying this nomenclature to the photographs in Figure 4, Number 3 is normal-key and Number 4 is high-key. This nomenclature refers to the predominant tones in the original photographic copy. Parts of the main interest area may be on other parts of the tone scale. For example, in Figure 4, the rim of the paint can in photograph Number 4 is on the shadow end of the scale.

A study of the high-score tone reproduction curves showed that they reproduced the

tones in the main interest areas with approximately the same visual contrast as were in the original photograph. This was true even when the values of the tones were lower than in the photograph. For example, the contrast or slope in the middletones and shadows of the normal-key curve in Figure 5 is approximately the same as in the photograph although all the tones are lighter. The lower slope occurs because density scales do not precisely represent the lightness contrasts in the upper-middle and shadow tones as seen by an observer. In the high-key curve (Figure 6) both the tone values and contrast are approximately the same in the highlights and middletones, but with less contrast and a lightening of the tones in the upper middletones and shadows.

A low-key photograph, one with its main interest area in the shadows, was not included in the four test photographs. However, one can speculate that the highest score tone reproduction curve for this type of subject would resemble that of Figure 5, where the densities in the shadow end of the scale tend to reproduce tone values with approximately the same visual contrast as the original photograph.

This study indicates that the contrasts between tone values in the main interest area of the photograph should be reproduced with the same contrasts on the press sheet, even if all the tones must be reproduced at a lighter level. To accommodate the shorter tone scale of the press sheet, the contrast between tones should be compressed in those parts of the

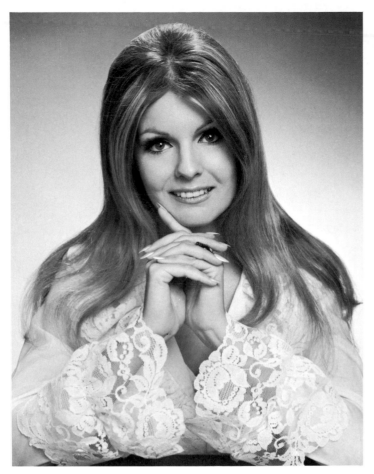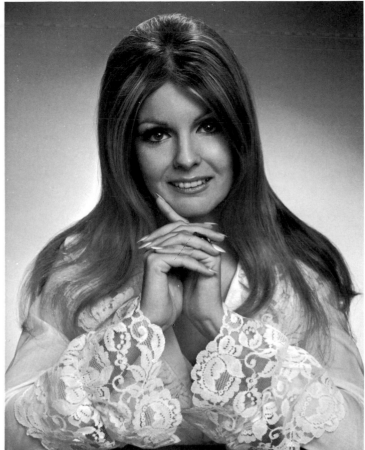

Figure 7: Normal-Key (left) and High-Key (right) Tone Reproduction Curves Used in Halftones from the Same Photograph.

scale which are subordinate to the main interest area.

Multiple Interest Areas

When possible, the printer should seek instructions from the client when in doubt as to what shape of tone reproduction curve should be used in the halftone. This often occurs when more than one area might be considered the main interest area. The printer should try to obtain from the customer a specific expression of what should be featured in the press print. The following example illustrates the confusion that often occurs: The client submits a photograph of a girl in a white bridal gown. The photograph has two possible interest areas, the girl and the gown. Details in the white gown are best reproduced by the high-key curve in Figure

6. However, this curve may give to the girl an objectionably dark facial tone and lose much of the detail in the shadows of her hair. A more pleasing reproduction of the girl is given by the normal-key curve in Figure 5, but this curve tends to wash-out the lighter details in the white gown. The proper choice of curve should be left to the client. If he wishes to feature the gown he will probably select the curve of Figure 6; if he wishes to feature the girl he will probably select the curve of Figure 5. These comparisons are shown in Figure 7.

If the customer insists on featuring both the white gown and the girl, then some compromise between the curves in Figures 5 and 6 will have to be worked out between the printer and the customer.

When such information is lacking from the client, one may use the following rule for selecting the tone reproduction curve for the halftone:

If the main interest area cannot be determined, or if all the possible interest areas are predominantly in the middletones and shadows, use the curve in Figure 5. On the other hand, if it is obvious that only the highlight contains interest areas, use the curve in Figure 6.

The Tone Reproduction Curve of the Halftone Negative

The tone reproduction curves in Figures 5 and 6 are those of the press sheet image. This section describes how to determine the tone reproduction curves for the halftone negatives which will result in the desired press sheet image. The curves for the halftone negatives that will produce the curves in Figure 5 and 6 ideally should be

determined by the printer for his own printing conditions. The choice of such factors as ink, paper, plate, and press will influence the shape of the curve required in the negative to produce the high-score curve in the press sheet image.

To illustrate how to determine the curve for the halftone negative, the following example will be used: the job is to run on dull coated

paper; the density of its solids will be about 1.30; and the photograph to be reproduced is normal-key.

There are several methods that can be used for deriving the tone reproduction curve for the halftone negative. The following illustrates one method that is fairly simple to use:

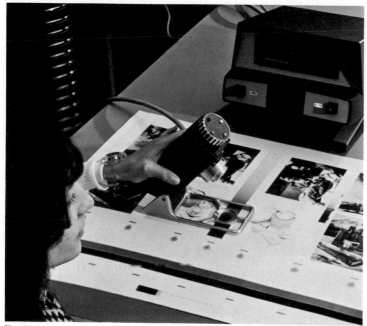

Figure 8: Measuring Reflection Densities Along Halftone Gray Wedge on Sample Press Sheet.

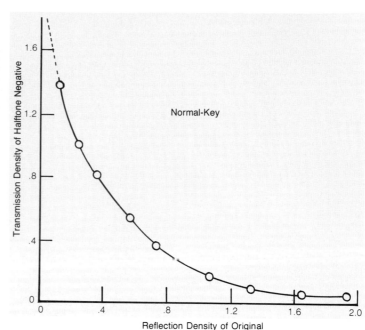

Figure 9: Tone Reproduction Curve of Halftone Negative of Normal-Key Subject.

1. Select a ten-step reflection gray scale, such as are available from photographic suppliers, and measure its reflection densities with a densitometer. Enter the step number in Column 1, and its density in in Column 2 of a table arranged as shown in Table I.

Table I
Densities of Gray Scale Steps in Original, High Score Print, and Negative

Step No.	Original Gray Scale	Normal Key High Score Print	Halftone Negative*
1	0.00	0.00	4.77**
2	.11	.03	1.39
3	.23	.09	1.05
4	.34	.13	.84
5	.54	.24	.58
6	.74	.45	.34
7	1.05	.73	.18
8	1.32	.90	.13
9	1.65	1.12	.09
10	1.95	1.27	.06

*(Includes Density of Film base) **Drop-out of dot

2. For normal-key originals, mark the densities measured in (1) along the horizontal axis in Figure 5.

3. Draw a vertical line from each mark on the horizontal axis up to the curve in Figure 5.

4. From each point where a vertical line touches the curve, draw a horizontal line to the vertical axis at the left, and note the density value where it crosses the vertical axis. Record these density values in Column 3 of Table I. These are the "aim densities" for the image of the gray scale on the press sheet.

5. A wedge shaped* gray scale is then screened as a halftone negative through the desired halftone screen. The resulting halftone should contain a full range of dot sizes (Figure 8.)

6. The halftone negative is then exposed on a press plate and the plate is printed on the press with the ink and paper to be used in the production run.

7. A reflection densitometer is then used to find the locations along the gray scale printed on the press sheet which correspond to the densities in Table I, Column 3, and their position marked on the press sheet.

8. The halftone negative of the gray scale in (5) is then placed in register alongside the marked print and the transmission densities of the negative are read at points opposite the marks on the print. These measurements are entered in Column 4 of Table I.

9. The data in Columns 2 and 4 are then plotted on the horizontal and vertical axes, respectively, on graph paper. Connecting the intersection points gives the required tone reproduction curve for the halftone negative of a normal-key photograph as shown in Figure 9.

This procedure was also used to derive the tone reproduction curve for high-key originals by using Figure 6 to develop the data needed for Column 3 in Table I. The resulting curve for the high-key negative is shown in Figure 10.

The curves in Figures 9 and 10 are specific to a given set of conditions, that is, plate, press, paper, and ink. Any change in these conditions requires that a test press sheet with a gray scale should be run, and the above procedure used to derive new high-score tone reproduction curves for the halftone negatives.

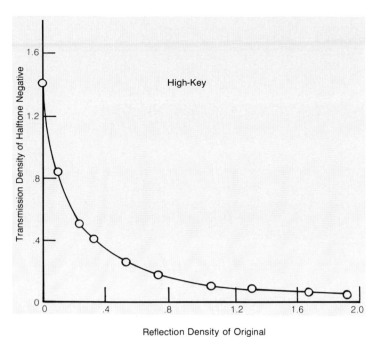

Figure 10: Tone Reproduction Curve of Halftone Negative of High-Key Subject.

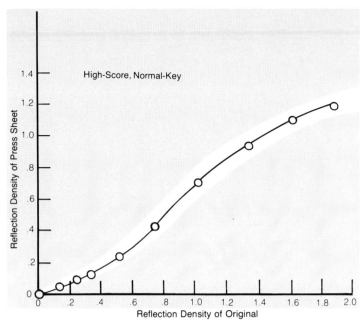

Figure 11: Unshaded Areas on Each Side of Tone Reproduction Curve for Normal-Key Subjects Indicates the Variations in Curve Shape Which Can Be Tolerated.

General Purpose Curves

In very few cases can a printer incur the expense of this testing in order to determine the specific tone reproduction curve for the halftone negatives of every job. But, he can easily standardize on just two halftone negative curves — one for normal-key photographs and one for high-key photographs.

It should be of interest to show the decrease in score value that might occur if a plant standardized on just the curves of Figures 7 and 8 for making its halftone negatives, even though copy and printing conditions varied from job to job. A partial answer is given in Figure 11 which shows the experimentally-determined plus and minus tolerances for the normal-key curve press sheet. The unshaded area indicates the variation in curve shape which can be tolerated with no significant drop in score value. The tolerance in the highlight is small but increases in the middletones and shadows. The rather large tolerances at the shadow end of the scale indicate that, except for unusual press conditions (such as a wide variation in ink density or large dot spread or distortions) the curves in Figures 7 and 8 could be used on most jobs with a drop in score value seldom more than a few percent. In such cases of unusual press conditions, the plant should construct suitable negative curves, following the procedures given on page 6.

Other Applications

The research on which this report is based was concerned with the reproduction of black-and-white photographs. While the process studied was offset lithography, the high-score tone reproduction curves for the press sheet may be expected to apply to other halftone processes such as letterpress and gravure. For these processes, appropriate changes must be made in calculating the tone reproduction curve of the platemaking transparencies.

* * * *

Graphic Arts Technical Foundation, Inc.
4615 Forbes Avenue, Pittsburgh, Pa. 15213
Printed in U.S.A.
©GATF, 1976

March, 1976

Black-and-white originals, other than photographs, were not included in this study. At this time one can only surmise the shapes for their high-score tone reproduction curves. For wash drawings with little shadow detail and separation, the high-key curve of Figure 6 might work best. For etchings, mezzotints, and lithos that have important detail in the deep shadows, the normal-key curve of Figure 5 might work best. Future studies may give more definitive answers for the tone reproduction curves of such non-photographic originals.

* * * *

Some special treatments in a photograph may not lend themselves to good reproduction with the curves of Figures 5 and 6. In this category are photographs which may have been subjected to poor or faulty processing. In other cases, the photographer may have deliberately distorted the normal tone-reproduction characteristics of either film or paper.

Examples of such deliberate distorting treatments are: photo-derivations, posterized effects, montages, solarization, photograms, etc. The best halftone curve for such photographs should be decided according to past experience, experimentation, and consultation with the client.

20:37

The Halftone Gray Wedge

```
0      1      2      3      4      5      6      7      8      9     10     11     12     13     14     15     16   m.m.
|IIII|IIII|IIII|IIII|IIII|IIII|IIII|IIII|IIII|IIII|IIII|IIII|IIII|IIII|IIII|IIII|IIII|IIII|IIII|IIII|IIII|IIII|IIII|IIII|IIII|IIII|IIII|IIII|IIII|IIII|IIII|IIII|
```

GATF

Graphic Arts Technical Foundation; Pittsburgh, Pennsylvania 15213

133 line/inch

```
0      1      2      3      4      5      6      7      8      9     10     11     12     13     14     15     16   m.m.
|IIII|IIII|IIII|IIII|IIII|IIII|IIII|IIII|IIII|IIII|IIII|IIII|IIII|IIII|IIII|IIII|IIII|IIII|IIII|IIII|IIII|IIII|IIII|IIII|IIII|IIII|IIII|IIII|IIII|IIII|IIII|IIII|
```

GATF

Graphic Arts Technical Foundation; Pittsburgh, Pennsylvania 15213

150 line/inch

The GATF Halftone Gray Wedge is a continuous gray scale screened as a halftone having a full range of dot sizes. This wedge is exposed on a lithographic plate and then printed with the press, ink, and paper to be used in the production run. Transmission densities are correlated with the observed reflection densities on the printed press sheet by using the numbers printed above the Halftone Gray Wedge as reference points. This analysis will permit accurate selection of camera halftone exposures and screen tint film values to achieve desired print results.

One set of two film wedges, 133 lines/in. and 150 lines/in., each wedge about 1x7 in. (trimmable to 3/8x6½ in.).

Catalog No. 7115

Research Project Report

Number 110

©Graphic Arts Technical Foundation, Inc., 1977

Improved B&W Halftones, Part II

by George W. Jorgensen

This report is for interested researchers and technologists dealing with graphic arts camera operations and for publishers' and printers' quality control department supervisors. The general background of black-and-white-reproduction viewing should be of interest to art directors.

Abstract

The preferred tone reproduction curve for a halftone that is to reproduce a black-and-white photograph at a lower density range has long been a problem in the graphic arts. This paper reviews some of the earlier studies on this problem and then describes new experiments made to determine the preferred curve. The results of this study indicate that an observer bases his quality evaluation on what he selects as his main interest area in the photograph and his memory of similar scenes. His preferred tone reproduction curve, when plotted on uniform lightness scales, shows that lightnesses in the main interest area of the photograph are reproduced with a slope of approximately 1.0 and compressed to lower slope values in the other areas. This circumstance leads to a need for two preferred curves: (1) for normal and low-key subjects, and (2) for high-key subjects. The apparent linear relationship between the lightness range of the reproduction and its print quality, tolerances for the preferred curves, and memory effects on evaluation of tone reproduction are also discussed.

[In Part I, Research Progress Report 105, practical suggestions were given on how the printer could best compress the tone scale of black-and-white photographs to fit his process conditions. In this Part II, the research study that led to these suggestions is reported.]

Introduction

Tone reproduction is one of the print quality factors that determine the degree of satisfaction a viewer receives when looking at a photograph. Tone reproduction involves objective measurements of relative intensities of light (objective tone reproduction) and subjective evaluations of the sensations and perceptions this light produces in the viewer (subjective tone reproduction). Objective tone reproduction can be studied by means of a curve which compares the macro-area tone scales in the original and its reproduction. Subjective tone reproduction involves the measurement of sensations experienced by the observer and must, of necessity, be done indirectly using psychometric methods.

The optimum tone reproduction curve in continuous-tone photography has been the subject of research for many years (1). Early studies on tone reproduction and print quality developed some qualitative relationships, but little success was achieved in obtaining a general relationship between subjective print quality and the shape of the objective tone reproduction curve. One of the difficulties was that of adequately characterizing the shape of the curve by a reasonable number of parameters that would permit regression on subjective quality.

More recent studies by Simonds (2), Clark (3), and Bartleson (4) have overcome many of these difficulties and laid the groundwork for the methodology used in modern studies on optimum tone reproduction. While the advances made in these later studies have been substantial, the human visual system is still not understood well enough to complete a theory of subjective tone reproduction.

Tone reproduction in halftone screen photography is a special case in the theory of tone reproduction in that it involves the reproduction of a continuous-tone photograph as a halftone screen printed with ink. Yule (5, 6) reviewed many of the earlier studies on tone reproduction in halftone photography and then applied the methods of Simonds, et al., to the problem of optimum tone rendering in the halftone process when the density range of the reproduction process is lower than that of the original photograph. Although these studies did not give a definitive answer as to the optimum tone reproduction curve, they considerably advanced our understanding of tone reproduction in halftones.

In 1971, GATF began a new research study on tone reproduction of halftones from black-and-white photographs. Since the tone range of the original photograph is usually too great to be reproduced by a halftone process that uses a single ink film impression, the printer has to compress the original's tone range to fit his printing process. GATF's study, reported here, was to find how the printer can best make the compression in the tone reproduction curve of his halftones.

Experiments

The initial studies were planned to repeat some of the psychological ranking procedures used in Yule's studies (6) to determine whether his results could be duplicated in our laboratory.

Selection of Test Subject

Since it had been reported that the optimum tone reproduction curve might vary with both the nature of the subject and the density range of the reproduction process, it was desirable that the test subject selected be similar to one used in Yule's studies. We had in our files an outdoor portrait photograph which had been used in a tone reproduction study several years ago. In addition, there were 39 halftone negatives of this photograph made by both glass and contact screens having 133 lines per inch. These halftones had a wide variety of tone reproduction curves, samples of which are shown in Figure 1, and had been contact-printed on a special semimatte paper that had a maximum density range of 1.52.

Psychometric Ranking of Prints

In the first test of these prints, four observers were asked to arrange the 39 prints in order of preference from most pleasing to least pleasing. The observers had varying amounts of experience in tone reproduction evaluation. The observers were not shown the original photograph in order that each print would be ranked on its own merits. Starting with a rank value of "1" for the most pleasing print and then using successively higher integers to a value of "39" for the least pleasing print, each observer's selections were given rank values. To test the null hypothesis that there was only chance agreement between the rankings of the four observers, the Friedman test (7) was applied. This test gave a probability of less than 0.1% that the agreement between observers was due just to chance. This indicated good consistency and agreement in the observers' rank selections.

After it was established that observers could agree on the ranking of prints for tone reproduction, two further ranking experiments were made. The experiments were intended to check a finding reported by Yule (6) that observers ranked prints in different orders when asked to rank the prints for (A) best print quality without comparison to the original photograph and (B) most accurate reproduction when compared to the original photograph. Yule found that the print selected for most accurate reproduction had greater highlight contrast and a darker appearance than the print selected for best print quality.

In experiment A, seven prints were selected from the original 39 and were then given to six observers to be ranked for most pleasing quality. In experiment B, which was made two weeks later to minimize memory effects, the same seven prints plus the original photograph were given to the same six observers and they were asked to rank the prints for most accurate reproduction of the photograph.

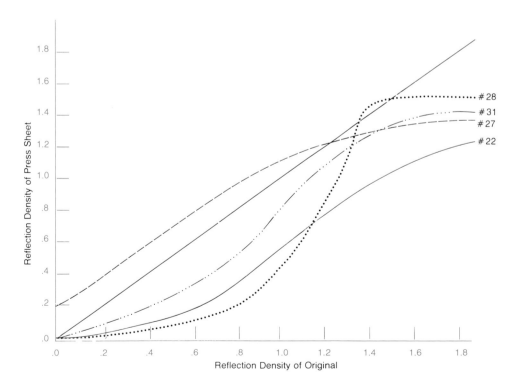

Figure 1. Random selection of tone reproduction curves in the set of 39 prints

Table I shows the mean rank numbers in these two experiments. In each experiment the Friedman test gave a probability of less than 0.1% that the agreement between observers was due just to chance. The rankings in the two experiments were compared using the Spearman Rank-Difference Correlation Test (8). This test gave a correlation coefficient of only 0.21, indicating a very low correlation between the ranking order in the two experiments.

Table I—Comparison of Mean Rank Numbers Given for (A) Best Print Quality and (B) Most Accurate Reproduction when Compared to the Original

Rank	Experiment A	Experiment B
1 (Best)	# 6	#30
2	#17	#17
3	# 4	#14
4	#26	# 6
5	#30	#26
6	#14	# 4
7 (Poorest)	#27	#27

The results tend to corroborate Yule's findings that indicate a difference in attitude of the observers when ranking for most pleasing reproduction and for most accurate reproduction of the photograph. Generally, the highest-ranking prints in experiment B were darker than the highest-ranking prints in experiment A, and this result is in agreement with Yule's results. Also, within each experiment no print was a unanimous first choice; rather, the highest-ranked print was the one which received the highest rank when all the observers' rankings were combined and averaged.

Ranking methods—that is, methods in which serial numbers 1, 2, 3...n are given to prints in their order of quality preference —were used in these initial experiments since they have an advantage of allowing rapid approximation methods to be used and they do not require the assumption of normality of the data that underlies the use of test procedures such as the analysis of variance. Both the Friedman and Spearman rank-difference correlation tests are non-parametric in this sense.

Tone Reproduction Curve and Print Quality

The relationship between changes in the shape of the tone reproduction curve and print quality must be understood, at least in a qualitative manner, in order to develop quality control methods for tone reproduction. In the simple case where only the slope of the curve changes (but remains in the same family of curves), Bartleson (4) in a study of photographic prints reported a simple measure for the change in quality:

$$Q = \left[\Sigma (b_v - b_a)^2 \right]^{1/2}$$

where Q is print quality, b_v is proportionated brightness of the original scene, and b_a is the proportionated brightness of the reproduction print. (Proportionated brightnesses are the ratios that the brightnesses of the scene elements bear to one another with respect to a reference white.) However, he found that this formula fails when other forms of curvature are introduced into the curve, the reason being that brightnesses along any one scale are not equally important in determining quality.

Bartleson then developed a quadratic function of scalar multiples which accomplished the preferential weightings needed to predict quality. This method requires analyzing the photograph by means of principal components, the lengthy computations of which are best handled by an electronic computer.

Since it was the aim of our project to find simple, if less accurate, methods of analysis which can be used as routine quality controls, the method of principal components as used by both Yule and Bartleson did not look promising. More appropriate would be a method that required only the simplest computation or graphic plotting to derive the quality value. One such approach might be to weight the density variations between a given sample and a reference tone reproduction curve of highest quality in order to derive a measure of the change in print quality.

Psychometric Scaling of Sample Prints

Acting upon the above possibilities, we decided to try this procedure, and a study was started for determining how a given curve variation will affect the quality score. One approach is to specify a set of halftone prints whose tone reproduction curves systematically sample the domain of tone reproduction curves obtainable in current halftone screen practice. Applying psychophysical scaling methods, one can obtain subjective quality indices or scores for each print in the set. These quality scores can be regressed on various treatments of the tone reproduction data to find a relationship which gives a high correlation coefficient. Such a relationship can then be used with tone reproduction measurements from a sample to predict its quality.

Guilford's psychometric scaling method of equal-appearing intervals selected for this test differs from the ranking methods described earlier in that it gives the spacing between rank values on an interval scale (9). This interval scale is linear, so that equal intervals are equal-appearing with respect to the sensation of how pleasing is the tone reproduction of the print.

To use the 39 original sample prints would be very time-consuming for psychometric scaling. Instead, a smaller set of 10 was selected from the 39. The selection of the 10 prints was based on the shape of their tone reproduction curves, with their rank values well spaced as determined in the earlier ranking experiment.

A group of 15 observers, whose experience in evaluating tone reproduction varied from considerable to nil, were given the 10 prints and were asked to arrange the prints in order of their preference, from most pleasing to least pleasing. After arranging the prints in this order, they were then asked to assign a quality score from 0 to 100 to each print, where a quality score of 100 would represent optimum quality of reproduction.

The observers' scores were arranged in a matrix in which each row showed the frequency distribution on the 0-to-100 interval scale for a given print. The quality score, Q, for that print was taken from the mean of that distribution. Table II shows the mean and standard deviation of the 15 observer scores for each print.

Table II—The Mean and Standard Deviation of 15 Observers' Scores for 10 Prints

Print Number	Mean (Q)	Standard Deviation
# 6	81	12.7
#30	80	13.1
#14	79	11.8
#41	74	17.4
#32	66	18.4
#29	47	20.0
#22	44	17.3
#27	42	27.4
#39	38	14.0
#37	21	19.3

The ranking and scaling experiments appear to be in general agreement with the findings in Yule's study (6). However, the sizes of the present experiments were too small to be considered conclusive, and fur-

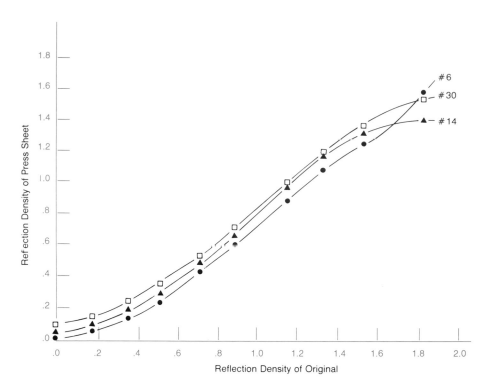

Figure 2. Tone reproduction curves of prints #6, #14, and #30

ther study was needed to resolve the many uncertainties regarding the fine details of optimum subjective tone reproduction.

The tone reproduction curves of the three highest-rated prints—#6, #30, and #14 —are shown in Figure 2.

The 100-interval scale showed a tendency of the observers to score their higher-quality selections to the nearest integer but the lower-quality selections to the nearest unit of 10. This probably reflects the difficulty of selecting a suitable reference anchor for the 0 end of the scale. The instructions had suggested blank white paper (the complete absence of a discernible image) as the 0, but this apparently did not serve very well. For the higher-quality selections, the observers apparently felt more confident that they could visualize a 100-quality print.

The spread in the selection of the highest-scored print among the 15 observers suggests that there probably is not a single optimum tone reproduction curve for a given type subject at a given density range. Instead, the indications were that there is a curve which will receive the highest average score from a large group of observers; a curve which is considered by almost all

as a high-quality print but which may not be the first choice of any of the observers. This average preference curve will be called the High-Score curve in this paper.

New Set of Test Halftone Negatives
The initial studies on this project made use of an existing set of halftone negatives that had a variety of tone reproduction curves. Based on the experience gained from these early studies, a new set of test halftone negatives was planned. Since an almost infinite variety of curve shapes is possible, several decisions had to be made so that the number of test halftones could be held to a reasonable figure. The most important of these decisions were:

a. The number and type of photographic subjects selected as the originals
b. The screening method to be used in preparing the halftones
c. The extremes in the range of quality rating to be covered by the halftones
d. The density range of the prints to be made from the halftone negatives

In regard to (a), it was decided that four general subjects would be used as originals. The initial series had used an outdoor portrait, and it was felt this subject would not have to be included in the new series.

The first selection was a studio scene that included two people in high-contrast lighting—one very strong source of illumination plus fill-in lights. The second was a daylight landscape with a lighthouse in a beach area. The third selection was a multilighted studio illustration of a map, binoculars, and books. The fourth subject was a very high-key type of studio picture of a group of white and near-white objects. The four photographs were matched so that they could be screened together on the same halftone. Two of the test photographs are shown in Part I, RPR 105, Figure 4.

With regard to (b), a conventional halftone screening procedure was selected. The screen was a 150-line-per-inch Kodak positive magenta screen, and the halftones were made using main, flash, and bump or no-screen exposures. For some negatives a magenta filter was used to increase contrast; otherwise, the exposures were to white light. This screening procedure was selected so that any of the tone reproduction curves used in this study could be reproduced by conventional cameraroom halftone procedures in production plants.

With regard to (c), it was decided that a quality score range from as near 100 as possible to a low of about 40 would be used. The reason for not including ratings below 40 is that such low ratings are rare in commercial work, and to have included them would have greatly increased the number of halftone negatives required for the tests.

Finally, for (d), two density ranges were of interest: 0-1.20 and 0-1.40. The former is common in better-quality commercial printing of black halftones on uncoated paper, while the latter is common for better-quality commercial printing of black halftones on coated and enamel papers. Based on earlier studies, a decision was made to use a single set of prints having a density range of 0-1.30. This set would give quality ratings slightly higher than uncoated paper and slightly lower than enamel paper, but would eliminate the need to duplicate the experiments on both kinds of paper.

For the above set limits, we felt that it would be necessary to sample only the domain of possible tone reproduction curves falling within the shaded area in Figure 3. This decision was based on the results of the studies on the old set of halftones. It was then estimated that a systematic sampling of the domain would require a mini-

mum of 15 test curves. The 15 test halftones of the four photographs were then prepared by the screening procedure described.

Test Prints

The shape for each tone reproduction curve in the halftone negatives was calculated so as to produce the desired shape in the positive image when printed on Du Pont Cronapaque paper at a solid density of 1.30. Contact printing on this semimatte photographic paper eliminated the need for closely controlled press runs, and the prints were more durable in handling. After printing, the four images of the photographs were cut apart to form four separate sets of 15 test prints each. The prints were all 4 by 5 inches, a 50% reduction of the original copy.

Each set of 15 prints was presented to each observer to score as to how pleasing their tone reproduction appeared. The psychometric scaling method of equal-appearing intervals was used in this part of the study. Eleven observers scored the four sets of prints under the same viewing, gray-surround, and lighting conditions (40 foot-candles). The original photographs were not shown to the observers so that each halftone print was visually evaluated on its own merits. This approach—the way

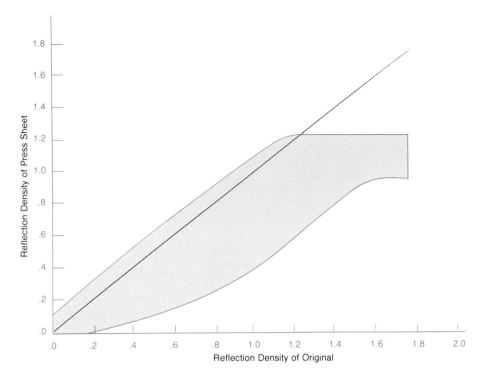

Figure 3. Shaded area is the estimated domain of tone reproduction curves having print quality ratings from maximum (near 100%) to minimum of 40% for density range of 0-1.30 on press sheet

the general public evaluates a print—was the basis for the criterion selected in GATF's studies.

Results and Discussion

Data Analysis

The data from the scaling tests were first plotted as histograms. In a histogram, the scale values are divided into class intervals and the height of the rectangular blocks represents the frequencies in each interval. Figure 4 shows the histograms of the scale values given the 15 prints of the restaurant scene.

The next step in the analysis was to describe, by a single number, a salient feature of the frequency distributions shown in the histograms. Three descriptive statistics which measure location, or where the distribution is centered, were calculated:

a. The mean, or what is commonly referred to as the average value, of the observations
b. The median, the value of the middle observation, or the value above which half the observations lie and below which half lie
c. The mode, the value at which the greatest concentration of observations occurs

These three statistics are shown in the first three columns to the right of the histograms in Figure 4. There is reasonable agreement between the values for the mean and median. However, while the mode values agree fairly well with the other two statistics at higher values, the agreement decreases as the scores decrease. The reason can be seen in the histograms: the high-scored prints tend to cluster in a near-normal bell-shaped distribution, but at lower scores the distributions tend to become bi- or multi-modal. These tendencies indicate that in the higher-scored prints the observers were evaluating the same aspects, but in the lower-scored prints some observers may have shifted their attention to other picture aspects or interest areas.

The above statistics give no information about the amount of dispersion in the individual measurements. One of the most common single numbers used as a descriptive statistic of deviation is the root mean square of the deviations, called the standard deviation. The analytical properties of the standard deviation center around its role in the normal distribution, a distribution which would give a mound or bell shape in the histogram. While this condition is approximately true for the higher-scored prints, the bi-modal distribution of the lower-scored prints would make it a weak statistic. In addition, the distributions are often skewed; that is, there is more spread to the distributions on one side of the average than on the other side. This is due in part to the truncated selection of tone reproduction curves to a lower-score limit of 40.

Because of the truncation and low normality in the data, it was decided to use the semi-interquartile range as a measure of the dispersion. This range, Θ, is one-half that for the middle 50% of the values:

$$\Theta = \frac{\Theta_3 - \Theta_1}{2}$$

where Θ_3 is the third quartile and Θ_1 is the first quartile. In a normal distribution the following relationship holds:

$$\Theta = 0.675 \text{ Standard Deviation}$$

The semi-interquartile ranges are given in column 6 of Figure 4.

Degree of Concordance in the Evaluations

Since the 15 test tone reproduction curves appear in each set of halftone prints of the four photographs, it was logical to compare the sets. Non-parametric statistical methods were used for these tests since they do not require normality in the data. To do these tests, each set of prints was placed in rank order, from 1 to 15, based on their score values. Ranks based on medians showed numerous tie ranks, and since ties are not handled well by the Spearman rank correlation method (4), the sets were ranked by their mean values, which gave fewer ties. Taken two at a time, the four sets were then compared by the Spearman method. The results are given in Table III, column 2.

Table III—Spearman Rank Correlation Test Between Print Sets

Sets	Rank Correlation Coefficient (r_s)	Standard Normal Variable (K)	Probability
#1 & #2	+0.89	3.29	0.001
#1 & #3	+0.78	2.89	0.0019
#1 & #4	−0.55	−2.06	0.0197

The Spearman test indicates a high positive correlation to the scores given the same tone reproduction curves in print sets 1, 2, and 3; i.e., a high-score curve in one set tends to have high-score values in the other two sets. However, the test for sets 1 and 4 shows a moderate negative correlation of −0.55. This indicates that high-score prints in Set 1 tend to have low-score values in Set 4, and vice versa. This is an indication that the subjects in the two photographs require different treatments of their tone reproduction curves. For comparison, Figure 5 shows the highest-average-score tone reproduction curves in Set 1 (left) and Set 4 (right).

As a further check, the null hypothesis that there is no correlation between sets was made by calculating K, the approximate standard normal variable, column 3 in Table III. The probability of this value of K is then taken from tables of the standard normal variable to determine the significance level, column 4, Table IV. The signif-

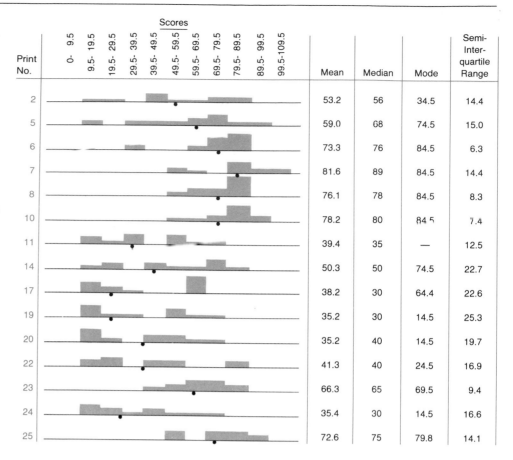

Print No.	0- 9.5	9.5- 19.5	19.5- 29.5	29.5- 39.5	39.5- 49.5	49.5- 59.5	59.5- 69.5	69.5- 79.5	79.5- 89.5	89.5- 99.5	99.5-109.5	Mean	Median	Mode	Semi-Inter-quartile Range
2												53.2	56	34.5	14.4
5												59.0	68	74.5	15.0
6												73.3	76	84.5	6.3
7												81.6	89	84.5	14.4
8												76.1	78	84.5	8.3
10												78.2	80	84.5	7.4
11												39.4	35	—	12.5
14												50.3	50	74.5	22.7
17												38.2	30	64.4	22.6
19												35.2	30	14.5	25.3
20												35.2	40	14.5	19.7
22												41.3	40	24.5	16.9
23												66.3	65	69.5	9.4
24												35.4	30	14.5	16.6
25												72.6	75	79.8	14.1

Figure 4. Histograms of scale values of 15 prints of restaurant scene

icance levels show there is less than a 2% chance that the sets are not correlated, and the null hypotheses were rejected.

Since the above tests were made using mean values to determine rank order, an additional test was made using the median values to determine rank order. The Kendall Tau Test (10) was used since it can be adjusted for ties. Kendall's tau, τ, is calculated as follows:

$$\tau = \frac{2R}{1/2\, n\,(n-1)} - 1$$

where R, the total score, is calculated by placing one set of rankings in natural order and comparing them to the rank values in the second set of rankings, counting the number of members greater than that number lying to the right of each number in the second set, and summing the total.

Table IV—Reproducibility of Scale Values by One Observer—(Print Set 1)

Print No.	Jan. 11	Jan. 16	Jan. 25	May 7	Single Mean	Observer Std. Error	All Observers Mean	All Observers Std. Error
7	80	79	79	76	78.5	2.0	81.6	16.2
8	85	78	72	79	78.5	6.5	76.1	11.9
10	81	77	78	74	77.5	3.5	78.2	11.6
25	76	75	80	79	77.5	2.5	72.6	12.9
6	79	73	76	77	76.2	3.0	73.3	18.7
5	82	70	70	76	74.5	6.0	59.0	25.8
23	70	67	78	72	71.7	5.5	66.3	15.2
14	68	64	45	60	59.2	11.5	50.3	22.6
2	64	59	50	40	53.2	12.0	53.2	22.6
20	49	55	58	50	53.0	4.5	35.2	19.3
19	50	46	65	36	49.2	14.5	35.2	21.0
22	59	39	62	34	48.5	14.0	41.3	22.5
17	55	43	50	47	48.7	6.0	38.2	17.7
11	46	40	47	36	42.2	5.5	39.4	20.9
24	40	37	48	38	40.7	5.5	35.4	20.9

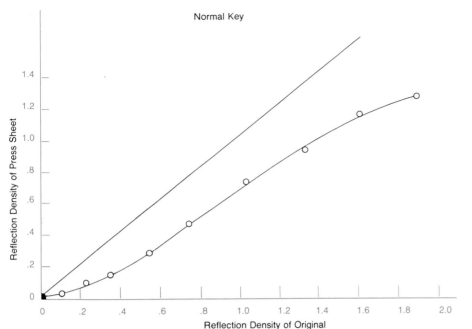

Normal Key

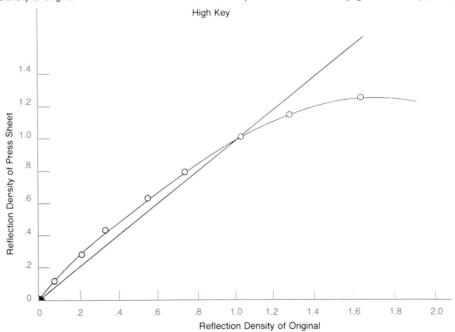

High Key

Figure 5. Tone reproduction curves of highest-score prints, density range 0-1.30, Set 1 (left) and Set 4 (right)

Comparing sets 1 and 4 gives $\tau = -0.31$. The approximate relationship of Spearman's r_S to τ is:

$$r_S \simeq 3\tau/2 \simeq \frac{3}{2}(-0.31) \simeq -0.46$$

This agrees fairly well with the r_S value -0.55 in Table III and further checks the results.

Returning to the comparison of the high-score curve for sets 1 and 4 in Figure 5, the Set 4 (right) curve shows much higher contrast in the highlights than does that of Set 1. Set 4 was made from the photograph of white and near-white objects, while Set 1 has important objects located from highlights to shadows. Since the photographs were similar in all other respects,

Notes on Observers' Scoring Methods

The observer panel was composed of men and women, only three of whom had experience in evaluating tone reproduction. The measure of their score variance (column 6 in Figure 4) indicates they tended to agree more closely on very high and very low score prints but showed poorer agreement on intermediate score prints. To check this further, one observer scored Print Set 1 on four occasions over a four-month period. Table IV gives the results on each individual day, columns 2 to 5; the means and standard errors of the four sets of scores, columns 6 and 7. Note the increase in the sizes of the standard error in the middle range of the table as compared to those at the top and bottom. This indicates that if a print was either very good or very poor, the

one might conclude that the treatment of the subject of the photograph is a principal determinant in selecting the shape of the halftone reproduction curve which will give the highest score. The corollary of this would be that there is no single optimum curve shape for halftones of photographs.

Studies using other photographs seemed to confirm the need for one or the other of these two tone reproduction curves, depending on the photograph. Further, the

studies indicated it wasn't the scene's subject matter or locale, but how the photographer had treated its tone values, that determined the type of tone reproduction curve required. Not all the tone areas in the scene carried equal weight in this determination; the tones in those areas where the observer tends to center his attention, the main interest area, carried the most weight. The main interest area is discussed more fully in Part I, RPR 105, pages 4 and 5.

observer was more consistent in assigning scores. The same pattern was shown for all the observers taken as a group, columns 8 and 9.

There are two factors which may help explain the lack of close agreement among observers. For example, it was noted that the highest score value assigned in a set by an observer seemed to reflect his interest in the scene in the photograph. The scores given by three observers to tone reproduction curve No. 10 when used on three different scenes are given in Table V.

Table V—Scores Given by Three Observers to the Same Tone Reproduction Curve in Halftone Prints from Three Photographs

Observer	Print Set 1	Print Set 2	Print Set 3
A	54	60	90
B	90	90	95
C	80	90	70

The difference in score values appears to represent the observers' bias for or against the subject matter of each photograph, since this tone reproduction curve had a very high relative score in each observer's three print sets.

Also, most observers tended to arrange the 15 prints in each set using some system; e.g., they arranged the prints in rows and columns before assigning scores. Thus, if one gave a high score to his first choice print in the set, the rest of the set would also tend to be scored higher. The result of these shifts in score level is to increase the size of the standard error, even though the rank-order agreement among observers is very good. That the rank-order agreement really is very good was shown by the Friedman test (7), which in earlier parts of this study indicated a probability of less than 0.1% that the agreement among observers could be due to chance alone.

Demerit Chart

It would be desirable to have some type of single graph which summarized the 15 test tone reproduction curves and their assigned scores. Since print sets 1, 2, and 3 had a high correlation, their data were grouped together and then examined to find any common elements from which such a graph could be constructed. The tone reproduction curves were first compared at 10 density steps according to a gray scale that had been screened along with the original photographs.

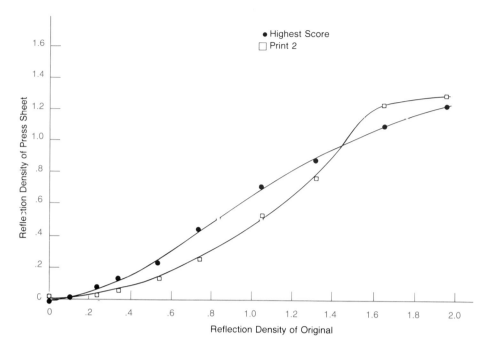

Figure 6. Tone reproduction curves of normal-key high-score print and Print 2

After several aspects of the data were studied, a decision was made to compare the density of each curve to the composite high-score curve of the three sets at each of the 10 steps. When the comparisons are made in this manner, a sample curve at any of the 10 points can differ in both density and tangent (slope) to that of the high-score curve. Figure 6 graphically illustrates the differences between the high-score curve and that of Print 2, one of the 15 sample curves in each print set. The data for the 10 density points for these two curves are listed in Table VI, columns 2, 3, and 4.

The density differences between the two curves are listed in Table VI, column 5, and are shown graphically in Figure 7, where the zero centerline represents the high-score curve.

In Table VI, column 6, are listed the differences between the "relative average tangent" of the nine sections between the 10 density points of the two curves.

Table VI—Densities, Density Differences, and Tangent Differences (High Score and Sample 2, Normal Key)

Gray Scale Step	Reflection Densities				Tangent Difference, $\Delta\overline{T}$
	Original	High Score, D	Sample 2, D′	ΔD	
				$(D'_i - D_i)$	$(\Delta D_{i+1} - \Delta D_i)$
1	0.00	0.00	0.01	+0.01	−0.01
2	.11	.03	.03	.00	− .03
3	.23	.09	.06	− .03	− .01
4	.34	.13	.09	− .04	− .04
5	.54	.24	.16	− .08	− .10
6	.74	.45	.27	− .18	0
7	1.05	.73	.55	− .18	+ .06
8	1.32	.90	.78	− .12	+ .27
9	1.65	1.12	1.27	+ .15	− .09
10	1.95	1.27	1.33	+ .06	

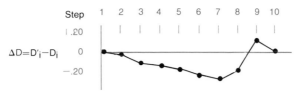

Figure 7. Density differences between gray steps in normal-key high-score print and Print 2

The reasoning used in deriving this tangent formula is as follows:

Suppose we compare the two curves in Figure 6 between steps 7 and 8 of the gray scale. These sections are shown in Figure 8. The dotted lines are the average gradients between steps 7 and 8 of the gray scale. The average tangent values are:

High-Score $\bar{T} = (0.90 - 0.73)/(1.32 - 1.05)$
and Print 2 $\bar{T}' = (0.78 - 0.55)/(1.32 - 1.05)$

Since the denominator will be the same in both curve sectors, it can be given a value of unity, thus simplifying the tangent formula to a relative value of the difference between the densities of adjacent steps; i.e.,

$$\bar{T} = D_{i+1} - D_i$$

The difference in relative average tangent of the two curve sectors is then:

$$\bar{T} - \bar{T}' = (D_{i+1} - D_i) - (D'_{i+1} - D'_i)$$

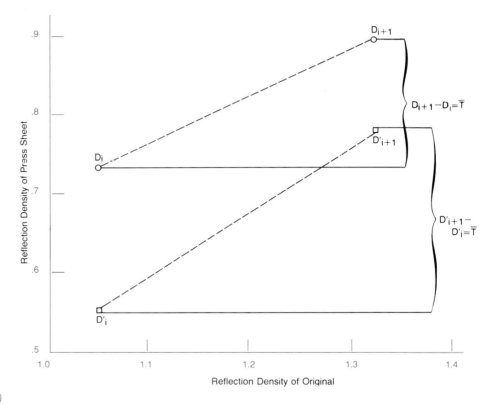

Figure 8. Average tangents between steps 7 and 8

Rearranging terms,

$$\bar{T} - \bar{T}' = (D'_i - D_i) - (D'_{i+1} - D_{i+1})$$

Since $(D'_i - D_i)$ and $(D'_{i+1} - D_{i+1})$ are successive lines in Table V, column 5, the tangent differences in column 6 are calculated simply by subtracting each line from its successive line in column 5.

Ideally, the density intervals between steps in the original should be equal when using this short-cut calculation. Although the density intervals are not equal in this experiment (the gray scale was designed for equal lightness intervals) this fact will not affect the conclusions to be drawn here, and will later be shown to be an advantage in estimating scale values.

The data in Table VI, column 6, are shown graphically in Figure 9. The close similarity to Figure 7 is apparent and is to be expected from the method of calculating the tangents. That is, if the density differences are plotted serially as in Figure 7, information on both density and gradient differences from the high-score curve are incorporated in the line plot.

The method of plotting used in Figure 7 suggested an empirical procedure for cal-

culating a correlate to the score values. After the sample prints are plotted as in Figure 7, a set of demerit zones is drawn on the graph which will assign demerit numbers at each of the 10 step values. Points which fall in a particular zone take on the demerit value of the zone. The sum of the demerits subtracted from the high-score value is used to predict the score of the sample curve. To locate the demerit zones and their values requires an iterative process of curve fitting of the demerit zones.

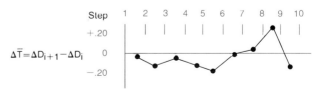

Figure 9. Differences between average tangent values of adjacent steps in the gray scales of the high-score curve and Print 2

20:47

As a measure of the correlation between calculated and observer score values, the absolute values of the errors of the 15 prints were summed. By continuing the iterative process of adjusting demerit zones to minimize the sum of the absolute errors, the graph shown in Figure 10 was developed. Table VII shows the errors between calculated and observer scores using this graph. The sum of the absolute errors is 37.

In Figure 10 the dotted lines are extrapolations where there is uncertainty due to lack of data points. Note that the zone lines rapidly converge at the highlight end of the scale. This convergence accounts for the advantage mentioned earlier of having the density intervals closer together in the highlights; there are more points for detecting the slopes of the zone lines in this region.

A demerit chart for high-key subjects was prepared using Print Set 4 and the same procedures as were used for the normal-key demerit chart. The resulting chart is Figure 11. This chart differs from that for normal-key prints in that densities higher than 1.30 in the original photograph contribute little to the image. Also, zone lines for densities greater than that of the high-score high-key print are incomplete due to lack of data points. These missing zone lines could be constructed by use of prints prepared from unconventional halftone screening techniques. (In this study the dot quality in the highlights became too poor to complete the upper zone lines.) For the purposes of this study, it is doubtful whether the missing zone lines contain much additional information. However, at some future time a more complete set of high-key tone reproduction curves should be prepared and scored in order to find the missing zone lines.

Correlation and regression statistics were calculated to determine the agreement between scores derived from the demerit charts and scores assigned by observers. For the normal-key chart, the average of the observers' mean scores for each tone reproduction curve used in print sets 1, 2, and 3 was compared to the score value of that curve calculated from the demerit chart in Figure 10. The coefficient of correlation of the chart score calculations to the scores given by the observers is 0.98. This indicates that the chart accounts for about 96% of the observers' scores. Figure 12 shows a plot of chart-to-observers' scores and also the line of regression.

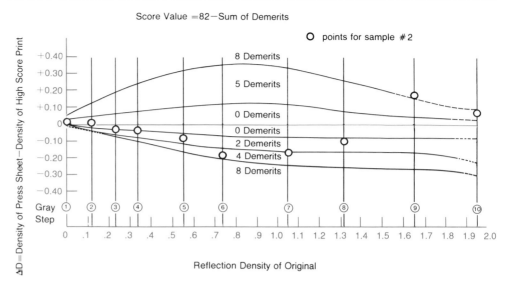

Figure 10. Demerit chart for calculating score values of normal-key halftone prints of density range 1.30

Table VII—Camparison of Calculated and Observers' Score Values

Print No.	2	5	6	7	8	10	11	14	17	19	20	22	23	24	25
Calculated	56	52	68	82	74	82	52	53	43	33	30	55	66	51	76
Observers'	57	53	72	80	74	82	54	47	39	36	36	54	71	51	78
Error	−1	−1	−4	+2	0	0	−2	+6	+4	−3	−6	+1	−5	0	−2

Σ |Errors| = 37

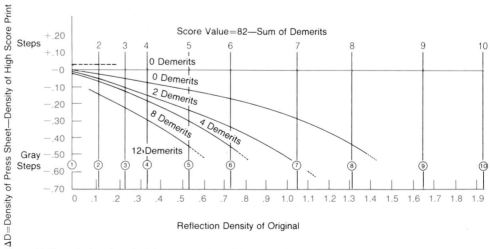

Figure 11. Demerit chart for calculating score values of high-key halftone prints for density range 1.30

In a similar manner, the observers' score value for each print in the high-key Print Set 4 was compared to the score calculated from the demerit chart in Figure 11. Figure 13 shows the regression line between score values assigned by a group of observers and those calculated by use of

the chart. The coefficient of correlation between the two sets of score values is 0.99.

The x and y distributions in figures 12 and 13 are more rectangular than Gaussion, or normal, tending to give slightly higher values to the coefficients of correlation.

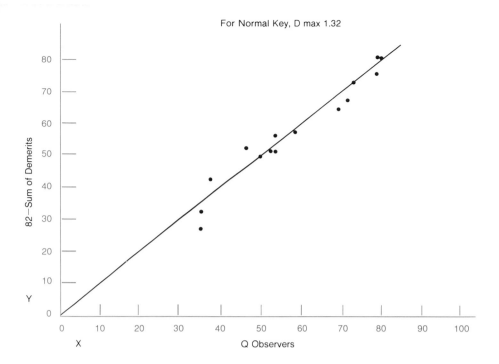

Figure 12. Comparison of observer and calculated tone reproduction scores for normal-key photographs

Use of Demerit Charts

Referring to the demerit chart for normal-key photographs in Figure 10, the zone lines indicate the drop in score as the tone reproduction curve of a sample departs from that of the highest-score curve. The score calculations are made by comparing densities of the sample to those of the highest-score curve, using as points of measurement the steps of a 10-step reflection gray scale that is screened along with the sample photograph. These 10 points are indicated by the vertical lines numbered 1 through 10 in the chart. The density differences are calculated and tabulated as shown in Table VI; the sample values being entered in column 4. Each density difference, ΔD_i, in column 5 is then plotted on the chart on the vertical line indicated by its gray scale step number. "Positive ΔD's" are plotted upward from the zero centerline and "negative ΔD's" are plotted downward. The zero centerline represents zero deviation of the step density of the sample to that of the high-score print. If any of the 10 plotted points lie in a demerit zone, its demerit value is added to the others and the sum then subtracted from 82 to give the sample's score value.

In Figure 10, the zero demerit zones indicate the size of plus-or-minus deviations

which will not significantly reduce the score value. This tolerance is very small in the highlights but increases in the middletones and shadows. The decreasing tolerance in the plus shadow zone reflects plugging of the finer shadow dots. In the extreme highlights there is more tolerance in the plus zone than in the minus zone. This is a bit surprising since it indicates that a very small dot in the whites and catchlights has little significant effect on print quality. Since the observers compared the prints side-by-side, they were aware of the slight graying effects of the fine dots in the whites but did not demerit the effect. However, if the dots were dropped out further up the highlight end of the scale from the catchlights, the demerits were significant. Note the minus zones for steps 1 to 3. These appear to indicate that the observers gave strong demerits if the slope of the tone reproduction curve was below some minimum, or was flat or zero in the extreme highlights. As the minus zone lines progress toward middletones and shadows the tolerance increases, and at the extreme shadows the minus-zero zone indicates little demerit effects even if open dots appear in the solids. The drop in density range due to the open shadow dots does not become significant until the open dot is quite large —about 5%.

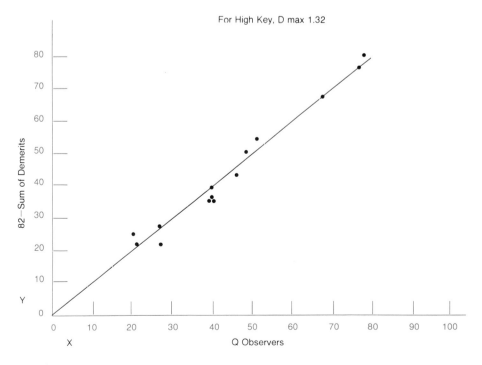

Figure 13. Comparison of observer and calculated tone reproduction scores for high-key photographs

The plus- and minus-side zero zones indicate the extent that the shape of the high-score curve can be varied with no drop in score. This latitude can be used to favor the curve in the direction of a customer's preference in tone reproduction of his photographs.

One goal of this study has been to find a means for estimating score values from density data. The type of chart shown in Figure 10 appears promising for achieving this goal. One point regarding figures 10 and 11 is the temptation to assign theoretical significance to the shape of the zone lines. At present so little is known about how the visual process evaluates tone reproduction that speculations might lead to erroneous conclusions. For the present, figures 10 and 11 should be considered as just empirically fitted sets of curves.

Selection of the Gray Scale
The vertical lines in figures 10 and 11 are the densities measured on the 10-step reflection gray scale used in this study. Their values are given in Table VI, column 2. Other gray scales can be used with the charts. In such cases, new vertical lines should be drawn corresponding to their measured reflection densities. Also, the values of the high-score print at these steps must be remeasured from its curve. (The curves in Figure 5 can be used to derive these values.) Referring to Table VI: the reflection densities of the new gray scale are entered in column 2, the remeasured high-score print densities are entered in column 3, the densities of the gray scale on the sample halftone print are entered in column 4, and the deviations between columns 3 and 4 are then entered in column 5 and used to locate the proper zone on the demerit charts.

Tone Reproduction Curve for the Halftone Negative
The procedure developed for determining the tone reproduction curve required in the negative to produce the normal-key high-score curve in the press sheet under a given set of printing conditions is given in Part I, RPR 105, pages 5 and 6.

Uniform Lightness Scales
Historically, objective tone reproduction data have been plotted on linear optical density and log exposure scale coordinates to produce tone reproduction curves. These curves show how the luminances, or light values, reflected from the original or scene relate to the luminances of the print reproduction.

In subjective tone reproduction studies, one is concerned with the responses of the human viewer and his subjective sensations produced by the luminances of the original and print. Lightness is the magnitude scale of the subjective sensation produced by the luminance or light which reaches the eye. Optical reflection density scales having equal density increments between steps do not appear to have constant grayness intervals between steps under usual viewing conditions. That is, the darker steps appear to have less separation in their grayness intervals.

Rhodes (11) and Yule (6) have suggested replacing the density scale with the Munsell Value scale in subjective tone reproduction studies. The difference between these two scale systems, with respect to reflectance of the gray steps, is that the density scale steps are spaced in logarithmic intervals, $D = \log 1/R$, while the Munsell Value scale steps are spaced by a power function, $V = 2.468\ R^{1/3} - 1.636$. When a gray scale with equal Munsell Value intervals between steps is viewed against a middle-gray background, the grayness spacing between steps appears more equal than that of an equal-interval density scale.

When viewing the complex field of grays in the average photograph, one finds that the Munsell Value scale does not seem to represent properly the shadow end of the scale. That is, the shadow grays appear to be darker than is indicated by their Munsell Values. This appearance is probably due to functions of the visual process coming into play which were suppressed in the viewing of a simple gray scale on a gray field.

Bartleson and Breneman (12) studied the lightness-luminance relationship in photographs in both bright-surround conditions (viewing a reflection print in a well-lighted room) and dark-surround conditions (slide photograph projected in a darkened room). From their studies they derived a lightness-luminance relationship of photographs for a range of illumination levels. According to their studies, brightness perception in the complex field of a photograph is related to the stimulus reflectances by a power function with exponential decay. In their equation,

$$L = 10^{\alpha}\ R^{\beta}\ /\text{anti-log}\ [\ \gamma\ \exp\ (\ \delta\ \text{Log}\ R)\]$$

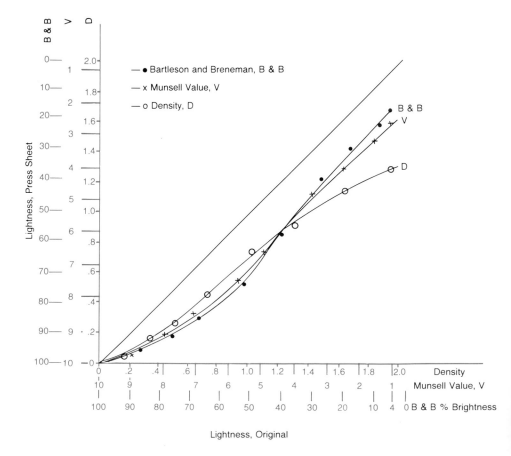

Figure 14. Comparison of tone reproduction curves of normal-key high-score plotted on linear density, Munsell Value, and Bartleson and Breneman lightness scales

α, β, γ, and δ are parametric constants, R is the reflectance, exp is the exponential form, and L is the lightness.

In our experimental work, we prepared graphs of the tone reproduction curves of test halftone prints using density, Munsell Value, and Bartleson and Breneman lightness scales. The Bartleson and Breneman scale appeared to give the best overall visual weight to the grayness levels in the print, particularly in the shadows. Figure 14 shows the three scale systems in a combined graph for the high-score normal-key halftone. The curve on the Bartleson and Breneman scale shows a slope of about 1.0 from the lighter middletones to the shadows, and gives the lowest lightness values to the shadows in the print. This indicates that the shadow contrasts in the high-score print is very similar to those of the original photograph, and is one of the reasons for thinking that the high-score curve for low-key subjects is very similar to that for normal-key subjects.

In a review on subjective tone reproduction (1), Nelson discusses a lightness scale developed by S. S. Stevens and J. C. Stevens, and compares it to the Munsell Value scale. He points out that the Munsell Value is on an interval scale, a scale that generally does not have a known zero point and so must be used with caution since the ratios of the numbers do not correspond to the true ratios of the variable being represented. The Stevens scale is a ratio scale, a scale that has a true zero, and its numbers indicate the correct ratio and the correct difference in brightness. The equation for the Stevens scale is $L = k (I - I_0)^n$, where L is lightness, I is luminance in millilamberts, and I_0 is the threshold luminance below which no lightness or brightness sensation is obtained from light. The values k, I_0, and n depend on the conditions of adaptation and on whether different luminances are presented successively or simultaneously and adjacent to each other. Bartleson and Breneman (12) are of the opinion that the differences between their complex-field results and the Stevenses' simple-field formulation, although small, are significant.

Munsell Value, Stevens, and Bartleson and Breneman scales are similar in that they all follow some type of power function, but differ in that the latter two can be adjusted for the intensity level of the illumination of the viewing situation.

It would seem that if a change were to be made from the density scale to another lightness scale system, either the Stevens or Bartleson and Breneman scales would be preferable to the Munsell scale. From a practical viewpoint, one can estimate the shape of curves plotted on these scales from a tone reproduction curve plotted on density coordinates by use of Figure 14. Any decision on choice of scale systems should not be made until there is a better understanding of optimum subjective tone reproduction.

Relationship Between Density Range and Print Quality

The density range, or difference in density between the extreme highlight and deepest shadow of a press sheet halftone, is an important factor in print quality, and a quality criterion of tone reproduction should include a weight factor for this range. While it is common experience that increasing the density range increases the print quality, we have not been able to find in the literature a quantitative equation for this relationship. Our studies on lightness scales suggested that there might be a simple linear relationship between the lightness range and print quality.

In a preliminary test for this relationship, a set of prints from the same halftone negative, with density ranges from 0-0.40 to 0-1.42 and scored for print quality, were compared for density and lightness ranges to quality ratings. The density ranges were converted to lightness ranges using the Bartleson and Breneman scale for bright-surround conditions. The relationships of the calculated lightness ranges to the density ranges and to print quality scores of the prints are shown in Table VIII.

Table VIII—Comparison of Density Range, Calculated Lightness Range, and Print Quality Rating of Halftone Prints

Print No.	Density Range (DR)	Lightness Range (LR)	Quality Score (Q)
1	0-0.40	37	28*
2	0-1.05	73	57*
3	0-1.21	80	78
4	0-1.32	82	81
5	0-1.38	83	83
6	0-1.42	85	84

*Interpolated value

The relationship of density range, DR, to print quality, Q, appears to have an exponential form, i.e., $Q = a(1 - e^{-DR})$. That is,

when DR is zero, Q is zero. As DR increases from zero, Q rises rapidly at first and then gradually diminishes its rate, until finally it asymptotically approaches a limiting value at very high values of DR.

Since lightness range, LR, has a similar exponential relationship to density range, substituting lightness range in the equation gives the simple linear equation $Q = LR$. Testing this equation on the data in Table VIII gave a good fit for prints 3 to 6. If new halftone negatives were made for prints 1 and 2 that were more nearly optimum for their density range, their quality ratings would increase, and this would improve their fit to the $Q = LR$ equation.

With regard to the effect of density range on print quality, we do not have enough data points for the lower range values to get a good estimate of the relationship. We hope that in time more data for the low ranges will be accumulated. At present, the simple relationship $Q = LR$, where LR is density range converted to lightness range, is attractive for its simplicity, but only further study will determine its validity.

General-Purpose Tone Reproduction Curves

Many camera departments do not adjust their halftones for differing press run conditions. Instead, an attempt is made to standardize the tone reproduction curve in the negatives. Although the negative curves for Figure 5 were developed to fit a given set of press conditions, it is of interest to try to estimate what would happen to their tone reproduction scores when printed at density ranges other than 1.30.

Using the relationship $Q = LR$, it was estimated that over the ranges 1.20 and 1.40, the maximum score would increase about 5 points, from 79.3 to 84.7. However, this increase assumes that the tone reproduction curve is optimized for each density range. If a standard tone reproduction curve optimized for a density range of 1.30 is used at density ranges of 1.20 and 1.40, the change in maximum score value might be expected to be slightly greater than 5.

A partial answer to the effect of a fixed curve shape for the negative's tone reproduction can be found in the demerit curves of Figure 10. The zones in the chart indicate the demerits for tone reproduction curves that depart from the high-score curve—the zero center line. Replotting the

Table X—Memory Influence on Print Scores (Effect of Equal Density Ranges)

Print No.	Density Range	Order of Viewing	Observers' Scores					1971 Scores
			A	B	C	D	Avg.	
29	0-1.52	First	50	30	10	40	33	47
6	0-1.52	Second	82	90	55	85	78	81
29	0-1.52	Third	40	30	10	55	34	47
29	0-1.52		40	30	10	55	34	47
6	0-1.52	Side-by-Side	80	90	70	80	80	81

zero demerit zones on the high-score tone reproduction curve, as shown in Part I, RPR 105, Figure 11, graphically shows the amounts of plus and minus variations (unshaded area) that do not appreciably reduce the score value.

The fact that many camera departments do not change their halftone curves for different press conditions suggests that their experience has shown that these differences made little difference, a conclusion in agreement with the above reasoning. However, if press conditions are such that a considerable change in dot quality takes place, then the above conclusion does not hold and, unless the tone reproduction curve is modified, a very measurable drop in score value can take place. Also, if one standardizes on a poor, or low-score, curve rather than a high-score curve, the score probably will be low under all press conditions.

Memory Effects in Evaluating Tone Reproduction

The mental criterion used by an observer when evaluating the tone reproduction of halftones in the absence of the original photograph is not known. The excellent agreement among observers indicates all are using similar criteria. There are some indications, based on studies done in continuous-tone photography, that their criteria are based on their memory of a scene similar to that in the halftone. That is, they are comparing the halftone to their recall memory of such scenes. In order to learn more about the memory effect, two experiments were made.

In the first experiment, two halftone prints of the same scene were evaluated singly and then side-by-side. One print had a single ink film impression with a density range of 0 to 1.24. The other print had a double ink film impression (duotone) with a density range of 0 to 1.93. When viewed singly (in the absence of the other print) the assigned scores varied depending on the order of viewing as shown in Table IX.

When Print 1 was scored first, it received a higher average score (89) than when scored immediately after Print 2 (76). When the two were scored side-by-side, Print 1 scored about the same (76) as when scored immediately after Print 2 (76).

Note that observer B, who preferred Print 1, dropped his score from 100 to 90 after viewing Print 2. This reduction in score was consistent with that of the other three observers.

These two prints differed in both density range and in the shapes of their tone reproduction curves, and a second experiment was made to try to separate the effects of these two tone reproduction variables. This second experiment followed the same order of scoring as the first; but the prints used were of the same scene and density range, while differing in their tone reproduction curves. Table X lists the score values of this second experiment. The results show little or no significant changes in average scores due to the order of viewing the prints. The far-right column shows the prints' scores from an experiment three years earlier (2), indicating

little change in memory effect on score value even over this long a period.

These results suggest that the differences in density range rather than in shape of the tone reproduction curve caused the change in score values in the first experiment. That is, memory tends to overestimate quality of tone reproduction at low-density ranges but not of tone reproduction curve shape when a print of superior tone reproduction quality is not available for comparison.

Other Factors that Influence the Choice of Curve

The experiments reported here have not covered all the factors which are known or have been suggested to have an influence on the shape of the high-score curve. Among such factors are size of reproduction, sharpness and resolution in the original, level of viewing illumination, color and brightness of the paper stock, and viewing-surround conditions. Such factors, singly and combined, may help explain some of the variations between ideal tone reproduction curves reported by earlier researchers.

One purpose of the present study was to develop information that could be used as general guidelines in selecting quality standards and controls for routine commercial printing. A more customized approach for handling individual photographs might insure the selection of more nearly optimum tone reproduction but not without considerably higher production costs. Thus, the concern in this study has been to determine curves that, on the average, produce high-score prints, but not necessarily the highest possible score for any given situation.

Table IX—Memory Influence on Print Scores (Effect of Order Viewed)

Print No.	Density Range	Order of Viewing	Observers' Scores (100 = maximum)				
			A	B	C	D	Avg.
1	0-1.24	First	82	100	90	85	89
2	0-1.93	Second	96	80	95	95	91
1	0-1.24	Third	65	90	75	75	76
1	0-1.24		65	90	75	75	76
2	0-1.93	Side-by-Side	96	80	90	90	89

Conclusions

In summary form the principal conclusions and findings of the project, excluding those which corroborated earlier studies, are:

1. In ranking and scaling experiments on halftone prints, the observer seems to base his quality evaluation on what he selects as the main interest in the photograph and his memory of similar scenes.

2. If the main interest area is in the highlight end of the print's tonal scale, the observer prefers a different tone reproduction curve than if his main interest area is spread over the entire tonal scale.

3. There may be more than a single main interest area in a photograph, and the area selected by the viewer will depend on his interests, taste, or bias. This difference in personal viewpoints precludes there being a single best, or optimum, tone reproduction curve for a given photograph.

4. Studies on the concordance among observers scoring halftone prints indicate that there are tone reproduction curves, called the high-score or preferred curves, which will generally score higher on the average even though they may not be unanimous first choices.

5. Empirically derived demerit charts, based on density differences to the preferred curves, show promise of being able to predict score values of sample curves.

6. The high-score curves, when plotted on Bartleson and Breneman lightness scales, indicate that the lightnesses in the main interest areas of the original should be reproduced with a slope of approximately 1.0 in the halftone print; i.e., the lightness intervals should be equal even if the lightnesses are not reproduced at the same values as in the original.

7. There appears to be a simple linear relationship between print quality and the brightness range of the printed halftone.

8. The tolerances for the high-score curves, as derived from the demerit charts, indicate that a printer might standardize the curves of his halftones with only a small loss in print quality (as against adjusting the curves for each printing job).

9. When direct visual comparisons cannot be made, an observer tends to overrate the density or lightness range of a print but not its tone reproduction curve.

Bibliography

1. Mees, C. E. K., and James, T. H. (editors). *The Theory of the Photographic Process.* New York, Macmillan, 1966, Chapter 22.

2. Simonds, J. L., "A Quantitative Study of the Influence of Tone Reproduction Factors on Print Quality." *Photographic Science and Engineering,* Vol. 5, No. 5, Sept.-Oct., 1961, pp. 270-277.

3. Clark, L. D., "Mathematical Prediction of Photographic Picture Quality from Tone Reproduction Data." *Photographic Science and Engineering,* Vol. 11, No. 5, Sept.-Oct., 1967, pp. 306 315.

4. Bartleson, C. J., "Criterion for Tone Reproduction." *Journal of the Optical Society of America,* Vol. 58, No. 7, July, 1968, pp. 992-995.

5. Yule, J. A. C., "Variation of Tone Reproduction in Halftone Processes." In: *Advances in Printing Science and Technology,* Vol. 1, *Printing Inks and Color,* edited by W. H. Banks. New York, Pergamon Press, 1961, pp. 48-66.

6. Yule, J. A. C., "The Optimum Tone Reproduction in Halftone Reproduction Processes." In: *Advances in Printing Science and Technology,* Vol. 3, *Halftone Printing,* edited by W. H. Banks. New York, Pergamon Press, 1964, pp. 17-42.

7. Wallis, W. A., and Roberts, H. V., *Statistics, A New Approach.* Glenco, Illinois, The Free Press, 1956, pp. 601-602.

8. Guilford, J. P., *Fundamental Statistics in Psychology and Education,* 2nd ed. New York, McGraw-Hill, 1950, pp. 310-312.

9. Guilford, J. P., *Psychometric Methods,* 2nd edition. New York, McGraw-Hill, 1954, pp. 203-208.

10. Yule, U. G. and Kendall, M. G., *An Introduction to the Theory of Statistics,* 14th edition. New York, Hafner, 1950, p. 266.

11. Rhodes, W. L., "Tone and Color Control in Reproduction Processes." *Proceedings 6th Annual Meeting of TAGA,* 1954, pp. 48-64.

12. Bartleson, C. J., and Breneman, E. J., "Brightness Reproduction in the Photographic Process." *Photographic Science and Engineering,* Vol. 11, No. 4, July, 1967, pp. 254-262.

Graphic Arts Technical Foundation, Inc.
4615 Forbes Avenue, Pittsburgh, Pa. 15213
Printed in U.S.A.

The information in this issue may not be quoted or reproduced without the prior written consent of GATF. Up to 50 words may be quoted without advance permission providing such quotation refers specifically to GATF as the source and does not contain formulas or processes.

GATF

Number 113

Research Progress Report

©Graphic Arts Technical Foundation, Inc., 1981

Control of Ink-Water Balance

by George W. Jorgensen

ABSTRACT
This report describes a simple visual technique for locating a near-optimum balance point for the ink and water feed rates to the plate. The technique uses either the GATF Star Target or QC Strip.

INTRODUCTION
Success in obtaining satisfactory print quality from the lithographic press depends on many factors. Among the most important are finding and maintaining the proper rates for ink and water flow to the plate—what is called its ink-water balance. Because we lack a complete understanding of how dampening works in lithography, the pressman has traditionally relied on various clues to select his ink and water settings. Among these visual clues are the gloss of the plate and the thickness of the ink film. Additional clues are the dot quality and the types of patterns or marks in the image and nonimage areas of the press sheet.

Experienced pressmen usually find a satisfactory balance point early in the makeready. However, due to such factors as plate coverage and layout, type of ink, paper, etc., there occasionally is uncertainty as to the best balance point. Also, inexperienced pressmen often need help in finding the best balance point for a given job. This article describes a simple visual technique for locating a near-optimum balance point and maintaining it during the pressrun.

INDICATORS OF INK-WATER BALANCE
It is necessary in any given pressrun for the balance between the ink and water to be achieved by trial-and-error adjustments of their feed rates. These adjustments are continued by the pressman until, based on his experience, he feels he has a satisfactory balance.

Among the tests used in his analysis is to watch that enough water is being fed to keep the nonimage areas clean and fine shadow dots open. However, the amount of water should not be enough to cause snowflake patterns in the ink film. Snowflakes are minute spots or holes in what should be a continuous ink film in dots and solids; see top of Figure 1. The onset of snowflakes is a sharp end point indicating no need for further increase in the water feed rate. However, there has been no sharp end point indicating not to further decrease the water feed because the plate is getting too dry. That is, after snowflakes disappear the water feed can often be reduced further before general signs of being too dry appear on the sheet. This dry-side problem can be seen when using the dot quality of very small shadow dots as indicators of too low a water feed rate. Once these dots close, or fill in, some important shadow detail may be lost, possibly causing the prints to be defective. Also, after the dots close they cannot give any further information on the degree of dryness. A more desirable indicator would warn the pressman before the dots close, and also show progressive degrees of plate dryness.

PATTERNS OF INK GRAINS OR SPECKS
A recent study was made to find an improved dry-side indicator by examining a large number of test press sheets that had been produced with varying degrees of plate dryness. The test sheets covered the range from wash marks (excess water) to large catch-up of ink deposits in the nonimage areas (lack of water). The sheets to the wet side were in agreement with our earlier studies (1) that showed the size and frequency of snowflakes to give a good measure of the degree of excess water.

The study then concentrated on those sheets in which the snowflakes had disappeared and the plate was getting progressively drier. The images on the test sheets comprised several of the images the pressman often uses in determining his ink-water balance point plus some GATF control targets. They included regular fine-screen halftones and tints, solids, Star Targets (2), and the QC Strip (3). In studying the sheets printed with progressively lower water feed rates, it was noted that well before spots of ink appeared on the surrounding open nonimage areas, patterns of small ink grains or specks appeared in the white areas within the image. These ink grains were too small to be seen individually at normal viewing distance, but their presence caused a slight change in the overall appearance of the target. In the Star Target's white (unprinted) wedges, or radial sectors, the ink grain pattern first began to appear near the center of the target where the radial ink sectors are closest to each other. These grains were either isolated or attached to the edges of the inked sectors. That is, the ink grains appeared first in very small unprinted areas closely surrounded by ink image areas. This condition in the target design seems necessary for high sensitivity in detecting plate dryness. As the plate became progressively drier, the frequency and size of the ink grains increased and they spread outward from the target's center to where the space between the radial sectors was becoming greater.

Figure 1. Ten-diameter enlargement of a series of center sections of Star Targets at left, and corresponding QC Strip segments at right, printed on enamel paper. These images are arranged to show the effects of either increasing ink feed at constant water feed (top to bottom) or the effects of increasing water feed at constant ink feed (bottom to top). Note the decreasing snowflake patterns in the ink film, and then the increasing ink grain patterns in the unprinted area going from top to bottom. The optimum ink-water balance is in the region of the fourth to fifth sections from the top.

20:56

Figure 2. A 60-diameter enlargement of a QC strip segment showing ink whiskers growing on a line tint. Note whisker bridging into two lines at lower right (circled) in illustration.

Figure 3. Star Targets (top) and QC Strip (bottom) at actual size. The segments of the QC Strip repeat at 3-in. intervals in the across-the-plate cylinder direction for up to four colors.

Also, the ink grains were more numerous in those radial sectors that were in the across-the-plate cylinder direction. As the grain pattern increased toward the widest spacing of the sectors, some ink grain began appearing in the nonprinting area immediately outside the target area.

In the line screen tint of the QC Strip, the ink grains first appeared between the ink lines or attached to the lines at about the same time they began to appear in the center of the Star Target. As the plate became progressively drier, the grains sometimes joined together to form "whiskers" of ink bridging the unprinted or white lines between the inked lines. The grains on the edges of the inked lines were not readily distinguishable from the normal roughening of the ink edges. However, the isolated ink grains and the whiskers bridging the closely spaced lines were easily detected with an 8- to 10-power magnifier. As the water feed was further reduced, these whiskers became more numerous, and small ink grains then began to appear in the nonimage areas surrounding the QC Strip, usually somewhat more numerous at the trailing edge of the strip. Figure 1 shows how these two GATF targets appear under a 10-power magnifier. While not easily seen in this figure, the grains are also more numerous in the sectors that ran parallel to the gripper edge.

To visualize the appearance of the original targets as they appeared on the press sheet when viewed at normal reading distance, examine Figure 1 at a distance of 10 to 12 ft. (3 to 3.6 m). Figure 2 is a 60-diameter enlargement of a QC Strip segment that more clearly shows the growth of ink whiskers at the edges of the lines in the tint.

In routine work, if the target or strip does not respond as above to the ink and water feed adjustments, it may indicate troubles somewhere in the press. Such troubles might be defective plates, damaged or incorrectly set rollers, or malfunctions in the dampening system. It is beyond the scope of this article to treat press troubleshooting, and the reader should refer to such GATF texts as *Solving Sheetfed Offset Press Problems* (4) and *Web Offset Press Troubles* (5).

What has been learned from this study is that these targets are more sensitive to ink-water balance than had been realized at their first introduction to the industry. That is, the design features in these targets can, if one uses a magnifier, give a very early warning that the plate is beginning to become too wet or dry. Figure 3 shows the targets at their actual size.

CONTROL PROCEDURES

While the above targets can give a sensitive measure of the state of the ink-water balance, the selection of the optimum balance point can vary from job to job. Due to such factors as the plate condition, ink, dampening system, etc., it might be more favorable to select a point slightly to the wet or dry side for a given job. Or, because of the layout of the plate, the same balance point cannot be achieved across the plate so that compromise balance settings must be used. Whatever target is selected, it should be repeated at about 3-in. (76-mm) intervals across the plate (parallel to the cylinder axis) since it can only indicate the balance in a band that wide around the cylinder (Figure 3).

The choice of initial settings for the ink and water fountains are usually based on the pressman's experience with the type of press and its dampening system. After completing the makeready, he generally has the ink film thickness or reflection density close to the required standard and has the water feed near a satisfactory balance. Fine adjustments in either feed rate during the production run may require corresponding adjustments in the other rate. For example, a slight decrease in the water feed rate may cause an increase in the ink film transferred unless a corresponding decrease is also made in the ink feed rate. After each adjustment to the feed rates, a sample of several inspection sheets should be pulled and checked after the press has reached a new equilibrium balance, to determine if the print quality is on standard.

Among the problems encountered in controlling the balance point is determining the normal sample-to-sample random print variations from those due to longer drifts that occur during the run. Some small sample-to-sample variations are inherent in the press operation. Thus, slight balance changes in the targets of an inspection sheet may not require press adjustments unless successive sampling of inspection sheets indicates a definite trend toward wetter or drier. The amount of allowable latitude for these variations

depends in part on the number of units in the press. Single- and two-color presses generally can be given the most latitude. On four-color presses the press sheet accumulates moisture at each successive impression and this can cause snowflaking in overprint areas of the later-down colors. To minimize this accumulation effect, the latitude should be reduced in the wet-side direction.

After the balance point is set, the use of a magnifier on the targets is usually not necessary on every pull of inspection sheets unless the job is very critical. Under most press running conditions, just comparing at normal viewing distance the inspection sheets' Star Targets or QC Strip to their appearance on the OK sheet will usually detect a change in the balance point. When a change is noted, checking with a magnifier will indicate the kind of press adjustments required.

While ink-water balance is an important control of the print quality of the sheet, the pressman's selection of the water and ink feed rates must consider the requirements of other print quality factors. These other factors, such as register, setoff, color reproduction, halftone quality and resolution, etc., must also meet the standards required of the job. These requirements sometimes are in conflict with each other and require compromises in their setting and control. Studies at GATF are now under way to combine ink-water balance control with the controls of other important print quality factors.

SUMMARY

Table I is a summary of the ink-water balance control procedure in tabular form.

BIBLIOGRAPHY

1. *GATF Research Progress No. 58*, "The GATF Press Inkometer and the Automatic Control of Press Dampening," Order No. 6058.

2. *GATF Research Progress No. 71*, "The GATF Star Target," Order No. 6052.

3. *GATF Research Progress No. 71*, "The GATF QC Strip," Order No. 6071.

4. *Solving Sheetfed Offset Press Problems*, GATF, 1981, Order No. 1501.

5. *Web Offset Press Troubles*, GATF, 1979, Order No. 1518.

The above publications are available from the Graphic Arts Technical Foundation, 4615 Forbes Avenue, Pittsburgh, PA 15213 U.S.A.

Table I
Control of Ink-Water Balance

No.	Print Condition	Press Adjustment
1	Snow in targets	Reduce water feed or increase ink feed
2	Ink grains in targets	Increase water feed or decrease ink feed
3	Targets OK, but ink film too light	Increase both ink and water feeds
4	Targets OK, but ink film too heavy	Reduce both ink and water feeds
5	Targets not OK, but cannot be corrected by adjustments of ink or water feed rates	Check condition of plate and press. See troubleshooting references 4 and 5 in Bibliography